SOCIETY OF ILLUSTRATORS
59TH ANNUAL OF ILLUSTRATION

SOCIETY OF ILLUSTRATORS
59TH ANNUAL OF ILLUSTRATION

FROM THE EXHIBITION HELD IN THE GALLERIES OF THE
MUSEUM OF ILLUSTRATION AT THE SOCIETY OF ILLUSTRATORS
128 EAST 63RD STREET, NEW YORK CITY
JANUARY 4–FEBRUARY 25, 2017

59

ILLUSTRATORS 59

SOCIETY OF ILLUSTRATORS, INC.

128 East 63rd Street, New York, NY 10065-7303
www.societyillustrators.org

Published and distributed by:
Society of Illustrators, Inc.
128 East 63rd Street
New York, NY 10065-7303

ISBN 10: 0-692-99308-8
ISBN 13: 978-0-692-99308-8

Editor, Jill Bossert
Book and cover design by Richard Berenson
Front cover illustration by Ofra Amit
Back cover illustration by Lisk Feng
Jury photos by Breann McGovern

Printed in Canada
First printing 2017

SI 59
TABLE OF CONTENTS

Portrait by James Yang

SOCIETY OF ILLUSTRATORS 59

PRESIDENT'S MESSAGE
TIM O'BRIEN

In this 59th Annual are all kinds of illustrators, from cartoonists to painters, watercolorists, sculptors, animators, digital wizards, idea people, technique people and everyone in between. We are in a most exciting era of illustration, one where we see increasingly diverse illustration styles, as well as diversity in the illustrators who create this work. This volume represents a great slice of the best of who we are today. Congratulations to all the artists fortunate enough to be included.

The Society of Illustrators is a unique organization, dedicated to the art of illustration in all its various forms. We are also an educational organization with lectures and workshops throughout the year. We run our annual Drawing Academy for inner-city kids. We also work with high school students to ready their portfolios, and of course we highlight the next generation of illustrators through our Student Scholarship Exhibition, which has been the first to discover and celebrate the talents of many of the stars of today, including James Jean, Kadir Nelson, Tomer Hanuka, Victo Ngai, JooHee Yoon among many others.

As a community-outreach organization, our members visit children's hospitals and draw for the young patients, others do the same for veterans at the VA hospital to help brighten their days. And, on occasion, we support those members of our community in need. And of course we provide a venue for countless events and gatherings all year long.

The Society of Illustrators is open to all kinds of illustration and we exhibit it all: editorial and book illustration, fashion illustration, advertising work, art for films, art for public spaces, comic and cartoon art, children's book illustration through our Original Art Exhibition, science fiction/fantasy illustration, and surface and product design.

In addition, we have an extensive and amazing Permanent Collection comprised of over 3,000 works of art.

The Society of Illustrators also hosts MoCCA Fest each spring, the largest indie comic and cartoon art festival in Manhattan.

If you are in this Annual book and are a member, we thank you so much for your support. If you're in this Annual book and are not a member, I ask that you join us now. We are your continual beacon for illustration.

I would like to thank ALL of the new members who joined us this year. You are doing us a great honor by supporting us and being a part of what the Society of Illustrators will be going forward.

The Society's hard-working staff is remarkable. Thank you Kate Feirtag, Breann McGovern, Johnny Dombrowski, Steve Compton, Lisa Cicerello, Ramon Bloomfield and Eric Fowler. I would like to thank our Director of Operations, John Capobianco; Jill Bossert, our Annual book editor; and Richard Berenson, who helps us not only with the Permanent Collection, but also with the design and production of the Annual book every year. Thanks also to our interns and volunteers, who are invaluable.

Finally, I would like to offer my heartfelt appreciation to Anelle Miller, our Executive Director. She is energetic, smart and really loves the Society. She has always had a vision for the Society that exceeds our own, and has helped to transform this organization into the modern one you see today.

Illustration is an amazing profession and this Annual is a beautiful snapshot of where we are today. The Society of Illustrators is an organization that celebrates where we came from, where we are, and where we are going.

CHAIR'S MESSAGE
JOSH COCHRAN

The year I spent as Chair of the Society of Illustrators 59th Annual of Illustration was an eye-opening experience. As illustrators, it seems more important than ever for us to have a strong, clear voice in this chaotic, frenzied field, especially during this crazy time in the world. The underrepresented, creative community needs to come together and support one another.

This year I had the honor of working with one of the most diverse and talented juries put together to judge an illustration contest. There were many lively and spirited discussions as the jury deliberated over the Medals. Because of this, a very distinctive and strong range of talent has been represented.

This year's poster features two very different takes on the theme of the orchestra. David Jien created a densely lush, graphite and color pencil drawing of grotesque and beautifully rendered creatures playing instruments. On the other side of the poster, Eric Hu created a typographic solution that included an email from his mom circa 2003. Both artists come from very different places artistically, but due to mutual friendship and respect they requested to work together.

It has been a great honor to serve as the Chair for Illustrators 59. I sincerely hope you take some time to peruse this amazing cross section of art, created by some of the most talented and inspiring illustrators and image makers working today.

Portrait by Jon Han

HALL OF FAME 2017

Since 1958, the Society of Illustrators has elected to its Hall of Fame artists
recognized for their "distinguished achievement in the art of illustration."
The list of previous winners is truly a "Who's Who" of illustration. Former presidents of the
Society and illustration historians meet annually to elect those who will be so honored.

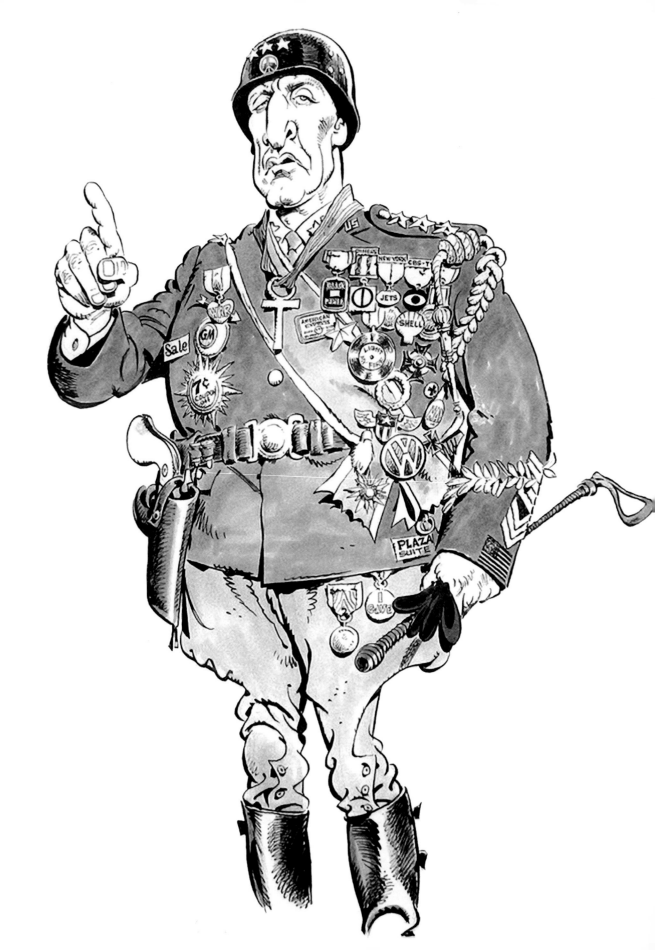

MORT DRUCKER

[b. 1929]

Mort Drucker by Drew Friedman

As any dedicated portrait artist will tell you, capturing the true likeness of your subject takes more than just a careful rendering of their features. Revealing the essence of a person—who that person is—requires greater insight. The art of caricature is even more difficult, for here the artist seeks to capture those essential qualities within the context of humor and/or commentary. This secondary layer is traditionally achieved through exaggeration and/or distortion of the subject's likeness. No easy task—except for a talent like Mort Drucker, who defines this particular art form and makes it look easy in the process.

A native of Brooklyn, New York, Drucker is a self-taught artist who learned his craft in the trenches of comic book publishing houses in the late 1940s. He started out as a studio artist doing backgrounds and corrections on the original pages of some of the cartoonists he admired most. Though he lacked experience, Drucker's talent soon became obvious to the various studio art directors for whom he worked and he quickly moved up in the ranks until he was offered scripts to pencil and/or ink on his own from start to finish.

Like many comic book artists at the time, Drucker aspired to one day be part of the world of syndicated comic strips, where cartoonists enjoyed far greater public recognition and financial reward for their efforts. When the opportunity came for him to ghost for artists with established daily strips or panel cartoons, Drucker gladly took on the work. Ironically, it was several assignments to illustrate humorous, celebrity-focused comic books (with stars such as Bob Hope and Jerry Lewis) that paved the way for Drucker's legendary career as one of the most admired and influential caricaturists in the field of humorous illustration.

As an editor of *MAD* magazine with a background in art, I found that one of my most satisfying tasks was to find and develop new writers and artists to amplify the freelance talent pool of our growing publication. In 1956, when Drucker answered a classified ad we had placed in *The New York Times* seeking a humorous illustrator, I was as much impressed with his ability as a panel-to-panel storyteller as I was with his virtuosity as a caricaturist. His pen-and-ink mastery, thoughtful composition, and varied use of light and shade gave me reason to call in the rest of the editorial

George C. Scott as Gen. George Patton
The artist holds both gentlemen in the highest esteem.
Courtesy *Mad* #140, EC Comics

and art staff to view Drucker's portfolio. All were in agreement—this was a talent beyond anything we had hoped for. And so Mort Drucker left the office with his first *MAD* assignment, beginning what would eventually become a magical fifty-plus year association.

As *MAD* became an established (albeit absurd) voice in the nation's cultural mainstream, many of the visual masters who showcased the magazine's written content eventually became icons in and of themselves. Indeed, Mort Drucker proved to be one of the most popular artists of the group that collectively came to be known as the "Usual Gang of Idiots." His renditions of personalities, despite their satiric bent, were sought by the personalities themselves. Alas, attempts by the celebrities to purchase Drucker's original art were thwarted by *MAD*'s policy at the time, of owning all the originals. *MAD*, however, had a non-exclusive policy with their freelance creators, which left the door open for Drucker to score far more lucrative illustration assignments for advertising, movie posters, book publishing, record albums and non-humor magazines.

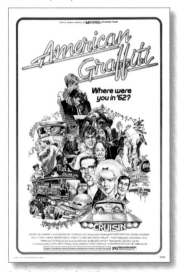

George Lucas, a *MAD* fan from his youth, had only Mort Drucker in mind to design the poster for his first mainstream film in 1973, *American Graffiti*. And Drucker's cover designs for *TIME* magazine and *TV Guide* were as lauded as his covers for *MAD*. When Michael J. Fox appeared as a guest on the Tonight Show with Johnny Carson in 1985 to promote *Back to the Future*, he was asked about the moment he realized he had made it. His reply, "When I was caricatured by Mort Drucker in *MAD* magazine," said it all.

Of course, nothing can match the importance of acknowledgment from one's peers in any profession. Along with the very highest honors from the National Cartoonists Society, Drucker's standing within the ranks of fellow artists was made more evident when Hanna-Barbera decided to create

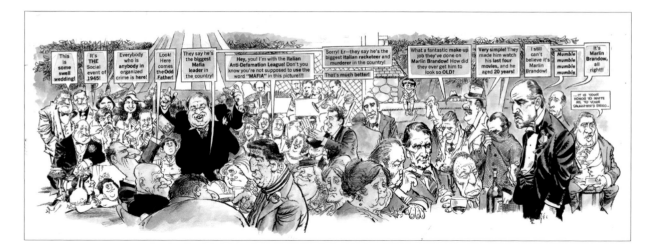

inspirational seminars for their studio art staff. Put to a vote as to who they would prefer to be the initial speaker for this series, they overwhelmingly chose Mort Drucker.

As word of the successful event traveled throughout the industry, the Disney studio decided to do the same for their famed art staff of animators. Once again the vote placed Drucker at the top of the list.

Being the modest and somewhat shy person he is, Mort requested that I, his close personal friend for so many years, introduce him and conduct the Q-and-A that would follow these presentations. At each of these special events, the mensch-like artist who had inspired countless others, thanked me for having "discovered

Drucker's Godfather Parody
"Don Minestrone" and his loving (but violent) family.
MAD #155, December 1972
EC Comics

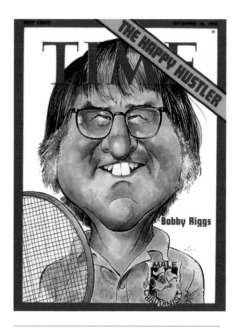

Bobby Riggs Before His Battle of the Sexes Match
TIME magazine cover, September 10, 1973
Ten days later, Riggs' female opponent, Billie Jean King, won the match 6–4, 6–3, 6–3.

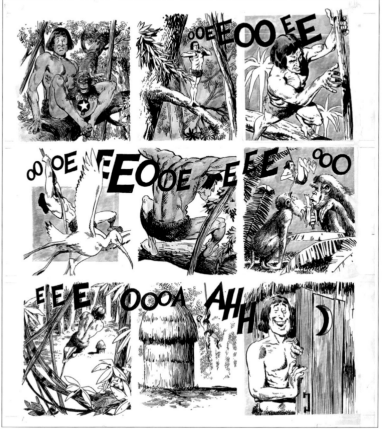

A Race Through the Jungle
1-page Tarzan Story
MAD #56, 1960, EC Comics

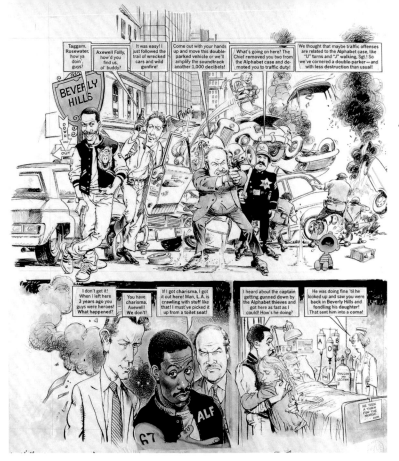

Beverly Hills Slop, Too

Those California Keystone Cops, Axel Folly, Taggem, and Rosewater, star in Mort Drucker's parody of "Beverly Hills Cop II." *MAD* #275, 1987, EC Comics

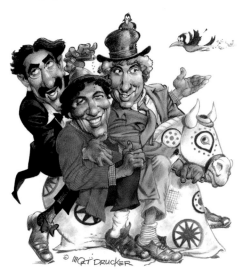

The Marx Brothers
Groucho, Chico and Harpo

him." My response to his nod of appreciation brought smiles of awareness and agreement from the knowing audience.

"Mort," I said, "giving me credit for discovering you is like giving credit to the first sailor who set eyes upon the Rock of Gibralter—there's no way anyone could have missed it!"

The Society of Illustrators is obviously in full agreement by inducting my friend into the Hall of Fame. And no humorous illustrator is more deserving of this great honor than Mort Drucker.

Nick Meglin
Former editor *MAD* magazine

The Shootist
The parody of John Wayne in his final film role. MAD #190, August 1976 EC Comics

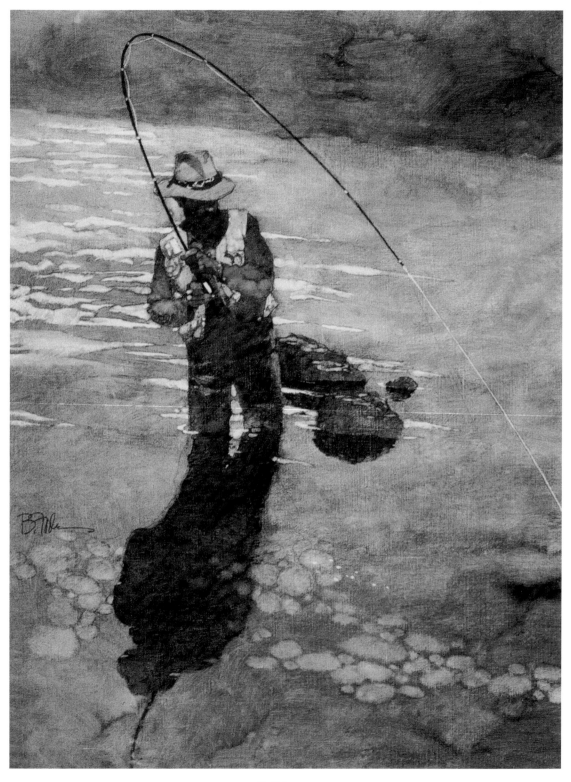

Fly Fisherman
Sports Afield, 1986, Oil on canvas
All images courtesy of Bart Forbes

BART FORBES

[b. 1939]

Portrait of Bart Forbes
by Mary Jo Forbes

My fifty-year friendship with Bart Forbes began in Dallas in the 1960s. He was a wannabe illustrator and I was a newly-minted studio artist. It's a relationship that has lasted through thick and thin, adversarial editors, antagonistic writers and impossible deadlines. It may be why Bart thought I could illuminate aspects of his life and career for this book.

Born in Oklahoma, Bart was raised in an Air Force family. By the time he was four, he knew he loved to make pictures. It was a love that would continue through high school in Cincinnati, Ohio, and then at the University of North Carolina, where he did artwork for the student newspaper, *The Daily Tar Heel*. Following an honorable discharge from the Army, he did postgraduate work at the prestigious Art Center College of Design in Los Angeles, where he was influenced by John La Gatta, also a Society of Illustrators Hall of Fame member.

Following La Gatta's suggestion to start out in the Southwest, Bart began his career at a small Dallas studio, where he did everything from storyboards to lettering. By the next year, when he went out on his own as a freelancer, he had developed his signature painting style, at first using Dr. Martin's aniline dyes. Though brilliant in color, the dyes had a propensity to fade over time, so not long after he began using Windsor & Newton watercolors.

Ready to go national, Bart took his portfolio to New York and got his first magazine assignment: the cover for *American Airlines* magazine, then art directed by award-winning designer B. Martin Pedersen. He also signed with esteemed artists representative, Barbara Gordon. Thereafter, most of his work came from the prestigious New York paperback and magazine publishers, and top ad agencies. His corporate client list is extensive and includes Exxon, the United States Mint, Hilton Hotels, Philip Morris, Pepsi Cola, Lockheed Martin, General Electric and ABC-TV.

In the 1970s and early '80s his work often appeared in *McCall's, Redbook* and *Seventeen*, alongside other leading illustrators, in the days when monthly works of fiction were accompanied by lush illustration. Despite the preponderance of work from the East Coast, Bart remained in Texas, thanks in part to the advent of overnight delivery services.

Over time the illustration markets changed and Bart was in a position to manage his own career. In the late 1980s and early '90s, he switched his medium to oil on canvas after a persistent client convinced the reluctant artist to tackle several 4' x 6' paintings. The large format made working with fast-drying watercolors problematic. Bart also devised a method of taping his canvas to foam core board, working on them (sometimes on a ladder), then when dry, rolling and shipping them off to clients.

Bart's list of first-class publications grew beyond the so-called "women's magazines" to include *TIME, Boys' Life* and *Sports Illustrated*. My introduction led to Bart's first assignment from Richard Gangel at *Sports Illustrated* in the early 1980s. His reputation as a sports artist grew to include clients such as the PGA Tour, for which he did golf posters and promotional materials for many of their tournaments and clubhouses, including several large murals for the TPC Sawgrass clubhouse at PGA Tour Headquarters. He also worked for the National Football League, and such events as the America's Cup, the Indianapolis 500, the Kentucky Derby and golf's Ryder Cup.

In 1986, Bart was named Sports Artist of the Year by the American Sport Art Museum and Archives, in Alabama. Two years later he was named the Official Artist for the Olympic Games in Seoul,

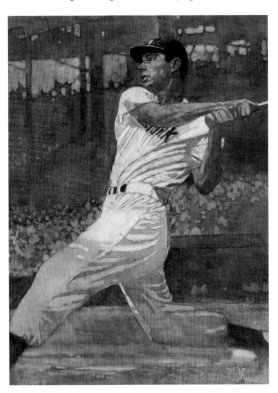

Joe Dimaggio
Boys' Life, 1999
Oil on canvas

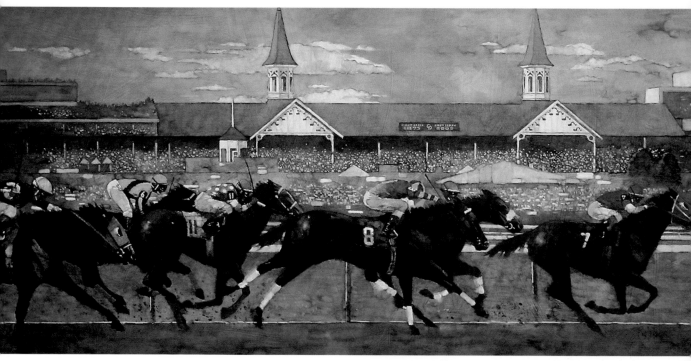

ABOVE:
The Kentucky Derby
2005
Oil on canvas

BELOW:
The 15th Winter Olympics
ABC-TV, 1987
Oil on canvas

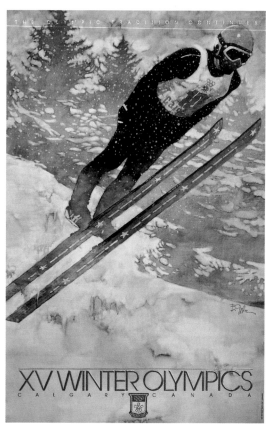

ABOVE:
Poster for the U.S. Olympic Team
1992
Oil on canvas

BELOW:
Morning Round
Professional Golfers Association, 1992
Oil on canvas

South Korea, where he created paintings of each Olympic event, works that are now housed in their Olympic Museum. He went on to do paintings for the United States Olympic Committee. His work for individual teams include the Atlanta Braves, Cincinnati Reds, New Jersey Devils and the Orlando Magic. Since the mid-2000s, he has been commissioned to create mural-sized paintings for the San Francisco 49ers, Dallas Cowboys and Green Bay Packers.

Bart has also designed 16 commemorative postage stamps and 11 postal cards for the U.S. Postal Service, including the 1988 Olympic Stamps, "America the Beautiful" series, the President Ronald Reagan Centennial stamp, and a stamp honoring singer Sarah Vaughn.

Two of Bart's paintings hang in the National Portrait Gallery in Washington, DC. A *TIME* cover of Larry Bird and Wayne Gretzky, and President Jimmy Carter for *TIME*'s Man of the Year issue.

Bart and I worked on many stories together when I was art director at *Sports Illustrated,* and never once did I worry about an unsuccessful outcome of an assignment. One such job required Bart to create cover art for a heavyweight championship boxing match—on three days' notice. He came to New York to meet with the editor and review reference material. He then returned to his studio to do the painting. The next morning he flew back to New York with the painting (and brushes in hand, just in case). The magazine was set to go to the printer that day. But the editor wanted a big change. He thought one of the boxer's profiles wasn't a clear enough likeness.

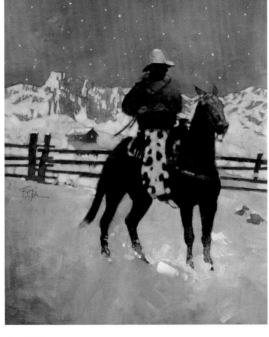

Boys' Life *cover*
1996, Oil on canvas

It needed to be re-worked. The other editors and writers were frantic. The minutes ticked away while we searched and found a reference photo that would work. Bart made the correction and the issue went to press on time—to everyone's great relief.

Not all our assignments were such high-pressure, "Breaking News" stories. Some were civilized, elegant, even charming, with quite respectable deadlines. As always, Bart's resulting artwork would do what it should: prompt the reader to "turn the page."

Respected by his peers, the award-winning artist is a role model to aspiring neophyte illustrators, not only as a teacher at East Texas State University and at workshops nationwide, but simply by the example he sets as a visual communicator.

He has always maintained his home and studio in Dallas, where for a number of years he owned a studio with designer Jack Summerford and the late illustrator/fisherman Jack Unruh (another Society Hall of Fame recipient). The building was on a street with antique shops and boutiques, so Bart's wife, Mary Jo, opened a gallery that featured works by illustrators. Throughout his career, Bart's family has played a key roll in his artistic journey and the success he still enjoys. He and Mary Jo were married 47 years ago—I attended the wedding as Bart's best man. Both his children chose creative fields; his son Ted is a videographer, and daughter Sarah is a graphic designer.

Bart continues his illustration assignments, and, since 2003, he has found time to create paintings for art galleries. So, when he's not resolving a client's visual problem, or designing stamps for the U.S. government, he creates remarkable, even transcendent, imaginary landscape paintings—expressions that are seductive and magnetic.

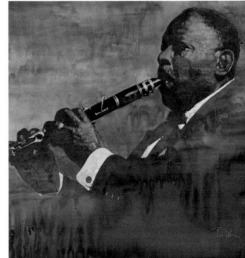

Giants of Jazz: Johnny Dodds
Time-Life cover, 3-Record Set
1982
Oil on canvas

Bart Forbes has achieved much in his long career and it is fitting that he be recognized by the Society of Illustrators and join the august company in its Hall of Fame.

Richard W. Warner
Former art director *Sports Illustrated*

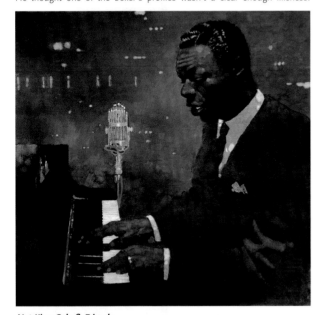

Nat King Cole & Friends
RIFFIN! The The Decca Jatp Keynote & Mercury Recording
Verve CD Cover, 2010
Oil on canvas

Tarzan

by EDGAR RICE BURROUGHS

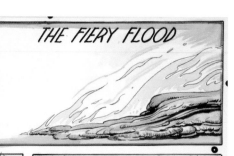

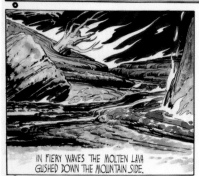

IN FIERY WAVES THE MOLTEN LAVA GUSHED DOWN THE MOUNTAIN SIDE.

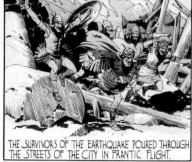

THE SURVIVORS OF THE EARTHQUAKE POURED THROUGH THE STREETS OF THE CITY IN FRANTIC FLIGHT.

TARZAN PICKED UP TANNY. THE BOY PROTESTED. "I DON'T WANT TO BE A BURDEN. I CAN RUN."

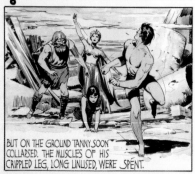

BUT ON THE GROUND TANNY SOON COLLAPSED. THE MUSCLES OF HIS CRIPPLED LEG, LONG UNUSED, WERE SPENT.

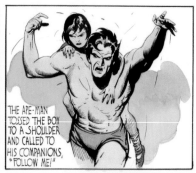

THE APE-MAN TOSSED THE BOY TO A SHOULDER AND CALLED TO HIS COMPANIONS, "FOLLOW ME!"

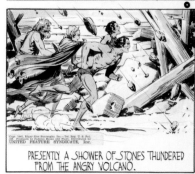

PRESENTLY A SHOWER OF STONES THUNDERED FROM THE ANGRY VOLCANO.

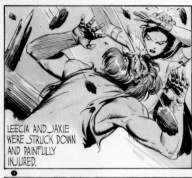

LEECIA AND JAXIE WERE STRUCK DOWN AND PAINFULLY INJURED.

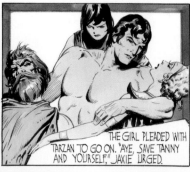

THE GIRL PLEADED WITH TARZAN TO GO ON. "AYE, SAVE TANNY AND YOURSELF," JAXIE URGED.

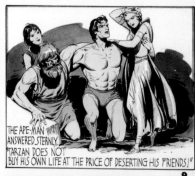

THE APE-MAN ANSWERED STERNLY. "TARZAN DOES NOT BUY HIS OWN LIFE AT THE PRICE OF DESERTING HIS FRIENDS!"

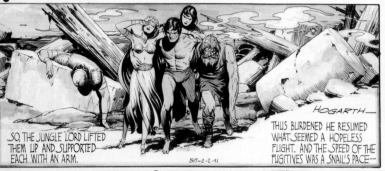

SO, THE JUNGLE LORD LIFTED THEM UP AND SUPPORTED EACH WITH AN ARM.

HOGARTH

THUS BURDENED HE RESUMED WHAT SEEMED A HOPELESS FLIGHT. AND THE SPEED OF THE FUGITIVES WAS A SNAIL'S PACE—

517-2-2-41

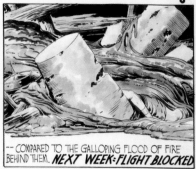

— COMPARED TO THE GALLOPING FLOOD OF FIRE BEHIND THEM. *NEXT WEEK: FLIGHT BLOCKED*

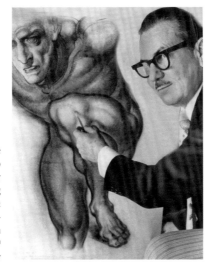

Born Bernard Ginsburg in Chicago in 1911, Burne Hogarth's instinct for showmanship led him to dominate in two major turns of his long career of hyperbolic drawing. He was a prodigy, earning a berth at the Chicago Art Institute at a mere 12 years of age, and becoming a professional cartoonist by age 15, while reinventing himself as a descendent of William Hogarth, the brilliant 18th century political caricaturist and great-grandfather of the comic strip.

Hogarth knocked around the newspaper art business for a decade, and attended a number of institutions of higher learning (including Columbia University), during which he drew a couple short-lived comic strips and taught at the WPA government arts project. 1937 brought his big break: Hogarth replaced Hal Foster at the helm of the newspaper adventure strip, *Tarzan of the Apes*, for the King Features Syndicate. In order to preserve continuity and maintain the attention of an audience, comic-strip syndicates usually chose artists who could work much like their predecessors for a seamless transition. Foster is said to have selected his successor, but it would turn out that their artistic sensibilities were at opposite poles, and in short order Hogarth radically remade the strip.

By the time Foster retired from drawing *Tarzan* in 1936, he had taken the strip from pulp fiction fantasy and established it as an adult staple of entertainment, one within the realm of the possible, which he staged like an historical epic silent movie. Burne Hogarth pulled the strip back to the juvenile and the fantastic. It featured blatantly superhero gymnastics, science-fiction characters, and a breathtaking succession of melodramatic moments, where all creatures and objects were crowded within a weapon's reach, mostly airborne. It was the comic strip you could read from across the room.

Hogarth left *Tarzan* in 1945 to create his own adventure strip, *Drago*, for the New York Post Syndicate, with its title character a classy Argentinian gaucho battling German villains. Judged unsuccessful, perhaps due to its flat characters and dialogue, it only lasted a year, though it was richly drawn, and is still prized by collectors.

Not much later, he was back at *Tarzan*. With newly-gained artistic license,

Tarzan Hand-Colored Sunday Comic Strip
February 2, 1941, United Feature Syndicate
The Lord of the Jungle braves fiery waves of molten lava and showers of stones from an angry volcano to save his friends.
Courtesy Heritage Auction Galleries

Hogarth took *Tarzan* well beyond Edgar Rice Burroughs's domain, with his depictions of the absurd yet treacherous creatures, the "Ononoes." He devoted himself to the *Tarzan* strip for 12 years altogether, and it is his indelible version of the character that is best known. He even circled back to the "Lord of the Jungle" during the 1970s, inventing new adventures in graphic novel form.

Teaching was a lifelong interest for Hogarth. Fueled by the post-war resurgence of interest in commercial art, and the funding implicit in the GI Bill, he threw himself into the challenge of starting an art school in the 1940s. This was the phase of his career that would have the most lasting impact. Using the selling point that he'd be teaching to a professional standard—because he knew what editors wanted—Hogarth founded the Academy of Newspaper Art in 1944. With structural and name changes, in 1947 this became the Cartoonists and Illustrators Art School, with partner, Silas Rhodes. Hogarth advertised for students with his drawing of a centaur wielding a pen as a javelin, which was enlarged onto New York City buses. This was his baby: he worked on the curriculum, as an instructor, and in the administration as well. By the time he left in 1970, the school had morphed

into The School of Visual Arts and become known as a top school for illustration, graphic design and more. Over the course of three decades, Hogarth bolstered his hands-on teaching by authoring six books on drawing, five of which had the word "dynamic" in the title.

Hogarth's drawing manner is best described as equal parts late-Michaelangelo (every muscle tensed), Paul Manship (every muscle etched), and Joe Shuster (every muscle massive), yet looking like no one else but Burne Hogarth. His heroic figures seem stripped of fat and almost even of

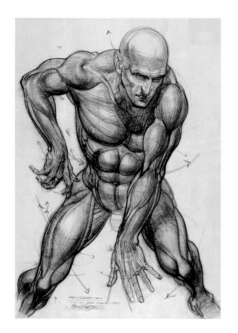

The thousands of classroom drawings
Hogarth produced for his students became the basis for the 1958 classic *Dynamic Anatomy*. The book defined the figural concept in art while giving solutions for drawing figures in deep foreshortening and from multiple perspectives.

Burne Hogarth is known today for six volumes of drawing anatomy, which are the foundation of art study for students around the world.

 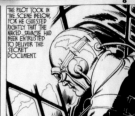

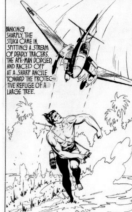 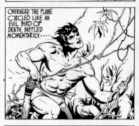 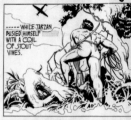

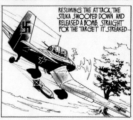 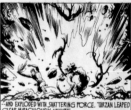

 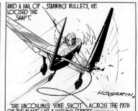

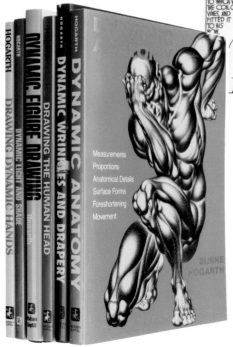

Tarzan #675 Sunday Comic Strip Original Art, February 13, 1944
United Feature Syndicate
Titled "Flying Death," this World War II-era strip features a German Stuka bomber strafing the Lord of the Apes.
Courtesy Heritage Auction Galleries

skin. This foregrounding of visual power over character and expression was enormously influential on the look—and function—of comic book art since its Golden Age. His followers could be numbered well beyond the hundreds who took his classes at SVA over two decades.

Like other outsized American talents, Hogarth received most of his awards and recognition at comic art festivals outside the USA: Montreal (1975), Lucca (1984), Barcelona (1989) and Angouleme (1996). It was just hours after he was feted for Lifetime Achievement at the latter that he died of heart-failure.

Roger T. Reed

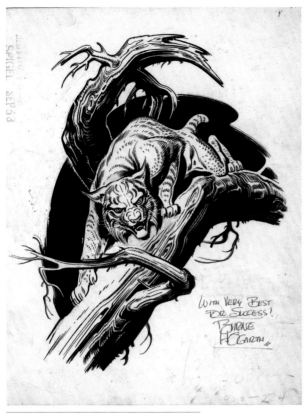

Cougar Illustration, Original Art
Spigel, 1953
Courtesy Heritage Auction Galleries

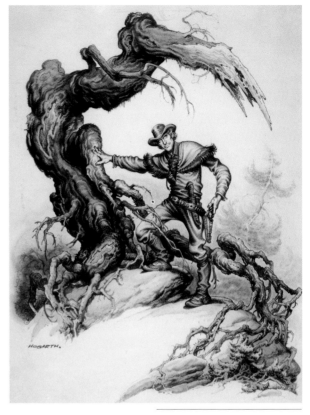

Gunslinger Illustration, Original Art
Courtesy Heritage Auction Galleries

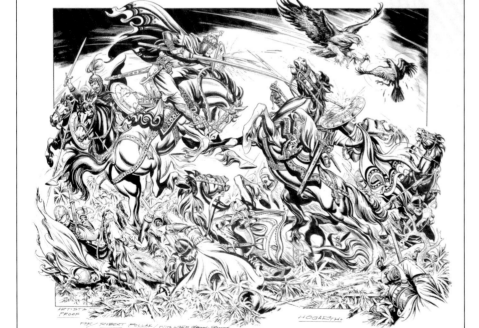

Artist proof for King Arthur Series
Lithograph on paper
Published 1983
Museum of Illustration at the
Society of Illustrators.
Donated by R. Robert Pollak

There's some monkey business going on. In her personal work, Anita Kunz re-imagines Old Master paintings, appropriating the cliché nudes, unseating men with women sitters, and not infrequently adding a monkey or two. The simians pinch nipples, draw blood, dance, haunt, cling, replace human babies, nurse human babies.

I've always been intrigued with the idea that we share so much genetic material with other species, particularly monkeys. I think that I've always wondered about human behaviour and whether or not ancient impulses are in fact what are to blame for our basic natures, particularly having to do with violence, warfare, love and mating etc. I really think I've used monkeys as metaphors for our own behaviour. –Anita Kunz, 2017

In art history, the monkey is also a traditional symbol standing in for the artist, who apes life on canvas. Monkey business underpins Kunz's editorial illustrations as well: Darwin clings to a tree-trunk; so does the rock band The Monkees (of course). But her foolery is more sophisticated than that. As illustrator—a role in which the artist acts as a medium, channeling society's every twitch—Kunz monkeys with meaning: on the cover of *The Progressive*, for instance, a Democrat senator in the guise of St. George attacks a money-scaled hydra.

The granddaughter of German immigrants, Kunz was born in Toronto in 1956, and raised in Kitchener, Ontario, Canada. Her upbringing was traditional and conservative, with an emphasis on discipline and being "nice." She rebelled.

As monkeys are like artists, so Canadians are uncanny doubles of Americans: almost, but not quite, the same; aping their neighbors to the south but criticizing them too. "We Canadians are so inundated with American culture and politics that to comment visually on various American themes is not merely easy, it is vital and facilitated by the fact that I'm one step removed," she said in 2003, on the occasion of her solo exhibition at the Library of Congress's Swann Gallery of Caricature and Cartoon. On *The Walrus* magazine (Canadian equivalent to *The New Yorker*), this Canadian literally gave a pictured Uncle Sam a black eye. Multiple times, she has both caricatured and honored presidents, senators and other deserving targets on the covers of *The New Yorker* and *TIME*. The cover of the annual juried book, *200 Best Illustrators Worldwide* for 2005 (she has been in every volume since its inception), bears an Orwellian likeness of George W. Bush—with two mouths.

Young Anita's first mentor was her uncle, Robert Kunz, a commercial artist who also illustrated a weekly Toronto newspaper column for kids. His motto was "art for education." She says, "Uncle Robert taught me that an artist's work could actually play a meaningful role in society and in culture, whether as education or journalism. That focus in me came very early on." For her, making meaningful images is an artist's responsibility.

After taking classes at nearby Sheridan College, where the renowned Frank Neufeld led illustration, Kunz transferred to Toronto's Ontario College of Art (now OCAD University), where she took classes with Canadian greats Will Davies, Gerry Sevier

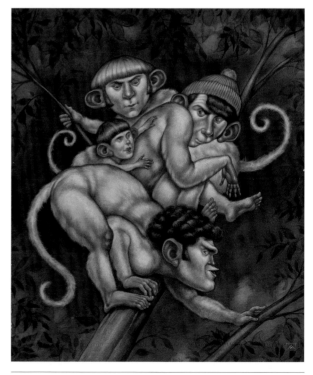

Girls Will Be Girls
The New Yorker, July 30, 2007
A.D. Françoise Mouly
A piece about how women are pressured to display their bodies in different cultures.

The Monkees
Rolling Stone, A.D. Fred Woodward
For an ongoing back page series that was a made-up history of Rock 'n Roll.

and Doug Johnson. She graduated in 1978.

At OCA Kunz also encountered visiting American illustrators such as Brad Holland and Bernie Fuchs. Because of them, Kunz participated in the Illustrators Workshop, an intensive summer course established by Fuchs and others. She recalls, "I went to the Workshop twice, and my teachers were Mark English, Bernie Fuchs, Alan E. Cober (loved him!), Bob Peak, Fred Otnes and Bob Heindel. It was eye opening, and great to witness these amazing artists and see their studios, particularly for someone like me from a small town. I saw their amazing lifestyles and fancy houses and cars and thought 'Ya! I want to do that!' Haha-ha!—Reality was quite different." Yet some thirty years later, in 2003, Steven Heller would include her in the highly selective book, *100 Illustrators*. That same year she also received Canada's highest civilian award, Officer of the Order of Canada; followed by the Queen Elizabeth II Diamond Jubilee Medal in 2012.

Such a future was unimaginable in 1980. Although her first magazine cover was published in 1979, young Kunz mainly gained experience through

No More Guns
VIBE magazine
About the dangerous proliferation of guns.

mundane jobs such as illustrating cat and dog food ads. In 1981 Kunz lived in London, drawn there by British luminaries Ralph Steadman, Sue Coe, Robert Mason, Janet Woolley and Russell Mills, who were known for gritty and politically-charged imagery. Returning to Canada she found there was not enough local work to live on, so she began soliciting assignments in New York. Marshall Arisman armed her with a list of art directors and wrote an article about her in *Communication Arts*.

Early clients were *Mother Jones*, *Saturday Night* and the eccentric *Regardie's* magazine. She also did around 50 book covers, and occasional advertising. Supportive art directors included Canadians Louis Fishauf and Fred Woodward. Although she never thought of portraiture as a specialty, it was confirmed as her métier when, between 1988 and 1990, Woodward gave her a steady monthly assignment with *Rolling Stone* to provide humorous portraits for its "History of Rock & Roll" endpaper. These frequently punned on some aspect of the subject's name or persona: the first, depicting Chuck Berry, shows the '50s rocker eyeballing a line of toddling

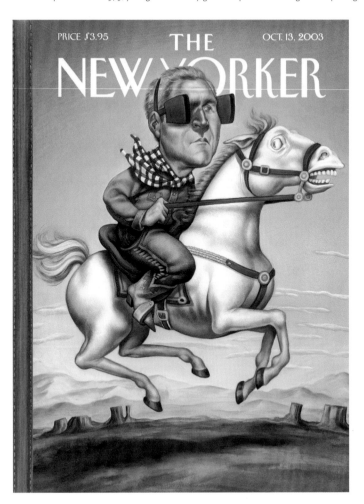

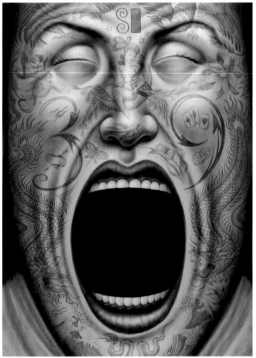

Society of Illustrators 39th Annual of Illustration
Call For Entries, 1996

President George W. Bush Blindly Leading the Nation to War
The New Yorker, October 11, 2003
A.D. Françoise Mouly
Published when the US invaded Iraq.

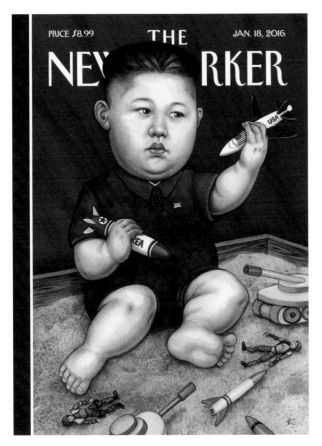

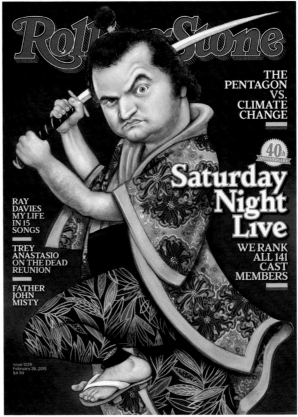

ducks—purportedly the inspiration for his famous "duck walk" stage act.

Kunz's celebrity parodies ape their subjects with cheek, as do her satires of politicians. "Humor is great for telling stories and making difficult things palatable," Kunz explains. On *The New Yorker* cover, George W. Bush blithely gallops along on horseback—wearing the blinders meant for the horse. North Korean dictator Kim Jong-un is an ominously somber, plump baby, playing by himself in a corner with toy missiles, tanks and soldiers. She's had her share of condemnation, lawsuits and stalking because of her visual banter.

Nobody was original who didn't take risks...[but] art has power—
let's make sure we use it wisely. — Anita Kunz, ICON9, Austin, 2016

Irony, comedy and wit also characterize her commentaries on diverse subjects from human cloning to global warming. In one, several spotted, phallic mushrooms illustrate an article on sexually transmitted disease. The unfunny has its place too: on another *New Yorker* cover a soldier calls home at Christmas, his too-many days away from family scored—the way prisoners mark time—in the shape of a Christmas tree on the barracks wall behind him.

Kunz found much leeway to illustrate controversial subjects in the earlier part of her career. It was in the aftermath of 9/11, when she attests that the editorial climate became more conservative and prohibitive, that she resolved to do more self-directed artwork (about one third of her time, alongside teaching and illustrating). This allowed her to work at a larger scale, to make social and political commentary at will, and to focus on subjects she finds emotionally moving—animal rights, social justice, and gender among them. It is in series such as *Precious Creatures* and *Redux* that we find explorations of archetypal women, often quoting art history to reclaim a feminist space; to explore the purported human/animal divide; and to question standards of beauty. It is here that the pranking primates have proliferated. One simian "other" holds hands with a human in friendship as her equal. Such jesting monkeys could not signify more seriously.

Jaleen Grove, Ph.D.
Historian of Illustration

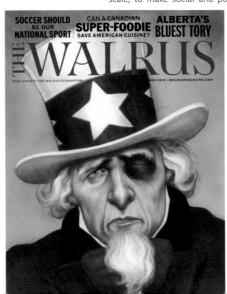

George Petty

[1894–1975]

When the first issue of *Esquire* magazine hit the market in October 1933, Chicago-based illustrator George Petty rose from journeyman regional advertising artist to a national arbiter of female beauty. Not yet 30 when *Esquire* made his name, Petty had been working steadily since his mid-teens. He began his career apprenticing in his father's photo studio refining airbrush techniques to retouch negatives. His family business approach to work would carry throughout his entire career. After his father's death in 1916, Petty supported his wife and two young children as a staff artist for a local advertising agency whose clients were Midwest brands like Marshall Fields department stores and Atlas beer. His early work offers hints of what would become his signature style—boneless tapered fingers, impossibly long legs, clothes that showcase what's beneath them—but little suggested that he would go on to become one of the central figures in the creation of pin-up art as we know it today.

Though Petty's long-lashed, lithe beauties emerged straight from the artist's imagination, another *Esquire* artist came up with the gags that first framed these images, and foregrounded the sophistication and sexual availability of these creations. In the earliest examples, Petty Girls were shown tangling with a character often called the "old geezer," who was at once emblem and foil for *Esquire*'s target audience. As a luxury-oriented magazine in Depression America, *Esquire* had to both glorify consumerist objects of desire and also give readers who couldn't afford access to them an outlet to mock the millionaire class. Petty's work offered just that. His full-page cartoons showed lithe gold-diggers in transparent satin evening gowns negotiating with balding Lotharios above double-entendre laden quips worthy of Mae West. It was never clear who was coming out ahead in these exchanges, but both sides knew what was being traded.

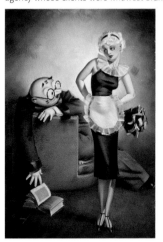

Will That Be All, Sir?
Watercolor on board
Courtesy Heritage Auction Galleries

Within two years, *Esquire* readers grew tired of the codger. They wanted to imagine themselves in the picture with the object of their desire. The magazine replaced the "old duffer" cartoons with a near-monthly illustration by Petty of a lone female figure against a stark white background, looking directly at the viewer, often while talking on the phone. She was a near-perfect symbol of her time. Her gown's implausibly sheer fabric was an extreme exaggeration of new lightweight synthetics, and the phone suggested the independence technology provided. Petty's airbrush technique gave the whole thing a plasticine quality. His play of fully formed bodies and faces against gesturally sketched extremities captured the focus on efficiency and speed of Fordism. They implied the question "who has time to finish anything these days?" Even Petty's reuse of his *Esquire* pin-ups in advertising campaigns was regarded as evidence of American entrepreneurialism. The Petty Girl became an embodiment of the machine age, and her creator became a household name.

The late '30s were Petty's apex. From 1936 to 1941, Petty was a celebrity judge at the Miss America pageant. Along with his illustrations, *Esquire* featured a long-form photo-essay on a hunting safari Petty took to Africa. He was hired to endorse a "Curvex" wristwatch, for who better to weigh in on curves than the man who made his name idealizing them. In 1939, students at Princeton University voted Petty their favorite artist. Rembrandt came in second.

On the Phone
Watercolor on board
Courtesy Heritage Auction Galleries

Not Today, I'm Getting Married
Esquire magazine, June 1937
Watercolor on board
Courtesy Heritage Auction Galleries

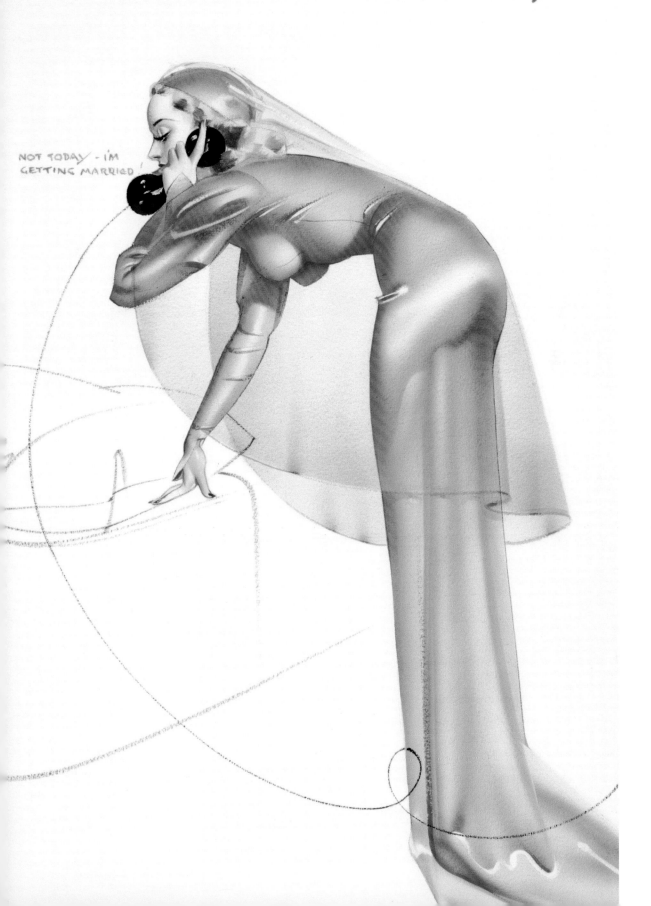

The old guard tsk-tsked, but Hollywood took notice. 1939 saw the start of negotiations for a film very loosely inspired by the artist's life, which would be released in 1950 as *The Petty Girl*.

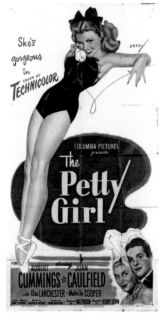

The Petty Girl
Columbia, 1950. Three Sheet poster
Courtesy Heritage Auction Galleries

Unfortunately, as Petty's popularity grew, so did tensions between the artist and *Esquire*. Advertising work paid substantially more than editorial, and everyone from Jantzen swimwear to Old Gold cigarettes wanted a Petty Girl. The artist worked himself to exhaustion trying to meet the demand, often missing magazine deadlines in the process. In the months leading up to their (first) formal split in 1941, *Esquire* used the letter pages of the magazine to express frustration and to roll out Petty's successor, Alberto Vargas.

Though Vargas and Petty were set up as direct competitors, the entrance of America into World War II left enough room for both—and a host of imitators. The appetite for "morale-boosting" pin up seemed endless in wartime. Petty took advantage, licensing old works as stationary, address books, playing cards and more. The patriotic appeal of pin up sanitized the genre and broadened its appeal. Petty's singular vision of athletic leggy womanhood branded the new family-friendly spectacle, the Ice Capades. *True* magazine re-introduced the Petty Girl as a monthly feature catering to returning GIs. Petty's ubiquity wouldn't last long. Within a few years, the Ice Capades and *True* associations ended in acrimony similar to his *Esquire* run.

Petty's loyalties extended only as far as his immediate family, who had a major hand in his enterprises. His wife handled administrative aspects of his business, and his favorite model was his daughter Marjorie. She began sitting for pin up illustrations when she was only 15. This choice sounds scandalous today, but at the time was taken as evidence that Petty's endeavors were less, rather than more, lewd.

By the 1950s, the public began to see the Petty Girl as a little old-fashioned, looking to magazines like *Playboy* for their girlie picture ration. Yet, he produced some of his most innovative work in this decade. His streamlined style hit its high water mark when he was commissioned to create a hood ornament for Nash automobiles, and his final major ongoing commission offers the purest expression of Petty's particular vision. The Ridgid girl was an advertising calendar campaign of the Ridge Tool Company. Each month showed a different image

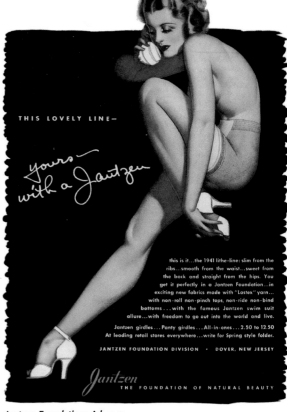

Jantzen Foundations Ad, 1941

of a smiling, underdressed pin-up girl frolicking on a larger than life depiction of one of their wares.

Throughout his career, Petty worked by beginning with a precisely sketched red line outline, which he would then surround with a transparent frisket layer to keep his curves precise and avoid the airbrush bleeding into the background. For the Ridgid calendar art, it was a short step to cut out the figures and intertwine them with the renderings of the machines. The surreal nature of the assignment allowed Petty a whimsical solution to one of his most long-term dissatisfactions with his work. A consummate leg man, Petty expressed ongoing frustration with how all shoes, even the highest stiletto, broke the line of the calf and made legs appear shorter. With the Ridgid girls, he solved the problem by putting his plucky, heavy machinery-operating pin up cuties in ballet point shoes. The juxtaposition of the smiling, scantily clad woman climbing, caressing, and even straddling these larger than life tools proves almost fetishistic. It's also delightful, and stands out as some of Petty's best and most collectible work. Even though he didn't incorporate the toe shoe into his illustrations until near the end

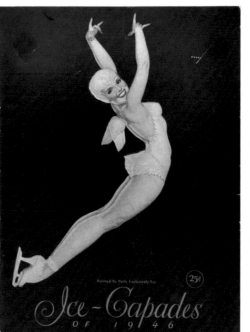

Cover Art for the 1946 Ice-Capades Souvenir Program
Mixed media on illustration board
Courtesy Grapefruit Moon Gallery

of his career, girls costumed as everything from farmhands to fencers inexplicably *en pointe* is one of the first things that comes to mind when defining Petty's style.

In the 1960s, Petty entered semi-retirement. He emerged for the occasional one-off illustration, including a final piece in 1973 celebrating *Esquire*'s 40th anniversary. It playfully shows the Petty Girl with grey hair and reading glasses, her gravity-defying bosom and coltish legs as youthful as ever. It is a fitting coda to a partnership that defined 20th century pin up.

George Petty died two years later in Southern California, where he lived with his daughter Marjorie and her family. He was 81.

Sarajane Blum
Co-owner of Grapefruit Moon Gallery

Rigid Tool Calendar Illustration
c. 1952–1953. Mixed media on board.
Courtesy Heritage Auction Galleries

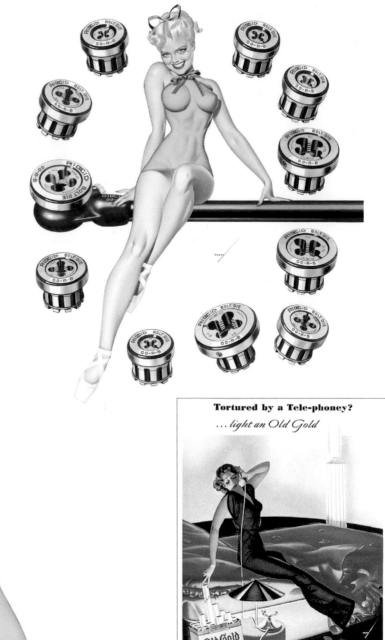

Old Gold Cigarette Ad, c. 1935
Courtesy Heritage Auction Galleries

Flirtatious on the Phone
Petty Girl Pin-Up Calendar Illustration,
December 1947
Watercolor on board with paper collage
Courtesy Heritage Auction Galleries

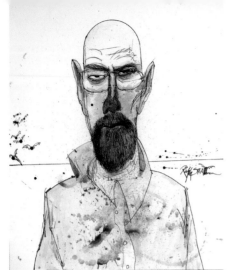

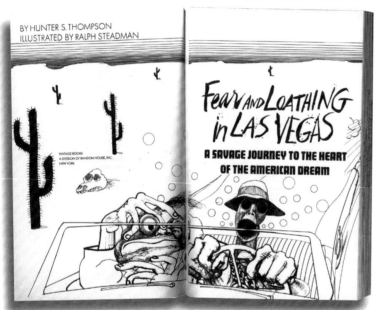

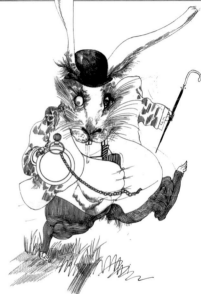

Clockwise from top left:
Steadman's take on the Walter White character from the *Breaking Bad* TV series. Steadman parody's of H.M. Bateman with *The Man Who Touched a Bunny*. The White Rabbit from his book *Alice in Wonderland*. An illustration from his biography of Leonardo da Vinci. Steadman immersed himself in Leonardo's life so deeply he painted a version of the Last Supper on a guest bedroom wall. And finally the title spread from his joint Gonzo-venture book with Hunter Thompson.

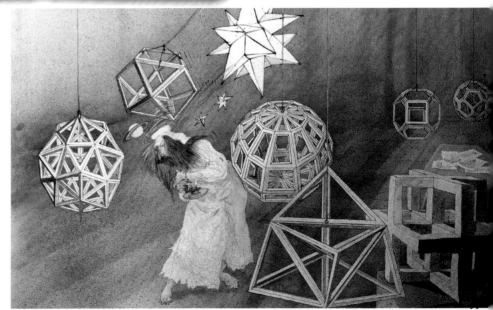

RALPH STEADMAN
[b. 1936]

Steadman by Rikard Österlund,
www.rikard.co.uk

A few years ago, sitting in a bar in Las Vegas, I asked Ralph Steadman how he expected history to judge him. What kind of assessments would he like to see in his obituary?

"Distasteful," he replied. "Unhygienic. Truculent. Moody. Tirelessly provocative towards bastards."

It is typical of this most modest of artists that he neglected to mention other adjectives that might more sensibly be applied to his life and career. Terms such as uniquely gifted, generous, ceaselessly inventive and extraordinarily prolific.

Whether you judge him on his classic artwork in books such as *Alice in Wonderland, Treasure Island* and *Animal Farm*, or the tormented visions that inhabit his original paintings, Steadman is a phenomenon of the kind that barely exists any more: a highly successful artist who has succeeded despite a general indifference towards money, fame, and the affection for self-promotion that afflicts some others in the profession.

Steadman is fond of saying that he set out to change the world and failed. "If anything," this most self-deprecating of artists will then tell you, "I made it worse." His popular success as a political satirist and his extraordinary illustrations for such diverse writers as Carroll, Flann O'Brien and Steadman's spiritual brother, Hunter S. Thompson, have to some degree led to an underappreciation of the artist's vision as an inspirational painter in his own right.

"I get irritated and bewildered," the film director Bruce Robinson once told me, "when people speak of Ralph Steadman as a 'mere' cartoonist, or illustrator. He is a supreme talent. I feel so fortunate to know him, because at his best, which is most of the time, he has the power of Goya. I don't say that lightly. He really does. There is no living artist in his league that I know of." In the foreword to Steadman's 2006 memoir, *The Joke's Over,* Kurt Vonnegut described him as: "The most gifted and effective existential artist of my time."

To stand at Ralph Steadman's shoulder while he works is a remarkable experience: there is a real sense that you are observing somebody who—no other phrase will do—is in touch with another reality. Steadman seizes those moments when—to borrow the phrase Francis Bacon once used—"chance and accident take over."

"When I tell people that I don't draw in pencil first," Steadman remarks, "they tend to say, 'Really? What if you made a mistake?' I tell them that, in my mind, there is no such thing as a mistake. A 'mistake' is simply an opportunity to do something else. Half the drawings I have ever done have started out as something else. I've always viewed that white sheet of paper as some kind of vacuum that demands to be filled. I have to splat it as soon as possible, if only to stop it from staring at me. You simply start with the first mistake—and after that, all will be well."

Ralph Steadman was born in Wallasey, near Liverpool, in 1936 but grew up in Abergele, North Wales. He and Gerald Scarfe shared the same art teacher, the late Leslie Richardson, at London's East Ham Technical College. Though Steadman and Scarfe are sometimes confused, even today, they were, as Richardson once explained, "very different artists from the start. Scarfe's drawing was clinical in character; suited to caricature. Ralph's work was always much more emotional. It was fuller, less orthodox, and far more expressive."

It is hard to think of any other artist whose true character is further removed from their personality as you might perceive it from their work. Steadman is renowned for the merciless brutality in many of his paintings; notably his images of Vietnam, Iraq and Guantanamo Bay, his horrific pictures of London in the plague year, and his scatological and unflattering portraits of leaders such as Nixon, Thatcher, Blair and Trump. (Latterly when drawing politicians he has tended to focus on their internal organs and skeletal structure, "because I'd noticed that when I drew them as portraits, they'd begun to enjoy it.") The cruelty and viciousness in his art is entirely absent in the man: Ralph Steadman is congenial, softly spoken and—undramatic a virtue as it may be—extremely kind.

The fury in his work springs from a moral core: a deeply ingrained distaste for the boastfulness, greed and indifference to the suffering of others manifested throughout history by many in the governing classes.

"I discovered at an early age how dreadful certain people can be," Steadman once said. "We had a lovely headmaster when I first went to school in Abergele, in Wales. Then this hideous monster took over. From then on I loathed that kind of authority figure. Because I had been brought up to believe that there was good in the world. I had been taught to be an

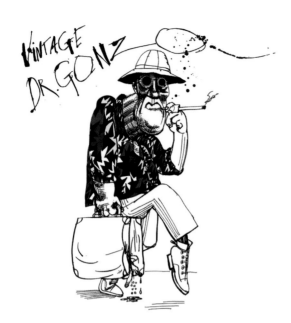

honest person by my mother and father. When I was growing up, honesty was the prime foundation in anyone's life. That idea was ingrained in me as a little lad."

Much of Steadman's work is a kind of cry of rage from a man born with a skin too few. It was his furious intolerance of injustice that facilitated his close bond with Hunter S. Thompson, a man who shared Steadman's pathological loathing of corruption in high places. Thompson took the Wodehousian bachelor's blithe and adventurous attitude to alcohol and extended it to LSD and munitions. Steadman, by contrast, was a peaceable and nonconfrontational person whose indulgences (before Thompson introduced him to hallucinogens) had been restricted to tobacco, ale and decent wine. But in their motivations, intelligence, love of playful subversion and their deep mutual affection, they were always on the same page.

"In many ways," Johnny Depp says, "I look upon Ralph as a kind of fucking miracle. It is just an incredible privilege to go down to see him in Kent and spend time with him and his family. He really is just so gentle and so . . . nice. At the same time he is . . . you know . . . a psychopath."

While Steadman's illustrations for their 1971 collaboration *Fear and Loathing in Las Vegas* represent only a fractional part of the range and originality of his later work, the book was crucial in introducing the Englishman to an international public.

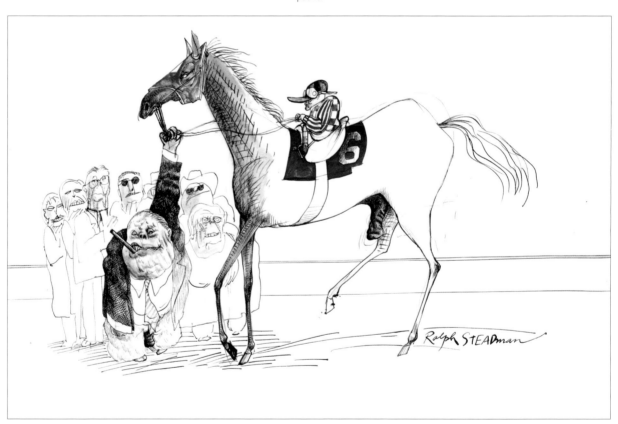

The 1969 Kentucky Derby

Steadman, paired with the infamous writer and journalist Hunter S. Thompson, opted to avoid focusing on the race itself. Instead, they chose to document the depravity and ghastly nature of those who were attending the race.

"The reason it says 'Sketched with eyebrow pencil and lipstick by Ralph Steadman' was that I used those very things. The then-editor of the newly formed *Scanlan's Monthly* said 'Come have dinner with us before you go get your flight to Kentucky.' And I left my bag with my inks in the cab. So I didn't have anything [before I traveled to the Derby]. His wife was a Revlon representative, and she had a whole load of these eye shadows and pencils and things that I could use. So that's what I used to do these pictures. We just didn't mention Revlon."

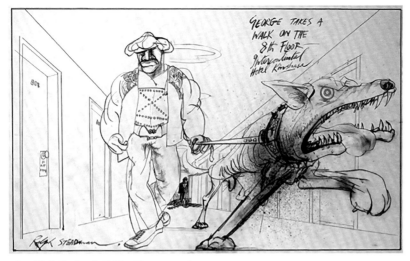

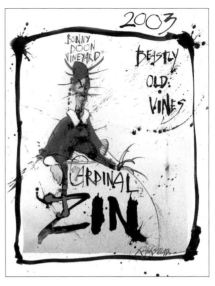

Rumble in the Jungle, Rolling Stone *magazine,* 1974
To cover the fight between George Foreman and Muhammad Ali in Zaire, Hunter Thompson convinced Ralph to skip the fight, so Ralph found other subjects to portray including a chance encounter with Foreman walking his dog in their hotel one night.

Steadman's commercial work for Bonny Doon vineyards includes the label for Cardinal Zin.

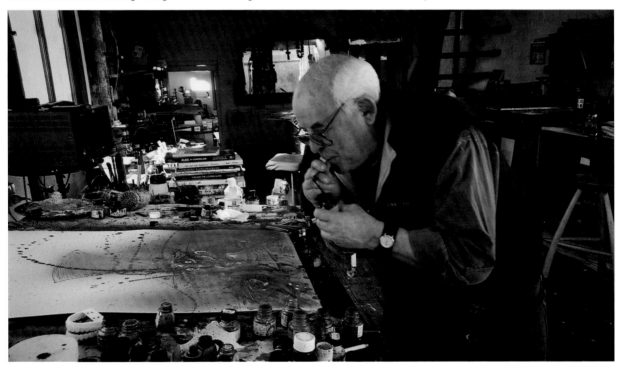

"Had it not been for those assignments with Hunter in the early Seventies," Steadman said, "I would not have made it in the same way in the United States. Until then I felt that my work lacked something. It lacked bite; it lacked rawness; an edge."

After Steadman had pondered the possible content of his death notice on that day at the bar in Las Vegas, I asked him if there was any other phrase he would like to add. How about, for instance, "Long-lived" ?

"Oh yes," he said. "I'd like my obituarist to say, 'Steadman was very long-lived. Endlessly lived. We thought he'd never go away.' A pause. "'And we were right,'" he added. "'He didn't. He went on forever.'" It's a promise which—through his art, his wit and his gloriously irreverent world view—Ralph Steadman is destined to fulfill.

Robert Chalmers
Contributing Editor, British *GQ*

At work in his home studio
Steadman generally employs pen and brush ink work along with a combination of spattering and, as seen in this photo, a mouth atomizer to create spray effects.
Charlie Paul/Courtesy of
Sony Pictures Classics

Norman Rockwell on the occasion of his accepting the first Society of Illustrators Hall of Fame Award in 1958 from then Society President Harry Carter.

HALL OF FAME LAUREATES

[1958–2016]

1958 Norman Rockwell
1959 Dean Cornwell
 Harold Von Schmidt
1960 Fred Cooper
1961 Floyd Davis
1962 Edward Wilson
1963 Walter Biggs
1964 Arthur William Brown
1965 Al Parker
1966 Al Dorne
1967 Robert Fawcett
1968 Peter Helck
1969 Austin Briggs
1970 Rube Goldberg
1971 Stevan Dohanos
1972 Ray Prohaska
1973 Jon Whitcomb
1974 Tom Lovell
 Charles Dana Gibson*
 N.C. Wyeth*
1975 Bernie Fuchs
 Maxfield Parrish*
 Howard Pyle*
1976 John Falter
 Winslow Homer*
 Harvey Dunn*
1977 Robert Peak
 Wallace Morgan*
 J.C. Leyendecker*
1978 Coby Whitmore
 Norman Price*
 Frederic Remington*
1979 Ben Stahl
 Edwin Austin Abbey*
 Lorraine Fox*
1980 Saul Tepper
 Howard Chandler
 Christy*
 James Montgomery
 Flagg*
1981 Stan Galli
 Frederic R. Gruger*
 John Gannam*
1982 John Clymer
 Henry P. Raleigh*
 Eric (Carl Erickson)*

1983 Mark English
 Noel Sickles*
 Franklin Booth*
1984 Neysa Moran
 McMein*
 John LaGatta*
 James Williamson*
1985 Robert Weaver
 Arthur Burdett Frost*
 Charles Marion
 Russell*
1986 Al Hirschfeld
 Rockwell Kent*
1987 Maurice Sendak
 Haddon Sundblom*
1988 Robert T. McCall
 René Bouché*
 Pruett Carter*
1989 Erté
 John Held Jr.*
 Arthur Ignatius Keller*
1990 Burt Silverman
 Robert Riggs*
 Morton Roberts*
1991 Donald Teague
 Jessie Willcox Smith*
 William A. Smith*
1992 Joe Bowler
 Edwin A. Georgi*
 Dorothy Hood*
1993 Robert McGinnis
 Thomas Nast*
 Coles Phillips*
1994 Harry Anderson
 Elizabeth Shippen
 Green*
 Ben Shahn*
1995 James Avati
 McClelland Barclay*
 Joseph Clement Coll*
 Frank E. Schoonover*
1996 Herb Tauss
 Anton Otto Fischer*
 Winsor McCay*
 Violet Oakley*
 Mead Schaeffer*
1997 Diane and Leo Dillon
 Frank McCarthy
 Chesley Bonestell*
 Joe DeMers*
 Maynard Dixon*
 Harrison Fisher*

1998 Robert M.
 Cunningham
 Frank Frazetta
 Boris Artzybasheff*
 Kerr Eby*
 Edward Penfield*
 Martha Sawyers*
1999 Mitchell Hooks
 Stanley Meltzoff
 Andrew Loomis*
 Antonio Lopez*
 Thomas Moran*
 Rose O'Neill*
 Adolph Treidler*
2000 James Bama
 Alice and Martin
 Provensen*
 Nell Brinkley*
 Charles Livingston
 Bull*
 David Stone Martin*
 J. Allen St. John*
2001 Howard Brodie
 Franklin McMahon
 John James Audubon*
 William H. Bradley*
 Felix Octavius Carr
 Darley*
 Charles R. Knight*
2002 Milton Glaser
 Daniel Schwartz
 Elmer Simms
 Campbell*
 Jean Leon Huens*
2003 Elaine Duillo
 David Levine
 Bill Mauldin*
 Jack Potter*
2004 John Berkey
 Robert Andrew
 Parker
 John Groth*
 Saul Steinberg*
2005 Jack Davis
 Brad Holland
 Herbert Paus*
 Albert Beck Wenzell*

2006 Keith Ferris
 Alvin J. Pimsler
 Jack Unruh
 Gilbert Bundy*
 Bradshaw Crandall*
 Hal Foster*
 Frank H. Netter,
 M.D.*
2007 David Grove
 Gary Kelley
 Edward Windsor
 Kemble*
 Russell Patterson*
 George Stavrinos*
2008 Kuniko Craft
 Naiad Einsel
 Walter Einsel*
 Benton Clark*
 Matt Clark*
2009 Paul Davis
 Arnold Roth
 Mario Cooper*
 Laurence Fellows*
 Herbert Morton
 Stoops*
2010 Wilson McLean
 Chris Van Allsburg
 Charles Edward
 Chambers*
 Earl Oliver Hurst*
2011 Fred Otnes
 Jerry Pinkney
 Kenneth Paul Block*
 Alan E. Cober*
 Robert Heindel*
2012 R.O. Blechman
 John Collier
 Nancy Stahl
 Ludwig Bemelmans*
 Edward Gorey*
 John Sloan*
2013 Ted CoConis
 Sanford Kossin
 Murray Tinkelman
 George Herriman*
 Arthur Rackham*
 Charles M. Schulz*

2014 Al Jaffee
 Syd Mead
 Edward Sorel
 Mary Blair*
 Walter Hunt Everett*
 William Cameron
 Menzies*
 Alex Raymond*
2015 Walter Baumhofer*
 Bernard D'Andrea
 Will Eisner*
 Virgil Finlay*
 Betsy Lewin
 Ted Lewin
 Pat Oliphant
 Arthur Szyk*
2016 Marshall Arisman
 Rolf Armstrong*
 Guy Billout
 Peter de Sève
 William Glackens*
 Richard Powers*
 Beatrix Potter*
2017 Mort Drucker
 Bart Forbes
 Burne Hogarth*
 Anita Kunz
 George Petty*
 Ralph Steadman
 Gustaf Tenggren*

* PRESENTED POSTHUMOUSLY

**HALL OF FAME
COMMITTEE 2017
Chairman**
 Dennis Dittrich
Committee
 Richard Berenson
 Alice Carter
 Vincent Di Fate
 Diane Dillon
 Judy Francis Zankel
 Wendell Minor
 Roger Reed
 Steve Stroud
 John Witt

2017 HAMILTON KING AWARD, RICHARD GANGEL ART DIRECTOR AWARD

The Hamilton King Award, created by Mrs. Hamilton King in memory of her husband through a bequest, is presented annually for the best illustration of the year by a member of the Society. The selection is made by former recipients of this award and may be won only once.

The Richard Gangel Art Director Award was established in 2005 to honor art directors currently working in the field who have supported and advanced the art of illustration. This award is named in honor of Richard Gangel (1918–2002), the influential art director at *Sports Illustrated* from 1960 to 1981, whose collaboration with illustrators during that period was exceptional.

HAMILTON KING AWARD
[1965–2017]

1965 Paul Calle	1979 William Teason	1992 Gary Kelley	2005 Steve Brodner
1966 Bernie Fuchs	1980 Wilson McLean	1993 Jerry Pinkney	2006 John Thompson
1967 Mark English	1981 Gerald McConnell	1994 John Collier	2007 Ted Lewin
1968 Robert Peak	1982 Robert Heindel	1995 C.F. Payne	2008 Donato Giancola
1969 Alan E. Cober	1983 Robert M. Cunningham	1996 Etienne Delessert	2009 Tim O'Brien
1970 Ray Ameijide	1984 Braldt Bralds	1997 Marshall Arisman	2010 John Jude Palencar
1971 Miriam Schottland	1985 Attila Hejja	1998 Jack Unruh	2011 Marc Burckhardt
1972 Charles Santore	1986 Doug Johnson	1999 Gregory Manchess	2012 John Cuneo
1973 Dave Blossom	1987 Kinuko Y. Craft	2000 Mark Summers	2013 Victor Juhasz
1974 Fred Otnes	1988 James McMullan	2001 James Bennett	2014 Kadir Nelson
1975 Carol Anthony	1989 Guy Billout	2002 Peter de Sève	2015 Robert Hunt
1976 Judith Jampel	1990 Edward Sorel	2003 Anita Kunz	2016 Joe Ciardiello
1977 Leo & Diane Dillon	1991 Brad Holland	2004 Michael Deas	2017 Gérard DuBois

RICHARD GANGEL ART DIRECTOR AWARD
[2005–2017]

2005 Steven Heller	2009 Gail Anderson	2014 Robert Newman
2006 Fred Woodward	2010 DJ Stout	2015 SooJin Buzelli
2007 Rita Marshall	2011 Françoise Mouly	2016 Irene Gallo
2008 Patrick J.B. Flynn	2012 Monte Beauchamp	2017 Nicholas Blechman
	2013 Robert Festino	

HAMILTON KING AWARD 2017
Gérard DuBois
[b. 1968]

"You can say I'm doing illustration part time because my true dream is to make cheese and wine." So goes a typical conversation with Gérard DuBois, a charming mix of wit, charm and self deprecation. I've known Gérard for about 15 years and it's been like this all along. He is one of my favorite artists, and one of my best friends.

Gérard's work and career is the epitome of what many of us aspire to—to create poetic work that communicates, informs and transcends, all while maintaining the integrity and timelessness of a true work of art. Time and again, Gérard creates images that turn the mundane into the ethereal, and it's always quite a thrill to see. From a host of topics that he is asked to illustrate, Gérard is able to illicit paintings that feel current and timeless, all at the same time.

Gérard was born in France in 1968. He grew up in the suburbs of Paris, but as a child never went to the museums in the legendary city nearby. This all changed when he moved to Paris to study graphic design and found new friends and perspectives at the city's bars and cafes—experiences he's remembered all his life. He graduated from college in 1989, accepted a job as a designer in Montreal with the French Ministry of Cooperation, crossed the Atlantic, and never looked back.

This was when I first came across the work of Gérard DuBois. I was the art director of *TIME* magazine's Canadian edition and began to notice the work of a young artist working in Montreal. Gérard's work stood out for its strong impact and delicate touch, a combination that is very hard to pull off. Much of his early work was dark, on cardboard, slashed throughout. His early paintings were also very large and carried the strength of art that wanted to make a big statement, which it did.

Slowly, his work began to appear on the covers and interiors of American magazines for a variety of stories. I soon began to work with him on a regular basis at *TIME* and loved every minute of it. As an art director, one usually tries to match the artist to the assignment, but with Gérard, I would ask him to create illustrations for articles that had nothing to do with his style just so I could sit back and watch how he would climb out of the trap I'd set (which he would always end up doing with pure innovation). Naturally, he would call me, angst ridden, never sure his ideas were coming together. We would talk on the phone, sometimes for hours, one topic moving on to the next, and we would both learn so much from the process. Anyone that knows Gérard well loves his conversations, he is one of the sharpest artists I know.

In time Gérard would work for most major American and international publications, and for corporate clients, too. Profiles about him are plentiful, as are awards from the top graphics organizations, including *Communications Arts, Print Design Annuals* and the Society of Illustrators, which has awarded Gérard Gold and Silver Medals—and now its Hamilton King Award.

Throughout my career as an art director I was often asked who my favorite illustrators were, whom would I recommend? Gérard DuBois was always at the top of my list. His sheer brilliance and touch always seems to slow down the viewer. He makes the viewer stop, notice the light emanating from his paintings, contemplate the poetry, and take in the subtle power of his images. In this fast-paced and distracted world, having something like Gérard's work to slow us down, look, study and contemplate, is a treasure.

Edel Rodriguez

RICHARD GANGEL ART DIRECTOR AWARD 2017
NICHOLAS BLECHMAN
[b. 1967]

I first met Nicholas over the phone in 1997. Nicholas was then Art Director of *The New York Times* Op-Ed page and he was calling to see if I was interested in doing an illustration. I had recently opened my own practice in Baltimore, where I was designing mostly book covers. When I told him I had no illustration experience whatsoever, he replied, "Good!" I have since done hundreds of illustrations for him over the years, following him around at his various art director positions at *The Times*, from *Op-Ed* to *Week in Review*, then to the *Book Review*. And most recently to *The New Yorker*, where he is creative director.

So, I can tell you with some authority that Nicholas is a great art director.

He has an impeccable eye, is even tempered, and often understands the work before the illustrator does. But what makes him great is all of the other things he is: illustrator, publisher, activist, teacher, author, lecturer and advocate.

As the son of the great R.O. Blechman (a member of the Society's Hall of Fame), Nicholas was weaned on comics and illustration. After college he took up the family business and became an in-demand, award-winning illustrator himself, with work in publications such as *GQ*, *Travel + Leisure*, *Wired* and *The New York Times*. Since 1990 he has published, edited and designed his own award-winning political underground magazine *NOZONE*, which was featured in the Smithsonian Institution's Design Triennial. Blechman has co-authored, with Christoph Niemann, a series of limited edition illustration books, *One Hundred Percent*, and he's written and illustrated his own children's book, *Night Light*.

He has taught design at the School of Visual Arts in New York and illustration at the Maryland Institute College of Art. An advocate of illustration as an international lecturer, he is a member of Alliance Graphique International and a former board member of the New York Chapter of the AIGA.

All of these things inform his art direction, and engender a sense of trust with the illustrators who work with him. I trust him to fight for my ideas, and to do the right thing with my work. It is only fitting that Nicholas Blechman, my friend and longtime collaborator, should be the recipient of the 2017 Richard Gangel Art Director Award.

Paul Sahre
Graphic designer

Portrait of Nicholas Blechman
by Christoph Niemann

EDITORIAL

CHELSEA CARDINAL
ART DIRECTOR/ FASHION DESIGNER

Canadian graphic designer and fashion designer Chelsea Cardinal is currently based in Brooklyn, NY. She was the art director at *GQ* before launching a women's fashion line called Cardinal. She is currently dividing her time between fashion, freelance graphic design and traveling. Chelsea's work has been recognized by the Society of Publication Designers, Type Director's Club, *Graphis* and *Communication Arts*.

JUN CEN
ILLUSTRATOR

Jun Cen is an award-winning illustrator and animator. He was born in Guangzhou, China, a subtropical city with warm and humid weather. He received his MFA in Illustration from Maryland Institute College of Art in 2013. He is the Overall New Talent winner of the 2013 Association of Illustrators Award. His work has been selected into the annual competitions of the Society of Illustrators, *American Illustration*, *3x3* Illustration Competition and more. He has worked with clients such as *The New York Times*, *The New Yorker*, *The Washington Post*, *The Economist*, *Travel + Leisure*, *Chevron* and many more. He has directed three animated short films that were shown in many film festivals worldwide. In addition to his commercial work, he creates works for gallery shows.

JENNIFER HEUER
ILLUSTRATOR

A Pratt grad and current instructor, Jennifer Heuer has worked in the book publishing world for 10 years. She worked in-house at HarperCollins and Simon & Schuster before stepping out to freelance. Jen currently works out of the Pencil Factory and works with Penguin, Random House, Little Brown, *The New York Times*, W.W. Norton, Knopf and many others. She's been selected for *The New York Times* Notable Opinion Art, has been featured in the Book Cover Designs, and on blogs like Casual Optimist and LitHub. Her work has been recognized by Design Observer's 50 Books/50 Covers, and the Type Directors Club.

BERNARD LEE
ILLUSTRATOR

Bernard Lee is a Los Angeles-based illustrator and former art director and designer at *Scientific American* and *Scientific American MIND*. As an art director, his past collaborations with illustrators have been featured in numerous annuals including the Society of Illustrators, SI-LA and *American Illustration*. Bernard now works as an illustrator primarily in the field of editorial and book publishing. His work can be seen at www.bernardleeart.com.

RACHEL LEVIT
ILLUSTRATOR

Mexican artist and illustrator Rachel Levit Ruiz (b. 1990) is based in Brooklyn, NY. She graduated from Parsons School of Design in 2012. She has since worked with publications such as *The New York Times*, *The New Yorker*, *Lucky Peach*, *Vice* and *Lenny Letter*. Her work has been exhibited in group exhibitions in Mexico City, New York, Copenhagen and the Philippines. Her piece, *The Aristocrat Man*, was selected in the Uncommissioned category of the Society of Illustrators 57th Annual of Illustration exhibit and book. *American Illustration 31* included her sculptural work in their annual, and *The New York Times* used it in the cover of the *Sunday Review* in April of 2015 to illustrate an article by David Brooks.

MICHAEL PANGILINAN
DIGITAL ART DIRECTOR, *GQ*

Michael Pangilinan, or Mickey, was born in Michigan in 1982 and raised in Florida. Mickey went to the University of Miami and the School of Visual Arts. He started as a designer at *Nylon* magazine in 2004 while still in school. From there he went to *GQ*, Simon & Schuster, back to *Nylon* as the art director, before operating as a small studio, Actualidea. While independent, he worked on projects for *Esquire*, *Good Housekeeping*, *New York* magazine, *Glamour* and various other books and websites. In 2012 Mickey joined Aritzia as the Digital Design Director for the launch of their e-commerce site. After stops at *New York* magazine and J.Crew he came back to *GQ* as the Digital Art Director from 2014 to 2016. Mickey is currently the design director of advertising at Harry's, a startup grooming company.

MARSHALL ARISMAN
ILLUSTRATOR/ PAINTER, CHAIR, MFA ILLUSTRATION AS VISUAL ESSAY, SCHOOL OF VISUAL ARTS

Marshall Arisman is an illustrator, painter, educator and storyteller. His graphic commentary illustrations have appeared on the covers of *TIME*, *U.S. News and World Report*, *The Nation*, *The Progressive* and *The New York Times Book Review*. His editorial work has appeared in every national publication including *Esquire*, *Rolling Stone*, *Playboy*, *The New York Times Op-Ed* page, *The Village Voice* and *Business Week*. His paintings and prints are in the permanent collections of the Metropolitan Museum of Art; the Brooklyn Museum; the New-York Historical Society; the National Museum of American Art, Smithsonian Institution; the Guang Dong Museum of Art and the Telfair Museum of Art. He is in the Society of Illustrators Hall of Fame and the Art Directors Club Hall of Fame. He founded the MFA degree program, Illustration as Visual Essay, at the School of Visual Arts in New York, in 1984. He has been a member of the faculty of the School of Visual Arts for 52 years.

SARAH WILLIAMSON
ILLUSTRATOR/ ART DIRECTOR, *THE NEW YORK TIMES*

Sarah Williamson works as a freelance art director at *The New York Times* on the editorial section. She commissions a wide variety of artists on an array of political and social topics, which are often challenging. She has published the picture book *Where Are You?* for Knopf, and is currently working on another, *Let's Go!*, both of which she wrote and illustrated. She has a degree in illustration from Art Center and a degree in political philosophy from the University of Wisconsin-Madison.

BEN WISEMAN
ILLUSTRATOR

Ben Wiseman is an illustrator originally from Lexington, Kentucky.

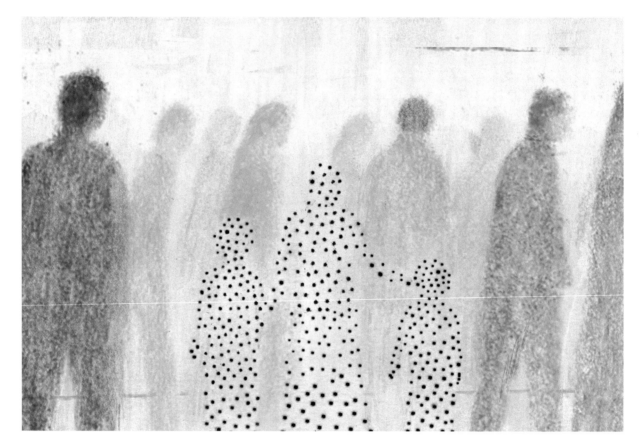

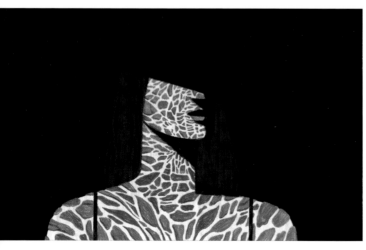

Disabilityy
Graphite, ink, digital
New York Times Op-Ed
Disability Series

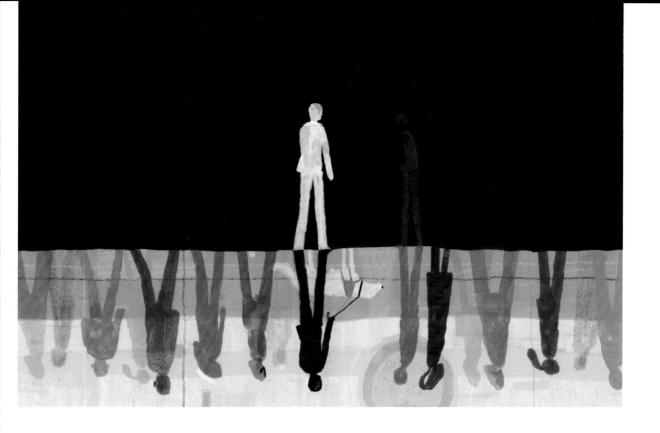

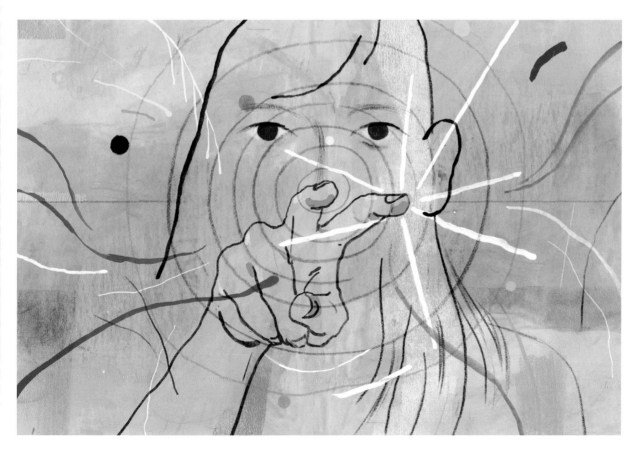

War Music
Graphite, digital
For *The New York Times Book Review* covering Christopher Logue's
War Music, a modern adaptation of Homer's *Iliad.*

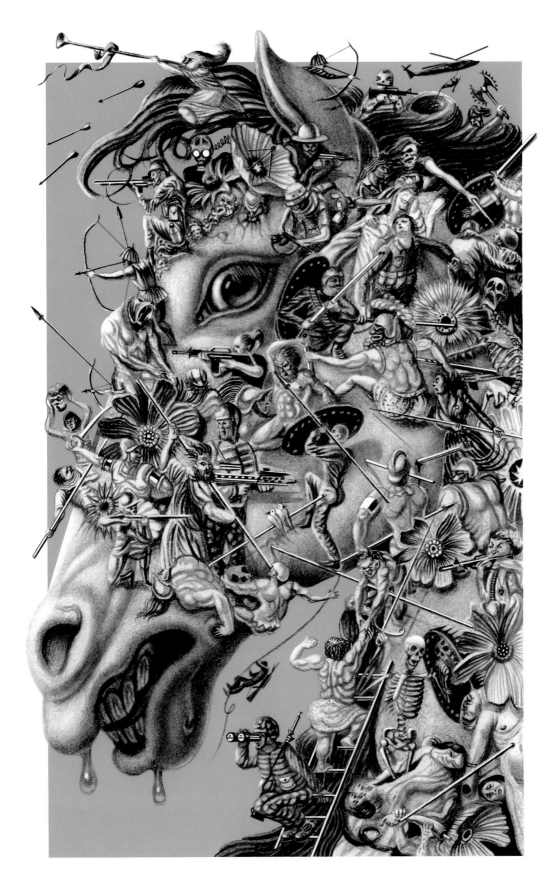

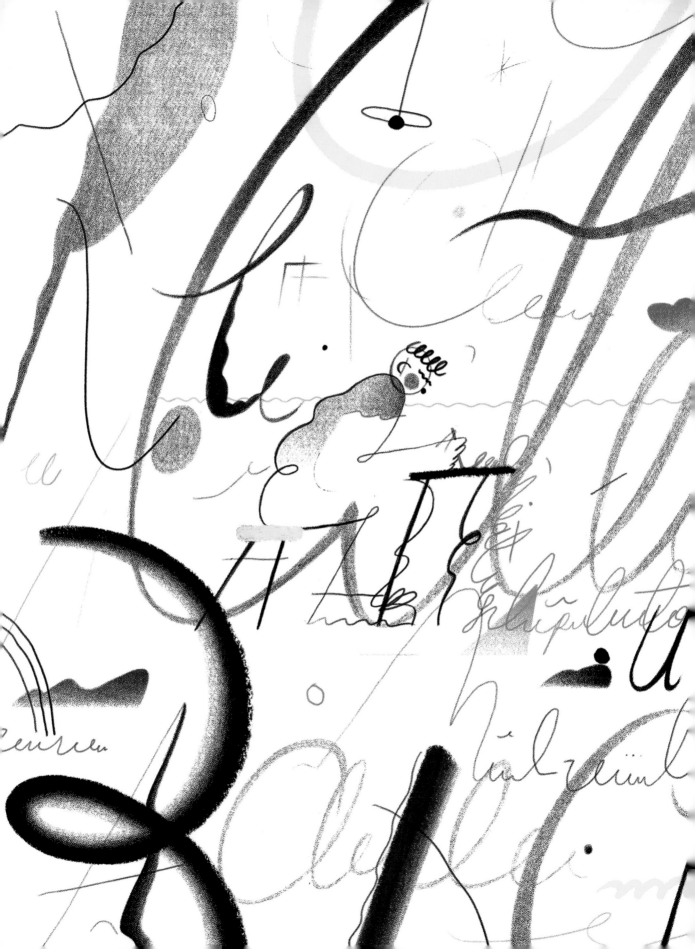

Cursive Handwriting and Other Education Myths
Digital
The article in *Nautilus* magazine is about the myths of cursive handwriting
in education, and the pressure it puts on school kids.

A Day at the Beach
Oil on canvas
Cover for *The New Yorker*.

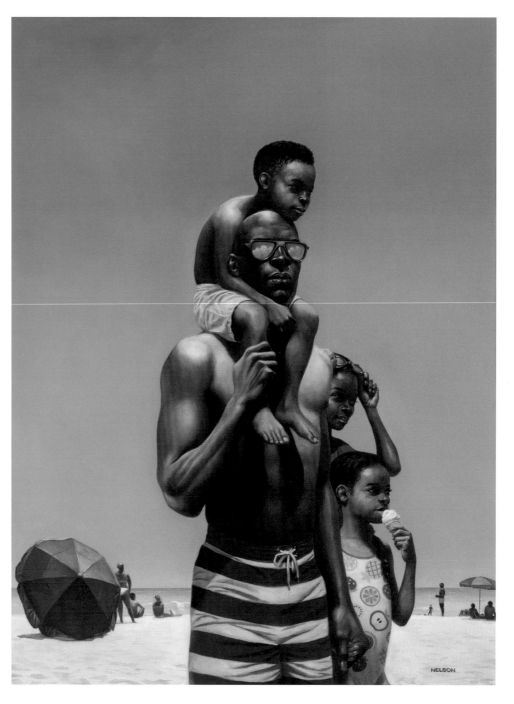

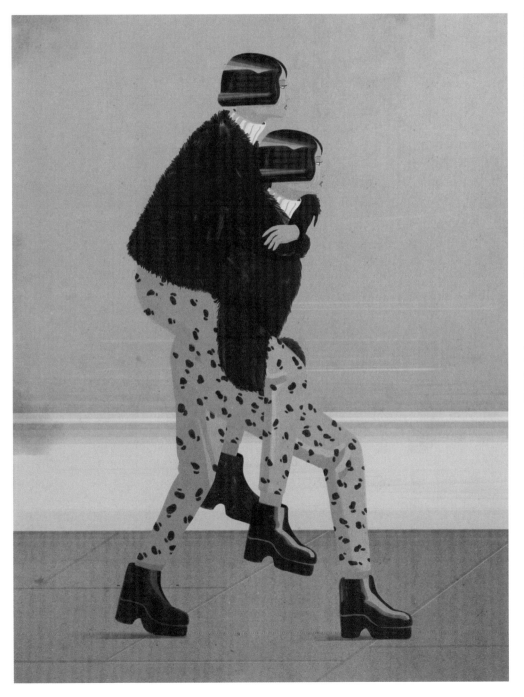

***Adulting: How to
Become a Grown-up
in 468 Easy(ish) Steps***
Digital
Illustration for *La Repubblica*.

Otherworldly
Digital, graphite
An ongoing series of science fiction illustrations for *The New York Times Book Review* section. Topics include alternate realities, schizophrenia, eerie buildings, human colonies, dying planets and the apocalypse.

PABLO AMARGO
The New Yorker *Spots*
Mixed media
Series of spot illustrations: 1 - SCARFS, 2 - TOWELS, 3 - FISHING

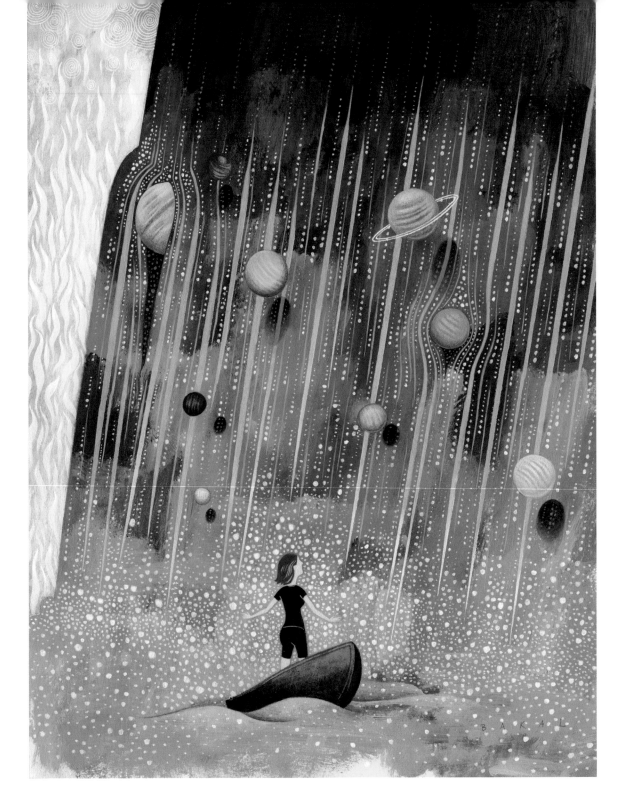

SCOTT BAKAL
The Overwhelming Universe!
Acrylic and ink
Back cover for *Nautilus Magazine*. The issue focused on all of the new
information being learned about the universe and how to analyze it.

JONATHAN BARTLETT
The Storied Man
Mixed media
Flying foxes, Caribbean monkeys, a tiny laboratory in a Wyoming cabin, a
young Mormon missionary who became a Samoan Indian chief.

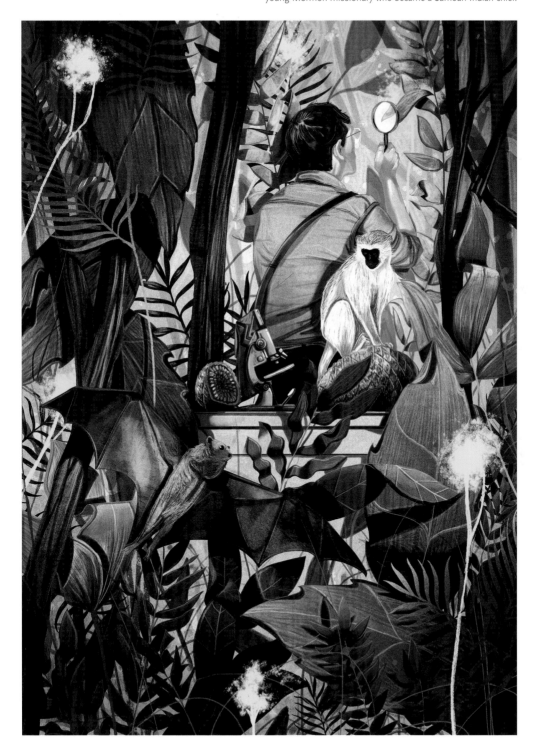

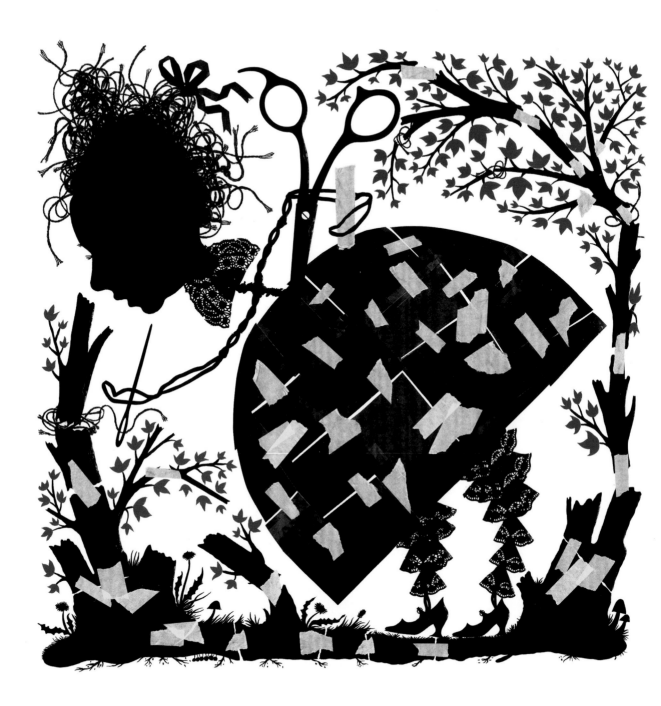

MELINDA BECK
Fixing Mistakes in the Tax Code
Digital
Illustration for Asset International

FACING PAGE

MATTEO BERTON
Tosca
Digital
One of the lasts scene of *Tosca* as represented by LoftOpera.

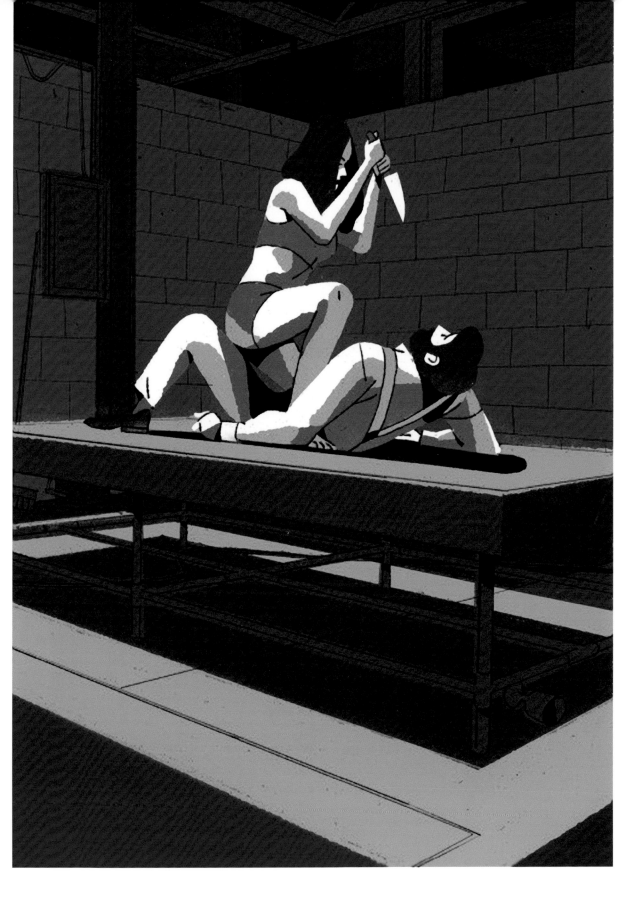

Nigel Buchanan
Ruth Bader Ginsberg
Digital
Portrait of the Supreme Court Judge titled, *Fighting Words.*

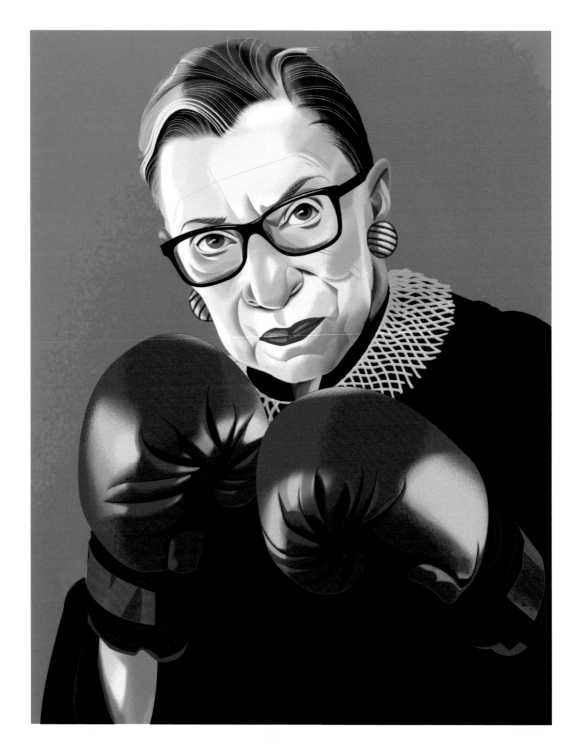

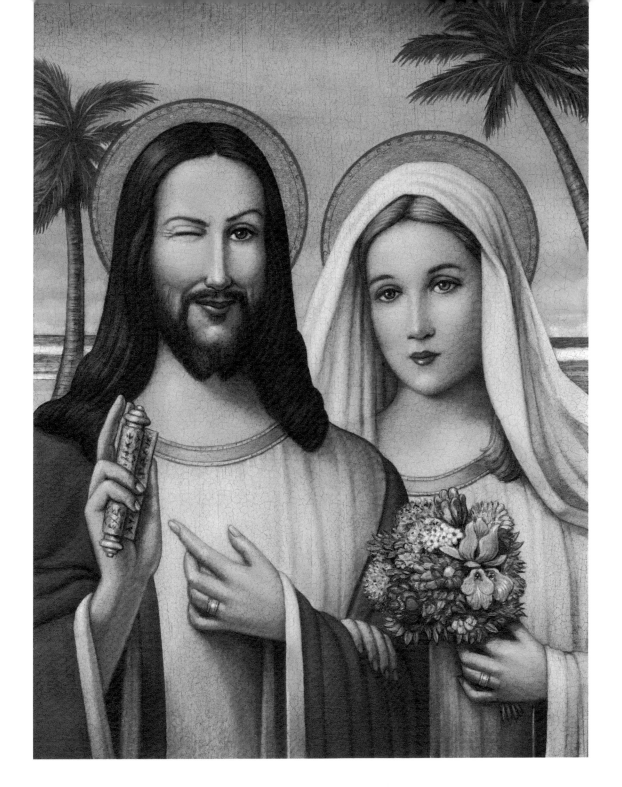

MARC BURCKHARDT
Jesus' Wife
Acrylic and oil on paper
Article about a forged Biblical scroll purporting to "prove" the existence of
Christ's marriage, and the trail leading to its sordid creator in Florida.

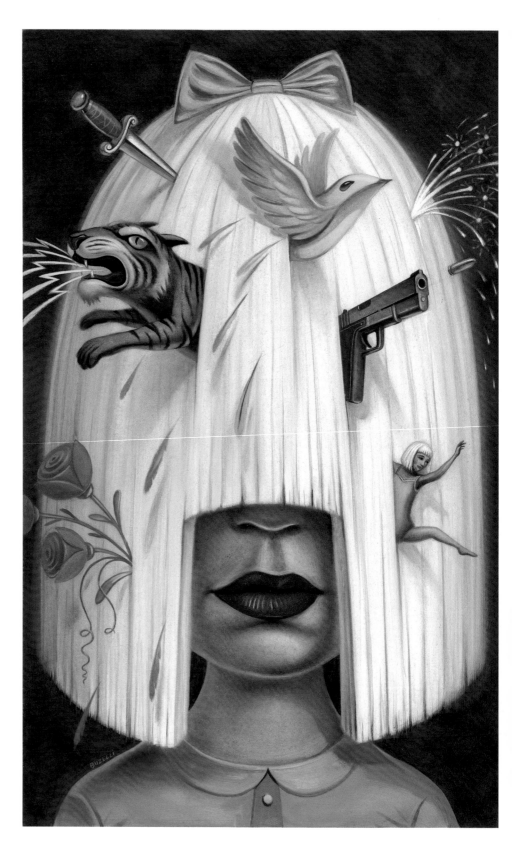

CHRIS BUZELLI
Sia: This Is Acting
Oil on board
The music review
illustration for Sia's new
album, *This Is Acting*.

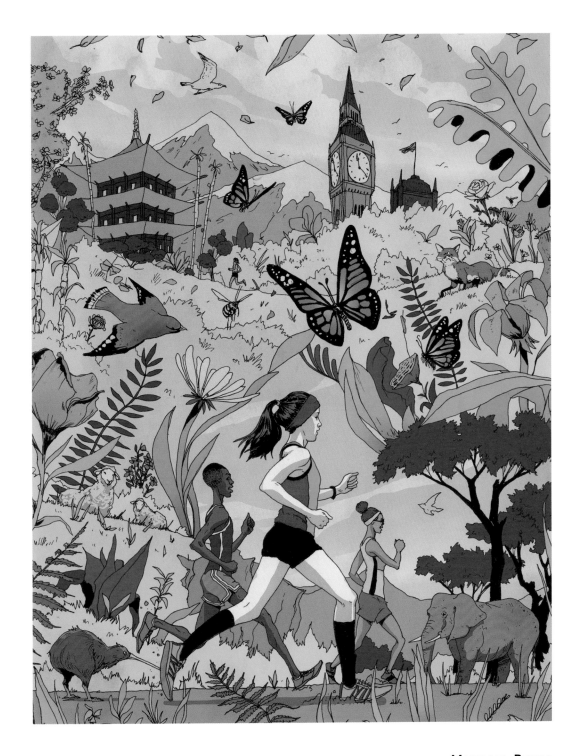

MICHAEL BYERS
Run Around the World
Digital
A story about runner Becky Wade and her running journey around the world.

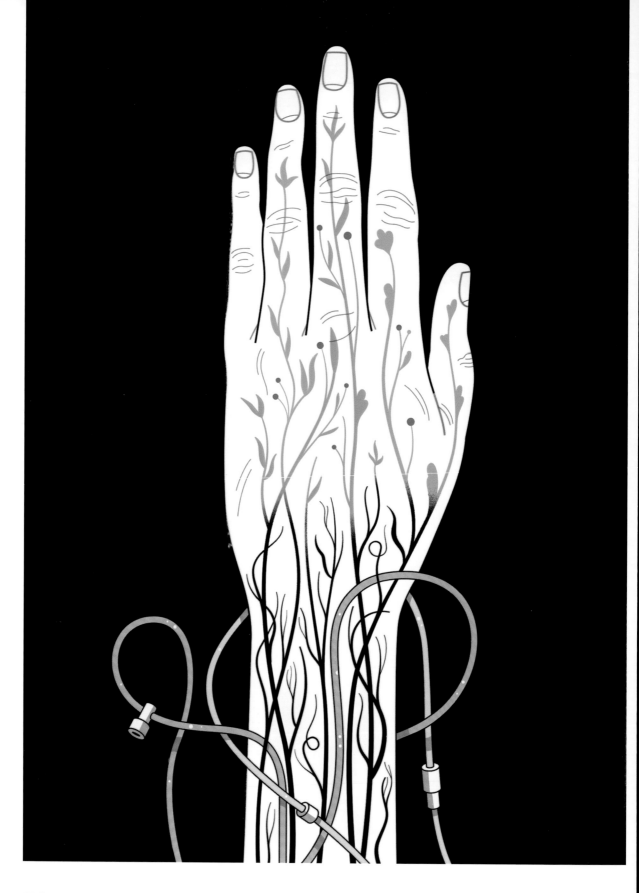

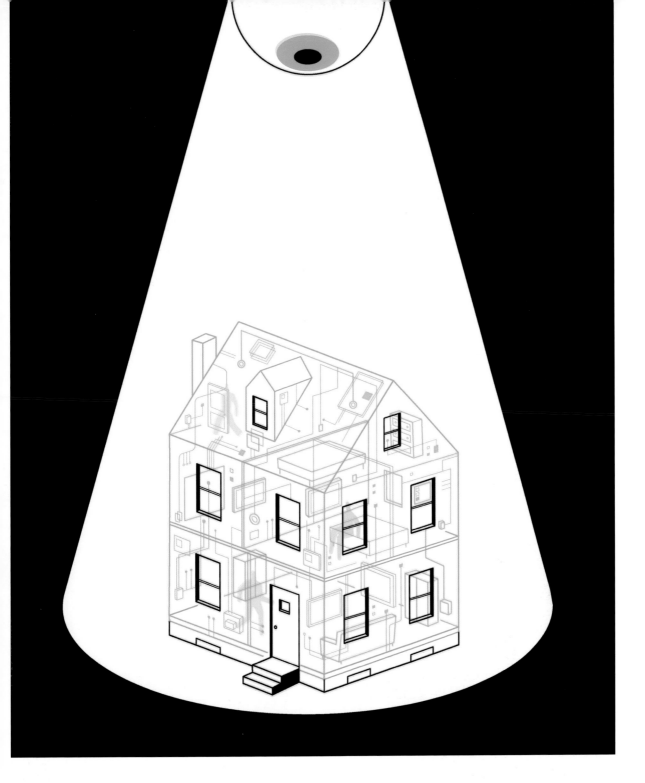

HARRY CAMPBELL
Cancer
Digital
Article about the book, *Death of Cancer.*

HARRY CAMPBELL
Surveillance
Digital
To accompany an article on privacy and surveillance.

HARRY CAMPBELL
Mexico Violence
Digital
Opinion piece on how
Mexico's media doesn't
report on violence.

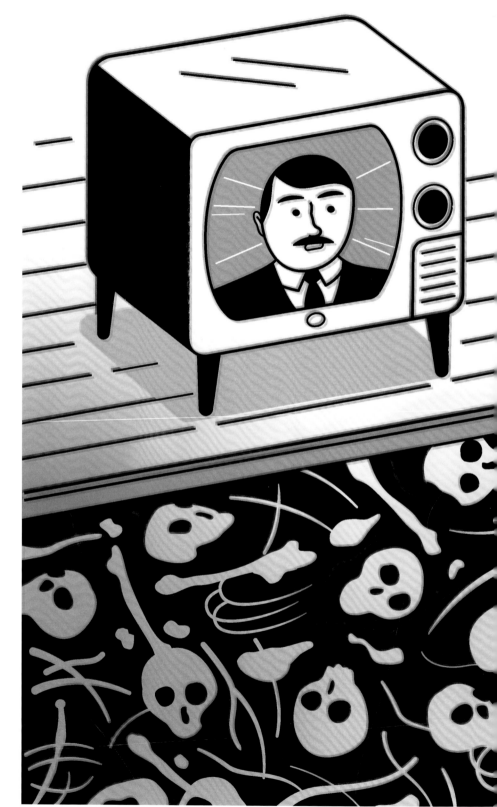

HARRY CAMPBELL
Place
Digital
A feature story on where people live and where they feel a sense of place.

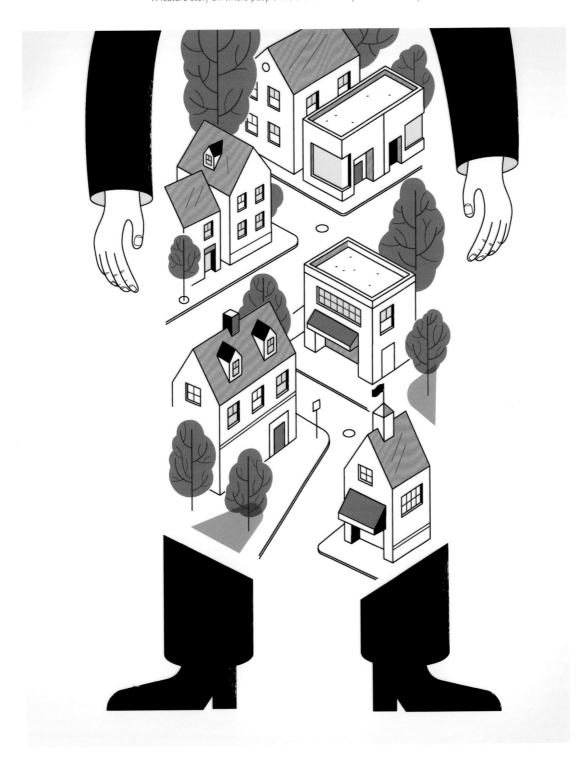

Harry Campbell
Reduced Emissions
Digital
An article about reducing emissions from power plants.

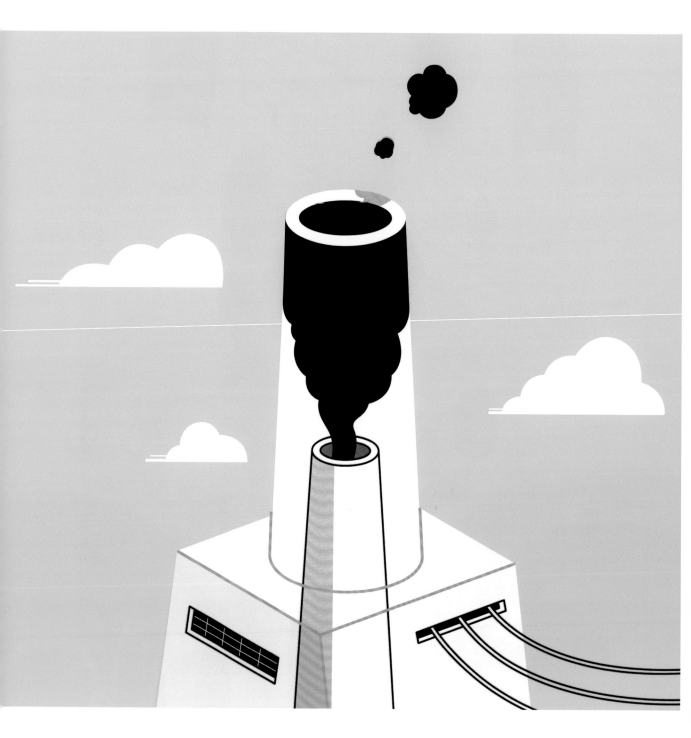

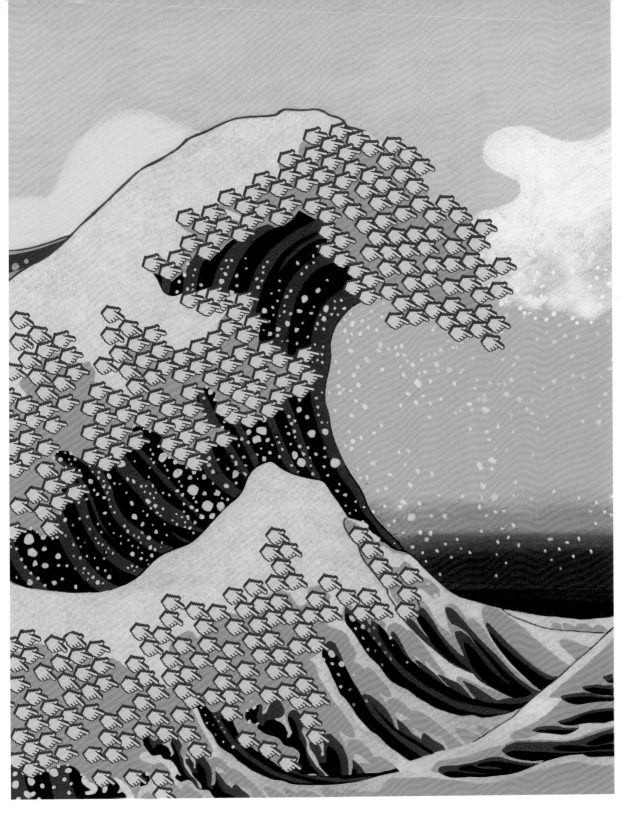

IVAN CANU
Shame!
Digital
Homage to Hokusai's great wave ,using the hater's emoji.

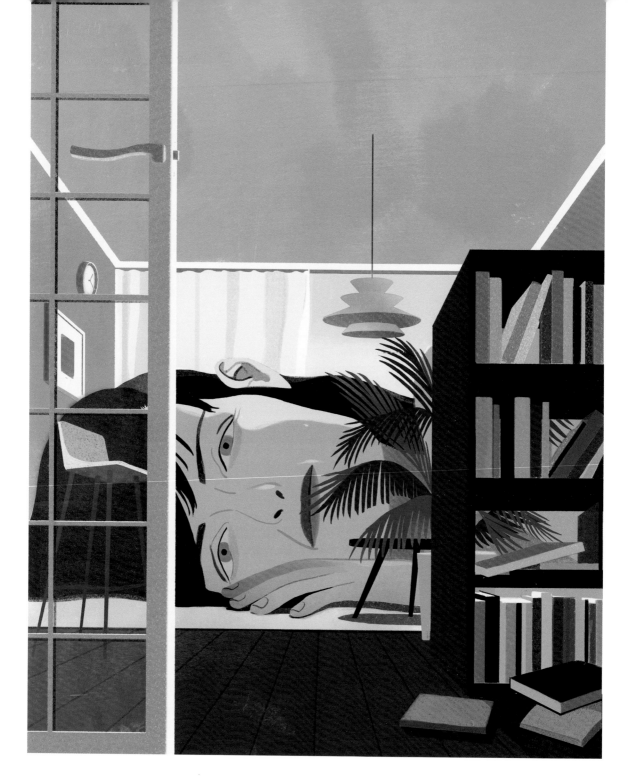

Jun Cen
The Ideal Home
Digital

Creating an ideal home has been a life-long goal for many people. However, when it comes to ideality, it is hard to judge if one's path of reaching this goal turns out to be a fact that he/she has been copying someone else's ideality.

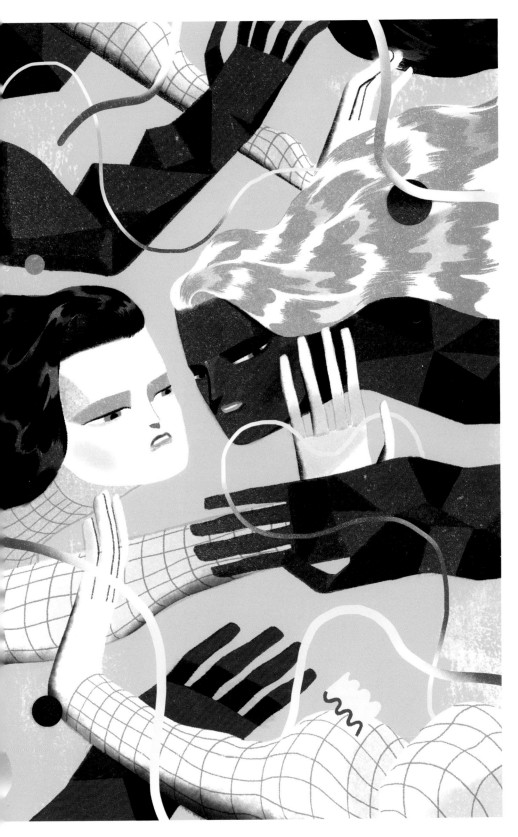

JUN CEN
The Tai Chi Master
Mixed media
The article is about
the similarity of Tai Chi
Push Hands and the
motion of bacteria.

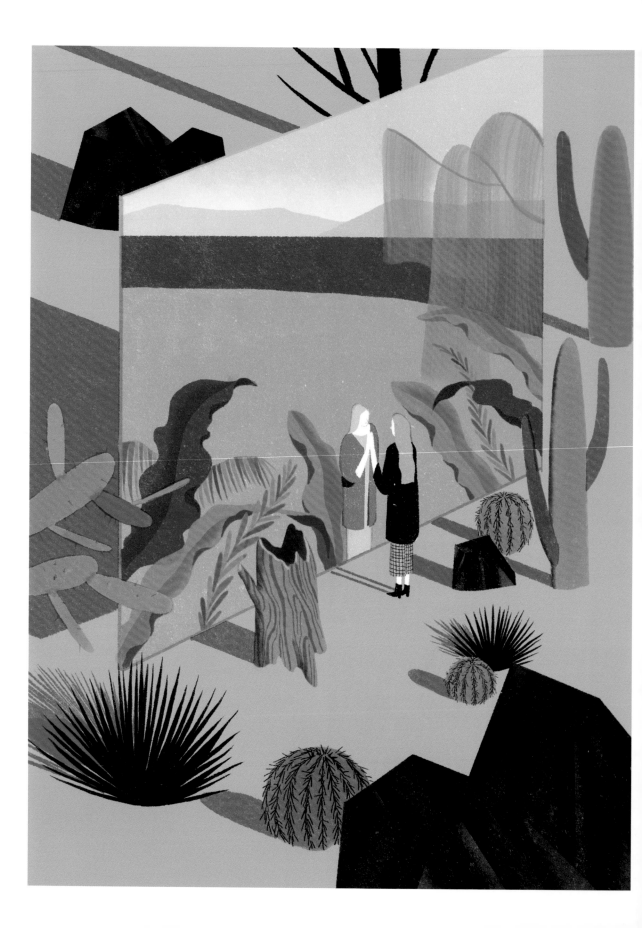

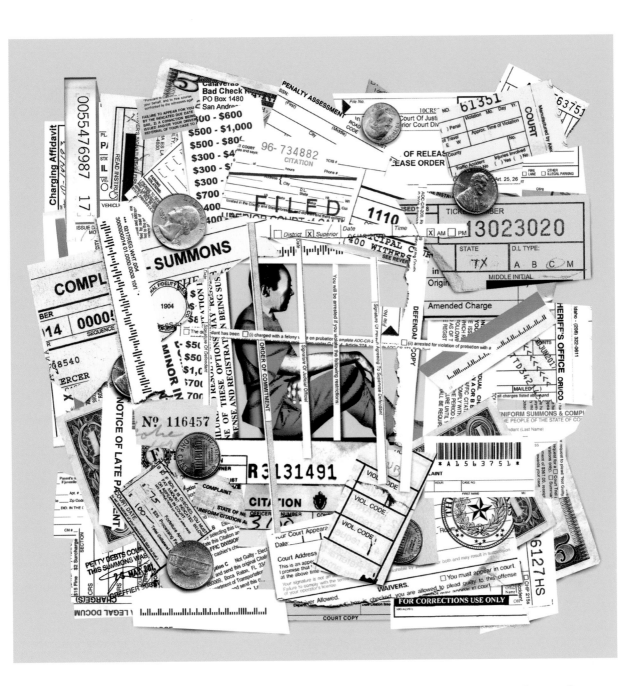

JUN CEN
Forgiving
Digital
A piece about self-forgiveness.

DOUG CHAYKA
Jailing the Poor
Collage
"Why I refuse to jail people for just being poor."

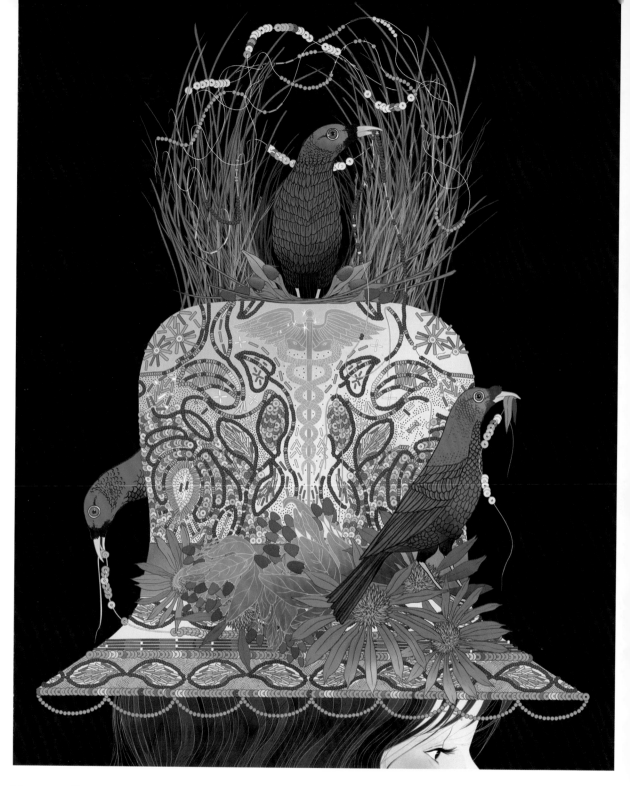

MARCOS CHIN
Something Precious
Mixed media, digital
Discovering a new source to draw upon.

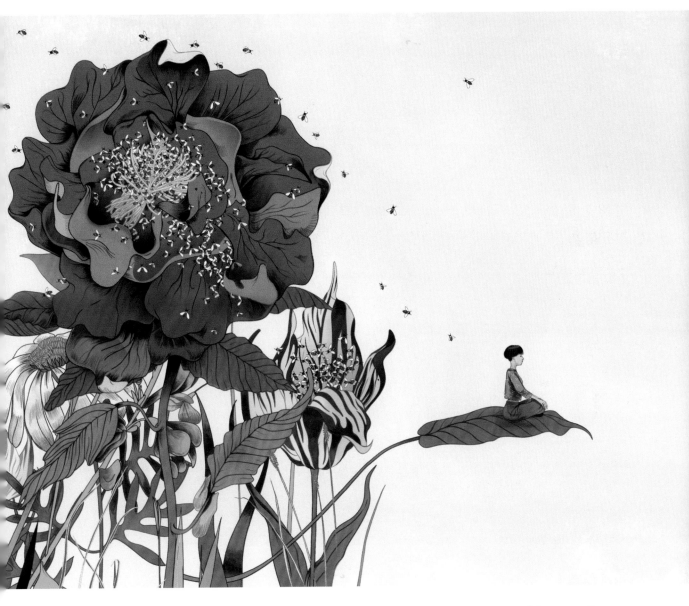

MARCOS CHIN
Mindfulness
Mixed media, digital
Meditation to quiet the non-stop noise of the CIO world.

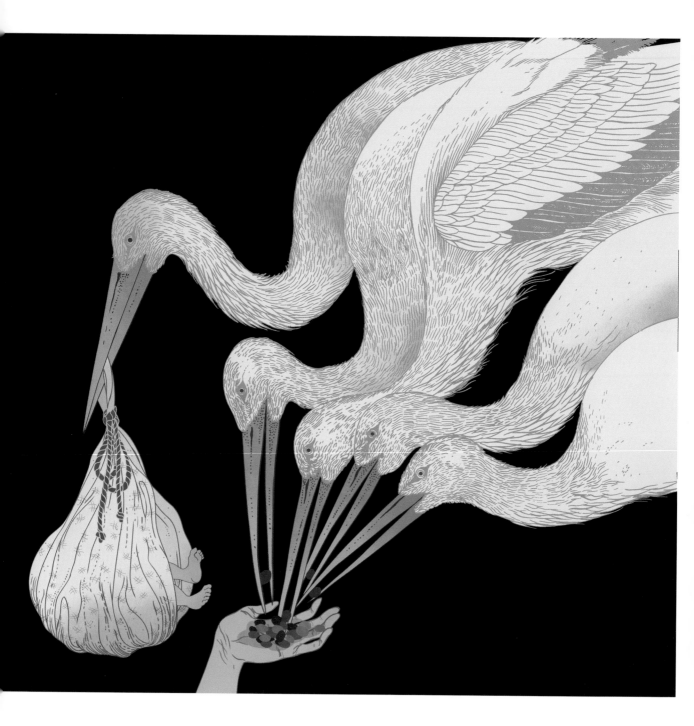

MARCOS CHIN
Delivering on Trust
Mixed media, digital
The story is about a startup that gives information to couples going through in vitro fertilization.

Rebecca Clarke
Icon Portraits
Colored pencils, pierre noir, watercolor, gouache
Portraits of architects and creatives: Ben van Berkel, Jacques Herzog,
Toan Nghiem and Walter van Beirendonck.

REBECCA CLARKE
Life After Bernie
Colored pencils, pierre noir,
watercolor, gouache
Portraits of Bernie Sanders supporters
for the *The New York Times* online.

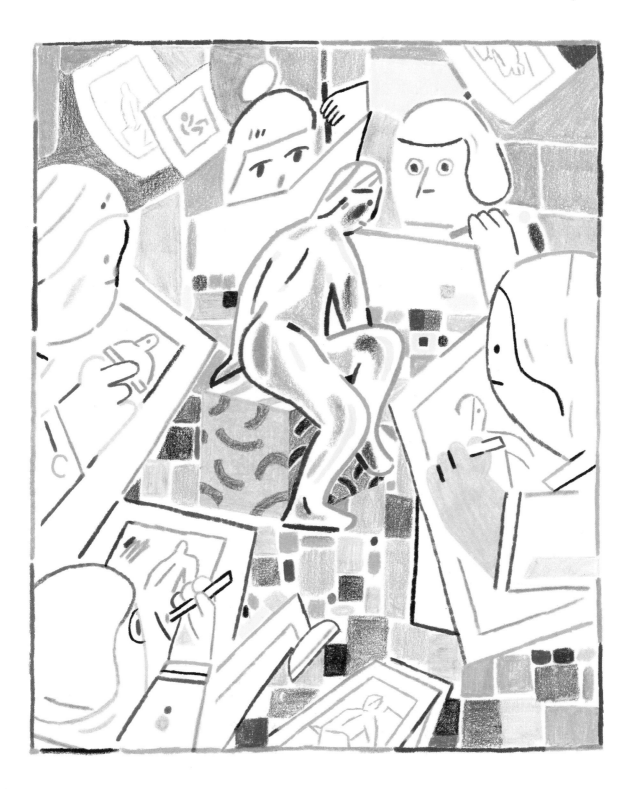

BRANCHE COVERDALE
The Sick Yeti
Gouache on paper
Spread from the short story.

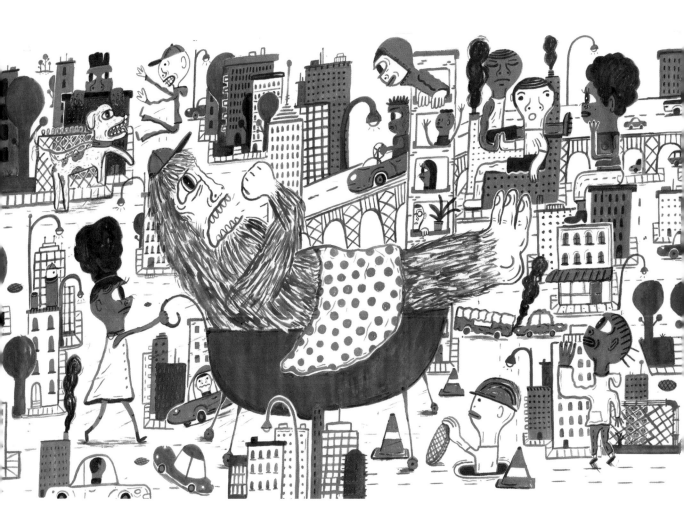

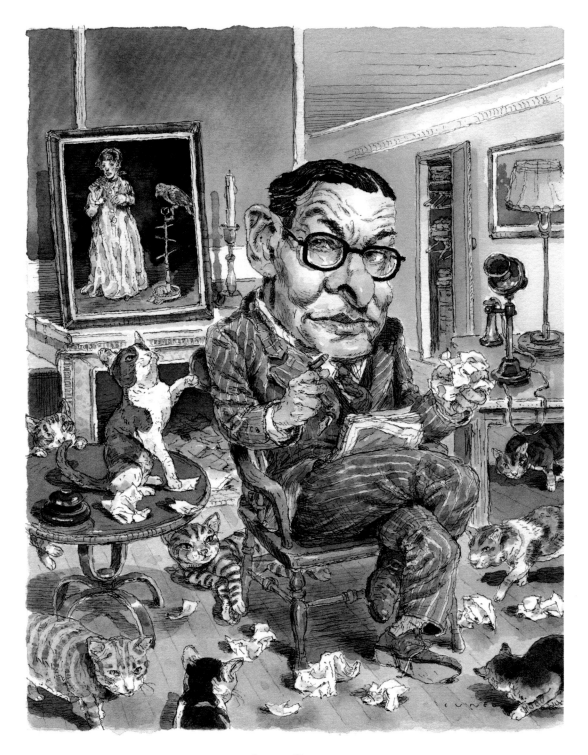

JOHN CUNEO
T. S. Eliot
Pen, ink and watercolor on paper
For a feature that discusses a recent collection of writings,
and his personal struggles with repressed homosexuality.

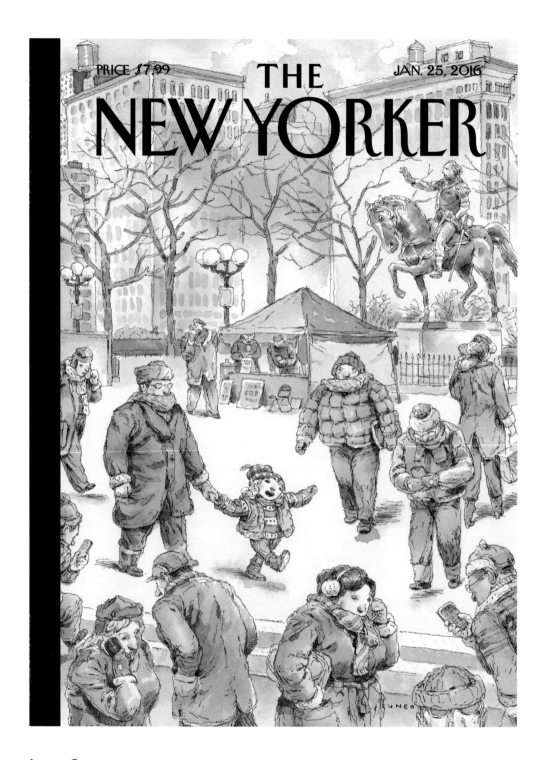

PRICE $7.99 JAN. 25, 2016

THE NEW YORKER

JOHN CUNEO
Winter Girl
Pen, ink and watercolor on paper
Something for the bleak season.

FACING PAGE

ANDRE DA LOBA
Designer Ethics
Digital
Series for an article about Designer Ethics.

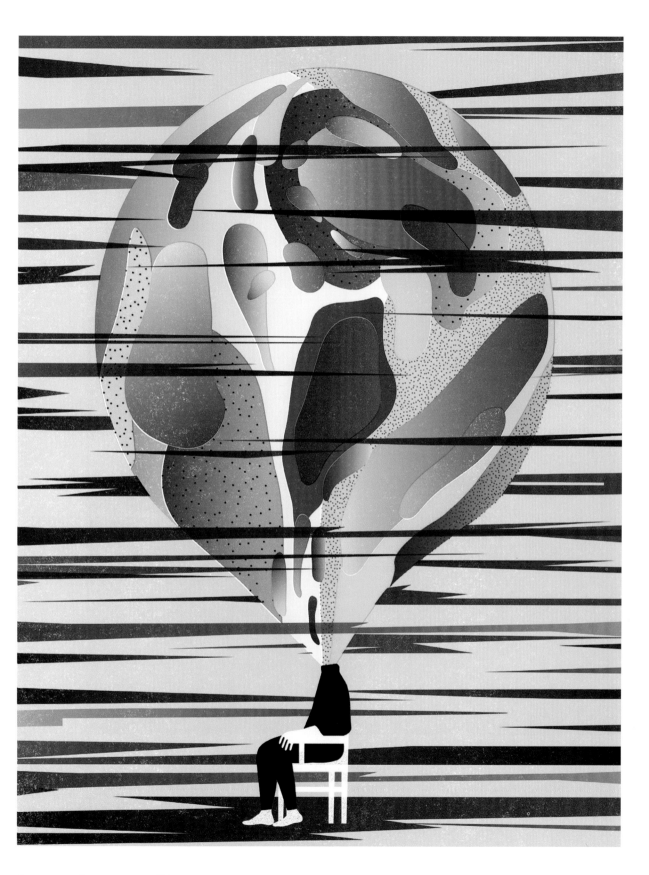

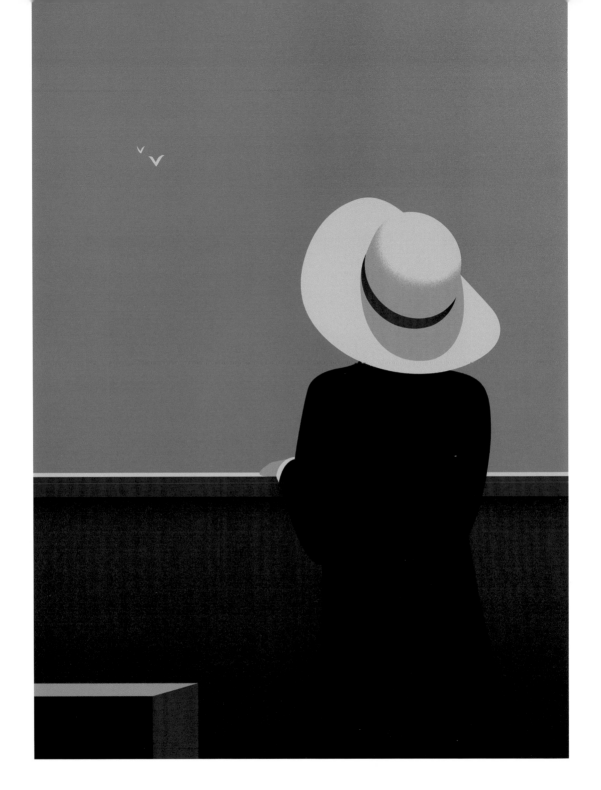

THOMAS DANTHONY
Lady with a Hat
Digital
Magazine cover for *Popshot* magazine. Wrapping around the front and back cover.

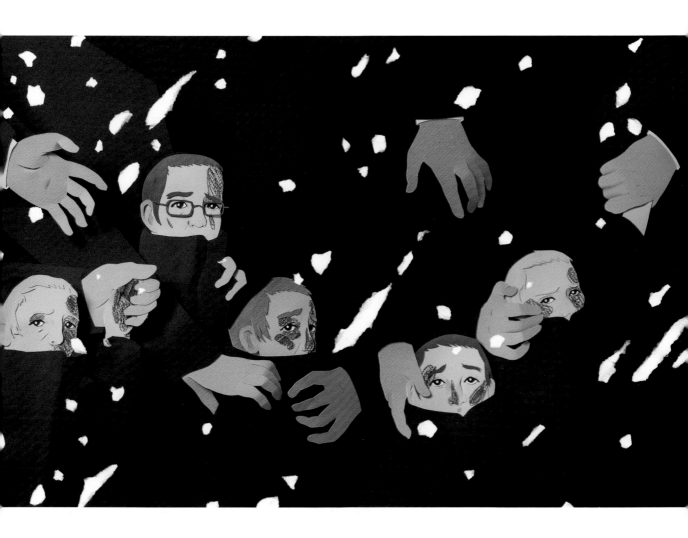

MAELLE DOLIVEUX
Hasidic Abuse 1
Cut paper, photography
Feature spread for an article on child abuse
in Brooklyn's Hasidic community.

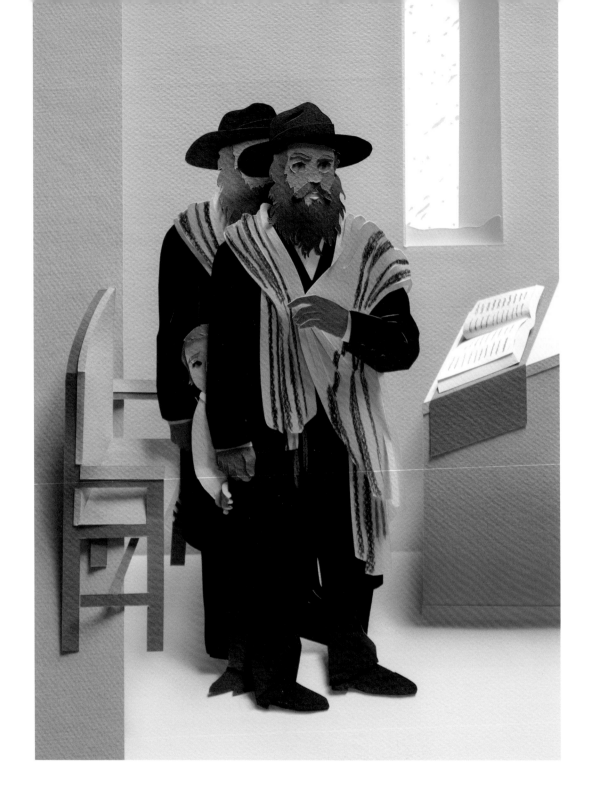

MAELLE DOLIVEUX
Hasidic Abuse 2
Cut paper, photography
Interior illustration for an article on child abuse in Brooklyn's Hasidic community.

MAELLE DOLIVEUX
Fractured
Cut paper, digital
A young woman goes on an impromptu first date that begins in a Brooklyn bar and ends in the hospital.

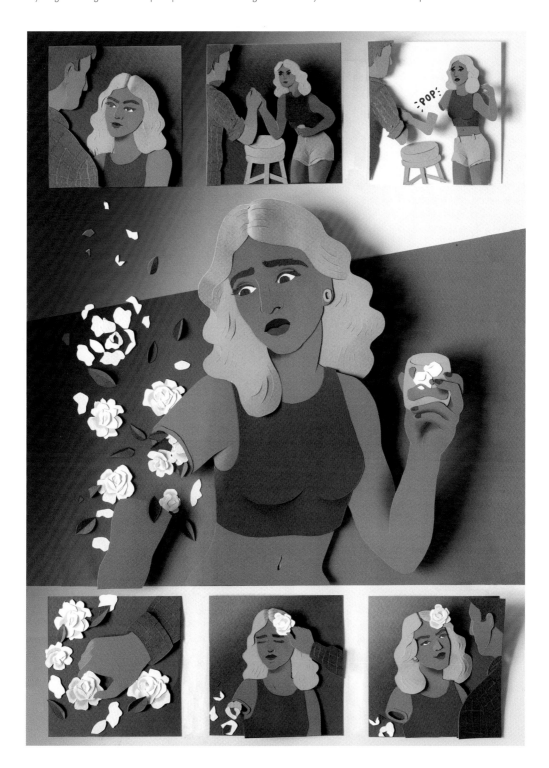

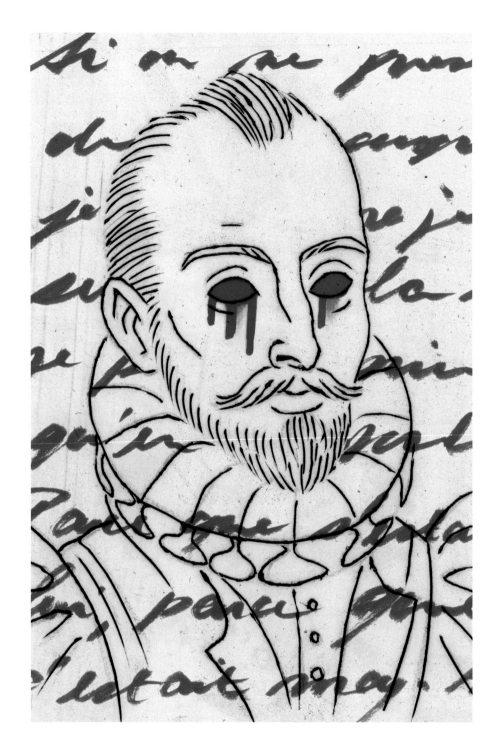

MAELLE DOLIVEUX
The Heart or the Head
Scratchboard, digital
Sixteenth-century French philosopher Montaigne urges writers to appeal to readers' intellects,
as opposed to pulling at their animal heartstrings and manipulating their emotions.

GERARD DuBOIS
Constructing the Modern Mind
Acrylic on paper and digital
Views on how the mind, brain and soul have evolved.

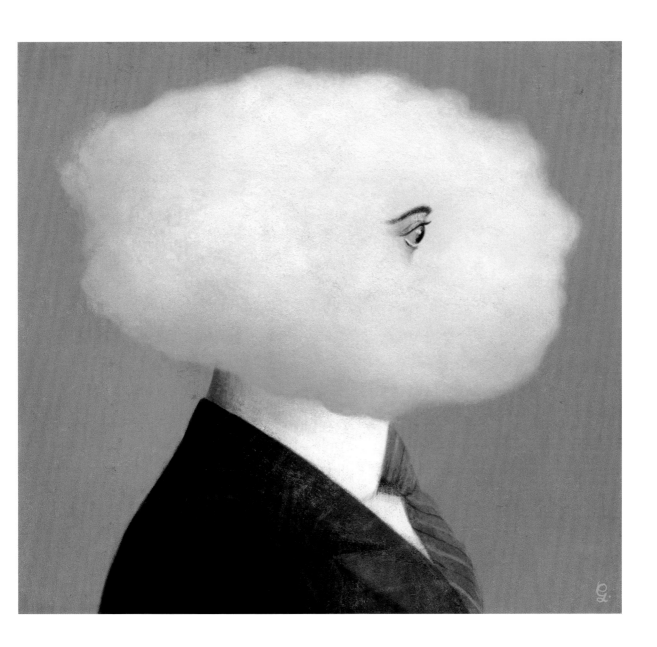

REBEKKA DUNLAP
When Satan Wants Me
Digital

A series of Images for the story "When Satan Wants Me" by Kathleen Hale about her experience of talking to the surviving members of the Rhoden family, eight of whom were mysteriously gunned down. In conclusion, Hale finds that because of their low social status, their own town has quickly made the choice to forget them. Their murders remain unsolved and Hale must grapple with the hopelessness of human cruelty and violence.

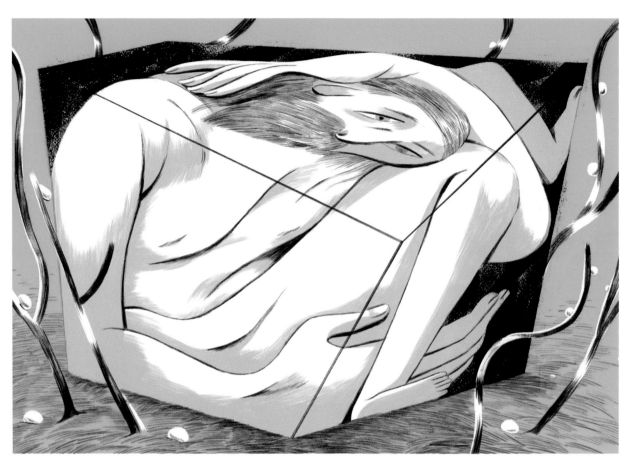

Rebekka Dunlap
Captcha
Digital

A series for the abstract short story "Captcha" by Naomi Skwarna about a man that is kept in a box for his entire life until one day he is let go with no explanation. He tries to find affection in humanity, but eventually returns to the forest, longing for his previous, barbaric, yet simple life of captivity.

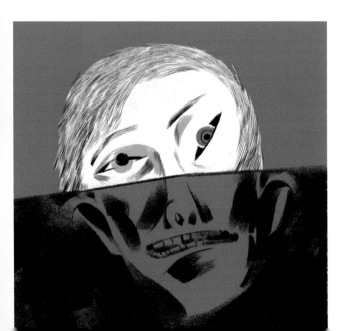

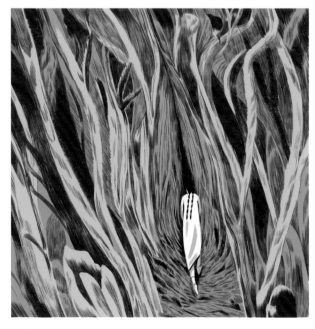

REBEKKA DUNLAP
Why Courts Shouldn't Ignore the Facts About Abortion Rights
Digital
A piece for Linda Greenhouse's *New York Times* article in which she talks about the dangers of forcing women to cross state borders to procure legal abortion.

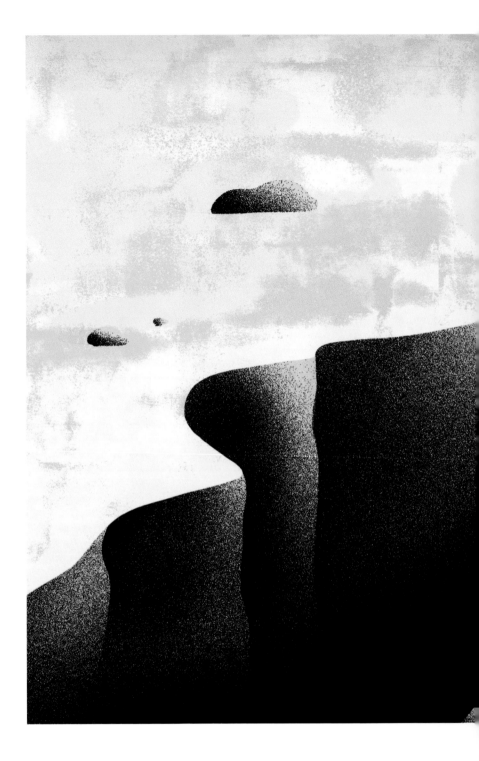

LISK FENG
Old & Future
Digital
A series in *Explore Magazine* about the older generation.

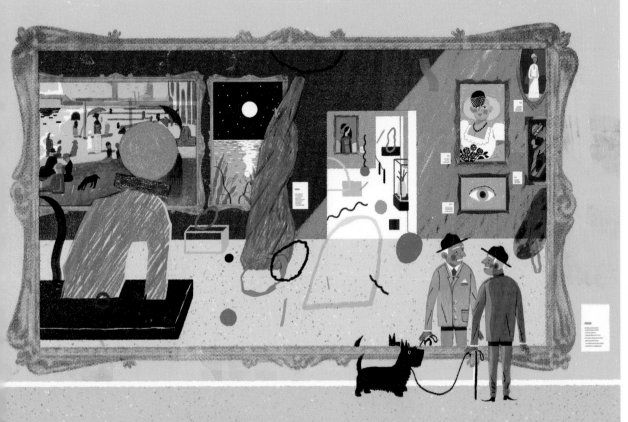

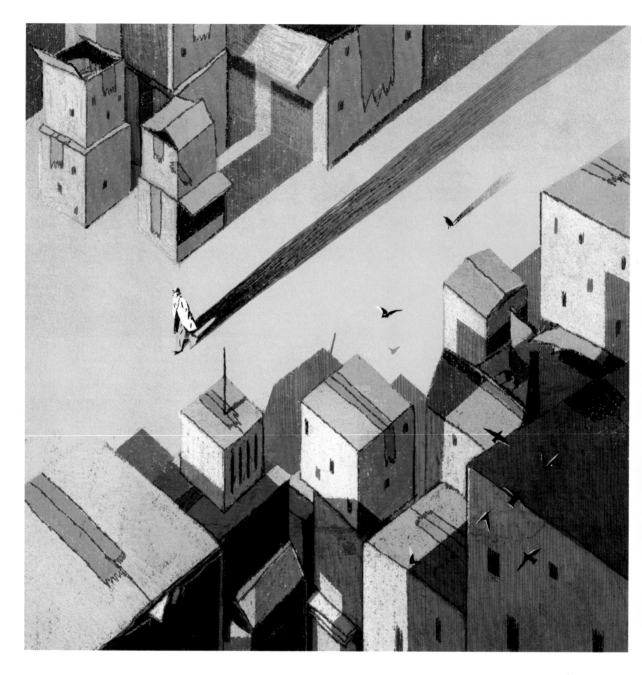

LISK FENG
I Am No One
Digital

A piece for a book review article in *The New York Times*. Jeremy O'Keefe, a middle-aged history professor, returns to his native New York after a decade teaching at Oxford, hoping to reconnect with his daughter and rebuild the life he left behind. He settles into a rhythm of long evenings spent alone after a day teaching students he barely knows. Then a strange encounter with a young man who presumes an acquaintance Jeremy cannot remember and a series of disconcerting events leave him with a growing conviction that he is being watched. The young man keeps appearing, a haunting figure lingers outside his apartment at night, and mysterious packages begin to arrive. As his grip on reality seems to shift and turn, Jeremy struggles to know whether he can believe what he is experiencing, or whether his mind is in the grip of an irrational obsession. *I Am No One* explores the tenuous link between fear and paranoia in our post-Snowden lives: a world of surveillance and self-censorship, where privacy no longer exists and our freedoms are inexorably eroded.

LISK FENG
Why Chinese Women Still Can't Get a Break
Digital
The article is written by a Chinese female writer talking about the past, present and future of female roles in Chinese society. It describes the relationship between females and marriage, kids, husband, house and jobs.

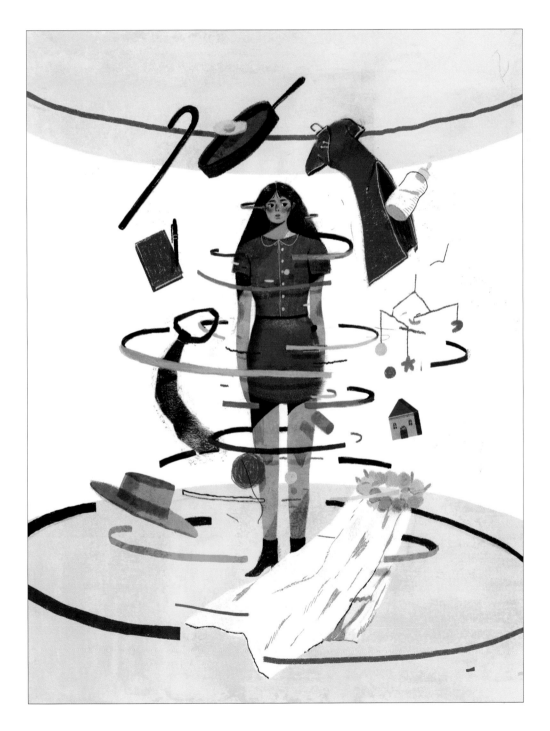

AARON FERNANDEZ
Inside the Playlist Factory
Digital
At the most powerful companies in Silicon Valley, small teams of anonymous, hardcore music fans race to solve the record industry's toughest problem.

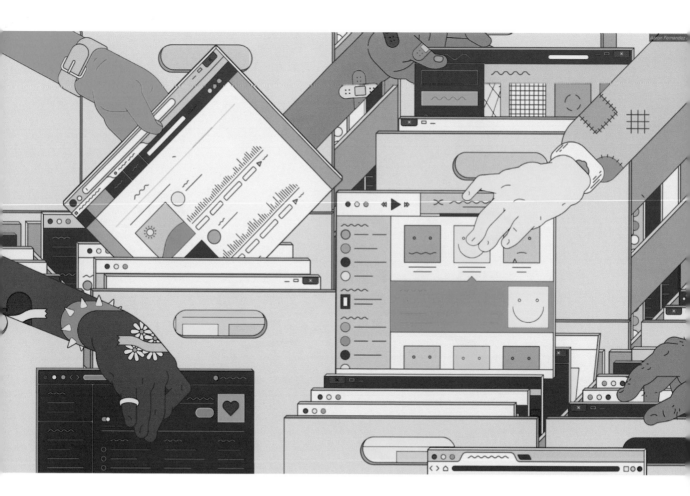

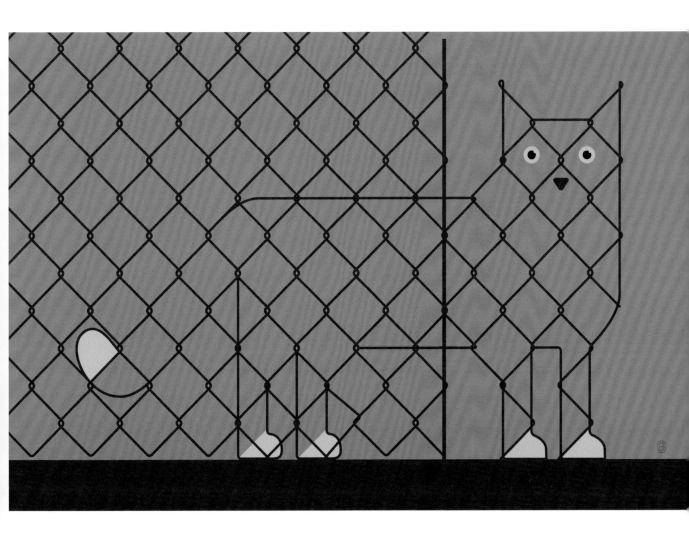

JOEY GUIDONE
The Zebra Hunter
Digital

Geneticist Ada Amosh is on a quest to find and treat some of the rarest
genetic diseases known to man, called "zebras" in health parlance.
Cover of the *Johns Hopkins Health Review* magazine.

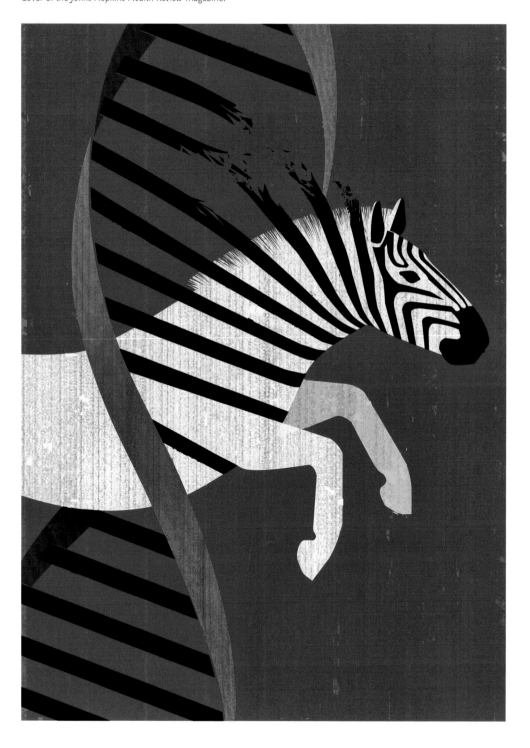

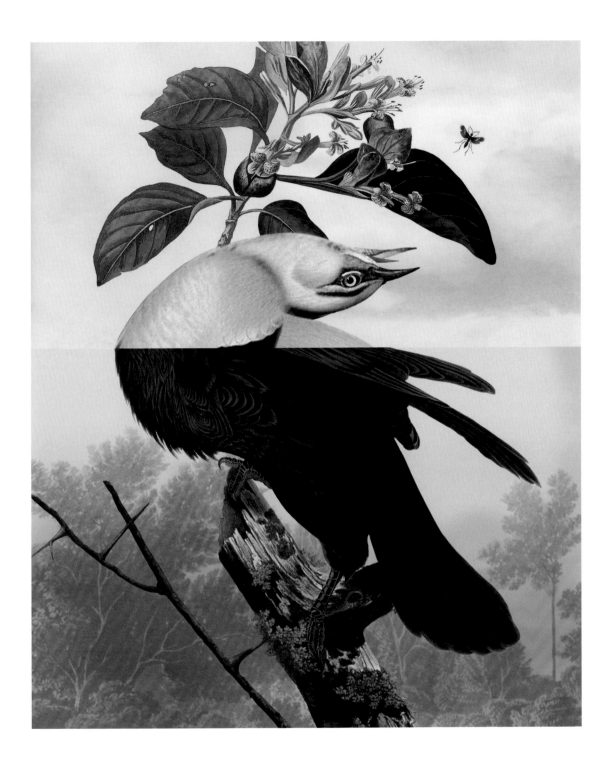

EDDIE GUY
Reinvent Your Life
Photocollage
Series of essays about women reinventing their lives.

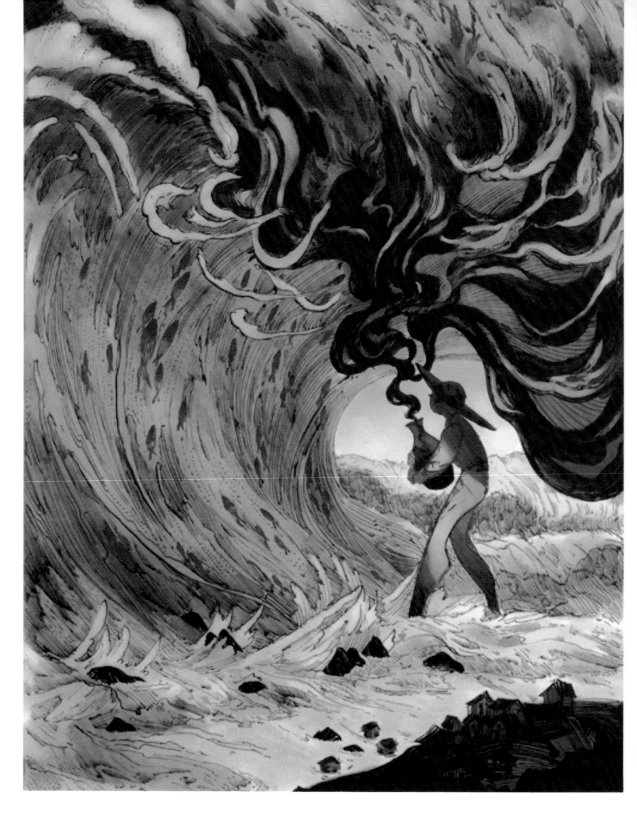

MING HAI
Risk Capture
Ink and digital color
How advisers can help plan sponsors with pension risk transfer.

JOHN HENDRIX
Serpent Rider

Pen and ink, fluid acrylics
Are the titans of Wall Street really in control of the powerful financial tools
under their feet? A visual representation of what we all hope is controlled chaos.

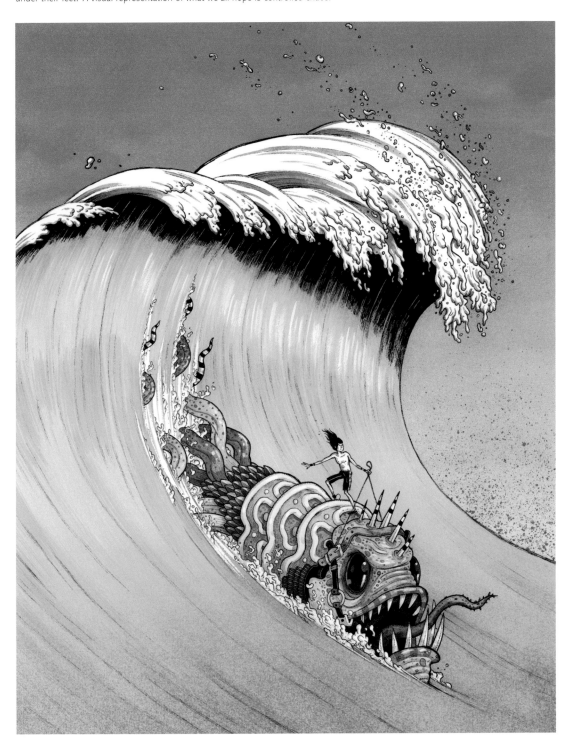

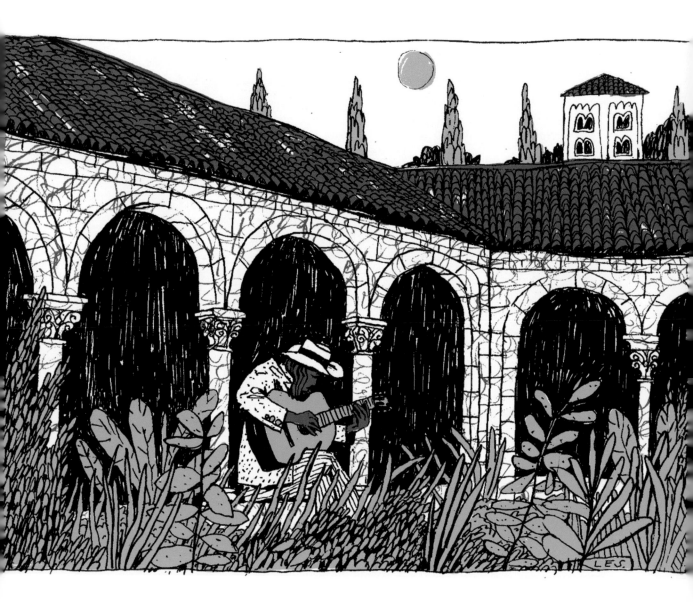

LESLIE HERMAN
Guitar Park
Graphite, digital
Illustration about the New York Guitar Festival at The Cloisters.

Jasu Hu
The Books She Left Behind
Digital
An illustration for an essay by the novelist about his sister, who died young of cancer, and
and how, through her extensive book collection, he learned about her after her passing.

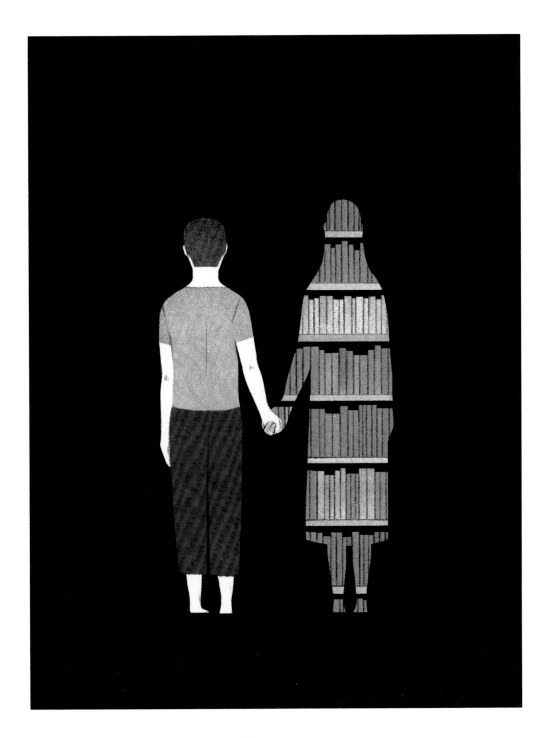

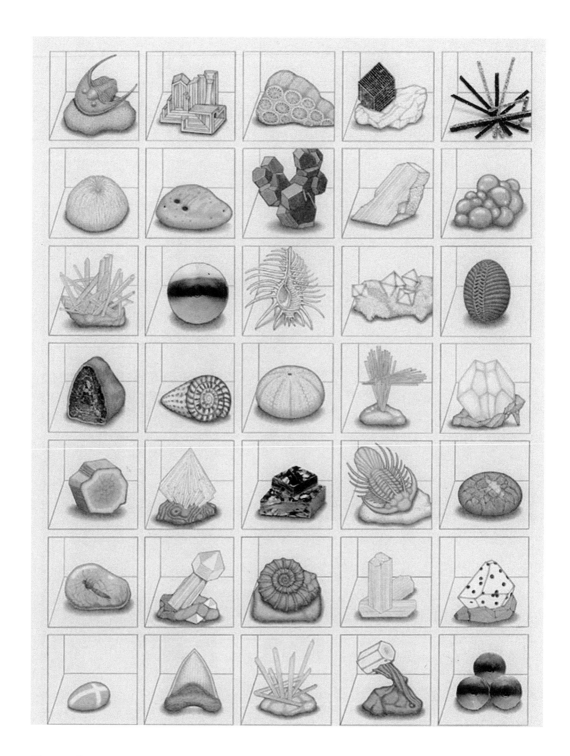

DAVID JIEN
Many Different Offerings
2016 PLANADVISER Retirement Plan Adviser Survey opening spread image. Although educating participants and helping plan sponsors craft the best possible plan design for their company may be two of the most important functions of a retirement plan adviser, aiding sponsors in their selection of investment options, not to mention the most appropriate recordkeeper for their plan, certainly are two other critical functions.

R. KIKUO JOHNSON
Commencement
Digital
Graduation-themed cover for the magazine.

Victor Juhasz
Bill DeBlasio on the Hot Seat
Pen and ink, watercolor
Parody of iconic Norman Rockwell painting *The Runaway* with NYPD,
Mayor DeBlasio and former Commissioner Bill Bratton.

KEREN KATZ
Breaking Water
Colored pencils on paper
A love story between a man and the quickly rotting corpse of a
woman rising from the water, and his subsequent devotion
to zombies. Written by Indrapramit Das.

EDWARD KINSELLA
Alfred Hitchcock Magazine Turns 50
Graphite, ink, gouache, colored pencil and watercolor
Cover for the 50th anniversary of *Alfred Hitchcock Mystery Magazine.*

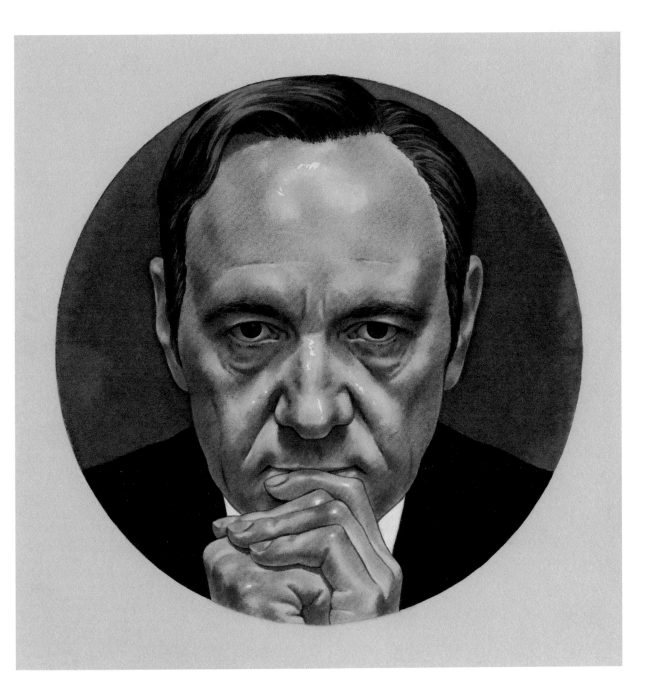

EDWARD KINSELLA
Frank Underwood
Graphite, ink, gouache, and watercolor
Kevin Spacey as Frank Underwood, from the Netflix series *House of Cards.*

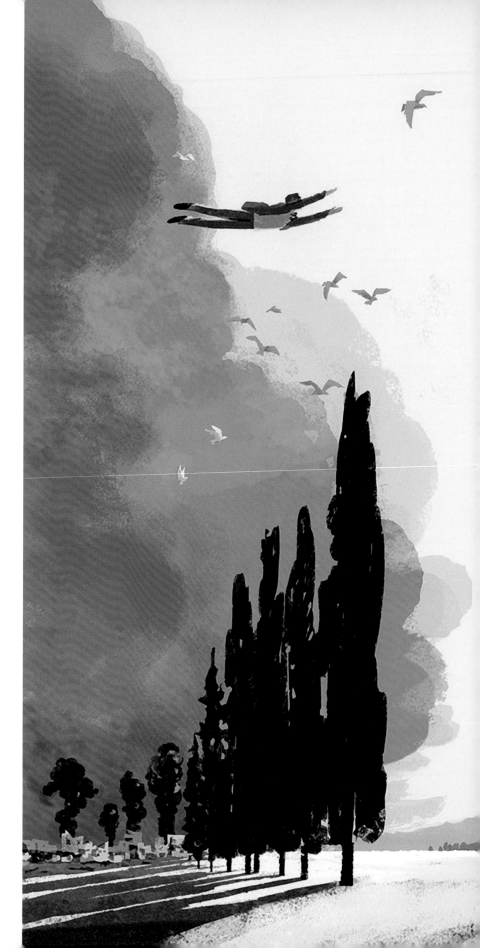

TATSURO KIUCHI
The Refugee Crisis
Digital
How can educational systems help those struggling to start life anew? Lehigh researchers and students hope to find out.

TATSURO KIUCHI

StoryBox covers

Digital

Cover illustrations for a monthly children's magazine.

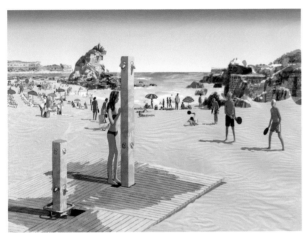
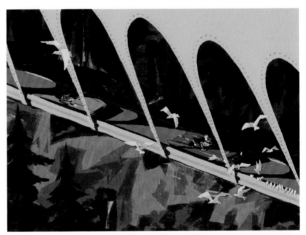
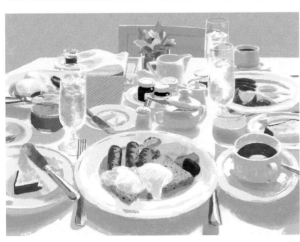
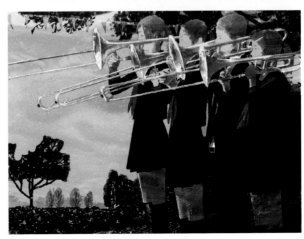

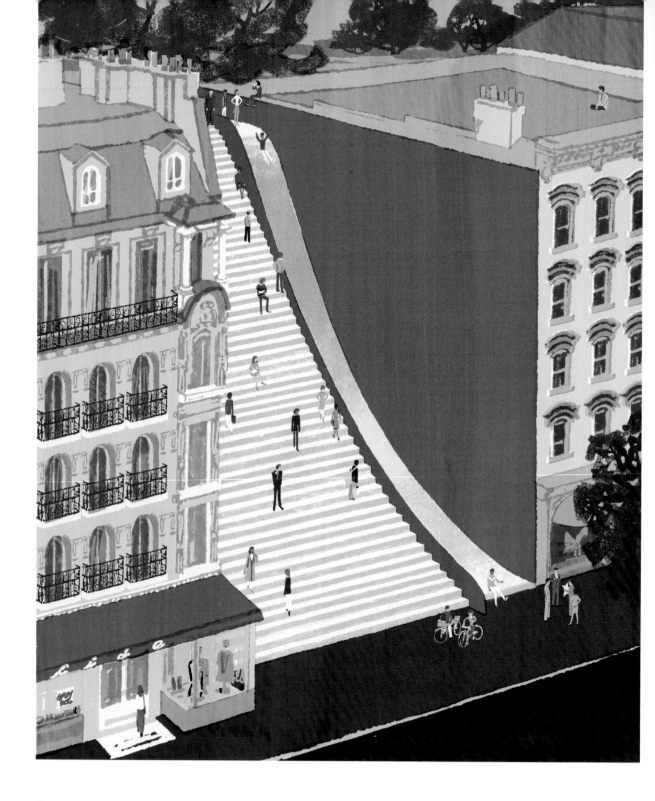

Tatsuro Kiuchi
Fill in the Blank
Digital

Every issue *Block* magazine asks a different artist: What would you do with your very own urban infill?

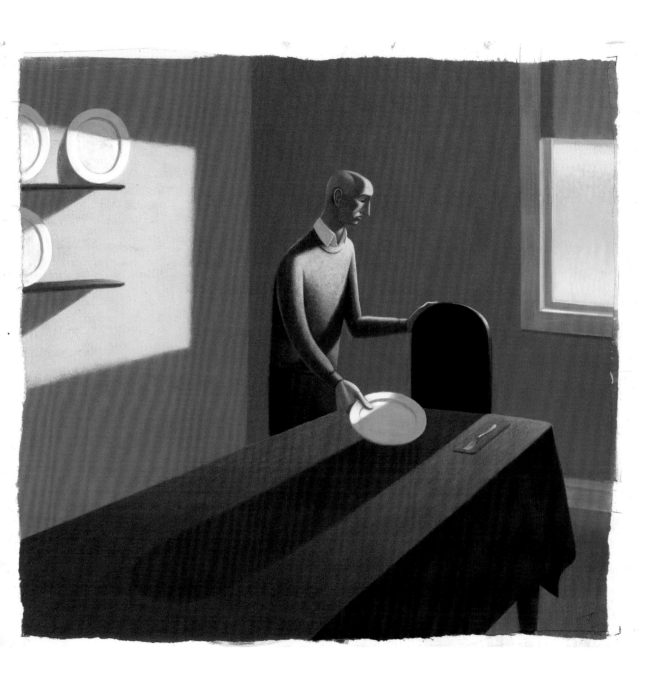

JON KRAUSE
Loneliness
Acrylic on masonite
For an article describing loneliness as an epidemic that can foreshadow death.

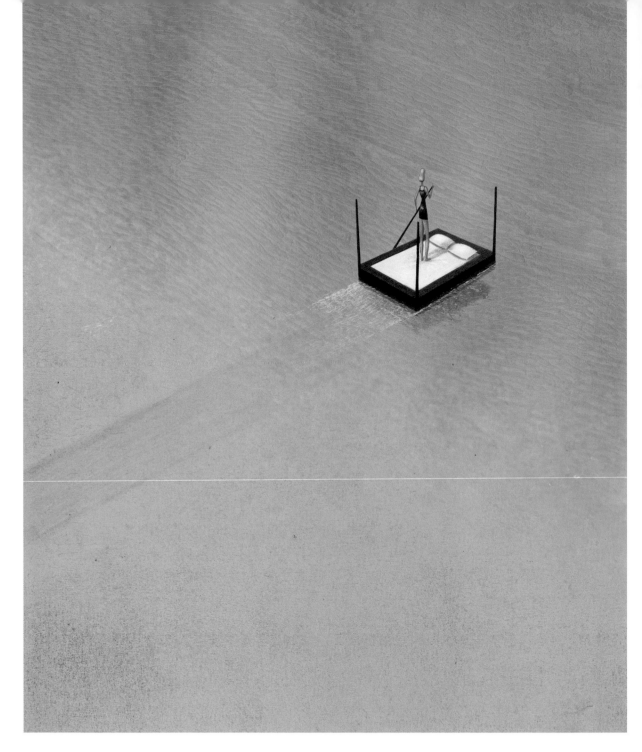

JON KRAUSE
No Man's Land
Acrylic, varnish, collage on paper
For an article about Harold Pinter's play and the author's celibacy vow.

FACING PAGE

GRACIA LAM
Menopause
Mixed Media
Menopause and its hot flashes.

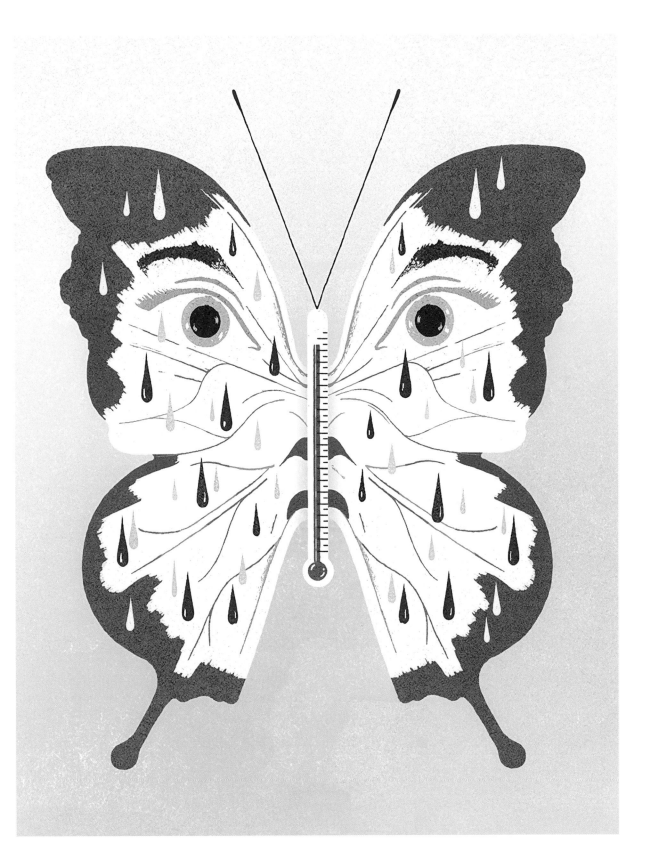

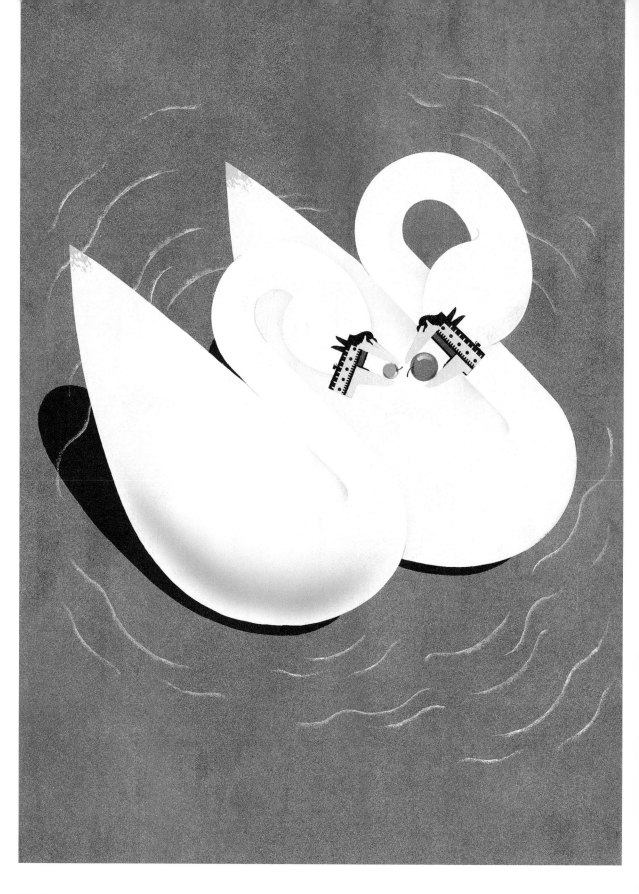

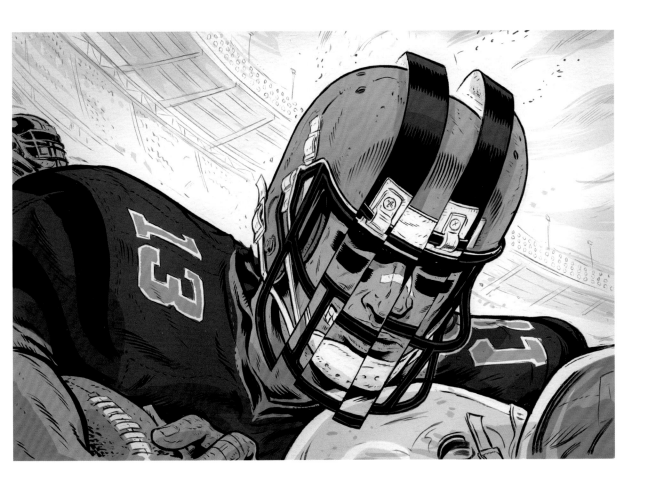

LARS LEETARU
Concussions
Ink and digital
For an article about the NFL reversing its stance on the
link between concussions and degenerative brain disease.

FACING PAGE

GRACIA LAM
Pink Money
Mixed media
An insight into LGBTQ couples' earning powers.

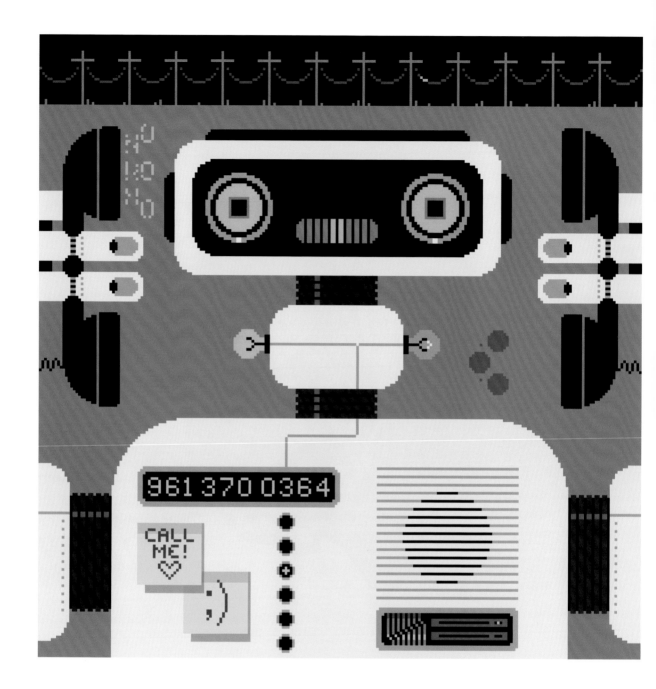

NICK LITTLE
Robocalling
Digital
An animated .gif for the MIT Technology Review on the topic of robocalling.

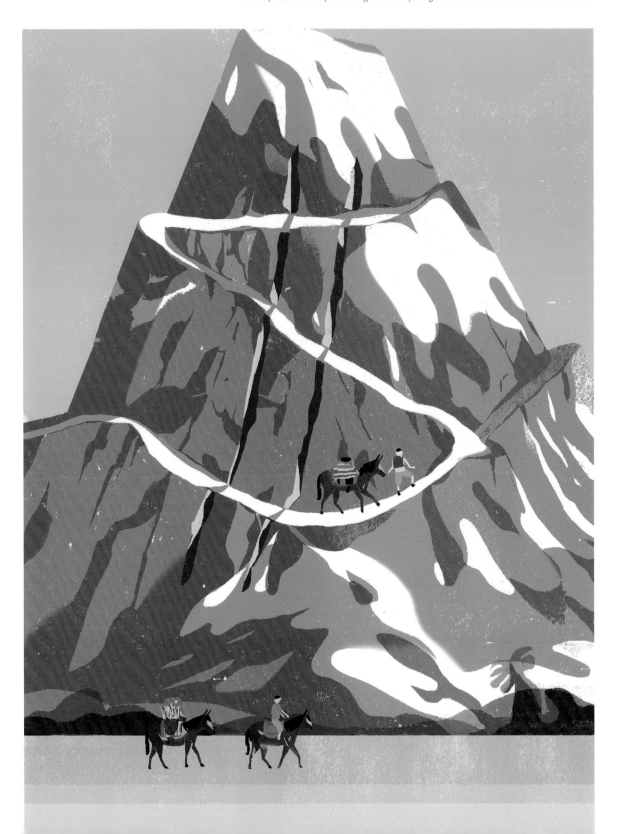

JENN LIV
Gun Trauma
Photoshop CC
Header illustration for *Narratively*. A story about a girl reflecting upon her
traumatic past of growing up in a gun-filled household with an abusive father.

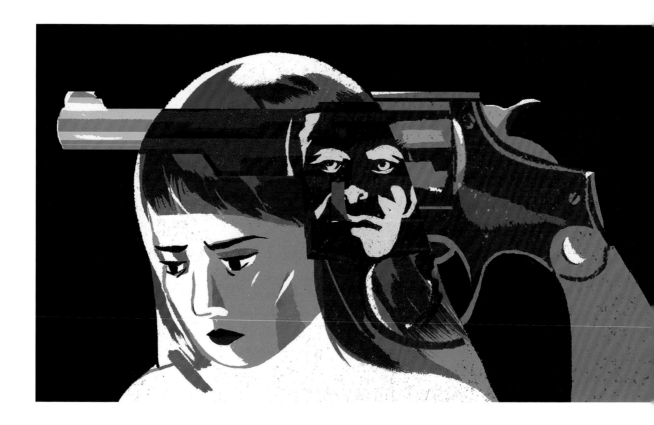

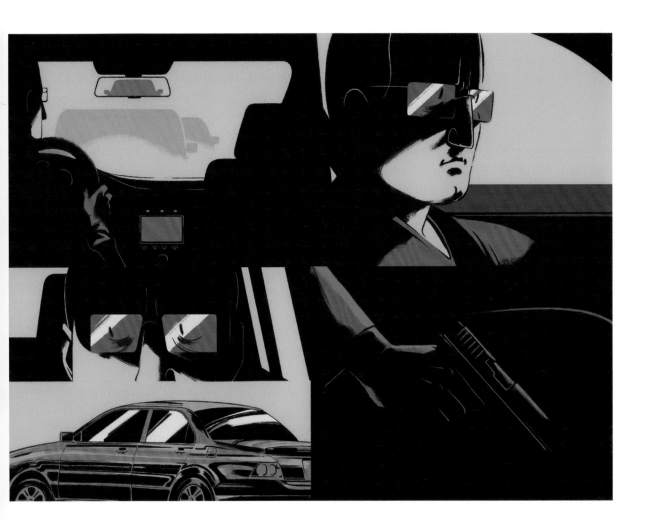

LOVELY CREATURES
Gunfight in Guatemala
Digital
An animated illustration for Pro Publica's story covering Enrique Degenhart's
(Guatemala's Director of Immigration) brush with death.

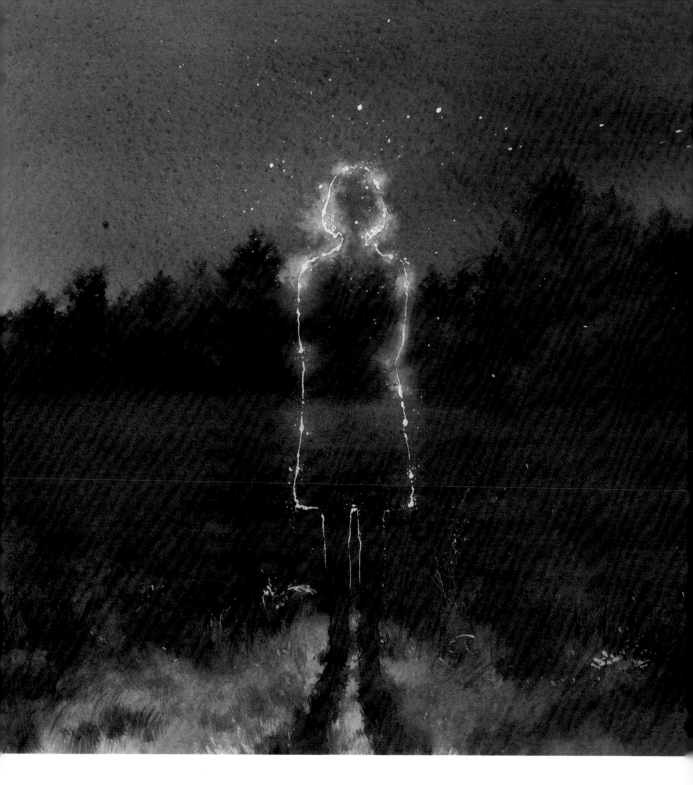

MARINA MARCOLIN
Lighten Up Yourself
Watercolor on paper
Christmas postcard self promotion.

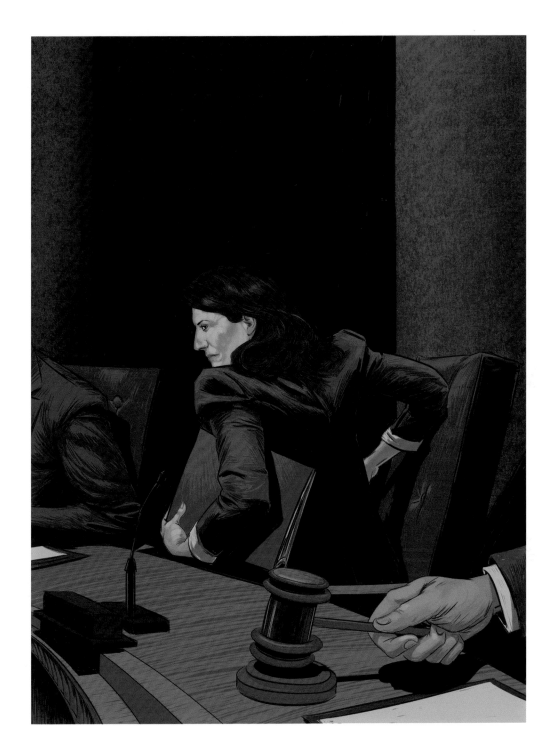

MICHAEL MARSICANO
"Lady Leah"
Digital
Leah Vukmir, a soft-spoken former nurse, has emerged as one of the
heaviest hitters in the Wisconsin Legislature, all by doing it her way.

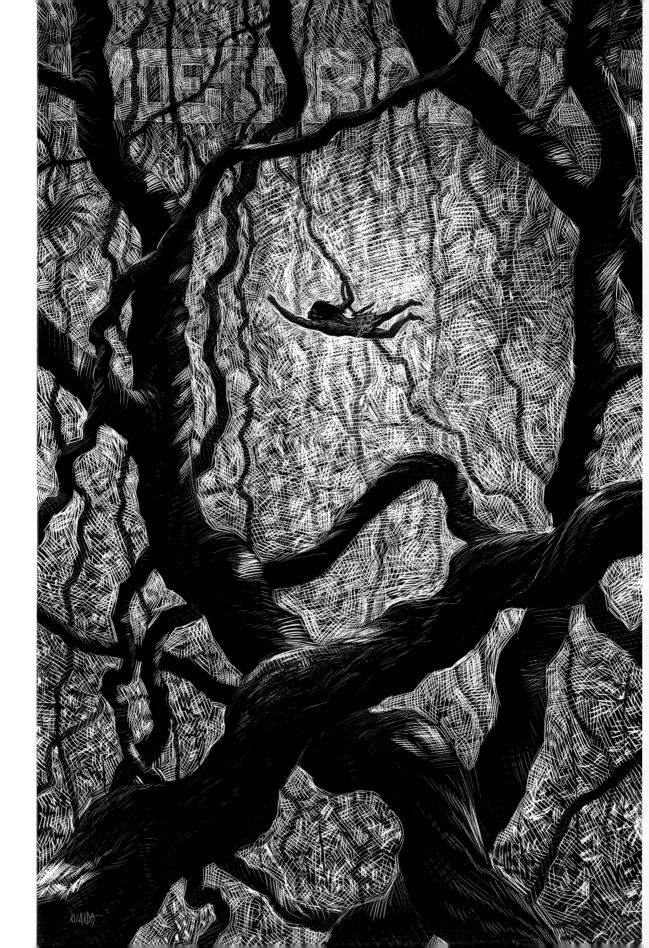

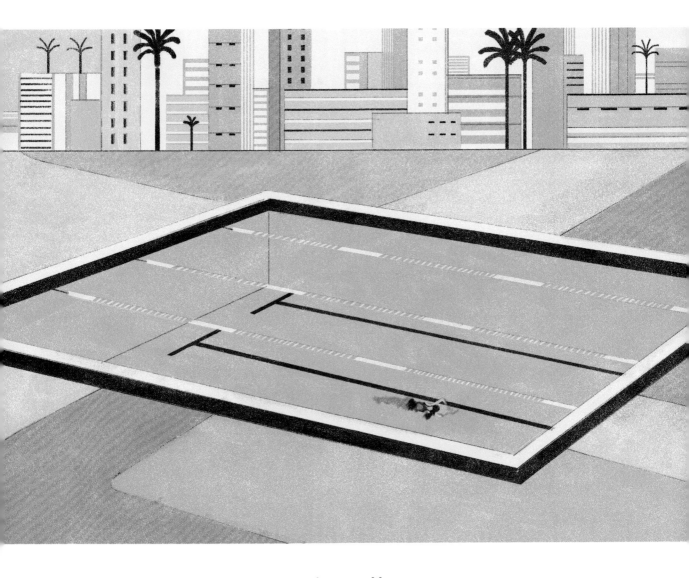

ANDREA MONGIA
The Depth of Swim
Digital
From a series of three illustrations about Olympic sports:
swimming, running and fencing.

FACING PAGE

RICARDO MARTINEZ ORTEGA
Tarzan
Scratchboard
Cover of *Metropoli* for the opening of the movie *Tarzan*.

ADAM McCAULEY
The Berm
Digital
Illustration for a *New York Times Op-Ed* piece about the inability of
aid workers to reach the Syrian refugees due to a variety of issues,
including a geological feature known as "the Berm."

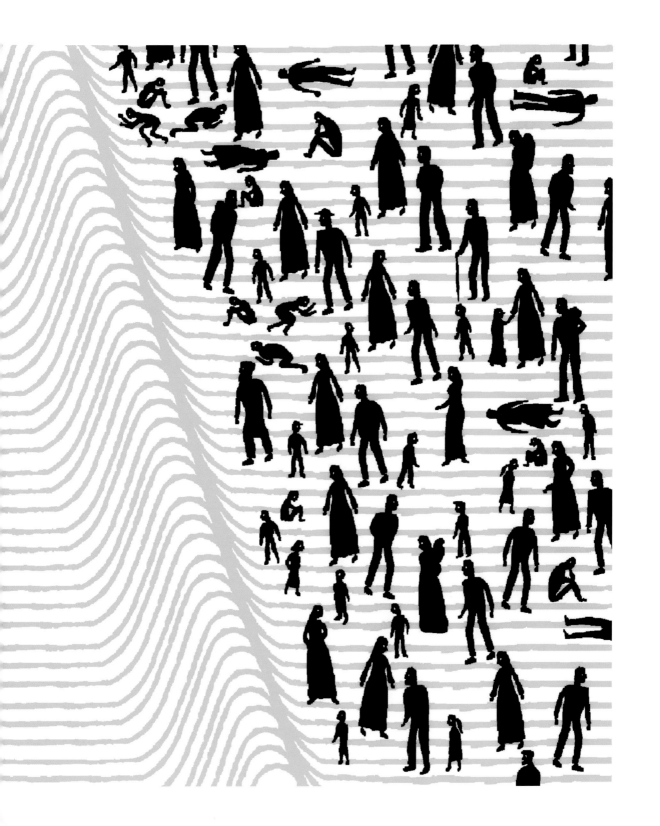

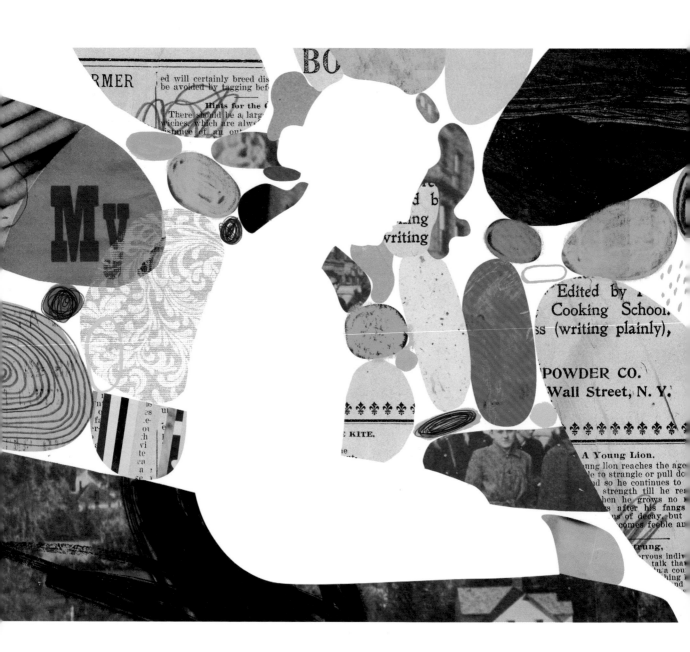

KEITH NEGLEY
Distant Memories
Mixed media, digital
Art for a feature story about living with Alzheimer's.

ROBERT NEUBECKER
Gay in the '50s
Digital
Article about two theater men who had a long-term relationship
in the fifties and how they had to hide it.

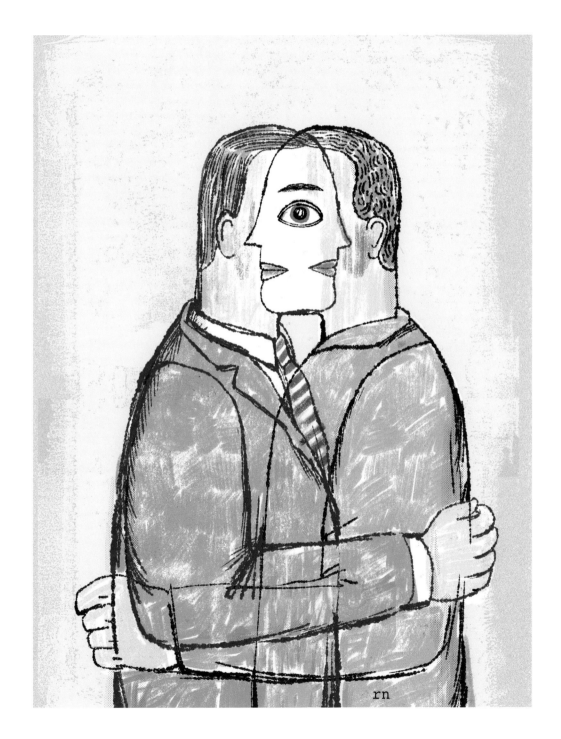

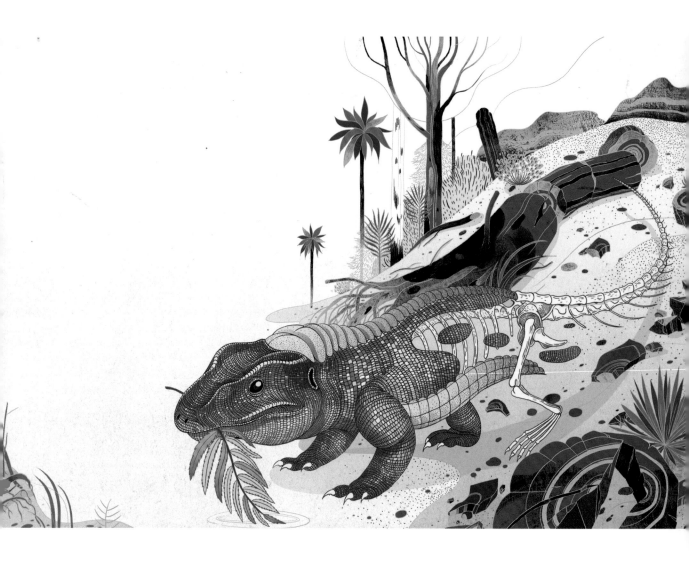

VICTO NGAI
Coming to Life
Mixed media
Study of the petrified forest and the fossils enable us to
get a glimpse of extinct species' life.

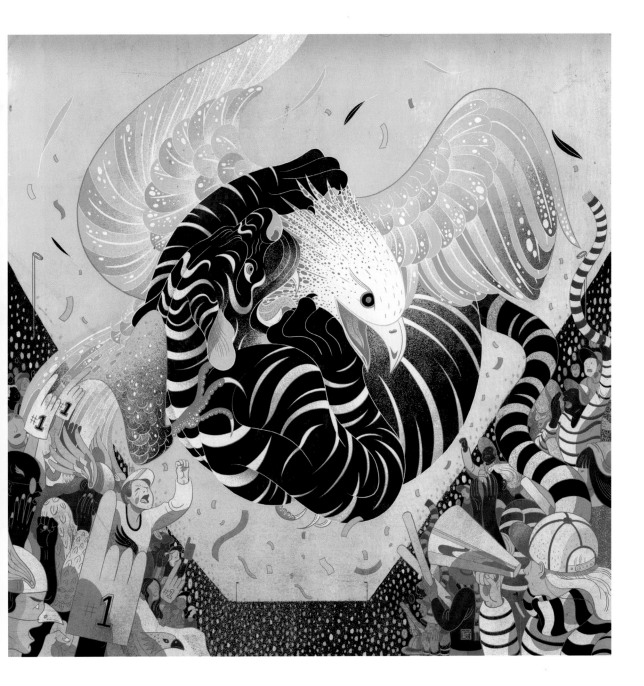

VICTO NGAI
Sport Fans
Mixed media
The battle between the fans.

Tim O'Brien
Space
Oil on board
Cover of *NAUTILUS* on the subject of space.

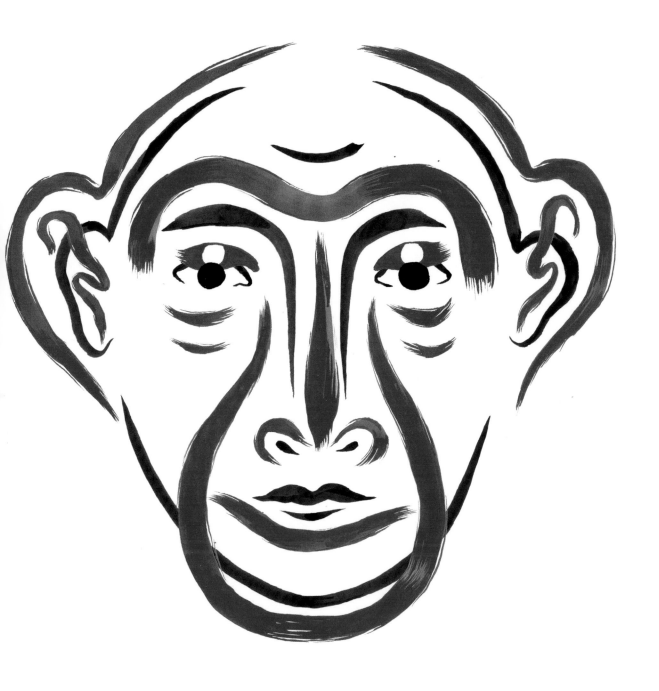

ENZO PÉRÈS-LABOURDETTE
What I Learned Tickling Apes
Ink
Cover illustration for an article in *The New York Times Sunday Review*
about the similarities between man and ape.

Eric Petersen
The Secret Rules of the Internet
Digital
Illustrations for a story about "the murky history of moderation, and how it's
shaping the future of free speech" by Catherine Buni and Soraya Chemaly.

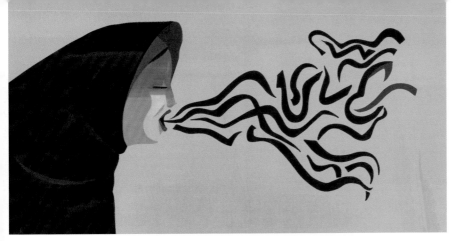

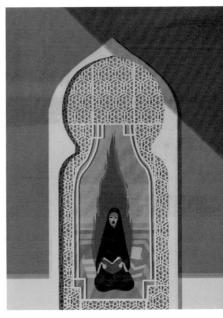

EMILIANO
PONZI
ISIS
Digital

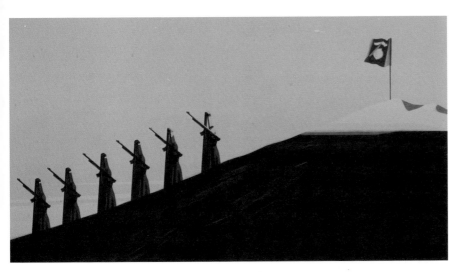

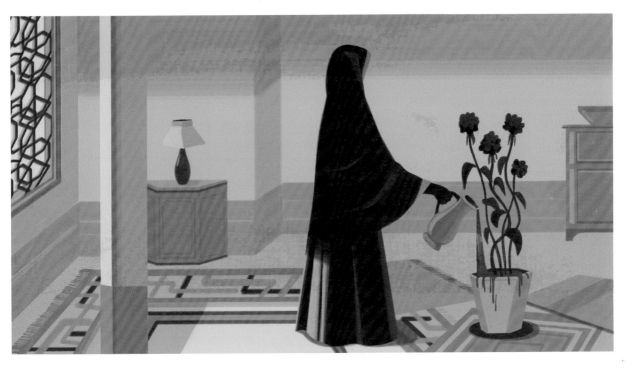

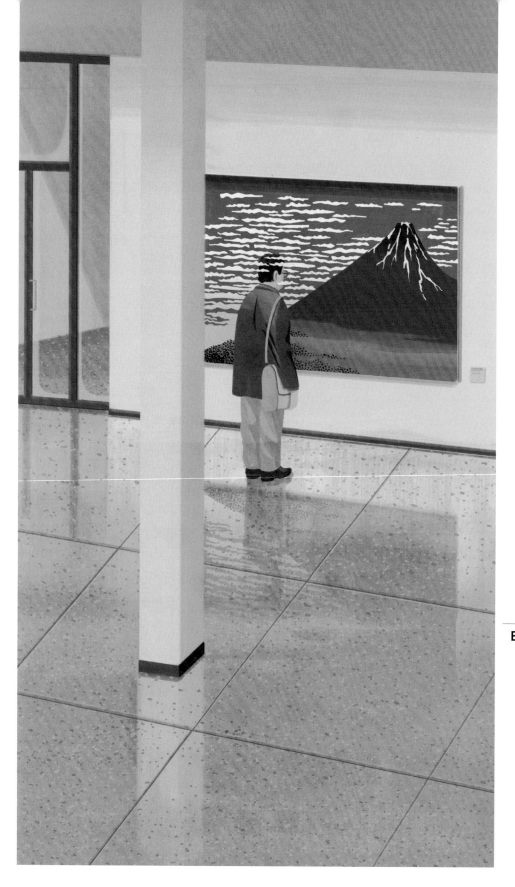

EMILIANO PONZI
Head in the Clouds
Digital

FACING PAGE

EMILIANO PONZI
Stuck Traveler
Digital

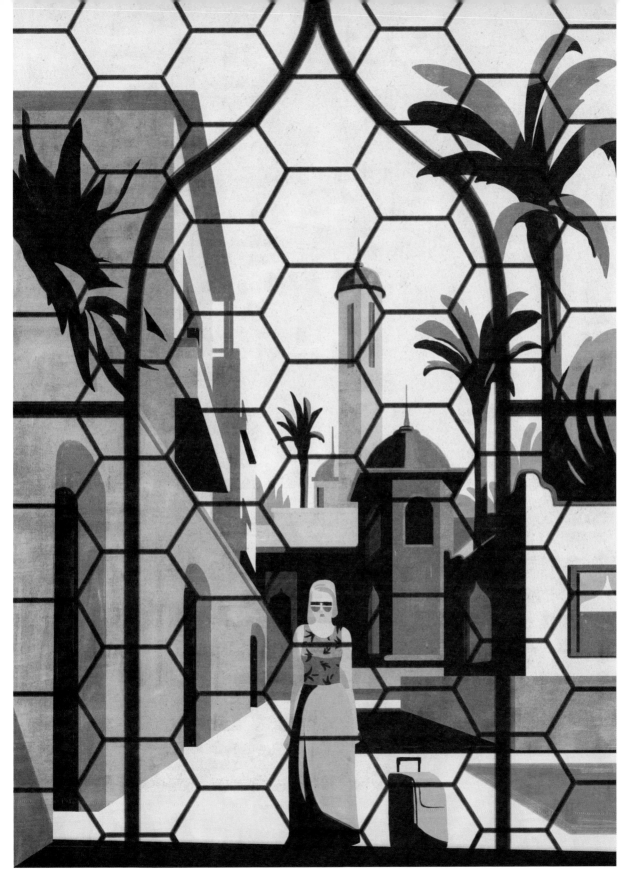

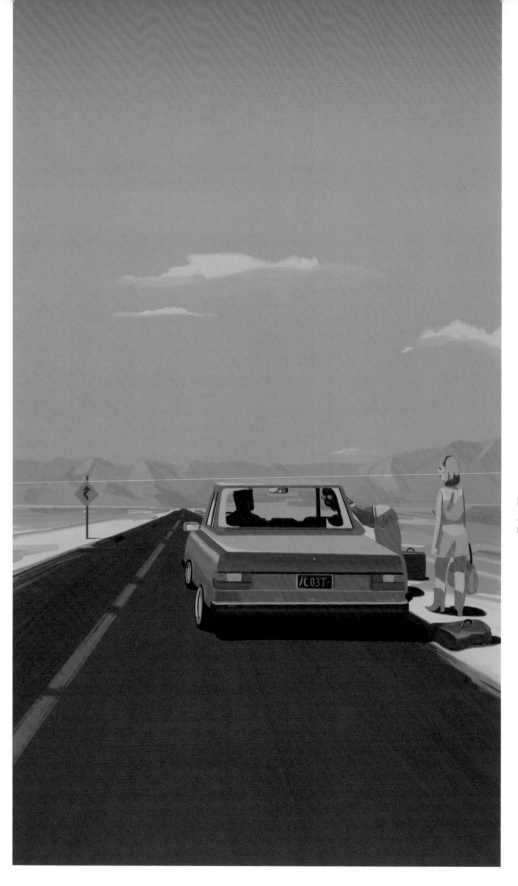

EMILIANO PONZ
Hitchhikers
Digital

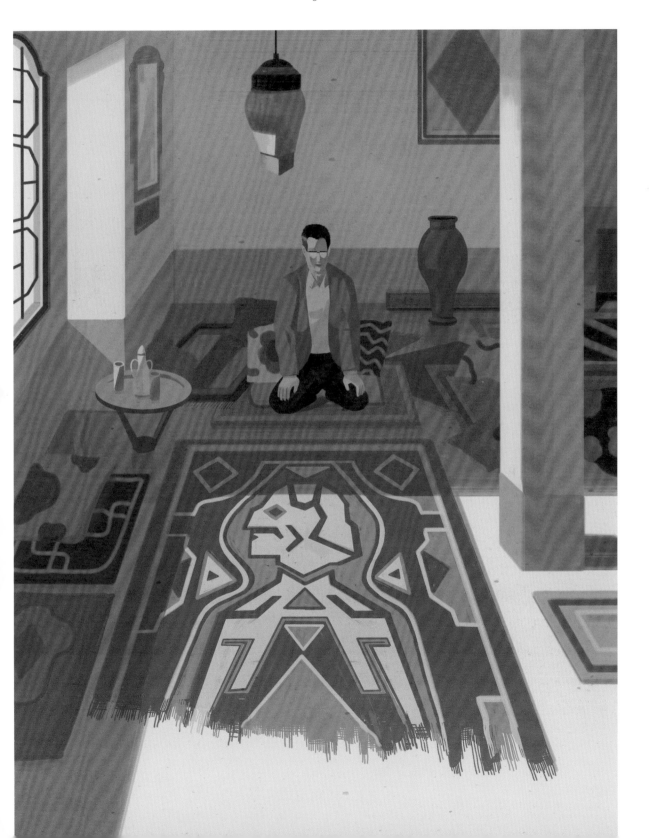

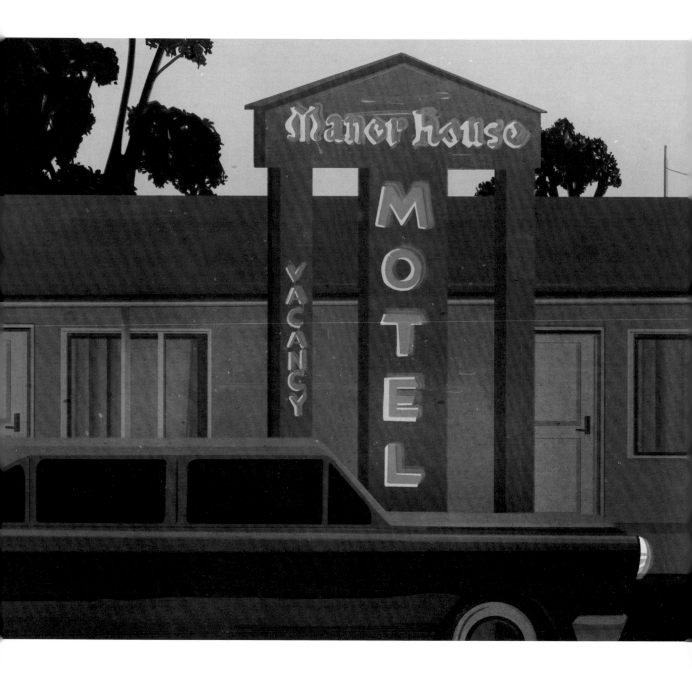

EMILIANO PONZI
The Voyeur's Motel
Illustration for the article "The Voyeur's Motel." Gerald Foos bought a motel
in order to watch his guests having sex. He saw a lot more than that.

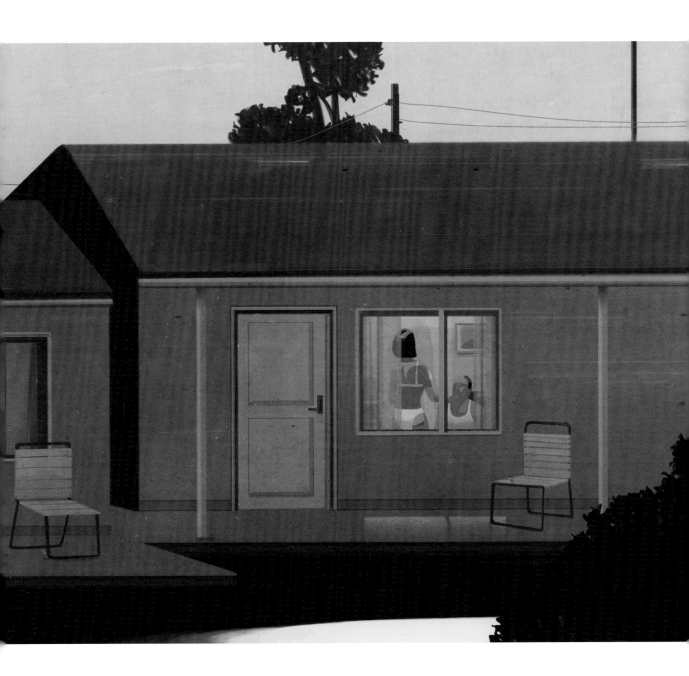

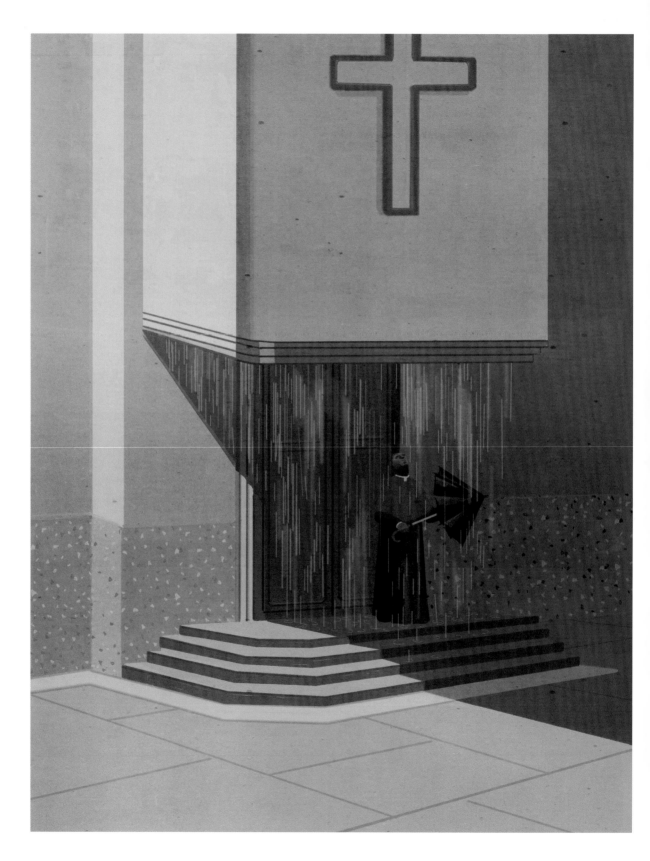

EMILIANO PONZI
Rain
Digital

EMILIANO PONZI
Flying Cars
Digital

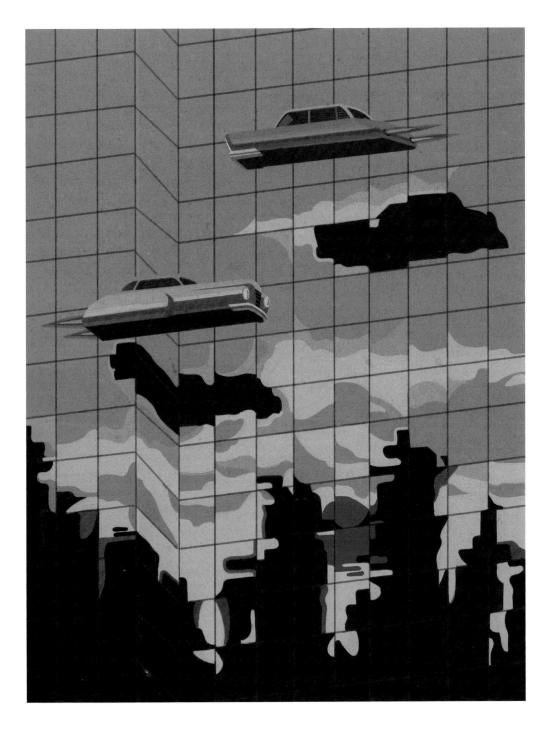

MIGUEL PORLAN
Says You
Mixed media
Illustration for an article in *The New Yorker* titled "Better Living Through Criticism"
about how to be a critic in an age of opinion.

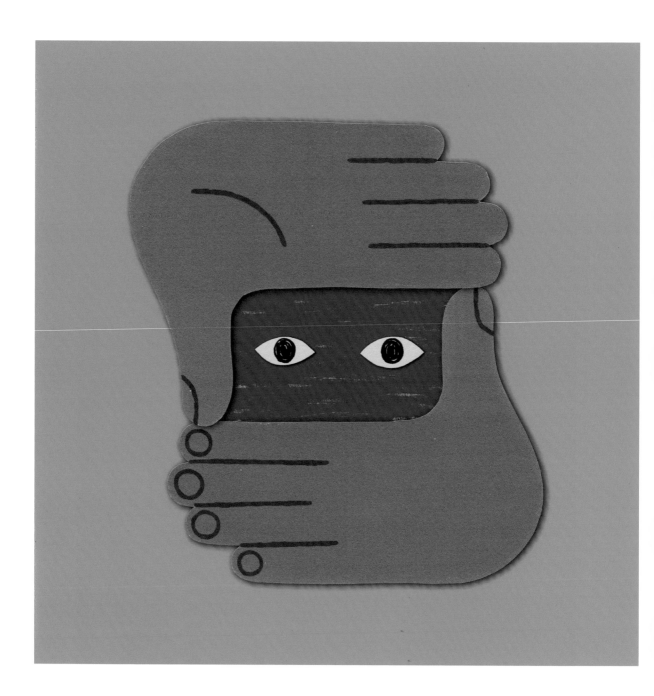

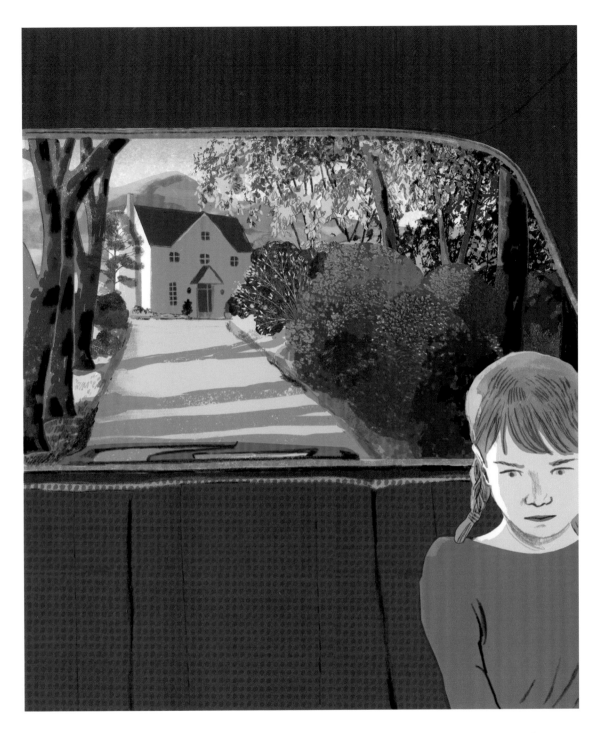

SONIA PULIDO
"Hello and Goodbye"
Print/Internet
Illustration for the article by Alice Cary in *The Boston Globe*.
"Because my father's railroad career meant frequent transfers, I lived in six
homes in four states before college. However, the place I truly consider
"home" is the house I lived in for the shortest time—not even a year."

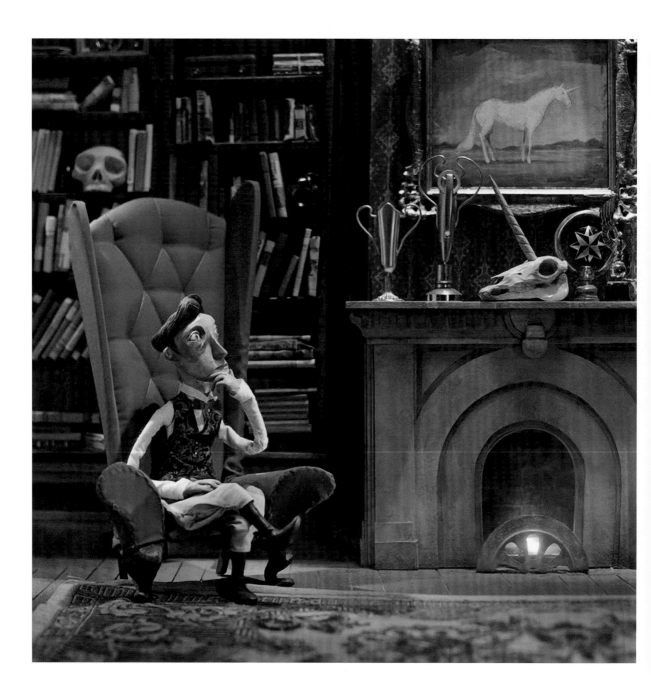

RED NOSE STUDIO
What is Still True?
3-D
For an article on "Unassailable Scientific Facts." A compendium of
irrefutable facts for these fact-starved times. Special thanks to Michael Mrak
whose confidence brought out the best in my work and for allowing me to
put unicorns into an issue of *Scientific American*.

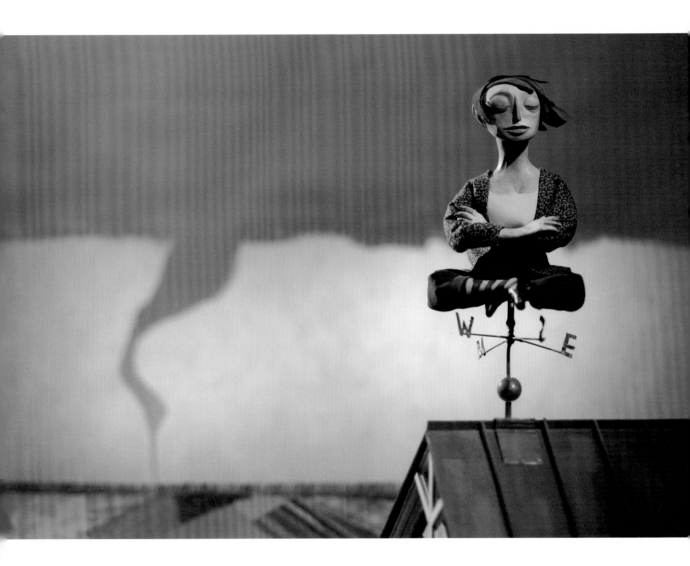

RED NOSE STUDIO
Weather Affects Mood
3-D
How ionic changes in weather might alter our moods. A class 5 tornado could have the same effect as an antidepressant! The day I shot this piece, the tornado sirens went off and there was a touchdown a couple counties over. A little too close for comfort even for this farm boy.

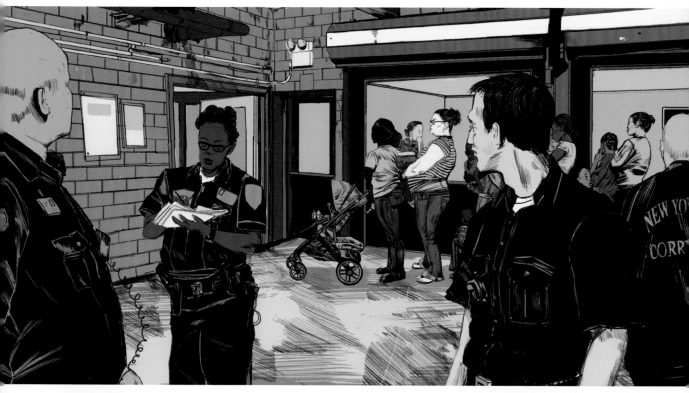

NICOLE RIFKIN
Happy Sunday, Welcome to Rikers
Digital

I was asked to do a series about a young man who has been imprisoned at Rikers Island since 2010, awaiting trial for the murder of a fellow graffiti artist. The story details the horrible day-to-day life of Rikers, the monotony of imprisonment, steps taken by New York to "improve" the treatment of prisoners, and the small bits of escapism that both the prisoners and their families utilize to maintain a semblance of humanity in an otherwise tortuous circumstance.

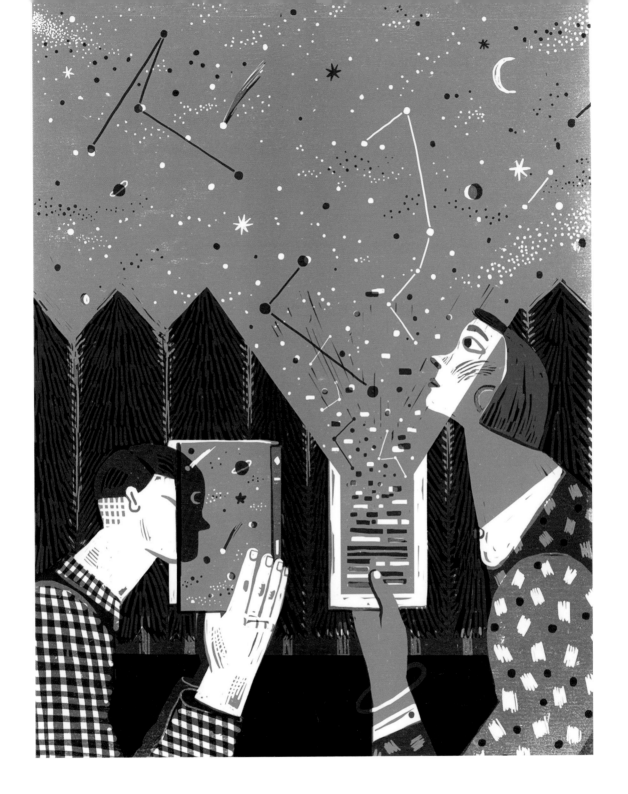

IRENE RINALDI
The Deep Space of Digital Reading
Mixed Media
Why we shouldn't worry about leaving print behind.

EDEL RODRIGUEZ
Meltdown
Mixed media
Cover of *TIME* magazine, Donald Trump's campaign,
August 2016.

EDEL RODRIGUEZ
Total Meltdown
Mixed media
Cover of *TIME* magazine, Donald Trump's campaign,
October 2016.

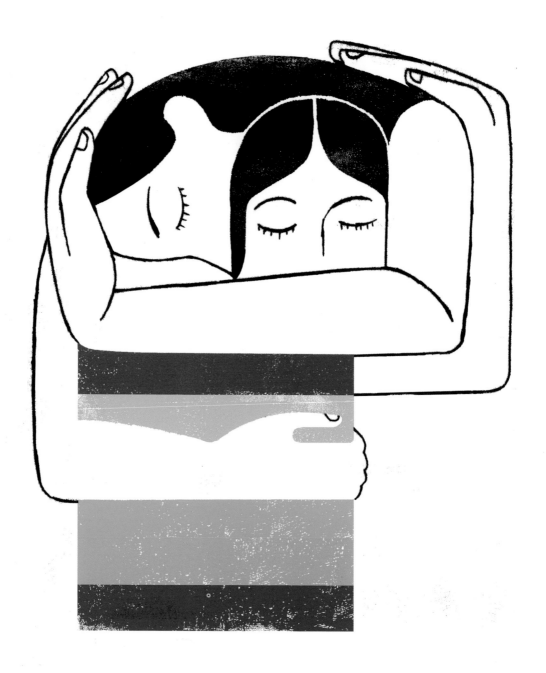

EDEL RODRIGUEZ
My Lesbian Daughter
Mixed media
Illustration for an article about a mother's relationship
with her daughter after the Orlando shooting.

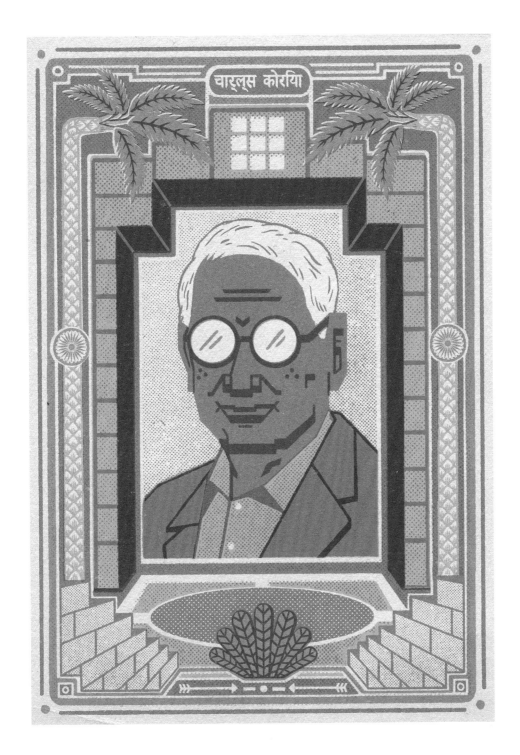

BENE ROHLMANN
Charles Correa
Digital drawing (Photoshop)
Portrait of Indian architect Charles Correa, for the
"India" issue of the magazine *Architectural Review*.

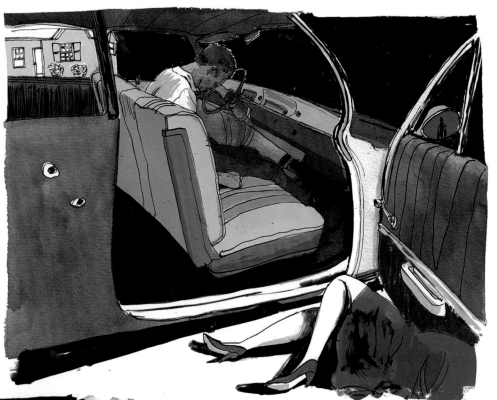

MATT ROTA
Terror in Little Saigon
Ink, watercolor, digital

After the Vietnam war, Vietnamese ex-patriot militants in the U.S. began to raise money to re-invade Vietnam. Once the Vietnamese-American press started to report on the militants plan, the militants set up death squads in the U.S. to assassinate the journalists. Several Vietnamese-American journalists were assassinated over a ten year period.

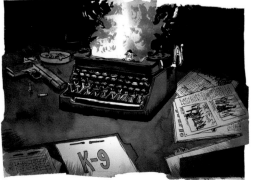

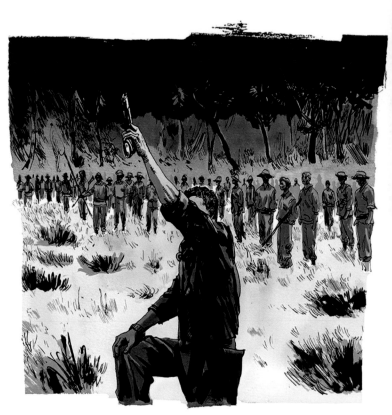

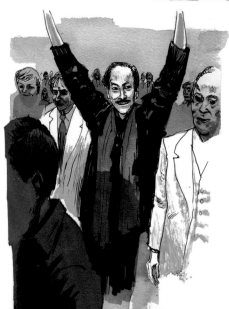

CUN SHI
Prince the Baller
Ink and digital on paper
According to insiders, not only was Prince a talented musician, but also one heck of a basketball player. Dave Chapelle once did a hilarious skit on Prince running the courts, and the musician's hooper lore has endured ever since.

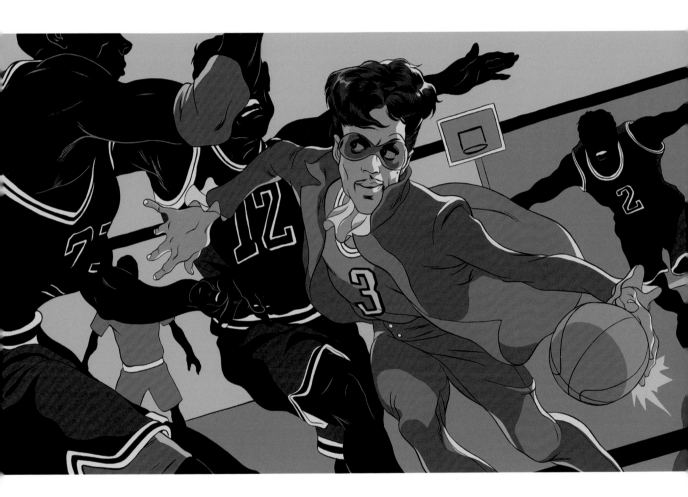

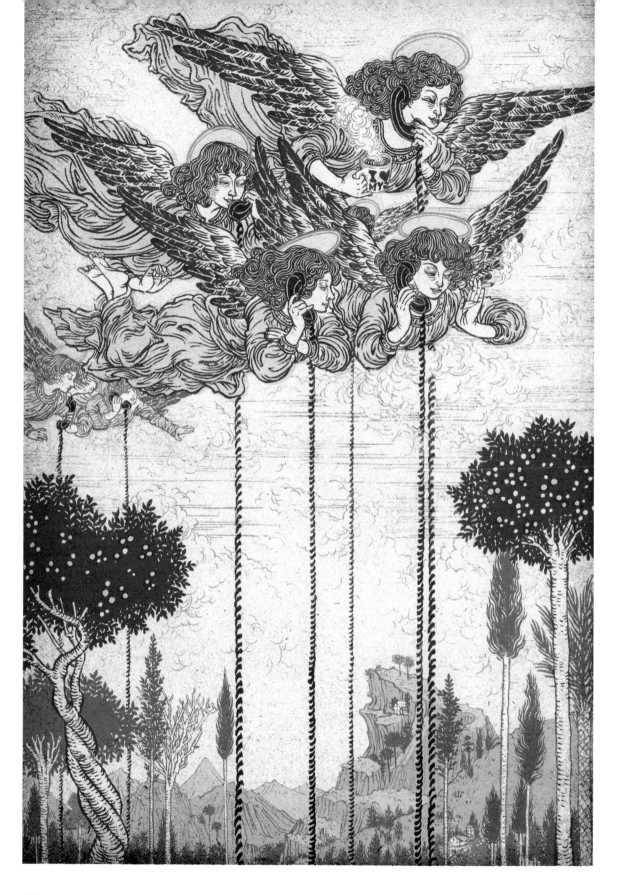

YUKO SHIMIZU
Your Orisons May Be Recorded
Ink and digital
Title page for an online short story
(fantasy/satire) about angels working
in a life-line call center.

YUKO SHIMIZU
Chinese Space Age
Ink and digital
Illustration reminiscent of Chinese propaganda poster,
and hand lettering to go with it. How China may be
winning the space-race against the U.S.

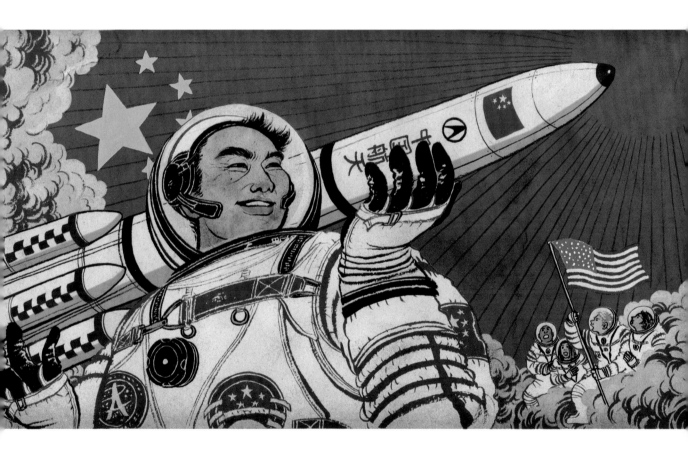

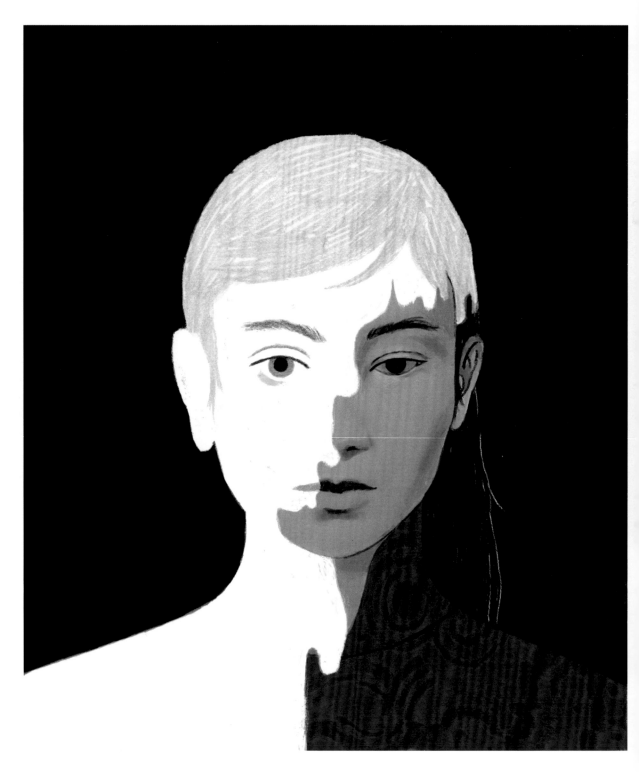

DADU SHIN
Whitewashing
Graphite, digital
Editorial illustration for the article "Why Won't Hollywood Cast Asian Actors?" in *The New York Times.*

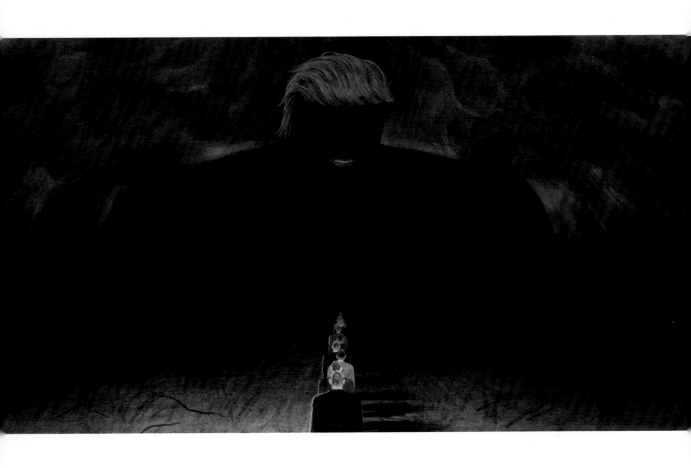

DADU SHIN
Drumpf
Graphite, digital
The New York Times Op-Ed essay about the Trump effect
and the hypocrisy of the GOP.

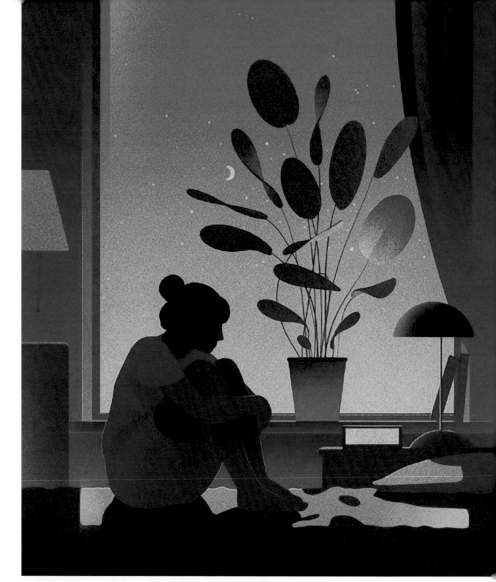

KAROLIS STRAUTNIEKAS
Sleep No More
Digital
Sleep deprivation can be part of the solution for insomnia in major depression.

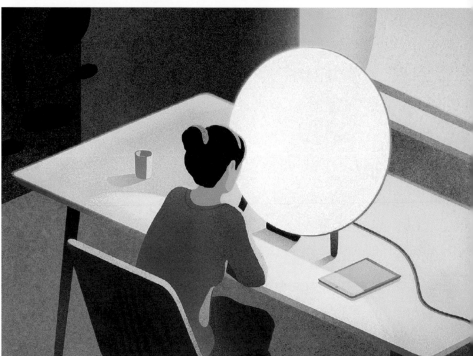

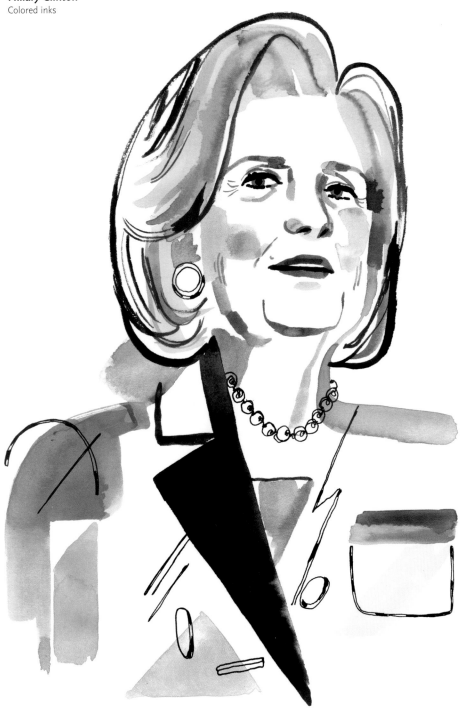

LAUREN TAMAKI
Hillary Clinton
Colored inks

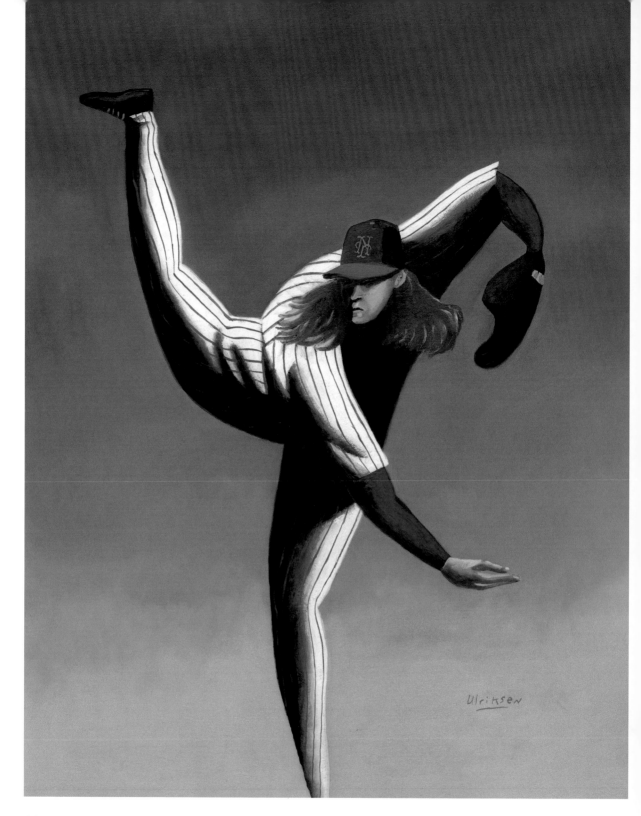

MARK ULRIKSEN
Late Innings
Acrylic and oil on paper
Cover for *The New Yorker* depicting NY Mets star pitcher Noah Syndergaard.

Klaas Verplancke
Pros & Cons
Brush and ink
How opposite forces keep each other in balance.

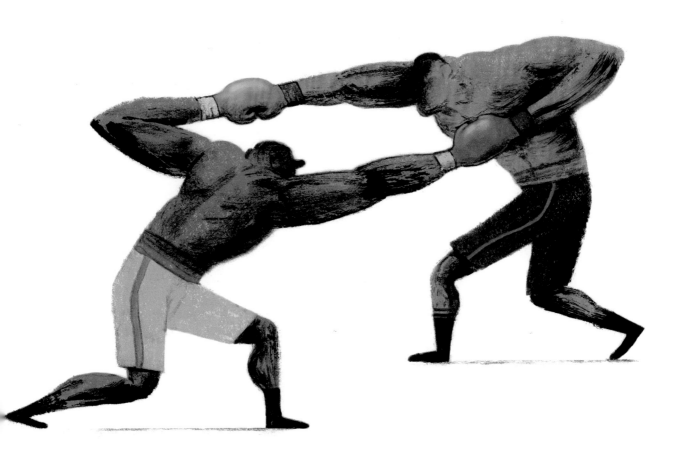

ARMANDO VEVE
Breakfast Trends on Instagram
Graphite, watercolor, digital
For an article analyzing breakfast trends on Instagram.

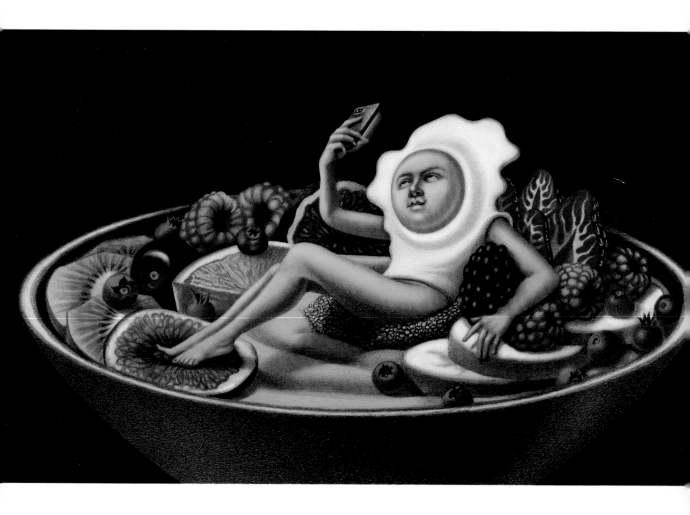

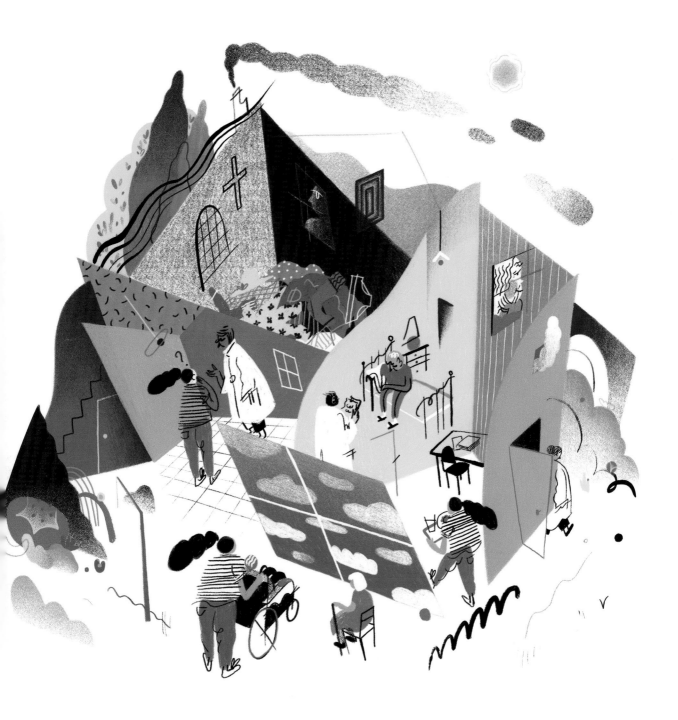

GIZEM VURAL
Paradise Lodge
Digital
Illustration for Nina Stibbe's book *Paradise Lodge* for *The New York Times Book Review* section. There is a teen girl who wants to learn about everything at a nursing home. But there are strange events, as laundry gets unwashed and dentures are accidentally switched, and the on-site morgue is located directly beside the pantry. I created an environment in a distorted perspective for the nursing home.

JING WEI
Majorca
Digital, graphite
An illustration about a couple whose relationship slowly
unravels during a vacation to Majorca.

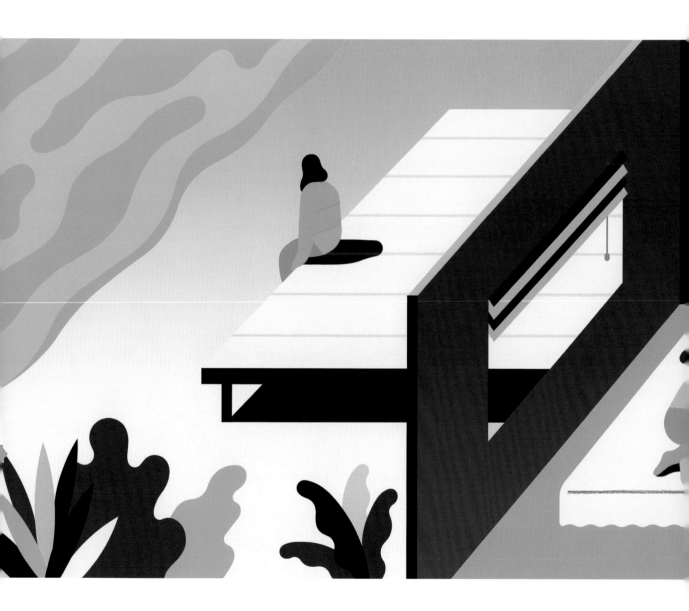

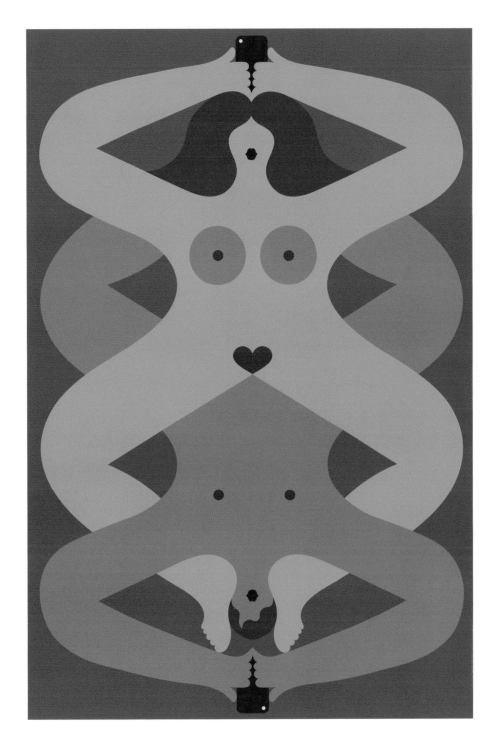

OLIMPIA ZAGNOLI
Future Sex
Digital
An illustration about Emily Witt's new book *Future Sex*.
An adventure through internet dating, internet pornography,
polyamory and avant-garde sexual subcultures as sites of possibility.

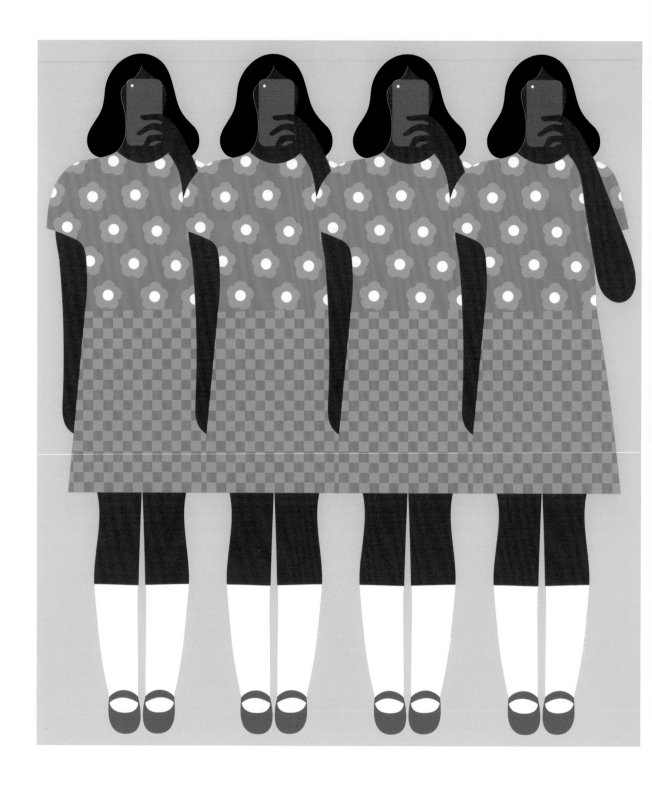

OLIMPIA ZAGNOLI
Selfie
Digital
An illustration about the falsified perception of the self in the era of selfies.

OLIMPIA ZAGNOLI
Pokemon at Auschwitz
Digital

An illustration about the debatable use of "Pokemon Go" in locations such
as Auschwitz, the Holocaust Memorial Museum and other memorial sites.

DANIEL ZENDER
The Real Problem With Police Video
Digital

A Chicago police officer shot and killed a teenager named Laquan McDonald in October of 2014, but most of us learned about Mr. McDonald in November, 2015, after a judge ordered the release of police video footage of his death. That is also when prosecutors finally brought first-degree murder charges against the officer. Clearly, such footage has considerable power.

DANIEL ZENDER
The Man the Founders Feared
Digital
The New York Times Sunday Review Op-Ed illustration about
riots and violence at Donald Trump rallies.

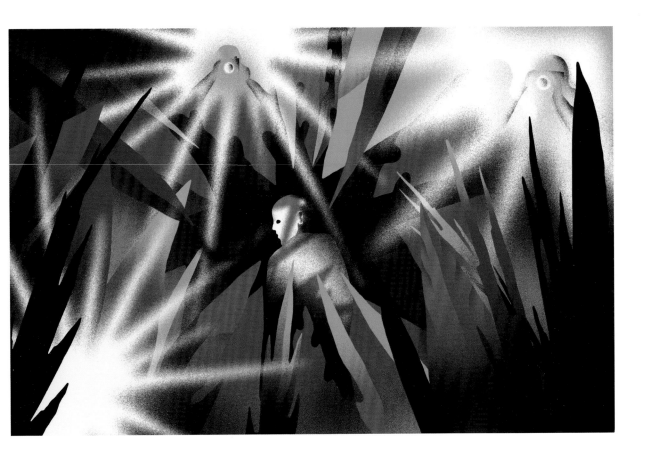

DANIEL ZENDER
Embarrassing Photos of Me, Thanks to My Right-Wing Stalkers
Digital
An environmentalist is followed by photographers, trying to catch him in
hypocritical or embarrassing situations.

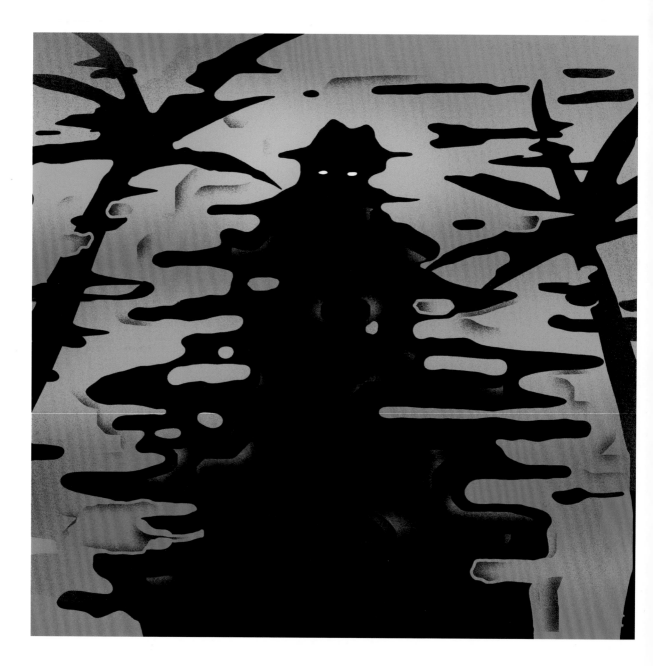

DANIEL ZENDER
Black Water
Digital
New York Times Book Review illustration for *Black Water,* a thriller that regards a longtime,
world-weary spy in Indonesia, and the toll of living life in which all relationships are functional
facades, home is permanently temporary, and asks why anyone would choose that life.

ADVERTISING

MELINDA BECK
**ILLUSTRATOR/
GRAPHIC DESIGNER**

Melinda Beck is an Emmy-nominated illustrator, animator and graphic designer based in Brooklyn, NY. She graduated summa cum laude in from the Rhode Island School of Design. Her clients include Neiman Marcus, Nickelodeon, Nike, *Real Simple* magazine, Supreme, *The New Yorker,The New York Times*, Random House, Simon & Schuster, Target and *TIME*. She received a Gold Medal from the Society of Illustrators, as well as awards from and publication in annuals including *American Illustration*, The Art Directors Club, Society of Publication Designers, *Communication Arts, Print*, the Society of Illustrators, the Broadcast Design Awards and AIGA. In addition her work has been exhibited in various shows. Recently a series of her prints was acquired by the Library of Congress for its permanent collection. Melinda is currently the vice president of ICON, the Illustration Conference.

SAIMAN CHOW
VISUAL ARTIST

Saiman Chow is a multidisciplinary director, designer and animator. Born and raised in Hong Kong, he immigrated to Los Angeles with his family at the age of 15. After graduating from Art Center College of Design in 2001, Chow gained early attention for his Art of Speed animation. Constantly re-inventing his approach, Chow's work spans media and takes a variety of forms, from intricate animations to illustrations and fine art. Chow's clients include: Apple, Adidas, Adult Swim, Google, Nike, *The New York Times*, Rayban, SONOS, Warby Parker and Uniqlo. He currently resides in Brooklyn, NY, where he shares a work/live space with his wife and two cats above a hardware store.

SEYMOUR CHWAST
**GRAPHIC DESIGNER/
ILLUSTRATOR/
TYPE DESIGNER**

Seymour Chwast is co-founder of Push Pin Studios and has been director of the Pushpin Group where he reintroduced graphic styles and transformed them into a contemporary vocabulary. His designs and illustrations have been used in advertising, animated films, and editorial, corporate and environmental graphics. He has created over 100 posters and has designed and illustrated more than 30 children's books. His work has been the subject of three books including, *Seymour Chwast: The Left Handed Designer* (Abrams, 1985). Many museums, such as the Museum of Modern Art (New York), the Library of Congress (Washington D.C.) and the Israel Museum (Jerusalem), have collected his posters. He has lectured and exhibited worldwide and is in the Art Directors Hall of Fame. He is the recipient of the 1985 Medal from the American Institute of Graphic Arts.

DAMIEN CORRELL
**ART DIRECTOR,
GOOGLE**

Damien Correll is a Brooklyn-based designer and artist. He's currently an art director at Google in New York City. He spent the last few years as the Brand Art Director at Tumblr, and before that he was a creative partner at the New York design studio, Part & Parcel. Over the past 13 years he has worked on a range of projects from directing videos and animations for large non-profits to designing retail experiences and conferences.

LISK FENG
ILLUSTRATOR

Orignally from China, Lisk Feng is an award-winning freelance illustrator based in New York. She earned an MFA Illustration Practice from Maryland Institute College of Art in 2014. That year she also received awards from the Society of Illustrators; *Communication Arts; 3x3* Student Award Silver Medal; *3x3* Children's Book Honorable Mention; *American Illustration* chosen winner, selected winner and annual; Adobe Design Award Semi-final; AOI Illustration Awards (UK) shortlist, and others. Her clients include the United Nation, *The New York Times, The Wall Street Journal, The Washington Post*, HSBC, Warby Parker, Abrams Books, Monocle, Medium, *Atlanta* magazine, Mr Porter, Scientific American among others.

JED HEUER
ART DIRECTOR, WIEDEN+KENNEDY

Jed Heuer is an art director and designer based in Brooklyn, NY. As a creative for Wieden+Kennedy he's made all sorts of stuff for Nike, Jordan, Spotify and ESPN to name a few. He's also done work for *The New York Times,* NYU and The Cooper Hewitt Smithsonian Design Museum. He's won Lions from Cannes, Clios, Webbys, awards from the Type Directors Club, and he won this cool silver eagle necklace from an arcade claw machine the other day. He designs patterns, but usually wears a plain t-shirt.

JIAE KIM
CREATIVE DIRECTOR, EMEHT

Jiae Kim is the creative director and co-founder of EMEHT, a creative agency in New York City. EMEHT produces branded content, brand identities, campaigns, strategy, books, magazines and art events for clients including Levi's, Nike, Uniqlo, Converse, DvF and Beats by Dr Dre. Prior to EMEHT, she co-founded *THEME* magazine, a lifestyle and culture quarterly. Within the first years of publication, *THEME* won awards from the Society of Publication Designers, *Print, Creative Review,* and was a finalist for the prestigious One Show design award. Previously Jiae worked at Pentagram as an associate with famed information designer Lisa Strausfeld.

THOMAS SCHMID
CREATIVE DIRECTOR, BUCK

Buck is a design-driven animation studio. Schmid started in the company's infancy, primarily as an illustrator, and has worked as a lead designer, art director and now as a creative director. Buck was founded in '04 in Los Angeles, and has opened offices in New York and Sydney, Australia. The studio houses a collaborative of artists that work under a shared "Directed by Buck" moniker. Thomas's specialty within the group is the more illustrative and pop-driven work, spots featuring cel animation, graphic illustration and puppets. Before Buck, he and Ben Langsfeld founded Eneone, an independent print design firm in Philadelphia. He lives in New Jersey with his wife and two children, and originates from Italy and Philadelphia.

TAMARA SHOPSIN
ILLUSTRATOR

Tamara Shopsin is a graphic designer and illustrator whose work is regularly featured in *The New York Times* and *The New Yorker.* She is the author of the memoir *Mumbai, New York, Scranton,* designer of the *5 Year Diary,* and co-author with Jason Fulford of the photobook for children, *This Equals That.* She is also a cook at her family's restaurant in New York.

Don't Be a Settler
Acrylic and oil on paper
"Don't Be a Settler" Campaign for DirecTV, a parody insert
"Settler Sports Illustrated" depicting boring and dumb sports,
which ran in the 2016 *Sports Illustrated* Swimsuit Edition

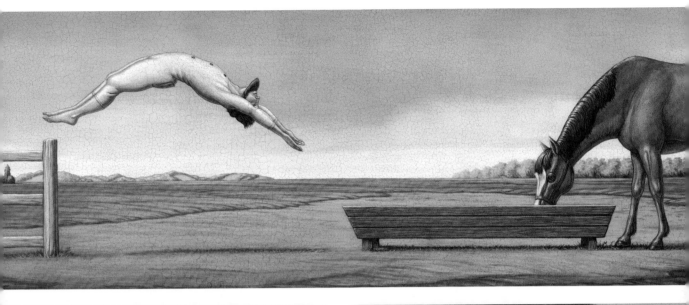

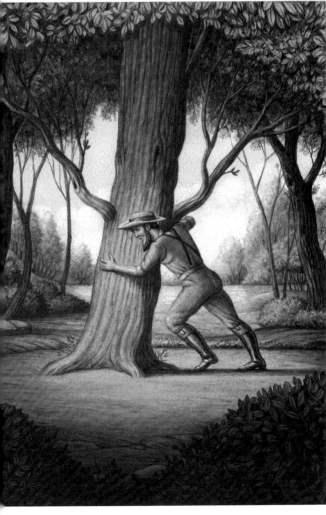

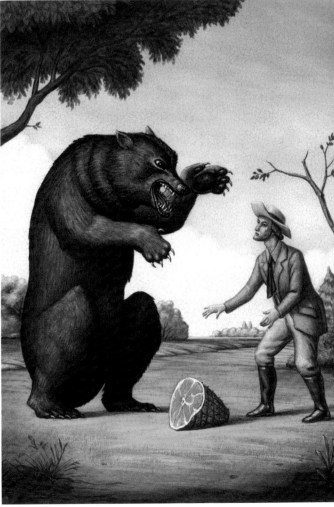

Jillian Tamaki

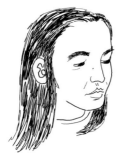

Platform
Digital print

Jillian Tamaki's comic strip *Platform* reveals a sequence of scenes showing the passing of time from multiple viewpoints. Tamaki presents us with quick snapshots—the life cycle of the subway platform—the process of entering the station, passing a bit of time, then finally entering the subway car—a cycle that repeats with every incoming train on every platform in the system.

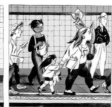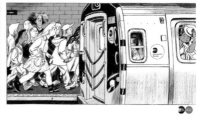

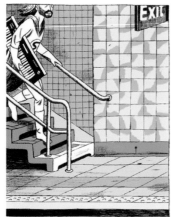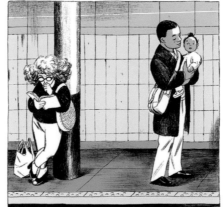

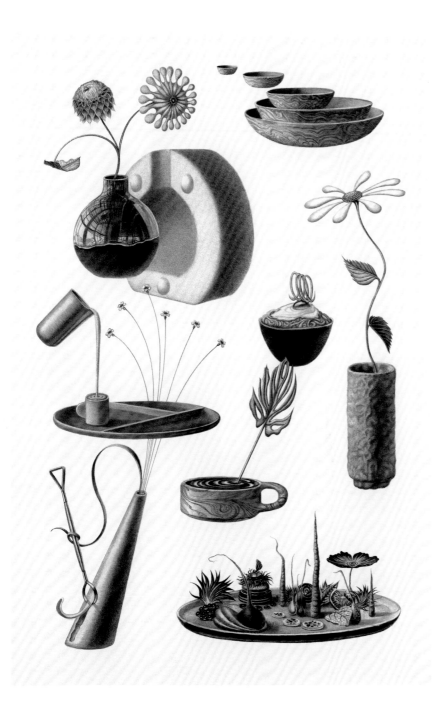

FELT+FAT
Graphite
This drawing reimagines new products
by FELT+FAT, a collaborative design and
manufacturing studio based in Philadelphia.
Printed as a folded poster and distributed
in the studio's booth at Sight Unseen
OFFSITE during New York Design Week.

Julian Glander

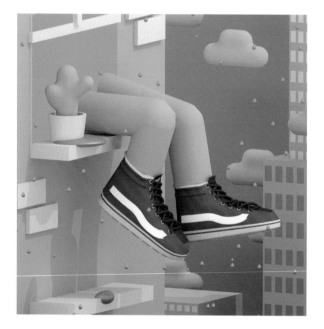

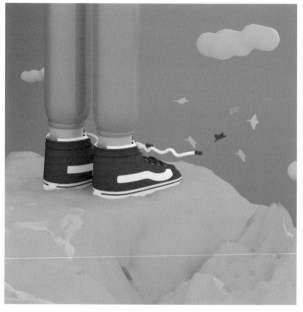

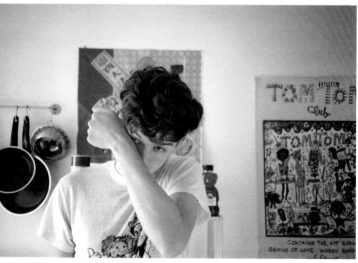

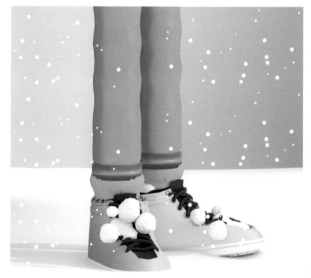

Vans: All Weather
GIF

SILVER MEDAL WINNER
Edward Kinsella

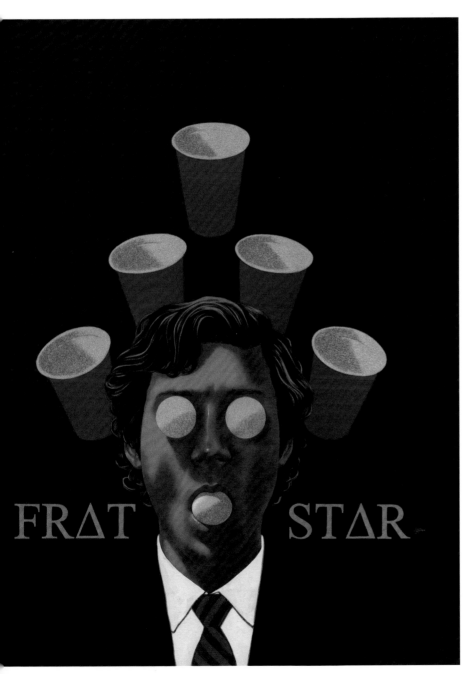

Frat Star
Graphite, ink, gouache
Cover art for Grant Johnson's
film *Frat Star*.

OLA NIEPSUJ

Lukullus Pâtisserie

Handmade collage from paper and ink Packaging design for Lukullus Pâtisserie, celebrating the 70th anniversary of opening the first pastry shop. Depicting the history of the owners family in Warsaw.

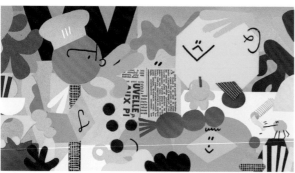

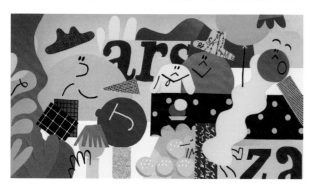

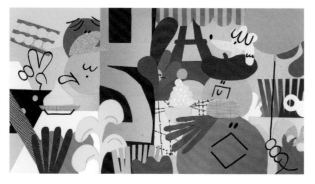

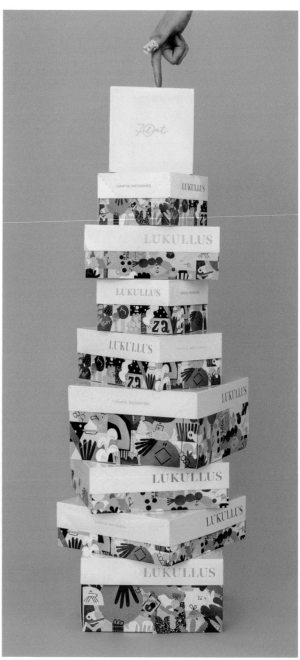

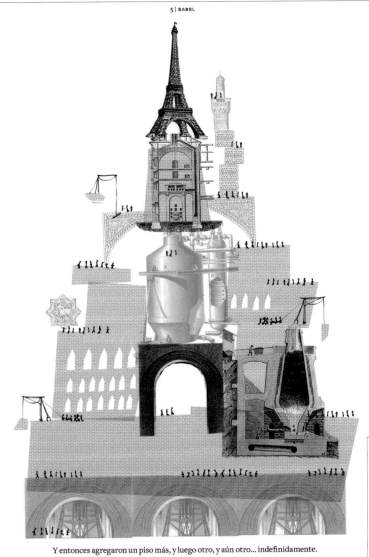

Y entonces agregaron un piso más, y luego otro, y aún otro… indefinidamente.

95

SERGE BLOCH
Babel, The Story of Totalitarian Madness
Mixed media
Animation of the story of the Tower of Babel
(audio in French).

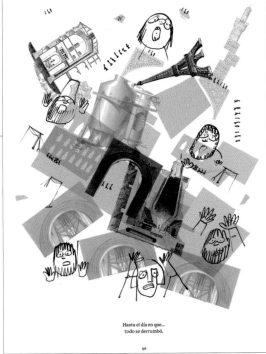

Hasta el día en que…
todo se derrumbó.

96

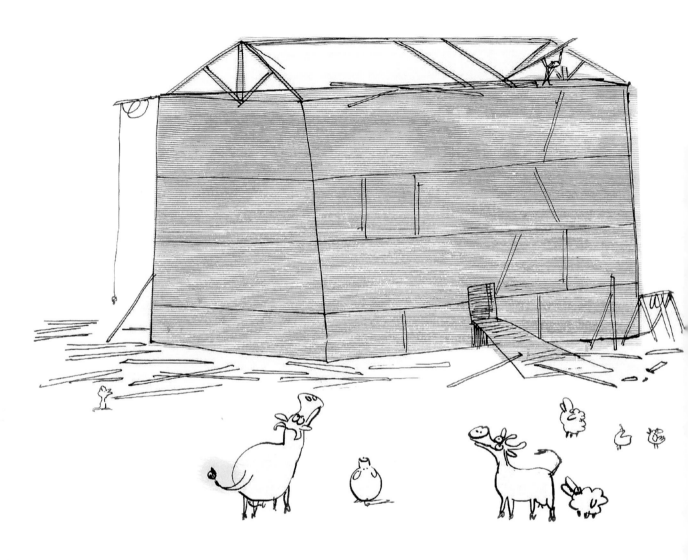

SERGE BLOCH
Bible, Story of Noah
Mixed media
Animation of the Bible story of Noah's Ark.

PAUL BLOW
Find Your Flow
Mixed media and digital
Illustrate the theme "Keeping creativity flowing."
For use on the WeTransfer web site and posters.

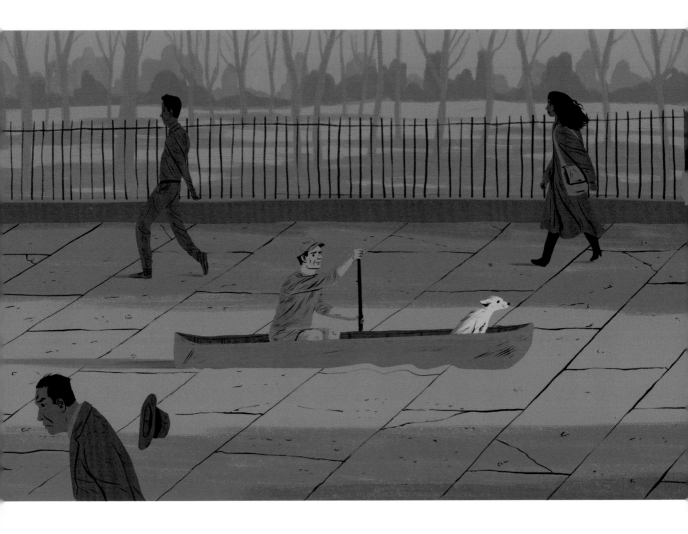

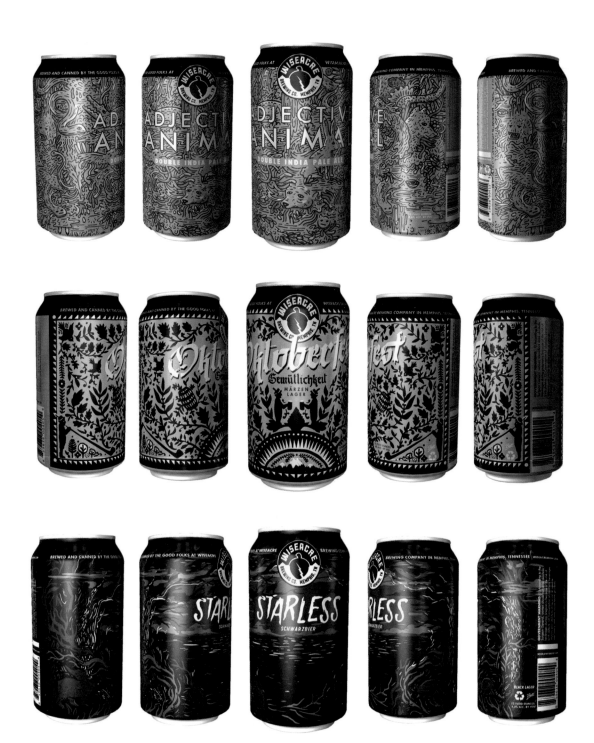

RACHEL BRIGGS
Wiseacre Brewing Company Beer Can
Ink, digital (for cans, printed on aluminum)
Beer can labels and additional advertising elements of brews for Wiseacre Brewing Company:
Adjective Animal Double IPA, Oktoberfest, Starless Black Lager.

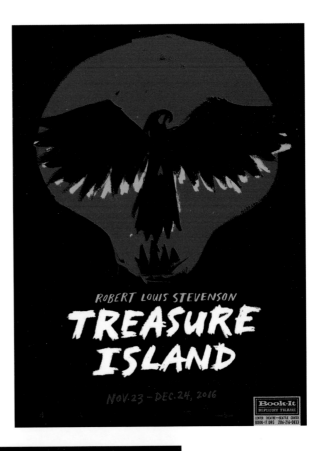

MICHAEL BUCHINO AND
JULIA McNAMARA,
NOPE.LTD

2016 Book-It Rep Posters
Pencil, pen and marker on paper,
distilled through Adobe Photoshop

Posters for the 2016 season of
Book-It Repertory Theatre plays.

DAVID DORAN
Nespresso - Cafezinho & Tinto
Digital

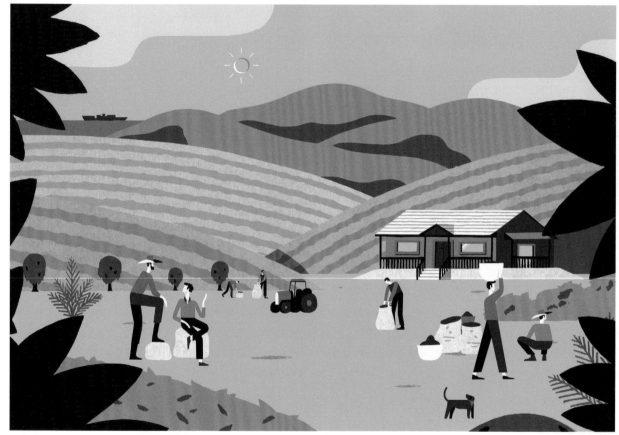

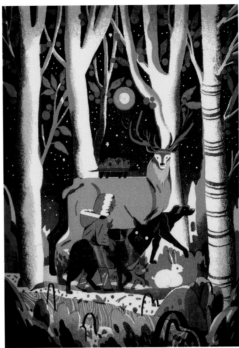
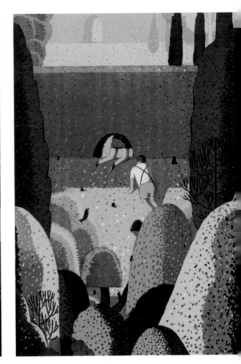

LISK FENG
Hello! Kongzi
Digital
A series branding the concept of Chinese traditional cultural theory from Kongzi. The project is presented to the audience via new media art and intellectual installations at Grand Central Terminal, NYC.

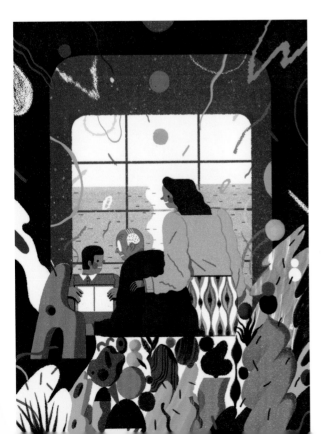

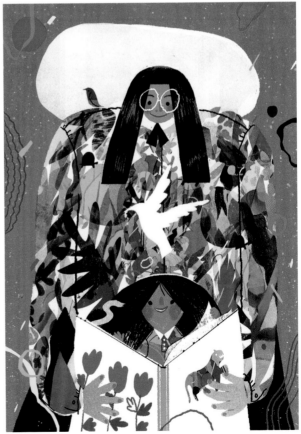

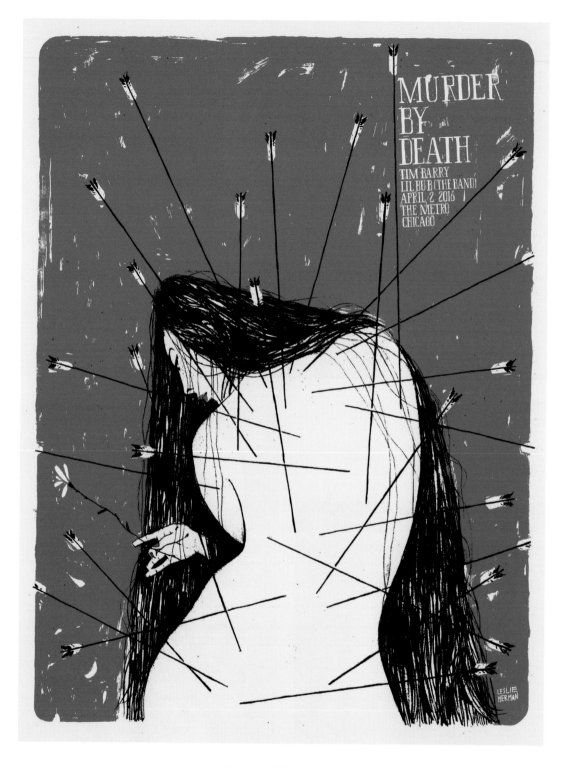

LESLIE HERMAN
Murder By Death
Silkscreen print
Concert poster created for the band Murder By Death
for their show in Chicago.

ROD HUNT
Where's Ezra? George Ezra Gam
Digital, Adobe Illustrator
A detailed illustration for the online game, Where's Ezra, for English singer
and songwriter George Ezra as part of the artist's record promotion.
The illustration included characters from the artwork of George's album
Wanted on Voyage and his music videos, as well as many other "Easter
Eggs" for observant fans.

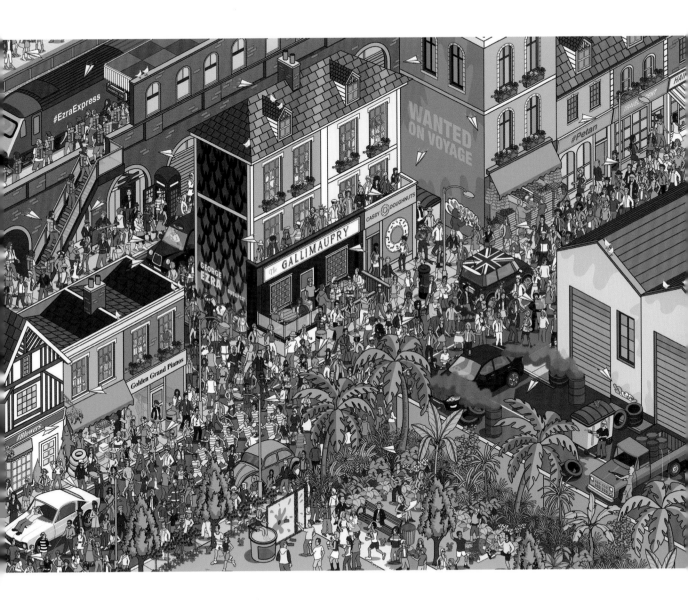

EDWARD KINSELLA
Carnival of Souls
Graphite, ink, gouache, colored pencil, and watercolor
Cover art for The Criterion Collection's special edition of *Carnival of Souls.*

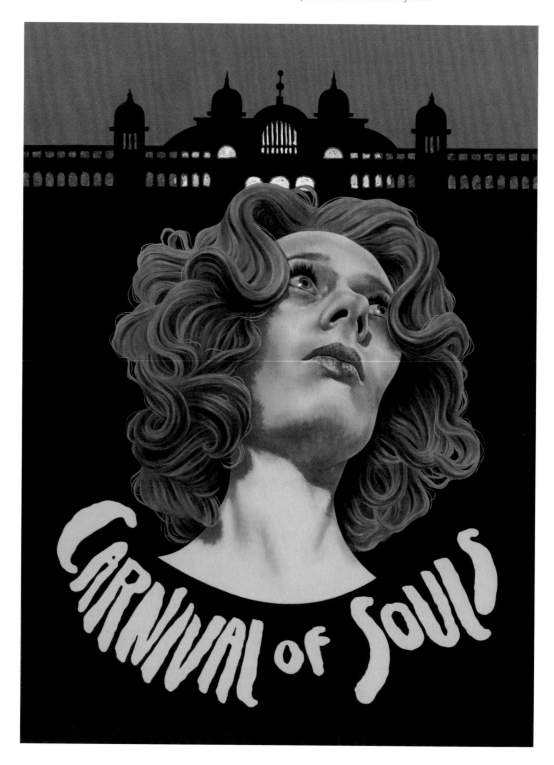

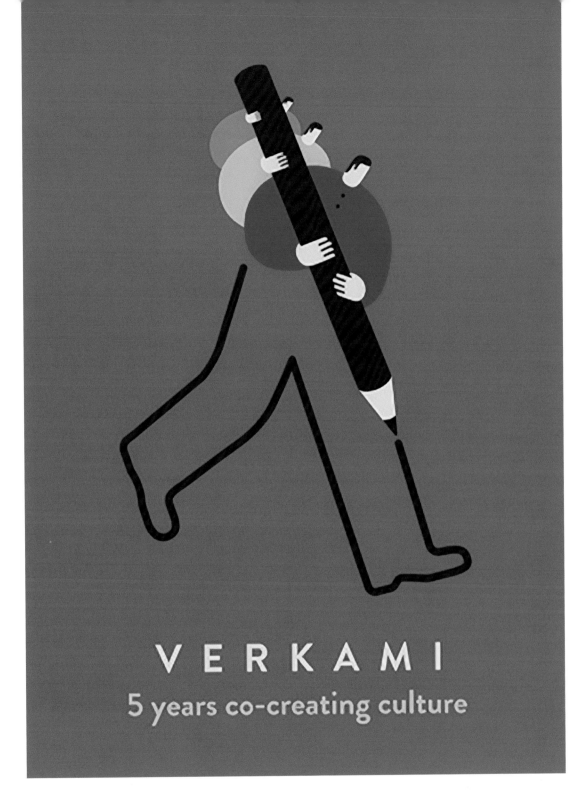

MAGOZ
Co-creating Culture
Adobe Illustrator
Poster for the fifth anniversary of Verkami.
Verkami is a crowdfunding platform for creative projects.

BILL MAYER
Cloud Nine
Ink and collage
Poster for the play
Cloud Nine for
Steppenwolf Theatre's
40th Anniversary.

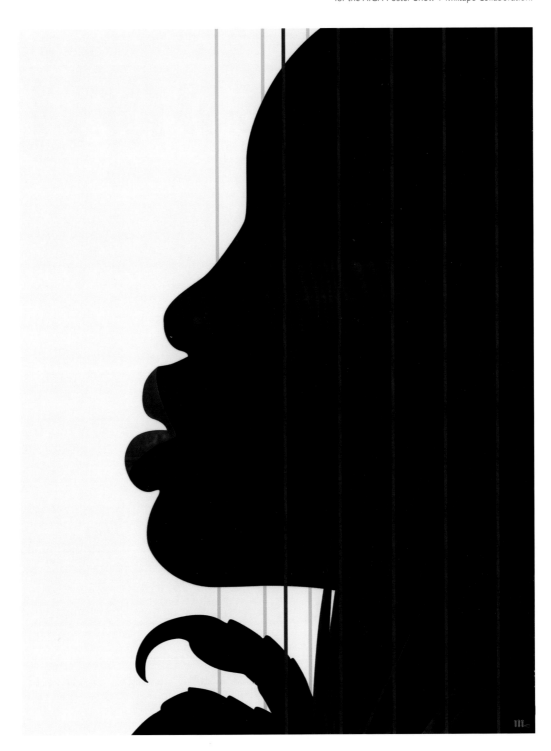

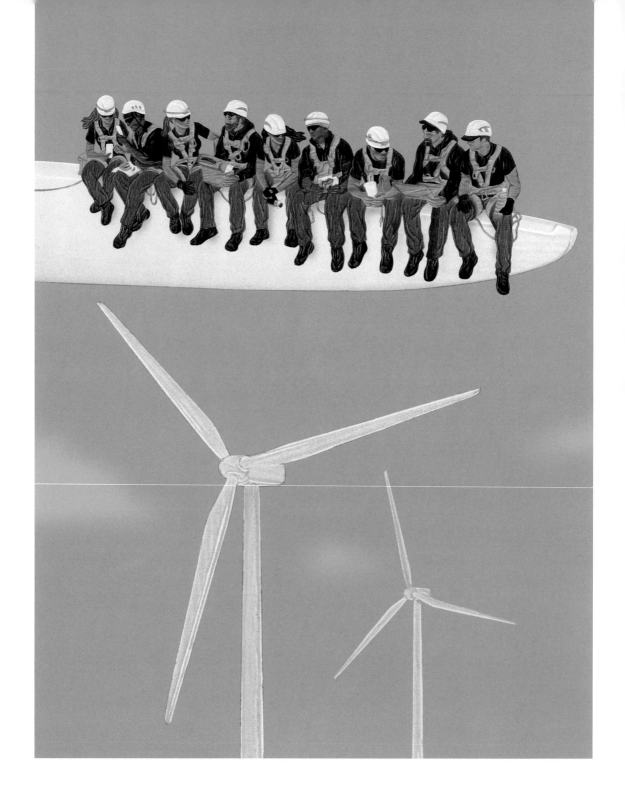

ALEX NABAUM
Wind Turbine Workers
Gouache
A public service announcement to promote
American blue collar jobs.

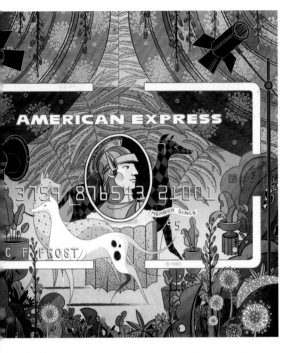

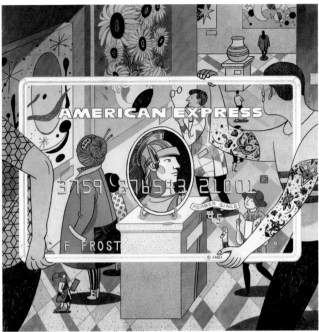

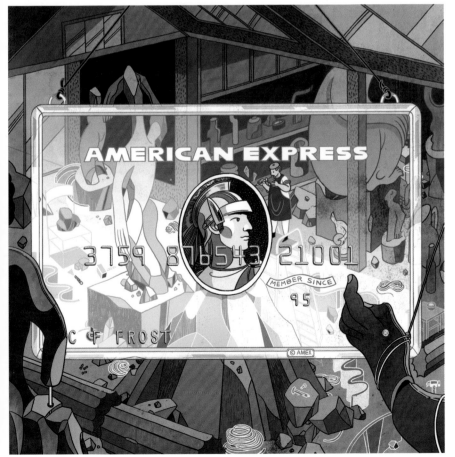

VICTO NGAI
Art Cards
Mixed media
Enjoy the VIP privileges with the card of style (Green), the card of art (Gold) and the card of creation (Platinum).

DAVID PLUNKERT
Baltimore Theatre Project 2016 Season
Digital mixed media
Series of posters
for the Baltimore
Theatre Project's 2016
production season.

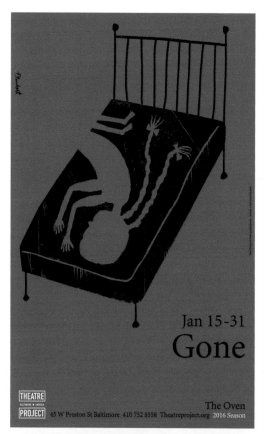

Jan 15-31
Gone

THEATRE PROJECT The Oven
45 W Preston St Baltimore 410 752 8558 Theatreproject.org 2016 Season

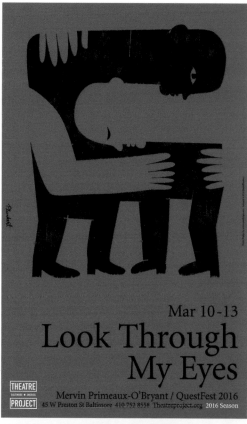

Mar 10-13
Look Through My Eyes

THEATRE PROJECT Mervin Primeaux-O'Bryant / QuestFest 2016
45 W Preston St Baltimore 410 752 8558 Theatreproject.org 2016 Season

Apr 15-17
Matter, Energy, Human

THEATRE PROJECT Deep Vision Dance Company
45 W Preston St Baltimore 410 752 8558 Theatreproject.org 2016 Season

Jun 23-26
Swing

THEATRE PROJECT Mara Neimanis / In-Flight Theater
45 W Preston St Baltimore 410 752 8558 Theatreproject.org 2016 Season

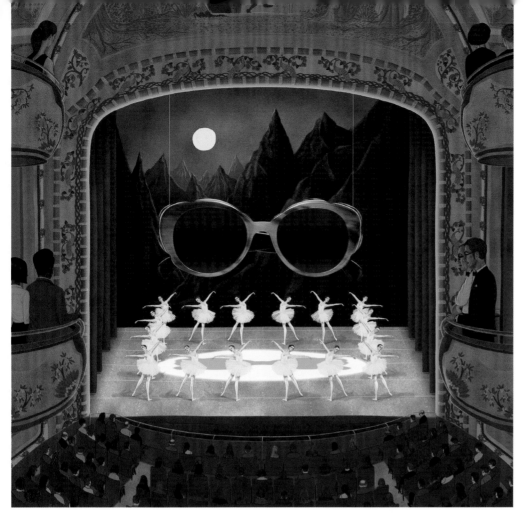

JASON RAISH
Morgenthal Fredericks
30 Years
Digital
Campaign for luxury
eyewear brand Morgenthal
Fredericks' 30th anniversary.
As a NYC brand they
wanted their glasses
interacting with scenes of
New York. Used for in-store
displays and banners,
magazine print ads and
social media.

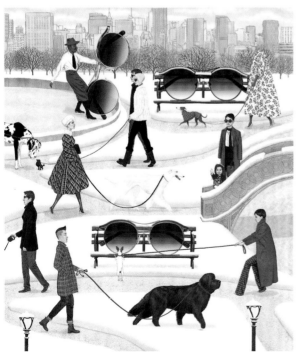

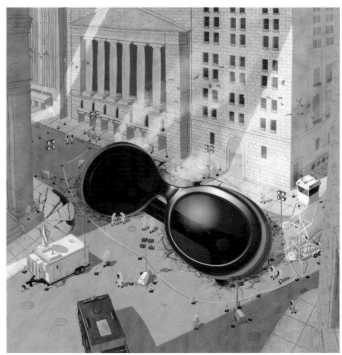

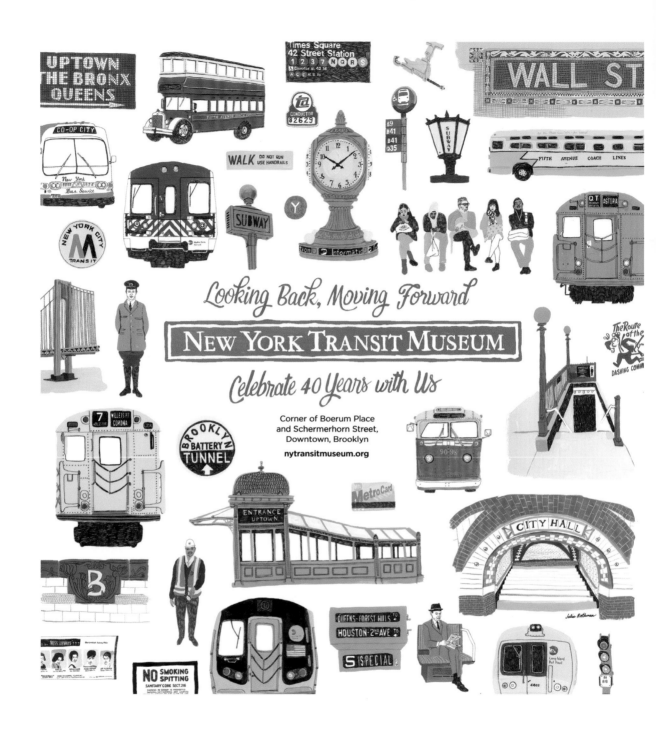

JULIA ROTHMAN
The NY Transit Museum 40th Anniversary
Gouache and ink
Forty paintings of select pieces from the museum's collection,
used as a pattern across a range of printed media and products.

MICHAEL P. SINCAVAGE
Nightmare on Ludlow Street
Brush and ink, Photoshop

I was hired by the Brooklyn band, The Black Black, to design a poster for a Halloween Cover show at Cake Shop, where local bands dress and perform as other bands. The poster depicts Donald Trump dressed as the frontman of the bands being covered: The Cure, Guns 'n Roses, Creedence Clearwater Revival, and the Forrest Gump Soundtrack. The drawings are all brush and ink, and the poster was colored, composited and designed with Photoshop. I really just wanted to see what Trump would look like in Goth makeup.

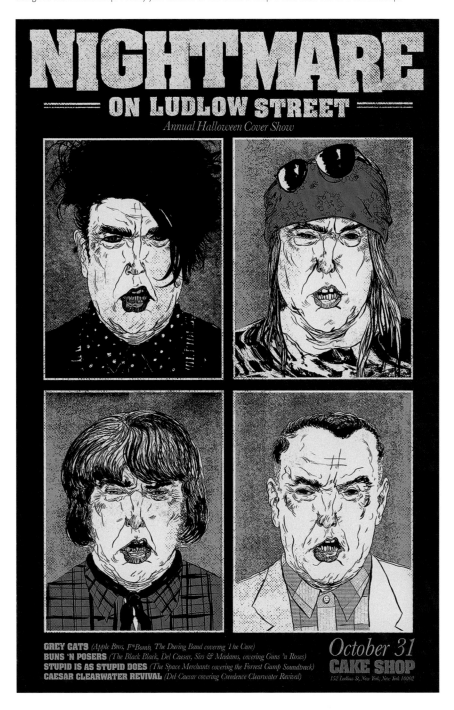

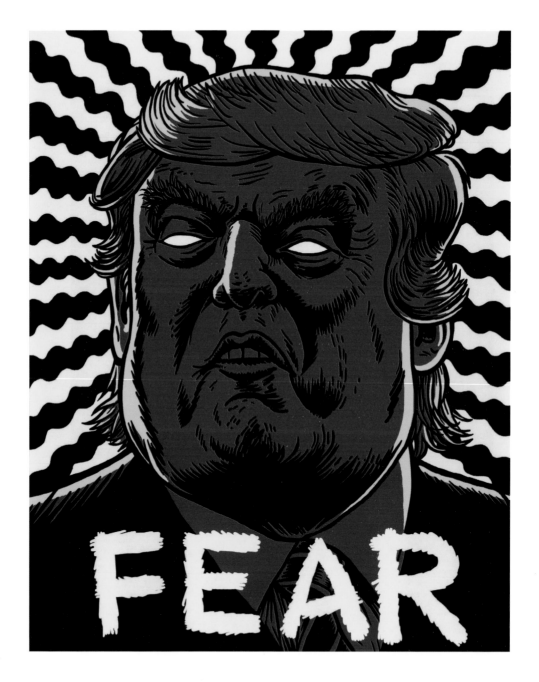

WARD SUTTON
Trump - Fear
Digital
Political poster.

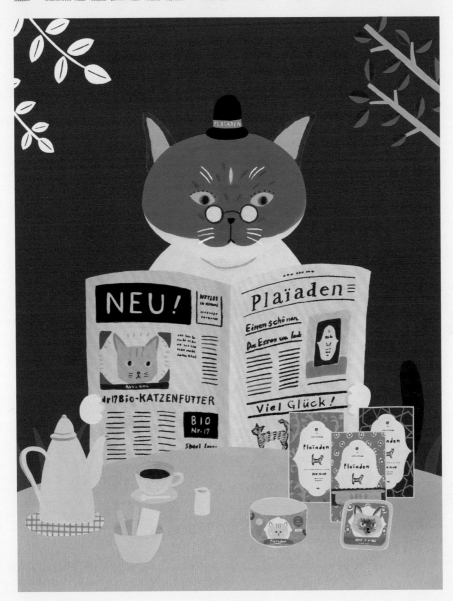

ALIE SUZUKI
Gentleman
Acrylic, digital media
The illustration for the German organic pet food brand Plaïaden.
This is the image of the original tabloid paper in Japan.

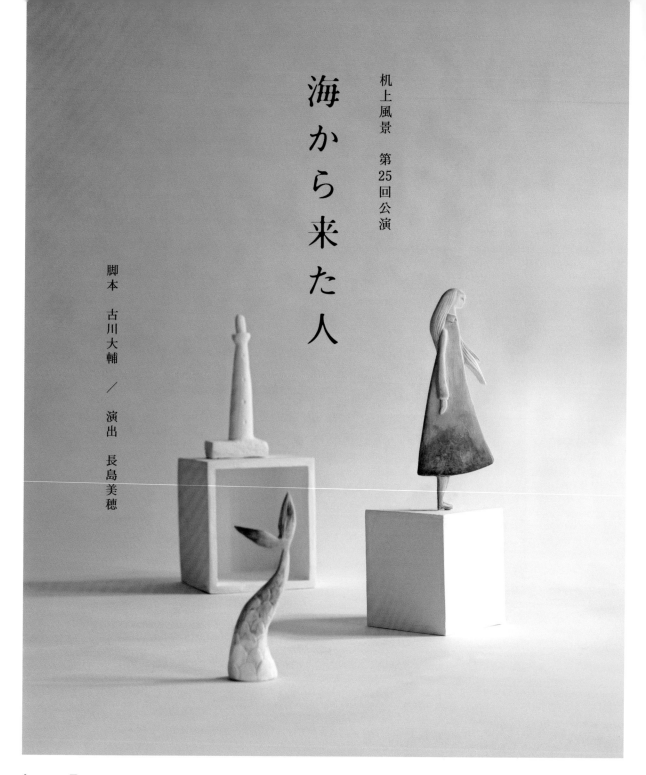

机上風景　第25回公演

海から来た人

脚本　古川大輔　／　演出　長島美穂

AYUKO TANAKA
Someone Who Came from the Sea
Clay and wooden objects, photography, Photoshop
This is a poster and flyer for a theater play called *Someone Who Came from the Sea*. I used clay and handmade wooden objects painted with acrylic ink for creation, and later shot as a photograph to be printed as a poster. The play was a tragic story about two mermaids. I was asked to represent the philosophical and quiet mood of the script, emphasizing the emptiness of a modern human's life. I wanted to convey the atmosphere of nothingness through simple white clay objects and the empty spaces between them.

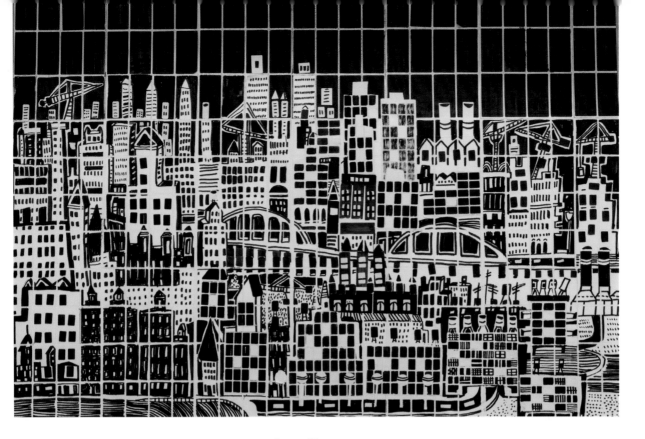

AMIT TRAININ
Moon
Stop motion animation
Illustrated video clip for the Hebrew song "Moon," made by drawing on thousands of white office stickers.

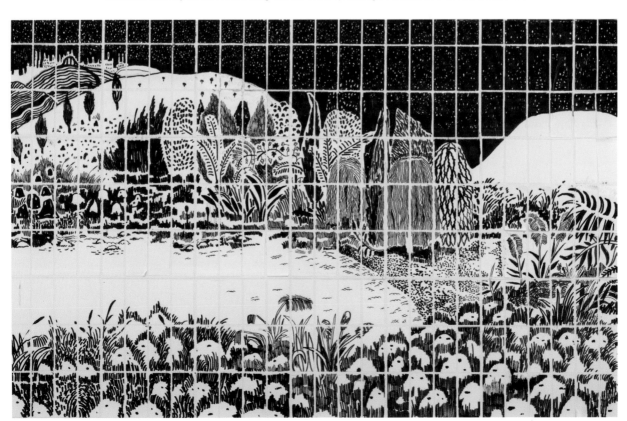

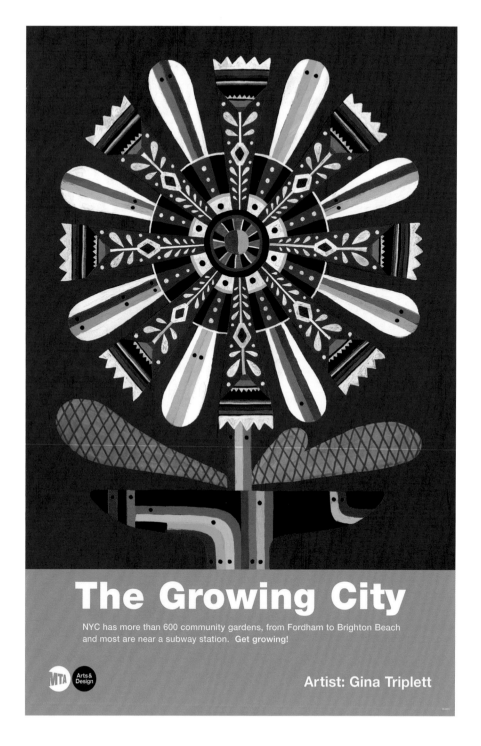

GINA TRIPLETT
The Growing City
Digital print

The illustrator, fascinated by American folk art's decoration, geometric simplicity and imperfections of handmade work, uses her own style to connect the mechanical transit system, specifically Massimo Vignelli's subway map, and ties it together to depict a growing city and the natural beauty of the city's public gardens.

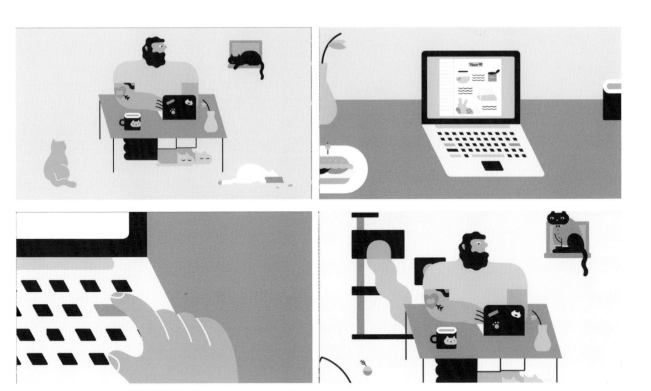

JING WEI
Personalization
Digital
A short animation about tailoring emails to your personal interests.

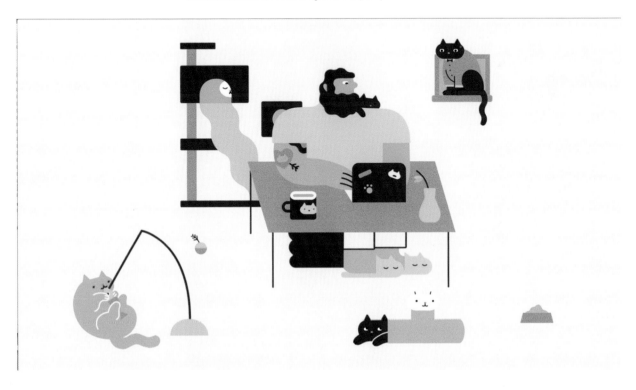

INSTITUTIONAL

MELINDA BECK
**ILLUSTRATOR/
GRAPHIC DESIGNER**

Melinda Beck is an Emmy-nominated illustrator, animator and graphic designer based in Brooklyn, NY. She graduated summa cum laude in from the Rhode Island School of Design. Her clients include Neiman Marcus, Nickelodeon, Nike, *Real Simple* magazine, Supreme, *The New Yorker, The New York Times*, Random House, Simon & Schuster, Target and *TIME*. She received a Gold Medal from the Society of Illustrators, as well as awards from and publication in annuals including *American Illustration*, The Art Directors Club, Society of Publication Designers, *Communication Arts, Print*, the Society of Illustrators, the Broadcast Design Awards and AIGA. In addition her work has been exhibited in various shows. Recently a series of her prints was acquired by the Library of Congress for its permanent collection. Melinda is currently the vice president of ICON, the Illustration Conference.

SAIMAN CHOW
VISUAL ARTIST

Saiman Chow is a multidisciplinary director, designer and animator. Born and raised in Hong Kong, he immigrated to Los Angeles with his family at the age of 15. After graduating from Art Center College of Design in 2001, Chow gained early attention for his Art of Speed animation. Constantly re-inventing his approach, Chow's work spans media and takes a variety of forms, from intricate animations to illustrations and fine art. Chow's clients include: Apple, Adidas, Adult Swim, Google, Nike, *The New York Times*, Rayban, SONOS, Warby Parker and Uniqlo. He currently resides in Brooklyn, NY, where he shares a work/live space with his wife and two cats above a hardware store.

SEYMOUR CHWAST
**GRAPHIC DESIGNER/
ILLUSTRATOR/
TYPE DESIGNER**

Seymour Chwast is co-founder of Push Pin Studios and has been director of the Pushpin Group where he reintroduced graphic styles and transformed them into a contemporary vocabulary. His designs and illustrations have been used in advertising, animated films, and editorial, corporate and environmental graphics. He has created over 100 posters and has designed and illustrated more than 30 children's books. His work has been the subject of three books including, *Seymour Chwast: The Left Handed Designer* (Abrams, 1985). Many museums, such as the Museum of Modern Art (New York), the Library of Congress (Washington D.C.) and the Israel Museum (Jerusalem), have collected his posters. He has lectured and exhibited worldwide and is in the Art Directors Hall of Fame. He is the recipient of the 1985 Medal from the American Institute of Graphic Arts.

DAMIEN CORRELL
ART DIRECTOR, GOOGLE

Damien Correll is a Brooklyn-based designer and artist. He's currently an art director at Google in New York City. He spent the last few years as the Brand Art Director at Tumblr, and before that he was a creative partner at the New York design studio, Part & Parcel. Over the past 13 years he has worked on a range of projects from directing videos and animations for large non-profits to designing retail experiences and conferences.

LISK FENG
ILLUSTRATOR

Orignally from China, Lisk Feng is an award-winning freelance illustrator based in New York. She earned an MFA Illustration Practice from Maryland Institute College of Art in 2014. That year she also received awards from the Society of Illustrators; *Communication Arts; 3x3* Student Award Silver Medal; *3x3* Children's Book Honorable Mention; *American Illustration* chosen winner, selected winner and annual; Adobe Design Award Semi-final; AOI Illustration Awards (UK) shortlist, and others. Her clients include the United Nation, *The New York Times, The Wall Street Journal, The Washington Post*, HSBC, Warby Parker, Abrams Books, Monocle, Medium, *Atlanta* magazine, Mr Porter, Scientific American among others.

JED HEUER
ART DIRECTOR,
WIEDEN+KENNEDY

Jed Heuer is an art director
and designer based in
Brooklyn, NY. As a creative
for Wieden+Kennedy he's
made all sorts of stuff for
Nike, Jordan, Spotify and
ESPN to name a few. He's
also done work for *The New
York Times,* NYU and The
Cooper Hewitt Smithsonian
Design Museum. He's won
Lions from Cannes, Clios,
Webbys, awards from the
Type Directors Club, and he
won this cool silver eagle
necklace from an arcade
claw machine the other day.
He designs patterns, but
usually wears a plain t-shirt.

JIAE KIM
CREATIVE DIRECTOR,
EMEHT

Jiae Kim is the creative
director and co-founder of
EMEHT, a creative agency
in New York City. EMEHT
produces branded content,
brand identities, campaigns,
strategy, books, magazines
and art events for clients
including Levi's, Nike,
Uniqlo, Converse, DvF and
Beats by Dr Dre. Prior to
EMEHT, she co-founded
THEME magazine, a lifestyle
and culture quarterly. Within
the first years of publication,
THEME won awards from
the Society of Publication
Designers, *Print, Creative
Review,* and was a finalist for
the prestigious One Show
design award. Previously
Jiae worked at Pentagram
as an associate with famed
information designer Lisa
Strausfeld.

THOMAS
SCHMID
CREATIVE DIRECTOR,
BUCK

Buck is a design-driven
animation studio. Schmid
started in the company's
infancy, primarily as an
illustrator, and has worked
as a lead designer, art
director and now as a
creative director. Buck
was founded in '04 in Los
Angeles, and has opened
offices in New York and
Sydney, Australia. The studio
houses a collaborative of
artists that work under
a shared "Directed by
Buck" moniker. Thomas's
specialty within the group
is the more illustrative and
pop-driven work, spots
featuring cel animation,
graphic illustration and
puppets. Before Buck, he
and Ben Langsfeld founded
Eneone, an independent
print design firm in
Philadelphia. He lives in
New Jersey with his wife and
two children, and originates
from Italy and Philadelphia.

TAMARA
SHOPSIN
ILLUSTRATOR

Tamara Shopsin is a graphic
designer and illustrator
whose work is regularly
featured in *The New
York Times* and *The New
Yorker.* She is the author of
the memoir *Mumbai, New
York, Scranton,* designer
of the *5 Year Diary,* and
co-author with Jason
Fulford of the photobook
for children, *This Equals
That.* She is also a cook at
her family's restaurant in
New York.

GOLD MEDAL WINNER
Patrick Doyon

The Junction - Chilly Gonzales & Peaches
Digital

It's a known fact that opposites attract. The classically trained Chilly Gonzales and rock provocateur Peaches brought out the best in each other when they first met at a basement jam session. Coming from opposite ends of the spectrum, they found common ground in their willingness to cross over . . . Sometimes, an apple rotten with old ways can grow into a sturdy new tree. Animated short film commissioned by Red Bull.

214 Institutional

Society of Illustrators 59

Mighty Casey: The Invincible Hero of Mudville
Oil on linen

The sneer is gone from Casey's lip, his teeth are clenched in hate;
He pounds with cruel violence his bat upon the plate.
And now the pitcher holds the ball, and now he lets it go,
And now the air is shattered by the force of Casey's blow.

Oh, somewhere in this favored land the sun is shining bright;
The band is playing somewhere, and somewhere hearts are light,
And somewhere men are laughing, and somewhere children shout;
But there is no joy in Mudville—mighty Casey has struck out.

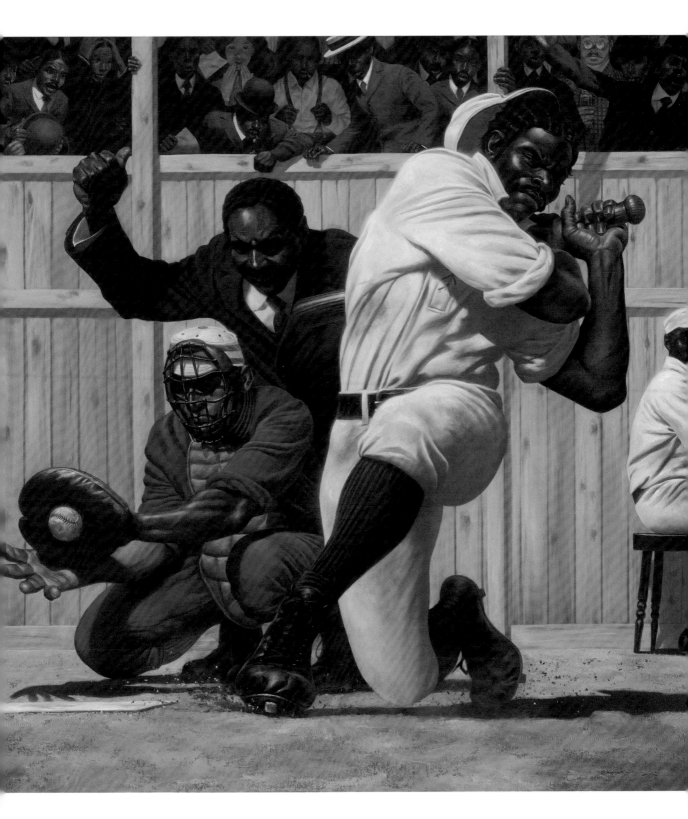

Adult Swim Food Chain Pyramid Repeating Pattern
Acrylic paint

A repeating pattern made from three illustrated food chain pyramids.
The pyramids contain subtle Adult Swim references and were painted
with acrylic paints. The pattern was printed on the inside of a backpack,
and later on a towel.

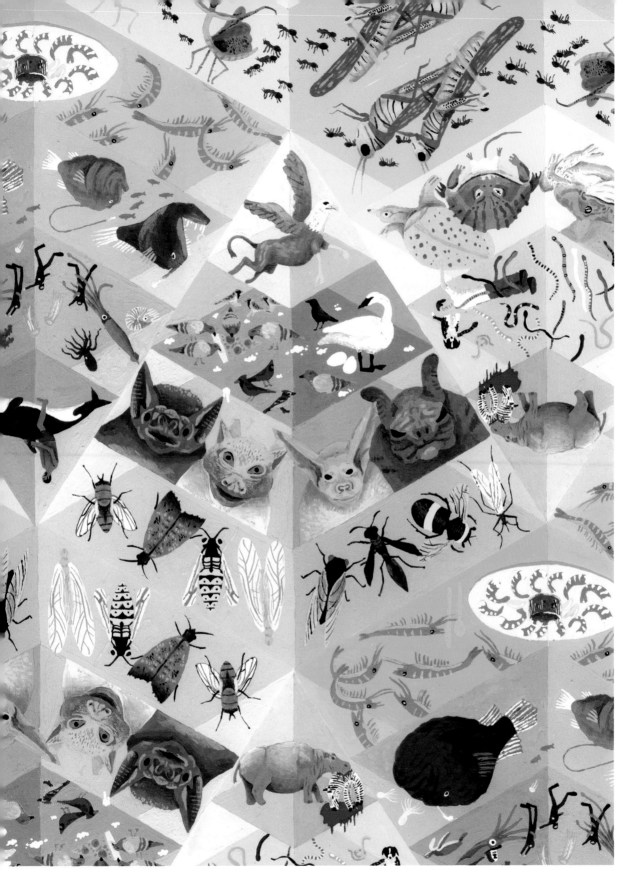

MVX

Acrylic on paper
A poster for the 2017 Youth Book
Month. MVX means male, female,
and everything in between. The focus
is on boys, girls, stereotypes, gender
and gender roles.

SILVER MEDAL WINNER
JING WEI

117 Adams
Digital and paint on high-density foam board
Ceiling mural and column illustrations
for Etsy's corporate office.

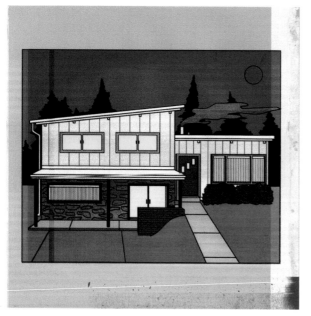

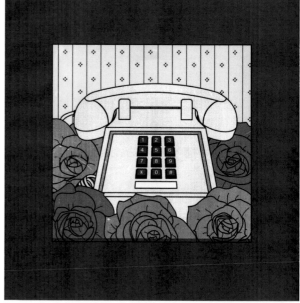

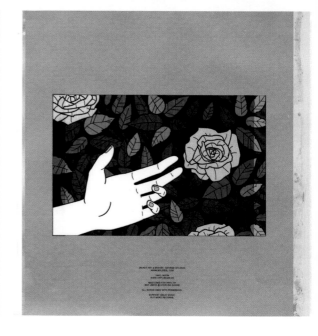

From The Window
Digital Processes
Four-panel vinyl record gatefold illustrations,
for mixtape-of-the-month club, *Vinyl Moon.*

PABLO AMARGO
Yoga in the Library
Mixed media
Poster promoting yoga activities in the Gran Canaria Island Library.

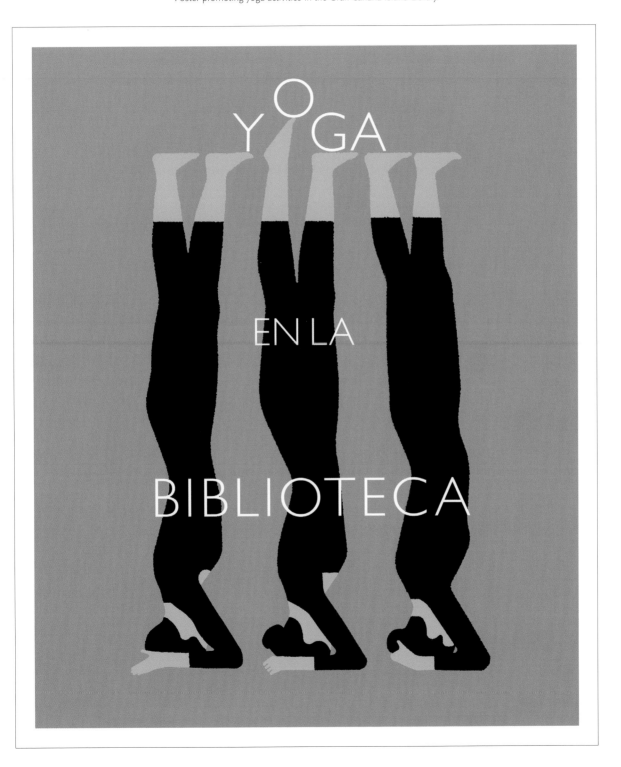

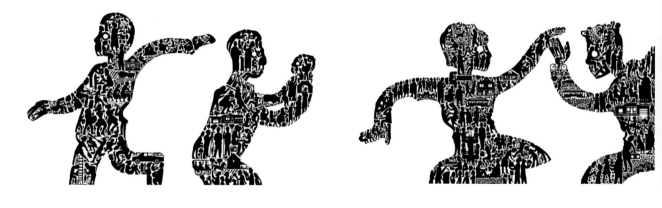

GEORGE BATES
The Worth of That, is That Which it Contains and That is This, and This With Thee Remains
Mixed

Illustrations for a mass transit public art project to be installed in 2017 in Charlotte, North Carolina. The project demanded that close attention and a deep sensitivity was paid to the significant individual and collective histories of the area in light of how the history, community and area has evolved, has been renewed and continues to be reinvented. The area is a historically African-American community that contains one of the first African-American universities created shortly after Emancipation by Presbyterian ministers.

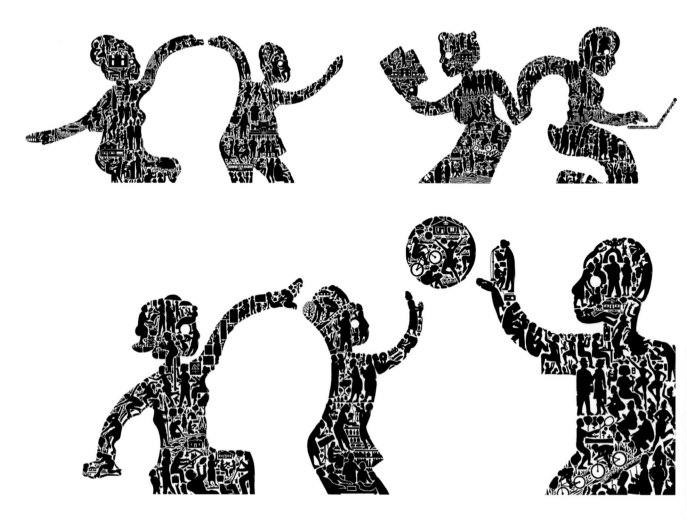

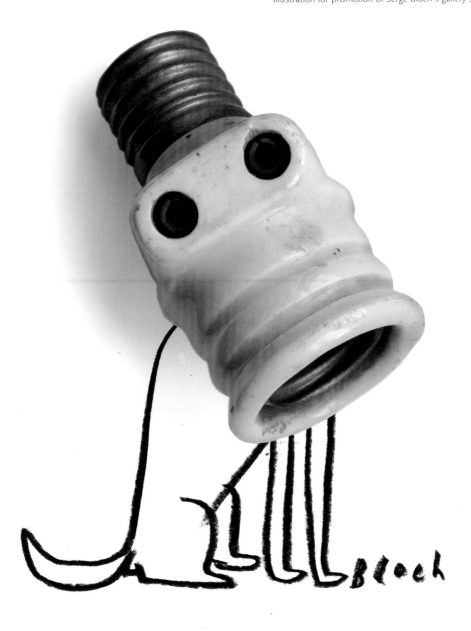

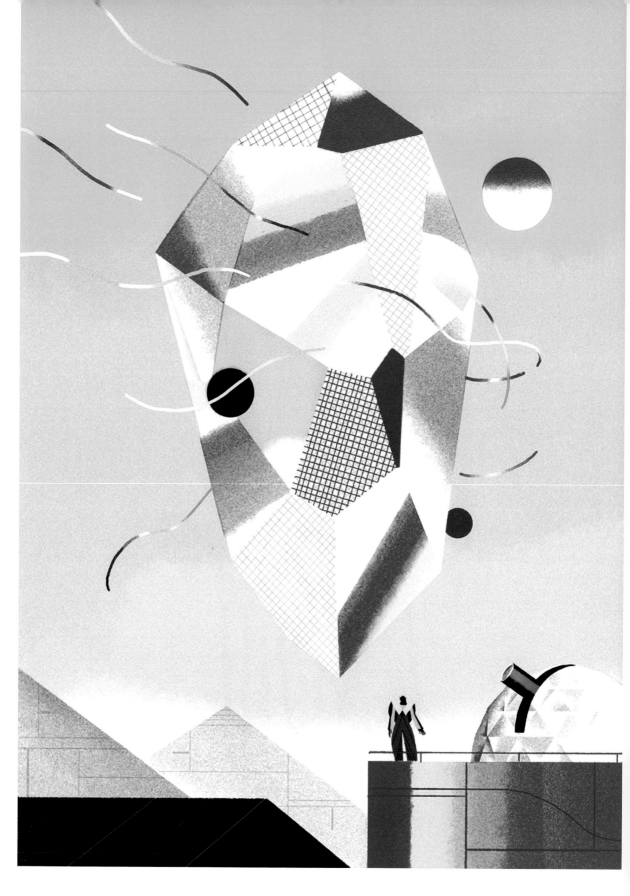

JUN CEN
Gravitational Wave
Digital
Poster for the China Independent
Animation Film Forum.

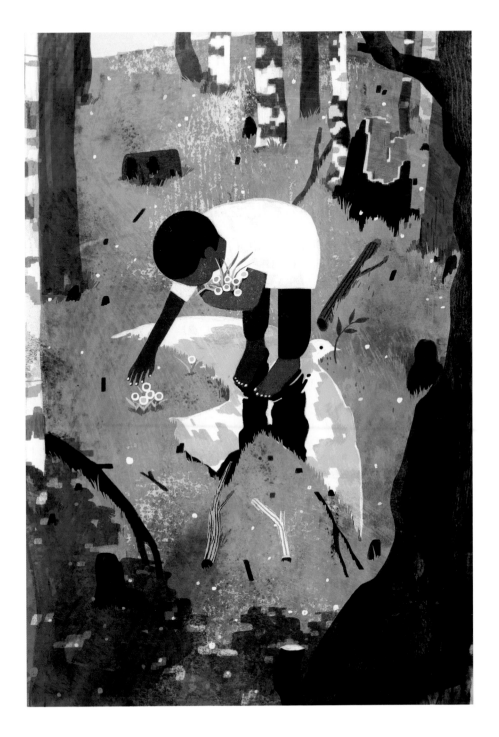

LISK FENG
Left No One Behind
Digital
A single image I did for the World Humanitarian Summit,
about kids after war.

EUGENIA MELLO
Conversations
Digital (Later, when painted on the wall I used water-based latex paint)
This piece was created to eventually become a 17-foot-wide by 8-foot-tall
mural at the DemoDuck office. The company makes explainer videos for
companies, so the idea of conversations, dialogues/exchanges came to
mind. The characters, loaded with personality, seem to be interacting with
each other in a sort of chain-like manner, one with the next, the result is a
series of small moments—conversations—occurring simultaneously that
felt as lively as what the company aims to provide to its clients.

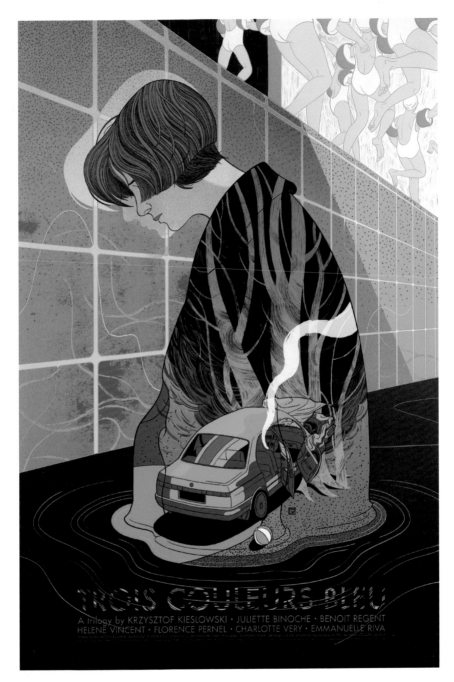

VICTO NGAI
Three Color Trilogy - Bleu
Silkscreen
A collectible poster of the movie *Three Color Trilogy - Bleu*.

ERIC NYQUIST
Science Friday Cephalopod Week
Ink and digital
Main image for Public Radio International's Science Friday: Cephalopod Week.

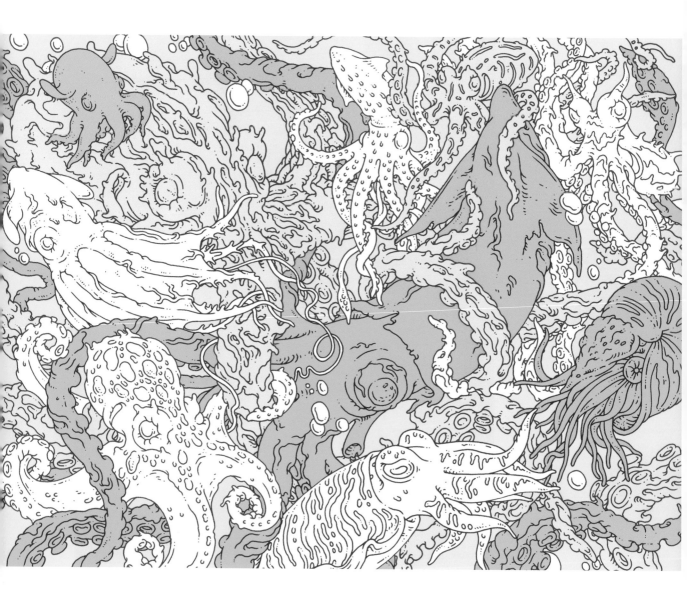

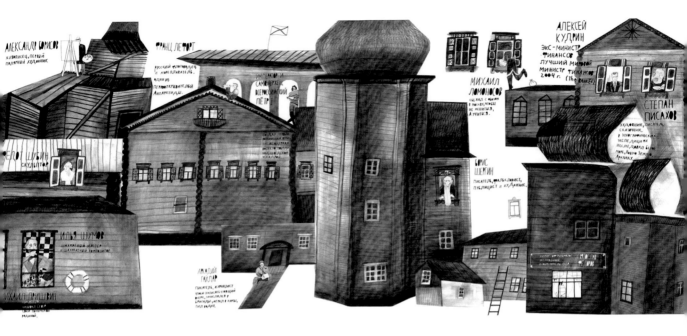

OLGA PTASHNIK
Arkhangelsk

Pencil, paper
The idea was to feature the city of Arkhangelsk and its population as an important place of Russian history. The geometry of the illustration is inspired by traditional architecture of Northern Russia.

BRIAN STAUFFER
An Agreement in Paris for Climate Change
Mixed Digital
About the talks in Paris that resulted in an agreement
between nations to address climate change.

JING WEI
Etsy SF Mural
Paint
Hand-painted mural for Etsy's San Francisco office.
The design was inspired by local admin stories.

OLIMPIA ZAGNOLI
At the Guggenheim
Digital
An illustration created for the Guggenheim Museum of New York to celebrate the
eccentricity of its visitors and the power of women in art.

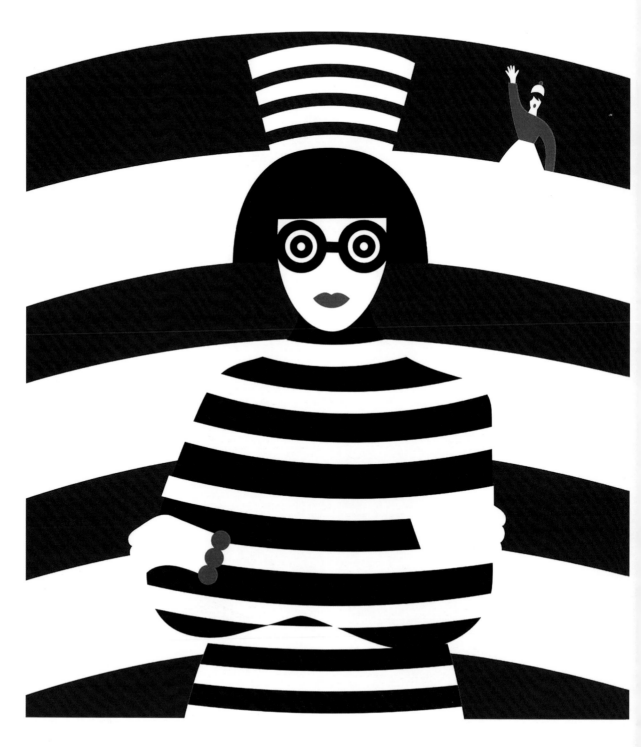

BOOK

CLAUDIA BEDRICK
PUBLISHER, EDITORIAL & ART DIRECTION, ENCHANTED LION

Claudia Bedrick is the publisher, editorial and art director of Enchanted Lion Books, an independent press based in Greenpoint, Brooklyn, that publishes the highest quality children's picture books. Prior to running Enchanted Lion, Claudia worked in Eastern Europe and the former Soviet Union countries in support of library collections and scholarly research across languages and borders. Enchanted Lion has received the Mildred L. Batchelder Award for *Mister Orange, The Wonderful Fluffy Little Squishy* and *Cry, Heart, But Never Break,* as well as Honors for four other titles. Enchanted Lion has also had seven books on *The New York Times* Best Illustrated list.

CHRISTOPHER BRAND
VP & CREATIVE DIRECTOR, THE CROWN PUBLISHING GROUP

Christopher Brand is Vice President and Creative Director at the Crown Publishing Group, a division of Penguin Random House. Previously, he's worked at Rodrigo Corral Design, Penguin Books, and run his own studio. His work has been recognized by AIGA 50 Books/50Covers, the Type Directors Club, *Print* and ADC Young Guns 13.

ROBERT HUNT
ILLUSTRATOR

Robert Hunt has been the recipient of numerous awards, most notably the Society of Illustrators 2017 Distinguished Educator in the Arts award as well as the Society's 2015 Hamilton King Award. Robert has created illustrations for a wide variety of projects that include hundreds of book covers, editorial illustrations, magazine covers, animated motion logos, advertisements, annual reports, packaging and documentary projects. A two-man, mid-career retrospective of his work, with Kazuhiko Sano, was held at the Society of Illustrators in 1996. He has also had three one-man shows of his landscape paintings. Robert is an Associate Professor at the California College of the Arts (formerly CCAC), where he teaches illustration and Professional Practice.

REID KIKUO JOHNSON
ILLUSTRATOR

Kikuo grew up on the island of Maui. He began a career in cartooning and illustration with the release of his debut graphic novel, *Night Fisher,* in 2005. Since then, his award-winning drawings have appeared on magazine covers, book jackets, in ad campaigns, animated films and in galleries around the world. His *New Yorker* cover, *Commencement,* reprinted in this volume, won the American Society of Magazine Editors 2017 best cover contest in the "Brainiest" category. He divides his time drawing and playing the ukulele in Brooklyn, NY, and teaching at the Rhode Island School of Design.

MONICA RAMOS
ILLUSTRATOR

Monica Ramos was born and raised in Manila, Philippines. She studied illustration at Parsons School of Design in New York. Her first assignment was with *The New York Times,* and since then she has done work for magazines, book covers, advertising and fashion. She has also exhibited her work across the country and abroad.

DANIEL SALMIERI
ILLUSTRATOR

Daniel Salmieri grew up drawing pictures of ninja turtles, fighter jets and '90s Knicks rosters. He has since gone on to create illustrations for bestselling books and publications including *The New York Times*. Daniel lives with his wife Sophia, and their dog Ronni, in Brooklyn, NY, where he was born and raised.

CHRISTOPHER SERGIO
ART DIRECTOR, PENGUIN RANDOM HOUSE

Christopher Sergio is an art director at Penguin Random House where he oversees three book imprints with his staff of kick-ass designers. He also runs Christopher Sergio Design, a freelance design practice with a special focus on book covers, art and photography books, and design for film. Sergio is a board member of the Type Directors Club and has won numerous awards in recognition of his design and art direction, including from AIGA, the TDC, *Print* and *Communication Arts*. He's a graduate of the Rhode Island School of Design, Fiorello H. LaGuardia High School of Music and Arts and Performing Arts, and is a native New Yorker.

DASHA TOLSTIKOVA
AUTHOR/ILLUSTRATOR

Dasha Tolstikova is a Brooklyn-based writer and illustrator. Her graphic-novel memoir, *A Year Without Mom*, has received four starred reviews and was named a Kirkus Best Middle-Grade Book of the Year and a Kirkus Best Middle-Grade Graphic Novel of the Year. It has been translated into Swedish and Korean. Her book, *The Jacket* (written by Kirsten Hall), was a *New York Times* Notable Book of 2014. She is currently illustrating a Little Red Riding Hood retelling for HarperCollins. Dasha's work has been recognized by the Society of Illustrators, *American Illustration* and others.

HELEN YENTUS
ART DIRECTOR, RIVERHEAD BOOKS

Helen Yentus is the art director of Riverhead Books and has been designing book covers for over a decade. Her work has been featured in *Print, Graphis, Communication Arts, The Creative Review*, and by the AIGA, the Society of Illustrators, the Type Directors Club and The London Design Museum. In 2007 she was named one of *Print*'s "20 under 30," and in 2014 she received an Art Director's Club Silver Award of Art + Craft in Advertising and Design.

GOLD MEDAL WINNER
OFRA AMIT

So and So
Colored pencils
A children's book.

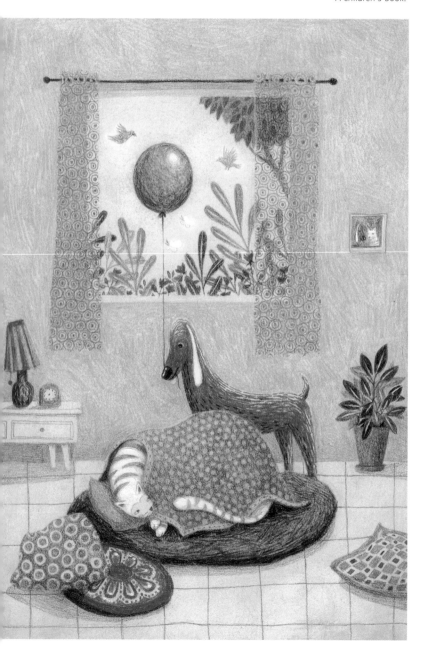

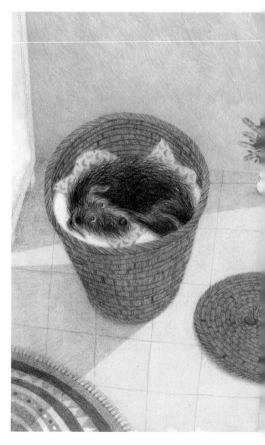

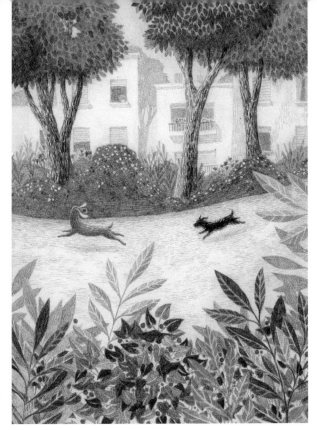
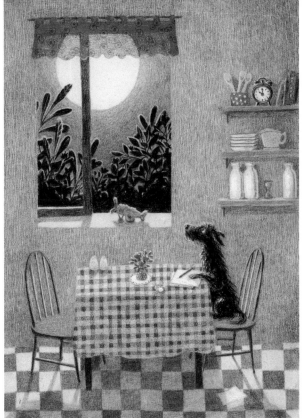
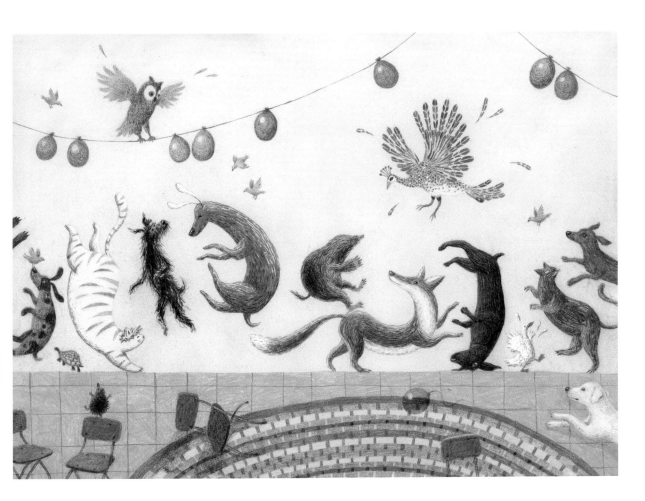

Cat Men: Past and Present
Digital
Final spread
illustration from
Of Cats and Men: Profiles of History's Great Cat-loving Artists, Writers, Thinkers, and Statesmen.

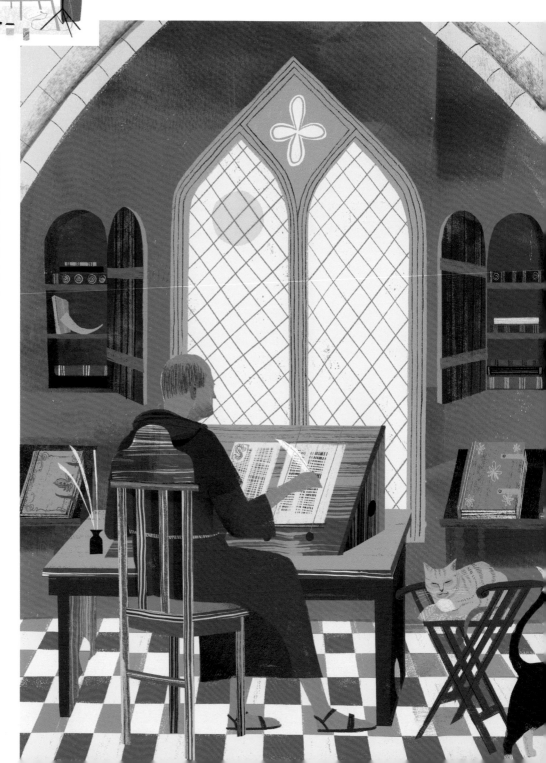

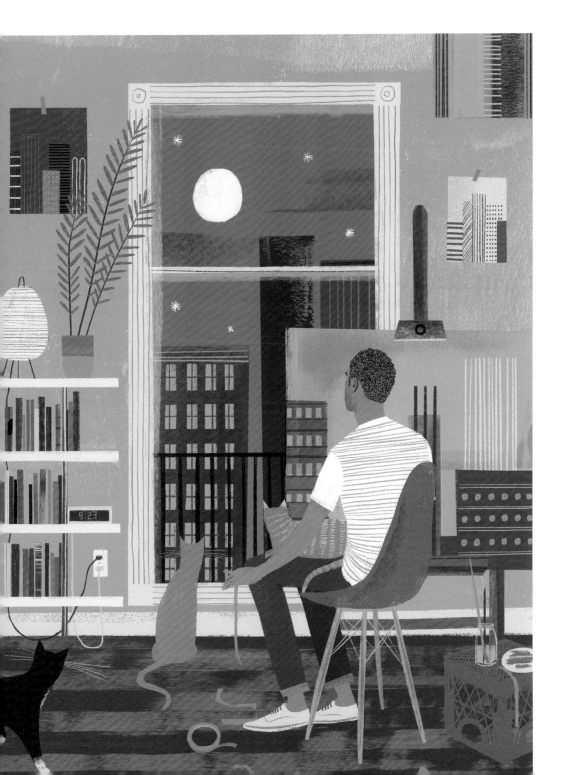

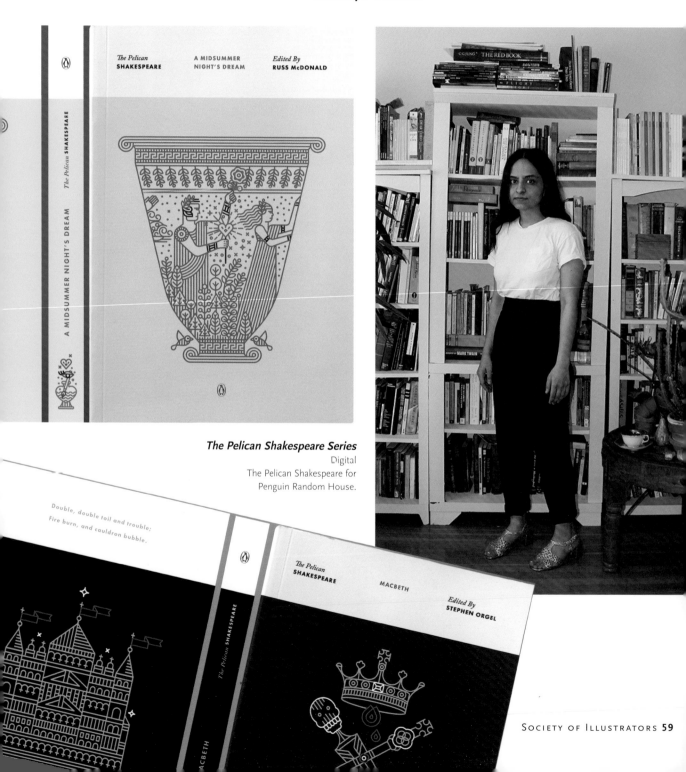

The Pelican Shakespeare Series
Digital
The Pelican Shakespeare for
Penguin Random House.

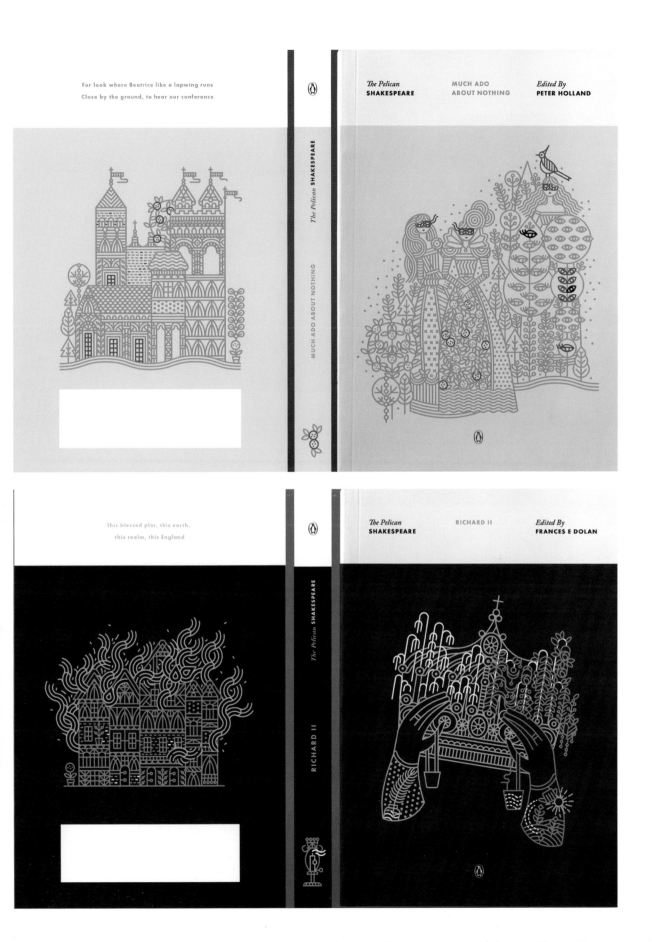

For look where Beatrice like a lapwing runs
Close by the ground, to hear our conference

The Pelican **SHAKESPEARE**

MUCH ADO ABOUT NOTHING

The Pelican
SHAKESPEARE

MUCH ADO
ABOUT NOTHING

Edited By
PETER HOLLAND

This blessed plot, this earth,
this realm, this England

The Pelican **SHAKESPEARE**

RICHARD II

The Pelican
SHAKESPEARE

RICHARD II

Edited By
FRANCES E DOLAN

ANDREW DAVIDSON

Tales of the Peculiar
Wood engraving
Cover and ten interior illustrations
for the book by Ransom Riggs.

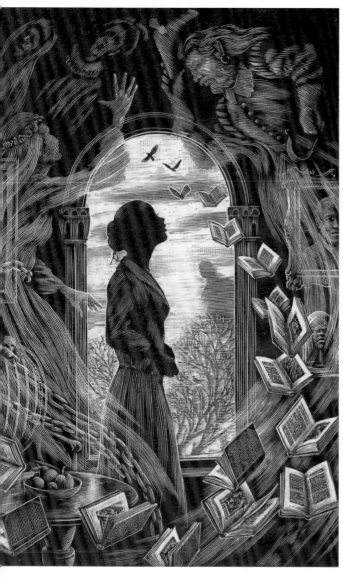

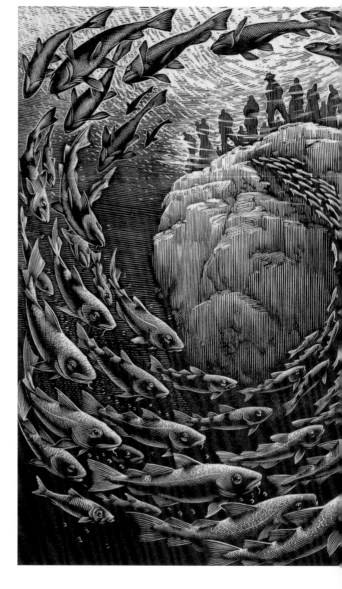

SILVER MEDAL WINNER
ROMAN MURADOV

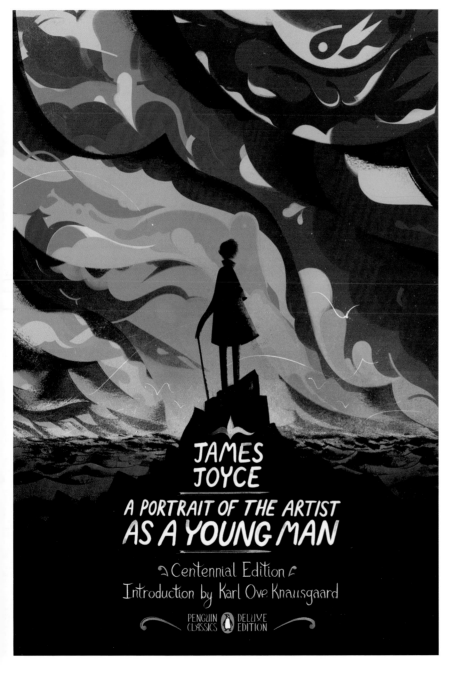

A Portrait of the Artist as a Young Man
Ink, digital
Illustration and design for the
Penguin Classics Centennial Edition
of the novel by James Joyce.

SILVER MEDAL WINNER
Victo Ngai

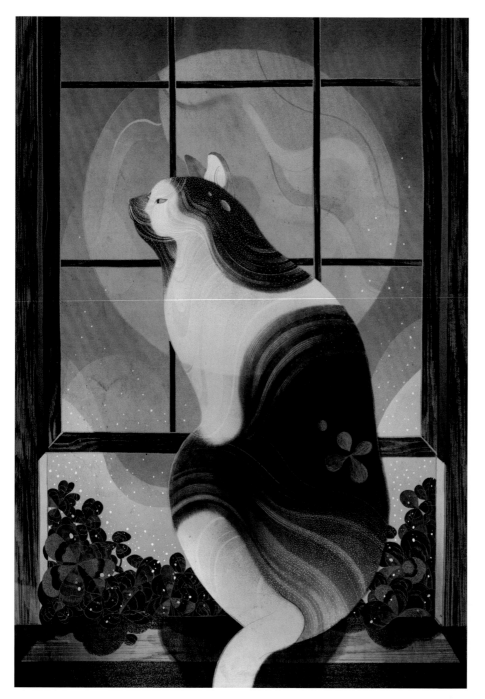

Clover
Mixed
A cat with a clover marking who can change the luck of her owner turns out to be much more than a cat.

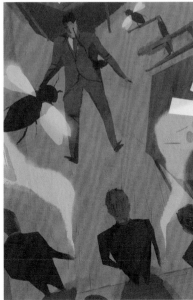

A. Richard Allen
Love Lies Bleeding
Pencil, acrylic, digital
Cover art, frontis and interior plates for the book
by Edmund Crispin for the Folio Society.

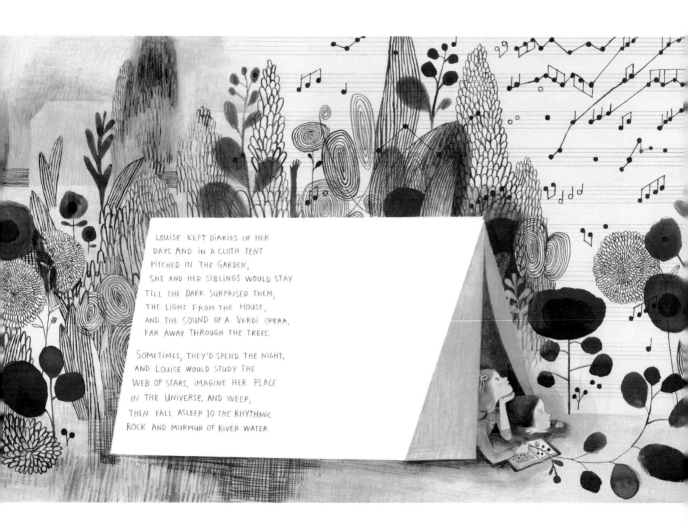

Louise kept diaries of her days. And in a cloth tent pitched in the garden, she and her siblings would stay till the dark surprised them, the light from the house, and the sound of a Verdi opera, far away through the trees.

Sometimes, they'd spend the night, and Louise would study the web of stars, imagine her place in the universe, and weep, then fall asleep to the rhythmic rock and murmur of river water.

ISABELLE ARSENAULT
Cloth Lullaby

Ink, pencil, pastel, watercolor and Photoshop

Louise Bourgeois (1911–2010) was a world-renowned modern artist noted for her sculptures made of wood, steel, stone and cast rubber. Her most famous spider sculpture, *Maman*, stands more than 30 feet high. Just as spiders spin and repair their webs, Louise's own mother was a weaver of tapestries. Louise spent her childhood in France as an apprentice to her mother before she became a tapestry artist herself. She worked with fabric throughout her career, and this biographical picture book shows how Bourgeois's childhood experiences weaving with her loving, nurturing mother provided the inspiration for her most famous works. With a beautifully nuanced and poetic story, this book stunningly captures the relationship between mother and daughter and illuminates how memories are woven into us all.

Anna and Elena Balbusso
Ratspeak

Mixed media: gouache, pencil, pen, collage, digital
Art for the standalone story *Ratspeak* by Sarah Porter, Tor Books. Ratspeak is the the shrill and sly language of the rats of New York City's subway. When a curious boy is granted his wish to speak and understand the secret language of the rats, he brings a curse upon his home.

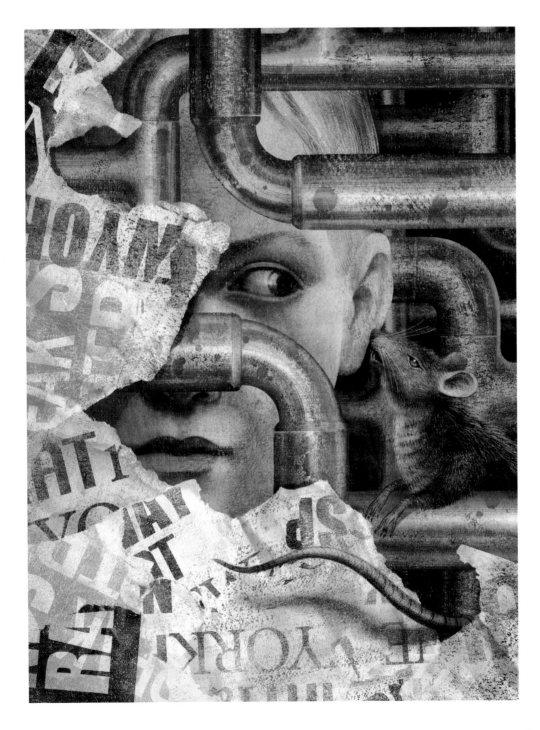

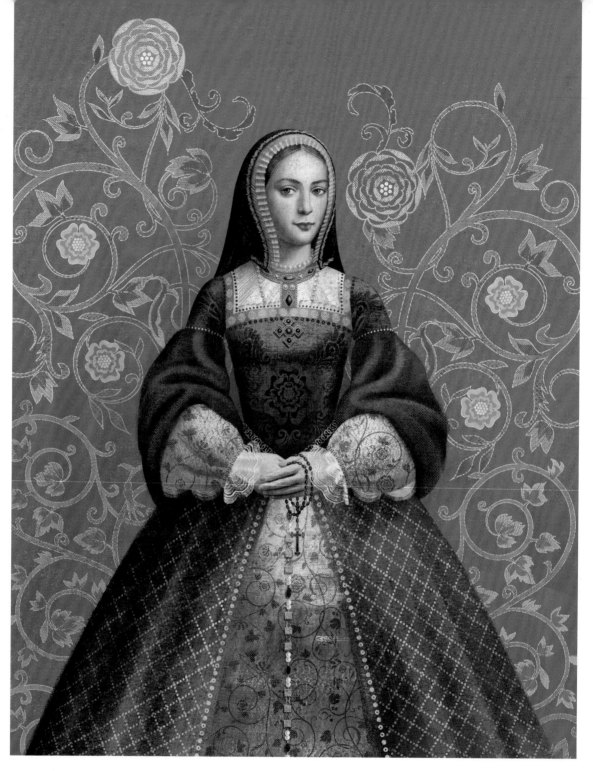

ANNA AND ELENA BALBUSSO
Six Tudor Queens: Katherine of Aragon
Traditional and digital media: gouache, pencil, pen
Cover art for *Six Tudor Queens: Katherine of Aragon* by Alison Weir. First in a series of historical fiction following the
wives of King Henry VIII. Portrait of Katherine of Aragon against a tapestry background. While the portrait wants to be
close to the historical paintings of the Queen, the Katherine face, expression and overall look and feel wants to be a
little more contemporary. The decorated background was inspired from tissues and tapestries at the Tudor Court.

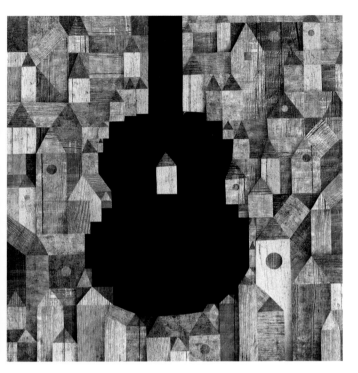

MARTÍN LEÓN BARRETO
Zitarrosa
Mixed media

120-plus page book published on the 80th anniversary of the Uruguayan songwriter Alfredo Zitarrosa. The book contains more than 60 lyrics and each song is illustrated by a different guitar. These wooden guitars relate to the mood of his rural and folkloric style.

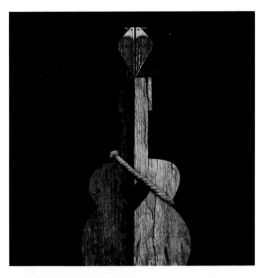

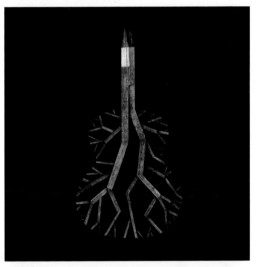

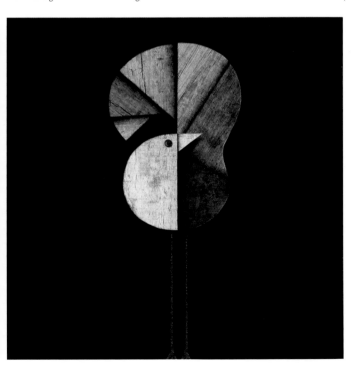

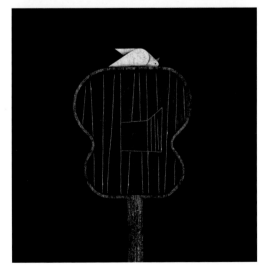

JONATHAN BARTLETT
Fever at Dawn
Mixed media
Holocaust survivors, love, distance, letters, and against the odds,
this is the true story of the unlikely romance that lasts a lifetime.

OVADIA BENISHU
Battle Ration
Digital
A comic book about a soldier's trip
from home back to his military base.

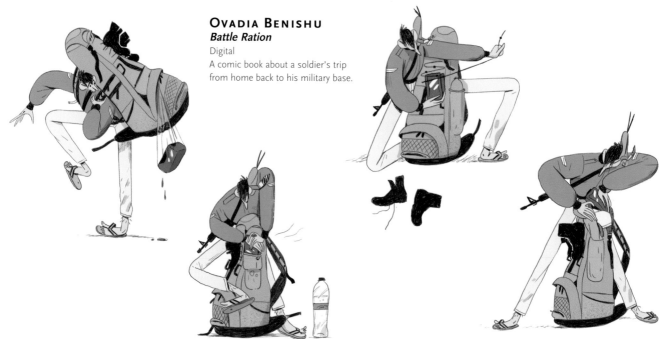

LAUREN SIMKIN BERKE
The Art of Business Value
Ink on paper

The Art of Business Value explores what business value means, why it matters, and how it should affect your software development and delivery practices. More than any other IT delivery approach, DevOps (and Agile thinking in general) makes business value a central concern. This book examines the role of business value in software and makes a compelling case for why a clear understanding of business value will change the way you deliver software.

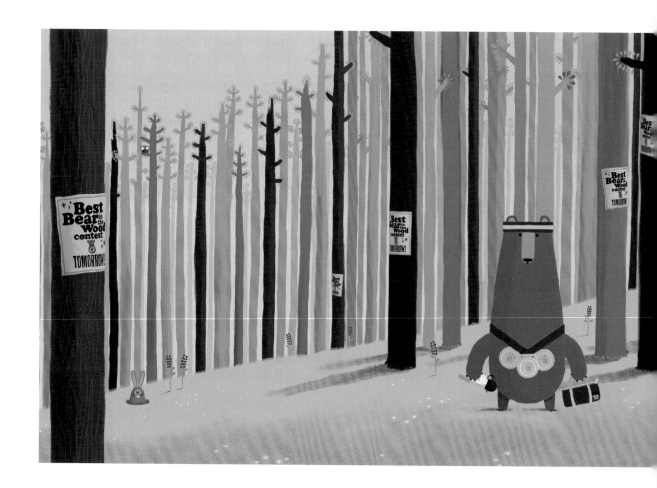

ROB BIDDULPH
The Grizzly Bear Who Lost His GRRRRR!
Pencil on paper, Photoshop, a Wacom Tablet, and a Cintiq 6D Art Pen
This illustration is the opening spread in my second picture book, *The Grizzly Bear Who Lost His GRRRRR!,* and as such needed to set the visual tone for the rest of the book and, most importantly, establish the protagonist, Fred Bear. When drawing for children I find it is best to understate the expression on the characters' faces. In this instance I simply drew two dots for the eyes, no eyebrows and only a tiny suggestion of a mouth. That way the child reading the book can project whatever emotions they feel onto a relatively blank canvas so that no matter what that emotion is, the image still works for them. I find that a little says a lot. Trees are a recurring motif in all my books and are created using very quick vertical brush strokes. I really like the imperfections and wobbles, especially when juxtaposed with the fine detail of the leaves and the posters. In fact, those imperfections are often my favorite part. The image is composed in a sketchbook and rendered digitally.

SOPHIE BLACKALL
The Great Gilly Hopkins
Chinese ink and watercolor
The front and back cover art from the
chapter book by Katherine Paterson.

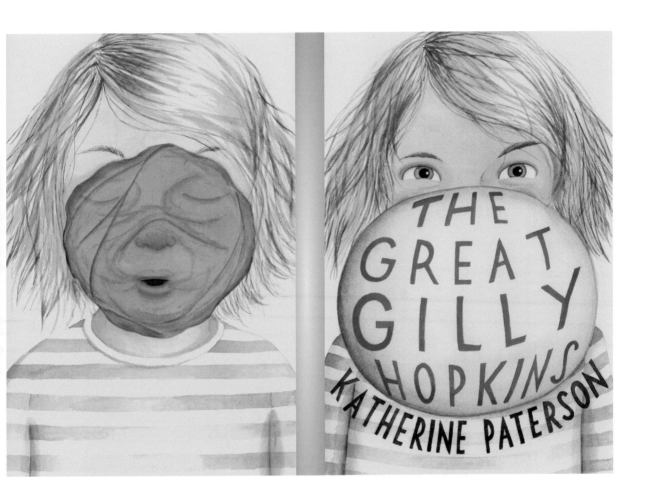

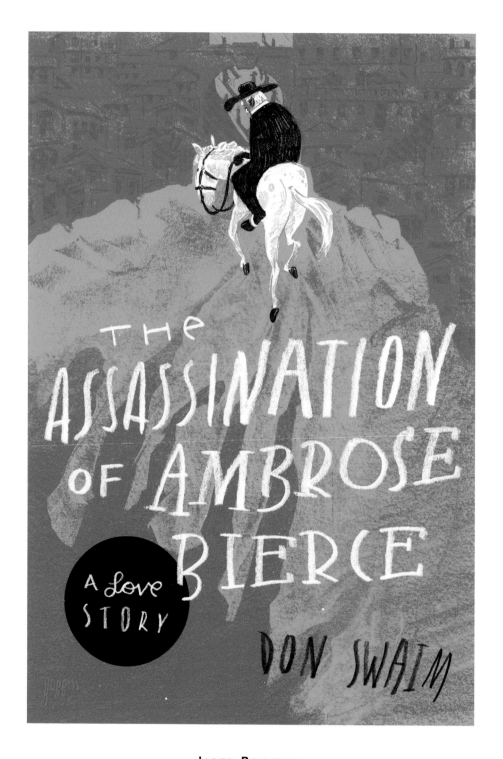

JARED BOGGESS
The Assassination of Ambrose Bierce
Graphite, pastel, digital
Cover art and lettering for a fictionalized account of the final days of the
mysteriously vanished author Ambrose Bierce.

ROBERT BRINKERHOFF
The Unfastening
Pencil, digital
Cover for a book of poems by Wesley McNair.

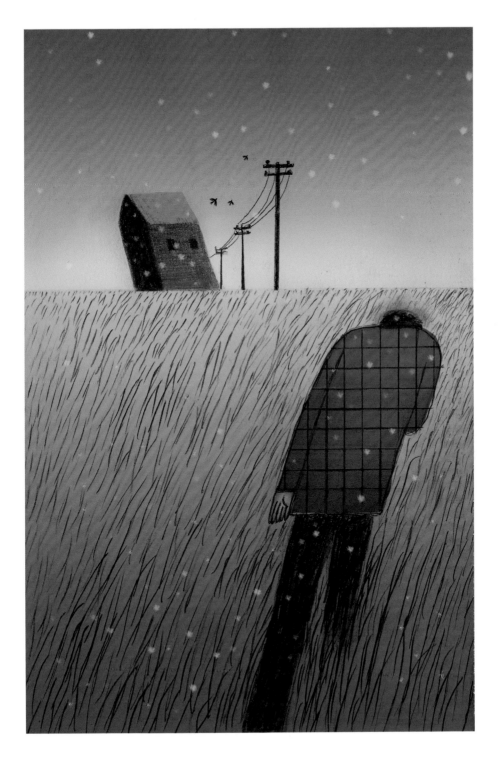

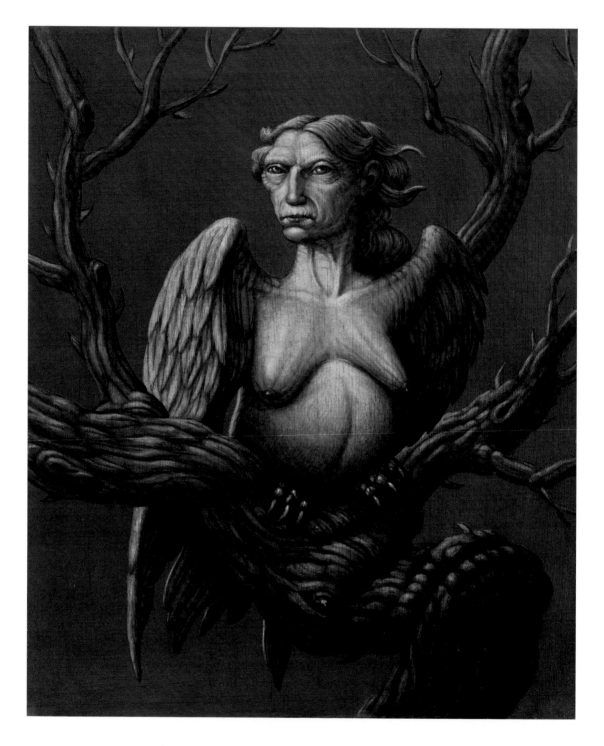

MARC BURCKHARDT
Dante's Inferno
Acrylic and oil on wood panel
Illustration for a new edition of Dante's classic, *Inferno*.

MARC BURCKHARDT
Dante's Inferno
Acrylic and oil on wood panel
Illustration for a new edition of Dante's classic, *Inferno*.

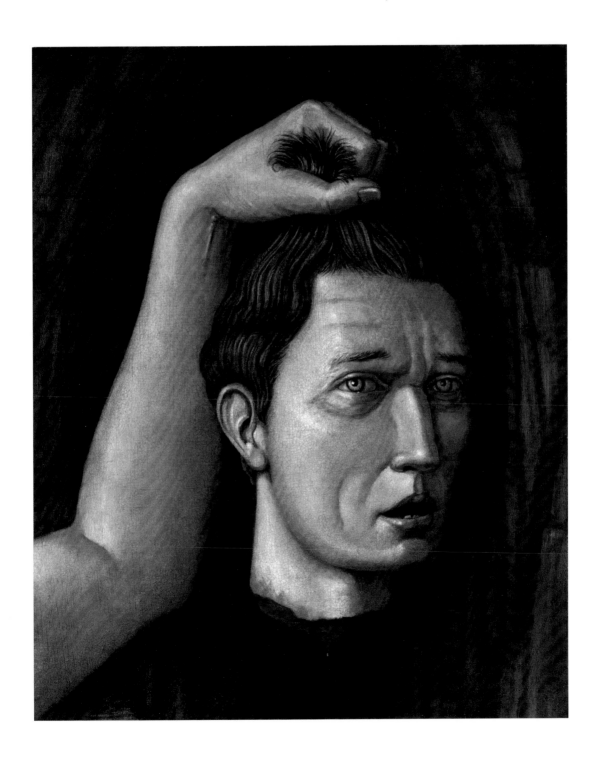

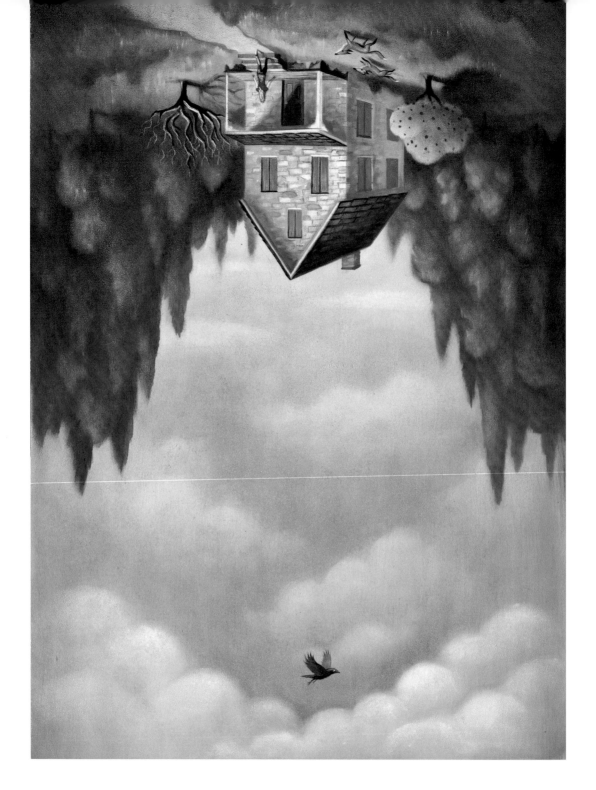

CHRIS BUZELLI
Get in Trouble *by Kelly Link*
Oil on board

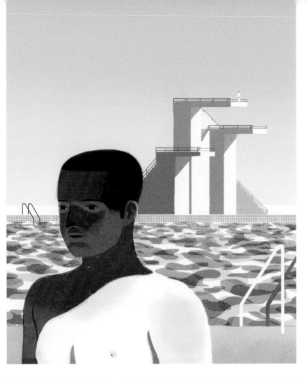

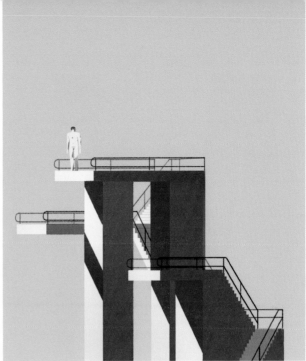

JUN CEN
By The Pool
Digital

The swimming pool in this series is a metaphor of a half-private/half-public venue where people sharing the same sexual identity would gather.

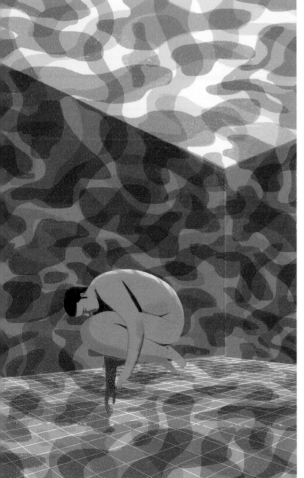

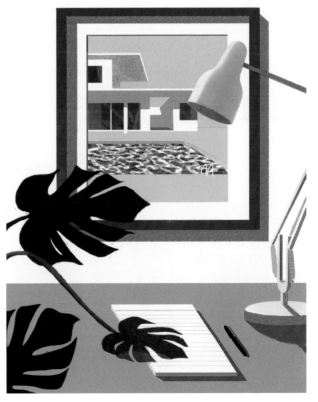

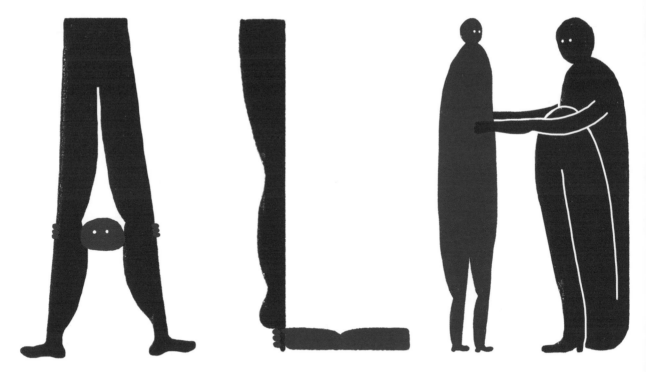

JORO CHEN
Two as One - A to Z
Digital
Two as One is an alphabet book about the relationship between parent and child.
Adopting only red and blue colors and simple shapes, the book aims
to evoke every moment one shares with their parent.

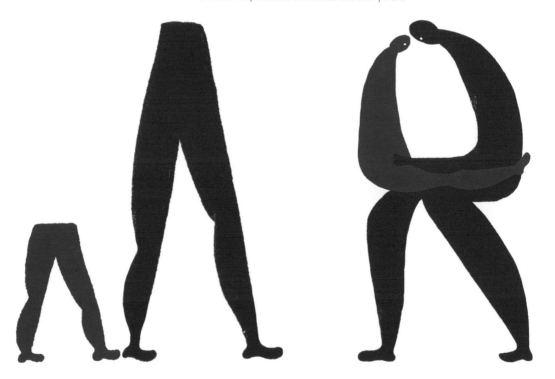

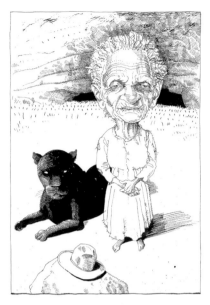

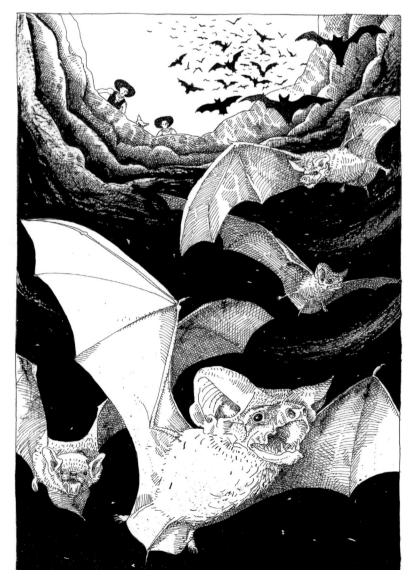

JOSEPH CIARDIELLO
The Devil's Sinkhole
Pen and ink
Novel by Bill Wittliff set in 1880s Central Texas.

BENJI DAVIES
I Love You Already!
Digital
The aim of the work is to tell the story of a humorous relationship of two friends: Bear and Duck. The colors are vibrant, and the layout graphic utilizes flat color and pattern to enhance the staging of the characters for a "sitcom" feel.

FACING PAGE

THOMAS DANTHONY
Gun
Digital
Book cover for the *Face on the Cutting Room Floor* by Cameron McCabe.

JOHNNY DOMBROWSKI
Turncoat
Digital
Incentive comic cover for Boom! Studios series, *TURNCOAT*. Three hundred years since humanity was brutally subjugated by the alien race known simply as the Management. Two years since these invaders abandoned Earth to return to their home world. Following her participation in the brutal massacre of human-alien hybrids left behind by the Management, resistance fighter Marta Gonzalez declines to join the new human government and starts her own private detective agency instead. Gonzalez is forced to confront her own bloody past and acknowledge the fact that the transition from oppression to emancipation is anything but clean.

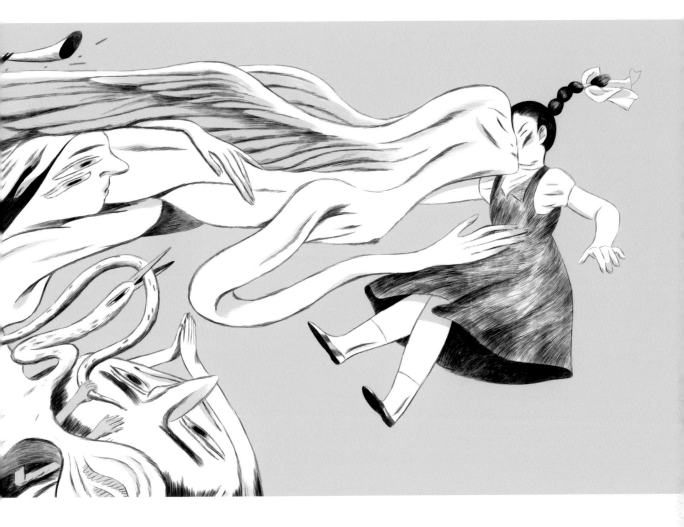

REBEKKA DUNLAP
Monster Parade
Digital
An interior spread commissioned by Gabe Fowler for his
Quarterly Comic anthology publication *Smoke Signal*.

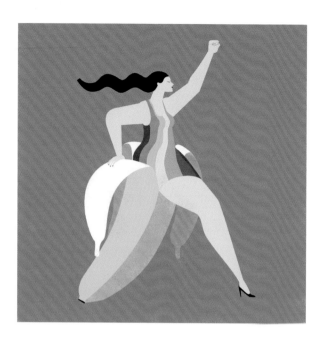
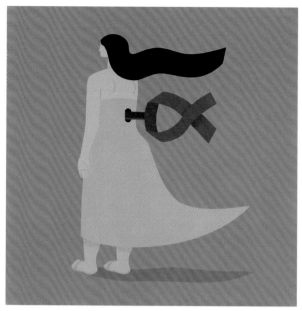
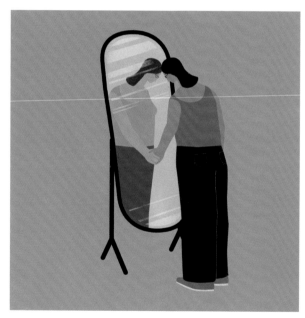
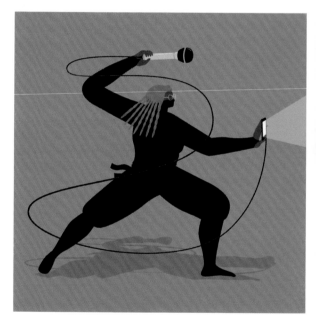

MARTIN ELFMAN
Latin America in Motion
Digital
Opening illustrations for the chronicles, written by renowned
journalists, about the incredible work done by human rights
activists throughout Latin America.

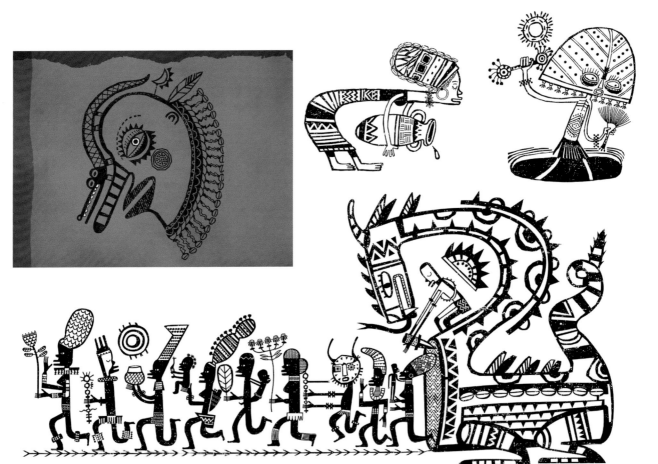

BRIAN FITZGERALD
Óró na Circíní
Gouache paint and digital
Old African tales.

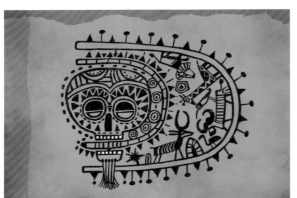

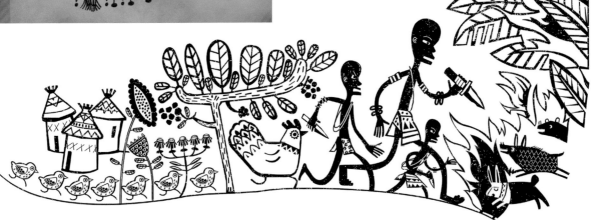

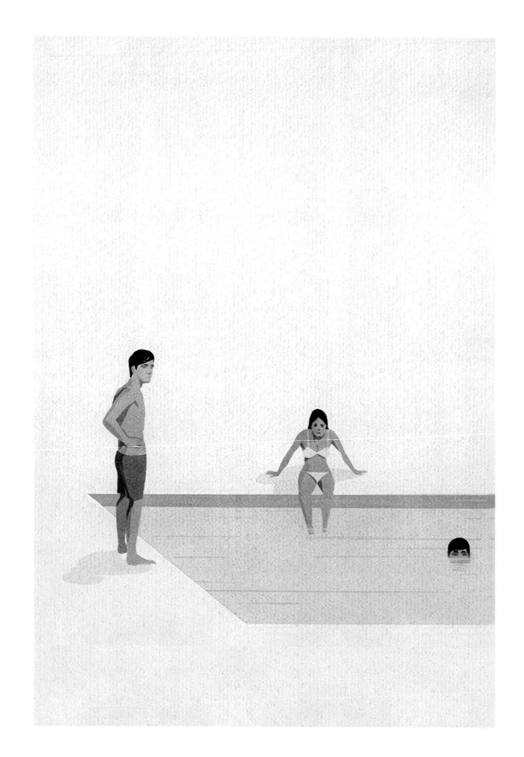

ALESSANDRO GOTTARDO
Beginners
digital
A book cover for the Ray Carver short stories collection *Beginners*.

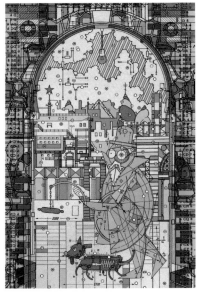
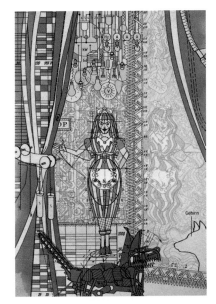
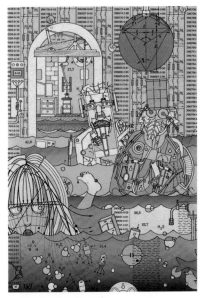
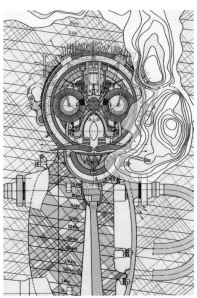
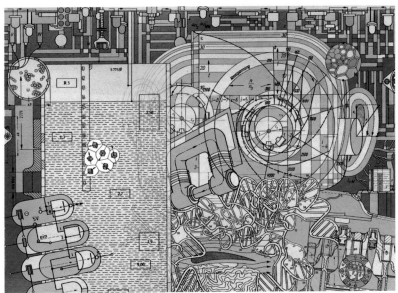
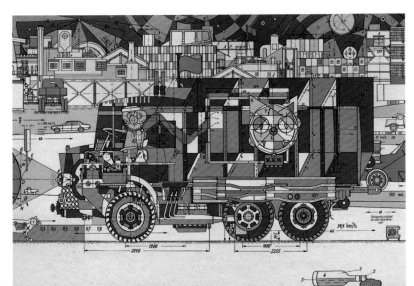

CHRISTIAN GRALINGEN
Heart of a Dog, Mikhail Bulgakov
Digital
With 36 illustrations and a postscript by the
illustrator. A biting satire of the New Soviet
man, it was written in 1925 at the height of
the New Economic Policy (NEP) period, when
communism appeared to be weakening in the
Soviet Union. It's generally interpreted as an
allegory of the Communist revolution and "the
revolution's misguided attempt to radically
transform mankind."

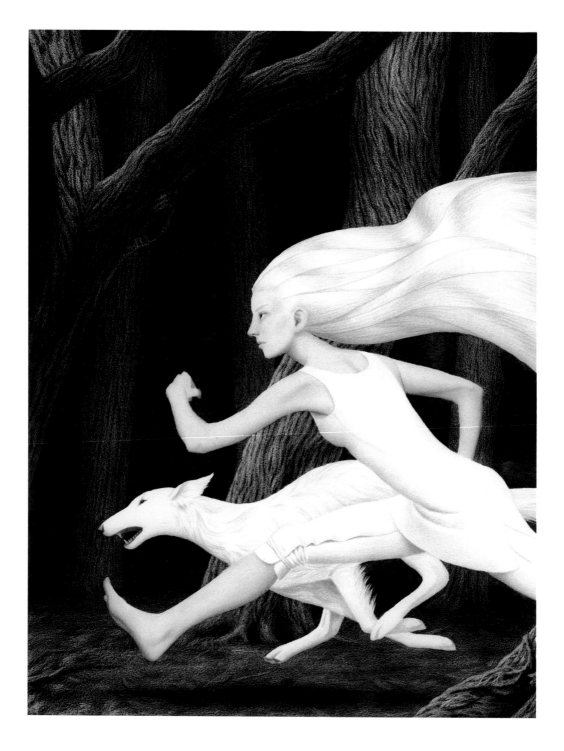

JULIA GRIFFIN
Lissar & Ash
Colored pencil

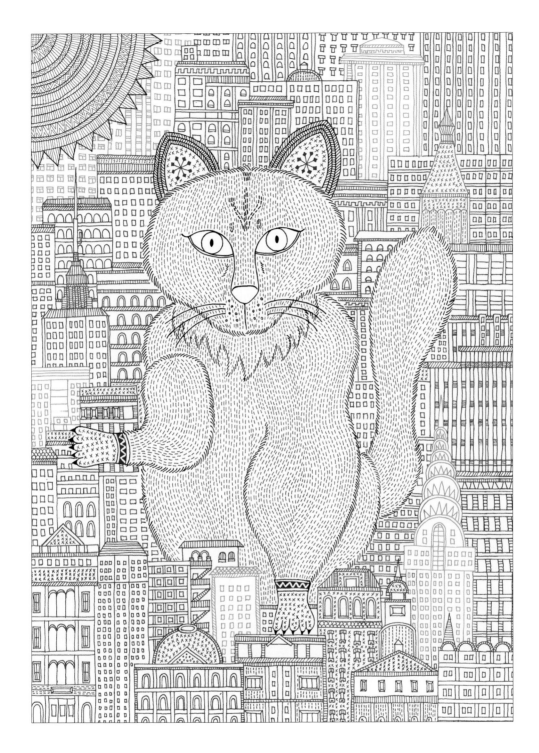

TAKAHISA HASHIMOTO
Jackson in New York
Pen and ink
An illustration for a book cover. I really enjoyed drawing Jackson
the cat with dignity, amongst the skyscrapers of New York;
as if I was him, enjoying his life in Manhattan.

YOHEY HORISHITA
The Reader
Mixed media
Book cover for a Young Adult novel, *The Reader*
(Sea of Ink and Gold Series #1), by Traci Chee.

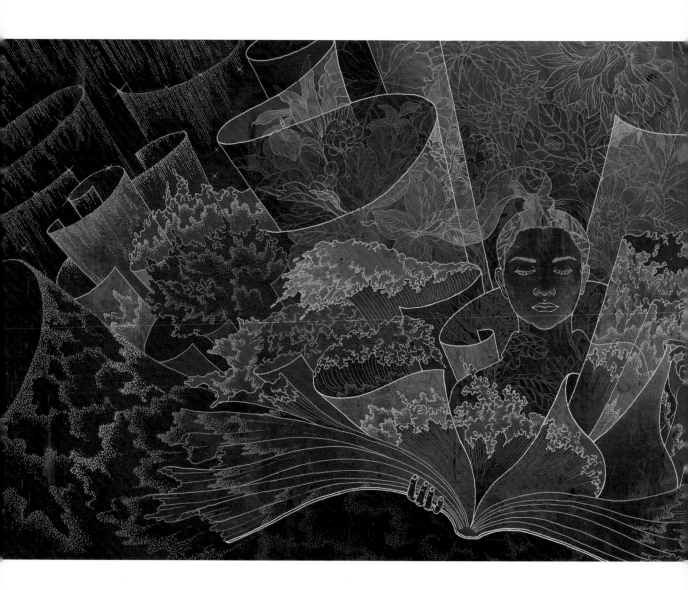

FACING PAGE

JASU HU
Blue is a Darkness
Weakened by Light
Digital
Cover illustration for a novel
written by Sarah McCarry.

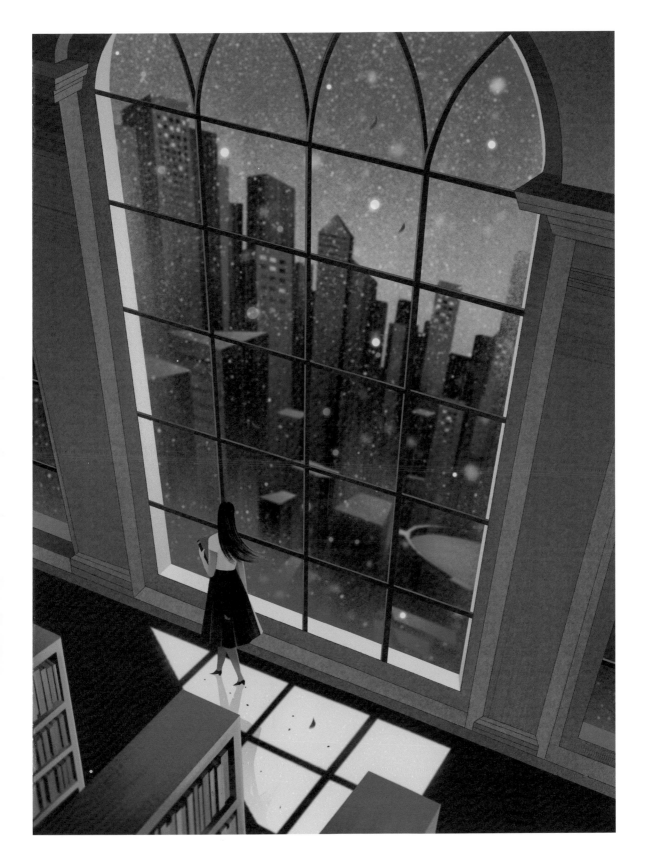

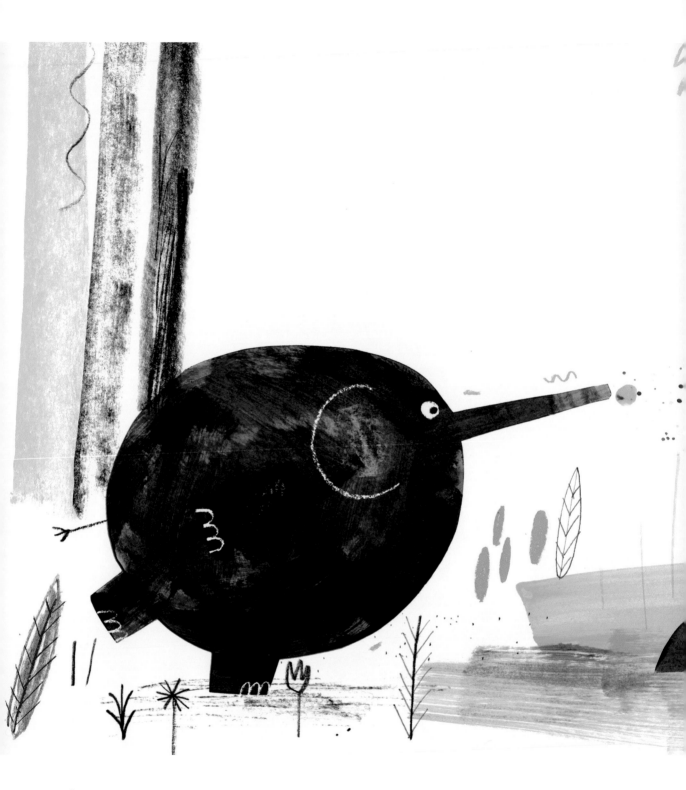

JARVIS
Fred Forgets
Pencil, paint and chalk
An interior spread from the picture book *Fred Forgets*.

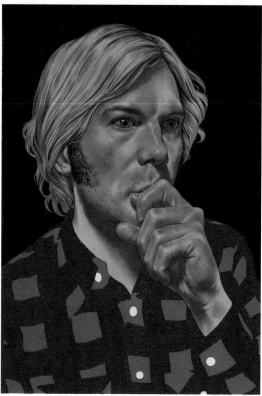

EDWARD KINSELLA
The Shining
Graphite, ink, gouache, colored pencil and watercolor
Cover and 12 interior illustrations for The Folio Society's
special edition of *The Shining*.

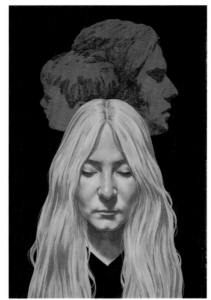

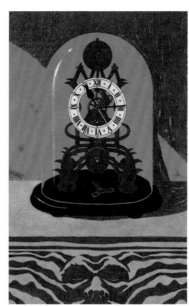

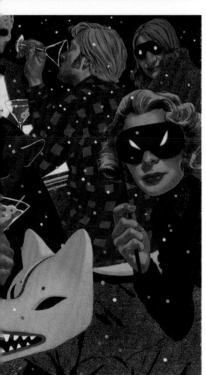

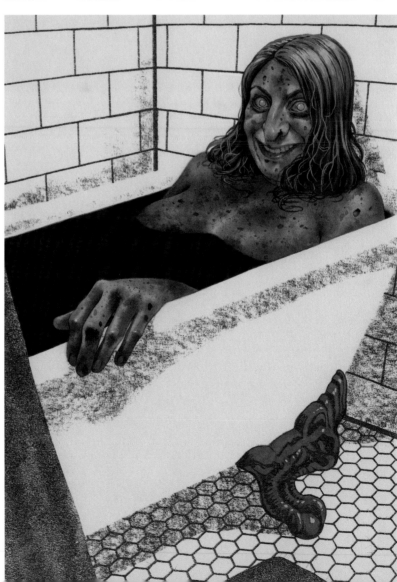

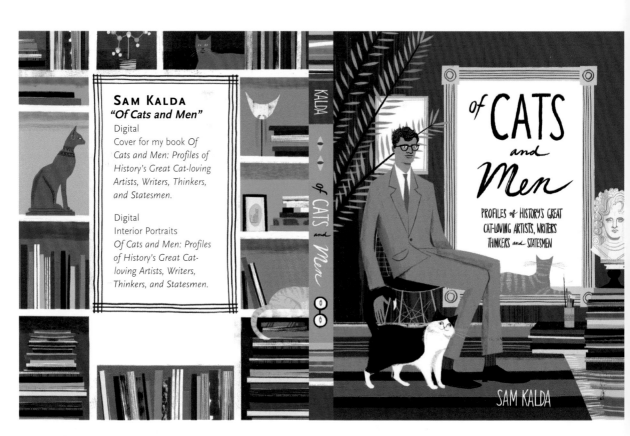

SAM KALDA
"Of Cats and Men"
Digital
Cover for my book *Of Cats and Men: Profiles of History's Great Cat-loving Artists, Writers, Thinkers, and Statesmen.*

Digital
Interior Portraits
Of Cats and Men: Profiles of History's Great Cat-loving Artists, Writers, Thinkers, and Statesmen.

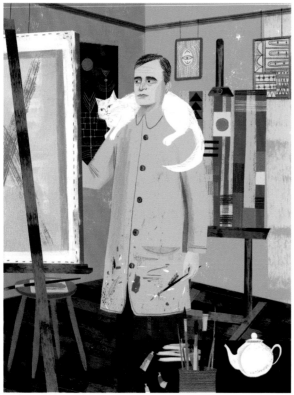

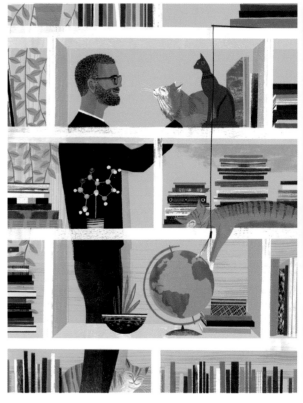

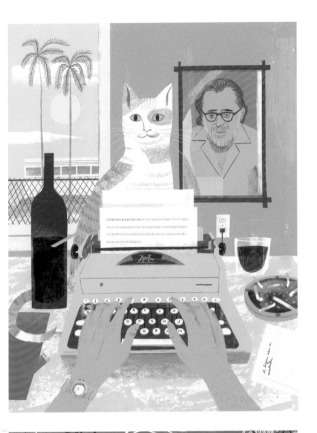
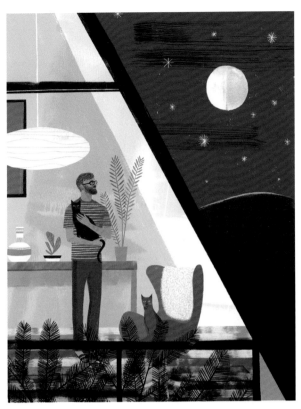
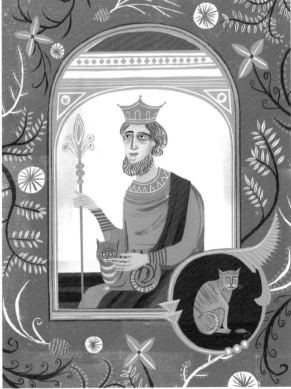
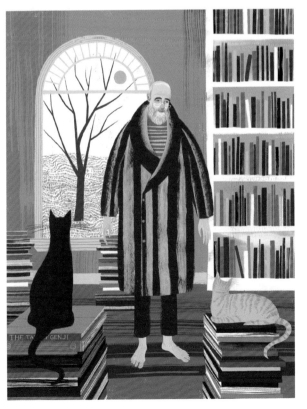

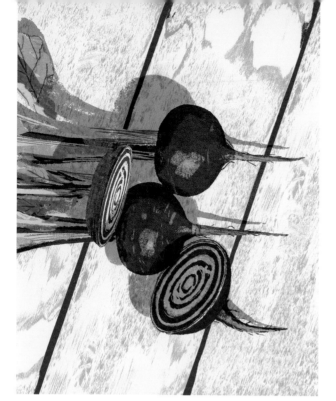

TATSURO KIUCHI
Deep Run Roots
Digital

Vivan Howard's first cookbook, *Deep Run Roots*, is oozing with delicious recipes and personal tales from her North Carolina roots. Designer Don Morris commissioned chapter header illustrations by Tatsuro Kiuchi to embolden Vivan's key ingredients.

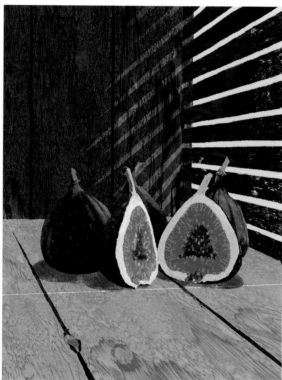

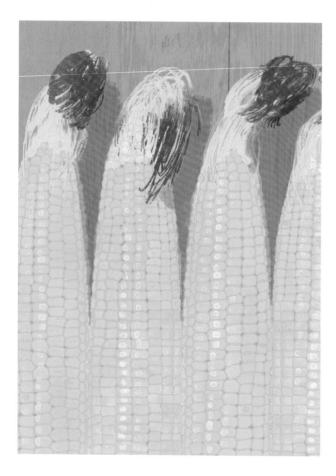

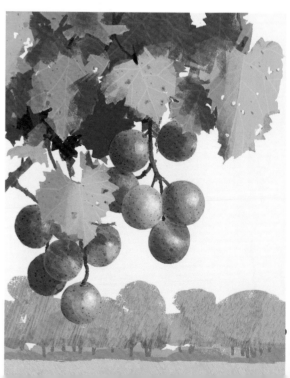

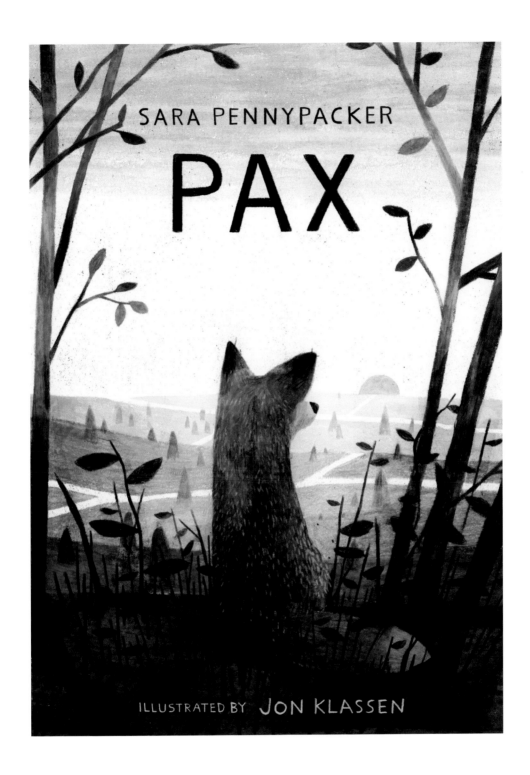

JON KLASSEN
Pax
Colored pencil and digital
The wraparound front and back cover illustration from the
chapter book, *Pax*, by Sarah Pennypacker.

JEANNIE LEE
Top Cop
Digital

This illustration poster is featured in the cover of *Locus zine #7*, themed "Upside Down." The objective is to promote a strong narrative of a cop turning upside down, bringing distorted justice. Sometimes, true justice can be chaotic when an elite police force is fighting the crime in their own way. As the "Top Cop," she will strike without cause, without mercy, to reveal the truth and keep the peace.

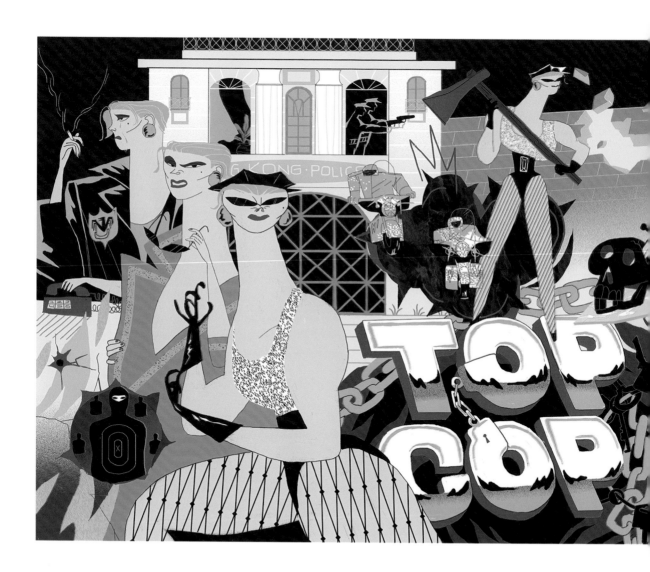

PATRICK LEGER
The Answers
Ink and digital

Mary, broke and suffering from an expensive medical condition, applies for the "Girlfriend Experiment," the brainchild of an eccentric and narcissistic actor, Kurt Sky, who is determined to find the perfect relationship—even if that means paying different women to fulfill distinctive roles.

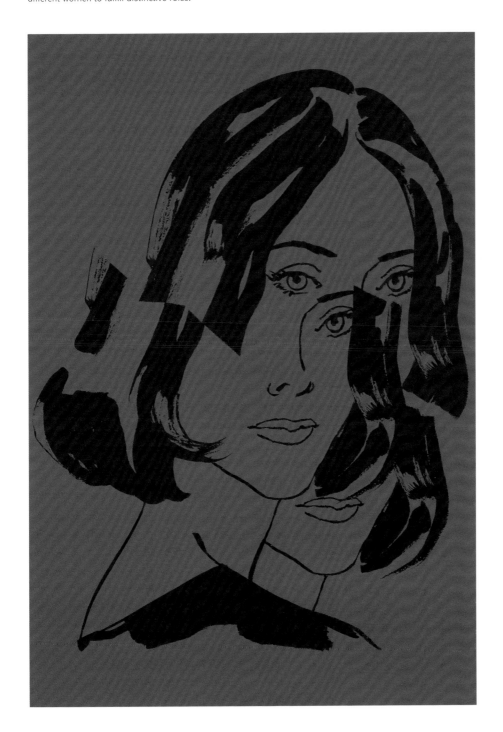

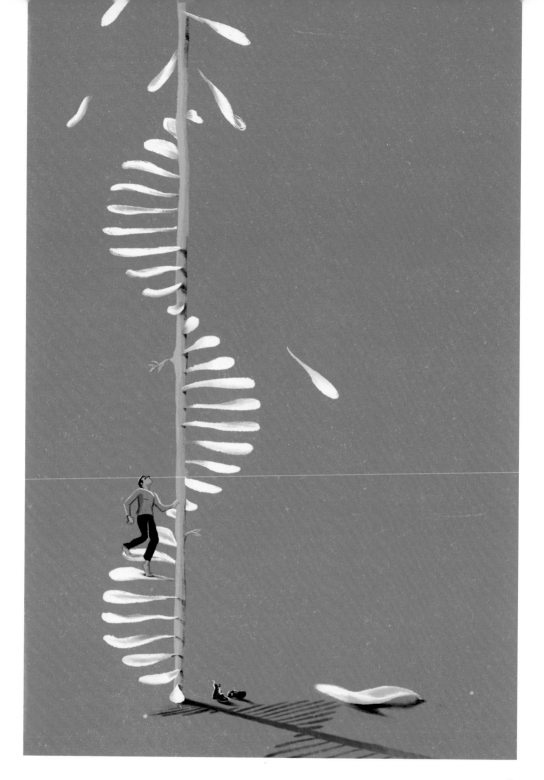

DANIEL LIEVANO
Stairs
Digital
Book cover for an anthology of poems written
by young emergent Colombian writers.

FACING PAGE

JEFFREY ALAN LOVE
Rumble
Acrylic on paper
Pinup for the trade paperback edition
of the comic book *RUMBLE*.

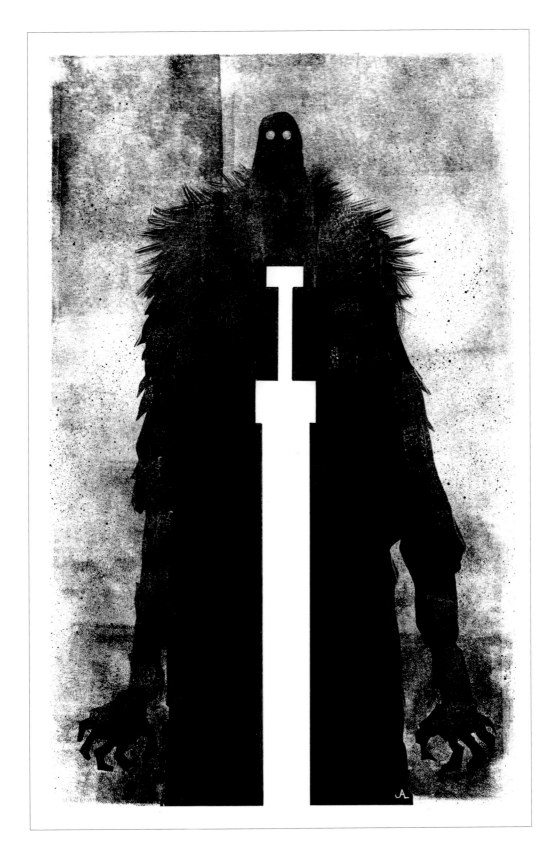

JEFFREY ALAN LOVE
Notes from the Shadowed City
Acrylic on paper
The travelogue/sketchbook of a young man who becomes stranded while researching lesser-known magical swords in a strange city. Written and illustrated by Jeffrey Alan Love.

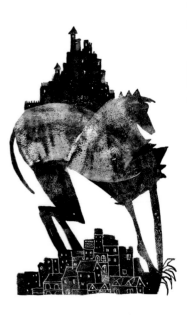

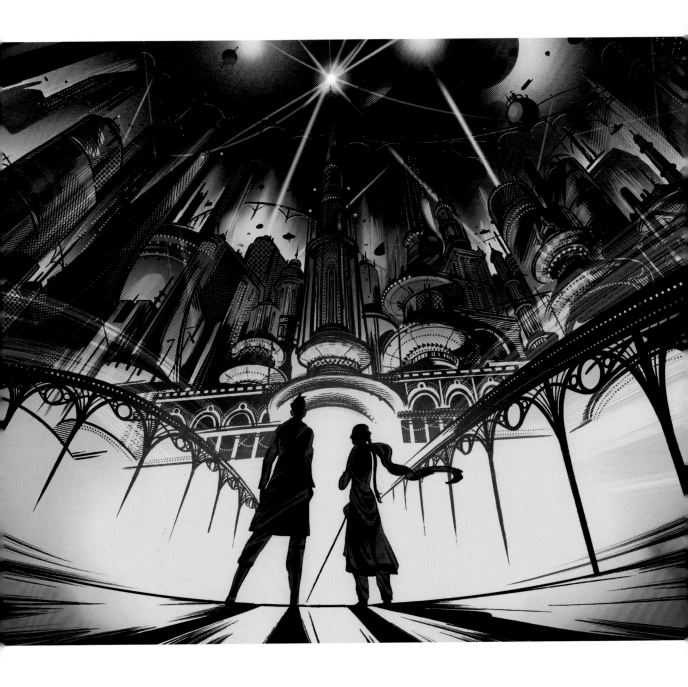

LOVELY CREATURES
New Delhi
Digital
Cover illustration for *Lightspeed* magazine's special issue:
"People of Color Destroy Science Fiction."

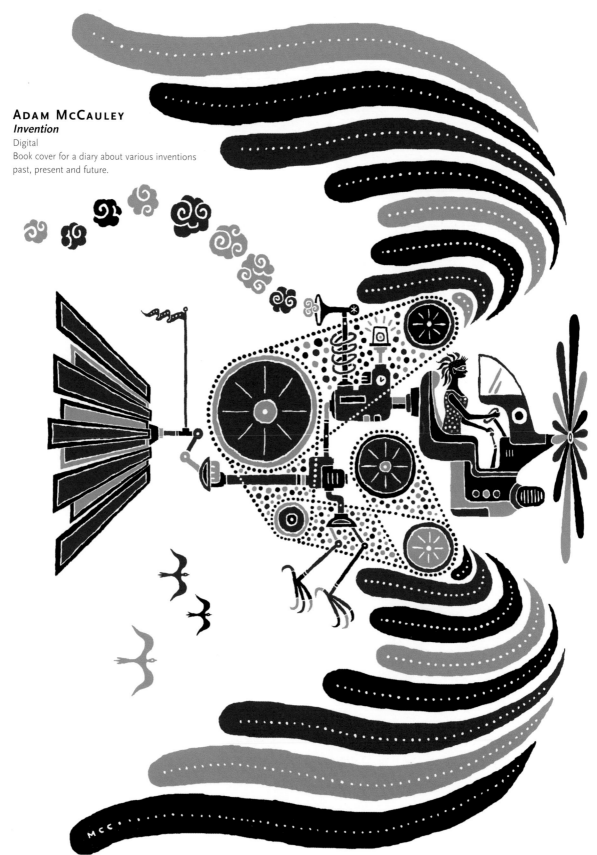

ADAM McCAULEY
Invention
Digital
Book cover for a diary about various inventions
past, present and future.

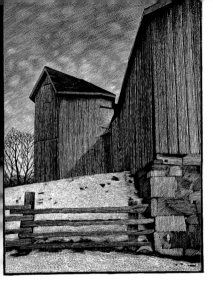

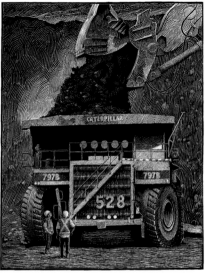

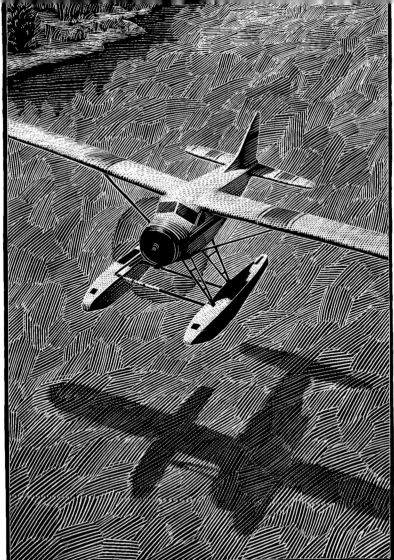

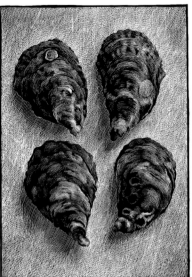

SCOTT MCKOWEN
A Number of Things *by Jane Urquhart*
Scratchboard
Illustrations for a series of objects that inspired stories of Canada, on the occasion of the sesquicentennial in July 2017.

ANDREA MONGIA
The Big Swim
Digital
Graphic design and illustration by the artist.

GONI MONTES
Tamiel, Angel of the Unseen
Digital

Under the surface of the world, an invisible force exerts itself upon us. Dull waves of its gravity pour across us without notice, without a trace. Even as it tosses us about, we do not see it. We are oblivious to its movement, even as it throws us to the ground.

KEITH NEGLEY
Listen

Mixed media, digital
Art for a short story about an evolved species of
humans whose language sounds like bird song,
and only a few people can interpret for them.

FACING PAGE

KEITH NEGLEY
Night Cyclist

Mixed media, digital
Cover art for a short
story about a cook who
bikes home from work
late at night and has
repeated run-ins with a
mysterious cyclist with
super natural powers
who kills and eats
people.

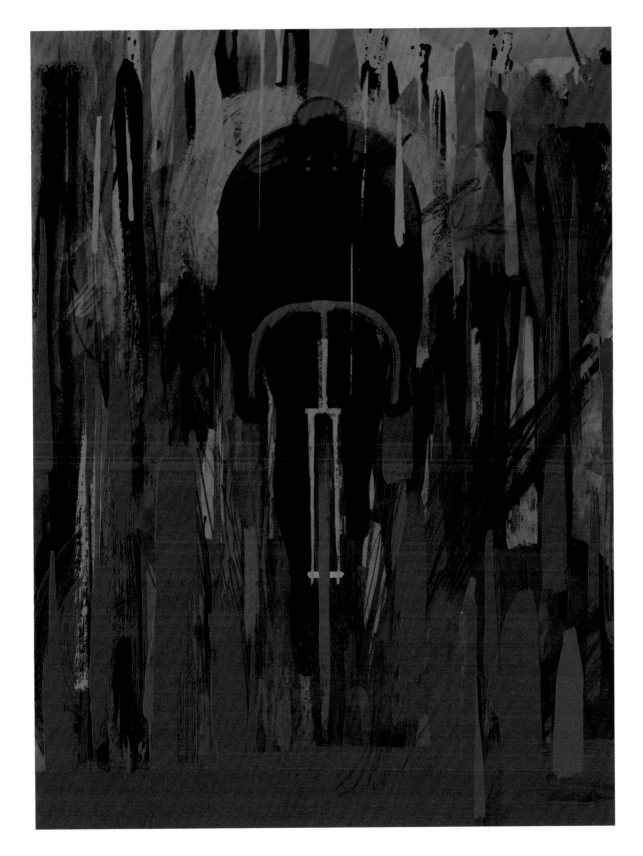

ROBERT NEUBECKER
King Louie's Shoes
Digital
Children's book about Louis XIV and how he invented platform shoes.

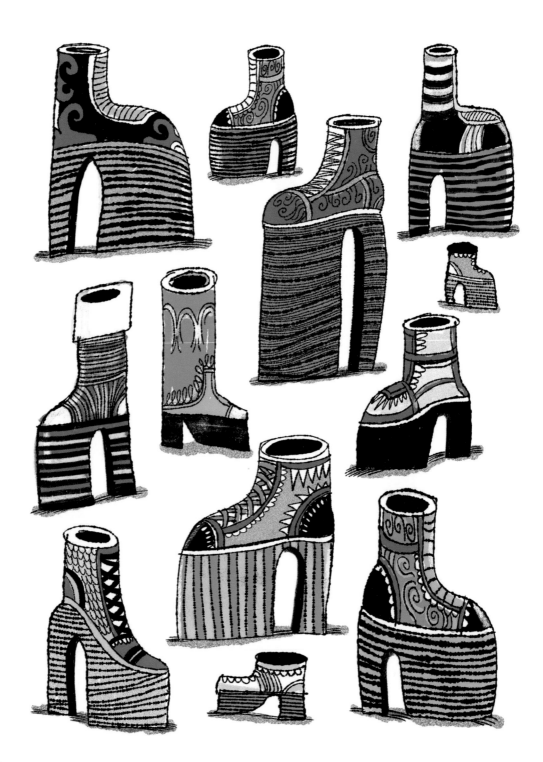

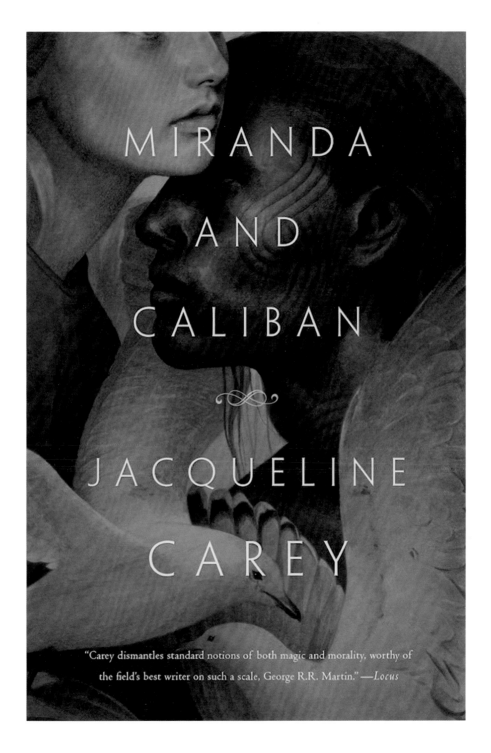

MIRANDA
AND
CALIBAN

JACQUELINE
CAREY

"Carey dismantles standard notions of both magic and morality, worthy of
the field's best writer on such a scale, George R.R. Martin." —*Locus*

TRAN NGUYEN
Miranda and Caliban
Acrylic and colored pencil
Cover illustration for Jacqueline Carey's new book based on *The Tempest*.

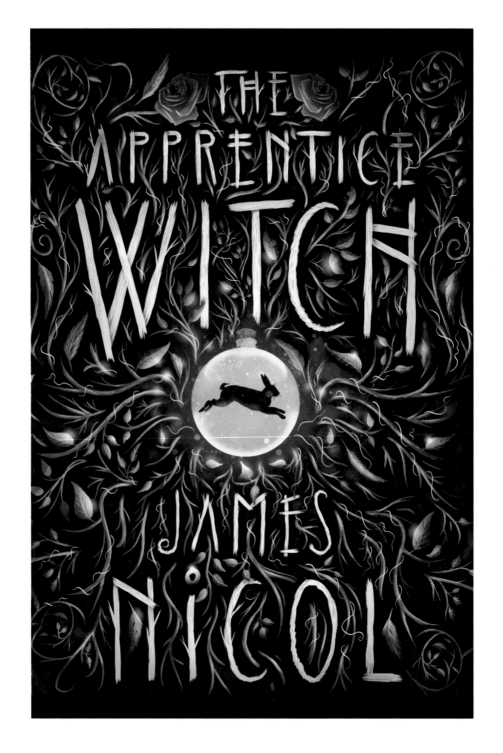

LEO NICKOLLS
The Apprentice Witch
Digital
Middle grade novel, jacketed hard cover.

ERIC NYQUIST
Pandora's Lab
Ink and digital
Seven stories of science gone wrong.

ERIC NYQUIST
Penguin Orange Collection

Ink and digital
7oth Anniversary
Limited Edition for
Penguin Classics.

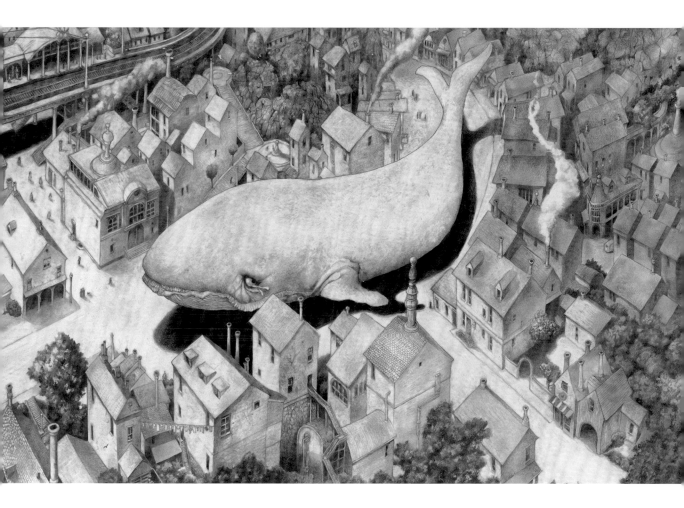

DAVID OUIMET
The Whale Who Lived on a Faraway Hill

Book illustration from *Daydreams for Night*. Thirteen very short stories from acclaimed musician John Southworth. Meet a boy with grey hair, who spends his days on a cargo ship peeling potatoes, a strange man who keeps a Ferris wheel in his backyard, and a whale that lives in a man-made lake on the top of a faraway hill. Intriguing and unusual black-and-white illustrations by David Ouimet bring the strange, bizarre characters to life.

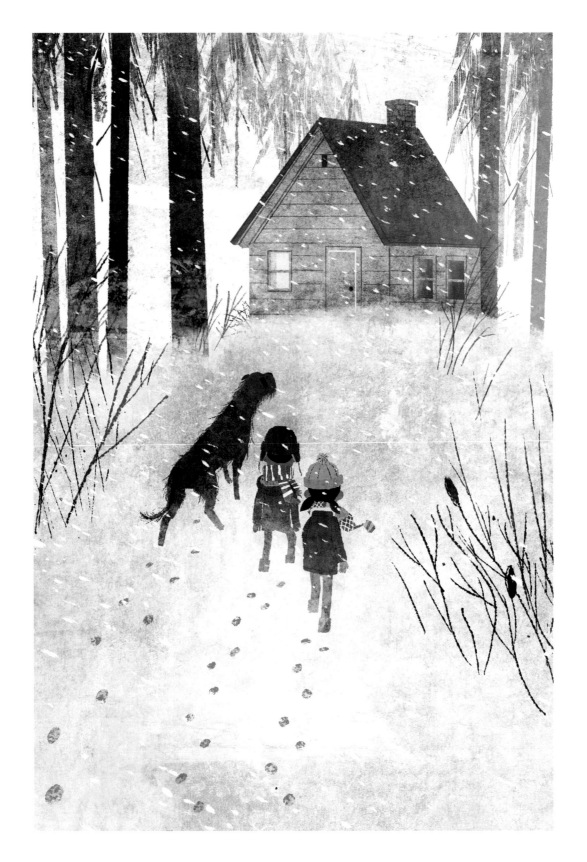

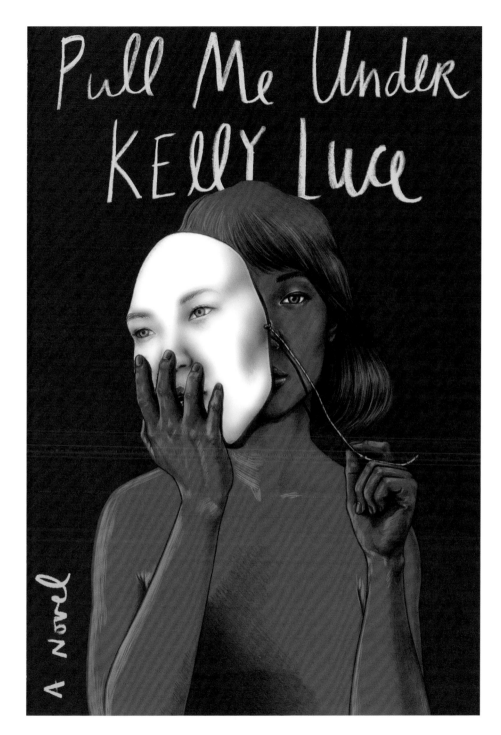

Cover illustration: *Pull Me Under*, Kelly Luce, "A Novel"

FACING PAGE

KENARD PAK
The Poet's Dog
Digital, watercolor, pencil
The cover illustration from the chapter book,
The Poet's Dog, by Patricia MacLachlan.

JUNE PARK
Pull Me Under
Mixed media
Cover for *Pull Me Under*, a novel by Kelly Luce.

SOCIETY OF ILLUSTRATORS **59**

BOOK **307**

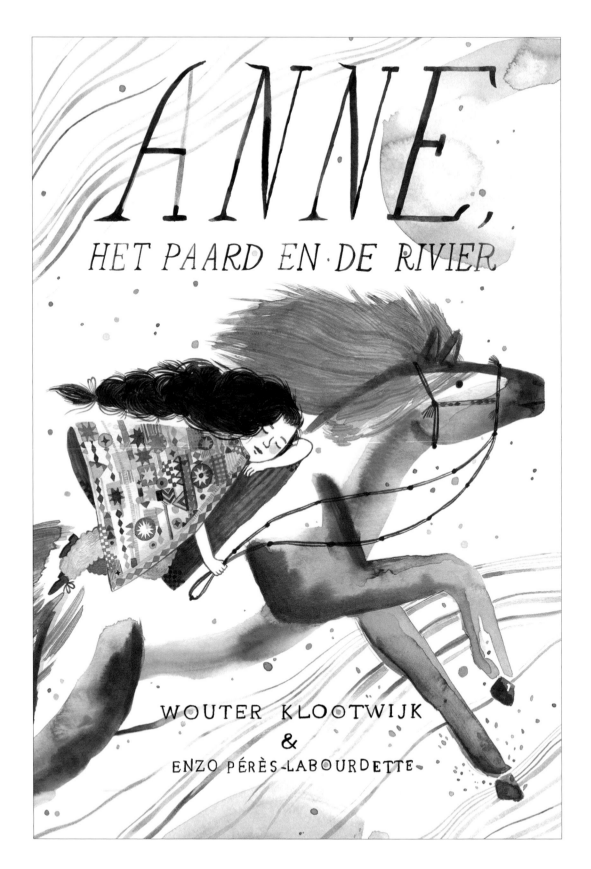

ANNE,
HET PAARD EN·DE RIVIER

WOUTER KLOOTWIJK
&
ENZO PÉRÈS-LABOURDETTE

ENZO PÉRÈS-LABOURDETTE
Anne Van Teun
Watercolor and digital
Cover illustration and hand lettering for a short children's novel.

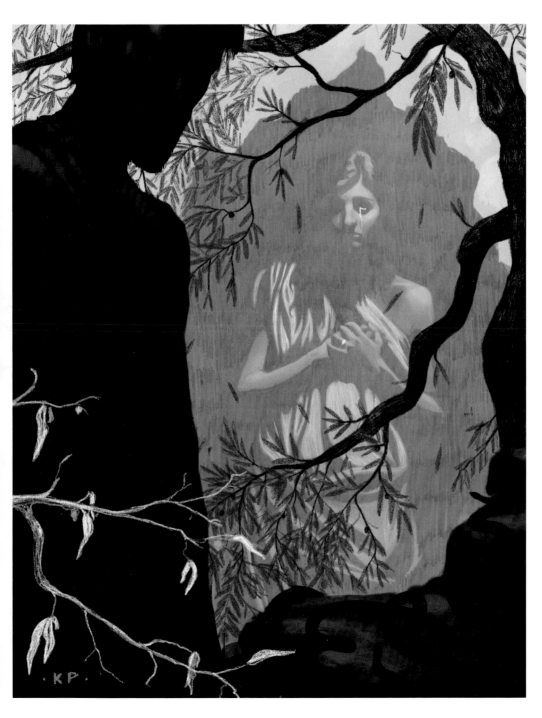

KEITH PFEIFFER
Calypso
Graphite, digital
Chapter illustration for an online novel. This chapter is the story of Odysseus leaving Calypso, as told through the eyes of Calypso.

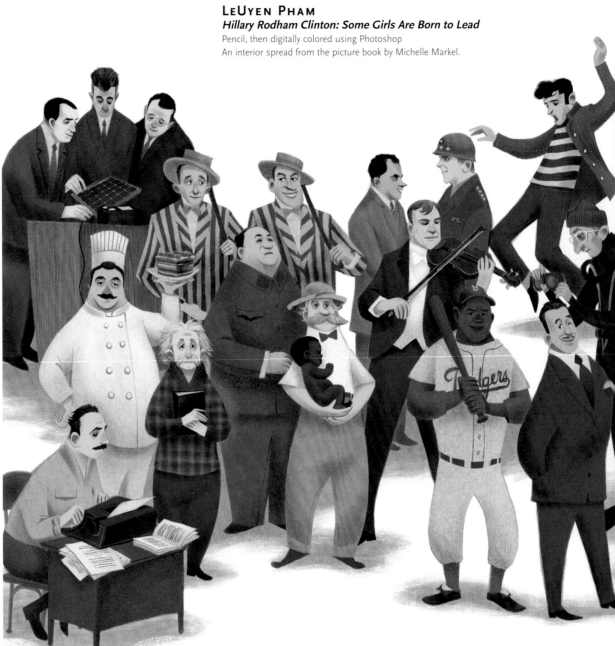

LeUyen Pham
Hillary Rodham Clinton: Some Girls Are Born to Lead
Pencil, then digitally colored using Photoshop
An interior spread from the picture book by Michelle Markel.

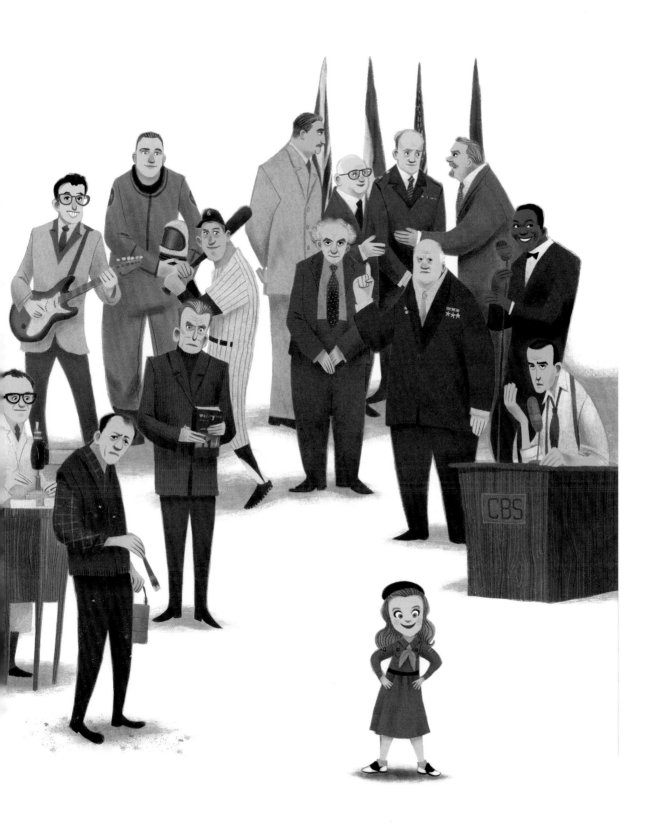

Narratori ◀ Feltrinelli

Marcela Serrano
Il giardino di Amelia

EMILIANO PONZI
Il Giardino di Amelia
Digital

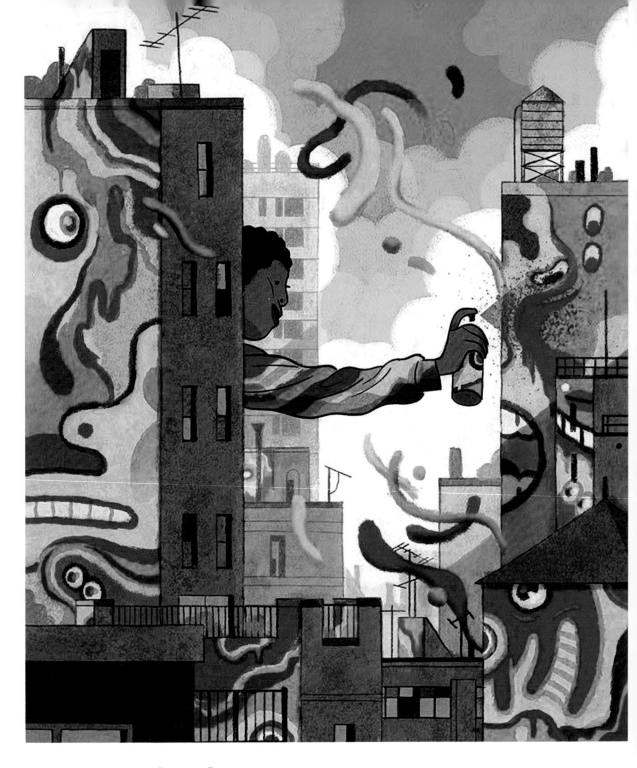

RICHIE POPE
The City Born Great
Digital
Cover for N.K. Jemisin's story, *The City Born Great.* The synopsis reads, "New York City is about to go through a few changes. Like all great metropolises before it, when a city gets big enough, old enough, it must be born; but there are ancient enemies who cannot tolerate new life. Thus New York will live or die by the efforts of a reluctant midwife . . . and how well he can learn to sing the city's mighty song."

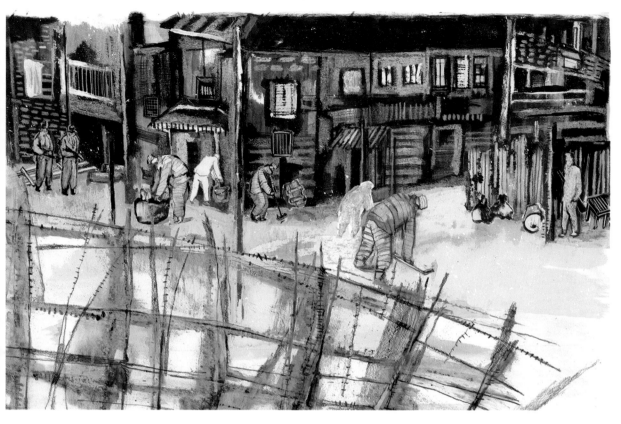

HADAR REUVEN
House of the Dead
Mixed media
Inspired by Dostoevsky's novel, *House of the Dead*.

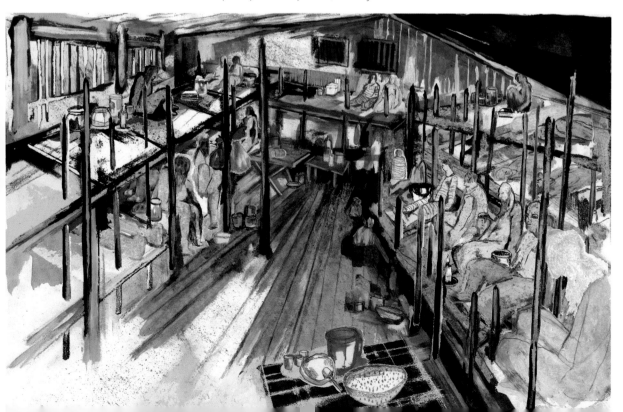

EDEL RODRIGUEZ
The Year 200
Mixed media
Cover of a Cuban scienc fiction book.

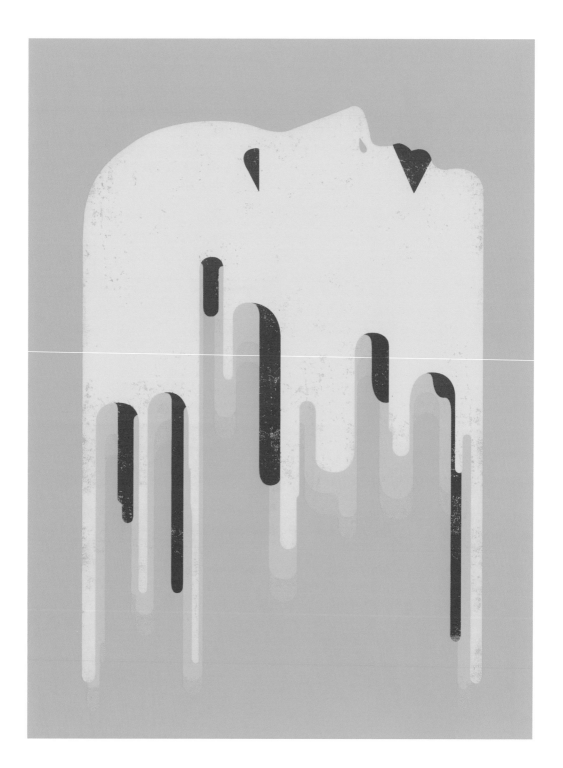

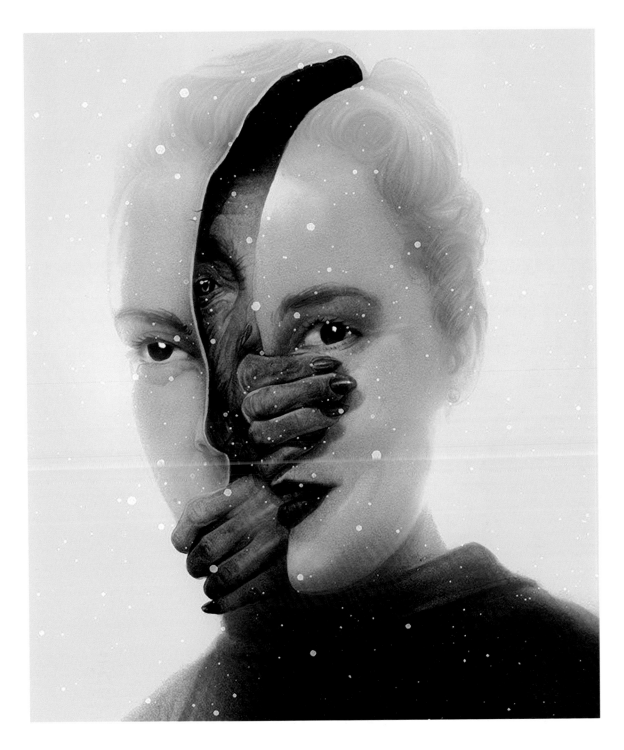

GREG RUTH
The Caretakers
Pencil, mixed media
The Caretakers by David Nickle is a strange tale about a group of people
called to a meeting with their intimidating boss. The newest member
of their organization is not so sure she wants to even be there.

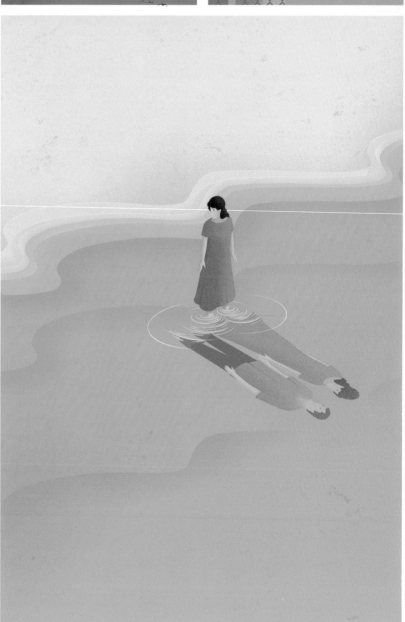

STEPHAN SCHMITZ
22 Things a Woman Must Know If She Loves a Man with Asperger's Syndrome
Acrylic, Photoshop
Illustrations for the German version of the book by Rudy Simone. I was asked to show the couple or the male in different situations where it becomes clear that they live together but somehow in different worlds.

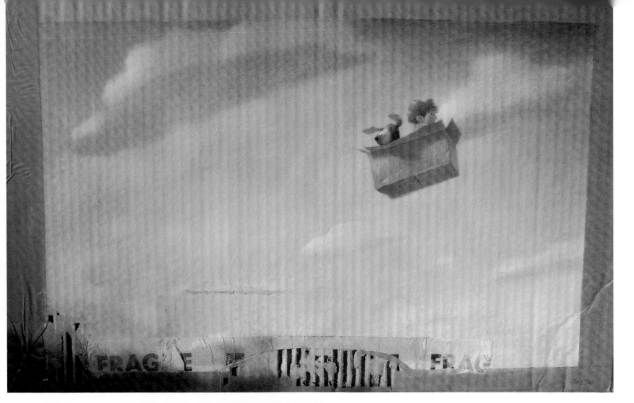

CHRIS SHEBAN
What To Do With a Box
Watercolor, gouache and color pencil on cardboard
A children's book about the joys of playing with a simple cardboard box.

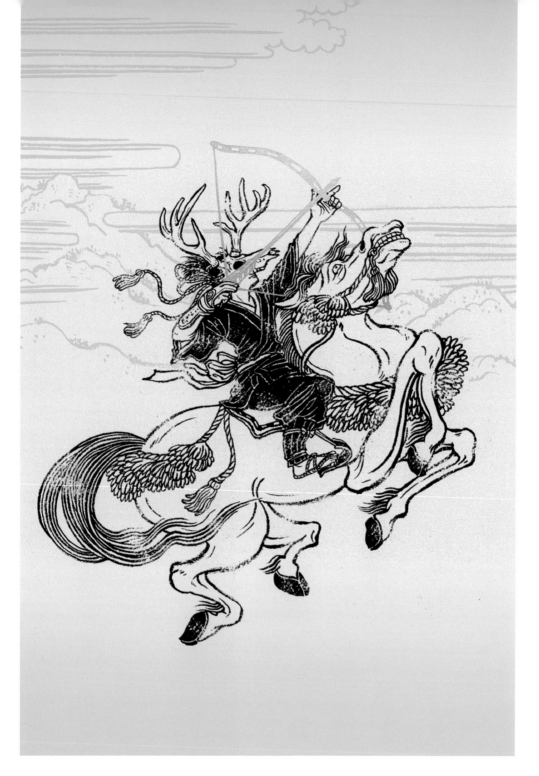

YUKO SHIMIZU
Tale of Shikanoko Series
Ink and digital
One of four book covers for a historic fantasy novel series
that takes place in an imaginary kingdom in Japan.

FACING PAGE

YUKO SHIMIZU
A Crack in the Sea
Ink drawing
One of ten interior illustrations for a young
adult fiction book depicting slavery.

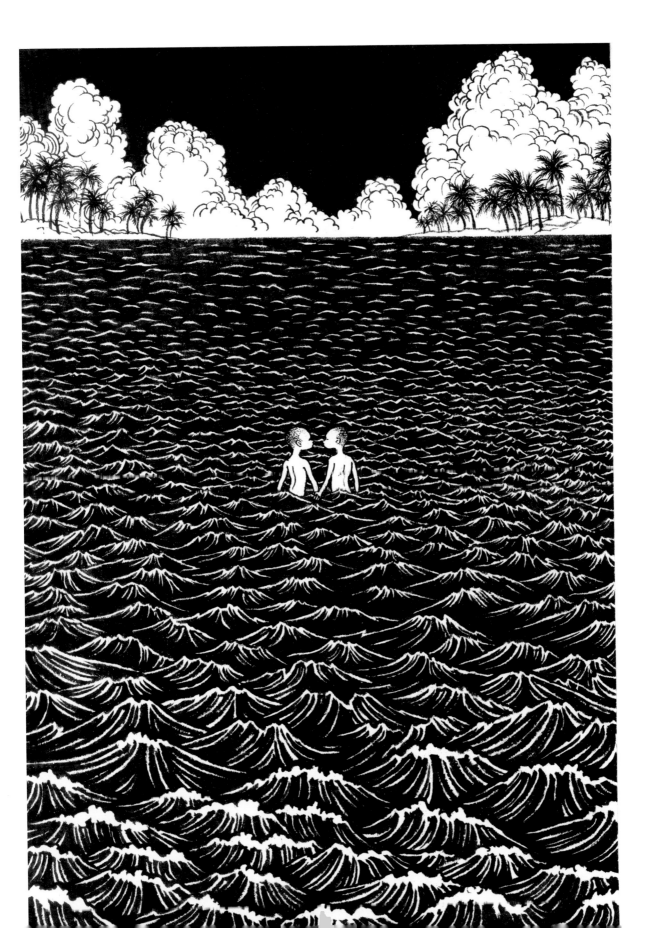

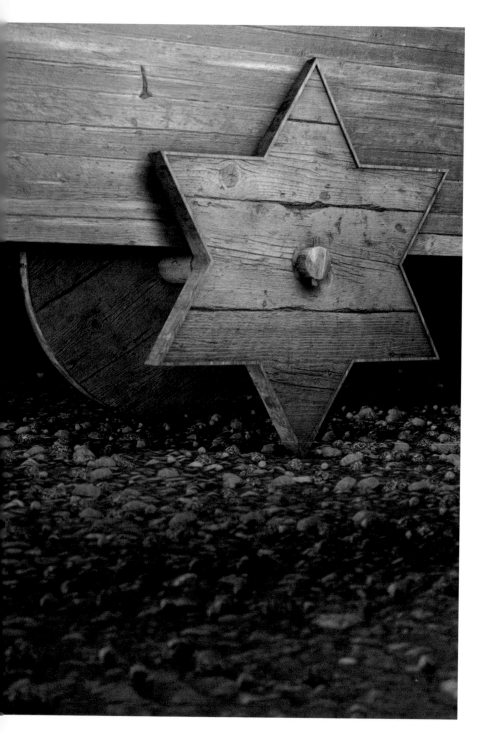

MAREK SKUPINSKI
*Swedish Refugee Policymaking in Transiti
Czechoslovaks and Polish Jews in Sweder
1968–1972*
Digital (3D, Photoshop)
The book considers the fate of Czechoslovak and
Polish-Jewish refugees fleeing their native countries
as a result of the Prague Spring, the Warsaw Pact
invasion of Czechoslovakia, and the anti-Semitic
campaigns in Poland during the period of the late
1960s and early 1970s. It examines the process fror
the decision to admit the refugees, to their receptio
and economic integration into Swedish society.

FACING PAGE

MARK SMITH
The Green Mile: Mouse on the Mile
Ink and digital
Cover image for the serialized version of
Steven King's *The Green Mile*. This cover was for
the episode titled *The Mouse on the Mile*.

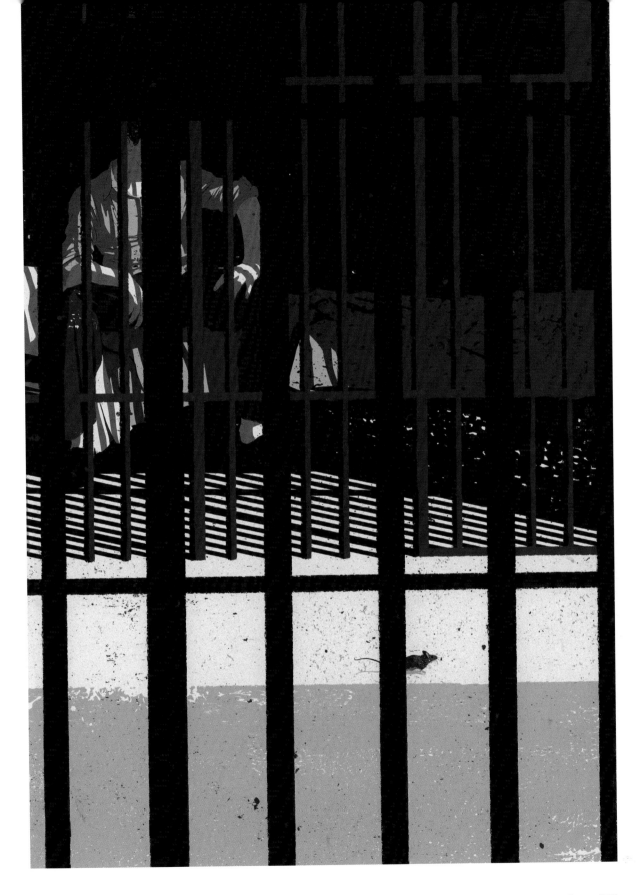

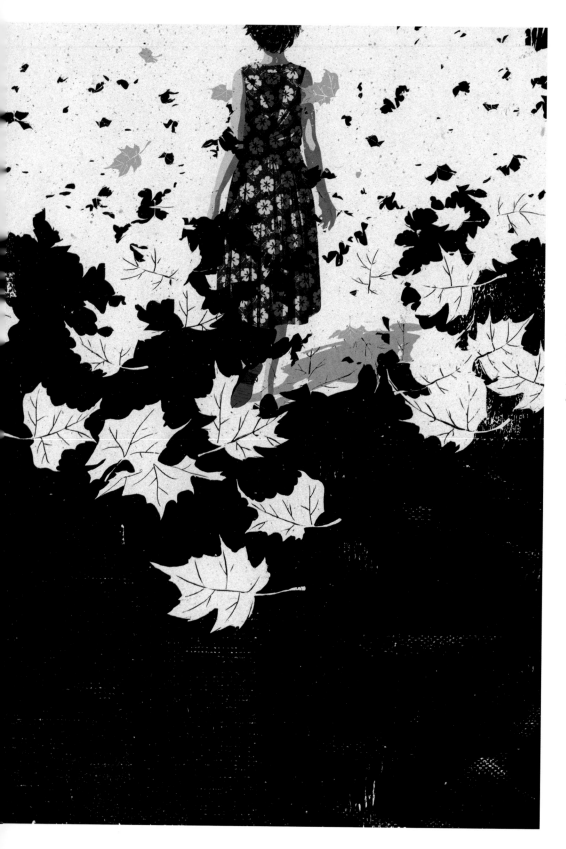

MARK SMITH
The Weight of the Dead
Ink and digital
Cover for a post-apocalyptic
tale about a young girl
coming of age in a world of ev

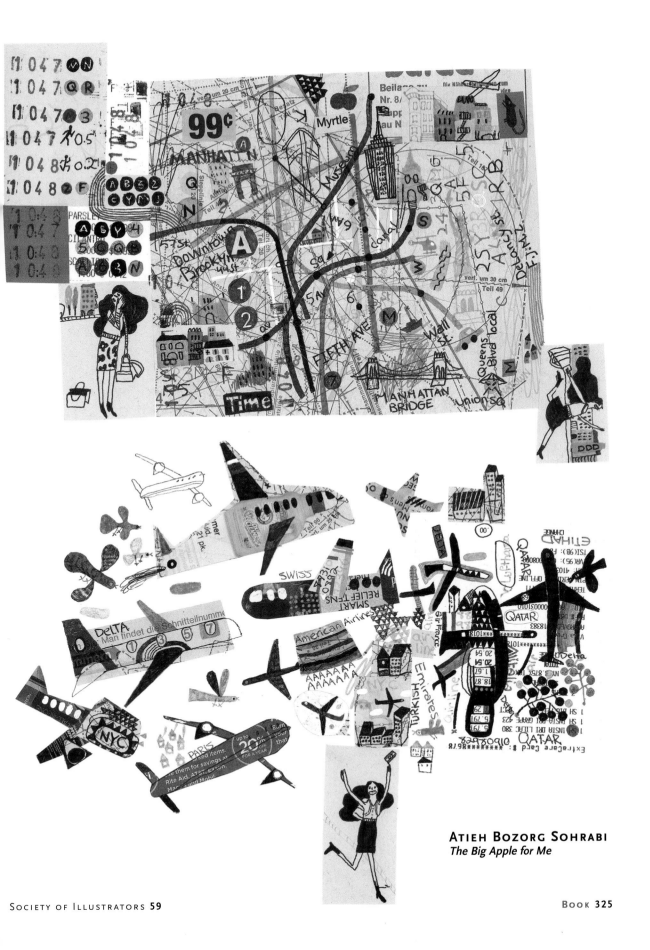

ATIEH BOZORG SOHRABI
The Big Apple for Me

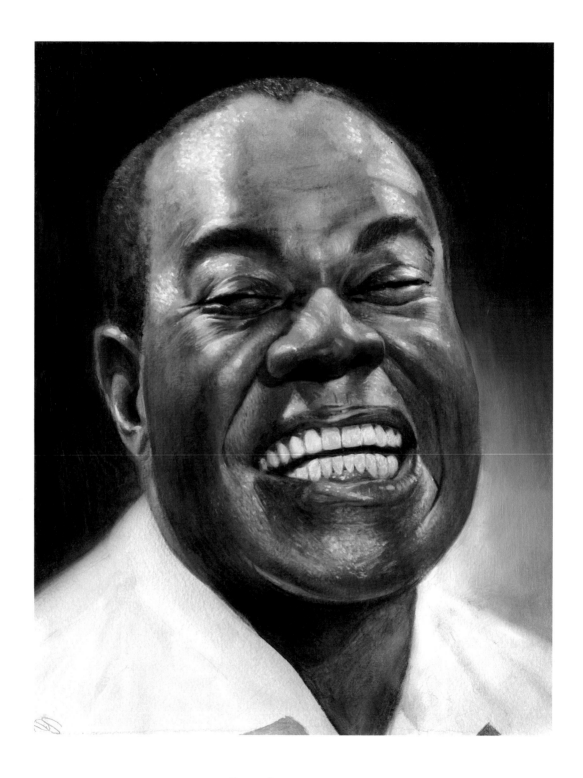

DALE STEPHANOS
Born on the Fourth of July
Oil on panel
Portrait of Louis Armstrong.

ELLEN SURREY
Freedom to Dance
Gouache
In response to the Nelson Mandela quote, "For to be free is not merely to cast off one's chains, but to live in a way that respects and enhances the freedom of others."

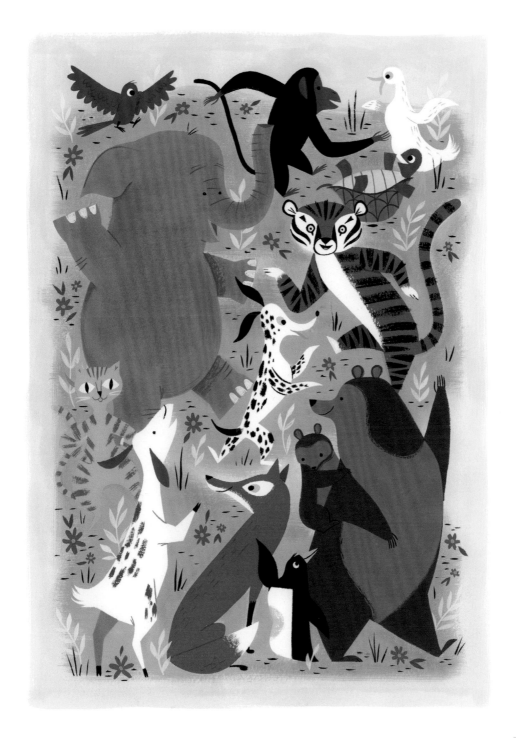

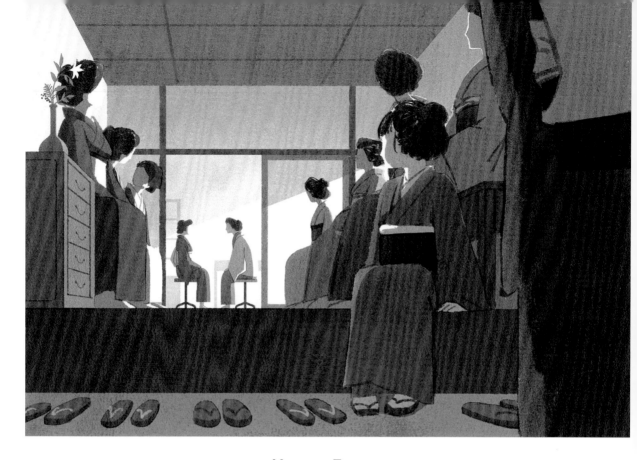

MIHOKO TAKATA
Ginko Ogino
Photoshop
Illustrations for the biography about Ginko Ogino,
the first female doctor in Japan.

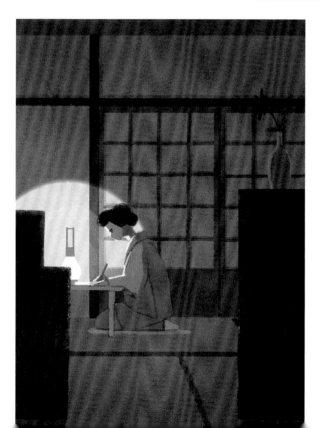

MIGUEL TANCO
You and Me, Me and You
Ink

The wonder of being a dad is on display in this touching tribute to fathers. After all, the connection between a father and child yields a lifetime of learning and love. In *You and Me, Me and You*, that special bond is honored through poignant, tenderly rendered illustrated vignettes: a father and son walk together, discuss life; amid a city's bustle; play; and, perhaps most profoundly, grow, side by side.

SAM WEBER
Norse Mythology
Digital
Cover for Neil Gaiman's *Norse Mythology*.

ELLEN WEINSTEIN
Yayoi Kusama's Obliteration Room
Gouache, collage
Young artist, Yayoi Kusama, starts to connect the dots.
For a children's book about Yayoi Kusama.

ELLEN WEINSTEIN
Augustus Caesar's Fear of the Dark
Gouache, collage
Roman emperor Augustus Caesar had a fear of the dark.
For a book about superstitions and rituals.

ELLEN WEINSTEIN
Mary Shelley's Frankensnake
Gouache, collage
Mary Shelley, author of *Frankenstein*, would write
with her pet boa constrictor wrapped around her.
For a book about superstitions and rituals.

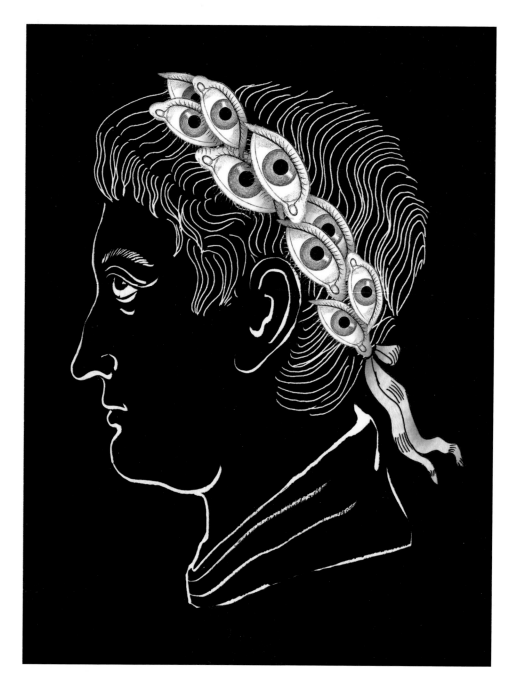

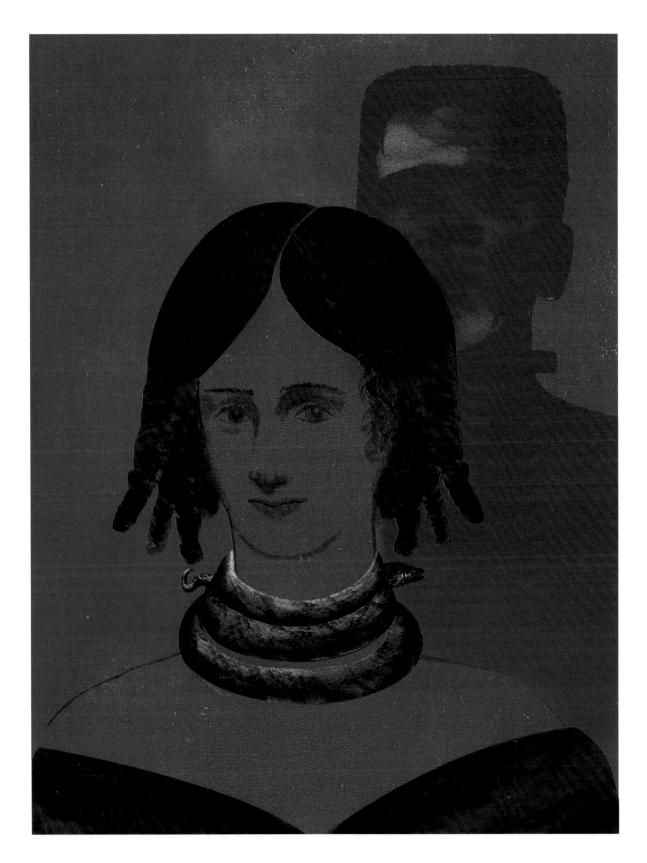

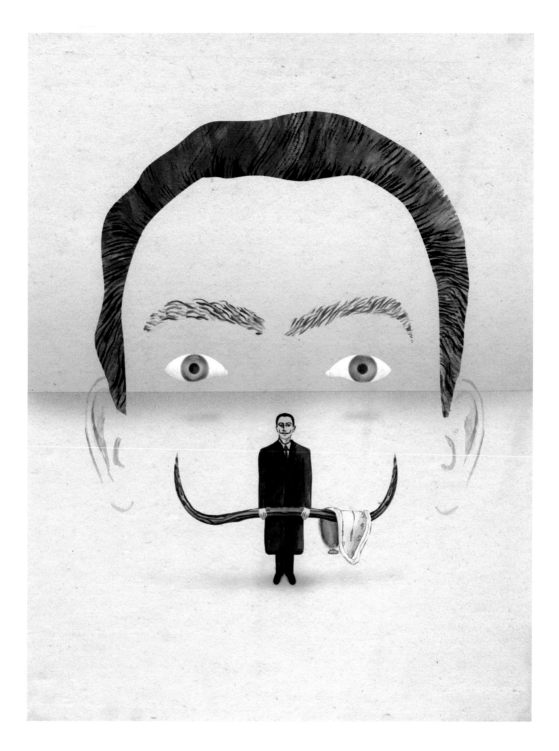

ELLEN WEINSTEIN
Dali's Driftwood
Gouache, collage
Surrealist painter Salvador Dali would carry a piece of driftwood to ward off evil spirits.
For a book about superstitions and rituals.

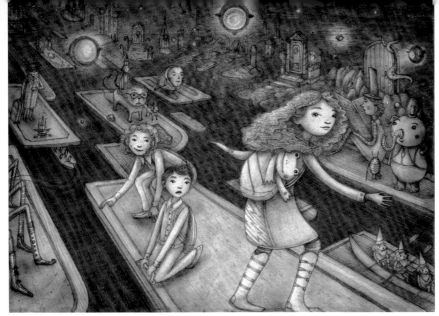

JAIME ZOLLARS
Enter a Glossy Web
Graphite, ink, and digital color
Illustrations for the quirky
middle-grade fantasy adventure novel,
Enter A Glossy Web, by McKenna Ruebush

UNCOMMISSIONED

SOOJIN BUZELLI
SENIOR VICE PRESIDENT, CREATIVE DIRECTOR, STRATEGIC INSIGHT

SooJin has been art directing and designing financial publications and industry events since 1996. She has been recognized for her art direction for *PLANSPONSOR, PLANADVISER* and *Chief Investment Officer* magazines. SooJin has a BFA from Rhode Island School of Design. She is very active in the illustration community: served as a board member to Illustration Conference and judged many illustration competitions, including *American Illustration* and the Society of Illustrators. SooJin was also awarded the Society's prestigious Richard Gangle Art Director Award. She lives in the East Village with her illustrator husband Chris and their dog Sota.

JIM DATZ
ART DIRECTOR,
THE NEW YORK TIMES OP-ED

Jim Datz is the art director for *The New York Times Op-Ed* page.He studied architecture and design theory at the University of Pennsylvania before embarking on a varied career in the applied arts. As the art director for Urban Outfitters' web and catalog division, he helped guide the brand through the launch of two media channels. His independent studio in Brooklyn's Pencil Factory specializes in illustration, design and branding projects for clients such as Alexa Chung, J.Crew, Ace Hotel, Sub Pop records and Google. In 2014, he illustrated two picture books for Abrams Appleseed. His screenprints and food maps are sold in small shops around the world. His work has been recognized by the Type Directors Club, *IdN Magazine* and featured in numerous publications.

HENRIK DRESCHER
VISUAL ARTIST

I was born in Denmark. I was 12 when my family moved to the US. After one semester in art school I opted for travel instead. While traveling I kept notebooks which served as my illustration portfolios. In 2014 I returned to New York after a 20 year absence spent living in Indonesia, New Zealand and, most recently, in China's Yunnan province, where I lived for 12 years. I've worked for a bunch of fancy-pants magazines and published lots of books, most of them for kids but also some for grown-up kids.

LEAH GOREN
ILLUSTRATOR

Leah Goren is an illustrator and surface pattern designer living in Brooklyn, NY. She graduated from Parsons School of Design in 2012 with a BFA in Illustration. Her clients include Anthropologie, Ban.do, Chronicle Books, The Land of Nod, Loeffler Randall, Penguin Random House, *Lenny Letter* and Revlon. She is the author of *BESTIES*, and co-author of *Ladies Drawing Night*.

HANNAH K. LEE
ILLUSTRATOR

Hannah K. Lee was born to Korean immigrants and raised in the suburbs of Los Angeles, CA. She received a BFA in illustration at Parsons School of Design. Now in Brooklyn, NY, she works as a commercial illustrator, letterer and designer. She is a regular self-publisher of zines and art books, which contain personal work and experiments in letterforms and production, and have been included in the collections of the libraries of the MoMA, SF MoMA and the Brooklyn Museum. Her work has been recognized by the Society of Illustrators, American Illustration and the Type Directors Club.

AVIVA MICHAELOV
DESIGN DIRECTOR, THE NEW YORKER

Aviva Michaelov is design director of *The New Yorker*. Through 2016, she was the art director of the Opinion pages at *The New York Times*, leading the design of the *Sunday Review* section. Her work has been recognized by the Society of News Design, Society of Publication Design and the Society of Illustrators.

LEANNE SHAPTON
ILLUSTRATOR/WRITER

Leanne Shapton is an author, illustrator, artist and publisher based in New York City. She is the co-founder, with photographer Jason Fulford, of J&L Books, an internationally-distributed, not-for-profit imprint specializing in art and photography books. She was an art director at *The New York Times Op-Ed* page and is a contributor to *The New York Times Magazine* and *T, The New York Times Style Magazine*. Shapton's *Swimming Studies* won the 2012 National Book Critic's Circle Award for autobiography, and was long-listed for the William Hill Sports Book of the Year 2012. Shapton grew up in Mississauga, Ontario, Canada.

KEITH A. WEBB
ART DIRECTOR, THE WALL STREET JOURNAL

Keith Webb, currently an award-winning senior art director for the weekly *Review* section of *The Wall Street Journal*, is a native Kansan. He began his career as part of an experimental ideas project focused on rethinking newspaper design for the Knight-Ridder company in South Florida. He then brought those insights to news publications such as *The Detroit Free Press* and *The Boston Globe*, where he won several awards from the Society of News Design for features design. Mr. Webb then shifted to designing for magazines as Deputy Art Director for *Inc.* magazine, and *Fast Company*. He then redesigned and oversaw design of *Philadelphia* magazine. Webb then founded Keith Webb Design consulting on projects ranging from publishing, branding, marketing and animation.

GHAZAAL VOJDANI
GRAPHIC DESIGNER, ART DIRCTOR

Ghazaal Vojdani is an independent graphic designer and art director from London, UK. She graduated from the BA Graphic Design course at Central Saint Martins College of Art and Design in 2010, and received her MFA in Graphic Design at Yale University School of Art in 2013. She has been working independently since, mainly with cultural institutions, independent galleries and artists. She has been adjunct professor at Rutgers University in NJ, and Fordham University in NY. Ghazaal is also freelance art director for the *Editorial* and *Op-Ed* pages at *The New York Times*. She currently lives and works in New York.

Portraits
Mixed media
Indiana Jones, Gene Wilder, Magnum,
Woody Allen, Rambo.

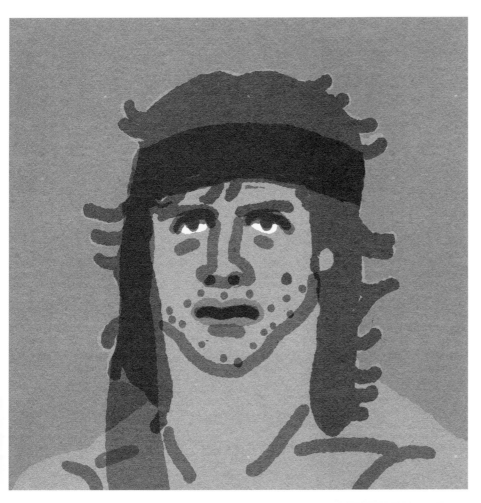

GOLD MEDAL WINNER
NANCY LIANG

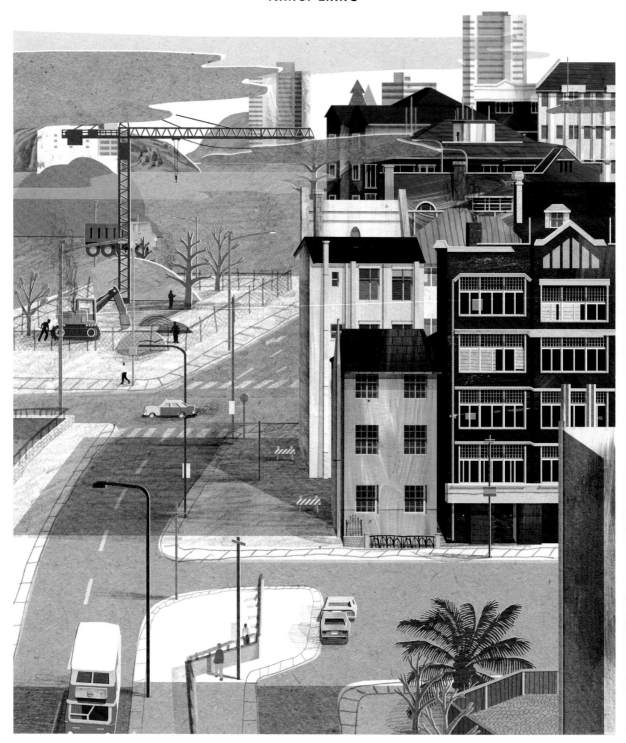

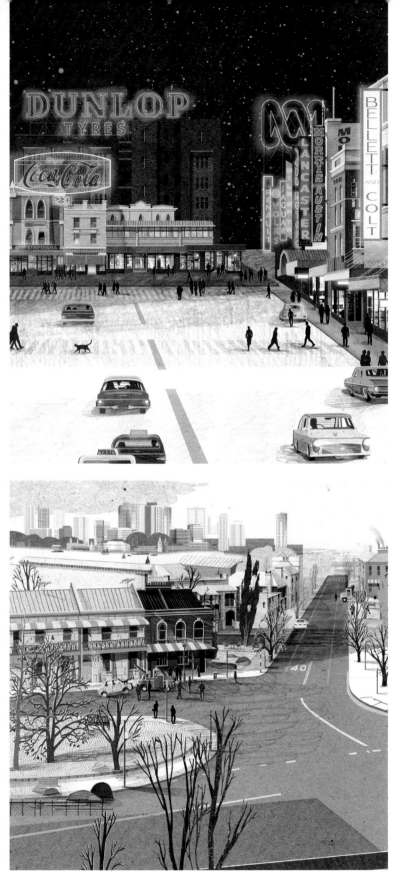

Old Spaces

Collage, mixed media

Old Spaces is an ongoing GIF project that visually documents spaces in Sydney, Australia, during the 1960s–1990s. The aim of the project is to unearth local history and re-animate the forgotten stories attached to these urban sites as moving images. Some stories include the iconic neon advertising signs on William Street in the 1960s and the construction of Kings Cross Tunnel, the first major tunnel in Sydney.

Pangs
2-D Animation
Wading through bodily
and emotional pangs.

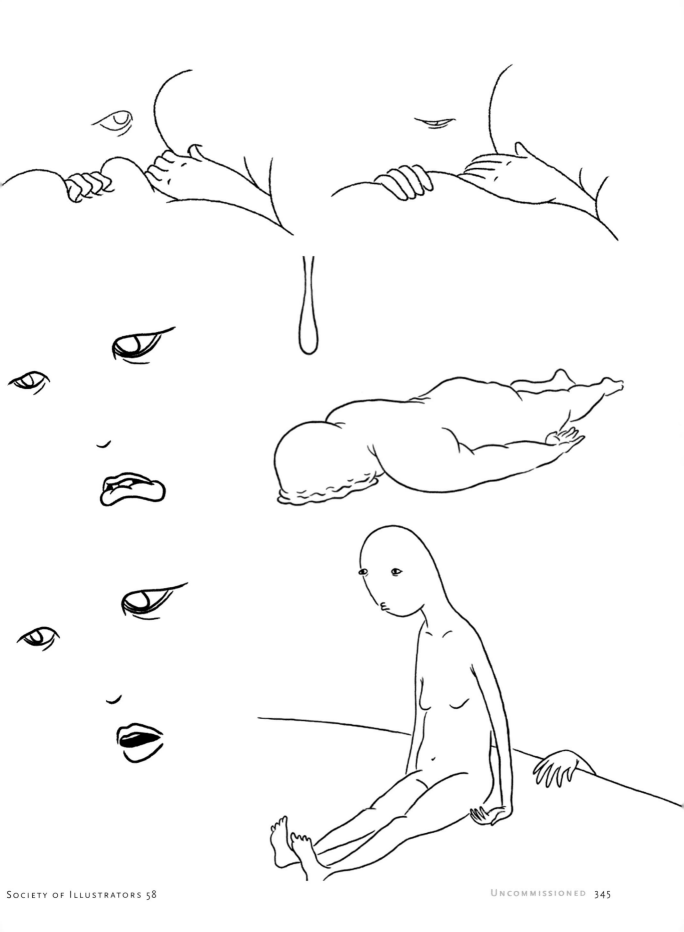

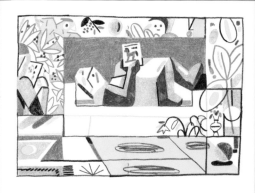

Small Notes
Risograph
A zine published b[...]
TXTBooks on the
occasion of the
2016 New York
Art Book Fair.

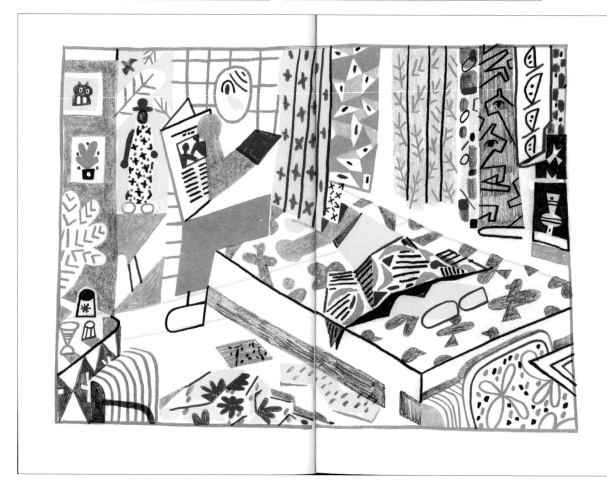

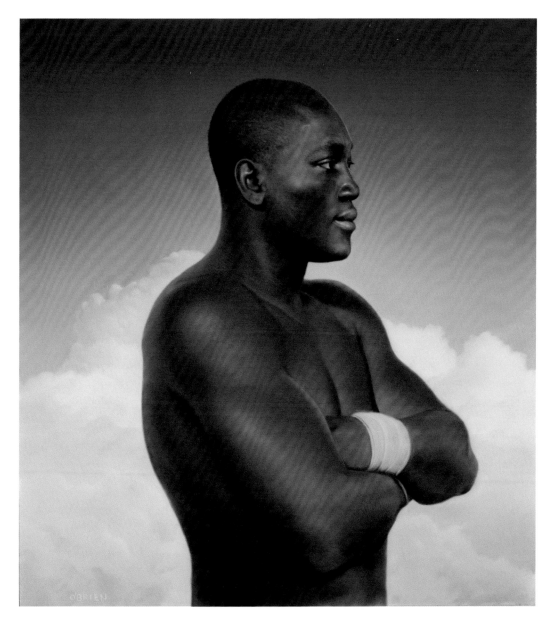

Jack Johnson
Oil on board
My portrait was created to raise awareness of Jack Johnson
and my effort to gain him a presidential pardon.

DANIEL ZENDER

Hyakki Yagyo Series

Digital
Part of a series of demons based on the Hyakki Yagyo or the
Hundred Demon Night Parade in Japanese mythology.

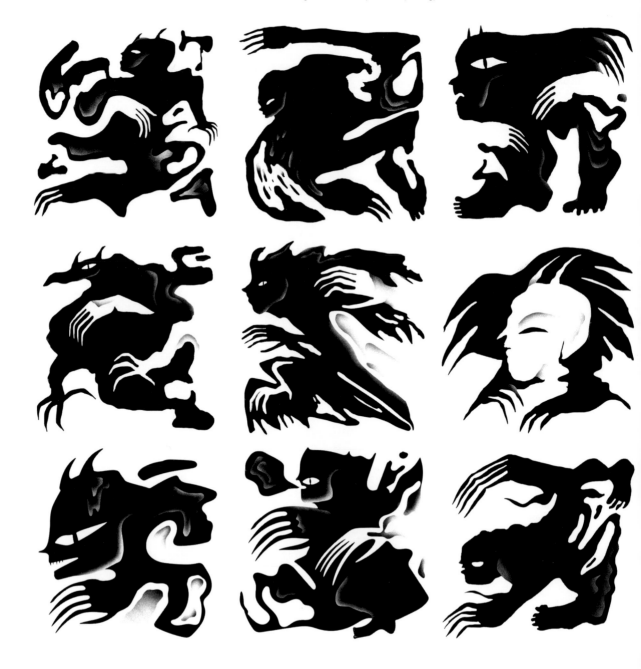

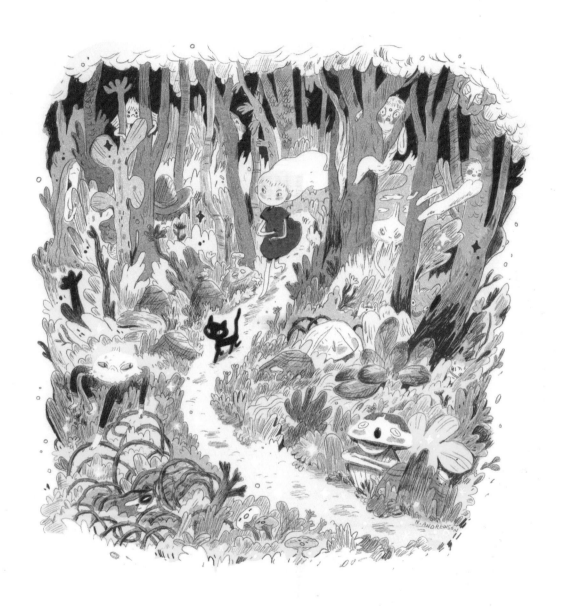

NATALIE ANDREWSON
MamuAnna
Three colored Risograph

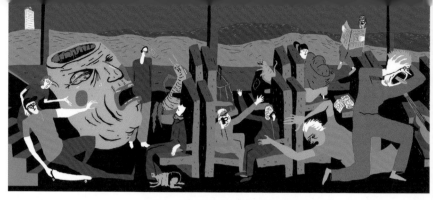

IDO BACK
Playground
Mixed media: digital illustrations, print,
illustrations on wood and plaster
Illustrated exhibition about
Israeli daily life.

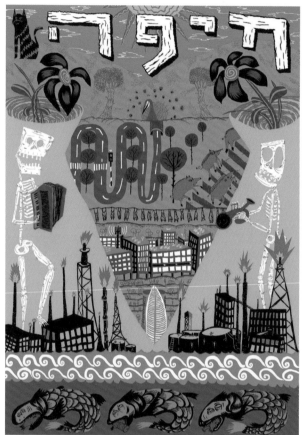

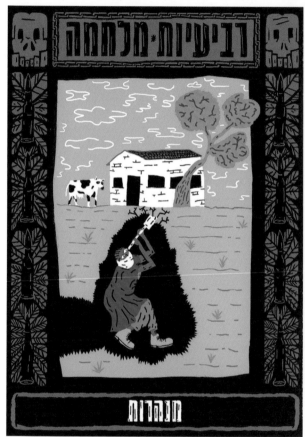

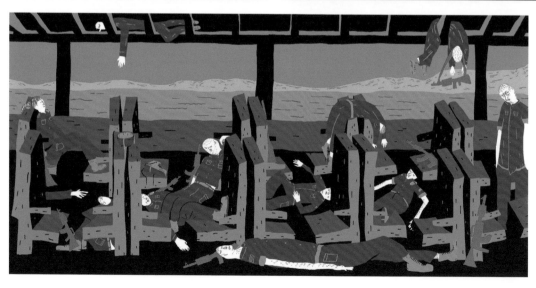

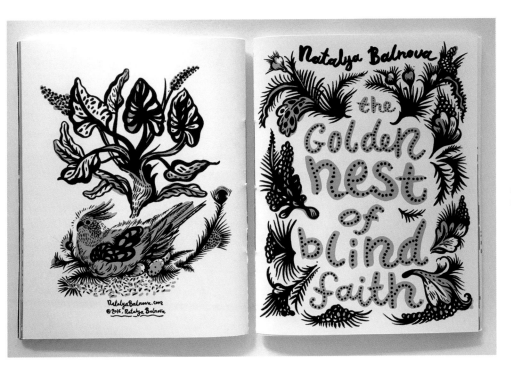

NATALYA BALNOVA
The Golden Nest of Blind Faith
Silkscreen

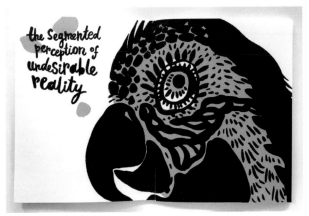

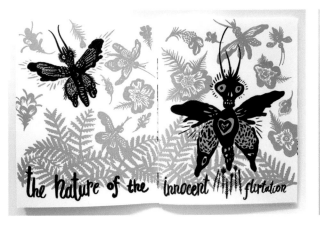

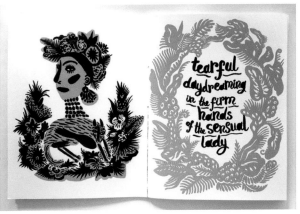

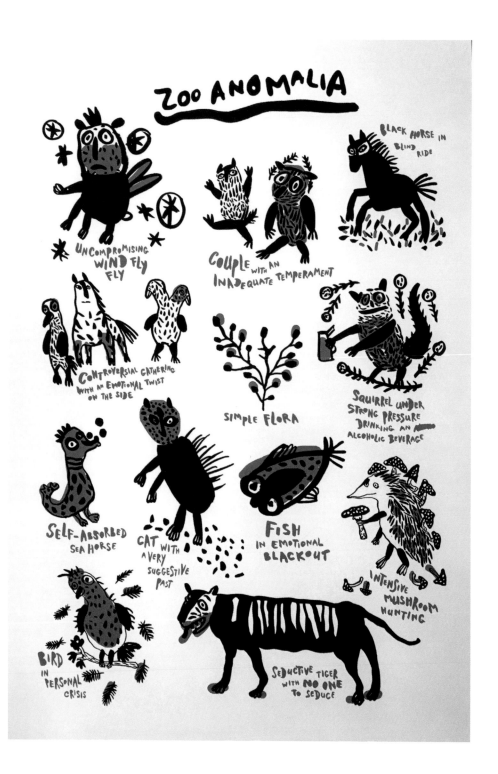

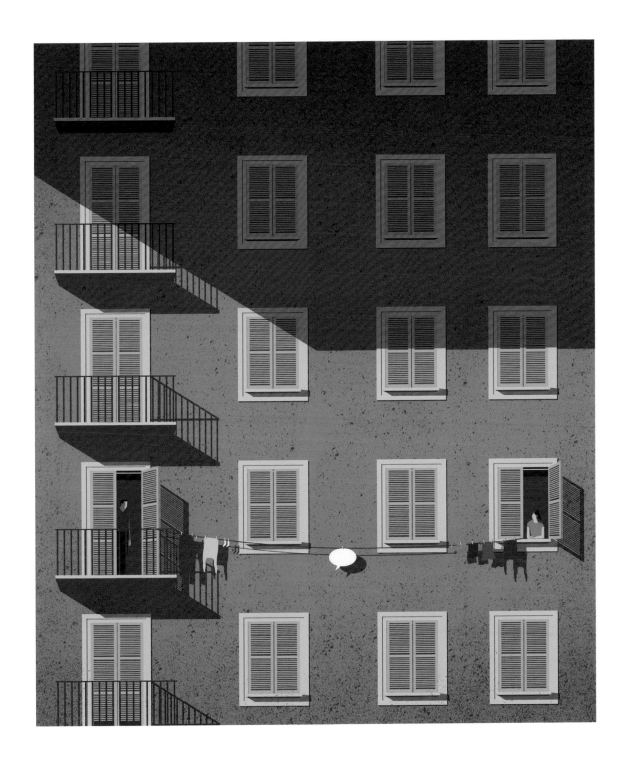

DAVIDE BONAZZI
Shyness
Digital
Image for an exhibition.

DAVIDE BONAZZI
Day Trippers
Digital
A personal project with an old couple on vacation as main subject.

ROVINA CAI
In Search of Flowers
Pencil and digital
Inspired by 19th century botanical artist Marianne North,
who travelled the world to paint rare flowers.

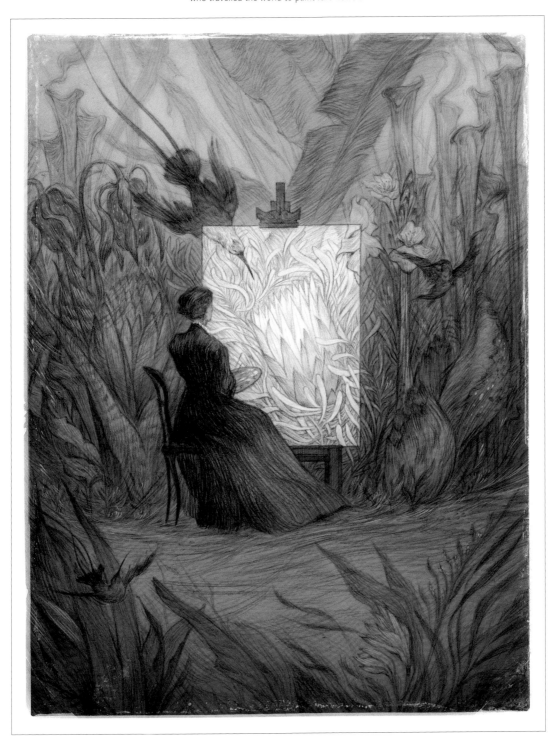

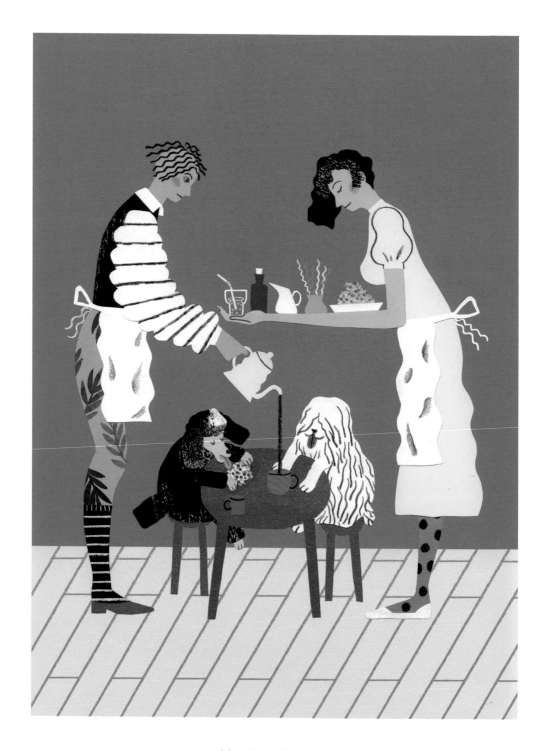

HYE JIN CHUNG
Cafe
Digital

I live with neighbors who are willing to devote their time and love to their dogs.
Their dedication led me to create this image and to hope that a
"dogs only" cafe would open soon in my neighborhood.

HYE JIN CHUNG
Female Bodybuilders
Digital

People who have their own fashion style inspire me
and give me motivation to draw. Recently,
I was inspired by female bodybuilders' body shapes,
poses and their faces, whose features/elements
also make their own unique styles.

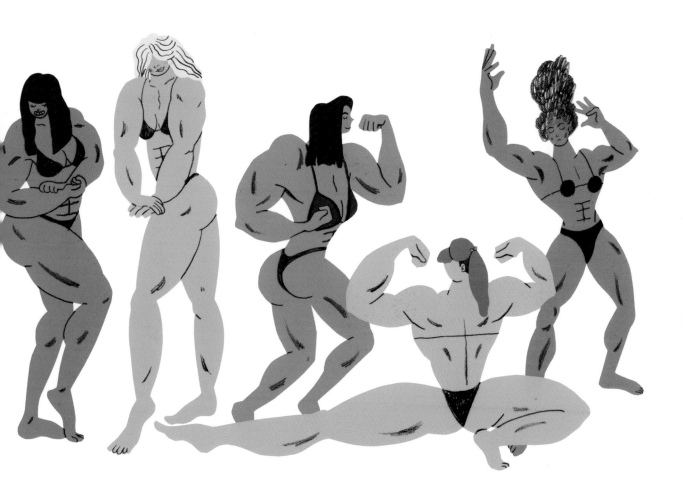

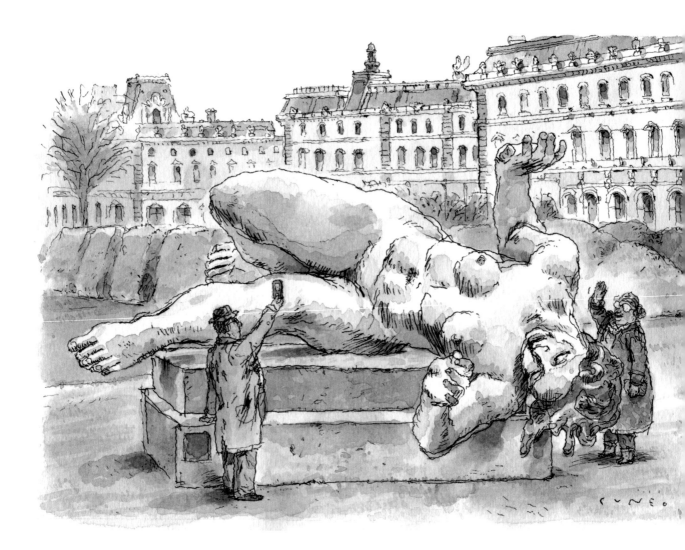

JOHN CUNEO
Louvre Sculpture
Pen, ink and watercolor on paper
A personal piece featuring a Louvre garden
sculpture by Aristide Maillol.

FACING PAGE

STEVEN DARDEN
Gaksis
Ink on paper

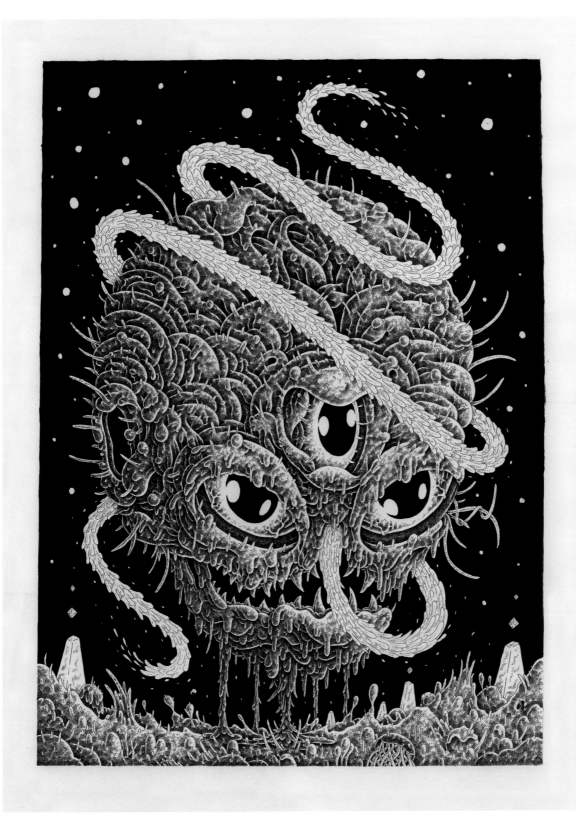

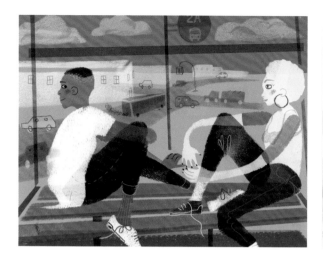

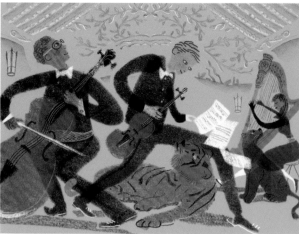

CHRISTOPHER DARLING
Everywhere is Cleveland
Block print, graphite, guache, digital

A series of works revolving around the city of Cleveland–people and places within the city. Tennessee Williams has a quote, "America has only three cities: New York, San Francisco, and New Orleans. Everywhere else is Cleveland." The series is a response to this attitude held by many, and seeks to expose different parts of the culturally rich, often misunderstood, and diverse city.

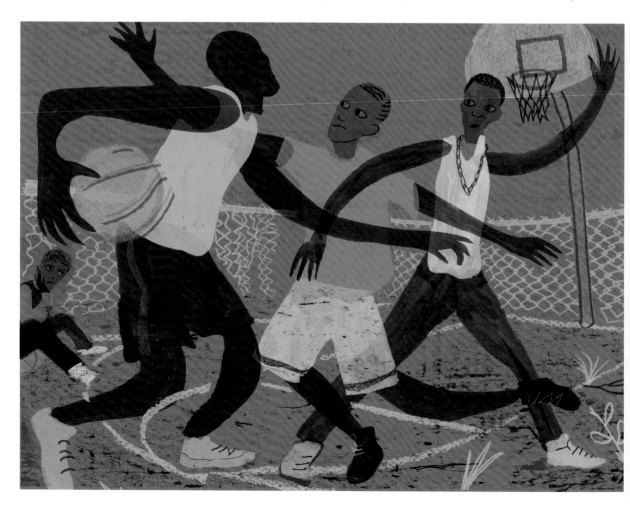

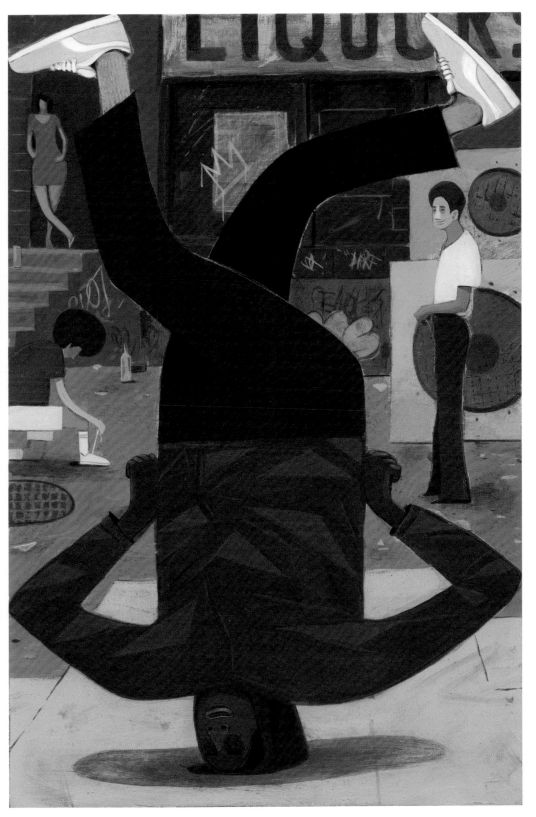

ERIC DIOTTE
Upside Down
Acrylic on Masonite
Self-promotional piece
exploring the theme
"upside down."

DB Dowd
Spartan Holiday No. 3: French Lesson
Ink, gouache and digital
Nonfiction graphic novel.

JENSINE ECKWALL, ALEX KROKUS
The Nighmare
Digital with watercolor texture
Written and storyboarded by
Jensine Eckwall. Animated by
Alex Krokus. Sound design by
James DeAngelis.

BARRY FITZGERALD
Rothko's PBJ
Ink on paper, and digital
An image inspired when making a sandwich for lunch
after spending the morning at an art gallery.

DYLAN GLYNN
Lost Daughter
Watercolor, digital

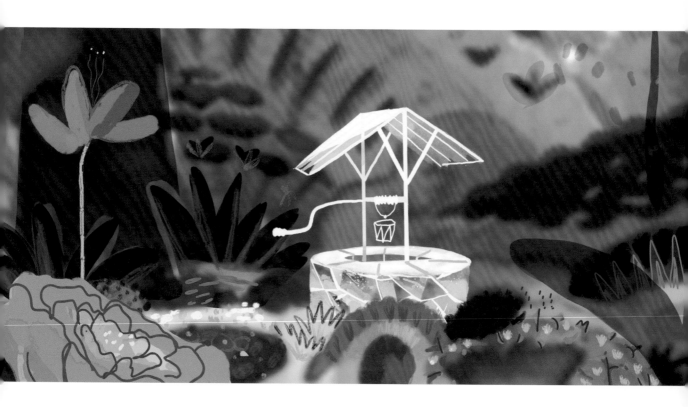

DYLAN GLYNN
Sister Narcissa
Watercolor, digital

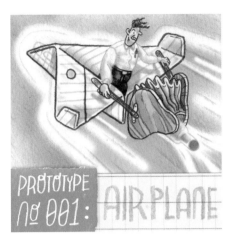

PROTOTYPE № 001: AIRPLANE

ERON HARE
Prototype Number One
Colored pencil, digital
An invented history of first inventions.

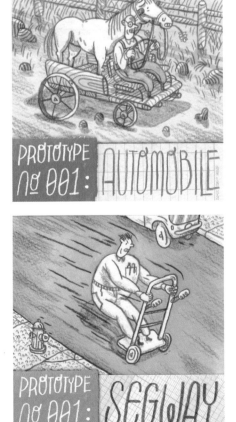

PROTOTYPE № 001: AUTOMOBILE

PROTOTYPE № 001: SEGWAY

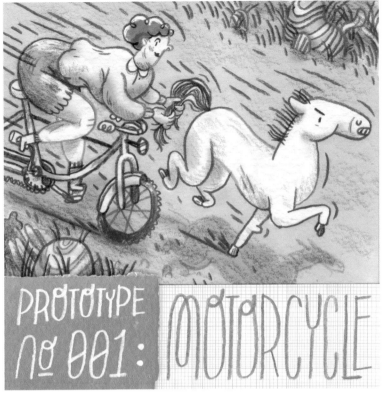

PROTOTYPE № 001: MOTORCYCLE

PROTOTYPE № 001: HANG GLIDER

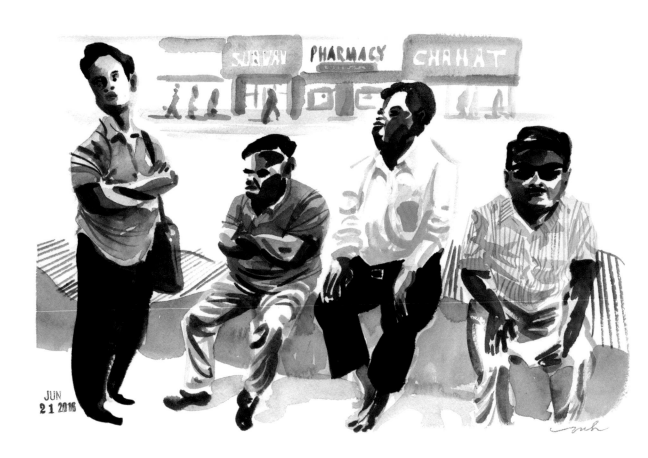

FACING PAGE

MARCELLUS HALL
Street Fashion NYC 2016
Watercolor

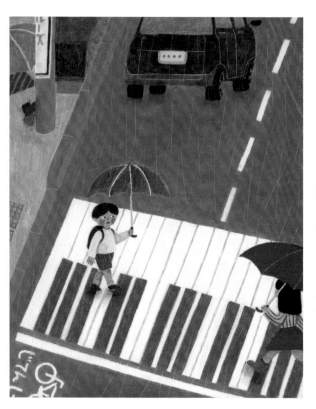

SAKUYA HIGUCHI
Fantagic
Crespas

FACING PAGE

SAKUYA HIGUCHI
Life
Crespas

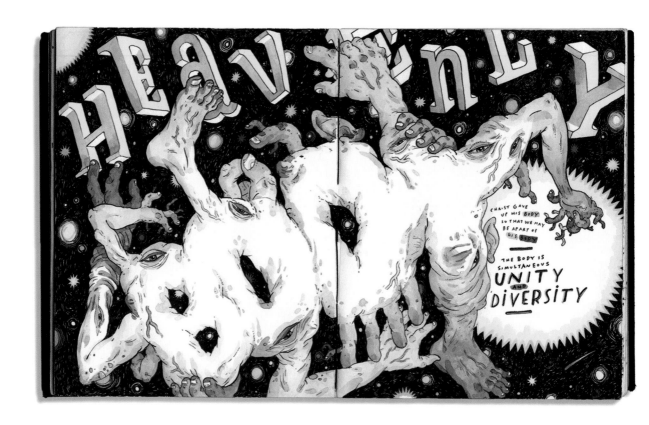

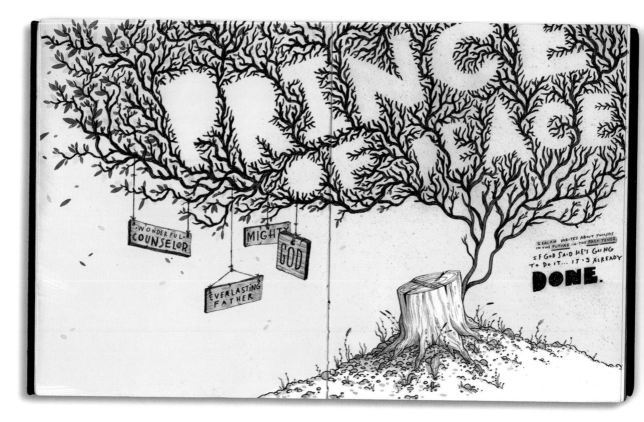

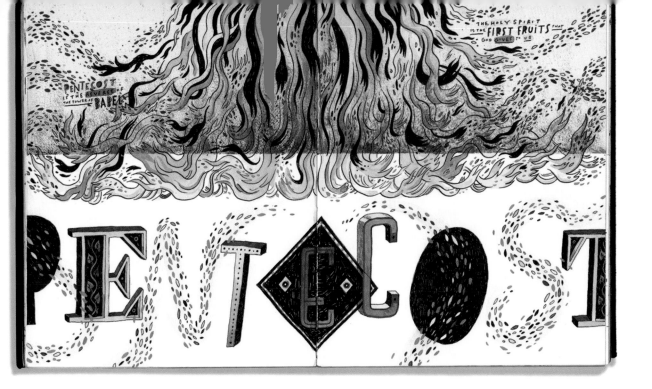

JOHN HENDRIX
Drawing in Church Sketchbook
Pen and ink, Fluid Acrylics

A series of drawings in my sketchbook done on Sunday mornings during the sermon while I'm sitting in the pews at my church, Grace & Peace Fellowship in St. Louis. I color them when I get home on Sunday nights as a weekly Sabbath ritual. They are a long form improvised visual musing on theology, spiritual metaphor and faith.

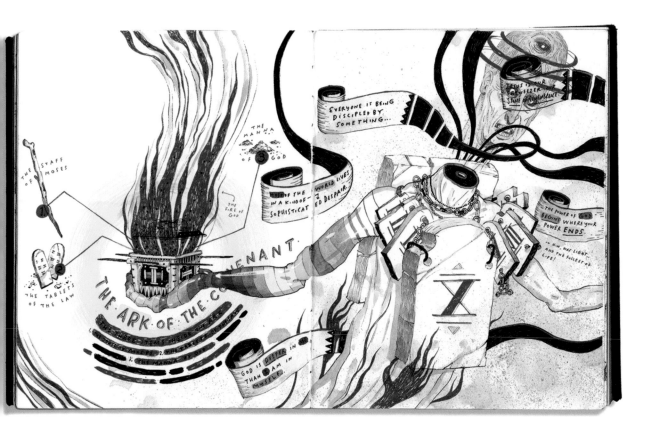

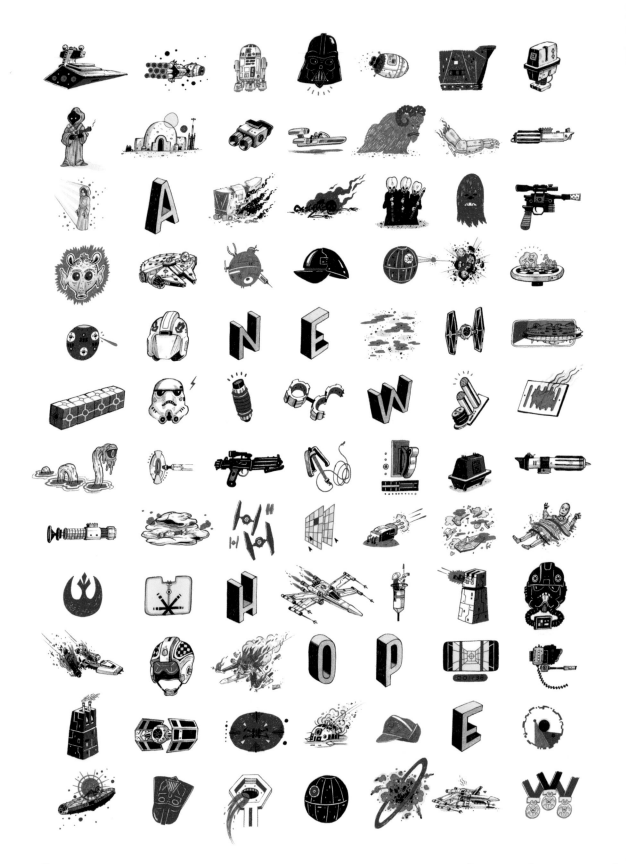

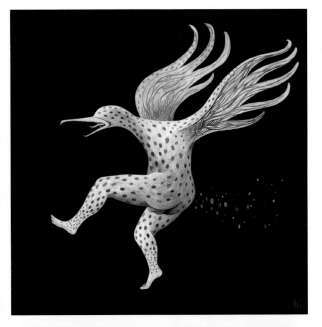

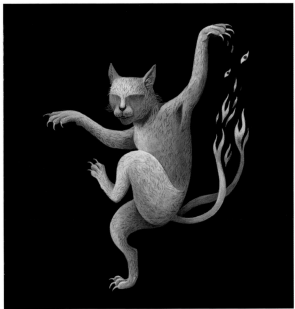

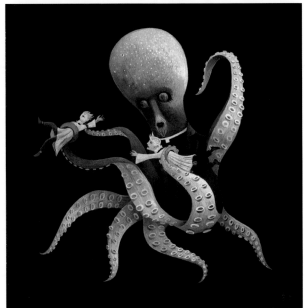

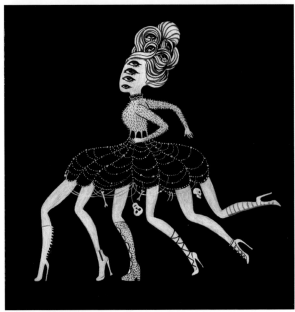

JODY HEWGILL
Night Parade of 100 Demons
Acrylic on birch panel
Each artist was asked to create four creatures for a re-interpretation of "Hyakki Yagyo: Night Parade of 100 Demons." The parameters were: white creatures on a black background and facing left (so they could be incorporated into one large montaged parade to accompany the artwork exhibited in the gallery). Curated by Hitoshi Murakami

FACING PAGE

JOHN HENDRIX
A New Hope in Icons
Pen and ink, Fluid Acrylics
For a gallery show celebrating the return of *Star Wars* to the cinema, I created a narrative of *Star Wars: A New Hope* in simple icons. These tiny moments tell the full saga of the film if you read it from top left to bottom right.

GENEVIEVE IRWIN
Urban Jungle
Sumi ink
This piece was made on location at the Brooklyn Botanic Garden,
as the winter light came through the greenhouse roof.

SARAH JACOBY
In the Wild in Captivity
Watercolor, ink, digital
A series for a gallery show
themed "Inside Out."

SARAH JACOBY
Hiding Places
Watercolor, pastel, digital

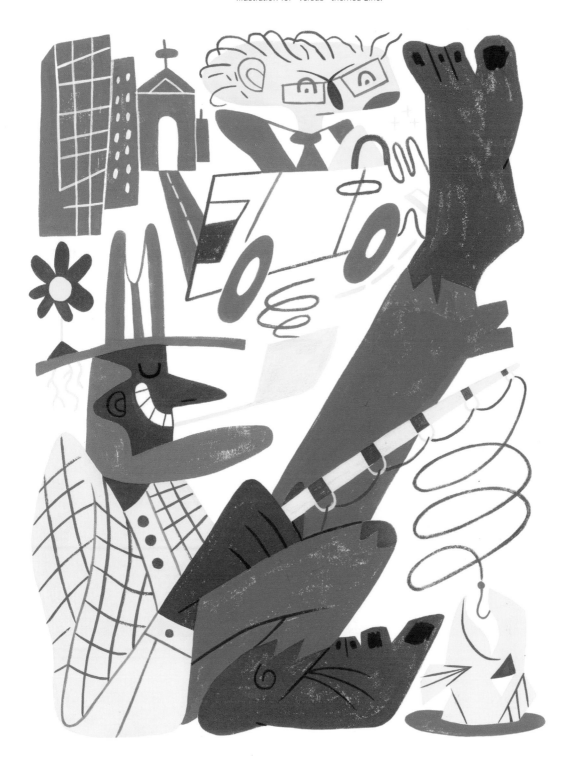

TIM LIEDTKE
Country vs. City
Gouache
Illustration for "versus" themed zine.

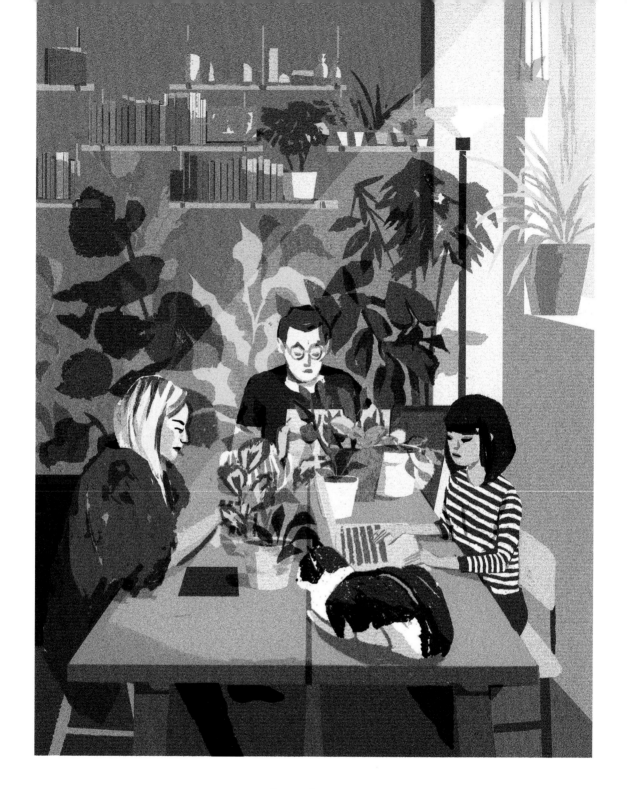

JENN LIV
Botanica: Lunchroom
Photoshop CC
For Light Grey Art Lab Gallery's BOTANICA Show. An experimental
digital painting study of Lunchroom Toronto, a small collective
where we share meals and work together in a studio space.

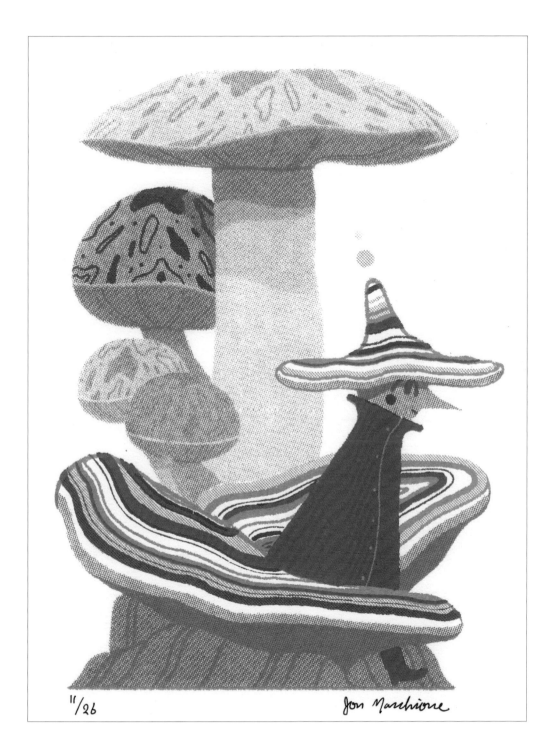

11/26

Jon Marchione

JON MARCHIONE
Fungal Witch
Digital, screenprint
A two-color screenprint of a witch obsessed with mushrooms.

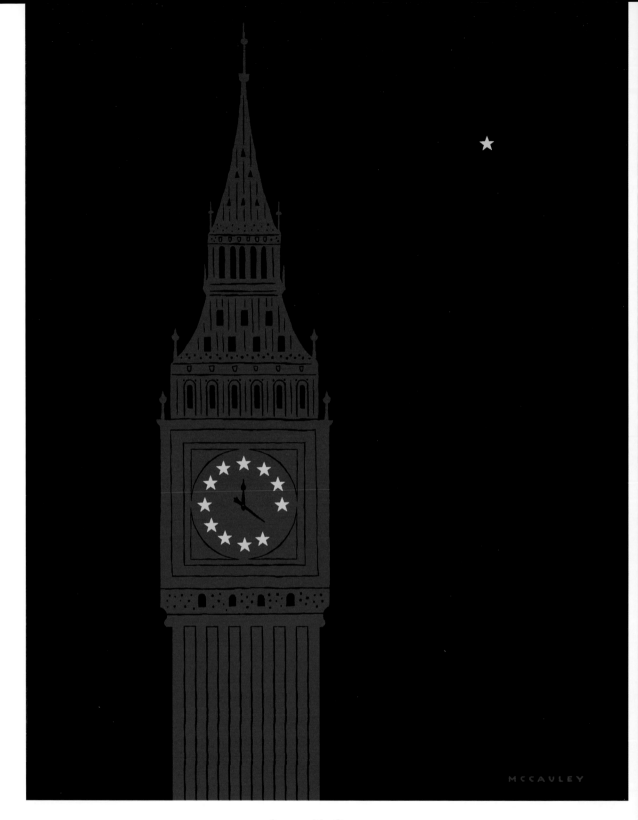

ADAM McCAULEY
Brexit
Digital
An image created in response to the Brexit vote.

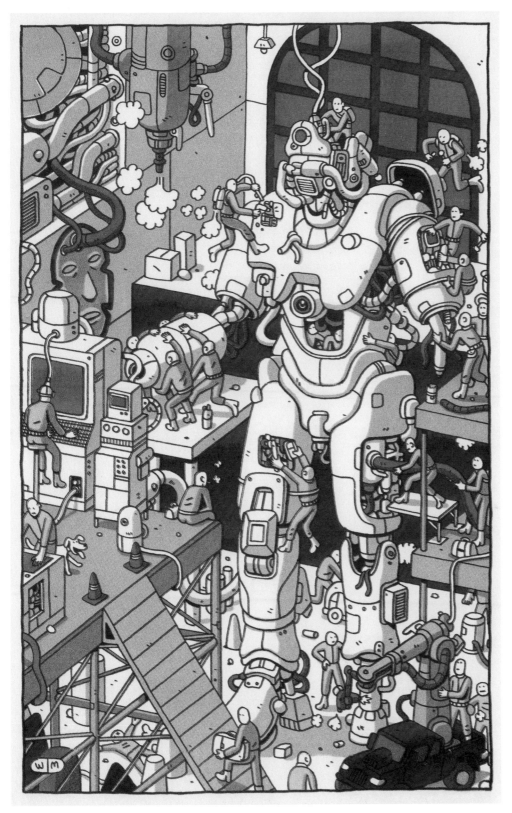

WREN McDONALD
Mech Makers
2-color Risograph print on
65 lb. natural parchment.
Teal and fluorescent pink inks
A self-generated illustration
depicting a busy scene
where lots of little people
are working together
to build a giant robot.

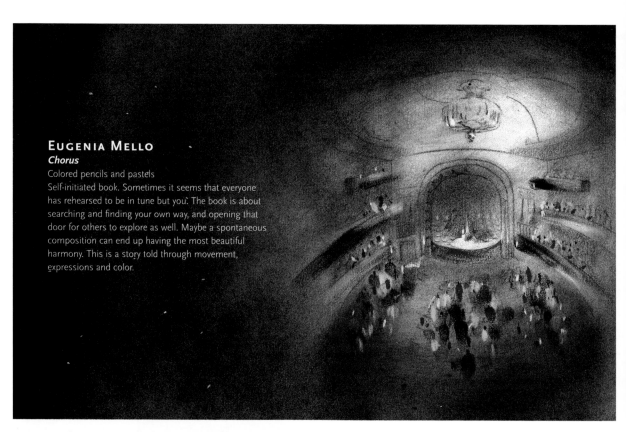

EUGENIA MELLO
Chorus
Colored pencils and pastels
Self-initiated book. Sometimes it seems that everyone
has rehearsed to be in tune but you. The book is about
searching and finding your own way, and opening that
door for others to explore as well. Maybe a spontaneous
composition can end up having the most beautiful
harmony. This is a story told through movement,
expressions and color.

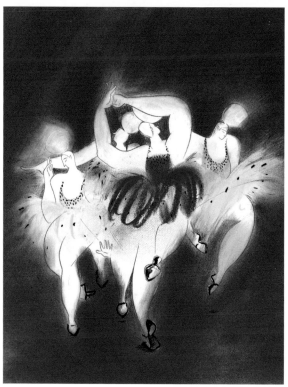

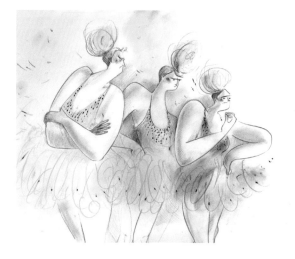

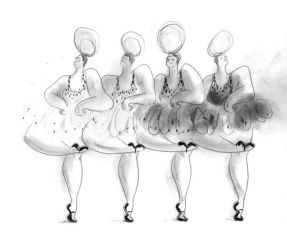
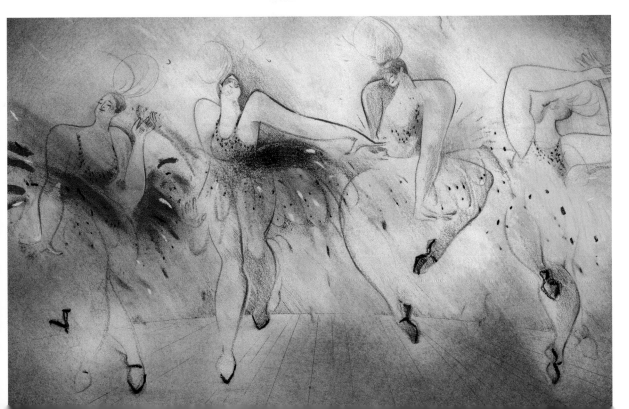

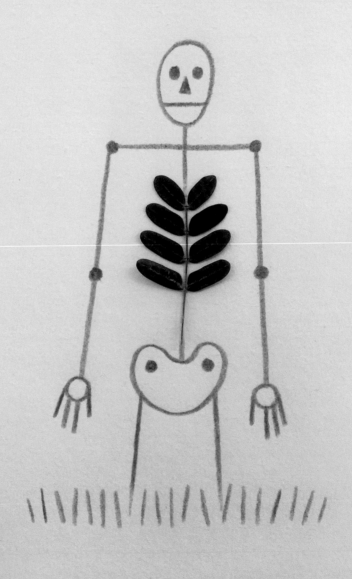

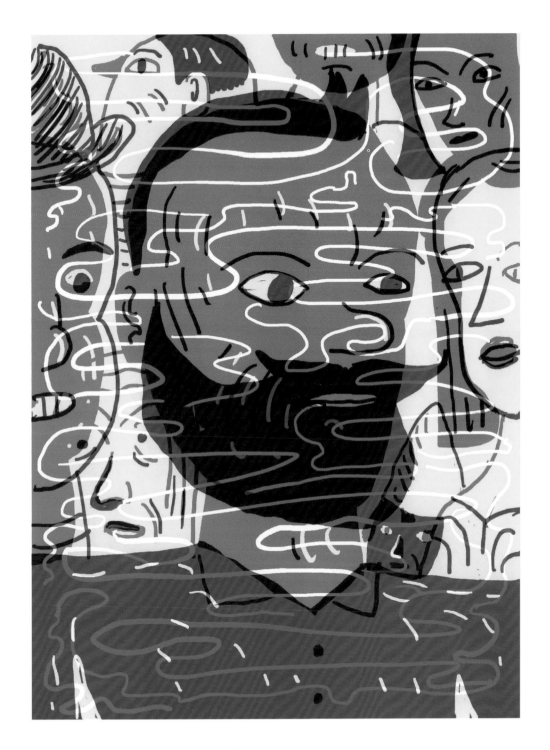

MARC ROSENTHAL
Faces
Digital
Various faces.

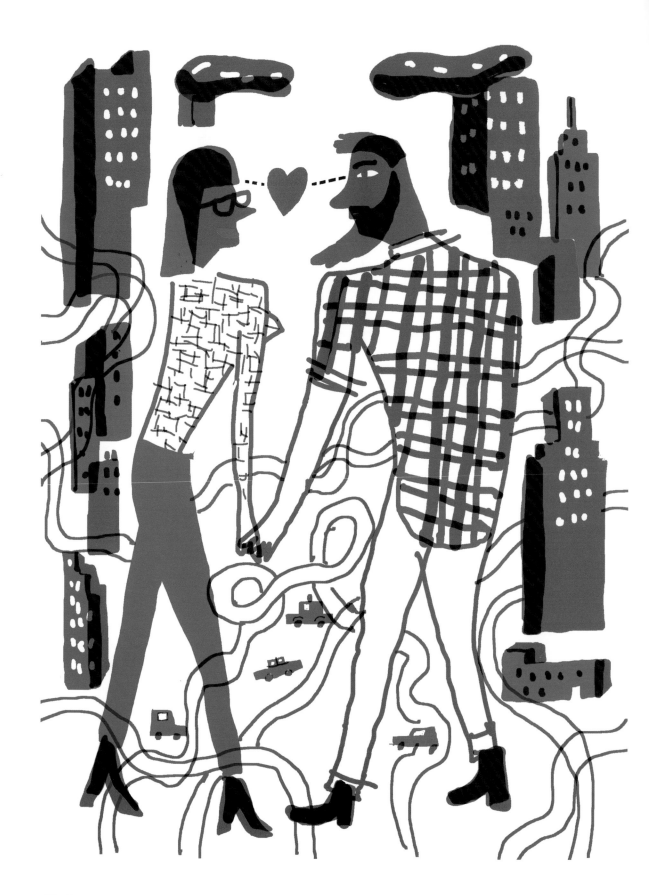

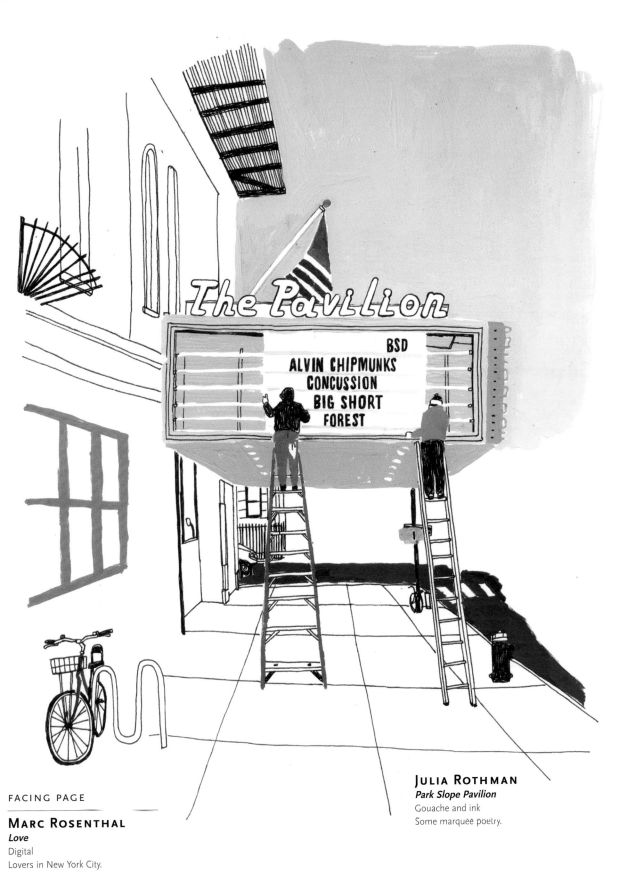

The Pavilion

BSD
ALVIN CHIPMUNKS
CONCUSSION
BIG SHORT
FOREST

Marc Rosenthal
Love
Digital
Lovers in New York City.

Julia Rothman
Park Slope Pavilion
Gouache and ink
Some marquee poetry.

DANIEL SAVAGE
Look-See
Photoshop, After Effects
https://vimeo.com/166896478

QIAOYI SHI
Mr. Balloon
Photo-lithograph on paper
My current project is titled "Mr. Balloon."
The Balloon is a symbol for a friend, a sibling,
a newborn infant or the beginning of life.

LASSE SKARBOVIK
Babe
Paint on canvas
Illustration for portfolio.

LASSE SKARBOVIK
Nude
Paint on canvas
illustration for exhibition.

ELLEN SURREY

Film Stills

Gouache

An ongoing project of painting my screen shot collection.

YOUNG FRANKENSTEIN 1974

AND THEN THERE WERE NONE 1945

HIS KIND OF WOMAN 1951

THE DAY THE EARTH STOOD STILL 1951

I MARRIED A WITCH 1942

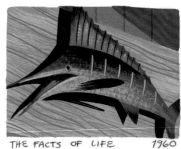
THE FACTS OF LIFE 1960

CITY LIGHTS 1931

MODERN TIMES 1936

FRANKENSTEIN 1931

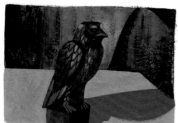
THE MALTESE FALCON 1941

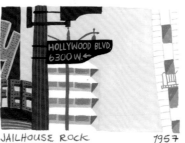
JAILHOUSE ROCK 1957

HIS KIND OF WOMAN 1951

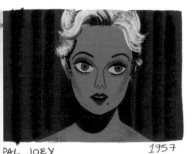

PAL JOEY 1957

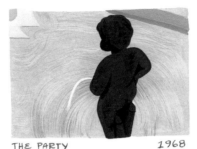

THE PARTY 1968

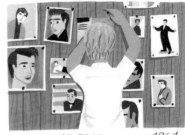

THE PARENT TRAP 1961

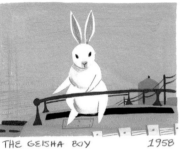

THE GEISHA BOY 1958

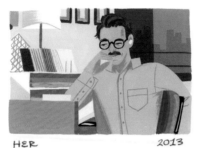

HER 2013

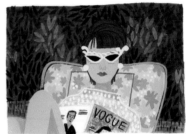

WHAT A WAY TO GO! 1964

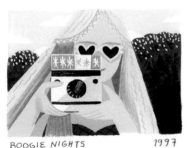

BOOGIE NIGHTS 1997

PAL JOEY 1957

PAL JOEY 1957

THE PARENT TRAP 1961

DIVORCE AMERICAN STYLE 1967

HER 2013

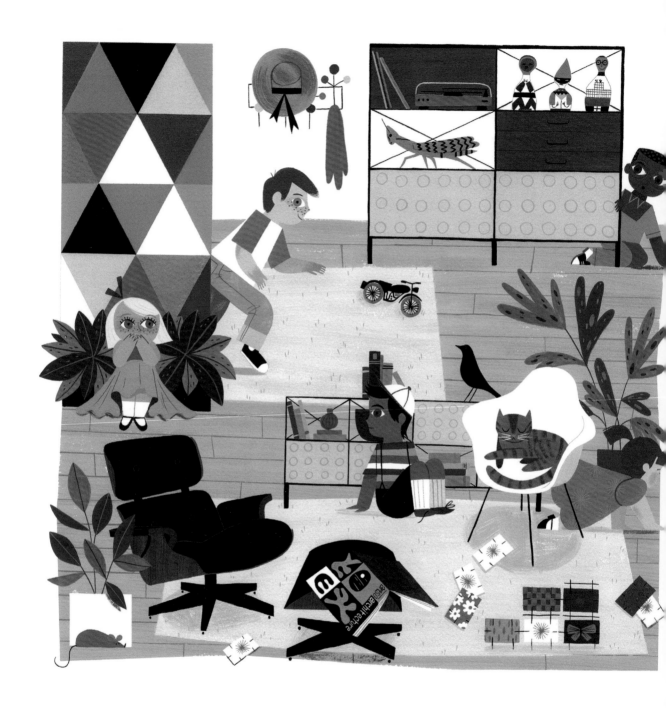

ELLEN SURREY
Hide and Seek
Gouache
Children playing hide-and-seek in a mid-century Eames living room.

LAUREN TAMAKI
Sketchbook 2016
Colored Ink, pen

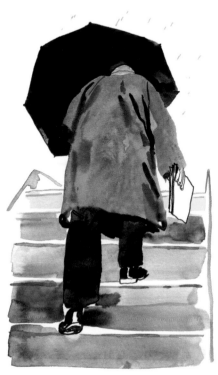

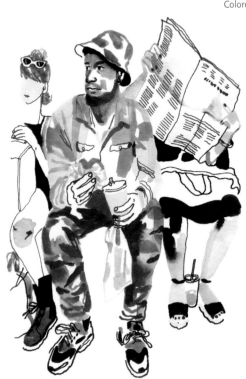

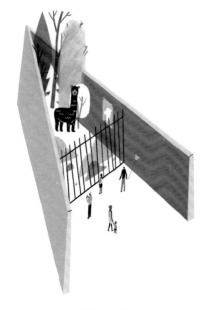

ALPACA

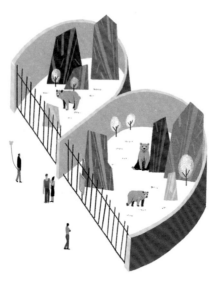

BEAR

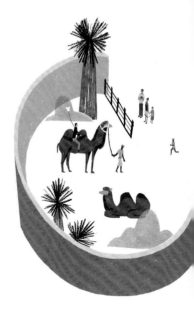

CAMEL

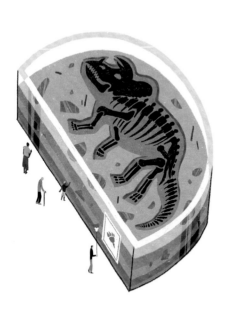

DINOSAUR

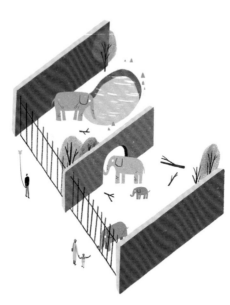

ELEPHANT

WENJIA TANG
Alphabet Zoo (A-E)
Digital

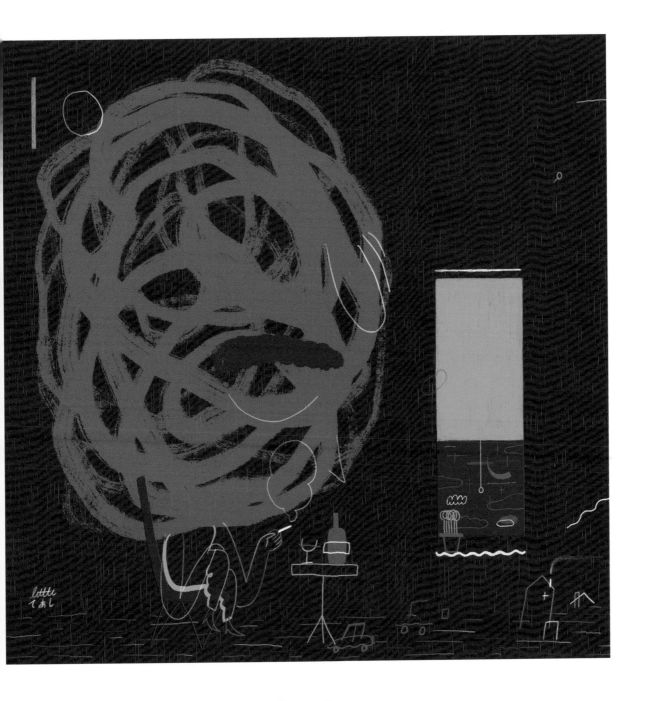

GIZEM VURAL
Lonely Night
Digital and hand drawn with ink
Lonely Night is a personal drawing. Sitting at night
alone having a glass of wine and my cigarette, as my
mind is full of thoughts and problems.

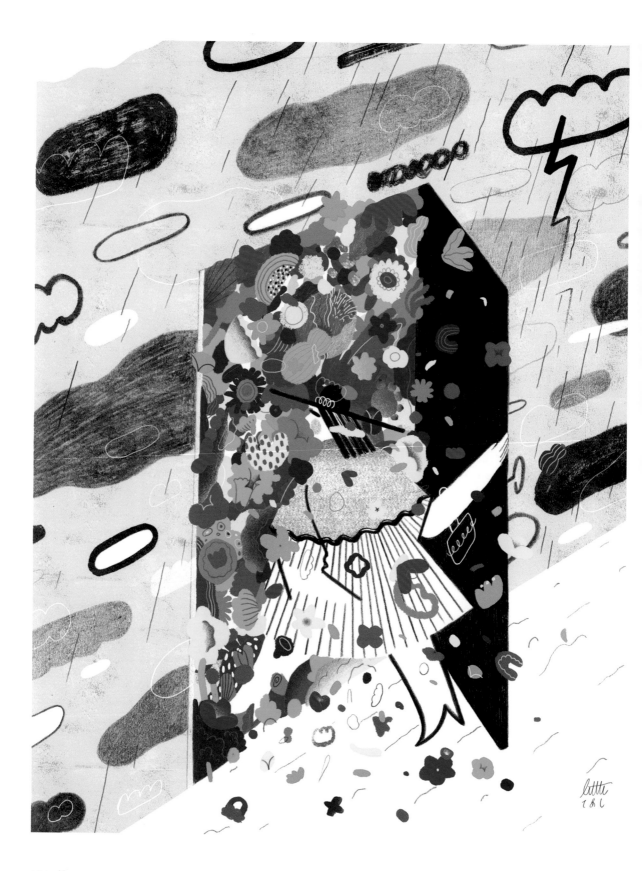

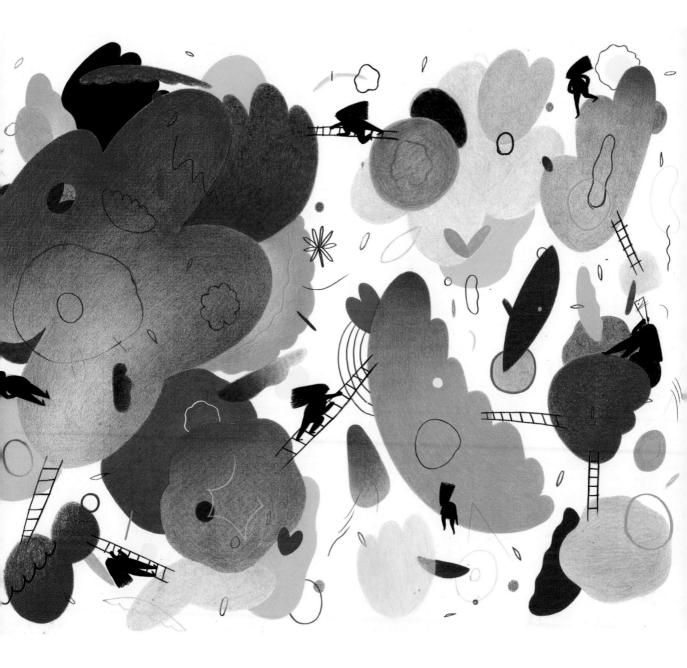

GIZEM VURAL
Wanderer
Colored pencil and digital
It's a personal piece. The girl is me on
a journey in my own surreal world.

FACING PAGE

GIZEM VURAL
Leaving for Spring
Digital and hand drawn with pencil
Leaving for Spring is a personal drawing.
It's about leaving behind the rain and winter,
welcoming the spring and flowers.

MANUJA WALDIA
Matriarchal Memories
Digital

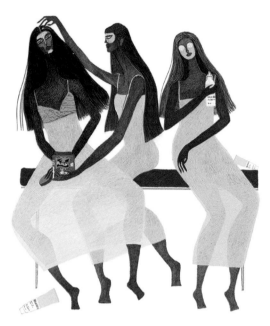

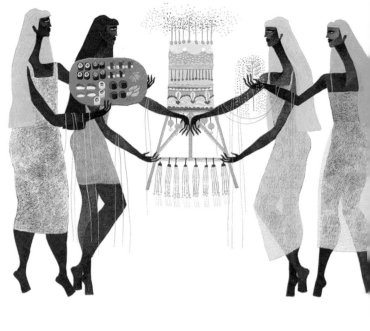

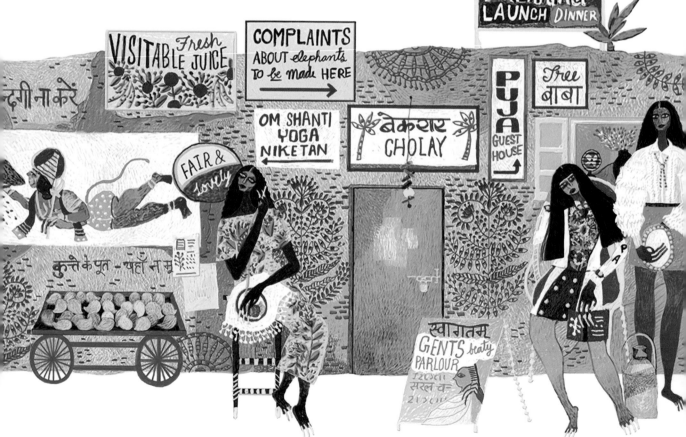

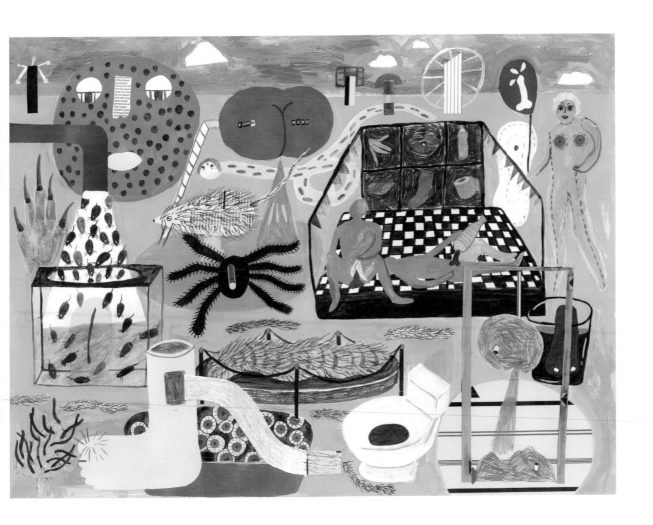

LUYI WANG
Wonderland
Collage, arcylic
This is one piece in a series about human emotions.

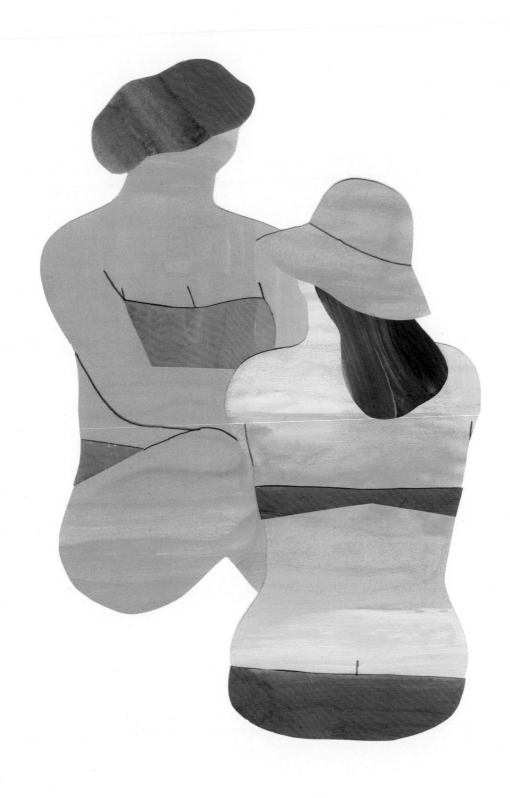

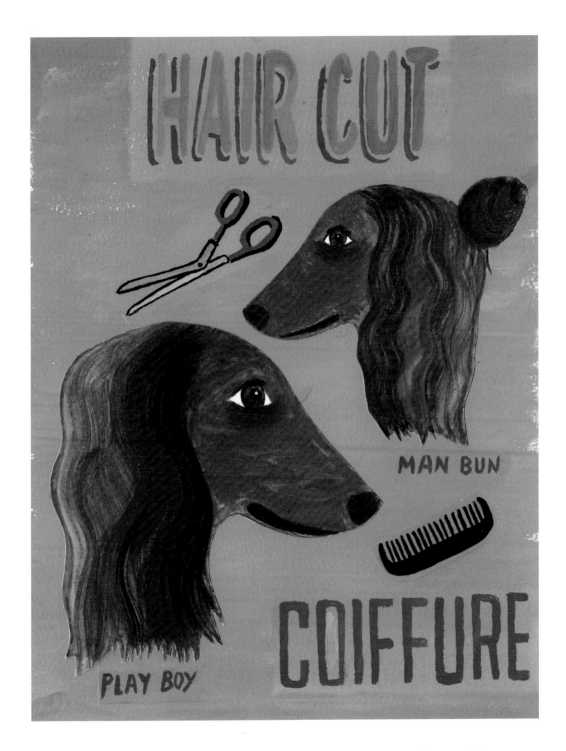

ELLEN WEINSTEIN
Coiffed
Gouache
Hairstyles for mini long-haired dachshunds.

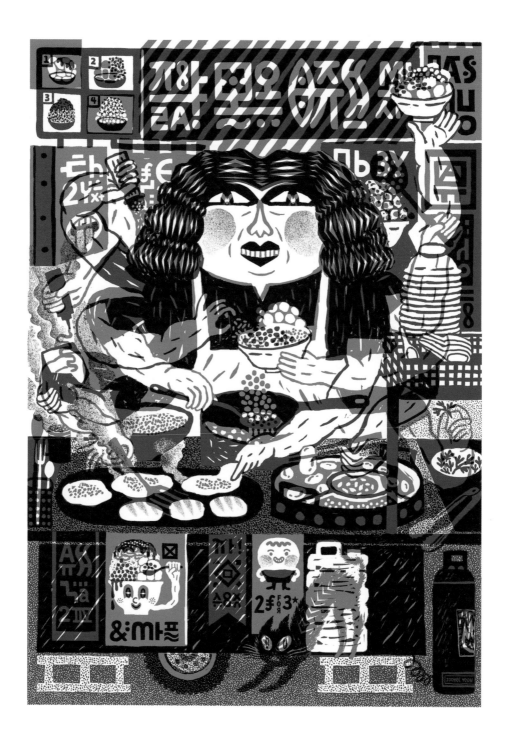

JooHee Yoon
Mochi Jelly
Offset printing with two Pantone colors
Poster for an illustration exhibition in Taipei, as part of their international design week.
The concept was to create a new piece on the theme of Taipei life.
This poster was inspired by the vibrant street food culture of the night markets.

DANIEL ZENDER
Mono
Acrylic ink
Series of experimental monoprints.

DANIEL ZENDER
Glowing Girl
Silkcreen
Self-promotional screen print.

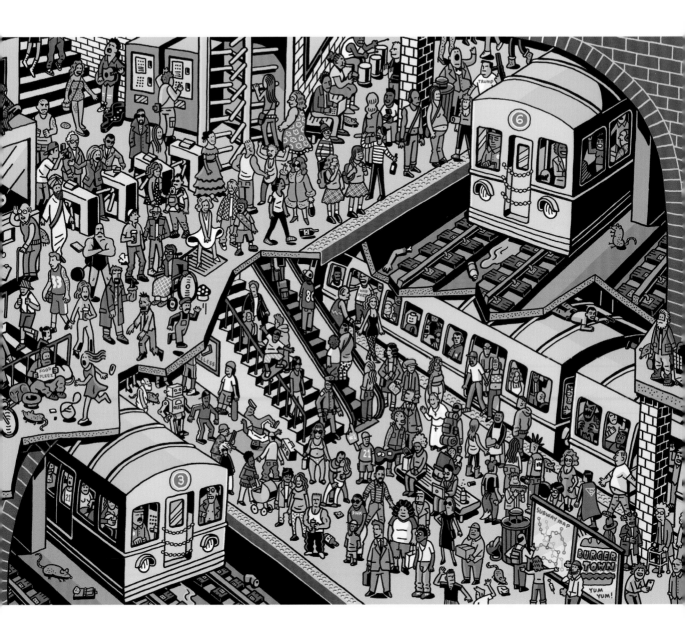

MARIO ZUCCA
Subway Party
Pen and ink, digital
Piece created for self-promotional purposes.

INDEX

SOCIETY *of* ILLUSTRATORS

BUSINESS MATH

Brief Edition

Eighth Edition

CHERYL CLEAVES
Southwest Tennessee Community College

MARGIE HOBBS
The University of Mississippi

PEARSON

Prentice
Hall

Upper Saddle River, New Jersey
Columbus, Ohio

Library of Congress Control Number: 2007936419

Editor in Chief: Vernon R. Anthony
Senior Acquisitions Editor: Gary Bauer
Editorial Assistant: Kathleen Rowland
Development Editor: Ohlinger Publishing Services
Production Editor: Louise N. Sette
Design Coordinator: Diane Ernsberger
AV Project Manager: Janet Portisch
Cover Designer: Wanda Espana
Senior Operations Supervisor: Patricia Tonneman
Director of Marketing: David Gesell
Marketing Manager: Leigh Ann Sims
Marketing Coordinator: Alicia Dysert

This book was set in Times Roman by Aptara, Inc. It was printed and bound by R.R. Donnelley & Sons Company. The cover was printed by Phoenix Color Corp.

Pearson Education Ltd.
Pearson Education Singapore Pte. Ltd.
Pearson Education Canada, Ltd.
Pearson Education—Japan

Pearson Education Australia Pty. Limited
Pearson Education North Asia Ltd.
Pearson Educación de Mexico, S.A. de C.V.
Pearson Education Malaysia Pte. Ltd.

10 9 8 7 6 5 4 3
ISBN 13: 978-0-13-515010-8
ISBN 10: 0-13-515010-8

FROM THE AUTHORS

About the 8th Edition of Business Math

The focus of the 8th edition of *Business Math* is to provide you with the tools you will need to solve mathematical problems you will encounter in both your personal and business lives. We present math in familiar contexts: math needed for everyday business transactions, math needed to make important personal finance decisions, and math needed to start or run a small business.

To carry out these themes, we strengthened the content and added new topics where appropriate. We expanded coverage of the math needed for everyday business transactions by providing additional exercises and examples of realistic business transactions. We sharpened the focus of math needed to manage personal finances by providing examples, exercises, and concept analysis questions that require you to think about your personal financial plans so you learn how to manage your money and make more intelligent transaction and investment decisions. Many of you are interested in entrepreneurship and small business, so we also cover the math needed to establish and run a small business.

To better connect the math with relevant real-world problems, this edition features 21 new chapter-opening cases that highlight how the math topic to be discussed is applied in a real-world context. We also added over 40 new end-of-chapter problem-solving cases on topics of interest to students and retained the 10 Video Cases from the 7th Edition in a new appendix.

Expanded coverage and new topics were added to several chapters based on comments from reviewers. We added coverage of formulas to find the future value and compound interest; to find the present value of an investment; to find the future value of an ordinary annuity or an annuity due; and to find a sinking fund payment or the present value of an annuity. We expanded the coverage for online banking in Chapter 4 and added to Chapter 7 coverage on relative frequency distributions, the mean of grouped data, and comparative and component bar graphs. In Chapter 11 we added learning outcomes on making partial payments before the maturity date and on finding the true or effective interest rate of a simple discount note. In Chapter 15 we added the formula for finding the principal and interest payment of a mortgage, and we added the topic of calculating the principal, interest, taxes, and insurance (PITI) payment on a home mortgage and calculating mortgage qualifying rates. The lower-of-cost-or-market (LCM) rule was added to Chapter 17 and to Chapter 18 we added coverage on insurance for multiple carriers. In general, more calculator steps were added and the number of Microsoft Excel exercises increased.

The teaching package has also been heavily upgraded for this edition. We are most excited about the addition of **MyMathLab® for** *Business Math*. MyMathLab is a powerful classroom management, homework, tutorial, and assessment tool that can be packaged with this textbook.

Reading Your Math Textbook

In developing an effective study plan it is important to use all your available resources to their maximum advantage. The most accessible of these resources is your textbook. Incorporate an effective strategy for reading your textbook into your study plan.

Beginning a Chapter

1. Examine the chapter opening pages. Read the Chapter Title, Section Titles, and Learning Outcomes to determine what will be covered in the chapter. Read the case to get a sense of the business topics covered in the chapter.
2. Read the Summary that is near the end of the chapter. The Summary lists each learning outcome of the chapter with some tips on what to remember and at least one example. Use the summary as a checklist to rate your initial knowledge of the chapter's learning outcomes.

This rating can be a numerical one. For example, 0 means that you know nothing about this topic; 1 means that you know a little about this topic; 2 means that you know quite a bit, but there may be a few gaps in your understanding; and 3 means that you know this topic very well.

Another possible rating strategy can be a minus/check/plus system. Minus means you need to work on this topic, check means you know the topic moderately well, and plus means you know the topic very well.

Beginning a Section

1. Read the section title and the learning outcomes for the section.
2. Read the introductory paragraph.
3. Locate the Section Exercises at the end of the section. Read the directions for each "clump" of exercises. This will give you an idea of the type of problems you will be working and what to look for as you read the section.
4. Begin reading the section. Make notes on concepts that you do not understand or examples for which you are not able to follow the explanation. This will be the basis for questions to ask in class.

Continuing Through the Chapter

1. Work on one learning outcome at a time. After reading and studying one learning outcome, work the Stop and Check exercises for that outcome. Always check your answers with the text or ReviewMaster CD and ask questions as appropriate. Assess your understanding of each outcome and practice or get help as you think necessary. Be realistic in your self-assessment!
2. Continue outcome by outcome, section by section, checking your understanding as you go.
3. Work the section or end-of-chapter exercises as assigned by your instructor.

Reviewing the Chapter

1. After finishing a chapter, thumb through the entire chapter and read the Tip Boxes and How To sections.
2. Read the Summary again and rate your understanding of each outcome again. Review or get assistance as necessary.
3. Use the key terms in the margin as a checklist for your understanding of the new terminology used in the chapter.
4. Work the Practice Test at the end of the chapter and check your answers. Review or get assistance as necessary.

Finishing the Chapter

1. Prepare for the test on the chapter. Ask your instructor which outcomes require mastery for testing purposes. Some outcomes may not require mastery, and others may even be optional.
2. Read the chapter-ending cases to gain some insight about where these concepts are used in real life.

General Tips

1. Practice an outcome until you feel comfortable that you understand the concept. Abundant practice material is available to you that is specifically geared to your text (Section Exercises, Exercise Sets A & B, and Companion Website). Other practice is available through generic mathematics software and other texts. Only you know when you have practiced enough. Be realistic in the self-assessment of your understanding. Practice helps you retain the information for a longer period of time, but don't wear yourself out! Finding that appropriate balance is your goal.
2. Use the Critical Thinking questions to help you check your conceptual understanding.
3. Don't forget the Glossary/Index as you move through the text so that you can remember definitions and concepts. Perhaps you are not starting your study at the beginning of the text and need to review a few concepts from chapters you did not cover. Examining the Glossary/Index should be your first step in accomplishing your review.

We wish you much success in your study of mathematics. Many of the features in this book were suggestions made by students such as yourself. If you have suggestions for improving the presentation, please give them to your instructor or email the authors at ccleaves@bellsouth.net or at margiehobbs@bellsouth.net

Good luck in your study of business mathematics.

TIME-TESTED PEDAGOGY AIDS STUDENT LEARNING

LEARNING OUTCOMES

7-1 Measures of Central Tendency
1. Find the mean.
2. Find the median.
3. Find the mode.
4. Make and interpret a frequency distribution.
5. Find the mean of grouped data.

7-3 Measures of Dispersion
1. Find the range.
2. Find the standard deviation.

LEARNING OUTCOMES outlined at the beginning of each chapter, repeated throughout the chapter, and reviewed in the summary keep students focused on important concepts.

HOW TO Find the mean of grouped data
1. Make a frequency distribution.
2. Find the products of the midpoint of the interval and the frequency for each interval for all intervals.

HOW TO sections take students through the steps to solve different business applications.

Net price rate: the complement of the trade discount rate.

Since the complement is a percent, it is a rate. The complement of the trade discount rate is the **net price rate**. The single trade discount rate is used to calculate the amount the retailer *does not* pay: the trade discount. The net price rate is used to calculate the amount the retailer *does* pay: the net price.

KEY TERMS are highlighted in bold in the text and called out in the margin with their definitions.

STOP AND CHECK
1. Find the net price of the PC software SystemWorks that lists for $70 and has a discount rate of 12%.
2. The InFocus LP 120 projector lists for $3,200 and has a trade discount rate of 15%. Find the net price.
3. Canon has a fancy new digital camera that lists for $1,299 and has a trade discount of 18%. What is the net price?
4. Find the net price of 100 sheets of display board that list for $3.99 each, 40 pairs of scissors that list for $1.89 each, and 20 boxes of push pins that list for $3.99 if a 22% trade discount is allowed.

STOP AND CHECK exercises give students practice so they can master every outcome. Solutions are in an appendix at the end of the text.

TIP

Who Pays and When
The chart summarizes the most common shipping terms.

Term	Who Pays	When	Who Doesn't Pay
FOB-shipping	Buyer	On receipt	Seller
Freight collect	Buyer	On receipt	Seller

TIP BOXES give students alternate strategies for solving problems, point out common mistakes to avoid, and give instruction on using calculators.

EXAMPLE 1 Calculate the cash discount and the net amount paid for an $800 order of business forms with sales terms of 3/10, 1/15, n/30 if the cost of shipping was $40 (which is included in the $800). The invoice was dated June 13, marked *freight prepay and add*, and paid June 24.

Net price of merchandise Apply the cash discount rate *only* to the net amount of

EXAMPLES show all the steps and use annotations and color to highlight the concepts.

11-2 SECTION EXERCISES

SKILL BUILDERS
1. Find the exact interest on a loan of $32,400 at 8% annually for 30 days.
2. Find the exact interest on a loan of $12,500 at 7.75% annually for 45 days.

SKILL BUILDERS AND APPLICATIONS are two types of exercises within section exercises that help students first master basic concepts and then apply them.

What You Know	What You Are Looking For	Solution Plan
Houses sold during the period: 9 Prices of these houses: $270,000, $250,000, $150,000, $150,000, $150,000, $150,000, $149,000, $145,000, and $125,000	Which statistic gives the most realistic picture of how much a home in Tyreville is likely to cost? Find the mean, median, and mode.	Mean = sum of values ÷ number of values Median = middle value when values are arranged in order Mode = most frequent value

Solution

FIVE-STEP PROBLEM-SOLVING STRATEGY gives students an efficient and effective way to approach problem solving and gives them a strategy for good decision making.

SUMMARY CHAPTER 7

Learning Outcomes What to Remember with Examples

EXERCISES SET A CHAPTER 7

Find the range, mean, median, and mode for the following. Round to the nearest hundredth if necessary.

PRACTICE TEST CHAPTER 7

1. Use the data to find the statistical measures.
 42 86 92 15 32 67 48 19 87 63

CRITICAL THINKING CHAPTER 7

1. What type of information does a circle graph show?
2. Give a situation in which it would be appropriate to organize the data in a circle graph.

- **SUMMARY** at the end of each chapter functions as a mini study–review with learning outcomes and step-by-step instructions and examples.
- **TWO PROBLEM SETS (A AND B)** are provided on perforated pages for easy removal. Ample room for students' work is provided, so these can be assigned as hand-in homework.
- **PRACTICE TEST** gives students a chance to gauge their knowledge of the chapter material and see where they need to review.
- **CRITICAL THINKING** questions ask students to apply their knowledge to more complex questions and build their decision-making skills.

ACKNOWLEDGMENTS

We especially thank the students and faculty who used the seventh edition for their thoughtful suggestions for improving this book. We also appreciate and thank the long list of reviewers who have contributed their ideas for improving the text.

Colleagues who reviewed the seventh edition and provided ideas and suggestions for improving the eighth edition are:

Dawn Addington, Albuquerque TVI
Mildred Battle, Marshall Community and Technical
Susan Bennet, Wake Technical Community College
Kathleen DiNisco, Erie Community College
Beverly Hallmon, Suffolk Community College
Jenna Johannpeter, Southwestern II College
Jean McArthur, Joliet JC
Karen S. Mozingo, Pitt Community College
Lisa Rombes, Washtenaw Community
Barbara Schlachter, Baker College, Auburn Hills
Kimberly D. Smith, County College of Morris
Thomas Watkins, Solano Community College
Joe Westfall, Carl Albert State College
Andrea Williams, Shasta College

Some of the reviewers of earlier editions include:

Benjamin W. Bean, Utah Valley State College
Anne L. Cremarosa, Reedley College
Marsha T. Faircloth, Southwest Georgia Technical College
Amy Fowler, Cleveland State Community College
John Lehnen, Heald College
Dyan Pease, Sacramento City College
Susan Peterson, Northwest Technical College–Moorhead
Sally P. Proffitt, Tarrant County College–Northeast Campus
Keith Purrington, Irvin Valley College
Don R. Stanley, Heald College
Margene E. Sunderland, Fayetteville Technical Community College
Joyce G. Walsh-Portillo, Broward Community College
Nancy Wellerp, Grand Rapids Community College (retired)

The Pearson Education team has been outstanding. The key players are listed on the copyright page and we want to thank all of them for the role they played in this project. Our team leader, Gary Bauer, Senior Acquisitions Editor, had the vision, expertise, and perseverance to bring the vision to reality. Louise Sette played a vital role in making sure the project progressed in a timely manner and taking care of every minute detail to ensure a quality product. We thank you, Louise. Monica Ohlinger and Diane Durkee of Ohlinger Publishing Services did an excellent job of coordinating aspects of the manuscript production. We thank you both. David Drewrey read and worked every example and exercise to ensure the business and mathematics were on target. Any errors found in the text are the direct responsibility of the authors. Rob Farinelli updated the test bank by adding exercises for new sections and accuracy checking the entire test bank.

Jeffrey Noble brought a fresh perspective to the eighth edition by writing exciting and interesting chapter opening features for all chapters and by writing many of the case studies found at the end of each chapter. Jeffrey also revised the PowerPoint presentation and scripted and recorded video tapes for each of the many learning outcomes in the text. Students will learn from his work while enjoying his presentations.

We also thank Tamra Davis, Tulsa Community College; Sally Proffitt, Tarrant County College; Cheryl Fetterman, Cape Fear Community College; Joyce Walsh-Portillo, Broward Community College; Blane Franckowiak, Tarrant County College; Anne Cremarosa, Reedley College; Alton Evans, Tarrant County College; and Beverly Vance, Southwest Tennessee Community College who contributed to

various aspects of the seventh edition and Rod Starns of Running Pony Productions, Memphis, TN, who produced the *Business Math in the Real World* videos and the learning outcome videos.

As the manuscript for this edition was developed, we consulted with numerous business professionals so that we could reflect current business practices in the examples and exercises. We thank all of our consults for so graciously sharing their expertise.

We also thank the friendly employees at our favorite FedEx Kinkos on Poplar Avenue in Memphis, Tennessee. They always greeted us with a smile and made sure that our packages were delivered on time and often ahead of schedule.

Our families have always been supportive in all our projects; but in this project we especially thank Shirley Riddle for her tireless sorting, researching, and organizing inventory throughout the process of selling The 7th Inning inventory and Allen Hobbs, who willingly made many trips to Memphis or to Batesville, MS, to make sure our mailings were sent in a timely manner.

CHERYL CLEAVES AND MARGIE HOBBS

BRIEF CONTENTS

CONTENTS

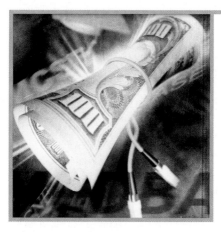

CHAPTER 9 **MARKUP AND MARKDOWN 294**

Review of Whole Numbers

How Much Is Your Degree Worth?

With revenues approaching $2 billion annually, on-line gaming has become more popular than ever. In fact, today in the United States, nearly 83,000,000 people play simple on-line games such as checkers, bridge, or mahjong. A typical Friday afternoon may find more than 36,000 people playing pool on Yahoo!. The incredible numbers of on-line gamers have led to soaring revenues, making on-line advertising one of the fastest growing business sectors in the world today. Yahoo!, for example, saw total revenues skyrocket in 2005 to over $5,000,000,000 ($5 billion)—Google to over $6 billion (yes, that's nine 0s!).

But while checkers or pool may be popular with more people, committed gamers have a number of alternatives to choose from. One of the most popular is EverQuest, a role-playing game that has been around since the mid-1990s. The virtual world inside EverQuest is called Norrath, and it took 6 years and $28 million to create. To date, more than 500,000 people have subscribed to the virtual world, and at any given time there are about 60,000 people from over 120 countries playing simultaneously. EverQuest represents an entire world with its own diverse species, economic systems, alliances, and politics. There are more than 40,000 unique items for players to discover, create, or buy within the game.

But what does playing EverQuest have to do with whole numbers, or with studying math in general? Research by U.S. economist, Edward Castronova, showed that EverQuest players earned an average of over $3 for every hour spent playing the game by trading skills and possessions with other players. But does studying math (or any other subject) have an economic value, as well? The answer, of course, is yes. The average college student will spend approximately 150 hours per subject studying or attending class, or 3,000 hours total for an associate's degree. Increased earnings for graduates with associate's degrees will total nearly $120,000 over a career, as compared to high school graduates. For every hour you spend studying or attending class, you will get $40 back! So before you get started gaming, make sure your math homework is finished!

LEARNING OUTCOMES

1-1 Place Value and Our Number System

1. Read whole numbers.
2. Write whole numbers.
3. Round whole numbers.

1-2 Operations with Whole Numbers

1. Add whole numbers.
2. Subtract whole numbers.
3. Multiply whole numbers.
4. Divide whole numbers.

This text will prepare you to enter the business world with mathematical tools for a variety of career paths. The chapters on business topics build on your knowledge of mathematics, so it is important to begin the course with a review of the mathematics and problem-solving skills you will need in the chapters to come.

In most businesses, arithmetic computations are done on a calculator or computer. Even so, every businessperson needs a thorough understanding of mathematical concepts and a basic number sense in order to make the best use of a calculator. A machine will do only what you tell it to do. Pressing a wrong key or performing the wrong operations on a calculator will result in a rapid but incorrect answer. If you understand the mathematics and know how to make reasonable estimates, you can catch and correct many errors.

1-1 PLACE VALUE AND OUR NUMBER SYSTEM

LEARNING OUTCOMES

1 Read whole numbers.
2 Write whole numbers.
3 Round whole numbers.

Digit: one of the ten symbols used in the decimal-number system: 0, 1, 2, 3, 4, 5, 6, 7, 8, 9.

Whole number: a number from the set of numbers including zero and the counting or natural numbers: 0, 1, 2, 3, 4,

Mathematical operations: calculations with numbers. The four operations that are often called basic operations are addition, subtraction, multiplication, and division.

Our system of numbers, the decimal-number system, uses ten symbols called **digits:** 0, 1, 2, 3, 4, 5, 6, 7, 8, 9. Numbers in the decimal system can have one or more digits. Each digit in a number that contains two or more digits must be arranged in a specific order to have the value we intend for the number to have. One set of numbers in the decimal system is the set of **whole numbers:** 0, 1, 2, 3, 4,

Most business calculations involving whole numbers include one or more of four basic **mathematical operations:** addition, subtraction, multiplication, and division.

1 Read whole numbers.

What business situations require that we read and write whole numbers? Communication is one of the most important skills of successful businesspersons. Both the giver and the receiver of communications must have the same interpretation for the communication to be effective. That is why understanding terminology and the meanings of symbolic representations is an important skill.

Period: a group of three place values in the decimal-number system.

Place-value system: a number system that determines the value of a digit by its position in a number.

Beginning with the ones place on the right, the place values are grouped in groups of three places. Each group of three place values is called a **period.** Each period has a name and a ones place, a tens place, and a hundreds place. In a number, the first period from the left may have less than three digits. In many cultures the periods are separated with commas.

Reading numbers is based on an understanding of the **place-value system** that is part of our decimal number system. The chart in Figure 1-1 shows that system applied to the number 381,345,287,369,021.

To apply the place-value chart to any number, follow the steps given in the HOW TO feature. You'll find this feature, and examples illustrating its use, throughout this text.

Trillions			Billions			Millions			Thousands			Units		
Hundred trillions (100,000,000,000,000)	Ten trillions (10,000,000,000,000)	Trillions (1,000,000,000,000)	Hundred billions (100,000,000,000)	Ten billions (10,000,000,000)	Billions (1,000,000,000)	Hundred millions (100,000,000)	Ten millions (10,000,000)	Millions (1,000,000)	Hundred thousands (100,000)	Ten thousands (10,000)	Thousands (1,000)	Hundreds (100)	Tens (10)	Ones (1)
3	8	1	3	4	5	2	8	7	3	6	9	0	2	1
381 trillion,			345 billion,			287 million,			369 thousand,			021		

FIGURE 1-1
Place-Value Chart for Whole Numbers

HOW TO Read a whole number

	Read the number 4,693,107
1. Separate the number into periods beginning with the rightmost digit and moving to the left.	
2. Identify the period name of the leftmost period.	4 million
3. For each period, beginning with the leftmost period:	
(a) Read the three-digit number from left to right.	4,693,107 four *million,* six hundred ninety-three *thousand,* one hundred seven
(b) Name the period.	
4. Note these exceptions:	
(a) Do not read or name a period that is all zeros.	
(b) Do not name the units period.	

EXAMPLE 1 Read the number 3,007,047,203.

3 007 047 203 Identify each period name.

3 billion, 007 million, 047 thousand, 203 Read the words for the numbers in each period. Name each period except the units period.

Three billion, seven million, forty-seven thousand, two hundred three.

TIP

Points to Remember in Reading Whole Numbers

1. Commas separating periods are inserted from right to left between groups of three numbers. The leftmost period may have fewer than three digits.
2. The period name will be read at each comma.
3. Period names are read in the singular: *million* instead of *millions,* for example.
4. Since no comma follows the units period, that will serve as your reminder that the period name *units* is not read.
5. *Hundreds* is NOT a period name.
6. Every period has a ones, tens, and hundreds *place.*
7. The word *and* is NOT used when reading whole numbers.
8. Commas ordinarily do not appear in calculator displays.
9. If a number has more than four digits, but no commas, such as you see on a calculator display, insert commas when you write the number. The comma is optional in numbers with four digits.

STOP AND CHECK

Write the words used to read the number.

1. 7,352,496 2. 4,023,508

3. 62,805,000,927 4. 587,000,000,912

2 Write whole numbers.

Suppose you are in a sales meeting and the marketing manager presents a report of the sales for the previous quarter, the projected sales for the current quarter, and the projected sales for the entire year. How would you record these figures in the notes you are taking for the meeting? You will need to have a mental picture of the place-value structure of our numbering system.

HOW TO Write a whole number

1. Begin recording digits from left to right.
2. Insert a comma at each period name.
3. Every period after the first period must have three digits. Insert zeros as necessary.

EXAMPLE 1 Write the number, given its word name.

(a) Fifteen million, three hundred sixty-two thousand, five hundred thirty-eight

(b) Five hundred forty-two billion, five hundred thousand, twenty-nine

(a) 15, __ __ __,__ __ __

15,362,538

The number is 15,362,538.

Record the first digits followed by a comma when the period name *million* is heard (or read). Then anticipate the periods to follow (thousand and unit).

Fill in each remaining period as the digits and period names are heard (or read).

(b) 542,__ __ __,__ __ __,__ __ __

542,__ __ __,500,__ __ __

542,000,500,029

Record the first period and anticipate the periods to follow (million, thousand, and unit).

The next period name you hear (or read) is *thousand,* so you place the 500 in the thousand period, saving space to place three zeros in the million period.

Place three zeros in the *million* period and listen for (read) the last three digits. You hear (read) *twenty-nine,* which is a two-digit number. Thus, a 0 is placed in the hundreds place.

The number is 542,000,500,029.

✓ STOP AND CHECK

1. Write the number for eighteen billion, seventy-eight million, three hundred ninety-seven thousand, two hundred three.

2. Write the number for thirty-six thousand, seventeen.

3. Krispy Kreme had profits of nine hundred thirty-two thousand, eight hundred six dollars. Write the profit in numbers.

4. Jet Blue, one of the nation's most profitable airlines, sold fifty-two thousand, eight hundred ninety-six tickets. Write the number.

3 Round whole numbers.

Rounded number: an approximate number that is obtained from rounding an exact amount.

Approximate number: a rounded amount.

Exact numbers are not always necessary or desirable. For example, the board of directors does not want to know to the penny how much was spent on office supplies (though the accounting staff should know). Approximate or rounded numbers are often used. A **rounded number** does not represent an exact amount. It is instead an **approximate number.** You round a number to a specified place, which may be the first digit from the left in a number.

HOW TO Round a whole number to a specified place

	Round 2,748 to the nearest hundred.
1. Find the digit in the specified place.	2,748
2. Look at the next digit to the right.	2,748
(a) If this digit is less than 5, replace it and all digits to its right with zeros.	2,700
(b) If this digit is 5 or more, add 1 to the digit in the specified place, and replace all digits to the right of the specified place with zeros.	

EXAMPLE 1 Round to the indicated place.

(a) 52,647 to the nearest hundred
(b) 16,982 to the nearest hundred

(a) 52,647	The hundreds digit is 6.
52,647	The digit to the right is 4.
52,600	4 is less than 5; leave 6 and replace all digits to the right with zeros.
(b) 16,982	The hundreds digit is 9.
16,982	The digit to the right is 8.
17,000	8 is 5 or more, so add 1 to 9 to get 10. Carry 1 (from 10) to 6 to get 7. Record 7 and replace all digits to the right with zeros.

EXAMPLE 2 Round 2,748 to the first digit.

The specified place is the place of the first digit.

2,748	The first digit is 2.
2,748	The digit to the right of 2 is 7.
3,000	7 is 5 or more, so step 2b applies: Add 1 to 2 to get 3, and replace all digits to its right with zeros.

2,748 rounded to the first digit is 3,000.

✓ STOP AND CHECK

1. Round 3,784,921 to the nearest thousand.

2. Round 6,098 to the nearest ten.

3. Round 52,973 to the nearest hundred.

4. Round 17,439 to the first digit.

5. Southwest Airlines, one of the largest in the United States, sold 584,917 tickets. Write this as a number rounded to the first digit.

6. The two-year-average median household income for Maryland in a recent year was $57,265. Round to the nearest thousand dollars.

SKILL BUILDERS

Write the words used to read the number.

1. 22,356,027

2. 106,357,291,582

3. 730,531,968

4. 21,000,017

5. 523,800,007,190

6. 713,205,538

Write as numbers.

7. Fourteen thousand, nine hundred eighty-five.

8. Thirty-two million, nine hundred forty-three thousand, six hundred eight.

9. Seventeen billion, eight hundred three thousand, seventy-five.

10. Fifty million, six hundred twelve thousand, seventy-eight.

11. Three hundred six thousand, five hundred forty-one.

12. Three hundred million, seven hundred sixty thousand, five hundred twelve.

13. Round 483 to tens.

14. Round 3,762 to hundreds.

15. Round 298,596 to ten-thousands.

16. Round 57,802 to the first digit.

APPLICATIONS

17. Cisco, the world's largest Internet equipment maker, recorded earnings of about $3,585,000,000. Write the words used to read Cisco's earnings.

18. Net income at Levi Strauss, the world's biggest maker of branded clothing, was expected to be twenty-five million, nine hundred seventy-two thousand, eight hundred dollars. Write as a number.

19. McDonald's produced 86,347,582 Big Macs. How many Big Macs were produced to the nearest million?

20. Oslo, Hong Kong, Tokyo, and New York City are the four most expensive cities in the world, according to one source. Workers in Oslo work 1,582 hours per year on average. Round the number of hours to the first digit.

LEARNING OUTCOMES

1 Add whole numbers.
2 Subtract whole numbers.
3 Multiply whole numbers.
4 Divide whole numbers.

The operation of addition is used to find the total of two or more quantities. At Dollar General you purchase two toys, three bottles of cleaning products, and four types of cosmetic products. We use addition to find the total number of items purchased.

1 Add whole numbers.

If you purchase more than one item, you do not ordinarily pay for each item separately. Instead, the prices of all items are added together and you pay the total amount.

Numbers being added are called **addends.** The answer, or result, of addition is called the **sum** or **total.**

Addends: numbers being added.

Sum or total: the answer or result of addition.

$$
\begin{array}{rl}
\text{addends} & \begin{array}{r} 2 \\ 3 \\ +4 \\ \hline \end{array} \quad \begin{array}{l} 2+3=5 \\ \\ 5+4=9 \end{array} \\
\text{sum or total} & 9
\end{array}
$$

Only two numbers are added at a time. These two numbers can be added in either order without changing the sum. This property is called the **commutative property of addition.** It is casually referred to as the *order property of addition.*

When more than two numbers are added, two are grouped and added first. Then, the sum of these two numbers is added to another number. The addends can be grouped two at a time in any way. This property is called the **associative property of addition** and is casually referred to as the *grouping property of addition.*

Commutative property of addition: two numbers can be added in either order without changing the sum.

Associative property of addition: when more than two numbers are added, the addends can be grouped two at a time in any way.

HOW TO Add whole numbers

1. Write the numbers in a vertical column, aligning digits according to their places.
2. For each *place* in turn, beginning with the ones place:
 (a) Add the *place* digits.
 (b) Write the units digit of this sum directly below the *place* digit of the last addend.
 (c) Write the remaining digits of the sum directly above the *next place* digit of the first addend.

EXAMPLE 1 Add 472 + 83 + 3,255.

Write the numbers in a vertical column, aligning digits by place value.

$$
\begin{array}{r}
{\scriptstyle 2\,1} \\
472 \\
83 \\
3,255 \\
\hline
3,810
\end{array}
$$

Add the ones place digits, carrying 1 to the tens place. Add the tens place digits, carrying 2 to the hundreds place. Add the hundreds place digits. Finally, add the thousands place digits.

The sum is 3,810.

Estimate: to find a reasonable approximate answer for a calculation.

There are several ways to improve your accuracy in calculations. One is to recalculate. A second way is to recalculate using a calculator. A third way is to **estimate** the result before or after you calculate.

A quick and often-used way to estimate a sum is to round each addend to its first digit and add the rounded addends.

Estimate $472 + 83 + 3{,}255$.

1. Estimate the sum by rounding each addend.
2. Add the rounded amounts, mentally if possible.
3. Check addition by adding the numbers again. The second time the numbers can be added in a different order or by using a different method.

472	500
83	80
+ 3,255	+ 3,000
3,810	3,580

Check:

	3,255
	472
+	83
	3,810

EXAMPLE 2 Estimate the sum by rounding each addend to its first digit. Compare the estimate to the exact sum.

		Estimate:		Exact sum:
885	rounds to	900	The rounded numbers	885
569	rounds to	600	have all zeros in the tens	569
343	rounds to	300	and ones places. Mentally	343
231	rounds to	200	add the digits in the	231
+ 562	rounds to	+ 600	hundreds place and affix	+ 562
		2,600	the two zeros.	2,590

(Exact sum carries: $\overset{2\ 22}{885}$)

The estimate is 2,600; the exact sum is 2,590.

When we perform calculations with a calculator or computer software, it is important to estimate and to check the reasonableness of our answer. There are many different types of calculators, and each type may operate slightly differently. You can teach yourself how to use your calculator using some helpful learning strategies.

TIP

Test Your Calculator by Entering a Problem That You Can Do Mentally

Add $3 + 5$ on your calculator. Some options are

3 $+$ 5 $=$

3 $+$ 5 $+$ T T represents Total.

3 $+$ 5 $ENTER$ EXE is equivalent to $ENTER$ or $=$ on some calculators.

When adding more than two numbers, does your calculator accumulate the total in the display as you enter numbers? Or does your calculator give the total after the $ENTER$, T, or $=$ key is pressed?

In general, we will provide calculator steps for a business or scientific calculator. To show the result of a calculation that appears in the display of the calculator, we will precede the result with the symbol \Rightarrow.

Five-Step Problem-Solving Strategy Decision making or problem solving is an important skill for the successful businessperson. The decision-making process can be applied by either individuals or action teams. Many strategies have been developed to enable individuals and teams to *organize* the information given and to *develop* a plan for finding the information needed to make effective business decisions or to solve business-related problems.

The plan we use is a five-step process. This feature will be highlighted throughout the text. The key words to identify each of the five steps are:

What You Know	What You Are Looking For	Solution Plan
What relevant facts are known or given?	What amounts do you need to find?	How are the known and unknown facts related? What formulas or definitions are used to establish a model? In what sequence should the operations be performed?

Solution

Perform the operations identified in the solution plan.

Conclusion

What does the solution represent within the context of the problem?

EXAMPLE 3 Holly Hobbs supervises the shipping department at AH Transportation and must schedule her employees to handle all shipping requests within a specified time frame while keeping the payroll amount within the amount budgeted. Complete the payroll report (Table 1-1) for the first quarter and decide if Holly has kept the payroll within the quarterly department payroll budget of $25,000.

TABLE 1-1
Quarterly Payroll Report for the Shipping Department

Employee	Quarterly Payroll
Doroshonko, Nataliya	$ 5,389
Campbell, Karen	5,781
Linebarger, Lydia	6,463
Ores, Vincent	5,389
Department Total	$23,022

What You Know	What You Are Looking For	Solution Plan
Quarterly pay for each employee (in table) Quarterly department budget: $25,000	Quarterly department payroll Is the payroll within budget?	Quarterly department payroll = sum of quarterly pay for each employee Compare the quarterly department payroll to the quarterly department budget

Solution

Find the quarterly department payroll.

Using a calculator:

5389 ⊞ 5781 ⊞ 6463 ⊞ 5389 ⊟ ⟹ 23022

The quarterly department payroll is $23,022, which is less than the budgeted amount of $25,000.

Conclusion

Holly's department payroll for the quarter _is_ within the amount budgeted for the department.

✓ STOP AND CHECK

Mentally estimate the sum by rounding to the first digit. Compare the estimate with the exact sum.

1. 372 + 583 + 697

2. 9,823 + 7,516 + 8,205

3. $618 + $736 + $107

4. $1,809 + $3,521

5. Hales Shipping Company is projecting revenue of $1,200,000. At the end of the year Hales had revenue of $789,000 from its ten largest clients and $342,000 from its other clients. Did the company reach its projection?

6. Marie's Costume Shop projected annual revenue of $2,500,000. Revenue for each quarter was $492,568; $648,942; $703,840; and $683,491. Did the shop achieve its revenue goal?

2 Subtract whole numbers.

Subtraction is the opposite of addition. We use subtraction to find a *part* when we know a total amount and one of two *parts*. We may need to know the amount of change when a price has increased to a higher price. If we do not have enough material to complete a job, we may need to know how much more material is needed.

When subtracting one number from another, the number subtracted from is called the **minuend.** The number being subtracted is called the **subtrahend.** The result of subtraction is called the **difference.**

Minuend: the beginning amount or the number that a second number is subtracted from.

Subtrahend: the number being subtracted.

Difference: the answer or the result of subtraction.

$$
\begin{array}{r}
135 \rightarrow \text{minuend} \\
- 72 \rightarrow \text{subtrahend} \\
\hline
63 \rightarrow \text{difference}
\end{array}
$$

The order of the numbers in a subtraction problem *is* important. That is, subtraction is *not* commutative. For example, $5 - 3 = 2$, but $3 - 5$ does not equal 2.

Grouping in subtraction *is* important. That is, subtraction is *not* associative. For example, $(8 - 3) - 1 = 5 - 1 = 4$, but $8 - (3 - 1) = 8 - 2 = 6$.

HOW TO Subtract and check whole numbers

1. Write the numbers in a vertical column, the subtrahend below the minuend, aligning digits according to their places.
2. For each *place* in turn, beginning with the ones place:

 (a) If the *place* digit of the minuend is less than the *place* digit of the subtrahend, **regroup** by subtracting 1 from the *next place* digit to the left. Add 10 to the *place* digit of the minuend.

 (b) Subtract the *place* digits.

 (c) Write this difference directly below the *place* digit of the subtrahend.
3. Check the difference by adding the subtrahend and the difference. Their sum should be the same as the minuend.

Regroup: regroup digits in the minuend by borrowing 1 from the digit to the left of a specified place and adding 10 to the digit in the specified place. This is also called *borrowing.*

EXAMPLE 1 Subtract 27 from 64.

$$\begin{array}{r} 64 \\ -27 \\ \hline \end{array}$$
Arrange the numbers so that the places align.

$$\begin{array}{r} {}^{5}\ {}^{14} \\ 6\ 4 \\ -2\ 7 \\ \hline 3\ 7 \end{array}$$
4 is smaller than 7, so regroup by subtracting 1 from the tens place (thus 6 becomes 5) and add 10 to the ones place.
Subtract ones-place digits; then subtract tens-place digits.

Using a calculator:

$64 \boxed{-} 27 \boxed{=} \Rightarrow 37$

Check:

$$\begin{array}{r} 27 \\ +37 \\ \hline 64 \end{array}$$
The sum of the subtrahend and difference equals the minuend.
The difference is correct.

The difference of 64 and 27 is 37.

✓ STOP AND CHECK

For each subtraction, mentally estimate by rounding to the first digit; then find the exact difference.

1. Subtract 96 from 138.

2. Subtract: $1{,}352 - 787$

3. Subtract: $\$3{,}807 - \$2{,}689$

4. Subtract 5,897 from 10,523.

5. Jet Blue sold 2,196,512 tickets and Southwest Airlines sold 1,993,813 tickets. How many more tickets did Jet Blue sell?

6. According to the Bureau of Labor Statistics, the number of U.S. firms with 1 to 4 employees was 2,734,133 and the number of firms with 5 to 9 employees was 1,025,497. How many more firms had 1 to 4 employees?

3 Multiply whole numbers.

Multiplication is a shortcut for repeated addition.

The new Krispy Kreme donut store at London-based Harrods sends 3 dozen (36) donuts each to 75 neighboring merchants to celebrate the grand opening of its first European location. We can multiply to get the total number of Krispy Kreme donuts sampled.

When multiplying one number by another, the number being multiplied is called the **multiplicand.** The number we multiply by is called the **multiplier.** Each number can also be called a **factor.** The result of multiplication is called the **product.** Numbers can be multiplied in any order without changing the product. When the multiplier has more than one digit, the product of each digit and the multiplicand is called a **partial product.**

Multiplicand: the number being multiplied.

Multiplier: the number multiplied by.

Factor: each number involved in multiplication.

Product: the answer or result of multiplication.

Partial product: the product of one digit of the multiplier and the entire multiplicand.

$$\begin{array}{r} 75 \\ \times\ 36 \\ \hline 450 \\ 2\ 25 \\ \hline 2{,}700 \end{array}$$

← multiplicand ⎫
← multiplier ⎬ ⟵ factors
 ⎭
⎫
⎬ ← partial products
⎭
← product

HOW TO — Multiply whole numbers

1. Write the numbers in a vertical column, aligning digits according to their places.
2. For each *place* of the multiplier in turn, beginning with the ones place:
 (a) Multiply the multiplicand by the *place* digit of the multiplier.
 (b) Write the partial product directly below the multiplier (or the last partial product), aligning the ones digit of the partial product with the *place* digit of the multiplier (and aligning all other digits to the left accordingly).
3. Add the partial products.

EXAMPLE 1 Multiply 127 by 53.

$$
\begin{array}{r}
127 \\
\times \quad 53 \\
\hline
381 \\
6\,35 \\
\hline
6{,}731
\end{array}
$$

- 127 ← multiplicand
- × 53 ← multiplier
- 381 ← first partial product: 3 × 127 = 381; 1 in 381 aligns with 3 in 53.
- 6 35 ← second partial product: 5 × 127 = 635; 5 in 635 aligns with 5 in 53.
- 6,731 ← product: add the partial products.

The product of 127 and 53 is 6,731.

TIP

Placing Partial Products Properly

When you multiply numbers that contain two or more digits, it is crucial to *place the partial products* properly. A common mistake in multiplying is to forget to "indent" the partial products that follow the first partial product.

$$
\begin{array}{r}
265 \\
\times \quad 23 \\
\hline
795 \\
5\,30 \\
\hline
6{,}095
\end{array}
$$

We get the second partial product, 530, by multiplying 265 × 2. Therefore, the 0 in 530 should be directly below the 2 in 23.

$$
\begin{array}{r}
265 \\
\times \quad 23 \\
\hline
795 \\
530 \\
\hline
1{,}325
\end{array}
$$

CORRECT **INCORRECT**

As in addition, you can improve your multiplication accuracy by recalculating manually, by recalculating using a calculator, and by estimating the product.

Zeros are used in many helpful shortcuts to multiplying. Pay careful attention to the position of zeros in partial products. When one of the numbers being multiplied has ending zeros, you can use a shortcut to find the product.

HOW TO — Multiply when numbers end in zero

1. Mentally eliminate zeros from the end of each number.
2. Multiply the new numbers.
3. Attach to the end of the product the total number of zeros mentally eliminated in step 1.

EXAMPLE 2 Multiply 20,700 by 860.

$$
\begin{array}{r}
20{,}7\,00 \\
\times \quad 86\,0 \\
\hline
1\,242 \\
16\,56 \\
\hline
17{,}802{,}000
\end{array}
$$

Mentally eliminate three zeros from the ends of 20,700 and 860.
Multiply 207 by 86, aligning digits and finding partial products.

Attach the three zeros that were mentally eliminated in step 1.

The product of 20,700 and 860 is 17,802,000.

EXAMPLE 3 Max Wertheimer works at the Wendy's warehouse and is processing store orders totaling 45,000 sixteen-ounce cups. He found 303 packages of sixteen-ounce cups. Each package contains a gross of cups. Does Max need to order more cups from the manufacturer to fill the store orders if one gross is 144 items?

What You Know	What You Are Looking For	Solution Plan
Store orders: 45,000 cups Packages of cups on hand: 303 Cups per package: 1 gross, or 144	Total quantity of cups on hand Should more cups be ordered?	Total quantity of cups on hand = packages of cups on hand × cups per package Compare the total quantity of cups on hand with 45,000 cups.

Solution

Using a calculator:

303 $\boxed{\times}$ 144 $\boxed{=}$ \Rightarrow 43632

Conclusion

There are 43,632 cups in the warehouse, but store orders total 45,000. **Max needs to order more cups from the manufacturer to fill all the store orders.**

 STOP AND CHECK

Mentally estimate the product by rounding to the first digit. Find the exact product.

1. 317 × 52

2. 6,723 × 87

3. 4,600 × 70

4. 538,000 × 420

5. A plastic film machine can produce 75 rolls of plastic in an hour. How many rolls of plastic can be produced by the machine in a 24-hour period? Arcaro Plastics has 15 of these machines. How many rolls of plastic can be produced if all 15 machines operate for 24 hours?

6. Malina Kodama creates 48 pottery coffee cups and 72 pottery bowls in a day. How many can be produced in a 22-day month? If 809 coffee cups and 1,242 bowls were sold in the same 22-day month, how many of each item remained in inventory?

4 Divide whole numbers.

Dividend: the number being divided or the total quantity.

Divisor: the number divided by.

Quotient: the answer or result of division.

Whole-number part of quotient: the quotient without regard to the remainder.

Remainder of quotient: a number that is smaller than the divisor that remains after the division is complete.

Partial dividend: the part of the dividend that is being considered at a given step of the process.

Partial quotient: the quotient of the partial dividend and the divisor.

Christine Shott received a price quote by fax for a limited quantity of discontinued telephone answering machines. The fax copy was not completely readable, but Christine could read that the total bill, including shipping, was $905 and each answering machine costs $35. How many answering machines were available and how much was the shipping cost? Division is used to find the number of equal parts a total quantity can be separated into.

When dividing one number by another, the number being divided (total quantity) is called the **dividend.** The number divided by is called the **divisor.** The result of division is called the **quotient.** When the quotient is not a whole number, the quotient has a **whole-number part** and a **remainder.** When a dividend has more digits than a divisor, parts of the dividend are called **partial dividends,** and the quotient of a partial dividend and the divisor is called a **partial quotient.**

Christine now knows that 25 answering machines are available. What does the remainder represent? The dividend, $905, is in dollars, so the remainder also represents dollars. The remainder of $30 is the shipping cost.

HOW TO Divide whole numbers

1. Beginning with its leftmost digit, identify the first group of digits of the dividend that is larger than or equal to the divisor. This group of digits is the first *partial dividend*.
2. For each partial dividend in turn, beginning with the first:
 (a) Divide the partial dividend by the divisor. Write this partial quotient above the rightmost digit of the partial dividend.
 (b) Multiply the partial quotient by the divisor. Write the product below the partial dividend, aligning places.
 (c) Subtract the product from the partial dividend. Write the difference below the product, aligning places. The difference must be less than the divisor.
 (d) Next to the ones place of the difference, write the next digit of the dividend. This is the new partial dividend.
3. When all the digits of the dividend have been used, write the final difference in step 2c as the remainder (unless the remainder is 0). The whole-number part of the quotient is the number written above the dividend.
4. To check, multiply the quotient by the divisor and add the remainder to the product. This sum equals the dividend.

$$905 \div 35$$

$$35\overline{)905}$$

$$\begin{array}{r} 25 \\ 35\overline{)905} \\ 70 \\ \hline 205 \\ 175 \\ \hline 30 \end{array}$$

Check:

$$\begin{array}{r} 25 \\ \times\ 35 \\ \hline 125 \\ 75 \\ \hline 875 \end{array} \qquad \begin{array}{r} 875 \\ +\ 30 \\ \hline 905 \end{array}$$

TIP

What Types of Situations Require Division?

Two types of common business situations require division. Both types involve distributing items equally into groups.

1. Distribute a specified total quantity of items so that each group gets a specific equal share. Division determines the number of groups.

 For example, you need to ship 78 crystal vases. With appropriate packaging to avoid breakage, only 5 vases fit in each box. How many boxes are required? You divide the total quantity of vases by the quantity of vases that will fit into one box to determine how many boxes are required.

2. Distribute a specified total quantity so that we have a specific number of groups. Division determines each group's equal share.

 For example, how many ounces will each of four cups contain if a carafe of coffee containing 32 ounces is poured equally into the cups? The capacity of the carafe is divided by the number of coffee cups: 32 ounces ÷ 4 coffee cups = 8 ounces. Eight ounces of coffee are contained in each of the four cups.

EXAMPLE 1 Tuesday Morning Discount Store needs to ship 78 crystal vases. With standard packing to avoid damage, 5 vases fit in each available box. How many boxes will be needed to ship the 78 vases? Does the Tuesday Morning shipping clerk need to arrange for extra packing or will each box contain exactly 5 vases?

What You Know	What You Are Looking For	Solution Plan
Total quantity of vases to be shipped: 78	How many boxes are required to ship the vases?	Quantity of boxes needed = total quantity of vases ÷ quantity of vases per box
Quantity of vases per box without the extra packing: 5	Is extra packing required?	Quantity of boxes needed = 78 ÷ 5

$$\begin{array}{r} 15\ R3 \\ 5\overline{)78} \\ \underline{5} \\ 28 \\ \underline{25} \\ 3 \end{array}$$ Divide 78 by 5. The whole-number part of the quotient is 15; the remainder is 3.

Check:

Multiply the whole-number part of the quotient, 15, by the divisor, 5. Then add the remainder. The sum should equal the dividend, 78.

$$\begin{array}{r} 15 \\ \times\ 5 \\ \hline 75 \end{array} \qquad \begin{array}{r} 75 \\ +\ 3 \\ \hline 78 \end{array}$$ The result checks.

The quantity of boxes needed is 15 boxes containing 5 vases and 1 box containing 3 vases.

Conclusion

Fifteen boxes will have 5 vases each, needing no extra packing. One additional box is required to ship the remaining 3 vases for a total of **16 boxes needed. Extra packing is needed to fill the additional box.**

TIP

Using Guess and Check to Solve Problems

An effective strategy for solving problems involves guessing. Make a guess that you think might be reasonable and check to see if the answer is correct. If your guess is not correct, decide if it is too high or too low. Make another guess based on what you learned from your first guess. Continue until you find the correct answer.

Let's try guessing in the previous example. Estimating we find that we can pack 70 vases in 14 boxes ($14 \times 5 = 70$). Since we need to pack 78 vases, how many vases can we pack with 15 boxes? $15 \times 5 = 75$. Still not enough. Therefore, we will need 16 boxes, but the last box will not be full.

TIP

Carefully Align Partial Dividends and Partial Quotients

Be careful in aligning the numbers in a division problem and in entering zeros in the quotient.

$$\begin{array}{r} 507 \\ 5\overline{)2,535} \\ \underline{2\ 5} \\ 3 \\ \underline{0} \\ 35 \\ \underline{35} \\ 0 \end{array}$$ 5 will not divide into 3. Place a zero in the quotient before bringing down the next digit.

CORRECT **INCORRECT**

As with multiplication, ending zeros in division can lead to a shortcut.

HOW TO Divide numbers ending in zero by place-value numbers like 10, 100, 1,000.

1. Mentally eliminate the same number of ending zeros from both the divisor and the dividend.
2. Divide the new numbers.

EXAMPLE 2 Divide the following: (a) $531,000 \div 300$ (b) $63,500,000 \div 1,000$

(a) $531,000 \div 300$ Eliminate two ending zeros from both numbers.

$5,310 \div 3$ Divide.

$$\frac{1,770}{3\overline{)5,310}}$$

$531,000 \div 300 = 1,770$

(b) $63,500,000 \div 1,000$ Eliminate three ending zeros from both numbers.

$63,500 \div 1 = 63,500$ Divide.

✔ STOP AND CHECK

Divide.

1. $2,772 \div 6$

2. $6,744 \div 24$

3. $14,335 \div 47$

4. $1,263 \div 15$

5. The Gap purchases 5,184 pairs of blue jeans to be distributed evenly among 324 stores. How many pairs should be sent to each store?

6. Auto Zone purchases 26,560 cans of car wax on a special manufacturer's offer. It distributes a case of 64 cans to each store. How many stores can get the special offer?

1-2 SECTION EXERCISES

SKILL BUILDERS

Mentally estimate the sum by rounding to the first digit.

1.
 328
 583
 +726

2.
 671
 982
 + 57

3. Add: $791 + 1,000 + 52$

Subtract and check the difference.

4.
 5 5
 − 3 6

5.
 3 0 8
 − 2 7 5

6. $5,409 - 2,176$

Multiply and check the product.

7.
 730
 × 60

8.
 904
 × 24

9. 1,005 by 89

Divide and check the quotient.

10. 96 ÷ 6

11. 13,838 ÷ 34

12. 17)‾4,420

APPLICATIONS

13. The menswear department of the Gap has a sales goal of $1,384,000 for its Spring sale. Complete the worksheet (Table 1-2) for the sales totals by region and by day. Decide if the goal was reached. What is the difference between the goal and the actual total sales amount?

TABLE 1-2						
Region	**W**	**Th**	**F**	**S**	**Su**	**Region Totals**
Eastern	$ 72,492	$ 81,948	$ 32,307	$ 24,301	$ 32,589	
Southern	81,897	59,421	48,598	61,025	21,897	
Central	71,708	22,096	23,222	21,507	42,801	
Western	61,723	71,687	52,196	41,737	22,186	
Daily Sales Total						

14. Atkinson's Candy Company manufactures seven types of hard candy for its Family Favorites mixed candy. The bulk candy is repackaged from 84 containers that each contain 25 pounds of candy. The bulk candy is bagged in 3-pound bags and then packed in boxes for shipping. Each box contains 12 bags of mixed candy. Wilma Jackson-Randle reports that she currently has 1,000 3-pound bags on hand and 100 boxes of the size that will be used to ship the candy. Decide if enough materials are in inventory to complete the mixing and packaging process.

15. University Trailer Sales Company sold 352 utility trailers during a recent year. If the gross annual sales for the company was $324,800, what was the average selling price for each trailer?

16. An acre of ground is a square piece of land that is 210 feet on each of the four equal sides. Fencing can be purchased in 50-foot rolls for $49 per roll. You are giving a bid to install the fencing at a cost of $1 per foot of fencing plus the cost of materials. If the customer has bids of $1,700, $2,500, and $2,340 in addition to your bid, decide if your bid is the low bid for the job to determine if you will likely get the business.

17. If you are paying three employees $7 per hour and the fence installation in Exercise 16 requires 21 hours when all three employees are working, determine how much you will be required to pay in wages. What will be your gross profit on the job?

18. The 7th Inning buys baseball cards from eight vendors. In the month of November the company purchased 8,832 boxes of cards. If an equal number of boxes were purchased from each vendor, how many boxes of cards were supplied by each vendor?

19. If you have 348 packages of holiday candy to rebox for shipment to a discount store and you can pack 12 packages in each box, how many boxes will you need?

20. Bio Fach, Germany's biggest ecologically sound consumer goods trade fair, had 21,960 visitors. This figure was up from 18,090 the previous year and 16,300 two years earlier. What is the increase in visitors to Bio Fach from two years earlier to the present?

21. The "communication revolution" has given us prepaid phone calling cards. These cards are used to make long-distance phone calls from any phone. In a recent year the industry posted sales of $500,000. Three years later the sales figure had risen to $200,000,000. What is the increase in sales over the three-year period?

22. Strategic Telecomm Systems, Inc. (STS), in Knoxville, Tennessee, made one of the largest single purchases of long-distance telephone time in history. STS purchased 42 million minutes. If STS paid 2 cents per minute, how much did they pay for the purchase? To convert cents to dollars, divide by 100.

23. If STS resells the phone time at an average of 6 cents per minute, how much profit will it make on the purchase?

24. American Communications Network (ACN) of Troy, Michigan, also markets prepaid phone cards, which it refers to as "equity calling cards." If ACN employs 214,302 persons in 32 locations, on the average, how many employees work at each location?

Section Outcome	What to Remember with Examples

Section 1-1

1 Read whole numbers. (p. 4)

1. Separate the number into periods beginning with the rightmost digit and moving to the left.
2. Identify the period name of the leftmost period.
3. For each period, beginning with the leftmost period:
 (a) Read the three-digit number from left to right.
 (b) Name the period.
4. Note these exceptions:
 (a) Do not read or name a period that is all zeros.
 (b) Do not name the units period.
 (c) The word *and* is never part of the word name for a whole number.

574 is read *five hundred seventy-four.*
3,804,321 is read *three million, eight hundred four thousand, three hundred twenty-one.*

2 Write whole numbers. (p. 6)

1. Begin recording digits from left to right.
2. Insert a comma at each period name.
3. Every period after the first period must have three digits. Insert zeros as necessary.

Write the number: twenty billion, fifteen million, two hundred four.

Record the first digits and anticipate the periods to follow.

20, __ 15,__ __ __, 204 Fill in the remaining periods, using zeros as necessary.

20,015,000,204

3 Round whole numbers. (p. 7)

1. Find the digit in the specified place.
2. Look at the next digit to the right.
 (a) If this digit is less than 5, replace it and all digits to its right with zeros.
 (b) If this digit is 5 or more, add 1 to the digit in the specified place, and replace all digits to the right of the specified place with zeros.

4,860 rounded to the nearest hundred is 4,900.
7,439 rounded to the nearest thousand is 7,000.
4,095 rounded to the first digit is 4,000.

Section 1-2

1 Add whole numbers. (p. 9)

1. Write the numbers in a vertical column, aligning digits according to their places.
2. For each *place* in turn, beginning with the ones place:
 (a) Add the *place* digits.
 (b) Write the units digit of this sum directly below the *place* digit of the last addend.
 (c) Write the remaining digits of the sum directly above the *next place* digit of the first addend.

$$
\begin{array}{r}
\text{Add:} \quad 364 \\
+\ 473 \\
\hline
837
\end{array}
$$

$$
\text{Add: } 2{,}074 + 485 + 12{,}592 \qquad
\begin{array}{r}
2{,}074 \\
485 \\
+\ 12{,}592 \\
\hline
15{,}151
\end{array}
$$

Estimate and check addition.

1. Estimate the sum by rounding each addend.
2. Add the rounded amounts, mentally if possible.
3. Check addition by adding the numbers again. The second time the numbers can be added in a different order or by using a different method.

Estimate and check the first sum in the previous example.

	Estimate	Check
364	400	473
+ 473	+ 500	+ 364
837	900	837

2 Subtract whole numbers. (p. 12)

1. Write the numbers in a vertical column, the subtrahend below the minuend, aligning digits according to their places.
2. For each *place* in turn, beginning with the ones place:
 (a) If the *place* digit of the minuend is less than the *place* digit of the subtrahend, add 10 to the *place* digit of the minuend and subtract 1 from the *next place* digit of the minuend.
 (b) Subtract the *place* digits.
 (c) Write this difference directly below the *place* digit of the subtrahend.
3. Check the difference by adding the subtrahend and the difference. Their sum should be the same as the minuend.

754	807	9,000	1079	10,000
− 329	− 321	− 3,521	− 298	− 999
425	486	5,479	781	9,001

3 Multiply whole numbers. (p. 13)

1. Write the numbers in a vertical column, aligning digits according to their places.
2. For each *place* of the multiplier in turn, beginning with the ones place:
 (a) Multiply the multiplicand by the *place* digit of the multiplier.
 (b) Write this partial product directly below the multiplier (or the last partial product), aligning the ones digit of the partial product with the *place* digit of the multiplier (and aligning all other digits to the left accordingly).
3. Add the partial products.

543	509
× 32	× 87
1 086	3 563
16 29	40 72
17,376	44,283

Multiply when numbers end in zero.

1. Mentally eliminate zeros from the end of each number.
2. Multiply the new numbers.
3. Attach to the end of the product the total number of zeros mentally eliminated in step 1.

8,1:00	$18 \times 10 = 180$
× 3:00	$18 \times 100 = 1,800$
2,4 3:0, 000	$18 \times 1,000 = 18,000$

4 Divide whole numbers. (p. 15)

1. Beginning with its leftmost digit, identify the first group of digits of the dividend that is larger than or equal to the divisor. This group of digits is the first *partial dividend.*
2. For each partial dividend in turn, beginning with the first:
 (a) *Divide* the partial dividend by the divisor. Write this partial quotient above the rightmost digit of the partial dividend.

(b) *Multiply* the partial quotient by the divisor. Write the product below the partial dividend, aligning places.

(c) *Subtract* the product from the partial dividend. Write the difference below the product, aligning places. The difference must be less than the divisor.

(d) Next to the ones place of the difference, *write* the next digit of the dividend. This is the new partial dividend.

3. When all the digits of the dividend have been used, *write* the final difference in step 2c as the remainder (unless the remainder is 0). The whole-number part of the quotient is the number written above the dividend.

4. To check, multiply the quotient by the divisor and add the remainder to the product. This sum will equal the dividend.

$$
\begin{array}{r}
287 \text{ R1} \\
3\overline{)862} \\
\underline{6} \\
26 \\
\underline{24} \\
22 \\
\underline{21} \\
1
\end{array}
\qquad
\begin{array}{r}
804 \\
56\overline{)45{,}024} \\
\underline{44\ 8} \\
22 \\
\underline{0} \\
224 \\
\underline{224}
\end{array}
\qquad
\begin{array}{l}
21{,}000 \div 10 = 2{,}100 \\
21{,}000 \div 100 = 210 \\
21{,}000 \div 1{,}000 = 21
\end{array}
$$

Divide numbers ending in zero by place-value numbers such as 10, 100, 1,000.

1. Mentally eliminate the same number of ending zeros from both the divisor and the dividend.
2. Divide the new numbers.

Divide $483{,}000 \div 200$

$483{,}000 \div 200$ Eliminate two ending zeros from both numbers.

$4830 \div 2$ Divide.

$$
\begin{array}{r}
2415 \\
2\overline{)4830}
\end{array}
$$

$483{,}000 \div 200 = 2{,}415$

EXERCISES SET A

CHAPTER 1

Write the word name for the number.

1. 4,209

Write the word name for the number.

2. 301,000,009

3. According to Toyota, the company has invested more than $7 billion in manufacturing, research, and design. Write this number as an ordinary number.

4. Toyota claims to be the fourth-largest vehicle manufacturer in America. It also claims to create more than twenty thousand direct jobs. Write this number as an ordinary number.

Round Exercises 5 through 7 to the specified place.

5. 378 (nearest hundred)

6. 9,374 (nearest thousand)

7. 834 (nearest ten)

8. A color video surveillance system with eight cameras is priced at $3,899. Round this price to the nearest thousand dollars.

9. Fiber-optic cable capacity for communications such as telephones grew from 265,472 miles to 6,316,436 miles in a six-year period. Round each of these numbers of miles to the nearest hundred thousand.

Round to the first digit.

10. 3,784,809

Round to the first digit.

11. 5,178

Add.

12. 47 + 385 + 87 + 439 + 874

Add.

13. 32,948 + 6,804 + 15,695 + 415 + 7,739

Mentally estimate the sum by rounding each number to the first digit. Then find the exact sum.

14.
74,374
82,849
72,494
+ 89,219

15.
3,748
9,409
3,577
+ 4,601

Mentally estimate the sum in Exercise 16 by rounding each number to the nearest hundred. Then find the exact sum.

16.
747
854
324
+ 687

17. Mary Luciana bought 48 pencils, 96 pens, 36 diskettes, and 50 bottles of correction fluid. How many items did she buy?

18. Kiesha had the following test scores: 92, 87, 96, 85, 72, 84, 57, 98. What is the student's total number of points?

Estimate the difference by rounding each number to the first digit in Exercises 19 through 21. Then find the exact difference.

19. 9,748
 −5,676

20. 83,748,194
 −27,209,104

21. 84,378
 −28,746

22. Sam Andrews has 42 packages of hamburger buns on hand but expects to use 130 packages. How many must he order?

23. An inventory shows 596 fan belts on hand. If the normal in-stock count is 840, how many should be ordered?

Multiply and check the product.

24. 5,931
 × 835

25. 1,987
 × 394

26. 33 × 500

27. 7,870 × 6,000

Mentally estimate the product in Exercise 28 by rounding each number to the first digit. Then find the exact product.

28. 7,489
 × 34

Mentally estimate the product in Exercise 29 by rounding each number to the nearest hundred. Then find the exact product.

29. 3,128
 × 478

30. A day-care center has 28 children. If each child eats one piece of fruit each day, how many pieces of fruit are required for a week (five days)?

31. Industrialized nations have 2,017 radios per thousand people. This is six times the number of radios per thousand people as there are in the underdeveloped nations. What is the number of radios per thousand people for the underdeveloped nations?

Divide and check the quotient.

32. 1,232 ÷ 16

Estimate the quotient in Exercise 33 by rounding each number. Then find the exact quotient.

33. 85)748,431

34. A parts dealer has 2,988 washers. The washers are packaged with 12 in each package. How many packages can be made?

35. If 127 employees earn $1,524 in one hour, what is the average hourly wage per employee?

Write the word name for the number.

1. 97,168

Write the word name for the number.

2. 5,200,000

3. Local people build Toyota vehicles in twenty-six countries around the world. Write this number as an ordinary number.

4. By its own claim, HFS, Inc., is the world's largest hotel franchising organization. It claims to have five thousand, four hundred hotels with four hundred ninety-five thousand rooms in over seventy countries, and more than twenty percent of the franchises are minority-owned. Write each of the numbers as an ordinary number.

Round Exercises 5 through 7 to the specified place.

5. 8,248 (nearest hundred)

6. 348,218 (nearest ten-thousand)

7. 29,712 (nearest thousand)

8. A black-and-white video surveillance system with eight cameras is priced at $2,499. What is the price to the nearest hundred dollars?

9. The industrialized nations of the world have six times the number of radios per thousand people as the underdeveloped nations. The industrialized nations have 2,017 radios per thousand people. Round the number of radios to the nearest hundred.

Round to the first digit.

10. 2,063,948

Round to the first digit.

11. 17,295,183,109

Add.

12. 72 + 385 + 29 + 523 + 816

Add.

13. 46,867 + 7,083 + 723 + 5,209

Mentally estimate the sum by rounding each number to the first digit. Then find the exact sum.

14.
```
   374
   847
   521
   873
 + 482
```

15.
```
   3,470
     843
   3,872
 +   574
```

Mentally estimate the sum in Exercise 16 by rounding each number to the nearest hundred. Then find the exact sum.

16.
```
   4,274
     643
   1,274
 +    97
```

17. Jorge Englade has 57 baseball cards from 1978, 43 cards from 1979, 104 cards from 1980, 210 cards from 1983, and 309 cards from 1987. How many cards does he have in all?

18. A furniture manufacturing plant had the following labor-hours in one week: Monday, 483; Tuesday, 472; Wednesday, 497; Thursday, 486; Friday, 464; Saturday, 146; Sunday, 87. Find the total labor-hours worked during the week.

Mentally estimate the difference by rounding each number to the first digit in Exercises 19 through 21. Then find the exact difference.

19. 370,408
 −187,506

20. 12,748
 − 5,438

21. 109,849
 − 35,464

22. Frieda Salla had 148 tickets to sell for a baseball show. If she has sold 75 tickets, how many does she still have to sell?

23. Veronica McCulley weighed 132 pounds before she began a weight-loss program. After eight weeks, she weighed 119 pounds. How many pounds did she lose?

Multiply and check the product.

24. 5,565
 × 839

25. 78,626
 × 87

26. 283 × 3,000

27. 405 × 400

Mentally estimate the product in Exercise 28 by rounding each number to the first digit. Then find the exact product.

28. 378
 × 72

Mentally estimate the product in Exercise 29 by rounding each number to the nearest hundred. Then find the exact product.

29. 378
 × 546

30. Auto Zone has a special on fuel filters. Normally, the price of one filter is $15, but with this sale, you can purchase two filters for only $27. How much can you save by purchasing two filters at the sale price?

31. Industrialized nations have 793 TV sets per thousand people. If this is nine times as many TVs per thousand people as there are in the underdeveloped nations, what is the number of TVs per thousand people in the underdeveloped nations?

Divide and check the quotient.

32. 4,020 ÷ 12

Estimate the quotient in Exercise 33 by rounding each number. Then find the exact quotient.

33. $346\overline{)174,891}$

34. A stack of countertops measures 238 inches. If each countertop is 2 inches thick, how many are in the stack?

35. Sequoia Brown has 15 New Zealand coins, 32 Canadian coins, 18 British coins, and 12 Australian coins in her British Commonwealth collection. How many coins does she have in this collection?

PRACTICE TEST

Write the word name for the number.

1. 503

2. 12,056,039

Round to the specified place.

3. 84,321 (nearest hundred)

4. 58,967 (nearest thousand)

5. 80,235 (first digit)

6. 587,213 (first digit)

Write the number.

7. Five billion, seventeen million, one hundred thirty-five thousand, six hundred thirty-two.

8. Seventeen million, five hundred thousand, six hundred eight.

Estimate by rounding to hundreds. Then find the exact result.

9. 863 + 983 + 271

10. 987 − 346

Estimate by rounding to the first digit. Then find the exact result.

11. 892 × 46

12. $53\overline{)4{,}021}$

13. An inventory clerk counted the following items: 438 rings, 72 watches, and 643 pen-and-pencil sets. How many items were counted?

14. A warehouse is 31 feet high. Boxes that are each two feet high are to be stacked in the warehouse. How many boxes can be stacked one on top of the other?

15. A parts dealer has 2,988 washers. The washers are packaged with 12 in each package. How many packages can be made?

16. Baker's Department Store sold 23 pairs of ladies' leather shoes. If the store's original inventory was 43 pairs of the shoes, how many pairs remain in inventory?

17. Galina makes $680 a week. If she works 40 hours a week, what is her hourly pay rate?

18. A day-care center has 28 children. If each child eats two pieces of fruit each day, how many pieces of fruit are required for a week (five days)?

19. An oral communication textbook contains three pages of review at the end of each of its 16 chapters. What is the total number of pages devoted to review?

20. John Chang ordered 48 paperback novels for his bookstore. When he received the shipment, he learned that 11 were on back order. How many novels did he receive?

1. Addition and subtraction are inverse operations. Write the following addition problem as a subtraction problem and find the value of the letter n.
 $12 + n = 17$

2. Multiplication and division are inverse operations. Write the following multiplication problem as a division problem and find the value of the letter n.
 $5 \times n = 45$

3. Give an example illustrating that the associative property does NOT apply to subtraction.

4. Give an example illustrating that the commutative property does NOT apply to division.

5. Describe a problem you have encountered that required you to add whole numbers.

6. Describe a problem you have encountered that required you to multiply whole numbers.

7. What operation is a shortcut for repeated addition? Give an example to illustrate your answer.

8. If you know a total amount and all the parts but one, explain what operations you would use to find the missing part.

9. What operation enables you to find the cost per item if you know the total cost of a certain number of items and you know each item has the same price?

10. Find and explain the mistake in the following. Rework the problem correctly.

$$
\begin{array}{r}
59 \\
12\overline{)6,108} \\
6\,0 \\
\hline
108 \\
108 \\
\hline
\end{array}
$$

Challenge Problem

Sales Quotas. A sales quota establishes a minimum amount of sales expected during a given period for a salesperson in some businesses, such as selling cars or houses. In setting sales quotas, sales managers take certain factors into consideration, such as the nature of the sales representative's territory and the experience of the salesperson. Such sales quotas enable a company to forecast the sales and future growth of the company for budget and profit purposes.

Try the following quota problem:

A sales representative for a time-sharing company has a monthly sales quota of 500 units. The representative sold 120 units during the first week, 135 units during the second week, and 165 units during the third week of the month. How many units must be sold before the end of the month if the salesperson is to meet the quota?

1.1 Take the Limo Liner

At Graphic Express, Inc., Bob is planning to take three managers to a weekly meeting in New York. Traveling from Boston to New York for meetings has been part of the normal course of doing business at Graphics Express for several years, and the travel expenses and wasted time represent a considerable cost to the company. Normally, Bob's managers set up travel arrangements individually and get a reimbursement from the company. Desiring to cut costs and increase productivity, Bob decides to investigate alternative modes of making this weekly trip. He discovered that Amtrak Acela Express costs $178 for the round trip from Boston to New York. A taxi from the train station to the meeting costs about $40. The managers live in different parts of Boston, so carpooling in one car has not worked well; however, if two of the managers drive the 440-mile round trip drive and each takes one of the other managers, the process might be manageable, and the cost is only the mileage reimbursement of $167 plus $25 parking for each car. A round trip airline ticket is about $265 if purchased in advance. Though the flight is only about one hour in duration, the total travel time when flying from home to the New York office is about the same as when driving—the trip takes between three and four hours depending on traffic. The taxi from the airport to the meeting costs about $40. A new service called Limo Liner, a sort of bus with upgrades, advertises that round-trip cost is about $40 less than an Amtrak ticket, and they offer extra services including a kitchen, TVs, restrooms, and a conference table that can be reserved. A taxi from the Limo Liner terminal to the meeting will cost around $20. In the past, most of the managers have flown to the meeting—citing the ability to work en route as a productivity advantage. The idea of using the Limo Liner intrigues Bob. He likes the idea that he and his managers could work together while they travel but wonders if this feature is worth the expense.

1. What is the cost of Bob and his three managers traveling by each method: by Amtrak with two taxi fares in New York, in individual cars including parking, carpooling in two cars including parking, by airplane with two taxi fares in New York, and by Limo Liner with two taxi fares in New York?

2. In the past, costs for the trip have totaled around $1,140 per trip for the group of four people using different methods of traveling to New York. Bob thinks he and his managers should probably drive in two cars to save the most money, but he is still intrigued by the possibility of conducting a meeting on the Limo Liner while traveling to New York. How much will the company save with either of these options? Which method of travel might yield the most productivity increase?

 Though the savings are greater if they carpool, taking the Limo Liner would allow the managers to work en route for three hours, either as a group or individually, for a cost of $208 over carpooling. Additionally, traveling by Limo Liner should also decrease the fatigue factor for 2 people having to drive for 3–4 hours. The Limo Liner seems like an idea worth trying.

3. Each year Bob and his managers attend 40 weekly meetings in New York. How much will the cost savings be in a year over past average cost if the group travels regularly by Limo Liner?

1.2 Two Degrees Better Than One

Vicki attends Cape Fear Community College, where she will graduate at the end of the current semester. She has thought about continuing her education to get another degree. Tuition for one semester for 16 or more credit hours is $568, or she can pay $35 per credit hour if she takes fewer than 16 credit hours. Student fees are $6 per credit hour, and there is a technology fee of $1 per credit hour. Vicki will be finishing a business administration degree and she will need to take 13 more 3-credit-hour courses to complete an E-commerce degree. Vicki hopes to use the combined degrees to get a job with a firm doing business on the Internet. The courses that she needs are offered on a planned schedule, so Vicki figures that she needs to stay in school for 3 more consecutive semesters to complete the E-commerce degree. Vicki has noticed that there is a customer service certificate program that would require her to take only 2 extra courses (Business Ethics and Customer Service) once she has finished her business administration degree. She could count Customer Service as an elective course toward her E-commerce degree, so it will serve two purposes. She figures that if she takes 14 courses

in 3 semesters, she will have two business degrees and the customer service certificate, which would greatly improve her prospects of landing the job that she wants.

1. Vicki has determined that she will need to take five courses during her first two semesters in the E-commerce program and four courses during the third semester. How much will each semester cost?

2. Vicki needs to determine how much money she will need to borrow if she works 15 hours a week at a local plant nursery. Her take-home pay will be $7 per hour, and she figures that she can work 50 weeks in a year. Her rent would be free because her Aunt Rosalyn has a spare room for her. Her share of the groceries will be $100 a month; a cell phone will cost $20 under her father's plan. Car insurance, clothes, and other expenses will come to about $300 per month. How much will she need to borrow to complete her school plan?

3. If Vicki works 20 hours a week and all other assumptions remain the same, can she avoid having to take out a loan?

1.3 The Cost of Giving

United Way comprises more than 1,300 local chapters that raise resources and mobilize care units for communities in need. According to their web site, the United Way raised $3.98 billion during their 2005–2006 fund drive. A substantial portion of those funds was raised through annual campaigns and corporate sponsorships. Alaina has been asked to coordinate her company's United Way fund drive. Because she has seen some of the projects United Way has supported in her own community, Alaina is excited to help her company try to reach its goal of raising $100,000 this year. Alaina will be distributing pledge cards to each of the company's employees to request donations. There are 150 people working on the first shift, 75 people working on the second shift, and a crew of 25 people working on the third shift.

1. If each person were to make a one-time donation, how much would each person need to donate for the company to reach its goal of raising $100,000?

2. Alaina feels that very few people can contribute this amount in one lump sum, so she is offering to divide this amount over 10 months. If the employees agree to this arrangement, how much will be deducted from each person's monthly paycheck?

3. Two weeks have passed and Alaina has collected the pledge cards from each of the employees with the following results:

- First Shift: 100 employees agreed to have $40 a month deducted for 10 months; 25 employees agreed to make a one-time contribution of $100; 15 employees agreed to make a one-time contribution of $50. The remaining employees agreed to have $20 withheld for the next 10 months.
- Second Shift: 25 people agreed to a one-time contribution of $150; 25 people agreed to have $40 a month deducted for 10 months; and the remaining employees agreed to a one-time contribution that averaged about $35 each.
- Third Shift: All 25 people agreed to double the $40 contribution and have it deducted over the next 10 months.

 How much was pledged or contributed on each shift?

4. Has Alaina met the company's goal of raising $100,000 for the year? By how much is she over or short?

5. If Alaina's company were to match the employee's contributions with $2 for every $1 the employees contributed, how much would the company contribute? What would be the total contribution to the United Way?

Source: Cape Fear Community College website, North Carolina, http://cfcc.net.

Extreme Makeover: Home Edition

One of ABC's top rated television series is *Extreme Makeover: Home Edition.* The hour-long episodes are devoted to providing a deserving family with a home makeover. In just seven days, a team of designers and workers attempts to renovate an entire house including the exterior, interior, and landscaping, while the family is sent on vacation. The majority of episodes are one hour; however, in some instances (mainly if there are complications) the episode will be aired in two parts, with half airing each week.

Most shows begin with a shot of the host in the design team's bus saying "I'm Ty Pennington, and the renovation starts right now." While a typical residential construction project may last three months, the builders and designers must accomplish their task in just one week, $\frac{1}{12}$ of the normal time! For the next seven days, the workers use fractions as they plan, measure, cut, and replace. For example, fractions are used to measure the length of 2 by 4s, roof trusses, shingles, siding, flooring, cabinets, appliances, countertops, and so on. Even the designers must use fractions to ensure that everything fits within the given space when they add the finishing touches such as furniture and appliances. All of this is important, because errors of $\frac{1}{8}$ or $\frac{1}{16}$ of an inch can have disastrous results!

Of course, plans don't always work out as expected. It's day five, and one of the local contractors has discovered a major problem in the kitchen. The countertop has been measured incorrectly by $3\frac{3}{4}$ inches. This means that none of the refrigerators on the market will fit the space. The team has the following choices: 1) order a custom refrigerator; 2) cut the countertop to the appropriate length; or 3) tear out a completed wall that has already been dry-walled, plastered, and painted. A custom refrigerator would cost $2,500 or $\frac{2}{3}$ more than a standard one, but with just two days remaining, would it arrive on time? The countertop could be cut, but the custom cabinets have already arrived and they can't be changed. Tearing out an existing wall is a hassle, but it would likely cost less than $500. If you were project manager, what would you do?

Finally, at the end of seven days and with all construction problems resolved, the family returns home. When Ty and the family give the order "Bus driver, move that bus!" the family sees the result of the team's efforts. The end result is a very happy and appreciative family who received a home makeover completed in just a fraction of the time it would normally take.

LEARNING OUTCOMES

2-1 Fractions

1. Identify types of fractions.
2. Convert an improper fraction to a whole or mixed number.
3. Convert a whole or mixed number to an improper fraction.
4. Reduce a fraction to lowest terms.
5. Raise a fraction to higher terms.

2-2 Adding and Subtracting Fractions

1. Add fractions with like (common) denominators.
2. Find the least common denominator for two or more fractions.
3. Add fractions and mixed numbers.
4. Subtract fractions and mixed numbers.

2-3 Multiplying and Dividing Fractions

1. Multiply fractions and mixed numbers.
2. Divide fractions and mixed numbers.

 A corresponding Business Math Case Video for this chapter, *Introduction to the 7th Inning Business and Personnel,* can be found in Appendix A.

LEARNING OUTCOMES

1 Identify types of fractions.
2 Convert an improper fraction to a whole or mixed number.
3 Convert a whole or mixed number to an improper fraction.
4 Reduce a fraction to lowest terms.
5 Raise a fraction to higher terms.

Fraction: a part of a whole amount. It is also a notation for showing division.

Fractions are used to represent parts of whole items. Often fractions are implied in the narrative portion of reports and news articles. For example, a news article may claim that three out of four voters are in favor of a proposed change in a city ordinance.

1 Identify types of fractions.

We use fractions as a way to represent parts of whole numbers. The fraction is also used to represent two relationships between numbers. The first relationship is the relationship between a part and a whole. If one whole quantity has four equal parts, then one of the four parts is represented by the fraction $\frac{1}{4}$ (Figure 2-1).

Denominator: the number of a fraction that shows how many parts one whole quantity is divided into. It is also the divisor of the indicated division.

Numerator: the number of a fraction that shows how many parts are considered. It is also the dividend of the indicated division.

Fraction line: the line that separates the numerator and denominator. It is also the division symbol.

Proper fraction: a fraction with a value that is less than 1. The numerator is smaller than the denominator.

Improper fraction: a fraction with a value that is equal to or greater than 1. The numerator is the same as or greater than the denominator.

FIGURE 2-1
One part out of four parts is
$\frac{1}{4}$ **of the whole.**

Another relationship represented by fractions is the relationship of division. The fraction $\frac{1}{4}$ can be interpreted as 1 divided by 4 or 1 ÷ 4.

In the fraction $\frac{1}{4}$, 4 represents the number of parts contained in one whole quantity and is called the **denominator**. When the fraction is interpreted as division, the denominator is the divisor. The 1 in the fraction $\frac{1}{4}$ represents the number of parts under consideration and is called the **numerator**. When the fraction is interpreted as division, the numerator is the dividend.

The line separating the numerator and denominator may be written as a horizontal line (—) or as a slash (/) and is called the **fraction line**. When the fraction is interpreted as division, the fraction line is interpreted as the division symbol.

A fraction that has a value less than 1 is called a **proper fraction**. A fraction that has a value equal to or greater than 1 is called an **improper fraction**.

EXAMPLE 1 Visualize the fraction to identify whether it is a proper fraction. Describe the relationship between the numerator and denominator of proper fractions.

(a) $\frac{2}{5}$ (b) $\frac{3}{2}$ (c) $\frac{4}{4}$

(a) Figure 2-2 represents $\frac{2}{5}$ or two parts out of five equal parts.

FIGURE 2-2

The fraction $\frac{2}{5}$ is a proper fraction, since it is less than one whole quantity. The numerator is smaller than the denominator.

(b) Figure 2-3 represents $\frac{3}{2}$ or three parts when the one whole quantity contains two equal parts.

FIGURE 2-3

The fraction $\frac{3}{2}$ is more than one whole quantity. It is an improper fraction.

(c) Figure 2-4 represents $\frac{4}{4}$ or four parts when the one whole quantity contains four equal parts.

FIGURE 2-4

The fraction $\frac{4}{4}$ represents one whole quantity. It is an improper fraction.

EXAMPLE 2 Which fractions in Example 1 are improper fractions? Describe the relationship between the numerator and denominator of improper fractions.

The fractions $\frac{3}{2}$ and $\frac{4}{4}$ are improper fractions. In an improper fraction, the numerator is equal to or greater than the denominator.

 STOP AND CHECK

Write the fraction that is illustrated. Indicate if the fraction is proper or improper.

1.

2.

Identify the fractions as proper or improper.

3. $\dfrac{3}{7}$ 4. $\dfrac{12}{5}$ 5. $\dfrac{16}{16}$ 6. $\dfrac{5}{9}$

2 Convert an improper fraction to a whole or mixed number.

In Figure 2-3, the fraction $\frac{3}{2}$ was shown as one whole quantity and $\frac{1}{2}$ of a second whole quantity. This amount, $\frac{3}{2}$, can also be written as $1\frac{1}{2}$. An amount written as a combination of a whole number and a fraction is called a **mixed number**. Every mixed number can also be written as an improper fraction.

Mixed number: an amount that is a combination of a whole number and a fraction.

To interpret the meaning of an improper fraction, we use its whole number or mixed number form. Thus, it is important to be able to convert between improper fractions and mixed numbers.

HOW TO Write an improper fraction as a whole or mixed number

Write $\frac{12}{3}$ and $\frac{13}{3}$ as whole or mixed numbers.

1. Divide the numerator of the improper fraction by the denominator.

$$3\overline{)12}\;^4 \qquad 3\overline{)13}\;^{4\,R1}$$

2. Examine the remainder.
 (a) If the remainder is 0, the quotient is a whole number: The improper fraction is equivalent to this whole number.

$$\frac{12}{3} = 4$$

 (b) If the remainder is not 0, the quotient is not a whole number: The improper fraction is equivalent to a mixed number. The whole-number part of this mixed number is the whole-number part of the quotient. The fraction part of the mixed number has a numerator and a denominator. The numerator is the remainder; the denominator is the divisor (the denominator of the improper fraction).

$$\frac{13}{3} = 4\frac{1}{3}$$

EXAMPLE 1 Write $\frac{139}{8}$ as a whole or mixed number.

$$\begin{array}{r} 17\ \text{R}3,\ \text{or}\ 17\frac{3}{8} \\ 8\overline{)139} \\ \underline{8} \\ 59 \\ \underline{56} \\ 3 \end{array}$$

Divide 139 by 8. The quotient is 17 R3, which equals $17\frac{3}{8}$.

$$\frac{139}{8} = 17\frac{3}{8}$$

✓ STOP AND CHECK

Write each improper fraction as a whole or mixed number.

1. $\dfrac{145}{28}$ **2.** $\dfrac{132}{12}$ **3.** $\dfrac{48}{12}$ **4.** $\dfrac{18}{7}$ **5.** $\dfrac{34}{17}$

3 Convert a whole or mixed number to an improper fraction.

A mixed number can be written as an improper fraction by "reversing" the steps you use to write an improper fraction as a mixed number. This process is similar to the process for checking a division problem. In the division of an improper fraction with a result of $3\frac{1}{5}$, the divisor is 5, the quotient is 3, and the remainder is 1. To check division, multiply the divisor by the quotient and add the remainder. Examine the similarities in changing a mixed number to an improper fraction. Figure 2-5 illustrates this process.

In words,
five times three
plus one written
over five.

In symbols,
$$3\frac{1}{5} = \frac{5 \times 3 + 1}{5} = \frac{16}{5}$$

FIGURE 2-5
$3\frac{1}{5}$ written as an improper fraction.

HOW TO	Write a mixed number or whole number as an improper fraction
Mixed number:	Write $1\frac{2}{5}$ and 9 as improper fractions.
1. Find the numerator of the improper fraction.	$(5 \times 1) + 2 = 7$
(a) Multiply the denominator of the mixed number by the whole-number part.	
(b) Add the product from step 1a to the numerator of the mixed number.	
2. For the denominator of the improper fraction use the denominator of the mixed number.	$\dfrac{7}{5}$
Whole number:	
1. Write the whole number as the numerator.	9
2. Write 1 as the denominator.	$\dfrac{9}{1}$

EXAMPLE 1 Write $2\frac{3}{4}$ and 8 as improper fractions.

$$2\frac{3}{4} = \frac{(4 \times 2) + 3}{4} = \frac{11}{4}$$ For the numerator, multiply 4 times 2 and add 3.

$$8 = \frac{8}{1}$$ Write the whole number as the numerator and 1 as the denominator.

$$2\frac{3}{4} = \frac{11}{4} \text{ and } 8 = \frac{8}{1}.$$

4 Reduce a fraction to lowest terms.

Equivalent fractions: fractions that indicate the same portion of the whole amount.

Lowest terms: the form of a fraction when its numerator and denominator cannot be evenly divided by any whole number except 1.

Many fractions represent the same portion of a whole. Such fractions are called **equivalent fractions**. For example, $\frac{1}{2}$, $\frac{2}{4}$, and $\frac{4}{8}$ are equivalent fractions (Figure 2-6).

To be able to recognize equivalent fractions, we often reduce fractions to lowest terms. A fraction in **lowest terms** has a numerator and denominator that cannot be evenly divided by any whole number except 1.

FIGURE 2-6
Equivalent fractions

> **HOW TO** Reduce a fraction to lowest terms
>
> Reduce $\frac{8}{10}$ to lowest terms.
>
> 1. Inspect the numerator and denominator to find any whole number that both can be evenly divided by.
> 2. Divide both the numerator and the denominator by that number and inspect the new fraction to find any other number that the numerator and denominator can be evenly divided by.
> 3. Repeat steps 1 and 2 until 1 is the only number that the numerator and denominator can be evenly divided by.
>
> 8 and 10 are divisible by 2.
>
> $\dfrac{8 \div 2}{10 \div 2} = \dfrac{4}{5}$

> **EXAMPLE 1** Reduce $\frac{30}{36}$ to lowest terms by inspection.
>
> $\dfrac{30}{36} = \dfrac{30 \div 2}{36 \div 2} = \dfrac{15}{18}$ Both the numerator and the denominator can be evenly divided by 2.
>
> $\dfrac{15}{18} = \dfrac{15 \div 3}{18 \div 3} = \dfrac{5}{6}$ Both the numerator and the denominator of the new fraction can be evenly divided by 3.
>
> $\frac{30}{36}$ **is reduced to** $\frac{5}{6}$**.** Now 1 is the only number that both the numerator and the denominator can be evenly divided by. The fraction is now in lowest terms.

Greatest common divisor (GCD): the greatest number by which both parts of a fraction can be evenly divided.

By inspection: using your number sense to mentally perform a mathematical process.

The most direct way to reduce a fraction to lowest terms is to divide the numerator and denominator by the **greatest common divisor (GCD)**. The GCD is the greatest number by which both parts of a fraction can be evenly divided. The GCD often can be found **by inspection**. Otherwise, a systematic process can be used.

Find the greatest common divisor of two numbers

1. Use the numerator as the original divisor and the denominator as the dividend.
2. Divide.
3. Divide the original divisor from step 2 by the remainder from step 2.
4. Divide the divisor from step 3 by the remainder from step 3.
5. Continue this division process until the remainder is 0. The last divisor is the greatest common divisor.

EXAMPLE 2 Find the GCD for $\frac{30}{36}$; then write the fraction in lowest terms.

$$\begin{array}{r} 1\,R6 \\ 30\overline{)36} \end{array}$$ Use the numerator as the original divisor and the denominator as the dividend.

$$\begin{array}{r} 5\,R0 \\ 6\overline{)30} \end{array}$$ Divide the original divisor by the original remainder.

GCD = 6. When the remainder is 0, the last divisor is the GCD.

Reduce using the GCD.

$$\frac{30}{36} = \frac{30 \div 6}{36 \div 6} = \frac{5}{6}$$ Divide the numerator and denominator by the GCD.

$\frac{30}{36}$ **reduced to lowest terms is $\frac{5}{6}$.**

✔ STOP AND CHECK

1. Reduce $\frac{18}{24}$ to lowest terms by inspection.

2. Reduce $\frac{12}{36}$ to lowest terms by inspection.

3. Find the GCD for $\frac{16}{24}$; reduce the fraction to lowest terms.

4. Find the GCD for $\frac{39}{51}$; reduce the fraction to lowest terms.

5. Find the GCD for $\frac{12}{28}$; reduce the fraction to lowest terms.

6. Find the GCD for $\frac{18}{24}$; reduce the fraction to lowest terms.

5 Raise a fraction to higher terms.

Just as you can reduce a fraction to lowest terms by dividing the numerator and denominator by the same number, you can write a fraction in *higher* terms by *multiplying* the numerator and denominator by the same number. This process is used in addition and subtraction of fractions.

Write a fraction in higher terms given the new denominator

1. Divide the *new* denominator by the *old* denominator.

2. Multiply *both* the old numerator and the old denominator by the quotient from step 1.

Change $\frac{1}{2}$ to eighths, or $\frac{1}{2} = \frac{?}{8}$.

$$\begin{array}{r} 4 \\ 2\overline{)8} \end{array}$$

$$\frac{1}{2} = \frac{1 \times 4}{2 \times 4} = \frac{4}{8}$$

EXAMPLE 1

Rewrite $\frac{5}{8}$ as a fraction with a denominator of 72.

$$\frac{5}{8} = \frac{?}{72}$$

Write the problem symbolically.

$$8\overline{)72}^{\,9}$$

Divide the new denominator (72) by the old denominator (8) to find the number by which the old numerator and the old denominator must be multiplied. That number is 9.

$$\frac{5}{8} = \frac{5 \times 9}{8 \times 9} = \frac{45}{72}$$

Multiply the numerator and denominator by 9 to get the new fraction with a denominator of 72.

$$\frac{5}{8} = \frac{45}{72}$$

✓ STOP AND CHECK

1. Write $\frac{7}{12}$ as a fraction with a denominator of 36.

2. Write $\frac{3}{4}$ as a fraction with a denominator of 32.

Change the fraction to an equivalent fraction with the given denominator.

3. $\frac{1}{2}, \frac{}{18}$

4. $\frac{3}{5}, \frac{}{25}$

5. $\frac{5}{12}, \frac{}{36}$

6. $\frac{7}{8}, \frac{}{24}$

2-1 SECTION EXERCISES

SKILL BUILDERS

Classify the fractions as proper or improper.

1. $\frac{5}{9}$

2. $\frac{12}{7}$

3. $\frac{7}{7}$

4. $\frac{1}{12}$

5. $\frac{12}{15}$

6. $\frac{21}{20}$

Write the fraction as a whole or mixed number.

7. $\frac{12}{7}$

8. $\frac{21}{20}$

9. $\frac{18}{18}$

10. $\frac{17}{7}$

11. $\frac{16}{8}$

12. $\frac{387}{16}$

Write the whole or mixed number as an improper fraction.

13. $6\frac{1}{4}$

14. $27\frac{2}{5}$

15. $2\frac{1}{3}$

16. $3\frac{4}{5}$

17. $1\frac{5}{8}$

18. $6\frac{2}{3}$

Reduce to lowest terms.

19. $\dfrac{12}{15}$

20. $\dfrac{12}{20}$

21. $\dfrac{18}{24}$

22. $\dfrac{18}{36}$

23. $\dfrac{24}{36}$

24. $\dfrac{13}{39}$

Change the fraction to an equivalent fraction with the given denominator.

25. $\dfrac{3}{8}, \dfrac{}{16}$

26. $\dfrac{4}{5}, \dfrac{}{20}$

27. $\dfrac{3}{8}, \dfrac{}{32}$

28. $\dfrac{5}{9}, \dfrac{}{27}$

29. $\dfrac{1}{3}, \dfrac{}{15}$

30. $\dfrac{3}{5}, \dfrac{}{15}$

2-2 ADDING AND SUBTRACTING FRACTIONS

LEARNING OUTCOMES

1 Add fractions with like (common) denominators.
2 Find the least common denominator for two or more fractions.
3 Add fractions and mixed numbers.
4 Subtract fractions and mixed numbers.

1 Add fractions with like (common) denominators.

The statement that three calculators plus four fax machines is the same as seven calculators is not true. The reason this is not true is that calculators and fax machines are *unlike* items, and we can only add *like* terms. It is true that three calculators plus four fax machines are the same as seven office machines. What we have done is to *rename* calculators and fax machines using a like term. Calculators and fax machines are both office machines. In the same way, to add fractions that have different denominators, we must rename the fractions using a like, or common, denominator. When fractions have like denominators, we can write their sum as a single fraction.

HOW TO	Add fractions with like (common) denominators
	Add $\dfrac{2}{9} + \dfrac{1}{9}$.
1. Find the numerator of the sum: Add the numerators of the addends.	$2 + 1 = 3$
2. Find the denominator of the sum: Use the like denominator of the addends.	$\dfrac{2}{9} + \dfrac{1}{9} = \dfrac{3}{9}$
3. Reduce the sum to lowest terms and/or write as a whole or mixed number.	$\dfrac{3}{9} = \dfrac{3 \div 3}{9 \div 3} = \dfrac{1}{3}$

EXAMPLE 1 Find the sum: $\dfrac{1}{4} + \dfrac{3}{4} + \dfrac{3}{4}$.

$\dfrac{1}{4} + \dfrac{3}{4} + \dfrac{3}{4} = \dfrac{1 + 3 + 3}{4} = \dfrac{7}{4}$ The sum of the numerators is the numerator of the sum. The original like (common) denominator is the denominator of the sum.

$\dfrac{7}{4} = 1\dfrac{3}{4}$ Convert the improper fraction to a whole or mixed number.

The sum is $1\dfrac{3}{4}$.

Add. Reduce or write as a whole or mixed number if appropriate.

1. $\dfrac{3}{4} + \dfrac{1}{4} + \dfrac{1}{4}$

2. $\dfrac{3}{8} + \dfrac{7}{8} + \dfrac{1}{8}$

3. $\dfrac{1}{5} + \dfrac{2}{5} + \dfrac{2}{5}$

4. $\dfrac{5}{8} + \dfrac{3}{8} + \dfrac{1}{8}$

5. $\dfrac{5}{12} + \dfrac{7}{12} + \dfrac{11}{12}$

2 Find the least common denominator for two or more fractions.

Least common denominator (LCD): the smallest number that can be divided evenly by each original denominator.

To add fractions with different denominators, the fractions must first be changed to equivalent fractions with a common denominator. It is desirable to use the **least common denominator (LCD)**—the smallest number that can be evenly divided by each original denominator.

The common denominator can sometimes be found by inspection—that is, mentally selecting a number that can be evenly divided by each denominator. However, there are several systematic processes for finding the least common denominator. One way to find the least common denominator is to use prime numbers.

Prime number: a number greater than 1 that can be divided evenly only by itself and 1.

A **prime number** is a number greater than 1 that can be evenly divided only by itself and 1. The first ten prime numbers are 2, 3, 5, 7, 11, 13, 17, 19, 23, and 29.

HOW TO — Find the least common denominator for two or more fractions

Find the LCD of $\dfrac{7}{12}$ and $\dfrac{11}{30}$.

1. Write the denominators in a row and divide each one by the smallest prime number that any of the numbers can be evenly divided by.
2. Write a new row of numbers using the quotients from step 1 and any numbers in the first row that cannot be evenly divided by the first prime number. Divide by the smallest prime that any of the numbers can be evenly divided by.
3. Continue this process until you have a row of 1s.

$2)\overline{12 \quad 30} \qquad 12 \div 2 = 6$
$ \qquad 30 \div 2 = 15$

$2)\overline{6 \quad 15} \qquad 6 \div 2 = 3$
$ \qquad$ Bring down 15.

$3)\overline{3 \quad 15} \quad 3 \div 3 = 1; 15 \div 3 = 5$
$5)\overline{1 \quad 5} \quad 5 \div 5 = 1;$ bring down 1.
$1 \quad 1$

4. Multiply all the prime numbers you used to divide the denominators. The product is the least common denominator.

$\text{LCD} = 2 \times 2 \times 3 \times 5 = 60$

EXAMPLE 1

Find the least common denominator (LCD) of $\dfrac{5}{6}, \dfrac{5}{8},$ and $\dfrac{1}{12}$.

$2)\overline{6 \quad 8 \quad 12}$ — Write the denominators in a row and divide by 2, the smallest prime divisor.
$6 \div 2 = 3; 8 \div 2 = 4; 12 \div 2 = 6$

$2)\overline{3 \quad 4 \quad 6}$ — Divide by 2 again.
Bring down 3. $4 \div 2 = 2; 6 \div 2 = 3$.

$2)\overline{3 \quad 2 \quad 3}$ — Divide by 2 again. Bring down both 3s.
$2 \div 2 = 1$.

$3)\overline{3 \quad 1 \quad 3}$ — Divide by 3.
$1 \quad 1 \quad 1$ — $3 \div 3 = 1$. Bring down 1.

$2 \times 2 \times 2 \times 3 = 24$ — The LCD is the product of all the divisors.

The LCD is 24.

✓ STOP AND CHECK

Find the least common denominator.

1. $\dfrac{1}{6}, \dfrac{5}{12}$ 2. $\dfrac{15}{24}, \dfrac{37}{48}$ 3. $\dfrac{1}{2}, \dfrac{5}{8}$ 4. $\dfrac{8}{11}, \dfrac{3}{7}$ 5. $\dfrac{5}{42}, \dfrac{7}{30}, \dfrac{9}{35}$

3 Add fractions and mixed numbers.

We can use the procedure for finding a least common denominator to add fractions with different denominators.

HOW TO Add fractions with different denominators

Add $\dfrac{2}{3} + \dfrac{3}{4}$.

1. Find the least common denominator. LCD = 12 by inspection

2. Change each fraction to an equivalent fraction using the least common denominator.

$$\dfrac{2}{3} = \dfrac{2 \times 4}{3 \times 4} = \dfrac{8}{12}$$

$$\dfrac{3}{4} = \dfrac{3 \times 3}{4 \times 3} = \dfrac{9}{12}$$

3. Add the new fractions with like (common) denominators.

$$\dfrac{8}{12} + \dfrac{9}{12} = \dfrac{17}{12}$$

4. Reduce to lowest terms and/or write as a whole or mixed number.

$$\dfrac{17}{12} = 1\dfrac{5}{12}$$

EXAMPLE 1 Find the sum of $\dfrac{5}{6}$, $\dfrac{5}{8}$, and $\dfrac{1}{12}$.

LCD = 24 From Example 1 in Learning Outcome 2.

$$\dfrac{5}{6} = \dfrac{5 \times 4}{6 \times 4} = \dfrac{20}{24}$$ Change each fraction to an equivalent fraction.

$$\dfrac{5}{8} = \dfrac{5 \times 3}{8 \times 3} = \dfrac{15}{24}$$

$$\dfrac{1}{12} = \dfrac{1 \times 2}{12 \times 2} = \dfrac{2}{24}$$ Add the numerators and use the common denominator.

$$\dfrac{37}{24} = 1\dfrac{13}{24}$$ Write the improper fraction as a mixed number.

The sum is $1\dfrac{13}{24}$.

HOW TO Add mixed numbers

1. Add the whole-number parts.
2. Add the fraction parts and reduce to lowest terms.
3. Change improper fractions to whole or mixed numbers.
4. Add the whole-number parts.

EXAMPLE 2 Add $3\frac{2}{5} + 10\frac{3}{10} + 4\frac{7}{15}$.

Find the LCD.

$2\overline{)5\quad 10\quad 15}$ Divide by 2. $10 \div 2 = 5$.
Bring down 5 and 15.

$3\overline{)5\quad 5\quad 15}$ Divide by 3. $15 \div 3 = 5$.
Bring down both 5s.

$5\overline{)5\quad 5\quad 5}$ Divide by 5. $5 \div 5 = 1$.
 1 1 1

$2 \times 3 \times 5 = 30$ LCD

$3\frac{2}{5} = 3\frac{2 \times 6}{5 \times 6} = 3\frac{12}{30}$ Change fraction parts to equivalent fractions with LCD.

$10\frac{3}{10} = 10\frac{3 \times 3}{10 \times 3} = 10\frac{9}{30}$ Add whole numbers. Add fractions.

$4\frac{7}{15} = 4\frac{7 \times 2}{15 \times 2} = 4\frac{14}{30}$

$ 17\frac{35}{30}$ Reduce fraction and change improper fraction to mixed number.

$$\frac{35}{30} = \frac{7}{6} = 1\frac{1}{6}$$

$17 + 1 + \frac{1}{6} = 18\frac{1}{6}$ Add whole numbers.

The sum is $18\frac{1}{6}$.

TIP

Estimate Sum of Mixed Numbers

A quick way to estimate the sum of mixed numbers is to add only the whole number parts. This estimate is smaller than the exact sum of the mixed numbers. To find an estimate that is larger than the exact sum, add 1 to the low estimate for each mixed number addend. Do not add 1 for whole number addends. Apply this estimation process to the example.

$3 + 10 + 4 = 17$ low estimate
$17 + 1 + 1 + 1 = 20$ high estimate

The exact sum is between 17 and 20. Refer to the example to see the exact sum is $18\frac{1}{6}$, which is in the interval of the estimate.

EXAMPLE 3 If an employee works the following overtime hours each day, find his total overtime for the week: $1\frac{3}{4}$ hours on Monday, $2\frac{1}{2}$ hours on Tuesday, $1\frac{1}{4}$ hours on Wednesday, $2\frac{1}{4}$ hours on Thursday, and $1\frac{3}{4}$ hours on Friday.

$1\frac{3}{4} = 1\frac{3}{4}$ LCD is 4.

$2\frac{1}{2} = 2\frac{2}{4}$ Change $2\frac{1}{2}$ to $2\frac{2}{4}$.

$1\frac{1}{4} = 1\frac{1}{4}$ Add fractions.

$2\frac{1}{4} = 2\frac{1}{4}$ Add whole numbers.

$1\frac{3}{4} = 1\frac{3}{4}$

$ = 7\frac{10}{4}$ $\frac{10}{4} = \frac{5}{2} = 2\frac{1}{2}$

$ = 9\frac{1}{2}$ $7 + 2\frac{1}{2} = 9\frac{1}{2}$

The total overtime is $9\frac{1}{2}$ hours.

Add.

1. $4\frac{3}{8} + 5\frac{5}{8} + 3\frac{7}{8}$

2. $\frac{5}{12} + \frac{3}{4} + \frac{2}{3}$

3. $4\frac{3}{5} + 5\frac{7}{10} + 3\frac{4}{15}$

4. $23\frac{5}{14} + 37\frac{9}{10}$

5. A decorator determines that $25\frac{3}{8}$ yards of fabric are needed as window covering and decides to order an additional $6\frac{3}{4}$ yards of the same fabric for a tablecloth. How many yards of fabric are needed for windows and table?

6. A decorator used $32\frac{5}{8}$ yards of fabric for window treatments and $8\frac{3}{4}$ yards for chair covering. How many yards of fabric were used?

4 Subtract fractions and mixed numbers.

In subtracting fractions, just as in adding fractions, you need to find a common denominator.

HOW TO	Subtract fractions

With like denominators

Subtract $\frac{5}{12} - \frac{1}{12}$.

1. Find the numerator of the difference:
 Subtract the numerators of the fractions.

 $5 - 1 = 4$

2. Find the denominator of the difference:
 Use the like denominator of the fractions.

 $\frac{5}{12} - \frac{1}{12} = \frac{4}{12}$

3. Reduce to lowest terms.

 $\frac{4}{12} = \frac{1}{3}$

With different denominators

Subtract $\frac{5}{12} - \frac{1}{3}$.

1. Find the least common denominator.

 $LCD = 12$

2. Change each fraction to an equivalent fraction using the least common denominator.

 $\frac{1}{3} = \frac{1 \times 4}{3 \times 4} = \frac{4}{12}$

3. Subtract the new fractions with like (common) denominators.
4. Reduce to lowest terms.

 $\frac{5}{12} - \frac{4}{12} = \frac{1}{12}$

EXAMPLE 1	Subtract: $\frac{5}{12} - \frac{4}{15}$.

Find the LCD.

$$
\begin{array}{r|ll}
2) & 12 & 15 \\
2) & 6 & 15 \\
3) & 3 & 15 \\
5) & 1 & 5 \\
\hline
 & 1 & 1
\end{array}
$$

$2 \times 2 \times 3 \times 5 = 60$

Divide by 2. $12 \div 2 = 6$. Bring down 15.

Divide by 2. $6 \div 2 = 3$. Bring down 15.

Divide by 3. $3 \div 3 = 1$; $15 \div 3 = 5$.

Divide by 5. $5 \div 5 = 1$. Bring down 1.

$LCD = 60$

$$\frac{5}{12} = \frac{5 \times 5}{12 \times 5} = \frac{25}{60}$$ Change to equivalent fractions.

$$-\frac{4}{15} = -\frac{4 \times 4}{15 \times 4} = -\frac{16}{60}$$ Subtract fractions.

$$\frac{9}{60} = \frac{3}{20}$$ Reduce.

The difference is $\frac{3}{20}$.

HOW TO Subtract mixed numbers

Subtract $2\frac{1}{3} - 1\frac{1}{2}$.

1. If the fractions have different denominators, find the LCD and change the fractions to equivalent fractions using the LCD.
2. If necessary, regroup by subtracting 1 from the whole number in the minuend and add 1 (in the form of LCD/LCD) to the fraction in the minuend.
3. Subtract the fractions and the whole numbers.
4. Reduce to lowest terms.

$$2\frac{1}{3} = 2\frac{2}{6} = 1 + \frac{6}{6} + \frac{2}{6} = 1\frac{8}{6}$$
$$-1\frac{1}{2} = -1\frac{3}{6} \qquad\qquad = -1\frac{3}{6}$$
$$\frac{5}{6}$$

EXAMPLE 2 Subtract $10\frac{1}{3} - 7\frac{3}{5}$.

$$10\frac{1}{3} = 10\frac{5}{15} = 9 + \frac{15}{15} + \frac{5}{15} = 9\frac{20}{15}$$ Change fractions to equivalent fractions with the same LCD. Regroup in the minuend.

$$-7\frac{3}{5} \qquad\qquad\qquad = -7\frac{9}{15}$$ Subtract fractions. Subtract whole numbers.

$$2\frac{11}{15}$$ The fraction is already in lowest terms, so you do not have to reduce it.

The difference is $2\frac{11}{15}$.

TIP

Regroup or Borrow

Regrouping is also referred to as borrowing. The original form of the number has the same value as the new form of the number. Reexamine the previous example.

$$10\frac{5}{15} = 10 - 1 + 1 + \frac{5}{15} = 9 + 1 + \frac{5}{15}$$

$$= 9 + \frac{15}{15} + \frac{5}{15}$$

$$= 9\frac{20}{15}$$

EXAMPLE 3 An interior designer had 65 yards of fabric wall covering on hand and used $35\frac{3}{8}$ yards for a client's sunroom. How many yards of fabric remain?

$$65 = 64\frac{8}{8}$$ Regroup by subtracting 1 from 65. $\qquad 1 = \frac{8}{8}$

$$-35\frac{3}{8} = -35\frac{3}{8}$$ Subtract: $\frac{8}{8} - \frac{3}{8} = \frac{5}{8}$. Then subtract $64 - 35 = 29$.

$$29\frac{5}{8}$$

$29\frac{5}{8}$ yards of fabric remain.

✔ STOP AND CHECK

Subtract.

1. $\dfrac{7}{8} - \dfrac{3}{8}$

2. $\dfrac{5}{8} - \dfrac{1}{12}$

3. $12\dfrac{5}{8} - 3\dfrac{7}{8}$

4. $15\dfrac{11}{12} - 7\dfrac{5}{18}$

5. $32 - 14\dfrac{5}{12}$

6. $27\dfrac{4}{15} - 14\dfrac{7}{12}$

7. Marcus Johnson, a real estate broker, owns 100 acres of land. During the year he purchased additional tracts of $12\dfrac{3}{4}$ acres, $23\dfrac{2}{3}$ acres, and $5\dfrac{1}{8}$ acres. If he sold a total of $65\dfrac{2}{3}$ acres during the year, how many acres does he still own?

8. To make a picture frame two pieces $10\dfrac{3}{4}$ inches and two pieces $12\dfrac{5}{8}$ inches are cut from 60 inches of frame material. How much frame material remains?

2-2 SECTION EXERCISES

SKILL BUILDERS

Perform the indicated operation. Write the sum as a fraction, whole number, or mixed number in lowest terms.

1. $\dfrac{1}{9} + \dfrac{2}{9} + \dfrac{5}{9}$

2. $\dfrac{7}{8} + \dfrac{5}{8}$

3. $\dfrac{5}{6} + \dfrac{7}{15}$

4. $\dfrac{5}{8} + \dfrac{7}{12}$

5. $4\dfrac{5}{6} + 7\dfrac{1}{2}$

6. $23\dfrac{5}{12} + 48\dfrac{7}{16}$

7. $51\dfrac{5}{18} + 86\dfrac{9}{24}$

8. $5\dfrac{7}{12} + 3\dfrac{1}{4} + 2\dfrac{2}{3}$

9. $\dfrac{7}{8} + 2\dfrac{3}{24} + 6\dfrac{1}{6}$

10. $3\dfrac{5}{9} + 5\dfrac{1}{12} + 2\dfrac{2}{3}$

Find the difference. Write the difference in lowest terms.

11. $\dfrac{7}{8} - \dfrac{3}{8}$

12. $\dfrac{8}{9} - \dfrac{2}{9}$

13. $\dfrac{3}{4} - \dfrac{5}{7}$

14. $9\dfrac{2}{3} - 6\dfrac{1}{2}$

15. $15 - 12\dfrac{7}{9}$

16. $21\dfrac{3}{5} - 12\dfrac{7}{10}$

17. $15\dfrac{8}{15} - 7\dfrac{5}{12}$

18. $23\dfrac{1}{8} - \dfrac{7}{12}$

19. $8\dfrac{1}{3} - 5$

20. $12\dfrac{1}{5} - 7\dfrac{4}{5}$

APPLICATIONS

21. Loretta McBride is determining the amount of fabric required for window treatments. A single window requires $11\dfrac{3}{4}$ yards and a double window requires $18\dfrac{5}{8}$ yards of fabric. If she has two single windows and one double window, how much fabric is required?

22. Marveen McCready, a commercial space designer, has taken these measurements for an office in which she plans to install a wallpaper border around the ceiling: $42\dfrac{3}{8}$ feet, $37\dfrac{5}{8}$ feet, $12\dfrac{3}{8}$ feet, and $23\dfrac{3}{4}$ feet. How much paper does she need for the job?

23. Rob Farinelli is building a gazebo and plans to use for the floor two boards that are $10\dfrac{3}{4}$ feet, four boards that are $12\dfrac{5}{8}$ feet, and two boards that are $8\dfrac{1}{2}$ feet. Find the total number of feet in all the boards.

24. Tenisha Gist cuts brass plates for an engraving job. From a sheet of brass, three pieces $4\dfrac{4}{5}$ inches wide and two pieces $7\dfrac{3}{8}$ inches wide are cut. What is the smallest piece of brass required to cut all five plates?

25. The fabric Loretta McBride has selected for the window treatment in Exercise 21 has only 45 yards on the only roll available. Will she be able to use the fabric or must she make an alternate selection?

26. Rob Farinelli purchased two boards that are 12 feet and will cut them to make $10\frac{3}{4}$-foot boards for the gazebo he is building. How much must be removed from each board?

27. Rob Farinelli purchased four boards that are each 14 feet to make $12\frac{5}{8}$ foot boards for his gazebo. Upon measuring, he finds they are $13\frac{15}{16}$ feet, $14\frac{1}{8}$ feet, 14 feet, and $13\frac{13}{16}$ feet. How much must be removed from each board to get $12\frac{5}{8}$-foot boards?

28. Charlie Carr has a sheet of brass that is 36 inches wide and cuts two pieces that are each $8\frac{3}{4}$ inches wide. What is the width of the leftover brass?

2-3 MULTIPLYING AND DIVIDING FRACTIONS

LEARNING OUTCOMES

1 Multiply fractions and mixed numbers.
2 Divide fractions and mixed numbers.

1 Multiply fractions and mixed numbers.

Alexa May has three Pizza Hut stores. Her distributor shipped only $\frac{3}{4}$ of a cheese order that Alexa had expected to distribute equally among her three stores. What fractional part of the original order will each store receive?

Each store will receive $\frac{1}{3}$ of the *shipment*, but the shipment is only $\frac{3}{4}$ of the *original order*. Each store, then, will receive only $\frac{1}{3}$ of $\frac{3}{4}$ of the original order. Finding $\frac{1}{3}$ of $\frac{3}{4}$ illustrates the use of multiplying fractions just as "2 boxes **of** 3 cans each" amounts to 2×3, or 6 cans. Similarly, $\frac{1}{3}$ **of** $\frac{3}{4}$ amounts to $\frac{1}{3} \times \frac{3}{4}$.

We can visualize $\frac{1}{3} \times \frac{3}{4}$, or $\frac{1}{3}$ **of** $\frac{3}{4}$, by first visualizing $\frac{3}{4}$ of a whole (Figure 2-7).

FIGURE 2-7
3 parts out of 4 parts = $\frac{3}{4}$ of a whole.

Now visualize $\frac{1}{3}$ of $\frac{3}{4}$ of a whole (Figure 2-8).

FIGURE 2-8
1 part out of 3 parts in $\frac{3}{4}$ of a whole =

1 part out of 4 parts or $\frac{1}{4}$ of a whole.

$$\frac{1}{3} \text{ of } \frac{3}{4} \text{ is } \frac{1}{4}$$
$$\frac{1}{3} \times \frac{3}{4} = \frac{1}{4}$$

Multiply fractions

Multiply $\frac{1}{2} \times \frac{7}{8}$.

1. Find the numerator of the product: Multiply the numerators of the fractions.

$1 \times 7 = 7$

2. Find the denominator of the product: Multiply the denominators of the fractions.

$2 \times 8 = 16$

3. Reduce to lowest terms.

$$\frac{1}{2} \times \frac{7}{8} = \frac{7}{16}$$

EXAMPLE 1 What fraction of the original cheese order will each of Alexa's three stores receive equally if $\frac{9}{10}$ of the original order is shipped?

What You Know	What You Are Looking For	Solution Plan
Fraction of shipment each store can receive: $\frac{1}{3}$ Fraction of original order received for all the stores: $\frac{9}{10}$	Fraction of original order that each store will receive equally	Fraction of original order that each store will receive = fraction of shipment each store can receive × fraction of original order received.

Solution

$$\frac{1}{3} \times \frac{9}{10} = \frac{1 \times 9}{3 \times 10} = \frac{9}{30}$$ Multiply numerators; multiply denominators.

$$\frac{9}{30} = \frac{3}{10}$$ Reduce to lowest terms.

Conclusion

Each store will receive $\frac{3}{10}$ of the original order.

TIP

Reduce Before Multiplying

When you multiply fractions, you save time by reducing fractions *before* you multiply. If *any* numerator and *any* denominator can be divided evenly by the same number, divide both the numerator and the denominator by that number. You can then multiply the reduced numbers with greater accuracy than you could multiply the larger numbers.

$$\frac{1}{\overset{}{\underset{1}{3}}} \times \frac{\overset{1}{3}}{4} = \frac{1}{4} \qquad \frac{1}{\overset{}{\underset{1}{3}}} \times \frac{\overset{3}{9}}{10} = \frac{3}{10}$$ A numerator and a denominator can be divided evenly by 3 in both examples.

Multiply mixed numbers and whole numbers

1. Write the mixed numbers and whole numbers as improper fractions.
2. Reduce numerators and denominators as appropriate.
3. Multiply the fractions.
4. Reduce to lowest terms and/or write as a whole or mixed number.

EXAMPLE 2 Multiply $2\frac{1}{3} \times 3\frac{3}{4}$.

$$2\frac{1}{3} \times 3\frac{3}{4} = \frac{(3 \times 2) + 1}{3} \times \frac{(4 \times 3) + 3}{4}$$ Write the mixed numbers as improper fractions.

$$= \frac{7}{\cancel{3}_{1}} \times \frac{\overset{5}{\cancel{15}}}{4}$$ Divide both 3 and 15 by 3, reducing to 1 and 5. Multiply the numerators and denominators.

$$= \frac{35}{4} = 8\frac{3}{4}$$ Write as a mixed number.

The product is $8\frac{3}{4}$.

TIP

Are Products Always Larger Than Their Factors?

A product is not always greater than the factors being multiplied.

When the *multiplier* is a proper fraction, the product is *less than* the original number. This is true whether the *multiplicand* is a whole number, fraction, or mixed number.

$5 \times \dfrac{3}{5} = 3$ Product 3 is less than factor 5.

$\dfrac{3}{4} \times \dfrac{4}{9} = \dfrac{1}{3}$ Product $\frac{1}{3}$ is less than factor $\frac{3}{4}$.

$2\dfrac{1}{2} \times \dfrac{1}{2} = \dfrac{5}{2} \times \dfrac{1}{2} = \dfrac{5}{4} = 1\dfrac{1}{4}$ Product $1\frac{1}{4}$ is less than factor $2\frac{1}{2}$.

 STOP AND CHECK

Multiply. Write products as proper fractions or mixed numbers in lowest terms.

1. $\dfrac{3}{7} \times \dfrac{5}{8}$ **2.** $\dfrac{4}{9} \times \dfrac{3}{8}$ **3.** $3\dfrac{1}{4} \times \dfrac{5}{13}$ **4.** $1\dfrac{1}{9} \times 3$ **5.** $2\dfrac{2}{5} \times \dfrac{15}{21}$

6. The outside width of a boxed cooktop is $2\frac{3}{8}$ feet, and a shipment of boxed cooktops is placed in a 45-foot trailer. How many feet will 16 cooktop boxes require?

7. Computer boxes are $2\frac{1}{3}$ feet high. How high is a stack of 14 computer boxes?

2 Divide fractions and mixed numbers.

Division of fractions is related to multiplication.

Total amount = number of units of a specified size times (×) the specified size. If you know the total amount and the number of equal units, you can find the size of each unit by dividing the total amount by the number of equal units. If you know the total amount and the specified size, you can find the number of equal units by dividing the total amount by the specified size.

Home Depot has a stack of plywood that is 32 inches high. If each sheet of plywood is $\frac{1}{2}$ inch, how many sheets of plywood are in the stack? How many equal units of plywood are contained in the total stack? Divide the height of the stack (total amount) by the thickness of each sheet (specified size).

$32 \div \dfrac{1}{2}$ Total thickness divided by thickness of one sheet of plywood

Another way of approaching the problem is to think of the number of sheets of plywood in 1 inch of height. If each sheet of plywood is $\frac{1}{2}$ inch, then two sheets of plywood are 1 inch thick. If there are two sheets of plywood for each inch, there will be 64 pieces of plywood in the 32-inch stack.

$$32 \div \frac{1}{2} = 32 \times \frac{2}{1} = 64$$

The relationship between multiplying and dividing fractions involves a concept called **reciprocals**. Two numbers are reciprocals if their product is 1. Thus, $\frac{2}{3}$ and $\frac{3}{2}$ are reciprocals ($\frac{2}{3} \times \frac{3}{2} = 1$) and $\frac{7}{8}$ and $\frac{8}{7}$ are reciprocals ($\frac{7}{8} \times \frac{8}{7} = 1$).

HOW TO Find the reciprocal of a number

Write the reciprocal of 3.

1. Write the number as a fraction. $\dfrac{3}{1}$

2. Interchange the numerator and denominator. $\dfrac{1}{3}$

EXAMPLE 1 Find the reciprocal of (a) $\frac{7}{9}$; (b) 5; (c) $4\frac{1}{2}$.

(a) The reciprocal of $\frac{7}{9}$ is $\frac{9}{7}$. The reciprocal can be stated as $1\frac{2}{7}$.

(b) The reciprocal of $\frac{5}{1}$ is $\frac{1}{5}$. Write 5 as the fraction $\frac{5}{1}$.

(c) The reciprocal of $4\frac{1}{2}$ is $\frac{2}{9}$. Write $4\frac{1}{2}$ as the fraction $\frac{9}{2}$.

In the Home Depot discussion, we reasoned that $32 \div \frac{1}{2}$ is the same as 32×2. So, to divide by a fraction, we *multiply* by the *reciprocal* of the divisor.

HOW TO Divide fractions or mixed numbers

Divide $\frac{3}{4}$ by 5.

1. Write numbers as fractions.
2. Find the reciprocal of the divisor. $\dfrac{3}{4} \div \dfrac{5}{1}$
3. Multiply the dividend by the reciprocal of the divisor. $\dfrac{3}{4} \times \dfrac{1}{5} = \dfrac{3}{20}$
4. Reduce to lowest terms and/or write as a whole or mixed number. $\dfrac{3}{20}$ (lowest terms)

EXAMPLE 2 Madison Duke makes appliqués from brocade fabric. A customer has ordered five appliqués. Can Madison fill the order without buying more fabric? She has $\frac{3}{4}$ yard of fabric and each appliqué requires $\frac{1}{6}$ of a yard.

What You Know	What You Are Looking For	Solution Plan
Total length of fabric: $\frac{3}{4}$ yard Length of fabric needed for each appliqué: $\frac{1}{6}$ yard	The number of appliqués that can be made from the fabric Can Madison fill the order?	Number of appliqués that can be made = total length of fabric ÷ length of fabric needed for each appliqué

Number of appliqués	$= \dfrac{3}{4} \div \dfrac{1}{6}$	Total fabric ÷ fabric in 1 appliqué
		Multiply by the reciprocal of the divisor.
	$= \dfrac{3}{\overset{}{\underset{2}{4}}} \times \dfrac{\overset{3}{6}}{1}$	Reduce and multiply.
	$= \dfrac{9}{2} = 4\dfrac{1}{2}$	Change improper fraction to mixed number.

Conclusion

Madison can make four appliqués from the $\frac{3}{4}$ yard of fabric.

Since the order is five appliqués, Madison cannot fill the order without buying more fabric.

EXAMPLE 3 — Find the quotient: $5\frac{1}{2} \div 7\frac{1}{3}$.

$$5\dfrac{1}{2} \div 7\dfrac{1}{3} =$$ Write the numbers as improper fractions.

$$\dfrac{11}{2} \div \dfrac{22}{3} =$$ Multiply $\frac{11}{2}$ by the reciprocal of the divisor, $\frac{3}{22}$.

$$\dfrac{\overset{1}{11}}{2} \times \dfrac{3}{\underset{2}{22}} = \dfrac{1 \times 3}{2 \times 2} = \dfrac{3}{4}$$ Reduce and multiply.

The quotient is $\frac{3}{4}$.

 STOP AND CHECK

Find the reciprocal.

1. $\dfrac{5}{12}$

2. 32

3. $7\dfrac{1}{8}$

Divide. Write the quotient as a proper fraction or mixed number in lowest terms.

4. $\dfrac{7}{8} \div \dfrac{3}{4}$

5. $2\dfrac{2}{5} \div 2\dfrac{1}{10}$

6. $3\dfrac{3}{8} \div 9$

7. Kisha stacks lumber in a storage bin that is 72 inches in height. If she stores $\frac{3}{4}$-inch-thick plywood in the bin, how many sheets can she expect to fit in the bin?

SKILL BUILDERS

Find the product.

1. $\dfrac{3}{8} \times \dfrac{4}{5}$

2. $\dfrac{5}{7} \times \dfrac{1}{6}$

3. $5\dfrac{3}{4} \times 3\dfrac{8}{9}$

4. $\dfrac{3}{8} \times 24$

Find the reciprocal.

5. $\dfrac{7}{12}$

6. $\dfrac{3}{5}$

7. 9

8. 12

9. $5\dfrac{4}{7}$

10. $3\dfrac{3}{8}$

Find the quotient.

11. $\dfrac{5}{8} \div \dfrac{3}{4}$

12. $\dfrac{3}{5} \div \dfrac{9}{10}$

13. $2\dfrac{2}{5} \div 1\dfrac{1}{7}$

14. $5\dfrac{1}{4} \div 2\dfrac{2}{3}$

APPLICATIONS

15. Pierre Hugo is handling the estate of a prominent business-woman. The will states that the surviving spouse is to receive $\frac{1}{4}$ of the estate and the remaining $\frac{3}{4}$ of the estate will be divided equally among five surviving children. What fraction of the estate does each child receive?

16. Marvin Jones needs to estimate the number of sheets of plywood in a stack that is 75 inches tall. If each sheet of plywood is $1\frac{1}{8}$ inch thick, how many sheets should he expect?

17. A roll of carpet that contains 200 yards of carpet will cover how many rooms if each room requires $9\frac{3}{4}$ yards of carpet?

18. A box of kitty litter is $8\frac{3}{4}$ inches tall. How many boxes of kitty litter can be stored on a warehouse shelf that can accommodate boxes up to a height of 40 inches?

19. Carl Heinrich has lateral filing cabinets that need to be placed on one wall of a storage closet. The filing cabinets are each $3\frac{1}{2}$ feet wide and the wall is 21 feet long. Decide how many cabinets can be placed on the wall.

20. Each of the four walls of a room measures $18\frac{5}{8}$ feet. How much chair rail must be purchased to install the chair rail on all four walls? Disregard any openings.

21. Four office desks that are $4\frac{1}{8}$ feet long are to be placed together on a wall that is $16\frac{5}{8}$ feet long. Will they fit on the wall?

22. Ariana Pope is making 28 trophies and each requires a brass plate that is $3\frac{1}{4}$ inches long and 1 inch wide. What size sheet of brass is required to make the plates if the plates are aligned with two plates per horizontal line?

Learning Outcomes

Section 2-1

1 Identify types of fractions. (p. 36)

What to Remember with Examples

The denominator of a fraction shows how many parts make up one whole quantity. The numerator shows how many parts are being considered. A proper fraction has a value less than 1. An improper fraction has a value equal to or greater than 1.

Write the fraction illustrated by the shaded parts.

$\dfrac{3}{7}$

Identify the fraction as proper or improper.

$\dfrac{5}{8}$ proper less than 1

$\dfrac{8}{8}$ improper equal to 1

$\dfrac{11}{8}$ improper greater than 1

2 Convert an improper fraction to a whole or mixed number. (p. 37)

1. Divide the numerator of the improper fraction by the denominator.
2. Examine the remainder.
 (a) If the remainder is 0, the quotient is a whole number: The improper fraction is equivalent to this whole number.
 (b) If the remainder is not 0, the quotient is not a whole number: The improper fraction is equivalent to a mixed number. The whole-number part of this mixed number is the whole-number part of the quotient. The fraction part of the mixed number has a numerator and a denominator. The numerator is the remainder; the denominator is the divisor (the denominator of the improper fraction).

$\dfrac{150}{3}$ $3\overline{)150}$ $\;$ 50 R0 $\dfrac{150}{3} = 50;$ $\dfrac{152}{3}$ $3\overline{)152}$ $\;$ 50 R2 $\dfrac{152}{3} = 50\dfrac{2}{3}$

3 Convert a whole or mixed number to an improper fraction. (p. 38)

1. Find the numerator of the improper fraction.
 (a) Multiply the denominator of the mixed number by the whole-number part.
 (b) Add the product from step 1a to the numerator of the mixed number.
2. For the denominator of the improper fraction use the denominator of the mixed number.
3. For a whole number write the whole number as the numerator and 1 as the denominator.

$5\dfrac{5}{8} = \dfrac{(8 \times 5) + 5}{8} = \dfrac{40 + 5}{8} = \dfrac{45}{8}$ Mixed number as improper fraction

$7 = \dfrac{7}{1}$ Whole number as improper fraction

4 Reduce a fraction to lowest terms. (p. 39)

1. Inspect the numerator and denominator to find any whole number that both can be evenly divided by.
2. Divide both the numerator and the denominator by that number and inspect the new fraction to find any other number that the numerator and denominator can be evenly divided by.
3. Repeat steps 1 and 2 until 1 is the only number that the numerator and denominator can be evenly divided by.

$$\frac{12}{36} = \frac{12}{36} \div \frac{2}{2} = \frac{6}{18} \quad \text{or} \quad \frac{12}{36} \div \frac{12}{12} = \frac{1}{3}; \qquad \frac{100}{250} = \frac{100}{250} \div \frac{50}{50} = \frac{2}{5}$$

$$= \frac{6}{18} \div \frac{2}{2} = \frac{3}{9}$$

$$= \frac{3}{9} \div \frac{3}{3} = \frac{1}{3}$$

Find the greatest common divisor of two numbers.

1. Use the numerator as the original divisor and the denominator as the dividend.
2. Divide.
3. Divide the original divisor from step 2 by the remainder from step 2.
4. Divide the divisor from step 3 by the remainder from step 3.
5. Continue this division process until the remainder is 0. The last divisor is the greatest common divisor.

Find the GCD of 27 and 36.

$$\begin{array}{r} 1\ R9 \\ 27\overline{)36} \\ \underline{27} \\ 9 \end{array} \qquad \begin{array}{r} 3 \\ 9\overline{)27} \\ \underline{27} \\ 0 \end{array}$$

The GCD is 9.

Find the GCD of 28 and 15.

$$\begin{array}{r} 1\ R13 \\ 15\overline{)28} \\ \underline{15} \\ 13 \end{array} \qquad \begin{array}{r} 1\ R2 \\ 13\overline{)15} \\ \underline{13} \\ 2 \end{array} \qquad \begin{array}{r} 6\ R1 \\ 2\overline{)13} \\ \underline{12} \\ 1 \end{array} \qquad \begin{array}{r} 2 \\ 1\overline{)2} \\ \underline{2} \\ 0 \end{array}$$

The GCD is 1.

5 Raise a fraction to higher terms. (p. 40)

1. Divide the *new* denominator by the *old* denominator.
2. Multiply both the old numerator and the old denominator by the quotient from step 1.

$$\frac{3}{4} = \frac{?}{20} \qquad\qquad \frac{2}{3} = \frac{?}{60}$$

$$\begin{array}{r} 5 \\ 4\overline{)20} \end{array} \qquad\qquad \begin{array}{r} 20 \\ 3\overline{)60} \end{array}$$

$$\frac{3}{4} = \frac{3}{4} \times \frac{5}{5} = \frac{15}{20} \qquad \frac{2}{3} \times \frac{20}{20} = \frac{40}{60}$$

Section 2-2

1 Add fractions with like (common) denominators. (p. 42)

1. Find the numerator of the sum: Add the numerators of the addends.
2. Find the denominator of the sum: Use the like denominator of the addends.
3. Reduce to lowest terms and/or write as a whole or mixed number.

$$\frac{3}{5} + \frac{7}{5} + \frac{5}{5} = \frac{15}{5} = 3 \qquad\qquad \frac{82}{109} + \frac{13}{109} = \frac{95}{109}$$

2 Find the least common denominator for two or more fractions. (p. 43)

1. Write the denominators in a row and divide each one by the smallest prime number that any of the numbers can be evenly divided by.
2. Write a new row of numbers using the quotients from step 1 and any numbers in the first row that cannot be evenly divided by the first prime number.
3. Continue this process until you have a row of 1s.
4. Multiply all the prime numbers you used to divide by. The product is the least common denominator (LCD).

Find the least common denominator of $\dfrac{5}{6}, \dfrac{6}{15},$ and $\dfrac{7}{20}.$

$2\overline{)6\ \ 15\ \ 20}$
$2\overline{)3\ \ 15\ \ 10}$
$3\overline{)3\ \ 15\ \ 5}$
$5\overline{)1\ \ 5\ \ 5}$
$\ \ \ \ 1\ \ \ 1\ \ \ 1$
LCD $= 2 \times 2 \times 3 \times 5 = 60$

Find the least common denominator of $\dfrac{4}{5}, \dfrac{3}{10},$ and $\dfrac{1}{6}.$

$2\overline{)5\ \ 10\ \ 6}$
$3\overline{)5\ \ 5\ \ 3}$
$5\overline{)5\ \ 5\ \ 1}$
$\ \ \ \ 1\ \ \ 1\ \ \ 1$
LCD $= 2 \times 3 \times 5 = 30$

3 Add fractions and mixed numbers. (p. 44)

Add fractions with different denominators.

1. Find the least common denominator.
2. Change each fraction to an equivalent fraction using the least common denominator.
3. Add the new fractions with like (common) denominators.
4. Reduce to lowest terms and/or write as a whole or mixed number.

Add $\dfrac{5}{6} + \dfrac{6}{15} + \dfrac{7}{20}.$

The LCD is 60.

$\dfrac{5}{6} = \dfrac{5}{6} \times \dfrac{10}{10} = \dfrac{50}{60}$

$\dfrac{6}{15} = \dfrac{6}{15} \times \dfrac{4}{4} = \dfrac{24}{60}$

$\dfrac{7}{20} = \dfrac{7}{20} \times \dfrac{3}{3} = \dfrac{21}{60}$

$\dfrac{5}{6} + \dfrac{6}{15} + \dfrac{7}{20} = \dfrac{50}{60} + \dfrac{24}{60} + \dfrac{21}{60} =$

$\dfrac{95}{60} = \dfrac{19}{12} = 1\dfrac{7}{12}$

Add $\dfrac{4}{5} + \dfrac{3}{10} + \dfrac{1}{6}.$

The LCD is 30.

$\dfrac{4}{5} \times \dfrac{6}{6} = \dfrac{24}{30}$

$\dfrac{3}{10} \times \dfrac{3}{3} = \dfrac{9}{30}$

$\dfrac{1}{6} \times \dfrac{5}{5} = \dfrac{5}{30}$

$\dfrac{4}{5} + \dfrac{3}{10} + \dfrac{1}{6} = \dfrac{24}{30} + \dfrac{9}{30} + \dfrac{5}{30} =$

$\dfrac{38}{30} = \dfrac{19}{15} = 1\dfrac{4}{15}$

Add mixed numbers.

1. Add the whole-number parts.
2. Add the fraction parts and reduce to lowest terms.
3. Change improper fractions to whole or mixed numbers.
4. Add the whole-number parts.

Add $2\dfrac{1}{2} + 5\dfrac{2}{3} + 4.$

The LCD is 6.

$2\dfrac{1}{2} = 2\dfrac{3}{6}$

$5\dfrac{2}{3} = 5\dfrac{4}{6}$

$\dfrac{4\ \ \ \ = \ \ 4\ \ \ }{11\dfrac{7}{6}} \quad \dfrac{7}{6} = 1\dfrac{1}{6}$

$11 + 1\dfrac{1}{6} = 12\dfrac{1}{6}$

4 Subtract fractions and mixed numbers. (p. 46)

Subtract fractions with like denominators.

1. Find the numerator of the difference: Subtract the numerators of the fractions.
2. Find the denominator of the difference: Use the like denominator of the fractions.
3. Reduce to lowest terms.

Subtract fractions with different denominators.

1. Find the least common denominator.
2. Change each fraction to an equivalent fraction using the least common denominator.
3. Subtract the new fractions with like (common) denominators.
4. Reduce to lowest terms.

$$\frac{10}{81} - \frac{7}{81} = \frac{3}{81} = \frac{1}{27} \qquad \frac{7}{8} - \frac{1}{3} = \frac{21}{24} - \frac{8}{24} = \frac{13}{24}$$

Subtract mixed numbers.

1. If the fractions have different denominators, find the LCD and change the fractions to equivalent fractions using the LCD.
2. If necessary, regroup by subtracting 1 from the whole number in the minuend and add 1 (in the form of LCD/LCD) to the fraction in the minuend.
3. Subtract the fractions and the whole numbers.
4. Reduce to lowest terms.

$$
\begin{array}{rcccc}
24\frac{1}{2} & = & 24\frac{2}{4} & = & 23\frac{6}{4} \\
-11\frac{3}{4} & = & -11\frac{3}{4} & = & -11\frac{3}{4} \\
\hline
& & & & 12\frac{3}{4}
\end{array}
\qquad
\begin{array}{rcccc}
53 & = & 53\frac{0}{5} & = & 52\frac{5}{5} \\
-37\frac{4}{5} & = & -37\frac{4}{5} & = & -37\frac{4}{5} \\
\hline
& & & & 15\frac{1}{5}
\end{array}
$$

Section 2-3

1 Multiply fractions and mixed numbers. (p. 50)

Multiply fractions.

1. Find the numerator of the product: Multiply the numerators of the fractions.
2. Find the denominator of the product: Multiply the denominators of the fractions.
3. Reduce to lowest terms.

$$\frac{3}{2} \times \frac{12}{17} = \frac{36}{34} = 1\frac{2}{34} = 1\frac{1}{17}; \qquad \frac{7}{9} \times \frac{15}{28} = \frac{5}{12}$$

or

$$\frac{3}{2} \times \frac{\cancel{12}}{17} = \frac{18}{17} = 1\frac{1}{17}$$

Multiply mixed numbers and whole numbers.

1. Write the mixed numbers and whole numbers as improper fractions.
2. Reduce numerators and denominators as appropriate.
3. Multiply the fractions.
4. Reduce to lowest terms and/or write as a whole or mixed number.

$$3\frac{3}{4} \times 3\frac{2}{3} = \frac{15}{4} \times \frac{11}{3} = \frac{165}{12} = \frac{55}{4} = 13\frac{3}{4}; \qquad 5\frac{7}{8} \times 3 = \frac{47}{8} \times \frac{3}{1} = \frac{141}{8} = 17\frac{5}{8}$$

or

$$\frac{\cancel{15}}{4} \times \frac{11}{\cancel{3}} = \frac{55}{4} = 13\frac{3}{4}$$

2 Divide fractions and mixed numbers. (p. 52)

Find the reciprocal of a number.

1. Write the number as a fraction.
2. Interchange the numerator and denominator.

The reciprocal of $\frac{2}{3}$ is $\frac{3}{2}$ or $1\frac{1}{2}$.

The reciprocal of 6 is $\frac{1}{6}$. $\qquad\qquad 6 = \frac{6}{1}$.

The reciprocal of $1\frac{1}{2}$ is $\frac{2}{3}$. $\qquad\qquad 1\frac{1}{2} = \frac{3}{2}$.

Divide fractions or mixed numbers.

1. Write the numbers as fractions.
2. Find the reciprocal of the divisor.
3. Multiply the dividend by the reciprocal of the divisor.
4. Reduce to lowest terms and/or write as a whole or mixed number.

$$\frac{55}{68} \div \frac{11}{17} = \frac{55}{68} \times \frac{17}{11} = \frac{5}{4} = 1\frac{1}{4};$$

$$3\frac{1}{4} \div 1\frac{1}{2} = \frac{13}{4} \div \frac{3}{2}$$

$$= \frac{13}{4} \times \frac{2}{3} = \frac{13}{6} = 2\frac{1}{6}$$

EXERCISES SET A

1. Give five examples of fractions whose value is less than 1. What are these fractions called?

2. Give five examples of fractions whose value is greater than or equal to 1. What are these fractions called?

Write the improper fraction as a whole or mixed number.

3. $\dfrac{124}{6}$

4. $\dfrac{84}{12}$

5. $\dfrac{17}{2}$

Write the mixed number as an improper fraction.

6. $5\dfrac{5}{6}$

7. $4\dfrac{1}{3}$

8. $33\dfrac{1}{3}$

Reduce to lowest terms. Try to use the greatest common divisor.

9. $\dfrac{15}{18}$

10. $\dfrac{20}{30}$

11. $\dfrac{30}{48}$

Rewrite as a fraction with the indicated denominator.

12. $\dfrac{5}{6} = \dfrac{}{12}$

13. $\dfrac{5}{8} = \dfrac{}{32}$

14. $\dfrac{9}{11} = \dfrac{}{143}$

15. A company employed 105 people. If 15 of the employees left the company in a three-month period, what fractional part of the employees left?

Find the least common denominator for these fractions.

16. $\dfrac{1}{4}, \dfrac{1}{12}, \dfrac{11}{16}$

17. $\dfrac{5}{56}, \dfrac{7}{24}, \dfrac{7}{12}, \dfrac{5}{42}$

18. $\dfrac{2}{1}, \dfrac{1}{5}, \dfrac{1}{10}, \dfrac{5}{6}$

Add. Reduce to lowest terms and/or write as whole or mixed numbers.

19. $\dfrac{3}{5} + \dfrac{4}{5}$

20. $\dfrac{2}{5} + \dfrac{2}{3}$

21. $7\dfrac{1}{2} + 4\dfrac{3}{8}$

22. $11\dfrac{5}{6} + 8\dfrac{2}{3}$

23. Two types of fabric are needed for curtains. The lining requires $12\dfrac{3}{8}$ yards and the curtain fabric needed is $16\dfrac{5}{8}$ yards. How many yards of fabric are needed?

Subtract. Borrow when necessary. Reduce the difference to lowest terms.

24. $\dfrac{5}{12} - \dfrac{1}{4}$

25. $7\dfrac{4}{5} - 4\dfrac{1}{2}$

26. $5 - 3\dfrac{2}{5}$

27. $4\dfrac{5}{6} - 3\dfrac{1}{3}$

28. A board $3\dfrac{5}{8}$ feet long must be sawed from a 6-foot board. How long is the remaining piece?

Multiply. Reduce to lowest terms and/or write as whole or mixed numbers.

29. $\dfrac{5}{6} \times \dfrac{1}{3}$

30. $5 \times \dfrac{2}{3}$

31. $6\dfrac{2}{9} \times 4\dfrac{1}{2}$

Find the reciprocal of the numbers.

32. $\dfrac{5}{8}$

33. $\dfrac{1}{4}$

34. $3\dfrac{1}{4}$

Divide. Reduce to lowest terms and/or write as whole or mixed numbers.

35. $\dfrac{3}{4} \div \dfrac{1}{4}$

36. $7\dfrac{1}{2} \div 2$

37. $3\dfrac{1}{7} \div 5\dfrac{1}{2}$

38. A board 244 inches long is cut into pieces that are each $7\dfrac{5}{8}$ inches long. How many pieces can be cut?

39. Bill New placed a piece of $\dfrac{5}{8}$-inch plywood and a piece of $\dfrac{3}{4}$-inch plywood on top of one another to create a spacer between two two-by-fours, but the spacer was $\dfrac{1}{8}$ inch too thick. How thick should the spacer be?

40. Certain financial aid students must pass $\dfrac{2}{3}$ of their courses each term in order to continue their aid. If a student is taking 18 hours, how many hours must be passed?

41. Sol's Hardware and Appliance Store is selling electric clothes dryers for $\dfrac{1}{3}$ off the regular price of \$288. What is the sale price of the dryer?

EXERCISES SET B

Write the improper fraction as a whole or mixed number.

1. $\dfrac{52}{15}$

2. $\dfrac{83}{4}$

3. $\dfrac{77}{11}$

4. $\dfrac{19}{10}$

Write the mixed number as an improper fraction.

5. $7\dfrac{3}{8}$

6. $10\dfrac{1}{5}$

Reduce to lowest terms. Try to use the greatest common divisor.

7. $\dfrac{18}{20}$

8. $\dfrac{27}{36}$

9. $\dfrac{18}{63}$

10. $\dfrac{78}{96}$

Rewrite as a fraction with the indicated denominator.

11. $\dfrac{7}{9} = \dfrac{}{81}$

12. $\dfrac{4}{7} = \dfrac{}{49}$

13. If 8 students in a class of 30 earned grades of A, what fractional part of the class earned A's?

Find the least common denominator for these fractions.

14. $\dfrac{7}{8}, \dfrac{1}{20}, \dfrac{13}{16}$

15. $\dfrac{1}{8}, \dfrac{5}{9}, \dfrac{7}{12}, \dfrac{9}{24}$

16. $\dfrac{5}{12}, \dfrac{3}{15}$

Add. Reduce to lowest terms and/or write as whole or mixed numbers.

17. $\dfrac{7}{8} + \dfrac{1}{8}$

18. $\dfrac{1}{4} + \dfrac{11}{12} + \dfrac{7}{16}$

19. $3\dfrac{1}{4} + 2\dfrac{1}{3} + 3\dfrac{5}{6}$

20. Three pieces of lumber measure $5\dfrac{3}{8}$ feet, $7\dfrac{1}{2}$ feet, and $9\dfrac{3}{4}$ feet. What is the total length of the lumber?

Subtract. Borrow when necessary. Reduce the difference to lowest terms.

21. $\dfrac{6}{7} - \dfrac{5}{14}$

22. $4\dfrac{1}{2} - 3\dfrac{6}{7}$

23. $12 - 4\dfrac{1}{8}$

24. $4\dfrac{1}{5} - 2\dfrac{3}{10}$

25. George Mackie worked the following hours during a week: $7\dfrac{3}{4}, 5\dfrac{1}{2}, 6\dfrac{1}{4}, 9\dfrac{1}{4},$ and $8\dfrac{3}{4}$. Maxine Ford worked 40 hours. Who worked the most hours? How many more?

Multiply. Reduce to lowest terms and/or write as whole or mixed numbers.

26. $\dfrac{9}{10} \times \dfrac{3}{4}$

27. $\dfrac{3}{7} \times 8$

28. $\dfrac{9}{10} \times \dfrac{2}{5} \times \dfrac{5}{9} \times \dfrac{3}{7}$

29. $10\dfrac{1}{2} \times 1\dfrac{5}{7}$

30. After a family reunion, $10\dfrac{2}{3}$ cakes were left. If Shirley McCool took $\dfrac{3}{8}$ of these cakes, how many did she take?

Find the reciprocal of the numbers.

31. $\dfrac{2}{3}$

32. 8

33. $2\dfrac{3}{8}$

34. $5\dfrac{1}{12}$

Divide. Reduce to lowest terms and/or write as whole or mixed numbers.

35. $\dfrac{5}{6} \div \dfrac{1}{8}$

36. $15 \div \dfrac{3}{4}$

37. $7\dfrac{1}{2} \div 1\dfrac{2}{3}$

38. A stack of $1\dfrac{5}{8}$-inch plywood measures 91 inches. How many pieces of plywood are in the stack?

39. Sue Parsons has three lengths of $\dfrac{3}{4}$-inch PVC pipe: $1\dfrac{1}{5}$ feet, $2\dfrac{3}{4}$ feet, and $1\dfrac{1}{2}$ feet. What is the total length of pipe?

40. Brienne Smith must trim $2\dfrac{3}{16}$ feet from a board 8 feet long. How long will the board be after it is cut?

41. Eight boxes that are each $1\dfrac{5}{8}$ feet high are stacked. Find the height of the stack.

PRACTICE TEST

Write the reciprocal.

1. 5

2. $\dfrac{3}{5}$

3. $1\dfrac{3}{5}$

Reduce.

4. $\dfrac{12}{15}$

5. $\dfrac{15}{35}$

6. $\dfrac{21}{51}$

Write as an improper fraction.

7. $2\dfrac{5}{8}$

8. $3\dfrac{1}{12}$

Write as a mixed number or whole number.

9. $\dfrac{21}{9}$

10. $\dfrac{56}{13}$

Perform the indicated operation. Reduce results to lowest terms and/or write as whole or mixed numbers.

11. $\dfrac{5}{6} - \dfrac{4}{6}$

12. $\dfrac{5}{8} + \dfrac{9}{10}$

13. $\dfrac{5}{8} \times \dfrac{7}{10}$

14. $\dfrac{5}{6} \div \dfrac{3}{4}$

15. $10\frac{1}{2} \div 5\frac{3}{4}$

16. $56 \times 32\frac{6}{7}$

17. $2\frac{1}{2} + 3\frac{1}{3}$

18. $137 - 89\frac{4}{5}$

19. Dale Burton ordered $\frac{3}{4}$ truckload of merchandise. If approximately $\frac{1}{3}$ of the $\frac{3}{4}$ truckload of merchandise has been unloaded, how much remains to be unloaded?

20. A company that employs 580 people expects to lay off 87 workers. What fractional part of the workers are expected to be laid off?

21. Wallboard measuring $\frac{5}{8}$ inch thick makes a stack $62\frac{1}{2}$ inches high. How many sheets of wallboard are there?

22. If city sales tax is $5\frac{1}{2}\%$ and state sales tax is $2\frac{1}{4}\%$, what is the total sales tax rate for purchases made in the city?

1. What two operations require a common denominator?

2. What number can be written as any fraction that has the same numerator and denominator? Give an example of a fraction that equals the number.

3. What is the product of any number and its reciprocal? Give an example to illustrate your answer.

4. What operation requires the use of the reciprocal of a fraction? Write an example of this operation and perform the operation.

5. What operations must be used to solve an applied problem if all of the parts but one are given and the total of all the parts is given? Write an example.

6. What steps must be followed to find the reciprocal of a mixed number? Give an example of a mixed number and its reciprocal.

7. Under what conditions are two fractions equal? Give an example to illustrate your answer.

8. Write three examples of dividing a whole number by a proper fraction.

9. Explain why the quotient of a whole number and a proper fraction is *more* than the whole number.

10. Explain the difference between a proper fraction and an improper fraction.

Challenge Problem

A room is $25\frac{1}{2}$ feet by $32\frac{3}{4}$ feet. How much will it cost to cover the floor with carpet costing $12 a square yard (9 square feet), if 4 extra square yards are needed for matching? If a portion of a square yard is needed, an entire square yard must be purchased.

CASE STUDIES

2.1 Bitsie's Pastry Sensations

It was the grand opening of Elizabeth's pastry business, and she wanted to make something extra special. As a tribute to her Grandma Gertrude—who had helped pay for culinary school (and incidentally nicknamed her Bitsie), she had decided to make her grandmother's favorite recipe, apple crisp. Although she thought she remembered the recipe by heart, she decided she had better write it down just to make sure.

Apple Crisp

4 cups tart apples Peel, core, and slice.

$\frac{1}{2}$ cup brown sugar

$\frac{1}{2}$ tsp ground cinnamon Add to apples and mix.

$\frac{1}{4}$ tsp ground nutmeg Pour into a buttered 9×13-inch

$\frac{1}{4}$ tsp ground cloves glass baking dish.

2 tsp lemon juice

$\frac{2}{3}$ cup granulated sugar

$\frac{1}{8}$ tsp salt Blend until crumbly.

$\frac{3}{4}$ cup unbleached white flour

$\frac{1}{3}$ cup butter

$\frac{1}{4}$ cup chopped walnuts, pecans, or raisins Add to the sugar/flour mixture
 and sprinkle over apples.

Heat oven to 375°F. Bake until topping is golden brown and apples are tender, approximately 30 minutes.

1. Elizabeth planned to make 6 pans of apple crisp for the day, using extra tart granny smith apples—just like her grandmother had. But after peeling, coring, and slicing she had a major problem: she only had 10 cups of apple slices. It was getting late and she needed to get some pans of apple crisp into the oven. She knew that 10 cups of apples was $2\frac{1}{2}$ times as much as the 4 cups she needed, so she decided to use multiplication to figure out $2\frac{1}{2}$ batches. Based on her hasty decision, how much of each ingredient will she need?

2. After looking at her math, Elizabeth realized her mistake. She didn't have a pan that she could use for half a batch, and her math seemed too complicated anyway. She decided she would just make a double batch for now, because then she wouldn't need to multiply. Using addition, how much of each ingredient would she need for a double batch?

3. The two pans of apple crisp were just starting to brown when Elizabeth returned from the store with more apples. But instead of tart apples, the store had only honey crisp, a much sweeter variety. After preparing 14 more cups of apples, she could make 3 batches using the honey crisp (12 cups) and the fourth and final batch using both kinds of apples. Her concern, though, was the sweetness of the apples. For the batches using the honey crisp only, if the brown sugar and granulated sugar were reduced by $\frac{1}{2}$, how much sugar should she use for each batch? How much for all 3 batches?

2.2 Atlantic Candy Company

Tom always loved the salt water taffy his parents bought while on summer vacations at the beach. His fond memories probably had something to do with his accepting a job with the Atlantic Candy Company as a marketing manager. Among other things, his new job involves assessing the mix of flavors in a box of taffy. He remembers saving the orange and green with red pieces for last because they were his favorites; however, the company has recent market research that shows that his favorite flavors are not the most popular flavors with most other people. Milk chocolate, dark chocolate, and chocolate mint are the most popular flavors, followed by peppermint and licorice. Tom knows that most 1-lb boxes of Atlantic Candy Company taffy containing 64 pieces include 4 green with red pieces, 3 white with red peppermint pieces, 3 white with green peppermint pieces, 3 milk chocolate pieces with white and pink bull's-eye centers, 2 milk chocolate with green peppermint pieces, 7 white pieces, 12 dark chocolate pieces, 9 orange pieces, 15 milk chocolate pieces, and 6 licorice pieces.

1. What fraction of the pieces of taffy have chocolate in them? What fraction of the pieces are Tom's favorite orange and green with red?

2. Does the Atlantic Candy Company assortment need to be adjusted to match the most people's taste preference better if the top five choices are considered? What fraction of the pieces in the Atlantic Candy Company 1-lb box are chocolate, peppermint, and licorice? Hint: If a piece falls in two categories, count it only once.

3. Based on the market research, Tom thinks it would be profitable to sell an assortment box that has double-size pieces of taffy in chocolate and peppermint in a special holiday gift box. If they use a $\frac{1}{2}$-lb box how many pieces should they include? (1 lb = 64 regular-size pieces)

4. If they produce another $\frac{1}{2}$-lb. box containing an equal number of double-size milk chocolate taffy, chocolate-mint taffy, and peppermint taffy, how many pieces of each flavor will there be in this special gift box?

Shaun White: Snowboarding

Shaun White scored 46.8 out of 50 to win the gold medal in the men's halfpipe in the 2006 Winter Olympics. Halfpipe is an aerial thrill show where snowboarders launch themselves more than 20 feet into the air, and spin, twist, and turn in ways that don't seem possible. The success of snowboarding is due largely to the success of skateboarding, which started with no rules and no judges. Now one of the hottest winter sports, it is scored by a point system and has required moves and degrees of difficulty. In the 2006 Games, there were five judges for overall impressions, and runs were scored according to the execution of tricks, variety of tricks, difficulty, pipe use, and amplitude (height). A 50 is a perfect score, and as little as 0.1 could keep competitors off the medal stand.

White has also participated in the Winter X Games, where he has medaled every year since 2002. Including all Winter X Games through 2007, his medal count stands at 10 (6 gold, 3 silver, 1 bronze). White is 5′ 8.5″ (1.73 m) tall, and weighs 140 lb (63.5 kg). He is also known as "The Flying Tomato" because of his mop of red hair.

Success hasn't always come easily to Shaun. He missed qualifying for the 2002 Olympics by only three-tenths of a point (0.3), and then had to watch as the Americans swept the halfpipe event. White made the 2006 U.S. Olympic snowboard team, but on his first of two qualifying runs, he fell during a landing, scoring just 37.7. The maximum deduction for a fall was 20% of the total score. So how much did Shaun's fall cost him? Only the judges knew for sure, but what decimal would you use to calculate the maximum deduction? Would you multiply, or would it be easier to divide?

One thing was certain, Shaun was in seventh place, 1.7 points behind the nearest competitor, and only the top six would advance to the finals. On his second (and final) qualifying run, White had to go big or go home. White soared, nailing his second qualifier and scoring 45.3 out of a possible 50 points, the best score in the field. The rest, of course, is history.

LEARNING OUTCOMES

3-1 Decimals and the Place-Value System
1. Read and write decimals.
2. Round decimals.

3-2 Operations with Decimals
1. Add and subtract decimals.
2. Multiply decimals.
3. Divide decimals.

3-3 Decimal and Fraction Conversions
1. Convert a decimal to a fraction.
2. Convert a fraction to a decimal.

LEARNING OUTCOMES

1 Read and write decimals.
2 Round decimals.

Decimals are another way to write fractions. We use decimals in some form or another every day—even our money system is based on decimals. Calculators use decimals, and decimals are the basis of percentages, interest, markups, and markdowns.

1 Read and write decimals.

Decimal system: a place-value number system based on 10.

Our money system, which is based on the dollar, uses the **decimal system**. In the decimal system, as you move right to left from one digit to the next, the place value of the digit increases by 10 times (multiply by 10). As you move left to right from one digit to the next, the place value of the digit gets 10 times smaller (divide by 10). The place value of the digit to the right of the ones place is 1 divided by 10.

There are several ways of indicating 1 divided by 10. In the decimal system, we write 1 divided by 10 as 0.1.

FIGURE 3-1
**1 whole divided into 10 parts.
The shaded part is 0.1.**

Decimal point: the notation that separates the whole-number part of a number from the decimal part.

Whole-number part: the digits to the left of the decimal point.

Decimal part: the digits to the right of the decimal point.

How much is 0.1? How much is 1 divided by 10? It is one part of a 10-part whole (Figure 3-1). We read 0.1 as one-tenth. Using decimal notation, we can extend our place-value chart to the right of the ones place and express quantities that are not whole numbers. When extending to the right of the ones place, a period called a **decimal point** separates the **whole-number part** from the **decimal part**.

The names of the places to the right of the decimal are tenths, hundredths, thousandths, and so on. These place names are similar to the place names for whole numbers, but they all end in *ths*. In Figure 3-2, we show the place names for the digits in the number 2,315.627432.

Millions			Thousands			Units				Tenths 0.1	Hundredths 0.01	Thousandths 0.001	Ten-thousandths 0.0001	Hundred-thousandths 0.00001	Millionths 0.000001	Ten-millionths 0.0000001	Hundred-millionths 0.00000001
Hundred millions (100,000,000)	Ten millions (10,000,000)	Millions (1,000,000)	Hundred thousands (100,000)	Ten thousands (10,000)	Thousands (1,000)	Hundreds (100)	Tens (10)	Ones (1)	Decimal point								
					2	3	1	5	.	6	2	7	4	3	2		

FIGURE 3-2
Place-Value Chart for Decimals

HOW TO	**Read or write a decimal**
	Read 3.12.
1. Read or write the whole-number part (to the left of the decimal point) as you would read or write a whole number.	Three
2. Use the word *and* for the decimal point.	and
3. Read or write the decimal part (to the right of the decimal point) as you would read or write a whole number.	twelve
4. Read or write the place name of the rightmost digit.	hundredths

EXAMPLE 1

Write the word name for these decimals: (a) 3.6, (b) 0.209, (c) $234.93.

(a) three and six-tenths

(b) two hundred nine thousandths

(c) two hundred thirty-four dollars and ninety-three cents

3 is the whole-number part. 6 is the decimal part.

The whole-number part, 0, is not written.

The whole-number part is dollars. The decimal part is cents.

TIP

Informal Use of the Word *Point*

Informally, the decimal point is sometimes read as *point*. Thus, 3.6 is read *three point six*. The decimal 0.209 can be read as *zero point two zero nine*. This informal process is often used in communication to ensure that numbers are not miscommunicated. However, without hearing the place value, it is more difficult to get a sense of the size of the number.

TIP

Reading Decimals as Money Amounts

When reading decimal numbers that represent money amounts:

Read whole numbers as *dollars*.

Decimal amounts are read as *cents*. In the number $234.93, the decimal part is read ninety-three *cents* rather than ninety-three *hundredths of a dollar*. Since 1 cent is one hundredth of a dollar, the words *cent* and *hundredth* have the same meaning.

 STOP AND CHECK

1. Write 5.8 in words.

2. Write 0.721 in words.

3. Write $38.15 in words.

4. Write four hundred thirty-four and seventy-six hundredths as a number.

5. Write three thousand five hundred forty-eight ten-thousandths as a number.

6. Write four dollars and eighty-seven cents as a number.

2 Round decimals.

As with whole numbers, we often need only an approximate amount. The process for rounding decimals is similar to rounding whole numbers.

HOW TO Round to a specified decimal place

	Round to hundredths:
1. Find the digit in the specified place.	17.3754
2. Look at the next digit to the right.	17.3754
	17.3754
(a) If this digit is less than 5, eliminate it and all digits to its right.	
(b) If this digit is 5 or more, add 1 to the digit in the specified place, and eliminate all digits to its right.	17.38

 STOP AND CHECK

1. Round 14.342 to the nearest tenth.

2. Round 48.7965 to the nearest hundredth.

3. Round $768.57 to the nearest dollar.

4. Round $54.834 to the nearest cent.

3-1 SECTION EXERCISES

SKILL BUILDERS

Write the word name for the decimal.

1. 0.582

2. 0.21

3. 1.0009

4. 2.83

5. 782.07

Write the number that represents the decimal.

6. Thirty-five hundredths

7. Three hundred twelve thousandths

8. Sixty and twenty-eight thousandths

9. Five and three hundredths

Round to the nearest dollar.

10. $493.91

11. $785.03

12. $19.80

Round to the nearest cent.

13. $0.5239

14. $21.09734

15. $32,048.87219

Round to the nearest tenth.

16. 42.3784

17. 17.03752

18. 4.293

APPLICATIONS

19. Tel-Sales, Inc., a prepaid phone card company in Oklahoma City, sells phone cards for $19.89. Write the card cost in words.

20. Destiny Telecom of Oakland, California introduced a Braille prepaid phone card that costs fourteen dollars and seventy cents. Write the digits to show Destiny's sales figure.

3-2 OPERATIONS WITH DECIMALS

LEARNING OUTCOMES

1 Add and subtract decimals.
2 Multiply decimals.
3 Divide decimals.

1 Add and subtract decimals.

Some math skills are used more often than others. Adding and subtracting decimal numbers are regularly used in transactions involving money. To increase your awareness of the use of decimals, refer to your paycheck stub, grocery store receipt, fast-food ticket, odometer on your car, bills you receive each month, and checking account statement balance.

HOW TO Add or subtract decimals

1. Write the numbers in a vertical column, aligning digits according to their places.
2. Attach extra zeros to the right end of each number so that each number has the same quantity of digits to the right of the decimal point. It is also acceptable to assume blank places to be zero.
3. Add or subtract as though the numbers are whole numbers.
4. Place the decimal point in the sum or difference to align with the decimal point in the addends or subtrahend and minuend.

Add 32 + 2.55 + 8.85 + 0.625.

$$
\begin{array}{r}
32 \\
2.55 \\
8.85 \\
\underline{0.625} \\
44.025
\end{array}
$$

TIP

Unwritten Decimals

When we write whole numbers using numerals, we usually omit the decimal point; the decimal point is understood to be at the end of the whole number. Therefore, any whole number, such as 32, can be written without a decimal (32) or with a decimal (32.).

TIP

Aligning Decimals in Addition or Subtraction

A common mistake in adding decimals is to misalign the digits or decimal points.

32	All digits and decimal	32 ← not aligned correctly
2.55	points are aligned	2.55
8.85	correctly.	8.85
0.625		0.625 ← not aligned correctly
44.025		1.797
CORRECT		**INCORRECT**

EXAMPLE 1 Subtract 26.3 − 15.84.

$$\begin{array}{r} \overset{5\ 12\ 10}{26.3\ 0} \\ -\ 15.8\ 4 \\ \hline 10.4\ 6 \end{array}$$

Write the numbers so that the digits align according to their places. Subtract the numbers, regrouping as you would in whole-number subtraction.

The difference of 26.3 and 15.84 is 10.46.

✓ STOP AND CHECK

1. Add: 67 + 4.38 + 0.291

2. Add: 57.5 + 13.4 + 5.238

3. Subtract: 17.53 − 12.17

4. Subtract: 542.83 − 219.593

5. Garza Humada purchased a shirt for $18.97 and paid with a $20 bill. What was his change?

6. The stock of FedEx Corporation had a high for the day of $120.01, a low of $95.79, and it closed at $117.58. By how much did the stock price change during the day?

2 Multiply decimals.

Suppose you want to calculate the amount of tip to add to a restaurant bill. A typical tip in the United States is 20 cents per dollar, which is 0.20 or 0.2 per dollar. To calculate the tip on a bill of $28.73 we multiply 28.73 × 0.2.

We multiply decimals as though they are whole numbers. Then we place the decimal point according to the quantity of digits in the decimal parts of the factors.

HOW TO Multiply decimals

1. Multiply the decimal numbers as though they are whole numbers.
2. Count the digits in the decimal parts of both decimal numbers.
3. Place the decimal point in the product so that there are as many digits in its decimal part as there are digits you counted in step 2. If necessary, attach zeros on the left end of the product so that you can place the decimal point accurately.

Multiply 3.5 × 0.3

$$\begin{array}{r} 3.5 \quad \text{one place} \\ \times\ 0.3 \quad \text{one place} \\ \hline 1.0\ 5 \quad \text{two places} \end{array}$$

EXAMPLE 1 Multiply 2.35 × 0.015.

$$\begin{array}{r} 2.35 \quad \text{two decimal places} \\ \times\ 0.015 \quad \text{three decimal places} \\ \hline 1175 \\ 235 \\ \hline 0.03525 \quad \text{five decimal places.} \end{array}$$

One 0 is attached on the left to accurately place the decimal point.

The product of 2.35 and 0.015 is 0.03525.

HOW TO — Multiply by place-value numbers such as 10, 100, and 1,000.

1. Determine the number of zeros in the multiplier.
2. Move the decimal in the multiplicand to the right the same number of places as there are zeros in the multiplier. Insert zeros as necessary.

EXAMPLE 2

Multiply 36.56 by (a) 10, (b) 100, and (c) 1,000.

(a) $36.56(10) = 365.6$ Move the decimal one place to the right.

(b) $36.56(100) = 3,656$ Move the decimal two places to the right.

(c) $36.56(1,000) = 36,560$ Move the decimal three places to the right. Insert a zero to have enough places.

EXAMPLE 3

Find the amount of tip you would pay on a restaurant bill of $28.73 if you tip 20 cents on the dollar (0.20, or 0.2) for the bill.

What You Know	What You Are Looking For	Solution Plan
Restaurant bill: $28.73 Rate of tip: 0.2 (20 cents on the dollar) of the bill	Amount of tip	Amount of tip = restaurant bill × rate of tip Amount of tip = 28.73 × 0.2

Solution

$28.73 \boxed{\times} .2 \boxed{=} \Rightarrow 5.746$ Round to the nearest cent.

Conclusion

The tip is $5.75 when rounded to the nearest cent.

 ## STOP AND CHECK

Multiply.

1. 4.35×0.27

2. 7.03×0.035

3. 5.32×15

4. $\$8.31 \times 4$

5. A dinner for 500 guests costs $27.42 per person. What is the total cost of the dinner?

6. Tromane Mohaned purchased 1,000 shares of IBM stock at a price of $94.05. How much did the stock cost?

3 Divide decimals.

Division of decimals has many uses in the business world. A common use is to determine how much one item costs if the cost of several items is known. Also, to compare the best buy of similar products that are packaged differently, we find the cost per common unit. A 12-ounce package and a 1-pound package of bacon can be compared by finding the cost per ounce of each package.

HOW TO Divide a decimal by a whole number

Divide 95.2 by 14.

$$14\overline{)95.2}$$

1. Place a decimal point for the quotient directly above the decimal point in the dividend.
2. Divide as though the decimal numbers are whole numbers.
3. If the division does not come out evenly, attach zeros as necessary and carry the division one place past the desired place of the quotient.
4. Round to the desired place.

$$
\begin{array}{r}
6.8 \\
14\overline{)95.2} \\
84 \\
\hline
11\ 2 \\
11\ 2 \\
\hline
\end{array}
$$

EXAMPLE 1 Divide 5.95 by 17.

$$
\begin{array}{r}
0.35 \\
17\overline{)5.95} \\
5\ 1 \\
\hline
85 \\
85 \\
\hline
\end{array}
$$

Place a decimal point for the quotient directly above the decimal point in the dividend.

The quotient of 5.95 and 17 is 0.35.

EXAMPLE 2 Find the quotient of 37.4 ÷ 24 to the nearest hundredth.

$$
\begin{array}{r}
1.558 \\
24\overline{)37.400} \\
24 \\
\hline
13\ 4 \\
12\ 0 \\
\hline
1\ 40 \\
1\ 20 \\
\hline
200 \\
192 \\
\hline
8
\end{array}
$$

rounds to 1.56

Carry the division to the thousandths place, and then round to hundredths. Attach two zeros to the right of 4.

The quotient is 1.56 to the nearest hundredth.

HOW TO Divide by place-value numbers such as 10, 100, and 1,000.

1. Determine the number of zeros in the divisor.
2. Move the decimal in the dividend to the left the same number of places as there are zeros in the divisor. Insert zeros as necessary.

EXAMPLE 3 Divide 23.71 by (a) 10, (b) 100, and (c) 1,000.

(a) 23.71 ÷ 10 = 2.371

Move the decimal one place to the left.

(b) 23.71 ÷ 100 = 0.2371

Move the decimal two places to the left. It is preferred to write a zero in front of the decimal point.

(c) 23.71 ÷ 1,000 = 0.02371

Move the decimal three places to the left. Insert zeros to have enough places.

If the divisor is a decimal rather than a whole number, we make use of an important fact: Multiplying both the divisor and the dividend by the same factor does not change the quotient. We can see this by writing a division as a fraction.

$$10 \div 5 = \frac{10}{5} = 2$$

$$\frac{10}{5} \times \frac{10}{10} = \frac{100}{50} = 2$$

$$\frac{100}{50} \times \frac{10}{10} = \frac{1,000}{500} = 2$$

We've multiplied both the divisor and the dividend by a factor of 10, and then by a factor of 10 again. The quotient is always 2.

HOW TO Divide by a decimal

1. Change the divisor to a whole number by moving the decimal point to the right, counting the places as you go. Use a caret (∧) to show the new position of the decimal point.
2. Move the decimal point in the dividend to the right as many places as you moved the decimal point in the divisor.
3. Place the decimal point for the quotient directly above the *new* decimal point in the dividend.
4. Divide as you would divide by a whole number.

Divide 3.4776 by 0.72.

$$0.72_\wedge \overline{)3.4776}$$

$$0.72_\wedge \overline{)3.47_\wedge 76}$$

$$0.72_\wedge \overline{)3.47_\wedge 76}^{\,\cdot}$$

$$
\begin{array}{r}
4.83 \\
0.72_\wedge \overline{)3.47_\wedge 76} \\
2\,88 \\
\hline
59\ 7 \\
57\ 6 \\
\hline
2\ 16 \\
2\ 16 \\
\hline
\end{array}
$$

EXAMPLE 4 Find the quotient of 59.9 ÷ 0.39 to the nearest hundredth.

$$0.39\overline{)59.90} \qquad 39_\wedge\overline{)5,990_\wedge}$$

Move the decimal point two places to the right in both the divisor and the dividend.

$$39\overline{)5,990_\wedge}^{\,\cdot}$$

Place the decimal point for the quotient directly above the new decimal point in the dividend.

$$
\begin{array}{r}
153.589 \\
39\overline{)5,990.000} \\
3\ 9 \\
\hline
2\ 09 \\
1\ 95 \\
\hline
140 \\
117 \\
\hline
23\ 0 \\
19\ 5 \\
\hline
3\ 50 \\
3\ 12 \\
\hline
380 \\
351 \\
\hline
29
\end{array}
$$

≈153.59 (rounded)

Divide, carrying out the division to the thousandths place. Add three zeros to the right of the decimal point.

The quotient is 153.59 to the nearest hundredth.

TIP

Symbol for Approximate Number
When numbers are rounded they become approximate numbers. A symbol that is often used to show approximate numbers is ≈.

EXAMPLE 5 Alicia Toliver is comparing the price of bacon to find the better buy. A 12-oz package costs $2.49 and a 16-oz package costs $2.99. Which package has the cheapest cost per ounce (often called **unit price**)?

Unit price or unit cost: price for 1 unit of a product.

What You Know	What You Are Looking For	Solution Plan
Price for 12-oz package = $2.49	Cost per ounce for each package	Price per ounce = $\dfrac{\text{Cost of 12-oz package}}{12}$
Price for 16-oz package = $2.99	Which package has the cheaper price per ounce?	Price per ounce = $\dfrac{\text{Cost of 16-oz package}}{16}$ Compare the prices per ounce

Solution

Price per ounce = 2.49 ÷ 12 = ⟹ 0.2075 12-oz package

Price per ounce = 2.99 ÷ 16 = ⟹ 0.186875 16-oz package

Rounding to the nearest cent, $0.2075 rounds to $0.21 and $0.186875 rounds to $0.19.

$0.19 is less than $0.21.

Conclusion

The 16-oz package of bacon has the cheaper unit price.

 STOP AND CHECK

Divide.

1. 100.80 ÷ 15

2. 358.26 ÷ 21

3. Round to tenths: 12.97 ÷ 3.8

4. Round to hundredths: 103.07 ÷ 5.9

5. Gwen Hilton's gross weekly pay is $716.32 and her hourly pay is $19.36. How many hours did she work in the week?

6. *The Denver Post* reported that Wal-Mart would sell 42-inch Hitachi plasma televisions in a 4-day online special for $1,198 each. If Wal-Mart had paid $648,000,000 for a million units, how much did each unit cost Wal-Mart?

3-2 SECTION EXERCISES

SKILL BUILDERS

Add.

1. 6.005 + 0.03 + 924 + 3.9

2. 82 + 5,000.1 + 101.703

3. $21.13 + $42.78 + $16.39

4. $203.87 + $1,986.65 + $3,047.38

Subtract.

5. 407.96 − 298.39

6. 500.7 from 8,097.125

7. $468.39 − $223.54

8. $21.65 − $15.96

9. $52,982.97 − $45,712.49

10. $38,517 − $21,837.46

Multiply.

11. 19.7
 × 4

12. 0.0321 × 10

13. 73.7 × 0.02

14. 43.7 × 1.23

15. 5.03 × 0.073

16. 642 × $12.98

Divide and round to the nearest hundredth if necessary.

17. 123.72 ÷ 12

18. $35\overline{)589.06}$

19. $0.35\overline{)0.0084}$

20. 1,482.97 ÷ 1.7

APPLICATIONS

21. Kathy Mowers purchased items costing $14.97, $28.14, $19.52, and $23.18. How much do her purchases total?

22. Jim Roznowski submitted a travel claim for meals, $138.42; hotel, $549.78; and airfare, $381.50. Total his expenses.

23. Joe Gallegos purchased a calculator for $12.48 and paid with a $20 bill. How much change did he get?

24. Martisha Jones purchased a jacket for $49.95 and a shirt for $18.50. She paid with a $100 bill. How much change did she receive?

25. Laura Voight earns $8.43 per hour as a telemarketing employee. One week she worked 28 hours. What was her gross pay before any deductions?

26. Cassie James works a 26-hour week at a part-time job while attending classes at Southwest Tennessee Community College. Her weekly gross pay is $213.46. What is her hourly rate of pay?

27. Calculate the cost of 1,000 gallons of gasoline if it costs $1.47 per gallon.

28. A buyer purchased 2,000 umbrellas for $4.62 each. What is the total cost?

29. All the employees in your department are splitting the cost of a celebratory lunch, catered at a cost of $142.14. If your department has 23 employees, will each employee be able to pay an equal share? How should the catering cost be divided?

30. BP Oil offers a prepaid phone card for $5. The card provides 20 minutes of long-distance phone service. Find the cost per minute.

3-3 DECIMAL AND FRACTION CONVERSIONS

LEARNING OUTCOMES

1 Convert a decimal to a fraction.
2 Convert a fraction to a decimal.

1 Convert a decimal to a fraction.

Decimals represent parts of a whole, just as fractions can. We can write a decimal as a fraction, or a fraction as a decimal.

HOW TO	Convert a decimal to a fraction
	Write 0.8 as a fraction.
1. Find the denominator: Write 1 followed by as many zeros as there are places to the right of the decimal point.	Denominator = 10
2. Find the numerator: Use the digits without the decimal point.	$\dfrac{8}{10}$
3. Reduce to lowest terms and/or write as a whole or mixed number.	$\dfrac{4}{5}$

EXAMPLE 1 Change 0.38 to a fraction.

$$0.38 = \frac{38}{100}$$

The digits without the decimal point form the numerator.

There are two places to the right of the decimal point, so the denominator is 1 followed by two zeros.

$$\frac{38}{100} = \frac{19}{50}$$

Reduce the fraction to lowest terms.

0.38 written as a fraction is $\frac{19}{50}$.

EXAMPLE 2 Change 2.43 to a mixed number.

$$2.43 = 2\frac{43}{100}$$

The whole-number part of the decimal stays as the whole-number part of the mixed number.

2.43 is $2\frac{43}{100}$ as a mixed number.

TIP

Relate the Number of Decimal Places and the Zeros in the Denominator to the Place Value

The number of places after the decimal point indicates the number of zeros in the denominator of the power of 10.

$$0.8 = \frac{8}{10} \qquad 0.38 = \frac{38}{100} \qquad 2.43 = 2\frac{43}{100}$$

Note that the number after the decimal point indicates the numerator of the fraction.

 STOP AND CHECK

Write as a fraction or mixed number, and write in simplest form.

1. 0.7 **2.** 0.32 **3.** 2.087 **4.** 23.41 **5.** 0.07

2 Convert a fraction to a decimal.

Fractions indicate division. Therefore, to write a fraction as a decimal, divide the numerator by the denominator, as you would divide decimals.

HOW TO Write a fraction as a decimal

1. Write the numerator as the dividend and the denominator as the divisor.
2. Divide the numerator by the denominator. Carry the division as many decimal places as necessary or desirable.
3. For repeating decimals:
 (a) Write the remainder as the numerator of a fraction and the divisor as the denominator.
 or
 (b) Carry the division one place past the desired place and round.

EXAMPLE 1 Change $\frac{1}{4}$ to a decimal number.

$$\begin{array}{r} 0.25 \\ 4\overline{)1.00} \\ \underline{8} \\ 20 \\ \underline{20} \end{array}$$

Divide the numerator by the denominator, adding zeros to the right of the decimal point as needed.

The decimal equivalent of $\frac{1}{4}$ is 0.25.

Terminating decimal: a quotient that has no remainder.

Nonterminating or repeating decimal: a quotient that never comes out evenly. The digits will eventually start to repeat.

When the division comes out even (there is no remainder), we say the division terminates, and the quotient is called a **terminating decimal**. If, however, the division *never* comes out even (there is always a remainder), we call the number a **nonterminating** or **repeating decimal**. If the quotient is a repeating decimal, either write the remainder as a fraction or round to a specified place.

EXAMPLE 2 Write $\frac{2}{3}$ as a decimal number in hundredths (a) with the remainder expressed as a fraction and (b) with the decimal rounded to hundredths.

(a)
$$3\overline{)2.00} \quad 0.66\frac{2}{3}$$
$$\underline{1\,8}$$
$$20$$
$$\underline{18}$$
$$2$$

(b)
$$3\overline{)2.000} \quad 0.666 \approx 0.67$$
$$\underline{1\,8}$$
$$20$$
$$\underline{18}$$
$$20$$
$$\underline{18}$$
$$2$$

$\frac{2}{3} = 0.66\frac{2}{3}$ **or** $\frac{2}{3} \approx 0.67$.

EXAMPLE 3 Write $3\frac{1}{4}$ as a decimal.

$$3\frac{1}{4} = 3.25$$

The whole-number part of the mixed number stays as the whole-number part of the decimal number.

$3\frac{1}{4}$ **is 3.25 as a decimal number.**

 STOP AND CHECK

Change to decimal numbers. Round to hundredths if necessary.

1. $\frac{3}{5}$ **2.** $\frac{7}{8}$ **3.** $\frac{5}{12}$ **4.** $7\frac{4}{5}$ **5.** $8\frac{4}{7}$

3-3 SECTION EXERCISES

SKILL BUILDERS

Write as a fraction or mixed number and write in simplest form.

1. 0.6 **2.** 0.58 **3.** 0.625

4. 0.1875 **5.** 7.3125 **6.** 28.875

Change to a decimal. Round to hundredths if necessary.

7. $\dfrac{7}{10}$

8. $\dfrac{3}{8}$

9. $\dfrac{7}{12}$

10. $\dfrac{7}{16}$

11. $2\dfrac{1}{8}$

12. $21\dfrac{11}{12}$

Learning Outcomes

What to Remember with Examples

Section 3-1

1 Read and write decimals. (p. 74)

Read or write a decimal.

1. Read or write the whole number part (to the left of the decimal point) as you would read or write a whole number.
2. Use the word *and* for the decimal point.
3. Read or write the decimal part (to the right of the decimal point) as you would read or write a whole number.
4. Name the place of the rightmost digit.

0.3869 is read *three thousand, eight-hundred sixty-nine ten-thousandths.*

2 Round decimals. (p. 75)

Round to a specified decimal place.

1. Find the digit in the specified place.
2. Look at the next digit to the right.
 (a) If this digit is less than 5, eliminate it and all digits to its right.
 (b) If this digit is 5 or more, add 1 to the digit in the specified place, and eliminate all digits to its right.

37.357 rounded to the nearest tenth is 37.4.
3.4819 rounded to the first digit is 3.

Section 3-2

1 Add and subtract decimals. (p. 77)

1. Write the numbers in a vertical column, aligning digits according to their places.
2. Attach extra zeros to the right end of each decimal number so that each number has the same quantity of digits to the right of the decimal point (optional).
3. Add or subtract as though the numbers are whole numbers.
4. Place the decimal point in the sum or difference to align with the decimal point in the addends or subtrahend and minuend.

Add: 32.68 + 3.31 + 49

$$
\begin{array}{r}
32.68 \\
3.31 \\
+\ 49. \\
\hline
84.99
\end{array}
$$

Subtract: 24.7 − 18.25

$$
\begin{array}{r}
24.70 \\
-18.25 \\
\hline
6.45
\end{array}
$$

2 Multiply decimals. (p. 78)

Multiply decimals.

1. Multiply the decimal numbers as though they are whole numbers.
2. Count the digits in the decimal parts of both decimal numbers.
3. Place the decimal point in the product so that there are as many digits in its decimal part as there are digits you counted in step 2. If necessary, attach zeros on the left end of the product so that you can place the decimal point accurately.

Multiply: 36.48 × 2.52

$$
\begin{array}{r}
36.48 \\
\times\ 2.52 \\
\hline
72\,96 \\
18\,24\,0 \\
72\,96 \\
\hline
91.92\,96
\end{array}
$$

Multiply: 2.03 × 0.036

$$
\begin{array}{r}
2.03 \\
\times\ 0.0\,36 \\
\hline
1\,2\,18 \\
6\,0\,9 \\
\hline
0.07\,3\,08
\end{array}
$$

Multiply by place-value numbers such as 10, 100, and 1,000.

1. Determine the number of zeros in the multiplier.
2. Move the decimal in the multiplicand to the right the same number of places as there are zeros in the multiplier.

Multiply: 4.52(1,000)

4.52(1,000) = 4,520 Move the decimal three places to the right. Insert a zero to have enough places.

3 Divide decimals. (p. 80)

Divide a decimal by a whole number.

1. Place a decimal point for the quotient directly above the decimal point in the dividend.
2. Divide as though the decimal numbers are whole numbers.
3. If the division does not come out even, attach zeros as necessary and carry the division one place past the desired place of the quotient.
4. Round to the desired place.

Divide: 58.5 ÷ 45

$$\begin{array}{r} 1.3 \\ 45\overline{)58.5} \\ 45 \\ \hline 13\,5 \\ 13\,5 \\ \hline \end{array}$$

Divide by place-value numbers such as 10, 100, and 1,000.

1. Determine the number of zeros in the divisor.
2. Move the decimal in the dividend to the left the same number of places as there are zeros in the divisor. Insert zeros as necessary.

Divide: 4.52 ÷ 100

4.52 ÷ 100 = 0.0452 Move the decimal two places to the left. Insert a zero to have enough places. It is preferred to write a zero in front of the decimal.

Divide by a decimal.

1. Change the divisor to a whole number by moving the decimal point to the right, counting the places as you go. Use a caret (∧) to show the new position of the decimal point.
2. Move the decimal point in the dividend to the right as many places as you moved the decimal point in the divisor.
3. Place the decimal point for the quotient directly above the *new* decimal point in the dividend.
4. Divide as you would divide by a whole number.

Divide: 0.770 ÷ 3.5

$$\begin{array}{r} 0.22 \\ 3.5_{\wedge}\overline{)0.7_{\wedge}70} \\ 7\ 0 \\ \hline 70 \\ 70 \\ \hline \end{array}$$

Divide: 0.485 ÷ 0.24
Round to the nearest tenth.

$$\begin{array}{r} 2.02 \quad = 2.0 \text{ rounded}\\ 0.24_{\wedge}\overline{)0.48_{\wedge}50} \\ 48 \\ \hline 50 \\ 48 \\ \hline 2 \end{array}$$

Section 3-3

1 Convert a decimal to a fraction. (p. 84)

1. Find the denominator: Write 1 followed by as many zeros as there are places to the right of the decimal point.
2. Find the numerator: Use the digits without the decimal point.
3. Reduce to lowest terms and/or write as a whole or mixed number.

$$0.05 = \frac{5}{100} \div \frac{5}{5} = \frac{1}{20} \qquad\qquad 0.584 = \frac{584}{1,000} \div \frac{8}{8} = \frac{73}{125}$$

2 Convert a fraction to a decimal. (p. 85)

1. Write the numerator as the dividend and the denominator as the divisor.
2. Divide the numerator by the denominator, taking the division out as many decimal places as necessary or desirable.
3. For repeating decimals:
 (a) Write the remainder as the numerator of a fraction and the divisor as the denominator.
 or
 (b) Carry the division one place past the desired place and round.

$$
\frac{5}{8} = 8\overline{)5.000} \qquad\qquad \frac{1}{6} = 6\overline{)1.000}
$$

$$
\begin{array}{r}
0.625 \\
8\,)\overline{5.000} \\
4\,8 \\
\hline
20 \\
16 \\
\hline
40 \\
40 \\
\hline
\end{array}
\qquad\qquad
\begin{array}{r}
0.166 \approx 0.17 \\
6\,)\overline{1.000} \\
6 \\
\hline
40 \\
36 \\
\hline
40 \\
36 \\
\hline
4 \\
\end{array}
$$

EXERCISES SET A

Write the word name for the decimal.

1. 0.5

2. 0.108

3. 0.00275

4. 17.8

5. 128.23

6. 500.0007

Round to the specified place.

7. 0.1345 (nearest thousandth)

8. 384.73 (nearest ten)

9. 1,745.376 (nearest hundred)

10. $175.24 (nearest dollar)

Add.

11. 0.3 + 0.05 + 0.266 + 0.63

12. 78.87 + 54 + 32.9569 + 0.0043

13. $5.13 + $8.96 + $14.73

14. $283.17 + $58.73 + $96.92

Subtract.

15. 500.05 − 123.31

16. 125.35 − 67.8975

17. 423 − 287.4

18. 482.073 − 62.97

Multiply.

19. $\begin{array}{r} 27.63 \\ \times\ \ \ \ 7 \\ \hline \end{array}$

20. $\begin{array}{r} 6.42 \\ \times\ 7.8 \\ \hline \end{array}$

21. $\begin{array}{r} 75.84 \\ \times\ 0.28 \\ \hline \end{array}$

22. 27.58 × 10

Divide. Round to hundredths if necessary.

23. $34\overline{)291.48}$ **24.** $2.8\overline{)94.546}$ **25.** $296.36 \div 0.19$ **26.** $41{,}285 \div 0.68$

Write as fractions or mixed numbers in simplest form.

27. 0.55 **28.** 191.82

Write as decimals. Round to hundredths if necessary.

29. $\dfrac{17}{20}$ **30.** $\dfrac{13}{16}$

31. A shopper purchased a cake pan for $8.95, a bath mat for $9.59, and a bottle of shampoo for $2.39. Find the total cost of the purchases.

32. Leon Treadwell's checking account had a balance of $196.82 before he wrote checks for $21.75 and $82.46. What was his balance after he wrote the checks?

33. Four tires that retailed for $486.95 are on sale for $397.99. By how much are the tires reduced?

34. If 100 gallons of gasoline cost $142.90, what is the cost per gallon?

35. What is the cost of 5.5 pounds of chicken breasts if they cost $3.49 per pound?

36. A.G. Edwards is purchasing 100 cell phones for $189.95. How much is the total purchase?

EXERCISES SET B

Write the word name for the decimal.

1. 0.27

2. 0.013

3. 0.120704

4. 3.04

5. 3,000.003

6. 184.271

Round to the specified place.

7. 384.72 (nearest tenth)

8. 1,745.376 (nearest hundredth)

9. 32.57 (nearest whole number)

10. $5.333 (nearest cent)

Add.

11. 31.005 + 5.36 + 0.708 + 4.16

12. 9.004 + 0.07 + 723 + 8.7

13. $7.19 + $5.78 + $21.96

14. $596.16 + $47.35 + $72.58

Subtract.

15. 815.01 − 335.6

16. 404.04 − 135.8716

17. 807.38 − 529.79

18. 5,003.02 − 689.23

Multiply.

19. $\begin{array}{r} 3\,84 \\ \times 3.51 \\ \hline \end{array}$

20. $\begin{array}{r} 0.0015 \\ \times 6.003 \\ \hline \end{array}$

21. $\begin{array}{r} 73.41 \\ \times \ \ 15 \\ \hline \end{array}$

22. 1.394 × 100

Divide. Round to the nearest hundredth if division does not terminate.

23. $27\overline{)365.04}$ **24.** $74\overline{)85.486}$ **25.** $923.19 \div 0.541$ **26.** $363.45 \div 2.5$

Write as fractions or mixed numbers in simplest form.

27. 0.75 **28.** 17.5

Write as decimals. Round to hundredths if necessary.

29. $\dfrac{1}{20}$ **30.** $3\dfrac{7}{20}$

31. Rob McNab ordered 18.3 square meters of carpet for his halls, 123.5 square meters for the bedrooms, 28.7 square meters for the family room, and 12.9 square meters for the playroom. Find the total amount of carpet he ordered.

32. Janet Morris weighed 149.3 pounds before she began a weight-loss program. After eight weeks she weighed 129.7 pounds. How much did she lose?

33. Ernie Jones worked 37.5 hours at the rate of $14.80 per hour. Calculate his earnings.

34. If sugar costs $2.87 for 80 ounces, what is the cost per ounce, rounded to the nearest cent?

35. If two lengths of metal sheeting measuring 12.5 inches and 15.36 inches are cut from a roll of metal measuring 240 inches, how much remains on the roll?

36. If 1,000 gallons of gasoline cost $1,589, what is the cost of 45 gallons?

PRACTICE TEST

1. Round 42.876 to tenths.

2. Round 30.5375 to one nonzero digit.

3. Write the word name for 24.1007.

4. Write the number for three and twenty-eight thousandths.

Perform the indicated operation.

5. $39.17 - 15.078$

6. 27.418×100

7. $0.387 + 3.17 + 17 + 204.3$

8. $28.34 \div 50$ (nearest hundredth)

9.
$$\begin{array}{r} 324 \\ \times\,1.38 \\ \hline \end{array}$$

10. $0.138 \div 10$

11. $128 - 38.18$

12.
$$\begin{array}{r} 17.75 \\ \times\;\;0.325 \\ \hline \end{array}$$

13. $2.347 + 0.178 + 3.5 + 28.341$

14. $91.25 \div 12.5$

15. $317.24 - 138$

16. 374.17×100

17. A patient's chart showed a temperature reading of 101.2 degrees Fahrenheit at 3 P.M. and 99.5 degrees Fahrenheit at 10 P.M. What was the drop in temperature?

18. Eastman Kodak's stock changed from $26.14 a share to $22.15 a share. Peter Carp owned 2,000 shares of stock. By how much did his stock decrease?

19. Stephen Lewis owns 100 shares of PepsiCo at $47.40; 50 shares of Alcoa at $27.19; and 200 shares of McDonald's at $24.72. What is the total stock value?

20. What is the average price per share of the 350 shares of stock held by Stephen Lewis if the total value is $11,043.50?

1. Explain why numbers are aligned on the decimal point when they are added or subtracted.

2. Describe the process for placing the decimal point in the product of two decimal numbers.

3. Explain the process of changing a fraction to a decimal number.

4. Explain the process of changing a decimal number to a fraction.

Identify the error and describe what caused the error. Then work the example correctly.

5. Change $\frac{5}{12}$ to a decimal number.

$$\begin{array}{r} 2.4 \\ 5{\overline{)12.0}} \\ 10 \\ \hline 2\,0 \end{array} \qquad \frac{5}{12} = 2.4$$

6. Add: 3.72 + 6 + 12.5 + 82.63

$$\begin{array}{r} 3.72 \\ 6 \\ 12.5 \\ 82.63 \\ \hline 87.66 \end{array}$$

7. Multiply: 4.37 × 2.1

$$\begin{array}{r} 4.37 \\ \times\,2.1 \\ \hline 4\,37 \\ 87\,4 \\ \hline 91.77 \end{array}$$

8. Divide: 18.27 ÷ 54. Round to tenths.

$$\begin{array}{r} 2.95 \approx 3.0 \\ 18.27{\overline{)54.00\,00}} \\ 36\,54 \\ \hline 17\,460 \\ 16\,443 \\ \hline 1\,0170 \\ 9135 \\ \hline 1035 \end{array}$$

Challenge Problem

Net income for Hershey Foods for the third quarter is $143,600,000 or $1.09 a share. This is compared with net income of $123,100,000 or $0.89 a share for the same quarter a year ago. What was the increase or decrease in shares of stock?

3.1 Pricing Stock Shares

Shantell recognized the stationery, and looked forward to another of her Aunt Mildred's letters. Inside, though, were a number of documents along with a short note. The note read: "Shantell, your Uncle William and I are so proud of you. You are the first female college graduate in our family. Your parents would have been so proud as well. Please accept these stocks as a gift towards the fulfillment of starting your new business. Cash them in or keep them for later, it's up to you! With love, Aunt Millie." Shantell didn't know how to react. Finishing college had been very difficult for her financially. Having to work two jobs meant little time for studying, and a nonexistent social life. But she never expected pecans, or raisins. With dreams of opening her own floral shop, any money would be a godsend. She opened each certificate and found the following information: Alcoa—35 shares at 15 3/8; Coca Cola—150 shares at 24 5/8; IBM—80 shares at 40 11/16; and AT&T—50 shares at 35 1/8.

1. Shantell knew the certificates were old, because stocks do not trade using fractions anymore. What would the stock prices be for each company if they were converted from fractions to decimals?

2. Using your answers with decimals from number 1, find the total value of each company's stock. What is the total value from all four companies?

3. Shantell couldn't believe her eyes. The total she came up with was over $9,000! Suddenly, though, she realized that the amounts she used could not possibly be the current stock prices. After 30 minutes online, she was confident she had the current prices: Alcoa: 35 shares at $34.19; Coca Cola: 150 shares at $48.05; IBM: 80 shares at $95.03; and AT&T: 50 shares at $38.88. Using the current prices, what would be the total value of each company's stock? What would be the total value for all of the stocks? Given the answer, would you cash the stocks in now or hold on to them to see if they increased in value?

3.2 JK Manufacturing Demographics

Carl has just started his new job as a human resource management assistant for JK Manufacturing. His first project is to gather demographic information on the personnel at their three locations in El Paso, San Diego, and Chicago. Carl studied some of the demographics collected by the Bureau of Labor Statistics (www.stats.bls.gov) in one of his human resource classes and decided to collect similar data. Primarily, he wants to know the gender, level of education, and ethnic/racial backgrounds of JK Manufacturing's workforce. He designs a survey using categories he found at the Bureau of Labor Statistics web site.

Employees at each of the locations completed Carl's survey, and reported the following information:

El Paso: 140 women, 310 men; 95 had a bachelor's degree or higher; 124 had some college or an associate's degree; 200 were high school graduates, and the rest had less than a high school diploma; 200 employees were white non-Hispanic, 200 were Hispanic or Latino, 20 were black or African American, 15 were Asian, and the rest were "other."

San Diego: 525 women, 375 men; 150 had a bachelor's degree or higher, 95 had some college or an associate's degree, 500 were high school graduates, and the rest had less than a high school diploma; 600 employees were Hispanic or Latino, 200 were black or African American, 50 were white non-Hispanic, 25 were Asian, and the rest were "other."

Chicago: 75 women, 100 men; 20 had a bachelor's degree or higher, 75 had some college or an associate's degree, 75 were high school graduates, and the rest had less than a high school diploma; 100 employees were white non-Hispanic, 50 were black or African American, 25 were Hispanic or Latino, there were no Asians or "other" at the facility.

1. Carl's supervisor asked him to summarize the information and convert the raw data to a decimal part of the total. Carl designed the following chart to organize the data. To complete the chart, write a fraction with the number of employees in each category as the numerator and the total number of employees in each city as the denominator. Then convert the fraction to a decimal rounded to the nearest hundredth. Enter the decimal in the chart. To check your calculations, the total of the decimal equivalents for each city should equal 1 or close to 1 due to rounding discrepancies.

Gender	El Paso		San Diego		Chicago	
Men	310		375		100	
Women	140		525		75	
Total	450		900		175	

Education	El Paso		San Diego		Chicago	
Bachelor's degree or higher	95		150		20	
Some college or an Associate's degree	124		95		75	
HS graduate	200		500		75	
Less than a HS diploma	31		155		5	
Total	450		900		175	

Race/Ethnicity	El Paso		San Diego		Chicago	
White/non-Hispanic	200		50		100	
Black/African American	20		200		50	
Hispanic/Latino	200		600		25	
Asian	15		25			
Other	15		25			
Total	450		900		175	

Banking

Record Keeping: Identity Theft

Last year, the Federal Trade Commission logged 635,000 consumer complaints for fraud and identity theft, with 61% for fraud and 39% for identity theft.

In response, the Federal Reserve, in cooperation with other regulatory agencies, issued rules that require banks to adopt a risk-based response program to address incidents of unauthorized access to the customer information they electronically hold. Banks must notify customers "as soon as possible" by e-mail or written letter of "an incident of unauthorized access to sensitive customer information," defined as Social Security numbers, account numbers, and other details.

To reduce or minimize the risk of becoming a victim of identity theft or fraud, you can take these basic steps:

- Keep a list of all your credit accounts and bank accounts in a secure place, so you can quickly call the issuers to inform them about missing or stolen cards. Include account numbers, expiration dates, and telephone numbers of customer service and fraud departments.
- Shred and destroy unwanted documents that contain personal information including credit, debit, and ATM card receipts and preapproved credit offers.
- Never permit your credit card number to be written onto your checks.
- Take credit card receipts with you. Never toss them into a public trash container.

- Do not carry extra credit cards, Social Security card, birth certificate, or passport in your wallet or purse except when necessary.
- Order your credit report at least once a year. If you are a victim of identity theft, your credit report will contain the telltale signs of activity.
- Ask your financial institutions to add extra security protection to your account.
- Install virus and spyware detection software and a firewall on your computer and keep them updated.
- Deposit mail in U.S. Postal Service collection boxes. Do not leave mail in your mailbox overnight or on weekends.

If you think you are a victim of identity theft, follow these guidelines:

- Contact the fraud departments of each one of the three consumer reporting companies to place a fraud alert on your credit report. A fraud alert tells creditors to follow certain procedures before opening any new accounts.
- Close the accounts that you know or believe have been tampered with or opened fraudulently.
- File a complaint with the FTC. You may print a copy of your complaint to provide important standardized information for your police report.
- File a report with your local police or police in the community where the identity theft took place.

LEARNING OUTCOMES

4-1 Checking Account Transactions

1. Make account transactions.
2. Record account transactions.

4-2 Bank Statements

1. Reconcile a bank statement with an account register.

 A corresponding Business Math Case Video for this chapter, *Which Bank Account is Best?*, can be found in Appendix A.

Most businesses and many individuals use computer software and online banking for making, recording, and reconciling transactions for a bank account. All of the processes discussed in this chapter are similar to the processes used with a computer. It is important to use banking forms correctly, to keep accurate records, and to track financial transactions carefully.

4-1 CHECKING ACCOUNT TRANSACTIONS

LEARNING OUTCOMES

1 Make account transactions.
2 Record account transactions.

Financial institutions such as banks and credit unions provide a variety of services for both individual and business customers. One of these services is a **checking account**. This account holds your money and disburses it according to the policies and procedures of the bank and to your instructions. Various checking account forms or records are needed to maintain a checking account for your personal or business financial matters. The bank must be able to account for all funds that flow into and out of your account, and written evidence of changes in your account is necessary.

1 Make account transactions.

Any activity that changes the amount of money in a bank account is called a **transaction**.

When money is put into a checking account, the transaction is called a **deposit**. The bank refers to this transaction as a **credit**. A deposit or credit *increases* the amount of the account. One bank record for deposits made by the account holder is called the **deposit ticket**. Figure 4-1 shows a sample deposit ticket for a personal account. Figure 4-2 shows a sample deposit ticket for a business account. Deposit tickets are available to the person opening an account along with a set of preprinted checks. The bank's account number and the customer's account number are written at the bottom of the ticket in magnetic ink using specially designed characters and symbols to facilitate machine processing. The bank also has generic forms that can be used for deposits by writing in the account information.

Checking account: a bank account for managing the flow of money into and out of the account.

Transaction: a banking activity that changes the amount of money in a bank account.

Deposit: a transaction that increases an account balance; this transaction is also called a credit.

Credit: a transaction that increases an account balance.

Deposit ticket: a banking form for recording the details of a deposit.

HOW TO	Make an account deposit on the appropriate deposit form

1. Record the date.
2. Enter the amount of currency or coins being deposited.
3. List the amount of each check to be deposited. Include an identifying name or company.
4. Add the amounts of currency, coins, and checks.
5. If the deposit is to a personal account and you want to receive some of the money in cash, enter the amount on the line "less cash received" and sign on the appropriate line.
6. Subtract the amount of cash received from the total for the net deposit.

EXAMPLE 1 Complete a deposit slip for Lee Wilson. The deposit on May 29, 2008, will include $392 in currency, $0.90 in coins, a $373.73 check from Nichols, and a tax refund check from the IRS for $438.25. Lee wants to get $100 in cash from the transaction.

FIGURE 4-1
Deposit Ticket for a Personal Account

Businesses generally will have several checks to deposit for each transaction. A different type of deposit ticket allows more checks to be entered on one side of the deposit ticket, and a copy of the ticket is kept by the business. When depositing to a business account, you do not have the option of receiving a portion of the deposit in cash.

EXAMPLE 2 Macon Florist makes a deposit on August 19, 2008, that includes the checks shown in Table 4-1. Complete the deposit ticket (Figure 4-2).

TABLE 4-1
Checks to be deposited

Carlisle	72.21	Shotwell	38.75
Smith	26.32	Yu	31.15
Mason	42.86	Collier	23.96
Malena	41.13	Taylor	46.12
Mays	18.97	Ores	32.84
James	17.85	Fly	28.15
Johnson	28.73	Jinkins	61.36
Miller	16.15	Young	37.52

FIGURE 4-2

Complete Deposit Ticket for Macon Florist

Personal Checking Account Versus Business Checking Account

Bank policies for a personal checking account are often different from the policies for a business checking account. Some of the most common differences are:

Personal	Business
Sometimes banking forms are provided free. Preprinted checks and deposit slips come together.	All banking forms have to be purchased. Preprinted deposit slips are purchased separately.
A separate check register is provided with the checks and deposit slips.	No check register is provided and preprinted checks have stubs.
A deposit slip can specify that a portion of the transaction can be received in cash.	There is no option for receiving a portion of a deposit back as cash.

Bank memo: a notification of a transaction error.

Credit memo: a notification of an error that increases the account balance.

Debit memo: a notification of an error that decreases the account balance.

Automatic teller machine (ATM): an electronic banking station that accepts deposits and disburses cash when you use an authorized ATM card, a debit card, or some credit cards.

Electronic deposit: a deposit that is made by an electronic transfer of funds.

Point-of-sale transaction: electronic transfer of funds when a sale is made.

Electronic funds transfer (EFT): a transaction that transfers funds electronically.

Withdrawal: a transaction that decreases an account balance; this transaction is also called a debit.

Debit: a transaction that decreases an account balance.

Check or bank draft: a banking form for recording the details of a withdrawal.

Payee: the one to whom the amount of money written on a check is paid.

Payor: the bank or institution that pays the amount of the check to the payee.

Maker: the one who is authorizing the payment of the check.

If the bank discovers an error in the deposit transaction, it will notify you of the correction through a **bank memo**. If the error correction increases your balance, the bank memo is called a **credit memo**. If the error correction decreases your balance, the bank memo is called a **debit memo**.

Deposits to bank accounts can be made electronically. Individuals or businesses may make deposits using a debit card or an **automatic teller machine (ATM)** card. Individuals may also request their employer to deposit their paychecks directly to their bank account by completing a form that gives the banking information, including the account number. Government agencies encourage recipients of Social Security and other government funds to have these funds **electronically deposited**. Businesses that permit customers to use credit cards to charge merchandise or subscribe to an automatic check processing service ordinarily receive payment through electronic deposit from the credit card or check processing company. These transactions are sometimes called **point-of-sale transactions,** since the money is transferred electronically when the sale is made. VISA, MasterCard, American Express, and Discover are examples of major credit card companies that electronically transmit funds to business accounts. Transactions made electronically are called **electronic funds transfers (EFTs)**.

When money is taken from a checking account, this transaction is called a **withdrawal**. The bank refers to this transaction as a **debit**. A withdrawal or debit *decreases* the amount of the account. One bank record for withdrawals made by the account holder is called a **check** or **bank draft**. Figure 4-3 shows the basic features of a check.

FIGURE 4-3
Bank Check

1. Enter the date of the check.
2. Enter the name of the payee.
3. Enter the amount of the check in numerals.
4. Write the amount of the check in words. Cents can be written as a fraction of a dollar or by using decimal notation.
5. Explain the purpose of the check.
6. Sign the check.

EXAMPLE 3 Write a check dated April 8, 20XX, to Disk-O-Mania in the amount of $84.97 for CDs.

Enter the date: 4/8/20XX.

Write the name of the payee: Disk-O-Mania.

Enter the amount of the check in numerals: 84.97.

Enter the amount of the check in words. Note the fraction $\frac{97}{100}$ showing cents, or hundredths of a dollar: eighty-four and $\frac{97}{100}$.

Write the purpose of the check on the memo line: CDs.

Sign your name.

The completed check is shown in Figure 4-4.

FIGURE 4-4

Completed Check

When a checking account is opened, those persons authorized to write checks on the account must sign a **signature card**, which is kept on file at the bank. Whenever a question arises regarding whether a person is authorized to write checks on an account, the bank refers to the signature card to resolve the question.

Withdrawals from personal and business bank accounts can also be made electronically. Many persons elect to have regular monthly bills, such as their house note, rent, utilities, and insurance, paid electronically through **automatic drafts** from their bank account. The amount of the debit is shown on the bank statement. One time electronic checks can be authorized when a company accepts an electronic check over the telephone. When this service is used, the bank routing number, your bank account number, and the amount of the check are given over the phone. Generally the customer is given a confirmation number to use if there is any dispute over the transaction. **Online banking services** are becoming more and more popular. These services allow you to pay bills and manage your account using the Internet. Accounts are accessible 24 hours a day, seven days a week. Bank statements are posted on line and account holders can file them electronically or print paper copies.

Individuals may also use a **debit card** to pay for services and goods. A debit card looks very similar to a credit card and often even includes a credit card name and logo such as Visa. The debit card works just like a check except the transaction is handled electronically at the time the transaction is made. Debit card transactions generally require a **personal identification number (PIN)** to authorize the transaction. ATM/debit cards can be used to make deposits to checking or savings accounts, get cash withdrawals from checking or savings accounts, transfer funds between checking and savings accounts, make payments on bank loan accounts, and to get checking and savings account information. Debit cards can be used to make purchases in person, by phone, or by computer. Debit cards can also be used to get cash from merchants who permit it.

Don't toss those ATM or debit card receipts! Customers are issued receipts when they deposit or withdraw money from an automatic teller machine. Use these receipts to update your account register and to verify against your next bank statement. When you are certain the transaction has been properly posted by your bank, dispose of the receipts by shredding or by some other means to maintain the security of your banking record.

Signature card: a document that a bank keeps on file to verify the signatures of persons authorized to write checks on an account.

Automatic drafts: periodic withdrawals that the owner of an account authorizes to be made electronically.

Online banking services: a variety of services and transaction options that can be made through Internet banking.

Debit card: a card that can be used like a credit card but the amount of debit (purchase or withdrawal) is deducted immediately from the checking account.

Personal identification number (PIN): a private code that is used to authorize a transaction on a debit card or ATM card.

TIP

Know the Services Offered by Your Bank and the Related Fees

Banks and other financial institutions are offering more and more services to customers. Get to know what services are offered and what fees are charged for these services. Some services are free, while others are not.

1. Complete the deposit ticket for Harrington's Pharmacy (Figure 4-5). The deposit includes $987 in cash, $41.93 in coins, and three checks in the amounts of $48.17, $153.92, and $105.18. The deposit was made on July 5.

FIGURE 4-5
Deposit Ticket

2. Complete the deposit ticket for SellIt.com (Figure 4-6). The deposit is made on April 11, 20XX, and includes the following items: cash: $821; and checks: Olson, $18.15; Drewrey, $38.15; Tinkler, $82.15; Brannon, $17.19; McCready, $38.57; Mowers, $132.86; Lee, $15.21; and Wang, $38.00.

FIGURE 4-6
Deposit Ticket

3. Write a check (Figure 4-7) dated October 18, 20XX, to Frances Johnson in the amount of $583.17 for a tool chest. Albert Adkins is the maker.

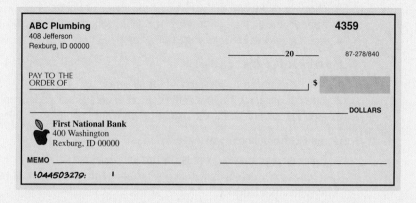

FIGURE 4-7
Check Number 4359

4. Max Murphy wrote a check dated August 18, 20XX, to Harley Davidson, Inc., for motorcycle parts. The amount of the check is $2,872.15. Complete the check in Figure 4-8 to show this transaction.

5. Describe some advantages of online banking.

FIGURE 4-8
Check Number 5887

TIP

Keep Accurate, Up-to-Date Account Records

The key to maintaining control of your banking account balance is to record and track every transaction. In today's busy world, it is easy to use a debit card or online banking to make many charges in a short time. Recording every transaction *when it is made* will help you keep track of your balance.

2 Record account transactions.

Businesses and individuals who have banking accounts must record all transactions made to the account.

Check writing supplies are available for handwritten, typed, or computer-generated checks. One type of checkbook has a **check stub** for each check. The check stub is used to record account transactions; computer-generated checks also produce a check stub. Another form for recording transactions is an **account register**. The account register is separate from the check but includes the same information as a check stub. Electronic money management systems generally produce a check stub and keep an account register automatically from the information entered on the check.

Check stub: a form attached to a check for recording checking account transactions that shows the account balance.

Account register: a separate form for recording all checking account transactions. It also shows the account balance.

For checks and other debits:

1. Make an entry for every account transaction.
2. Enter the date, the amount of the check or debit, the person or company that will receive the check or debit, and the purpose of the check or debit.
3. Subtract the amount of the check or debit from the previous balance to obtain the new balance.
4. For handwritten checks with stubs, carry the new balance forward to the next stub.

For deposits or other credits:

1. Make an entry for every account transaction.
2. Enter the date, the amount of the deposit or credit, and a brief explanation of the deposit or credit.
3. Add the amount of the deposit or credit from the previous balance to obtain the new balance.

On an electronic money management system:

1. Enter the appropriate details for producing a check.
2. Record other debits and all deposits and credits. The account register is maintained by the system automatically.
3. For business accounts or personal accounts that are used for tracking expenses, record the type of expense or budget account number.

FIGURE 4-9
Completed Stub

EXAMPLE 1 Complete the stub (Figure 4-9) for the check written in the preceding example. The balance forward is $8,324.09. Deposits of $325, $694.30, and $82.53 were made after the previous check was written.

The check number, 123, is preprinted in this case.
Enter the date: 4/8/20XX.
Enter the amount of this check: $84.97.
Enter the payee: Disk-O-Mania.
Enter the purpose: CDs.
Enter the balance forward if it has not already been entered: $8,324.09
Enter the total of the deposits: $1,101.83.
Add the balance forward and the deposits to find the total: $9,425.92.
Enter the amount of this check: $84.97.
Subtract the amount of the check from the total to find the balance: $9,340.95.

The completed stub is shown in Figure 4-9. Carry the balance to the next stub as the Balance Forward.

Account registers for individual account holders are generally supplied with an order of personalized checks. Most banks also supply an account register upon request. Figure 4-10 shows a sample of a standard account register page.

		RECORD ALL TRANSACTIONS THAT AFFECT YOUR ACCOUNT					BALANCE	
NUMBER	DATE	DESCRIPTION OF TRANSACTION	DEBIT (−)	√ T	FEE (IF ANY) (−)	CREDIT (+)	8,324	09
	3/31	Deposit				325 00	+325	00
		tax refund					8,649	09
	4/3	Deposit				694 30	+694	30
		paycheck					9,343	39
	4/5	Deposit				82 53	+82	53
		travel reimbursement					9,425	92
123	4/8	Disk-O-Mania	84 97				−84	97
		computer diskettes					9,340	95

FIGURE 4-10
Check Register

As banking becomes increasingly complex and more electronic and the penalty for overdrawing bank accounts escalates, it becomes more important to carefully maintain an account register of all transactions. Debit cards are very common as a substitute for checks. With the increased use of electronic transactions, it becomes more important to keep systematic records of all account transactions. Thus, the account register can be used to record transactions made while away from your computer. Then the computer can be used to calculate balances as new transactions are entered.

TIP

I'll Do It Later

The details of a check or debit should be recorded in the account register as soon as the transaction is made. Write checks in numerical order to make it easier to verify that all checks have been recorded in the account register or on the check stub.

Detaching checks from the checkbook and using them out of order creates a greater risk for errors and oversights.

For transactions made with a debit card, keep the receipts in a specified place. Your checkbook or account register wallet is a good temporary place to keep receipts until the transactions have been properly recorded.

Endorsement: a signature, stamp, or electronic imprint on the back of a check that authorizes payment in cash or directs payment to a third party or account.

Before a check can be cashed, it must be **endorsed**. That is, the payee must sign or stamp the check on the back. There are several ways to endorse a check. The simplest way is for the payee to sign the back of the check exactly as the payee's name is written on the front of the check. Banks generally cash checks drawn on their own bank or checks presented by payees who are account holders. A bank cashing checks drawn on its own bank normally requires the payees to present appropriate identification if they are not account holders at that bank. Banks will cash checks drawn on a different bank for payees who are account holders and require the payee's account number to be written below the signature. The payee's account will be debited if the check is returned unpaid.

Appropriate identification is required for receiving cash from an account or for cashing a check. This identification is also required for opening an account. The Patriot Act of 2001 now requires financial institutions to follow specific identification procedures. Most banks require two forms of identification (ID), with at least one being a primary form of identification. An acceptable primary ID must include a photo and be issued by a government agency. Some examples are a state driver's license or ID, a military ID, or a passport or visa. Some secondary forms of identification are a credit card, utility bill, property tax bill, or employer ID.

Restricted endorsement: a type of endorsement that reassigns the check to a different payee or directs the check to be deposited to a specified account.

While banking procedures are designed to prevent misuse of checks, it is a good idea to use a **restricted endorsement** for signing checks. One type of restricted endorsement changes the payee of the check. The original payee writes "pay to the order of," lists the name of the new payee, and then signs the check. This choice would be used when you want to assign the check to someone else. Another type of restricted endorsement is used for depositing the check into the payee's bank account. The payee writes "for deposit only," lists the account number, and then endorses the check. Most banking practices only allow checks to be deposited to a business account if they have a business listed as the payee. That is, they do not allow cash to be received for a check made out to a business. For greater security most businesses endorse checks as soon as they are received. Many businesses imprint the endorsement on checks using an electronic cash register or an ink stamp.

The Federal Reserve Board regulates the way endorsements can be placed on checks. As Figure 4-11 shows, the endorsement must be placed within $1\frac{1}{2}$ inches of the left edge of the

FIGURE 4-11
The Back of a Check Showing Areas for Endorsements

check. The rest of the back of the check is reserved for bank endorsements. Many check-printing companies now mark this space and provide lines for endorsements.

Electronic checks do not require the same type of endorsement. Personal identification numbers (PINs) and knowledge of bank routing numbers and account numbers are used to maintain security with electronic transactions.

 STOP AND CHECK

1. Examine the check stub in Figure 4-12 to answer these questions.
 a. How much is check 1492 written for?

 b. What was the account balance from the previous transaction?

 c. What is the new balance?

1492	Date Mar 15 20 XX
Amount $152.87	
To Brown's Shoes	
For Shoes	

Balance Forward	2,896	15
Deposits	+800	00
Total	3,696	15
Amount This Check	−152	87
Balance	3,543	28

FIGURE 4-12
Check Stub Number 1492

2. Complete the check stub for check 4359 (Figure 4-13) written to Frances Johnson on October 18, 20XX, in the amount of $583.17 for a tool chest.

4359	Date 20
Amount	
To	
For	

Balance Forward	5,902	08
Deposits		
Total		
Amount This Check		
Balance		

FIGURE 4-13
Check Stub Number 4359

3. Complete the account register in Figure 4-14 to record check 5887 written on August 18, 20XX, to Harley Davidson, Inc., for motorcycle parts that cost $2,872.15. Also record a debit card entry of $498.31 made on August 20, 20XX, to Remmie Raynor for pool services.

RECORD ALL TRANSACTIONS THAT AFFECT YOUR ACCOUNT							
NUMBER	DATE	DESCRIPTION OF TRANSACTION	DEBIT (−)	√T	FEE (IF ANY) (−)	CREDIT (+)	BALANCE

FIGURE 4-14
Account Register

4. Complete the account register in Figure 4-15 to show the purchase of a tool chest using check number 4359 written to Frances Johnson on October 8, 20XX. Also record an ATM withdrawal of $250 on October 8, 20XX.

RECORD ALL TRANSACTIONS THAT AFFECT YOUR ACCOUNT

NUMBER	DATE	DESCRIPTION OF TRANSACTION	DEBIT (–)		√ T	FEE (IF ANY) (–)	CREDIT (+)		BALANCE	
									5,108	31
4358	10/6	Quesha Blunt	49	80					–49	80
		Cleaning Service							5,058	51
Dep	10/6	Deposit					843	57	+843	57
		travel reimb.							5,902	08

FIGURE 4-15
Account Register

4-1 SECTION EXERCISES

SKILL BUILDERS

1. On April 29, 20XX, Mr. Yan Yu made a deposit to the account for Park's Oriental Shop. He deposited $850.00 in cash, $8.63 in coins, and two checks, one in the amount of $157.38, the other in the amount of $32.49. Fill out Mr. Yu's deposit ticket for April 29, 20XX (Figure 4-16).

FIGURE 4-16
Deposit Ticket for Park's Oriental Shop

2. Complete the deposit ticket for Delectables Candies in Figure 4-17. The deposit is made on March 31, 20XX, and includes the following items: cash: $196.00; and checks: Cavanaugh, $14.72; Bryan, $31.18; Wossum, $16.97; Wright, $28.46; Howell, $17.21; Coe, $32.17; Beulke, $17.84; Palinchak, $31.96; and Paszel, $19.16.

FIGURE 4-17
Deposit Ticket for Delectables Candies

3. On April 29, 20XX, after Mr. Yu made his deposit (see Exercise 1), he wrote a check to Green Harvest in the amount of $155.30 for fresh vegetables. Write a check (Figure 4-18) as Mr. Yu wrote it.

FIGURE 4-18
Check Number 456

4. Write a check dated June 20, 20XX, to Ronald H. Cox Realty in the amount of $596.13 for house repairs (Figure 4-19).

FIGURE 4-19
Check Number 3215

5. Before Mr. Yu made his deposit (see Exercise 1), the balance in the account was $7,869.40. Complete the check stub for the check you wrote in Exercise 3 (Figure 4-20).

FIGURE 4-20
Check Stub Number 456

6. Complete the check stub for the check you wrote in Exercise 4 if the balance brought forward is $2,213.56 (Figure 4-21).

FIGURE 4-21
Check Stub Number 3215

7. Enter in the account register in Figure 4-22 all the transactions described in Exercises 1, 3, and 5, and find the ending balance.

		RECORD ALL TRANSACTIONS THAT AFFECT YOUR ACCOUNT					BALANCE	
NUMBER	DATE	DESCRIPTION OF TRANSACTION	DEBIT	√	FEE	CREDIT		
			$			$		

FIGURE 4-22
Account Register

8. On September 30 you deposited your payroll check of $932.15. You then wrote the following checks on the same day:

Check Number	Payee	Amount
3176	Electric Co-op.	$107.13
3177	BP Oil	$47.15
3178	Visa	$97.00

You made a deposit of $280 at your bank's ATM on October 3. Show these transactions in your account register in Figure 4-23, and show the ending balance if your beginning balance was $435.97.

		RECORD ALL TRANSACTIONS THAT AFFECT YOUR ACCOUNT					BALANCE	
NUMBER	DATE	DESCRIPTION OF TRANSACTION	DEBIT (−)	√ T	FEE (IF ANY) (−)	CREDIT (+)		

FIGURE 4-23
Account Register

9. Describe how the check in Exercise 4 would be endorsed for deposit to account number 26-8224021. What type of endorsement is this called?

10. If you were the owner of Green Harvest (Exercise 3), would you be able to exchange this check for cash? If so, describe how you would endorse the check. If not, explain how you could handle the check.

11. List three banking transactions that can be made with an ATM/debit card.

12. How can you use a debit card to make purchase of goods?

4-2 BANK STATEMENTS

LEARNING OUTCOME

1 Reconcile a bank statement with an account register.

Financial institutions provide account statements to their checking account customers to enable account holders to reconcile any differences between that statement and the customer's own account register. These statements are either mailed or provided online.

1 Reconcile a bank statement with an account register.

Bank statement: an account record periodically provided by the bank for matching your records with the bank's records.

Service charge: a fee the bank charges for maintaining the checking account or for other banking services.

Returned check: a deposited check that was returned because the maker's account did not have sufficient funds.

Returned check fee: a fee the bank charges the depositor for returned checks.

Nonsufficient funds (NSF) fee: a fee charged to the account holder when a check is written for which there are not sufficient funds.

Automatic teller machine (ATM): an electronic banking station that accepts deposits and disburses cash when you use an authorized ATM card, a debit card, and some credit cards.

Outstanding checks: checks that have been written and given to the payee but have not been processed at the bank.

Outstanding deposits: deposits that have been made but have not yet been posted to the maker's account.

Bank reconciliation: the process of making the account register agree with the bank statement.

The primary tool for reconciling an account is the **bank statement**, a listing of all transactions that take place in the customer's account. It includes checks and other debits and deposits and other credits.

Most bank statements explain the various letter codes and symbols contained in the statement. One of the first steps to take when you receive a bank statement is to check this explanatory section for any terms that you do not understand in the statement.

One of the items that may appear on a bank statement is a **service charge**. This is a fee the bank charges for maintaining the checking account; it may be a standard monthly fee, a charge for each check or transaction, or some combination.

Another type of bank charge appearing on a bank statement is for checks that "bounce" (are not backed by sufficient funds). Suppose Joe writes you a check and you cash the check or deposit it. Later your bank is notified that Joe does not have enough money in his bank account to cover the check. So Joe's bank returns the check to your bank. Such a check is called a **returned check**. Your bank will deduct the amount of the returned check from your account. Your bank may also deduct a **returned check fee** from your account to cover the cost of handling this transaction. If you write a check for which you do not have sufficient funds in your account, your bank will charge you a **nonsufficient funds (NSF) fee**. The bank notifies you through a debit memo of the decrease in your account balance.

Your bank statement also reflects electronic funds transfers such as withdrawals and deposits made using an **automatic teller machine (ATM),** debit cards, wire transfers, online transfers, and authorized electronic withdrawals and deposits.

What does *not* appear on the bank statement is the amount of any check you wrote or deposit you made that reaches the bank *after* the statement is printed. Such transactions may be called **outstanding checks** or **deposits**. This is one reason your bank statement and your account register may not agree initially.

When a bank statement and an account register do not agree initially, you need to take steps to make them agree. The process of making the bank statement agree with the account register is called reconciling a bank statement or **bank reconciliation**.

The first thing to do when you receive a bank statement is to go over it and compare its contents with your account register. You can check off all the checks and deposits listed on the statement by using the ✓ column in the account register (refer to Figure 4-10) or by marking the check stub.

There are several methods for reconciling your banking records. We will use a method that uses an account reconciliation form. Figure 4-24 shows a sample bank statement reconciliation

FIGURE 4-24
Account Reconciliation Form

form. A reconciliation form is often printed on the back of the bank statement. The bank's form leads you through a reconciliation process that may be slightly different from the one given in this book, but the result is the same: a reconciled statement.

HOW TO — Reconcile a bank statement

1. Check off all matching transactions appearing on both the bank statement and the account register.
2. Enter into the register the transactions appearing on the bank statement that have not been checked off. Check off these transactions in the register as they are entered. Update the register balance accordingly. This is the adjusted register balance.
3. Make a list of all the checks and other debits appearing in the register that have not been checked off. Add the amounts on the list to find the *total outstanding debits*. Use Figure 4-24 as a guide.
4. Make a list of all the deposits and other credits appearing in the register that have not been checked off in step 1. Add the amounts on the list to find the *total outstanding credits*. Use Figure 4-24 as a guide.
5. Calculate the *adjusted statement balance* by adding the statement balance and the total outstanding deposits and other credits, and then subtracting the total outstanding checks and other debits: Adjusted statement balance = statement balance + total outstanding credits − total outstanding debits.
6. Compare the adjusted statement balance with the adjusted register balance. These amounts should be equal.
7. If the adjusted statement balance does not equal the register balance, locate the cause of the discrepancy and correct the register or notify the bank accordingly.
8. Write *statement reconciled* on the next blank line in the account register and record the statement date.

TIP

Finding Discrepancies

When your adjusted statement balance does not equal your account register balance, you need to locate the cause of the discrepancy and correct the register accordingly.

To do so, first be sure you have calculated the adjusted statement balance accurately. Double-check, for instance, that the list of outstanding debits is complete and their sum is accurate. Double-check the list of outstanding credits, too. Double-check that you correctly added the total outstanding credits and subtracted the total outstanding debits from the statement balance. If you are sure you have carried out all the reconciliation steps correctly, the discrepancy may be due to an error that you made in the account register or to an error made by the bank. Here are some common errors and strategies to locate them.

Error: You entered a transaction in the register, but you did not update the account register balance.
Strategy: To locate the transaction, calculate the difference of the adjusted statement balance and the register balance (subtract one from the other). Compare this difference with each transaction amount in the register to see if this difference matches a transaction amount exactly.
Error: You transposed digits—for instance, 39 was entered as 93—when entering the amount in the register or when listing outstanding items from the statement.
Strategy: Divide the difference between the adjusted statement balance and the adjusted register balance by 9. If the quotient has no remainder, check the entries to find the transposed digits.
Error: You entered the check number as the amount of the check.
Strategy: Check the amount of each check as you check off the correct amount.
Error: You entered a transaction in the register, but to update the register balance, you added the transaction amount when you should have subtracted, or vice versa.
Strategy: To locate the transaction, calculate the difference of the adjusted statement balance and the adjusted register balance (subtract one from the other.) Divide the difference by 2. Compare this result with each transaction in the register to see if it matches a transaction amount exactly.
Error: You entered a transaction in the register, but to update the register balance, you added (or subtracted) the transaction amount incorrectly.
Strategy: To locate the transaction, begin with the first transaction in the register following the previous reconciliation. From this point on, redo your addition (or subtraction) for each transaction to see if you originally added (or subtracted) the transaction amount correctly.

When using software programs to keep banking records, the user enters transaction amounts into the computer, and the program updates the register balance. At reconciliation time, the user enters information from the bank statement into the computer, and the program reconciles the bank statement with the account register.

These programs can also be useful for budgeting and tax purposes. Transactions can be categorized and tracked according to the user's specifications. Monthly and yearly budgets can be prepared accordingly, for both individuals and businesses. At tax time, these programs may even be used to generate tax forms.

EXAMPLE 1

Pope Animal Clinic regularly transfers money from its checking account to a special account used for one-time expenditures such as equipment. The decision to transfer is made each month when the bank statement is reconciled. Money is transferred only if the adjusted statement balance exceeds $2,500; all the excess is transferred. The bank statement is shown in Figure 4-26, and the register is shown in Figure 4-27. Should money be transferred? If so, how much?

What You Know	What You Are Looking For	Solution Plan
Bank statement transactions (Figure 4-26) and register transactions (Figure 4-27) Balance in excess of $2,500 is transferred.	The adjusted statement balance and the adjusted checkbook balance. Should money be transferred? If so, how much?	Adjusted statement balance = statement balance + total outstanding credits − total outstanding debits (Figure 4-25). Transfer any amount that is more than $2,500.

Solution

Check off all matching transactions appearing on both the statement and the register (Figures 4-26 and 4-27).

Now enter into the register the transactions appearing on the bank statement that have not been checked off. The service fee is the only transaction not checked off. As you enter it into the register, check it off the bank statement and the register. Now use the account reconciliation form (Figure 4-25) to list the outstanding credits and debits: transactions appearing on the register that have not been checked off.

Conclusion

The adjusted statement balance is more than $2,500.
Money should be transferred. Since the excess over $2,500 should be transferred, **the amount to be transferred is** $3,167.85 − $2,500, or **$667.85**.

$ 3,177 82	BALANCE AS SHOWN ON BANK STATEMENT		BALANCE AS SHOWN IN YOUR CHECKBOOK	$ 3,172 85
200 00	ADD DEPOSITS NOT SHOWN ON STATEMENT		SUBTRACT AMOUNT OF SERVICE CHARGE	5 00
3,377 82	NEW TOTAL		NEW TOTAL	3,167 85
209 97	SUBTRACT TOTAL OF OUTSTANDING CHECKS		ADJUSTMENTS IF ANY	0
3,167 85	YOUR ADJUSTED STATEMENT BALANCE	SHOULD EQUAL	YOUR ADJUSTED CHECKBOOK BALANCE	3,167 85

Outstanding Deposits (Credits)	
Date	Amount
5/25	$ 200 00
Total	$ 200 00

Outstanding Checks (Debits)		
Check Number	Date	Amount
239		$ 117 28
240		92 69
Total		$ 209 97

FIGURE 4-25
Account Reconciliation Form

FIGURE 4-26
Matching Transactions Checked Off the Bank Statement

Community First Bank
2177 Germantown Rd. South • Germantown, Tennessee 38138 • (901) 555-2400 • Member FDIC

Pope Animal Clinic
5012 Winchester
Memphis, TN 38118

ACCOUNT NUMBER 43-7432156
FEDERAL ID NUMBER 46-076435176 DATE 5/30/20XX PAGE 1

		BALANCE OF YOUR FUNDS
PREVIOUS BALANCE -----		$2,571.28
3	DEPOSITS TOTALING	835.00
5	WITHDRAWALS TOTALING	228.46
NEW BALANCE -----------		$3,177.82

ACCOUNT TRANSACTIONS FOR THE PERIOD FROM 5/1/20XX THROUGH 5/30/20XX

DATE	AMOUNT	DESCRIPTION
5/1	110.00 ✓	DEPOSIT
5/8	200.00 ✓	DEPOSIT
5/11	12.15 ✓	DEBIT CARD
5/20	525.00 ✓	DEPOSIT
5/30	5.00 ✓	SERVICE FEE

DATE	CHECK #	AMOUNT	DATE	CHECK #	AMOUNT
5/1	235	42.95 ✓	5/15	237	95.73 ✓
5/7	236	72.63 ✓			

CHECKING DAILY BALANCE SUMMARY

DATE	BALANCE OF YOUR FUNDS	DATE	BALANCE OF YOUR FUNDS
5/1	2,638.33	5/15	2,657.82
5/3	2,626.18	5/20	3,182.82
5/7	2,553.55	5/30	3,177.82
5/8	2,753.55		

FIGURE 4-27
Reconciled Account Register

RECORD ALL TRANSACTIONS THAT AFFECT YOUR ACCOUNT

NUMBER	DATE	DESCRIPTION OF TRANSACTION	DEBIT (−)		√T	FEE (IF ANY) (−)	CREDIT (+)		BALANCE	
									2,571	28
235	4/20	Pet Supply Company	42	95	✓				−42	95
									2,528	33
Deposit	5/1	Customer Receipts			✓		110	00	+110	00
									2,638	33
Debit	5/1	K-mart	12	15	✓				−12	15
									2,626	18
236	5/1	Telephone Company	72	63	✓				−72	63
									2,553	55
Deposit	5/8	Customer Receipts			✓		200	00	+200	00
									2,753	55
237	5/10	Chickasaw Electric Co.	95	73	✓				−95	73
									2,657	82
238	5/15	Protein Technologies Dog food	117	28					−117	28
									2,540	54
239	5/15	Rand M Drug Co.	92	69					−92	69
									2,447	85
Deposit	5/20	Customer Receipts			✓		525	00	+525	00
									2,972	85
Deposit	5/25	Customer Receipts					200	00	200	00
									3,172	85
	5/30	Service Fee	5	00	✓				5	00
									3,167	85
	5/30	Statement reconciled							—	

REMEMBER TO RECORD AUTOMATIC PAYMENTS/DEPOSITS ON DATE AUTHORIZED.

✔ STOP AND CHECK

The bank statement for Katherine Adam's Apparel Shop is shown in Figure 4-28.

1. How many deposits were made during the month?

2. What amount of interest was earned?

3. How much were the total deposits?

4. How many checks appear on the bank statement?

5. What is the balance at the beginning of the statement period?

6. What is the balance at the end of the statement period?

7. What is the amount of check 8214?

8. On what date did check 8219 clear the bank?

9. Kroger Stores permit customers to get cash with a debit card. Lindy Rascoe has an ATM/debit card from her bank in Illinois. Can she use the card to get $200 cash at the Kroger checkout counter in her college town of Fresno, CA?

10. The account register for Katherine Adam's Apparel Shop is shown in Figure 4-29. Update the register and reconcile the bank statement (see Figure 4-28) with the account register using the account reconciliation form in Figure 4-30.

🍎 Community First Bank

2177 Germantown Rd. South • Germantown, Tennessee 38138 • (901) 555-2400 • Member FDIC

KATHERINE ADAM'S APPAREL SHOP
1396 MALL OF AMERICA
MINNEAPOLIS, MN

ACCOUNT NUMBER 12-324134523
FEDERAL ID NUMBER 33-35462445

DATE 6/30/20XX PAGE 1

		BALANCE OF YOUR FUNDS
PREVIOUS BALANCE -----		700.81
4	DEPOSITS TOTALING	8,218.00
5	WITHDRAWALS TOTALING	5,433.08
NEW BALANCE ----------		3,485.73

ACCOUNT TRANSACTIONS FOR THE PERIOD FROM 6/1/20XX THROUGH 6/30/20XX

DATE	AMOUNT	DESCRIPTION
6/1	1,830.00	DEPOSIT
6/5	2,583.00	DEPOSIT
6/15	3,800.00	DEPOSIT
6/30	5.00	INTEREST EARNED

DATE	CHECK #	AMOUNT	DATE	CHECK #	AMOUNT
6/2	8213	647.93	6/12	8217*	416.83
6/3	8214	490.00	6/20	8219*	3,150.00
6/5	8215	728.32			

CHECKING DAILY BALANCE SUMMARY

DATE	BALANCE OF YOUR FUNDS	DATE	BALANCE OF YOUR FUNDS
6/1	2,530.81	6/12	2,830.73
6/2	1,882.88	6/15	6,630.73
6/3	1,392.88	6/20	3,480.73
6/5	3,247.56	6/30	3,485.73

FIGURE 4-28

Bank Statement for Katherine Adam's Apparel Shop

RECORD ALL TRANSACTIONS THAT AFFECT YOUR ACCOUNT

NUMBER	DATE	DESCRIPTION OF TRANSACTION	DEBIT (-)	√ T	FEE (IF ANY) (-)	CREDIT (+)	BALANCE	
							700	81
8213	5/28	Lands End	647 93				-647	93
							52	88
Deposit	6/1	Receipts				1,830 00	+1,830	00
							1,882	88
8214	6/11	Collier Management Co.	490 00				-490	00
							1,392	88
8215	6/13	Jinkins Wholesale	728 32				-728	32
							664	56
Deposit	6/15	Receipts				2,583 00	+2,583	00
							3,247	56
8216	6/15	Minneapolis Utility Co.	257 13				-257	13
							2,990	43
8217	6/10	State of MN	416 83				-416	83
							2,573	60
Deposit	6/15	Receipts				3,800 00	+3,800	00
							6,373	60
8218	6/15	Tracie Burke salary	2,000 00				-2,000	00
							4,373	60
8219	6/20	Brown's Wholesale	3,150 00				-3,150	00
							1,223	60
Deposit	7/2	Receipts				1,720 00	+1,720	00
							2,943	60

FIGURE 4-29
Account Register for Katherine Adam's Apparel Shop

$	BALANCE AS SHOWN ON BANK STATEMENT		BALANCE AS SHOWN IN YOUR REGISTER	$
	TOTAL OF OUTSTANDING DEPOSITS		SUBTRACT AMOUNT OF SERVICE CHARGE	
	NEW TOTAL		NEW TOTAL	
	SUBTRACT TOTAL OF OUTSTANDING CHECKS		ADJUSTMENTS IF ANY Interest	
	YOUR ADJUSTED STATEMENT BALANCE	SHOULD EQUAL	YOUR ADJUSTED REGISTER BALANCE	

Outstanding Deposits (Credits)	
Date	Amount
	$
Total	$

Outstanding Checks (Debits)		
Check Number	Date	Amount
		$
Total		$

FIGURE 4-30
Account Reconciliation Form

4-2 SECTION EXERCISES

SKILL BUILDERS

Use Tom Deskin's bank statement (Figure 4-31) for Exercises 1–3.

1. Does Tom pay bills through electronic funds transfer? If so, which ones?

2. Did Tom use the automatic teller machine during the month? If so, what transactions were made and for what amounts?

Community First Bank

2177 Germantown Rd. South • Germantown, Tennessee 38138 • (901) 555-2400 • Member FDIC

Tom Deskin
1234 South Street
Germantown, TN 38138

ACCOUNT NUMBER 13-2882139
SOCIAL SECURITY NUMBER SECURED DATE 9-29-20XX PAGE 1

		BALANCE OF YOUR FUNDS
PREVIOUS BALANCE -----		$2,472.86
3	DEPOSITS TOTALING	4,812.12
15	WITHDRAWALS TOTALING	4,684.40
NEW BALANCE -----------		$2,600.58

ACCOUNT TRANSACTIONS FOR THE PERIOD FROM 8-28-20XX THROUGH 9-27-20XX

DATE	AMOUNT	DESCRIPTION
9/1	2,401.32	DEPOSIT - SCHERING-PLOUGH PAYROLL 213446688
9/1	942.18	WITHDRAWAL - LEADER FEDERAL MTG PMT 314123
9/4	217.17	WITHDRAWAL - LG&W PMT 21814
9/15	2,401.32	DEPOSIT - SCHERING-PLOUGH PAYROLL 213446688
9/20	60.00	WITHDRAWAL - ATM KIRBY WOODS
9/27	9.48	INTEREST EARNED

DATE	CHECK #	AMOUNT	DATE	CHECK #	AMOUNT	DATE	CHECK #	AMOUNT
8/31	1094	42.37	9/10	1099	583.21	9/25	1106*	1,238.42
9/2	1095	12.96	9/16	1100	283.21	9/25	1107	500.00
9/5	1096	36.01	9/18	1102*	48.23			
9/5	1097	178.13	9/21	1103	71.16			
9/5	1098	458.60	9/23	1104	12.75			

CHECKING DAILY BALANCE SUMMARY

DATE	BALANCE OF YOUR FUNDS	DATE	BALANCE OF YOUR FUNDS
8/28	2,472.86	9/15	4,804.87
8/31	2,430.49	9/16	4,521.66
9/1	3,889.63	9/18	4,473.43
9/2	3,876.67	9/20	4,413.43
9/4	3,659.50	9/21	4,342.27
9/5	2,986.76	9/23	4,329.52
9/10	2,403.55	9/25	2,591.10
		9/27	2,600.58

FIGURE 4-31
Tom Deskin's Bank Statement

3. What were the lowest and highest daily bank balances for the month?

5. Tom Deskin's account register is shown in Figure 4-32. Use one of the account reconciliation forms in Figure 4-33 to reconcile the bank statement in Figure 4-31 with the account register.

4. A bank statement shows a balance of $12.32. The service charge for the month was $2.95. The account register shows deposits of $300, $100, and $250 that do not appear on the statement. Outstanding checks are in the amount of $36.52, $205.16, $18.92, $25.93, and $200. The register balance is $178.74. Find the adjusted statement balance and the adjusted register balance. Use one of the account reconciliation forms in Figure 4-33.

RECORD ALL TRANSACTIONS THAT AFFECT YOUR ACCOUNT

NUMBER	DATE	DESCRIPTION OF TRANSACTION	DEBIT (-)	√T	FEE (IF ANY) (-)	CREDIT (+)	BALANCE
							2472 86
1094	8/28	K-mart	42 37				-42 37
							2430 49
1095	8/28	Walgreen's	12 96				-12 96
							2417 53
Deposit	9/1	Payroll Schering-Plough				2,401 32	+2,401 32
							4,818 85
AW	9/1	Leader Federal	942 18				-942 18
							3,876 67
AW	9/1	LG&W	217 17				-217 17
							3,659 50
1096	9/1	Kroger	36 01				-36 01
							3,623 49
1097	9/1	Texaco	178 13				-178 13
							3,445 36
1098	9/1	Univ. of Memphis	458 60				-458 60
							2,986 76
1099	9/15	GMAC Credit Corp	583 21				-583 21
							2403 55
1100	9/8	VISA	283 21				-283 21
							2,120 34
1101	9/10	Radio Shack	189 37				-189 37
							1930 97
1102	9/10	Auto Zone	48 23				-48 23
							1,882 74
Deposit	9/15	Payroll-Schering Plough				2401 32	+2,401 32
							4,284 06

REMEMBER TO RECORD AUTOMATIC PAYMENTS/DEPOSITS ON DATE AUTHORIZED.

RECORD ALL TRANSACTIONS THAT AFFECT YOUR ACCOUNT

NUMBER	DATE	DESCRIPTION OF TRANSACTION	DEBIT (-)	√T	FEE (IF ANY) (-)	CREDIT (+)	BALANCE
							4,284 06
1103	9/15	Geoffrey Beane	71 16				-71 16
							4,212 90
1104	9/14	Heaven Scent Flowers	12 75				-12 75
							4,200 15
1105	9/20	Kroger	87 75				-87 75
							4,112 40
ATM	9/20	Kirby Woods	60 00				-60 00
							4052 40
1106	9/21	Traveler's Insurance	1,238 42				-1,238 42
							2,813 98
1107	9/23	Nation's Bank-Savings	500 00				-500 00
							2,313 98

FIGURE 4-32
Tom Deskin's Account Register

$	BALANCE AS SHOWN ON BANK STATEMENT
	TOTAL OF OUTSTANDING DEPOSITS
	NEW TOTAL
	SUBTRACT TOTAL OF OUTSTANDING CHECKS
	YOUR ADJUSTED STATEMENT BALANCE

=

BALANCE AS SHOWN IN YOUR REGISTER	$
SUBTRACT AMOUNT OF SERVICE CHARGE	
NEW TOTAL	
ADJUSTMENTS IF ANY *Interest*	
YOUR ADJUSTED REGISTER BALANCE	

Outstanding Deposits (Credits)

Date	Amount
	$
Total	$

Outstanding Checks (Debits)

Check Number	Date	Amount
		$
	Total	$

$	BALANCE AS SHOWN ON BANK STATEMENT
	TOTAL OF OUTSTANDING DEPOSITS
	NEW TOTAL
	SUBTRACT TOTAL OF OUTSTANDING CHECKS
	YOUR ADJUSTED STATEMENT BALANCE

=

BALANCE AS SHOWN IN YOUR REGISTER	$
SUBTRACT AMOUNT OF SERVICE CHARGE	
NEW TOTAL	
ADJUSTMENTS IF ANY *Interest*	
YOUR ADJUSTED REGISTER BALANCE	

Outstanding Deposits (Credits)

Date	Amount
	$
Total	$

Outstanding Checks (Debits)

Check Number	Date	Amount
		$
	Total	$

FIGURE 4-33
Reconciliation Form

Learning Outcomes	What to Remember with Examples

Section 4-1

1 Make account transactions. (p. 102)

To make account deposits, on the appropriate deposit form (Figures 4-34 and 4-35):

1. Record the date.
2. Enter the amount of currency or coins being deposited.
3. List the amount of each check to be deposited, including an identifying name or company.
4. Add the amounts of currency, coins, and checks.
5. If the deposit is to a personal account and you want to receive some of the money in cash, enter the amount on the line "less cash received" and sign on the appropriate line.
6. Subtract any cash received from the total for the net deposit.

FIGURE 4-34
Deposit Ticket

FIGURE 4-35
Deposit Ticket

To make a withdrawal using a check:

1. Enter the date of the check.
2. Enter the name of the payee.
3. Enter the amount of the check in numerals.
4. Write the amount of the check in words. Cents can be written as a fraction of a dollar or by using decimal notation.
5. Explain the purpose of the check.
6. Sign the check.

On a check stub or an account register (Figures 4-36 and 4-37):

For checks and other debits:

1. Make an entry for every account transaction.
2. Enter the date, the amount of the check or debit, the person or company that will receive the check or debit, and the purpose of the check or debit.
3. Subtract the amount of the check or debit from the previous balance to obtain the new balance.
4. For handwritten checks with stubs, carry the new balance forward to the next stub.

For deposits or other credits:

1. Make an entry for every account transaction.
2. Enter the date, the amount of the deposit or credit, and a brief explanation of the deposit or credit.
3. Add the amount of the deposit or credit from the previous balance to obtain the new balance.

On an electronic money management system:

1. Enter the appropriate details for producing a check.
2. Record other debits and all deposits and credits. The account register is maintained by the system automatically.
3. For business accounts or personal accounts that are used for tracking expenses, record the type of expense or budget account number.

FIGURE 4-36
Business Check and Stub

FIGURE 4-37
Account Register

	RECORD ALL TRANSACTIONS THAT AFFECT YOUR ACCOUNT							BALANCE	
NUMBER	DATE	DESCRIPTION OF TRANSACTION	DEBIT	√	FEE	CREDIT		5,298	76
	4/21	Deposit				298	96	+298	96
								5,597	72
468	4/28	Arachne Mills	1,578	40				−1,578	40
								4,019	32

Section 4-2

1. Check off all matching transactions appearing on both the bank statement and the account register.
2. Enter into the register the transactions appearing on the bank statement that have not been checked off. Check off these transactions in the register as they are entered. Update the register balance accordingly.
3. Make a list of all the checks and other debits appearing in the register that have not been checked off. Add the amounts on the list to find the *total outstanding debits*.
4. Make a list of all the deposits and other credits appearing in the register that have not been checked off in step 1. Add the amounts on the list to find the *total outstanding credits*.
5. Calculate the *adjusted statement balance* by adding the statement balance and the total outstanding credits, and then subtracting the total outstanding debits: Adjusted statement balance = statement balance + total outstanding credits − total outstanding debits (Figure 4-39).
6. Compare the adjusted statement balance with the register balance. These amounts should be equal.

7. If the adjusted statement balance does not equal the register balance, locate the cause of the discrepancy and correct the register accordingly.
8. Write *statement reconciled* on the next blank line in the account register and record the statement date.

Figure 4-38 shows the bank statement for Eiland's Information Services. Steps 1 and 2 of the reconciliation process have been carried out: matching transactions have been checked off and all transactions appearing on the bank statement have been entered in the register and checked off including the service charge of $0.72 and interest earned of $14.32. The updated register balance is $18,020.36.

Now we complete the account reconciliation form in Figure 4-39 by recording the total outstanding debits and the total outstanding credits, transactions in the register that do not appear on the bank statement.

The adjusted statement balance does not equal the register balance. To locate the error, first find the difference of the two amounts: 19,304.72 − 18,020.36 = 1,284.36. This amount does not match any transaction exactly. So, divide the difference by 2: 1,284.36 ÷ 2 = 642.18. This amount matches a deposit made on 6/15. The deposit was subtracted from the balance when it should have been added. Make an entry in the account register to offset the error: deposit $1,284.36, which is the amount that was subtracted in error plus the amount of the 6/15 deposit. Figure 4-40 shows the reconciled register. Notice the entry "statement reconciled" dated 7/2.

Community First Bank

2177 Germantown Rd. South • Germantown, Tennessee 38138 • (901) 555-2400 • Member FDIC

EILAND'S INFORMATION SERVICES
314 ROSAMOND ST
DRUMMONDS, TN 38072

ACCOUNT NUMBER 21-4658321
FEDERAL ID NUMBER 13-8467214 DATE 7/2/20XX PAGE 1

		BALANCE OF YOUR FUNDS
PREVIOUS BALANCE -----		$3,472.16
3	DEPOSITS TOTALING	2,498.50
7	WITHDRAWALS TOTALING	1,647.55
NEW BALANCE ----------		$4,323.11

ACCOUNT TRANSACTIONS FOR THE PERIOD FROM 6/3/20XX THROUGH 7/2/20XX

DATE	AMOUNT	DESCRIPTION
6/15	642.18 ✓	DEPOSIT
6/20	1,842.00 ✓	DEPOSIT
7/2	.72 ✓	SERVICE CHARGE
7/2	14.32 ✓	INTEREST EARNED

DATE	CHECK #	AMOUNT	DATE	CHECK #	AMOUNT
6/15	5832	200.00 ✓	6/17	5835	82.37 ✓
6/16	5833	225.00 ✓	7/2	5837*	175.00 ✓
6/17	5834	72.00 ✓	7/2	5839*	892.46 ✓

CHECKING DAILY BALANCE SUMMARY

DATE	BALANCE OF YOUR FUNDS	DATE	BALANCE OF YOUR FUNDS
6/3	3,472.16	6/17	3,534.97
6/15	3,914.34	6/20	5,376.97
6/16	3,689.34	7/2	4,323.11

FIGURE 4-38
Bank Statement

Account Reconciliation Form

$ 4,323 11	BALANCE AS SHOWN ON BANK STATEMENT		BALANCE AS SHOWN IN YOUR REGISTER	$ 18,006 76
20,000 00	TOTAL OF OUTSTANDING DEPOSITS		SUBTRACT AMOUNT OF SERVICE CHARGE	− 72
24,323 11	NEW TOTAL		NEW TOTAL	18,006 04
5,018 39	SUBTRACT TOTAL OF OUTSTANDING CHECKS		ADJUSTMENTS IF ANY	+14 32 + 1,284 36
$19,304 72	YOUR ADJUSTED STATEMENT BALANCE	SHOULD EQUAL	YOUR ADJUSTED REGISTER BALANCE	$19,304 72

Outstanding Deposits (Credits)			Outstanding Checks (Debits)		
Date	Amount		Check Number	Date	Amount
6/25	$ 20,000 00		5836		$ 42 18
			5838		4,976 21
Total	$ 20,000 00			Total	$ 5,018 39

FIGURE 4-39
Account Reconciliation Form

RECORD ALL TRANSACTIONS THAT AFFECT YOUR ACCOUNT

NUMBER	DATE	DESCRIPTION OF TRANSACTION	DEBIT (−)	√T	FEE (IF ANY) (−)	CREDIT (+)	BALANCE
							3,472 16
5832	6/13	City of Chicago	200 00	√			−200 00
							3,272 16
5833	6/13	City of Phoenix	225 00	√			−225 00
							3,047 16
5834	6/14	City of Fresno	72 00	√			−72 00
							2,975 16
5835	6/15	Hardware house	82 37	√			−82 37
							2,892 79
Deposit	6/15	Can Com, Inc. ✱	642 18	√			−642 18
							2,250 61
5836	6/18	Office Max copies	42 18				−42 18
							2,208 43
5837	6/20	City of New Orleans	175 00	√			−175 00
							2,033 43
Deposit	6/20	List Purchases		√		1842 00	+1842 00
							3,875 43
Deposit	6/25	Federal Credit Union Small business loan				20,000 00	+20,000 00
							23,875 43
5838	6/30	Hardware house computer	4976 21				−4976 21
							18,899 22
5839	6/30	Wade office Furniture Desk chair, file cabinet	892 46	√			−892 46
							18006 76
	7/2	Service Charge		√	72		−72
							18,006 04
	7/2	Interest earned		√		14 32	+14 32
							18,020 36

REMEMBER TO RECORD AUTOMATIC PAYMENTS/DEPOSITS ON DATE AUTHORIZED.

✱ Posting error (should be in deposit column)

RECORD ALL TRANSACTIONS THAT AFFECT YOUR ACCOUNT

NUMBER	DATE	DESCRIPTION OF TRANSACTION	DEBIT (−)	√T	FEE (IF ANY) (−)	CREDIT (+)	BALANCE
							18,020 36
	7/4	Correction to deposit on 6/15		√		1284 36	+1,284 36
							19,304 72
	7/2	Statement Reconciled		√			

FIGURE 4-40
Account Register

EXERCISES SET A

1. Write a check (Figure 4-41) dated June 13, 20XX, to Byron Johnson in the amount of $296.83 for a washing machine. Complete the check stub.

FIGURE 4-41
Check Number 456

2. Write a check (Figure 4-42) dated June 12, 20XX, to Alpine Industries in the amount of $85.50 for building supplies. Complete the check stub.

8212

Date_____20___	
Amount _____	
To _____	
For _____	
Balance Forward	$2,087 05
Deposits	+1,500 00
Total	
Amount This Check	
Balance	

Barter Home Repair
302 Cannon Dr.
Germantown, TN 38138 8212

_____20_____ 87-278/840

PAY TO THE
ORDER OF _____ $

_____ DOLLARS

Community First Bank
2177 Germantown Rd. South
Germantown, Tennessee 38138

MEMO _____

⑆035008212⑆

FIGURE 4-42
Check Number 8212

3. Complete a deposit slip (Figure 4-43) to deposit checks in the amounts of $136.00 and $278.96, and $480 cash on May 8, 20XX.

FIGURE 4-43
Deposit Ticket for S & R Consulting Co.

4. Enter the following information and transactions in the check register for Happy Center Day Care (Figure 4-44). On July 10, 20XX, with an account balance of $983.47, the account debit card was used at Linens, Inc., for $220 for laundry services, and check 1214 was written to Bugs Away for $65 for extermination services. On July 11, $80 was withdrawn from an automatic teller machine, and on July 12, checks in the amounts of $123.86, $123.86, and $67.52 were deposited. Show the balance after these transactions.

		RECORD ALL TRANSACTIONS THAT AFFECT YOUR ACCOUNT					
NUMBER	DATE	DESCRIPTION OF TRANSACTION	DEBIT (–)	√ T	FEE (IF ANY) (–)	CREDIT (+)	BALANCE

FIGURE 4-44
Check Register

Tree Top Landscape Service's bank statement is shown in Figure 4-45.

5. How many deposits were cleared during the month?

6. What amount of service charge was paid?

7. What was the amount of the largest check written?

8. How many checks appear on the bank statement?

9. What is the balance at the beginning of the statement period?

10. What is the balance at the end of the statement period?

11. What is the amount of check 718?

12. On what date did check 717 clear the bank?

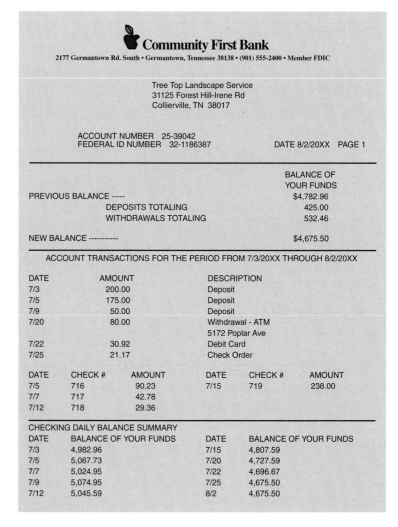

FIGURE 4-45
Bank Statement for Tree Top Landscape Service

13. Tree Top Landscape Service's account register is shown in Figure 4-46 and its bank statement in Figure 4-45. Update the account register and use the reconciliation form in Figure 4-47 to reconcile the bank statement with the account register.

RECORD ALL TRANSACTIONS THAT AFFECT YOUR ACCOUNT

NUMBER	DATE	DESCRIPTION OF TRANSACTION	DEBIT (−)	√ T	FEE (IF ANY) (−)	CREDIT (+)	BALANCE
							4,782 96
716	7/1	Dabney Nursery	90 23				4,692 73
717	7/1	Office Max	42 78				4,649 95
Deposit	7/3	Louis Lechlefter				200 00	4,849 95
Deposit	7/5	Tony Trim				175 00	5,024 95
Deposit	7/9	Dale Crosby				50 00	5,074 95
718	7/10	Texaco Gas	29 36				5,045 59
719	7/10	Nation's Bank	238 00				4,807 59
Deposit	7/15	Bobby Cornelius				300 00	5,107 59
ATM	7/20	Withdrawl Branch	80 00				5,027 59
Debit card	7/20	AT&T	30 92				4,996 67
720	7/20	Visa	172 83				4,823 84

REMEMBER TO RECORD AUTOMATIC PAYMENTS/DEPOSITS ON DATE AUTHORIZED.

FIGURE 4-46
Account Register for Tree Top Landscape Service

$	BALANCE AS SHOWN ON BANK STATEMENT		BALANCE AS SHOWN IN YOUR REGISTER	$
	TOTAL OF OUTSTANDING DEPOSITS		SUBTRACT AMOUNT OF SERVICE CHARGE	
	NEW TOTAL		NEW TOTAL	
	SUBTRACT TOTAL OF OUTSTANDING CHECKS		ADJUSTMENTS IF ANY Check Order	
	YOUR ADJUSTED STATEMENT BALANCE	SHOULD EQUAL	YOUR ADJUSTED REGISTER BALANCE	

Outstanding Deposits (Credits)	
Date	Amount
	$
Total	$

Outstanding Checks (Debits)		
Check Number	Date	Amount
		$
Total		$

FIGURE 4-47
Account Reconciliation Form

14. The July bank statement for A & H Iron Works shows a balance of $37.94 and a service charge of $8.00. The account register shows deposits of $650 and $375.56 that do not appear on the statement. Checks in the amounts of $217.45, $57.82, $17.45, and $58.62 are outstanding. The register balance before reconciliation is $720.16. Reconcile the bank statement with the account register using the form in Figure 4-48.

$	BALANCE AS SHOWN ON BANK STATEMENT		BALANCE AS SHOWN IN YOUR REGISTER	$
	TOTAL OF OUTSTANDING DEPOSITS		SUBTRACT AMOUNT OF SERVICE CHARGE	
	NEW TOTAL		NEW TOTAL	
	SUBTRACT TOTAL OF OUTSTANDING CHECKS		ADJUSTMENTS IF ANY	
	YOUR ADJUSTED STATEMENT BALANCE	SHOULD EQUAL	YOUR ADJUSTED REGISTER BALANCE	

Outstanding Deposits (Credits)			Outstanding Checks (Debits)		
Date	Amount		Check Number	Date	Amount
	$				$
Total	$			Total	$

FIGURE 4-48
Account Reconciliation Form

15. The September bank statement for Dixon Fence Company shows a balance of $275.25 and a service charge of $7.50. The account register shows deposits of $120.43 and $625.56 that do not appear on the statement. Checks in the amounts of $144.24, $154.48, $24.17, and $18.22 are outstanding. A $100 ATM withdrawal does not appear on the statement. The register balance before reconciliation is $587.63. Reconcile the bank statement with the account register using the form in Figure 4-49.

$	BALANCE AS SHOWN ON BANK STATEMENT		BALANCE AS SHOWN IN YOUR REGISTER	$
	TOTAL OF OUTSTANDING DEPOSITS		SUBTRACT AMOUNT OF SERVICE CHARGE	
	NEW TOTAL		NEW TOTAL	
	SUBTRACT TOTAL OF OUTSTANDING CHECKS		ADJUSTMENTS IF ANY	
$	YOUR ADJUSTED STATEMENT BALANCE	SHOULD EQUAL	YOUR ADJUSTED REGISTER BALANCE	

Outstanding Deposits (Credits)			Outstanding Checks (Debits)		
Date	Amount		Check Number	Date	Amount
	$				$
Total	$			Total	$

FIGURE 4-49
Account Reconciliation Form

EXERCISES SET B

1. Write a check dated August 18, 20XX (Figure 4-50), to Valley Electric Co-op in the amount of $189.32 for utilities. Complete the check stub in Figure 4-50.

FIGURE 4-50
Check Number 789

2. Write a check dated December 28, 20XX (Figure 4-51), to Lundy Daniel in the amount of $450.00 for legal services. James Ludwig is the maker. Complete the check stub.

FIGURE 4-51
Check Number 1599

3. Complete a deposit slip on November 11, 20XX (Figure 4-52), to show the deposit of $100 in cash, checks in the amounts of $87.83, $42.97, and $106.32, with a $472.13 total from the other side of the deposit slip.

FIGURE 4-52
Deposit Ticket for T. J. Jackson

4. Enter the following information and transactions in the check register for Sloan's Tree Service (Figure 4-53). On May 3, 20XX, with an account balance of $876.54, check 234 was written to Organic Materials for $175 for fertilizer and check 235 was written to Klean Kuts in the amount of $524.82 for a chain saw. On May 5, checks in the amounts of $147.63 and $324.76 were deposited at the bank ATM. Show the balance after these transactions.

		RECORD ALL TRANSACTIONS THAT AFFECT YOUR ACCOUNT					BALANCE	
NUMBER	DATE	DESCRIPTION OF TRANSACTION	DEBIT (−)	√ T	FEE (IF ANY) (−)	CREDIT (+)		

FIGURE 4-53
Account Register

Enrique Anglade's bank statement is shown in Figure 4-54.

5. How many deposits were made during the month?

6. What amount of service charge was paid?

7. What was the amount of the smallest check written?

8. How many checks appear on the bank statement?

9. What is the balance at the beginning of the statement period?

10. What is the balance at the end of the statement period?

11. What is the amount of check 5375?

12. On what date did check 5376 clear the bank?

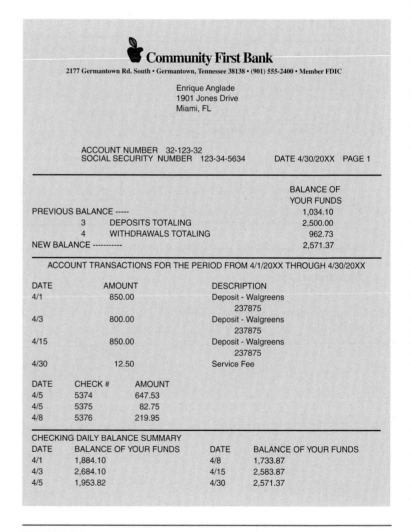

Community First Bank
2177 Germantown Rd. South • Germantown, Tennessee 38138 • (901) 555-2400 • Member FDIC

Enrique Anglade
1901 Jones Drive
Miami, FL

ACCOUNT NUMBER 32-123-32
SOCIAL SECURITY NUMBER 123-34-5634 DATE 4/30/20XX PAGE 1

			BALANCE OF YOUR FUNDS
PREVIOUS BALANCE -----			1,034.10
	3	DEPOSITS TOTALING	2,500.00
	4	WITHDRAWALS TOTALING	962.73
NEW BALANCE ----------			2,571.37

ACCOUNT TRANSACTIONS FOR THE PERIOD FROM 4/1/20XX THROUGH 4/30/20XX

DATE	AMOUNT	DESCRIPTION
4/1	850.00	Deposit - Walgreens 237875
4/3	800.00	Deposit - Walgreens 237875
4/15	850.00	Deposit - Walgreens 237875
4/30	12.50	Service Fee

DATE	CHECK #	AMOUNT
4/5	5374	647.53
4/5	5375	82.75
4/8	5376	219.95

CHECKING DAILY BALANCE SUMMARY

DATE	BALANCE OF YOUR FUNDS	DATE	BALANCE OF YOUR FUNDS
4/1	1,884.10	4/8	1,733.87
4/3	2,684.10	4/15	2,583.87
4/5	1,953.82	4/30	2,571.37

FIGURE 4-54
Bank Statement for Enrique Anglade

13. Enrique Anglade's account register is shown in Figure 4-55. Update the account register and reconcile the bank statement (see Figure 4-54) with the account register by using the reconciliation form in Figure 4-56.

RECORD ALL TRANSACTIONS THAT AFFECT YOUR ACCOUNT

NUMBER	DATE	DESCRIPTION OF TRANSACTION	DEBIT (−)	√T	FEE (IF ANY) (−)	CREDIT (+)	BALANCE
							1,034 10
Deposit	4/1	Payroll				850 00	+850 00
							1,884 10
Deposit	4/3	Payroll – Bonus				800 00	+800 00
							2,684 10
5374	4/3	First Union Mortgage Co.	647 53				−647 53
							2,036 57
5375	4/3	South Florida Utility	82 75				−82 75
							1,953 82
5376	4/5	First Federal Credit Union	219 95				−219 95
							1,733 87
5377	4/15	Banc Boston	510 48				−510 48
							1,223 39
Deposit	4/15	Payroll				850 00	+850 00
							2,073 39
5378	4/20	Northwest Airlines	403 21				−403 21
							1,670 18
5379	4/26	Auto Zone	18 97				−18 97
							1,651 21
ATM	5/4	Cordova Branch	100 00				−100 00
							1,551 21

REMEMBER TO RECORD AUTOMATIC PAYMENTS/DEPOSITS ON DATE AUTHORIZED.

FIGURE 4-55
Account Register for Enrique Anglade

$	BALANCE AS SHOWN ON BANK STATEMENT		BALANCE AS SHOWN IN YOUR REGISTER	$
	TOTAL OF OUTSTANDING DEPOSITS		SUBTRACT AMOUNT OF SERVICE CHARGE	
	NEW TOTAL		NEW TOTAL	
	SUBTRACT TOTAL OF OUTSTANDING CHECKS		ADJUSTMENTS IF ANY	
	YOUR ADJUSTED STATEMENT BALANCE	SHOULD EQUAL	YOUR ADJUSTED REGISTER BALANCE	

Outstanding Deposits (Credits)	
Date	Amount
	$
Total	$

Outstanding Checks (Debits)		
Check Number	Date	Amount
		$
Total		$

FIGURE 4-56
Account Reconciliation Form

14. Taylor Flowers' bank statement shows a balance of $135.42 and a service charge of $8.00. The account register shows deposits of $112.88 and $235.45 that do not appear on the statement. The register shows outstanding checks in the amounts of $17.42 and $67.90 and two cleared checks recorded in the account register as $145.69 and $18.22. The two cleared checks actually were written for and are shown on the statement as $145.96 and $18.22. The register balance before reconciliation is $406.70. Reconcile the bank statement with the account register using the form in Figure 4-57.

$	BALANCE AS SHOWN ON BANK STATEMENT		BALANCE AS SHOWN IN YOUR REGISTER	$
	TOTAL OF OUTSTANDING DEPOSITS		SUBTRACT AMOUNT OF SERVICE CHARGE	
	NEW TOTAL		NEW TOTAL	
	SUBTRACT TOTAL OF OUTSTANDING CHECKS		ADJUSTMENTS IF ANY	
	YOUR ADJUSTED STATEMENT BALANCE	SHOULD EQUAL	YOUR ADJUSTED REGISTER BALANCE	

Outstanding Deposits (Credits)			Outstanding Checks (Debits)		
Date	Amount		Check Number	Date	Amount
	$				$
Total	$			Total	$

FIGURE 4-57
Account Reconciliation Form

15. The bank statement for Randazzo's Market shows a balance of $1,102.35 and a service charge of $6.50. The account register shows a deposit of $265.49 that does not appear on the statement. The account register shows outstanding checks in the amounts of $617.23 and $456.60 and two cleared checks recorded as $45.71 and $348.70. The two cleared checks actually were written for $45.71 and $384.70. The register balance before reconciliation is $336.51. Reconcile the bank statement with the account register using the form in Figure 4-58.

$	BALANCE AS SHOWN ON BANK STATEMENT		BALANCE AS SHOWN IN YOUR REGISTER	$
	TOTAL OF OUTSTANDING DEPOSITS		SUBTRACT AMOUNT OF SERVICE CHARGE	
	NEW TOTAL		NEW TOTAL	
	SUBTRACT TOTAL OF OUTSTANDING CHECKS		ADJUSTMENTS IF ANY	
	YOUR ADJUSTED STATEMENT BALANCE	SHOULD EQUAL	YOUR ADJUSTED REGISTER BALANCE	

Outstanding Deposits (Credits)			Outstanding Checks (Debits)		
Date	Amount		Check Number	Date	Amount
	$				$
Total	$			Total	$

FIGURE 4-58
Account Reconciliation Form

PRACTICE TEST

1. Write the check and fill out the check stub provided in Figure 4-59. The balance brought forward is $2,301.42, deposits were made for $200 on May 12 and $83.17 on May 20, and check 195 was written on May 25 to Lon Associates for $152.50 for supplies. The check was signed by Lonny Branch.

195	Date_____20____
Amount _____	
To _____	
For _____	

Balance Forward		
Deposits		
Total		
Amount This Check		
Balance		

Khayat Cleaners
2438 Broad St.
Oklahoma City, OK 00000

_____ 20 _____ 87-278/840

195

PAY TO THE
ORDER OF _____ $ []

_____ DOLLARS

First State Bank
1543 S. Main
Oklahoma City, OK 00000

MEMO _____ _____

⑆074200195⑆ ⑈

FIGURE 4-59
Check Number 195

D.G. Hernandez Equipment's bank statement is shown in Figure 4-60.

2. What is the balance at the beginning of the statement period?

3. How many checks cleared the bank during the statement period?

4. What was the service charge for the statement period?

5. Check 3786 was written for what amount?

6. On what date did check 3788 clear the account?

7. What was the total of the deposits?

8. What was the balance at the end of the statement period?

9. What was the total amount for all checks written during the period?

Community First Bank

2177 Germantown Rd. South • Germantown, Tennessee 38138 • (901) 555-2400 • Member FDIC

D. G. Hernandez Equipment
25 Santa Rosa Dr.
Piperton, TN 38027

ACCOUNT NUMBER 8-523145
FEDERAL ID NUMBER 46-28345135 DATE 3/31/20XX PAGE 1

			BALANCE OF YOUR FUNDS
PREVIOUS BALANCE -----			5,283.17
	2	DEPOSITS TOTALING	3,600.00
	6	WITHDRAWALS TOTALING	1,900.49
NEW BALANCE ----------			6,982.68

ACCOUNT TRANSACTIONS FOR THE PERIOD FROM 3/1/20xx THROUGH 3/31/20xx

DATE	AMOUNT	DESCRIPTION
3/15	1,600.00	Deposit
3/17	19.00	Returned Check Charge
3/31	2,000.00	Deposit

DATE	CHECK #	AMOUNT	DATE	CHECK #	AMOUNT
3/2	3784	96.03	3/15	3788	973.12
3/7	3786*	142.38	3/31	3792*	182.03
3/12	3787	487.93			

CHECKING DAILY BALANCE SUMMARY			
DATE	BALANCE OF YOUR FUNDS	DATE	BALANCE OF YOUR FUNDS
3/2	5,187.14	3/15	5,183.71
3/7	5,044.76	3/17	5,164.71
3/12	4,556.83	3/31	6,982.68

FIGURE 4-60
Bank Statement for D. G. Hernandez Equipment

10. D. G. Hernandez Equipment's account register is shown in Figure 4-61. Reconcile the bank statement in Figure 4-60 with the account register in Figure 4-61. Use the account reconciliation form in Figure 4-62.

RECORD ALL TRANSACTIONS THAT AFFECT YOUR ACCOUNT

NUMBER	DATE	DESCRIPTION OF TRANSACTION	DEBIT (−)	√T	FEE (IF ANY) (−)	CREDIT (+)	BALANCE
							5,283 17
3784	2/27		96 03				−96 03
							5,187 14
3785	3/5		346 18				−346 18
							4,840 96
3786	3/5		142 38				−142 38
							4,698 58
3787	3/11		487 93				−487 93
							4,210 65
3788	3/11		973 12				−973 12
							3,237 53
3789	3/15		72 83				−72 83
							3,164 70
Dep.	3/15					1,600 00	+1,600 00
							4,764 70
3790	3/17		146 17				−146 17
							4,618 53
3791	3/20		152 03				−152 03
							4,466 50
3792	3/31		* 182 08				−182 08
							4,284 42
Deposit	3/31					2,000 00	+2,000 00
							6,284 42

REMEMBER TO RECORD AUTOMATIC PAYMENTS/DEPOSITS ON DATE AUTHORIZED.

FIGURE 4-61
Account Register

$	BALANCE AS SHOWN ON BANK STATEMENT		BALANCE AS SHOWN IN YOUR REGISTER	$
	TOTAL OF OUTSTANDING DEPOSITS		SUBTRACT AMOUNT OF SERVICE CHARGE	
	NEW TOTAL		NEW TOTAL	
	SUBTRACT TOTAL OF OUTSTANDING CHECKS		ADJUSTMENTS IF ANY	
	YOUR ADJUSTED STATEMENT BALANCE	SHOULD EQUAL	YOUR ADJUSTED REGISTER BALANCE	

Outstanding Deposits (Credits)			Outstanding Checks (Debits)		
Date	Amount		Check Number	Date	Amount
	$				$
Total	$			Total	$

FIGURE 4-62
Account Reconciliation Form

11. Before reconciliation, an account register balance is $1,817.93. The bank statement balance is $860.21. A service fee of $15 and one returned item of $213.83 were charged against the account. Deposits in the amounts of $800 and $412.13 are outstanding. Checks written for $243.17, $167.18, $13.97, $42.12, and $16.80 are outstanding. Complete the account reconciliation form in Figure 4-63 to reconcile the bank statement with the account register.

$	BALANCE AS SHOWN ON BANK STATEMENT		BALANCE AS SHOWN IN YOUR REGISTER	$
	TOTAL OF OUTSTANDING DEPOSITS		SUBTRACT AMOUNT OF SERVICE CHARGE	
	NEW TOTAL		NEW TOTAL	
	SUBTRACT TOTAL OF OUTSTANDING CHECKS		ADJUSTMENTS IF ANY	
	YOUR ADJUSTED STATEMENT BALANCE	SHOULD EQUAL	YOUR ADJUSTED REGISTER BALANCE	

Outstanding Deposits (Credits)			Outstanding Checks (Debits)		
Date	Amount		Check Number	Date	Amount
	$				$
Total	$			Total	$

FIGURE 4-63
Account Reconciliation Form

1. If adjacent digits of an account register entry have been transposed, the error will produce a difference that is divisible by 9. Give an example of a two-digit number and the number formed by transposing the digits, and show that the difference is divisible by 9.

2. Give an example of a three-digit number and the number formed by transposing two adjacent digits. Show that the difference is divisible by 9.

3. Give an example of a four-digit number and a number formed by transposing any two adjacent digits. Show that the difference is divisible by 9.

4. Will the difference be divisible by 9 if two digits that are *not* adjacent are interchanged to form a new number? Illustrate your answer.

5. What if more than two digits are interchanged? Will the difference still be divisible by 9? Illustrate your answer.

6. When you receive your bank statement, you should first identify any items on the statement that are not listed in your account register. Discuss some items you may find on a bank statement and explain what should be done with them.

7. Explain the various types of endorsements for checks.

8. Explain why you would not want to use a deposit ticket that had someone else's name printed on it to make a deposit for your account even if you cross out the account number and name and enter your own.

9. Describe the process for reconciling a bank statement with the account register.

10. Discuss at least three advantages for a business to have a checking account.

Challenge Problem

Terry Kelly talked with her investment counselor. She was advised to calculate her current net worth and to project her 2008 net worth to determine if her 2008 projections would accomplish her objective of increasing her net worth. She listed the following assets and liabilities for 2007. To calculate her net worth, she found the difference between total assets and total liabilities.

ASSETS:

Checking account	2,099	
Savings account	2,821	
Auto	10,500	
Home and furnishings	65,000	
Stocks and bonds	4,017	
Other personal property	3,200	
Total assets		

LIABILITIES:

Car loan	8,752	6,652
Home mortgage	54,879	53,992
Personal loan	1,791	0
Total liabilities		

Terry's home appreciated (increased) in value by 0.04 times the 2007 value while her car depreciated (decreased) in value by 0.125 times the 2007 value. Her car loan decreased by $2,100 while her home mortgage balance decreased by $887. Terry plans to pay her personal loan in full by the end of 2008. Of her $2,000 planned investment, she will place $1,000 in savings and $1,000 in stocks and bonds. She also plans to reinvest the interest income of $141 (in savings) and the dividend income of $364 (in stocks and bonds) earned in 2007. She projects her checking account balance will be $1,500 at year-end for 2008.

Calculate Terry's total assets and total liabilities for 2007. Then calculate her net worth for 2007. Use the information given to project Terry's assets and liabilities for 2008. Then project her 2008 net worth. How much does Terry expect her net worth to increase (or decrease) from 2007 to 2008?

4.1 Mark's First Checking Account

During his first year in college, Mark Sutherland opened a checking account at the First National Bank of Westerly, Nebraska. His account does not have a minimum balance requirement, but he does pay a monthly service charge of $3.00. Mark has just received his first monthly bank statement and notices that the end-of-month balance on the statement is quite different from the end-of-month balance he shows in his check record. The bank statement and Mark's check record are summarized below.

ACCOUNT: Mark J. Sutherland ACCOUNT # 43967				PERIOD: January 3, 2008 through January 31, 2008
Bank Statement of Activity This Month				
Beginning Balance		**Deposits and Other Credits to Your Account**	**Checks and Other Charges to Your Account**	**Ending Balance**
		300.00	206.25	93.75
03	Deposit	300.00		
05	100		16.50	
07	101		20.00	
09	Debit card transaction		17.45	
12	103		42.96	
14	104		16.87	
17	105		5.00	
17	106		11.43	
17	ATM withdrawal		25.00	
19	107		25.00	
24	108		14.04	
28	109		9.00	
31	Service Charge		3.00	

Mark's Check Record					
Date	No.	Payee	For	Amount	Balance
1/3		Deposit		300.00	300.00
1/3	100	Harmon Foods	Food	16.50	283.50
1/4	101	Cash		20.00	263.50
1/5	102	VOID			
1/7	103	Mel's Sporting Goods	Gym shoes	42.96	220.54
1/10	104	Valley Cleaners	Dry cleaning	18.67	201.87
1/13	105	Sharon Mackey	Birthday present	5.00	196.87
1/14	106	University Bookstore	Supplies	11.43	190.44
1/14	107	Cash		25.00	175.44
1/19	108	Harmon Foods	Food	14.04	161.40
1/24	109	Mom	Repay loan	9.00	152.40
1/25	110	Poindexter's Café	Sharon's birthday party	20.00	132.40
1/26		Deposit		50.00	182.40
1/28	111	Exxon	Monthly statement	12.96	169.44

1. What are the steps Mark needs to include when reconciling his account record with the bank's statement?

2. Reconcile Mark's record with the bank statement using the steps listed in the previous answer.

3. Why are there differences between Mark's records and the bank's statement? What could Mark do during the next month to make the month-end reconciliation easier?

4. Suppose Mark finds a $100 deposit in his bank statement that he knows he did not make. What should he do?

4.2 Expressions Dance Studio

It was the end of a very long first month in her sole proprietorship, and Kara Noble was exhausted. Between moving into a new apartment and teaching dance classes five nights a week, there was not much downtime. Consequently, the mail had started to pile up. After sorting through a few bills and way too much junk mail, Kara spotted her first bank statement from U.S. Bank. The format was different from what she was used to, and she was startled to see the ending balance of only $506.18, less than the balance she thought she had. Kara went to find her business check book, which along with the bank statement is summarized below:

Source: Winger and Frasca, *Personal Finance: An Integrated Planning Approach,* 6th edition (Upper Saddle River, NJ: Prentice Hall, 2002).

FINANCIAL SUMMARY: 08/25/07 to 09/25/07

ACCOUNT: Expressions Dance ACCOUNT #: 1007508279			ENDING BALANCE: $506.18	
Date	**Activity**	**Deposits/Other Additions**	**Withdrawals/Other Deductions**	**Ending Balance**
9/1/2007	Deposit	2,475.00		2,475.00
9/7/2007	1001		110.00	2,365.00
9/7/2007	1000		900.00	1,465.00
9/14/2007	1003		156.00	1,309.00
9/14/2007	1002		29.49	1,279.51
9/20/2007	Deposit	336.19		1,615.70
9/24/2007	Debit		93.50	1,522.20
9/24/2007	Debit		25.75	1,496.45
9/24/2007	Debit		4.79	1,491.66
9/25/2007	1005		900.00	591.66
9/25/2007	Service charge		3.00	588.66
9/25/2007	Check printing		82.48	506.18

Check #	Date	Pay to	Memo	Amount	Balance
Deposit	9/1/2007	Deposit	Business Loan	$2,475.00	$2,475.00
1000	9/1/2007	Stephens Properties	Sept. Studio Rent	$900.00	$1,575.00
1001	9/5/2007	Renae Peterson	Refund	$110.00	$1,685.00
1002	9/10/2007	Gannett Newspapers	Ad Bill	$29.49	$1,655.51
1003	9/12/2007	Liturgical Publications	Ad Bill	$156.00	$1,499.51
Deposit	9/20/2007	Deposit	Students	$336.19	$1,835.70
1004	9/21/2007	Wisconsin Dance	Owed money to Kari	$133.62	$1,702.08
1005	9/22/2007	Stephens Properties	Oct. Studio Rent	$900.00	$802.08
Debit card	9/23/2007	Pom Express	Poms	$39.50	$762.58
Debit card	9/23/2007	Gas	Gas	$25.75	$736.83
Deposit	9/27/2007	Deposit	Students	$319.71	$1,056.45
Deposit	9/29/2007	Deposit	Studio rental fee	$200.00	$1,256.54
1006	9/30/2007	VOID	Mistake	$	$1,256.54
1007	9/30/2007	Cintas Fire Protection	Extinguisher Replace	$36.93	$1,219.61
1008	9/30/2007	Besberg Realty	October Apt. Rent	$570.00	$649.61

1. What steps should Kara take to reconcile her bank statement? (Hint: they are listed in your text.)

2. Reconcile Kara's checkbook for Expressions Dance with the bank statement following the steps you provided in your answer to question 1.

3. What are some ways that Kara can avoid discrepancies in the future?

4. The last entry in Kara's Expressions Dance checkbook register is for check #1008 written to Besberg Realty for her personal apartment rent. Is it legal to write checks for personal expenses out of a business account? Even if it is legal, is it a good idea?

CHAPTER 5 | Equations

Bungee Jumping: How High Should You Go?

Bungee jumping, like many extreme sports, has become increasingly popular in recent years. Few things are quite as exhilarating as seeing the ground come rushing at you—only to be yanked back skyward in the nick of time. But did you know that bungee jumping safety is based on applied math equations?

Tim does, and he is opening a new business, Extreme Bungee Jumping. His primary concern, of course, is with the safety of the jumpers. One mistake and the results could be catastrophic! He has been reviewing the math equation used in the computer program that came with the bungee jump cord he purchased, and realizes there are five variables: the height of the platform, the length of the cord, the elasticity or spring of the cord, the weight of the individual, and an appropriate safety margin. Tim learns that a safety margin of 2 m is acceptable. He knows the length and spring of the cord, as stated by the manufacturer.

Tim wants to try out his new bungee jumping equipment, but is unsure how tall the tower must be to ensure a safe jump. For Tim to complete the calculations, he must know his weight, which is 165 lb or 75 kg. He uses 75 kg, and gets the following results:

height $= 47.285 + 2$ meters (added for safety) $= 49.285$ m (based on solving the quadratic equation: $h^2 - 755h + 100 = 0$)

The tower must be at least 49.285 m tall to accommodate jumpers who are 165 lb or less. Tim was glad that the computer did the calculations for him. But the good news was that he could now bungee jump safely. Luckily for you, the equations in this chapter are much easier to follow. So, it is time to jump in!

LEARNING OUTCOMES

5-1 Equations
1. Solve equations using multiplication or division.
2. Solve equations using addition or subtraction.
3. Solve equations using more than one operation.
4. Solve equations containing multiple unknown terms.
5. Solve equations containing parentheses.
6. Solve equations that are proportions.

5-2 Using Equations to Solve Problems
1. Use the problem-solving approach to analyze and solve word problems.

5-3 Formulas
1. Evaluate a formula.
2. Find a variation of a formula by rearranging the formula.

LEARNING OUTCOMES

1 Solve equations using multiplication or division.
2 Solve equations using addition or subtraction.
3 Solve equations using more than one operation.
4 Solve equations containing multiple unknown terms.
5 Solve equations containing parentheses.
6 Solve equations that are proportions.

Equation: a mathematical statement in which two quantities are equal.

Unknown or **variable:** the missing amount or amounts that are represented as letters in an equation.

Known or **given amount:** the known amounts or numbers in an equation.

Solve: find the value of the unknown or variable that makes the equation true.

Isolate: perform systematic operations to both sides of the equation so that the unknown or variable is alone on one side of the equation. Its value is identified on the other side of the equation.

An **equation** is a mathematical statement in which two quantities are equal. Equations are represented by mathematical shorthand that uses numbers, letters, and operational symbols. The letters represent unknown amounts and are called **unknowns** or **variables**. The numbers are called **known** or **given amounts**. The numbers, letters, and mathematical symbols show how the knowns and unknowns are related. *Solving an equation* like $10 = 2 \times B$ means finding the value of B so that 2 times this value is the same as 10. We accomplish this by performing systematic operations so that the unknown value is **isolated**. That is, the letter representing the unknown or variable stands alone on one side of the equation.

1 Solve equations using multiplication or division.

To begin our examination of equations, we look at equations that involve multiplication or division and one unknown value.

HOW TO Solve an equation with multiplication or division

Solve the equation
$$5N = 20$$

1. Isolate the unknown value:
 (a) If the equation contains the *product* of the unknown factor and a known factor, then *divide* both sides of the equation by the known factor.

 $$\frac{5N}{5} = \frac{20}{5}$$

 (b) If the equation contains the *quotient* of the unknown value and the divisor, then *multiply* both sides of the equation by the divisor.
2. Identify the solution: The solution is the number on the side opposite the isolated unknown-value letter.

 $$N = 4$$
3. Check the solution: In the original equation, replace the unknown-value letter with the solution; perform the indicated operations; and verify that both sides of the equation are the same number.

 $$5(4) \stackrel{?}{=} 20$$
 $$20 = 20$$

TIP

Multiplication Notation

If there is no sign of operation between a number and a letter, a number and a parenthesis, or two letters, it means multiplication. So $2A$ means $2 \times A$, $2(9)$ means 2×9, and AB means $A \times B$. In equations, multiplication is usually indicated without the \times sign.

TIP

What Does $\stackrel{?}{=}$ Mean?

The symbol $\stackrel{?}{=}$ is used when checking a solution until the solution is verified.
$2(9) \stackrel{?}{=} 18$ can be read as *Does 2 times 9 equal 18?*

EXAMPLE 1 Solve the equation $2A = 18$. (A number multiplied by 2 is 18.)

$2A = 18$ The product and one factor are known.

$\dfrac{2A}{2} = \dfrac{18}{2}$ Divide by the known factor on both sides of the equation.

$A = 9$ The solution is 9.

Check:

$2A = 18$ Replace A with the solution 9 and see if both sides are equal.

$2(9) \stackrel{?}{=} 18$

$18 = 18$

The solution of the equation is 9.

EXAMPLE 2 Find the value of A if $\dfrac{A}{4} = 5$. (A number divided by 4 is 5.)

$\dfrac{A}{4} = 5$ The quotient and divisor are known. The dividend is unknown.

$4\left(\dfrac{A}{4}\right) = 5(4)$ Multiply both sides of the equation by the divisor, 4.

$A = 20$ The solution is 20.

Check:

$\dfrac{A}{4} = 5$ Replace A with the solution 20 and see if both sides are equal.

$\dfrac{20}{4} \overset{?}{=} 5$

$5 = 5$

The solution of the equation is 20.

TIP

Why Divide or Multiply Both Sides?

In Examples 1 and 2, both sides of the equation were divided or multiplied by the known factor. This applies an important property of equality. *If you perform an operation on one side, you must perform the same operation on the other side.*

STOP AND CHECK

1. Solve for A: $3A = 24$

2. Solve for N: $5N = 30$

3. Solve for B: $8 = \dfrac{B}{6}$

4. Solve for M: $\dfrac{M}{5} = 7$

5. Solve for K: $\dfrac{K}{2} = 3$

6. Solve for A: $7 = \dfrac{A}{3}$

2 Solve equations using addition or subtraction.

Suppose 15 of the 25 people who work at Carton Manufacturers work on the day shift. How many people work there in the evening? You know that 15 people work there during the day, that 25 people work there in all, and that some unknown quantity work there in the evening. Assign the letter N to the unknown number of night-shift workers. The information from the problem can then be written in words as "the night-shift workers plus the day-shift workers equal 25" and in symbols: $N + 15 = 25$. This equation is one that can be solved with subtraction.

HOW TO Solve an equation with addition or subtraction

Solve the equation
$B + 2 = 8$

1. Isolate the unknown value:
 (a) If the equation contains the *sum* of an unknown value and a known value, then *subtract* the known value from both sides of the equation.

 $\begin{aligned} B + 2 &= 8 \\ -2 & \quad -2 \end{aligned}$

 (b) If the equation contains the *difference* of an unknown value and a known value, then *add* the known value to both sides of the equation.
2. Identify the solution: The solution is the number on the side opposite the isolated unknown-value letter.

 $B = 6$

3. Check the solution: In the original equation, replace the unknown-value letter with the solution, perform the indicated operations, and verify that both sides of the equation are the same number.

 $6 + 2 \overset{?}{=} 8$
 $8 = 8$

EXAMPLE 1

Solve the equation $N + 15 = 25$. (A number increased by 15 is 25.)

$$\begin{array}{rl} N + 15 = & 25 \\ -15 & -15 \\ \hline N = & 10 \end{array}$$

$N = 10$

The sum and one value are known.
Subtract the known value, 15, from both sides.

The solution is 10.

Check:

$N + 15 = 25$
$10 + 15 \stackrel{?}{=} 25$
$25 = 25$

Replace N with the solution, 10, and see if both sides are equal.

The solution is 10.

EXAMPLE 2

Find the value of A if $A - 5 = 8$. (A number decreased by 5 is 8.)

$$\begin{array}{rl} A - 5 = & 8 \\ +5 & +5 \\ \hline A = & 13 \end{array}$$

The difference and the number being subtracted, 5, are known.
Add 5 to both sides.
The solution is 13.

Check:

$A - 5 = 8$
$13 - 5 \stackrel{?}{=} 8$
$8 = 8$

Replace A with the solution, 13, and see if both sides are equal.

The solution is 13.

TIP

Solve by Undoing

In general, unknowns are isolated in an equation by "undoing" all operations associated with the unknown.
- Use addition to undo subtraction.
- Use subtraction to undo addition.
- Use multiplication to undo division.
- Use division to undo multiplication.

To keep the equation in balance, we perform the same operation on both sides of the equation.

 STOP AND CHECK

Solve for the missing number.

1. $A + 12 = 20$

2. $A + 5 = 28$

3. $N - 7 = 10$

4. $N - 5 = 11$

5. $15 = A + 3$

6. $28 = M - 5$

3 Solve equations using more than one operation.

Many business equations contain more than one operation. To solve such equations, we undo each operation in turn. We first undo all additions or subtractions and then undo all multiplications or divisions. Our goal is still to isolate the unknown.

Solve an equation with more than one operation

Solve the equation
$$3N - 1 = 14$$

1. Isolate the unknown value:
 (a) Add or subtract as necessary *first*.

$$\begin{array}{rcr} 3N - 1 &=& 14 \\ +1 & & +1 \\ \hline 3N & = & 15 \end{array}$$

 (b) Multiply or divide as necessary *second*.

$$\frac{3N}{3} = \frac{15}{3}$$

2. Identify the solution: The solution is the number on the side opposite the isolated unknown-value letter.

$$N = 5$$

3. Check the solution: In the original equation, replace the unknown-value letter with the solution and perform the indicated operations.

$$3(5) - 1 \stackrel{?}{=} 14$$
$$15 - 1 \stackrel{?}{=} 14$$
$$14 = 14$$

Order of Operations: the specific order in which calculations must be performed to evaluate a series of calculations.

TIP

Order of Operations

When two or more calculations are written symbolically, the operations are performed in a specified order.

1. Perform multiplication and division as they appear from left to right.
2. Perform addition and subtraction as they appear from left to right.

To solve an equation, we *undo* the operations, so we work in reverse order.

1. Undo addition or subtraction.
2. Undo multiplication or division.

In the example in the preceding How To box, examine the sequence of steps.

To solve: Undo subtraction.
 Undo multiplication.
To check: Multiply first.
 Subtract.

EXAMPLE 1 Find A if $2A + 1 = 15$. (Two times a number increased by 1 is 15.) The equation contains both addition and multiplication. Undo addition first, and then undo multiplication.

$$\begin{array}{rcr} 2A + 1 &=& 15 \\ -1 & & -1 \\ \hline 2A & = & 14 \end{array}$$ Undo addition.

$$2A = 14$$ Undo multiplication.
$$\frac{2A}{2} = \frac{14}{2}$$
$$A = \boxed{7}$$ Solution.

Check:

$$2A + 1 = 15$$ Replace A with 7 in the original equation and see if both sides are equal.
$$2(7) + 1 \stackrel{?}{=} 15$$ Multiply first.
$$14 + 1 \stackrel{?}{=} 15$$ Add.
$$15 = 15$$

The solution is 7.

EXAMPLE 2 Solve the equation $\dfrac{A}{5} - 3 = 1$. (A number divided by 5 and decreased by 3 is 1.)

The equation contains both subtraction and division: Undo subtraction first, and then undo division.

$$\dfrac{A}{5} - 3 = 1$$ Undo subtraction.

$$\underline{\phantom{\dfrac{A}{5}}+3 \quad +3}$$

$$\dfrac{A}{5} = 4$$ Undo division.

$$5\left(\dfrac{A}{5}\right) = 4(5)$$

$$A = \boxed{20}$$ Solution.

Check:

$$\dfrac{A}{5} - 3 = 1$$ Replace A with 20 in the original equation and see if both sides are equal.

$$\dfrac{20}{5} - 3 \overset{?}{=} 1$$ Divide first.

$$4 - 3 \overset{?}{=} 1$$ Subtract.

$$1 = 1$$

The solution is 20.

 STOP AND CHECK

Solve.

1. $3N + 4 = 16$

2. $5N - 7 = 13$

3. $\dfrac{B}{8} - 2 = 2$

4. $\dfrac{M}{3} + 2 = 5$

5. $\dfrac{S}{6} - 3 = 4$

6. $12 = \dfrac{A}{5} - 8$

4 Solve equations containing multiple unknown terms.

In some equations, the unknown value may occur more than once. The simplest instance is when the unknown value occurs in two addends. We solve such equations by first combining these addends. Remember that $5A$, for instance, means 5 times A, or $A + A + A + A + A$. To combine $2A + 3A$, we add 2 and 3, to get 5, and then multiply 5 by A, to get $5A$. Thus, $2A + 3A$ is the same as $5A$.

HOW TO **Solve an equation when the unknown value occurs in two addends**

Find A if $2A + 3A = 10$

1. Combine the unknown-value addends that are on the same side of the equation:
 (a) Add the numbers in each addend.
 (b) Represent the multiplication of their sum by the unknown value.
2. Solve the resulting equation.

$$(2 + 3)A = 10$$
$$5A = 10$$
$$\dfrac{5A}{5} = \dfrac{10}{5}$$
$$A = 2$$

Find A if $A + 3A - 2 = 14$.

$A + 3A - 2 = 14$

First, combine the unknown-value addends. Note that A is the same as $1A$, so $A + 3A = (1 + 3)A = 4A$.

$$\begin{array}{r} 4A - 2 = 14 \\ \underline{+\,2 \quad +\,2} \\ 4A = 16 \end{array}$$

Undo subtraction.

$$\frac{4A}{4} = \frac{16}{4}$$

Undo multiplication.

$A = 4$

Solution.

Check:

$A + 3A - 2 = 14$

Replace A with 4 and see if both sides are the same.

$4 + 3(4) - 2 \overset{?}{=} 14$

Multiply first.

$4 + 12 - 2 \overset{?}{=} 14$

Add.

$16 - 2 \overset{?}{=} 14$

Subtract.

$14 = 14$

The solution is 4.

Adding Unknown Values

A is the same as $1A$. When combining unknown-value addends, and one of the addends is A, it may help you to write A as $1A$ first.

$$A + 3A = 1A + 3A = 4A$$

 STOP AND CHECK

Solve.

1. $B + 3B - 5 = 19$

2. $4B - 7 = 13$

3. $7 + 3B + 2B = 17$

4. $5A - 3 + 2A = 18.$

5. $3C - C = 16$

6. $12 = 8C - 5C$

5 Solve equations containing parentheses.

To solve an equation containing parentheses, we first write the equation in a form that contains no parentheses.

Solve an equation containing parentheses

Find A if $2(3A + 1) = 14$

1. Eliminate the parentheses:
 (a) Multiply the number just outside the parentheses by each addend inside the parentheses.

 $2(3A + 1) = 14$

 (b) Show the resulting products as addition or subtraction as indicated.

 $6A + 2 = 14$

2. Solve the resulting equation.

$$\begin{array}{r} 6A + 2 = 14 \\ \underline{-\,2 \quad -\,2} \\ 6A = 12 \end{array}$$

$$\frac{6A}{6} = \frac{12}{6}$$

$A = 2$

Solve the equation $5(A + 3) = 25$.

$5(A + 3) = 25$	First eliminate the parentheses. Multiply 5 by A, multiply 5 by 3, and
$5A + 15 = 25$	then show the products as addition.
$5A + 15 = \quad 25$	Undo addition.
$\underline{\quad\quad -15 \quad -15}$	
$5A \quad\quad = \quad 10$	Undo multiplication.
$\dfrac{5A}{5} = \dfrac{10}{5}$	
$A = 2$	Solution

Check:

$5(A + 3) = 25$	Replace A with 2 and see if both sides are equal.
$5(2 + 3) \stackrel{?}{=} 25$	Add inside parentheses.
$5(5) \stackrel{?}{=} 25$	Multiply.
$25 = 25$	

The solution is 2.

TIP

Having Parentheses in a Series of Calculations Expands the Order of Operations.

To perform a series of calculations:

1. Perform the operations inside the parentheses or eliminate the parentheses by multiplying.
2. Perform multiplication and division as they appear from left to right.
3. Perform addition and subtraction as they appear from left to right.

To solve an equation:

1. Eliminate parentheses by multiplying each addend inside the parentheses by the factor outside the parentheses.
2. Undo addition or subtraction.
3. Undo multiplication or division.

In the preceding example, examine the sequence of steps.

To solve:	Eliminate parentheses.
	Undo addition.
	Undo multiplication.
To check:	Add inside parentheses.
	Multiply.

 STOP AND CHECK

Solve.

1. $2(N + 4) = 26$

2. $3(N - 30) = 45$

3. $4(R - 3) = 8$

4. $7(2R - 3) = 21$

5. $5(3R + 2) = 40$

6. $30 = 6(2A + 3)$

6 Solve equations that are proportions.

Ratio: the comparison of two numbers through division. Ratios are most often written as fractions.

Proportion: two fractions or ratios that are equal.

Cross product: the product of the numerator of one fraction times the denominator of the other fraction of a proportion.

A proportion is based on two pairs of related quantities. The most common way to write proportions is to use fraction notation. A number written in fraction notation is also called a **ratio**. When two fractions or ratios are equal, they form a **proportion**.

An important property of proportions is that the cross products are equal. A **cross product** is the product of the numerator of one fraction times the denominator of another fraction. In the proportion $\frac{1}{2} = \frac{2}{4}$, one cross product is 1×4 and the other cross product is 2×2. Notice that the two cross products are both equal to 4. Let's look at other proportions.

$$\frac{3}{6} = \frac{5}{10}$$
$$3(10) = 6(5)$$
$$30 = 30$$

$$\frac{2}{4} = \frac{5}{10}$$
$$2(10) = 4(5)$$
$$20 = 20$$

$$\frac{4}{8} = \frac{6}{12}$$
$$4(12) = 8(6)$$
$$48 = 48$$

HOW TO — Verify that two fractions form a proportion

1. Find the two cross products.
2. Compare the two cross products.
3. If the cross products are equal, the two fractions form a proportion.

Do $\frac{4}{12}$ and $\frac{6}{18}$ form a proportion?
$4(18) = 72 \quad 12(6) = 72$
Cross products are equal. $72 = 72$
Fractions form a proportion.

EXAMPLE 1

Of the fractions $\frac{2}{3}$ and $\frac{3}{4}$, which one is proportional to $\frac{12}{16}$?

Are $\frac{2}{3}$ and $\frac{12}{16}$ proportional?

$$\frac{2}{3} \overset{?}{=} \frac{12}{16}$$
Find the cross products.

$$2(16) \overset{?}{=} 3(12)$$
Multiply.

$$32 \overset{?}{=} 36$$
Not equal, not a proportion.

Are $\frac{3}{4}$ and $\frac{12}{16}$ proportional?

$$\frac{3}{4} \overset{?}{=} \frac{12}{16}$$
Find the cross products.

$$3(16) \overset{?}{=} 4(12)$$
Multiply.

$$48 \overset{?}{=} 48$$
Equal, proportional.

$\frac{3}{4}$ **is proportional to** $\frac{12}{16}$.

HOW TO — Solve a proportion

1. Find the cross products.
2. Isolate the unknown by undoing the multiplication.

EXAMPLE 2

Solve: $\frac{3}{8} = \frac{21}{N}$

$$\frac{3}{8} = \frac{21}{N}$$
Find the cross products.

$$3N = 8(21)$$
Multiply.

$$3N = 168$$
Undo multiplication.

$$\frac{3N}{3} = \frac{168}{3}$$
Divide.

$$N = \mathbf{56}$$

STOP AND CHECK

1. Which of the fractions $\frac{5}{7}$ or $\frac{3}{4}$ is proportional to $\frac{20}{28}$?

2. Which of the fractions $\frac{1}{2}$ or $\frac{2}{3}$ is proportional to $\frac{12}{18}$?

3. Solve: $\frac{3}{4} = \frac{N}{8}$

4. Solve: $\frac{5}{N} = \frac{4}{12}$

5. Solve: $\frac{N}{4} = \frac{9}{6}$

6. Solve: $\frac{5}{12} = \frac{15}{N}$

5-1 SECTION EXERCISES

SKILL BUILDERS

Solve for the unknown in each equation.

1. $5A = 20$

2. $\dfrac{B}{7} = 4$

3. $7C = 56$

4. $4M = 48$

5. $\dfrac{R}{12} = 3$

6. $\dfrac{P}{5} = 8$

7. $B + 7 = 12$

8. $A - 9 = 15$

9. $R + 7 = 28$

10. $A - 16 = 3$

11. $X - 48 = 36$

12. $C + 5 = 21$

13. $4A + 3 = 27$

14. $\dfrac{B}{3} + 2 = 7$

15. $3B - 1 = 11$

16. $\dfrac{K}{4} - 5 = 3$

17. $\dfrac{K}{2} + 3 = 5$

18. $7B - 1 = 6$

19. $\dfrac{C}{2} - 1 = 9$

20. $8A - 1 = 19$

21. $2A + 5A = 35$

22. $B + 2B = 27$

23. $5K - 3K = 40$

24. $8K - 2K = 42$

25. $3J + J = 28$ **26.** $2J - J = 21$ **27.** $3B + 2B - 6 = 9$ **28.** $8C - C + 6 = 48$

29. $2(X - 3) = 6$ **30.** $4(A + 3) = 16$ **31.** $3(B - 1) = 21$ **32.** $6(B + 2) = 30$

Solve each proportion for N.

33. $\dfrac{N}{5} = \dfrac{9}{15}$ **34.** $\dfrac{3}{N} = \dfrac{4}{12}$ **35.** $\dfrac{2}{5} = \dfrac{N}{20}$ **36.** $\dfrac{2}{4} = \dfrac{9}{N}$

5-2 USING EQUATIONS TO SOLVE PROBLEMS

LEARNING OUTCOME

1 Use the problem-solving approach to analyze and solve word problems.

Equations are powerful business tools because equations use mathematical shorthand for expressing relationships. As we know from our problem-solving strategies, developing a solution plan is a critical step.

1 Use the problem-solving approach to analyze and solve word problems.

Certain key words in a problem give you clues as to whether a certain quantity is added to, subtracted from, or multiplied or divided by another quantity. For example, if a word problem tells you that Carol's salary in 2008 *exceeds* her 2007 salary by $2,500, you know that you should *add* $2,500 to her 2007 salary to find her 2008 salary. Many times, when you see the word *of* in a problem, the problem often involves multiplication. Table 5-1 summarizes important key words and what they generally imply when they are used in a word problem. This list should help you analyze the information in word problems and write the information in symbols.

TABLE 5-1
Key Words and What They Generally Imply in Word Problems

Addition	Subtraction	Multiplication	Division	Equality
The sum of	Less than	Times	Divide(s)	Equals
Plus/total	Decreased by	Multiplied by	Divided by	Is/was/are
Increased by	Subtracted from	Of	Divided into	Is equal to
More/more than	Difference between	The product of	Half of (divided by two)	The result is
Added to	Diminished by	Twice (two times)	Third of (divided by three)	What is left
Exceeds	Take away	Double (two times)	Per	What remains
Expands	Reduced by	Triple (three times)		The same as
Greater than	Less/minus	Half ($\frac{1}{2}$ times)		Gives/giving
Gain/profit	Loss	Third of ($\frac{1}{3}$ times)		Makes
Longer	Lower			Leaves
Older	Shrinks			
Heavier	Smaller than			
Wider	Younger			
Taller	Slower			

We can relate the steps in our five-step problem-solving approach to writing and solving equations.

What You Know	Known or given facts
What You Are Looking For	Unknown amounts (Assign a letter to represent an unknown amount. Other unknown amounts are written related to the assigned letter.)
Solution Plan	Equation or relationship among the known and unknown facts
Solution	Solving the equation
Conclusion	Solution interpreted within the context of the problem

EXAMPLE 1 Full-time employees at Charlie's Steakhouse work more hours per day than part-time employees. If the difference of working hours is 4 hours per day, and if part-timers work 6 hours per day, how many hours per day do full-timers work?

What You Know	What You Are Looking For	Solution Plan
Hours per day that part-timers work: 6 Difference between hours worked by full-timers and hours worked by part-timers: 4	Hours per day that full-timers work: N	The word *difference* implies subtraction. Full-time hours − part-time hours = difference of hours $N - 6 = 4$

Solution

$$N - 6 = 4$$

Undo subtraction.

$$\underline{+6 \quad +6}$$
$$N = 10$$

The solution is 10.

Check:

$$10 - 6 \overset{?}{=} 4$$

Replace N with 4. Subtract.

$$4 = 4$$

The sides are equal.

Conclusion

The hours per day that full-timers work is 10.

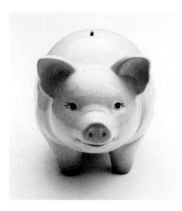

EXAMPLE 2
Wanda plans to save $\frac{1}{10}$ of her salary each week. If her weekly salary is $350, how much will she save each week?

What You Know	What You Are Looking For	Solution Plan
Salary = $350 Rate of saving: $\frac{1}{10}$	Amount to be saved: S	The word *of* implies multiplication. Amount to be saved $=$ rate of saving \times salary $S = \dfrac{1}{10}(\$350)$

Solution	
$S = \dfrac{1}{10}(\$350)$	Reduce and multiply.
$S = \$35$	The solution is 35.
Check:	
$\$35 \overset{?}{=} \dfrac{1}{10}(\$350)$	Replace S with $35 and see if the sides are equal.
$\$35 = \35	

Conclusion
Wanda will save $35 per week.

TIP

The Process Is Important!

Learn the process for solving applied problems with intuitive examples. In Examples 1 and 2 you may have been able to determine the solutions mentally, even intuitively. Learn the process for easier applications so that you can use the process for more complex applications.

Many times a problem requires finding more than one unknown value. Our strategy will be to choose a letter to represent one unknown value. Using known facts, we can then express all other unknown values *in terms of* the one letter. For instance, if we know that twice as many men as women attended a conference, then we might represent the number of women as W and the number of men as $2W$, twice as many as W.

EXAMPLE 3
At Alexander's Cafe last Wednesday, there were twice as many requests for seats in the nonsmoking section as there were requests for seats in the smoking section. If 342 customers came to the cafe that day, how many requested the smoking section? How many requested the nonsmoking section?

What You Know	What You Are Looking For	Solution Plan
Total customers: 342 There are twice as many nonsmokers as smokers.	Both the number of smokers and the number of non-smokers are unknown, but we choose one—smokers to be represented by a letter, S. Number of smokers: S Since the number of non-smokers is *twice* the number of smokers, we represent the number of nonsmokers as $2S$, or 2 times S. Number of nonsmokers: $2S$	Smoker + nonsmokers = total customers $S + 2S = 342$

$$S + 2S = 342 \qquad \text{Combine addends.}$$
$$3S = 342$$

$$\frac{\cancel{3}S}{\cancel{3}} = \frac{342}{3} \qquad \text{Divide both sides by 3.}$$
$$S = 114 \qquad \text{The solution is 114, which represents the number of smokers.}$$
$$2S = 2(114)$$
$$= 228 \qquad \text{Twice } S \text{ is twice 114, or 228 nonsmokers.}$$

Check:
$$S + 2S = 342 \qquad \text{Substitute } S = 114 \text{ and } 2S = 228.$$
$$114 + 228 \overset{?}{=} 342$$
$$342 = 342$$

Conclusion

There were 114 smokers and 228 nonsmokers.

Many problems give a *total* number of two types of items. You want to know the number of each of the two types of items. The next example illustrates this type of problem.

EXAMPLE 4 Diane's Card Shop spent a total of $950 ordering 600 cards from Wit's End Co., whose humorous cards cost $1.75 each and whose nature cards cost $1.50 each. How many of each style of card did the card shop order?

What You Know

| Total cost of cards: $950 | Cost per humorous card: $1.75 |
| Total number of cards: 600 | Cost per nature card: $1.50 |

What You Are Looking For

There are two unknown facts, but we choose one—the number of humorous cards—to be represented by a letter, H.
Number of humorous cards: H
Knowing that the total number of cards is 600, we represent the number of nature cards as 600 minus the humorous cards, or $600 - H$.

Solution Plan

Total cost = (cost per humorous card)(number of humorous cards)
\qquad + (cost per nature card)(number of nature cards)
$$950 = (1.75)(H) + (1.50)(600 - H)$$

Solution

$$950 = 1.75H + 1.50(600 - H) \qquad \text{Eliminate parentheses showing grouping.}$$
$$950 = 1.75H + (1.50)(600) - 1.50H \qquad \text{Multiply 1.50(600).}$$
$$950 = 1.75H + 900 - 1.50H \qquad \text{Combine letter terms.}$$
$$950 = 0.25H + 900$$
$$\underline{-900 \qquad\qquad\quad -900} \qquad \text{Subtract 900 from both sides.}$$
$$50 = 0.25H$$

$$\frac{50}{0.25} = \frac{0.25H}{0.25} \qquad \text{Divide both sides by 0.25.}$$

$$\boxed{200} = H \qquad \text{The solution is 200, which represents the number of humorous cards.}$$

$$600 - H = 600 - \boxed{200} \qquad \text{Subtract 200 from 600 to find } 600 - H,$$
$$= 400 \qquad\qquad\quad \text{or 400, the number of nature cards.}$$

Check:
$$950 \overset{?}{=} (1.75)(200) + (1.50)(600 - 200) \qquad \text{Substitute 200 in place of } H. \text{ Then perform}$$
$$950 \overset{?}{=} (1.75)(200) + (1.50)(400) \qquad \text{calculations using the order of operations.}$$
$$950 \overset{?}{=} 350 + 600 \qquad\qquad\qquad\qquad \text{Subtract inside parentheses first.}$$
$$950 = 950$$

Conclusion

The card shop ordered 200 humorous cards and 400 nature cards.

Many problems encountered daily involve two pairs of values that are proportional.

EXAMPLE 5

Your car gets 23 miles to a gallon of gas. How far can you go on 16 gallons of gas?

What You Know	What You Are Looking For	Solution Plan
Distance traveled using 1 gallon: 23 miles (Pair 1)	Distance traveled using 16 gallons: M miles (Pair 2)	Miles traveled per 16 gallons is proportional to miles traveled for each 1 gallon. $$\underset{\text{Pair 1}}{\frac{1 \text{ gallon}}{23 \text{ miles}}} = \underset{\text{Pair 2}}{\frac{16 \text{ gallons}}{M \text{ miles}}}$$

Solution

$$\frac{1}{23} = \frac{16}{M}$$ Cross multiply.

$$1M = (16)(23)$$ Multiply.

$$M = 368$$

Check:

$$\frac{1}{23} \stackrel{?}{=} \frac{16}{368}$$ Substitute 368 for M and cross multiply.

$$(1)(368) \stackrel{?}{=} (23)(16)$$ Multiply.

$$368 = 368$$

Conclusion

You can travel 368 miles using 16 gallons of gas.

TIP

Arranging the Proportion

Many business-related problems that involve pairs of numbers that are proportional are *direct proportions*. That means an increase in one amount causes an increase in the number that pairs with it. Or, a decrease in one amount causes a decrease in the second amount.

In the preceding example, for 1 gallon of gas, the car can travel 23 miles. It is a direct proportion: More gas *yields* more miles.

The pairs of values in a direct proportion can be arranged in other ways. Another way to arrange the pairs from the preceding example is *across* the equal sign.

$$\underset{\substack{\text{Pair 1} \\ \text{Pair 2}}}{\frac{1 \text{ gallon}}{16 \text{ gallons}}} = \frac{23 \text{ miles}}{M \text{ miles}}$$

$$1M = 16(23)$$

$$M = 368$$

EXAMPLE 6

The label on a container of concentrated weed killer gives directions to mix 3 ounces of weed killer with every 2 gallons of water. For 5 gallons of water, how many ounces of weed killer should you use?

What You Know	What You Are Looking For	Solution Plan
Amount of weed killer for 2 gallons of water: 3 ounces (Pair 1)	Amount of weed killer for 5 gallons of water: W ounces (Pair 2)	Amount of weed killer per 5 gallons is proportional to an amount of weed killer for each 2 gallons. $$\underset{\text{Pair 1}}{\frac{2 \text{ gallons}}{3 \text{ ounces}}} = \underset{\text{Pair 2}}{\frac{5 \text{ gallons}}{W \text{ ounces}}}$$

Solution

$$\frac{2}{3} = \frac{5}{W}$$

Cross multiply.

$2W = (3)(5)$ Multiply.

$2W = 15$ Divide both sides by 2.

$$\frac{2W}{2} = \frac{15}{2}$$

$$W = 7\frac{1}{2}$$

The solution is $7\frac{1}{2}$.

Check: $\frac{2}{3} \overset{?}{=} \frac{5}{7\frac{1}{2}}$

Substitute $7\frac{1}{2}$ for W and simplify each side.

$$\frac{2}{3} \overset{?}{=} 5 \div 7\frac{1}{2}$$

$$\frac{2}{3} \overset{?}{=} 5 \div \frac{15}{2}$$

$$\frac{2}{3} \overset{?}{=} 5\left(\frac{2}{15}\right)$$

$$\frac{2}{3} = \frac{2}{3}$$

Conclusion

You should use $7\frac{1}{2}$ ounces of weed killer for 5 gallons of water.

✓ STOP AND CHECK

1. Carrie McConnell spends $\frac{1}{6}$ of her weekly earnings on groceries. What are her weekly earnings if she spends $117.50 on groceries each week?

2. Marcus James purchased 2,500 pounds of produce. Records indicate he purchased 800 pounds of potatoes, 150 pounds of broccoli, and 390 pounds of tomatoes. He also purchased apples. How many pounds of apples did he purchase?

3. Hilton Hotel has 8 times as many nonsmoking rooms as it has smoking rooms. If the hotel has 873 rooms in its inventory, how many are smoking rooms?

4. Four hundred eighty notebooks can be purchased for $1,656. How many notebooks can be purchased for $2,242.50?

5-2 SECTION EXERCISES

APPLICATIONS

1. The difference in hours between full-timers and the part-timers who work 5 hours a day is 4 hours. How long do full-timers work?

2. Manny plans to save $\frac{1}{12}$ of his salary each week. If his weekly salary is $372, find the amount he will save each week.

3. Last week at the Sunshine Valley Rock Festival, Joel sold 3 times as many tie-dyed T-shirts as silk-screened shirts. He sold 176 shirts altogether. How many tie-dyed shirts did he sell?

4. Elaine sold 3 times as many magazine subscriptions as Ron did. Ron sold 16 fewer subscriptions than Elaine did. How many subscriptions did each sell?

5. Will ordered 2 times as many boxes of ballpoint pens as boxes of felt-tip pens. Ballpoint pens cost $3.50 per box, and felt-tip pens cost $4.50. If Will's order of pens totaled $46, how many boxes of each type of pen did he buy?

6. A real estate salesperson bought promotional calendars and date books to give to her customers at the end of the year. The calendars cost $0.75 each, and the date books cost $0.50 each. She ordered a total of 500 promotional items and spent $300. How many of each item did she order?

Use proportions to solve each problem.

7. Hershey Foods stock earned $151,000,000. If these earnings represent $1.15 per share, how many shares of stock are there?

8. A scale drawing of an office building is not labeled, but indicates $\frac{1}{4}$ inches $= 5$ feet. On the drawing, one wall measures 2 inches. How long is the wall?

9. A recipe uses 3 cups of flour to $1\frac{1}{4}$ cups of milk. If you have 2 cups of flour, how much milk should you use?

10. For 32 hours of work, you are paid $241.60. How much would you receive for 37 hours?

11. The annual real estate tax on a duplex house is $2,321 and the owner sells the house after 9 months of the tax year. How much of the annual tax will the seller pay? How much will the buyer pay?

12. A wholesale price list shows that 18 dozen headlights cost $702. If 16 dozen can be bought at the same rate, how much will they cost?

13. Two part-time employees share one full-time job. Charris works Mondays, Wednesdays, and Fridays, and Chloe works Tuesdays and Thursdays. The job pays an annual salary of $28,592. What annual salary does each employee earn?

14. A car that leases for $5,400 annually is leased for 8 months of the year. How much will it cost to lease the car for the 8 months?

15. If 1.0000 U.S. Dollar is equivalent to 0.1273 Chinese Yuan, convert $12,000 to Yuan.

5-3 FORMULAS

LEARNING OUTCOMES

1 Evaluate a formula.
2 Find a variation of a formula by rearranging the formula.

1 Evaluate a formula.

Formulas are procedures that have been used so frequently to solve certain types of problems that they have become the accepted means of solving these problems. Formulas are composed of numbers, letters, or **variables**, used to represent unknown numbers, and operations that relate these known and unknown values. To **evaluate** a formula is to substitute known values for the appropriate letters of the formula and perform the indicated operations to find the unknown value. Sometimes the equation must be solved to isolate the unknown value in the formula.

HOW TO Evaluate a formula

1. Write the formula.
2. Rewrite the formula substituting known values for the letters of the formula.
3. Solve the equation for the unknown letter or perform the indicated operations, applying the order of operations.
4. Interpret the solution within the context of the formula.

EXAMPLE 1 Wal-Mart purchases a Sony plasma television for $875 and marks it up $400. What is the selling price of the television? Use the formula $S = C + M$ where S is the selling price, C is the cost, and M is the markup.

$S = C + M$	Write the formula. Substitute known values for C and M.
$S = \$875 + \400	Add.
$S = \$1{,}275$	

The selling price for the television is $1,275.

In some instances, the missing value is not the value that is isolated in the formula. After the known values are substituted into the formula, use the techniques for solving equations to find the missing value.

EXAMPLE 2 A DVD player that costs $85 sells for $129. What is the markup on the player? Use the formula $S = C + M$ where S is the selling price, C is the cost, and M is the markup.

$S = C + M$	Write the formula. Substitute known values for C and S.
$\$129 = \$85 + M$	Subtract $85 from each side of the equation.
$\underline{-85 \quad -85}$	
$\$44 = M$	

The markup for the DVD player is $44.

TIP

Interchanging the Sides of an Equation

In Example 2, the solved equation was $\$44 = M$. Since equations show equality, it is allowable to interchange the sides of the equation. The equation can also be written as $M = \$44$.

STOP AND CHECK

1. Office Depot purchased an office chair for $317 and marked it up $250. Find the selling price of the chair. Use the formula $S = C + M$.

2. Office Max purchased a computer workstation for $463 and marked its retail (selling) price at $629. Use the formula $S = C + M$ to find the markup on the workstation.

3. Trios Mixon worked 40 hours at $19.26 per hour. Find his pay. Use the formula $P = RH$, where P is the pay, R is the rate per hour, and H is the number of hours worked.

4. Luis Pardo earned $612 for a 40-hour week. Use the formula $P = RH$ to find his hourly rate.

2 Find a variation of a formula by rearranging the formula.

A formula can have as many variations as there are letters or variables in the formula. Using the techniques for solving equations, any missing number can be found no matter where it appears in the formula. Variations of formulas are desirable when the variation is used frequently. Also, in using an electronic spreadsheet, the missing number should be isolated on the left side of the equation. To **isolate** a variable is to **solve for** that variable.

HOW TO Find a variation of a formula by rearranging the formula

1. Determine which variable of the formula is to be isolated (solved for).
2. Highlight or mentally locate all instances of the variable to be isolated.
3. Treat all other variables of the formula as you would treat a number in an equation, and perform normal steps for solving an equation.
4. If the isolated variable is on the right side of the equation, interchange the sides so that it appears on the left side.

EXAMPLE 1

Solve the formula $S = C + M$ for C.

$S = C + M$	Isolate C. Subtract M from both sides of the equation.
$S - M = C + M - M$	Simplify. $M - M = 0$. $C + 0 = C$.
$S - M = C$	Interchange the sides of the equation.
$C = S - M$	Formula variation

The unit price of a product is used when comparing prices of a product available in different quantities. The formula for finding the unit price is $U = \frac{P}{N}$, where U is the unit price of a specified amount of a product, P is the total price of the product, and N is the number of specified units contained in the product. The specified unit can be identified in many ways. The unit could be any measuring unit such as pounds (lb) or ounces (oz) or the number of items such as an individual snack cake in a package of cakes.

EXAMPLE 2

Find a variation of the formula $U = \dfrac{P}{N}$ that is solved for P.

$U = \dfrac{P}{N}$	Isolate P. Multiply both sides of the equation by N.
$N(U) = \left(\dfrac{P}{N}\right)N$	Simplify. $\dfrac{N}{N} = 1$. $P(1) = P$.
$NU = P$	Interchange the sides of the equation.
$P = NU$	Formula variation.

STOP AND CHECK

1. Solve the formula $S = C + M$ for M.

2. Solve the formula $M = S - N$ for S.

3. Solve the formula $U = \dfrac{P}{N}$ for N.

4. The unit depreciation formula, Unit depreciation = $\dfrac{\text{depreciable Value}}{\text{units Produced during expected life}}$ can be written in symbols as $U = \dfrac{V}{P}$. Solve the formula to find V, the depreciable value.

5-3 SECTION EXERCISES

SKILL BUILDERS

1. Sears purchased 10,000 pairs of men's slacks for $18.46 a pair and marked them up $21.53. What was the selling price of each pair of slacks? Use the formula $S = C + M$.

2. K-Mart had 896 swimsuits that were marked to sell at $49.99. Each suit was marked down $18.95. Find the reduced price using the formula $M = S - N$, where M is the markdown, S is the original selling price, and N is the reduced price.

3. Home Depot sold bird feeders for $69.99 and had marked them up $36.12. What was the cost of the feeders? Use the formula $S = C + M$.

4. Dollar General sold garden hoses at a reduced price of $7.64 and took an end-of-season markdown of $12.35. What was the original selling price of each hose? Use the formula $M = S - N$.

5. The formula Total cost = Cost + Shipping + Installation is used to find the total cost of a business asset when setting up a depreciation schedule for the asset. The formula can be written in symbols as $T = C + S + I$. Solve the formula for C, the cost of the asset.

6. The formula, depreciable Value = total Cost − Salvage value is used to set up a depreciation schedule for an asset. The formula can be written in symbols as $V = C − S$. Solve the formula for C.

7. The formula, **Y̲early depreciation** $= \frac{\text{depreciable V̲alue}}{\text{years of expected L̲ife}}$ is used to find yearly depreciation using the straight line depreciation method. The formula can be written in symbols as $Y = \frac{V}{L}$. Solve the formula for V.

8. Solve the formula $Y = \frac{V}{L}$ for L.

Learning Outcomes

What to Remember with Examples

Section 5-1

1 Solve equations using multiplication or division. (p. 146)

1. Isolate the unknown value:
 (a) If the equation contains the *product* of the unknown value and a number, then *divide* both sides of the equation by the number.
 (b) If the equation contains the *quotient* of the unknown value and the divisor, then *multiply* both sides of the equation by the divisor.
2. Identify the solution: The solution is the number on the side opposite the isolated unknown-value letter.
3. Check the solution: In the original equation, replace the unknown-value letter with the solution, perform the indicated operations, and verify that both sides of the equation are the same number.

Find the value of A.

$4A = 36$ Divide both sides by 4. check: $4(9) \overset{?}{=} 36$

$$\frac{4A}{4} = \frac{36}{4}$$

$$36 = 36$$

$$A = 9$$

Find the value of B.

$$\frac{B}{7} = 6 \qquad \text{Multiply both sides by 7.} \qquad \text{check: } \frac{42}{7} \overset{?}{=} 6$$

$$\left(\frac{B}{7}\right)(7) = 6(7) \qquad\qquad\qquad\qquad\qquad 6 = 6$$

$$B = 42$$

2 Solve equations using addition or subtraction. (p. 147)

1. Isolate the unknown value:
 (a) If the equation contains the *sum* of the unknown value and another number, then *subtract* the number from both sides of the equation.
 (b) If the equation contains the *difference* of the unknown value and another number, then *add* the number to both sides of the equation.
2. Identify the solution: The solution is the number on the side opposite the isolated unknown-value letter.
3. Check the solution: In the original equation, replace the unknown-value letter with the solution, perform the indicated operations, and verify that both sides of the equation are the same number.

Find the value of A.

$$A - 7 = 12 \quad \text{Add 7 to both sides.}$$
$$\underline{+ 7 \qquad + 7}$$
$$A \qquad = 19$$

Find the value of B.

$$B + 5 = 32 \quad \text{Subtract 5 from both sides.}$$
$$\underline{- 5 \qquad - 5}$$
$$B \qquad = 27$$

3 Solve equations using more than one operation. (p. 148)

1. Isolate the unknown value:
 (a) Add or subtract as necessary *first*.
 (b) Multiply or divide as necessary *second*.
2. Identify the solution: The solution is the number on the side opposite the isolated unknown-value letter.
3. Check the solution: In the original equation, replace the unknown-value letter with the solution, and perform the indicated operations.

Find the value of A.

$4A + 4 = 20$ Undo addition first.

$$\begin{array}{rcl} 4A + 4 &=& 20 \\ -4 & & -4 \\ \hline 4A &=& 16 \end{array}$$ Undo multiplication.

$$\frac{4A}{4} = \frac{16}{4}$$

$$A = 4$$

Find the value of B.

$\dfrac{B}{3} - 5 = 12$ Undo subtraction first.

$$\begin{array}{rcl} +5 & & +5 \\ \hline \dfrac{B}{3} &=& 17 \end{array}$$ Undo division.

$$\left(\frac{B}{3}\right)(3) = 17(3)$$

$$B = 51$$

4 Solve equations containing multiple unknown terms. (p. 150)

Solve an equation when the unknown value occurs in two or more addends.

1. Combine the unknown-value addends when the addends are on the same side of the equal sign:
 (a) Add the numbers in each addend.
 (b) Multiply their sum by the unknown value.
2. Solve the resulting equation.

Find the value of A.

$$\begin{array}{rcl} A - 5 + 5A &=& 25 \end{array}$$ Combine addends that have unknown factors. $A + 5A = 6A$

$$6A - 5 = 25$$ Add 5 to both sides.

$$\begin{array}{rcl} +5 & & +5 \\ \hline 6A &=& 30 \end{array}$$ Divide both sides by 6.

$$\frac{6A}{6} = \frac{30}{6}$$

$$A = 5$$

5 Solve equations containing parentheses. (p. 151)

1. Eliminate the parentheses:
 (a) Multiply the number just outside the parentheses by each addend inside the parentheses.
 (b) Show the resulting products as addition or subtraction as indicated.
2. Solve the resulting equation.

Find the value of A.

$$3(A + 4) = 27$$ Eliminate parentheses first. $3(A) = 3A; 3(4) = 12$

$$3A + 12 = 27$$ Subtract 12 from both sides.

$$\begin{array}{rcl} -12 & & -12 \\ \hline 3A &=& 15 \end{array}$$ Divide both sides by 3.

$$\frac{3A}{3} = \frac{15}{3}$$

$$A = 5$$

6 Solve equations that are proportions. (p. 152)

1. Find the cross products.
2. Isolate the unknown by undoing the multiplication.

Solve the proportion $\dfrac{5}{x} = \dfrac{7}{12}$.

$$\frac{5}{x} = \frac{7}{12}$$ Cross multiply.

$$7x = 5(12)$$ Multiply.

$$7x = 60$$ Divide.

$$\frac{7x}{7} = \frac{60}{7}$$ Convert $\dfrac{60}{7}$ to a mixed number.

$$x = 8\frac{4}{7}$$

Section 5-2

1 Use the problem-solving approach to analyze and solve word problems. (p. 155)

Keywords and what they generally imply in word problems.

Addition	Subtraction	Multiplication	Division	Equality
The sum of	Less than	Times	Divide(s)	Equals
Plus/total	Decreased by	Multiplied by	Divided by	Is/was/are
Increased by	Subtracted from	Of	Divided into	Is equal to
More/more than	Difference between	The product of	Half of (divided by two)	The result is
Added to	Diminished by	Twice (two times)	Per	What is left
Exceeds	Take away	Double (two times)	Third of (divide by 3)	What remains
Expands	Reduced by	Triple (three times)		The same as
Greater than	Less/minus	Half of ($\frac{1}{2}$ times)		Gives/giving
Gain/profit	Loss	Third of ($\frac{1}{3}$ times)		Makes
Longer	Lower			Leaves
Older	Shrinks			
Heavier	Smaller than			
Wider	Younger			
Taller	Slower			

Use the five-step problem-solving approach.

What You Know	Known or given facts
What You Are Looking For	Unknown or missing amounts
Solution Plan	Equation or relationship among the known and unknown facts
Solution	Solve the equation.
Conclusion	Solution interpreted within the context of the problem

If 4 printer cartridges cost $56.80, how much would 7 cartridges cost?

What You Know	What You Are Looking For	Solution Plan
4 cartridges cost $56.80 Pair 1	7 cartridges cost $N Pair 2	$\dfrac{4\ \text{cartridges}}{\$56.80} = \dfrac{7\ \text{cartridges}}{\$N}$ Pair 1 Pair 2

Solution

$\dfrac{4}{\$56.80} = \dfrac{7}{N}$ Cross multiply.

$4N = \$56.80(7)$ Multiply.

$4N = \$397.60$ Divide.

$\dfrac{4N}{4} = \dfrac{\$397.60}{4}$

$N = \$99.40$

Conclusion

7 cartridges cost $99.40.

Section 5-3

1 Evaluate a formula. (p. 162)

1. Write the formula.
2. Rewrite the formula substituting known values for the letters of the formula.
3. Perform the indicated operations, applying the order of operations.
4. Interpret the solution within the context of the formula.

Find the unit price of a snack cake that is available in a package of 6 cakes for $1.98. Use the formula $U = \frac{P}{N}$, where U is the unit price of a specified amount of a product, P is the total price of the product, and N is the number of specified units contained in the product.

$U = \dfrac{P}{N}$ Substitute known values.

$U = \dfrac{\$1.98}{6}$ Divide.

$U = \$0.33$ Cost per cake

2 Find a variation of a formula by rearranging the formula. (p. 163)

1. Determine which variable of the formula is to be isolated (solved for).
2. Highlight or mentally locate all instances of the variable to be isolated.
3. Treat all other variables of the formula as you would treat a number in an equation, and perform the normal steps for solving an equation.
4. If the isolated variable is on the right side of the equation, interchange the sides so that it appears on the left side.

The distance formula is $D = RT$, where D is the distance traveled, R is the rate or speed traveled, and T is the time traveled. Find a variation of the distance formula that is solved for the time traveled.

$D = RT$ Isolate T. Divide both sides of the equation by R.

$\dfrac{D}{R} = \dfrac{RT}{R}$ Simplify. $\dfrac{R}{R} = 1.\ 1(T) = T.$

$\dfrac{D}{R} = T$ Interchange the sides of the equation.

$T = \dfrac{D}{R}$ Formula variation.

EXERCISES SET A

Find the value of the variable:

1. $5N = 35$

2. $\dfrac{A}{6} = 2$

3. $N - 5 = 12$

4. $2N + 4 = 12$

5. $\dfrac{A}{3} + 4 = 12$

6. $2(x - 3) = 8$

7. $3(x - 1) = 30$

8. $8A - 3A = 40$

9. $4X - X = 21$

10. $12N + 5 - 7N = 45$

11. Ace Motors sold a total of 15 cars and trucks during one promotion sale. Six of the vehicles sold were trucks. What is the number of cars that were sold?

12. Bottletree Bakery and Card Shop ordered an equal number of 12 different cards. If a total of 60 cards were ordered, how many of each type of card were ordered?

13. An electrician pays $\dfrac{2}{5}$ of the amount he charges for a job for supplies. If he was paid $240 for a certain job, how much did he spend on supplies?

14. An inventory clerk is expected to have 2,000 fan belts in stock. If the current count is 1,584 fan belts, how many more should be ordered?

15. Shaquita Davis earns $350 for working 40 hours. How much does she make for each hour of work?

16. Wallpaper costs $12.97 per roll and a kitchen requires 9 rolls. What is the cost of the wallpaper needed to paper the kitchen?

17. Bright Ideas purchased 1,000 lightbulbs. Headlight bulbs cost $13.95 each, and taillight bulbs cost $7.55 each. If Bright Ideas spent $9,342 on lightbulb stock, how many headlights and how many taillights did it get? What was the dollar value of the headlights ordered? What was the dollar value of the taillights ordered?

18. If 5 dozen roses can be purchased for $62.50, how much will 8 dozen cost?

19. For an installment loan, a formula is used to find the total amount of installment payments. The formula is \underline{T}otal installment payments = installment \underline{P}rice − \underline{D}own payment. The formula can be written in symbols as $T = P - D$. Find the total installment payments if $P = \$6,508.72$ and $D = \$2,250$.

20. In the formula $T = P - D$, T represents total installment payments, P represents installment price, and D represents down payment amount. Find the installment price if the total of installment payments is $15,892.65 and the down payment is $3,973.16.

21. To find the amount of each installment payment for a loan, use the formula $p = \frac{T}{N}$, where p is the installment payment, T is the total of installment payments, and N is the number of payments. Solve the formula to find the total of installment payments.

22. Solve the installment payment formula $p = \frac{T}{N}$ for N.

EXERCISES SET B

Solve.

1. $3N = 27$

2. $\dfrac{A}{2} = 3$

3. $N + 8 = 20$

4. $3N - 5 = 10$

5. $\dfrac{A}{2} - 5 = 1$

6. $5A - 45 = 10$

7. $7B - 14 = 21$

8. $3A = 3$

9. $5X - 4 = 11$

10. $5(2A - 3) = 15$

11. Edna's Book Carousel ordered several cookbooks and received 12. The shipping invoice indicated that 6 books would be shipped later. What was the original number of books ordered?

12. The Stork Club is a chain of baby clothing stores. The owner of the chain divided a number of bonnets equally among the 7 stores in the chain. If each store got 9 bonnets, what was the number of bonnets distributed by the owner of the chain?

13. Liz Bliss spends 18 hours on a project and estimates that she has completed $\frac{2}{3}$ of the project. How many hours does she expect the project to take?

14. A personal computer costs $4,000 and a printer costs $1,500. What is the total cost of the equipment?

15. A purse that sells for $68.99 is reduced by $25.50. What is the price of the purse after the reduction?

16. Wilson's Auto, Inc., has 37 employees and a weekly payroll of $10,878. If each employee makes the same amount, how much does each make?

17. An imprint machine makes 22,764 imprints in 12 hours. How many imprints can be made in 1 hour?

18. If a delivery van travels 252 miles on 12 gallons of gasoline, how many gallons are needed to travel 378 miles?

19. Financial statements use the formula working Capital = current Assets − current Liabilities. This formula can be written in symbols as $C = A - L$. Find the working capital if current assets are $483,596 and current liabilities are $346,087.

20. In the formula $C = A - L$, C represents working capital, A represents current assets, and L represents current liabilities. Find the current assets of Premier Travel Company if working capital is $1,803,516 and current liabilities are $483,948.

21. Financial ratios are used to evaluate the performance of a business. One ratio is expressed by the formula Current ratio = $\frac{\text{current Assets}}{\text{current Liabilities}}$. The formula can be written in symbols as $C = \frac{A}{L}$. Solve the formula for A.

22. Solve the current ratio formula $C = \frac{A}{L}$ for L.

PRACTICE TEST

Solve.

1. $N + 7 = 18$

2. $\dfrac{A}{3} = 6$

3. $3A - 5 = 10$

4. $2(N + 1) = 14$

5. $4A = 48$

6. $3R + 5 - R = 7$

7. $5N = 45$

8. $B - 8 = 7$

9. $5A + 8 = 33$

10. $5A + A = 30$

11. An employee who was earning $249 weekly received a raise of $36. How much is the new salary?

12. A container of oil holds 585 gallons. How many containers each holding 4.5 gallons will be needed if all the oil is to be transferred to the smaller containers?

13. A discount store sold plastic cups for $3.50 each and ceramic cups for $4 each. If 400 cups were sold for a total of $1,458, how many cups of each type were sold? What was the dollar value of each type of cup sold?

14. Find the cost of 200 suits if 75 suits cost $10,200.

15. Lashonna Harris is a buyer for Plough. She can purchase 100 pounds of chemicals for $97. At this same rate, how much would 2,000 pounds of the chemical cost?

16. From the currency exchange rate table shown in Table 5-2, 1.0000 EUR (Euro) is equivalent to 0.7615 USD (U.S. Dollars). Use a proportion to convert $2,500 to EUR.

17. From Table 5-2, 1.0000 USD is equivalent to 0.008626 JPY. Use a proportion to convert 250 USD to the equivalent amount of JPY currency.

TABLE 5-2
Currency Exchange Rate Table

Currency names	United Kingdom Pound (GBP)	Canadian Dollar (CAD)	Euro (EUR)	Japanese Yen (JPY)	US Dollar (USD)	Chinese Yuan Renminbi (CNY)
United Kingdom Pound	1.0000	0.4552	0.6774	0.004450	0.5159	0.06569
Canadian Dollar	2.1957	1.0000	1.4876	0.009773	1.1330	0.1443
Euro	1.4756	0.6718	1.0000	0.006569	0.7615	0.09696
Japanese Yen	224.610	102.249	152.196	1.0000	115.899	14.7577
US Dollar	1.9379	0.8822	1.3130	0.008626	1.0000	0.1273
Chinese Yuan Renminbi	15.1806	6.9109	10.2853	0.06757	7.8335	1.0000

Source: Currency Exchange Rates provided by OANDA, the currency site.

18. The formula for the installment price of an item purchased with financing is Installment price = Total of installment payments + Down payment. The formula can be written in symbols as $I = T + D$. Find the installment price I if $T = \$24{,}846.38$ and $D = \$2{,}500$.

19. In the formula $I = T + D$, the letter I represents installment price, T represents total of installment payments, and D represents the amount of down payment. Find the down payment for an installment loan if the installment price is $13,846.76 and the total of installment payments is $10,673.26.

20. Rearrange the formula $I = T + D$ to solve for D.

1. Give some instances when it would be desirable to have more than one version of a formula. For example,

$$P = R \times B, R = \frac{P}{B}, B = \frac{P}{R}.$$

2. Explain why $1.2 + n = 1.7$ and $1.7 - 1.2 = n$ will give the same result for n.

3. Explain why $5n = 4.5$ and $n = \frac{4.5}{5}$ give the same result for n.

4. Either of these two formulas, $P = 2l + 2w$ or $P = 2(l + w)$, can be used to find the perimeter of a rectangle. Explain why.

5. Test both of the formulas $P = s + s + s + s$ and $P = 4s$ to see if each formula gives the same perimeter for a square of your choosing. If each formula gives the same result, explain why.

6. Find the mistake in the following problem. Explain the mistake and rework the problem correctly.

$$10 + 7(8 + 4) =$$
$$17(8 + 4) =$$
$$17(12) = 204$$

7. If the wholesale cost of 36 printer cartridges is $188, explain how a proportion can be used to find the cost of one cartridge.

Challenge Problem

Solve $\frac{5}{8}X + \frac{3}{5} = 8$

5.1 Shiver Me Timbers

Cape Fear Riverwood is a lumber company that specializes in recovering, cutting, and selling wood from trees discarded long ago, even those that have been underwater or buried in the ground for more than 100 years! Historically, the logging industry used rafts made of wood to transport cut trees to logging pens along the Cape Fear River in North Carolina. Some of the heavier trees sank during transportation. Other trees were intentionally dumped in the river for disposal after being bled for turpentine. The company used side-scan penetrating radar to find large quantities of logs in 30 locations in and around the river. The first two sites the company salvaged contained heart pine and river pine. A more recent site contained a treasure trove of perfectly preserved 38,000-year-old cypress trees buried 30 feet in a sand pit. Scientists have identified these as trees that became extinct more than 20,000 years ago.

1. The cypress trees are 60 to 80 feet long. If there are 14,285 trees at an average length of 70 feet, how many feet of wood will the company have?

2. If the cypress is worth $80 per foot, what are the 14,285 trees worth?

3. If the cost to recover the 60- to 70-foot cypress trees is $375.00 each and the cost to harvest the larger trees is $500.00, how much would it cost to recover all of the trees if $\frac{2}{5}$ of the trees are more than 70 feet long?

4. Because the harvested lumber depletes the total amount of natural resources available to the citizens of North Carolina, the state of North Carolina places an excise tax of $\frac{1}{20}$ of all profits earned by lumber companies within the state. If the wood is worth approximately $80,000,000 and the only expense of obtaining the wood is the recovery cost, how much excise tax is owed to North Carolina?

5.2 Artist's Performance Royalties

Performance rights organizations track and pay royalties to song writers, publishers, and musicians. Royalties are paid to an artist based on a complicated credit system using a formula with weights assigned for a variety of factors, including the following:

- **Use:** weight based on the type of song or performance (theme, underscore, or promotional).
- **Licensee:** weight based on the station's licensing fee, which is determined by the size of the licensee's markets and number of stations carrying its broadcast signal.
- **Time-of-Day:** weight assigned according to whether the performances are during peak viewing or listening times.
- **Follow-the-Dollar:** factor based on the medium from which the money came (radio play, live performance, TV performance, etc.).
- **General Licensing Allocation:** based on fees collected from bars, hotels, and other non-broadcast licensees.

These amounts are multiplied together, and then a **radio feature premium** is added, if applicable, to arrive at a total number of credits for the particular artist, or his or her **credit total** for a particular reporting period. Royalties are usually split among the writer, the publisher, and possibly a performer if the writer does not perform his or her own work. The proportion that each party receives is called the **share value.** All of the money collected for the reporting period divided by the total number of credits for all performers is called the **credit value.** An artist who wants to figure out what money he or she will receive for a period has to multiply the three factors; credit total, share value, and credit value.

1. Ziam wants to know how much his royalty will be for a song he has written. How will it be calculated? Write the steps or the formulas that will be used to calculate his royalty payment.

Source: Rachel Wimberly, "Shiver Me Timbers," *Wilmington Star-News,* November 2, 2003, p. El.

2. Ziam has written a popular song entitled "Going There," which has been recorded by a well-known performer. He recently received a royalty check for $7,000. If Ziam gets a 0.5 share of the royalties and the credit value is $3.50, what was the credit total that his song earned? Write out the problem in the form of an equation and solve it.

3. Ziam quickly published another song, "Take Me There," that is played even more often than "Going There." If his first song earns 4,000 credits and his second song earns 6,000 credits, what will the royalty payment be from the two songs if the credit value remains at $3.50?

4. Ziam is considering an offer to perform his own songs on a CD to be titled "Waiting There." In the past he has written, but not performed, his music. If Ziam's royalty is 0.12 of the suggested retail price of $15.00, but 0.25 of the retail price is deducted for packaging before Ziam's royalty is calculated, how much will he receive for sale of the CD? Write your answer in the form of an equation and solve it.

5.3 Educational Consultant

Jerome Erickson is a retired school district administrator who now works as a consultant specializing in hiring administrators for school districts. Jerome used to charge a flat fee of $5,000 for each administrator hired, but decided to develop a new pricing structure. The new structure is as follows:

Due at signing:	$1,500
Contract review:	$125/hr capped at 8 hours
Contract formulation:	$125/hr capped at 12 hours
Applicant screening:	$25 per applicant
Preliminary interviews:	$125 per interview
Final interviews:	$175 per interview

Carol Ferguson is an overworked accounting clerk in a small school district. She sits at her desk, reviewing the pricing structure in the brochure from Erickson Consulting. She knows that Mr. Erickson is one of the most highly regarded educational consultants in the state, but is not sure that the district can afford him. The school board had voted to budget $5,000 for the District Administrator search, based on Carol's recommendation.

1. Write a formula reflecting the pricing structure for Erickson Consulting.

2. Carol presumes that there will be approximately 90 applicants, 10 preliminary interviews, and 3 final interviews. Using her numbers, what is the maximum that the district will have to pay Mr. Erickson?

3. Presuming that Carol is correct about the number of applicants, what are some ways that Carol can reduce her costs? What would you recommend?

4. Why do you think Jerome Erickson changed his pricing structure? What were some of those inherent problems? What are the benefits of the current pricing structure?

Source: http://entertainment.howstuffworks.com/music-royalties.htm

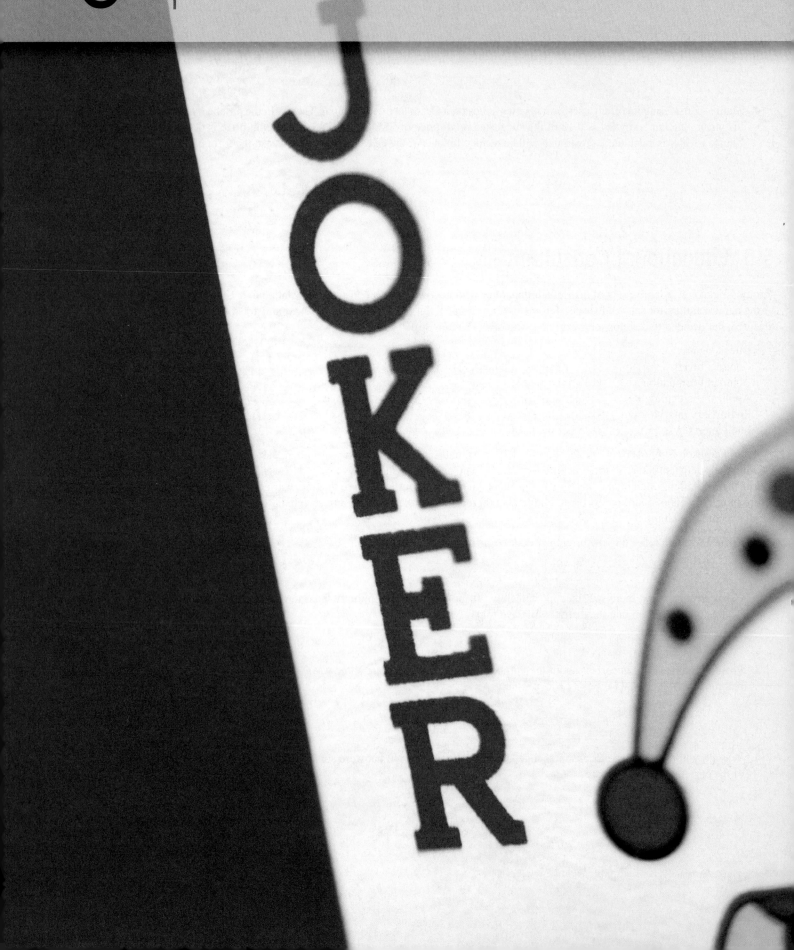

World Series of Poker: Do You Have What It Takes?

In 2006, over 8,000 players participated in World Series of Poker, with an entry fee of $10,000 each and a first prize of $12 million—incredibly high stakes. Texas Hold'em was the name of the game. But does the average player stand a chance? Perhaps, but the probability of winning first place is 0.0001139 or 0.01139%.

Probability is a huge factor in Texas Hold'em. Players use odds or percentages—the focus of this chapter—to determine their actions. The knowledge of poker odds helps them decide on a course of action. Why are poker odds so important? Knowing odds gives players an idea of whether they are in a good or bad situation. Most good players trust the numbers and take the time to learn the odds.

Hand odds are the chances of making a hand in Texas Hold'em poker. Pot odds are calculated as the ratio of the amount of money in the pot to the amount of money it costs to call. Pot odds ratios are useful to see how often you need to win the hand to break even. For instance, if there is $100 in the pot and it takes $10 to call, you must win this hand 1 out of 11 times in order to break even. The rationale is, if you play 11 times, it will cost you $110, but if you win once, you will get $110 ($100 + your $10 call). Sometimes pot odds can be precisely calculated; other times you may have to take your best guess.

Knowing the odds is very helpful, but there are many more aspects of the game you will need to learn if you want to become a winning player.

So whether you play with friends or online, knowledge of percents is essential for knowing your odds. By studying percents in this chapter, who knows—maybe you will discover many ways to use percents.

LEARNING OUTCOMES

6-1 Percent Equivalents

1. Write a whole number, fraction, or decimal as a percent.
2. Write a percent as a whole number, fraction, or decimal.

6-2 Solving Percentage Problems

1. Identify the rate, base, and portion in percent problems.
2. Use the percentage formula to find the unknown value when two values are known.

6-3 Increases and Decreases

1. Find the amount of increase or decease in percent problems.
2. Find the new amount directly in percent problems.
3. Find the rate or the base in increase or decrease problems.

 A corresponding Business Math Case Video for this chapter, *How Many Hamburgers?* can be found in Appendix A.

6-1 PERCENT EQUIVALENTS

LEARNING OUTCOMES

1 Write a whole number, fraction, or decimal as a percent.
2 Write a percent as a whole number, fraction, or decimal.

Percent: a standardized way of expressing quantities in relation to a standard unit of 100 (hundredth, per 100, out of 100, over 100).

With fractions and decimals, we compare only like quantities, that is, fractions with common denominators and decimals with the same number of decimal places. We can standardize our representation of quantities so that they can be more easily compared. We standardize by expressing quantities in relation to a standard unit of 100. This relationship, called a **percent**, is used to solve many different types of business problems.

The word *percent* means *hundredths* or *out of 100* or *per 100* or *over 100* (in a fraction). That is, 44 percent means 44 hundredths, or 44 out of 100, or 44 per 100, or 44 over 100. We can write 44 hundredths as 0.44 or $\frac{44}{100}$.

The symbol for *percent* is %. You can write 44 percent using the percent symbol: 44%; using fractional notation: $\frac{44}{100}$; or using decimal notation: 0.44.

$$44\% = 44 \text{ percent} = 44 \text{ hundredths} = \frac{44}{100} = 0.44$$

Mixed percents: percents with mixed numbers or mixed decimals.

Percents can contain whole numbers, decimals, fractions, mixed numbers, or mixed decimals. Percents with mixed numbers and mixed decimals are often referred to as **mixed percents**. Examples are $33\frac{1}{3}\%$, $0.05\frac{3}{4}\%$, and $0.23\frac{1}{3}\%$.

1 Write a whole number, fraction, or decimal as a percent.

The businessperson must be able to write whole numbers, decimals, or fractions as percents, and to write percents as whole numbers, decimals, or fractions. First we examine writing whole numbers, decimals, and fractions as percents.

Hundredths and percent have the same meaning: per hundred. Just as 100 cents is the same as 1 dollar, 100 percent is the same as 1 whole quantity.

$$100\% = 1$$

This fact is used to write percent equivalents of numbers, and to write numerical equivalents of percents. It is also used to calculate markups, markdowns, discounts, and numerous other business applications.

When we multiply a number by 1, the product has the same value as the original number. $N \times 1 = N$. We have used this concept to change a fraction to an equivalent fraction with a higher denominator. For example,

$$1 = \frac{2}{2} \quad \text{and} \quad \frac{1}{2}\left(\frac{2}{2}\right) = \frac{2}{4}$$

We can also use the fact that $N \times 1 = N$ to change numbers to equivalent percents.

$$1 = 100\% \qquad \frac{1}{2} = \frac{1}{2}(100\%) = \frac{1}{2}\left(\frac{100\%}{1}\right) = 50\%$$

$$0.5 = 0.5(100\%) = 050.\% = 50\%$$

In each case when we multiply by 1 in some form, the value of the product is equivalent to the value of the original number even though the product *looks different.*

HOW TO Write a number as its percent equivalent

Write 0.3 as a percent.

1. Multiply the number by 1 in the form of 100%. ⟶ $0.3 = 0.3(100\%) =$
2. The product has a % symbol. ⟶ $030.\% = 30\%$

EXAMPLE 1 Write the decimal or whole number as a percent.

(a) 0.27　(b) 0.875　(c) 1.73　(d) 0.004　(e) 2

(a) $0.27 = 0.27(100\%) = 027.\% = 27\%$
0.27 as a percent is 27%.

Multiply 0.27 by 100% (move the decimal point two places to the right).

(b) $0.875 = 0.875(100\%) = 087.5\% = 87.5\%$
0.875 as a percent is 87.5%.

Multiply 0.875 by 100% (move the decimal point two places to the right).

(c) $1.73 = 1.73(100\%) = 173.\% = 173\%$
1.73 as a percent is 173%.

Multiply 1.73 by 100% (move the decimal point two places to the right).

(d) $0.004 = 0.004(100\%) = 000.4\% = 0.4\%$
0.004 as a percent is 0.4%

Multiply 0.004 by 100% (move the decimal point two places to the right).

(e) $2 = 2(100\%) = 200.\% = 200\%$
2 as a percent is 200%.

Multiply 2 by 100% (move the decimal point two places to the right).

As you can see, the procedure is the same regardless of the number of decimal places in the number and regardless of whether the number is greater than, equal to, or less than 1.

EXAMPLE 2 Write the fraction as a percent.

(a) $\frac{67}{100}$　(b) $\frac{1}{4}$　(c) $3\frac{1}{2}$　(d) $\frac{7}{4}$　(e) $\frac{2}{3}$

(a) $\frac{67}{100} = \frac{67}{100}\left(\frac{100\%}{1}\right) = \mathbf{67\%}$

Reduce and multiply.

(b) $\frac{1}{4} = \frac{1}{4}\left(\frac{100\%}{1}\right) = \mathbf{25\%}$

Reduce and multiply.

(c) $3\frac{1}{2} = 3\frac{1}{2}\left(\frac{100\%}{1}\right) = \frac{7}{2}\left(\frac{100\%}{1}\right) = \mathbf{350\%}$

Change to an improper fraction, reduce, and multiply.

(d) $\frac{7}{4} = \frac{7}{4}\left(\frac{100\%}{1}\right) = \mathbf{175\%}$

Reduce and multiply.

(e) $\frac{2}{3} = \frac{2}{3}\left(\frac{100\%}{1}\right) = \frac{200\%}{3} = \mathbf{66\frac{2}{3}\%}$

Multiply.

✓ STOP AND CHECK

Write the decimal or whole number as a percent.

1. 0.82　　　2. 3.45　　　3. 0.0007　　　4. 5

Write the fraction or mixed number as a percent.

5. $\frac{43}{100}$　　　6. $\frac{3}{10}$　　　7. $8\frac{1}{4}$　　　8. $\frac{1}{6}$

2 Write a percent as a whole number, fraction, or decimal.

When a number is divided by 1, the quotient has the same value as the original number. $N \div 1 = N$ or $\frac{N}{1} = N$. We have used this concept to reduce fractions. For example,

$$1 = \frac{2}{2} \qquad \frac{2}{4} \div \frac{2}{2} = \frac{1}{2}$$

We can also use the fact that $N \div 1 = N$ or $\frac{N}{1} = N$ to change percents to numerical equivalents.

$$50\% \div 100\% = \frac{50\%}{100\%} = \frac{50}{100} = \frac{1}{2}$$

$$50\% \div 100\% = 50 \div 100 = 0.50 = 0.5$$

| **HOW TO** | Write a percent as a number |

1. Divide the number by 1 in the form of 100% or multiply by $\frac{1}{100\%}$.
2. The quotient does not have a % symbol.

| **EXAMPLE 1** | Write the percent as a decimal. |

(a) 37% (b) 26.5% (c) 127% (d) 7% (e) 0.9% (f) $2\frac{19}{20}\%$ (g) $167\frac{1}{3}\%$

(a) $37\% = 37\% \div 100\% = 0.37 = \mathbf{0.37}$ Divide by 100 mentally.

(b) $26.5\% = 26.5\% \div 100\% = 0.265 = \mathbf{0.265}$ Divide by 100 mentally.

(c) $127\% = 127\% \div 100\% = 1.27 = \mathbf{1.27}$ Divide by 100 mentally.

(d) $7\% = 7\% \div 100\% = 0.07 = \mathbf{0.07}$ Divide by 100 mentally.

(e) $0.9\% = 0.9\% \div 100\% = 0.009 = \mathbf{0.009}$ Divide by 100 mentally.

(f) $2\frac{19}{20}\% = 2.95\% \div 100\% = 0.0295 = \mathbf{0.0295}$ Write the mixed number in front of the percent symbol as a mixed decimal before dividing by 100%.

(g) $167\frac{1}{3}\% = 167.3\overline{3}\% \div 100\%$

$= 1.673\overline{3} = \mathbf{1.673\overline{3}}$ **or 1.673 (rounded)** Write the mixed number in front of the percent symbol as a repeating decimal before dividing by 100.

| **TIP** |

What Happens to the % (Percent) Sign?

In multiplying fractions we reduce or cancel common factors from a numerator to a denominator. Percent signs and other types of labels also cancel.

$$\frac{\%}{\%} = 1$$

| **EXAMPLE 2** | Write the percent as a fraction or mixed number. |

(a) 65% (b) $\frac{1}{4}\%$ (c) 250% (d) $83\frac{1}{3}\%$ (e) 12.5%

(a) $65\% = 65\% \div 100\% = \frac{65\%}{1}\left(\frac{1}{100\%}\right) = \frac{\mathbf{13}}{\mathbf{20}}$ Convert division to multiplication.

(b) $\frac{1}{4}\% = \frac{1}{4}\% \div 100\% = \frac{1\%}{4}\left(\frac{1}{100\%}\right) = \frac{\mathbf{1}}{\mathbf{400}}$

(c) $250\% = 250\% \div 100\% = \frac{250\%}{1}\left(\frac{1}{100\%}\right) = \frac{5}{2} = \mathbf{2\frac{1}{2}}$

(d) $83\frac{1}{3}\% = 83\frac{1}{3}\% \div 100\% = \frac{250\%}{3}\left(\frac{1}{100\%}\right) = \frac{5}{6}$ Convert to improper fraction.

(e) $12.5\% = 12\frac{1}{2}\% = 12\frac{1}{2}\% \div 100\% = \frac{25\%}{2}\left(\frac{1}{100\%}\right) = \frac{1}{8}$ Convert mixed decimal to mixed number.

 ## STOP AND CHECK

Write the percent as a decimal.

1. 52% **2.** 38.5% **3.** 143% **4.** 0.72%

Write the percent as a fraction or mixed number.

5. 72% **6.** $\frac{1}{8}\%$ **7.** 325% **8.** $16\frac{2}{3}\%$

6-1 SECTION EXERCISES

SKILL BUILDERS

Write the decimal as a percent.

1. 0.39 **2.** 0.693 **3.** 0.75

4. 0.2 **5.** 2.92 **6.** 0.0007

Write the fraction and mixed number as a percent.

7. $\frac{39}{100}$ **8.** $\frac{3}{4}$ **9.** $3\frac{2}{5}$

10. $5\frac{1}{4}$ **11.** $\frac{9}{4}$ **12.** $\frac{7}{5}$

13. $\frac{2}{300}$ **14.** $\frac{3}{8}$ **15.** $\frac{4}{5}$

Write the percent as a decimal. Round to the nearest thousandth if the division does not terminate.

16. $15\dfrac{1}{2}\%$

17. $\dfrac{1}{8}\%$

18. 45%

19. 150%

20. $125\dfrac{1}{3}\%$

21. $\dfrac{3}{7}\%$

Write the percent as a fraction or mixed number.

22. 45%

23. 60%

24. 250%

25. 180%

26. $\dfrac{3}{4}\%$

27. $33\dfrac{1}{3}\%$

6-2 SOLVING PERCENTAGE PROBLEMS

LEARNING OUTCOMES

1 Identify the rate, base, and portion in percent problems.
2 Use the percentage formula to find the unknown value when two values are known.

Formula: a relationship among quantities expressed in words or numbers and letters.

Base: the original number or one entire quantity.

Percentage: a part or portion of the base.

Portion: another term for percentage.

Rate: the relationship of the base and portion expressed as a percent.

1 Identify the rate, base, and portion in percent problems.

A **formula** expresses a relationship among quantities. When you use the five-step problem-solving approach, the third step, the Solution Plan, is often a formula written in words and letters.

The percentage formula, \underline{P}ercentage $= \underline{R}$ate $\times \underline{B}$ase, can be written as $P = RB$. The letters or words represent numbers.

In the formula $P = RB$, the **base** (B) represents the original number or one entire quantity. The **percentage** (P) represents a **portion** of the base. The **rate** (R) is a percent that tells us how

the base and portion are related. In the statement "50 is 20% of 250," 250 is the base (the entire quantity), 50 is the portion (part), and 20% is the rate (percent).

HOW TO Identify the rate, base, and portion.

1. Identify the rate. *Rate* is usually written as a percent, but it may be a decimal or fraction.
2. Identify the base. *Base* is the total amount, original amount, or entire amount. The base is often closely associated with the preposition *of*.
3. Identify the portion. *Portion* can refer to the part, partial amount, amount of increase or decrease, or amount of change. It is a portion of the *base*. The portion is often closely associated with a form of the verb *is*.

EXAMPLE 1 Identify the given and missing elements for each example.

(a) 20% of 75 is what number?
(b) What percent of 50 is 30?
(c) Eight is 10% of what number?

 R *B* *P*
(a) 20% of 75 is what number?
 Percent Total Part

 R *B* *P*
(b) What percent of 50 is 30?
 Percent Total Part

 P *R* *B*
(c) Eight is 10% of what number?
 Part Percent Total

Use the identifying key words for rate (*percent* or %), base (*total, original*, associated with the word *of*), and portion (*part*, associated with the word *is*).

✓ **STOP AND CHECK**

Identify the base, rate, and portion.

1. 42% of 85 is what number?

2. Fifty is 15% of what number?

3. What percent of 80 is 20?

4. Twenty percent of what number is 17?

5. Find 125% of 72.

6. Thirty-two is what percent of 160?

2 Use the percentage formula to find the unknown value when two values are known.

The percentage formula, <u>P</u>ercentage = <u>R</u>ate × <u>B</u>ase, can be written as $P = RB$. Another word for percentage is portion. When the numbers are put in place of the letters, the formula guides you through the calculations.

The three percentage formulas are

Portion = Rate × Base	$P = RB$	For finding the percentage or portion.
Base = $\dfrac{\text{Portion}}{\text{Rate}}$	$B = \dfrac{P}{R}$	For finding the base.
Rate = $\dfrac{\text{Portion}}{\text{Base}}$	$R = \dfrac{P}{B}$	For finding the rate.

Circles can help us visualize these formulas. The shaded part of the circle in Figure 6-1 represents the missing amount. The unshaded parts represent the known amounts. If the unshaded parts

$$P = RB \qquad B = \frac{P}{R} \qquad R = \frac{P}{B}$$

FIGURE 6-1
Forms of the Portion (Percentage) Formula

are *side by side, multiply* their corresponding numbers to find the unknown number. If the unshaded parts are *one on top of the other, divide* the corresponding numbers to find the unknown number.

> **HOW TO** Use the percentage (portion) formula to solve percentage problems
>
> 1. Identify and classify the two known values and the one unknown value.
> 2. Choose the appropriate portion (percentage) formula for finding the unknown value.
> 3. Substitute the known values into the formula. For the rate, use the decimal or fractional equivalent of the percent.
> 4. Perform the calculation indicated by the formula.
> 5. Interpret the result. If finding the rate, convert decimal or fractional equivalents of the rate to a percent.

> **EXAMPLE 1** Solve the problems.
>
> (a) 20% of 400 is what number?
> (b) 20% of what number is 80?
> (c) 80 is what percent of 400?
>
> | (a) 20% = Rate | Identify known values and unknown value. |
> | 400 = Base | |
> | Portion is unknown | |
> | $P = RB$ | Choose the appropriate formula. |
> | $P = 0.2(400)$ | Substitute values using the decimal equivalent of 20%. |
> | $P = \mathbf{80}$ | Perform calculation. |
> | **20% of 400 is 80.** | Interpret result. |
> | (b) 20% = Rate | Identify known values and unknown value. |
> | 80 = Portion | |
> | Base is unknown | |
> | $B = \dfrac{P}{R}$ | Choose the appropriate formula. |
> | $B = \dfrac{80}{0.2}$ | Substitute values. Perform calculation. |
> | $B = \mathbf{400}$ | |
> | **20% of 400 is 80.** | Interpret result. |
> | (c) 80 = Portion | Identify known values and unknown value. |
> | 400 = Base | |
> | Rate is unknown | |
> | $R = \dfrac{P}{B}$ | Choose the appropriate formula. |
> | $R = \dfrac{80}{400}$ | Substitute values. Perform calculation. |
> | $R = 0.2$ or **20%** | |
> | **80 is 20% of 400.** | Interpret result. $0.2 = 20\%$. |

Very few percentage problems that you encounter in business tell you the values of *P*, *R*, and *B* directly. Percentage problems are usually written in words that must be interpreted before you can tell which form of the percentage formula you should use.

FIGURE 6-2

EXAMPLE 2 During a special one-day sale, 600 customers bought the on-sale pizza. Of these customers, 20% used coupons. The manager will run the sale again the next day if more than 100 coupons were used. Should she run the sale again?

What You Know	What You Are Looking For	Solution Plan
Total customers: 600 Coupon-using customers as a percent of total customers: 20%	Quantity of coupon-using customers Should the manager run the sale again?	The quantity of coupon-using customers is a *portion* of the *base* of total customers, at a *rate* of 20% (Figure 6-2). $P = RB$ Quantity of coupon-using customers = RB

Solution

$P = RB$	P is unknown; $R = 20\%$; $B = 600$
$P = 20\%(600)$	Substitute known values. Change % to decimal equivalent.
$P = 0.2(600)$	Multiply.
$P = 120$	

Conclusion

The quantity of coupon-using customers is 120.
Since 120 is more than 100, the manager should run the sale again.

EXAMPLE 3 If $66\frac{2}{3}\%$ of the 900 employees in a company choose the Preferred Provider insurance plan, how many people from that company are enrolled in the plan?

First, identify the terms. The rate is the percent, and the base is the total number of employees. The portion is the quantity of employees enrolled in the plan.

$P = RB$	The portion is the unknown.
$P = 66\frac{2}{3}\%(900)$	The rate is $66\frac{2}{3}\%$; the base is 900. Write $66\frac{2}{3}\%$ as a fraction.
$P = \frac{2}{3}\left(\frac{900}{1}\right) = 600$	Multiply.

The Preferred Provider plan has 600 people enrolled.

TIP

Continuous Sequence Versus Noncontinuous Sequence

We can write the fractional equivalent of the percent as a rounded decimal and divide using a calculator.

\boxed{AC} 2 $\boxed{\div}$ 3 $\boxed{=}$ \Rightarrow 0.6666666667
\boxed{AC} 900 $\boxed{\times}$.6666666667 $\boxed{=}$ \Rightarrow 599.9999994

As one continuous sequence, enter

\boxed{AC} 2 $\boxed{\div}$ 3 $\boxed{\times}$ 900 $\boxed{=}$ \Rightarrow 600

Note slight discrepancies due to rounding. However, the answer obtained by using a continuous sequence of steps is more accurate.

EXAMPLE 4 Stan sets aside 15% of his weekly income for rent. If he sets aside $75 each week, what is his weekly income?

FIGURE 6-3

FIGURE 6-4

Identify the terms: The rate is the number written as a percent, 15%. The portion is given, $75; it is a portion of his weekly income, the unknown base.

$$B = \frac{P}{R}$$ The rate is 15% and the portion is $75 (Figure 6-3). The base is the weekly income to be found.

$$B = \frac{\$75}{15\%}$$ Convert 15% to a decimal equivalent.

$$B = \frac{75}{0.15}$$ Divide.

$$B = \$500$$

Stan's weekly income is $500.

EXAMPLE 5 If 20 cars were sold from a lot that had 50 cars, what percent of the cars were sold?

$$R = \frac{P}{B}$$ The portion is 20; the base is 50 (Figure 6-4). The rate is the unknown to find.

$$R = \frac{20}{50}$$ Divide.

$$R = 0.4$$ Convert to % equivalent.

$$R = 0.4(100\%)$$

$$R = 40\%$$

Of the cars on the lot, 40% were sold.

Many students mistakenly think that the portion can never be larger than the base. The portion (percentage) is smaller than the base only when the rate is less than 100%. The portion is larger than the base when the rate is larger than 100%.

EXAMPLE 6 48 is what percent of 24?

$$R = \frac{P}{B}$$ The rate is unknown. The percentage is 48. The base is 24.

$$R = \frac{48}{24}$$ Divide.

$$R = 2$$ Rate written as a whole number.

$$\mathbf{R = 200\%}$$ Rate written as a percent.

 STOP AND CHECK

1. 15% of 200 is what number?

2. 25% of what number is 120?

3. 150 is what percent of 750?

4. Find $12\frac{1}{2}\%$ of 64.

5. Seventy-five percent of students in a class of 40 passed the first test. How many passed?

6. What percent of 500 is 150?

6-2 SECTION EXERCISES

SKILL BUILDERS

Identify the rate, base, and portion.

1. 48% of 12 is what number?

2. 32% of what number is 28?

3. What percent of 158 is 47.4?

4. What number is 130% of 149?

5. 15% of what number is 80?

6. 48% of what number is 120?

Use the appropriate form of the percentage formula. Round division to the nearest hundredth if necessary.

7. Find P if $R = 25\%$ and $B = 300$.

8. Find 40% of 160.

9. What number is $33\frac{1}{3}\%$ of 150?

10. What number is 154% of 30?

11. Find B if $P = 36$ and $R = 66\frac{2}{3}\%$

12. Find R if $P = 70$ and $B = 280$.

13. 40% of 30 is what number?

14. 52% of 17.8 is what number?

15. 30% of what number is 21?

16. 17.5% of what number is 18? Round to hundredths.

17. What percent of 16 is 4?

18. What percent of 50 is 30?

19. 172% of 50 is what number?

20. 0.8% of 50 is what number?

21. What percent of 15.2 is 12.7? Round to the nearest hundredth of a percent.

22. What percent of 73 is 120? Round to the nearest hundredth of a percent.

23. 0.28% of what number is 12? Round to the nearest hundredth.

24. 1.5% of what number is 20? Round to the nearest hundredth.

APPLICATIONS

25. At the Evans Formal Wear department store, all suits are reduced 20% from the retail price. If Charles Stewart purchased a suit that originally retailed for $258.30, how much did he save?

26. Joe Passarelli earns $8.67 per hour working for Dracken International. If Joe earns a merit raise of 12%, how much was his raise?

27. An ice cream truck began its daily route with 95 gallons of ice cream. The truck driver sold 78% of the ice cream. How many gallons of ice cream were sold?

28. Stacy Bauer sold 80% of the tie-dyed T-shirts she took to the Green Valley Music Festival. If she sold 42 shirts, how many shirts did she take?

29. A stockholder sold her shares and made a profit of $1,466. If this is a profit of 23%, how much were the shares worth when she originally purchased them?

30. The Drammelonnie Department Store sold 30% of its shirts in stock. If the department store sold 267 shirts, how many shirts did the store have in stock?

31. Ali gave correct answers to 23 of the 25 questions on the driving test. What percent of the questions did he get correct?

32. A soccer stadium in Manchester, England, has a capacity of 78,753 seats. If 67,388 seats were filled, what percent of the stadium seats were vacant? Round to the nearest hundredth of a percent.

33. Holly Hobbs purchased a magazine at the Atlanta airport for $2.99. The tax on the purchase was $0.18. What is the tax rate at the Atlanta airport? Round to the nearest percent.

34. A receipt from Wal-Mart in Memphis showed $4.69 tax on a subtotal of $53.63. What is the tax rate? Round to the nearest tenth percent.

6-3 INCREASES AND DECREASES

LEARNING OUTCOMES

1 Find the amount of increase or decrease in percent problems.
2 Find the new amount directly in percent problems.
3 Find the rate or the base in increase or decrease problems.

New amount: the ending amount after an amount has changed (increased or decreased).

In many business applications an original amount is increased or decreased to give a **new amount**. Some examples of increases are the sales tax on a purchase, the raise in a salary, and the markup on a wholesale price. Some examples of decreases are the deductions on your paycheck and the markdown or the discount on an item for sale.

1 Find the amount of increase or decrease in percent problems.

The amount of increase or decrease is the amount that an original number changes. Subtraction is used to find the amount of change when the beginning and ending (or new) amounts are known.

HOW TO	Find the amount of increase or decrease from the beginning and ending amounts

1. To find the amount of increase:

 Amount of increase = new amount − beginning amount

2. To find the amount of decrease:

 Amount of decrease = beginning amount − new amount

EXAMPLE 1

David Spear's salary increased from $58,240 to $63,190. What is the amount of increase?

Beginning amount = $58,240
New amount = $63,190
Increase = new amount − beginning amount
= $63,190 − $58,240
= $4,950

David's salary increase was $4,950.

EXAMPLE 2

A coat was marked down from $98 to $79. What is the amount of markdown?

Beginning amount = $98
New amount = $79
Decrease = beginning amount − new amount
= $98 − $79
= $19

The coat was marked down $19.

Percent of change: the percent by which a beginning amount has changed (increased or decreased).

A change is often expressed as a **percent of change.** The amount of change is a percent of the original or beginning amount.

HOW TO Find the amount of change (increase or decrease) from a percent of change

1. Identify the original or beginning amount and the percent or rate of change.
2. Multiply the decimal or fractional equivalent of the rate of change times the original or beginning amount.

Amount of change = percent of change × original amount

EXAMPLE 3

Your company has announced that you will receive a 3.2% raise. If your current salary is $42,560, how much will your raise be?

What You Know	What You Are Looking For
Current salary = $42,560 Rate of change = 3.2%	Amount of raise

Solution Plan

$$\frac{\text{Amount}}{\text{of raise}} = \left(\begin{array}{c}\text{percent of}\\\text{change}\end{array}\right)\left(\begin{array}{c}\text{original}\\\text{amount}\end{array}\right)$$

Solution

Amount of raise = percent of change × original amount
= 3.2%($42,560)
= 0.032($42,560) Multiply.
= $1,361.92

Conclusion

The raise will be $1,361.92.

1. The price of a new Lexus is $53,444. The previous year's model cost $51,989. What is the amount of increase?

2. In trading on the New York Stock Exchange, Bank of America fell to $73.57. The stock had sold for $81.99. What is the amount of decrease in the stock price per share?

3. Marilyn Bauer earns $62,870 and gets a 4.3% raise. How much is her raise?

4. International Paper reported third-quarter earnings were down 16% from $145 million. What was the amount of decrease?

5. Zack weighed 230 pounds before experiencing a 12% weight loss. How many pounds did he lose?

6. The number of active registered nurses is currently 2,249,000. A 20.3% increase by 2020 will be needed. How many nurses will need to be added to the existing workforce?

2 Find the new amount directly in percent problems.

Often in increase or decrease problems we are more interested in the new amount than the amount of change. We can find the new amount directly by adding or subtracting percents first. The original or beginning amount is always considered to be our *base* and is represented by 100%.

HOW TO Find the new amount directly in a percent problem

1. Find the rate of the new amount.

 For increase: 100% + rate of increase
 For decrease: 100% − rate of decrease

2. Find the new amount.

$$P = RB$$

 New amount = rate of new amount × original amount

EXAMPLE 1

Medical assistants are to receive a 9% increase in wages per hour. If they were making $15.25 an hour, what is the *new wage per hour* to the nearest cent?

Rate of new amount =	100% + rate of increase	
	= 100% + 9%	
	= 109%	
New amount =	rate of new amount × original amount	
	= 109%($15.25)	Change % to its decimal equivalent.
	= 1.09(15.25)	Multiply.
	= $16.6225	New amount
	= $16.62	Nearest cent

The new hourly wage is $16.62.

EXAMPLE 2

A pair of jeans that cost $49.99 is advertised as 70% off. What is the sale price of the jeans?

Rate of new amount =	100% − rate of decrease	
	= 100% − 70%	
	= 30%	
New amount =	rate of new amount × original amount	
	= 30%($49.99)	Change % to its decimal equivalent.
	= 0.3(49.99)	Multiply.
	= $14.997	New amount
	= $15.00	Nearest cent

1. Marilyn Bauer earns $62,870 and gets a 4.3% raise. How much is her new salary?

2. International Paper reported third-quarter earnings were down 16% from $145 million. Find the third-quarter earnings.

3. Zack weighed 230 pounds before experiencing a 12% weight loss. How many pounds does he now weigh?

4. Over the next ten years Stacy Bauer plans to increase her investment of $9,500 by 250%. How much will she have invested altogether?

5. Shares of McDonald's, the world's largest hamburger restaurant chain, rose 51% this year. Find the new share price if the stock sold for $24.25 last year.

6. The number of registered nurses is currently 2,249,000. If a 20.3% increase in this number is projected for 2020, how many nurses will be needed in 2020?

3 Find the rate or the base in increase or decrease problems.

Many kinds of increase or decrease problems involve finding either the rate or the base.

The rate is the *percent of change* or the *percent of increase or decrease*. The base is still the *original amount*.

HOW TO Find the rate or the base in increase or decrease problems

1. Identify or find the amount of increase or decrease.
2. To find the rate of increase or decrease, use the percentage formula $R = \dfrac{P}{B}$.

$$R = \frac{\text{amount of change}}{\text{original amount}}$$

3. To find the base or original amount, use the percentage formula $B = \dfrac{P}{R}$.

$$B = \frac{\text{amount of change}}{\text{rate of change}}$$

EXAMPLE 1 During the month of May, a graphic artist made a profit of $1,525. In June she made a profit of $1,708. What is the percent of increase in profit?

What You Know	What You Are Looking For
Original amount = $1,525 New amount = $1,708	Percent of increase

Solution Plan
Amount of increase = new amount − original amount Percent of increase = $\dfrac{\text{amount of increase}}{\text{original amount}}$

Solution

Amount of increase = $1,708 − $1,525 Subtract.
 = $183

Percent of increase = $\dfrac{\$183}{\$1,525}$ Divide.

 = 0.12 Convert to % equivalent.
 = 0.12(100%)
 = 12%

Conclusion

The percent of increase in profit is 12%.

In some cases you may not have enough information to determine the amount of increase or decrease. Then we must match the rate with the information we are given.

EXAMPLE 2 At Best Buy the price of a DVD player dropped by 20% to $179. What was the original price to the nearest dollar?

What You Know	What You Are Looking For
Reduced price = new amount = $179 Rate of decrease = 20%	Original price

Solution Plan

Rate of reduced price = 100% − rate of decrease

$$B = \frac{P}{R}$$

$$\text{Original price} = \frac{\text{reduced price}}{\text{rate of reduced price}}$$

Solution

Rate of reduced price = 100% − 20%
 = 80%

Original price = $\dfrac{\$179}{80\%}$ Convert % to decimal equivalent.

 = $\dfrac{179}{0.8}$ Divide.

 = $223.75 Round to nearest dollar.
 = $224

Conclusion

The original price of the DVD player was $224.

TIP

Be Sure to Use the Correct Rate

When using the percentage formula, the description for the rate must match the description of the portion.

	Example 2 above DVD Problem	Example 2 on p. 194 Jeans Problem
Form of percentage formula	$B = \dfrac{P}{R}$	$P = RB$
Description of rate	Rate of *reduced price*	Rate of *new amount*
Description of portion	*Reduced price*	*New amount*

STOP AND CHECK

1. Emily Sien reported sales of $23,583,000 for the third quarter and $38,792,000 for the fourth quarter. What is the percent of increase in profit? Round to the nearest tenth of a percent.

2. Ken Sien reduced his college spending from $9,524 in the fall semester to $8,756 in the spring semester. What percent was the decrease? Round to the nearest percent.

3. Sydney Sien showed a house that was advertised as a 10% decrease on the original price. The sale price is $148,500. What was the original price?

4. You know that a DVD is reduced 25% and the amount of reduction is $6.25. Find the original price and the discounted price of the movie.

5. A used truck is reduced by 48% of its new price. You know the used price is $14,799. Find the new price to the nearest dollar.

6. The average NFL ticket price was $62.38 for 2006 and for 2005 it was $58.95. What was the percent increase in ticket price? Round to the nearest tenth percent.

6-3 SECTION EXERCISES

SKILL BUILDERS

1. A number increased from 5,286 to 7,595. Find the amount of increase.

2. A number decreased from 486 to 104. Find the amount of decrease.

3. Find the amount of increase if 432 is increased by 25%.

4. Find the amount of decrease if 68 is decreased by 15%.

5. If 135 is decreased by 75%, what is the new amount?

6. If 78 is increased by 40%, what is the new amount?

7. A number increased from 224 to 336. Find the percent of increase.

8. A number decreased from 250 to 195. Find the rate of decrease.

9. A number is decreased by 40% to 525. What is the original amount?

10. A number is increased by 15% to 43.7. Find the original amount.

APPLICATIONS

11. The cost of a pound of nails increased from $2.36 to $2.53. What is the percent of increase to the nearest whole-number percent?

12. Wrigley announced the first increase in 16 years in the price of a five-stick pack of gum. The price was raised by 5 cents to 30 cents. Find the percent of increase. Round to the nearest percent.

13. Bret Davis is getting a 4.5% raise. His current salary is $38,950. How much will his raise be?

14. Kewanna Johns plans to lose 12% of her weight in the next 12 weeks. She currently weighs 218 pounds. How much does she expect to lose?

15. DeMarco Jones makes $13.95 per hour but is getting a 5.5% increase. What is his new wage per hour to the nearest cent?

16. Carol Wynne bought a silver tray that originally cost $195 and was advertised at 65% off. What was the sale price of the tray?

17. A laptop computer that was originally priced at $2,400 now sells for $2,700. What is the percent of increase?

18. Federated Department Stores dropped the price of a winter coat by 15% to $149. What was the original price to the nearest cent?

Learning Outcomes

Section 6-1

1 Write a whole number, fraction, or decimal as a percent. (p. 182)

What to Remember with Examples

1. Multiply the number by 1 in the form of 100%.
2. The product has a % symbol.

$$6 = 6(100\%) = 600\% \qquad \frac{3}{5} = \frac{3}{5}\left(\frac{100}{1}\%\right) = 60\%$$

$$0.075 = 0.075(100\%) = 7.5\%$$

2 Write a percent as a whole number, fraction, or decimal. (p. 184)

1. Divide by 1 in the form of 100% or multiply by $\frac{1}{100\%}$.
2. The quotient does not have a % symbol.

$$48\% = 48\% \div 100\% = 0.48 \qquad 20\% = 20\% \div 100\% = \frac{20}{100} = \frac{1}{5}$$

$$157\% = 157\% \div 100\% = 1.57 \qquad 33\frac{1}{3}\% = 33\frac{1}{3}\% \div 100\% = 0.33\frac{1}{3} \text{ or } 0.3\overline{3}$$

Section 6-2

1 Identify the rate, base, and portion in percent problems. (p. 186)

1. *Rate* is usually written as a percent, but may be a decimal or fraction.
2. *Base* is the total or original amount.
3. *Portion* is the part, or amount of increase or decrease. It is also called the *percentage*.

Identify the rate, base, and portion.
42% of 18 is what number?
42% is the rate.
18 is the base.
The missing number is the portion.

2 Use the percentage formula to find the unknown value when two values are known. (p. 187)

1. Identify and classify the two known values and the one missing value.
2. Choose the appropriate percentage formula for finding the missing value.
3. Substitute the known values into the formula. For the rate, use the decimal or fractional equivalent of the percent.
4. Perform the calculation indicated by the formula.
5. Interpret the result. If finding the rate, convert decimal or fractional equivalents of the rate to a percent.

Find P if $B = 20$ and $R = 15\%$.

$$P = RB$$

$$P = 15\%(20) = 0.15(20)$$

$$P = 3$$

Find B if $P = 36$ and $R = 9\%$.

$$B = \frac{P}{R}$$

$$B = \frac{36}{9\%} = \frac{36}{0.09}$$

$$B = 400$$

Section 6-3

1 Find the amount of increase or decrease in percent problems. (p. 192)

1. To find the amount of increase:

 Amount of increase = new amount − beginning amount

2. To find the amount of decrease:

 Amount of decrease = beginning amount − new amount.

A truck odometer increased from 37,580.3 to 42,719.6. What was the increase?

$42,719.6 - 37,580.3 = 5,139.3$

A truck carrying 62,980 pounds of food delivered 36,520 pounds. What was the amount of food (in pounds) remaining on the truck?

$62,980 - 36,520 = 26,460$ pounds

2 Find the new amount directly in percent problems. (p. 194)

1. Find the rate of the new amount.

 For increase: 100% + rate of increase

 For decrease: 100% − rate of decrease

2. Find the new amount.

 $P = RB$

 New amount = rate of new amount × original amount

Emily Denly works 30 hours a week but plans to increase her work hours by 20%. How many hours will she be working after the increase?

For increase: $100\% + 20\% = 120\%$
$P = RB$
$P = 120\%(30 \text{ hours})$
$\quad = 1.20(30)$
$\quad = 36 \text{ hours}$

3 Find the rate or the base in increase or decrease problems. (p. 195)

1. Identify or find the amount of increase or decrease.
2. To find the rate of increase or decrease, use the percentage formula $R = \dfrac{P}{B}$.

 $R = \dfrac{\text{amount of change}}{\text{original amount}}$

3. To find the base or original amount, use the percentage formula $B = \dfrac{P}{R}$.

 $B = \dfrac{\text{amount of change}}{\text{rate of change}}$

Tancia Brown made a profit of $5,896 in June and a profit of $6,265 in July. What is the percent of increase? Round to tenths of a percent.

Amount of increase $= \$6,265 - \$5,896 = \$369$

$R = \dfrac{\text{amount of change}}{\text{original amount}}$

$\quad = \dfrac{\$369}{\$5,896}$

$\quad = 0.06258(100\%)$

$\quad = 6.3\%$ (rounded)

EXERCISES SET A

Write the decimal as a percent.

1. 0.23

2. 0.82

3. 0.03

4. 0.34

5. 0.601

6. 1

7. 3

8. 0.37

9. 0.2

10. 4

Write the fraction or mixed number as a percent. Round to the nearest hundredth of a percent if necessary.

11. $\dfrac{17}{100}$

12. $\dfrac{6}{100}$

13. $\dfrac{52}{100}$

14. $\dfrac{1}{10}$

15. $\dfrac{5}{4}$

16. $2\dfrac{3}{5}$

Write the percent as a decimal.

17. 0.25%

18. 98%

19. 256%

20. 91.7%

21. 0.5%

22. 6%

Write the percent as a whole number, mixed number, or fraction, reduced to lowest terms.

23. 10%

24. 6%

25. 89%

26. 45%

27. 225%

Percent	Fraction	Decimal
28. $33\dfrac{1}{3}\%$	_____	_____
29. _____	_____	0.125
30. _____	_____	0.8

Find P, R, or B using the percentage formula or one of its forms. Round decimals to the nearest hundredth and percents to the nearest whole number percent.

31. $B = 300$, $R = 27\%$

32. $P = 25$, $B = 100$

33. $P = \$600$, $R = 5\%$

34. $P = \$835$, $R = 3.2\%$

35. $P = 125$, $B = 50$

36. Find 30% of 80.

37. 90% of what number is 27?

38. 51.52 is what percent of 2,576?

39. Jaime McMahan received a 7% pay increase. If he was earning $2,418 per month, what was the amount of the pay increase?

40. Eighty percent of one store's customers paid with credit cards. Forty customers came in that day. How many customers paid for their purchases with credit cards?

41. Seventy percent of a town's population voted in an election. If 1,589 people voted, what is the population of the town?

42. Thirty-seven of 50 shareholders attended a meeting. What percent of the shareholders attended the meeting?

43. The financial officer allows $3,400 for supplies in the annual budget. After three months, $898.32 has been spent on supplies. Is this figure within 25% of the annual budget?

44. Chloe Denley's rent of $940 per month was increased by 8%. What is her new monthly rent?

45. The price of a wireless phone increased by 14% to $165. What was the original price to the nearest dollar?

EXCEL

46. Global wind energy had a record growth in 2006 achieving a level of 11,531 megawatts compared to 8,207 megawatts for 2005. What was the percent increase in additional megawatts to the global market? Round to the nearest tenth percent.

EXERCISES SET B

Write the decimal as a percent.

1. 0.675

2. 2.63

3. 0.007

4. 3.741

5. 0.0004

6. 0.6

7. 0.242

8. 0.811

Write the fraction or mixed number as a percent. Round to the nearest hundredth of a percent if necessary.

9. $\dfrac{99}{100}$

10. $\dfrac{20}{100}$

11. $\dfrac{13}{20}$

12. $3\dfrac{2}{5}$

13. $\dfrac{2}{5}$

14. $2\dfrac{3}{4}$

Write the percent as a decimal.

15. 328.4%

16. 84.6%

17. 52%

18. 3%

19. 0.02%

20. 274%

Write the percent as a whole number, mixed number, or fraction, reduced to lowest terms.

21. 20%

22. 170%

23. 361%

24. 25%

25. $12\dfrac{1}{2}\%$

	Percent	Fraction	Decimal
26.	_____	$\dfrac{2}{5}$	_____
27.	50%	_____	_____
28.	$87\dfrac{1}{2}\%$	_____	_____
29.	_____	_____	0.45

Find P, R, or B using the percentage formula or one of its forms.

30. $B = \$1{,}900, R = 106\%$ **31.** $P = 170, B = 85$ **32.** $P = \$15.50, R = 7.75\%$

Round decimals to the nearest hundredth and percents to the nearest whole number percent.

33. $P = 68, B = 85$ **34.** $R = 72\%, B = 16$ **35.** $P = 52, R = 17\%$

Use the percentage formula or one of its forms.

36. Find 150% of 20.

37. 82% of what number is 94.3?

38. 27 is what percent of 9?

39. Ernestine Monahan draws $1,800 monthly retirement. On January 1, she received a 3% cost of living increase. How much was the increase?

40. If a picture frame costs $30 and the tax on the frame is 6% of the cost, how much is the tax on the picture frame?

41. Five percent of a batch of fuses were found to be faulty during an inspection. If 27 fuses were faulty, how many fuses were inspected?

42. The United Way expects to raise $63 million in its current drive. The chairperson projects that 60% of the funds will be raised in the first 12 weeks. How many dollars are expected to be raised in the first 12 weeks?

43. An accountant who is currently earning $42,380 annually expects a 6.5% raise. What is the amount of the expected raise?

44. Last year Docie Johnson had net sales of $582,496. This year her sales decreased by 12%. What were her net sales this year?

45. The price of Internet service decreased by 7% to $52. What was the original price to the nearest dollar?

PRACTICE TEST

CHAPTER 6

Write the decimal as a percent.

1. 0.24

2. 0.925

3. 0.6

Write the fraction or mixed number as a percent.

4. $\dfrac{21}{100}$

5. $\dfrac{3}{8}$

6. Write $\dfrac{1}{4}\%$ as a fraction.

Use the percentage formula or one of its forms.

7. Find 30% of $240.

8. 50 is what percent of 20?

9. What percent of 8 is 7?

10. What is the sales tax on an item that costs $42 if the tax rate is 6%?

11. If 100% of 22 rooms are full, how many rooms are full?

12. Twelve employees at a meat packing plant were sick on Monday. If the plant employs 360 people, what percent to the nearest whole percent of the employees was sick on Monday?

13. A department store had 15% turnover in personnel last year. If the store employs 600 people, how many employees were replaced last year?

14. The Dawson family left a 15% tip for a restaurant check. If the check totaled $19.47, find the amount of the tip. What was the total cost of the meal, including the tip?

15. A certain make and model of automobile was projected to have a 3% rate of defective autos. If the number of defective automobiles was projected to be 1,698, how many automobiles were to be produced?

16. Of the 20 questions on this practice test, 11 are word problems. What percent of the problems are word problems? (Round to the nearest whole number percent.)

17. Frances Johnson received a 6.2% increase in earnings. She was earning $86,900 annually. What is her new annual earnings?

18. Byron Johnson took a pay cut of 5%. He was earning $148,200 annually. What is his new annual salary?

19. Sylvia Williams bought a microwave oven that had been reduced by 30% to $340. What was the original price of the oven? Round to the nearest dollar.

20. Sony decided to increase the wholesale price of its DVD players by 18% to $320. What was the original price rounded to the nearest cent?

1. Numbers between $\frac{1}{100}$ and 1 are equivalent to percents that are between 1% and 100%. Numbers greater than 1 are equivalent to percents that are _____.

2. Percents between 0% and 1% are equivalent to fractions or decimals in what interval?

3. Explain why any number can be multiplied by 100% without changing the value of the number.

4. Can any number be divided by 100% without changing the value of the number? Explain.

5. A conjugate of a percent is the difference of 100% and the given percent. What is the conjugate percent of 48%?

6. Finding which one of the three elements of the percentage formula requires multiplication?

7. If the cost of an item increases by 100%, what is the effect of the increase on the original amount? Give an example to illustrate your point.

8. Describe two ways to find the new amount when a given number is increased by a given percent.

Challenge Problem

Brian Sangean has been offered a job in which he will be paid strictly on a commission basis. He expects to receive a 4% commission on all sales of computer hardware he closes. Brian's goal for a gross yearly salary is $60,000. How much computer hardware must Brian sell in order to meet his target salary?

6.1 Wasting Money or Shaping Up?

Sarah belongs to a gym and health spa that is conveniently located between her home and her job. It is one of the nicer gyms in town, and Sarah pays $90 a month for membership. Sarah works out three times a week regularly. While she was getting off the treadmill one day, one of the club's personal trainers came by to talk and offered to plan a routine for Sarah that would help her train for an upcoming marathon. The trainer had noticed that Sarah came in regularly, and she commented that most members don't have the self-control to do that. In fact, she explained that there is a study of 8,000 members in Boston area gyms that showed that members went to the gym only about five times per month. The study also found that people who choose a pay-per-visit membership spend less money than people who choose a monthly or annual membership fee.

1. At Sarah's club the pay-per-visit fee is $5 per day. Would Sarah save money paying per visit? Assume that a month has 4.3 weeks. What percentage of her monthly $90 fee would she spend if she paid on a per-visit basis?

2. If Sarah goes to the gym three times per week, what portion of the year does she use the gym?

3. If Sarah went to the gym every day, how much would she pay per day on the monthly payment plan? Assume 30 days in a month. If she went every day and paid $5 per day, how much would she be spending per month? How much more is this in percentage terms compared to the $90 monthly rate rounded to the nearest percent?

6.2 Customer Relationship Management

Minh Phan is going over the numbers one more time. He is about to make the most important sales presentation of his young career, and wants everything to be right. His prospective client, Media Systems, Inc., is one of the country's leading media and communications organizations. Media Systems' primary challenge is how to effectively manage its diverse customer base. The company has 70,000 publication subscribers, 58,000 advertisers, 30,000 telephone services customers, and 18,000 ISP (Internet service provider) customers. The company had little information about who its customers truly were, which products they were using, and how satisfied they were with the service they received. That's where Minh and his company, Customer Solution Technologies, LLC, came in. Through the use of customer relationship management software, Minh believed Media Systems would be able to substantially improve its ability to cross-sell and up-sell multiple media and communications services to customers, while substantially reducing customer complaints.

Source: "Why You Waste So Much Money," *Wall Street Journal*, Wednesday, July 14, 2003, p. D1.

1. What percentage of the total does each of the four customer groups represent?

2. Minh's data shows that on average, only 4.6% of customers were purchasing complementary services available within Media Systems. By using his company's services, Minh was projecting that these percentages would triple across all user groups within one year. How many customers would that equate to in total for each group? What would the difference be compared to current levels?

3. Customer complaint data showed that within the last year, complaints by category were as follows: publication subscribers, 1,174; advertisers, 423; telephone service customers, 4,411; and ISP customers 823. What percentage of customers (round to two decimal places) complained within the last year in each category? If the CRM software were able to reduce complaints by 50% each year over the next two years, how many complaints would there be by category at the end of that time period? What would the number of complaints at the end of two years represent on a percentage basis?

6.3 Buying a New Home

Knowing that home ownership is a good step toward a sound financial future, Jeremy and Catherine are excited about buying their first home. They saved and lived frugally the first four years of their marriage and added their savings to the money they received as wedding gifts. They are now ready to pay $20,000 toward their down payment. The house they are buying is in Lakeland, a good family-oriented location, and the results of a home inspection indicate that the house is built soundly. The foundation and roof are in good repair, but they would like to make several improvements on the home in the near future. The mortgage payments on their new home fit well within their budget, but they want to make certain they can afford the improvements as well.

Their first-priority improvement is to replace the carpeting. Jeremy recognized that their house was priced below market because the sellers knew the carpeting would need to be replaced. Catherine also knows that should they want to sell their home in the foreseeable future, nice carpeting would help the resale value and perhaps help it to sell more quickly. Their plan is to recarpet the three bedrooms, the living room, and the hallway. The dimensions of the rooms are as follows:

Room	Dimensions	Square Feet	Cost to Carpet
Master bedroom	16 ft by 18 ft		
Bedroom #1	12 ft by 13 ft		
Bedroom #2	10 ft by 12 ft		
Hallway	10 ft by 3 ft		
Living room	15 ft by 20 ft		
Total Cost			

1. Find the area of each room and record your results in the chart above. Hint: The area is found by multiplying length by width. The result is "square feet" and is written ft^2.

2. Jeremy and Catherine have comparison shopped the carpet retailers in their area. Because Lowe's can guarantee completion of the carpeting job within a week of closing, Jeremy and Catherine have decided to buy their carpet from Lowe's. Although they have not yet decided on a color, the grade of carpet Jeremy and Catherine are interested in costs $36 a square yard. How much does it cost per square foot? Hint: There are 9 square feet in a square yard.

3. How much will it cost to carpet the areas listed above? Report your answers by room in the chart above and then determine the total cost.

4. Lowe's is offering Jeremy and Catherine a 10% discount if they carpet the whole area with the same color carpet. How much will they save if they decide to do this?

5. Jeremy and Catherine feel they can pay $2,000 in cash for carpeting right now. How many square feet of carpet can they afford to buy with the cash they have? How much would they need to borrow if they decide to carpet all the areas listed above with the same color carpet?

6. How much would it cost to carpet only the bedrooms (assume no 10% discount)? How much would it cost to carpet only the living room and hallway (again, assume no discount)?

7. Jeremy would prefer to carpet the whole area at once with the same color carpeting rather than doing it room by room; however, he is hesitant to take out another loan since they will be taking out a mortgage at the same time. He would prefer to save the full amount so that they can pay cash for their entire purchase. How long would it take for them to have enough money if they can save $300 each month? Remember, they already have $2,000 to put toward their purchase.

Business Statistics

Big Business in the NFL

The sports business means many different things to different people. This is a truly global industry, and sports stir up deep passion within spectators and players alike in countries around the world. To athletes, sports may lead to high levels of personal achievement; and to professionals, sports can bring fame and fortune. To businesspeople, sports provide a lucrative and continually growing marketplace worthy of immense investment.

When the astonishing variety of sports-related sectors are considered, a significant portion of the workforce in developed nations such as the U.S., the U.K., Australia, and Japan rely on the sports industry for their livelihoods. Official U.S. Bureau of Labor Statistics figures state that 128,070 people work in U.S. spectator sports alone (including about 12,200 professional athletes), while 467,860 work in fitness centers, about 30,000 work in snow skiing facilities, and about 300,000 work at country clubs or golf courses. In total, approximately 1,339,000 Americans work directly in the amusement and recreation sectors.

Nowhere is the impact of sports-related marketing as prevalent as in the NFL. Experts say that the marketing of top stars has played a big role in driving the NFL's business to new heights, which has benefited everyone. Today's $1.4 million average salary is more than double the level in 1994. A look at NFL MVP salaries over the past 25 years shows that, overall, they made 3.3 times the average league salary during the 1980s, a ratio that rose to 5.3 in the 1990s, and to 6.2 times the average in the 2000s. Peyton Manning's $14.1 million salary in 2004 was more than ten times the $1.3 million average. The league's current television package brings in over $2 billion a year, or about $75 million per team.

Coinciding with the birth of the salary cap in the mid-1990s, of course, was the high-tech age. In the new media world, in which fans are interactively involved through games and online fantasy leagues in addition to television, football's "top down" star system is working. Business is booming in the NFL, with both television revenue and player salaries at record levels. Fantasy football and Madden video games, which help drive TV viewership, surely wouldn't be what they are without identifiable names like Peyton Manning, LaDainian Tomlinson, and Brett Favre.

LEARNING OUTCOMES

7-1 Measures of Central Tendency

1. Find the mean.
2. Find the median.
3. Find the mode.
4. Make and interpret a frequency distribution.
5. Find the mean of grouped data.

7-2 Graphs and Charts

1. Interpret and draw a bar graph.
2. Interpret and draw a line graph.
3. Interpret and draw a circle graph.

7-3 Measures of Dispersion

1. Find the range.
2. Find the standard deviation.

 A corresponding Business Math Case Video for this chapter, *How Many Baseball Cards?* can be found in Appendix A.

Galileo once said that mathematics is the language of science. In the 21st century, he might have said that mathematics is also the language of business. Through numbers, businesspeople communicate their business history, status, and goals. Statistics, tables, and graphs are three important tools with which to do so.

7-1 MEASURES OF CENTRAL TENDENCY

LEARNING OUTCOMES

1 Find the mean.
2 Find the median.
3 Find the mode.
4 Make and interpret a frequency distribution.
5 Find the mean of grouped data.

Data set: a collection of values or measurements that have a common characteristic.

Statistic: a standardized, meaningful measure of a set of data that reveals a certain feature or characteristic of the data.

All through the year, a business records its daily sales. At the end of the year, 365 values—one for each day—are on record. These values are a **data set**. With this data set, and using the right *statistical* methods, we may calculate manageable and meaningful information; this information is called **statistics**. Recording the statistics, we should be able to reconstruct—well enough—the original data set or make predictions about a future data set.

1 Find the mean.

Mean: the arithmetic average of a set of data or the sum of the values divided by the number of values.

One common statistic we may calculate for a data set is its mean. The **mean** is the statistical term for the ordinary arithmetic average. To find the mean, or arithmetic average, we divide the sum of the values by the total number of values.

HOW TO	Find the mean of a data set

Find the mean for these scores:
96, 86, 95, 89, 92.

1. Find the sum of the values. $96 + 86 + 95 + 89 + 92 = 458$
2. Divide the sum by the total number of values.

$$\text{Mean} = \frac{\text{sum of values}}{\text{number of values}}$$

$$\text{Mean} = \frac{458}{5} = 91.6$$

TABLE 7-1
Prices of Used Automobiles Sold in Tyreville over the Weekend of May 1–2

$7,850	$ 9,600
6,300	6,100
9,600	7,800
6,750	9,400
8,800	11,500
8,200	15,450

EXAMPLE 1 Find the mean used car price for the prices in Table 7-1. Round to the nearest ten dollars.

First find the sum of the values.

$$
\begin{array}{ll}
\$ \quad 7,850 & \text{Add all the prices.} \\
\quad 6,300 \\
\quad 9,600 \\
\quad 6,750 \\
\quad 8,800 \\
\quad 8,200 \\
\quad 9,600 \\
\quad 6,100 \\
\quad 7,800 \\
\quad 9,400 \\
\quad 11,500 \\
+\ 15,450 \\
\hline
\$107,350
\end{array}
$$

$\$107,350 \div 12 = \$8,945.8\overline{3}$ There are 12 prices listed, so find the mean by dividing the sum of the values by 12.

The mean price is $8,950, rounded to the nearest 10 dollars.

STOP AND CHECK

1. Find the mean salary to the nearest dollar: $37,500; $32,000; $28,800; $35,750; $29,500; $47,300.

2. Find the mean number of hours for the life of a lightbulb to the nearest whole hour: 2,400; 2,100; 1,800; 2,800; 3,450.

3. Find the mean number of days a patient stays in the hospital rounded to the nearest whole day: 2 days; 15 days; 7 days; 3 days; 1 day; 3 days; 5 days; 2 days; 4 days; 1 day; 2 days; 6 days; 4 days; 2 days.

4. Find the mean number of CDs purchased per month by college students: 12, 7, 5, 2, 1, 8, 0, 3, 1, 2, 7, 5, 30, 5, 2.

5. Find the mean for the Internal Revenue gross collection of estate taxes for a recent 10-year period: $9,633,736,000; $10,237,247,000; $10,411,450,000; $11,433,495,000; $13,500,126,000; $13,326,051,000; $15,350,591,000; $17,595,484,000; $21,314,933,000; $23,627,320,000. (*Source: IRS Data Book FY 2002*, Publication 55b)

2 Find the median.

Median: the middle value of a data set when the values are arranged in order of size.

A second kind of average is a statistic called the **median**. To find the median of a data set, we arrange the values in order from the smallest to the largest or from the largest to the smallest and select the value in the middle.

HOW TO Find the median of a data set

	Find the median for 22, 25, 28, 21, and 30.
1. Arrange the values in order from smallest to largest or largest to smallest.	21, 22, 25, 28, 30
2. Count the number of values.	five values
(a) If the number of values is odd, identify the value in the middle.	25
(b) If the number of values is even, find the mean of the middle two values.	
Median = middle value or mean of middle two values	median = 25

EXAMPLE 1 Find the median price of used cars in Table 7-1.

$15,450
11,500
9,600
9,600
9,400
8,800 ←
8,200 ←
7,850
7,800
6,750
6,300
6,100

Arrange the values from largest to smallest. There are 12 prices, an even number, so there are two "middle" prices.

These two are the "middle" values. Five values are above and 5 values are below these two values.

$$\frac{8,800 + 8,200}{2} = \frac{17,000}{2} = 8,500 \quad \text{Find the mean of the two middle values.}$$

The median price is $8,500.

1. Find the median salary: $37,500; $32,000; $28,800; $35,750; $29,500; $47,300.

2. Find the median number of hours for the life of a lightbulb: 2,400; 2,100; 1,800; 2,800; 3,450.

3. Find the median number of days a patient stays in the hospital: 2 days; 15 days; 7 days; 3 days; 1 day; 3 days; 5 days; 2 days; 4 days; 1 day; 2 days; 6 days; 4 days; 2 days.

4. Find the median number of CDs purchased per month by college students: 12, 7, 5, 2, 1, 8, 0, 3, 1, 2, 7, 5, 30, 5, 2.

5. Find the median Internal Revenue gross collection of estate taxes for a recent 10-year period: $9,633,736,000; $10,237,247,000; $10,411,450,000; $11,433,495,000; $13,500,126,000; $13,326,051,000; $15,350,591,000; $17,595,484,000; $21,314,933,000; $23,627,320,000. (*Source: IRS Data Book FY 2002,* Publication 55b)

3 Find the mode.

Mode: the value or values that occur most frequently in a data set.

A third kind of average is the **mode**. The mode is the value or values that occur most frequently in a data set. If no value occurs most frequently, then there is no mode for that data set. In Table 7-1 there are two cars priced at $9,600. The mode for that set of prices is $9,600.

HOW TO Find the mode(s) of a data set

Find the mode(s) for 95, 96, 98, 72, 96, 95, 96.

1. For each value, count the number of times the value occurs.

95 occurs twice.
96 occurs three times.
All others occur only once.

2. Identify the value or values that occur most frequently.
 Mode = most frequent value(s)

96 occurs most frequently.

96 is the mode.

EXAMPLE 1 Find the mode(s) for this set of test grades in a business class:
76, 83, 94, 76, 53, 83, 74, 76, 97, 83, 65, 77, 76, 83

The grade of 76 occurs four times. The grade of 83 also occurs four times. All other grades occur only once. Therefore, both 76 and 83 occur the same number of times and are modes.

Both 76 and 83 are modes for this set of test grades.

The mean, median, and mode may each be called an *average*. Taken together, the mean, median, and mode describe the tendencies of a data set to cluster between the smallest and largest values. Sometimes it is useful to know all three of these statistical averages, since each represents a different way of describing the data set. It is like looking at the same thing from three different points of view.

Looking at just one statistic for a set of numbers often distorts the total picture. It is advisable to find the mean, median, and mode of a data set and then analyze the results.

EXAMPLE 2 A real estate agent told a prospective buyer that the average cost of a home in Tyreville was $171,000 during the past three months. The agent based this statement on this list of selling prices: $270,000, $250,000, $150,000, $150,000, $150,000, $150,000, $149,000, $145,000, $125,000.

Which statistic—the mean, the median, or the mode—gives the most realistic picture of how much a home in Tyreville is likely to cost?

What You Know	What You Are Looking For	Solution Plan
Houses sold during the period: 9 Prices of these houses: $270,000, $250,000, $150,000, $150,000, $150,000, $150,000, $149,000, $145,000, and $125,000	Which statistic gives the most realistic picture of how much a home in Tyreville is likely to cost? Find the mean, median, and mode.	Mean = sum of values ÷ number of values Median = middle value when values are arranged in order Mode = most frequent value

Solution

Mean = sum of values ÷ number of values
$$= \$1,539,000 \div 9$$
$$= \$171,000$$

The values are listed in order from largest to smallest, and the middle value is $150,000.
Median = middle value = $150,000
Mode = most frequent amount = $150,000
The mean is $171,000. The median is $150,000. The mode is $150,000.

Conclusion

Since two values are significantly different from the other values, the mean is probably not the most useful statistic.

The median and mode give a more realistic picture of how much a home is likely to cost—about $150,000.

 STOP AND CHECK

1. From Table 7-2 find the mode score for vacation days.

2. State sales tax rates are given in Table 7-3. What is the mode?

TABLE 7-2
Number of Vacation Days Accumulated by Staff at Tulsa Community College

2	62	7	23	32	48	32	92	48
56	17	0	12	19	21	9	17	32
32	86	73	74	18	32	18	66	6
38	62	32	48	32	48	83	32	23

TABLE 7-3
State Sales Tax Rates

State	Tax Rate	State	Tax Rate	State	Tax Rate
Alabama	4	Louisiana	4	Ohio	5
Alaska	0	Maine	5	Oklahoma	4.5
Arizona	5.6	Maryland	5	Oregon	0
Arkansas	5.125	Massachusetts	5	Pennsylvania	6
California	7.25	Michigan	6	Rhode Island	7
Colorado	2.9	Minnesota	6.5	South Carolina	5
Connecticut	6	Mississippi	7	South Dakota	4
Delaware	0	Missouri	4.225	Tennessee	7
Florida	6	Montana	0	Texas	6.25
Georgia	4	Nebraska	5.5	Utah	4.75
Hawaii	4	Nevada	6.5	Vermont	5
Idaho	5	New Hampshire	0	Virginia	4.5
Illinois	6.25	New Jersey	6	Washington	6.5
Indiana	6	New Mexico	5	West Virginia	6
Iowa	5	New York	4	Wisconsin	5
Kansas	5.3	North Carolina	4.5	Wyoming	4
Kentucky	6	North Dakota	5		

Compiled by Federation of Tax Administrators from various sources.

(continued)

 STOP AND CHECK—*continued*

3. Michelle Baragona recorded the test scores on a biology exam. Find the mode score: 98, 92, 76, 48, 97, 83, 42, 86, 79, 100.

4. What is the mode score for number of points scored by players in the season-opening basketball game?

Baragona 11	Kennedy 7
Byrd 8	Nock 22
Freese 2	Pounds 0
Guest 12	Ramsey 11

5. What is the mode weight of soccer players?
148, 172, 158, 160, 170, 158, 170, 165, 162, 173, 155, 161

4 Make and interpret a frequency distribution.

Suppose for a class of 25 students the instructor records the following grades:

76	91	71	83	97	87	77	88	93	77	93	81	63
79	74	77	76	97	87	89	68	90	84	88	91	

Class intervals: special categories for grouping the values in a data set.

Tally: a mark that is used to count data in class intervals.

Class frequency: the number of tallies or values in a class interval.

Grouped frequency distribution: a compilation of class intervals, tallies, and class frequencies of a data set.

It is difficult to make sense of all these numbers as they appear here. But the instructor can arrange the scores into several smaller groups, called **class intervals**. The word *class* means a special category.

These scores can be grouped into class intervals of 5, such as 60–64, 65–69, 70–74, 75–79, 80–84, 85–89, 90–94, and 95–99. Each class interval has an odd number of scores.

The instructor can now **tally** the number of scores that fall into each class interval to get a **class frequency**, the number of scores in each class interval.

A compilation of class intervals, tallies, and class frequencies is called a **grouped frequency distribution**.

HOW TO Make a frequency distribution

1. Identify appropriate intervals for the data.
2. Tally the data for the intervals.
3. Count the number in each interval.

EXAMPLE 1 Examine the grouped frequency distribution in Table 7-4, and answer the questions.

(a) How many students scored 70 or above?

$$2 + 6 + 3 + 5 + 5 + 2 = 23$$ Add the frequencies for class intervals with scores 70 or higher.

23 students scored 70 or above.

TABLE 7-4
Frequency Distribution of 25 Scores

Class Interval	Tally	Class Frequency
60–64	/	1
65–69	/	1
70–74	//	2
75–79	⊬⊦⊦ /	6
80–84	///	3
85–89	⊬⊦⊦	5
90–94	⊬⊦⊦	5
95–99	//	2
		25

(b) How many students made As (90 or higher)?

$$5 + 2 = 7$$

Add the frequencies for class intervals 90–94 and 95–99.

7 students made As (90 or higher).

(c) What percent of the total grades were As (90s)?

$$\frac{7 \text{ As}}{25 \text{ total}} = \frac{7}{25} = 0.28 = 28\% \text{ As}$$

The portion or part is 7 and the base or total is 25.

(d) Were the students prepared for the test or was the test too difficult?

The relatively high number of 90s (7) compared to the relatively low number of 60s (2) suggests that **in general, most students were prepared for the test**.

(e) What is the ratio of As (90s) to Fs (60s)?

$$\frac{7 \text{ As}}{2 \text{ Fs}} = \frac{7}{2}$$

The ratio is $\frac{7}{2}$.

Sometimes you want more information about how data are distributed. For instance, you may want to know how each class interval of a frequency distribution relates to the whole set of data. This information is called a relative frequency distribution. A **relative frequency distribution** is the percent that each class interval of a frequency distribution relates to the whole.

HOW TO Make a relative frequency distribution

1. Make the frequency distribution.
2. Calculate the percent that the frequency of each class interval is of the total number of data items in the set.

$$\text{Relative frequency} = \frac{\text{class interval frequency}}{\text{total number in the data set}} \times 100\%$$

EXAMPLE 2 Make a relative frequency distribution of the data in Table 7-4.

Class interval	Class frequency	Calculations	Relative frequency
60–64	1	$\frac{1}{25}(100\%) = \frac{100\%}{25} = 4\%$	4%
65–69	1	$\frac{1}{25}(100\%) = \frac{100\%}{25} = 4\%$	4%
70–74	2	$\frac{2}{25}(100\%) = \frac{200\%}{25} = 8\%$	8%
75–79	6	$\frac{6}{25}(100\%) = \frac{600\%}{25} = 24\%$	24%
80–84	3	$\frac{3}{25}(100\%) = \frac{300\%}{25} = 12\%$	12%
85–89	5	$\frac{5}{25}(100\%) = \frac{500\%}{25} = 20\%$	20%
90–94	5	$\frac{5}{25}(100\%) = \frac{500\%}{25} = 20\%$	20%
95–99	2	$\frac{2}{25}(100\%) = \frac{200\%}{25} = 8\%$	8%
Total	25		100%

1. Make a frequency distribution for the number of vacation days accumulated by staff at Tulsa Community College (Table 7-2). Use intervals 0–19, 20–39, 40–59, 60–79, and 80–99.

Use the frequency distribution to answer the questions.

2. How many staff have more than 39 vacation days?

3. How many staff have fewer than 40 vacation days?

4. What percent of the staff have 80 or more vacation days? Round to the nearest tenth of a percent.

5. What percent of the staff have 20 to 59 vacation days? Round to the nearest tenth of a percent.

6. Make a relative frequency distribution of the data in Table 7-2 on page 217. Round percents to the nearest tenth percent.

5 Find the mean of grouped data.

When data are grouped, it may be desirable to find the mean of the grouped data. To do this we extend our frequency distribution.

HOW TO	Find the mean of grouped data

1. Make a frequency distribution.
2. Find the products of the midpoint of the interval and the frequency for each interval for all intervals.
3. Find the sum of the frequencies.
4. Find the sum of the products from Step 2.
5. Divide the sum of the products by the sum of the frequencies.

$$\text{Mean of grouped data} = \frac{\text{sum of the products of the midpoints and the frequencies}}{\text{sum of the frequencies}}$$

EXAMPLE 1 Find the grouped mean of the scores in Table 7-4.

Find the midpoint of each class interval:

$$\frac{60 + 64}{2} = \frac{124}{2} = 62 \qquad \frac{65 + 69}{2} = \frac{134}{2} = 67 \qquad \frac{70 + 74}{2} = \frac{144}{2} = 72$$

$$\frac{75 + 79}{2} = \frac{154}{2} = 77 \qquad \frac{80 + 84}{2} = \frac{164}{2} = 82 \qquad \frac{85 + 89}{2} = \frac{174}{2} = 87$$

$$\frac{90 + 94}{2} = \frac{184}{2} = 92 \qquad \frac{95 + 99}{2} = \frac{194}{2} = 97$$

Class interval	Class frequency	Midpoint	Product of midpoint and frequency
60–64	1	62	62
65–69	1	67	67
70–74	2	72	144
75–79	6	77	462
80–84	3	82	246
85–89	5	87	435
90–94	5	92	460
95–99	2	97	194
Total	25		2,070

$$\text{Mean of grouped data} = \frac{\text{sum of the products of the midpoints and the frequencies}}{\text{sum of the frequencies}}$$

$$= \frac{2,070}{25}$$

$$= 82.8$$

The grouped mean of the scores is 82.8.

TIP

Is the Mean of Grouped Data Exact?

No. The mean of grouped data is based on the assumption that all the data in an interval have a mean that is exactly equal to the midpoint of the interval. Because this is usually not the case, the mean of grouped data is a reasonable approximation.

 STOP AND CHECK

1. Find the grouped mean of the scores in Table 7-2 on page 217. Round to tenths.

2. Use the grouped frequency distribution in Table 7-5 to find the grouped mean. Round to hundredths.

3. Find the grouped mean to the nearest whole number of the data in the frequency distribution in Table 7-6. Round to hundredths.

TABLE 7-5
Frequency Distribution of 25 Scores

Class interval	Midpoint	Class frequency
60–64	62	6
65–69	67	8
70–74	72	12
75–79	77	22
80–84	82	18
85–89	87	9

TABLE 7-6
Frequency Distribution of Credit-Hour Loads

Class interval	Midpoint	Class frequency
0–4	2	3
5–9	7	7
10–14	12	4
15–19	17	2
Total		16

Mean of grouped data = 8.56

7-1 SECTION EXERCISES

SKILL BUILDERS

1. Find the mean for the scores: 3,850; 5,300; 8,550; 4,300; 5,350.

2. Find the mean for the amounts: 92, 68, 72, 83, 72, 95, 88, 76, 72, 89, 89, 96, 74, 72. Round to the nearest whole number.

3. Find the mean for the amounts: $17,485; $14,978; $13,592; $14,500; $18,540; $14,978. Round to the nearest whole number.

4. Find the median for the scores: 3,850; 5,300; 8,550; 4,300; 5,350.

5. Find the median for the scores: 92, 68, 72, 83, 72, 95, 88, 76, 72, 89, 89, 96, 74, 72.

6. Find the median for the amounts: $17,485; $14,978; $13,592; $14,500; $18,540; $14,978.

7. Find the mode for the scores: 3,850; 5,300; 8,550; 4,300; 5,350.

8. Find the mode for the scores: 92, 68, 72, 83, 72, 95, 88, 76, 72, 89, 89, 96, 74, 72.

9. Find the mode for the amounts: $17,485; $14,978; $13,592; $14,500; $18,540; $14,978.

APPLICATIONS

10. Weekly expenses of students taking a business mathematics class are shown in Table 7-7.
 a. Find the mean rounded to the nearest whole number.
 b. Find the median.
 c. Find the mode.

TABLE 7-7 Weekly Expenses of Students												
89	42	78	156	67	85	92	80	55	75	85	99	88
90	85	95	100	95	79	93	56	78	81	84	105	77

11. Salaries for the research and development department of Richman Chemical are given as $48,397; $27,982; $42,591; $19,522; $32,400; and $37,582.
 a. Find the mean rounded to the nearest dollar.
 b. Find the median.
 c. Find the mode.

12. Sales in thousands of dollars for men's suits at a Macy's department store for a 12-month period were $127; $215; $135; $842; $687; $512; $687; $742; $984; $752; $984; $1,992.
 a. Find the mean rounded to the nearest whole thousand.
 b. Find the median.
 c. Find the mode.

13. Accountants often use the median when studying salaries for various businesses. What is the median of the following salary list: $32,084, $21,983, $27,596, $43,702, $38,840, $25,997?

14. Weather forecasters sometimes give the average (mean) temperature for a particular city. The following temperatures were recorded as highs on June 30 of the last 10 years in a certain city: 89°, 88°, 90°, 92°, 95°, 89°, 93°, 98°, 93°, 97°. What is the mean high temperature for June 30 for the last 10 years?

15. The following grades were earned by students on a mid-term business math exam:

75	82	63	88	94
81	90	72	84	87
98	93	85	68	91
78	86	91	83	92

Make a frequency distribution of the data using the intervals 60–69, 70–79, 80–89, and 90–99.

16. What percent of the students in Exercise 15 earned a grade that was below 80?

17. The 7th Inning wants to group a collection of autographed photos by price ranges. Make a frequency distribution of the prices using the intervals $0–$9.99, $10–$19.99, $20–$29.99, $30–$39.99, and $40–$49.99.

$2.50	$3.75	$1.25	$21.50	$43.00	$15.00
$26.00	$14.50	$12.75	$35.00	$37.50	$48.00
$7.50	$6.50	$7.50	$8.00	$12.50	$15.00
$9.50	$8.25	$14.00	$25.00	$18.50	$45.00
$32.50	$20.00	$10.00	$17.50	$6.75	$28.50

18. In Exercise 17, what percent to the nearest whole percent of the collection is priced below $20?

19. In Exercise 17, what percent of the collection is priced $40 or over?

20. Use the given hourly rates (rounded to the nearest whole dollar) for 35 support employees in a private college to complete the frequency distribution and find the grouped mean rounded to the nearest cent.

$14	$16	$9	$10	$12	$13	$15
$11	$12	$16	$17	$22	$19	$28
$18	$16	$12	$9	$11	$12	$17
$26	$16	$18	$21	$18	$16	$14
$10	$13	$12	$15	$12	$12	$9

Class interval	Tally	Class frequency	Midpoint	Product of midpoint and frequency
6–10				
11–15				
16–20				
21–25				
26–30				
Total				

7-2 GRAPHS AND CHARTS

LEARNING OUTCOMES

1 Interpret and draw a bar graph.
2 Interpret and draw a line graph.
3 Interpret and draw a circle graph.

Scan a newspaper, a magazine, or a business report, and you are likely to see graphs. Graphs do more than present sets of data. They make visual the relationship between the sets. The relationship between data sets might be visualized by a bar graph, a line graph, or a circle graph. Depending on "what you want to see," one of these forms helps you to see the relationship more meaningfully.

1 Interpret and draw a bar graph.

Bar graph: a graph that uses horizontal or vertical bars to show how values compare to each other.

Bar graphs are used to make visual the relationship between data. As its name implies, a bar graph uses horizontal or vertical bars to show relative quantities. Figure 7-1 is a bar graph representing the data in the frequency distribution of the 25 scores in Table 7-4.

Along the bottom of the bar graph are the class intervals that correspond to the first column of Table 7-4. Along the left side of the bar graph is a scale from 0 to 6. In relation to the scale, each bar corresponds to the class frequency.

Figure 7-1 demonstrates why bar graphs are so useful: We can easily compare the scores for grade intervals at a glance.

FIGURE 7-1
Distribution of 25 Scores Grouped

EXAMPLE 1 Answer the questions using the data represented in Figure 7-1.

(a) Which grade interval(s) had the highest number of scores?
(b) Which grade interval(s) had the lowest number of scores?
(c) If 90–99 is a grade of A, how many As were there?

(a) Which grade interval(s) had the highest number of scores?

The interval 75–79 had the highest number of scores, 6.

(b) Which grade interval(s) had the lowest number of scores?

The intervals 60–64 and 65–69 had the lowest number of scores, 1.

(c) If 90–99 is a grade of A, how many As were there?

There are 5 scores in the 90–94 interval and 2 scores in the 95–99 interval. There are 5 + 2 or **7 scores that are As.**

A **histogram** is a special type of bar graph that represents the data from a frequency distribution. Figure 7-1 is a histogram. Since there are no gaps in the intervals, the bars in a histogram are drawn with no space between them.

> **Histogram:** a special type of bar graph that represents the data from a frequency distribution.

HOW TO Draw a bar graph

1. Write an appropriate title.
2. Make appropriate labels for the bars and scale. The intervals on the scale should be equally spaced and include the smallest and largest values.
3. Draw bars to represent the data. Bars should be of uniform width.
4. Make additional notes as appropriate. For example, "Amounts in Thousands of Dollars" allows values such as $30,000 to be represented as 30.

EXAMPLE 2 The data show Corky's Barbecue Restaurant sales during January through June. Draw a bar graph that represents the data.

January	$37,734	April	$52,175
February	$43,284	May	$56,394
March	$58,107	June	$63,784

The title of the graph is "Corky's Barbecue Restaurant Sales, January–June."

The smallest value is $37,734 and the largest value is $63,784. Therefore, the graph should show values from $30,000 to $70,000. To avoid using very large numbers, indicate on the graph that the numbers represent dollars in thousands. Therefore, 65 on the graph would represent $65,000. The bars can be either horizontal or vertical. In Figure 7-2 we make the bars horizontal. Months are labeled along the vertical line, and the dollar scale is labeled along the horizontal line. For each month, the length of the bar corresponds to the sales for the month.

Figure 7-3 interchanges the labeling of the scales, and the bars are drawn vertically.

FIGURE 7-2
Horizontal Bar Graph Showing Corky's Barbecue Restaurant Sales, January–June

FIGURE 7-3
Vertical Bar Graph Showing Corky's Barbecue Restaurant Sales, January–June

> **Standard bar graph:** bar graph with just one variable.

Bar graphs may illustrate relationships among more than one variable. A **standard bar graph** illustrates the change in magnitude of just one variable. Figure 7-2 is a standard bar graph. A **comparative bar graph** is used to illustrate two or more related variables. The bars representing each variable are shaded or colored differently so that visual comparisons can be made more easily. Figure 7-4 is a comparative bar graph.

A **component bar graph** is used to show that each bar is the total of various components. The components are stacked immediately next to each other and shaded or colored differently. Figure 7-5 is a component bar graph.

TIP

Constructing Graphs Electronically

Electronic spreadsheets have a function that translates the data from a spreadsheet to various types of graphs, also called *charts*. The type of graph (bar, line, circle), titles of scales, and labels are still determined by the user. The software then produces the graph electronically.

Comparative bar graph: bar graph with two or more variables.

FIGURE 7-4
The 7th Inning Sales by Department

Component bar graph: bar graph with each bar having more than one component.

FIGURE 7-5
The 7th Inning Annual Sales

STOP AND CHECK

1. Use the frequency distribution for Table 7-2 (Stop and Check, Exercise 1 on page 217) to construct a bar graph.

2. From the graph identify the number of vacation days (interval) that 12 staff members have.

Fifty business students were given a project to complete. The bar graph in Figure 7-6 shows the number of days it took the students to complete the assignment.

3. How many students took 4 days to complete the assignment?

4. How many students completed the project in 3 days or less?

5. What percent of students completed the project in 3 days or less?

FIGURE 7-6

2 Interpret and draw a line graph.

Line graphs are very similar to vertical bar graphs. The difference is that a line graph uses a single dot to represent height, rather than a whole bar. When the dots are in place, they are connected by a line. Line graphs make even more apparent the rising and falling trends of the data. Figure 7-7 is a line graph representing the data in the vertical bar graph in Figure 7-3.

Line graphs may have enough points that connecting them yields a curve rather than angles. Figure 7-8 shows such a line graph, relating the time film is developed to the degree of contrast achieved in the developed film. To read the graph, we locate a specific degree of contrast on the vertical scale, and then move horizontally until we intersect the curve. From that point, we move down to locate the corresponding number of minutes on the horizontal scale.

EXAMPLE 1 Use Figure 7-8 to answer the following questions:

(a) If the film is to be developed to a contrast of 0.5, how long must it be developed?
(b) If the film is developed for 13 minutes, what is its degree of contrast?

(a) Find 0.5 on the vertical scale, and then move horizontally until you intersect the curve. From the point of intersection, move down to locate the corresponding number of minutes on the horizontal scale. **Figure 7-9 shows the minutes are 9.**
(b) Find 13 minutes on the horizontal scale, and move up until you intersect the curve. From the point of intersection, move across to locate the corresponding degree of contrast. **Figure 7-9 shows the degree of contrast is 0.7.**

FIGURE 7-7

Line Graph Showing Corky's Barbecue Restaurant Sales, January–June

FIGURE 7-8

Developing Time Required for Degrees of Contrast

FIGURE 7-9

Reading a Line Graph

As in drawing bar graphs, drawing line graphs often means using approximations of the given data.

HOW TO Draw a line graph

1. Write an appropriate title.
2. Make and label appropriate horizontal and vertical scales, each with equally spaced intervals. Often, the horizontal scale represents time.
3. Use points to locate data on the graph.
4. Connect data points with line segments or a smooth curve.

TABLE 7-8
Neighborhood Grocery Daily Sales for Week Beginning Monday, June 21

Monday	$1,567
Tuesday	1,323
Wednesday	1,237
Thursday	1,435
Friday	1,848
Saturday	1,984

EXAMPLE 2 Draw a line graph to represent the data in Table 7-8.

The smallest and greatest values in the table are $1,237 and $1,984, respectively, so the graph may go from $1,000 to $2,000 in $100 increments. Do not label every increment. This would crowd the side of the graph and make it hard to read. The purpose of any graph is to give information that is quick and easy to understand and interpret.

The horizontal side of the graph will show the days of the week, and the vertical side will show the daily sales. Plot each day's sales by placing a dot directly above the appropriate day of the week across from the approximate value. For example, the sales for Monday totaled $1,567. Place the dot above Monday between $1,500 and $1,600. After each amount has been plotted, connect the dots with straight lines.

Figure 7-10 shows the resulting graph.

FIGURE 7-10
Neighborhood Grocery Daily Sales for Week
Beginning Monday, June 21

Days of the Week

 STOP AND CHECK

1. Draw a line graph to represent the data in Table 7-9.

TABLE 7-9	
Personal Income for March 2003–September 2003 (Billions of dollars)	
March 2003	9,102.0
April 2003	9,119.8
May 2003	9,155.4
June 2003	9,192.9
July 2003	9,219.4
August 2003	9,248.9
September 2003	9,277.5

Source: Bureau of Economic Analysis, an agency of the U.S. Department of Commerce.

2. Is the graph in Exercise 1 increasing, decreasing, or fluctuating?

3. Which month showed the highest personal income?

4. Is the graph in Figure 7-11 increasing, decreasing, or fluctuating?

5. Find the monthly average number of CDs sold by House of Music for the 6-month period January–June.

FIGURE 7-11

CDs sold by House of Music

3 Interpret and draw a circle graph.

Circle graph: a circle that is divided into parts to show how a whole quantity is being divided.

A **circle graph** is a circle divided into sections to give a visual picture of *how some whole quantity* (represented by the whole circle) *is being divided*. Each section represents a portion of the total amount. Figure 7-12 shows a circle graph illustrating how different portions of a family's total take-home income are spent on nine categories of expenses: food, housing, contributions, savings, clothing, insurance, education, personal items, and miscellaneous items.

FIGURE 7-12
Distribution of Family Monthly Take-Home Pay

Circle graphs are relatively easy to read, and they make it easy to visually compare categories. Constructing a circle graph requires that you make several calculations and use a measuring device called a **protractor** that measures angles. Each value in the data set should be represented as a fraction of the sum of all the values. We calculate these fractions and then draw the graph.

Protractor: a measuring device that measures angles.

HOW TO Draw a circle graph

1. Write an appropriate title.
2. Find the sum of the values in the data set.
3. Represent each value as a fractional or decimal part of the sum of values.
4. For each fraction or decimal, find the number of degrees in the **sector** of the circle to be represented by the fraction or decimal: Multiply the fraction or decimal by 360 degrees. The sum of the degrees for all sectors should be 360 degrees.
5. Use a **compass** (a tool for drawing circles) to draw a circle. Indicate the center of the circle and a starting point on the circle.
6. For each degree value, draw a sector: Use a protractor (a measuring instrument for angles) to measure the number of degrees for the sector of the circle to be represented by the value. Where the first sector ends, the next sector begins. The last sector should end at the starting point.
7. Label each sector of the circle and make additional explanatory notes as necessary.

Sector: portion or wedge of a circle identified by two lines from the center to the outer edge of the circle.

Compass: a tool for drawing circles.

EXAMPLE 1 Construct a circle graph showing the budgeted operating expenses for one month for Silver's Spa: salary, $25,000; rent, $8,500; depreciation, $2,500; miscellaneous, $2,000; taxes and insurance, $10,000; utilities, $2,000; advertising, $3,000. The title of the graph is "Silver's Spa Monthly Budgeted Operating Expenses."

Since several calculations are required, it is helpful to organize the calculation results in a chart (Table 7-10).

TABLE 7-10
Silver's Spa Monthly Budgeted Operating Expenses

Type of Expense	Amount of Expense	Expense as Fraction of Total Expenses	Degrees in Sector: Fraction × 360
Salary	$25,000	$\frac{25,000}{53,000}$ or $\frac{25}{53}$	$\frac{25}{53}(360)$, or 170
Rent	8,500	$\frac{8,500}{53,000}$ or $\frac{17}{106}$	$\frac{17}{106}(360)$, or 58
Depreciation	2,500	$\frac{2,500}{53,000}$ or $\frac{5}{106}$	$\frac{5}{106}(360)$, or 17
Miscellaneous	2,000	$\frac{2,000}{53,000}$ or $\frac{2}{53}$	$\frac{2}{53}(360)$, or 14
Taxes and insurance	10,000	$\frac{10,000}{53,000}$ or $\frac{10}{53}$	$\frac{10}{53}(360)$, or 68
Utilities	2,000	$\frac{2,000}{53,000}$ or $\frac{2}{53}$	$\frac{2}{53}(360)$, or 14
Advertising	3,000	$\frac{3,000}{53,000}$ or $\frac{3}{53}$	$\frac{3}{53}(360)$, or 20
Total	$53,000	1	361*

*Extra degree due to rounding.

Decimal equivalents can be used instead of fractions of total expenses. The sum of the fractions or decimal equivalents is 1. To the nearest thousandth, the decimal equivalents are 0.472, 0.160, 0.047, 0.038, 0.189, 0.038, and 0.057. The sum is 1.001. Rounding causes the sum to be slightly more than 1, just as the sum of the degrees is slightly more than 360°.

Use a compass to draw a circle. Measure the sectors of the circle with a protractor, using the calculations you just made. **The finished circle graph is shown in Figure 7-13.**

FIGURE 7-13
Monthly Budgeted Operating Expenses for Silver's Spa

✔ STOP AND CHECK

1. Construct a circle graph showing the distribution of market share using data in Table 7-11.

TABLE 7-11
Percent Dollar Market Share of Comics and Magazine Sales for September (Rounded to the Nearest Whole Percent)

Publisher	Market Share
Marvel Comics	35%
DC Comics	32%
Image Comics	5%
Dark Horse Comics	4%
Dreamweave Productions	4%
All others	20%

2. What percent of market share is held by the largest three companies?

3. If the total market had $80,000,000 in comics and magazine sales for September, what were the sales for Marvel Comics?

4. What was Image Comics' sales for September if the total market was $80,000,000?

7-2 SECTION EXERCISES

APPLICATIONS

Use Table 7-12 for Exercises 1–4.

TABLE 7-12
Sales by Each Salesperson at Happy's Gift Shoppe

			Sales				
Salesperson	**Mon.**	**Tues.**	**Wed.**	**Thurs.**	**Fri.**	**Sat.**	**Total**
Brown	Off	$110.25	$114.52	$186.42	$126.81	$315.60	$ 853.60
Jackson	$121.68	Off	$118.29	Off	$125.42	Off	$ 365.39
Ulster	$112.26	$119.40	$122.35	$174.51	$116.78	Off	$ 645.30
Young	Off	$122.90	Off	$181.25	Off	$296.17	$ 600.32
Totals	**$233.94**	**$352.55**	**$355.16**	**$542.18**	**$369.01**	**$611.77**	**$2,464.61**

1. What day of the week had the highest amount in sales? What day had the lowest amount in sales?

2. Which salesperson made the most sales for the week? Which salesperson made the second highest amount in sales?

3. Construct a bar graph showing total sales by salesperson for Happy's Gift Shoppe in Table 7-12.

4. Construct a bar graph showing total sales by the days of the week for Happy's Gift Shoppe in Table 7-12.

Use Figure 7-14 for Exercises 5–7.

5. Which quarter had the highest dollar volume?

6. What percent of the yearly sales were the sales for October–December?

7. What was the percent of increase in sales from the first to the second quarter?

FIGURE 7-14

Quarterly Dollar Volume of Batesville Tire Company

8. Draw a bar graph comparing the quarterly sales of the Oxford Company: January–March, $280,000; April–June, $310,000; July–September, $250,000; October–December, $400,000.

Use Figure 7-15 for Exercises 9–12.

FIGURE 7-15
Automobile Gasoline Mileage Comparisons

9. What speed gave the highest gasoline mileage for both types of automobiles?

10. What speed gave the lowest gasoline mileage for both types of automobiles?

11. At what speed did the first noticeable decrease in gasoline mileage occur? Which car showed this decrease?

12. Identify factors other than gasoline mileage that should be considered when deciding which type of car to purchase, full size or compact.

13. The family budget is illustrated in Figure 7-16. What is the total take-home pay and what percent is allocated for transportation?

14. Match the dollar values with the names in the circle graph of Figure 7-17: $192, $144, $96, $72, $72.

FIGURE 7-16
Distribution of Family Monthly Take-Home Pay

FIGURE 7-17
Daily Sales by Salesperson

Use Figure 7-12 on page 229 for Exercises 15 through 17.

15. What percent of the take-home pay is allocated for food?

16. What percent of take-home pay is spent for education?

17. What percent of take-home pay is spent for education if education, savings, and miscellaneous funds are used for education?

Use Figure 7-18 for Exercises 18–21. Round to the nearest tenth of a percent.

FIGURE 7-18
Dale Crosby's Salary History

18. What is the percent of increase in Dale's salary from 2003 to 2004?

19. Calculate the amount and percent of increase in Dale's salary from 2005 to 2006.

20. Calculate the amount and percent of increase in Dale's salary from 2007 to 2008.

21. If the cost-of-living increase was 10% from 2002 to 2008, determine if Dale's salary for this period of time kept pace with inflation.

7-3 MEASURES OF DISPERSION

LEARNING OUTCOMES

1 Find the range.
2 Find the standard deviation.

Measures of central tendency: statistical measurements such as the mean, median, or mode that indicate how data group toward the center.

Measures of variation or dispersion: statistical measurements such as the range and standard deviation that indicate how data are dispersed or spread.

Spread: the variation or dispersion of a set of data.

Range: the difference between the highest and lowest values in a data set.

The mean, the median, and the mode are **measures of central tendency**. Another group of statistical measures is **measures of variation or dispersion**. The variation or dispersion of a set of data may also be referred to as the **spread**.

1 Find the range.

One measure of dispersion of a set of data is the **range**. The range is the difference between the highest value and the lowest value in a set of data.

HOW TO	Find the range

1. Find the highest and lowest values.
2. Find the difference between the highest and lowest values.

EXAMPLE 1 **EXAMPLE 1** Find the range for the data in Table 7-1 in the example on page 214 for prices of used automobiles sold.

The high value is $15,450. The low value is $6,100.
Range = $15,450 − $6,100 = **$9,350.**

TIP

Use More Than One Statistical Measure

A common mistake when making conclusions or inferences from statistical measures is to examine only one statistic, such as the range. To obtain a complete picture of the data requires looking at more than one statistic.

 STOP AND CHECK

1. Find the range for salary: $37,500; $32,000; $28,800; $35,750; $29,500; $47,300.

2. Find the range for the number of hours for the life of a lightbulb: 2,400; 2,100; 1,800; 2,800; 3,450.

3. Find the range for the number of days a patient stays in the hospital: 2 days; 15 days; 7 days; 3 days; 1 day; 3 days; 5 days; 2 days; 4 days; 1 day; 2 days; 6 days; 4 days; 2 days.

4. Find the range for the number of CDs purchased per month by college students: 12, 7, 5, 2, 1, 8, 0, 3, 1, 2, 7, 5, 30, 5, 2.

5. Find the range for the Internal Revenue gross collection of estate taxes for a recent 10-year period: $9,633,736,000; $10,237,247,000; $10,411,450,000; $11,433,495,000; $13,500,126,000; $13,326,051,000; $15,350,591,000; $17,595,484,000; $21,314,933,000; $23,627,320,000. (*Source: IRS Data Book FY 2002*, Publication 55b)

2 Find the standard deviation.

Although the range gives us some information about dispersion, it does not tell us whether the highest or lowest values are typical values or extreme *outliers*. We can get a clearer picture of the data set by examining how much each data point *differs* or *deviates* from the mean.

The **deviation from the mean** of a data value is the difference between the value and the mean.

Deviation from the mean: the difference between a value of a data set and the mean.

HOW TO Find the deviations from the mean

Data set: 38, 43, 45, 44.

1. Find the mean of the set of data.

$$\text{Mean} = \frac{\text{sum of data values}}{\text{number of values}}$$

$$\frac{38 + 43 + 45 + 44}{4} = \frac{170}{4} = 42.5$$

2. Find the amount that each data value deviates or is different from the mean.

Deviation from the mean = data value − mean

38 − 42.5 = −4.5 (below the mean)
43 − 42.5 = 0.5 (above the mean)
45 − 42.5 = 2.5 (above the mean)
44 − 42.5 = 1.5 (above the mean)

When the value is smaller than the mean, the difference is represented by a *negative* number, indicating the value is *below* or less than the mean. When the value is larger than the mean, the difference is represented by a positive number, indicating the value is *above* or greater than the mean. In the example in the How To feature, only one value is below the mean, and its deviation is −4.5. Three values are above the mean, and the sum of these deviations is $0.5 + 2.5 + 1.5 = 4.5$. We say that *the sum of all deviations from the mean is zero*. This is true for all sets of data.

EXAMPLE 1

Find the deviations from the mean for the set of data 45, 63, 87, and 91.

$$\frac{\text{Sum of values}}{\text{Number of values}} = \frac{45 + 63 + 87 + 91}{4} = \frac{286}{4} = 71.5 \quad \text{Mean}$$

To find the deviation from the mean, subtract the mean from each value. We arrange these values in a table.

Data Values	Deviations (Data Value − Mean)
45	$45 - 71.5 = -26.5$
63	$63 - 71.5 = -8.5$
87	$87 - 71.5 = 15.5$
91	$91 - 71.5 = 19.5$

The sum of deviations are found as follows:

Opposites: a positive and negative number that represent the same distance from 0 but in opposite directions.

$-26.5 + -8.5 = -35$	The sum of two negative numbers is negative.
$15.5 + 19.5 = 35$	The sum of two positive numbers is positive.
$-35 + 35 = 0$	−35 and 35 are **opposites**. The sum of opposites is 0.

TIP

Adding and Subtracting Negative Numbers

Some business applications involve negative numbers. A combination of positive and negative numbers is referred to as **signed numbers**. We will introduce the appropriate rules for signed numbers as they are needed.

Signed numbers: a combination of positive and negative numbers.

When subtracting a larger number from a smaller number, the result is a negative number.

$$45 - 71.5 = -26.5$$

To perform the subtraction, subtract 45 from 71.5 and assign the difference the negative sign. When adding two negative numbers, the sum is also negative. $-26.5 + -8.5 = -35$.

We have not gained any statistical insight or new information by analyzing the sum of the deviations from the mean or even by analyzing the average of the deviations.

$$\text{Average deviation} = \frac{\text{sum of deviations}}{\text{number of values}} = \frac{0}{n} = 0$$

Standard deviation: a statistical measurement that shows how data are spread above and below the mean. The square root of the variance is the standard deviation.

To compensate for this situation, we use a statistical measure called the **standard deviation**, which uses the square of each deviation from the mean. The square of a negative value is always positive. The squared deviations are averaged (mean), and the result is called the **variance**.

Variance: a statistical measurement that is the average of the squared deviations of data from the mean.

The square root of the variance is taken so that the result can be interpreted within the context of the problem. Various formulas exist for finding the standard deviation of a set of values, but we examine only one formula, the formula for a sample of data or a small data set. This formula averages the values by dividing by 1 less than the number of values ($n - 1$). Several calculations are necessary and are best organized in a table.

Find the standard deviation of a sample of a set of data

1. Find the mean of the sample.

$$\frac{\text{Sum of values}}{\text{Number of values}}$$

2. Find the deviation of each value from the mean.

Data value − mean

3. Square each deviation.

Deviation × deviation

4. Find the sum of the squared deviations.

5. Divide the sum of the squared deviations by 1 *less than* the number of values in the data set. This amount is called the *variance*.

$$\frac{\text{Sum of squared deviations}}{n-1}$$

6. Find the standard deviation by taking the square root of the variance found in Step 5.

EXAMPLE 1 Find the standard deviation for the values 45, 63, 87, and 91.

From the previous example the mean is 71.5 and the number of values is 4.

Data Values	Deviations from the Mean: Data Value − Mean	Squares of the Deviations from the Mean
45	45 − 71.5 = −26.5	(−26.5)(−26.5) = 702.25
63	63 − 71.5 = −8.5	(−8.5)(−8.5) = 72.25
87	87 − 71.5 = 15.5	(15.5)(15.5) = 240.25
91	91 − 71.5 = 19.5	(19.5)(19.5) = 380.25
Sum of Values = 286	Sum of Deviations = 0	Sum of Squared Deviations = 1,395

$$\text{Variance} = \frac{\text{sum of squared deviations}}{n-1} = \frac{1,395}{4-1} = \frac{1,395}{3} = 465$$

$$\text{Standard deviation} = \text{square root of variance} = \sqrt{465}$$
$$= 21.56385865 \text{ or } \textbf{21.6}$$

TIP

Multiplying Negative Numbers

When multiplying two negative numbers, the product is positive.

(−26.5)(−26.5) = 702.25.
(−8.5)(−8.5) = 72.25

A small standard deviation indicates that the mean is a typical value in the data set. A large standard deviation indicates that the mean is not typical, and other statistical measures should be examined to better understand the characteristics of the data set.

Examine the various statistics for the data set on a number line (Figure 7-19). We can confirm visually that the dispersion of the data is broad and the mean is not a typical value in the data set.

$$\text{Median} = \frac{63 + 87}{2} = \frac{150}{2} = 75$$

Mean − 1 standard deviation =
71.5 − 21.6 = 49.9

Mean + 1 standard deviation =
71.5 + 21.6 = 93.1.

FIGURE 7-19
Dispersion of Data Using a Number Line

Normal distribution: a characteristic of many data sets that shows that data graphs into a bell-shaped curve around the mean.

Symmetrical: a figure that if folded at a middle point, the two halves will match.

Another interpretation of the standard deviation is in its relationship to the **normal distribution**. Many data sets are normally distributed, and the graph of a normal distribution is a bell-shaped curve, as in Figure 7-20. The curve is **symmetrical**; that is, if folded at the highest point of the curve, the two halves would match. The mean of the data set is at the highest point or fold line. Then, half the data (50%) is to the left or *below* the mean and half the data (50%) is to the right or *above* the mean. Other characteristics of the normal distribution are:

68.3% of the data are within 1 standard deviation of the mean.
95.4% of the data are within 2 standard deviations of the mean.
99.7% of the data are within 3 standard deviations of the mean.

FIGURE 7-20
The Normal Distribution

EXAMPLE 3 An Auto Zone Duralast Gold automobile battery has an expected mean life of 46 months with a standard deviation of 4 months. In an order of 100 batteries, how many do you expect to last 54 months? Round to the nearest battery.

54 months is 8 months above the mean.
4 months is 1 standard deviation.
8 months is 2 standard deviations.
Visualize the facts (Figure 7-21).
 50% + 34.13% + 13.59% = 97.72%

$54 - 46 = 8$
$\dfrac{8}{4} = 2$
Sum of percents

FIGURE 7-21
Mean Life for Automotive Batteries

97.72% of the batteries should last *less* than 54 months.

 100% − 97.72% = 2.28% Complement of 97.72%

2.28% of the batteries should last 54 months or longer.

 2.28% × 100 batteries = 0.0228(100) = 2.28 batteries

2 batteries (rounded) should last 54 months or longer.

 STOP AND CHECK

1. Find the deviations from the mean for the set of data: 72, 75, 68, 73, 69.

2. Show that the sum of the deviations from the mean in Exercise 1 is 0.

(*continued*)

STOP AND CHECK—continued

3. Find the sum of the squares of the deviations from the mean in Exercise 1.

4. Find the variance for the data in Exercise 1.

5. Find the standard deviation for the data in Exercise 1.

6. Refer to Example 3 on Auto Zone Duralast Gold batteries. In an order of 100 batteries, how many do you expect to last less than 50 months?

7-3 SECTION EXERCISES

SKILL BUILDERS

Use the sample ACT test scores 24, 30, 17, 22, 22 for Exercises 1–7.

1. Find the range.

2. Find the mean.

3. Find the deviations from the mean.

4. Find the sum of squares of the deviations from the mean.

5. Find the variance.

6. Find the standard deviation.

7. In a set of 100 ACT scores that are normally distributed and based on the information in Exercises 1–6, (a) how many scores are expected to be lower than 18.31 (one standard deviation below the mean)? (b) How many of the 100 scores are expected to be below 32.38 (two standard deviations above the mean)?

APPLICATIONS

The data shows the total number of employee medical leave days taken for on-the-job accidents in the first six months of the year: 12, 6, 15, 9, 18, 12. Use the data for Exercises 8–14.

8. Find the range of days taken for medical leave for each month.

9. Find the mean number of days taken for medical leave each month.

10. Find the deviations from the mean.

11. Find the sum of squares of the deviations from the mean.

12. Find the variance.

13. Find the standard deviation.

14. In a set of 36 months and based on the information in Exercises 8–13, how many months are expected to have fewer than 16.24 days per month reported medical leave (one standard deviation above the mean)?

Learning Outcomes

What to Remember with Examples

Section 7-1

1 Find the mean. (p. 214)

1. Find the sum of the values.
2. Divide the sum by the total number of values.

$$\text{Mean} = \frac{\text{sum of values}}{\text{number of values}}$$

Find the mean price of the printers: \$435, \$398, \$429, \$435, \$479, \$495, \$435

$$\text{Mean} = \frac{\text{sum of values}}{\text{number of values}}$$

$$= \$435 + \$398 + \$429 + \$479 + \$435 + \$495 + \$435 = \frac{\$3,106}{7}$$

$$= \$443.71 \text{ (rounded)}$$

2 Find the median. (p. 215)

1. Arrange the values in order from smallest to largest or largest to smallest.
2. Count the number of values:
 (a) If the number of values is odd, identify the value in the middle.
 (b) If the number of values is even, find the mean of the middle two values.

$$\text{Median} = \text{middle value or mean of middle two values}$$

Find the median price of the printers.

Median = middle value of \$495, \$479, \$435, $\underline{\$435}$, \$435, \$429, \$398
= \$435

3 Find the mode. (p. 216)

1. For each value, count the number of times the value occurs.
2. Identify the value or values that occur most frequently.

$$\text{Mode} = \text{most frequent value(s)}$$

Find the mode price of the printers for the prices given above.

Mode = most frequent value
= \$435

4 Make and interpret a frequency distribution. (p. 218).

1. Identify the appropriate interval for classifying the data.
2. Tally the data.
3. Count the number in each interval.

Make a frequency distribution with the following data, indicating leave days for State College employees (see Table 7-13).

2	2	4	4	4	5	5	6	6	8
8	8	9	12	12	12	14	15	20	20

TABLE 7-13
Annual Leave Days of 20 State College Employees

Class Interval	Tally	Class Frequency
16–20	//	2
11–15	////	5
6–10	//// /	6
1–5	//// //	7

To make a relative frequency distribution:

1. Make the frequency distribution.
2. Calculate the percent that the frequency of each class interval is of the total number of data items in the set.

$$\text{Relative frequency} = \frac{\text{class interval frequency}}{\text{total number in the data set}} \times 100\%$$

Make a relative frequency distribution for the leave days for State College employees.

Class interval	Class frequency	Relative frequency
16–20	2	$\frac{2}{20}(100\%) = \frac{200\%}{20} = 10\%$
11–15	5	$\frac{5}{20}(100\%) = \frac{500\%}{20} = 25\%$
6–10	6	$\frac{6}{20}(100\%) = \frac{600\%}{20} = 30\%$
1–5	7	$\frac{7}{20}(100\%) = \frac{700\%}{20} = 35\%$
Total	20	100%

5 Find the mean of grouped data. (p. 220)

1. Make a frequency distribution.
2. Find the products of the midpoint of the interval and the frequency for each interval for all intervals.
3. Find the sum of the frequencies.
4. Find the sum of the products from Step 2.
5. Divide the sum of the products by the sum of the frequencies.

$$\text{Mean of grouped data} = \frac{\text{Sum of the products of the midpoints and the frequencies}}{\text{sum of the frequencies}}$$

Find the grouped mean of the number of leave days taken by the State College employees (see Table 7-12).

Find the midpoint of each class interval:

$$\frac{16 + 20}{2} = \frac{36}{2} = 18 \qquad \frac{11 + 15}{2} = \frac{26}{2} = 13$$

$$\frac{6 + 10}{2} = \frac{16}{2} = 8 \qquad \frac{1 + 5}{2} = \frac{6}{2} = 3$$

	Class frequency	Midpoint	Product of midpoint and frequency
16–20	2	18	36
11–15	5	13	65
6–10	6	8	48
1–5	7	3	21
Total	20		170

$$\text{mean of grouped data} = \frac{170}{20}$$
$$= 8.5$$

Section 7-2

1 Interpret and draw a bar graph. (p. 224)

Draw a bar graph.

1. Write an appropriate title.
2. Make appropriate labels for the bars and scale. The intervals on the scale should be equally spaced and include the smallest and largest values.
3. Draw bars to represent the data. Bars should be of uniform width.
4. Make additional notes as appropriate. For example, "Amounts in Thousands of Dollars" allows values such as $30,000 to be represented by 30.

Draw a bar graph to represent daily sales for the week.

Monday:	$18,000
Tuesday:	$30,000
Wednesday:	$50,000
Thursday:	$29,000
Friday:	$40,000
Saturday:	$32,000
Sunday:	$8,000

FIGURE 7-22
Daily Sales in Thousands of Dollars

2 Interpret and draw a line graph. (p. 227)

Draw a line graph.

1. Write an appropriate title.
2. Make and label appropriate horizontal and vertical scales, each with equally spaced intervals. Often, the horizontal scale represents time.
3. Use points to locate data on the graph.
4. Connect data points with line segments or a smooth curve.

Draw a line graph to show temperature changes: 12 A.M., 62°; 4 A.M., 65°; 8 A.M., 68°; 12 P.M., 73°; 4 P.M., 76°; 8 P.M., 72°; 12 A.M., 59°.

FIGURE 7-23
Temperature for a 24-Hour Period

3 Interpret and draw a circle graph. (p. 229)

Draw a circle graph.

1. Write an appropriate title.
2. Find the sum of the values in the data set.
3. Represent each value as a fractional or decimal part of the sum of values.
4. For each fraction or decimal, find the number of degrees in the sector of the circle to be represented by the fraction or decimal: Multiply the fraction or decimal by 360 degrees. The sum of the degrees for all sectors should be 360 degrees.
5. Use a compass (a tool for drawing circles) to draw a circle. Indicate the center of the circle and a starting point on the circle.
6. For each degree value, draw a sector: Use a protractor (a measuring instrument for angles) to measure the number of degrees for the sector of the circle to be represented by the value. Where the first sector ends, the next sector begins. The last sector should end at the starting point.
7. Label each sector of the circle and make additional explanatory notes as necessary.

Draw a circle graph to represent the data.

Total salary: $28,000
Housing: $8,000
Food: $6,000
Clothing: $1,000
Transportation: $2,000

Taxes: $5,000
Insurance: $1,800
Utilities: $1,200
Savings: $3,000

Housing: $\dfrac{\$8,000}{\$28,000}(360°) = 103°$

Food: $\dfrac{\$6,000}{\$28,000}(360°) = 77°$

Clothing: $\dfrac{\$1,000}{\$28,000}(360°) = 13°$

Transportation: $\dfrac{\$2,000}{\$28,000}(360°) = 26°$

Taxes: $\dfrac{\$5,000}{\$28,000}(360°) = 64°$

Insurance: $\dfrac{\$1,800}{\$28,000}(360°) = 23°$

Utilities: $\dfrac{\$1,200}{\$28,000}(360°) = 15°$

Savings: $\dfrac{\$3,000}{\$28,000}(360°) = 39°$

FIGURE 7-24
Distribution of $28,000 Salary

Section 7-3

1 Find the range. (p. 233)

1. Find the highest and lowest value.
2. Find the difference between the highest and lowest values.

$$\text{Range} = \text{highest value} - \text{lowest value}$$

A survey of computer stores in a large city shows that a certain printer was sold for the following prices: $435, $398, $429, $479, $435, $495, and $435. Find the range.

Range = largest value − smallest value = $495 − $398 = $97

2 Find the standard deviation (p. 234)

1. Find the mean of the sample. Mean $= \dfrac{\text{sum of data values}}{\text{number of values}}$
2. Find the deviation of each value from the mean. Deviation = data value − mean
3. Square each deviation. Deviation × deviation
4. Find the sum of the squared deviations.
5. Divide the sum of the squared deviations by 1 *less* than the number of values in the data set. This is called the *variance*.

$$\frac{\text{sum of squared deviations}}{n - 1}$$

6. Find the standard deviation by taking the square root of the *variance*.

Find the standard deviation of these test scores: 68, 76, 76, 86, 87, 88, 93.

$$\text{Mean} = \frac{68 + 76 + 76 + 86 + 87 + 88 + 93}{7} = \frac{574}{7} = 82$$

Deviations	Squared Deviations
68 − 82 = −14	196
76 − 82 = −6	36
76 − 82 = −6	36
86 − 82 = 4	16
87 − 82 = 5	25
88 − 82 = 6	36
93 − 82 = 11	121
	466 Sum of squared deviations

$$\text{Variance} = \frac{\text{sum of squared deviations}}{n - 1} = \frac{466}{6} = 77.66666667$$

$$\text{Standard deviation} = \sqrt{\text{variance}} = \sqrt{77.66666667} = 8.812869378 = 8.8 \quad \text{Rounded}$$

EXERCISES SET A

Find the range, mean, median, and mode for the following. Round to the nearest hundredth if necessary.

1. New car mileages

17 mi/gal	16 mi/gal
25 mi/gal	22 mi/gal
30 mi/gal	

2. Sandwiches

$0.95	$1.65
$1.27	$1.97
$1.65	$1.15

3. Find the range, mean, median, and mode of the hourly pay rates for the employees.

Thompson	$13.95	Cleveland	$ 5.25
Chang	$ 5.80	Gandolfo	$ 4.90
Jackson	$ 4.68	DuBois	$13.95
Smith	$ 4.90	Serpas	$13.95

4. During the past year, Piazza's Clothiers sold a certain sweater at different prices: $42.95, $36.50, $40.75, $38.25, and $43.25. Find the range, mean, median, and mode of the selling prices.

Use Table 7-14 for Exercises 5–9.

TABLE 7-14
Class Enrollment by Period and Days of the First Week for the Second Semester

Period		Mon.	Tues.	Wed.	Thur.	Fri.
1.	7:00–7:50 A.M.	277	374	259	340	207
2.	7:55–8:45 A.M.	653	728	593	691	453
3.	8:50–9:40 A.M.	908	863	824	798	604
4.	9:45–10:35 A.M.	962	782	849	795	561
5.	10:40–11:30 A.M.	914	858	795	927	510
6.	11:35–12:25 P.M.	711	773	375	816	527
7.	12:30–1:20 P.M.	686	734	696	733	348
8.	1:25–2:15 P.M.	638	647	659	627	349
9.	2:20–3:10 P.M.	341	313	325	351	136
10.	3:15–4:05 P.M.	110	149	151	160	45

5. Find the mean number of students for each period in Table 7-14. Round to the nearest whole number.

6. Which period had the highest average enrollment?

7. Which period had the lowest average enrollment?

8. Draw a bar graph representing the mean enrollment for each period.

9. Identify enrollment trends for the 10 periods from the bar graph in Exercise 8.

Use Table 7-15 for Exercises 10–13.

10. What is the least value for 2006 sales? For 2007 sales?

TABLE 7-15
Sales for The Family Store, 2006–2007

	2006	2007
Girls' clothing	$ 74,675	$ 81,534
Boys' clothing	65,153	68,324
Women's clothing	125,115	137,340
Men's clothing	83,895	96,315

11. What is the greatest value for 2006 sales? For 2007 sales?

12. Using the values in Table 7-15, which of the following interval sizes would be more appropriate in making a bar graph? Why?
 (a) $1,000 intervals ($60,000, $61,000, $62,000, . . .)
 (b) $10,000 intervals ($60,000, $70,000, $80,000, . . .)

13. Draw a comparative bar graph to show both the 2006 and 2007 values for The Family Store (see Table 7-15). Be sure to include a title, explanation of the scales, and any additional information needed.

Use Figure 7-25 for Exercises 14–15.

14. What three-month period maintained a fairly constant sales record?

15. What month showed a dramatic drop in sales?

FIGURE 7-25
Monthly Sales for 7th Inning Sports Memorabilia

Use Figure 7-26 for Exercises 16–19.

16. What percent of the gross pay goes into savings? (Round to tenths.)

17. What percent of the gross pay is federal income tax? (Round to tenths.)

18. What percent of the gross pay is the take-home pay? (Round to tenths.)

FIGURE 7-26
Distribution of Gross Pay ($350)

19. What are the total deductions for this payroll check?

20. Find the range for the data set: 90, 89, 82, 87, 93, 92, 98, 79, 81, 80.

21. Find the mean, median, and mode for the data set: 90, 89, 82, 87, 93, 92, 98, 79, 81, 80.

22. Find the variance for the scores in the following data set: 90, 89, 82, 87, 93, 92, 98, 79, 81, 80.

23. Find the standard deviation from the variance in Exercise 22.

24. Use the test scores of 24 students taking Marketing 235 to complete the frequency distribution and find the grouped mean rounded to the nearest whole number.

57	91	76	89	82	59	72	88
76	84	67	59	77	66	56	76
77	84	85	79	69	88	75	58

EXERCISES SET B

Find the range, mean, median, and mode for the following. Round to the nearest hundredth if necessary.

1. Test scores

61	72
63	70
93	87

2. Credit hours

16	12
18	15
16	12
12	

3. Find the range, mean, median, and mode of the weights of the metal castings after being milled.

Casting A	1.08 kg	Casting D	1.1 kg
Casting B	1.15 kg	Casting E	1.25 kg
Casting C	1.19 kg	Casting F	1.1 kg

Use Figure 7-27 for Exercises 4–7.

4. What expenditure is expected to be the same next year as this year?

5. What two expenditures are expected to increase next year?

6. What two expenditures are expected to decrease next year?

FIGURE 7-27
Distribution of Tax Dollars

7. What expenditure was greatest both years?

Use the following information for Exercises 8–11. The temperatures were recorded at two-hour intervals on June 24.

12 A.M.	76°	8 A.M.	70°	2 P.M.	84°	8 P.M.	82°
2 A.M.	75°	10 A.M.	76°	4 P.M.	90°	10 P.M.	79°
4 A.M.	72°	12 P.M.	81°	6 P.M.	90°	12 A.M.	77°
6 A.M.	70°						

8. What is the smallest value?

9. What is the greatest value?

10. Which interval size is most appropriate when making a line graph for the data? Why?
 a. 1°
 b. 5°
 c. 50°
 d. 100°

11. Draw a line graph representing the data. Be sure to include the title, explanation of the scales, and any additional information needed.

12. Which of the following terms would describe the line graph in Exercise 11.
 a. Continually increasing
 b. Continually decreasing
 c. Fluctuating

Use Figure 7-28 for Exercises 13–15.

13. What percent of the overall cost does the lot represent? (Round to the nearest tenth.)

14. What is the cost of the lot with landscaping? What percent of the total cost does this represent? Round to the nearest tenth.

FIGURE 7-28

Distribution of Costs for an $86,000 Home

15. What is the cost of the house with furnishings? What percent of the total cost does this represent? Round to the nearest tenth.

Use Table 7-16 for Exercises 16–19.

TABLE 7-16
Automobile Dealership's New and Repeat Business

Customer	Cars Sold
New	920
Repeat	278

16. What was the total number of cars sold?

17. How many degrees should be used to represent the new car business on a circle (to the nearest whole degree)?

18. How many degrees should be used to represent the repeat business on the circle graph (to the nearest whole degree)?

19. Construct a circle graph for the data in Table 7-16. Label the parts of the graph as "New" and "Repeat." Be sure to include a title and any additional information needed.

Use Table 7-17 for Exercises 20 and 21.

TABLE 7-17

First Semester Fall			Second Semester Spring			Third Semester Fall			Fourth Semester Spring		
Course	Cr. Hr.	Gr.	Course	Cr. Hr.	Gr.	Course	Cr. Hr.	Gr.	Course	Cr. Hr.	Gr.
BUS MATH	4	90	SOC	3	92	FUNS	4	88	CAL I	4	89
ACC I	4	89	PSYC	3	91	ACC II	4	89	ACC IV	4	90
ENG I	3	91	ENG II	3	90	ENG III	3	95	ENG IV	3	96
HISTORY	3	92	ACC II	4	88	PURCH	3	96	ADV	3	93
ECON	5	85	ECON II	4	86	MGMT I	5	84	MGMT II	5	83

20. Give the range and mode of grades for each semester.

21. Give the range and mode of grades for the entire two-year program.

22. Find the mean, variance, and standard deviation for the scores:

82, 60, 78, 81, 65, 72, 72, 78.

23. Use the test scores of 32 students taking Business 205 to complete the frequency distribution and find the grouped mean rounded to the nearest whole number.

88	91	68	83	72	69	82	94
86	94	69	59	75	66	62	66
87	88	95	92	95	90	89	60
92	83	79	78	74	70	79	68

PRACTICE TEST

CHAPTER 7

1. Use the data to find the statistical measures.

42 86 92 15 32 67 48 19 87 63
15 19 21 17 53 27 21 15 82 15

a. What is the range? b. What is the mean? c. What is the median? d. What is the mode?

The costs of producing a piece of luggage at ACME Luggage Company are labor, $45; materials, $40; overhead, $35. Use this information for Exercises 2–7.

2. What is the total cost of producing a piece of luggage?

3. What percent of the total cost is attributed to labor?

4. What percent of the total cost is attributed to materials?

5. What percent of the total cost is attributed to overhead?

6. Compute the number of degrees for labor, materials, and overhead needed for a circle graph.

7. Construct a circle graph for the cost of producing a piece of luggage.

Katz Florist recorded the sales for a six-month period for fresh and silk flowers in Table 7-18. Use the table for Exercises 8–11.

8. What is the greatest value of fresh flowers? Of silk flowers?

TABLE 7-18
Sales for Katz Florist, January–June

	January	February	March	April	May	June
Fresh	$11,520	$22,873	$10,380	$12,562	$23,712	$15,816
Silk	$ 8,460	$14,952	$ 5,829	$10,621	$17,892	$ 7,583

9. What is the smallest value of fresh flowers? Of silk flowers?

10. What interval size would be most appropriate when making a bar graph? Why?
 a. $100
 b. $1,000
 c. $5,000
 d. $10,000

11. Construct a bar graph for the sales at Katz Florist.

Use the following data for Exercises 12–13. The totals of the number of laser printers sold in the years 2006 through 2011 by Smart Brothers Computer Store are as follows:

2006	2007	2008	2009	2010	2011
983	1,052	1,117	615	250	400

12. What is the smallest value? The greatest value?

13. Draw a line graph representing the data. Use an interval of 250. Be sure to include a title and explanation of the scales.

14. A dusk-to-dawn outdoor lightbulb has an expected (mean) life of 8,000 hours with a standard deviation of 250 hours. How many bulbs in a batch of 500 can be expected to last no longer than 7,500 hours?

1. What type of information does a circle graph show?

2. Give a situation in which it would be appropriate to organize the data in a circle graph.

3. What type of information does a bar graph show?

4. Give a situation in which it would be appropriate to organize the data in a bar graph.

5. What type of information does a line graph show?

6. Give a situation in which it would be appropriate to organize the data in a line graph.

7. Explain the differences among the three types of averages: the mean, the median, and the mode.

8. What can we say about the mean for a data set with a large range?

9. What can we say about the mean for a data set with a small range?

10. What components of a graph enable us to analyze and interpret the data given in the graph?

Challenge Problem

Have the computers made a mistake? You have been attending Northeastern State College (which follows a percentage grading system) for two years. You have received good grades, but after four semesters you have not made the Dean's List, which requires an overall average of 90% for all accumulated credits or 90% for any given semester. Your grade reports are shown in Table 7-19.

TABLE 7-19

First Semester Fall			Second Semester Spring			Third Semester Fall			Fourth Semester Spring		
Course	Cr. Hr.	Gr.	Course	Cr. Hr.	Gr.	Course	Cr. Hr.	Gr.	Course	Cr. Hr.	Gr.
BUS MATH	4	90	SOC	3	92	FUNS	4	88	CAL I	4	89
ACC I	4	89	PSYC	3	91	ACC II	4	89	ACC IV	4	90
ENG I	3	91	ENG II	3	90	ENG III	3	95	ENG IV	3	96
HISTORY	3	92	ACC II	4	88	PURCH	3	96	ADV	3	93
ECON	5	85	ECON II	4	86	MGMT I	5	84	MGMT II	5	83

To find the grade point average for a semester, multiply each grade by the credit hours. Add the products and then divide by the total number of credit hours for the semester. To calculate the overall grade point average, proceed similarly, but divide the sum of the products for all semesters by the total accumulated credit hours. Find the grade point average for each semester and the overall grade point average.

7.1 Cell Phone Company Uses Robotic Assembly Line

A small cell phone manufacturing company using a robotic assembly line employs 13 people with the following annual salaries:

$120,000 President $100,000 Vice president
$ 75,000 Financial manager $ 65,000 Sales manager
$ 40,000 Production manager $ 30,000 Production supervisor
$ 30,000 Warehouse supervisor $ 16,000 Six unskilled laborers

1. Calculate the mean, median, and mode for the salaries rounded up to the nearest thousand.

2. The statistic most often used to describe company salaries is the median or the mean. For this company, does the mean give an accurate description of the salaries? Why or why not?

3. Which statistic would this company's labor union representative be most likely to cite during contract negotiations and why? Which statistic would the company president most likely report at the annual shareholders' meeting and why?

4. Name another situation in which it would be beneficial to report the highest average salary, and name another situation where it would be beneficial to use the lowest average salary.

7.2 Ink Hombre: Tattoos and Piercing

At 42 years of age, Enrique Chavez was starting to think more and more about retirement. After 17 years of running one of the bay area's most popular tattoo parlors, Ink Hombre, he decided to take on a partner—his 21-year-old bilingual niece Diana. Her words still echoed in his head—the same words she repeated every time someone left his shop to go elsewhere: "Tío, debe ofrecer la perforación del cuerpo: You should offer body piercing." She would go on to say, "Piercing gives people the opportunity to express their identity, just like a tattoo." She was right, of course. After she got her piercing certification, Diana came to work with Enrique full-time. But she didn't come cheaply. Between her salary and benefits, she was costing the business $1,000 per month! Enrique kept very detailed records, and her first month's sales were a bit disappointing. Piercings were offered as Category I, II, or III, and cost $35, $55, and $75 for stainless steel jewelry, respectively, and $55, $85, and $120 for gold. Diana sold five Category I, two Category II, and three Category III in stainless, and one each of categories I, II, and III in gold.

1. Find the mean, median, and mode for Diana's first month of sales.

2. Given the total sales value for Diana's first month, how long will it take for her to break even with her salary and benefits, assuming a 10 percent increase in sales value each month? Is the increase more likely to come from increased number of sales or a higher average sales value?

3. Diana's second month results show that she made six sales at $35, two at $55, three at $75, three at $85, and two at $120. Calculate the standard deviation for this data set. Does your answer for the standard deviation indicate that this is a normal distribution? If not, what are the implications?

Trade and Cash Discounts

Wisconsin Dells: Mount Olympus

Wisconsin Dells is known as "The Waterpark Capital of the World." One of the newer attractions, Mount Olympus Water and Theme Park, is the Dells' first "mega park," and it has a theme of Greek mythology. The park has 37 water slides, 15 kiddie rides, 9 go-cart tracks, 7 rollercoasters, a wave pool, water play areas, and much more.

The main attraction is a wooden roller coaster named Hades. With a 65-degree drop, the world's longest underground tunnel, and speeds up to 70 mph, it was voted "Best New Ride" in 2005 by *Amusement Today*. Slowly you scale the 160-foot height of Hades, then with heart-pounding speed, reach the bottom of the first 140-foot drop, make a 90-degree turn underground in complete darkness, then blast into daylight to dip, spin around, and do it again. You won't forget the experience of riding Hades, the master of the Underworld!

How do you get tickets to Mount Olympus, or one of over 70 other Wisconsin Dells attractions? More importantly, how can you get the best discounts available? One of the best places to start is www.wisdells.com, where you can find a number of vacation packages offering substantial discounts. There are waterpark packages, a Murder Mystery Dinner Party package, and even a Will You Marry Me? package. Some packages offer discounts of $100 or more per day.

Angela was organizing a youth trip for her church, and decided to check out ticket prices at the Mount Olympus website at: www.mtolympusthemepark.com. There she learned she could receive a $3 discount off the regular price of $21, on an all day unlimited pass for tickets purchased online. She also discovered the discount could be as much as $6 per person for a group of 15 or more. Although Angela wasn't sure yet which would be the best deal, she knew that she wanted to save her church group as much as possible—in this case it could be $60 or more. Either way, Angela, enjoy the rides and hang on to your hat.

LEARNING OUTCOMES

8-1 Single Trade Discounts

1. Find the trade discount using a single trade discount rate; find the net price using the trade discount.
2. Find the net price using the complement of the single trade discount rate.

8-2 Trade Discount Series

1. Find the net price applying a trade discount series and using the net decimal equivalent.
2. Find the trade discount, applying a trade discount series and using the single discount equivalent.

8-3 Cash Discounts and Sales Terms

1. Find the cash discount and the net amount using ordinary dating terms.
2. Interpret and apply end-of-month (EOM) terms.
3. Interpret and apply receipt-of-goods (ROG) terms.
4. Find the amount credited and the outstanding balance from partial payments.
5. Interpret freight terms.

A discount is money deducted from the list price. Manufacturers and distributors give *trade discounts* as incentives for a sale and *cash discounts* as incentives for paying promptly. Discounts are usually established by *discount rates,* given in percent or decimal form, based on the money owed. The discount, then, is a percentage of the list price.

8-1 SINGLE TRADE DISCOUNTS

LEARNING OUTCOMES

1 Find the trade discount using a single trade discount rate; find the net price using the trade discount.
2 Find the net price using the complement of the single trade discount rate.

Most products go from the manufacturer to the consumer by way of the wholesale merchant (wholesaler or distributor) and the retail merchant (retailer).

Product flow

Manufacturer → Wholesaler → Retailer → Consumer

Price flow

Consumer	→	Retailer	→	Wholesaler	→	Manufacturer
List price		Net price		Net price		Cost
		Discount off list		Discount off list		
$80		$56		$40		$20
		30% off list		50% off list		

Manufacturers often describe each of their products in a book or catalog that is made available to wholesalers or retailers. In such catalogs, manufacturers suggest a price at which each product should be sold to the consumer. This price is called the **suggested retail price**, the **catalog price**, or, most commonly, the **list price**.

When a manufacturer sells an item to the wholesaler, the manufacturer deducts a certain amount from the list price of the item. The amount deducted is called the **trade discount**. The wholesaler pays the **net price**, which is the difference between the list price and the trade discount. Likewise, the wholesaler discounts the list price when selling to the retailer. The discount rate that the wholesaler gives the retailer is smaller than the discount rate that the manufacturer gives the wholesaler. The consumer pays the list price.

The trade discount is not usually stated in the published catalog. Instead, the wholesaler or retailer calculates it using the list price and the **discount rate**. The discount rate is a *percent* of the list price.

The manufacturer makes available lists of discount rates for all items in the catalog. The discount rates vary considerably depending on such factors as the wholesaler's and retailer's purchasing history, the season, the condition of the economy, whether a product is being discontinued, and the manufacturer's efforts to encourage volume purchases. Each time the discount rate changes, the manufacturer updates the listing. Each new discount rate applies to the original list price in the catalog.

Suggested retail price, catalog price, list price: three common terms for the price at which the manufacturer suggests an item should be sold to the consumer.

Trade discount: the amount of discount that the wholesaler or retailer receives off the list price, or the difference between the list price and the net price.

Net price: the price the wholesaler or retailer pays or the list price minus the trade discount.

Discount rate: a percent of the list price.

1 Find the trade discount using a single trade discount rate; find the net price using the trade discount.

List prices and discounts apply the percentage formula.

$$\text{Portion (part)} = \text{rate (percent)} \times \text{base (whole)}$$

The portion is the trade discount T, the rate is the single trade discount rate R, and the base is the list price L.

$$P = RB$$
$$T = RL$$

HOW TO Find the trade discount using a single trade discount rate

1. Identify the single discount rate and the list price.
2. Multiply the list price by the decimal equivalent of the single trade discount rate.

$$\text{Trade discount} = \text{single trade discount rate} \times \text{list price}$$
$$T = RL$$

Since the trade discount is deducted from the list price to get the net price, once you know the trade discount, you can calculate the net price.

1. Identify the list price and the trade discount.
2. Subtract the trade discount from the list price.

$$\text{Net price} = \text{list price} - \text{trade discount}$$
$$N = L - T$$

EXAMPLE 1 The list price of a refrigerator is $1,200. Young's Appliance Store can buy the refrigerator at the list price less 20%. (a) Find the trade discount. (b) Find the net price of the refrigerator.

(a) Trade discount = single trade discount rate × list price

$$20\%(\$1,200) = 0.2(\$1,200)$$
$$= \$240$$

Discount rate is 20%; list price is $1,200. Change the percent to a decimal equivalent. Multiply.

The trade discount is $240.

(b) Net price = list price − trade discount
$$= \$1,200 - \$240$$
$$= \$960$$

List price is $1,200; trade discount is $240. Subtract.

The net price is $960.

STOP AND CHECK

1. The list price of an NSX-T Acura is $89,765. Shavells Automobiles can buy the car at the list price less 12%.
 a. Find the trade discount.

 b. Find the net price of the car.

2. Find the trade discount and net price of an electric VeloBinder that has a retail price of $124 and a trade discount of 32%.

3. Direct Safes offers a Depository Safe for $425 with an 8% trade discount. Find the amount of the trade discount and the net price.

4. PlumbingStore.com buys one model of tankless water heater that has a list price of $395. The trade discount is 18%. What is the trade discount and net price of the heater?

5. The *Generation Money Book* has a suggested list price of $21.00 and ECampus.com can get a 24% trade discount on each copy of the book. Find the trade discount and net price.

6. Duty Free Stores purchased handbags, wallets, and key fobs for a total of $20,588.24 from Gucci, the manufacturer. The order has a trade discount of 15%. Find the amount of trade discount and find the net price of the goods.

2 Find the net price using the complement of the single trade discount rate.

Complement of a percent: the difference between 100% and the given percent.

Another method for calculating the net price uses the *complement* of a percent. The **complement of a percent** is the difference between 100% and the given percent. For example, the complement of 35% is 65%, since $100\% - 35\% = 65\%$. The complement of 20% is 80% because $100\% - 20\% = 80\%$.

The complement of the single trade discount rate can be used to find the net price. Observe the relationships among the rates for the list price, discount, and net price.

List price	Discount (amount off list)	Net price (amount paid)
100%	25% of list price	75% of list price
100%	20% of list price	80% of list price
100%	40% of list price	60% of list price
100%	50% of list price	50% of list price

Since the complement is a percent, it is a rate. The complement of the trade discount rate is the **net price rate**. The single trade discount rate is used to calculate the amount the retailer *does not* pay: the trade discount. The net price rate is used to calculate the amount the retailer *does* pay: the net price.

HOW TO Find the net price using the complement of the single trade discount rate

Find the net price of a computer that lists for $3,200 with a trade discount of 35%.

1. Find the net price rate: Subtract the single trade discount rate from 100%.

$$100\% - 35\% = 65\%$$

2. Multiply the decimal equivalent of the net price rate by the list price.

$$\text{Net price} = 0.65(\$3,200)$$
$$= \$2,080$$

$$\text{Net price} = \text{Net price rate} \times \text{list price}$$

or

$$\text{Net Price} = (100\% - \text{single trade discount rate}) \times \text{list price}$$

TIP

To Summarize the Concept of Trade Discounts

$$\text{Trade discount} = \text{amount list price is reduced}$$
$$= \text{part of list price you } do\ not \text{ pay}$$
$$\text{Net price} = \text{part of list price you } do \text{ pay}$$

EXAMPLE 1 Mays' Stationery Store buys 300 pens at $0.30 each, 200 legal pads at $0.60 each, and 100 boxes of paper clips at $0.90 each. The single trade discount rate for the order is 12%. Find the net price of the order.

$300(\$0.30) = \$\ 90$	Find the list price of the pens.
$200(\$0.60) = \120	Find the list price of the legal pads.
$100(\$0.90) = \$\ 90$	Find the list price of the paper clips.
$\$300$	Add to find the total list price.

$$\text{Net price} = (100\% - \text{single trade discount rate}) \times \text{list price}$$

The single trade discount rate is 12%; the list price is $300.

$$= (100\% - 12\%)(\$300)$$

The complement of 12% is 88%.

$$= 88\%(\$300)$$
$$= 0.88(\$300)$$
$$= \$264$$

Write 88% as a decimal.
Multiply.

The net price is $264.

 STOP AND CHECK

1. Find the net price of the PC software SystemWorks that lists for $70 and has a discount rate of 12%.

2. The InFocus LP 120 projector lists for $3,200 and has a trade discount rate of 15%. Find the net price.

3. Canon has a fancy new digital camera that lists for $1,299 and has a trade discount of 18%. What is the net price?

4. Find the net price of 100 sheets of display board that list for $3.99 each, 40 pairs of scissors that list for $1.89 each, and 20 boxes of push pins that list for $3.99 if a 22% trade discount is allowed.

8-1 SECTION EXERCISES

SKILL BUILDERS

1. Find the trade discount on a computer that lists for $400 if a discount rate of 30% is offered.

2. Find the net price of the computer in Exercise 1.

3. Calculate the trade discount for 20 boxes of computer paper if the unit price is $14.67 and a single trade discount rate of 20% is allowed.

4. Calculate the trade discount for 30 cases of antifreeze coolant if each case contains 6 one-gallon units that cost $2.18 per gallon and a single trade discount rate of 18% is allowed.

5. Calculate the net price for the 20 boxes of computer paper in Exercise 3.

6. Calculate the net price for the 30 cases of antifreeze coolant in Exercise 4.

7. Use the net price rate to calculate the net price for the 20 boxes of computer paper in Exercise 3. Compare this net price with the net price found in Exercise 5.

8. Use the net price rate to calculate the net price for the 30 cases of antifreeze coolant in Exercise 4. Compare this net price with the net price found in Exercise 6.

9. Which method of calculating net price do you prefer? Why?

EXCEL 10. If you were writing a spreadsheet program to calculate the net price for several items and you were not interested in showing the trade discount, which method would you be likely to use? Why?

11. Complete the following invoice 2501, finding the net price using the single trade discount rate.

12. Verify that the net price calculated in Exercise 11 is correct by recalculating the net price using the net price rate.

Invoice No. 2501
October 15, 20XX

Qty.	Item	Unit price	List price
15	Notebooks	$1.50	
10	Loose leaf paper	0.89	
30	Ballpoint pens	0.79	
		Total list price	
		40% trade discount	
		Net price	

13. Best Buy Company, Inc. purchased video and digital cameras from Sony for its new store in Shanghai, China, with a total of $148,287. The order has a trade discount of 28%. Use the net price rate to find the net price of the merchandise.

8-2 TRADE DISCOUNT SERIES

LEARNING OUTCOMES

1 Find the net price applying a trade discount series and using the net decimal equivalent.
2 Find the trade discount, applying a trade discount series and using the single discount equivalent.

Sometimes a manufacturer wants to promote a particular item or encourage additional business from a buyer. Also, buyers may be entitled to additional discounts as a result of buying large quantities. In such cases, the manufacturer may offer additional discounts that are deducted one after another from the list price. Such discounts are called a **trade discount series** or **chain discounts**. An example of a discount series is $400 (list price) with a discount series of 20/10/5 (discount rates). That is, a discount of 20% is allowed off the list price, a discount of 10% is allowed off the amount that was left after the first discount, and a discount of 5% is allowed off the amount that was left after the second discount. It *does not* mean a total discount of 35% is allowed on the original list price.

One way to calculate the net price is to make a series of calculations:

$400(0.2) = $80 $400 − $80 = $320 The first discount is taken on the list price of $400, which leaves $320.

$320(0.1) = $32 $320 − $32 = $288 The second discount is taken on $320, which leaves $288.

$288(0.05) = $14.40 $288 − $14.40 = $273.60 The third discount is taken on $288, which leaves the net price of $273.60.

Thus, the net price of a $400 order with a discount series of 20/10/5 is $273.60.

It is time-consuming to calculate a trade discount series this way. The business world uses a faster way of calculating the net price of a purchase when a series of discounts are taken.

1 Find the net price applying a trade discount series and using the net decimal equivalent.

Complements are used to find net prices directly. For the $400 purchase with discounts of 20/10/5, the net price after the first discount is 80% of $400 since 100% − 20% = 80%.

$$0.8(400) = $320$$

The net price after the second discount is 90% of $320.

$$0.9($320) = $288$$

The net price after the third discount is 95% of $288.

$$0.95($288) = $273.60$$

To condense this process, the decimal equivalents of the complements of the discount rates can be multiplied in a continuous sequence.

$$(0.8)(0.9)(0.95)($400) = 0.684($400) = $273.60$$

The product of the decimal equivalents of the complements of the discount rates in a series is the **net decimal equivalent** of the net price rate.

HOW TO	Find net price using the net decimal equivalent of a trade discount series
	Find the net price of a copy machine if the list price is $1,830 with a series discount of 10/10.
1. Find the net decimal equivalent: Multiply the decimal form of the complement of each trade discount rate in the series.	$0.9(0.9) = 0.81$
2. Multiply the net decimal equivalent by the list price.	Net price = 0.81($1,830) Net price = $1,482.30
Net price = net decimal equivalent × list price	

EXAMPLE 1 Find the net price of an order with a list price of $600 and a trade discount series of 15/10/5.

100% − 15% = 85% = 0.85 Find the complement of each discount rate and write it as an
100% − 10% = 90% = 0.9 equivalent decimal.
100% − 5% = 95% = 0.95
0.85(0.9)(0.95) = 0.72675 Multiply the complements to find the net decimal equivalent.

Net price = net decimal equivalent × list price

= 0.72675($600)

= $436.05

The net decimal equivalent is 0.72675; the list price is $600.

The net price for a $600 order with a trade discount series of 15/10/5 is $436.05.

TIP

A Trade Discount Series Does Not Add Up!

The trade discount series of 15/10/5 is *not* equivalent to the single discount rate of 30% (which is the *sum* of 15%, 10%, and 5%). Look at Example 1 worked incorrectly.

Net price = net decimal equivalent × list price

= (100% − 30%) × list price

= 0.70($600)

= $420

INCORRECT

To add the discount rates implies that all the discounts are taken from the list price. In a series of discounts, each successive discount is taken from the remaining price.

EXAMPLE 2

One manufacturer lists a desk at $700 with a discount series of 20/10/10. A second manufacturer lists the same desk at $650 with a discount series of 10/10/10. Which is the better deal?

What You Know	What You Are Looking For	Solution Plan
List price for first deal: $700	Net price for the first deal	Net price = net decimal equivalent × list price
Discount series for first deal: 20/10/10	Net price for the second deal	
List price for second deal: $650	Which deal on the desk is better?	
Discount series for second deal: 10/10/10		

Solution

Decimal equivalents of complements of 20%, 10%, and 10% are 0.8, 0.9, and 0.9, respectively.

Net decimal equivalent = 0.8(0.9)(0.9) Deal 1

= 0.648

Net price for first deal = (0.648)$700

= $453.60

Decimal equivalents of complements of 10%, 10%, and 10% are 0.9, 0.9, and 0.9, respectively.

Net decimal equivalent = 0.9(0.9)(0.9) Deal 2

= 0.729

Net price for second deal = (0.729)$650

= $473.85

Conclusion

The net price for the first deal is $20.25 less than the net price for the second deal ($473.85 − $453.60 = $20.25).

The first deal—the $700 desk with the 20/10/10 discount series—is the better deal.

 STOP AND CHECK

1. Find the net price of a piano that has a list price of $4,800 and a trade discount series of 10/5.

2. The website www.Mobile-Tronics.com offers a three-deck Instrument Cart at a retail (list) price of $535 and a trade discount series of 12/6. What is the net price?

(continued)

3. A five-shelf Instrument Cart that lists for $600 has a trade discount series of 15/10. What is the net price?

4. A Tuffy Utility Cart listing for $219 has a chain discount of 10/6/5. What is the net price?

5. One manufacturer lists a Stand-up Workstation for $448 with a chain discount of 10/6/4. Another manufacturer lists a station of similar quality for $550 with a discount series of 15/10/10. Which is the better deal?

6. Home Depot can purchase gas grills from one manufacturer for $695 with a 5/10/10 discount. Another manufacturer offers a similar grill for $705 with a 6/10/12 discount. Which is the better deal?

2 Find the trade discount, applying a trade discount series and using the single discount equivalent.

If you want to know how much you have *saved* by using a discount series, you can calculate the savings—the trade discount—the long way, by finding the net price and then subtracting the net price from the list price. Or you can apply another, quicker complement method. In percent form, the complement of the net decimal equivalent is the **single discount equivalent**.

> **Single discount equivalent:** the complement of net decimal equivalent. It is the decimal equivalent of a single discount rate that is equal to the series of discount rates.

Total amount of a series of discounts = single discount equivalent × list price
Net amount you pay after a series of discounts = net decimal equivalent × list price

HOW TO Find the trade discount using the single discount equivalent

1. Find the single discount equivalent: Subtract the net decimal equivalent from 1.

 Single discount equivalent = 1 − net decimal equivalent

2. Multiply the single discount equivalent by the list price.

 Trade discount = single discount equivalent × list price

EXAMPLE 1 Use the single discount equivalent to calculate the trade discount on a $1,500 fax machine with a discount series of 30/20/10.

The single discount equivalent is the complement of the net decimal equivalent. So first find the net decimal equivalent.

100% − 30% = 70% = 0.7	Find the complement of each discount rate and write it as
100% − 20% = 80% = 0.8	an equivalent decimal.
100% − 10% = 90% = 0.9	
0.7(0.8)(0.9) = 0.504	Net decimal equivalent
1.000 − 0.504 = 0.496	Subtract the net decimal equivalent from 1 to find the single discount equivalent.

Thus, the single discount equivalent for the trade discount series 30/20/10 is 0.496, or 49.6%.

Trade discount = single discount equivalent × list price The single discount equivalent
 = 0.496($1,500) is 0.496; the list price is $1,500.
 = $744

The trade discount on the $1,500 fax machine with a trade discount series of 30/20/10 is $744.

Some calculators have a key labeled ANS which allows you to enter the answer from the last calculation. To find the single discount equivalent and the trade discount using the ANS key and parentheses:

AC 1 − (. 7 × . 8 × . 9) = ⇒ 0.496

ANS × 1500 = ⇒ 744

STOP AND CHECK

1. Use the single discount equivalent to find the trade discount on a wood desk that lists for $504 and has a trade discount series of 12/10/5.

2. A child's adjustable computer workstation lists for $317 and has a chain discount of 10/5. What is the discount amount?

3. A children's chair lists for $24.00 with a chain discount of 10/5/3. Find the amount of discount.

4. What is the discount amount of a toddler's work desk that lists for $74 with discounts of 12/8/6?

5. Tots Room offers a play-a-round table and chairs at a list price of $289.95 with a chain discount of 8/6/5. What is the trade discount?

6. If you want to know how much you have *saved* by using a discount series, would you use the net decimal equivalent or the single discount equivalent? Explain the reason for your choice.

8-2 SECTION EXERCISES

SKILL BUILDERS

1. Guadalupe Mesa manages an electronic equipment store and has ordered 100 color TVs with remote control for a special sale. The list price for each TV is $215 with a trade discount series of 7/10/5. Find the net price of the order by using the net decimal equivalent.

2. Tim Warren purchased computers for his computer store. Find the net price of the order of 36 computers if each one has a list price of $1,599 and a trade discount series of 5/5/10 is offered by the distributor.

3. Donna McAnally needs to calculate the net price of an order with a list price of $800 and a trade discount series of 12/10/6. Use the net decimal equivalent to find the net price.

4. Shinder Blunt is responsible for Cummins Appliance Store's accounts payable department and has an invoice that shows a list price of $2,200 with a trade discount series of 25/15/10. Use the single discount equivalent to calculate the trade discount on the purchase.

5. Mary Harrington is calculating the trade discount on a dog kennel with a list price of $269 and a trade discount series of 10/10/10. What is the trade discount? What is the net price for the kennel?

6. Christy Hunsucker manages a computer software distributorship and offers a desktop publishing software package for $395 with a trade discount series of 5/5/8. What is the trade discount on this package?

APPLICATIONS

7. One distributor lists ink jet printers with 360 dpi and six scalable fonts that can print envelopes, labels, and transparencies for $189.97 with a trade discount series of 5/5/10. Another distributor lists the same brand and model printer at $210 with a trade discount series of 5/10/10. Which is the better deal if all other aspects of the deal, such as shipping, time of availability, and warranty are the same or equivalent?

8. Two distributors offer the same brand and model PC computer. One distributor lists the computer at $1,899 with a trade discount series of 8/8/5 and free shipping. The other distributor offers the computer at $2,000 with a trade discount series of 10/5/5 and $50 shipping cost added to the net price. Which computer is the better deal?

9. Stephen Black currently receives a trade discount series of 5/10/10 on merchandise purchased from a furniture company. He is negotiating with another furniture manufacturer to purchase similar furniture of the same quality. The first company lists a dining room table and six chairs for $1,899. The other company lists a similar set for $1,800 and a trade discount series of 5/5/10. Which deal is better?

10. We have seen that the trade discount series 20/10/5 is *not* equal to a single trade discount rate of 35%. Does the trade discount series 20/10/5 equal the trade discount series 5/10/20? Use an item with a list price of $1,000 and calculate the trade discount for both series to justify your answer.

11. One distributor lists a printer at $460 with a trade discount series of 15/12/5. Another distributor lists the same printer at $410 with a trade discount series of 10/10/5. Which is the better deal?

12. A Sony Playstation has a list price of $289 and a trade discount series of 8/8. Find the net price and trade discount.

8-3 CASH DISCOUNTS AND SALES TERMS

LEARNING OUTCOMES

1 Find the cash discount and the net amount using ordinary dating terms.
2 Interpret and apply end-of-month (EOM) terms.
3 Interpret and apply receipt-of-goods (ROG) terms.
4 Find the amount credited and the outstanding balance from partial payments.
5 Interpret freight terms.

1 Find the cash discount and the net amount using ordinary dating terms.

Cash discount: a discount on the amount due on an invoice that is given for prompt payment.

To encourage prompt payment, many manufacturers and wholesalers allow buyers to take a **cash discount**, a reduction of the amount due on an invoice. The cash discount is a specified percentage of the price of the goods. Customers who pay their bills within a certain time receive a cash discount. Many companies use computerized billing systems to compute the exact amount of a cash discount and show it on the invoice, so the customer does not need to calculate the discount and resulting net price. But the customer still determines when the bill must be paid to receive the discount.

Bills are often due within 30 days from the date of the invoice. To determine the exact day of the month the payment is due, you have to know how many days are in the month, 30, 31, 28, or 29 in the case of February. There are two ways to help remember which months have 31 days and which have 30 or fewer days. The first method, shown in Figure 8-1, is called the *knuckle method*. Each knuckle represents a month with 31 days and each space between knuckles represents a month with 30 days (except February, which has 28 days except in a leap year, when it has 29).

FIGURE 8-1

The knuckle months (Jan., Mar., May, July, Aug., Oct., and Dec.) have 31 days. The other months have 30 or fewer days.

Another way to remember which months have 30 days and which months have 31 is the following rhyme:

Thirty days has September,

April, June, and November.

All the rest have 31,

'cept February has 28 alone.

And leap year, that's the time

when February has 29.

HOW TO Find the ending date of an interval of time

1. Add the beginning date and the number of days in the interval.
2. If the sum exceeds the number of days in the month, subtract the number of days in the month from the sum.
3. The result of Step 2 will be the ending date in the next month of the interval.

EXAMPLE 1 If an invoice is dated March 19, what is the date (a) 10 days later and (b) 15 days later?

(a) $19 + 10 = 29$

Ten days later is March 29.

(b) $19 + 15 = 34$ March has 31 days.
$34 - 31 = 3$

Fifteen days later is April 3.

With this in mind, let's look at one of the most common credit terms and dating methods.

Many firms offer credit terms 2/10, n/30 (read *two ten, net thirty*). The 2/10 means a 2% cash discount rate may be applied if the bill is paid within 10 days of the invoice date. The n/30 means that the full amount or net amount of the bill is due within 30 days. After the 30th day, the bill is overdue, and the buyer may have to pay interest charges or late fees.

For example, say an invoice is dated January 4 with credit terms of 2/10, n/30. If the buyer pays on or before January 14, then a 2% cash discount rate is applied. If the buyer pays on or after January 15, no cash discount is allowed. Finally, since 30 days from January 4 is February 3, if the buyer pays on or after February 4, interest charges or a late fee may be added to the bill.

HOW TO Find the cash discount

1. Identify the cash discount rate and the net price.
2. Multiply the cash discount rate by the net price.

$$\text{Cash discount} = \text{cash discount rate} \times \text{net price}$$

EXAMPLE 2 An invoice dated July 27 shows a net price of $450 with the terms 2/10, n/30. (a) Find the latest date the cash discount is allowed. (b) Find the cash discount.

(a) The cash discount is allowed up to and including 10 days from the invoice date, July 27.

27th of July	Invoice date
+ 10 days	Days allowed according to terms 2/10
"37th of July"	If July had 37 days . . .
− 31 days in July	July has 31 days.
6th of August	Latest date allowed

August 6 is the latest date the cash discount is allowed.

(b) Cash discount = Cash discount rate × net price
Cash discount = 2%($450)
= 0.02($450)
= $9.00

The cash discount is $9.00.

Net amount: the amount you owe if a cash discount is applied.

Once a cash discount is deducted from a net price, the amount remaining is called the **net amount**. The net amount is the amount the buyer actually pays. Like the net price, there are two ways to calculate the net amount.

Because we attempt to use terms that are commonly used in the business world, the terms *net price* and *net amount* can be confusing. The list price is the suggested retail price, the net price is the price a retailer pays to the distributor or manufacturer for the merchandise, and the net amount is the net price minus any additional discount for paying the bill promptly.

HOW TO Find the net amount

Using the cash discount:
1. Identify the net price and the cash discount.
2. Subtract the cash discount from the net price.

$$\text{Net amount} = \text{net price} - \text{cash discount}$$

Using the complement of the cash discount rate:
1. Identify the net price and the complement of the cash discount rate.
2. Multiply the complement of the cash discount rate by the net price.

$$\text{Net amount} = \text{complement of cash discount rate} \times \text{net price}$$

TIP

The Check Is in the Mail

The requirement for a bill to be paid on or before a specific date means that the payment must be *received* by the supplier on or before that date. For the payment to be postmarked by the due date does not generally count.

EXAMPLE 3 Find the net amount for the invoice in Example 2.

Using the cash discount:

$$\begin{aligned}
\text{Net amount} &= \text{net price} - \text{cash discount} \\
&= \$450 - \$9 \\
&= \$441
\end{aligned}$$

Using the complement of cash discount rate:

$$\begin{aligned}
\text{Net amount} &= \text{complement of cash discount rate} \times \text{net price} \\
&= (100\% - 2\%)(\$450) \\
&= 0.98(\$450) \\
&= \$441
\end{aligned}$$

The net amount is $441.

Another common set of discount terms is 2/10, 1/15, n/30. These terms are read *two ten, one fifteen, net thirty*. A 2% cash discount is allowed if the bill is paid within 10 days after the invoice date, a 1% cash discount is allowed if the bill is paid during the 11th through 15th days, and no discount is allowed during the 16th through 30th days. Interest charges or late fees may accrue if the bill is paid after the 30th day from the date of the invoice.

EXAMPLE 4 Charming Shoppes received a $1,248 invoice for computer supplies, dated September 2, with sales terms 2/10, 1/15, n/30. A 5% late fee is charged for payment after 30 days. Find the amount due if the bill is paid (a) on or before September 12; (b) on or between September 13 and September 17; (c) on or between September 18 and October 2; and (d) on or after October 3.

(a) If the bill is paid on or before September 12 (within 10 days), the 2% discount applies:

$$\text{Cash discount} = 2\%(\$1,248) = 0.02(\$1,248) = \$24.96$$
$$\text{Net amount} = \$1,248 - \$24.96 = \$1,223.04$$

The net amount due on or before September 12 is $1,223.04.

(b) If the bill is paid on or between September 13 and September 17 (within 15 days), the 1% discount applies:

$$\text{Cash discount} = 1\%(\$1,248) = 0.01(\$1,248) = \boxed{\$12.48}$$
$$\text{Net amount} = \$1,248 - \$12.48 = 1,235.52$$

The net amount due on or between September 13 and September 17 is $1,235.52.

(c) If the bill is paid on or between September 18 and October 2, no cash discount applies.

The net price of $1,248 is due.

(d) If the bill is paid on or after October 3, a 5% late fee is added:

$$\text{Late fee} = 5\%(\$1,248) = 0.05(\$1,248) = \boxed{\$62.40}$$
$$\text{Net amount} = \$1,248 + \$62.40 = \$1,310.40$$

The net amount due on or after October 3 is $1,310.40.

✔ STOP AND CHECK

1. An invoice received by Circuit City and dated March 15 has a net price of $985 with terms 2/15, n/30. Find the latest date a cash discount is allowed and find the cash discount. Find the net amount.

2. Dillard's Department Stores received an invoice dated April 18 that shows a billing for $3,848.96 with terms 2/10, 1/15, n/30. Find the cash discount and net amount if the invoice is paid within 15 days but after 10 days.

3. The Gap has an invoice dated August 20 with terms 3/15, n/30. It must be paid by what date to get the discount?

4. Office Depot has an invoice for $3,814 dated May 8, with terms of 3/10, 2/15, n/30. The invoice also has a 1% penalty per month for payment after 30 days.
 a. What amount is due if paid on May 12?

 b. What amount is due if paid on May 25?

 c. What amount is due if paid on June 7?

 d. What amount is due if paid on June 13?

2 Interpret and apply end-of-month (EOM) terms.

End-of-month (EOM) terms: a discount is applied if the bill is paid within the specified days after the end of the month. An exception occurs when an invoice is dated on or after the 26th of a month.

Another type of sales terms is **end-of-month (EOM) terms**. For example, the term might be 2/10 EOM, meaning that a 2% discount is allowed if the bill is paid during the first 10 days of the month *after* the month in the date of the invoice. Thus, if a bill is dated November 19, a 2% discount is allowed as long as the bill is paid on or before December 10.

An exception to the EOM rule occurs when the invoice is dated *on or after the 26th of the month*. When this happens, the discount is allowed if the bill is paid during the first 10 days of the month after the next month. If an invoice is dated May 28 with terms 2/10 EOM, a 2% discount is allowed as long as the bill is paid on or before *July* 10. This exception allows retailers adequate time to receive and pay the invoice.

HOW TO Apply EOM terms

To an invoice dated **before the 26th** day of the month:

1. A cash discount is allowed when the bill is paid by the specified day of the *next month*.
2. To find the net amount, multiply the invoice amount times the complement of the discount rate.

To an invoice dated **on or after the 26th day** of the month:

1. A cash discount is allowed when the bill is paid by the specified day of the *month after the next month*.
2. To find the net amount, multiply the invoice amount times the complement of the discount rate.

EXAMPLE 1 Newman, Inc., received a bill for cleaning services dated September 17 for $5,000 with terms 2/10 EOM. The invoice was paid on October 9. How much did Newman, Inc., pay?

Since the bill was paid within the first 10 days of the next month, a 2% discount was allowed. The complement of 2% is 98%. Thus, 98% is the rate that is paid.

$$\text{Net amount} = 98\%(\$5,000) = 0.98(\$5,000) = \$4,900$$

The net amount paid on October 9 is $4,900.

EXAMPLE 2 H-E-B of San Antonio received a $200 bill for copying services dated April 27. The terms on the invoice were 3/10 EOM. The firm paid the bill on June 2. How much did it pay?

Since the bill was paid within the first 10 days of the second month after the month on the invoice, a 3% discount was allowed. The complement of 3% is 97%.

$$\text{Net amount} = 97\%(\$200) = 0.97(\$200) = \$194$$

The net amount paid was $194.

 STOP AND CHECK

1. An invoice dated November 2 for $2,697 with terms 3/15 EOM was paid on November 14. How much was paid?

2. An invoice dated December 1 for $598.46 with terms 2/10 EOM must be paid by what date to get a cash discount? How much is the cash discount?

3. Domino's Pizza received an invoice dated April 29 with terms 2/10 EOM. What is the latest date the invoice can be paid at a discount? What percent of the invoice must be paid if the discount applies?

4. Find the net amount to be paid on an invoice for $1,096.82 dated May 26 with terms of 1/10 EOM if the invoice is paid on July 7.

5. Find the net amount required on an invoice for $187.17 with terms of 2/10 EOM if it is dated February 15 and paid March 12.

6. Target Stores received an invoice for $84,896 dated July 28 with terms 3/15 EOM. If the invoice is paid on September 10, what is the net amount due?

3 Interpret and apply receipt-of-goods (ROG) terms.

Receipt-of-goods (ROG) terms: a discount applied if the bill is paid within the specified number of days of the receipt of the goods.

Sometimes sales terms apply to the day the *goods are received* instead of the invoice date. For example, the terms may be written 1/10 ROG, where **ROG** stands for **receipt of goods**. The terms 1/10 ROG mean that a 1% discount is allowed on the bill if it is paid within 10 days of the receipt of goods.

An invoice is dated September 6 but the goods do not arrive until the 14th. If the sales terms are 2/15 ROG, then a 2% discount is allowed if the bill is paid on any date up to and including September 29.

HOW TO Apply ROG terms

1. A cash discount is allowed when the bill is paid within the specified number of days from the **receipt of goods**, not from the date of the invoice.
2. To find the net amount, multiply the invoice amount times the complement of the discount rate.

EXAMPLE 1 An invoice for machine parts for $400 is dated November 9 and has sales terms 2/10 ROG. The machine parts arrive November 13.

(a) If the bill is paid on November 21, what is the net amount due?
(b) If the bill is paid on December 2, what is the net amount due?

(a) Since the bill is being paid within 10 days of the receipt of goods, a 2% discount is allowed. The complement of 2% is 98%.

$$\text{Net amount} = 98\%(\$400) = 0.98(\$400) = \$392$$

The net amount due is $392.

(b) No discount is allowed since the bill is not being paid within 10 days of the receipt of goods.

Thus, $400 is due.

 STOP AND CHECK

1. An invoice for $3,097.15 is dated September 8 with terms of 3/15 ROG. The goods being invoiced arrived on September 12. By what date must the invoice be paid to get the cash discount? How much should be paid?

2. Johnson's Furniture purchased furniture that totaled $8,917.48 and received the furniture on March 12. The invoice dated March 5 arrived on March 15 and had discount terms of 2/10, n/30, ROG. Explain the discount terms. How much is paid if the invoice is paid on March 20?

3. Columbus Fitness Center received three new weight machines on May 15 and the invoice in the amount of $1,215 for these goods arrived on May 1 with discount terms of 2/15, n/30, ROG. How much must be paid if the invoice is paid on May 28? June 14?

4. Tracy Burford purchased two new dryers for Fashion Flair Beauty Salon at a cost of $797. The dryers were delivered on June 17 and the invoice arrived on June 13 with cash terms of 3/15, n/30, ROG. Tracy decided to pay the invoice on July 12. How much did she pay?

Partial payment: a payment that does not equal the full amount of the invoice less any cash discount.

Partial cash discount: a cash discount applied only to the amount of the partial payment.

Amount credited: the sum of the partial payment and the partial discount.

Outstanding balance: the invoice amount minus the amount credited.

4 Find the amount credited and the outstanding balance from partial payments.

A company sometimes cannot pay the full amount due in time to take advantage of cash discount terms. Most sellers allow buyers to make a **partial payment** and still get a **partial cash discount** off the net price if the partial payment is made within the time specified in the credit terms. The **amount credited** to the account, then, is the partial payment plus this partial cash discount. The **outstanding balance** is the amount still owed and is expected to be paid within the time specified by the sales terms.

HOW TO Find the amount credited and the outstanding balance from partial payments

1. Find the amount credited to the account: Divide the partial payment by the complement of the cash discount rate.

$$\text{Amount credited} = \frac{\text{partial payment}}{\text{complement of cash discount rate}}$$

2. Find the outstanding balance: Subtract the amount credited from the net price.

$$\text{Outstanding balance} = \text{net price} - \text{amount credited}$$

EXAMPLE 1 The Semmes Corporation received an $875 invoice for cardboard cartons with terms of 3/10, n/30. The firm could not pay the entire bill within 10 days but sent a check for $500. What amount was credited to Semmes' account?

$$\text{Amount credited} = \frac{\text{partial payment}}{\text{complement of rate}} = \frac{\$500}{0.97}$$
$$= \$515.46$$

Divide the amount of the partial payment by the complement of the discount rate to find the amount credited.

Outstanding balance = $875 − $515.46 = $359.54

Subtract the amount credited from the net price to find the outstanding balance.

A $515.46 payment was credited to the account, and the outstanding balance was $359.54.

TIP

Get Proper Credit for Partial Payments

Remember to find the *complement* of the discount rate and then divide the partial payment by this complement. Students sometimes just multiply the discount rate times the partial payment, which does not allow the proper credit.

From Example 1,

$$\frac{\$500}{0.97} = \$515.46$$

$875 − $515.46 = $359.54

CORRECT

From Example 1,

$500(0.03) = $15
$500 + $15 = $515
$875 − $515 = $360

INCORRECT

 STOP AND CHECK

1. Coach of New York sold DFS in San Francisco $340,800 in leather goods with terms of 3/10, n/30. DFS decided to make a partial payment of $200,000 within 10 days. What amount was credited to DFS's invoice?

2. DFS purchased handbags from Burberry in the amount of $2,840,000 with terms of 2/10, n/30, ROG. If the goods arrived on November 12 and DFS made a partial payment of $1,900,000 on November 15, how much should be credited to the DFS account?

3. Office Max purchased office furniture in the amount of $89,517 and was invoiced with terms of 2/10, n/30. Cash-strapped at the time, Office Max decided to make a partial payment of $50,000 within 10 days. How much should be credited to its account?

4. Cellular North sold 6,000 new phones to BellSouth Wireless for $79 each. The invoice arrived with terms of 3/10, n/30, and BellSouth paid $400,000 immediately. How much should be credited to BellSouth Wireless's account? How much was still to be paid on the invoice?

5 Interpret freight terms.

Bill of lading: shipping document that includes a description of the merchandise, number of pieces, weight, name of consignee (sender), destination, and method of payment of freight charges.

FOB shipping point: free on board at the shipping point. The buyer pays the shipping when the shipment is received.

Freight collect: The buyer pays the shipping when the shipment is received.

Manufacturers rely on a wide variety of carriers (truck, rail, ship, plane, and the like) to distribute their goods. The terms of freight shipment are indicated on a document called a **bill of lading** that is attached to each shipment. This document includes a description of the merchandise, number of pieces, weight, name of consignee, destination, and method of payment of freight charges. Freight payment terms are usually specified on the *manufacturer's price list* so that purchasers clearly understand who is responsible for freight charges and under what circumstances before purchases are made. The cost of shipping may be paid by the buyer or seller. If the freight is paid by the buyer, the bill of lading is marked **FOB shipping point**—meaning "free on board" at the shipping point—or **freight collect**. For example, CCC Industries located in Tulsa purchased

FOB destination: free on board at the destination point. The seller pays the shipping when the merchandise is shipped.

Freight paid: the seller pays the shipping when the merchandise is shipped.

Prepay and add: the seller pays the shipping when the merchandise is shipped, but the shipping costs are added to the invoice for the buyer to pay.

parts from Rawhide in Chicago. Rawhide ships FOB Chicago, so CCC Industries must pay the freight from Chicago to Tulsa. The freight company then collects freight charges from CCC upon delivery of the goods.

If the freight is paid by the seller, the bill of lading may be marked **FOB destination**—meaning "free on board" at the destination point—or **freight paid**. If Rawhide paid the freight in the preceding example, the term *FOB Tulsa* could also have been used. Many manufacturers pay shipping charges for shipments above some minimum dollar value. Some shipments of very small items may be marked **prepay and add**. That is, the seller pays the shipping charge and adds it to the invoice, so the buyer pays the shipping charge to the seller rather than to the freight company. **Cash discounts do *not* apply to freight or shipping charges**.

EXAMPLE 1

Calculate the cash discount and the net amount paid for an $800 order of business forms with sales terms of 3/10, 1/15, n/30 if the cost of shipping was $40 (which is included in the $800). The invoice was dated June 13, marked *freight prepay and add*, and paid June 24.

Net price of merchandise	Apply the cash discount rate *only* to the net amount of the merchandise.
= total invoice − shipping fee	
= $800 − $40 = $760	The net price is $760.
Cash discount	
= $760(0.01) = $7.60	The bill was paid after 10 days but within 15 days, so the 1% discount applies.
Net amount	
= $800 − $7.60 = $792.40	Discount is taken from total bill.

The cash discount was $7.60 and the net amount paid was $792.40, which included the shipping fee.

TIP

Who Pays and When

The chart summarizes the most common shipping terms.

Term	Who Pays	When	Who Doesn't Pay
FOB-shipping	Buyer	On receipt	Seller
Freight collect	Buyer	On receipt	Seller
FOB-destination	Seller	When shipped	Buyer
Freight paid	Seller	When shipped	Buyer
Prepay and add	Both	Shipper pays when shipped; buyer pays with invoice payment	Shipper gets reimbursed for shipping

 STOP AND CHECK

1. Windshield Rescue received a shipment of glass on May 3 marked *freight prepay and add*. The invoice dated April 25 showed the cost of the glass to be $2,896 and the freight to be $72. The invoice also showed sales terms of 2/10, n/30. Find the cash discount and the net amount if the invoice is paid within the discount period. Find the total amount to be paid within the discount period.

2. Stout's Carpet, Inc., in Oxford, MS, received a shipment of carpet from Nortex Mills in Dalton, GA, delivered by M.S. Carriers truck line. The shipment was marked *FOB destination*. Who is responsible for paying shipping costs?

3. Dee's Discount Tires received a shipment from Cooper Tires in Novi, MI, that was marked *Freight collect* $215. The invoice Dee received was dated March 21 with terms 2/10, 1/15, n/30. Find the total amount paid for the tires if the invoice showed a balance of $7,925 before discounts and the invoice was paid 7 days after it was dated.

4. Memphis Hardwood Lumber in Memphis, NY, shipped 10 teak boards $6'' \times 24'' \times \frac{1}{2}''$ that cost $26.50 per board and 25 mahogany boards $6'' \times 24'' \times \frac{1}{2}''$ that cost $7.95 per board. High Point Furniture received the shipment marked *Prepay and add*. The invoice showed $65 for freight and was dated July 15 with terms 3/10, n/30. The invoice was paid on July 23. How much was paid?

8-3 SECTION EXERCISES

SKILL BUILDERS

Ken Bonnett received an invoice dated March 9, with terms 2/10, n/30, amounting to $540. He paid the bill on March 12.

1. How much was the cash discount?

2. What is the net amount Ken will pay?

Jim Bettendorf gets an invoice for $450 with terms 4/10, 1/15, n/30.

3. How much would Jim pay 7 days after the invoice date?

4. How much would Jim pay 15 days after the invoice date?

5. How much would Jim pay 25 days after the invoice date?

Alexa May, director of accounts, received a bill for $648, dated April 6, with sales terms 2/10, 1/15, n/30. A 3% penalty is charged for payment after 30 days.

6. Find the amount due if the bill is paid on or before April 16.

7. What amount is due if the bill is paid on or between April 17 and April 21?

8. What amount is due if Alexa pays on or between April 22 and May 6?

9. If Alexa pays on or after May 7, how much must she pay?

Chloe Duke is an accounts payable officer for her company and must calculate cash discounts before paying invoices. She is paying bills on June 18 and has an invoice dated June 12 with terms 3/10, n/30.

10. If the net price of the invoice is $1,296.45, how much cash discount can she take?

11. What is the net amount Chloe will need to pay?

12. Charlene Watson received a bill for $800 dated July 5, with sales terms of 2/10 EOM. She paid the bill on August 8. How much did Charlene pay?

13. An invoice for a camcorder that cost $1,250 is dated August 1, with sales terms of 2/10 EOM. If the bill is paid on September 8, how much is due?

14. Ruby Wossum received an invoice for $798.53 dated February 27 with sales terms of 3/10 EOM. How much should she pay if she pays the bill on April 15?

15. Sylvester Young received an invoice for a leaf blower for $493 dated April 15 with sales terms of 3/10 EOM. How much should he pay if he pays the bill on April 30?

An invoice for $900 is dated October 15 and has sales terms of 2/10 ROG. The merchandise arrives October 21.

16. How much is due if the bill is paid October 27?

17. How much is due if the bill is paid on November 3?

18. Sharron Smith is paying an invoice showing a total of $5,835 and dated June 2. The invoice shows sales terms of 2/10 ROG. The merchandise delivery slip shows a receiving date of 6/5. How much is due if the bill for the merchandise is paid on June 12?

19. Kariem Salaam is directing the accounts payable office and is training a new accounts payable associate. They are processing an invoice for a credenza that is dated August 19 in the amount of $392.34. The delivery ticket for the credenza is dated August 23. If the sales terms indicated on the invoice are 3/10 ROG, how much needs to be paid if the bill is paid on September 5?

20. Clordia Patterson-Nathanial handles all accounts payable for her company. She has a bill for $730 and plans to make a partial payment of $400 within the discount period. If the terms of the transaction were 3/10, n/30, find the amount credited to the account and find the outstanding balance.

21. Robert Palinchak has an invoice for a complete computer system for $3,982.48. The invoice shows terms of 3/10, 2/15, n/30. He can afford to pay $2,000 within 10 days of the date on the invoice and the remainder within the 30-day period. How much should be credited to the account for the $2,000 payment, and how much is still due?

22. Ada Shotwell has been directed to pay all invoices in time to receive any discounts offered by vendors. However, she has an invoice with terms of 2/10, n/30 for $2,983 and the fund for accounts payable has a balance of $2,196.83. So she elects to pay $2,000 on the invoice within the 10-day discount period and the remainder within the 30-day period. How much should be credited to the account for the $2,000 payment and how much remains to be paid?

23. Dorothy Rogers' Bicycle Shop received a shipment of bicycles via truck from Better Bilt Bicycles. The bill of lading was marked FOB destination. Who paid the freight? To whom was the freight paid?

24. Joseph Denatti is negotiating the freight payment for a large shipment of office furniture and will take a discount on the invoice offered by the vendor since the freight terms are FOB destination. Who is to pay the freight?

25. Phyllis Porter receives a shipment with the bill of lading marked "prepay and add." Who is responsible for freight charges? Who pays the freight company?

26. Explain the difference in the freight terms *FOB shipping point* and *prepay and add*.

Learning Outcomes

Section 8-1

1 Find the trade discount using a single trade discount rate; find the net price using the trade discount. (p. 260)

2 Find the net price using the complement of the single trade discount rate. (p. 261)

Section 8-2

1 Find the net price, applying a trade discount series and using the net decimal equivalent. (p. 264)

2 Find the trade discount, applying a trade discount series and using the single discount equivalent. (p. 266)

What to Remember with Examples

Find the trade discount using a single trade discount rate.

1. Identify the single discount rate and the list price.
2. Multiply the list price by the single trade discount rate.

$$\text{Trade discount} = \text{single trade discount rate} \times \text{list price}$$

> The list price of a laminating machine is $76 and the single trade discount rate is 25%. Find the trade discount.
>
> Trade discount = 25%($76)
> = 0.25(76)
> = $19

Find the net price using the trade discount.

1. Identify the list price and the trade discount.
2. Subtract the trade discount from the list price.

$$\text{Net price} = \text{list price} - \text{trade discount}$$

> Find the net price when the list price is $76 and the trade discount is $19.
>
> Net price = $76 − $19
> = $57

1. Find the net price rate: Subtract the single trade discount rate from 100%.
2. Multiply the decimal equivalent of the net price rate by the list price.

$$\text{Net price} = (100\% - \text{single trade discount rate}) \times \text{list price}$$

> The list price is $480 and the single trade discount rate is 15%. Find the net price.
>
> Net price = (100% − 15%)($480)
> = 0.85($480)
> = $408

1. Find the net decimal equivalent: Multiply the complement of each trade discount rate, in decimal form, in the series.
2. Multiply the net decimal equivalent by the list price.

$$\text{Net price} = \text{net decimal equivalent} \times \text{list price}$$

> The list price is $960 and the discount series is 10/5/2. Find the net price.
>
> Net decimal equivalent = (0.9)(0.95)(0.98) = 0.8379
> Net price = (0.8379)($960)
> = $804.38

1. Find the single discount equivalent: Subtract the net decimal equivalent from 1.

$$\text{Single discount equivalent} = 1 - \text{net decimal equivalent}$$

2. Multiply the single discount equivalent by the list price.

$$\text{Trade discount} = \text{single discount equivalent} \times \text{list price}$$

The list price is $2,800 and the discount series is 25/15/10. Find the trade discount.

Net decimal equivalent = (0.75)(0.85)(0.9) = 0.57375
Single decimal equivalent = 1 − 0.57375 = 0.42625
Trade discount = (0.42625)($2,800)
= $1,193.50

Section 8-3

1 Find the cash discount and the net amount using ordinary dating terms. (p. 269)

Find the ending date of an interval of time:

1. Add the beginning date and the number of days in the interval.
2. If the sum exceeds the number of days in the month, subtract the number of days in the month from the sum.
3. The result of Step 2 will be the ending date in the next month of the interval.

Interpret ordinary dating terms:

To find the last day to receive a discount, add to the invoice date the number of days specified in the terms. If this sum is greater than the number of days in the month the invoice is dated, subtract from the sum the number of days in the month the invoice is dated. The result is the last date the cash discount is allowed in the next month. Use the knuckle method to remember how many days are in each month or use the days-in-a-month rhyme.

By what date must an invoice dated July 10 be paid if it is due in 10 days?

July 10 + 10 days = July 20

By what date must an invoice dated May 15 be paid if it is due in 30 days?

May 15 + 30 = "May 45"

May is a "knuckle" month, so it has 31 days.

"May 45" − 31 days in May = June 14

The invoice must be paid on or before June 14.

1. Find the cash discount: Multiply the cash discount rate by the net price.

Cash discount = cash discount rate × net price

2. Find the net amount using the cash discount: Subtract the cash discount from the net price.

Net amount = net price − cash discount

3. Find the net amount using the complement of the cash discount rate: Multiply the complement of the cash discount rate by the net price.

Net amount = complement of cash discount rate × net price

An invoice is dated July 17 with terms 2/10, n/30 on a $2,500 net price. What is the latest date a cash discount is allowed? What is the net amount due on that date? On what date may interest begin accruing? What is the net amount due one day earlier?

Sale terms 2/10, n/30 mean the buyer takes a 2% cash discount if he or she pays within 10 days of the invoice date; interest may accrue after the 30th day.

Latest discount date = July 17 + 10 days = July 27

Net amount = (100% − 2%)($2,500)
= (0.98)($2,500)
= $2,450

Latest no-interest date = July 17 + 30 = "July 47"

"July 47" − 31 days in July = August 16

Interest begins accruing August 17. On August 16 the amount due is the net price of $2,500.

2 Interpret and apply end-of-month (EOM) terms. (p. 272)

For an invoice dated *before the 26th* day of the month, a cash discount is allowed when the bill is paid by the specified day of the *next month*. For an invoice dated *on or after the 26th* day of the month, a cash discount is allowed when the bill is paid by the specified day of the *month after the next month*.

An invoice dated November 5 shows terms of 2/10 EOM on an $880 net price. By what date does the invoice have to be paid in order to get the cash discount? What is the net amount due on that date?

Sale terms 2/10 EOM for an invoice dated before the 26th day of a month mean that a 2% cash discount is allowed if the invoice is paid on or before the 10th day of the next month.

Latest discount day = December 10
Net amount = (100% − 2%)($880)
= (0.98)($880)
= $862.40

3 Interpret and apply receipt-of-goods (ROG) terms. (p. 273)

A cash discount is allowed when the bill is paid within the specified number of days from the *receipt of goods,* not from the date of the invoice.

What is the net amount due on April 8 for an invoice dated March 28 with terms of 1/10 ROG on a net price of $500? The shipment arrived April 1.

Sales terms 1/10 ROG mean that a 1% cash discount is allowed if the invoice is paid within 10 days of the receipt of goods.

April 8 is within 10 days of April 1, the date the shipment is received, so the cash discount is allowed.

Net amount = (100% − 1%)($500)
= (0.99)($500)
= $495

4 Find the amount credited and the outstanding balance from partial payments. (p. 274)

1. Find the amount credited to the account: Divide the partial payment by the complement of the cash discount rate.

$$\text{Amount credited} = \frac{\text{partial payment}}{\text{complement of cash discount rate}}$$

2. Find the outstanding balance: Subtract the amount credited from the net price.

$$\text{Outstanding balance} = \text{net price} - \text{amount credited}$$

Estrada's Restaurant purchased carpet for $1,568 with sales terms of 3/10, n/30 and paid $1,000 on the bill within the 10 days specified. How much was credited to Estrada's account and what balance remained?

Amount credited to account = $1,000 ÷ 0.97 = $1,030.93
Outstanding balance = $1,568 − $1,030.93 = $537.07

5 Interpret freight terms. (p. 275)

If the bill of lading is marked FOB (free on board) *shipping point,* or *freight collect,* the buyer is responsible for paying freight expenses directly to the freight company. If the bill of lading is marked *FOB destination* or *freight paid,* the shipper is responsible for paying freight expenses directly to the freight company. If the bill of lading is marked *prepay and add,* the buyer is responsible for paying the freight expenses to the seller, who pays the freight company. Cash discounts do not apply to freight charges.

A shipment is sent from a manufacturer in Boston to a wholesaler in Dallas and is marked FOB destination. Who is responsible for the freight cost?

The manufacturer is responsible and pays the shipper.

EXERCISES SET A

Skill Builders

Find the trade discount. Round to the nearest cent.

Item	List price	Single discount rate	Trade discount
1. Water heater	$300	15%	_____
2. Mountain bike	$149.50	20%	_____
3. Sun Unicycle	$49.97	12%	_____

Find the net price. Round to the nearest cent.

Item	List price	Trade discount	Net price
4. Home Gym	$279	$49	_____
5. Dagger Kayak	$399	$91.77	_____

Find the trade discount and net price. Round to the nearest cent.

Item	List price	Single discount rate	Trade discount	Net price
6. Spaulding golf club	$25	5%	_____	_____
7. Minolta camera	$199.95	2%	_____	_____
8. Jeep radio	$100	17%	_____	_____

Find the complement and net price. Round the net price to the nearest cent.

Item	List price	Single discount rate	Net price rate	Net price
9. Casio camera watch	$329	4%	_____	_____
10. MP3 Player	$399.98	6%	_____	_____
11. Teslar watch	$1,595	11%	_____	_____

Find the decimal equivalents of complements, net decimal equivalent, and net price. Round the net price to the nearest cent.

Item	List price	Trade discount series	Decimal equivalents of complements	Net decimal equivalent	Net price
12. Ralph sunglasses	$200	20/10	_____	_____	_____
13. HDTV monitor	$1,399.99	10/15/10	_____	_____	_____
14. Nintendo Gameboy	$99.99	15/5	_____	_____	_____

Round to the nearest hundredth of a percent when necessary.

Net decimal equivalent	Net decimal equivalent in percent form	Single discount equivalent in percent form
15. 0.765	_____	_____
16. 0.6835	_____	_____
17. 0.7434	_____	_____

Find the single discount equivalent in percent form for the discount series.

18. 20/10

19. 10%, 5%, 2%

20. 10/5

Applications

21. Find the trade discount on a conference table listed at $1,025 less 10% (single discount rate).

22. Find the trade discount on a suite listed for $165 less 12%.

23. Find the trade discount on an order of 30 lamps listed at $35 each less 9%.

24. The list price on slacks is $22, and the list price on jumpers is $37. If Petit's Clothing Store orders 30 pairs of slacks and 40 jumpers at a discount rate of 11%, what is the trade discount on the purchase?

25. A trade discount series of 10/5 was given on ladies' scarves listed at $4. Find the net price of each scarf.

26. A trade discount series of 10/5/5 is offered on a printer, which is listed at $800. Also, a trade discount series of 5/10/5 is offered on a desk chair listed at $250. Find the total net price for the printer and the chair. Round to the nearest cent.

27. One manufacturer lists an aquarium for $58.95 with a trade discount of $5.90. Another manufacturer lists the same aquarium for $60 with a trade discount of $9.45. Which is the better deal?

28. Beverly Vance received a bill dated March 1 with sales terms of 3/10, n/30. What percent discount will she receive if she pays the bill on March 5?

29. Find the cash discount on an invoice for $270 dated April 17 with terms of 2/10, n/30 if the bill was paid April 22.

30. Christy Hunsucker received an invoice for $650 dated January 26. The sales terms in the invoice were 2/10 EOM. She paid the bill on March 4. How much did Christy pay?

31. An invoice for $5,298 has terms of 3/10 ROG and is dated March 15. The merchandise is received on March 20. How much should be paid if the invoice is paid on March 25?

32. An invoice for $1,200 is dated on June 3, and terms of 3/10, n/30 are offered. A payment of $800 is made on June 12, and the remainder is paid on July 12. Find the amount remitted on July 12 and the total amount paid.

EXERCISES SET B

Skill Builders

Find the trade discount or net price as indicated. Round to the nearest cent.

	List price	Single discount rate	Trade discount		List price	Trade discount	Net price
1.	$48	10%	_____	**4.**	$24.62	$5.93	_____
2.	$100	12%	_____	**5.**	$0.89	$0.12	_____
3.	$425	15%	_____				

Find the net price. Round to the nearest cent.

	List price	Single discount rate	Trade discount	Net price		List price	Single discount rate	Complement	Net price
6.	$1,263	12%	_____	_____	**9.**	$421	5%	_____	_____
7.	$27.50	3%	_____	_____	**10.**	$721.18	3%	_____	_____
8.	$8,952	18%	_____	_____	**11.**	$3,983.00	8%	_____	_____

Find the decimal equivalents of complements, net decimal equivalent, and net price. Round to the nearest cent.

	List price	Trade discount series	Decimal equivalents of complements	Net decimal equivalent	Net price
12.	$50	10/7/5	_____	_____	_____
13.	$35	20/15/5	_____	_____	_____
14.	$2,834	5/10/10	_____	_____	_____

Round to the nearest hundredth of a percent when necessary.

	Net decimal equivalent	Net decimal equivalent in percent form	Single discount equivalent in percent form
15.	0.82	_____	_____

Net decimal equivalent	Net decimal equivalent in percent form	Single discount equivalent in percent form
16. 0.6502	_____	_____
17. 0.758	_____	_____

Find the single discount equivalent.

18. 30/20/5 **19.** 10%, 10%, 5% **20.** 20/15

Applications

21. The list price for velvet at Harris Fabrics is $6.25 per yard less 6%. What is the trade discount?

22. Rocha Bros. offered a $12\frac{1}{2}\%$ trade discount on a tractor listed at $10,851. What was the trade discount?

23. The list price for a big-screen TV is $1,480 and the trade discount is $301. What is the net price?

24. A stationery shop bought 10 boxes of writing paper listed at $5 each and 200 greeting cards listed at $3.00 each. If the single discount rate for the purchase is 15%, find the trade discount.

25. Find the net price of an item listed at $800 with a trade discount series of 25/10/5.

26. Five desks are listed at $400 each, with a trade discount series of 20/10/10. Also, 10 bookcases are listed at $200 each, discounted 10/20/10. Find the total net price for the desks and bookcases.

27. One manufacturer lists a table at $200 less 12%. Another manufacturer lists the same table at $190 less 10%. Which is the better deal?

28. Chris Merillat received a bill dated September 3 with sales terms of 2/10, n/30. Did she receive a discount if she paid the bill on September 15?

29. Find the cash discount on an invoice for $50 dated May 3 with terms 1/15, n/30 if the bill was paid May 14.

30. How much would have to be paid on an invoice for $328 with terms of 2/10 ROG if the merchandise invoice is dated January 3, the merchandise arrives January 8, and the invoice is paid (a) January 11; (b) January 25?

31. Find the amount credited and the outstanding balance on an invoice dated August 19 if a partial payment of $500 is paid on August 25 and has terms of 3/10, 1/15, n/30. The amount of the invoice is $826.

EXCEL 32. Campbell Sales purchased merchandise worth $745 and made a partial payment of $300 on day 13. If the sales terms were 2/15, n/30, how much was credited to the account? What was the outstanding balance?

1. The list price of a refrigerator is $550. The retailer can buy the refrigerator at the list price minus 20%. Find the trade discount.

2. The list price of a television is $560. The trade discount is $27.50. What is the net price?

3. A retailer can buy a lamp that is listed at $36.55 for 20% less than the list price. How much does the retailer have to pay for the lamp?

4. One manufacturer lists a chair for $250 less 20%. Another manufacturer lists the same chair at $240 less 10%. Which manufacturer offers the better deal?

5. Find the net price if a discount series of 20/10/5 is deducted from $70.

6. Find the single discount equivalent for the discount series 20/20/10.

7. Find the net decimal equivalent of the series 20/10/5.

8. What is the complement of 15%?

9. A retailer buys 20 boxes of stationery at $4 each and 400 greeting cards at $0.50 each. The discount rate for the order is 15%. Find the trade discount.

10. A retailer buys 30 electric frying pans listed at $40 each for 10% less than the list price. How much does the retailer have to pay for the frying pans?

11. Domingo Castro received an invoice for $200 dated March 6 with sales terms 1/10, n/30. He paid the bill on March 9. What was his cash discount?

12. Shareesh Raz received a bill dated September 1 with sales terms of 3/10, 1/15, n/30. What percent discount will she receive if she pays the bill on September 6?

13. An invoice for $400 dated December 7 has sales terms of 2/10 ROG. The merchandise arrived December 11. If the bill is paid on December 18, what is the amount due?

14. Gladys Quaweay received a bill for $300 dated April 7. The sales terms on the invoice were 2/10 EOM. If she paid the bill on May 2, how much did she pay?

15. If the bill in Exercise 13 is paid on January 2, what is the amount due?

16. Zing Manufacturing lists artificial flower arrangements at $30 less 10% and 10%. Another manufacturer lists the same flower arrangements at $31 less 10%, 10%, and 5%. Which is the better deal?

17. A trade discount series of 10% and 20% is offered on 20 dartboards that are listed at $14 each. Also, a trade discount series of 20% and 10% is offered on 10 bowling balls that are listed at $40 each. Find the total net price for the dartboards and bowling balls.

18. The monogrammed items purchased by Dean Specialty Company are shipped by rail from the manufacturer. The bill of lading is marked "FOB destination." Who is responsible for paying freight expenses?

1. Who generally pays the list price? Who generally pays the net price?

2. Use an example to illustrate that a trade discount series of 20/10 is not the same as a discount of 30%. Why are the discounts not the same?

3. The net price can be found by first finding the trade discount as discussed in Outcome 1 in Section 8.1, then subtracting to get the net price. When is it advantageous to use the complement of the discount rate for finding the net price directly?

4. To find the amount credited for a partial payment, we must find the complement of the discount rate and then divide the partial payment by this complement. Explain why we cannot multiply the payment by the discount rate and then add the product to the payment to find the amount to be credited to the account balance.

5. If the single discount rate is 20%, the complement is 80%. What does the complement represent?

6. Describe a procedure for mentally finding a 1% discount on an invoice. Illustrate with an example.

7. Describe the calculations used to project a due date of 60 days from a date of purchase, assuming the 60 days are within the same year.

8. Expand the mental process for using a 1% discount on an invoice to find a 2% discount. Illustrate with an example.

9. Develop a process for estimating a cash discount on an invoice. Illustrate with an example.

10. Why is it important to estimate the discount amount on an invoice?

Challenge Problems

1. Swift's Dairy Mart receives a shipment of refrigeration units totaling $2,386.50 including a shipping charge of $32. Swift's returns $350 worth of the units. Terms of the purchase are 2/10, n/30. If Swift's takes advantage of the discount, what is the net amount payable?

2. An important part of owning a business is the purchasing of equipment and supplies to run the office. Before paying an invoice, all items must be checked and amounts refigured before writing the check for payment. At this time the terms of the invoice can be applied.

 Using the information on the invoice in Figure 8-2, fill in the extended amount for each line, the merchandise total, the tax amount, and the total invoice amount. Locate the terms of the invoice and find what you would write on a check to pay Harper on each of the following dates: Discounts are applied before sales tax is calculated.

 March 5, 20XX

 March 12, 20XX

 March 25, 20XX

INVOICE DATE	TERMS	DATE OF ORDER	ORDERED BY		PHONE NO.	REMIT TO ▶	HARPER General Accounting Office
02/27/XX	2/10, 1/15, n/30	02/27/XX			803-000-4488		

LINE NO.	MANUFACTURER PRODUCT NUMBER	QTY. ORD.	QTY. B.O.	QTY. SHP.	U/M	DESCRIPTION	UNIT PRICE		EXTENDED AMOUNT
001	REMYY370/02253	3	0	3	EA	TONER, F/ROYAL TA210 COP 1	11.90		
002	Sk 1230M402	5	2	3	PK	CORRECTABLE FILM RIBBON	10.95		
003	JRLM01023	10	0	10	PK	COVER-UP CORRECTION TAPE	9.90		
004	rTu123456	9	0	9	CS	PAPER, BOND, WHITE 8 1/2 x 11	58.23		

DATE REC'D.	01460900001		5%		$0.00	TOTAL INVOICE AMOUNT ▶	
	OUR ORDER NO.	MDSE. TOTAL	TAX RATE	TAX AMOUNT	FREIGHT AMOUNT		

FIGURE 8-2

Harper Invoice

CASE STUDIES

8.1 Image Manufacturing's Rebate Offer

Misuse and abuse of trade discounts infringe on fair trade laws and can cost companies stiff fines and legal fees. One way to avoid misuse is to establish the same discount for everyone and give rebates based solely on volume. Image Manufacturing, Inc., uses this policy for equipment sales to companies that develop photographs. For example, one developing machine component, a special hinge, sells for about $3 to a company buying 15,000 pieces per month. In an effort to run more cost-efficient large jobs and capture market share, Image Manufacturing will give an incentive for higher volume. It offers a 5% rebate on orders of 20,000 pieces per month, or a 17–18 cents apiece rebate for orders of at least 22,000 pieces per month. The increased volume needed for a rebate is determined by market research that tells Image Manufacturing factors such as the volume a customer is capable of ordering per month, the volume and cost of the same part a customer currently buys from other suppliers. The rebate amount is determined by Image Manufacturing's profit margin and the company's ability to acquire sufficient raw materials to produce larger volumes without raising production costs. In some industries this is called a bill-back because the buyer receives credit toward the next order rather than a rebate check.

1. Suppose Photo Magic currently orders 15,000 hinges per month from Image Manufacturing at $3 each, which is about half of what they buy each month from other suppliers. If they move 5,000 pieces per month from another company to Image Manufacturing, what will be their rebate on the total order? What will be the discounted cost per piece?

2. If Photo Magic increases its order to 22,000 pieces per month and negotiates an 18 cents-per-piece trade discount, what will be the rebate? What is the percent of the discount?

3. If Photo Magic also receives a $\frac{1}{2}$% cash discount (10 days, net 30), calculate the cash discount and total rebate on a 30,000-piece-per-month order, and then find the net price. Note: Cash discount of $\frac{1}{2}$% is allowed to be taken on total purchase before the rebate is applied.

4. Another company currently orders about 6,000 hinges per month from Image Manufacturing at $3 each. Image Manufacturing's marketing manager believes this company is capable of expanding its business to 8,000 pieces per month and recommends a rebate of 17 cents per piece if they do so. Rounded to the nearest tenth, what is the rebate percentage? Do you think this trade discount violates fair trade laws? Why and why not?

CHAPTER 9 | Markup and Markdown

Hip Hop Clothing

Kendra and Mikala were excited about opening their own hip hop clothing store, 'Nue Rhythm. 'Nue was short for Avenue, and they wanted their clothing to capture the "rhythm of the street." They know that the urban clothing market is one of the most exciting and fastest growing markets for today's consumers. Urban wear has increased in popularity as the number of new, musical hip hop artists has increased. This style of baggy pants, baseball caps worn backwards (NBA, NFL, or successful university teams), oversized rugby or polo shirts, and expensive tennis shoes, although still very popular, is being replaced in some areas with a trend toward tighter hipster-inspired items such as polo shirts, sports coats, large ornamental belt buckles, and tighter jeans. But what really concerned Kendra and Mikala was pricing their new hip hop clothing lines. While typical markups on clothing and accessories can be 30–85%, they knew from research that the markup for hip hop clothing is often 100–200% or more.

What if you're a new business owner (like Kendra and Mikala) and don't have any experience on which to base an estimate? Then you need to research material costs by getting quotes from suppliers as well as study the labor rates in the area. You should also research industry manufacturing prices, as well as competitor's prices. Armed with this information, you will have a well-educated "guess" on which to base your pricing.

For now, 'Nue Rhythm is strictly a retail operation; however, the owners have hopes of introducing their own retail line, "Hip Hop Tops," in the future. Kendra and Mikala felt they were on the right track, and decided to take a seasonal approach to pricing. For the peak shopping months during the summer and leading up to Christmas, they would institute markups of 150% across the board on all lines. To draw customers into the store, a specific designer or line would be marked down as much as 50% off the normal price, and would still be profitable for them. During the rest of the year, 10–50% markdowns would be taken to generate interest among shoppers or to move obsolete inventory. Their focus would be creating competitive prices on truly unique hip hop clothing pieces that their customers would not hesitate to buy.

LEARNING OUTCOMES

9-1 Markup Based on Cost

1. Find the cost, markup, or selling price when any two of the three are known.
2. Find the percent of markup based on the cost when the cost and selling price are known.
3. Find the selling price when the cost and the percent of markup based on the cost are known.
4. Find the cost when the amount of markup and the percent of markup based on the cost are known.
5. Find the cost when the selling price and the percent of markup based on the cost are known.

9-2 Markup Based on Selling Price and Markup Comparisons

1. Find the amount of markup and the percent of markup based on the selling price when the cost and selling price are known.
2. Find the selling price when the amount of markup and the percent of markup based on the selling price are known.
3. Find the selling price when the cost and the percent of markup based on the selling price are known.
4. Find the cost when the selling price and the percent of markup based on the selling price are known.
5. Compare the markup based on the cost with the markup based on the selling price.

9-3 Markdown, Series of Markdowns, and Perishables

1. Find the amount of markdown, the reduced (new) price, and the percent of markdown.
2. Find the final selling price for a series of markups and markdowns.
3. Find the selling price for a desired profit on perishable and seasonal goods.

 A corresponding Business Math Case Video for this chapter, *An All-Star Signing!* can be found in Appendix A.

Cost: price at which a business purchases merchandise.

Selling price (retail price): price at which a business sells merchandise.

Markup (gross profit or gross margin): difference between the selling price and the cost.

Net profit: difference between markup (gross profit or gross margin) and operating expenses and overhead.

Markdown: amount the original selling price is reduced.

Chapter 8 introduced the mathematics associated with buying for a small business. This chapter will focus on the mathematics of selling. Any successful business must keep prices low enough to attract customers, yet high enough to pay expenses and make a profit.

The price at which a retail business purchases merchandise is called the **cost**. The merchandise is then sold at a higher price called the **selling price** or the **retail price**. The difference between the selling price and the cost is the **markup**. The markup is also called the **gross profit** or **gross margin**. The gross profit or margin includes operating expenses and the overhead. The difference between the gross profit and the expenses and overhead is the **net profit**. In Chapter 20 we will look at these concepts. For now, we will only consider the gross profit or markup.

Merchandise may also be reduced from the original selling price. The amount the original selling price is reduced is the **markdown**.

9-1 MARKUP BASED ON COST

LEARNING OUTCOMES

1 Find the cost, markup, or selling price when any two of the three are known.
2 Find the percent of markup based on the cost when the cost and selling price are known.
3 Find the selling price when the cost and the percent of markup based on the cost are known.
4 Find the cost when the amount of markup and the percent of markup based on the cost are known.
5 Find the cost when the selling price and the percent of markup based on the cost are known.

In business situations it is common to need to find missing information. The cost, markup, and selling price are related so that when any two amounts are known, the third amount can be found.

1 Find the cost, markup, or selling price when any two of the three are known.

Visualize the relationships among the cost, markup, and the selling price. The basic relationship can be written as the formula

$$\text{Selling price} = \text{cost} + \text{markup}$$
$$S = C + M$$

Relate this to the concept that two parts add together to get a sum or total. Then we can develop variations of the formula using the concept that the sum or total minus one part gives the other part.

$$\text{Cost} = \text{selling price} - \text{markup}$$
$$C = S - M$$
$$\text{Markup} = \text{selling price} - \text{cost}$$
$$M = S - C$$

HOW TO	Find the cost, markup, or selling price when any two of the three are known

1. Identify the two known amounts.
2. Identify the missing amount.
3. Select the appropriate formula.
4. Substitute the known amounts into the formula.
5. Evaluate the formula.

EXAMPLE 1 What is the selling price of an item if the cost is $28.35 and the markup is $5.64?

What You Know	What You Are Looking For	Solution Plan
Cost = $28.35 Markup = $5.64	Selling price	Selling price = cost + markup

Solution	
$S = C + M$	Substitute known values.
$S = \$28.35 + \5.64	Add.
$S = \$33.99$	

Conclusion
The selling price is \$33.99.

EXAMPLE 2

Mapco buys travel mugs for \$2.45 and sells them for \$5.88. What is the markup?

What You Know	What You Are Looking For	Solution Plan
Cost = \$2.45	Markup	Cost = selling price − markup
Selling price = \$5.88		

Solution	
$M = S - C$	Substitute known values.
$M = \$5.88 - \2.45	Subtract.
$M = \$3.43$	

Conclusion
The markup is \$3.43.

EXAMPLE 3

Kroger is selling 2-liter Coke at \$1.29. If the markup is \$0.35, what is the cost?

What You Know	What You Are Looking For	Solution Plan
Selling price = \$1.29	Cost	Cost = selling price − markup
Markup = \$0.35		

Solution	
$C = S - M$	Substitute known values.
$C = \$1.29 - \0.35	Subtract.
$M = \$0.94$	

Conclusion
The cost of the 2-liter Coke is \$0.94.

 STOP AND CHECK

1. Charlie Cook bought a light fixture that cost \$32 and marked it up \$40. Find the selling price.

2. Margaret Davis sells a key fob for \$12.95 and it costs \$7. Find the markup.

3. Sylvia Knight bought a printer cartridge and marked it up \$18 and set the selling price at \$34.95. Find the cost.

4. Berlin Jones introduced a new veggie sandwich at Subway, the sandwich shop. He determines that each sandwich costs \$3 and plans to sell each sandwich for \$5.25, which is 175% of the cost. Find the markup.

2 Find the percent of markup based on the cost when the cost and selling price are known.

Whether markup is based on cost or selling price, the *rate* of markup, the *rate* of the selling price, and the *rate* of cost are related in the same way.

Rate of S = rate of C + rate of M $S\% = C\% + M\%$
Rate of C = rate of S − rate of M $C\% = S\% − M\%$
Rate of M = rate of S − rate of C $M\% = S\% − C\%$

When the markup is based on cost, the rate of the cost is known and is 100%. The cost is the base in the basic percentage formulas

$$P = R \times B \quad R = \frac{P}{B} \text{ and } B = \frac{P}{R}.$$

Variations of the percentage formula for markup based on cost are

$$\text{Markup} = \text{Rate of markup based on cost} \times \text{cost}$$

$$\text{Rate of markup based on cost} = \frac{\text{Markup}}{\text{Cost}}$$

$$\text{Cost} = \frac{\text{Markup}}{\text{Rate of markup based on cost}}$$

HOW TO **Find the percent or rate of markup based on the cost when the cost and selling price are known**

1. Find the amount of markup using the formula

$$\begin{aligned}\text{Markup} &= \text{Selling price} − \text{Cost}\\ M &= \quad\quad S \quad\quad − \quad C\end{aligned}$$

2. Find the percent of markup based on cost using the formula

$$\text{Rate of markup based on cost} = \frac{\text{markup}}{\text{cost}} \times 100\%$$

$$M\% = \frac{\text{markup}}{\text{cost}} \times 100\%$$

EXAMPLE 1 Duke's Photography pays $9 for a 5 in.-by-7 in. photograph. If the photograph is sold for $15, what is the percent of markup based on cost? Round to the nearest tenth of a percent.

What You Know	What You Are Looking For	Solution Plan
Cost = $9 Cost% = 100% Selling price = $15	Rate of markup	Markup = selling price − cost $M\% = \frac{\text{markup}}{\text{cost}} \times 100\%$

Solution

Find the amount of markup:

$M = S − C$	Substitute known values into the formula.
$M = \$15 − \9	Subtract.
$M = \$6$	Amount of markup

Find the rate of markup:

$M\% = \dfrac{\text{markup}}{\text{cost}} \times 100\%$	Substitute known values into the formula.
$M\% = \dfrac{\$6}{\$9}(100\%)$	Divide.
$M\% = 0.667(100\%)$	Rounded to thousandths. Change to percent equivalent.
$M\% = 66.7\%$	Rate or percent of markup

Conclusion

The percent of markup based on cost is 66.7%.

 STOP AND CHECK

1. Find the percent of markup based on cost for a table that costs $220 and sells for $599. Round to the nearest tenth of a percent.

2. A file cabinet costs $145 and sells for $197.20. Find the percent of markup based on cost.

3. A bicycle costs $245 and sells for $395. Find the percent of markup based on cost. Round to the nearest tenth percent.

4. A motorcycle costs $690 and sells for $1,420. Find the percent of markup based on cost. Round to the nearest tenth percent.

5. A patio lounger costs $89 and is sold for $249. What is the percent of markup based on cost? Round to the nearest tenth percent.

6. Lowe's can purchase a KitchenAid Energy Star dishwasher for $738. Find the percent markup based on cost if the dishwasher sells for $1,048.00. Round to the nearest tenth percent.

3 Find the selling price when the cost and the percent of markup based on the cost are known.

When the markup is based on the cost, the cost is 100% and represents the base in the percentage formula. The selling price percent or rate is found by adding the cost percent and the markup percent. The selling price rate will be more than 100%.

HOW TO	Find the selling price when the cost and the percent of markup based on the cost are known

1. Find the rate of the selling price based on cost using the formula

$$\text{Rate of } S = \text{rate of } C + \text{rate of } M$$
$$S\% = C\% + M\%$$

2. Find the selling price using the formula

$$\text{Selling price} = \text{rate of selling price based on cost} \times \text{cost}$$
$$S = S\% \times C$$

TIP

Alternative Procedure for Finding the Selling Price when the Cost and the Percent of Markup Based on the Cost Are Known

1. Find the amount of markup using the formula
 $$M = M\% \times C$$

2. Find the selling price using the formula
 $$S = C + M$$

EXAMPLE 1 A boutique pays $5 a pair for handmade earrings and sells them at a 50% markup rate based on cost. Find the selling price of the earrings.

What You Know	What You Are Looking For	Solution Plan
Cost = $5 $C\%$ = 100% Markup % = 50%	Selling price	$S\% = C\% + M\%$ $S = S\% \times C$

Solution

Find the rate of selling price:

$S\% = C\% + M\%$	Substitute known amounts.
$S\% = 100\% + 50\%$	Add.
$S\% = 150\%$	

Find the selling price:

$S = \boxed{S\%} \times C$ Substitute known amounts.
$S = \boxed{150\%}(\$5)$ Change percent to equivalent decimal.
$S = 1.5(\$5)$ Multiply.
$S = \$7.50$ Selling price

Conclusion

The selling price is $7.50.

 STOP AND CHECK

1. Ed's Camera Shop pays $218 for a camera and sells it at a 78% markup based on cost. What is the selling price of the camera?

2. Holly's Leather Shop pays $87.50 for a Coach bag and sells it at a 95% markup based on cost. What is the selling price of the bag rounded to the nearest cent?

3. Wimberly Computers buys computers for $465 and sells them at an 80% markup based on cost. What will the computers sell for?

4. The National Parks Conservation Association purchases calendars for $0.86 and sells them at a 365% markup based on cost. What will the calendars sell for rounded to the nearest cent?

5. A 4-oz bottle of Vanilla Bean Panache lotion is purchased for $0.45 and sells at a 110% markup based on cost. What is the selling price of the lotion?

6. J. C. Penney buys Casio watches for $58.82 and sells them at a 70% markup based on cost. Find the selling price of the watches.

4 Find the cost when the amount of markup and the percent of markup based on the cost are known.

When markup is based on cost, the rate of cost is 100%. The cost is found by dividing the markup by the percent of markup.

$$B = \frac{P}{R} \qquad \text{Cost} = \frac{\text{markup}}{\text{rate of markup based on cost}}$$

HOW TO Find the cost when the amount of markup and the percent of markup based on the cost are known

1. Find the cost using the formula

$$\text{Cost} = \frac{\text{markup}}{\text{rate of markup based on cost}} \qquad C = \frac{M}{M\%}$$

2. Change the rate of markup to a numerical equivalent and divide.

EXAMPLE 1 A DVD movie was marked up $6.50, which was a 40% markup based on cost. What was the cost of the DVD?

What You Know	What You Are Looking For	Solution Plan
Markup = $6.50 M% = 40%	Cost	$C = \dfrac{M}{M\%}$

$$C = \frac{M}{M\%}$$ Substitute known amounts.

$$C = \frac{\$6.50}{40\%}$$ Change percent to its decimal equivalent.

$$C = \frac{\$6.50}{0.4}$$ Divide.

$$C = \$16.25$$

The cost of the DVD movie was $16.25.

 STOP AND CHECK

1. A pair of New Balance running shoes is marked up $38, which is a 62% markup based on cost. Find the cost of the shoes.

2. Bradley's Sound Shop marks up a music system $650 and sells it at a 92% markup based on cost. What is the cost of the system? Round to the nearest cent.

3. Wiggins Clock Shop marked up an order of marble clocks $358 each and sells them at a 65% markup based on cost. What is the cost of each clock? Round to the nearest cent.

4. EnviroTote can purchase laundry bags in large quantities and mark them up $4.14 each. What is the cost of each bag if it is marked up 125% of cost? Round to the nearest cent.

5. EnviroTote can purchase a 10-oz Organic Barrel Bag with 25″ handles and mark it up $7.82. What is the cost of each bag if it is marked up 80% of cost? Round to the nearest cent.

6. Kroger marks up Armour chili $0.24 and sells it at a 32% markup. What is the cost of each can of chili?

5 Find the cost when the selling price and the percent of markup based on the cost are known.

If the markup is based on cost, the cost percent is 100% and the selling price percent is 100% + the markup percent.

HOW TO	Find the cost when the selling price and the percent of markup based on the cost are known

1. Find the rate of selling price.

$$\text{Rate of selling price} = \text{rate of cost} + \text{rate of markup}$$
$$S\% = 100\% + M\%$$

2. Find the cost using the formula

$$\text{Cost} = \frac{\text{selling price}}{\text{rate of selling price based on cost}} \qquad C = \frac{S}{S\%}$$

3. Change the rate of selling price to a numerical equivalent and divide.

EXAMPLE 1 A camera sells for $20. The markup rate is 50% of the cost. Find the cost of the camera and the markup.

What You Know	What You Are Looking For	Solution Plan
Selling price = $20	Cost	$S\% = 100\% + M\%$
$M\% = 50\%$	Markup	$C = \dfrac{S}{S\%}$
$C\% = 100\%$		$M = S - C$

Find the selling price rate:

$S\% = 100\% + \boxed{M\%}$ Substitute known amounts.
$S\% = 100\% + \boxed{50\%}$ Add.
$S\% = \boxed{150\%}$

Find the cost:

$C = \dfrac{S}{S\%}$ Substitute known amounts.

$C = \dfrac{\$20}{150\%}$ Change percent to its decimal equivalent.

$C = \dfrac{\$20}{1.5}$ Divide.

$C = \$13.33$ Rounded to the nearest cent

Find the markup:

$M = S - C$ Substitute known amounts.
$M = \boxed{\$20} - \13.33 Subtract.
$M = \$6.67$

The cost of the camera is \$13.33 and the markup is \$6.67.

 STOP AND CHECK

Round to the nearest cent.

1. A paper cutter sells for $39. The markup rate is 60% of the cost. Find the cost of the camera and find the markup.

2. A leather jacket sells for $149. The markup rate is 110% of the cost. Find the cost of the jacket and find the markup.

3. Find the cost and markup of a box of cereal that sells for $4.65 and has a markup rate of 85% based on the cost.

4. A model train engine sells for $595 and has a markup rate of 165% based on the cost. What is the cost and markup of the engine?

5. Charlie at The 7th Inning sells Topps baseball cards for $65 a box and has a markup rate of 45% based on cost. Find the cost and markup of each box of cards.

6. AutoZone sells Anco windshield wiper blades for $9.99 and has a markup rate of 62% based on cost. What is the cost and markup for the wiper blades?

9-1 SECTION EXERCISES

SKILL BUILDERS

Round amounts to the nearest cent and percents to the nearest whole percent.

1. Cost = $30; Markup = $20. Find the selling price.

2. Selling price = $75; Cost = $50. Find the markup.

3. Selling price = $36.99; Markup = $12.99. Find the cost.

4. Cost = $40; Rate of markup based on cost = 35%.
 a. Find the markup.

 b. Find the selling price.

5. Markup = $70; Rate of markup based on cost = 83%.
 a. Find the cost.

 b. Find the selling price.

6. Selling price = $148.27; Rate of markup based on cost = 40%.
 a. Find the cost.

 b. Find the markup.

7. Cost = $60; Selling price = $150.
 a. Find the markup.

 b. Find the rate of markup based on cost.

8. Cost = $82; Markup = $46.
 a. Find the rate of markup based on cost.

 b. Find the selling price.

APPLICATIONS

9. Mugs cost $2 each and sell for $6 each. Find the markup.

10. Belts cost $4 and sell with a markup of $2.40. Find the selling price of the belts.

11. A compact disc player sells for $300. The cost is $86. Find the markup of the CD player.

12. Twenty decorative enamel balls cost $12.75 each and are marked up $9.56.
 a. Find the selling price for each one.

 b. Find the total amount of margin or markup for the 20 balls.

13. A DVD costs $4 and sells for $12. Find the amount of markup.

14. Find the cost if a hard hat is marked up $5 and has a selling price of $12.50.

15. Find the cost of a magazine that sells for $3.50 and is marked up $1.75.

16. Find the selling price if a case of photocopier paper costs $8 and is marked up $14.

17. A sofa costs $398 and sells for $716.40, which is 180% of the cost.
 a. Find the rate of markup.

 b. Find the markup.

18. An audio system sells for $2,980, which is 160% of the cost. The cost is $1,862.50.
 a. What is the rate of markup?

 b. What is the markup?

19. A lamp costs $32 and is marked up based on cost. If the lamp sold for $72, what was the percent of markup?

20. A TV that costs $1,899 sells for a 63% markup based on the cost. What is the selling price of the TV?

21. A computer desk costs $196 and sells for $395. What is the percent of markup based on cost? Round to the nearest tenth percent.

22. Battery-powered massagers cost $8.50 if they are purchased in lots of 36 or more. The Gift Horse Shoppe purchased 48 and sells them at a 45% markup based on cost. Find the selling price of each massager.

23. What is the cost of a sink that is marked up $188 if the markup rate is 70% based on cost?

24. A wristwatch sells for $289. The markup rate is 250% of cost.
a. Find the cost of the watch.

b. Find the markup.

25. A wallet is marked up $12, which is an 80% markup based on cost. What is the cost of the wallet?

26. Tombo Mono Correction Tape sells for $3.29. The markup rate is 65% of the cost.
a. What is the cost?

b. What is the markup of the tape?

9-2 MARKUP BASED ON SELLING PRICE AND MARKUP COMPARISONS

LEARNING OUTCOMES

1 Find the amount of markup and the percent of markup based on the selling price when the cost and selling price are known.
2 Find the selling price when the amount of markup and the percent of markup based on the selling price are known.
3 Find the selling price when the cost and the percent of markup based on the selling price are known.
4 Find the cost when the selling price and the percent of markup based on the selling price are known.
5 Compare the markup based on the cost with the markup based on the selling price.

The markup rate can be calculated as a portion of either the cost or the selling price of an item. Most manufacturers and distributors calculate markup as a portion of *cost*, since they typically keep their records in terms of cost. Some wholesalers and a few retailers also use this method. Many retailers, however, use the *selling price* or *retail price* as a base in computing markup since they keep most of their records in terms of selling price.

1 Find the amount of markup and the percent of markup based on the selling price when the cost and selling price are known.

When the markup is based on selling price, the rate of the selling price is known and is 100%. The amount of the selling price is the base in the basic percentage formulas $P = RB$, $R = \dfrac{P}{B}$, and $B = \dfrac{P}{R}$.

Variations of the percentage formula for markup based on selling price are

$$\text{Markup} = \text{rate of markup based on selling price} \times \text{selling price}$$

$$\text{Rate of markup based on selling price} = \frac{\text{markup}}{\text{selling price}} \times 100\%$$

$$\text{Selling price} = \frac{\text{markup}}{\text{rate of markup based on selling price}}$$

HOW TO Find the amount of markup and the percent of markup based on the selling price when the cost and selling price are known:

1. Find the amount of markup using the formula

$$\begin{aligned} \text{Markup} &= \text{Selling price} - \text{Cost} \\ M &= S - C \end{aligned}$$

2. Find the percent of markup based on selling price using the formula

$$\text{Rate of markup based on selling price} = \frac{\text{markup}}{\text{selling price}} \times 100\%$$

$$M\% = \frac{\text{markup}}{\text{selling price}} \times 100\%$$

EXAMPLE 1 A calculator costs $4 and sells for $10. Find the rate of markup based on the selling price.

What You Know	What You Are Looking For	Solution Plan
Cost = $4 Selling price = $10 $S\% = 100\%$	Rate of markup	Markup = selling price − cost $M\% = \dfrac{\text{markup}}{\text{selling price}} \times 100\%$

Solution

Find the markup:

$M = S - C$	Substitute known values into the formula.
$M = \$10 - \4	Subtract.
$M = \$6$	Amount of markup

Find the rate of markup:

$$M\% = \frac{\text{markup}}{\text{selling price}} \times 100\%$$ Substitute known values into the formula.

$$M\% = \frac{\$6}{\$10}(100\%)$$ Divide.

$$M\% = 0.6(100\%)$$ Change to percent equivalent.

$$M\% = 60\%$$ Rate or percent of markup

Conclusion

The rate of markup for the calculator is 60%.

 STOP AND CHECK

1. A textbook costs $58 and sells for $70. Find the rate of markup based on the selling price. Round to the nearest tenth percent.

2. The manufacturer's suggested retail price for a refrigerator is $1,499 and it costs $385. What is the rate of markup based on the suggested retail price?

3. Hale's Trailers purchases 16-ft trailers for $395 and sells them for $795. What is the rate of markup based on the selling price? Round to the nearest tenth percent.

4. Martha's Birding Society purchases humming bird feeders for $2.40 and sells them for $6.00. Find the rate of markup based on the selling price.

5. AutoZone purchases tire cleaner for $0.84 and sells it for $2.39. What is the rate of markup based on the selling price? Round to the nearest tenth percent.

6. Federated Department Stores purchased men's shoes for $132 and sells them for $229. What is the rate of markup based on selling price? Round to the nearest cent.

2 Find the selling price when the amount of markup and the percent of markup based on the selling price are known.

When the percent of markup is based on the selling price, the selling price is found by dividing the markup by the percent of markup.

HOW TO Find the selling price when the amount of markup and the percent of markup based on the selling price are known

1. Find the selling price using the formula

$$\text{Selling price} = \frac{\text{markup}}{\text{rate of markup based on selling price}} \qquad S = \frac{M}{M\%}$$

2. Change the rate of markup to the numerical equivalent and divide.

EXAMPLE 1 Find the cost and selling price if a handbook is marked up $5 with a 20% markup rate based on selling price.

What You Know	What You Are Looking For	Solution Plan
Markup = $5 $M\% = 20\%$	Selling price Cost	$S = \dfrac{M}{M\%}$ $C = S - M$

Find the selling price:

$$S = \frac{M}{M\%}$$ Substitute known amounts.

$$S = \frac{\$5}{20\%}$$ Change percent to its decimal equivalent.

$$S = \frac{\$5}{0.2}$$ Divide.

$$S = \$25$$ Selling price

Find the cost:

$$C = S - M$$ Substitute known amounts.

$$C = \$25 - \$5$$ Subtract.

$$C = \$20$$ Cost

Conclusion

The selling price of the handbook is $25 and the cost is $20.

 STOP AND CHECK

1. Find the cost and selling price if a handbook is marked up $195 with a 60% markup rate based on selling price.

2. Find the cost and selling price of a baseball that is marked up $21 with an 80% markup based on the selling price.

3. The 7th Inning marks a soccer trophy up $14, a 75% markup based on the selling price. What is the cost and selling price of the trophy?

4. Wolf Camera marks a camera up 25% of the selling price. If the markup is $145, what is the cost and selling price of the camera?

5. Shekenna's Dress Shop marks up a Sag Harbor suit $38. This represents a 70% markup based on the selling price. What is the cost and selling price of the suit?

6. May Department Store marks one stock keeping unit (SKU) of its Coach handbags up $70.08 or 32% of the selling price. Find the cost and selling price of the handbags.

3 Find the selling price when the cost and the percent of markup based on the selling price are known.

When the percent of markup is based on the selling price, the selling price is found by dividing the cost by the rate of cost based on the selling price. The rate of cost based on the selling price is 100% − rate of markup. The rate of cost based on selling price will be less than 100%.

HOW TO Find the selling price when the cost and the percent of markup based on the selling price are known

1. Find the rate of the cost using the formula

$$\text{Rate of } C = \text{rate of } S - \text{rate of } M$$
$$C\% = 100\% - M\%$$

2. Find the selling price using the formula

$$\text{Selling price} = \frac{\text{cost}}{\text{rate of cost based on selling price}}$$
$$S = \frac{C}{C\%}$$

EXAMPLE 1 Find the selling price and markup for a pair of jeans that costs the retailer $28 and is marked up 30% of the selling price.

What You Know	What You Are Looking For	Solution Plan
Cost = $28	Rate of cost	$C\% = 100\% - M\%$
Markup % = 30%	Selling price	$S = \dfrac{C}{C\%}$
Selling price % = 100%	Markup	$M = S - C$

Solution

Find the rate of cost:

$C\% = 100\% - M\%$	Substitute known amounts.
$C\% = 100\% - 30\%$	Subtract.
$C\% = 70\%$	Rate of cost

Find the selling price:

$S = \dfrac{C}{C\%}$	Substitute known amounts.
$S = \dfrac{\$28}{70\%}$	Change percent to its decimal equivalent.
$S = \dfrac{\$28}{0.7}$	Divide.
$S = \$40$	Selling price

Find the markup:

$M = S - C$	Substitute known amounts.
$M = \$40 - \28	Subtract.
$M = \$12$	Markup

Conclusion

The selling price is $40 and the markup is $12.

 STOP AND CHECK

1. Dollar General Stores buys detergent from the manufacturer for $2.99 and marks it up 25% of the selling price. Find the selling price and markup for the detergent.

2. Best Buy buys a digital camera for $187 and marks it up 38% of the selling price. Find the selling price and markup for the camera.

3. Lucinda Gallegos buys scissors for $3.84 and sells them with a 27% markup based on selling price. What is the selling price and markup for the scissors?

4. A Singer sewing machine costs $127.59 and the Fabric Center marks it up 23% of the selling price. What is the selling price and markup for the machine?

5. The Fabric Center pays $1.92 per yard for bridal satin then marks it up 65% of the selling price. What is the selling price and markup for the fabric?

6. IZZE sparkling grapefruit soda costs $32.49 per case and Trader Joe's marks it up 35% of the selling price. Find the selling price and markup per case.

4 Find the cost when the selling price and the percent of markup based on the selling price are known.

When the percent of markup is based on the selling price, the cost percent equals 100% minus the markup percent.

Find the cost when the selling price and the percent of markup based on the selling price are known

1. Find the rate of cost.

$$\text{Rate of cost} = \text{rate of selling price} - \text{rate of markup}$$
$$C\% = 100\% - M\%$$

2. Find the cost.

$$\text{Cost based on selling price} = \text{rate of cost} \times \text{selling price}$$
$$C = C\% \times S$$

3. Change $C\%$ to a numerical equivalent and multiply.

EXAMPLE 1 Find the markup and cost of a box of pencils that sells for $2.99 and is marked up 25% of the selling price.

What You Know	What You Are Looking For	Solution Plan
Selling price = $2.99 $S\% = 100\%$ $M\% = 25\%$	Cost Markup	$C\% = 100\% - M\%$ $C = C\% \times S$ $M = S - C$

Solution

Find the cost rate:

$C\% = 100\% - M\%$	Substitute known amounts.
$C\% = 100\% - 25\%$	Subtract.
$C\% = 75\%$	Cost rate

Find the cost:

$C = C\% \times S$	Substitute known amounts.
$C = 75\%(\$2.99)$	Change percent to its decimal equivalent.
$C = 0.75(\$2.99)$	Multiply.
$C = \$2.24$	Rounded to the nearest cent

Find the markup:

$M = S - C$	Substitute known amounts.
$M = \$2.99 - \2.24	Subtract.
$M = \$0.75$	

Conclusion

The cost of the box of pencils is $2.24 and the markup is $0.75.

To summarize the concepts we have covered in this chapter to this point, all markup problems are solved in basically the same way. One key point is that one rate is known when you know if the markup is based on the cost or the selling price. When the markup is based on cost, the rate of the cost is 100%. When the markup is based on selling price, the rate of the selling price is 100%.

In markup problems there are three amounts and three percents (rates). If three of the six parts are known and at least one known part is an amount and another is whether the markup is based on the cost or the selling price, the other three parts can be determined.

To organize the known and unknown parts, we can use a chart. This chart can guide you in selecting the appropriate formula.

Find all the missing parts if three parts are known and at least one part is an amount and it is known whether the markup is based on the cost or the selling price

1. Place the three known parts into the chart.

	$	%
C		
M		
S		

If the $ column has two entries:	If the % column has two entries:
2. Add or subtract as appropriate to find the third amount.	Add or subtract as appropriate to find the third percent.
3. Find a second percent by using the formula $R = \dfrac{P}{B}$.	Find an additional amount by using the formula $P = RB$ or $B = \dfrac{P}{R}$.
4. Find the third percent by adding or subtracting as appropriate.	Find the third amount by adding or subtracting as appropriate.

EXAMPLE 2

Wal-Mart plans to mark up a package of 8 AA batteries $3.50 over cost. This will be a 50% markup based on cost. Find the missing information.

What You Know	What You Are Looking For	Solution Plan
$C\% = 100\%$ $M\% = 50\%$ $M = \$3.50$	$S\%$, C, and S	$S\% = C\% + M\%$ $B = \dfrac{P}{R}$ or $C = \dfrac{M}{M\%}$ $S = C + M$

	$	%
C		100
M	3.50	50
S		

Solution

Find the rate of the selling price:

$S\% = C\% + M\%$ Two percents are known.

 Substitute known percents.

$S\% = 100\% + 50\%$ Add.

$S\% = 150\%$ Rate of selling price

Find the cost:

$C = \dfrac{M}{M\%}$ Substitute known amounts.

$C = \dfrac{\$3.50}{50\%}$ Change percent to its decimal equivalent.

$C = \dfrac{\$3.50}{0.5}$ Divide.

$C = \$7.00$ Cost

Find the selling price:

$S = C + M$ Substitute known amounts.

$S = \$7.00 + \3.50 Add.

$S = \$10.50$ Selling price

	$	%
C	7.00	100
M	3.50	50
S	10.50	150

Conclusion

The rate of the selling price is 150%, the cost is $7.00, and the selling price is $10.50.

TIP

Check for Reasonableness

When so many formulas can be used in a process, it is important to have a sense of the reasonableness of an answer.

Markup based on cost:	Markup based on selling price:
$C\% = 100\%$	$S\% = 100\%$
$S\% = $ more than 100%	$C\% = $ less than 100%
$M\% = S\% - 100\%$	$M\% = 100\% - C\%$

 STOP AND CHECK

1. Find the markup and cost of a fishing lure that sells for $18.99 and is marked up 38% of the selling price.

2. Al's Golf Supply plans to mark up its persimmon wood drivers by 60% based on cost, or $135. Find the cost and selling price for the drivers.

3. What is the markup and cost of a chair that sells for $349 and is marked up 58% of the selling price?

4. Ronin Copies marks up signs that sell for $49. The markup is 80% based on the selling price. What is the amount of the markup and cost of a sign?

5. A scanner that is marked up 46% of the selling price sells for $675. Find the amount of markup and the cost of the scanner.

6. A Canon copier is marked up 38% of the selling price. It costs $3,034.90. Find the markup and selling price of the copier.

5 Compare the markup based on the cost with the markup based on the selling price.

If a store manager tells you that the standard markup rate is 25%, you don't know if that means markup based on cost or on selling price. What's the difference?

EXAMPLE 1 Find the rate of markup based on cost and based on selling price of a computer that costs $1,500 and sells for $2,000.

What You Know	What You Are Looking For	Solution Plan
$C = \$1,500$	$M\%$ based on cost	$M = S - C$
$S = \$2,000$	$M\%$ based on selling price	$M\%_{cost} = \dfrac{M}{C} \times 100\%$
		$M\%_{selling\ price} = \dfrac{M}{S} \times 100\%$

Solution

Find the markup:

$M = S - C$ Substitute known amounts.

$M = \$2,000 - \$1,500$ Subtract.

$M = \$500$ Amount of markup

Find the rate of markup based on cost:

$M\%_{cost} = \dfrac{M}{C} \times 100\%$ Substitute known amounts.

$M\%_{cost} = \dfrac{\$500}{\$1,500}(100\%)$ Divide and write percent equivalent.

$M\%_{cost} = 33\dfrac{1}{3}\%$ Markup rate based on cost

Find the rate of markup based on selling price:

$M\%_{selling\ price} = \dfrac{M}{S} \times 100\%$ Substitute known amounts.

$M\%_{selling\ price} = \dfrac{\$500}{\$2,000}(100\%)$ Divide and write percent equivalent.

$M\%_{selling\ price} = 25\%$ Markup rate based on selling price

Conclusion

The markup rate based on cost is $33\dfrac{1}{3}\%$ and the markup rate based on selling price is 25%.

Sometimes it is necessary to switch from a markup based on selling price to a markup based on cost, or vice versa.

HOW TO Convert a markup rate based on selling price to a markup rate based on cost

1. Find the complement of the markup rate based on the selling price. That is, subtract the markup rate from 100%.
2. Divide the decimal equivalent of the markup rate based on the selling price by the decimal equivalent of the complement of the rate.

$$M\%_{\text{cost}} = \frac{M\%_{\text{selling price}}}{100\% - M\%_{\text{selling price}}}(100\%)$$

EXAMPLE 2 A desk is marked up 30% based on selling price. What is the equivalent markup based on the cost?

What You Know	What You Are Looking For	Solution Plan
$M\%_{\text{selling price}} = 30\%$	$M\%_{\text{cost}}$	$M\%_{\text{cost}} = \dfrac{M\%_{\text{selling price}}}{100\% - M\%_{\text{selling price}}}(100\%)$

Solution

$$M\%_{\text{cost}} = \frac{M\%_{\text{selling price}}}{100\% - M\%_{\text{selling price}}} \times 100\%$$ Substitute known amounts.

$$M\%_{\text{cost}} = \frac{30\%}{100\% - 30\%} \times 100\%$$ Subtract in denominator.

$$M\%_{\text{cost}} = \frac{30\%}{70\%}(100\%)$$ Change percents to decimal equivalents.

$$M\%_{\text{cost}} = \frac{0.3}{0.7}(100\%)$$ Divide and round to hundredths.

$$M\%_{\text{cost}} = 0.43(100\%)$$ Change to percent equivalent rounded to the
$$M\%_{\text{cost}} = 43\%$$ nearest whole-number percent.

Conclusion

A 30% markup based on selling price is equivalent to a 43% markup based on cost.

HOW TO Convert a markup rate based on cost to a markup rate based on selling price

1. Add 100% to the markup rate based on the cost.
2. Divide the decimal equivalent of the markup rate based on the cost by the decimal equivalent of the sum found in step 1.

$$M\%_{\text{selling price}} = \frac{M\%_{\text{cost}}}{100\% + M\%_{\text{cost}}} \times 100\%$$

A DVD player is marked up 40% based on cost. What is the markup rate based on selling price?

What You Know	What You Are Looking For	Solution Plan
$M\%_{cost} = 40\%$	$M\%_{selling\ price}$	$M\%_{selling\ price} = \dfrac{M\%_{cost}}{100\% + M\%_{cost}}(100\%)$

Solution

$M\%_{selling\ price} = \dfrac{M\%_{cost}}{100\% + M\%_{cost}} \times 100\%$	Substitute known amounts.
$M\%_{selling\ price} = \dfrac{40\%_{cost}}{100\% + 40\%_{cost}}(100\%)$	Add in denominator.
$M\%_{selling\ price} = \dfrac{40\%}{140\%}(100\%)$	Change percents to decimal equivalents.
$M\%_{selling\ price} = \dfrac{0.4}{1.4}(100\%)$	Divide and round to hundredths.
$M\%_{selling\ price} = 0.29(100\%)$	Change to percent equivalent rounded to
$M\%_{selling\ price} = 29\%$	the nearest whole-number percent.

Conclusion

A 40% markup based on cost is equivalent to a 29% markup based on selling price.

TIP

Estimating Markup Equivalencies

Known	Unknown	Estimate
$M\%_{cost}$	$M\%_{selling\ price}$	$M\%_{selling\ price}$ will be smaller
$M\%_{selling\ price}$	$M\%_{cost}$	$M\%_{cost}$ will be larger

 STOP AND CHECK

1. Find the rate of markup based on cost and based on selling price of a blanket that costs $12.50 and sells for $38. Round to the nearest tenth percent.

2. Find the rate of markup based on cost and based on selling price of a copy machine that costs $12,500 and sells for $18,900. Round to the nearest tenth of a percent.

3. Find the rate of markup based on cost and based on selling price of a postage meter that costs $375 and sells for $535. Round to the nearest tenth percent.

4. A stroller is marked up 40% based on selling price. What is the equivalent markup based on cost? Round to the nearest tenth percent.

5. A DVD is marked up 120% of cost. What is the equivalent rate of markup based on selling price? Round to the nearest tenth percent.

6. A diamond ring is marked up 75% based on selling price. Find the equivalent markup based on cost. Round to the nearest tenth percent.

SKILL BUILDERS

Round to the nearest cent or tenth of a percent.

1. Cost = $32; selling price = $40. Find the rate of markup based on the selling price.

2. Markup = $75; markup rate of 60% based on the selling price.
 a. Find the selling price.

 b. Find the cost.

3. Selling price = $1,980; cost = $795. Find the rate of markup based on the selling price.

4. Markup = $2,050; markup rate is 42% of the selling price.
 a. Find the selling price.

 b. Find the cost.

5. Markup rate based on selling price = 15%; markup = $250. Find the selling price.

6. Find the selling price for an item that costs $792 and is marked up 42% of the selling price.
 a. Find the cost.

 b. Find the selling price.

7. An item is marked up $12. The markup rate based on selling price is 65%.
 a. Find the selling price.

 b. Find the cost.

8. Selling price = $1.98; markup is 48% of the selling price.
 a. What is the cost?

 b. What is the markup?

9. An item sells for $5,980 and costs $3,420. What is the rate of markup based on selling price?

10. The selling price of an item is $18.50 and the markup rate is 86% of the selling price.
 a. Find the markup.

 b. Find the cost.

11. An item has a 30% markup based on selling price. The markup is $100.
 a. Find the selling price.

 b. Find the cost.

12. An item costs $20 and sells for $50.
 a. Find the rate of markup based on cost.

 b. Find the rate of markup based on selling price.

13. An item has a 60% markup based on selling price. What is the equivalent markup percent based on the cost?

14. A 40% markup based on cost is equivalent to what percent based on selling price (retail)?

APPLICATIONS

15. An air compressor costs $350 and sells for $695. Find the rate of markup based on the selling price.

16. A lateral file is marked up $140, which represents a 28% markup based on the selling price.
 a. Find the selling price.

 b. Find the cost.

17. A lawn tractor that costs the retailer $599 is marked up 36% of the selling price.
 a. Find the selling price.

 b. Find the markup.

18. A recliner chair that sells for $1,499 is marked up 60% of the selling price.
 a. What is the cost?

 b. What is the markup?

19. Lowe's plans to sell its best-quality floor tiles for $15 each. This is a 48% markup based on selling price.
 a. Find the cost.

 b. Find the markup.

20. A serving tray costs $1,400 and sells for $2,015.
 a. Find the rate of markup based on cost.

 b. Find the rate of markup based on selling price.

21. What is the equivalent markup based on cost of a water fountain that is marked up 63% based on the selling price?

22. A box of Acco paper clips is marked up 46% based on cost. What is the markup based on selling price?

LEARNING OUTCOMES

1 Find the amount of markdown, the reduced (new) price, and the percent of markdown.
2 Find the final selling price for a series of markups and markdowns.
3 Find the selling price for a desired profit on perishable and seasonal goods.

Markdown: amount by which an original selling price is reduced.

Perishable: an item for sale that has a relatively short time during which the quality of the item is acceptable for sale.

Merchants often have to reduce the price of merchandise from the price at which it was originally sold. The amount that the original selling price is reduced is called the **markdown**.

There are many reasons for making markdowns. Sometimes merchandise is marked too high to begin with. Sometimes it gets worn or dirty or goes out of style. Flowers, fruits, vegetables, and baked goods are called **perishables** and are sold for less when the quality of the item is not as good as the original quality. Competition from other stores may also require that a retailer mark prices down.

1 Find the amount of markdown, the reduced (new) price, and the percent of markdown.

Markdowns are generally based on the original selling price. That is, the original selling price is the base in the percentage formulas and the rate of the selling price is 100%.

HOW TO Find the amount of markdown, the reduced (new) price, and the percent of markdown

1. Place the known values into the chart:

	$	%
Original Selling Price (S)		100%
Markdown (M)		
Reduced (New) Price (N)		

2. Select the appropriate formula based on the known values:

Markdown = original selling price − reduced price $M = S - N$

Reduced price = original selling price − markdown $N = S - M$

$$M\% = \frac{M}{S}(100\%)$$

EXAMPLE 1 A lamp originally sold for $36 and was marked down to sell for $30. Find the markdown and the rate of markdown (to the nearest hundredth).

What You Know	What You Are Looking For	Solution Plan
$S = \$36$ $N = \$30$	Markdown Rate of markdown	<table><tr><td></td><td>$</td><td>%</td></tr><tr><td>S</td><td>36</td><td>100%</td></tr><tr><td>M</td><td></td><td></td></tr><tr><td>N</td><td>30</td><td></td></tr></table> $M = S - N$ $M\% = \dfrac{M}{S} \times 100\%$

Find the markdown:

$M = S - N$	Substitute known values.
$M = \$36 - \30	Subtract.
$M = \$6$	Markdown

Find the rate of markdown:

$M\% = \dfrac{M}{S} \times 100\%$	Substitute known values.
$M\% = \dfrac{\$6}{\$36}(100\%)$	Perform calculations.
$M\% = 0.166666667(100\%)$	Rate of markdown
$M\% = 16.7\%$	Rounded

Conclusion

The markdown is \$6 and the rate of markdown is 16.7%.

TIP

Making Connections between Markup and Markdown

Some business processes use the same or similar terminology in different contexts. Examine the terms *original price* and *new price* when associated with markup and markdown.

Markup
Original price = cost (C)
Upward change = markup (M)
New price = selling price (S)
$S = C + M$

Markdown
Original price = selling price (S)
Downward change = markdown (M)
New price = reduced or sale price (N)
$N = S - M$

EXAMPLE 2

A wallet was originally priced at \$12 and was reduced by 25%. Find the markdown and the sale (new) price.

What You Know	What You Are Looking For	Solution Plan
$S = \$12$ $M\% = 25\%$	Markdown Sale price	(see table below)

	\$	%
S	12	100%
M		25%
N		

$M = M\% \times S$
$N = S - M$

Solution

Find the markdown:

$M = M\% \times S$	Substitute known values.
$M = 25\%(\$12)$	Change percent to its decimal equivalent.
$M = 0.25(\$12)$	Multiply.
$M = \$3$	Markdown

Find the sale (new) price:

$N = S - M$	Substitute known values.
$N = \$12 - \3	Subtract.
$N = \$9$	

Conclusion

The markdown is \$3 and the sale price is \$9.

1. A purse originally sold for $135 and was marked down to sell for $75. Find the markdown and the rate of markdown (to the nearest tenth).

2. An umbrella originally sold for $15 and was marked down to sell for $8. Find the markdown and rate of markdown rounded to the nearest tenth of a percent.

3. A ladder was originally priced to sell for $249 and was reduced by 35%. Find the amount of markdown and the reduced price.

4. A book bag is priced to sell for $38.99. If the bag was reduced 25%, find the amount of markdown and the reduced price.

5. A corkboard was originally priced to sell at $85 and was reduced by 40%. Find the amount of markdown and the reduced price.

6. Lowe's reduced a Maytag dishwasher 12.563%. If the dishwasher was priced at $398, find the amount of markdown and the reduced price.

2 Find the final selling price for a series of markups and markdowns.

Prices are in a continuous state of flux in the business world. Markups are made to cover increased costs. Markdowns are made to move merchandise more rapidly, to move dated or perishable merchandise, or to draw customers into a store.

Sometimes prices are marked down several times or marked up between markdowns before the merchandise is sold. In calculating each stage of prices, markups, markdowns, and rates, we use exactly the same markup/markdown formulas and procedures as before. To apply these formulas and procedures, we agree that both the markup and the markdown are based on the *previous selling price* in the series.

HOW TO Find the final selling price for a series of markups and markdowns

1. Find the first selling price using the given facts and markup procedures in Sections 9-1 and 9-2.
2. For each remaining stage in the series:
 (a) If the stage requires a *markdown*, identify the previous selling price as the *original selling price S* for this stage. Find the *reduced price N*. This reduced price is the new selling price for this stage.
 (b) If the stage requires a *markup*, identify the previous selling price as the *cost C* for this stage. Find the *selling price S*. This price is the new selling price for this stage.
3. Identify the selling price for the last stage as the *final selling price*.

EXAMPLE 1 Belinda's China Shop paid a wholesale price of $800 for a set of imported china. On August 8, Belinda marked up the china 50% based on the cost. On October 1, she marked the china down 25% for a special 10-day promotion. On October 11, she marked the china up 15%. The china was again marked down 30% for a preholiday sale. What was the final selling price of the china?

What You Know	What You Are Looking For	Solution Plan
Cost = $800	Selling price for stage 1 (S_1)	Find the selling price for each stage using the formulas:
Stage 1: markup of 50% based on cost	Selling price for stage 2 (N_2)	
	Selling price for stage 3 (S_3)	
Stage 2: markdown of 25% based on selling price	Selling price for stage 4 (N_4)	$S\% = C\% + M\%$
		$N\% = S\% - M\%$
Stage 3: markup of 15% based on new selling price		$S = S\% \times C$
		$N = N\% \times S$
Stage 4: markdown of 30% based on new selling price		

Stage 1: August 8

Find the first selling price (S_1), which is a markup, based on cost:

	$	%
C	800	100
M		50
S	1,200	150

$S_1\% = C\% + M\%$
$S_1\% = 100\% + 50\%$
$S_1\% = 150\%$

$S_1 = S_1\% \times C$
$S_1 = 150\%(\$800)$
$S_1 = 1.5(\$800)$
$S_1 = \$1,200$

Stage 2: October 1

Find the second selling price (N_2), which is a markdown, using S_1 as the original selling price:

	$	%
S_1	1,200	100
M		25
N_2	900	75

$N_2\% = S\% - M\%$
$N_2\% = 100\% - 25\%$
$N_2\% = 75\%$

$N_2 = N\% \times S_1$
$N_2 = 75\%(\$1,200)$
$N_2 = 0.75(\$1,200)$
$N_2 = \$900$

Stage 3: October 11

Find the third selling price (S_3), which is a markup, using N_2 as the cost:

	$	%
N_2	900	100
M		15
S_3	1,035	115

$S_3\% = N_2\% + M\%$
$S_3\% = 100\% + 15\%$
$S_3\% = 115\%$

$S_3 = S_3\% \times N_2$
$S_3 = 115\%(\$900)$
$S_3 = 1.15(\$900)$
$S_3 = \$1,035$

Stage 4: Final markdown

Find the final selling price (N_4), which is a markup, using S_3 as the selling price:

	$	%
S_3	1,035	100
M		30
N_4	724.50	70

$N_4\% = S\% - M\%$
$N_4\% = 100\% - 30\%$
$N_4\% = 70\%$

$N_4 = N_4\% \times S_3$
$N_4 = 70\%(\$1,035)$
$N_4 = 0.7(\$1,035)$
$N_4 = \$724.50$

The final price in the series is $724.50.

Sometimes in retail marketing the series of changes are all markdowns. We can adapt our procedure for finding the net price after applying a trade discount series, which was discussed in Chapter 8. Repricing individual items can be very time-consuming, and many department stores have chosen to use a single sign on an entire table or rack to indicate the same percent markdown on a variety of items. Also, as a further incentive to buy, they may publish a coupon that entitles you to "take an extra 10% off already reduced prices." This is a situation that can model the procedure for finding the net price after applying a trade discount series.

Net decimal equivalent = product of decimal equivalents of the complements of each discount rate

Net price = net decimal equivalent \times original price

Total rate of reduction = $(1 -$ net decimal equivalent$)(100\%)$

EXAMPLE 2 Burdines' has various sales racks throughout the store. Chloe Duke finds a coat that she would like to purchase from a rack labeled 40% off. She also has a newspaper coupon that reads "Take an additional 10% off any already reduced price." How much will a coat cost (net price) that was originally priced at $145? What is the total percent of reduction?

What You Know	What You Are Looking For	Solution Plan
Original price = $145 Discount rates are 40% and 10%.	Final reduced price Total percent of reduction	Find the net decimal equivalent of the rate you pay: Net price = net decimal equivalent \times original price Total rate of reduction = $(1 -$ net decimal equivalent$)$ $\times 100\%$

Solution

Find the net decimal equivalent:

$0.6(0.9) = 0.54$ Multiply the complements of each rate.

Find the final reduced price:

$(0.54)(\$145) = \78.30 Multiply the net decimal equivalent times the original price.

Find the total percent of reduction:

$1 - 0.54 = 0.46$ The complement of the net decimal equivalent is the decimal equivalent of the total percent of reduction

$0.46(100\%) = 46\%$ Percent equivalent

Conclusion

The final reduced price is \$78.30 and the total percent of reduction is 46%.

 STOP AND CHECK

1. Holly's Interior Design Shoppe paid \$189 for a fern stand and marked it up 60% based on the cost. Holly included it in a special promotional markdown of 30%. The stand was damaged during the sale and was marked down an additional 40%. What was the final selling price of the stand?

2. Rich's placed a "10% off" coupon in a newspaper for a holiday sale. Becca selected shoes from the sale rack that were marked 30% off and also used the coupon. How much will Becca pay for the shoes if they were originally priced at \$128? What is the total percent reduction?

3. Johnson's Furniture bought a table for \$262 and marked it up 85% based on the cost. For a special promotion, it was marked down 25%. Store management decided to mark it down an additional 30%. What was the final reduced price?

4. Neilson's Department Store placed a "15% off" coupon in the newspaper for an after-Thanksgiving sale. Lakisha purchased a formal dress that was marked 40% off and used the coupon. The dress was originally priced at \$249. How much did Lakisha pay for the dress?

3 Find the selling price for a desired profit on perishable and seasonal goods.

Most businesses anticipate that some seasonal merchandise will not sell at the original selling price. Stores that sell perishable or strictly seasonal items (fresh fruits, vegetables, swimsuits, or coats, for example) usually anticipate from past experience how much merchandise will be marked down or discarded due to spoilage or merchandise out of date. For example, most retail stores mark down holiday items to 50% of the original price the day after the holiday. Thus, merchants set the original markup of such items to obtain the desired profit level based on the projected number of items sold at "full price" (the original selling price).

HOW TO Find the selling price to achieve a desired profit

1. Establish the rate of profit (markup)—based on cost—desired on the sale of the merchandise.
2. Find the total cost of the merchandise by multiplying the unit cost by the quantity of merchandise. Add in additional charges such as shipping.
3. Find the total desired profit (markup) based on cost by multiplying the rate of profit (markup) by the total cost.
4. Find the total selling price by adding the total cost and the total desired profit.
5. Establish the quantity expected to sell.
6. Divide the total selling price (step 4) by the expect-to-sell quantity (step 5).

$$\text{Selling price per item to achieve desired profit (markup)} = \frac{\text{total selling price}}{\text{expect-to-sell quantity}}$$

EXAMPLE 1 Green's Grocery specializes in fresh fruits and vegetables. Merchandise is priced for quick sale and some must be discarded because of spoilage. Hardy Green, the owner, receives 400 pounds of bananas, for which he pays $0.15 per pound. On the average, 8% of the bananas will spoil. Find the selling price per pound to obtain a 175% markup on cost.

What You Know	What You Are Looking For	Solution Plan
400 lb of bananas at $0.15 per pound 175% markup on cost (desired profit) 8% expected spoilage	Selling price per pound	Total cost = cost per pound × number of pounds Markup = $M\%$ × C Total selling price = $C + M$ Pounds expected to sell = 92%(400) Selling price per pound = $\dfrac{\text{total selling price}}{\text{pounds expected to sell}}$

Solution

$C = \$0.15(400) = \60	Find the total cost of the bananas.
$M = 1.75(\$60) = \105	175% = 1.75. Find the desired profit (markup).
$S = C + M = \$60 + \$105 = \boxed{\$165}$	Find the total selling price.

Hardy must receive $165 for the bananas he expects to sell. He expects 8% not to sell, or 92% to sell.

$0.92(400) = \boxed{368}$ Establish how many pounds he can expect to sell.

He can expect to sell 368 pounds of bananas.

$$\text{Selling price per pound} = \frac{\text{total selling price}}{\text{pounds expected to sell}}$$

$$= \frac{\$165}{368} = \$0.4483695652 \text{ or } \$0.45$$

Conclusion

Hardy must sell the bananas for $0.45 per pound to receive the profit he desires. If he sells more than 92% of the bananas, he will receive additional profit.

 STOP AND CHECK

1. Drewrey's Market pays $0.30 per pound for 300 pounds of peaches. On average 5% of the peaches will spoil before they sell. Find the selling price per pound needed to obtain a 180% markup on cost.

2. Cozort's Produce pays $0.35 per pound for 500 pounds of apples. On average, 8% of the apples will spoil before they sell. Find the selling price per pound needed to obtain a 175% markup on cost.

3. Wesson grocery buys tomatoes for $0.27 per pound. On average, 4% of the tomatoes must be discarded. Find the selling price per pound needed to obtain a 160% markup on cost for 2,000 pounds.

4. EZ Way Produce pays $0.92 per pound for 1,000 lb of mushrooms. On average 10% of the mushrooms will spoil before they sell. Find the selling price per pound needed to obtain a 180% markup based on cost.

SKILL BUILDERS

Round dollar amounts to the nearest cent, and percents to the nearest tenth percent.

1. An item sells for $48 and is reduced to sell for $30. Find the markdown amount and the rate of markdown.

2. An item is reduced from $585 to sell for $499. What is the markdown amount and the rate of markdown?

3. Selling price = $850; reduced (New) price = $500. Find the markdown amount and the rate of markdown.

4. Selling price = $795; reduced price = $650. Find the markdown amount and the rate of markdown.

5. An item is originally priced to sell for $75 and is marked down 40%. A customer has a coupon for an additional 15%. What is the total percent reduction?

6. An item costs $400 and is marked up 60% based on the cost. The first markdown rate is 20% and the second markdown rate is 30%. What is the final selling price?

APPLICATIONS

7. Jung's Grocery received 1,000 pounds of onions at $0.12 per pound. On the average, 4% of the onions will spoil before selling. Find the selling price per pound to obtain a markup rate of 200% based on cost.

8. Deron marks down pillows at the end of the season. They sell for $35 and are reduced to $20. What is the markdown and the rate of markdown?

9. Desmond found a bicycle with an original price tag of $349 but it had been reduced by 45%. What is the amount of markdown and the sale price?

10. Julia purchased a sweatshirt that was reduced from $42 to sell for $26. How much was her markdown? What was the markdown and the rate of markdown?

11. A ladies' suit selling for $135 is marked down 25% for a special promotion. It is later marked down 15% of the sale price. Since the suit still hasn't sold, it is marked down to a price that is 75% off the original selling price. What are the two sale prices of the suit? What is the final selling price of the suit?

12. The Swim Shop paid a wholesale price of $24 each for Le Paris swimsuits. On May 5 it marked up the suits 50% of the cost. On June 15 the swimsuits were marked down 15% for a two-day sale, and on June 17 they were marked up again to the original selling price. On August 30, the shop sold all remaining swimsuits for 40% off. What was the May 5 price, the June 15 price, and the final selling price of a Le Paris swimsuit?

13. Tancia Boone ordered 600 pounds of Red Delicious apples for the produce section of the supermarket. She paid $0.32 per pound for the apples and expected 15% of them to spoil. If the store wants to make a profit of 90% on the cost, what should be the per-pound selling price?

14. Drewrey's fruit stand sells fresh fruits and vegetables. Becky Drewrey, the manager, must mark the selling price of incoming produce high enough to make the desired profit while taking expected markdowns and spoilage into account. Becky paid $0.35 per pound for 300 pounds of grapes. On average, 12% of the grapes will spoil. Find the selling price per pound needed to achieve a 175% markup on cost.

15. The 7th Inning is buying Ohio State T-shirts. The cost of the shirts, which includes permission fees paid to Ohio State, will be $10.90 each if 1,000 shirts are purchased. Charlie sells 800 shirts before the football season begins at a 50% markup based on cost. What is the gross margin (markup) if Charlie sells the remaining 200 shirts at a 25% reduction from the selling price?

Find the selling price of an item that is marked up $68 when the percent of markup based on the selling price is 54%.

$$S = \frac{M}{M\%}$$

$$S = \frac{\$68}{54\%}$$

$$S = \frac{\$68}{0.54}$$

$$S = \$125.93 \text{ rounded}$$

3 Find the selling price when the cost and the percent of markup based on the selling price are known. (p. 307)

1. Find the rate of the cost using the formula

$$\text{Rate of } C = \text{rate of } S - \text{rate of } M \qquad C\% = 100\% - M\%$$

2. Find the selling price using the formula

$$\text{Selling price} = \frac{\text{cost}}{\text{rate of cost based on selling price}} \qquad S = \frac{C}{C\%}$$

Find the selling price of an item that costs $40 and is marked up 35% based on selling price.

$$C\% = 100\% - M\%$$
$$C\% = 100\% - 35\%$$
$$C\% = 65\%$$

$$S = \frac{C}{C\%}$$

$$S = \frac{\$40}{65\%}$$

$$S = \frac{\$40}{0.65}$$

$$S = \$61.54 \text{ rounded}$$

4 Find the cost when the selling price and the percent of markup based on the selling price are known. (p. 308)

1. Find the rate of cost.

$$C\% = 100\% - M\%$$

2. Find the cost using the formula

$$C = C\% \times S$$

3. Change $C\%$ to its numerical equivalent and multiply.

An item sells for $85 and is marked up 60% based on the selling price. Find the cost.

$$C\% = 100\% - 60\%$$
$$C\% = 40\%$$

$$C = C\% \times S$$
$$C = 40\%(\$85)$$
$$C = 0.4(\$85)$$
$$C = \$34$$

To find all the missing parts if three parts are known and at least one part is an amount and it is known whether the markup is based on the cost or the selling price:

1. Place the three known parts into the chart.

	$	%
C		
M		
S		

If the $ column has two entries:

2. Add or subtract as appropriate to find the third amount.
3. Find a second percent by using the formula $R = \dfrac{P}{B}$.
4. Find the third percent by adding or subtracting as appropriate.

If the % column has two entries:

Add or subtract as appropriate to find the third percent.

Find an additional amount using the formula $P = RB$ or $B = \dfrac{P}{R}$.

Find the third amount by adding or subtracting as appropriate.

Find the markup of an item if it is based on the cost of $38 and the selling price is $76.

$$M = S - C$$
$$M = \$76 - \$38$$
$$M = \$38$$

$$M\% = \frac{M}{C} \times 100\%$$
$$M\% = \frac{\$38}{\$38}(100\%)$$
$$M\% = 100\%$$

5 Compare the markup based on the cost with the markup based on the selling price. (p. 311)

To convert a markup rate based on selling price to a markup rate based on cost:

1. Find the complement of the markup rate based on the selling price. That is, subtract the markup rate from 100%.
2. Divide the decimal equivalent of the markup rate based on the selling price by the decimal equivalent of the complement of the rate.

$$M\%_{cost} = \frac{M\%_{selling\ price}}{100\% - M\%_{selling\ price}} \times 100\%$$

A fax machine is marked up 30% based on selling price. What is the rate of markup based on cost?

$$M\%_{cost} = \frac{M\%_{selling\ price}}{100\% - M\%_{selling\ price}} \times 100\%$$ Substitute known values.

$$M\%_{cost} = \frac{30\%}{100\% - 30\%}(100\%)$$ Change percent to its decimal equivalent.

$$M\%_{cost} = \frac{0.3}{1 - 0.3}(100\%)$$ Subtract in the denominator.

$$M\%_{cost} = \frac{0.3}{0.7}(100\%)$$ Divide. Round to thousandths.

$$M\%_{cost} = 0.429$$ Change to the percent equivalent.
$$M\%_{cost} = 42.9\%$$

To convert a markup rate based on cost to a markup rate based on selling price:

1. Add 100% to the markup rate based on the cost.
2. Divide the decimal equivalent of the markup rate based on the cost by the decimal equivalent of the sum found in step 1.

$$M\%_{selling\ price} = \frac{M\%_{cost}}{100\% + M\%_{cost}}(100\%)$$

A DVD player is marked up 80% based on cost. What is the rate of markup based on selling price?

$$M\%_{selling\ price} = \frac{M\%_{cost}}{100\% + M\%_{cost}} \times 100\%$$ Substitute known values.

$$M\%_{selling\ price} = \frac{80\%}{100\% + 80\%}(100\%)$$ Change percent to its decimal equivalent.

$$M\%_{selling\ price} = \frac{0.8}{1 + 0.8}(100\%)$$ Add in denominator.

$$M\%_{selling\ price} = \frac{0.8}{1.8}(100\%)$$ Divide. Round to thousandths.

$$M\%_{selling\ price} = 0.444(100\%)$$ Change to the percent equivalent.
$$M\%_{selling\ price} = 44.4\%$$

Section 9-3

1 Find the amount of markdown, the reduced (new) price, and the percent of markdown. (p. 316)

1. Place the known values into the chart.

	$	%
Original Selling Price (S)		100
Markdown (M)		
Reduced (New) Price (N)		

2. Select the appropriate formula based on the known values.

Markdown = original selling price − reduced price $M = S - N$

Reduced price = original selling price − markdown $N = S - M$

$$M\% = \frac{M}{S} \times 100\%$$

Find the markdown and rate of markdown if the original selling price is \$4.50 and the sale (new) price is \$3.

$M = S - N$

$M = \$4.50 - \3

$M = \$1.50$

$M\% = \dfrac{M}{S} \times 100\%$

$M\% = \dfrac{\$1.50}{\$4.50}(100\%)$

$M\% = 0.333(100\%)$

$M\% = 33.3\%$

	\$	%
S	4.50	100
M		
N	3.00	

2 Find the final selling price for a series of markups and markdowns. (p. 318)

1. Find the first selling price using the given facts and markup procedures in Sections 9-1 and 9-2.

2. For each remaining stage in the series:

 (a) If the stage requires a *markdown*, identify the previous selling price as the *original selling price S* for this stage. Find the *reduced price N*. This reduced price is the new selling price for this stage.

 (b) If the stage requires a *markup*, identify the previous selling price as the *cost C* for this stage. Find the *selling price S*. This price is the new selling price for this stage.

3. Identify the selling price for the last stage as the *final selling price*.

An item costing \$7 was marked up 70% on cost, then marked down 20%, marked up 10%, and finally marked down 20%. What was the final selling price?

First stage:
Markup

$S\% = C\% + M\%$
$S\% = 100\% + 70\%$
$S\% = 170\%$

$S_1 = S\% \times C$
$S_1 = 170\%(\$7)$
$S_1 = 1.7(\$7)$
$S_1 = \$11.90$

Second stage:
Markdown
$S_1 = S$

$N\% = 100\% - M\%$
$N\% = 100\% - 20\%$
$N\% = 80\%$

$N_2 = N\% \times S_1$
$N_2 = 80\%(\$11.90)$
$N_2 = 0.8(\$11.90)$
$N_2 = \$9.52$

Third stage:
Markup
$N_2 = C$

$S\% = C\% + M\%$
$S\% = 100\% + 10\%$
$S\% = 110\%$

$S_3 = S\% \times N_2$
$S_3 = 110\%(\$9.52)$
$S_3 = 1.1(\$9.52)$
$S_3 = \$10.47$

Final stage:
Markdown
$S_3 = S$

$N\% = 100\% - M\%$
$N\% = 100\% - 20\%$
$N\% - 80\%$

$N_4 = N\% \times S_3$
$N_4 = 80\%(\$10.47)$
$N_4 = 0.8(\$10.47)$
$N_4 = \$8.38$

The final selling price was \$8.38.

3 Find the selling price for a desired profit on perishable and seasonal goods. (p. 320)

1. Establish the rate of profit (markup)—based on cost—desired on the sale of the merchandise.

2. Find the total cost of the merchandise by multiplying the unit cost by the quantity of merchandise. Add in additional charges such as shipping.

3. Find the total desired profit (markup) based on cost by multiplying the rate of profit (markup) by the total cost.

4. Find the total selling price by adding the total cost and the total desired profit.

5. Establish the quantity expected to sell.

6. Divide the total selling price (step 4) by the expect-to-sell quantity (step 5).

$$\text{Selling price per item to achieve desired profit} = \frac{\text{total selling price}}{\text{expect-to-sell quantity}}$$

At a total cost of $25, 25% of 400 lemons are expected to spoil before being sold. A 75% rate of profit (markup) on cost is needed. At what selling price must each lemon be sold to achieve the needed profit?

C = total cost of lemons = $25
$M\%$ = total rate of profit (markup) = 75%

$M = M\% \times C$ $S = C + M$
$M = 75\%(\$25)$ $S = \$25 + \18.75
$M = 0.75(\$25)$ $S = \$43.75$
$M = \$18.75$

Quantity expected to sell = $(100\% - 25\%)(400)$
$= (75\%)(400)$
$= 0.75(400)$
$= 300$ lemons

Selling price per item $= \dfrac{\$43.75}{300 \text{ lemons}}$

$= \$0.15$ per lemon (rounded)

EXERCISES SET A

Find the missing numbers in the table if the markup is based on cost.

1.

	$	%
C	$50	
+M	$25	50%
S		

2.

	$	%
C	$41	
+M		100%
S		

Find the missing numbers in the table if the markup is based on the selling price.

3.

	$	%
C	$38	42%
+M		
S		

4.

	$	%
C		
+M	$8	15%
S		

Fill in the blanks in Exercises 5 through 9. Round amounts to the nearest cent and rates to the nearest hundredth percent.

	Cost	Markup	Selling price	Rate of markup based on cost	Rate of markup based on selling price
5.		$32	$89		
6.	$1.56		$2		
7.		$27.38		40%	
8.		$124		150%	
9.			$18.95		15%

10. A hairdryer costs $15 and is marked up 40% of the cost.
a. Find the markup.

b. Find the selling price.

11. A blender is marked up $9 and sells for $45.
a. Find the cost.

b. Find the rate of markup if the markup is based on cost.

12. A computer table sells for $198.50 and costs $158.70.
a. Find the markup.

b. Find the rate of markup based on the cost.

13. A flower arrangement is marked up $12, which is 50% of the cost.
a. Find the cost.

b. Find the selling price.

14. A briefcase is marked up $15.30, which is 30% of the selling price.
a. Find the selling price of the briefcase.

b. Find the cost.

15. A hole punch costs $40 and sells for $58.50.
a. Find the markup.

b. Find the rate of markup based on selling price.

16. A desk organizer sells for $35, which includes a markup rate of 60% of the selling price.
a. Find the cost.

b. Find the markup.

17. Find the rate of markup based on cost of a textbook that is marked up 20% based on the selling price.

18. A chest is marked up 63% based on cost. What is the rate of markup based on selling price?

19. A fiberglass shower originally sold for $379.98 and was marked down to sell for $341.98.
a. Find the markdown.

b. Find the rate of markdown.

20. An area rug originally sold for $699.99 and was reduced to sell for $500.
a. Find the markdown.

b. Find the rate of markdown.

21. A portable DVD player was originally priced at $249.99 and was reduced by 20%.
a. Find the markdown.

b. Find the sale (reduced) price.

22. A set of stainless steel cookware was originally priced at $79 and was reduced by 25%.
a. Find the markdown.

b. Find the sale price.

23. Crystal stemware originally marked to sell for $49.50 was reduced 20% for a special promotion. The stemware was then reduced an additional 30% to turn inventory. What were the markdown and the sale price for each reduction?

24. James McDonnell operates a vegetable store. He purchases 800 pounds of potatoes at a cost of $0.18 per pound. If he anticipates a spoilage rate of 20% of the potatoes and wishes to make a profit of 140% of the cost, for how much must he sell the potatoes per pound?

EXERCISES SET B

Find the missing numbers in the table if the markup is based on cost.

1.

	$	%
C	$4	
+M	$1	25%
S		

2.

	$	%
C		
+M	$ 5	20%
S		

Find the missing numbers in the table if the markup is based on the selling price.

3.

	$	%
C	$86	
+M		50%
S		

4.

	$	%
C		42%
+M	$22.10	
S		

Fill in the blanks in Exercises 5 through 9. Round amounts to the nearest cent and rates to the nearest hundredth percent.

	Cost	Markup	Selling price	Rate of markup based on cost	Rate of markup based on selling price
5.		$208.29	$694.29		
6.	$39.27		$45.16		
7.	$25	$23.08			
8.		$28			27%
9.			$32.20		49.44%

10. A hairbrush costs $3 and is marked up 40% of the cost.
 a. Find the markup.

 b. Find the selling price.

11. A package of cassette tapes costs $12 and is marked up $7.20.
 a. Find the selling price.

 b. Find the rate of markup based on the cost.

12. The selling price of an office chair is $75 and this item is marked up 100% of the cost.
 a. Find the cost.

 b. Find the rate of markup based on selling price.

13. A toaster sells for $28.70 and has a markup rate of 50% based on selling price.
 a. Find the cost.

 b. Find the markup.

14. A three-ringed binder costs $4.60 and is marked up $3.07. Find the selling price and the rate of markup based on selling price. Round to the nearest tenth percent.

15. A pair of bookends sells for $15 and costs $10. Find the rate of markup based on the selling price. Round to the nearest tenth percent.

16. A pair of athletic shoes costs $38 and is marked up $20. Find the selling price and rate of markup based on selling price. Round to the nearest tenth percent.

17. A desk has an 84% markup based on selling price. What is the rate of markup based on cost?

18. A dining room suite is marked up 45% based on cost. What is the rate of markup based on selling price? Round to the nearest tenth percent.

19. A three-speed fan originally sold for $29.98 and was reduced to sell for $25.40. Find the markdown and the rate of markdown. Round to the nearest tenth percent.

20. A room air conditioner that originally sold for $599.99 was reduced to sell for $400. Find the markdown and the rate of markdown. Round to the nearest tenth percent.

21. A set of rollers was originally priced at $39.99 and was reduced by 30%. Find the markdown and the sale price.

22. A down comforter was originally priced to sell at $280 and was reduced by 65%. Find the markdown and the sale price.

23. A camcorder that originally sold for $1,199 was reduced to sell for $999. What is the amount of reduction? What is the percent of reduction? Round to the nearest tenth percent.

PRACTICE TEST

1. A calculator sells for $23.99 and costs $16.83. What is the markup?

2. A mixer sells for $109.98 and has a markup of $36.18. Find the cost.

3. A cookbook has a 34% markup rate based on cost. If the markup is $5.27, find the cost of the cookbook.

4. A computer stand sells for $385. What is the markup if it is 45% of the selling price?

5. A box of printer paper costs $16.80. Find the selling price if there is a 35% markup rate based on cost.

6. The reduced price of a dress is $54.99. Find the original selling price if a reduction of 40% has been taken.

7. A daily organizer that originally sold for $86.90 was marked down by 30%. What is the markdown?

8. What is the sale price of the organizer in Exercise 7?

9. If a television costs $498.15 and was marked up $300, what is the selling price?

10. A refrigerator that sells for $589.99 was marked down $100. What is the sale price?

11. What is the rate of markdown of a scanner that sells for $498 and is marked down $142? Round to the nearest tenth percent.

12. A wallet costs $16.05 to produce. The wallet sells for $25.68. What is the rate of markup based on the cost?

13. A lamp costs $88. What is the selling price if the markup is 45% of the selling price?

14. A file cabinet originally sold for $215 but was damaged and had to be reduced. If the reduced cabinet sold for $129, what was the rate of markdown based on the original selling price?

15. A desk that originally sold for $589 was marked down 25%. During the sale it was scratched and had to be reduced an additional 25% of the original price. What was the final selling price of the desk?

16. Brenda Wimberly calculates the selling price for all produce at Quick Stop Produce. If 400 pounds of potatoes were purchased for $0.13 per pound and 18% of the potatoes were expected to spoil before being sold, determine the price per pound that the potatoes must sell for if a profit of 120% of the purchase price is desired.

17. The college bookstore marks up loose-leaf paper 40% of its cost. Find the cost if the selling price is $2.34 per package.

18. A CD costs $0.90 and sells for $1.50. Find the rate of markup based on selling price. Find the rate of markup based on cost. Round to the nearest whole percent.

19. A radio sells for $45, which includes a markup of 65% of the selling price. Find the cost and the markup.

20. Becky Drewery purchased a small refrigerator for her dorm room for $159, which included a markup of $32 based on the cost. Find the cost and the rate of markup based on cost. Round the rate to the nearest tenth percent.

1. Will the series markdown of 25% and 30% be more than or less than 55%? Explain why.

2. Explain why taking a series of markdowns of 25% and 30% is not the same as taking a single markdown of 55%. Illustrate your answer with a specific example.

3. Under what circumstances would you be likely to base the markup of an item on the selling price?

4. Under what circumstances would you be likely to base the markup for an item on cost?

5. What clues do you look for to determine whether the cost or selling price represents 100% in a markup problem?

6. If you were a retailer, would you prefer to base your markup on selling price or cost? Why? Give an example to illustrate your preference.

7. When given the rate of markup, describe at least one situation that leads to adding the rate to 100%. Describe at least one situation that leads to subtracting the rate from 100%.

8. Show by giving an example that the final reduced price in a series markdown can be found by doing a series of computations or by using the net decimal equivalent.

9. An item is marked up 60% based on a selling price of $400. What is the cost of the item? Find and correct the error in the solution.

$C\% = S\% - M\%$
$C\% = 100\% - 60\%$
$C\% = 40\%$

$C = \dfrac{S}{S\%}$

$C = \dfrac{\$400}{100\%}$

$C = \dfrac{\$400}{1}$

$C = \$400$

10. Explain why the percent of markup based on selling price cannot be greater than 100%.

Challenge Problem

Pro Peds, a local athletic shoe manufacturer, makes a training shoe at a cost of $22 per pair. This cost includes raw materials and labor only. A check of previous factory runs indicates that 10% of the training shoes will be defective and must be sold to Odd Tops, Inc., as irregulars for $32 per pair. If Pro Peds produces 1,000 pairs of the training shoes and desires a markup of 100% on cost, find the selling price per pair of the regular shoes to the nearest cent.

CASE STUDIES

9.1 Acupuncture, Tea, and Rice-Filled Heating Pads

Karen is an acupuncturist with a busy practice. In addition to acupuncture services Karen sells teas, herbal supplements, and rice-filled heating pads. Because Karen's primary income is from acupuncture, she feels that she is providing the other items simply to fill a need and not as an important source of profits. As a matter of fact, the rice filled heating pads are made by a patient who receives acupuncture instead of cash. The rice filled pads cost her $5.00, $8.00, and $12.00 respectively for small, medium, and large sizes. The ginger tea, relaxing tea, cold & flu tea, and detox tea cost her $2.59 per box plus $5.00 shipping and handling for 24 boxes. Karen uses a cost plus markup method, whereby she adds the same set amount to each box of tea. She figures that each box costs $2.59 plus $0.21 shipping and handling, which totals $2.80, then she adds $0.70 profit to each box and sells it for $3.50. Do you think this is a good pricing strategy? How would it compare to marking up by a percentage of the cost?

1. What is the markup percentage for a box of ginger tea?

2. If the rice-filled heating pads sell for $7.00, $10.00, and $15.00 for small, medium, and large, respectively, what is the markup percentage on each one?

3. Karen wants to compare using the cost plus method to the percentage markup method. If she sells 2 small rice pads, 4 medium rice pads, 2 large rice pads, and 20 boxes of $3.50 tea in a month, how much profit does she accumulate? What markup percentage would she have to use to make the same amount of profit on this month's sales?

4. What prices should Karen charge (using the markup percentage) to obtain the same amount of profit as she did with the cost plus method? Do not include shipping.

9.2 Carolina Crystals

Carolina Crystals, a mid-range jewelry store located at Harbor Village in San Diego, serves two clienteles: regular customers who purchase gifts and special-occasion jewelry year-round, and tourists visiting the city. Although tourism is high in San Diego most months of the year, the proprietor of Carolina Crystals, Amanda, knows that her regular customers tend to purchase more jewelry during November and December for Christmas presents; in late January and early February for Valentine's Day; and in late April and May for summer weddings. Typically, jewelry is marked up 100% based on cost, but Amanda adjusts her pricing throughout the year to reflect seasonal needs. Amanda always carries a selection of diamond engagement and eternity rings, a wide array of gold charms that appeal to tourists, both regular and baroque pearl strands, and other types of jewelry.

1. If Amanda purchases diamond rings at $1,200 each, what would be the regular selling price to her customers, assuming a 100% markup on cost?

2. If Amanda feels that an 85% markup on cost is more appropriate for gold charms, what would be the selling price on a gold sailboat charm Amanda purchases for $135?

Source: Cape Fear Community College Website, North Carolina

3. Amanda also sells gold bracelets on which the charms can be mounted. She runs a special all year that allows a customer to purchase a gold charm bracelet at 50% off if the customer also buys three gold charms at the same time. If a 7" gold bracelet costs Amanda $125, what would the price be if the customer bought only the bracelet (without the charms) at a regular 100% markup on cost?

4. What would be the total price of the purchase if a customer purchased 3 charms and the bracelet, assuming the first charm cost Amanda $150, the second $185, and the third $125, and were marked up 85% based on cost?

5. Amanda often suggests to her male customers who buy diamond engagement rings, that they also purchase a pearl necklace as a wedding gift for their bride. As a courtesy to men purchasing diamond engagement rings, Amanda discounts pearl strands 18" and shorter by 35% and pearl strands longer than 18" by 45%. If the diamond rings have a 100% markup on cost and the pearl necklaces have a 60% markup on cost, what would be Amanda's cost for a ring selling at $4,500 and a 22" pearl necklace selling for $1,500?

6. If a customer purchases both the diamond ring for $4,500 and the 22" pearl strand for $1,500 and receives the 45% discount applied, what would be the total purchase price? How much did the customer save by purchasing the ring and necklace together?

9.3 Deer Valley Organics, LLC

With an original goal of selling fresh apples from the family orchard at a roadside stand, Deer Valley Organics has become a unique operation featuring a wide variety of locally grown organic produce and farm products that include their own fruit as well as products from the area's finest growers. A number of different products are available, including: apples, strawberries, and raspberries as either prepackaged or pick your own; assorted fresh vegetables; ciders, jams, and jellies; and organic fresh eggs and free-range chicken whole fryers. Prepackaged apples are still the mainstay of the business, and after adding all production and labor costs, Deer Valley determined that the cost of these apples was 64 cents per pound.

1. What would be the selling price per pound for the prepackaged apples using a 30% markup based on cost? A 40% markup? A 50% markup?

2. Based on the national average for apples sold on a retail basis, Deer Creek sets a target price of $1.10 per pound for the prepackaged apples. Using this selling price, compute the percent of markup **based on cost** for the prepackaged apples. Then, compute the percent of markup **based on selling price**.

3. Deer Valley allows customers to pick their own apples for $8 a bag, which works out to approximately 47 cents per pound. How is that possible given the cost data in the introductory paragraph? Would the orchard be losing money? Explain.

4. Deer Valley receives a delivery of 1,250 lb of tomatoes from a local supplier, for which they pay 18 cents per pound. Normally, 6% of the tomatoes will be discarded due to appearance or spoilage. Find the selling price needed per pound to obtain a 120% markup based on cost.

Your First Job: Understanding Your Paycheck

"My paycheck isn't right!" Tom can't believe it: $461.69? He's supposed to be paid $600 each week! That's the salary he was quoted when he was hired.

Many people, when they receive their first paycheck, are surprised at the amount of money that is deducted from it before they get paid. These are payroll taxes. There's a big difference between gross income, salary or hourly rate times the number of hours; and net income, or take-home pay.

In Tom's case, his tax filing status is single with zero exemptions. His withholding is calculated using state tax tables and IRS information. The deductions from his pay are:

- Federal taxes, money sent to the IRS to pay federal income taxes. Federal taxes pay for a number of programs such as national defense, foreign affairs, law enforcement, education, and transportation.

- Social Security, money set aside for a federal program that provides monthly benefits to retired and disabled workers, their dependents, and their survivors.
- Medicare provides health care coverage for older Americans and people with disabilities.
- State tax, money withheld and sent to your state of residence to pay state income taxes. State taxes pay for state programs such as education, health, and welfare, public safety, and the court justice system. Some states may require additional deductions for state disability insurance and local taxes.

Always check your pay stub. It should include your identification information and the pay period (dates you worked for this check). It also lists your gross income, all your deductions, and your net income (the amount you get to keep).

LEARNING OUTCOMES

10-1 Gross Pay

1. Find the gross pay per paycheck based on salary.
2. Find the gross pay per weekly paycheck based on hourly wage.
3. Find the gross pay per paycheck based on piecework wage.
4. Find the gross pay per paycheck based on commission.

10-2 Payroll Deductions

1. Find federal tax withholding per paycheck using IRS tax tables.
2. Find federal tax withholding per paycheck using the IRS percentage method.
3. Find Social Security tax and Medicare tax per paycheck.
4. Find net earnings per paycheck.

10-3 The Employer's Payroll Taxes

1. Find an employer's total deposit for withholding tax, Social Security tax, and Medicare tax per pay period.
2. Find an employer's SUTA tax and FUTA tax due for a quarter.

Pay is an important concern of employees and employers alike. If you have worked and received a paycheck, you know that part of your earnings is taken out of your paycheck before you ever see it. Your employer *withholds* (deducts) taxes, union dues, medical insurance payments, and so on. Thus, there is a difference between **gross earnings (gross pay)**, the amount earned before deductions, and **net earnings (net pay)—take-home pay**—the amount of your paycheck.

Employers have the option of paying their employees in salary or in wages and of distributing these earnings at various time intervals. **Wages** are based on an hourly rate of pay and the number of hours worked. **Salary** is most often stated as a certain amount of money paid each year. Salaried employees are paid the agreed-upon salary, whether they work fewer or more than the usual number of hours.

> **Gross earnings (gross pay):** the amount earned before deductions.
>
> **Net earnings (net pay) or (take-home pay):** the amount of your paycheck.
>
> **Wages:** earnings based on an hourly rate of pay and the number of hours worked.
>
> **Salary:** an agreed-upon amount of pay that is not based on the number of hours worked.

10-1 GROSS PAY

LEARNING OUTCOMES

1 Find the gross pay per paycheck based on salary.
2 Find the gross pay per weekly paycheck based on hourly wage.
3 Find the gross pay per paycheck based on piecework wage.
4 Find the gross pay per paycheck based on commission.

Employees may be paid according to a salary, an hourly wage, a piecework rate, or a commission rate. Employers are required to withhold taxes from employee paychecks and forward these taxes to federal, state, and local governments.

1 Find the gross pay per paycheck based on salary.

Companies differ in how often they pay salaried employees, which determines how many paychecks an employee receives in a year. If employees are paid **weekly**, they receive 52 paychecks a year; if they are paid **biweekly** (every two weeks), they receive 26 paychecks a year. **Semimonthly** (twice a month) paychecks are issued 24 times a year, and **monthly** paychecks come 12 times a year.

> **Weekly:** once a week or 52 times a year.
>
> **Biweekly:** every two weeks or 26 times a year.
>
> **Semimonthly:** twice a month or 24 times a year.
>
> **Monthly:** once a month or 12 times a year.

HOW TO Find the gross pay per paycheck based on annual salary

1. Identify the number of pay periods per year:
 Monthly—12 pay periods per year
 Semimonthly—24 pay periods per year
 Biweekly—26 pay periods per year
 Weekly—52 pay periods per year
2. Divide the annual salary by the number of pay periods per year.

EXAMPLE 1 Charles Demetriou earns a salary of $30,000 a year.

(a) If Charles is paid biweekly, how much is his gross pay per pay period before taxes are taken out?
(b) If Charles is paid semimonthly, how much is his gross pay per pay period?

(a) $30,000 ÷ 26 = $1,153.85
Charles earns $1,153.85 biweekly before deductions.

Biweekly paychecks are issued 26 times a year, so divide Charles's salary by 26.

(b) $30,000 ÷ 24 = $1,250
Charles earns $1,250 semimonthly before deductions.

Semimonthly paychecks are issued 24 times a year, so divide Charles's salary by 24.

✔ STOP AND CHECK

1. Ryan Thomas earns $42,822 a year. What is his biweekly gross pay?

2. Jaswant Jain earns $32,928 annually and is paid semimonthly. Find his earnings per pay period.

3. Alison Bishay earns $1,872 each pay period and is paid weekly. Find her annual gross pay.

4. Annette Ford earns $3,315 monthly. What is her gross annual pay?

2 Find the gross pay per weekly paycheck based on hourly wage.

Hourly rate or hourly wage: the amount of pay per hour worked based on a standard 40-hour work week.

Overtime rate: rate of pay for hours worked that are more than 40 hours in a week.

Time and a half: standard overtime rate that is $1\frac{1}{2}$ (or 1.5) times the hourly rate.

Regular pay: earnings based on hourly rate of pay.

Overtime pay: earnings based on overtime rate of pay.

Many jobs pay according to an *hourly wage*. The **hourly rate**, or **hourly wage**, is the amount of money paid for each hour the employee works in a standard 40-hour work week. The Fair Labor Standards Act of 1938 set the standard work week at 40 hours. When hourly employees work more than 40 hours in a week, they earn the hourly wage for the first 40 hours, and they earn an **overtime rate** for the remaining hours. The standard overtime rate is often called **time and a half**. By law, it must be at least 1.5 (one and one-half) times the hourly wage. Earnings based on the hourly wage are called **regular pay**. Earnings based on the overtime rate are called **overtime pay**. An hourly employee's gross pay for a pay period is the sum of his or her regular pay and his or her overtime pay.

HOW TO Find the gross pay per week based on hourly wages

1. Find the regular pay:
 (a) If the hours worked in the week are 40 or fewer, multiply the hours worked by the hourly wage.
 (b) If the hours worked are more than 40, multiply 40 hours by the hourly wage.
2. Find the overtime pay:
 (a) If the hours worked are 40 or fewer, the overtime pay is $0.
 (b) If the hours worked are more than 40, subtract 40 from the hours worked and multiply the difference by the overtime rate.
3. Add the regular pay and the overtime pay.

When Does the Week Start? Even if an employee is paid biweekly, overtime pay is still based on the 40-hour standard work week. So overtime pay for each week in the pay period must be calculated separately. Also, each employer establishes the formal work week. For example, an employer's work week may begin at 12:01 A.M. Thursday and end at 12:00 midnight on Wednesday of the following week, allowing the payroll department to process payroll checks for distribution on Friday. Another employer may begin the work week at 11:01 P.M. on Sunday evening and end at 11:00 P.M. on Sunday the following week so that the new week coincides with the beginning of the 11 P.M.–7 A.M. shift on Sunday.

EXAMPLE 1 Marcia Scott, whose hourly wage is $10.25, worked 46 hours last week. Find her gross pay for last week if she earns time and a half for overtime.

$40(\$10.25) = \410 Find the regular pay for 40 hours of work at the hourly wage.

$46 - 40 = 6$ Find the overtime hours.

$\underbrace{6(\$10.25)(1.5)}_{\text{overtime rate}} = \92.25 Find the overtime pay by multiplying the overtime hours by the overtime rate, which is the hourly wage times 1.5. Round to the nearest cent.

$\$410 + \$92.25 = \$502.25$ Add the regular pay and the overtime pay to find Marcia's total gross earnings.

Marcia's gross pay is $502.25.

1. Shekenna Chapman earns $15.83 per hour and worked 48 hours in a week. Overtime is paid at 1.5 times hourly pay. What is her gross pay?

2. McDonald's pays Kelyn Blackburn 1.5 times her hourly pay for overtime. She worked 52 hours one week and her hourly pay is $13.56. Find her gross pay for the week.

3. Mark Kozlowski earns $14.27 per hour and worked 55 hours in one weekly pay period. What is his gross pay?

4. Marc Showalter earns $22.75 per hour with time and a half for regular overtime and double time on holidays. He worked 62 hours the week of July 4th and 8 of those hours were on July 4th. Find his gross pay.

3 Find the gross pay per paycheck based on piecework wage.

Piecework rate: amount of pay for each acceptable item produced.

Straight piecework rate: piecework rate where the pay is the same per item no matter how many items are produced.

Differential piece rate (escalating piece rate): piecework rate that increases as more items are produced.

Many employers motivate employees to produce more by paying according to the quantity of acceptable work done. Such **piecework rates** are typically offered in production or manufacturing jobs. Garment makers and some other types of factory workers, agricultural workers, and employees who perform repetitive tasks such as stuffing envelopes or packaging parts may be paid by this method. In the simplest cases, the gross earnings of such workers are calculated by multiplying the number of items produced by the **straight piecework rate**.

Sometimes employees earn wages at a **differential piece rate**, also called an **escalating piece rate**. As the number of items produced by the worker increases, so does the pay per item. This method of paying wages offers employees an even greater incentive to complete more pieces of work in a given period of time.

HOW TO Find the gross pay per paycheck based on piecework wage

1. If a *straight piecework rate* is used, multiply the number of items completed by the straight piecework rate.
2. If a *differential piecework rate* is used:
 (a) For each rate category, multiply the number of items produced for the category by the rate for the category.
 (b) Add the pay for all rate categories.

EXAMPLE 1 A shirt manufacturer pays a worker $0.47 for each acceptable shirt inspected under the prescribed job description. If the worker had the following work record, find the gross earnings for the week: Monday, 250 shirts; Tuesday, 300 shirts; Wednesday, 178 shirts; Thursday, 326 shirts; Friday, 296 shirts.

250 + 300 + 178 + 326 + 296 Find the total number of shirts inspected.
= 1,350 shirts

1,350($0.47) = $634.50 Multiply the number of shirts by the piecework rate.

The weekly gross earnings are $634.50.

EXAMPLE 2 Last week, Jorge Sanchez assembled 317 game boards. Find Jorge's gross earnings for the week if the manufacturer pays at the following differential piece rates:

Boards assembled per week	Pay per board
First 100	$1.82
Next 200	$1.92
Over 300	$2.08

Find how many boards were completed at each pay rate, multiply the number of boards by the rate, and add the amounts.

First 100 items: 100($1.82) = $182.00
Next 200 items: 200($1.92) = $384.00
Last 17 items: 17($2.08) = $ 35.36
 $601.36

Jorge's gross earnings were $601.36.

 STOP AND CHECK

1. JR Tinkler and Co. employs pear and peach pickers on a piecework basis. Paul Larson picks enough pears to fill 12 bins in the 40-hour work week. He is paid at the rate of $70 per bin. What is his pay for the week?

2. A rubber worker is paid $5.50 for each finished tire. In a given week, Dennis Swartz completed 21 tires on Monday, 27 tires on Tuesday, 18 tires on Wednesday, 29 tires on Thursday, and 24 tires on Friday. How much were his gross weekly earnings?

3. A tool assembly company pays differential piecework wages:

Units Assembled	Pay per Unit
1–200	$1.18
201–400	$1.35
401 and over	$1.55

Find Virginia March's gross pay if she assembled 535 units in one week.

4. Thai Notebaert assembles computer keyboards according to this differential piecework scale on a weekly basis.

Units Assembled	Pay per Unit
1–50	$2.95
51–150	$3.10
Over 150	$3.35

He assembled 37 keyboards on Monday, 42 on Tuesday, 40 on Wednesday, 46 on Thursday, and 52 keyboards on Friday. What is his gross pay for the week?

4 Find the gross pay per paycheck based on commission.

Commission: earnings based on sales.

Straight commission: entire pay based on sales.

Salary-plus-commission: a set amount of pay plus an additional amount based on sales.

Commission rate: the percent used to calculate the commission based on sales.

Quota: a minimum amount of sales that is required before a commission is applicable.

Many salespeople earn a **commission**, a percentage based on sales. Those whose entire pay is commission are said to work on **straight commission**. Those who receive a salary in addition to a commission are said to work on a **salary-plus-commission** basis. A **commission rate** can be a percent of total sales or a percent of sales greater than a specified **quota** of sales.

HOW TO Find the gross pay per paycheck based on commission

1. Find the commission:
 (a) If the commission is *commission based on total sales,* multiply the commission rate by the total sales for the pay period.
 (b) If the commission is *commission based on quota,* subtract the quota from the total sales and multiply the difference by the commission rate.
2. Find the salary:
 (a) If the wage is *straight commission,* the salary is $0.
 (b) If the wage is *commission-plus-salary,* determine the gross pay based on salary.
3. Add the commission and the salary.

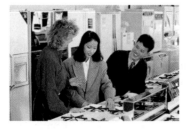

EXAMPLE 1 Shirley Garcia is a restaurant supplies salesperson and receives 8% of her total sales as commission. Her sales totaled $15,000 during a given week. Find her gross earnings.

Use the percentage formula $P = RB$.

$P = 0.08(\$15,000) = \$1,200$ Change the rate of 8% to an equivalent decimal and multiply it times the base of $15,000.

Shirley's gross earnings were $1,200.

EXAMPLE 2 Eloise Brown is paid on a salary-plus-commission basis. She receives $450 weekly in salary and 3% of all sales over $8,000. If she sold $15,000 worth of goods, find her gross pay.

$15,000 − $8,000 = $7,000	Subtract the quota from total sales to find the sales on which commission is paid.
$P = RB$	Change the rate of 3% to an equivalent decimal.
$P = 0.03($7,000)$	Multiply the rate by the base of $7,000.
$P = \$210$ (commission)	
$210 + $450 = $660	Add the commission and salary to find gross pay.

Eloise Brown's gross earnings were $660.

 STOP AND CHECK

1. Reyna Mata sells furniture and is paid 6% of her total sales as commission. One week her sales totaled $17,945. What are her gross earnings?

2. Acacio Sweazea receives 1% of eBay sales plus $4.00 for each item he lists through his eBay listing service. One month he listed 547 items that sold for a total of $30,248. Find his gross earnings.

3. Kate Citrino is paid $200 weekly plus 2% of her sales above $3,000. One week she sold $26,572 in merchandise. Find her gross pay. Find her estimated annual gross pay.

4. Arita Hannus earns $275 biweekly and 4% of her sales. In one pay period her sales were $32,017. Find her gross pay. At this same rate find her estimated annual gross pay.

10-1 SECTION EXERCISES

SKILL BUILDERS

1. If Timothy Oaks earns a salary of $35,204 a year and is paid weekly, how much is his weekly paycheck before taxes?

2. If Nita McMillan earns a salary of $31,107.96 a year and is paid biweekly, how much is her biweekly paycheck before taxes are taken out?

3. Gregory Maksi earns a salary of $52,980 annually and is paid monthly. How much is his gross monthly income?

4. Amelia Mattix is an accountant and is paid semimonthly. Her annual salary is $38,184. How much is her gross pay per period?

5. William Melton worked 47 hours in one week. His regular pay was $7.60 per hour with time and a half for overtime. Find his gross earnings for the week.

6. Bethany Colangelo, whose regular rate of pay is $8.25 per hour, with time and a half for overtime, worked 44 hours last week. Find her gross pay for the week.

7. Carlos Espinosa earns $15.90 per hour with time and a half for overtime and worked 47 hours during a recent week. Find his gross pay for the week.

8. A belt manufacturer pays a worker $0.84 for each buckle she correctly attaches to a belt. If Yolanda Jackson had the following work record, find the gross earnings for the week: Monday, 132 buckles; Tuesday, 134 buckles; Wednesday, 138 buckles; Thursday, 134 buckles; Friday, 130 buckles.

APPLICATIONS

9. Last week, Laurie Golson packaged 289 boxes of Holiday Cheese Assortment. Find her gross weekly earnings if she is paid at the following differential piece rate.

Cheese boxes

packaged per week	Pay per package
1–100	$1.88
101–300	$2.08
301 and over	$2.18

10. Joe Thweatt makes icons for a major distributor. He is paid $9.13 for each icon and records the following number of completed icons: Monday, 14; Tuesday, 11; Wednesday, 10; Thursday, 12; Friday, 12. How much will he be paid for his work for the week?

11. Mark Moses is a paper mill sales representative who receives 6% of his total sales as commission. His sales last week totaled $8,972. Find his gross earnings for the week.

12. Mary Lee Strode is paid a straight commission on sales as a real estate salesperson. In one pay period she had a total of $452,493 in sales. What is her gross pay if the commission rate is $3\frac{1}{2}\%$?

13. Dwayne Moody is paid on a salary-plus-commission basis. He receives $275 weekly in salary and a commission based on 5% of all weekly sales over $2,000. If he sold $7,821 in merchandise in one week, find his gross earnings for the week.

14. Vincent Ores sells equipment to receive satellite signals. He earns a 3% commission on monthly sales above $2,000. One month his sales totaled $145,938. What is his commission for the month?

10-2 PAYROLL DEDUCTIONS

LEARNING OUTCOMES

1 Find federal tax withholding per paycheck using IRS tax tables.
2 Find federal tax withholding per paycheck using the IRS percentage method.
3 Find Social Security tax and Medicare tax per paycheck.
4 Find net earnings per paycheck.

As anyone who has ever drawn a paycheck knows, many deductions may be subtracted from gross pay. Deductions may include federal, state, and local income or payroll taxes, Social Security and Medicare taxes, union dues, medical insurance payments, credit union payments, and a host of others. By law, employers are responsible for withholding and paying their employee's payroll taxes.

One of the largest deductions from an employee's paycheck usually comes in the form of **income tax**. The tax paid to the federal government is called **federal tax withholding**. The tax withheld is based on three things: the employee's gross earnings, the employee's **tax-filing status**, and the number of *withholding allowances* the person claims.

The employee's filing status is determined by marital status and eligibility to be classified as a head of household. A **withholding allowance**, called an **exemption**, is a portion of gross earnings that is not subject to tax. Each employee is permitted one withholding allowance for himself or herself, one for a spouse, and one for each eligible dependent (such as a child or elderly parent). A detailed discussion on eligibility for various allowances can be found in several IRS publications, such as Publication 15 [Circular E, Employer's Tax Guide], Publication 505 [Tax Withholding and Estimated Tax], and Publication 17 [Your Federal Income Tax for Individuals].

There are several ways to figure the withholding tax for an employee. The most common methods use tax tables and tax rates. These and other methods are referenced in IRS Publication 15 (Circular E, Employer's Tax Guide).

Income tax: local, state, or federal tax paid on one's income.

Federal tax withholding: the amount required to be withheld from a person's pay to be paid to the federal government.

Tax-filing status: status based on whether the employee is married, single, or a head of household that determines the tax rate.

Withholding allowance (exemption): a portion of gross earnings that is not subject to tax.

1 Find federal tax withholding per paycheck using IRS tax tables.

To calculate federal withholding tax using IRS tax tables, an employer must know the employee's filing status (single, married, or head of household), the number of withholding allowances the employee claims, the type of pay period (weekly, biweekly, and so on), and the employee's *adjusted gross income*. When an employee is hired for a job, he or she is asked for payroll purposes to complete a federal W-4 form. Figure 10-1 shows a 2007 W-4 form. On this form an

W-4 form: form required to be held by the employer for determining the amount of federal tax to be withheld.

Form W-4 (2007)

Purpose. Complete Form W-4 so that your employer can withhold the correct federal income tax from your pay. Because your tax situation may change, you may want to refigure your withholding each year.

Exemption from withholding. If you are exempt, complete **only** lines 1, 2, 3, 4, and 7 and sign the form to validate it. Your exemption for 2007 expires February 16, 2008. See Pub. 505, Tax Withholding and Estimated Tax.

Note. You cannot claim exemption from withholding if (a) your income exceeds $850 and includes more than $300 of unearned income (for example, interest and dividends) and (b) another person can claim you as a dependent on their tax return.

Basic instructions. If you are not exempt, complete the **Personal Allowances Worksheet** below. The worksheets on page 2 adjust your withholding allowances based on

itemized deductions, certain credits, adjustments to income, or two-earner/multiple job situations. Complete all worksheets that apply. However, you may claim fewer (or zero) allowances.

Head of household. Generally, you may claim head of household filing status on your tax return only if you are unmarried and pay more than 50% of the costs of keeping up a home for yourself and your dependent(s) or other qualifying individuals.

Tax credits. You can take projected tax credits into account in figuring your allowable number of withholding allowances. Credits for child or dependent care expenses and the child tax credit may be claimed using the **Personal Allowances Worksheet** below. See Pub. 919, How Do I Adjust My Tax Withholding, for information on converting your other credits into withholding allowances.

Nonwage income. If you have a large amount of nonwage income, such as interest or dividends, consider making estimated tax payments using Form 1040-ES, Estimated Tax

for Individuals. Otherwise, you may owe additional tax. If you have pension or annuity income, see Pub. 919 to find out if you should adjust your withholding on Form W-4 or W-4P.

Two earners/Multiple jobs. If you have a working spouse or more than one job, figure the total number of allowances you are entitled to claim on all jobs using worksheets from only one Form W-4. Your withholding usually will be most accurate when all allowances are claimed on the Form W-4 for the highest paying job and zero allowances are claimed on the others.

Nonresident alien. If you are a nonresident alien, see the Instructions for Form 8233 before completing this Form W-4.

Check your withholding. After your Form W-4 takes effect, use Pub. 919 to see how the dollar amount you are having withheld compares to your projected total tax for 2007. See Pub. 919, especially if your earnings exceed $130,000 (Single) or $180,000 (Married).

Personal Allowances Worksheet (Keep for your records.)

A Enter "1" for **yourself** if no one else can claim you as a dependent **A** _____

B Enter "1" if: { ● You are single and have only one job; or
● You are married, have only one job, and your spouse does not work; or
● Your wages from a second job or your spouse's wages (or the total of both) are $1,000 or less. } . . **B** _____

C Enter "1" for your **spouse**. But, you may choose to enter "-0-" if you are married and have either a working spouse or more than one job. (Entering "-0-" may help you avoid having too little tax withheld.) **C** _____

D Enter number of **dependents** (other than your spouse or yourself) you will claim on your tax return **D** _____

E Enter "1" if you will file as **head of household** on your tax return (see conditions under **Head of household** above) . **E** _____

F Enter "1" if you have at least $1,500 of **child or dependent care expenses** for which you plan to claim a credit . . **F** _____
(**Note.** Do **not** include child support payments. See Pub. 503, Child and Dependent Care Expenses, for details.)

G **Child Tax Credit** (including additional child tax credit). See Pub 972, Child Tax Credit, for more information.
● If your total income will be less than $57,000 ($85,000 if married), enter "2" for each eligible child.
● If your total income will be between $57,000 and $84,000 ($85,000 and $119,000 if married), enter "1" for each eligible child plus "1" **additional** if you have 4 or more eligible children. **G** _____

H Add lines A through G and enter total here. (**Note.** This may be different from the number of exemptions you claim on your tax return.) ▶ **H** _____

For accuracy, complete all worksheets that apply. {
● If you plan to **itemize or claim adjustments to income** and want to reduce your withholding, see the **Deductions and Adjustments Worksheet** on page 2.
● If you have **more than one job** or are **married and you and your spouse both work** and the combined earnings from all jobs exceed $40,000 ($25,000 if married) see the **Two-Earners/Multiple Jobs Worksheet** on page 2 to avoid having too little tax withheld.
● If **neither** of the above situations applies, **stop here** and enter the number from line H on line 5 of Form W-4 below.
}

- - - - - - - - - - Cut here and give Form W-4 to your employer. Keep the top part for your records. - - - - - - - - - -

| Form **W-4** | **Employee's Withholding Allowance Certificate** | OMB No. 1545-0074 |
|---|---|---|
| Department of the Treasury Internal Revenue Service | ▶ Whether you are entitled to claim a certain number of allowances or exemption from withholding is subject to review by the IRS. Your employer may be required to send a copy of this form to the IRS. | 2007 |

| **1** Type or print your first name and middle initial. | Last name | **2** Your social security number |
|---|---|---|

| Home address (number and street or rural route) | **3** ☐ Single ☐ Married ☐ Married, but withhold at higher Single rate. Note. If married, but legally separated, or spouse is a nonresident alien, check the "Single" box. |
|---|---|
| City or town, state, and ZIP code | **4** If your last name differs from that shown on your social security card, check here. You must call 1-800-772-1213 for a replacement card. ▶ ☐ |

5 Total number of allowances you are claiming (from line **H** above **or** from the applicable worksheet on page 2) **5** ____

6 Additional amount, if any, you want withheld from each paycheck **6** $ ____

7 I claim exemption from withholding for 2007, and I certify that I meet **both** of the following conditions for exemption.
● Last year I had a right to a refund of **all** federal income tax withheld because I had **no** tax liability **and**
● This year I expect a refund of **all** federal income tax withheld because I expect to have **no** tax liability.
If you meet both conditions, write "Exempt" here ▶ **7**

Under penalties of perjury, I declare that I have examined this certificate and to the best of my knowledge and belief, it is true, correct, and complete.

Employee's signature
(Form is not valid unless you sign it.) ▶ _____ Date ▶ _____

| **8** Employer's name and address (Employer: Complete lines 8 and 10 only if sending to the IRS.) | **9** Office code (optional) | **10** Employer identification number (EIN) |
|---|---|---|

For Privacy Act and Paperwork Reduction Act Notice, see page 2. Cat. No. 10220Q Form **W-4** (2007)

FIGURE 10-1

Employee's Withholding Allowance Certificate

Adjustment: amount that can be subtracted from the gross income, such as qualifying IRAs, tax-sheltered annuities, 401Ks, or employer-sponsored child care of medical plans.

Adjusted gross income: the income that remains after allowable adjustments have been made.

employee must indicate tax-filing status and number of exemptions claimed. This information is necessary in order to compute the amount of federal income tax to be withheld from the employee's earnings.

In many cases, adjusted gross income is the same as gross pay. However, earnings contributed to funds such as qualifying IRAs, tax-sheltered annuities, 401ks, or some employer-sponsored child care and medical plans are called **adjustments** to income and are subtracted from gross pay to determine the **adjusted gross income**.

Figures 10-2 and 10-3 show a portion of two IRS tax tables.

SINGLE Persons—SEMIMONTHLY Payroll Period
(For Wages Paid in 2007)

| If the wages are— | | And the number of withholding allowances claimed is— | | | | | | | | | | |
|---|---|---|---|---|---|---|---|---|---|---|---|---|
| At least | But less than | 0 | 1 | 2 | 3 | 4 | 5 | 6 | 7 | 8 | 9 | 10 |
| | | The amount of income tax to be withheld is— | | | | | | | | | | |
| $840 | $860 | $95 | $74 | $53 | $32 | $17 | $3 | $0 | $0 | $0 | $0 | $0 |
| 860 | 880 | 98 | 77 | 56 | 35 | 19 | 5 | 0 | 0 | 0 | 0 | 0 |
| 880 | 900 | 101 | 80 | 59 | 38 | 21 | 7 | 0 | 0 | 0 | 0 | 0 |
| 900 | 920 | 104 | 83 | 62 | 41 | 23 | 9 | 0 | 0 | 0 | 0 | 0 |
| 920 | 940 | 107 | 86 | 65 | 44 | 25 | 11 | 0 | 0 | 0 | 0 | 0 |
| 940 | 960 | 110 | 89 | 68 | 47 | 27 | 13 | 0 | 0 | 0 | 0 | 0 |
| 960 | 980 | 113 | 92 | 71 | 50 | 29 | 15 | 1 | 0 | 0 | 0 | 0 |
| 980 | 1,000 | 116 | 95 | 74 | 53 | 31 | 17 | 3 | 0 | 0 | 0 | 0 |
| 1,000 | 1,020 | 119 | 98 | 77 | 56 | 34 | 19 | 5 | 0 | 0 | 0 | 0 |
| 1,020 | 1,040 | 122 | 101 | 80 | 59 | 37 | 21 | 7 | 0 | 0 | 0 | 0 |
| 1,040 | 1,060 | 125 | 104 | 83 | 62 | 40 | 23 | 9 | 0 | 0 | 0 | 0 |
| 1,060 | 1,080 | 128 | 107 | 86 | 65 | 43 | 25 | 11 | 0 | 0 | 0 | 0 |
| 1,080 | 1,100 | 131 | 110 | 89 | 68 | 46 | 27 | 13 | 0 | 0 | 0 | 0 |
| 1,100 | 1,120 | 134 | 113 | 92 | 71 | 49 | 29 | 15 | 1 | 0 | 0 | 0 |
| 1,120 | 1,140 | 137 | 116 | 95 | 74 | 52 | 31 | 17 | 3 | 0 | 0 | 0 |
| 1,140 | 1,160 | 140 | 119 | 98 | 77 | 55 | 34 | 19 | 5 | 0 | 0 | 0 |
| 1,160 | 1,180 | 143 | 122 | 101 | 80 | 58 | 37 | 21 | 7 | 0 | 0 | 0 |
| 1,180 | 1,200 | 146 | 125 | 104 | 83 | 61 | 40 | 23 | 9 | 0 | 0 | 0 |
| 1,200 | 1,220 | 149 | 128 | 107 | 86 | 64 | 43 | 25 | 11 | 0 | 0 | 0 |
| 1,220 | 1,240 | 152 | 131 | 110 | 89 | 67 | 46 | 27 | 13 | 0 | 0 | 0 |
| 1,240 | 1,260 | 155 | 134 | 113 | 92 | 70 | 49 | 29 | 15 | 1 | 0 | 0 |
| 1,260 | 1,280 | 158 | 137 | 116 | 95 | 73 | 52 | 31 | 17 | 3 | 0 | 0 |
| 1,280 | 1,300 | 161 | 140 | 119 | 98 | 76 | 55 | 34 | 19 | 5 | 0 | 0 |
| 1,300 | 1,320 | 164 | 143 | 122 | 101 | 79 | 58 | 37 | 21 | 7 | 0 | 0 |
| 1,320 | 1,340 | 167 | 146 | 125 | 104 | 82 | 61 | 40 | 23 | 9 | 0 | 0 |
| 1,340 | 1,360 | 170 | 149 | 128 | 107 | 85 | 64 | 43 | 25 | 11 | 0 | 0 |
| 1,360 | 1,380 | 173 | 152 | 131 | 110 | 88 | 67 | 46 | 27 | 13 | 0 | 0 |
| 1,380 | 1,400 | 176 | 155 | 134 | 113 | 91 | 70 | 49 | 29 | 15 | 0 | 0 |
| 1,400 | 1,420 | 181 | 158 | 137 | 116 | 94 | 73 | 52 | 31 | 17 | 2 | 0 |
| 1,420 | 1,440 | 186 | 161 | 140 | 119 | 97 | 76 | 55 | 34 | 19 | 4 | 0 |
| 1,440 | 1,460 | 191 | 164 | 143 | 122 | 100 | 79 | 58 | 37 | 21 | 6 | 0 |
| 1,460 | 1,480 | 196 | 167 | 146 | 125 | 103 | 82 | 61 | 40 | 23 | 8 | 0 |
| 1,480 | 1,500 | 201 | 170 | 149 | 128 | 106 | 85 | 64 | 43 | 25 | 10 | 0 |
| 1,500 | 1,520 | 206 | 173 | 152 | 131 | 109 | 88 | 67 | 46 | 27 | 12 | 0 |
| 1,520 | 1,540 | 211 | 176 | 155 | 134 | 112 | 91 | 70 | 49 | 29 | 14 | 0 |
| 1,540 | 1,560 | 216 | 180 | 158 | 137 | 115 | 94 | 73 | 52 | 31 | 16 | 2 |
| 1,560 | 1,580 | 221 | 185 | 161 | 140 | 118 | 97 | 76 | 55 | 33 | 18 | 4 |
| 1,580 | 1,600 | 226 | 190 | 164 | 143 | 121 | 100 | 79 | 58 | 36 | 20 | 6 |
| 1,600 | 1,620 | 231 | 195 | 167 | 146 | 124 | 103 | 82 | 61 | 39 | 22 | 8 |
| 1,620 | 1,640 | 236 | 200 | 170 | 149 | 127 | 106 | 85 | 64 | 42 | 24 | 10 |
| 1,640 | 1,660 | 241 | 205 | 173 | 152 | 130 | 109 | 88 | 67 | 45 | 26 | 12 |
| 1,660 | 1,680 | 246 | 210 | 176 | 155 | 133 | 112 | 91 | 70 | 48 | 28 | 14 |
| 1,680 | 1,700 | 251 | 215 | 180 | 158 | 136 | 115 | 94 | 73 | 51 | 30 | 16 |
| 1,700 | 1,720 | 256 | 220 | 185 | 161 | 139 | 118 | 97 | 76 | 54 | 33 | 18 |
| 1,720 | 1,740 | 261 | 225 | 190 | 164 | 142 | 121 | 100 | 79 | 57 | 36 | 20 |
| 1,740 | 1,760 | 266 | 230 | 195 | 167 | 145 | 124 | 103 | 82 | 60 | 39 | 22 |
| 1,760 | 1,780 | 271 | 235 | 200 | 170 | 148 | 127 | 106 | 85 | 63 | 42 | 24 |
| 1,780 | 1,800 | 276 | 240 | 205 | 173 | 151 | 130 | 109 | 88 | 66 | 45 | 26 |
| 1,800 | 1,820 | 281 | 245 | 210 | 176 | 154 | 133 | 112 | 91 | 69 | 48 | 28 |
| 1,820 | 1,840 | 286 | 250 | 215 | 179 | 157 | 136 | 115 | 94 | 72 | 51 | 30 |
| 1,840 | 1,860 | 291 | 255 | 220 | 184 | 160 | 139 | 118 | 97 | 75 | 54 | 33 |
| 1,860 | 1,880 | 296 | 260 | 225 | 189 | 163 | 142 | 121 | 100 | 78 | 57 | 36 |
| 1,880 | 1,900 | 301 | 265 | 230 | 194 | 166 | 145 | 124 | 103 | 81 | 60 | 39 |
| 1,900 | 1,920 | 306 | 270 | 235 | 199 | 169 | 148 | 127 | 106 | 84 | 63 | 42 |
| 1,920 | 1,940 | 311 | 275 | 240 | 204 | 172 | 151 | 130 | 109 | 87 | 66 | 45 |
| 1,940 | 1,960 | 316 | 280 | 245 | 209 | 175 | 154 | 133 | 112 | 90 | 69 | 48 |
| 1,960 | 1,980 | 321 | 285 | 250 | 214 | 179 | 157 | 136 | 115 | 93 | 72 | 51 |
| 1,980 | 2,000 | 326 | 290 | 255 | 219 | 184 | 160 | 139 | 118 | 96 | 75 | 54 |
| 2,000 | 2,020 | 331 | 295 | 260 | 224 | 189 | 163 | 142 | 121 | 99 | 78 | 57 |
| 2,020 | 2,040 | 336 | 300 | 265 | 229 | 194 | 166 | 145 | 124 | 102 | 81 | 60 |
| 2,040 | 2,060 | 341 | 305 | 270 | 234 | 199 | 169 | 148 | 127 | 105 | 84 | 63 |
| 2,060 | 2,080 | 346 | 310 | 275 | 239 | 204 | 172 | 151 | 130 | 108 | 87 | 66 |
| 2,080 | 2,100 | 351 | 315 | 280 | 244 | 209 | 175 | 154 | 133 | 111 | 90 | 69 |
| 2,100 | 2,120 | 356 | 320 | 285 | 249 | 214 | 179 | 157 | 136 | 114 | 93 | 72 |
| 2,120 | 2,140 | 361 | 325 | 290 | 254 | 219 | 184 | 160 | 139 | 117 | 96 | 75 |

$2,140 and over — Use Table 3(a) for a **SINGLE person** on page 37. Also see the instructions on page 35.

FIGURE 10-2

Portion of IRS Withholding Table for Single Persons Paid Semimonthly

MARRIED Persons—WEEKLY Payroll Period

(For Wages Paid in 2007)

| If the wages are— | | And the number of withholding allowances claimed is— | | | | | | | | | | |
|---|---|---|---|---|---|---|---|---|---|---|---|---|
| At least | But less than | 0 | 1 | 2 | 3 | 4 | 5 | 6 | 7 | 8 | 9 | 10 |
| | | The amount of income tax to be withheld is— | | | | | | | | | | |
| $0 | $125 | $0 | $0 | $0 | $0 | $0 | $0 | $0 | $0 | $0 | $0 | $0 |
| 125 | 130 | 0 | 0 | 0 | 0 | 0 | 0 | 0 | 0 | 0 | 0 | 0 |
| 130 | 135 | 0 | 0 | 0 | 0 | 0 | 0 | 0 | 0 | 0 | 0 | 0 |
| 135 | 140 | 0 | 0 | 0 | 0 | 0 | 0 | 0 | 0 | 0 | 0 | 0 |
| 140 | 145 | 0 | 0 | 0 | 0 | 0 | 0 | 0 | 0 | 0 | 0 | 0 |
| 145 | 150 | 0 | 0 | 0 | 0 | 0 | 0 | 0 | 0 | 0 | 0 | 0 |
| 150 | 155 | 0 | 0 | 0 | 0 | 0 | 0 | 0 | 0 | 0 | 0 | 0 |
| 155 | 160 | 0 | 0 | 0 | 0 | 0 | 0 | 0 | 0 | 0 | 0 | 0 |
| 160 | 165 | 1 | 0 | 0 | 0 | 0 | 0 | 0 | 0 | 0 | 0 | 0 |
| 165 | 170 | 1 | 0 | 0 | 0 | 0 | 0 | 0 | 0 | 0 | 0 | 0 |
| 170 | 175 | 2 | 0 | 0 | 0 | 0 | 0 | 0 | 0 | 0 | 0 | 0 |
| 175 | 180 | 2 | 0 | 0 | 0 | 0 | 0 | 0 | 0 | 0 | 0 | 0 |
| 180 | 185 | 3 | 0 | 0 | 0 | 0 | 0 | 0 | 0 | 0 | 0 | 0 |
| 185 | 190 | 3 | 0 | 0 | 0 | 0 | 0 | 0 | 0 | 0 | 0 | 0 |
| 190 | 195 | 4 | 0 | 0 | 0 | 0 | 0 | 0 | 0 | 0 | 0 | 0 |
| 195 | 200 | 4 | 0 | 0 | 0 | 0 | 0 | 0 | 0 | 0 | 0 | 0 |
| 200 | 210 | 5 | 0 | 0 | 0 | 0 | 0 | 0 | 0 | 0 | 0 | 0 |
| 210 | 220 | 6 | 0 | 0 | 0 | 0 | 0 | 0 | 0 | 0 | 0 | 0 |
| 220 | 230 | 7 | 1 | 0 | 0 | 0 | 0 | 0 | 0 | 0 | 0 | 0 |
| 230 | 240 | 8 | 2 | 0 | 0 | 0 | 0 | 0 | 0 | 0 | 0 | 0 |
| 240 | 250 | 9 | 3 | 0 | 0 | 0 | 0 | 0 | 0 | 0 | 0 | 0 |
| 250 | 260 | 10 | 4 | 0 | 0 | 0 | 0 | 0 | 0 | 0 | 0 | 0 |
| 260 | 270 | 11 | 5 | 0 | 0 | 0 | 0 | 0 | 0 | 0 | 0 | 0 |
| 270 | 280 | 12 | 6 | 0 | 0 | 0 | 0 | 0 | 0 | 0 | 0 | 0 |
| 280 | 290 | 13 | 7 | 0 | 0 | 0 | 0 | 0 | 0 | 0 | 0 | 0 |
| 290 | 300 | 14 | 8 | 1 | 0 | 0 | 0 | 0 | 0 | 0 | 0 | 0 |
| 300 | 310 | 15 | 9 | 2 | 0 | 0 | 0 | 0 | 0 | 0 | 0 | 0 |
| 310 | 320 | 16 | 10 | 3 | 0 | 0 | 0 | 0 | 0 | 0 | 0 | 0 |
| 320 | 330 | 17 | 11 | 4 | 0 | 0 | 0 | 0 | 0 | 0 | 0 | 0 |
| 330 | 340 | 18 | 12 | 5 | 0 | 0 | 0 | 0 | 0 | 0 | 0 | 0 |
| 340 | 350 | 19 | 13 | 6 | 0 | 0 | 0 | 0 | 0 | 0 | 0 | 0 |
| 350 | 360 | 20 | 14 | 7 | 1 | 0 | 0 | 0 | 0 | 0 | 0 | 0 |
| 360 | 370 | 21 | 15 | 8 | 2 | 0 | 0 | 0 | 0 | 0 | 0 | 0 |
| 370 | 380 | 22 | 16 | 9 | 3 | 0 | 0 | 0 | 0 | 0 | 0 | 0 |
| 380 | 390 | 23 | 17 | 10 | 4 | 0 | 0 | 0 | 0 | 0 | 0 | 0 |
| 390 | 400 | 24 | 18 | 11 | 5 | 0 | 0 | 0 | 0 | 0 | 0 | 0 |
| 400 | 410 | 25 | 19 | 12 | 6 | 0 | 0 | 0 | 0 | 0 | 0 | 0 |
| 410 | 420 | 26 | 20 | 13 | 7 | 0 | 0 | 0 | 0 | 0 | 0 | 0 |
| 420 | 430 | 27 | 21 | 14 | 8 | 1 | 0 | 0 | 0 | 0 | 0 | 0 |
| 430 | 440 | 28 | 22 | 15 | 9 | 2 | 0 | 0 | 0 | 0 | 0 | 0 |
| 440 | 450 | 29 | 23 | 16 | 10 | 3 | 0 | 0 | 0 | 0 | 0 | 0 |
| 450 | 460 | 30 | 24 | 17 | 11 | 4 | 0 | 0 | 0 | 0 | 0 | 0 |
| 460 | 470 | 32 | 25 | 18 | 12 | 5 | 0 | 0 | 0 | 0 | 0 | 0 |
| 470 | 480 | 33 | 26 | 19 | 13 | 6 | 0 | 0 | 0 | 0 | 0 | 0 |
| 480 | 490 | 35 | 27 | 20 | 14 | 7 | 0 | 0 | 0 | 0 | 0 | 0 |
| 490 | 500 | 36 | 28 | 21 | 15 | 8 | 1 | 0 | 0 | 0 | 0 | 0 |
| 500 | 510 | 38 | 29 | 22 | 16 | 9 | 2 | 0 | 0 | 0 | 0 | 0 |
| 510 | 520 | 39 | 30 | 23 | 17 | 10 | 3 | 0 | 0 | 0 | 0 | 0 |
| 520 | 530 | 41 | 31 | 24 | 18 | 11 | 4 | 0 | 0 | 0 | 0 | 0 |
| 530 | 540 | 42 | 33 | 25 | 19 | 12 | 5 | 0 | 0 | 0 | 0 | 0 |
| 540 | 550 | 44 | 34 | 26 | 20 | 13 | 6 | 0 | 0 | 0 | 0 | 0 |
| 550 | 560 | 45 | 36 | 27 | 21 | 14 | 7 | 1 | 0 | 0 | 0 | 0 |
| 560 | 570 | 47 | 37 | 28 | 22 | 15 | 8 | 2 | 0 | 0 | 0 | 0 |
| 570 | 580 | 48 | 39 | 29 | 23 | 16 | 9 | 3 | 0 | 0 | 0 | 0 |
| 580 | 590 | 50 | 40 | 30 | 24 | 17 | 10 | 4 | 0 | 0 | 0 | 0 |
| 590 | 600 | 51 | 42 | 32 | 25 | 18 | 11 | 5 | 0 | 0 | 0 | 0 |
| 600 | 610 | 53 | 43 | 33 | 26 | 19 | 12 | 6 | 0 | 0 | 0 | 0 |
| 610 | 620 | 54 | 45 | 35 | 27 | 20 | 13 | 7 | 0 | 0 | 0 | 0 |
| 620 | 630 | 56 | 46 | 36 | 28 | 21 | 14 | 8 | 1 | 0 | 0 | 0 |
| 630 | 640 | 57 | 48 | 38 | 29 | 22 | 15 | 9 | 2 | 0 | 0 | 0 |
| 640 | 650 | 59 | 49 | 39 | 30 | 23 | 16 | 10 | 3 | 0 | 0 | 0 |
| 650 | 660 | 60 | 51 | 41 | 31 | 24 | 17 | 11 | 4 | 0 | 0 | 0 |
| 660 | 670 | 62 | 52 | 42 | 32 | 25 | 18 | 12 | 5 | 0 | 0 | 0 |
| 670 | 680 | 63 | 54 | 44 | 34 | 26 | 19 | 13 | 6 | 0 | 0 | 0 |
| 680 | 690 | 65 | 55 | 45 | 35 | 27 | 20 | 14 | 7 | 1 | 0 | 0 |
| 690 | 700 | 66 | 57 | 47 | 37 | 28 | 21 | 15 | 8 | 2 | 0 | 0 |
| 700 | 710 | 68 | 58 | 48 | 38 | 29 | 22 | 16 | 9 | 3 | 0 | 0 |
| 710 | 720 | 69 | 60 | 50 | 40 | 30 | 23 | 17 | 10 | 4 | 0 | 0 |
| 720 | 730 | 71 | 61 | 51 | 41 | 32 | 24 | 18 | 11 | 5 | 0 | 0 |
| 730 | 740 | 72 | 63 | 53 | 43 | 33 | 25 | 19 | 12 | 6 | 0 | 0 |

FIGURE 10-3

Portion of IRS Withholding Table for Married Persons Paid Weekly

Find federal tax withholding per paycheck using the IRS tax tables

1. Find the adjusted gross income by subtracting the total *allowable* adjustments from the gross pay per pay period. Select the appropriate table according to the employee's filing status (single, married, or head of household) and according to the type of pay period (weekly, biweekly, and so on).
2. Find the income row: In the columns labeled "If the wages are—," select the "At least" and "But less than" interval that includes the employee's adjusted gross income for the pay period.
3. Find the allowances column: In the columns labeled "And the number of withholding allowances claimed is—," select the number of allowances the employee claims.
4. Find the cell where the income row and allowance column intersect. The correct tax is given in this cell.

EXAMPLE 1 Jeremy Dawson has a gross semimonthly income of $1,240, is single, claims three withholding allowances, and has no qualified adjustments. Find the amount of federal tax withholding to be deducted from his gross earnings.

| | |
|---|---|
| Use Figure 10-2. | Select appropriate tax table for a single person who is paid semimonthly. |
| Use row for interval "At least $1,240 but less than $1,260." | $1,240 is in the selected interval. |
| Use the column for three withholding allowances. | Find the intersection of the row and column. |

The withholding tax is $92.

EXAMPLE 2 Haruna Jing is married, has a gross weekly salary of $585, claims two withholding allowances, and has no qualified adjustments. Find the amount of withholding tax to be deducted from her gross salary.

| | |
|---|---|
| Use Figure 10-3. | Select appropriate tax table for a married person who is paid weekly. |
| Use row for interval "At least $580 but less than $590." | $585 is in the selected interval. |
| Use the column for two withholding allowances. | Find the intersection of the row and column. |

The withholding tax is $30.

 STOP AND CHECK

1. W. F. Kenoyer is single, claims two withholding allowances, has no allowable adjustments, and has a gross semimonthly income of $1,685. Find the amount of withholding tax to be deducted.

2. Kiyoshi Maruyama is married, has a weekly gross salary of $705, and has no allowable adjustments. He claims four withholding allowances. How much withholding tax will be deducted?

3. Karita Merrill is single and has no allowable adjustments but claims one exemption for herself. Her semimonthly earnings are $2,020. How much withholding tax will be deducted?

4. D. M. Park earns $640 weekly and has allowable adjustments of $30. Find his withholding tax if he is married and claims seven withholding allowances.

2 Find federal tax withholding per paycheck using the IRS percentage method.

Percentage method income: the result of subtracting the appropriate withholding allowances when using the percentage method of withholding.

Percentage method of withholding: an alternative method to the tax tables for calculating employees' withholding taxes.

Instead of using the tax tables, many companies calculate federal tax withholding using software such as QuickBooks or Peachtree Accounting that uses the tax rates. In order to use tax rates, the employer must deduct from the employee's adjusted gross income a tax-exempt amount based on the number of withholding allowances the employee claims. The resulting amount is sometimes called the **percentage method income**.

Figure 10-4 shows how much of an employee's adjusted gross income is exempt for each withholding allowance claimed, according to the type of pay period—weekly, biweekly, and so on. The table in Figure 10-4 is available from the IRS and is one of the tables used for calculating employees' withholding taxes. This method is called the **percentage method of withholding**.

FIGURE 10-4

IRS Table for Figuring Withholding Allowance According to the Percentage Method

| Payroll Period | One Withholding Allowance |
|---|---|
| Weekly....................... | $ 65.38 |
| Biweekly | 130.77 |
| Semimonthly | 141.67 |
| Monthly...................... | 283.33 |
| Quarterly | 850.00 |
| Semiannually................. | 1,700.00 |
| Annually | 3,400.00 |
| Daily or miscellaneous (each day of the payroll period) | 13.08 |

HOW TO Find the percentage method income per paycheck

1. Find the exempt-per-allowance amount: From the withholding allowance table (in Figure 10-4), identify the amount exempt for one withholding allowance according to the type of pay period.
2. Find the total exempt amount: Multiply the number of withholding allowances the employee claims by the exempt-per-allowance amount.
3. Subtract the total exempt amount from the employee's adjusted gross income for the pay period.

EXAMPLE 1 Find the percentage method income on Dollie Calloway's biweekly gross earnings of $3,150. She has no adjustments to income, is single, and claims two withholding allowances on her W-4 form.

Since Dollie has no adjustments to income, her gross earnings of $3,150 is her adjusted gross income. From the table in Figure 10-4, the amount exempt for one withholding allowance in a biweekly pay period is $130.77.

| | |
|---|---|
| 2($130.77) = $261.54 | Multiply the number of withholding allowances by the exempt-per-allowance amount. |
| $3,150 − $261.54 = $2,888.46 | Subtract the total exempt amount from the adjusted gross income. |

The percentage method income is $2,888.46.

Once an employee's percentage method income is found, the employer consults the percentage method tables, also available from the IRS, to know how much of this income should be taxed at the appropriate tax rate, according to the employee's marital status and the type of pay period. Figure 10-5 shows the IRS percentage method tables.

Tables for Percentage Method of Withholding
(For Wages Paid in 2007)

TABLE 1—WEEKLY Payroll Period

(a) SINGLE person (including head of household)—

| If the amount of wages (after subtracting withholding allowances) is: | | The amount of income tax to withhold is: | |
|---|---|---|---|
| Not over $51 | | $0 | |

| Over— | But not over— | | of excess over— |
|---|---|---|---|
| $51 | —$195 . . | 10% | —$51 |
| $195 | —$645 . . | $14.40 plus 15% | —$195 |
| $645 | —$1,482 . . | $81.90 plus 25% | —$645 |
| $1,482 | —$3,131 . . | $291.15 plus 28% | —$1,482 |
| $3,131 | —$6,763 . . | $752.87 plus 33% | —$3,131 |
| $6,763 | | $1,951.43 plus 35% | —$6,763 |

(b) MARRIED person—

| If the amount of wages (after subtracting withholding allowances) is: | | The amount of income tax to withhold is: | |
|---|---|---|---|
| Not over $154 | | $0 | |

| Over— | But not over— | | of excess over— |
|---|---|---|---|
| $154 | —$449 . . | 10% | —$154 |
| $449 | —$1,360 . . | $29.50 plus 15% | —$449 |
| $1,360 | —$2,573 . . | $166.15 plus 25% | —$1,360 |
| $2,573 | —$3,907 . . | $469.40 plus 28% | —$2,573 |
| $3,907 | —$6,865 . . | $842.92 plus 33% | —$3,907 |
| $6,865 | | $1,819.06 plus 35% | —$6,865 |

TABLE 2—BIWEEKLY Payroll Period

(a) SINGLE person (including head of household)—

| If the amount of wages (after subtracting withholding allowances) is: | | The amount of income tax to withhold is: | |
|---|---|---|---|
| Not over $102 | | $0 | |

| Over— | But not over— | | of excess over— |
|---|---|---|---|
| $102 | —$389 . . | 10% | —$102 |
| $389 | —$1,289 . . | $28.70 plus 15% | —$389 |
| $1,289 | —$2,964 . . | $163.70 plus 25% | —$1,289 |
| $2,964 | —$6,262 . . | $582.45 plus 28% | —$2,964 |
| $6,262 | —$13,525 . . | $1,505.89 plus 33% | —$6,262 |
| $13,525 | | $3,902.68 plus 35% | —$13,525 |

(b) MARRIED person—

| If the amount of wages (after subtracting withholding allowances) is: | | The amount of income tax to withhold is: | |
|---|---|---|---|
| Not over $308 | | $0 | |

| Over— | But not over— | | of excess over— |
|---|---|---|---|
| $308 | —$898 . . | 10% | —$308 |
| $898 | —$2,719 . . | $59.00 plus 15% | —$898 |
| $2,719 | —$5,146 . . | $332.15 plus 25% | —$2,719 |
| $5,146 | —$7,813 . . | $938.90 plus 28% | —$5,146 |
| $7,813 | —$13,731 . . | $1,685.66 plus 33% | —$7,813 |
| $13,731 | | $3,638.60 plus 35% | —$13,731 |

TABLE 3—SEMIMONTHLY Payroll Period

(a) SINGLE person (including head of household)—

| If the amount of wages (after subtracting withholding allowances) is: | | The amount of income tax to withhold is: | |
|---|---|---|---|
| Not over $110 | | $0 | |

| Over— | But not over— | | of excess over— |
|---|---|---|---|
| $110 | —$422 . . | 10% | —$110 |
| $422 | —$1,397 . . | $31.20 plus 15% | —$422 |
| $1,397 | —$3,211 . . | $177.45 plus 25% | —$1,397 |
| $3,211 | —$6,783 . . | $630.95 plus 28% | —$3,211 |
| $6,783 | —$14,652 . . | $1,631.11 plus 33% | —$6,783 |
| $14,652 | | $4,227.88 plus 35% | —$14,652 |

(b) MARRIED person—

| If the amount of wages (after subtracting withholding allowances) is: | | The amount of income tax to withhold is: | |
|---|---|---|---|
| Not over $333 | | $0 | |

| Over— | But not over— | | of excess over— |
|---|---|---|---|
| $333 | —$973 . . | 10% | —$333 |
| $973 | —$2,946 . . | $64.00 plus 15% | —$973 |
| $2,946 | —$5,575 . . | $359.95 plus 25% | —$2,946 |
| $5,575 | —$8,465 . . | $1,017.20 plus 28% | —$5,575 |
| $8,465 | —$14,875 . . | $1,826.40 plus 33% | —$8,465 |
| $14,875 | | $3,941.70 plus 35% | —$14,875 |

TABLE 4—MONTHLY Payroll Period

(a) SINGLE person (including head of household)—

| If the amount of wages (after subtracting withholding allowances) is: | | The amount of income tax to withhold is: | |
|---|---|---|---|
| Not over $221 | | $0 | |

| Over— | But not over— | | of excess over— |
|---|---|---|---|
| $221 | —$843 . . | 10% | —$221 |
| $843 | —$2,793 . . | $62.20 plus 15% | —$843 |
| $2,793 | —$6,423 . . | $354.70 plus 25% | —$2,793 |
| $6,423 | —$13,567 . . | $1,262.20 plus 28% | —$6,423 |
| $13,567 | —$29,304 . . | $3,262.52 plus 33% | —$13,567 |
| $29,304 | | $8,455.73 plus 35% | —$29,304 |

(b) MARRIED person—

| If the amount of wages (after subtracting withholding allowances) is: | | The amount of income tax to withhold is: | |
|---|---|---|---|
| Not over $667 | | $0 | |

| Over— | But not over— | | of excess over— |
|---|---|---|---|
| $667 | —$1,946 . . | 10% | —$667 |
| $1,946 | —$5,892 . . | $127.90 plus 15% | —$1,946 |
| $5,892 | —$11,150 . . | $719.80 plus 25% | —$5,892 |
| $11,150 | —$16,929 . . | $2,034.30 plus 28% | —$11,150 |
| $16,929 | —$29,750 . . | $3,652.42 plus 33% | —$16,929 |
| $29,750 | | $7,883.35 plus 35% | —$29,750 |

FIGURE 10-5

IRS Tables for Percentage Method of Withholding

| **HOW TO** | Find federal tax withholding per paycheck using the IRS percentage method tables |
|---|---|

1. Select the appropriate table according to the employee's filing status and the type of pay period.
2. Find the income row: In the columns labeled "If the amount of wages (after subtracting withholding allowances) is:" select the "Over—" and "But not over—" interval that includes the employee's percentage method income for the pay period.
3. Find the cell where the income row and the column labeled "of excess over—" intersect, and subtract the amount given in this cell from the employee's percentage method income for the pay period.
4. Multiply the difference from step 3 by the percent given in the income row.
5. Add the product from step 4 to the amount given with the *percent* in the income row and "The amount of income tax to withhold is:" column.

EXAMPLE 2 Find the federal tax withholding to be deducted from Dollie's income in Example 1.

From Figure 10-5 select Table 2(a) for single employees paid biweekly. We found Dollie's percentage method income to be $2,888.46 for the pay period. Table 2(a) tells us that the tax for that income is $163.70 plus 25% of the income in excess of $1,289.

| | |
|---|---|
| $2,888.46 − $1,289 = $1,599.46 | Subtract $1,289 from the percentage method income to find the amount in excess of $1,289. |
| $1,599.46(0.25) = $399.87 | Find 25% of the income in excess of $1,289. |
| $163.70 + $399.87 = $563.57 | Add $399.87 to $163.70 to find the withholding tax. |

The federal tax withholding is $563.57 for the pay period.

The withholding tax calculated by the percentage method may differ slightly from the withholding tax given in the tax table. The tax table uses $20 income intervals and tax amounts are rounded to the nearest dollar.

 STOP AND CHECK

1. Use the percentage method to find the total withholding allowance for weekly gross earnings of $850 with no adjustments if the wage earner is single and claims three withholding allowances.

2. Find the adjusted gross income for the wage earner in Exercise 1.

3. Find the amount of income tax to withhold for the wage earner in Exercise 1.

4. Emily Harrington earns $1,700 semimonthly and claims four withholding allowances and no other income adjustments. Emily is married. Find the amount of income tax to be withheld each pay period.

3 Find Social Security tax and Medicare tax per paycheck.

Two other amounts withheld from an employee's paycheck are the deductions for Social Security and Medicare taxes. The Federal Insurance Contribution Act (FICA) was established by Congress during the depression of the 1930s. Prior to 1991, funds collected under the Social Security tax act were used for both Social Security and Medicare benefits. Beginning in 1991, funds were collected separately for these two programs.

The Social Security tax rate and the income subject to Social Security tax change periodically as Congress passes new legislation. In a recent year, the Social Security tax rate was 6.2% (0.062) of the first $97,500 of gross earnings. This means that after a person has earned $97,500 in a year, no Social Security tax will be withheld on any additional money he or she earns during that year. A person who earns $100,000 in a year pays exactly the same Social Security tax as a person who earns $97,500. In this same year, the rate for Medicare was 1.45% (0.0145). All wages earned are subject to Medicare tax, unless the employee participates in a flexible benefits plan that is exempt from Medicare tax and under certain other conditions specified in the Internal Revenue Code. These plans are written to provide employees with a choice or "menu" of benefits such as health insurance, child care, and so on. In some instances, the wages used to pay for these benefits are subtracted from gross earnings to give an adjusted gross income that is used as the basis for withholding tax, Social Security tax, and Medicare tax.

Employers also pay a share of Social Security and Medicare taxes: The employer contributes the same amount as the employee contributes to that employee's Social Security account and Medicare account.

| HOW TO | Find the amount of Social Security and Medicare tax to be paid by an employee |
|---|---|

Social Security tax:

1. Determine the amount of the earnings subject to tax.
 - (a) If the year-to-date earnings for the previous pay period exceeded $97,500, no additional Social Security tax is to be paid.
 - (b) If the year-to-date earnings exceed $97,500 for the first time this pay period, from this period's year-to-date earnings subtract $97,500.
 - (c) If the year-to-date earnings for this period are less than $97,500, the entire earnings for this period are subject to tax.
2. Multiply the earnings to be taxed by 6.2% (0.062). Round to the nearest cent.

Medicare tax:

Multiply the earnings to be taxed by 1.45% (0.0145). Round to the nearest cent.

EXAMPLE 1 Mickey Beloate has a gross weekly income of $967. How much Social Security tax and Medicare tax should be withheld?

| | |
|---|---|
| $967(52) = $50,284 | The salary for the entire year will not exceed $97,500. The entire salary is to be taxed. |
| $967(0.062) = $59.95 | Social Security tax on $967 |
| $967(0.0145) = $14.02 | Medicare tax on $967 |

The Social Security tax withheld per week should be $59.95, and the Medicare tax withheld should be $14.02.

EXAMPLE 2 John Friedlander, vice president of marketing for Golden Sun Enterprises, earns $99,580 annually, or $1,915 per week. Find the amount of Social Security and Medicare taxes that should be withheld for the 51st week.

At the end of the 50th week, John will have earned a total gross salary for the year of $95,750. Since Social Security tax is withheld on the first $97,500 annually, he needs to pay Social Security tax on $1,750 for the remainder of the year ($97,500 − $95,750 = $1,750).

| | |
|---|---|
| $1,750(0.062) = $108.50 | Multiply $1,750 by the 6.2% tax rate to find the Social Security tax for the 51st week. |

Since Medicare tax is paid on the entire salary, John must pay the Medicare tax on the full week's salary of $1,915.

$$\$1,915(0.0145) = \$27.77$$

The Social Security tax for the 51st week is $108.50 and the Medicare tax is $27.77.

Self-employment (SE) tax: the equivalent of both the employee's and the employer's tax for both Social Security and Medicare. It is two times the employee's rate.

A person who is self-employed must also pay Social Security tax and Medicare tax. Since there is no employer involved to make matching contributions, the self-employed person must pay the equivalent of both amounts. The self-employment rates are 12.4% Social Security and 2.9% Medicare tax for a total of 15.3%. The tax is called the **self-employment (SE) tax**. However, one-half of the self-employment tax can be deducted as an adjustment to income when finding the adjusted income for paying income tax. Self-employed persons report and pay taxes differently.

1. Lars Pacheco has a gross biweekly income of $1,730. How much Social Security tax and Medicare tax should be withheld?

2. George Pacheco earns $6,230 monthly. How much Social Security tax and Medicare tax should be withheld from his monthly pay?

3. Sarah Grafe earns $99,240 annually or $4,135 semimonthly. How much Social Security tax and Medicare tax should be withheld from her 24th paycheck of the year?

4. Sollaug Pacheco earns $98,384 annually or $1,892 per week. How much Social Security tax and Medicare tax should be withheld for the 47th week?

4 Find net earnings per paycheck.

In addition to federal taxes, a number of other deductions may be made from an employee's paycheck. Often, state and local income taxes must also be withheld by the employer. Other deductions are made at the employee's request, such as insurance payments or union dues. Some retirement plans and insurance plans are tax exempt; others are not. When all these deductions have been made, the amount left is called net earnings, net pay, or take-home pay.

HOW TO Find net earnings per paycheck

1. Find the gross pay for the pay period.
2. Find the adjustments-to-income deductions, such as tax-exempt retirement, tax-exempt medical insurance, and so on.
3. Find the Social Security tax and Medicare tax based on the adjusted gross income.
4. Find the federal tax withholding based on (a) or (b):
 (a) Adjusted gross income (gross pay minus adjustments to income) using IRS tax tables
 (b) Percentage method income (adjusted gross income minus amount exempt for withholding allowances) using IRS percentage method tables
5. Find other withholding taxes, such as local or state taxes.
6. Find other deductions, such as insurance payments or union dues.
7. Find the sum of all deductions from steps 2–6, and subtract the sum from the gross pay.

EXAMPLE 1 Jeanetta Grandberry's gross weekly earnings are $676. She is married and claims two withholding allowances. Five percent of her gross earnings is deducted for her nonexempt retirement fund and $25.83 is deducted for nonexempt insurance. Find her net earnings.

| | |
|---|---|
| Income tax withholding: $44 | In Figure 10-3, find the amount of income tax to be withheld. |
| Social Security tax withholding: $676(0.062) = $41.91 | Find the Social Security tax by the percentage method. |
| Medicare tax withholding: $676(0.0145) = $9.80 | Find the Medicare tax by the percentage method. |
| Retirement fund withholding: 0.05($676) = $33.80 | Use the formula $P = R \times B$. Multiply rate (5% = 0.05) by base (gross pay of $676). |
| Total deductions | Add all deductions including the nonexempt insurance. |

= withholding tax + Social Security tax + Medicare tax + retirement fund + insurance
= $44.00 + $41.91 + $9.80 + $33.80 + $25.83 = $155.34

Net earnings:
Gross earnings − total deductions
 $676 − $155.34 = $520.66 Subtract total deductions from the gross earnings.

The net earnings are $520.66.

✓ STOP AND CHECK

1. Olena Koduri earns $732 weekly. She is married and claims three withholding allowances. $110.15 is deducted for nonexempt insurance and 6% of her gross earnings is deducted for nonexempt retirement. Find the amount deducted for retirement and Social Security and Medicare taxes.

2. Find the amount of withholding tax deducted.

3. Find the total deductions.

4. Find the net pay for Olena.

10-2 SECTION EXERCISES

1. Khalid Khouri is married, has a gross weekly salary of $486 (all of which is taxable), and claims three withholding allowances. Use the tax tables to find the federal tax withholding to be deducted from his weekly salary.

2. Mae Swift is married and has a gross weekly salary of $583. She has $32 in adjustments to income for tax-exempt health insurance and claims two withholding allowances. Use the tax tables to find the federal tax withholding to be deducted from her weekly salary.

3. Jacob Drewrey is paid semimonthly an adjusted gross income of $1,431. He is single and claims two withholding allowances. Use the tax tables to find the federal tax withholding to be deducted from his salary.

4. Dieter Tillman earns a semimonthly salary of $1,698. He has a $100 adjustment-to-income flexible benefits package, is single, and claims three withholding allowances. Find the federal tax withholding to be deducted from his salary using the percentage method tables.

5. Mohammad Hajibeigy has a weekly adjusted gross income of $580, is single, and claims one withholding allowance. Find the federal tax withholding to be deducted from his weekly paycheck using the percentage method tables.

6. Margie Young is an associate professor at a major research university and earns $4,598 monthly with no adjustments to income. She is married and claims one withholding allowance. Find the federal tax withholding that is deducted from her monthly paycheck using the percentage method tables.

7. Dr. Josef Young earns an adjusted gross weekly income of $2,583. How much Social Security tax should be withheld the first week of the year? How much Medicare tax should be withheld?

8. Dierdri Williams earns a gross biweekly income of $1,020 and has no adjustments to income. How much Social Security tax should be withheld? How much Medicare tax should be withheld?

9. Rodney Whitaker earns $98,604 annually and is paid monthly. How much Social Security tax will be deducted from his December earnings? How much Medicare tax will be deducted from his December earnings?

10. Pam Trim earns $5,291 monthly, is married, and claims four withholding allowances. Her company pays her retirement, but she pays $52.83 each month for nonexempt insurance premiums. Find her net pay.

11. Shirley Riddle earns $1,319 biweekly. She is single and claims no withholding allowances. She pays 2% of her salary for retirement and $22.80 in nonexempt insurance premiums each pay period. What are her net earnings for each pay period?

12. Donna Wood's gross weekly earnings are $615. Three percent of her gross earnings is deducted for her nonexempt retirement fund and $25.97 is deducted for nonexempt insurance. Find the net earnings if Donna is married and claims two withholding allowances.

10-3 THE EMPLOYER'S PAYROLL TAXES

LEARNING OUTCOMES

1 Find an employer's total deposit for withholding tax, Social Security tax, and Medicare tax per pay period.
2 Find an employer's SUTA tax and FUTA tax due for a quarter.

1 Find an employer's total deposit for withholding tax, Social Security tax, and Medicare tax per pay period.

The employer must pay to the Internal Revenue Service the income tax withheld and both the employees' and employer's Social Security and Medicare taxes. This payment is made by making a deposit at an authorized financial institution or Federal Reserve bank. If the employer's

accumulated tax is less than $500, this payment may be made with the tax return (generally Form 941, Employer's Quarterly Federal Tax Return). Other circumstances create a different employer's deposit schedule. This schedule varies depending on the amount of tax liability and other criteria. IRS Publication 15 (Circular E, Employer's Tax Guide) and Publication 334 (Tax Guide for Small Business) give the criteria for depositing and reporting these taxes.

HOW TO Find an employer's total deposit for withholding tax, Social Security tax, and Medicare tax per pay period

1. Find the withholding tax deposit: From employee payroll records, find the total withholding tax for all employees for the period.
2. Find the Social Security tax deposit: Find the total Social Security tax paid by all employees and multiply this total by 2 to include the employer's matching tax.
3. Find the Medicare tax deposit: Find the total Medicare tax paid by all employees for the pay period and multiply the total by 2 to include the employer's matching tax.
4. Add the withholding tax deposit, Social Security tax deposit, and Medicare tax deposit.

EXAMPLE 1 Determine the employer's total deposit of withholding tax, Social Security tax, and Medicare tax for the payroll register.

Payroll for June 1 through June 15, 2007

| Employee | Gross earnings | Withholding | Social Security | Medicare | Net earnings |
|---|---|---|---|---|---|
| Plumlee, C. | $1,050.00 | $ 57.73 | $ 65.10 | $15.23 | $ 911.94 |
| Powell, M. | 2,085.00 | 168.05 | 129.27 | 30.23 | 1,757.45 |
| Randle, M. | 1,995.00 | 174.80 | 123.69 | 28.93 | 1,667.58 |
| Robinson, J. | 2,089.00 | 350.45 | 129.52 | 30.29 | 1,578.74 |

Total withholding = $57.73 + $168.05 + $174.80 + $350.45 = $751.03
Total Social Security = $65.10 + $129.27 + $123.69 + $129.52 = $447.58
Total Medicare = $15.23 + $30.23 + $28.93 + $30.29 = $104.68
Total Social Security and Medicare(2) = ($447.58 + $104.68)(2) = $552.26(2) = $1,104.52
Total employer's deposit = $751.03 + $1,104.52 = $1,855.55

The total amount of the employer's deposit for this payroll is $1,855.55.

Bookkeeping software will compile payroll records and generate a report of tax liability for a month, quarter, or any selected time interval.

 STOP AND CHECK

Use the following weekly payroll register to answer questions 1–4.

Weekly Payroll Register

| Employee | Gross earnings | Withholding | Social Security | Medicare | Net earnings |
|---|---|---|---|---|---|
| Cohen, P. | $740 | $63 | $45.88 | $10.73 | $620.39 |
| Faneca, T. | 867 | 88.37 | 53.75 | 12.57 | 712.32 |
| Gex, M. | 630 | 29 | 39.06 | 9.14 | 552.80 |
| Hasan, F. | 695 | 57 | 43.09 | 10.08 | 584.83 |

1. Find the total withholding tax for the employer payroll register.

2. Find the total Social Security tax withheld from employees' pay.

3. Find the total Medicare tax withheld from employees' pay.

4. Find the employer's total deposit for the payroll register.

2 Find an employer's SUTA tax and FUTA tax due for a quarter.

Federal unemployment (FUTA) tax: a federal tax required of most employers. The tax provides for payment of unemployment compensation to workers who have lost their jobs.

State unemployment (SUTA) tax: a state tax required of most employers. The tax also provides payment of unemployment compensation to workers who have lost their jobs.

The major employee-related taxes paid by employers are the employer's share of the Social Security and Medicare taxes, which we have already discussed, and federal and state unemployment taxes. Federal and state unemployment taxes do not affect the paycheck of the employee. They are paid entirely by the employer. Under the Federal Unemployment Tax Act (FUTA) most employers pay a federal unemployment tax. This tax, along with state unemployment tax, provides for payment of unemployment compensation to workers who have lost their job. **Federal unemployment (FUTA) tax** is currently 6.2% of the first $7,000 earned by an employee. According to IRS Publication *Instructions for Form 940*, employers "are entitled to the maximum credit if [they] paid all state unemployment tax by the due date of [their] Form 940 or if [they] were not required to pay state unemployment tax during the calendar year due to [their] state experience rate." The FUTA tax rate of an employer receiving the maximum credit against FUTA taxes is 0.8% of the first $7,000 of each employee's annual wages. **State Unemployment (SUTA) tax** is a state tax required of most employers that provides funds for payments of unemployment compensation to workers who have lost their jobs. The SUTA tax rate varies from state to state depending on the employer's experience rate and is paid to each state separately from FUTA tax. SUTA tax guidelines vary from state to state. For our examples, we will use 5.4% of the first $7,000 of each employee's annual wages.

HOW TO Find the SUTA tax due for a quarter

1. For each employee, multiply the employer's appropriate rate by the employee's cumulative earnings for the quarter (up to $7,000 annually).
2. Add the SUTA tax owed on all employees.

According to the IRS, "If [employers] were not required to pay state unemployment tax because all of the wages [employers] paid were excluded from state unemployment tax, [employers] must pay FUTA tax at the 6.2% (0.062) rate." FUTA tax is accumulated for all employees and is deposited quarterly if the amount exceeds $500. Amounts less than $500 are paid with the annual tax return that is due January 31 of the following year.

HOW TO Find the FUTA tax due for a quarter

1. For each employee:
 (a) If no SUTA tax is required, multiply 6.2% by the employee's cumulative earnings for the quarter (up to $7,000 annually).
 (b) If SUTA tax is required and paid by the due date, multiply 0.8% by the employee's cumulative earnings for the quarter (up to $7,000 annually).
2. Add the FUTA tax owed on all employees' wages for the quarter.
3. If the total from step 2 is less than $500, no FUTA tax is due for the quarter, but the total from step 2 must be added to the amount due for the next quarter.

EXAMPLE 1

Melanie McFarren earned $32,500 last year and over $7,000 in the first quarter of this year. If the state unemployment (SUTA) tax rate for her employer is 5.4% of the first $7,000 earned in a year, how much SUTA tax must Melanie's employer pay on her behalf? Also, how much FUTA must be paid?

SUTA = tax rate × taxable wages $7,000 is subject to SUTA tax in the first quarter.
SUTA = 5.4%($7,000)
SUTA = 0.054($7,000) = $378
FUTA = 0.8% × taxable wages $7,000 is subject to FUTA tax in the first quarter.
 0.008($7,000) = $56

SUTA tax is $378 and FUTA tax is $56.

EXAMPLE 2

Leak Busters has two employees who are paid semimonthly. One employee earns $1,040 per pay period and the other earns $985 per pay period. Based on the SUTA tax rate of 5.4%, the FUTA tax rate is 0.8% of the first $7,000 of each employee's annual gross pay. At the end of which quarter should the FUTA tax first be deposited?

| What You Know | What You Are Looking For | Solution Plan |
|---|---|---|
| Employee 1 pay = $1,040
Employee 2 pay = $985
Semimonthly pay period
FUTA rate = 0.8% of 1st $7,000

FUTA deposit not required until accumulated amount is more than $500. | First FUTA deposit should be made at the end of which quarter? | Find the FUTA tax for each employee for each pay period and total the tax by quarters. |

Solution

| Pay period | Employee 1 salary | Accumulated salary subject to FUTA tax | FUTA tax | Employee 2 salary | Accumulated salary subject to FUTA tax | FUTA tax |
|---|---|---|---|---|---|---|
| Jan. 15 | $1,040 | $1,040 | $8.32 | $985 | $ 985 | $7.88 |
| Jan. 31 | 1,040 | 2,080 | 8.32 | 985 | 1,970 | 7.88 |
| Feb. 15 | 1,040 | 3,120 | 8.32 | 985 | 2,955 | 7.88 |
| Feb. 28 | 1,040 | 4,160 | 8.32 | 985 | 3,940 | 7.88 |
| Mar. 15 | 1,040 | 5,200 | 8.32 | 985 | 4,925 | 7.88 |
| Mar. 31 | 1,040 | 6,240 | 8.32 | 985 | 5,910 | 7.88 |

First quarter FUTA tax totals: $8.32(6) + $7.88(6) = 49.92 + 47.28 = $97.20
$97.20 is less than $500.00, so no deposit should be made at the end of the first quarter.

| Pay period | Employee 1 salary | Accumulated salary subject to FUTA tax | FUTA tax | Employee 2 salary | Accumulated salary subject to FUTA tax | FUTA tax |
|---|---|---|---|---|---|---|
| Apr. 15 | $1,040 | $7,000 | $6.08* | $985 | $6,895 | $7.88 |
| Apr. 30 | 1,040 | | | 985 | 7,000 | 0.84** |
| May 15 | 1,040 | | | 985 | | |
| May 31 | 1,040 | | | 985 | | |
| Jun. 15 | 1,040 | | | 985 | | |
| Jun. 30 | 1,040 | | | 985 | | |

*$7,000 − $6,240 = $760; $760(0.008) = $6.08
**$7,000 − $6,895 = $105; $105(0.008) = $0.84

Second quarter FUTA tax totals: $6.08 + $8.72 = $14.80
Total FUTA tax for first two quarters = $97.20 + $14.80 = $112.00

Conclusion

Since both employees have reached the $7,000 accumulated salary subject to FUTA tax, and the accumulated FUTA tax is less than $500, the amount of $112.00 should be deposited by January 31 of the following year.

 STOP AND CHECK

1. Kumar Konde earned $35,200 last year and over $7,000 in the first quarter of this year. State unemployment tax for Kumar's employer is 5.4% of the first $7,000 earned in a year. How much SUTA tax must Kumar's employer pay on his behalf?

2. How much FUTA tax must Kumar's employer pay on his behalf?

3. Powell's Lumber Company has two employees who are paid semimonthly. One employee earns $1,320 and the other earns $1,275 per pay period. At the end of which quarter must the first FUTA tax be deposited for the year if the company's SUTA rate is 5.4% of the first $7,000 earnings for each employee?

4. How much FUTA tax should be deposited by Powell's Lumber Company with the first payment of the year?

SKILL BUILDERS

1. Carolyn Luttrell owns Just the Right Thing, a small antiques shop with four employees. For one payroll period the total withholding tax for all employees was $1,633. The total Social Security tax was $482, and the total Medicare tax was $113. How much tax must Carolyn deposit as the employer's share of Social Security and Medicare? What is the total tax that must be deposited?

2. Hughes' Trailer Manufacturer makes utility trailers and has seven employees who are paid weekly. For one payroll period the withholding tax for all employees was $1,661. The total Social Security tax withheld from employees' paychecks was $608, and the total Medicare tax withheld was $142. What is the total tax that must be deposited by Hughes?

3. Determine the employer's deposit of withholding, Social Security, and Medicare for the payroll register.

| Employee | Gross earnings | Withholding | Social Security | Medicare | Net earnings |
|---|---|---|---|---|---|
| Paszel, J. | $1,905 | $169 | $118.11 | $27.62 | $1,590.27 |
| Thomas, P. | 1,598 | 143 | 99.08 | 23.17 | 1,332.75 |
| Tillman, D. | 1,431 | 97 | 88.72 | 20.75 | 1,224.53 |

4. Heaven Sent Gifts, a small business that provides custom meals, flowers, and other specialty gifts, has three employees who are paid weekly. One employee earns $475 per week, is single, and claims one withholding allowance. Another employee earns $450 per week, is single, and claims two withholding allowances. The manager earns $740 per week, is married, and claims one withholding allowance. Calculate the amount of withholding tax, Social Security tax, and Medicare tax that will need to be deposited by Heaven Sent Gifts.

APPLICATIONS

Bruce Young earned $20,418 last year. His employer's SUTA tax rate is 5.4% of the first $7,000.

5. How much SUTA tax must Bruce's employer pay for him?

6. How much FUTA tax must Bruce's company pay for him?

7. Bailey Plyler has three employees in his carpet cleaning business. The payroll is semimonthly and the employees earn $745, $780, and $1,030 per pay period. Calculate when and in what amounts FUTA tax payments are to be made for the year.

Learning Outcomes

Section 10-1

What to Remember with Examples

1 Find the gross pay per paycheck based on salary. (p. 342)

1. Identify the number of pay periods per year: monthly, 12; semimonthly, 24; biweekly, 26; weekly, 52
2. Divide the annual salary by the number of pay periods per year.

If Barbara earns $23,500 per year, how much is her weekly gross pay?

$$\frac{\$23,500}{52} = \$451.92$$

Clemetee earns $32,808 annually and is paid twice a month. What is her gross pay per pay period?

$$\frac{\$32,808}{24} = \$1,367$$

2 Find the gross pay per weekly paycheck based on hourly wage. (p. 343)

1. Find the regular pay:
 (a) If the hours worked in the week are 40 or fewer, multiply the hours worked by the hourly wage.
 (b) If the hours worked are more than 40, multiply 40 hours by the hourly wage.
2. Find the overtime pay:
 (a) If the hours worked are 40 or fewer, the overtime pay is $0.
 (b) If the hours worked are more than 40, subtract 40 from the hours worked and multiply the difference by the overtime rate.
3. Add the regular pay and the overtime pay.

Aldo earns $10.25 per hour. He worked 38 hours this week. What is his gross pay?

38($10.25) = $389.50

Belinda worked 44 hours one week. Her regular pay was $7.75 per hour and time and a half for overtime. Find her gross earnings.

$$40(\$7.75) = \$310$$
$$4(\$7.75)(1.5) = \$46.50$$
$$\$310 + \$46.50 = \$356.50$$

3 Find the gross pay per paycheck based on piecework wage. (p. 344)

1. If a *straight piecework* rate is used, multiply the number of items completed by the straight piecework rate.
2. If a *differential piecework* rate is used:
 (a) For each rate category, multiply the number of items produced for the category by the rate for the category.
 (b) Add the pay for all rate categories.

Willy earns $0.53 for each widget he twists. He twisted 1,224 widgets last week. Find his gross earnings.

1,224($0.53) = $648.72

Nadine does piecework for a jeweler and earns $0.65 per piece for finishing 1 to 25 pins, $0.70 per piece for 26 to 50 pins, and $0.75 per piece for pins over 50. Yesterday she finished 130 pins. How much did she earn?

$$25(\$0.65) + 25(\$0.70) + 80(\$0.75) =$$
$$\$16.25 + \$17.50 + \$60 = \$93.75$$

4 Find the gross pay per paycheck based on commission. (p. 345)

1. Find the commission:
 (a) If the commission is *commission based on total sales,* multiply the commission rate by the total sales for the pay period.
 (b) If the commission is *commission based on quota,* subtract the quota from the total sales and multiply the difference by the commission rate.

2. Find the salary:
 (a) If the wage is *straight commission,* the salary is $0.
 (b) If the wage is *commission-plus-salary,* use the How To steps for finding gross pay based on salary.
3. Add the commission and the salary.

Bart earns a 4% commission on the appliances he sells. His sales last week totaled $18,000. Find his gross earnings.

0.04($18,000) = $720

Elaine earns $250 weekly plus 6% of all sales over $1,500. Last week she had $9,500 worth of sales. Find her gross earnings.

$$\$9,500 - \$1,500 = \$8,000$$
$$\text{Commission} = 0.06(\$8,000) = \$480$$
$$\$250 + \$480 = \$730$$

Section 10-2

1 Find federal tax withholding per paycheck using IRS tax tables. (p. 348)

1. Find the adjusted gross income by subtracting the total allowable adjustments from the gross pay per pay period. Select the appropriate table according to the employee's filing status (single, married, or head of household) and according to the type of pay period (weekly, biweekly, and so on).
2. Find the income row: In the columns labeled "If the wages are—," select the "At least" and "But less than" interval that includes the employee's adjusted gross income for the pay period.
3. Find the allowances column: In the columns labeled "And the number of withholding allowances claimed is—," select the number of allowances the employee claims.
4. Find the cell where the income row and allowance column intersect. The correct tax is given in this cell.

Archy is married, has a gross weekly salary of $680, and claims two withholding allowances. Find his withholding tax.

Look in the first two columns of Figure 10-3 to find the range for $680. Move across to the column for two withholding allowances. The amount of federal tax to be withheld is $45.

Lexie Lagen is married and has a gross weekly salary of $655. He claims three withholding allowances and has $20 deducted weekly from his paycheck for a flexible benefits plan, which is exempted from federal income taxes. Find the amount of his withholding tax.

Adjusted gross income = $655 − $20 = $635

Find the range for $635 and three withholding allowances in Figure 10-3. The tax is $29.

2 Find federal tax withholding per paycheck using the IRS percentage method. (p. 352)

Find the percentage method income per paycheck.

1. Find the exempt-per-allowance amount: From the withholding allowance table (Figure 10-4), identify the amount exempt for one withholding allowance according to the type of pay period.
2. Find the total exempt amount: Multiply the number of withholding allowances the employee claims by the exempt-per-allowance amount.
3. Subtract the total exempt amount from the employee's adjusted gross income for the pay period.

Edith Sailor has weekly gross earnings of $890. Find her percentage method income if she has no adjustments to income, is married, and claims three withholding allowances.

Use Figure 10-4 to find one withholding allowance for a weekly payroll period. Multiply by 3.

$65.38(3) = $196.14

Percentage method income = $890.00 − $196.14 = $693.86.

Find the federal tax withholding per paycheck using the IRS percentage method tables.

1. Select the appropriate table in Figure 10-5 according to the employee's filing status and the type of pay period.
2. Find the income row: In the columns labeled "If the amount of wages (after subtracting withholding allowances) is:" select the "Over—" and "But not over—" interval that includes the employee's percentage method income for the pay period.

3. Find the cell where the income row and the column labeled "of excess over—" intersect, and subtract the amount given in this cell from the employee's percentage method income for the pay period.
4. Multiply the difference from step 3 by the percent given in the income row.
5. Add the product from step 4 to the amount given with the *percent* in the income row and "The amount of tax to withhold is:" column.

Find the federal tax on Ruth's monthly income of $1,938. She is single and claims one exemption.

1 exemption = $283.33 (Figure 10-4)
$1,938 − $283.33 = $1,654.67
$1,654.67 is in the $843 to $2,793 range (Figure 10-5, Table 4a), so the amount of withholding tax is $62.20 plus 15% of the amount over $843.

$1,654.67 − $843 = $811.67
$811.67(0.15) = $121.75
$62.20 + $121.75 = $183.95

3 Find Social Security tax and Medicare tax per paycheck. (p. 354)

Social Security tax:

1. Determine the amount of the earnings subject to tax.
 (a) If the year-to-date earnings for the previous pay period exceeded $97,500, no additional Social Security tax is to be paid.
 (b) If the year-to-date earnings exceed $97,500 for the first time this pay period, from this period's year-to-date earnings subtract $97,500.
 (c) If the year-to-date earnings for this period are less than $97,500, the entire earnings for this period are subject to tax.
2. Multiply the earnings to be taxed by 6.2% (0.062). Round to the nearest cent.

Medicare tax:
 Multiply the earnings to be taxed by 1.45% (0.0145). Round to the nearest cent.

Find the Social Security and Medicare taxes for Abbas Laknahour, who earns $938 every two weeks.

Social Security = $938(0.062) = $58.16
Medicare = $938(0.0145) = $13.60

Donna Shroyer earns $9,170 monthly. Find the Social Security and Medicare taxes that will be deducted from her November paycheck.

Pay for first 10 months = $9,170(10) = $91,700
November pay subject to Social Security = $97,500 − $91,700 = $5,800
Social Security tax = $5,800(0.062) = $359.60
Medicare tax = $9,170(0.0145) = $132.97

4 Find net earnings per paycheck. (p. 356)

1. Find the gross pay for the pay period.
2. Find the adjustments-to-income deductions, such as retirement, insurance, and so on.
3. Find the Social Security tax and Medicare tax based on the adjusted gross income.
4. Find the federal tax withholding based on (a) or (b):
 (a) adjusted gross income (gross pay minus adjustments to income) using IRS tax tables;
 (b) percentage method income (adjusted gross income minus amount exempt for withholding allowances) using IRS percentage method tables.
5. Find other withholding taxes, such as local or state taxes.
6. Find other deductions, such as insurance payments or union dues.
7. Find the sum of all deductions from steps 2–6, and subtract the sum from the gross pay.

Beth Cooley's gross weekly earnings are $588. Four percent of her gross earnings is deducted for her nonexempt retirement fund and $27.48 is deducted for insurance. Find her net earnings if Beth is married and claims three withholding allowances.

Retirement fund = $588(0.04) = $23.52
Withholding tax = $24.00 (from Figure 10-3)
Social Security = $588(0.062) = $36.46
Medicare = $588(0.0145) = $8.53
Total deductions = $23.52 + $27.48 + $24.00 + $36.46 + $8.53 = $119.99
Net earnings = $588 − $119.99 = $468.01

Section 10-3

1 Find an employer's total deposit for withholding tax, Social Security tax, and Medicare tax per pay period. (p. 358)

1. Find the withholding tax deposit: From employee payroll records, find the total withholding tax for all employees for the pay period.
2. Find the Social Security tax deposit: Find the total Social Security tax for all employees for the pay period and multiply this total by 2 to include the employer's matching tax.
3. Find the Medicare tax deposit: Find the total Medicare tax for all employees for the pay period and multiply this total by 2 to include the employer's matching tax.
4. Add the withholding tax deposit, Social Security tax deposit, and Medicare tax deposit.

Determine the employer's total deposit.

| Employee | Gross earnings | Withholding | Social Security | Medicare | Net earnings |
|---|---|---|---|---|---|
| Davis, T. | $ 485.00 | $ 27.00 | $ 30.07 | $ 7.03 | $ 420.90 |
| Dobbins, L. | 632.00 | 57.00 | 39.18 | 9.16 | 526.66 |
| Harris, M. | 590.00 | 51.00 | 36.58 | 8.56 | 493.86 |
| Totals | $1,707.00 | $135.00 | $105.83 | $24.75 | $1,441.42 |

Employer's tax deposit = $135 + 2($105.83 + $24.75) = $396.16

2 Find an employer's SUTA tax and FUTA tax due for a quarter. (p. 360)

Find the SUTA tax due for a quarter.

1. For each employee, multiply the appropriate rate by the employee's cumulative earnings for the quarter (up to $7,000 annually).
2. Add the SUTA tax owed on all employees.

Kim Brown has three employees who each earn $8,250 in the first three months of the year. How much SUTA tax should Kim pay for the first quarter if the SUTA rate is 5.4% of the first $7,000 earnings?

$7,000(0.054)(3) = $1,134

Kim should pay $1,134 in SUTA tax for the first quarter.

Find the FUTA tax due for a quarter.

1. For each employee:
 (a) If no SUTA tax is required, multiply 6.2% by the employee's cumulative earnings for the quarter (up to $7,000 annually).
 (b) If SUTA tax is required and paid by the due date, multiply 0.8% by the employee's cumulative earnings for the quarter (up to $7,000 annually).
2. Add the FUTA tax owed on all employees' wages for the quarter.
3. If the total from step 2 is less than $100, no FUTA tax is due for the quarter, but the total from step 2 must be added to the amount due for the next quarter.

How much FUTA tax should Kim pay for the three employees?

$7,000(0.008)(3) = $168

EXERCISES SET A

SKILL BUILDERS

Find the gross earnings for each employee in Table 10-1. A regular week is 40 hours and the overtime rate is 1.5 times the regular rate.

TABLE 10-1

| Employee | M | T | W | T | F | S | S | Hourly wage | Regular hours | Regular pay | Overtime hours | Overtime pay | Gross pay |
|----------|---|---|---|---|---|---|---|-------------|---------------|-------------|----------------|--------------|-----------|
| 1. Allen, H. | 8 | 9 | 8 | 7 | 10 | 4 | 0 | $ 9.86 | | | | | |
| 2. Pick, J. | 8 | 8 | 8 | 8 | 8 | 4 | 0 | $11.35 | | | | | |
| 3. Lovett, L. | 8 | 8 | 8 | 8 | 0 | 0 | 0 | $14.15 | | | | | |
| 4. Mitze, A. | 8 | 8 | 8 | 8 | 8 | 2 | 4 | $12.00 | | | | | |

5. Brian Williams is a salaried employee who earns $95,256 and is paid monthly. What is his pay each payroll period?

6. Varonia Reed is paid a weekly salary of $1,036. What is her annual salary?

7. Melanie Michael has a salaried job. She earns $425 a week. One week she worked 46 hours. Find her gross weekly earnings.

8. Glenda Chaille worked 27 hours in one week at $9.45 per hour. Find her gross earnings.

9. Susan Wood worked 52 hours in a week. She was paid at the hourly rate of $12.45 with time and a half for overtime. Find her gross earnings.

10. Ronald James is paid 1.5 times his hourly wage for all hours worked in a week exceeding 40. His hourly pay is $11.55 and he worked 52 hours in a week. Calculate his gross pay.

11. For sewing buttons on shirts, employees are paid $0.28 a shirt. Marty Hughes completes an average of 500 shirts a day. Find her average gross weekly earnings for a five-day week.

12. Patsy Hilliard is paid 5% commission on sales of $18,200. Find her gross pay.

13. Vincent Ores is paid a salary of $400 plus 8% of sales. Calculate his gross income if his sales total $9,890 in the current pay period.

14. Find the gross earnings if Juanita Wilson earns $275 plus 4% of all sales over $3,000 and the sales for a week are $8,756.

Use Figure 10-3 to find the amount of federal tax withholding for the gross earnings of the following married persons who are paid weekly and have the indicated number of withholding allowances.

15. $525, four allowances

16. $682, zero allowances

17. $495, three allowances

18. $709, five allowances

Use Figures 10-4 and 10-5, the percentage method tables, to find the amount of federal income tax to be withheld from the gross earnings of married persons who are paid weekly and have the indicated number of withholding allowances in Exercises 19 and 20.

19. $755, five allowances

20. $2,215, two allowances

Find the Social Security and Medicare taxes deducted for each pay period in Exercises 21–24.

21. Weekly gross income of $842

22. Yearly gross income of $24,000

23. Semimonthly gross income of $1,856

24. Biweekly gross income of $1,426

APPLICATIONS

25. Irene Gamble earns $675 weekly and is married with 1 withholding allowance. She has a deduction for nonexempt insurance of $12.45. A 5% deduction is made for retirement. Find her total deductions including Social Security and Medicare taxes and find her net earnings.

26. Vince Bremaldi earned $32,876 last year. The state unemployment tax paid by his employer is 5.4% of the first $7,000 earned in a year. How much SUTA tax must Vince's employer pay for him? How much FUTA tax must Vince's employer pay?

27. Media Services, Inc. has a payroll in which the total employee withholding is $765.26; the total employee Social Security is $273.92; the total employee Medicare is $64.06. How much must the employer pay for this payroll? What is the total amount of taxes that must be paid for the payroll?

EXERCISES SET B

CHAPTER 10

SKILL BUILDERS

Find the gross earnings for each employee in Table 10-2. A regular week is 40 hours and the overtime rate is 1.5 times the regular rate.

TABLE 10-2

| Employee | M | T | W | T | F | S | S | Hourly wage | Regular hours | Regular pay | Overtime hours | Overtime pay | Gross pay |
|----------|---|---|---|---|---|---|---|-------------|---------------|-------------|----------------|--------------|-----------|
| 1. Brown, J. | 4 | 6 | 8 | 9 | 9 | 5 | 0 | $10.43 | | | | | |
| 2. Sayer, C. | 9 | 10 | 8 | 9 | 11 | 9 | 0 | $ 8.45 | | | | | |
| 3. Lovett, L. | 8 | 8 | 8 | 8 | 0 | 0 | 0 | $ 9.95 | | | | | |
| 4. James, M. | 8 | 8 | 4 | 8 | 8 | 8 | 0 | $11.10 | | | | | |

5. Arsella Gallagher earns a salary of $63,552 and is paid semimonthly. What is her gross salary for each payroll period?

6. John Edmonds is paid a biweekly salary of $1,398. What is his annual salary?

7. Fran Coley earns $1,896 biweekly on a salaried job. If she works 89 hours in one pay period, how much does she earn?

8. Robert Stout worked 40 hours at $12 per hour. Find his gross earnings for the week.

9. Leslie Jinkins worked a total of 58 hours in one week. Eight hours were paid at 1.5 times his hourly wage and 10 hours were paid at the holiday rate of 2 times his hourly wage. Find his gross earnings for the week if his hourly wage is $14.95.

10. Mike Kelly earns $21.30 per hour as a chemical technician. One week he works 38 hours. What is his gross pay for the week?

11. Employees are paid $3.50 per piece for a certain job. In a week's time, Maria Sanchez produced a total of 218 pieces. Find her gross earnings for the week.

12. Ada Shotwell is paid 4% commission on all computer sales. If she needs a monthly income of $2,500, find the monthly sales volume she must meet.

13. Cassie Lyons earns $350 plus 7% commission on all sales over $2,000. What are the gross earnings if sales for a week are $5,276?

14. Dieter Tillman is paid $2,000 plus 5% of the total sales volume. If he sold $3,000 in merchandise, find the gross earnings.

Use Figure 10-3 to find the amount of federal tax withholding for the gross earnings of the following married persons with the indicated number of withholding allowances.

15. $724, two allowances

16. $695, three allowances

17. $728, three allowances

18. $694, zero allowances

Use Figures 10-4 and 10-5, the percentage method tables, to find the amount of federal income tax to be withheld from the gross earnings of married persons who are paid weekly and have the indicated number of withholding allowances.

19. $620, eight allowances

20. $7,290, four allowances

Find the Social Security and Medicare taxes deducted for each pay period for Exercises 21–24.

21. Monthly gross income of $3,500

22. Yearly gross income of $78,500

23. Semimonthly gross income of $1,226

24. Biweekly gross income of $1,684

APPLICATIONS

25. Anita Loyd earns $1,775 semimonthly. She is single and claims two withholding allowances. She also pays $12.83 each pay period for nonexempt health insurance. What is her net pay?

26. Elisa Marus has three employees who earn $2,500, $2,980, and $3,200 monthly. How much SUTA tax will she need to pay at the end of the first quarter if the SUTA tax rate is 5.4% of the first $7,000 for each employee?

27. Computer Solutions, Inc. has a payroll in which the total employee withholding is $1,250.37; the total employee Social Security is $395.56; the total employee Medicare is $92.51. How much must the employer pay for this payroll? What is the total amount of taxes that must be paid for the payroll?

PRACTICE TEST

1. Cheryl Douglas works 43 hours in a week for a salary of $1,827 per week. What are Cheryl's gross weekly earnings?

2. June Jackson earns $7.59 an hour. Find her gross earnings if she worked 46 hours (time and a half for overtime over 40 hours).

3. Willy Bell checks wrappers on cans in a cannery. He receives $0.15 for each case of cans. If he checks 1,400 cases on an average day, find his gross weekly salary. (A work week is five days.)

4. Stacey Ellis is paid at the following differential piece rate: 1–100, $2.58; 101–250, $2.72; 251 and up, $3.15. Find her gross earnings for completing 475 pieces.

5. Dorothy Ford, who sells restaurant supplies, works on 6% commission. If her sales for a week are $18,200, find her gross earnings.

6. Carlo Mason works on 5% commission. If he sells $17,500 in merchandise, find his gross earnings.

7. Find the gross earnings of Sallie Johnson who receives a 9% commission and whose sales totaled $7,852.

8. Find the Social Security tax (at 6.2%) and the Medicare tax (at 1.45%) for Anna Jones, whose gross earnings are $513.86. Round to the nearest cent.

9. Find the Social Security and Medicare taxes for Michele Cottrell, whose gross earnings are $861.25.

10. How much income tax should be withheld for Terry McLean, a married employee who earns $486 weekly and claims two allowances? (Use Figure 10-3.)

11. Use Figure 10-3 to find the federal income tax paid by Charlotte Jordan, who is married with four exemptions, if her weekly gross earnings are $576.

12. If LaQuita White had net earnings of $877.58 and total deductions of $261.32, find her gross earnings.

Complete the weekly register for married employees in Table 10-3. The number of each person's allowances is listed after each name. Round to the nearest cent. Use Figure 10-3.

TABLE 10-3

| Employee (exemptions) | Gross earnings | Social Security | Medicare | Withholding tax | Other nonexempt deductions | Net earnings |
|---|---|---|---|---|---|---|
| **13.** Jackson (0) | $735.00 | | | | $25.12 | |
| **14.** Love (1) | $673.80 | | | | $12.87 | |
| **15.** Chow (2) | $492.17 | | | | 0 | |
| **16.** Ferrante (3) | $577.15 | | | | $ 4.88 | |
| **17.** Towns (4) | $610.13 | | | | 0 | |

18. How much SUTA tax must Anaston, Inc., pay to the state for a part-time employee who earns $5,290? The SUTA tax rate is 5.4% of the wages.

19. How much SUTA tax must University Dry Cleaners pay to the state for an employee who earns $38,200?

20. How much FUTA tax must University Dry Cleaners pay for the employee in Exercise 19? The FUTA tax rate is 6.2% of the first $7,000 minus the SUTA tax.

21. Use Figures 10-4 and 10-5 to find the amount of federal income tax to be withheld from Joey Surrette's gross biweekly earnings of $2,555 if Joey is married and claims 3 withholding allowances.

1. Anita Loyd works 45 hours in one week, is paid $8.98 per hour, and earns 1.5 times her hourly wage for all hours worked over 40 in a given week. Calculate Anita's gross pay using the method described in the chapter.

2. Calculate Anita Loyd's gross pay by multiplying the total number of hours worked by the hourly rate and multiplying the hours over 40 by 0.5 the hourly rate. Compare this gross pay to the gross pay found in Exercise 1.

3. Explain why the methods for calculating gross pay in Exercises 1 and 2 are mathematically equivalent.

4. Most businesses prefer to use the method used in Exercise 1 to calculate gross pay. Discuss reasons for this preference.

Assume that the taxpayers in questions 5–7 claim zero withholding allowances.

5. If a person is paid weekly and is married, use Figure 10-5 to find the annual salary range that causes a portion of the person's salary to fall in the "28% bracket" for withholding purposes.

6. Compare the annual salary range found in Exercise 5 with the annual salary range for a person who is paid biweekly, is married, and whose salary is in the "28% bracket."

7. Predict the annual salary range a married person who is paid semimonthly would need to earn to fall in the "28% bracket." Use Table 3 of Figure 10-5 to verify or refute your prediction.

8. Use Exercises 5, 6, and 7 to make a general statement about the amount of withholding tax on an annual salary for the various types of pay periods. To what can you attribute any differences you noted?

9. Many people think that if an increase in earnings moves their salary to a higher tax bracket, their entire salary will be taxed at the higher rate. Is this true? Give an example to justify your answer.

10. Shameka Jones earns $98,520 and is paid semimonthly. Her last pay stub for the year shows $254.51 is deducted for Social Security and $59.52 is deducted for Medicare. Should she call her payroll office for a correction? If so, what would that correction be?

Challenge Problem

Complete the following time card for Janice Anderson in Figure 10-6. She earns time and a half overtime when she works more than eight hours on a weekday or on Saturday. She earns double time on Sundays and holidays. Calculate Janice's net pay if she earns $9.75 per hour, is married, and claims one withholding allowance.

WEEKLY TIME CARD
CHD Company

Name: Janice Anderson SS# 000-00-0000
Pay for period ending

| DATE | IN | OUT | IN | OUT | Total Regular Hours | Total Overtime Hours |
|------|------|------|------|------|------|------|
| M 8/4 | 7:00 | 11:00 | 11:30 | 7:30 | | |
| Tu 8/5 | 8:00 | 12:00 | 12:30 | 4:30 | | |
| W 8/6 | 8:00 | 12:00 | 12:30 | 4:30 | | |
| Th 8/7 | 7:00 | 11:00 | 12:30 | 5:30 | | |
| F 8/8 | 8:00 | 12:00 | 12:30 | 4:30 | | |
| Sa 8/9 | 7:00 | 12:00 | | | | |
| Su 8/10 | | | | | | |

| | HOURS | RATE | GROSS PAY |
|------|------|------|------|
| Regular | | | |
| Overtime (1.5X) | | | |
| Overtime (2X) | | | |
| Total | | | |

FIGURE 10-6

10.1 Score Skateboard Company

Score Skateboard Company is a small firm that designs and manufactures skateboards for high school and college students who want effective, fast transportation around campus. Score has two employees who receive $1,100 gross pay per semimonthly pay period and four employees who receive $850 gross pay per semimonthly pay period. The company owner and manager, Christie, needs to determine how much to include in her budget for each employee. Starting in January, Score will be contributing $75 per pay period to each employee's retirement fund. Score is in a state that has a maximum of $7,000 gross pay for SUTA and Score is required to pay 5.4% of the first $7,000 for each employee.

1. Calculate the cost to Score for an employee with $1,100 gross pay in the first period in January.

2. Calculate the cost to Score for an employee with $850 gross pay in the first period in January.

3. Find the total gross semimonthly pay for all six employees and compare this to the total amount Score must include in its budget. How much extra is needed in the budget?

4. Calculate the total amount Score will need for its first quarter FUTA and SUTA deposit. There are six semimonthly pay periods in the first quarter of the year.

10.2 Welcome Care

Welcome Care, a senior citizen day care center, pays the major portion of its employees' medical insurance—$150 of the $204 monthly premium for an individual employee. If an employee wishes coverage for a spouse or family, the employee must pay $126 or $212 per month respectively to cover herself or himself and the additional person(s). The center hires three new employees. Calculate their semimonthly take-home pay using the percentage method tables. The company pays time and a half for overtime hours in excess of 40 hours in a given week. Medical insurance premiums can be paid with pretax dollars. Withholding taxes, Social Security, and Medicare deductions are calculated on the lower adjusted gross salary.

1. An activities director is hired at an annual salary of $32,000. He is single with two dependent children (three withholding allowances) and wants family medical insurance coverage. Find his total deductions and his net income.

2. A dietitian is hired at a monthly salary of $3,500 a month paid semimonthly. She is married with one withholding allowance and wants medical insurance for herself and her spouse. Find her take-home pay if she is subject to an IRS garnishment of $100 per month for back taxes. Use the percentage method of withholding.

3. A vehicle driver is hired at $12 per hour to transport seniors to appointments and leisure activities. The driver is single and claims no withholding allowances. He needs medical coverage for himself only. Find his net pay if he worked 77 hours regular time, 8 hours overtime, and has $200 per month taken out for court-ordered child support payments.

4. A part-time caregiver comes daily to sit with and talk with senior citizens at Welcome Care. He is paid $8 per hour and works 4 hours each day for 10 days in the pay period. He is single and claims one withholding allowance. He has medical insurance coverage through another job. Find his net pay for a semimonthly paycheck using the percentage method of withholding.

10.3 First Foreign Auto Parts

Ryan Larson, owner of First Foreign Auto Parts, is considering expanding his operation for the new year by manufacturing rebuilt shock absorbers. This will require two additional full-time employees. Due to a tight labor market, Ryan presumes he will have to pay $10 per hour, along with health insurance, to attract quality employees. He decides he will contribute 50% towards the $260 monthly health insurance premium, in addition to the federal and state unemployment taxes and Medicare and Social Security taxes that he must pay on the employees' behalf. Ryan needs to decide how much to include in his budget for each employee.

1. Based on a 40-hour work week, calculate the cost to First Foreign Auto Parts for each employee in the first month in January.

2. Ryan hires a new employee at $10 per hour to rebuild shock absorbers. The employee is single and claims no withholding allowances, and needs the health coverage. Calculate his weekly take-home pay using the percentage method tables, assuming he works 40 regular hours and 10 overtime hours, and pays 29% of his earnings for court-ordered child support. His health insurance premiums can be paid with pre-tax dollars. Use Table 10-4 to determine the federal tax to be withheld.

3. Ryan is considering a differential piecework rate to give his new employees incentive to produce more and increase their wages. Ryan came up with the following schedule:

| Shocks assembled per week | Pay per shock |
|---|---|
| First 40 shocks | $4.50 |
| Next 40 shocks | $5.50 |
| Over 80 shocks | $6.50 |

4. How much would each employee make for completing 75 shocks per week? How much more would each employee make by completing just 15 additional shocks per week beyond the first 75 shocks?

CHAPTER 11 | Simple Interest and Simple Discount

18 Months Same as Cash Financing on New TVs*

Radhika had just received mail for the first time in her new apartment, and there it was in big bold letters: 18 MONTHS SAME AS CASH FINANCING*. The ad read: The minimum monthly payment for this purchase does not include interest charges during the promotional period. You'll pay no interest for 18 months. Simply pay at least the total minimum monthly payment due as indicated on your billing statement. There's no prepayment penalty, and this offer provides you with the flexibility you need to meet your specific budget and purchasing requirements.

It sounded like a great deal. She really wanted to buy a flat panel TV and was short on cash. But Radhika had some concerns. First, she didn't know much about financing or how interest was computed; and second, she knew that the asterisk would probably mean trouble. After reading further, she found the following:

*The 18-month promotion is for televisions with a minimum value of $499.99. The 12-month promotion requires a minimum purchase of $299.99. These are "same as cash" promotions. If the balance on these purchases is paid in full before the expiration of the promotional period indicated on your billing statement and your account is kept current, then accrued finance

charges will not be imposed on these purchases. If the balance on these purchases is not paid in full, finance charges will be assessed from the purchase date at the annual simple interest rate of 24.99%. For accounts not kept current, the default simple interest rate of 27.99% will be applied to all balances on your account. Minimum monthly payments are required. The minimum finance charge is $2.00. Certain rules apply to the allocation of payments and finance charges on your promotional purchase if you make more than one purchase on your account.

Wow! That was a lot to digest. Radhika had her heart set on a TV that cost about $800, and she was hoping to keep her payments under $20 per month. Would that be enough to pay the account in full in 18 months? And if she came up short by a few hundred dollars, would she still be charged all of that interest? If so, how much would 24.99% cost her during that time? What was simple interest, anyway? None of this sounded simple to her. And the late penalties—she didn't even want to think about those.

Radhika took a deep breath. Maybe this wasn't such a good idea, she thought as she reached for her keys. But she really wanted that TV.

LEARNING OUTCOMES

11-1 The Simple Interest Formula

1. Find simple interest using the simple interest formula.
2. Find the maturity value of a loan.
3. Convert months to a fractional or decimal part of a year.
4. Find the principal, rate, or time using the simple interest formula.

11-2 Ordinary and Exact Interest

1. Find the exact time.
2. Find the due date.
3. Find the ordinary interest and the exact interest.
4. Make a partial payment before the maturity date.

11-3 Promissory Notes

1. Find the bank discount and proceeds for a simple discount note.
2. Find the true or effective interest rate of a simple discount note.
3. Find the third-party discount and proceeds for a third-party discount note.

 *A corresponding Business Math Case Video for this chapter, *The Real World: Video Case: Should I Buy New Equipment Now?* can be found in Appendix A.

Interest: an amount paid or earned for the use of money.

Simple interest: interest when a loan or investment is repaid in a lump sum.

Principal: the amount of money borrowed or invested.

Rate: the percent of the principal paid as interest per time period.

Time: the number of days, months, or years that the money is borrowed or invested.

Every business and every person at some time borrows or invests money. A person (or business) who borrows money must pay for the use of the money. A person who invests money must be paid by the person or firm who uses the money. The price paid for using money is called **interest**.

In the business world, we encounter two basic kinds of interest, *simple* and *compound*. **Simple interest** applies when a loan or investment is repaid in a lump sum. The person using the money has use of the full amount of money for the entire time of the loan or investment. Compound interest, which is explained in Chapter 13, most often applies to savings accounts, installment loans, and credit cards.

Both types of interest take into account three factors: the principal, the interest rate, and the time period involved. **Principal** is the amount of money borrowed or invested. **Rate** is the percent of the principal paid as interest per time period. **Time** is the number of days, months, or years that the money is borrowed or invested.

11-1 THE SIMPLE INTEREST FORMULA

LEARNING OUTCOMES

1 Find simple interest using the simple interest formula.
2 Find the maturity value of a loan.
3 Convert months to a fractional or decimal part of a year.
4 Find the principal, rate, or time using the simple interest formula.

1 Find simple interest using the simple interest formula.

The interest formula $I = PRT$ shows how interest, principal, rate, and time are related and gives us a way of finding one of these values if the other three values are known.

> **HOW TO** Find simple interest using the simple interest formula
>
> 1. Identify the principal, rate, and time.
> 2. Multiply the principal by the rate and time.
>
> $$\text{Interest} = \text{principal} \times \text{rate} \times \text{time}$$
> $$I = PRT$$

The rate of interest is a percent for a given time period, usually one year. The time in the interest formula must be expressed in the same unit of time as the rate. If the rate is a percent per year, the time must be expressed in years or a decimal or fractional part of a year. Similarly, if the rate is a percent per month, the time must be expressed in months.

> **EXAMPLE 1** Find the interest paid on a loan of $1,500 for one year at a simple interest rate of 9% per year.
>
> $I = PRT$ Use the simple interest formula. Principal P is $1,500, rate R is 9% per year, and time T is one year.
> $I = (\$1,500)(9\%)(1)$ Write 9% as a decimal. Multiply.
> $I = (\$1,500)(0.09)(1)$
> $I = \$135$
>
> **The interest on the loan is $135.**

> **EXAMPLE 2** Kanette's Salon borrowed $5,000 at $8\frac{1}{2}\%$ per year simple interest for two years to buy new hair dryers. How much interest must be paid?
>
> $I = PRT$ Use the simple interest formula. Principal P is $5,000, rate R is $8\frac{1}{2}\%$ per year, and time T is two years.
> $I = (\$5,000)(8\frac{1}{2}\%)(2)$
> $I = (\$5,000)(0.085)(2)$ Write $8\frac{1}{2}\%$ as a decimal. Multiply.
> $I = \$850$
>
> **Kanette's Salon will pay $850 interest.**

A loan that is made using simple interest is to be repaid in a lump sum at the end of the time of the loan. Banks and lending institutions make loans at a variety of different rates based on factors such as prime interest rate and the amount of risk that the loan will be repaid. The **prime interest rate** is the lowest rate of interest charged by banks for short-term loans to their most creditworthy customers. Banks establish the rate of a loan based on the current prime rate and the likelihood that it will not change significantly over the time of the loan.

Loans are made at the prime rate or higher, often significantly higher. Investments such as savings accounts and certificates of deposit earn interest at a rate less than prime. Lending institutions make a profit based on the difference between the rate of interest charged for loans and the rate of interest given for investments.

Prime interest rate (prime): the lowest rate of interest charged by banks for short-term loans to their most creditworthy customers.

 STOP AND CHECK

1. Find the interest paid on a loan of $38,000 for one year at a simple interest rate of 10.5%.

2. A loan of $17,500 for six years has a simple interest rate of 7.75%. Find the interest.

3. The 7th Inning borrowed $6,700 at 9.5% simple interest for three years. How much interest is paid?

4. Find the interest on a $38,500 loan at a simple interest rate of 12.3% for five years.

2 Find the maturity value of a loan.

The *total* amount of money due at the end of a loan period—the amount of the loan *and* the interest—is called the **maturity value** of the loan. When the principal and interest of a loan are known, the maturity value is found by adding the principal and the interest. The maturity value can also be found directly from the principal, rate, and time.

Maturity value: the total amount of money due at the end of a loan period—the amount of the loan and the interest.

HOW TO Find the maturity value of a loan

1. If the principal and interest are known, add them.

$$\text{Maturity value} = \text{principal} + \text{interest}$$
$$MV = P + I$$

2. If the principal, rate, and time are known, use either of the formulas:
 (a) Maturity value = principal + (principal × rate × time)
$$MV = P + PRT$$
 (b) Maturity value = principal (1 + rate × time)
$$MV = P(1 + RT)$$

Both variations of the formula for finding the maturity value when the principal, rate, and time are known require that the operations be performed according to the standard order of operations. To review briefly, when more than one operation is to be performed, perform operations within parentheses first. Perform multiplications and divisions before additions and subtractions. Perform additions and subtractions last. For a more detailed discussion of the order of operations, review Chapter 5, Section 1, Learning Outcome 3.

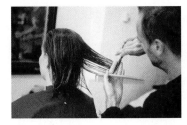

EXAMPLE 1 In Example 2 on page 382, we found that Kanette's Salon would pay $850 interest on a $5,000 loan. How much money will Kanette's Salon pay at the end of two years?

Maturity value = principal + interest *P* and *I* are known.
$$MV = P + I$$ Substitute known values.
$$= \$5,000 + \$850 = \$5,850$$

Kanette's Salon will pay $5,850 at the end of the loan period.

EXAMPLE 2 Marcus Logan can purchase furniture with a two-year simple interest loan at 9% interest per year. What is the maturity value for a $2,500 loan?

| | |
|---|---|
| Maturity value = principal (1 + rate × time) | P, R, and T are known. |
| $MV = P(1 + RT)$ | Substitute $P = \$2,500$, |
| | $R = 9\%$ or 0.09, |
| | $T = 2$ years. |
| $MV = \$2,500(1 + 0.09 \times 2)$ | Multiply in parentheses. |
| $MV = \$2,500(1 + 0.18)$ | Add in parentheses. |
| $MV = \$2,500(1.18)$ | Multiply. |
| $MV = \$2,950$ | |

Marcus will pay $2,950 at the end of two years.

TIP

Does a Calculator Know the Proper Order of Operations? Some Do, Some Don't.

Using a basic calculator, you enter calculations as they should be performed according to the standard order of operations.

$$\boxed{AC} \ .09 \ \boxed{\times} \ 2 \ \boxed{=}\boxed{+} \ 1 \ \boxed{=} \ \boxed{\times} \ 2500 \ \boxed{=} \ \Rightarrow \ 2950$$

Using a business or scientific calculator with parentheses keys allows you to enter values for the maturity value formula as they appear. The calculator is programmed to perform the operations in the standard order. The calculator has special keys for entering parentheses, $\boxed{(}$ and $\boxed{)}$.

$$\boxed{AC} \ 2500 \ \boxed{\times}\boxed{(} \ 1 \ \boxed{+} \ .09 \ \boxed{\times} \ 2 \ \boxed{)}\boxed{=} \ \Rightarrow \ 2950$$

 STOP AND CHECK

1. How much is paid at the end of two years for a loan of $8,000 if the total interest is $660?

2. A loan of $7,250 is to be repaid in three years and has a simple interest rate of 12%. How much is paid after the three years?

3. Find the maturity value of a $1,800 loan made for two years at $9\frac{3}{4}\%$ simple interest per year.

4. Find the maturity value of a three-year, simple interest loan at 11% per year in the amount of $7,275.

3 Convert months to a fractional or decimal part of a year.

Not all loans or investments are made for a whole number of years; but, since the interest rate is most often given per year, the time must also be expressed in the same unit of time as the rate.

HOW TO Convert months to a fractional or decimal part of a year

1. Write the number of months as the numerator of a fraction.
2. Write 12 as the denominator of the fraction.
3. Reduce the fraction to lowest terms if using the fractional equivalent.
4. Divide the numerator by the denominator to get the decimal equivalent of the fraction.

EXAMPLE 1

Convert (a) 5 months and (b) 15 months to years, expressed in both fraction or mixed-number and decimal form.

(a) 5 months = $\frac{5}{12}$ year

5 months equal $\frac{5}{12}$ year.

$$12\overline{)5.0000000} \quad \frac{0.4166666 \text{ year} = 0.42 \text{ year}}{}$$

To write the fraction as a decimal, divide the number of months (the numerator) by the number of months in a year (the denominator).

5 months = $\frac{5}{12}$ year or 0.42 year (rounded)

(b) 15 months = $\frac{15}{12}$ years = $\frac{5}{4}$ or $1\frac{1}{4}$ years

15 months equal $\frac{15}{12}$ years.

$$12\overline{)15.00} \quad \frac{1.25 \text{ years}}{}$$
$$\underline{12}$$
$$3\,0$$
$$\underline{2\,4}$$
$$60$$
$$\underline{60}$$
$$0$$

To write the fraction as a decimal, divide the number of months (the numerator) by the number of months in a year (the denominator).

15 months = $1\frac{1}{4}$ years or 1.25 years

EXAMPLE 2

To save money for a shoe repair shop, Stan Wright invested $2,500 for 45 months at $3\frac{1}{2}\%$ simple interest per year. How much interest did he earn?

$T = 45$ months $= \frac{45}{12}$ years $= 3\frac{3}{4}$ or 3.75 years

Write the time in terms of years.

$I = PRT$

Use the simple interest formula.

$I = \$2,500\,(0.035)(3.75)$

Principal P is $2,500, rate R is 0.035, and time T is $\frac{45}{12}$ or 3.75. Multiply.

$I = \$328.13$

Round to the nearest cent.

Stan Wright earned $328.13 in interest.

TIP

Check Calculations by Estimating

As careful as we are, there will always be times that we hit an incorrect key or use an improper sequence of steps and produce an incorrect solution. You can catch most of these mistakes by first anticipating what a reasonable answer should be.

In the preceding example, 1% interest for one year would be $25. At that rate the interest for four years would be $100. The actual rate is $3\frac{1}{2}$ times one percent and the time is less than four years, so a reasonable estimate would be $350.

TIP

So Many Choices!

When time is expressed in months, the calculator sequence is the same as when time is expressed in years, except that you do not enter a whole number for the time. Months can be changed to years in the sequence rather than as a separate calculation. All other steps are the same. To solve the equation using a calculator without the percent key, use the decimal equivalent of $3\frac{1}{2}\%$ and the fraction for the time.

AC 2500 × .035 × 45 ÷ 12 = ⟹ 328.125

It is not necessary to find the decimal equivalent of $\frac{45}{12}$ or to reduce $\frac{45}{12}$. However, you will get the same result if you use 3.75 or $\frac{15}{4}$.

AC 2500 × .035 × 3.75 = ⟹ 328.125
AC 2500 × .035 × 15 ÷ 4 = ⟹ 328.125

✓ STOP AND CHECK

1. Change eight months to years, expressed in fraction and decimal form. Round to the nearest millionth.

2. Change 15 months to years, expressed in both fraction and decimal form.

3. Carrie made a $1,200 loan for 18 months at 9.5% simple interest. How much interest was paid?

4. Find the maturity value of a loan of $1,750 for 28 months at 9.8% simple interest.

4 Find the principal, rate, or time using the simple interest formula.

So far in this chapter, we have used the formula $I = PRT$ to find the simple interest on a loan. However, sometimes you need to find the principal or the rate or the time instead of the interest. You can remember the different forms of this formula with a circle diagram (see Figure 11-1) like the one used for the percentage formula. Cover the unknown term to see the form of the simple interest formula needed to find the missing value.

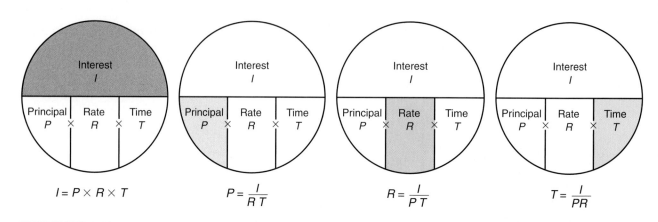

FIGURE 11-1
Various Forms of the Simple Interest Formula

HOW TO Find the principal, rate, or time using the simple interest formula

1. Select the appropriate form of the formula.
 (a) If the principal is unknown, use

$$P = \frac{I}{RT}$$

 (b) If the rate is unknown, use

$$R = \frac{I}{PT}$$

 (c) If the time is unknown, use

$$T = \frac{I}{PR}$$

2. Replace letters with known values and perform the indicated operations.

EXAMPLE 1 To buy a food preparation table for his restaurant, the owner of The 7th Inning borrowed $1,800 for $1\frac{1}{2}$ years and paid $202.50 simple interest on the loan. What rate of interest did he pay?

$$R = \frac{I}{PT}$$

R is unknown. Select the correct form of the simple interest formula. Replace letters with known values: I is $202.50, P is $1,800, T is 1.5 years. Perform the operations.

$$R = \frac{\$202.50}{(\$1,800)(1.5)}$$

$$R = 0.075$$

Write the rate in percent form by moving the decimal point two places to the right and attaching a % symbol.

$$R = 7.5\%$$

The owner paid 7.5% interest.

EXAMPLE 2

Phyllis Cox wanted to borrow some money to expand her photography business. She was told she could borrow a sum of money for 18 months at 6% simple interest per year. She thinks she can afford to pay as much as $540 in interest charges. How much money could she borrow?

$$P = \frac{I}{RT}$$

$I = \$540$

$R = 6\% = 0.06$

$T = 18 \text{ months} = \frac{18}{12}$

$\qquad\qquad\quad = 1.5 \text{ years}$

$$P = \frac{\$540}{0.06(1.5)}$$

$P = \$6,000$

The principal is $6,000.

P is unknown. Select the correct form of the simple interest formula.

Write the percent as a decimal equivalent.

The interest rate is per year, so write 18 months as 1.5 years.

Replace letters with known values: I is $540, R is 0.06, T is 1.5.
Perform the operations.

TIP

Numerator Divided by Denominator

When a series of calculations has fractions and a calculation in the denominator, the numerator must be divided by the entire denominator.

With a basic calculator and using memory, multiply 0.06 × 1.5, store the result in memory and clear the display, and divide 540 by the stored product:

$$\boxed{\text{AC}}\ .06\ \boxed{\times}\ 1.5\ \boxed{=}\boxed{\text{M}^+}\ \text{CE/C}\ 540\ \boxed{\div}\ \text{MRC}\ \boxed{=}\ \Rightarrow 6000$$

Using repeated division, divide 540 by both .06 and 1.5:

$$\boxed{\text{AC}}\ 540\ \boxed{\div}\ .06\ \boxed{\div}\ 1.5\ \boxed{=}\ \Rightarrow 6000$$

With a business or scientific calculator and parentheses, group the calculation in the denominator using parentheses:

$$\boxed{\text{AC}}\ 540\ \boxed{\div}\ \boxed{(}\ .06\ \boxed{\times}\ 1.5\ \boxed{)}\ \boxed{=}\ \Rightarrow 6000$$

EXAMPLE 3

The 7th Inning borrowed $2,400 at 7% simple interest per year to buy new tables for Brubaker's Restaurant. If it paid $420 interest, what was the duration of the loan?

$$T = \frac{I}{PR}$$

$$T = \frac{\$420}{\$2,400(0.07)} = 2.5 \text{ years}$$

T is unknown. Select the correct form of the simple interest formula. Replace letters with known values: $I = \$420$, $P = \$2,400$, $R = 0.07$.
Perform the operations.

The duration of the loan is 2.5 years.

TIP

Is the Answer Reasonable?

Suppose in the previous example we had mistakenly made the following calculations:

$$420 \div 2400 \times 0.07 = \Rightarrow 0.01225$$

Is it reasonable to think that $420 in interest would be paid on a $2,400 loan that is made for such a small portion of a year? The interest on a 10% loan for one year would be $240. The interest on a 10% loan for two years would be $480. This type of reasoning draws attention to an unreasonable answer.

You can reexamine your steps to discover that you should have used your memory function, repeated division, or your parentheses keys.

STOP AND CHECK

1. What is the simple interest rate of a loan of $2,680 for $2\frac{1}{2}$ years if $636.50 interest is paid?

2. Find the simple interest rate of a loan of $5,000 that is made for three years and requires $1,762.50 in interest.

3. How much money is borrowed if the interest rate is $9\frac{1}{4}\%$ simple interest and the loan is made for 3.5 years and has $904.88 interest?

4. A loan of $16,840 is borrowed at 9% simple interest and is repaid with $4,167.90 interest. What is the duration of the loan?

11-1 SECTION EXERCISES

SKILL BUILDERS

1. Find the interest paid on a loan of $2,400 for one year at a simple interest rate of 11% per year.

2. Find the interest paid on a loan of $800 at $8\frac{1}{2}\%$ annual simple interest for two years.

3. How much interest will have to be paid on a loan of $7,980 for two years at a simple interest rate of 6.2% per year?

4. Find the total amount of money (maturity value) that the borrower will pay back on a loan of $1,400 at $12\frac{1}{2}\%$ annual simple interest for three years.

5. Find the maturity value of a loan of $2,800 after three years. The loan carries a simple interest rate of 7.5% per year.

6. Susan Duke borrowed $20,000 for four years to purchase a car. The simple interest loan has a rate of 8.2% per year. What is the maturity value of the loan?

Convert to years, expressed in decimal form to the nearest hundredth.

7. 9 months

8. 40 months

9. A loan is made for 18 months. Convert the time to years.

10. Express 28 months as years in decimal form.

APPLICATIONS

11. Alexa May took out a $42,000 construction loan to remodel a house. The loan rate is 8.3% simple interest per year and will be repaid in six months. How much is paid back?

12. Madison Duke needed start-up money for her bakery. She borrowed $1,200 for 30 months and paid $360 simple interest on the loan. What interest rate did she pay?

13. Raul Fletes needed money to buy lawn equipment. He borrowed $500 for seven months and paid $53.96 in interest. What was the rate of interest?

14. Linda Davis agreed to lend money to Alex Luciano at a special interest rate of 9% per year, on the condition that he borrow enough that he would pay her $500 in interest over a two-year period. What was the minimum amount Alex could borrow?

15. Jake McAnally needed money for college. He borrowed $6,000 at 12% simple interest per year. If he paid $360 interest, what was the duration of the loan?

16. Keaton Smith borrowed $25,000 to purchase stock for his baseball card shop. He repaid the simple interest loan after three years. He paid interest of $6,750. What was the interest rate?

11-2 ORDINARY AND EXACT INTEREST

LEARNING OUTCOMES

1 Find the exact time.
2 Find the due date.
3 Find the ordinary interest and the exact interest.
4 Make a partial payment before the maturity date.

Sometimes the time period of a loan is indicated by the beginning date and the due date of the loan rather than by a specific number of months or days. In such cases, you must first determine the time of the loan.

1 Find the exact time.

Exact time: time that is based on counting the exact number of days in a time period.

In Chapter 8, Section 3, Learning Outcome 1 we found the exact days in each month of a year. The exact number of days in a time period is called **exact time**.

EXAMPLE 1 Find the exact time of a loan made on July 12 and due on September 12.

| | | |
|---|---|---|
| Days in July | $31 - 12 = 19$ | July has 31 days. |
| Days in August | $= 31$ | August has 31 days. |
| Days in September | $= 12$ | |
| Total days | 62 | |

The exact time from July 12 to September 12 is 62 days.

Another way to calculate exact time is by using a table or calendar that assigns each day of the year a numerical value. See Table 11-1.

HOW TO Find the exact time of a loan using the sequential numbers table (Table 11-1)

1. If the beginning and due dates of the loan fall within the same year, subtract the beginning date's sequential number from the due date's sequential number.

From May 15 to Oct. 15
$288 - 135 = 153$ days

2. If the beginning and due dates of the loan do not fall within the same year:

From May 15 to March 15

(a) Subtract the beginning date's sequential number from 365.

$365 - 135 = 230$

(b) Add the due date's sequential number to the difference from step 2a.

$230 + 74 = 304$ days
(non-leap year)

3. If February 29 is between the beginning and due dates, add 1 to the difference from step 1 or the sum from step 2b.

$304 + 1 = 305$ days
(leap year)

EXAMPLE 2 Find the exact time of a loan from July 12 to September 12.

```
  255      Sequence number for September 12
− 193      Sequence number for July 12
───────
   62 days
```

TABLE 11-1
Sequential Numbers for Dates of the Year

| Day of Month | Jan. | Feb. | Mar. | Apr. | May | June | July | Aug. | Sept. | Oct. | Nov. | Dec. |
|---|---|---|---|---|---|---|---|---|---|---|---|---|
| 1 | 1 | 32 | 60 | 91 | 121 | 152 | 182 | 213 | 244 | 274 | 305 | 335 |
| 2 | 2 | 33 | 61 | 92 | 122 | 153 | 183 | 214 | 245 | 275 | 306 | 336 |
| 3 | 3 | 34 | 62 | 93 | 123 | 154 | 184 | 215 | 246 | 276 | 307 | 337 |
| 4 | 4 | 35 | 63 | 94 | 124 | 155 | 185 | 216 | 247 | 277 | 308 | 338 |
| 5 | 5 | 36 | 64 | 95 | 125 | 156 | 186 | 217 | 248 | 278 | 309 | 339 |
| 6 | 6 | 37 | 65 | 96 | 126 | 157 | 187 | 218 | 249 | 279 | 310 | 340 |
| 7 | 7 | 38 | 66 | 97 | 127 | 158 | 188 | 219 | 250 | 280 | 311 | 341 |
| 8 | 8 | 39 | 67 | 98 | 128 | 159 | 189 | 220 | 251 | 281 | 312 | 342 |
| 9 | 9 | 40 | 68 | 99 | 129 | 160 | 190 | 221 | 252 | 282 | 313 | 343 |
| 10 | 10 | 41 | 69 | 100 | 130 | 161 | 191 | 222 | 253 | 283 | 314 | 344 |
| 11 | 11 | 42 | 70 | 101 | 131 | 162 | 192 | 223 | 254 | 284 | 315 | 345 |
| 12 | 12 | 43 | 71 | 102 | 132 | 163 | 193 | 224 | 255 | 285 | 316 | 346 |
| 13 | 13 | 44 | 72 | 103 | 133 | 164 | 194 | 225 | 256 | 286 | 317 | 347 |
| 14 | 14 | 45 | 73 | 104 | 134 | 165 | 195 | 226 | 257 | 287 | 318 | 348 |
| 15 | 15 | 46 | 74 | 105 | 135 | 166 | 196 | 227 | 258 | 288 | 319 | 349 |
| 16 | 16 | 47 | 75 | 106 | 136 | 167 | 197 | 228 | 259 | 289 | 320 | 350 |
| 17 | 17 | 48 | 76 | 107 | 137 | 168 | 198 | 229 | 260 | 290 | 321 | 351 |
| 18 | 18 | 49 | 77 | 108 | 138 | 169 | 199 | 230 | 261 | 291 | 322 | 352 |
| 19 | 19 | 50 | 78 | 109 | 139 | 170 | 200 | 231 | 262 | 292 | 323 | 353 |
| 20 | 20 | 51 | 79 | 110 | 140 | 171 | 201 | 232 | 263 | 293 | 324 | 354 |
| 21 | 21 | 52 | 80 | 111 | 141 | 172 | 202 | 233 | 264 | 294 | 325 | 355 |
| 22 | 22 | 53 | 81 | 112 | 142 | 173 | 203 | 234 | 265 | 295 | 326 | 356 |
| 23 | 23 | 54 | 82 | 113 | 143 | 174 | 204 | 235 | 266 | 296 | 327 | 357 |
| 24 | 24 | 55 | 83 | 114 | 144 | 175 | 205 | 236 | 267 | 297 | 328 | 358 |
| 25 | 25 | 56 | 84 | 115 | 145 | 176 | 206 | 237 | 268 | 298 | 329 | 359 |
| 26 | 26 | 57 | 85 | 116 | 146 | 177 | 207 | 238 | 269 | 299 | 330 | 360 |
| 27 | 27 | 58 | 86 | 117 | 147 | 178 | 208 | 239 | 270 | 300 | 331 | 361 |
| 28 | 28 | 59 | 87 | 118 | 148 | 179 | 209 | 240 | 271 | 301 | 332 | 362 |
| 29 | 29 | * | 88 | 119 | 149 | 180 | 210 | 241 | 272 | 302 | 333 | 363 |
| 30 | 30 | | 89 | 120 | 150 | 181 | 211 | 242 | 273 | 303 | 334 | 364 |
| 31 | 31 | | 90 | | 151 | | 212 | 243 | | 304 | | 365 |

*For centennial years (those at the turn of the century), leap years occur only when the number of the year is divisible by 400. Thus, 2000 was a leap year (2000/400 divides exactly), but 1700, 1800, and 1900 were not leap years.

EXAMPLE 3 A loan made on September 5 is due July 5 of the *following year*. Find (a) the exact time for the loan in a non-leap year and (b) the exact time in a leap year.

(a) *Exact time in a non-leap year*
From Table 11-1, September 5 is the 248th day.

$$
\begin{array}{r}
365 \\
-248 \\
\hline
117 \text{ days}
\end{array}
$$

Subtract 248 from 365.
Days from September 5 through December 31

July 5 is the 186th day.
117 + 186 = 303 days

Add 117 and 186 to find the exact time of the loan.

(b) *Exact time in a leap year*
303 + 1 = 304 days

Since Feb. 29 is between the beginning and due dates, add 1 to the non-leap year total.

Exact time is 303 days in a non-leap year and 304 days in a leap year.

 STOP AND CHECK

1. Find the exact time of a loan made on April 15 and due on October 15.

2. Find the exact time of a loan made on March 20 and due on September 20.

3. Find the exact number of days of a loan made on October 14 and due on December 21.

4. A loan made on November 1 is due on March 1 of the following year. How many days are in the loan using exact time?

2 Find the due date.

Sometimes the beginning date of a loan and the time period of the loan are known and the due date must be determined.

HOW TO Find the due date of a loan given the beginning date and the time period in days

1. Add the sequential number of the beginning date to the number of days in the time period.
2. If the sum is less than or equal to 365, find the date (Table 11-1) corresponding to the sum.
3. If the sum is more than 365, subtract 365 from the sum. Then find the date (Table 11-1) in the following year corresponding to the difference.
4. Adjust for February 29 in a leap year if appropriate by *subtracting* 1 from the result in step 2 or 3.

60-day loan beginning on July 1:
July 1 = Day 182
182 + 60 = 242
242nd day = August 30

EXAMPLE 1 Find the due date for a 90-day loan made on November 15.

From Table 11-1, November 15 is the 319th day.

$$
\begin{array}{r}
319 \\
+\ 90 \\
\hline
409
\end{array}
$$

Add 319 to 90 days in the time period.

409 is greater than 365, so the loan is due in the following year.

$$
\begin{array}{r}
409 \\
-365 \\
\hline
44
\end{array}
$$

Subtract 365 from 409.

In Table 11-1, day 44 corresponds to February 13.

The loan is due February 13 of the following year.

STOP AND CHECK

1. Find the due date for a 120-day loan made on June 12.

2. What is the due date for a loan made on July 17 for 150 days?

3. Use exact time and find the due date of a $3,200 loan made on January 29 for 90 days.

4. Use exact time and find the due date of a $2,582 loan made on November 22 for 120 days.

3 Find the ordinary interest and the exact interest.

Ordinary interest: assumes 360 days per year.

Exact interest: assumes 365 days per year.

An interest rate is normally given as a rate *per year*. But if the time period of the loan is in days, then using the simple interest formula requires that the rate *also* be expressed as a rate *per day*. We convert a rate per year to a rate per day in two different ways, depending on whether the rate per day is to be an **ordinary interest** or an **exact interest**. Ordinary interest assumes 360 days per year; exact interest assumes 365 days per year.

> **HOW TO** Find the ordinary interest and the exact interest
>
> 1. To find the ordinary interest, use 360 as the number of days in a year.
> 2. To find the exact interest, use 365 as the number of days in a year.

> **EXAMPLE 1** Find the ordinary interest for a loan of $500 at a 7% annual interest rate. The loan was made on March 15 and is due May 15.
>
> Exact time $= 135 - 74 = 61$ days Find each date's sequential number in Table 11-1 and subtract.
>
> $I = PRT$ Replace with known values.
>
> $I = \$500(0.07)\left(\dfrac{61}{360}\right)$ Perform the operations.
>
> $I = \$5.93$ Round to the nearest cent.
>
> **The interest is $5.93.**

> **EXAMPLE 2** Find the exact interest on the loan in Example 1.
>
> Exact time $= 61$ days
>
> $I = PRT$ Replace with known values.
>
> $I = \$500(0.07)\left(\dfrac{61}{365}\right)$ Perform the operations.
>
> $I = \$5.85$ Round to the nearest cent.
>
> **The interest is $5.85.**

> **TIP**
>
> **Make Comparisons Quickly by Storing Common Portions of Problems**
>
> The two preceding examples can be calculated and compared using the memory function of a calculator.
>
> Be sure memory is clear or equal to 0 before you begin. Store the first calculation (500 × 0.07) in memory.
>
> AC 500 × .07 = M⁺
> AC MR × 61 ÷ 360 = ⟹ 5.930555556
> AC MR × 61 ÷ 365 = ⟹ 5.849315068

Banker's rule: calculating interest on a loan based on ordinary interest–which yields a slightly higher amount of interest.

Note that the interest varies in the two cases. The first method illustrated, *ordinary interest,* is most often used by bankers when they are *lending* money because it yields a slightly higher amount of interest. It is sometimes called the **banker's rule**. On the other hand, when bankers *pay* interest on savings accounts, they normally use a 365-day year—exact interest—which yields the most accurate amount of interest but is less than the amount yielded by the banker's rule.

EXAMPLE 3 Borrowing money to pay cash for large purchases is sometimes profitable when a cash discount is allowed on the purchases. Joann Jimanez purchased a computer, printer, copier, and fax machine for her consulting firm that regularly sold for $5,999. A special promotion offered the equipment for $5,890, with cash terms of 3/10, n/30. She does not have the cash to pay the bill now, but she will within the next three months. She finds a bank that will loan her the money for the equipment at 10% (using ordinary interest) for 90 days. Should she take out the loan to take advantage of the special promotion and cash discount?

| What You Know | What You Are Looking For | Solution Plan |
|---|---|---|
| Regular price: $5,999
 Special price: $5,890
 Cash discount rate: 0.03
 Exact term of loan: 90 days
 Ordinary interest uses 360 days. | Should Joann Jimanez take out the loan?

 Cash discount on special price, compared with interest on loan | Cash discount = special price \times discount rate
 Ordinary interest on loan = principal \times rate \times time
 The principal of the loan is the net amount Joann would pay, once the cash discount is allowed on the special price, or 97% of the cash price. |

Solution

$$\text{Cash discount} = \$5,890(0.03)$$
$$= \$176.70$$
$$\text{Principal} = \$5,890(0.97)$$
$$= \$5,713.30$$
$$\text{Interest on loan} = \$5,713.30(0.1)\left(\frac{90}{360}\right)$$
$$= \$142.83$$
$$\text{Difference} = \$176.70 - \$142.83$$
$$= \$33.87$$

Conclusion

The interest on the loan is $142.83, which is $33.87 less than the cash discount of $176.70. Since the cash discount is more than the interest on the loan, Joann will not lose money by borrowing to take advantage of the discount terms of the sale. But other factors—the time she spends to take out the loan, for example—should be considered.

 STOP AND CHECK

1. Find the ordinary interest on a loan of $1,350 at 6.5% annual interest rate if the loan is made on March 3 and due on September 3.

2. Find the exact interest for the loan in Exercise 1.

3. Compare the interest amounts from the two methods. Which method would you guess bankers offer to borrowers?

4. Use the banker's rule to find the maturity value of a loan of $4,250 made on April 12 and repaid on October 12. The interest rate is 7.2% simple interest.

4 Make a partial payment before the maturity date.

U. S. rule: any partial loan payment first covers any interest that has accumulated. The remainder of the partial payment reduces the loan principal.

Simple interest loans are intended to be paid with a lump sum payment at the maturity date. To save some interest, a borrower may decide to make one or more partial payments before the maturity date. The most common method for properly crediting a partial payment is to first apply the loan payment to the accumulated interest. The remainder of the partial payment is applied to the principal. This process is called the **U. S. Rule**.

Some states have passed legislation that forbids a lender from charging interest on interest. That means if the partial payment does not cover the accumulated interest, the principal for calculating the interest cannot be increased by the unpaid interest.

Adjusted principal: the remaining principal after a partial payment has been properly credited.

Adjusted balance due at maturity: the remaining balance due at maturity after one or more partial payments have been made.

HOW TO Find the adjusted principal and adjusted balance due at maturity for a partial payment made before the maturity date.

1. Determine the exact time from the date of the loan to the first partial payment.
2. Calculate the interest using the time found in Step 1.
3. Subtract the amount of interest found in Step 2 from the partial payment.
4. Subtract the remainder of the partial payment (Step 3) from the original principal. This is the **adjusted principal**.
5. Repeat the process with the adjusted principal if additional partial payments are made.
6. At maturity, calculate the interest from the last partial payment. Add this interest to the adjusted principal from the last partial payment. This is the **adjusted balance due at maturity**.

EXAMPLE 1
Tony Powers borrows $5,000 on a 10%, 90 day note. On the 30th day, Tony pays $1,500 on the note. If ordinary interest is applied, what is Tony's adjusted principal after the partial payment? What is the adjusted balance due at maturity?

$$\$5,000(0.1)\left(\frac{30}{360}\right) = \$41.67$$ Calculate the ordinary interest on 30 days.

$\$1,500 - \$41.67 = \$1,458.33$ Amount of partial payment applied to principal

$\$5,000 - \$1,458.33 = \$3,541.67$ Adjusted principal

$$\$3,541.67(0.1)\left(\frac{60}{360}\right) = \$59.03$$ Interest on adjusted principal

$\$3,541.67 + \$59.03 = \$3,600.70$ Adjusted balance due at maturity

The adjusted principal after 30 days is $3,541.67 and the adjusted balance due at maturity is $3,600.70.

EXAMPLE 2
How much interest was saved by making the partial payment in Example 1?

$\$41.67 + \$59.03 = \$100.70$ Total interest paid

$$\$5,000(0.1)\left(\frac{90}{360}\right) = \$125$$ Interest if no partial payment is made

$\$125 - \$100.70 = \$24.30$ Interest saved

The interest saved by making a partial payment is $24.30.

✓ STOP AND CHECK

1. James Ligon borrowed $10,000 at 9% for 270 days with ordinary interest applied. On the 60th day he paid $3,000 on the note. What is the adjusted balance due at maturity?

2. Jennifer Raymond borrowed $5,800 on a 120 day note that required ordinary interest at 7.5%. Jennifer paid $2,500 on the note on the 30th day. How much interest did she save by making the partial payment?

11-2 SECTION EXERCISES

SKILL BUILDERS

1. Find the exact interest on a loan of $32,400 at 8% annually for 30 days.

2. Find the exact interest on a loan of $12,500 at 7.75% annually for 45 days.

3. Find the exact interest on a loan of $6,000 at 8.25% annually for 50 days.

4. Find the exact interest on a loan of $9,580 at 8.5% annually for 40 days.

5. A loan made on March 10 is due September 10 of the *following year.* Find the exact time for the loan in a non-leap year and a leap year.

6. Find the exact time of a loan made on March 25 and due on November 15 of the same year.

7. A loan is made on January 15 and has a due date of October 20 during a leap year. Find the exact time of the loan.

8. Find the due date for a loan made on October 15 for 120 days.

9. A loan is made on March 20 for 180 days. Find the due date.

10. Find the due date of a loan that is made on February 10 of a leap year and is due in 60 days.

APPLICATIONS

Exercises 11–12: A loan for $3,000 with a simple annual interest rate of 15% was made on June 15 and was due on August 15.

11. Find the exact interest.

12. Find the ordinary interest.

EXAMPLE 1 What is the effective interest rate of a simple discount note for $5,000, at an ordinary bank discount rate of 12%, for 90 days? Round to the nearest tenth of a percent.

Find the bank discount:

$$I = PRT$$

$$I = \$5,000(0.12)\left(\frac{90}{360}\right)$$

$$I = \$150 \qquad \text{Bank discount}$$

Find the proceeds:

Proceeds = principal − bank discount
Proceeds = $5,000 − $150
Proceeds = $4,850

Find the effective interest rate:

$$R = \frac{I}{PT} \qquad \text{Substitute proceeds for principal.}$$

$$R = \frac{\$150}{\$4,850\left(\dfrac{90}{360}\right)}$$

$$R = \frac{\$150}{\$1,212.50}$$

$$R = 0.1237113402$$

$$R = 12.4\% \qquad \text{Effective interest rate}$$

The effective interest rate for a simple discount note of $5,000 for 90 days is 12.4%.

 STOP AND CHECK

1. What is the effective interest rate of a simple discount note for $8,000, at an ordinary bank discount rate of 11%, for 120 days? Round to the nearest tenth of a percent.

2. What is the effective interest rate of a simple discount note for $22,000, at an ordinary bank discount rate of 8.36%, for 90 days? Round to the nearest tenth of a percent.

3 Find the third-party discount and proceeds for a third-party discount note.

Third party: an investment group or individual that assumes a note that was made between two other parties.

Third-party discount note: a note that is sold to a third party (usually a bank) so that the original payee gets the proceeds immediately and the maker pays the third party the original amount at maturity.

Discount period: the amount of time that the third party owns the third-party discounted note.

Many businesses agree to be the payee for a promissory note as payment for the sale of goods. If these businesses in turn need cash, they may sell such a note to an investment group or person who is the **third party** of the note. Selling a note to a third party in return for cash is called *discounting* a note. The note is called a **third-party discount note**.

When the third party discounts a note, it gives the business owning the note the maturity value of the note minus a third-party discount. The discount is based on how long the third party holds the note, called the **discount period**. The third party receives the full maturity value of the note from the maker when it comes due. From the standpoint of the note maker (the borrower), the term of the note is the same because the maturity (due) date is the same, and the maturity value is the same.

The following diagram shows how the discount period is determined.

HOW TO Find the third-party discount and proceeds for a third-party discount note

1. For the third-party discount, use:

 Third-party discount = maturity value of original note × discount rate
 × discount period

 $$I = PRT$$

2. For the proceeds to the original payee, use:

 Proceeds = maturity value of original note − third-party discount
 $$A = P - I$$

EXAMPLE 1

Alpine Pleasures, Inc., delivers ski equipment to retailers in July but does not expect payment until mid-September, so the retailers agree to sign promissory notes for the equipment. These notes are based on exact interest, with a 10% annual simple interest rate. One promissory note held by Alpine is for $8,000, was made on July 14, and is due September 12. Alpine needs cash, so it takes the note to an investment group. On August 3, the group agrees to buy the note at a 12% discount rate using the banker's rule (ordinary interest). Find the proceeds for the note.

A table can help you organize the facts:

| Date of original note | Principal of note | Simple interest rate | Date of discount note | Third-party discount rate | Maturity date |
|---|---|---|---|---|---|
| July 14 | $8,000 | 10% | Aug. 3 | 12% | Sept. 12 |

Calculate the time and maturity value of the original note.

| 255 | September 12 (Table 11-1) |
|---|---|
| −195 | July 14 (Table 11-1) |
| 60 days | Exact days of the original loan |

$I = PRT$ Use the simple interest formula to find exact interest.

$I = \$8,000(0.1)\left(\dfrac{60}{365}\right)$ Use 365 days in a year.

$I = \$131.51$ (rounded)

The simple interest for the original loan is $131.51.

To find the maturity value, add the principal and interest.

Maturity value = principal + interest
Maturity value = $8,000 + $131.51
Maturity value = $8,131.51

The maturity value of the original loan is $8,131.51.

Now calculate the discount period.

Discount period = number of days from August 3 to September 12

August 3 is the 215th day.

| 255 | September 12 |
|---|---|
| −215 | August 3 |
| 40 days | Exact days of discount period |

The discount period for the discount note is 40 days.

Now calculate the third-party discount based on the banker's rule (ordinary interest).

Third-party discount = maturity value × third-party discount rate × discount period

Third-party discount = $8,131.51(0.12)\left(\dfrac{40}{360}\right)$ Use 360 days in a year.

Third-party discount = $108.42

The third-party discount is $108.42.

Now calculate the proceeds that will be received by Alpine.

$$\text{Proceeds} = \text{maturity value} - \text{third-party discount}$$
$$\text{Proceeds} = \$8,131.51 - \$108.42$$
$$\text{Proceeds} = \$8,023.09$$

The proceeds to Alpine are $8,023.09.

TIP

Interest-Free Money

A non-interest-bearing note is very uncommon but sometimes available. This means that you borrow a certain amount and pay that same amount back later. The note itself carries no interest, and the maturity value of the note is the same as the face value or principal. The payee or person loaning the money only wants the original amount of money at the maturity date.

What happens if a non-interest-bearing note is discounted? Use the information from Example 1, without the simple interest on the original loan.

$$\text{Third-party discount} = \text{maturity value} \times \text{discount rate} \times \text{discount period}$$

$$\text{Third-party discount} = \$8,000(0.12)\left(\frac{40}{360}\right)$$

$$\text{Third-party discount} = \$106.67$$

The maturity value is the face value, or $8,000, rather than $8,131.51, which included interest.

The third-party discount is $106.67.

$$\text{Proceeds} = \text{maturity value} - \text{third-party discount}$$
$$\text{Proceeds} = \$8,000 - \$106.67$$

The maturity value is $8,000.

$$\text{Proceeds} = \$7,893.33$$

The proceeds are $7,893.33.

The original payee loans $8,000 and receives $7,893.33 in cash from the third party.

 STOP AND CHECK

1. Hugh's Trailers delivers trailers to retailers in February and expects payment in July. The retailers sign promissory notes based on exact interest with 8.25% annual simple interest. One promissory note held by Hugh's for $19,500 was made on February 15 and is due July 20. On May 5 a third party buys the note at a 10% discount using the banker's rule. Find the maturity exact time of the original note.

2. Find the maturity value of the original note in Exercise 1.

3. Find the third-party discount for the note in Exercise 1.

4. Find the proceeds to Hugh's Trailers for the discounted note in Exercise 1.

11-3 SECTION EXERCISES

SKILL BUILDERS

Use the banker's rule unless otherwise specified.

1. José makes a simple discount note with a face value of $2,500, a term of 120 days, and a 9% discount rate. Find the discount.

2. Find the proceeds for Exercise 1.

SKILL BUILDERS

1. Find the exact interest on a loan of $32,400 at 8% annually for 30 days.

2. Find the exact interest on a loan of $12,500 at 7.75% annually for 45 days.

3. Find the exact interest on a loan of $6,000 at 8.25% annually for 50 days.

4. Find the exact interest on a loan of $9,580 at 8.5% annually for 40 days.

5. A loan made on March 10 is due September 10 of the *following year.* Find the exact time for the loan in a non-leap year and a leap year.

6. Find the exact time of a loan made on March 25 and due on November 15 of the same year.

7. A loan is made on January 15 and has a due date of October 20 during a leap year. Find the exact time of the loan.

8. Find the due date for a loan made on October 15 for 120 days.

9. A loan is made on March 20 for 180 days. Find the due date.

10. Find the due date of a loan that is made on February 10 of a leap year and is due in 60 days.

APPLICATIONS

Exercises 11–12: A loan for $3,000 with a simple annual interest rate of 15% was made on June 15 and was due on August 15.

11. Find the exact interest.

12. Find the ordinary interest.

13. Find the adjusted balance due at maturity for a 90-day note of $15,000 at 13.8% ordinary interest if a partial payment of $5,000 is made on the 60th day of the loan.

14. Raul Fletes borrowed $8,500 on a 300-day note that required ordinary interest at 11.76%. Raul paid $4,250 on the note on the 60th day. How much interest did he save by making the partial payment?

11-3 PROMISSORY NOTES

LEARNING OUTCOMES

1 Find the bank discount and proceeds for a simple discount note.
2 Find the true or effective interest rate of a simple discount note.
3 Find the third-party discount and proceeds for a third-party discount note.

Promissory note: a legal document promising to repay a loan.

Maker: the person or business that borrows the money.

Payee: the person or business loaning the money.

Term: the length of time for which the money is borrowed.

Maturity date: the date on which the loan is due to be repaid.

Face value: the amount borrowed.

When a business or individual borrows money, it is customary for the borrower to sign a legal document promising to repay the loan. The document is called a **promissory note**. The note includes all necessary information about the loan. The **maker** is the person borrowing the money. The **payee** is the person loaning the money. The **term** of the note is the length of time for which the money is borrowed; the **maturity date** is the date on which the loan is due to be repaid. The **face value** of the note is the amount borrowed.

1 Find the bank discount and proceeds for a simple discount note.

If money is borrowed from a bank at a simple interest rate, the bank sometimes collects the interest, which is also called the **bank discount**, at the time the loan is made. Thus, the maker receives the face value of the loan minus the bank discount. This difference is called the **proceeds**. Such a loan is called a **simple discount note**. Loans of this type allow the bank or payee of the loan to receive all fees and interest at the time the loan is made. This increases the yield on the loan since the interest and fees can be reinvested immediately. Besides increased yields, a bank may require this type of loan when the maker of the loan has an inadequate or poor credit history. This decreases the amount of risk to the bank or lender.

> **HOW TO** Find the bank discount and proceeds for a simple discount note
>
> 1. For the bank discount, use:
>
> $$\text{Bank discount} = \text{face value} \times \text{discount rate} \times \text{time}$$
> $$I = PRT$$
>
> 2. For the proceeds, use:
>
> $$\text{Proceeds} = \text{face value} - \text{bank discount}$$
> $$A = P - I$$

> **EXAMPLE 1** Find the (a) bank discount and (b) proceeds using ordinary interest on a promissory note to Mary Fisher for $4,000 at 8% annual simple interest from June 5 to September 5.
>
> (a) Exact days = $248 - 156 = 92$ Subtract sequential numbers (Table 11-1).
> Bank discount = PRT
>
> Bank discount = $\$4,000(0.08)\left(\dfrac{92}{360}\right)$ Multiply.
>
> Bank discount = $\boxed{\$81.78}$ Rounded to the nearest cent.
>
> **The bank discount is $81.78.**

(b) Proceeds $= A = P - I$
Proceeds $= \$4,000 -$ $\boxed{\$81.78}$ Subtract the bank discount from the face value of the
Proceeds $= \$3,918.22$ note.

The proceeds are \$3,918.22.

Undiscounted note: another term for a simple interest note.

The difference between the simple interest note—which is also called an **undiscounted note**—and the simple discount note is the amount of money the borrower has use of for the length of the loan, and also the maturity value of the loan—the amount owed at the end of the loan term. Interest is paid on the same amount for the same period of time in both cases. In the simple interest note, the borrower has use of the full principal of the loan, but the maturity value is principal plus interest. In the simple discount note, the borrower has use of only the proceeds (face value − discount), but the maturity value is just the face value, since the interest (the discount) was paid "in advance."

Suppose Bill borrows \$5,000 with a discount (interest) rate of 10%. The discount is 10% × \$5,000, or \$500, so he gets the use of only \$4,500, though the bank charges interest on the full \$5,000. The maturity value is \$5,000.

Here is a comparison of simple interest notes versus simple discount notes:

| | Simple interest note | Simple discount note |
|---|---|---|
| Principal or face value | \$5,000 | \$5,000 |
| Interest or discount | 500 | 500 |
| Amount available to borrower or proceeds | 5,000 | 4,500 |
| Amount to be repaid or maturity value | 5,500 | 5,000 |

 STOP AND CHECK

1. Find the bank discount and proceeds using ordinary interest for a loan to Michelle Anders for \$7,200 at 8.25% annual simple interest from August 8 to November 8.

2. Find the bank discount and proceeds using ordinary interest for a loan to Andre Peters for \$9,250 at 7.75% annual simple interest from January 17 to July 17.

3. Find the bank discount and proceeds using ordinary interest for a loan to Megan Anders for \$3,250 at 8.75% annual simple interest from February 23 to November 23.

4. Frances Johnson is making a bank loan for \$32,800 at 7.5% annual simple interest from May 10 to July 10. Find the bank discount and proceeds using ordinary interest.

2 Find the true or effective interest rate of a simple discount note.

For a simple interest note, the borrower uses the full face value of the loan for the entire period of the loan. In a simple discount note, the borrower only uses the proceeds of the loan for the period of the loan. Since the proceeds are less than the face value of the loan, the stated discount rate is not the true or effective rate of interest of the note. To find the **effective interest rate of a simple discount note**, the proceeds of the loan is used as the principal in the interest formula.

Effective interest rate for a simple discount note: the actual interest rate based on the proceeds of the loan.

HOW TO Find the true or effective interest rate of a simple discount note

1. Find the bank discount (interest).

$$I = PRT$$

2. Find the proceeds.

$$\text{Proceeds} = \text{principal} - \text{bank discount}$$

3. Find the effective interest rate.

$$R = \frac{I}{PT} \text{ using the proceeds as the principal.}$$

EXAMPLE 1 What is the effective interest rate of a simple discount note for $5,000, at an ordinary bank discount rate of 12%, for 90 days? Round to the nearest tenth of a percent.

Find the bank discount:

$$I = PRT$$

$$I = \$5,000(0.12)\left(\frac{90}{360}\right)$$

$$I = \$150 \qquad\qquad\qquad \text{Bank discount}$$

Find the proceeds:

$$\text{Proceeds} = \text{principal} - \text{bank discount}$$

$$\text{Proceeds} = \$5,000 - \$150$$

$$\text{Proceeds} = \$4,850$$

Find the effective interest rate:

$$R = \frac{I}{PT} \qquad\qquad\qquad \text{Substitute proceeds for principal.}$$

$$R = \frac{\$150}{\$4,850\left(\dfrac{90}{360}\right)}$$

$$R = \frac{\$150}{\$1,212.50}$$

$$R = 0.1237113402$$

$$R = 12.4\% \qquad\qquad\qquad \text{Effective interest rate}$$

The effective interest rate for a simple discount note of $5,000 for 90 days is 12.4%.

 STOP AND CHECK

1. What is the effective interest rate of a simple discount note for $8,000, at an ordinary bank discount rate of 11%, for 120 days? Round to the nearest tenth of a percent.

2. What is the effective interest rate of a simple discount note for $22,000, at an ordinary bank discount rate of 8.36%, for 90 days? Round to the nearest tenth of a percent.

3 Find the third-party discount and proceeds for a third-party discount note.

Third party: an investment group or individual that assumes a note that was made between two other parties.

Third-party discount note: a note that is sold to a third party (usually a bank) so that the original payee gets the proceeds immediately and the maker pays the third party the original amount at maturity.

Discount period: the amount of time that the third party owns the third-party discounted note.

Many businesses agree to be the payee for a promissory note as payment for the sale of goods. If these businesses in turn need cash, they may sell such a note to an investment group or person who is the **third party** of the note. Selling a note to a third party in return for cash is called *discounting* a note. The note is called a **third-party discount note**.

When the third party discounts a note, it gives the business owning the note the maturity value of the note minus a third-party discount. The discount is based on how long the third party holds the note, called the **discount period**. The third party receives the full maturity value of the note from the maker when it comes due. From the standpoint of the note maker (the borrower), the term of the note is the same because the maturity (due) date is the same, and the maturity value is the same.

The following diagram shows how the discount period is determined.

3. Find the discount and proceeds on a $3,250 face-value note for six months if the discount rate is 9.2%.

4. Find the maturity value of the undiscounted promissory note shown in Figure 11-2.

$ 3,000 Rockville, M.D. Aug. 5, 20 08

Nine Months after date I promise to pay to

City Bank

three thousand and 00/100 Dollars

Payable at City Bank

Value received with ordinary interest at 9 per cent per annum

Due May 5, 2009

Phillip Esterey

FIGURE 11-2
Promissory Note

5. Roland Clark has a simple discount note for $6,500, at an ordinary bank discount rate of 8.74%, for 60 days. What is the effective interest rate? Round to the nearest tenth of a percent.

6. What is the effective interest rate of a simple discount note for $30,800, at an ordinary bank discount rate of 14%, for 20 days? Round to the nearest tenth of a percent.

7. Carter Manufacturing holds a note of $5,000 that has an interest rate of 11% annually. The note was made on March 18 and is due November 13. Carter sells the note to a bank on June 13 at a discount rate of 10% annually. Find the proceeds on the third-party discount note.

8. Discuss reasons a payee might agree to a non-interest-bearing note.

9. Discuss reasons a payee would sell a note to a third party and lose money in the process.

Learning Outcomes

Section 11-1

What to Remember with Examples

1 Find simple interest using the simple interest formula. (p. 382)

1. Identify the principal, rate, and time.
2. Multiply the principal by the rate and time.

$$\text{Interest} = \text{principal} \times \text{rate} \times \text{time}$$
$$I = PRT$$

| Find the interest paid on a loan of $8,400 for one year at $9\frac{1}{2}\%$ annual simple interest rate. | Find the interest paid on a loan of $4,500 for two years at a simple interest rate of 12% per year. |
|---|---|
| $\text{Interest} = \text{principal} \times \text{rate} \times \text{time}$
 $= \$8,400(0.095)(1)$
 $= \$798$ | $\text{Interest} = \text{principal} \times \text{rate} \times \text{time}$
 $= \$4,500(0.12)(2)$
 $= \$1,080$ |

2 Find the maturity value of a loan. (p. 383)

1. If the principal and interest are known, add them.

$$\text{Maturity value} = \text{principal} + \text{interest}$$
$$MV = P + I$$

2. If the principal, rate, and time are known, use either of the formulas:
 (a) Maturity value = principal + principal × rate × time
$$MV = P + PRT$$

 (b) Maturity value = principal (1 + rate × time)
$$MV = P(1 + RT)$$

| Find the maturity value of a loan of $8,400 with $798 interest. | Find the maturity value of a loan of $4,500 for two years at a simple interest rate of 12% per year. |
|---|---|
| $MV = P + I$
 $MV = \$8,400 + \798
 $MV = \$9,198$ | $MV = P(1 + RT)$
 $MV = \$4,500[1 + 0.12(2)]$
 $MV = \$4,500(1.24)$
 $MV = \$5,580$ |

3 Convert months to a fractional or decimal part of a year. (p. 384)

1. Write the number of months as the numerator of a fraction.
2. Write 12 as the denominator of the fraction.
3. Reduce the fraction to lowest terms if using the fractional equivalent.
4. Divide the numerator by the denominator to get the decimal equivalent of the fraction.

| Convert 42 months to years. | Convert 3 months to years. |
|---|---|
| $\dfrac{42}{12} = \dfrac{7}{2} = 3.5$ years | $\dfrac{3}{12} = \dfrac{1}{4} = 0.25$ years |

4 Find the principal, rate, or time using the simple interest formula. (p. 386)

1. Select the appropriate form of the formula.

 (a) If the principal is unknown, use $P = \dfrac{I}{RT}$

 (b) If the rate is unknown, use $R = \dfrac{I}{PT}$

 (c) If the time is unknown, use $T = \dfrac{I}{PR}$

2. Replace letters with known values and perform the indicated operations.

| | |
|---|---|
| Nancy Jeggle borrowed \$6,000 for $3\frac{1}{2}$ years and paid \$2,800 simple interest. What was the annual interest rate? | R is unknown.

$R = \dfrac{I}{PT}$

$R = \dfrac{\$2,800}{(\$6,000)(3.5)}$

$R = 0.133$
$R = 13.3\%$ annually |

| | |
|---|---|
| Donna Ruscitti paid \$675 interest on an 18-month loan at 10% annual simple interest. What was the principal? | P is unknown.

$P = \dfrac{I}{RT}$ $\dfrac{18}{12} = \dfrac{3}{2} = 1.5$

$P = \dfrac{\$675}{0.10(1.5)}$

$P = \$4,500$ |

| | |
|---|---|
| Ashish Paranjape borrowed \$1,500 at 8% annual simple interest. If he paid \$866.25 interest, what was the time period of the loan? | T is unknown.

$T = \dfrac{I}{PR}$

$T = \dfrac{\$866.25}{\$1,500(0.08)}$

$T = 7.2$ years (rounded) |

Section 11-2

1 Find the exact time. (p. 389)

Change months and years to exact time in days.

> 1 month = exact number of days in the month
> 1 year = 365 days (or 366 days in a leap year)

| |
|---|
| Find the exact time of a loan made October 1 and due May 1 (non-leap year).

October, December, January, and March have 31 days. November and April have 30 days. February has 28 days.

$4(31) + 2(30) + 28 = 212$ days |

Find the exact time of a loan using the sequential numbers table (Table 11-1).

1. If the beginning and due dates of the loan fall within the same year, subtract the beginning date's sequential number from the due date's sequential number.
2. If the beginning and due dates of the loan do not fall within the same year:
 (a) Subtract the beginning date's sequential number from 365.
 (b) Add the due date's sequential number to the difference from step 2a.
3. If February 29 is between the beginning and due dates, add 1 to the difference from step 1 or to the sum from step 2b.

| | |
|---|---|
| Find the exact time of a loan made on March 25 and due on October 10.

October 10 = day 283
March 25 = day 84
 199 days
The loan is made for 199 days. | Find the exact time of a loan made on June 7 and due the following March 7 in a non-leap year.

December 31 = day 365
June 7 = day 158
 207 days
March 7 = + 66 days
 273 days
The loan is made for 273 days in all. |

2 Find the due date. (p. 391)

Find the due date of a loan given the beginning date and the time period in days.

1. Add the sequential number of the beginning date to the number of days in the time period.
2. If the sum is less than or equal to 365, find the date (Table 11-1) corresponding to the sum.
3. If the sum is more than 365, subtract 365 from the sum. Then find the date (Table 11-1) in the following year corresponding to the difference.
4. Adjust for February 29 in a leap year if appropriate by subtracting 1 from the difference.

Figure the due date for a 60-day loan made on August 12.

August 12 = day 224

$$\begin{array}{r} 224 \\ +\ 60 \\ \hline 284 \end{array}$$

Day 284 is October 11.

3 Find the ordinary interest and the exact interest. (p. 392)

1. To find the ordinary interest, use 360 as the number of days in a year.
2. To find the exact interest, use 365 as the number of days in a year.

On May 15, Roberta Krech borrowed $6,000 at 12.5% annual simple interest. The loan was due on November 15. Find the ordinary interest due on the loan.

Use Table 11-1 to find exact time. November 15 is day 319. May 15 is day 135. So time is $319 - 135 = 184$ days.

$$I = PRT$$
$$I = (\$6,000)(0.125)\left(\frac{184}{360}\right)$$
$$I = \$383.33$$

Find the exact interest due on Roberta's loan (see above).

$$I = PRT$$
$$I = (\$6,000)(0.125)\left(\frac{184}{365}\right)$$
$$I = \$378.08$$

4 Make a partial payment before the maturity date. (p. 394)

1. Determine the exact time from the date of the loan to the first partial payment.
2. Calculate the interest using the time found in Step 1.
3. Subtract the amount of interest found in Step 2 from the partial payment.
4. Subtract the remainder of the partial payment (Step 3) from the original principal. This is the **adjusted principal**.
5. Repeat the process with the adjusted principal if additional partial payments are made.
6. At maturity, calculate the interest from the last partial payment. Add this interest to the adjusted principal from the last partial payment. This is the **adjusted balance due at maturity**.

Tony Powers borrows $7,000 on a 12%, 90 day note. On the 60th day, Tony pays $1,500 on the note. If ordinary interest is applied, what is Tony's adjusted principal after the partial payment? What is the adjusted balance due at maturity?

| | |
|---|---|
| $\$7,000(0.12)\left(\dfrac{60}{360}\right) = \140 | Calculate the ordinary interest on 60 days. |
| $\$1,500 - \$140 = \$1,360$ | Amount of partial payment applied to principal |
| $\$7,000 - \$1,360 = \$5,640$ | Adjusted principal |
| $\$5,640(0.12)\left(\dfrac{30}{360}\right) = \56.40 | Interest on adjusted principal |
| $\$5,640 + \$56.40 = \$5,696.40$ | Adjusted balance due at maturity |

The adjusted principal after 90 days is $5,640 and the adjusted balance due at maturity is $5,696.40.

1 Find the bank discount and proceeds for a simple discount note. (p. 396)

1. For the bank discount, use:

$$\text{Bank discount} = \text{face value} \times \text{discount rate} \times \text{time}$$
$$I = PRT$$

2. For the proceeds, use:

$$\text{Proceeds} = \text{face value} - \text{bank discount}$$
$$A = P - I$$

The bank charged Robert Milewsky a 11.5% annual discount rate on a bank note of $1,500 for 120 days. Find the proceeds of the note using the banker's rule.

First find the discount, and then subtract the discount from the face value of $1,500.

$$\text{Discount} = I = PRT$$
$$\text{Discount} = \$1,500(0.115)\left(\frac{120}{360}\right) \qquad \text{Ordinary interest}$$
$$\text{Discount} = \$57.50$$
$$\text{Proceeds} = A = P - I$$
$$\text{Proceeds} = \$1,500 - \$57.50$$
$$\text{Proceeds} = \$1,442.50$$

2 Find the true or effective interest rate of a simple discount note. (p. 397)

1. Find the bank discount (interest).

$$I = PRT$$

2. Find the proceeds.

$$\text{Proceeds} = \text{principal} - \text{bank discount}$$

3. Find the effective interest rate.

$$R = \frac{I}{PT} \qquad \text{Use the proceeds as the principal.}$$

Larinda Temple has a simple discount note for $5,000, at an ordinary bank discount rate of 8%, for 90 days. What is the effective interest rate? Round to the nearest tenth of a percent.

Find the bank discount:

$$I = PRT$$
$$I = \$5,000(0.08)\left(\frac{90}{360}\right)$$
$$I = \$100$$
$$\text{Proceeds} = \text{principal} - \text{bank discount}$$
$$\text{Proceeds} = \$5,000 - \$100$$
$$\text{Proceeds} = \$4,900$$
$$R = \frac{I}{PT}$$
$$R = \frac{\$100}{\$4,900\left(\frac{90}{360}\right)}$$
$$R = \frac{\$100}{\$1,225}$$
$$R = 0.0816326531$$
$$R = 8.1\%$$

The effective interest rate for a simple discount note of $5,000 for 90 days is 8.1%.

3 Find the third-party discount and proceeds for a third-party discount note. (p. 398)

1. For the third-party discount, use:

$$\text{Third-party discount} = \text{maturity value of original note} \times \text{discount rate} \times \text{discount period}$$
$$I = PRT$$

2. For the proceeds, use:

$$\text{Proceeds} = \text{maturity value of original note} - \text{third-party discount}$$
$$A = P - I$$

Mihoc Trailer Sales made a note of $10,000 with Darcy Mihoc, company owner, at 9% simple interest based on exact interest. The note is made on August 12 and due on November 10. However, Mihoc Trailer Sales needs cash, so the note is taken to a third party on September 5. The third party agrees to accept the note with a 13% annual discount rate using the banker's rule. Find the proceeds of the note to the original payee.

To find the proceeds, we find the maturity value of the original note and then find the third-party discount. Exact time is 90 days (314 − 224).

$$\text{Maturity value} = P(1 + RT)$$
$$\text{Maturity value} = \$10{,}000\left(1 + 0.09 \cdot \frac{90}{365}\right) \text{ Exact interest}$$
$$\text{Maturity value} = \$10{,}221.92$$

Exact time of the discount period is 66 days (314 − 248). Use the banker's rule.

$$\text{Third-party discount} = I = PRT$$
$$\text{Third-party discount} = \$10{,}221.92(0.13)\left(\frac{66}{360}\right) \text{ Ordinary interest}$$
$$\text{Third-party discount} = \$243.62$$
$$\text{Proceeds} = A = P - I$$
$$\text{Proceeds} = \$10{,}221.92 - \$243.62$$
$$\text{Proceeds} = \$9{,}978.30$$

EXERCISES SET B

SKILL BUILDERS

Find the simple interest. Round to the nearest cent when necessary.

| | Principal | Annual rate | Time | Interest |
|---|---|---|---|---|
| **EL 1.** | $1,000 | $9\frac{1}{2}\%$ | 3 years | _____ |
| **EL 2.** | $2,975 | $12\frac{1}{2}\%$ | 2 years | _____ |

3. Legan Company borrowed $15,280 at $10\frac{1}{2}\%$ for 12 years. How much simple interest did the company pay? What was the total amount paid back?

Find the rate of annual simple interest in each of the following problems.

| | Principal | Interest | Time | Rate |
|---|---|---|---|---|
| **4.** | $1,280 | $256 | 2 years | _____ |
| **5.** | $40,000 | $32,000 | 10 years | _____ |

Find the time period of the loan using the formula for simple interest.

| | Principal | Annual rate | Interest | Time |
|---|---|---|---|---|
| **6.** | $700 | 6% | $84 | _____ |
| **7.** | $3,549 | 9.2% | $979.52 | _____ |

In each of the following problems, find the principal, based on simple interest.

| | Interest | Annual rate | Time | Principal |
|---|---|---|---|---|
| **8.** | $56.25 | $2\frac{1}{2}\%$ | 3 years | _____ |
| **9.** | $20 | 1.25% | 2 years | _____ |

10. An investor earned $1,170 interest on funds invested at $9\frac{3}{4}\%$ annual simple interest for four years. How much was invested?

Write a fraction expressing each amount of time as a part of a year (12 months = 1 year).

11. 18 months

12. 9 months

APPLICATIONS

13. Alpha Hodge borrowed $500 for three months and paid $12.50 interest. What was the annual rate of interest?

14. Find the ordinary interest paid on a loan of $2,100 for 90 days at a simple interest rate of 4% annually.

15. Find the ordinary interest paid on a loan of $15,835 for 45 days at a simple interest rate of 8.1% annually.

16. When the exact number of days in a year is used to figure time, it is called what kind of interest?

Use Table 11-1 to find the exact time from the first date to the second date for non-leap years unless a leap year is identified.

17. April 12 to November 15

18. November 12 to April 15 of the next year

19. February 3, 2008, to August 12, 2008

If a loan is made on the given date, find the date it is due.

20. May 30 for 240 days

21. June 13 for 90 days

For problem 27, find (a) the exact interest and (b) the ordinary interest. Round answers to the nearest cent.

22. A loan of $8,900 at 7.75% annually made on September 10 and due on December 10

23. Find the discount and proceeds using the banker's rule on a promissory note for $1,980 at 8% made by Alexa Green on January 30, 2007, and payable to Enterprise Bank on July 30, 2007.

24. Find the exact interest on a loan of $2,100 at 7.75% annual interest for 40 days.

25. Allan Stojanovich can purchase an office desk for $1,500 with cash terms of 2/10, n/30. If he can borrow the money at 12% annual simple ordinary interest for 20 days, will he save money by taking advantage of the cash discount offered?

26. Shaunda Sanders borrows $16,000 on a 10.8%, 120-day note. On the 60th day, Shaunda pays $10,000 on the note. If ordinary interest is applied, what is Shaunda's adjusted principal after the partial payment? What is the adjusted balance due at maturity?

27. Bam Doyen has a simple discount note for $6,250, at an ordinary bank discount rate of 9%, for 90 days. What is the effective interest rate? Round to the nearest tenth of a percent.

1. Find the simple interest on $500 invested at 4% annually for three years.

2. How much money was borrowed at 12% annually for 6 months if the interest was $90?

3. A loan of $3,000 was made for 210 days. If ordinary interest is $218.75, find the rate.

4. A loan of $5,000 at 12% annually requires $1,200 interest. For how long is the money borrowed?

5. Find the exact time from February 13 to November 27 in a non-leap year.

6. Find the exact time from October 12 to March 28 of the following year (a leap year).

7. Find the exact time from January 28, 2008, to July 5, 2008.

8. Sondra Davis borrows $6,000 on a 10%, 120 day note. On the 60th day, Sondra pays $2,000 on the note. If ordinary interest is applied, what is Sondra's adjusted principal after the partial payment? What is the adjusted balance due at maturity?

9. Find the ordinary interest on a loan of $2,800 at 10% annually made on March 15 for 270 days.

10. A bread machine with a cash price of $188 can be purchased with a one-year loan at 10% annual simple interest. Find the total amount to be repaid.

11. A copier that originally cost $3,000 was purchased with a loan for 12 months at 15% annual simple interest. What was the *total* cost of the copier?

12. Find the exact interest on a loan of $850 at 11% annually. The loan was made January 15 and was due March 15.

13. Michael Denton has a simple discount note for $2,000, at an ordinary bank discount rate of 12%, for 240 days. What is the effective interest rate? Round to the nearest tenth of a percent.

14. Find the duration of a loan of $3,000 if the loan required interest of $213.75 and was at a rate of $9\frac{1}{2}$% annual simple interest.

15. Find the rate of simple interest on a $1,200 loan that requires the borrower to repay a total of $1,302 after one year.

16. A promissory note using the banker's rule has a face value of $5,000 and is discounted by the bank at the rate of 14%. If the note is made for 180 days, find the discount of the note.

17. Find the ordinary interest paid on a loan of $1,600 for 90 days at a simple interest rate of 13% annually.

18. Jerry Brooks purchases office supplies totaling $1,890. He can take advantage of cash terms of 2/10, n/30 if he obtains a short-term loan. If he can borrow the money at $10\frac{1}{2}$% annual simple ordinary interest for 20 days, will he save money if he borrows to take advantage of the cash discount? How much will he save?

19. Find the exact interest on a loan of $25,000 at $8\frac{1}{2}$% annually for 21 days.

20. Find the exact interest on a loan of $1,510 at $7\frac{3}{4}$% annual interest for 27 days.

1. In applying most formulas involving a rate, a fractional or decimal equivalent of the rate is used. Explain how a rate can be mentally changed to a decimal equivalent.

2. When solving problems, one should devise a method to estimate the solution. Describe a strategy for estimating the interest in the first example of Section 11-1 on page 382.

3. Explain how the rate can be estimated in Example 1 on page 386.

4. Use the formula $I = P\left(R \times \dfrac{D}{365}\right)$ to find the exact interest on $100 for 30 days and 7.50%.

5. Find the exact interest on $1,000 for 60 days at 5.3% annual interest rate.

6. The ordinary interest using exact time (banker's rule) will always be higher than exact interest using exact time. Explain why this is true.

7. Show how the formulas $I = PRT$ and $MV = P + I$ lead to the formula $MV = P(I + RT)$.

8. The maturity value for a loan of $2,000 at 9% interest for two years was found to be $4,360. Examine the solution to identify the incorrect mathematical process. Explain the correct process and rework the problem correctly.

 $MV = P(1 + RT)$
 $MV = \$2,000(1 + 0.09 \times 2)$
 $MV = \$2,000(1.09 \times 2)$
 $MV = \$2,000(2.18)$
 $MV = \$4,360$

Challenge Problem

A simple interest loan with a final "balloon payment" can be a good deal for both the consumer and the banker. For the banker, this loan reduces the rate risk, since the loan rate is locked in for a short period of time. For the consumer, this loan allows lower monthly payments.

You borrow $5,000 at 13% simple interest rate for a year.

For 12 monthly payments:

$$\$5,000(13\%)(1) = \$650 \text{ interest}$$

$$\frac{\$5,650}{12} = \$470.83 \text{ monthly payment}$$

Your banker offers to make the loan as if it is to be extended over five years but with interest for only one year, or 60 monthly payments, but with a final balloon payment on the 12th payment. This means a much lower monthly payment.

For 60 monthly payments:

$$\frac{\$5,650}{60} = \$94.17 \text{ monthly payment}$$

The lower monthly payment is tempting! The banker will expect you to make these lower payments for *one* year. You will actually make 11 payments of $94.17: $94.17(11) = $1,035.87, which is the amount paid during the first 11 months.

The 12th and final payment, the *balloon payment,* is the *remainder* of the loan.

$$\$5,650 - \$1,035.87 = \$4,614.13$$

At this time you are expected to pay the balance of the loan in the balloon payment shown above. Don't panic! Usually the loan is refinanced for another year. But beware—you may have to pay a higher interest rate for the next year.

a. Find the monthly payment for a $2,500 loan at 12% interest for one year, extended over a three-year period with a balloon payment at the end of the first year.

b. What is the amount of the final balloon payment for a $1,000 loan at 10% interest for one year, extended over five years?

c. You need a loan of $5,000 at 10% interest for one year. What is the amount of the monthly payment?

CASE STUDIES

11.1 90 Days Same as Cash!

Sara has just rented her first apartment starting December 1 before beginning college in January. The apartment has washer and dryer hook-ups, so Sara wanted to buy the appliances to avoid trips to the laundromat. The Saturday newspaper had an advertisement for a local appliance store offering "90 days, same as cash!" financing. Sara asked how the financing worked and learned that she could pay for the washer and dryer anytime during the first 90 days for the purchase price plus sales tax. If she waited longer, she would have to pay the purchase price, plus sales tax, plus 26.8% annual simple interest for the first 90 days, plus 2% simple interest per month on the unpaid balance after 90 days, with minimum payments of $50 per month after the 90-day period. Together, the washer and dryer cost $699 plus the 8.25% sales tax. Sara knew that her tax refund from the IRS would be $1,000 so she bought the washer and dryer confident that she could pay off the balance within the 90 days.

1. If Sara pays off the balance within 90 days how much will she pay?

2. If Sara bought the washer and dryer on December 15, using the exact interest, what is her deadline for paying no interest in a non-leap year? In a leap year? Is the finance company likely to use exact or ordinary interest and why?

3. If Sara's IRS refund does not come until April 1, what is her payoff amount? (Assume ordinary interest and a non-leap year.)

4. How much did it cost her to pay off this loan 17 days late? What annual simple interest rate does this amount to?

11.2 The Price of Money

James wants to buy a flat screen television for his new apartment. He has saved $700, but still needs $500 more. The bank where he has a checking and savings account will loan him $500 at 12% annual interest using a 90-day promissory note. James also visited the PayDay Loan store to compare the cost of borrowing. The manager told James that he could borrow $500 at 12% for two weeks. If James needed more time to repay the loan, he would be charged 16% on the balance due for each additional week. He wondered how much it would cost to pay the loan back in 12 weeks so he could compare the cost to the bank's lending rate. He recognized that 12 weeks is a few days less than 90 days.

1. Calculate the total cost (principal plus interest) for the 90-day promissory note from the bank.

2. How much will James pay if he gets the loan from the PayDay Loan store and pays the balance back in two weeks?

3. How much will it cost if James gets his loan from the PayDay Loan store and pays it back in 12 weeks (nearly 90 days)?

4. James wondered how PayDay Loan can stay in business unless its customers neglect to determine how much they owe before agreeing to borrow. What do you think? When would a PayDay loan be an appropriate choice?

11.3 Quality Photo Printing

As a professional photographer, Jillian had seen a significant shift in customer demand for digital technologies in photography. Many customers, attempting to save a few dollars, had invested in low-end digital cameras (and even lower-end printers) to avoid processing fees typically associated with printing photographs. The end result, for most customers, was a bounty of digital photographic images but with limited options for creating quality printed digital photographs. Jillian was hoping to tap into this underserved market by offering customers superior quality digital printing using advanced pigment inks to produce exquisite color prints. In order to provide this service, Jillian needs to purchase a state-of-the-art photo printer she found listed through a photography supply company for $8,725, plus sales tax of 5.5%. The supply company is offering cash terms of 3/15, n/30, with a 1.5% service charge on late payments, or 90 days same as cash financing if Jillian will apply and is approved for a company credit card. If she is unable to pay within 90 days under the second option, she would have to pay 24.9% annual simple interest for the first 90 days, plus 2% simple interest per month on the unpaid balance after 90 days. Jillian has an excellent credit rating, but is not sure what to do.

1. If Jillian took the cash option and was able to pay off the printer within the 15-day discount period, how much would she save? How much would she owe?

2. If Jillian takes the 90 days same as cash option and purchases the printer on December 30 to get a current-year tax deduction, using exact time, what is her deadline for paying no interest in a non-leap year? In a leap year? Find the dates in ordinary time. Is the finance company likely to use exact or ordinary interest and why?

3. If Jillian takes the 90 days same as cash and pays within 90 days, what is her payoff amount? If she can't pay until April 30, how much additional money would she owe? (Assume ordinary interest and exact time and a non-leap year.)

4. Jillian finds financing available through a local bank. Find the bank discount and proceeds using ordinary interest and ordinary time for a 90-day promissory note for $9,200 at 8% annual simple interest. Is this enough money for Jillian to cover the purchase price of the printer? Is this a better option for Jillian to pursue, and why or why not?

Get Out of Debt Diet

Having trouble paying your bills? Constantly making minimum payments each month? Don't know how much you owe? Worried about getting a bad credit report? According to CardWeb.com, the average U.S. household has credit card debt of over $9,000, with interest rates ranging from the mid to high teens. Credit card companies have made running up that balance deceptively easy.

However, there are a number of steps you can take to pay off the debt and get back on track. Of course, this will require you to adjust your spending habits and become more careful about your spending.

1. **Determine what you owe.** Make a list of all the debts you have including the name of the creditor, your total balance, your minimum monthly payment, and your interest rate. This will help you determine in which order you should pay down your debts.
2. **Pay it down.** Work overtime or take on a second job and devote that income to paying down debt. Cash in CDs, pay down home equity loans, and pay down loans against retirement. Have a garage sale. Do whatever you can to earn extra money and devote that money to paying down your debt.
3. **Reduce expenses.** Eliminate any unnecessary expenses such as eating out and expensive entertainment. Clip coupons, shop at sales, and avoid impulse purchases. Brown bag it at work and be creative about gifts. Above all, stop using credit cards. Just giving up that expensive cup of coffee each morning can save you more than $750 dollars a year.
4. **Record your spending.** This is actually your key to getting out of debt. You're in debt because you spent money you didn't have. Avoiding more debt starts with knowing what you are spending your money on. Each day for at least one month, write down every amount you spend, no matter how small. Reviewing how you spend your money allows you to set priorities.
5. **Make a budget based on your spending record.** Write down the amount you spent in each category of spending last month as you budget for spending for the next month. Categorize your monthly expenses into logical groups such as *necessities* (food, rent, medicine, pet food, etc.), *should have* (things you need but not immediately, such as new workout gear), and *like to have* (things you don't need but enjoy (magazines, cable television). One expense should be paying off your debt. Did you know that making a minimum payment of $26 on a single credit card with a $1,000 balance and 19% interest will take more than five years to pay off?
6. **Pay cash.** This results in a significant savings in terms of what you purchase and not having to pay interest on those purchases. When you don't have the cash, you don't buy.
7. **Resolve to spend less than you make.** Realize once and for all that if you can't pay for it today then you can't afford it.

Managing your credit and knowing exactly how much you are paying for using credit are important concepts that you will learn in this chapter.

LEARNING OUTCOMES

12-1 Installment Loans and Closed-End Credit

1. Find the amount financed, the installment price, and the finance charge of an installment loan.
2. Find the installment payment of an installment loan.
3. Find the estimated annual percentage rate (APR) using a table.

12-2 Paying a Loan Before It Is Due: The Rule of 78

1. Find the interest refund using the rule of 78.

12-3 Open-End Credit

1. Find the finance charge and new balance using the average daily balance method.
2. Find the finance charge and new balance using the unpaid or previous month's balance.

 Two corresponding Business Math Case Videos for this chapter, *Which Credit Card Deal is Best?* and *Should I Buy or Lease a Car?* can be found in Appendix A.

Consumer credit: a type of credit or loan that is available to individuals or businesses. The loan is repaid in regular payments.

Installment loan: a loan that is repaid in regular payments.

Closed-end credit: a type of installment loan in which the amount borrowed and the interest are repaid in a specified number of equal payments.

Open-end credit: a type of installment loan in which there is no fixed amount borrowed or fixed number of payments. Payments are made until the loan is paid off.

Many individuals and businesses make purchases for which they do not pay the full amount at the time of purchase. These purchases are paid for by paying a portion of the amount owed in regular payments until the loan is completely paid. This type of loan or credit is often referred to as **consumer credit**.

In the preceding chapters we discussed the interest to be paid on loans that are paid in full on the date of maturity of the loan. Many times, loans are made so that the maker (the borrower) pays a given amount in regular payments. Loans with regular payments are called **installment loans**.

There are two kinds of installment loans. **Closed-end credit** is a type of loan in which the amount borrowed plus interest is repaid in a specified number of equal payments. Examples include bank loans and loans for large purchases such as cars and appliances. **Open-end credit** is a type of loan in which there is no fixed number of payments—the person keeps making payments until the amount is paid off, and the interest is computed on the unpaid balance at the end of each payment period. Credit card accounts, retail store accounts, and line-of-credit accounts are types of open-end credit.

12-1 INSTALLMENT LOANS AND CLOSED-END CREDIT

LEARNING OUTCOMES

1 Find the amount financed, the installment price, and the finance charge of an installment loan.
2 Find the installment payment of an installment loan.
3 Find the estimated annual percentage rate (APR) using a table.

Should you or your business take out an installment loan? That depends on the interest you will pay and how it is computed. The interest associated with an installment loan is part of the charges referred to as **finance charges** or **carrying charges**. In addition to accrued interest charges, installment loans often include charges for insurance, credit-report fees, or loan fees. Under the truth-in-lending law, all of these charges must be disclosed in writing to the consumer.

Finance charges or carrying charges: the interest and any fee associated with an installment loan.

1 Find the amount financed, the installment price, and the finance charge of an installment loan.

The **cash price** is the price you pay if you pay all at once at the time of the purchase. If you pay on an installment basis instead, the **down payment** is a partial payment of the cash price at the time of the purchase. The **amount financed** is the cash price minus the down payment. The **installment payment** is the amount you pay each period, including interest, to pay off the loan. The **installment price** is the total paid, including all of the installment payments, the finance charges, and the down payment.

Cash price: the price if all charges are paid at once at the time of the purchase.

Down payment: a partial payment that is paid at the time of the purchase.

Amount financed: the cash price minus the down payment.

Installment payment: the amount that is paid (including interest) in each regular payment.

Installment price: the total amount paid for a purchase, including all payments, the finance charges, and the down payment.

> **HOW TO** Find the amount financed and the installment price
>
> 1. Find the amount financed: Subtract the down payment from the cash price.
>
> $$\text{Amount financed} = \text{cash price} - \text{down payment}$$
>
> 2. Find the installment price: Add the down payment to the total of the installment payments.
>
> $$\text{Installment price} = \text{total of installment payments} + \text{down payment}$$

EXAMPLE 1 The 7th Inning purchased a mat cutter for the framing department on the installment plan with a $600 down payment and 12 payments of $145.58. Find the installment price of the mat cutter.

$$\text{Total of installment payments} = \binom{\text{number of installments}}{} \times \binom{\text{installment payment}}{}$$

$$= \quad 12 \quad \times \quad \$145.58$$

$$= \$1,746.96$$

$$\text{Installment price} = \text{total of installment payments} + \text{down payment}$$
$$= \$1{,}746.96 + \$600$$
$$= \$2{,}346.96$$

The installment price is $2,346.96.

HOW TO — Find the finance charge of an installment loan

1. Determine the cash price of the item.
2. Find the installment price of the item.
3. Subtract the result found in step 2 from the result of step 1.

Finance charge = installment price − cash price

EXAMPLE 2

If the cash price of the mat cutter in Example 1 was $2,200, find the finance charge and the amount financed.

$$\text{Finance charge} = \text{installment price} - \text{cash price}$$
$$= \$2{,}346.96 - \$2{,}200.00$$
$$= \$146.96$$

Installment price = $2,346.96
Cash price = $2,200.00
Down payment = $600

$$\text{Amount financed} = \text{cash price} - \text{down payment.}$$
$$= \$2{,}200 - \$600$$
$$= \$1{,}600$$

The finance charge is $146.96 and the amount financed is $1,600.

 STOP AND CHECK

1. An ice machine with a cash price of $1,095 is purchased on the installment plan with a $100 down payment and 18 monthly payments of $62.50. Find the amount financed, installment price, and finance charge for the machine.

2. A copy machine is purchased on the installment plan with a $200 down payment and 24 monthly payments of $118.50. The cash price is $2,695. Find the amount financed, installment price, and finance charge for the machine.

3. An industrial freezer with a cash price of $2,295 is purchased on the installment plan with a $275 down payment and 30 monthly installment payments of $78.98. Find the amount financed, installment price, and finance charge for the freezer.

4. The cash price of a music system is $2,859 and the installment price is $3,115.35. How much is the finance charge?

2 Find the installment payment of an installment loan.

Since the installment price is the total of the installment payments plus the down payment, we can find the installment payment if we know the installment price, the down payment, and the number of payments.

HOW TO — Find the installment payment, given the installment price, the down payment, and the number of payments

1. Find the total of the installment payments: Subtract the down payment from the installment price.

$$\text{Total of installment payments} = \text{installment price} - \text{down payment}$$

2. Divide the total of the installment payments by the number of installment payments.

$$\text{Installment payment} = \frac{\text{total of installment payments}}{\text{number of payments}}$$

EXAMPLE 1 The installment price of a drafting table was $1,627 for a 12-month loan. If a $175 down payment had been made, find the installment payment.

Total of installment payments = installment price − down payment

$$= \$1,627 - \$175 = \$1,452 \qquad \text{Subtract.}$$

$$\text{Installment payment} = \frac{\text{total of installment payments}}{\text{number of payments}}$$

$$= \frac{\$1,452}{12} = \$121 \qquad \text{Divide.}$$

The installment payment is $121.

STOP AND CHECK

1. The installment price of a refrigerator is $2,087 for a 24-month loan. If a down payment of $150 had been made, what is the installment payment?

2. The installment price of a piano is $8,997.40 and a down payment of $1,000 is made. What is the monthly installment payment if the piano is financed for 36 months?

3. The installment price of a tire machine is $2,795.28. A down payment of $600 is made. What is the installment payment if the machine is financed for 36 months?

4. Find the installment payment for a trailer if its installment price is $3,296.96 over 30 months and an $800 down payment is made.

3 Find the estimated annual percentage rate (APR) using a table.

In 1969 the federal government passed the Consumer Credit Protection Act, Regulation Z, also known as the Truth-in-Lending Act. It requires that a lending institution tell the borrower, in writing, what the actual annual rate of interest is as it applies to the balance due on the loan each period. This interest rate tells the borrower the true cost of the loan.

For example, if you borrowed $1,500 for a year and paid an interest charge of $165, you would be paying an interest rate of 11% annually on the entire $1,500 (165 ÷ $1,500 = 0.11 = 11%). But if you paid the money back in 12 monthly installments of $138.75 ([$1,500 + $165] ÷ 12 = $138.75), you would not have the use of the $1,500 for a full year. Instead, you would be paying it back in 12 payments of $138.75 each. Thus, you are losing the use of some of the money every month but are still paying interest at the rate of 11% of *the entire amount*. This means that you are actually paying *more than* 11% interest. The true rate is the **annual percentage rate (APR)**. Applied to installment loans, the APR is the *annual simple interest rate equivalent* that is actually being paid on the unpaid balances. The APR can be determined using a government-issued table.

The federal government issues annual percentage rate tables, which are used to find APR rates (within $\frac{1}{4}$%, which is the federal standard). A portion of one of these tables, based on the number of monthly payments, is shown in Table 12-1.

Annual percentage rate (APR): the true rate of an installment loan that is equivalent to an annual simple interest rate.

HOW TO Find the estimated annual percentage rate using a per $100 of amount financed table

1. Find the interest per $100 of amount financed: Divide the finance charge including interest by the amount financed and multiply by $100.

$$\text{Interest per } \$100 = \frac{\text{finance charge}}{\text{amount financed}} \times \$100$$

2. Find the row corresponding to the number of monthly payments. Move across the row to find the number closest to the value from step 1. Read up the column to find the annual percentage rate for that column. If the result in step 1 is exactly halfway between two table values, a rate halfway between the two rates can be used.

TABLE 12-1
Interest per $100 of Amount Financed

| Number of monthly payments | APR (Annual Percentage Rate) | | | | | | | | | | | | | | | |
|---|---|---|---|---|---|---|---|---|---|---|---|---|---|---|---|---|
| | 10.00% | 10.25% | 10.50% | 10.75% | 11.00% | 11.25% | 11.50% | 11.75% | 12.00% | 12.25% | 12.50% | 12.75% | 13.00% | 13.25% | 13.50% | 13.75% |
| 1 | 0.83 | 0.85 | 0.87 | 0.90 | 0.92 | 0.94 | 0.96 | 0.98 | 1.00 | 1.02 | 1.04 | 1.06 | 1.08 | 1.10 | 1.12 | 1.15 |
| 2 | 1.25 | 1.28 | 1.31 | 1.35 | 1.38 | 1.41 | 1.44 | 1.47 | 1.50 | 1.53 | 1.57 | 1.60 | 1.63 | 1.66 | 1.69 | 1.72 |
| 3 | 1.67 | 1.71 | 1.76 | 1.80 | 1.84 | 1.88 | 1.92 | 1.96 | 2.01 | 2.05 | 2.09 | 2.13 | 2.17 | 2.22 | 2.26 | 2.30 |
| 4 | 2.09 | 2.14 | 2.20 | 2.25 | 2.30 | 2.35 | 2.41 | 2.46 | 2.51 | 2.57 | 2.62 | 2.67 | 2.72 | 2.78 | 2.83 | 2.88 |
| 5 | 2.51 | 2.58 | 2.64 | 2.70 | 2.77 | 2.83 | 2.89 | 2.96 | 3.02 | 3.08 | 3.15 | 3.21 | 3.27 | 3.34 | 3.40 | 3.46 |
| 6 | 2.94 | 3.01 | 3.08 | 3.16 | 3.23 | 3.31 | 3.38 | 3.45 | 3.53 | 3.60 | 3.68 | 3.75 | 3.83 | 3.90 | 3.97 | 4.05 |
| 7 | 3.36 | 3.45 | 3.53 | 3.62 | 3.70 | 3.78 | 3.87 | 3.95 | 4.04 | 4.12 | 4.21 | 4.29 | 4.38 | 4.47 | 4.55 | 4.64 |
| 8 | 3.79 | 3.88 | 3.98 | 4.07 | 4.17 | 4.26 | 4.36 | 4.46 | 4.55 | 4.65 | 4.74 | 4.84 | 4.94 | 5.03 | 5.13 | 5.22 |
| 9 | 4.21 | 4.32 | 4.43 | 4.53 | 4.64 | 4.75 | 4.85 | 4.96 | 5.07 | 5.17 | 5.28 | 5.39 | 5.49 | 5.60 | 5.71 | 5.82 |
| 10 | 4.64 | 4.76 | 4.88 | 4.99 | 5.11 | 5.23 | 5.35 | 5.46 | 5.58 | 5.70 | 5.82 | 5.94 | 6.05 | 6.17 | 6.29 | 6.41 |
| 11 | 5.07 | 5.20 | 5.33 | 5.45 | 5.58 | 5.71 | 5.84 | 5.97 | 6.10 | 6.23 | 6.36 | 6.49 | 6.62 | 6.75 | 6.88 | 7.01 |
| 12 | 5.50 | 5.64 | 5.78 | 5.92 | 6.06 | 6.20 | 6.34 | 6.48 | 6.62 | 6.76 | 6.90 | 7.04 | 7.18 | 7.32 | 7.46 | 7.60 |
| 13 | 5.93 | 6.08 | 6.23 | 6.38 | 6.53 | 6.68 | 6.84 | 6.99 | 7.14 | 7.29 | 7.44 | 7.59 | 7.75 | 7.90 | 8.05 | 8.20 |
| 14 | 6.36 | 6.52 | 6.69 | 6.85 | 7.01 | 7.17 | 7.34 | 7.50 | 7.66 | 7.82 | 7.99 | 8.15 | 8.31 | 8.48 | 8.64 | 8.81 |
| 15 | 6.80 | 6.97 | 7.14 | 7.32 | 7.49 | 7.66 | 7.84 | 8.01 | 8.19 | 8.36 | 8.53 | 8.71 | 8.88 | 9.06 | 9.23 | 9.41 |
| 16 | 7.23 | 7.41 | 7.60 | 7.78 | 7.97 | 8.15 | 8.34 | 8.53 | 8.71 | 8.90 | 9.08 | 9.27 | 9.46 | 9.64 | 9.83 | 10.02 |
| 17 | 7.67 | 7.86 | 8.06 | 8.25 | 8.45 | 8.65 | 8.84 | 9.04 | 9.24 | 9.44 | 9.63 | 9.83 | 10.03 | 10.23 | 10.43 | 10.63 |
| 18 | 8.10 | 8.31 | 8.52 | 8.73 | 8.93 | 9.14 | 9.35 | 9.56 | 9.77 | 9.98 | 10.19 | 10.40 | 10.61 | 10.82 | 11.03 | 11.24 |
| 19 | 8.54 | 8.76 | 8.98 | 9.20 | 9.42 | 9.64 | 9.86 | 10.08 | 10.30 | 10.52 | 10.74 | 10.96 | 11.18 | 11.41 | 11.63 | 11.85 |
| 20 | 8.98 | 9.21 | 9.44 | 9.67 | 9.90 | 10.13 | 10.37 | 10.60 | 10.83 | 11.06 | 11.30 | 11.53 | 11.76 | 12.00 | 12.23 | 12.46 |
| 21 | 9.42 | 9.66 | 9.90 | 10.15 | 10.39 | 10.63 | 10.88 | 11.12 | 11.36 | 11.61 | 11.85 | 12.10 | 12.34 | 12.59 | 12.84 | 13.08 |
| 22 | 9.86 | 10.12 | 10.37 | 10.62 | 10.88 | 11.13 | 11.39 | 11.64 | 11.90 | 12.16 | 12.41 | 12.67 | 12.93 | 13.19 | 13.44 | 13.70 |
| 23 | 10.30 | 10.57 | 10.84 | 11.10 | 11.37 | 11.63 | 11.90 | 12.17 | 12.44 | 12.71 | 12.97 | 13.24 | 13.51 | 13.78 | 14.05 | 14.32 |
| 24 | 10.75 | 11.02 | 11.30 | 11.58 | 11.86 | 12.14 | 12.42 | 12.70 | 12.98 | 13.26 | 13.54 | 13.82 | 14.10 | 14.38 | 14.66 | 14.95 |
| 25 | 11.19 | 11.48 | 11.77 | 12.06 | 12.35 | 12.64 | 12.93 | 13.22 | 13.52 | 13.81 | 14.10 | 14.40 | 14.69 | 14.98 | 15.28 | 15.57 |
| 26 | 11.64 | 11.94 | 12.24 | 12.54 | 12.85 | 13.15 | 13.45 | 13.75 | 14.06 | 14.36 | 14.67 | 14.97 | 15.28 | 15.59 | 15.89 | 16.20 |
| 27 | 12.09 | 12.40 | 12.71 | 13.03 | 13.34 | 13.66 | 13.97 | 14.29 | 14.60 | 14.92 | 15.24 | 15.56 | 15.87 | 16.19 | 16.51 | 16.83 |
| 28 | 12.53 | 12.86 | 13.18 | 13.51 | 13.84 | 14.16 | 14.49 | 14.82 | 15.15 | 15.48 | 15.81 | 16.14 | 16.47 | 16.80 | 17.13 | 17.46 |
| 29 | 12.98 | 13.32 | 13.66 | 14.00 | 14.33 | 14.67 | 15.01 | 15.35 | 15.70 | 16.04 | 16.38 | 16.72 | 17.07 | 17.41 | 17.75 | 18.10 |
| 30 | 13.43 | 13.78 | 14.13 | 14.48 | 14.83 | 15.19 | 15.54 | 15.89 | 16.24 | 16.60 | 16.95 | 17.31 | 17.66 | 18.02 | 18.38 | 18.74 |
| 31 | 13.89 | 14.25 | 14.61 | 14.97 | 15.33 | 15.70 | 16.06 | 16.43 | 16.79 | 17.16 | 17.53 | 17.90 | 18.27 | 18.63 | 19.00 | 19.38 |
| 32 | 14.34 | 14.71 | 15.09 | 15.46 | 15.84 | 16.21 | 16.59 | 16.97 | 17.35 | 17.73 | 18.11 | 18.49 | 18.87 | 19.25 | 19.63 | 20.02 |
| 33 | 14.79 | 15.18 | 15.57 | 15.95 | 16.34 | 16.73 | 17.12 | 17.51 | 17.90 | 18.29 | 18.69 | 19.08 | 19.47 | 19.87 | 20.26 | 20.66 |
| 34 | 15.25 | 15.65 | 16.05 | 16.44 | 16.85 | 17.25 | 17.65 | 18.05 | 18.46 | 18.86 | 19.27 | 19.67 | 20.08 | 20.49 | 20.90 | 21.31 |
| 35 | 15.70 | 16.11 | 16.53 | 16.94 | 17.35 | 17.77 | 18.18 | 18.60 | 19.01 | 19.43 | 19.85 | 20.27 | 20.69 | 21.11 | 21.53 | 21.95 |
| 36 | 16.16 | 16.58 | 17.01 | 17.43 | 17.86 | 18.29 | 18.71 | 19.14 | 19.57 | 20.00 | 20.43 | 20.87 | 21.30 | 21.73 | 22.17 | 22.60 |
| 37 | 16.62 | 17.06 | 17.49 | 17.93 | 18.37 | 18.81 | 19.25 | 19.69 | 20.13 | 20.58 | 21.02 | 21.46 | 21.91 | 22.36 | 22.81 | 23.25 |
| 38 | 17.08 | 17.53 | 17.98 | 18.43 | 18.88 | 19.33 | 19.78 | 20.24 | 20.69 | 21.15 | 21.61 | 22.07 | 22.52 | 22.99 | 23.45 | 23.91 |
| 39 | 17.54 | 18.00 | 18.46 | 18.93 | 19.39 | 19.86 | 20.32 | 20.79 | 21.26 | 21.73 | 22.20 | 22.67 | 23.14 | 23.61 | 24.09 | 24.56 |
| 40 | 18.00 | 18.48 | 18.95 | 19.43 | 19.90 | 20.38 | 20.86 | 21.34 | 21.82 | 22.30 | 22.79 | 23.27 | 23.76 | 24.25 | 24.73 | 25.22 |
| 41 | 18.47 | 18.95 | 19.44 | 19.93 | 20.42 | 20.91 | 21.40 | 21.89 | 22.39 | 22.88 | 23.38 | 23.88 | 24.38 | 24.88 | 25.38 | 25.88 |
| 42 | 18.93 | 19.43 | 19.93 | 20.43 | 20.93 | 21.44 | 21.94 | 22.45 | 22.96 | 23.47 | 23.98 | 24.49 | 25.00 | 25.51 | 26.03 | 26.55 |
| 43 | 19.40 | 19.91 | 20.42 | 20.94 | 21.45 | 21.97 | 22.49 | 23.01 | 23.53 | 24.05 | 24.57 | 25.10 | 25.62 | 26.15 | 26.68 | 27.21 |
| 44 | 19.86 | 20.39 | 20.91 | 21.44 | 21.97 | 22.50 | 23.03 | 23.57 | 24.10 | 24.64 | 25.17 | 25.71 | 26.25 | 26.79 | 27.33 | 27.88 |
| 45 | 20.33 | 20.87 | 21.41 | 21.95 | 22.49 | 23.03 | 23.58 | 24.12 | 24.67 | 25.22 | 25.77 | 26.32 | 26.88 | 27.43 | 27.99 | 28.55 |
| 46 | 20.80 | 21.35 | 21.90 | 22.46 | 23.01 | 23.57 | 24.13 | 24.69 | 25.25 | 25.81 | 26.37 | 26.94 | 27.51 | 28.08 | 28.65 | 29.22 |
| 47 | 21.27 | 21.83 | 22.40 | 22.97 | 23.53 | 24.10 | 24.68 | 25.25 | 25.82 | 26.40 | 26.98 | 27.56 | 28.14 | 28.72 | 29.31 | 29.89 |
| 48 | 21.74 | 22.32 | 22.90 | 23.48 | 24.06 | 24.64 | 25.23 | 25.81 | 26.40 | 26.99 | 27.58 | 28.18 | 28.77 | 29.37 | 29.97 | 30.57 |
| 49 | 22.21 | 22.80 | 23.39 | 23.99 | 24.58 | 25.18 | 25.78 | 26.38 | 26.98 | 27.59 | 28.19 | 28.80 | 29.41 | 30.02 | 30.63 | 31.24 |
| 50 | 22.69 | 23.29 | 23.89 | 24.50 | 25.11 | 25.72 | 26.33 | 26.95 | 27.56 | 28.18 | 28.80 | 29.42 | 30.04 | 30.67 | 31.29 | 31.92 |
| 51 | 23.16 | 23.78 | 24.40 | 25.02 | 25.64 | 26.26 | 26.89 | 27.52 | 28.15 | 28.78 | 29.41 | 30.05 | 30.68 | 31.32 | 31.96 | 32.60 |
| 52 | 23.64 | 24.27 | 24.90 | 25.53 | 26.17 | 26.81 | 27.45 | 28.09 | 28.73 | 29.38 | 30.02 | 30.67 | 31.32 | 31.98 | 32.63 | 33.29 |
| 53 | 24.11 | 24.76 | 25.40 | 26.05 | 26.70 | 27.35 | 28.00 | 28.66 | 29.32 | 29.98 | 30.64 | 31.30 | 31.97 | 32.63 | 33.30 | 33.97 |
| 54 | 24.59 | 25.25 | 25.91 | 26.57 | 27.23 | 27.90 | 28.56 | 29.23 | 29.91 | 30.58 | 31.25 | 31.93 | 32.61 | 33.29 | 33.98 | 34.66 |
| 55 | 25.07 | 25.74 | 26.41 | 27.09 | 27.77 | 28.44 | 29.13 | 29.81 | 30.50 | 31.18 | 31.87 | 32.56 | 33.26 | 33.95 | 34.65 | 35.35 |
| 56 | 25.55 | 26.23 | 26.92 | 27.61 | 28.30 | 28.99 | 29.69 | 30.39 | 31.09 | 31.79 | 32.49 | 33.20 | 33.91 | 34.62 | 35.33 | 36.04 |
| 57 | 26.03 | 26.73 | 27.43 | 28.13 | 28.84 | 29.54 | 30.25 | 30.97 | 31.68 | 32.39 | 33.11 | 33.83 | 34.56 | 35.28 | 36.01 | 36.74 |
| 58 | 26.51 | 27.23 | 27.94 | 28.66 | 29.37 | 30.10 | 30.82 | 31.55 | 32.27 | 33.00 | 33.74 | 34.47 | 35.21 | 35.95 | 36.69 | 37.43 |
| 59 | 27.00 | 27.72 | 28.45 | 29.18 | 29.91 | 30.65 | 31.39 | 32.13 | 32.87 | 33.61 | 34.36 | 35.11 | 35.86 | 36.62 | 37.37 | 38.13 |
| 60 | 27.48 | 28.22 | 28.96 | 29.71 | 30.45 | 31.20 | 31.96 | 32.71 | 33.47 | 34.23 | 34.99 | 35.75 | 36.52 | 37.29 | 38.06 | 38.83 |

TABLE 12-1
Interest per $100 of Amount Financed—*Continued*

| Number of monthly payments | APR (Annual Percentage Rate) | | | | | | | | | | | | | | | |
|---|---|---|---|---|---|---|---|---|---|---|---|---|---|---|---|---|
| | 14.00% | 14.25% | 14.50% | 14.75% | 15.00% | 15.25% | 15.50% | 15.75% | 16.00% | 16.25% | 16.50% | 16.75% | 17.00% | 17.25% | 17.50% | 17.75% |
| 1 | 1.17 | 1.19 | 1.21 | 1.23 | 1.25 | 1.27 | 1.29 | 1.31 | 1.33 | 1.35 | 1.37 | 1.40 | 1.42 | 1.44 | 1.46 | 1.48 |
| 2 | 1.75 | 1.78 | 1.82 | 1.85 | 1.88 | 1.91 | 1.94 | 1.97 | 2.00 | 2.04 | 2.07 | 2.10 | 2.13 | 2.16 | 2.19 | 2.22 |
| 3 | 2.34 | 2.38 | 2.43 | 2.47 | 2.51 | 2.55 | 2.59 | 2.64 | 2.68 | 2.72 | 2.76 | 2.80 | 2.85 | 2.89 | 2.93 | 2.97 |
| 4 | 2.93 | 2.99 | 3.04 | 3.09 | 3.14 | 3.20 | 3.25 | 3.30 | 3.36 | 3.41 | 3.46 | 3.51 | 3.57 | 3.62 | 3.67 | 3.73 |
| 5 | 3.53 | 3.59 | 3.65 | 3.72 | 3.78 | 3.84 | 3.91 | 3.97 | 4.04 | 4.10 | 4.16 | 4.23 | 4.29 | 4.35 | 4.42 | 4.48 |
| 6 | 4.12 | 4.20 | 4.27 | 4.35 | 4.42 | 4.49 | 4.57 | 4.64 | 4.72 | 4.79 | 4.87 | 4.94 | 5.02 | 5.09 | 5.17 | 5.24 |
| 7 | 4.72 | 4.81 | 4.89 | 4.98 | 5.06 | 5.15 | 5.23 | 5.32 | 5.40 | 5.49 | 5.58 | 5.66 | 5.75 | 5.83 | 5.92 | 6.00 |
| 8 | 5.32 | 5.42 | 5.51 | 5.61 | 5.71 | 5.80 | 5.90 | 6.00 | 6.09 | 6.19 | 6.29 | 6.38 | 6.48 | 6.58 | 6.67 | 6.77 |
| 9 | 5.92 | 6.03 | 6.14 | 6.25 | 6.35 | 6.46 | 6.57 | 6.68 | 6.78 | 6.89 | 7.00 | 7.11 | 7.22 | 7.32 | 7.43 | 7.54 |
| 10 | 6.53 | 6.65 | 6.77 | 6.88 | 7.00 | 7.12 | 7.24 | 7.36 | 7.48 | 7.60 | 7.72 | 7.84 | 7.96 | 8.08 | 8.19 | 8.31 |
| 11 | 7.14 | 7.27 | 7.40 | 7.53 | 7.66 | 7.79 | 7.92 | 8.05 | 8.18 | 8.31 | 8.44 | 8.57 | 8.70 | 8.83 | 8.96 | 9.09 |
| 12 | 7.74 | 7.89 | 8.03 | 8.17 | 8.31 | 8.45 | 8.59 | 8.74 | 8.88 | 9.02 | 9.16 | 9.30 | 9.45 | 9.59 | 9.73 | 9.87 |
| 13 | 8.36 | 8.51 | 8.66 | 8.81 | 8.97 | 9.12 | 9.27 | 9.43 | 9.58 | 9.73 | 9.89 | 10.04 | 10.20 | 10.35 | 10.50 | 10.66 |
| 14 | 8.97 | 9.13 | 9.30 | 9.46 | 9.63 | 9.79 | 9.96 | 10.12 | 10.29 | 10.45 | 10.67 | 10.78 | 10.95 | 11.11 | 11.28 | 11.45 |
| 15 | 9.59 | 9.76 | 9.94 | 10.11 | 10.29 | 10.47 | 10.64 | 10.82 | 11.00 | 11.17 | 11.35 | 11.53 | 11.71 | 11.88 | 12.06 | 12.24 |
| 16 | 10.20 | 10.39 | 10.58 | 10.77 | 10.95 | 11.14 | 11.33 | 11.52 | 11.71 | 11.90 | 12.09 | 12.28 | 12.46 | 12.65 | 12.84 | 13.03 |
| 17 | 10.82 | 11.02 | 11.22 | 11.42 | 11.62 | 11.82 | 12.02 | 12.22 | 12.42 | 12.62 | 12.83 | 13.03 | 13.23 | 13.43 | 13.63 | 13.83 |
| 18 | 11.45 | 11.66 | 11.87 | 12.08 | 12.29 | 12.50 | 12.72 | 12.93 | 13.14 | 13.35 | 13.57 | 13.78 | 13.99 | 14.21 | 14.42 | 14.64 |
| 19 | 12.07 | 12.30 | 12.52 | 12.74 | 12.97 | 13.19 | 13.41 | 13.64 | 13.86 | 14.09 | 14.31 | 14.54 | 14.76 | 14.99 | 15.22 | 15.44 |
| 20 | 12.70 | 12.93 | 13.17 | 13.41 | 13.64 | 13.88 | 14.11 | 14.35 | 14.59 | 14.82 | 15.06 | 15.30 | 15.54 | 15.77 | 16.01 | 16.25 |
| 21 | 13.33 | 13.58 | 13.82 | 14.07 | 14.32 | 14.57 | 14.82 | 15.06 | 15.31 | 15.56 | 15.81 | 16.06 | 16.31 | 16.56 | 16.81 | 17.07 |
| 22 | 13.96 | 14.22 | 14.48 | 14.74 | 15.00 | 15.26 | 15.52 | 15.78 | 16.04 | 16.30 | 16.57 | 16.83 | 17.09 | 17.36 | 17.62 | 17.88 |
| 23 | 14.59 | 14.87 | 15.14 | 15.41 | 15.68 | 15.96 | 16.23 | 16.50 | 16.78 | 17.05 | 17.32 | 17.60 | 17.88 | 18.15 | 18.43 | 18.70 |
| 24 | 15.23 | 15.51 | 15.80 | 16.08 | 16.37 | 16.65 | 16.94 | 17.22 | 17.51 | 17.80 | 18.09 | 18.37 | 18.66 | 18.95 | 19.24 | 19.53 |
| 25 | 15.87 | 16.17 | 16.46 | 16.76 | 17.06 | 17.35 | 17.65 | 17.95 | 18.25 | 18.55 | 18.85 | 19.15 | 19.45 | 19.75 | 20.05 | 20.36 |
| 26 | 16.51 | 16.82 | 17.13 | 17.44 | 17.75 | 18.06 | 18.37 | 18.68 | 18.99 | 19.30 | 19.62 | 19.93 | 20.24 | 20.56 | 20.87 | 21.19 |
| 27 | 17.15 | 17.47 | 17.80 | 18.12 | 18.44 | 18.76 | 19.09 | 19.41 | 19.74 | 20.06 | 20.39 | 20.71 | 21.04 | 21.37 | 21.69 | 22.02 |
| 28 | 17.80 | 18.13 | 18.47 | 18.80 | 19.14 | 19.47 | 19.81 | 20.15 | 20.48 | 20.82 | 21.16 | 21.50 | 21.84 | 22.18 | 22.52 | 22.86 |
| 29 | 18.45 | 18.79 | 19.14 | 19.49 | 19.83 | 20.18 | 20.53 | 20.88 | 21.23 | 21.58 | 21.94 | 22.29 | 22.64 | 22.99 | 23.35 | 23.70 |
| 30 | 19.10 | 19.45 | 19.81 | 20.17 | 20.54 | 20.90 | 21.26 | 21.62 | 21.99 | 22.35 | 22.72 | 23.08 | 23.45 | 23.81 | 24.18 | 24.55 |
| 31 | 19.75 | 20.12 | 20.49 | 20.87 | 21.24 | 21.61 | 21.99 | 22.37 | 22.74 | 23.12 | 23.50 | 23.88 | 24.26 | 24.64 | 25.02 | 25.40 |
| 32 | 20.40 | 20.79 | 21.17 | 21.56 | 21.95 | 22.33 | 22.72 | 23.11 | 23.50 | 23.89 | 24.28 | 24.68 | 25.07 | 25.46 | 25.86 | 26.25 |
| 33 | 21.06 | 21.46 | 21.85 | 22.25 | 22.65 | 23.06 | 23.46 | 23.86 | 24.26 | 24.67 | 25.07 | 25.48 | 25.88 | 26.29 | 26.70 | 27.11 |
| 34 | 21.72 | 22.13 | 22.54 | 22.95 | 23.37 | 23.78 | 24.19 | 24.61 | 25.03 | 25.44 | 25.86 | 26.28 | 26.70 | 27.12 | 27.54 | 27.97 |
| 35 | 22.38 | 22.80 | 23.23 | 23.65 | 24.08 | 24.51 | 24.94 | 25.36 | 25.79 | 26.23 | 26.66 | 27.09 | 27.52 | 27.96 | 28.39 | 28.83 |
| 36 | 23.04 | 23.48 | 23.92 | 24.35 | 24.80 | 25.24 | 25.68 | 26.12 | 26.57 | 27.01 | 27.46 | 27.90 | 28.35 | 28.80 | 29.25 | 29.70 |
| 37 | 23.70 | 24.16 | 24.61 | 25.06 | 25.51 | 25.97 | 26.42 | 26.88 | 27.34 | 27.80 | 28.26 | 28.72 | 29.18 | 29.64 | 30.10 | 30.57 |
| 38 | 24.37 | 24.84 | 25.30 | 25.77 | 26.24 | 26.70 | 27.17 | 27.64 | 28.11 | 28.59 | 29.06 | 29.53 | 30.01 | 30.49 | 30.96 | 31.44 |
| 39 | 25.04 | 25.52 | 26.00 | 26.48 | 26.96 | 27.44 | 27.92 | 28.41 | 28.89 | 29.38 | 29.87 | 30.36 | 30.85 | 31.34 | 31.83 | 32.32 |
| 40 | 25.71 | 26.20 | 26.70 | 27.19 | 27.69 | 28.18 | 28.68 | 29.18 | 29.68 | 30.18 | 30.68 | 31.18 | 31.68 | 32.19 | 32.69 | 33.20 |
| 41 | 26.39 | 26.89 | 27.40 | 27.91 | 28.41 | 28.92 | 29.44 | 29.95 | 30.46 | 30.97 | 31.49 | 32.01 | 32.52 | 33.04 | 33.56 | 34.08 |
| 42 | 27.06 | 27.58 | 28.10 | 28.62 | 29.15 | 29.67 | 30.19 | 30.72 | 31.25 | 31.78 | 32.31 | 32.84 | 33.37 | 33.90 | 34.44 | 34.97 |
| 43 | 27.74 | 28.27 | 28.81 | 29.34 | 29.88 | 30.42 | 30.96 | 31.50 | 32.04 | 32.58 | 33.13 | 33.67 | 34.22 | 34.76 | 35.31 | 35.86 |
| 44 | 28.42 | 28.97 | 29.52 | 30.07 | 30.62 | 31.17 | 31.72 | 32.28 | 32.83 | 33.39 | 33.95 | 34.51 | 35.07 | 35.63 | 36.19 | 36.76 |
| 45 | 29.11 | 29.67 | 30.23 | 30.79 | 31.36 | 31.92 | 32.49 | 33.06 | 33.63 | 34.20 | 34.77 | 35.35 | 35.92 | 36.50 | 37.08 | 37.66 |
| 46 | 29.79 | 30.36 | 30.94 | 31.52 | 32.10 | 32.68 | 33.26 | 33.84 | 34.43 | 35.01 | 35.60 | 36.19 | 36.78 | 37.37 | 37.96 | 38.56 |
| 47 | 30.48 | 31.07 | 31.66 | 32.25 | 32.84 | 33.44 | 34.03 | 34.63 | 35.23 | 35.83 | 36.43 | 37.04 | 37.64 | 38.25 | 38.86 | 39.46 |
| 48 | 31.17 | 31.77 | 32.37 | 32.98 | 33.59 | 34.20 | 34.81 | 35.42 | 36.03 | 36.65 | 37.27 | 37.88 | 38.50 | 39.13 | 39.75 | 40.37 |
| 49 | 31.86 | 32.48 | 33.09 | 33.71 | 34.34 | 34.96 | 35.59 | 36.21 | 36.84 | 37.47 | 38.10 | 38.74 | 39.37 | 40.01 | 40.65 | 41.29 |
| 50 | 32.55 | 33.18 | 33.82 | 34.45 | 35.09 | 35.73 | 36.37 | 37.01 | 37.65 | 38.30 | 38.94 | 39.59 | 40.24 | 40.89 | 41.55 | 42.20 |
| 51 | 33.25 | 33.89 | 34.54 | 35.19 | 35.84 | 36.49 | 37.15 | 37.81 | 38.46 | 39.12 | 39.79 | 40.45 | 41.11 | 41.78 | 42.45 | 43.12 |
| 52 | 33.95 | 34.61 | 35.27 | 35.93 | 36.60 | 37.27 | 37.94 | 38.61 | 39.28 | 39.96 | 40.63 | 41.31 | 41.99 | 42.67 | 43.36 | 44.04 |
| 53 | 34.65 | 35.32 | 36.00 | 36.68 | 37.36 | 38.04 | 38.72 | 39.41 | 40.10 | 40.79 | 41.48 | 42.17 | 42.87 | 43.57 | 44.27 | 44.97 |
| 54 | 35.35 | 36.04 | 36.73 | 37.42 | 38.12 | 38.82 | 39.52 | 40.22 | 40.92 | 41.63 | 42.33 | 43.04 | 43.75 | 44.47 | 45.18 | 45.90 |
| 55 | 36.05 | 36.76 | 37.46 | 38.17 | 38.88 | 39.60 | 40.31 | 41.03 | 41.74 | 42.47 | 43.19 | 43.91 | 44.64 | 45.37 | 46.10 | 46.83 |
| 56 | 36.76 | 37.48 | 38.20 | 38.92 | 39.65 | 40.38 | 41.11 | 41.84 | 42.57 | 43.31 | 44.05 | 44.79 | 45.53 | 46.27 | 47.02 | 47.77 |
| 57 | 37.47 | 38.20 | 38.94 | 39.68 | 40.42 | 41.16 | 41.91 | 42.65 | 43.40 | 44.15 | 44.91 | 45.66 | 46.42 | 47.18 | 47.94 | 48.71 |
| 58 | 38.18 | 38.93 | 39.68 | 40.43 | 41.19 | 41.95 | 42.71 | 43.47 | 44.23 | 45.00 | 45.77 | 46.54 | 47.32 | 48.09 | 48.87 | 49.65 |
| 59 | 38.89 | 39.66 | 40.42 | 41.19 | 41.96 | 42.74 | 43.51 | 44.29 | 45.07 | 45.85 | 46.64 | 47.42 | 48.21 | 49.01 | 49.80 | 50.60 |
| 60 | 39.61 | 40.39 | 41.17 | 41.95 | 42.74 | 43.53 | 44.32 | 45.11 | 45.91 | 46.71 | 47.51 | 48.31 | 49.12 | 49.92 | 50.73 | 51.55 |

TABLE 12-1
Interest per $100 of Amount Financed—*Continued*

| Number of monthly payments | APR (Annual Percentage Rate) | | | | | | | | | | | | | | | |
|---|---|---|---|---|---|---|---|---|---|---|---|---|---|---|---|---|
| | 18.00% | 18.25% | 18.50% | 18.75% | 19.00% | 19.25% | 19.50% | 19.75% | 20.00% | 20.25% | 20.50% | 20.75% | 21.00% | 21.25% | 21.50% | 21.75% |
| 1 | 1.50 | 1.52 | 1.54 | 1.56 | 1.58 | 1.60 | 1.62 | 1.65 | 1.67 | 1.69 | 1.71 | 1.73 | 1.75 | 1.77 | 1.79 | 1.81 |
| 2 | 2.26 | 2.29 | 2.32 | 2.35 | 2.38 | 2.41 | 2.44 | 2.48 | 2.51 | 2.54 | 2.57 | 2.60 | 2.63 | 2.66 | 2.70 | 2.73 |
| 3 | 3.01 | 3.06 | 3.10 | 3.14 | 3.18 | 3.23 | 3.27 | 3.31 | 3.35 | 3.39 | 3.44 | 3.48 | 3.52 | 3.56 | 3.60 | 3.65 |
| 4 | 3.78 | 3.83 | 3.88 | 3.94 | 3.99 | 4.04 | 4.10 | 4.15 | 4.20 | 4.25 | 4.31 | 4.36 | 4.41 | 4.47 | 4.52 | 4.57 |
| 5 | 4.54 | 4.61 | 4.67 | 4.74 | 4.80 | 4.86 | 4.93 | 4.99 | 5.06 | 5.12 | 5.18 | 5.25 | 5.31 | 5.37 | 5.44 | 5.50 |
| 6 | 5.32 | 5.39 | 5.46 | 5.54 | 5.61 | 5.69 | 5.76 | 5.84 | 5.91 | 5.99 | 6.06 | 6.14 | 6.21 | 6.29 | 6.36 | 6.44 |
| 7 | 6.09 | 6.18 | 6.26 | 6.35 | 6.43 | 6.52 | 6.60 | 6.69 | 6.78 | 6.86 | 6.95 | 7.04 | 7.12 | 7.21 | 7.29 | 7.38 |
| 8 | 6.87 | 6.96 | 7.06 | 7.16 | 7.26 | 7.35 | 7.45 | 7.55 | 7.64 | 7.74 | 7.84 | 7.94 | 8.03 | 8.13 | 8.23 | 8.33 |
| 9 | 7.65 | 7.76 | 7.87 | 7.97 | 8.08 | 8.19 | 8.30 | 8.41 | 8.52 | 8.63 | 8.73 | 8.84 | 8.95 | 9.06 | 9.17 | 9.28 |
| 10 | 8.43 | 8.55 | 8.67 | 8.79 | 8.91 | 9.03 | 9.15 | 9.27 | 9.39 | 9.51 | 9.63 | 9.75 | 9.88 | 10.00 | 10.12 | 10.24 |
| 11 | 9.22 | 9.35 | 9.49 | 9.62 | 9.75 | 9.88 | 10.01 | 10.14 | 10.28 | 10.41 | 10.54 | 10.67 | 10.80 | 10.94 | 11.07 | 11.20 |
| 12 | 10.02 | 10.16 | 10.30 | 10.44 | 10.59 | 10.73 | 10.87 | 11.02 | 11.16 | 11.31 | 11.45 | 11.59 | 11.74 | 11.88 | 12.02 | 12.17 |
| 13 | 10.81 | 10.97 | 11.12 | 11.28 | 11.43 | 11.59 | 11.74 | 11.90 | 12.05 | 12.21 | 12.36 | 12.52 | 12.67 | 12.83 | 12.99 | 13.14 |
| 14 | 11.61 | 11.78 | 11.95 | 12.11 | 12.28 | 12.45 | 12.61 | 12.78 | 12.95 | 13.11 | 13.28 | 13.45 | 13.62 | 13.79 | 13.95 | 14.12 |
| 15 | 12.42 | 12.59 | 12.77 | 12.95 | 13.13 | 13.31 | 13.49 | 13.67 | 13.85 | 14.03 | 14.21 | 14.39 | 14.57 | 14.75 | 14.93 | 15.11 |
| 16 | 13.22 | 13.41 | 13.60 | 13.80 | 13.99 | 14.18 | 14.37 | 14.56 | 14.75 | 14.94 | 15.13 | 15.33 | 15.52 | 15.71 | 15.90 | 16.10 |
| 17 | 14.04 | 14.24 | 14.44 | 14.64 | 14.85 | 15.05 | 15.25 | 15.46 | 15.66 | 15.86 | 16.07 | 16.27 | 16.48 | 16.68 | 16.89 | 17.09 |
| 18 | 14.85 | 15.07 | 15.28 | 15.49 | 15.71 | 15.93 | 16.14 | 16.36 | 16.57 | 16.79 | 17.01 | 17.22 | 17.44 | 17.66 | 17.88 | 18.09 |
| 19 | 15.67 | 15.90 | 16.12 | 16.35 | 16.58 | 16.81 | 17.03 | 17.26 | 17.49 | 17.72 | 17.95 | 18.18 | 18.41 | 18.64 | 18.87 | 19.10 |
| 20 | 16.49 | 16.73 | 16.97 | 17.21 | 17.45 | 17.69 | 17.93 | 18.17 | 18.41 | 18.66 | 18.90 | 19.14 | 19.38 | 19.63 | 19.87 | 20.11 |
| 21 | 17.32 | 17.57 | 17.82 | 18.07 | 18.33 | 18.58 | 18.83 | 19.09 | 19.34 | 19.60 | 19.85 | 20.11 | 20.36 | 20.62 | 20.87 | 21.13 |
| 22 | 18.15 | 18.41 | 18.68 | 18.94 | 19.21 | 19.47 | 19.74 | 20.01 | 20.27 | 20.54 | 20.81 | 21.08 | 21.34 | 21.61 | 21.88 | 22.15 |
| 23 | 18.98 | 19.26 | 19.54 | 19.81 | 20.09 | 20.37 | 20.65 | 20.93 | 21.21 | 21.49 | 21.77 | 22.05 | 22.33 | 22.61 | 22.90 | 23.18 |
| 24 | 19.82 | 20.11 | 20.40 | 20.69 | 20.98 | 21.27 | 21.56 | 21.86 | 22.15 | 22.44 | 22.74 | 23.03 | 23.33 | 23.62 | 23.92 | 24.21 |
| 25 | 20.66 | 20.96 | 21.27 | 21.57 | 21.87 | 22.18 | 22.48 | 22.79 | 23.10 | 23.40 | 23.71 | 24.02 | 24.32 | 24.63 | 24.94 | 25.25 |
| 26 | 21.50 | 21.82 | 22.14 | 22.45 | 22.77 | 23.09 | 23.41 | 23.73 | 24.04 | 24.36 | 24.68 | 25.01 | 25.33 | 25.65 | 25.97 | 26.29 |
| 27 | 22.35 | 22.68 | 23.01 | 23.44 | 23.67 | 24.00 | 24.33 | 24.67 | 25.00 | 25.33 | 25.67 | 26.00 | 26.34 | 26.67 | 27.01 | 27.34 |
| 28 | 23.20 | 23.55 | 23.89 | 24.23 | 24.58 | 24.92 | 25.27 | 25.61 | 25.96 | 26.30 | 26.65 | 27.00 | 27.35 | 27.70 | 28.05 | 28.40 |
| 29 | 24.06 | 24.41 | 24.27 | 25.13 | 25.49 | 25.84 | 26.20 | 26.56 | 26.92 | 27.28 | 27.64 | 28.00 | 28.37 | 28.73 | 29.09 | 29.46 |
| 30 | 24.92 | 25.29 | 25.66 | 26.03 | 26.40 | 26.77 | 27.14 | 27.52 | 27.89 | 28.26 | 28.64 | 29.01 | 29.39 | 29.77 | 30.14 | 30.52 |
| 31 | 25.78 | 26.16 | 26.55 | 26.93 | 27.32 | 27.70 | 28.09 | 28.47 | 28.86 | 29.25 | 29.64 | 30.03 | 30.42 | 30.81 | 31.20 | 31.59 |
| 32 | 26.65 | 27.04 | 27.44 | 27.84 | 28.24 | 28.64 | 29.04 | 29.44 | 29.84 | 30.24 | 30.64 | 31.05 | 31.45 | 31.85 | 32.26 | 32.67 |
| 33 | 27.52 | 27.93 | 28.34 | 28.75 | 29.16 | 29.57 | 29.99 | 30.40 | 30.82 | 31.23 | 31.65 | 32.07 | 32.49 | 32.91 | 33.33 | 33.75 |
| 34 | 28.39 | 28.81 | 29.24 | 29.66 | 30.09 | 30.52 | 30.95 | 31.37 | 31.80 | 32.23 | 32.67 | 33.10 | 33.53 | 33.96 | 34.40 | 34.83 |
| 35 | 29.27 | 29.71 | 30.14 | 30.58 | 31.02 | 31.47 | 31.91 | 32.35 | 32.79 | 33.24 | 33.68 | 34.13 | 34.58 | 35.03 | 35.47 | 35.92 |
| 36 | 30.15 | 30.60 | 31.05 | 31.51 | 31.96 | 32.42 | 32.87 | 33.33 | 33.79 | 34.25 | 34.71 | 35.17 | 35.63 | 36.09 | 36.56 | 37.02 |
| 37 | 31.03 | 31.50 | 31.97 | 32.43 | 32.90 | 33.37 | 33.84 | 34.32 | 34.79 | 35.26 | 35.74 | 36.21 | 36.69 | 37.16 | 37.64 | 38.12 |
| 38 | 31.92 | 32.40 | 32.88 | 33.37 | 33.85 | 34.33 | 34.82 | 35.30 | 35.79 | 36.28 | 36.77 | 37.26 | 37.75 | 38.24 | 38.73 | 39.23 |
| 39 | 32.81 | 33.31 | 33.80 | 34.30 | 34.80 | 35.30 | 35.80 | 36.30 | 36.80 | 37.30 | 37.81 | 38.31 | 38.82 | 39.32 | 39.83 | 40.34 |
| 40 | 33.71 | 34.22 | 34.73 | 35.24 | 35.75 | 36.26 | 36.78 | 37.29 | 37.81 | 38.33 | 38.85 | 39.37 | 39.89 | 40.41 | 40.93 | 41.46 |
| 41 | 34.61 | 35.13 | 35.66 | 36.18 | 36.71 | 37.24 | 37.77 | 38.30 | 38.83 | 39.36 | 39.89 | 40.43 | 40.96 | 41.50 | 42.04 | 42.58 |
| 42 | 35.51 | 36.05 | 36.59 | 37.13 | 37.67 | 38.21 | 38.76 | 39.30 | 39.85 | 40.40 | 40.95 | 41.50 | 42.05 | 42.60 | 43.15 | 43.71 |
| 43 | 36.42 | 36.97 | 37.52 | 38.08 | 38.63 | 39.19 | 39.75 | 40.31 | 40.87 | 41.44 | 42.00 | 42.57 | 43.13 | 43.70 | 44.27 | 44.84 |
| 44 | 37.33 | 37.89 | 38.46 | 39.03 | 39.60 | 40.18 | 40.75 | 41.33 | 41.90 | 42.48 | 43.06 | 43.64 | 44.22 | 44.81 | 45.39 | 45.98 |
| 45 | 38.24 | 38.82 | 39.41 | 39.99 | 40.58 | 41.17 | 41.75 | 42.35 | 42.94 | 43.53 | 44.13 | 44.72 | 45.32 | 45.92 | 46.52 | 47.12 |
| 46 | 39.16 | 39.75 | 40.35 | 40.95 | 41.55 | 42.16 | 42.76 | 43.37 | 43.98 | 44.58 | 45.20 | 45.81 | 46.42 | 47.03 | 47.65 | 48.27 |
| 47 | 40.08 | 40.69 | 41.30 | 41.92 | 42.54 | 43.15 | 43.77 | 44.40 | 45.02 | 45.64 | 46.27 | 46.90 | 47.53 | 48.16 | 48.79 | 49.42 |
| 48 | 41.00 | 41.63 | 42.26 | 42.89 | 43.52 | 44.15 | 44.79 | 45.43 | 46.07 | 46.71 | 47.35 | 47.99 | 48.64 | 49.28 | 49.93 | 50.58 |
| 49 | 41.93 | 42.57 | 43.22 | 43.86 | 44.51 | 45.16 | 45.81 | 46.46 | 47.12 | 47.77 | 48.43 | 49.09 | 49.75 | 50.41 | 51.08 | 51.74 |
| 50 | 42.86 | 43.52 | 44.18 | 44.84 | 45.50 | 46.17 | 46.83 | 47.50 | 48.17 | 48.84 | 49.52 | 50.19 | 50.87 | 51.55 | 52.23 | 52.91 |
| 51 | 43.79 | 44.47 | 45.14 | 45.82 | 46.50 | 47.18 | 47.86 | 48.55 | 49.23 | 49.92 | 50.61 | 51.30 | 51.99 | 52.69 | 53.38 | 54.08 |
| 52 | 44.73 | 45.42 | 46.11 | 46.80 | 47.50 | 48.20 | 48.89 | 49.59 | 50.30 | 51.00 | 51.71 | 52.41 | 53.12 | 53.83 | 54.55 | 55.26 |
| 53 | 45.67 | 46.38 | 47.08 | 47.79 | 48.50 | 49.22 | 49.93 | 50.65 | 51.37 | 52.09 | 52.81 | 53.53 | 54.26 | 54.98 | 55.71 | 56.44 |
| 54 | 46.62 | 47.34 | 48.06 | 48.79 | 49.51 | 50.24 | 50.97 | 51.70 | 52.44 | 53.17 | 53.91 | 54.65 | 55.39 | 56.14 | 56.88 | 57.63 |
| 55 | 47.57 | 48.30 | 49.04 | 49.78 | 50.52 | 51.27 | 52.02 | 52.76 | 53.52 | 54.27 | 55.02 | 55.78 | 56.54 | 57.30 | 58.06 | 58.82 |
| 56 | 48.52 | 49.27 | 50.03 | 50.78 | 51.54 | 52.30 | 53.06 | 53.83 | 54.60 | 55.37 | 56.14 | 56.91 | 57.68 | 58.46 | 59.24 | 60.02 |
| 57 | 49.47 | 50.24 | 51.01 | 51.79 | 52.56 | 53.34 | 54.12 | 54.90 | 55.68 | 56.47 | 57.25 | 58.04 | 58.84 | 59.63 | 60.43 | 61.22 |
| 58 | 50.43 | 51.22 | 52.00 | 52.79 | 53.58 | 54.38 | 55.17 | 55.97 | 56.77 | 57.57 | 58.38 | 59.18 | 59.99 | 60.80 | 61.62 | 62.43 |
| 59 | 51.39 | 52.20 | 53.00 | 53.80 | 54.61 | 55.42 | 56.23 | 57.05 | 57.87 | 58.68 | 59.51 | 60.33 | 61.15 | 61.98 | 62.81 | 63.64 |
| 60 | 52.36 | 53.18 | 54.00 | 54.82 | 55.64 | 56.47 | 57.30 | 58.13 | 58.96 | 59.80 | 60.64 | 61.48 | 62.32 | 63.17 | 64.01 | 64.86 |

EXAMPLE 1 Lewis Strang bought a motorcycle for $3,500, which was financed at $142 per month for 24 months. The down payment was $500. Find the APR.

Installment price = 24($142) + $500 = $3,408 + $500 = $3,908
Finance charge = $3,908 − $3,500 = $408
Amount financed = $3,500 − $500 = $3,000

$$\text{Interest per } \$100 = \frac{\text{finance charge}}{\text{amount financed}} \times \$100 = \frac{\$408}{\$3,000}(\$100) = \$13.60$$

Find the row for 24 monthly payments. Move across to find the number nearest to $13.60.

| | |
|---|---|
| $13.60 | $13.82 |
| − $13.54 | − 13.60 |
| $ 0.06 | $ 0.22 |
| Closest | |
| value | |

Find the table value closest to $13.60.

Move up to the top of that column to find the **annual percentage rate, which is 12.5%.**

TIP

Finding the Closest Table Value

Another way to find the closest table value to the interest per $100 is to compare the interest to the amount halfway between two table values. The halfway amount is the average of the two table values.

$$\text{Halfway} = \frac{\text{larger value } + \text{ smaller value}}{2}$$

In the previous example, $13.60 is between $13.54 and $13.82.

$$\text{Halfway} = \frac{\$13.54 + \$13.82}{2} = \frac{\$27.36}{2}$$
$$= \$13.68$$

Since $13.60 is less than the halfway amount ($13.68), it is closer to the lower table value ($13.54).

 STOP AND CHECK

1. Jaime Lopez purchased a preowned car that listed for $11,935. After making a down payment of $1,500, he financed the balance over 36 months with payments of $347.49 per month. Use Table 12-1 to find the annual percentage rate (APR) of the loan.

2. Peggy Portzen purchased new kitchen appliances with a cash price of $6,800. After making a down payment of $900, she financed the balance over 24 months with payments of $279.65. Find the annual percentage rate (APR) of the loan.

3. Alan Dan could purchase a jet ski for $9,995 cash. He paid $2,000 down and financed the balance with 36 monthly payments of $295.34. Find the APR of the loan.

4. Nellie Chapman bought a Harley-Davidson motorcycle that had a cash price of $12,799 with a $2,500 down payment. She paid for the motorcycle in 48 monthly payments of $296.37. Find the APR for the loan.

12-1 SECTION EXERCISES

SKILL BUILDERS

1. Find the installment price of a recliner bought on the installment plan with a down payment of $100 and six payments of $108.20.

2. Find the amount financed if a $125 down payment is made on a TV with a cash price of $579.

3. Stephen Helba purchased a TV with surround sound and remote control on an installment plan with $100 down and 12 payments of $106.32. Find the installment price of the TV.

4. A queen-size bedroom suite can be purchased on an installment plan with 18 payments of $97.42 if an $80 down payment is made. What is the installment price of the suite?

5. Zack's Trailer Sales will finance a 16-foot utility trailer with ramps and electric brakes. If a down payment of $100 and eight monthly payments of $82.56 are required, what is the installment price of the trailer?

6. A forklift is purchased for $10,000. The forklift is used as collateral and no down payment is required. Twenty-four monthly payments of $503 are required to repay the loan. What is the installment price of the forklift?

7. A computer with software costs $2,987, and Docie Johnson has agreed to pay a 19% per year finance charge on the cash price. If she contracts to pay the loan in 18 months, how much will she pay each month?

8. The cash price of a bedroom suite is $2,590. There is a 24% finance charge on the cash price and 12 monthly payments. Find the monthly payment.

9. Find the monthly payment on a VCR with an installment price of $929, 12 monthly payments, and a down payment of $100.

10. The installment price of a teakwood extension table and four chairs is $625 with 18 monthly payments and a down payment of $75. What is the monthly payment?

APPLICATIONS

11. An entertainment center is financed at a total cost of $2,357 including a down payment of $250. If the center is financed over 24 months, find the monthly payment.

12. A Hepplewhite sofa costs $3,780 in cash. Jaquanna Wilson will purchase the sofa in 36 monthly installment payments. A 13% per year finance charge will be assessed on the amount financed. Find the finance charge, the installment price, and the monthly payment.

13. A fishing boat is purchased for $5,600 and financed for 36 months. If the total finance charge is $1,025, find the annual percentage rate using Table 12-1.

14. An air compressor costs $780 and is financed with monthly payments for 12 months. The total finance charge is $90. Find the annual percentage rate using Table 12-1.

15. Jim Meriweather purchased an engraving machine for $28,000 and financed it for 36 months. The total finance charge was $5,036. Use Table 12-1 to find the annual percentage rate.

12-2 PAYING A LOAN BEFORE IT IS DUE: THE RULE OF 78

LEARNING OUTCOME

1 Find the interest refund using the rule of 78.

If a closed-end installment loan is paid entirely before the last payment is actually due, is part of the interest refundable? In most cases it is, but not always at the rate you might hope. If you paid a 12-month loan in 6 months, you might expect a refund of half the total interest. However, this is

Rule of 78: method for determining the amount of refund of the finance charge for an installment loan that is paid before it is due.

often not the case because the portion of the monthly payment that is interest is not the same from month to month. In some cases, interest or finance charge refunds are made according to the **rule of 78**. Some states allow this method to be used for short-term loans, generally 60 months or less. Laws and court rulings protect and inform the consumer in matters involving interest.

1 Find the interest refund using the rule of 78.

The rule of 78 is not based on the actual unpaid balance after a payment is made. Instead, it is an approximation that assumes the amount financed (which includes the interest) of a one-year loan is paid in 12 equal parts. For the first payment, the interest is based on the total amount financed, or $\frac{12}{12}$ of the loan. The interest for the second payment is based on $\frac{11}{12}$ of the amount financed since $\frac{1}{12}$ of this amount has already been paid. The interest for the third payment is $\frac{10}{12}$ of the amount financed, and so on. The interest on the last payment is based on $\frac{1}{12}$ of the amount financed.

The sum of all the parts accruing interest for a 12-month loan is $12 + 11 + 10 + 9 + 8 + 7 + 6 + 5 + 4 + 3 + 2 + 1$, or 78.

Thus, 78 equal parts accrue interest. The interest each part accrues is the same because the rate is the same and the parts are the same (each is $\frac{1}{12}$ of the principal). Since 78 equal parts each accrue equal interest, the interest each part accrues must be $\frac{1}{78}$ of the total interest for the one-year loan. So if the loan is paid in full with three months remaining, then the interest that would have accrued in the 10th, 11th, and 12th months is refunded. In the 10th month, three parts each accrue $\frac{1}{78}$ of the total interest; in the 11th month, two parts each accrue $\frac{1}{78}$ of the total interest; and in the 12th month, one part accrues $\frac{1}{78}$ of the total interest. So each of the $3 + 2 + 1$ parts, or 6 parts, accrues $\frac{1}{78}$ of the total interest. Thus $\frac{6}{78}$ of the total interest is refunded. The fraction $\frac{6}{78}$ is called the **refund fraction**.

Refund fraction: the fractional part of the total interest that is refunded when a loan is paid early using the rule of 78.

All installment loans are not for 12 months, but the rule of 78 gives us a pattern that we can apply to loans of any allowable length.

HOW TO Find the refund fraction for the interest refund

1. The numerator is the sum of the digits from 1 through the number of months remaining of a loan paid off before it was due.
2. The denominator is the sum of the digits from 1 through the original number of months of the loan.
3. The original fraction, the reduced fraction, or the decimal equivalent of the fraction can be used.

The sum-of-digits table in Table 12-2 can be used to find the numerator and denominator of the refund fraction.

TABLE 12-2
Sum-of-Digits

| Months | Sum of digits | Months | Sum of digits | Months | Sum of digits |
|--------|---------------|--------|---------------|--------|---------------|
| 1 | 1 | 21 | 231 | 41 | 861 |
| 2 | 3 | 22 | 253 | 42 | 903 |
| 3 | 6 | 23 | 276 | 43 | 946 |
| 4 | 10 | 24 | 300 | 44 | 990 |
| 5 | 15 | 25 | 325 | 45 | 1,035 |
| 6 | 21 | 26 | 351 | 46 | 1,081 |
| 7 | 28 | 27 | 378 | 47 | 1,128 |
| 8 | 36 | 28 | 406 | 48 | 1,176 |
| 9 | 45 | 29 | 435 | 49 | 1,225 |
| 10 | 55 | 30 | 465 | 50 | 1,275 |
| 11 | 66 | 31 | 496 | 51 | 1,326 |
| 12 | 78 | 32 | 528 | 52 | 1,378 |
| 13 | 91 | 33 | 561 | 53 | 1,431 |
| 14 | 105 | 34 | 595 | 54 | 1,485 |
| 15 | 120 | 35 | 630 | 55 | 1,540 |
| 16 | 136 | 36 | 666 | 56 | 1,596 |
| 17 | 153 | 37 | 703 | 57 | 1,653 |
| 18 | 171 | 38 | 741 | 58 | 1,711 |
| 19 | 190 | 39 | 780 | 59 | 1,770 |
| 20 | 210 | 40 | 820 | 60 | 1,830 |

There is a shortcut for finding the sum of consecutive numbers beginning with 1. You may be interested to know that a young boy in elementary school discovered this shortcut in the late 18th century. He later went on to be one of the greatest mathematicians of all time. His name was Carl Friedrich Gauss (1777–1855).

TIP

The Sum of Consecutive Numbers Beginning with 1

Multiply the largest number by 1 more than the largest number and divide the product by 2.

$$\text{Sum of consecutive numbers beginning with 1} = \frac{\text{largest number} \times (\text{largest number} + 1)}{2}$$

$$\text{Sum of consecutive numbers from 1 through 4} = \frac{4(5)}{2} = \frac{20}{2} = 10$$

$$\text{Sum of consecutive numbers from 1 through 12} = \frac{12(13)}{2} = \frac{156}{2} = 78$$

HOW TO — Find the interest refund using the rule of 78

1. Find the refund fraction.
2. Multiply the total interest by the refund fraction.

$$\text{Interest refund} = \text{total interest} \times \text{refund fraction}$$

EXAMPLE 1

A loan for 12 months with interest of $117 is paid in full with four payments remaining. Find the refund fraction for the interest refund.

$$\text{Refund fraction} = \frac{\text{sum of the digits for number of payments remaining}}{\text{sum of the digits for total number of payments}}$$

$$= \frac{1 + 2 + 3 + 4}{1 + 2 + 3 + 4 + 5 + 6 + 7 + 8 + 9 + 10 + 11 + 12}$$

$$= \frac{10}{78} = \frac{5}{39} \text{ or } 0.1282051282 \qquad\qquad 10 \div 78 = 0.1282051282$$

The refund fraction is $\frac{10}{78}$ or $\frac{5}{39}$ or 0.1282051282.

EXAMPLE 2

Find the interest refund for the installment loan in Example 1.

Interest refund = total interest × refund fraction Total interest = $117

$$\text{Refund fraction} = \frac{10}{78} \text{ or } \frac{5}{39} \text{ or } 0.1282051282$$

$$= \$117(0.1282051282) \qquad \text{Multiply.}$$

$$= \$15$$

The interest refund is $15.

TIP

Continuous Sequence of Steps Using a Calculator

It is advisable in making calculations as in Example 2 that you use a continuous sequence of steps in a calculator. It is time consuming and more mistakes are made if you reenter the result of a previous calculation to make another calculation.

For Example 2, the continuous sequence of steps is:

$\boxed{\text{CLEAR}}\,117\,\boxed{\times}\,10\,\boxed{\div}\,78\,\boxed{=}\;\Rightarrow 15$

When using a calculator, there is no need to reduce fractions first.

 STOP AND CHECK

1. A loan for 12 months with interest of $397.85 is paid in full with five payments remaining. What is the refund fraction for the interest refund?

2. A loan for 48 months has interest of $2,896 and is paid in full with 18 months remaining. What is the refund fraction for the interest refund?

3. A loan for 36 months requires $1,798 interest. The loan is paid in full with 6 months remaining. How much interest is refunded?

4. Ruth Brechner borrowed money to purchase a retail business. The 60-month loan had $4,917 interest. Ruth's business flourished and she repaid the loan after 50 months. How much interest refund did she receive?

12-2 SECTION EXERCISES

SKILL BUILDERS

1. Calculate the refund fraction for a 60-month loan that is paid off with 18 months remaining.

2. Find the refund fraction on an 18-month loan if it is paid off with 8 months remaining.

3. Find the interest refund on a 36-month loan with interest of $2,817 if the loan is paid in full with 9 months remaining.

4. Stephen Helba took out a loan to purchase a computer. He originally agreed to pay off the loan in 18 months with a finance charge of $205. He paid the loan in full after 12 payments. How much finance charge refund should he get?

APPLICATIONS

5. John Paszel took out a loan for 48 months but paid it in full after 28 months. Find the refund fraction he should use to calculate the amount of his refund.

6. If the finance charge on a loan made by Marjorie Young is $1,645 and the loan is to be paid in 48 monthly payments, find the finance charge refund if the loan is paid in full with 28 months remaining.

7. Phillamone Berry has a car loan with a company that refunds interest using the rule of 78 when loans are paid in full ahead of schedule. He is using an employee bonus to pay off his Taurus, which is on a 42-month loan. The total interest for the loan is $2,397, and he has 15 more payments to make. How much finance charge will he get credit for if he pays the loan in full immediately?

8. Dwayne Moody purchased a four-wheel drive vehicle and is using severance pay from his current job to pay off the vehicle loan before moving to his new job. The total interest on the 36-month loan is $3,227. How much finance charge refund will he receive if he pays the loan in full with 10 more payments left?

12-3 OPEN-END CREDIT

LEARNING OUTCOMES

1 Find the finance charge and new balance using the average daily balance method.
2 Find the finance charge and new balance using the unpaid or previous month's balance.

Line-of-credit accounts: a type of open-end loan.

Open-end loans are often called **line-of-credit accounts**. While a person or company is paying off loans, that person or company may also be adding to the total loan account by making a new purchase or otherwise borrowing money on the account.

For example, you may want to use your Visa card to buy new textbooks even though you still owe for clothes bought last winter. Likewise, a business may use an open-end credit account to buy a new machine this month even though it still owes the bank for funds used to pay a major supplier six months ago.

Nearly all open-end accounts are billed monthly. Interest rates are most often stated as annual rates. The Fair Credit and Charge Card Disclosure Act of 1988 and updates passed since that time specify the required details that must be disclosed for charge cards and line-of-credit accounts. These details include all fees, grace period, how finance charges are calculated, how late fees are assessed, and so on. Interest on many open-end credit accounts is figured according to the *average daily balance method.*

1 Find the finance charge and new balance using the average daily balance method.

Average daily balance: the average of the daily balances for each day of the billing cycle.

Many lenders determine the finance charge using the **average daily balance** method. In this method, the daily balances of the account are determined, and then the sum of these balances is divided by the number of days in the billing cycle. This average daily balance is then multiplied by the monthly interest rate to find the finance charge for the month.

Billing cycle: the days that are included on a statement or bill.

Even though open-end credit accounts are billed monthly, the monthly period may not coincide with the first and last days of a calendar month. To spread out the workload for the billing department, each account is given a monthly billing cycle. The **billing cycle** is the days that are included on a statement or bill. This cycle can start on any day of a month. For example, a billing cycle may start on the 22nd of one month and end on the 21st of the next month. This means that the number of days of a billing cycle will vary from month to month based on the number of days in the months involved.

HOW TO Find the average daily balance

1. Find the daily unpaid balance for each day in the billing cycle.
 (a) Find the total purchases and cash advances charged to the account during the day.
 (b) Find the total credits (payments and adjustments) credited to the account during the day.
 (c) To the previous daily unpaid balance, add the total purchases and cash advances for the day (from step 1a). Then subtract the total credits for the day (from step 1b).

> Daily unpaid balance = previous daily unpaid balance + total purchases and cash advances for the day − total credits for the day

2. Add the unpaid balances from step 1 for each day of the billing cycle, and divide the sum by the number of days in the cycle.

$$\text{Average daily balance} = \frac{\text{sum of daily unpaid balances}}{\text{number of days in billing cycle}}$$

HOW TO Find the finance charge using the average daily balance

1. Determine the decimal equivalent of the rate per period.
2. Multiply the average daily balance by the decimal equivalent of the rate per period.

EXAMPLE 1 Use the chart showing May activity in the Hodge's Tax Service charge account to determine the average daily balance and finance charge for the month. The bank's finance charge is 1.5% per month on the average daily balance.

| Date transaction posted | Transaction | Transaction amount |
|---|---|---|
| May 1 | Billing date | Balance $122.70 |
| May 7 | Payment | 25.00 |
| May 10 | Purchase (pencils) | 12.00 |
| May 13 | Purchase (envelopes) | 20.00 |
| May 20 | Cash advance | 50.00 |
| May 23 | Purchase (business forms) | 100.00 |

To find the average daily balance, we must find the unpaid balance for each day, add these balances, and divide by the number of days.

| Day | Balance | Day | Balance | Day | Balance |
|---|---|---|---|---|---|
| 1 | 122.70 | 11 | 109.70 | 21 | 179.70 |
| 2 | 122.70 | 12 | 109.70 | 22 | 179.70 |
| 3 | 122.70 | 13 | 129.70 (109.70 + 20) | 23 | 279.70 (179.70 + 100) |
| 4 | 122.70 | 14 | 129.70 | 24 | 279.70 |
| 5 | 122.70 | 15 | 129.70 | 25 | 279.70 |
| 6 | 122.70 | 16 | 129.70 | 26 | 279.70 |
| 7 | 97.70 (122.70 − 25) | 17 | 129.70 | 27 | 279.70 |
| 8 | 97.70 | 18 | 129.70 | 28 | 279.70 |
| 9 | 97.70 | 19 | 129.70 | 29 | 279.70 |
| 10 | 109.70 (97.70 + 12) | 20 | 179.70 (129.70 + 50) | 30 | 279.70 |
| | | | | 31 | 279.70 |

Total: $5,322.70 Average Daily Balance: $171.70

The average daily balance can also be determined by grouping days that have the same balance.
 For the first six days, May 1–May 6, there is no activity, so the daily unpaid balance is the previous unpaid balance of $122.70. The sum of daily unpaid balances for these six days, then, is 122.70(6).

$$\$122.70(6) = \$736.20$$

On May 7 there is a payment of $25, which reduces the daily unpaid balance.

$$\$122.70 - \$25 = \$97.70$$

The new balance of $97.70 holds for the three days (May 7, 8, and 9) until May 10.

$$\$97.70(3) = \$293.10$$

Continue doing this until you get to the end of the cycle. The calculations can be organized in a chart.

| Date | Change | Daily unpaid balance | Number of days | Partial sum |
|---|---|---|---|---|
| May 1–May 6 | | $122.70 | 6 | $ 736.20 |
| May 7–May 9 | −$25.00 | 97.70 | 3 | 293.10 |
| May 10–May 12 | +10.00 | 109.70 | 3 | 329.10 |
| May 13–May 19 | +20.00 | 129.70 | 7 | 907.90 |
| May 20–May 22 | +50.00 | 179.70 | 3 | 539.10 |
| May 23–May 31 | +100.00 | 279.70 | 9 | 2,517.30 |
| | | | Total 31 | $5,322.70 |

Divide the sum of $5,322.70 by the 31 days.

$$\text{Average daily balance} = \frac{\text{sum of daily unpaid balances}}{\text{number of days}}$$

$$= \frac{\$5,322.70}{31} = \$171.70$$

To find the interest, multiply the average daily balance by the monthly interest rate of 1.5%.

$$\text{Finance charge} = \$171.70(0.015)$$
$$= \$2.58$$

The average daily balance is $171.70 and the finance charge is $2.58.

☑ STOP AND CHECK

| Account Number | Credit Limit | Available Credit | Billing Period |
|---|---|---|---|
| xxxx-xxxx-xxxx-xxxx | $5,000 | $ | 9/24/05 to 10/24/05 |

| Posting Date | Transaction Date | Description | Amount CR–Credit PY–Payment |
|---|---|---|---|
| 9/26 | 9/24 | The Store Oxford MS | $11.93 CR |
| 10/6 | 10/02 | Chili's Oxford MS | $15.24 CR |
| 10/8 | 10/06 | Durall St Cloud FL | $86.98 CR |
| 10/10 | 10/10 | Payment Received–Thank You | $927.86 PY |
| 10/14 | 10/12 | Foley's Knitwear San Antonio TX | $113.19 CR |
| 10/20 | 10/16 | Red Lobster Tupelo MS | $22.88 CR |
| 10/20 | 10/19 | JC Penny Co Oxford MS | $47.36 CR |

Finance Charge

| Average Daily Balance | Monthly Periodic Rate | Corresponding Annual Percentage Rate | Finance Charge |
|---|---|---|---|
| Purchases | | Variable | |
| | 1.0750% | 12.90% | |
| Cash Advances | | Variable | |
| $0.00 | 1.0750% | 12.90% | |

Balance

| | | |
|---|---|---|
| Previous Balance | $ | 1,406.54 |
| Purchases | + | 297.58 |
| Other Charges | + | .00 |
| Cash Advances | + | 0.00 |
| Credits | − | .00 |
| Payments | − | 927.86 |
| Late Charges | + | .00 |
| Finance Charges | + | |
| New Balance | $ | |

FIGURE 12-1

Use the statement in Figure 12-1 for Exercises 1–4.

1. Make a table showing the unpaid balance for each day in the billing period.

2. Find the average daily balance for the month.

3. Find the finance charge for the month.

4. Find the new balance for the month.

2 Find the finance charge and new balance using the unpaid or previous month's balance.

Not all open-end credit accounts use the average daily balance method for determining the monthly finance charge. Another method uses the unpaid or previous month's balance as the basis for determining the finance charge. In this method, the new purchases or payments made during a month do not affect the finance charge for that month.

HOW TO Find the finance charge and new balance using the unpaid or previous month's balance.

Finance charge:

1. Find the monthly rate.

$$\text{Monthly rate} = \frac{\text{Annual percentage rate}}{12}$$

2. Multiply the unpaid or previous month's balance by the monthly rate.

Finance charge = Unpaid balance × Monthly rate

New balance:

1. Total the purchases and cash advances for the billing cycle.
2. Total the payments and credits for the billing cycle.
3. Adjust the unpaid balance of the previous month using the totals in steps 1 and 2.

New balance = Previous balance + Finance charge + Purchases and cash advances − Payments and credits

EXAMPLE 1 Hanna Stein has a department store revolving credit account with an annual percentage rate of 21%. Her unpaid balance for her March billing cycle is $285.45. During the billing cycle she purchased shoes for $62.58 and a handbag for $35.18. She returned a blouse that she had purchased in the previous billing cycle and received a credit of $22.79 and she made a payment of $75. If the store uses the unpaid balance method, what are the finance charge and the new balance?

Monthly rate:

$$\text{Monthly rate} = \frac{\text{Annual percentage rate}}{12}$$

$$\text{Monthly rate} = \frac{21\%}{12} = \frac{0.21}{12} = 0.0175$$

Finance charge:

Finance charge = Unpaid balance × Monthly rate

Finance charge = $285.45(0.0175) = $5.00 Rounded from $4.995375

New balance:

Total purchases and cash advances = $62.58 + $35.18 = $97.76

Total payments and credits = $75 + $22.79 = $97.79

New balance = Previous balance + Finance charge + Purchases and cash advances −
 Payments and credits

New balance = $285.45 + $5 + $97.76 − $97.79 = $290.42

STOP AND CHECK

1. Shakina Brewster has a Target revolving credit account that has an annual percentage rate of 18% on the unpaid balance. Her unpaid balance for the July billing cycle is $1,285.96. During the billing cycle, Shakina purchased groceries for $98.76 and received $50 in cash. She purchased linens for $46.98. Shakina made a payment of $135. Find the finance charge and new balance if Target uses the unpaid balance method.

2. Shameka Brown has a Best Buy Stores revolving credit account that has an annual percentage rate of 15% on the unpaid balance. Her unpaid balance for the October billing cycle is $2,531.77. During the billing cycle, Shameka purchased movies for $58.63 and received $70 in cash. She purchased a camera for $562.78 and returned a printer purchased in September for credit of $85.46. Shameka made a payment of $455. Find the finance charge and new balance if Best Buy uses the unpaid balance method.

3. Dallas Hunsucker has a Master Card account with an annual percentage rate of 24%. The unpaid balance for his January billing cycle is $2,094.54. During the billing cycle he made grocery purchases of $65.82, $83.92, $12.73, and gasoline purchases of $29.12 and $28.87. He made a payment of $400. If the account applies the unpaid balance method, what were the finance charge and the new balance?

4. Ryan Bradley has a Visa Card with an introductory annual percentage rate of 9%. The unpaid balance for his February billing cycle is $245.18. During the billing cycle he purchased fresh flowers for $45.00, candy for $22.38, and gasoline for $36.53. He made a payment of $100 and had a return for credit of $74.93. If the account applies the unpaid balance method, what are the finance charge and the new balance?

12-3 SECTION EXERCISES

SKILL BUILDERS

1. What is the monthly interest rate if an annual rate is 13.8%?

2. Find the monthly interest rate if the annual rate is 15.6%.

3. A credit card has an average daily balance of $2,817.48 and the monthly periodic rate is 1.325%. What is the finance charge for the month?

4. What is the finance charge on a credit card account that has an average daily balance of $5,826.42 and the monthly interest rate is 1.55%?

APPLICATIONS

5. Jim Riddle has a credit card that charges 10% annual interest on the monthly average daily balance for the billing cycle. The current billing cycle has 29 days. For 15 days his balance was $2,534.95. For 7 days the balance was $1,534.95. And for 7 days the balance was $1,892.57. Find the average daily balance. Find the amount of interest.

6. Suppose the charge account of Strong's Mailing Service at the local supply store had a 1.8% interest rate per month on the average daily balance. Find the average daily balance if Strong's had an unpaid balance on March 1 of $128.50, a payment of $20 posted on March 6, and a purchase of $25.60 posted on March 20. The billing cycle ends March 31.

7. Using Exercise 6, find Strong's finance charge on April 1.

8. Make a chart to show the transactions for Rick Schiendler's credit card account in which interest is charged on the average daily balance. The cycle begins on May 4, and the cycle ends on June 3. The beginning balance is $283.57. A payment of $200 is posted on May 18. A charge of $19.73 is posted on May 7. A charge of $53.82 is posted on May 12. A charge of $115.18 is posted on May 29. How many days are in the cycle? What is the average daily balance?

9. Rick is charged 1.42% per period. What is the finance charge for the cycle?

10. What is the beginning balance for the next cycle of Rick's credit card account?

11. Jamel Cisco has a Visa Card with an annual percentage rate of 16.8%. The unpaid balance for his June billing cycle is $1,300.84. During the billing cycle he purchased a printer cartridge for $42.39, books for $286.50 and gasoline for $16.71. He made a payment of $1,200. If the account applies the unpaid balance method, what are the finance charge and the new balance?

12. Chaundra Mixon has a Master Card with an annual percentage rate of 19.8%. The unpaid balance for her August billing cycle is $675.21. During the billing cycle she purchased shoes for $87.52, a suit for $132.48, and a wallet for $28.94. She made a payment of $225. If the account applies the unpaid balance method, what are the finance charge and the new balance?

Learning Outcomes

What to Remember with Examples

Section 12-1

1 Find the amount financed, the installment price, and the finance charge of an installment loan. (p. 422)

1. Find the amount financed: Subtract the down payment from the cash price.

$$\text{Amount financed} = \text{cash price} - \text{down payment}$$

2. Find the installment price: Add the down payment to the total of the installment payments.

$$\text{Installment price} = \text{total of installment payments} + \text{down payment}$$

> Find the installment price of a computer that is paid for in 24 monthly payments of $113 if a down payment of $50 is made.
>
> $$(24)(\$113) + \$50 = \$2,712 + \$50 = \$2,762$$

Find the finance charge of an installment loan: Subtract the cash price from the installment price.

$$\text{Finance charge} = \text{installment price} - \text{cash price}$$

> If the cash price of the computer in the previous example was $2,499, how much is the finance charge?
>
> $$\$2,762 - \$2,499 = \$263$$

2 Find the installment payment of an installment loan. (p. 423)

1. Find the total of the installment payments: Subtract the down payment from the installment price.

$$\text{Total of installment payments} = \text{installment price} - \text{down payment}$$

2. Divide the total of installment payments by the number of installment payments.

$$\text{Installment payment} = \frac{\text{total of installment payments}}{\text{number of payments}}$$

> Find the monthly payment on a computer if the cash price is $3,285. A 14% interest rate is charged on the cash price, and there are 12 monthly payments.
>
> $$\$3,285(0.14)(1) = \$459.90$$
> $$\text{Installment price} = \$3,285 + \$459.90 = \$3,744.90$$
> $$\text{Monthly payment} = \frac{\$3,744.90}{12} = \$312.08$$
>
> A computer has an installment price of $2,187.25 when financed over 18 months. If a $100 down payment is made, find the monthly payment.
>
> $$\$2,187.25 - \$100 = \$2,087.25$$
> $$\text{Monthly payment} - \frac{\$2,087.25}{18} = \$115.96$$

3 Find the estimated annual percentage rate (APR) using a table. (p. 424)

1. Find the interest per $100 of amount financed: Divide the finance charge by the amount financed and multiply by $100.

$$\text{Interest per \$100} = \frac{\text{total finance charge}}{\text{amount financed}} \times \$100$$

2. Find the row corresponding to the number of monthly payments. Move across the row to find the number closest to the value from step 1. Read up the column to find the annual percentage rate for that column.

Find the annual percentage rate on a loan of $500 that is repaid in 36 monthly installments. The interest for the loan is $95.

$$\text{Interest per }\$100 = \frac{\$95}{\$500}(\$100) = \$19$$

In the row for 36 months, move across to 19.14 (nearest to 19). APR is at the top of the column, 11.75%.

Section 12-2

1 Find the interest refund using the rule of 78. (p. 430)

Find the refund fraction.

1. The numerator is the sum of the digits from 1 through the number of months remaining of a loan paid off before it was due.
2. The denominator is the sum of the digits from 1 through the original number of months of the loan.
3. The original fraction, the reduced fraction or the decimal equivalent of the fraction can be used.

Find the refund fraction on a loan that has a total finance charge of $892 and was made for 24 months. The loan is paid in full with 10 months (payments) remaining.

$$\text{Refund fraction} = \frac{\text{sum of digits from 1 to the number of periods remaining}}{\text{sum of digits from 1 through original number of periods}}$$

$$= \frac{\text{sum of 1 to 10}}{\text{sum of 1 to 24}}$$

$$= \frac{55}{300} \text{ or } \frac{11}{60} \text{ or } 0.1833333333$$

Find the interest refund using the rule of 78.

1. Find the refund fraction.
2. Multiply the total interest by the refund fraction.

$$\text{Interest refund} = \text{total interest} \times \text{refund fraction}$$

Find the interest refund for the previous example.

$$\text{Interest refund} = \$892\left(\frac{11}{60}\right) = \$163.53 \quad 892 \times 11 \div 60 = \Rightarrow 163.5333333$$

Section 12-3

1 Find the finance charge and new balance using the average daily balance method. (p. 433)

1. Find the daily unpaid balance for each day in the billing cycle.
 (a) Find the total purchases and cash advances charged to the account during the day.
 (b) Find the total credits (payments and adjustments) credited to the account during the day.
 (c) To the previous daily unpaid balance, add the total purchases and cash advances for the day (from step 1a). Then subtract the total payments for the day (from step 1b).

 $$\text{Daily unpaid balance} = \text{previous daily unpaid balance} + \text{total purchases and cash advances for the day} - \text{total credits for the day}$$

2. Add the unpaid balances from step 1 for each day of the billing cycle, and divide the sum by the number of days in the cycle.

 $$\text{Average daily balance} = \frac{\text{sum of daily unpaid balances}}{\text{number of days in billing cycle}}$$

A credit card has a balance of $398.42 on September 14, the first day of the billing cycle. A charge of $182.37 is posted to the account on September 16. Another charge of $82.21 is posted to the account on September 25. The amount of a returned item ($19.98) is posted to the account on October 10 and a payment of $500 is made on October 12. The billing period ends on October 13. Find the average daily balance.

| Date | Change | Daily Unpaid Balance | Number of Days | Partial Sum |
|---|---|---|---|---|
| September 14–15 | | $398.42 | 2 days | $ 796.84 |
| September 16–24 | +$182.37 | 580.79 | 9 days | 5,227.11 |
| September 25–October 9 | +82.21 | 663.00 | 15 days | 9,945.00 |
| October 10–11 | −19.98 | 643.02 | 2 days | 1,286.04 |
| October 12–13 | −500.00 | 143.02 | 2 days | 286.04 |
| | | | Total 30 days | $17,541.03 |

Average daily balance = $17,541.03 ÷ 30 = $584.70

Find the finance charge using the average daily balance.

1. Determine the decimal equivalent of the rate per period.
2. Multiply the average daily balance by the decimal equivalent of the rate per period.

Find the finance charge for the average daily balance in the preceding example if the monthly rate is 1.3%.

$$\text{Finance charge} = \$584.70(0.013) = \$7.60$$

2 Find the finance charge and new balance using the unpaid or previous month's balance. (p. 436)

Finance charge:

1. Find the monthly rate.

$$\text{Monthly rate} = \frac{\text{Annual percentage rate}}{12}$$

2. Multiply the unpaid or previous month's balance by the monthly rate.

$$\text{Finance charge} = \text{Unpaid balance} \times \text{Monthly rate}$$

New balance:

1. Total the purchases and cash advances for the billing cycle.
2. Total the payments and credits for the billing cycle.
3. Adjust the unpaid balance of the previous month using the totals in steps 1 and 2.

Dakota Beasley has a Visa account with an annual percentage rate of 24%. Her unpaid balance for her September billing cycle is $381.15. During the billing cycle she made gasoline purchases of $25.18, $18.29, $22.75, and $19.12. She made a payment of $100. If the account applies the unpaid balance method, what is the finance charge and the new balance?

$$\text{Monthly rate} = \frac{\text{Annual percentage rate}}{12}$$

$$\text{Monthly rate} = \frac{24\%}{12} = \frac{0.24}{12} = 0.02$$

Finance charge = Unpaid balance × Monthly rate
Finance charge = $381.15(0.02) = $7.62 Rounded from $7.623
Total purchases = $25.18 + $18.29 + $22.75 + $19.12
 = $85.34
 Payments = $100
New balance = $381.15 + $7.62 + $85.34 − $100
 = $374.11

EXERCISES SET A

CHAPTER 12

1. Find the installment price of a notebook computer system bought on the installment plan with $250 down and 12 payments of $111.33.

2. Find the monthly payment on a water bed if the installment price is $1,050, the down payment is $200, and there are 10 monthly payments.

3. If the cash price of a refrigerator is $879 and a down payment of $150 is made, how much is to be financed?

4. Find the refund fraction for a 60-month loan if it is paid in full with 22 months remaining.

Use the rule of 78 to find the finance charge (interest) refund in each of the following.

| | Finance charge | Number of monthly payments | Remaining payments | Interest refund |
|---|---|---|---|---|
| CEL 5. | $238 | 12 | 4 | |
| CEL 6. | $2,175 | 24 | 10 | |
| CEL 7. | $896 | 18 | 4 | |

8. The finance charge on a copier was $1,778. The loan for the copier was to be paid in 18 monthly payments. Find the finance charge refund if it is paid off in eight months.

9. Becky Whitehead has a loan with $1,115 in finance charges, which she paid in full after 10 of the 24 monthly payments. What is her finance charge refund?

10. Alice Dubois was charged $455 in finance charges on a loan for 15 months. Find the finance charge refund if she pays off the loan in full after 10 payments.

11. Find the finance charge refund on a 24-month loan with monthly payments of $103.50 if you decide to pay off the loan with 10 months remaining. The finance charge is $215.55.

12. If you purchase a fishing boat for 18 monthly payments of $106 and an interest charge of $238, how much is the refund after 10 payments?

13. Find the interest on an average daily balance of $265 with an interest rate of $1\frac{1}{2}\%$.

14. Find the finance charge on a credit card with an average daily balance of $465 if the rate charged is 1.25%.

15. Use the following activity chart to find the unpaid balance on November 1. The billing cycle ended on October 31, and the finance charge is 1.5% of the average daily balance.

| Date posted | Activity | Amount |
|---|---|---|
| October 1 | Billing date | Previous balance $426.40 |
| October 8 | Purchase | 41.60 |
| October 11 | Payment | 70.00 |
| October 16 | Purchase | 31.25 |
| October 21 | Purchase | 26.80 |

Use Table 12-1 to find the annual percentage rate (APR) for the following exercises.

16. Find the annual percentage rate on a loan of $1,500 for 18 months if the loan requires $190 interest and is repaid monthly.

17. Find the annual percentage rate on a loan of $3,820 if the monthly payment is $130 for 36 months.

18. A vacuum cleaner was purchased on the installment plan with 12 monthly payments of $36.98 each. If the cash price was $415 and there was no down payment, find the annual percentage rate.

19. A merchant charged $420 in cash for a dining room set that could be bought for $50 down and $40.75 per month for 10 months. What is the annual percentage rate?

20. An electric mixer was purchased on the installment plan for a down payment of $60 and 11 monthly payments of $11.05 each. The cash price was $170. Find the annual percentage rate.

21. A computer was purchased by paying $50 down and 24 monthly payments of $65 each. The cash price was $1,400. Find the annual percentage rate to the nearest tenth of a percent.

EXERCISES SET B

1. A television set has been purchased on the installment plan with a down payment of $120 and six monthly payments of $98.50. Find the installment price of the television set.

2. A dishwasher sold for a $983 installment price with a down payment of $150 and 12 monthly payments. How much is each payment?

3. What is the cash price of a chair if the installment price is $679, the finance charge is $102, and there was no down payment?

4. Find the refund fraction for a 42-month loan if it is paid in full with 16 months remaining.

Use the rule of 78 to find the finance charge refund in each of the following.

| | Finance charge | Number of monthly payments | Remaining payments | Interest refund |
|---|---|---|---|---|
| XCEL 5. | $1,076 | 18 | 6 | |
| XCEL 6. | $476 | 12 | 5 | |
| XCEL 7. | $683 | 15 | 11 | |

8. Find the refund fraction on a 48-month loan if it is paid off after 20 months.

9. Lanny Jacobs made a loan to purchase a computer. Find the refund due on this loan with interest charges of $657 if it is paid off after paying 7 of the 12 monthly payments.

10. Suppose you have borrowed money that is being repaid at $45 a month for 12 months. What is the finance charge refund after making eight payments if the finance charge is $105?

11. You have purchased a new stereo on the installment plan. The plan calls for 12 monthly payments of $45 and a $115 finance charge. After nine months you decide to pay off the loan. How much is the refund?

12. The interest for an automobile loan is $2,843. The automobile is financed for 36 monthly payments, and interest refunds are made using the rule of 78. How much interest should be refunded if the loan is paid in full with 22 months still remaining?

13. Find the finance charge on $371 if the interest charge is 1.4% of the average daily balance.

14. A new desk for an office has a cash price of $1,500 and can be purchased on the installment plan with a 12.5% finance charge. The desk will be paid for in 12 monthly payments. Find the amount of the finance charge, the total price, and the amount of each monthly payment, if there was no down payment.

15. On January 1 the previous balance for Lynn's charge account was $569.80. On the following days, purchases were posted:

January 13 $38.50 jewelry
January 21 $44.56 clothing

On January 16 a $50 payment was posted. Using the average daily balance method, find the finance charge and unpaid balance on February 1 if the bank charges interest of 1.5% per month.

Use Table 12-1 to find the annual percentage rate for the following exercises.

16. Find the annual percentage rate on a loan for 25 months if the amount of the loan without interest is $300. The loan requires $40 interest.

17. Find the annual percentage rate on a loan of $700 without interest with 12 monthly payments. The loan requires $50 interest.

18. A queen-size brass bed costs $1,155 and is financed with monthly payments for three years. The total finance charge is $415.80. Find the annual percentage rate.

19. John Edmonds borrowed $500. He repaid the loan in 22 monthly payments of $26.30 each. Find the annual percentage rate.

20. A loan of $3,380 was paid back in 30 monthly payments with an interest charge of $620. Find the annual percentage rate.

21. A 6 × 6 color enlarger costs $1,295 and is financed with monthly payments for two years. The total finance charge is $310.80. Find the annual percentage rate.

PRACTICE TEST

1. Find the finance charge on an item with a cash price of $469 if the installment price is $503 and no down payment was made.

2. An item with a cash price of $578 can be purchased on the installment plan in 15 monthly payments of $46. Find the installment price if no down payment was made. Find the finance charge.

3. A copier that originally cost $300 was sold on the installment plan at $28 per month for 12 months. Find the installment price if no down payment was made. Find the finance charge.

4. Use Table 12-1 to find the annual percentage rate for the loan in Exercise 3.

5. Use Table 12-1 to find the APR on a loan of $3,000 for three years if the loan had $810 interest and was repaid monthly.

6. Find the interest on an average daily balance of $165 if the monthly interest rate is $1\frac{3}{4}\%$.

7. Find the yearly rate of interest on a loan if the monthly rate is 2%.

8. Find the interest refunded on a 15-month loan with total interest of $72 if the loan is paid in full with six months remaining.

9. Find the annual percentage rate on a loan of $1,600 for 24 months if $200 interest is charged and the loan is repaid in monthly payments. Use Table 12-1.

10. Find the annual interest rate on a loan that is repaid monthly for 26 months if the amount of the loan is $1,075. The interest charged is $134.85.

11. Office equipment was purchased on the installment plan with 12 monthly payments of $11.20 each. If the cash price was $120 and there was no down payment, find the annual percentage rate.

12. A canoe has been purchased on the installment plan with a down payment of $75 and 10 monthly payments of $80 each. Find the installment price of the canoe.

13. Find the monthly payment when the installment price is $2,300, a down payment of $400 is made, and there are 12 monthly payments.

14. How much is to be financed on a cash price of $729 if a down payment of $75 is made?

15. A 30-month loan that has interest of $3,987 is paid in full with 7 months remaining. Find the amount of interest to be refunded.

16. Use the following activity chart to find the average daily balance, finance charge, and unpaid balance for July. The monthly interest rate is 1.75%. The billing cycle has 31 days.

| Date Posted | Activity | Amount |
|---|---|---|
| July 1 | Billing date | Previous balance $441.05 |
| July 5 | Payment | $75.00 |
| July 16 | Purchase | 23.50 |
| July 26 | Purchase | 31.40 |

17. Mary Lawson has a credit card account with an annual percentage rate of 18.24%. The unpaid balance for her November billing cycle is $783.56. During the billing cycle she purchased a desk chair for $134.77 and a floor mat for $82.36. Mary returned a grill purchased in the previous month for a credit of $186.21 and she made a payment of $80. If the account applies the unpaid balance method, what are the finance charge and the new balance?

1. Explain the mistake in the solution of the problem and correct the solution.

Dawn Mayhall financed a car and the loan of 42 months required $3,827 interest. She paid the loan off after making 20 payments. How much interest should be refunded if the rule of 78 is used?

Solution:

Refund fraction $= \dfrac{210}{903}$

$\dfrac{210}{903}(\$3,827) = \890

Thus, $890 should be refunded.

2. Explain the mistake in the solution and correct the solution.

Ava Landry agreed to pay $2,847 interest for a 36-month loan to redecorate her greeting card shop. However, business was better than expected and she repaid the loan with 16 months remaining. If the rule of 78 was used, how much interest should she get back?

Solution:

$\dfrac{16}{36}(\$2,847) = \$1,265.33$

Thus, $1,265.33 should be refunded.

3. Arrange the consecutive numbers from 1 to 10 in ascending order, then in descending order, so that 1 and 10, 2 and 9, 3 and 8, etc., align vertically. Add vertically. Find the grand total. Finally divide the grand total by 2.

4. Explain why finding the sum of consecutive numbers by using the process in Exercise 3 requires that the product be divided by 2.

5. Explain why the formula for finding the sum of consecutive numbers requires the product of the largest number and one *more* than the largest number rather than one *less* than the largest number.

6. Give three examples of finding the sum of consecutive odd numbers beginning with 1.

Challenge Problem

It pays to read the details! Bank One Delaware offers a Platinum Visa Credit Card to qualifying persons with an introductory 0% fixed APR on all purchases and balance transfers and, after the 12-month introductory period, a low variable APR on purchases and balance transfers at a current rate of 8.99%. However, the default rate is 24.99% APR. A default occurs if the minimum payment is not received by the due date on the billing statement or if your balance ever exceeds your credit limit. Find the difference in just one month's interest on an average daily balance of $1,000 if the payment is not received by the date.

12.1 Know What You Owe

Nancy Tai has recently opened a revolving charge account with MasterCard. Her credit limit is $1,000, but she has not charged that much since opening the account. Nancy hasn't had the time to review her monthly statements promptly as she should, but over the upcoming weekend she plans to catch up on her work. She has been putting it off because she can't tell how much interest she paid or the unpaid balance in November. She spilled watercolor paint on that portion of the statement.

In reviewing November's statement she notices that her beginning balance was $600 and that she made a $200 payment on November 10. She also charged purchases of $80 on November 5, $100 on November 15, and $50 on November 30. She paid $5.27 in interest the month before. She does remember, though, seeing the letters APR and the number 16 percent. Also, the back of her statement indicates that interest was charged using the average daily balance method, including current purchases, which considers the day of a charge or credit.

1. Find the unpaid balance on November 30 before the interest is charged.

2. Assuming a 30-day period in November find the average daily balance.

3. Calculate the interest for November.

4. What was the unpaid balance for November after interest is charged?

12.2 Massage Therapy

It was time to expand her massage therapy business, and Arminte had finally found a commercial space that met her needs. With room for herself and the two new massage therapists she planned to hire, and adjacent to a chiropractor's office, the space was everything that she had hoped for. Now all she needed was to finalize purchases for three massage rooms, furniture for the reception area, various artwork, and miscellaneous supplies. Arminte started to make a list of massage equipment: 3 tables at $1,695 each; 3 stools at $189 each; a portable massage chair for $399; and the list went on—bolsters, pillows, sheets, table warmers, and music. By the time Arminte was finished, her massage equipment alone totaled $7,644.25, including sales tax. The supplier offered in-house financing of 24 monthly payments at $325.33 per month, with a 10% down payment.

1. Find the amount financed, installment price, and the finance charge presuming Arminte goes with the financing available through her supplier.

2. Use Table 12-1 to find the annual percentage rate (APR) of the financing.

Source: Adapted from Winger and Frasca, *Personal Finance: An Integrated Approach,* 6th edition, Upper Saddle River, NJ: Prentice Hall, p. 162.

3. If Arminte takes the financing but pays it in full with 9 months remaining, what is the amount of the finance charge to be refunded using the rule of 78?

4. Arminte had recently opened a revolving charge account with MasterCard, to pick up some miscellaneous supplies for her business. Her credit limit is $1,500, with 18% APR. Her beginning balance for the month of April was $440, and she made a payment of $60, which was received on April 10. She purchased massage oil for $240 on April 6, office supplies for $68.45 on April 14, a CD player for $129.44 on April 20, and $25 in gas on April 27. Arminte's statement indicates that interest is charged using the average daily balance method, including current purchases, which considers the day of a charge or credit. Assuming a 30-day period in April, find the average daily balance and the interest for April.

Auto Loans: When Is 4% APR Better Than 0% APR?

What could possibly be wrong with a zero percent auto loan? Nothing could be more enticing than free money, and that's exactly what zero-percent finance deals seem to offer. With an auto loan, zero-percent financing may cost more than you think. Before taking on any loan, there are many things to consider. Compound interest—one of the topics you'll learn about in Chapter 13, is of special concern. With compound interest, you will actually pay more interest than you expect. Look for the annual percentage rate (APR) on your loan information. The APR tells you the effective interest rate that you will actually pay for the term of your loan. Does that mean a lower interest rate is the best deal? Not always. Here are a few things you should know about this special financing arrangement.

Anyone who purchases a vehicle with a cash rebate gets the rebate. But only about 5 percent of all consumers qualify for zero percent financing. You must have an excellent credit rating and a certain amount of income to qualify. Most zero percent loans have short payback terms, which mean higher monthly payments. You may have to make a large down payment and be subject to prepayment penalties. Also, most zero percent financing applies only to certain makes and models of vehicles or those already on the lot.

Want to make the best deal? Consider rebates instead of special financing. Rebates are simply a form of discount, or savings, which may be greater than the amount you would save with zero percent financing. The table below shows a comparison of zero percent financing versus a rebate. In the table, the rebate deals saved money compared to the zero percent financing—more than $800 savings over the life of the loan. Do the math ahead of time to find out whether the rebate or the special financing would save you more money.

| Financing a $20,000 New Car | | | | |
|---|---|---|---|---|
| **Loan terms** | **36 Months** | | **60 Months** | |
| APR | 0% | 4.0% | 2.9% | 5.6% |
| Price of new car | $20,000.00 | $20,000.00 | $20,000.00 | $20,000.00 |
| Less dealer rebate | $0 | $2,000.00 | $0 | $2,000.00 |
| Amount to finance | $20,000.00 | $18,000.00 | $20,000.00 | $18,000.00 |
| Monthly payment | $555.56 | $531.43 | $358.49 | $344.65 |
| Total financing cost | $20,000.00 | $19,131.48 | $21,509.40 | $20,679.00 |
| **Savings** | | **$868.52** | | **$830.40** |

LEARNING OUTCOMES

13-1 Compound Interest and Future Value

1. Find the future value and compound interest by compounding manually.
2. Find the future value and compound interest using a $1.00 future value table.
3. Find the future value and compound interest using a formula (optional).
4. Find the effective interest rate.
5. Find the interest compounded daily using a table.

13-2 Present Value

1. Find the present value based on annual compounding for one year.
2. Find the present value using a $1.00 present value table.
3. Find the present value using a formula (optional).

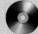 A corresponding Business Math Case Video for this chapter, *The Real World: Video Case: Should I Invest in Elvis?* can be found in Appendix A.

For some loans made on a short-term basis, interest is computed once, using the simple interest formula. For other loans, interest may be *compounded:* Interest is calculated more than once during the term of the loan or investment and this interest is added to the principal. This sum (principal + interest) then becomes the principal for the next calculation of interest, and interest is charged or paid on this new amount. This process of adding interest to the principal before interest is calculated for the next period is called *compounding interest.*

13-1 COMPOUND INTEREST AND FUTURE VALUE

LEARNING OUTCOMES

1 Find the future value and compound interest by compounding manually.
2 Find the future value and compound interest using a $1.00 future value table.
3 Find the future value and compound interest using a formula (optional).
4 Find the effective interest rate.
5 Find the interest compounded daily using a table.

Interest period: the amount of time after which interest is calculated and added to the principal.

Whether the interest rate is simple or compound, interest is calculated for each **interest period**. The entire period of the loan or investment is the single, simple interest period. When the interest is compounded, there are two or more interest periods, each of the same duration. The interest period may be one day, one week, one month, one quarter, one year, or some other designated period of time. The greater the number of interest periods in the time period of the loan or investment, the greater the total interest that accumulates during the time period. The total interest that accumulates is the **compound interest**. The sum of the compound interest and the original principal is the **future value** or **maturity value** or **compound amount** in the case of an investment, or the compound amount in the case of a loan. In this chapter we use the term *future value* to mean future value *or* compound amount, depending on whether the principal is an investment or a loan.

Compound interest: the total interest that accumulated after more than one interest period.

Future value, maturity value, compound amount: the accumulated principal and interest after one or more interest periods.

1 Find the future value and compound interest by compounding manually.

We can calculate the future value of the principal using the simple interest formula method. The terms of a loan or investment indicate the annual number of interest periods and the annual interest rate. Dividing the annual interest rate by the annual number of interest periods gives us the **period interest rate** or interest rate per period. We can use the period interest rate to calculate the interest that accumulates for each period using the familiar simple interest formula: $I = PRT$. I is the interest for the period, P is the principal at the beginning of the period, R is the period interest rate, and T is one period. Since we are calculating the interest for only one period, the length of time is one period. So the value of T in the formula is one period, and the formula is simplified to $I = PR(1)$, or $I = PR$. The value of P is different for each period in turn because the principal at the beginning of each period includes the original principal and all the interest so far accumulated.

Period interest rate: the rate for calculating interest for one interest period—the annual interest rate divided by the number of interest periods per year.

HOW TO Find the period interest rate

Divide the annual interest rate by the number of interest periods per year.

$$\text{Period interest rate} = \frac{\text{annual interest rate}}{\text{number of interest periods per year}}$$

HOW TO Find the future value using the simple interest formula method

1. Find the first end-of-period principal: Multiply the original principal by the sum of 1 and the period interest rate.

$$\text{First end-of-period principal} = \text{original principal} \times (1 + \text{period interest rate})$$
$$A = P(1 + R)$$

2. For each remaining period in turn, find the next end-of-period principal: Multiply the previous end-of-period principal by the sum of 1 and the period interest rate.

$$\text{End-of-period principal} = \text{previous end-of-period principal} \times (1 + \text{period interest rate})$$

3. Identify the last end-of-period principal as the future value.

Future value = last end-of-period principal

The future value is calculated before the compound interest can be calculated.

HOW TO **Find the compound interest**

Subtract the original principal from the future value.

Compound interest = future value − original principal

$$I = A - P$$

EXAMPLE 1 Duke's Photography secured a small business loan of $8,000 for three years, compounded annually. If the interest rate was 9%, find (a) the future value (compound amount) and (b) the compound interest paid on the loan. (c) Compare the compound interest with simple interest for the same loan period, original principal, and annual interest rate.

$$\text{Period interest rate} = \frac{\text{rate per year}}{\text{number of interest periods per year}}$$

(a) Since the loan is compounded annually, there is one interest period per year. So the period interest rate is 0.09. There are three interest periods, one for each of the three years.

First end-of-period principal = $8,000(1 + 0.09) 8,000(1.09) = 8,720
= $8,720

Next end-of-period principal = $8,720(1 + 0.09) 8,720(1.09) = 9,504.8
= $9,504.80

Third end-of-period principal = $9,504.80(1 + 0.09) 9,504.80(1.09) = 10,360.232
= $10,360.23

The future value is $10,360.23.

(b) Compound interest is the future value (compound amount) minus the original principal.

$10,360.23 Future value
−8,000.00 Original principal
$ 2,360.23 Compound interest

The compound interest is $2,360.23.

(c) Use the simple interest formula to find the simple interest on $8,000 at 9% annually for three years.

$$I = PRT$$
$$I = \$8,000(0.09)(3)$$
$$I = \$2,160.00 \qquad \text{Simple interest}$$

Difference: $2,360.23 − $2,160.00 = $200.23

The simple interest is $2,160.00, which is $200.23 less than the compound interest.

EXAMPLE 2 Find the future value of a $10,000 investment at 8% annual interest compounded semiannually for three years.

$$\text{Period interest rate} = \frac{8\% \text{ annually}}{2 \text{ periods annually}} = \frac{0.08}{2} = 0.04$$

Number of periods = years(2) = 3(2) = 6

First end-of-period principal $= \$10,000(1 + 0.04)$ $10,000(1.04) = 10,400$
 $= \$10,400$

Second end-of-period principal $= \$10,400(1 + 0.04)$ $10,400(1.04) = 10,816$
 $= \$10,816$

Third end-of-period principal $= \$11,248.64$ $10,816(1.04) = 11,248.64$

Fourth end-of-period principal $= \$11,698.59$ $11,248.64(1.04) = 11,698.59$

Fifth end-of-period principal $= \$12,166.53$ $11,698.59(1.04) = 12,166.53$

Sixth end-of-period principal $= \$12,653.19$ $12,166.53(1.04) = 12,653.19$

The future value is \$12,653.19.

TIP

Calculator Shortcut for Compounding

Many calculators keep the result of a calculation in the calculator and allow the next calculation to begin with this amount.

Examine the calculator steps that can be used for Example 2.

$10000 \;\boxed{\times}\; 1.04 \;\boxed{=}\; \Rightarrow 10400$ Record display as first end-of-period principal.

Do not clear the calculator.

$\boxed{\times}\; 1.04 \;\boxed{=}\; \Rightarrow 10816$ Record display as second end-of-period principal.

Continue without clearing the calculator.

$\boxed{\times}\; 1.04 \;\boxed{=}\; \Rightarrow 11248.64$ Record display as third end-of-period principal.
$\boxed{\times}\; 1.04 \;\boxed{=}\; \Rightarrow 11698.5856$ Record display as fourth end-of-period principal.
$\boxed{\times}\; 1.04 \;\boxed{=}\; \Rightarrow 12166.52902$ Record display as fifth end-of-period principal.
$\boxed{\times}\; 1.04 \;\boxed{=}\; \Rightarrow 12653.19018$ Record display as sixth end-of-period principal.

✔ STOP AND CHECK

1. Find the monthly interest rate on a loan that has an annual interest rate of 9.2%.

2. A loan of $2,950 at 8% annually is made for two years compounded annually. Find the future value (compound amount) of the loan. Find the amount of interest paid on the loan.

3. Find the future value of a $20,000 investment at 3.5% annual interest compounded semiannually for two years.

4. Find the future value of a $15,000 money market investment at 2.8% annual interest compounded semiannually for three years.

2 Find the future value and compound interest using a $1.00 future value table.

As you may have guessed from the previous examples, compounding interest for a large number of periods is very time-consuming. This task is done more quickly if you use a compound interest table, as shown in Table 13-1.

Table 13-1 gives the future value of $1.00, depending on the number of interest periods per year and the interest rate per period.

TABLE 13-1
Future Value or Compound Amount of $1.00

| Periods | 1% | 1.5% | 2% | 2.5% | 3% | 4% | 5% | 6% | 8% | 10% | 12% |
|---|---|---|---|---|---|---|---|---|---|---|---|
| 1 | 1.01000 | 1.01500 | 1.02000 | 1.02500 | 1.03000 | 1.04000 | 1.05000 | 1.06000 | 1.08000 | 1.10000 | 1.12000 |
| 2 | 1.02010 | 1.03023 | 1.04040 | 1.05063 | 1.06090 | 1.08160 | 1.10250 | 1.12360 | 1.16640 | 1.21000 | 1.25440 |
| 3 | 1.03030 | 1.04568 | 1.06121 | 1.07689 | 1.09273 | 1.12486 | 1.15763 | 1.19102 | 1.25971 | 1.33100 | 1.40493 |
| 4 | 1.04060 | 1.06136 | 1.08243 | 1.10381 | 1.12551 | 1.16986 | 1.21551 | 1.26248 | 1.36049 | 1.46410 | 1.57352 |
| 5 | 1.05101 | 1.07728 | 1.10408 | 1.13141 | 1.15927 | 1.21665 | 1.27628 | 1.33823 | 1.46933 | 1.61051 | 1.76234 |
| 6 | 1.06152 | 1.09344 | 1.12616 | 1.15969 | 1.19405 | 1.26532 | 1.34010 | 1.41852 | 1.58687 | 1.77156 | 1.97382 |
| 7 | 1.07214 | 1.10984 | 1.14869 | 1.18869 | 1.22987 | 1.31593 | 1.40710 | 1.50363 | 1.71382 | 1.94872 | 2.21068 |
| 8 | 1.08286 | 1.12649 | 1.17166 | 1.21840 | 1.26677 | 1.36857 | 1.47746 | 1.59385 | 1.85093 | 2.14359 | 2.47596 |
| 9 | 1.09369 | 1.14339 | 1.19509 | 1.24886 | 1.30477 | 1.42331 | 1.55133 | 1.68948 | 1.99900 | 2.35795 | 2.77308 |
| 10 | 1.10462 | 1.16054 | 1.21899 | 1.28008 | 1.34392 | 1.48024 | 1.62889 | 1.79085 | 2.15892 | 2.59374 | 3.10585 |
| 11 | 1.11567 | 1.17795 | 1.24337 | 1.31209 | 1.38423 | 1.53945 | 1.71034 | 1.89830 | 2.33164 | 2.85312 | 3.47855 |
| 12 | 1.12683 | 1.19562 | 1.26824 | 1.34489 | 1.42576 | 1.60103 | 1.79586 | 2.01220 | 2.51817 | 3.13843 | 3.89598 |
| 13 | 1.13809 | 1.21355 | 1.29361 | 1.37851 | 1.46853 | 1.66507 | 1.88565 | 2.13293 | 2.71962 | 3.45227 | 4.36349 |
| 14 | 1.14947 | 1.23176 | 1.31948 | 1.41297 | 1.51259 | 1.73168 | 1.97993 | 2.26090 | 2.93719 | 3.79750 | 4.88711 |
| 15 | 1.16097 | 1.25023 | 1.34587 | 1.44830 | 1.55797 | 1.80094 | 2.07893 | 2.39656 | 3.17217 | 4.17725 | 5.47357 |
| 16 | 1.17258 | 1.26899 | 1.37279 | 1.48451 | 1.60471 | 1.87298 | 2.18287 | 2.54035 | 3.42594 | 4.59497 | 6.13039 |
| 17 | 1.18430 | 1.28802 | 1.40024 | 1.52162 | 1.65285 | 1.94790 | 2.29202 | 2.69277 | 3.70002 | 5.05447 | 6.86604 |
| 18 | 1.19615 | 1.30734 | 1.42825 | 1.55966 | 1.70243 | 2.02582 | 2.40662 | 2.85434 | 3.99602 | 5.55992 | 7.68997 |
| 19 | 1.20811 | 1.32695 | 1.45681 | 1.59865 | 1.75351 | 2.10685 | 2.52695 | 3.02560 | 4.31570 | 6.11591 | 8.61276 |
| 20 | 1.22019 | 1.34686 | 1.48595 | 1.63862 | 1.80611 | 2.19112 | 2.65330 | 3.20714 | 4.66096 | 6.72750 | 9.64629 |
| 21 | 1.23239 | 1.36706 | 1.51567 | 1.67958 | 1.86029 | 2.27877 | 2.78596 | 3.39956 | 5.03383 | 7.40025 | 10.80385 |
| 22 | 1.24472 | 1.38756 | 1.54598 | 1.72157 | 1.91610 | 2.36992 | 2.92526 | 3.60354 | 5.43654 | 8.14027 | 12.10031 |
| 23 | 1.25716 | 1.40838 | 1.57690 | 1.76461 | 1.97359 | 2.46472 | 3.07152 | 3.81975 | 5.87146 | 8.95430 | 13.55235 |
| 24 | 1.26973 | 1.42950 | 1.60844 | 1.80873 | 2.03279 | 2.56330 | 3.22510 | 4.04893 | 6.34118 | 9.84973 | 15.17863 |
| 25 | 1.28243 | 1.45095 | 1.64061 | 1.85394 | 2.09378 | 2.66584 | 3.38635 | 4.29187 | 6.84848 | 10.83471 | 17.00006 |
| 26 | 1.29526 | 1.47271 | 1.67342 | 1.90029 | 2.15659 | 2.77247 | 3.55567 | 4.54938 | 7.39635 | 11.91818 | 19.04007 |
| 27 | 1.30821 | 1.49480 | 1.70689 | 1.94780 | 2.22129 | 2.88337 | 3.73346 | 4.82235 | 7.98806 | 13.10999 | 21.32488 |
| 28 | 1.32129 | 1.51722 | 1.74102 | 1.99650 | 2.28793 | 2.99870 | 3.92013 | 5.11169 | 8.62711 | 14.42099 | 23.88387 |
| 29 | 1.33450 | 1.53998 | 1.77584 | 2.04641 | 2.35657 | 3.11865 | 4.11614 | 5.41839 | 9.31727 | 15.86309 | 26.74993 |
| 30 | 1.34785 | 1.56308 | 1.81136 | 2.09757 | 2.42726 | 3.24340 | 4.32194 | 5.74349 | 10.06266 | 17.44940 | 29.95992 |

Table shows future value (*FV*) of $1.00 compounded for *N* periods at *R* rate per period.
Table values can be generated using the formula $FV = \$1(1 + R)^N$.

EXAMPLE 1 Use Table 13-1 to compute the compound interest on a $5,000 loan for six years compounded annually at 8%.

Interest periods = number of years × interest periods per year

$$= 6(1) = 6 \text{ periods}$$

$$\text{Period interest rate} = \frac{\text{annual interest rate}}{\text{interest periods per year}}$$

$$= \frac{8\%}{1} = 8\%$$

Find period row 6 of the table and the 8% rate column. The value in the intersecting cell is 1.58687. This means that $1 would be worth $1.58687, or $1.59 rounded, compounded annually at the end of six years.

$5,000(1.58687) = $7,934.35 The loan is for $5,000, so multiply $5,000 by 1.58687 to find the future value of the loan.

The future value is $7,934.35.

$7,934.35 − $5,000 = $2,934.35 The future value minus the principal is the compound interest.

The compound interest on $5,000 for six years compounded annually at 8% is $2,934.35.

EXAMPLE 2 An investment of $3,000 at 8% annually is compounded *quarterly* (four times a year) for three years. Find the future value and the compound interest.

Interest periods = number of years × number of interest periods per year

$$= 3(4) = 12$$ The investment is compounded four times a year for three years.

$$\text{Period interest rate} = \frac{\text{annual interest rate}}{\text{number of interest periods per year}}$$ Divide the annual rate of 8% by the number of periods per year to find the period interest rate.

$$= \frac{8\%}{4} = 2\%$$

Future value of $1 = 1.26824 Find the 12 periods row in Table 13-1. Move across to the 2% column.

$3,000(1.26824) = $3,804.72 The principal times the future value per dollar equals the total future value.

$3,804.72 is the future value.

Compound interest = future value − original principal

$$= \$3,804.72 - \$3,000$$

$$= \$804.72$$

The compound interest is $804.72.

✔ STOP AND CHECK

1. Use Table 13-2 to compute the compound interest on $2,890 for five years compounded annually at 4%.

2. A loan of $2,982 is repaid in three years. Find the amount of interest paid on the loan if it is compounded quarterly at 10%.

3. Andre Castello owns a savings account that is paying 2.5% interest compounded annually. His current balance is $7,598.42. How much interest will he earn over five years if the rate remains constant?

4. Natalie Bradley invested $25,000 at 5% for three years compounded semiannually. Find the future value at the end of three years using Table 13-1.

3 Find the future value and compound interest using a formula (optional).

Table values are most often generated with a formula. When the table does not include the rate you need or does not have as many periods as you need, the equivalent table value can be found by using the formula. The formula for finding the future value or the compound interest will require a calculator or electronic spreadsheet that has a power function. A business or scientific calculator or an electronic spreadsheet, such as Excel, is normally used.

> **HOW TO** Find the future value using a formula.
>
> The future value formula is
>
> $$FV = P(1 + R)^N$$
>
> where FV is the future value, P is the principal, R is the period interest rate, and N is the number of periods.

Business calculators, scientific calculators, and electronic spreadsheets impose a standard order of operations when making calculations. However, it is helpful to make some of the calculations in a formula mentally or before you begin the evaluation of the formula. For instance, in the future value formula you can find the period interest rate and the number of periods first. Also, you can change the period interest rate to a decimal equivalent and add one mentally.

EXAMPLE 1 Find the future value of a three-year investment of $5,000 that earns 6% compounded monthly.

Find the period interest rate:

$$R = \frac{6\%}{12} = \frac{0.06}{12} = 0.005$$ Change the annual rate to a decimal equivalent and divide by 12.

Find the number of periods:

$N = 3(12) = 36$ Multiply the number of years by 12.

Evaluate the future value formula:

$FV = P(1 + R)^N$ Substitute known values.

$FV = 5,000(1 + 0.005)^{36}$ Mentally add inside of parentheses.

$FV = 5,000(1.005)^{36}$ Evaluate using a calculator or spreadsheet.

$5000 \boxed{(}\, 1.005 \boxed{)}\, \boxed{\wedge}\, 36 \boxed{=} \Rightarrow$ 5983.402624

$FV = \$5,983.40$ Rounded

The compound interest is found by subtracting the original principal from the future value. The compound interest formula is

$$I = P(1 + R)^N - P$$

where I is the compound interest, P is the principal, R is the period rate, and N is the number of periods.

EXAMPLE 2 Find the compound interest earned on a four-year investment of $3,500 at 4.5% compounded monthly.

Find the period interest rate:

$$R = \frac{4.5\%}{12} = \frac{0.045}{12} = 0.00375$$ Change the annual rate to a decimal equivalent and divide by 12.

Find the number of periods:

$N = 4(12) = 48$ Multiply the number of years by 12.

Evaluate the compound interest formula:

$I = P(1 + R)^N - P$ Substitute known values.

$I = 3,500(1 + 0.00375)^{48} - 3,500$ Mentally add inside of parentheses.

$I = 3,500(1.00375)^{48} - 3,500$ Evaluate using a calculator or spreadsheet.

$3500 \boxed{(}\, 1.00375 \boxed{)}\, \boxed{\wedge}\, 48 \boxed{=} \boxed{-}\, 3500 \boxed{=} \Rightarrow$ 688.850321

$I = \$688.85$ Rounded

EXAMPLE 3 Joe Gallegos can invest $10,000 at 8% compounded quarterly for two years. Or he can invest the same $10,000 at 8.2% compounded annually for the same two years. If all other conditions (such as early withdrawal penalty, etc.) are the same, which deal should he take?

| What You Know | What You Are Looking For |
|---|---|
| Principal: $10,000 | Which deal should Joe take? |
| Time period: 2 years | Future value for each investment |
| Deal 1 annual rate: 8% | |
| Deal 1 interest periods per year: 4 | |
| Deal 2 annual rate: 8.2% | |
| Deal 2 interest periods per year: 1 | |

Solution Plan

Number of interest periods = number of years × number of interest periods per year

Deal 1 interest periods = 2(4) = 8 Deal 2 interest periods = 2(1) = 2

$$\text{Period interest rate} = \frac{\text{annual interest rate}}{\text{number of interest periods per year}}$$

Deal 1 period interest rate = $\dfrac{8\%}{4} = 2\%$ Deal 2 period interest rate = $\dfrac{8.2\%}{1} = 8.2\%$

Solution

Deal 1: Using the future value formula for $10,000 at 2% per period for 8 periods

| | |
|---|---|
| $FV = P(1 + R)^N$ | Substitute known values. |
| $FV = \$10{,}000(1 + 0.02)^8$ | Mentally add inside of parentheses. |
| $FV = 10{,}000(1.02)^8$ | Evaluate using a calculator or spreadsheet. |
| 10000 (1.02) ^ 8 = ⟹ 11716.59381 | |
| $FV = \$11{,}716.59$ | Future value for Deal 1 |

Deal 2: Using the future value formula for $10,000 at 8.2% per period for 2 periods

| | |
|---|---|
| $FV = P(1 + R)^N$ | Substitute known values. |
| $FV = \$10{,}000(1 + 0.082)^2$ | Mentally add inside of parentheses. |
| $FV = 10{,}000(1.082)^2$ | Evaluate using a calculator or spreadsheet. |
| 10000 (1.082) ^ 2 = ⟹ 11707.24 | |
| $FV = \$11{,}707.24$ | Future value for Deal 2 |

Conclusion

Deal 1, the lower interest rate of 8% compounded more frequently (quarterly), is a slightly better deal because it yields the greater future value.

✔ STOP AND CHECK

1. Kellen Davis invested $20,000 that earns 4.68% compounded monthly for four years. Find the future value of Kellen's investment.

2. Jonathan Vergues invested $17,500 that earns 5.2% compounded semiannually for 10 years. What is the future value of the investment after 10 years?

3. Hanna Stein has a $18,200 certificate of deposit (CD) that earns 4.8% interest compounded quarterly for 5 years. Find the compound interest after 5 years.

4. Susan Bertrees can invest $12,000 at 4% interest compounded twice a year or compounded quarterly. If either investment is for five years, which investment results in more interest? How much more interest is yielded by the better investment?

4 Find the effective interest rate.

If the investment in Example 2 on page 458 is compounded annually instead of quarterly for three years—three periods at 8% per period—the future value is $3,779.22 (using table value 1.25971), and the compound interest is $779.22. The simple interest at the end of three years is $3,000 × 8% × 3, or $720. $3,000 at 8% for 3 years:

| $720 | $799.22 | $804.72 |
|------|---------|---------|
| Simple interest | Compounded annually using table value | Compounded quarterly using table value |

You can see from these comparisons that a loan or investment with an interest rate of 8% compounded quarterly carries higher interest than a loan with an interest rate of 8% compounded annually or a loan with an annual simple interest rate of 8%. When you compare interest rates, you need to know the actual or **effective rate** of interest. The effective rate of interest equates compound interest rates to equivalent simple interest rates so that comparisons can be made.

The effective rate of interest is also referred to as the **annual percentage yield (APY)** when identifying the rate of earnings on an investment. It is referred to as the **annual percentage rate (APR)** when identifying the rate of interest on a loan.

Effective rate: the simple interest rate that is equivalent to a compound rate.

Annual percentage yield (APY): effective rate of interest for an investment.

Annual percentage rate (APR): effective rate of interest for a loan.

HOW TO Find the effective interest rate of a compound interest rate

Using the manual compound interest method: Divide the compound interest for the first year by the principal.

$$\text{Effective annual interest rate} = \frac{\text{compound interest for first year}}{\text{principal}} \times 100\%$$

Using the table method: Find the future value of $1.00 by using the future value table, Table 13-1. Subtract $1.00 from the future value of $1.00 after one year and divide by $1.00 to remove the dollar sign.

$$\text{Effective annual interest rate} = \frac{\text{future value of \$1.00 after 1 year} - \$1.00}{\$1.00} \times 100\%$$

EXAMPLE 1 Marcia borrowed $6,000 at 10% compounded semiannually. What is the effective interest rate?

Using the manual compound interest method:

$$\text{Period interest rate} = \frac{10\%}{2} = 5\% = 0.05$$

First end-of-period principal $= \$6,000(1 + 0.05)$
$$= \$6,300$$

Second end-of-period principal $= \$6,300(1 + 0.05)$
$$= \$6,615$$

Compound interest after first year $= \$6,615 - \$6,000 = \$615$

$$\text{Effective annual interest rate} = \frac{\$615}{\$6,000}(100\%)$$

$$= 0.1025(100\%)$$

$$= 10.25\%$$

Using the table method:
10% compounded semiannually means two periods in the first (and every) year and a period interest rate of 5%. The Table 13-1 value is 1.10250. Subtract 1.00.

$$\text{Effective annual interest rate} = (1.10250 - 1.00)(100\%)$$

$$= 0.10250(100\%)$$

$$= 10.25\%$$

The effective interest rate is 10.25%.

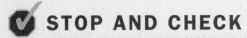
1. Willy Spears borrowed $2,800 at 8% compounded semiannually. Use the manual compound interest method to find the effective interest rate.

2. Use Table 13-1 to find the effective interest rate on Willy Spears' loan in Exercise 1. Compare the rate using the table with the rate found manually.

3. Mindi Lancaster invested $82,500 at 4% compounded quarterly. Use Table 13-1 to find the annual percentage yield (APY) for her investment.

4. Una Sircy invested $5,000 at 3% compounded semiannually. Use Table 13-1 to find the APY for her investment.

5 Find the interest compounded daily using a table.

Some banks compound interest daily and others use continuous compounding to compute interest on savings accounts. There is no significant difference in the interest earned on money using interest compounded daily and interest compounded continuously. A computer is generally used in calculating interest if either daily or continuous compounding is used.

Table 13-2 gives compound interest for $100 compounded daily (using 365 days as a year). Notice that this table gives the *compound interest* rather than the future value of the principal, as is given in Table 13-1.

Using Table 13-2 is exactly like using Table 11-2, which gives the *simple* interest on $100.

| **HOW TO** | Find the compounded daily interest using a table |
| --- | --- |

1. Determine the amount of money the table uses as the principal ($1, $100, or $1,000).
2. Divide the loan principal by the table principal.
3. Using Table 13-2, select the days row corresponding to the time period (in days) of the loan.
4. Select the interest rate column corresponding to the interest rate of the loan.
5. Locate the value in the cell where the interest column intersects the days row.
6. Multiply the quotient from step 2 by the value from step 5.

TIP

Examine Table Title and Footnote Carefully!

All tables are not alike! Different reference sources may approach finding the same information using different methods.

In working with compound interest, you may more frequently want to know the accumulated amount than the accumulated interest, or vice versa. A table can be designed to give a factor for finding either amount directly.

- Determine whether the table will help you find the compound amount or the compound interest. Table 13-1 finds the compound amount and Table 13-2 finds the compound interest. Also, the principal that is used to determine the table value may be $1, $10, $100, or some other amount.

- Determine the principal amount used in calculating table values. Table 13-1 uses $1 as the principal and Table 13-2 uses $100 as the principal.

| **EXAMPLE 1** | Find the interest on $800 at 7.5% annually, compounded daily, for 28 days. |
| --- | --- |

| $800 \div $100 = 8 | Find the number of $100 units in the principal. Find the 28 days row in Table 13-2. Move across to the 7.5% column and find the interest for $100. |
| $8(0.576941) = $4.615528 | Multiply the table value by 8, the number of $100 units. |

The interest is $4.62.

Annual rate

| Days | 5.00% | 5.25% | 5.50% | 5.75% | 6.00% | 6.25% | 6.50% | 6.75% | 7.00% |
|---|---|---|---|---|---|---|---|---|---|
| 1 | 0.013699 | 0.014384 | 0.015068 | 0.015753 | 0.016438 | 0.017123 | 0.017808 | 0.018493 | 0.019178 |
| 2 | 0.027399 | 0.028769 | 0.030139 | 0.031509 | 0.032879 | 0.034250 | 0.035620 | 0.036990 | 0.038360 |
| 3 | 0.041102 | 0.043157 | 0.045212 | 0.047268 | 0.049323 | 0.051379 | 0.053434 | 0.055490 | 0.057545 |
| 4 | 0.054806 | 0.057547 | 0.060288 | 0.063029 | 0.065770 | 0.068511 | 0.071252 | 0.073993 | 0.076734 |
| 5 | 0.068512 | 0.071938 | 0.075365 | 0.078792 | 0.082219 | 0.085646 | 0.089073 | 0.092500 | 0.095927 |
| 6 | 0.082220 | 0.086332 | 0.090445 | 0.094558 | 0.098671 | 0.102784 | 0.106897 | 0.111010 | 0.115124 |
| 7 | 0.095930 | 0.100728 | 0.105527 | 0.110326 | 0.115125 | 0.119925 | 0.124724 | 0.129524 | 0.134324 |
| 8 | 0.109642 | 0.115126 | 0.120612 | 0.126097 | 0.131583 | 0.137068 | 0.142555 | 0.148041 | 0.153528 |
| 9 | 0.123355 | 0.129527 | 0.135698 | 0.141870 | 0.148043 | 0.154215 | 0.160388 | 0.166562 | 0.172735 |
| 10 | 0.137071 | 0.143929 | 0.150787 | 0.157646 | 0.164505 | 0.171365 | 0.178225 | 0.185085 | 0.191946 |
| 11 | 0.150788 | 0.158333 | 0.165878 | 0.173424 | 0.180971 | 0.188518 | 0.196065 | 0.203613 | 0.211161 |
| 12 | 0.164507 | 0.172739 | 0.180972 | 0.189205 | 0.197439 | 0.205673 | 0.213908 | 0.222144 | 0.230380 |
| 13 | 0.178229 | 0.187148 | 0.196068 | 0.204988 | 0.213910 | 0.222832 | 0.231754 | 0.240678 | 0.249602 |
| 14 | 0.191952 | 0.201558 | 0.211166 | 0.220774 | 0.230383 | 0.239993 | 0.249604 | 0.259216 | 0.268828 |
| 15 | 0.205677 | 0.215971 | 0.226266 | 0.236562 | 0.246859 | 0.257157 | 0.267457 | 0.277757 | 0.288058 |
| 16 | 0.219403 | 0.230385 | 0.241369 | 0.252353 | 0.263338 | 0.274325 | 0.285312 | 0.296301 | 0.307291 |
| 17 | 0.233132 | 0.244802 | 0.256473 | 0.268146 | 0.279820 | 0.291495 | 0.303171 | 0.314849 | 0.326528 |
| 18 | 0.246863 | 0.259221 | 0.271581 | 0.283942 | 0.296304 | 0.308668 | 0.321034 | 0.333400 | 0.345769 |
| 19 | 0.260595 | 0.273642 | 0.286690 | 0.299740 | 0.312791 | 0.325844 | 0.338899 | 0.351955 | 0.365013 |
| 20 | 0.274329 | 0.288065 | 0.301802 | 0.315540 | 0.329281 | 0.343023 | 0.356768 | 0.370514 | 0.384261 |
| 21 | 0.288066 | 0.302490 | 0.316916 | 0.331344 | 0.345774 | 0.360205 | 0.374639 | 0.389075 | 0.403513 |
| 22 | 0.301804 | 0.316917 | 0.332032 | 0.347149 | 0.362269 | 0.377390 | 0.392514 | 0.407640 | 0.422769 |
| 23 | 0.315544 | 0.331346 | 0.347150 | 0.362957 | 0.378767 | 0.394578 | 0.410392 | 0.426209 | 0.442028 |
| 24 | 0.329286 | 0.345777 | 0.362271 | 0.378768 | 0.395267 | 0.411769 | 0.428274 | 0.444781 | 0.461291 |
| 25 | 0.343029 | 0.360210 | 0.377394 | 0.394581 | 0.411771 | 0.428963 | 0.446158 | 0.463356 | 0.480557 |
| 26 | 0.356775 | 0.374646 | 0.392520 | 0.410397 | 0.428277 | 0.446160 | 0.464046 | 0.481935 | 0.499827 |
| 27 | 0.370522 | 0.389083 | 0.407647 | 0.426215 | 0.444785 | 0.463359 | 0.481937 | 0.500517 | 0.519101 |
| 28 | 0.384272 | 0.403523 | 0.422777 | 0.442035 | 0.461297 | 0.480562 | 0.499831 | 0.519103 | 0.538379 |
| 29 | 0.398023 | 0.417964 | 0.437909 | 0.457858 | 0.477811 | 0.497768 | 0.517728 | 0.537692 | 0.557660 |
| 30 | 0.411776 | 0.432408 | 0.453044 | 0.473684 | 0.494328 | 0.514976 | 0.535628 | 0.556285 | 0.576945 |
| 35 | 0.480570 | 0.504658 | 0.528751 | 0.552849 | 0.576953 | 0.601063 | 0.625178 | 0.649299 | 0.673426 |
| 40 | 0.549411 | 0.576959 | 0.604514 | 0.632077 | 0.659646 | 0.687223 | 0.714808 | 0.742400 | 0.769999 |
| 45 | 0.618300 | 0.649313 | 0.680335 | 0.711367 | 0.742408 | 0.773458 | 0.804518 | 0.835587 | 0.866665 |
| 50 | 0.687235 | 0.721718 | 0.756213 | 0.790719 | 0.825237 | 0.859766 | 0.894307 | 0.928859 | 0.963424 |
| 55 | 0.756218 | 0.794176 | 0.832148 | 0.870134 | 0.908134 | 0.946148 | 0.984176 | 1.022219 | 1.060275 |
| 60 | 0.825248 | 0.866686 | 0.908140 | 0.949612 | 0.991099 | 1.032604 | 1.074126 | 1.115664 | 1.157219 |
| 90 | 1.240422 | 1.302841 | 1.365298 | 1.427794 | 1.490327 | 1.552898 | 1.615507 | 1.678155 | 1.740841 |
| 120 | 1.657306 | 1.740883 | 1.824528 | 1.908241 | 1.992022 | 2.075871 | 2.159789 | 2.243775 | 2.327830 |
| 150 | 2.075907 | 2.180819 | 2.285838 | 2.390964 | 2.496197 | 2.601538 | 2.706986 | 2.812542 | 2.918205 |
| 180 | 2.496231 | 2.622657 | 2.749237 | 2.875973 | 3.002864 | 3.129911 | 3.257114 | 3.384472 | 3.511987 |
| 240 | 3.342080 | 3.512073 | 3.682344 | 3.852895 | 4.023725 | 4.194835 | 4.366225 | 4.537896 | 4.709848 |
| 360 | 5.054775 | 5.314097 | 5.574058 | 5.834658 | 6.095900 | 6.357785 | 6.620315 | 6.883491 | 7.147315 |
| 365 | 5.126750 | 5.389858 | 5.653624 | 5.918047 | 6.183131 | 6.448876 | 6.715285 | 6.982358 | 7.250098 |
| 730 | 10.516335 | 11.070222 | 11.626882 | 12.186328 | 12.748573 | 13.313633 | 13.881520 | 14.452250 | 15.025836 |
| 1095 | 16.182231 | 17.056750 | 17.937846 | 18.825568 | 19.719965 | 20.621089 | 21.528989 | 22.443716 | 23.365322 |
| 1825 | 28.400343 | 30.015193 | 31.650340 | 33.306041 | 34.982553 | 36.680138 | 38.399060 | 40.139588 | 41.901993 |
| 3650 | 64.866481 | 69.039503 | 73.318120 | 77.705005 | 82.202895 | 86.814600 | 91.542998 | 96.391041 | 101.361756 |

Table shows interest (I) on $100 compounded daily for N days at an annual rate of R. Table values can be generated using the formula $I = 100(1 + R/365)^N - 100$.

Annual rate

| Days | 7.25% | 7.50% | 7.75% | 8.00% | 8.25% | 8.50% | 8.75% | 9.00% |
|---|---|---|---|---|---|---|---|---|
| 1 | 0.019863 | 0.020548 | 0.021233 | 0.021918 | 0.022603 | 0.023288 | 0.023973 | 0.024658 |
| 2 | 0.039730 | 0.041100 | 0.042470 | 0.043840 | 0.045211 | 0.046581 | 0.047951 | 0.049321 |
| 3 | 0.059601 | 0.061657 | 0.063712 | 0.065768 | 0.067824 | 0.069879 | 0.071935 | 0.073991 |
| 4 | 0.079476 | 0.082217 | 0.084959 | 0.087700 | 0.090442 | 0.093183 | 0.095925 | 0.098667 |
| 5 | 0.099355 | 0.102782 | 0.106209 | 0.109637 | 0.113065 | 0.116493 | 0.119920 | 0.123348 |
| 6 | 0.119237 | 0.123351 | 0.127465 | 0.131579 | 0.135693 | 0.139807 | 0.143922 | 0.148036 |
| 7 | 0.139124 | 0.143924 | 0.148725 | 0.153526 | 0.158327 | 0.163128 | 0.167929 | 0.172730 |
| 8 | 0.159015 | 0.164502 | 0.169989 | 0.175477 | 0.180965 | 0.186453 | 0.191942 | 0.197431 |
| 9 | 0.178909 | 0.185084 | 0.191258 | 0.197433 | 0.203609 | 0.209784 | 0.215960 | 0.222137 |
| 10 | 0.198808 | 0.205670 | 0.212532 | 0.219394 | 0.226257 | 0.233121 | 0.239985 | 0.246849 |
| 11 | 0.218710 | 0.226260 | 0.233810 | 0.241360 | 0.248911 | 0.256463 | 0.264015 | 0.271568 |
| 12 | 0.238617 | 0.246854 | 0.255092 | 0.263331 | 0.271570 | 0.279810 | 0.288051 | 0.296292 |
| 13 | 0.258527 | 0.267453 | 0.276379 | 0.285307 | 0.294234 | 0.303163 | 0.312092 | 0.321023 |
| 14 | 0.278442 | 0.288056 | 0.297671 | 0.307287 | 0.316904 | 0.326521 | 0.336140 | 0.345759 |
| 15 | 0.298360 | 0.308663 | 0.318967 | 0.329272 | 0.339578 | 0.349885 | 0.360193 | 0.370502 |
| 16 | 0.318282 | 0.329274 | 0.340268 | 0.351262 | 0.362258 | 0.373254 | 0.384252 | 0.395251 |
| 17 | 0.338208 | 0.349890 | 0.361573 | 0.373257 | 0.384942 | 0.396629 | 0.408317 | 0.420006 |
| 18 | 0.358139 | 0.370510 | 0.382882 | 0.395256 | 0.407632 | 0.420009 | 0.432387 | 0.444767 |
| 19 | 0.378073 | 0.391134 | 0.404197 | 0.417261 | 0.430327 | 0.443394 | 0.456464 | 0.469534 |
| 20 | 0.398011 | 0.411762 | 0.425515 | 0.439270 | 0.453027 | 0.466785 | 0.480546 | 0.494308 |
| 21 | 0.417953 | 0.432395 | 0.446838 | 0.461284 | 0.475732 | 0.490182 | 0.504633 | 0.519087 |
| 22 | 0.437899 | 0.453031 | 0.468166 | 0.483303 | 0.498442 | 0.513583 | 0.528727 | 0.543873 |
| 23 | 0.457849 | 0.473672 | 0.489498 | 0.505327 | 0.521158 | 0.536991 | 0.552826 | 0.568664 |
| 24 | 0.477803 | 0.494318 | 0.510835 | 0.527355 | 0.543878 | 0.560403 | 0.576931 | 0.593462 |
| 25 | 0.497761 | 0.514967 | 0.532177 | 0.549389 | 0.566604 | 0.583822 | 0.601042 | 0.618266 |
| 26 | 0.517723 | 0.535621 | 0.553523 | 0.571427 | 0.589335 | 0.607245 | 0.625159 | 0.643076 |
| 27 | 0.537688 | 0.556279 | 0.574873 | 0.593470 | 0.612071 | 0.630674 | 0.649281 | 0.667892 |
| 28 | 0.557658 | 0.576941 | 0.596228 | 0.615518 | 0.634812 | 0.654109 | 0.673410 | 0.692714 |
| 29 | 0.577632 | 0.597608 | 0.617587 | 0.637571 | 0.657558 | 0.677549 | 0.697544 | 0.717542 |
| 30 | 0.597610 | 0.618279 | 0.638951 | 0.659628 | 0.680309 | 0.700994 | 0.721684 | 0.742377 |
| 35 | 0.697558 | 0.721696 | 0.745839 | 0.769989 | 0.794143 | 0.818304 | 0.842470 | 0.866641 |
| 40 | 0.797606 | 0.825220 | 0.852841 | 0.880470 | 0.908106 | 0.935749 | 0.963400 | 0.991059 |
| 45 | 0.897753 | 0.928850 | 0.959956 | 0.991072 | 1.022197 | 1.053332 | 1.084476 | 1.115630 |
| 50 | 0.997999 | 1.032586 | 1.067185 | 1.101796 | 1.136418 | 1.171052 | 1.205697 | 1.240354 |
| 55 | 1.098345 | 1.136430 | 1.174528 | 1.212641 | 1.250768 | 1.288909 | 1.327063 | 1.365233 |
| 60 | 1.198791 | 1.240380 | 1.281985 | 1.323608 | 1.365247 | 1.406903 | 1.448575 | 1.490265 |
| 90 | 1.803565 | 1.866327 | 1.929128 | 1.991967 | 2.054844 | 2.117759 | 2.180713 | 2.243705 |
| 120 | 2.411953 | 2.496145 | 2.580405 | 2.664734 | 2.749132 | 2.833599 | 2.918135 | 3.002739 |
| 150 | 3.023977 | 3.129857 | 3.235844 | 3.341940 | 3.448144 | 3.554457 | 3.660878 | 3.767407 |
| 180 | 3.639658 | 3.767486 | 3.895471 | 4.023613 | 4.151911 | 4.280368 | 4.408981 | 4.537753 |
| 240 | 4.882081 | 5.054597 | 5.227396 | 5.400477 | 5.573842 | 5.747491 | 5.921424 | 6.095642 |
| 360 | 7.411788 | 7.676912 | 7.942689 | 8.209120 | 8.476207 | 8.743951 | 9.012354 | 9.281418 |
| 365 | 7.518507 | 7.787585 | 8.057334 | 8.327757 | 8.598855 | 8.870629 | 9.143082 | 9.416214 |
| 730 | 15.602292 | 16.181634 | 16.763875 | 17.349030 | 17.937113 | 18.528139 | 19.122123 | 19.719080 |
| 1095 | 24.293858 | 25.229377 | 26.171931 | 27.121572 | 28.078354 | 29.042331 | 30.013557 | 30.992085 |
| 1825 | 43.686550 | 45.493537 | 47.323235 | 49.175931 | 51.051913 | 52.951474 | 54.874909 | 56.822519 |
| 3650 | 106.458246 | 111.683692 | 117.041357 | 122.534585 | 128.166805 | 133.941534 | 139.862375 | 145.933026 |

Table shows interest (I) on $100 compounded daily for N days at an annual rate of R. Table values can be generated using the formula $I = 100(1 + R/365)^N - 100$.

STOP AND CHECK

1. Find the interest on $1,850 at 7.25% annually, compounded daily for 60 days.

2. Find the interest on $3,050 at 6% annually, compounded daily for 365 days.

3. Find the interest on $10,000 at 6.75% annually, compounded daily for 730 days.

4. Bob Weaver has $20,000 invested for three years at a 5.25% annual rate compounded daily. How much interest will he earn?

13-1 SECTION EXERCISES

SKILL BUILDERS

Find the future value and compound interest. Use Table 13-1 or the future value and compound interest formula.

1. $5,000 at 6% compounded semiannually for two years

2. $18,500 at 6% compounded quarterly for four years

3. $7,000 at 2% compounded semiannually for six years

4. $500 at 5% compounded semiannually for five years

5. $1,000 at 12% compounded monthly for two years

6. $2,000 at 1.5% compounded annually for ten years

APPLICATIONS

Use the simple interest formula method for Exercises 7–10.

7. Thayer Farm Trust made a farmer a loan of $1,200 at 16% for three years compounded annually. Find the future value and the compound interest paid on the loan. Compare the compound interest with simple interest for the same period.

8. Maeola Killebrew invests $3,800 at 3% compounded semiannually for two years. What is the future value of the investment, and how much interest will she earn over the two-year period?

9. Carolyn Smith borrowed $6,300 at $8\frac{1}{2}\%$ for three years compounded annually. What is the compound amount of the loan and how much interest will she pay on the loan?

10. Margaret Hillman invested $5,000 at 6% compounded quarterly for one year. Find the future value and the interest earned for the year.

Use Table 13-1 or the appropriate formula for Exercises 11–16.

11. First State Bank loaned Doug Morgan $2,000 for four years compounded annually at 8%. How much interest was Doug required to pay on the loan?

12. A loan of $8,000 for two acres of woodland is compounded quarterly at an annual rate of 12% for five years. Find the compound amount and the compound interest.

13. Compute the compound amount and the interest on a loan of $10,500 compounded annually for four years at 10%.

14. Find the future value of an investment of $10,500 if it is invested for four years and compounded quarterly at an annual rate of 4%.

15. You have $8,000 that you plan to invest in a compound-interest-bearing instrument. Your investment agent advises you that you can invest the $8,000 at 8% compounded quarterly for three years or you can invest the $8,000 at $8\frac{1}{4}\%$ compounded annually for three years. Which investment should you choose to receive the most interest?

16. Find the future value of $50,000 at 6% compounded semiannually for ten years.

17. Find the effective interest rate for a loan for four years compounded quarterly at an annual rate of 4%. Use the table method.

18. What is the effective interest rate for a loan of $5,000 at 10% compounded semiannually for three years? Use the simple interest formula method.

19. Ross Land has a loan of $8,500 compounded quarterly for four years at 6%. What is the effective interest rate for the loan? Use the table method.

20. What is the effective interest rate for a loan of $20,000 for three years if the interest is compounded quarterly at a rate of 12%?

Use Table 13-2 for Exercises 21–24.

21. Find the compound interest on $2,500 at $6\frac{3}{4}$% compounded daily by Leader Financial Bank for 20 days.

22. How much compound interest is earned on a deposit of $1,500 at 6.25% compounded daily for 30 days?

23. John McCormick has found a short-term investment opportunity. He can invest $8,000 at 8.5% interest for 15 days. How much interest will he earn on this investment if the interest is compounded daily?

24. What is the compound interest on $8,000 invested at 8% for 180 days if it is compounded daily?

13-2 PRESENT VALUE

LEARNING OUTCOMES

1 Find the present value based on annual compounding for one year.
2 Find the present value using a $1.00 present value table.
3 Find the present value using a formula (optional).

In Section 1 of this chapter we learned how to find the future value of money invested at the present time. Sometimes businesses and individuals need to know how much to invest at the present time to yield a certain amount at some specified future date. For example, a business may want to set aside a lump sum of money to provide pensions for employees in years to come. Individuals may want to set aside a lump sum of money now to pay for a child's college education or for a vacation. You can use the concepts of compound interest to determine the amount of money that must be set aside at present and compounded periodically to yield a certain amount of money at some specific time in the future. The amount of money set aside now is called *present value.* See Figure 13-1.

1 Find the present value based on annual compounding for one year.

Present value: the amount that must be invested now and compounded at a specified rate and time to reach a specified future value.

Finding the present value of $100 means finding the *principal* that we must invest today so that $100 is its future value. We know that the future value of principal depends on the period interest rate and the number of interest periods. Just as calculating future value by hand is time-consuming when there are many interest periods, so is calculating **present value** by hand. A present value table is more efficient. For now, we find present value based on the simplest case—annual

compounding for one year. In this case, the number of interest periods is 1, and the period interest rate is the annual interest rate. In this case,

$$\text{Future value} = \text{principal}(1 + \text{annual interest rate})$$

If we know the future value and want to know the present value,

$$\text{Principal(present value)} = \frac{\text{future value}}{1 + \text{annual interest rate}}$$

$$FV = P(1 + R) \qquad\qquad PV = \frac{FV}{1 + R}$$

FIGURE 13-1
Relationship between future value and present value.

HOW TO Find the present value based on annual compounding for one year

Divide the future value by the sum of 1 and the decimal equivalent of the annual interest rate.

$$\text{Present value(principal)} = \frac{\text{future value}}{1 + \text{annual interest rate}}$$

EXAMPLE 1 Find the amount of money that The 7th Inning needs to set aside today to ensure that $10,000 will be available to buy a new large-screen plasma television in one year if the annual interest rate is 4% compounded annually.

$1 + 0.04 = 1.04$ Convert the annual interest rate to a decimal and add to 1.

$\dfrac{\$10,000}{1.04} = \$9,615.38$ Divide the future value by 1.04 to get the present value.

An investment of $9,615.38 at 4% would have a value of $10,000 in one year.

✔ STOP AND CHECK

1. How much money needs to be set aside today to have $15,000 in one year if the annual interest rate is 2% compounded annually?

2. How much should be set aside today to have $15,000 in one year if the annual interest rate is 4% compounded annually?

3. Greg Karrass should set aside how much money today to have $30,000 in one year if the annual interest rate is 2.8% compounded annually?

4. Jamie Puckett plans to purchase real estate in one year that costs $148,000. How much should be set aside today at an annual interest rate of 3.46% compounded annually?

2 Find the present value using a $1.00 present value table.

If the interest in the preceding example had been compounded more than once a year, you would have to make calculations for each time the money was compounded. One method for finding the present value when the principal is compounded for more than one period is to use Table 13-3, which shows the present value of $1.00 at different interest rates for different periods. Table 13-3 is used like Table 13-1, which gives the future value of $1.00.

HOW TO Find the present value using a $1.00 present value table

1. Find the number of interest periods: Multiply the time period, in years, by the number of interest periods per year.

$$\text{Interest periods} = \text{number of years} \times \text{number of interest periods per year}$$

2. Find the period interest rate: Divide the annual interest rate by the number of interest periods per year.

$$\text{Period interest rate} = \frac{\text{annual interest rate}}{\text{number of interest periods per year}}$$

3. Using Table 13-3, select the periods row corresponding to the number of interest periods.
4. Select the rate-per-period column corresponding to the period interest rate.
5. Locate the value in the cell where the periods row intersects the rate-per-period column.
6. Multiply the future value by the value from step 5.

EXAMPLE 1 The Absorbent Diaper Company needs $20,000 in five years to buy a new diaper edging machine. How much must the firm invest at the present if it receives 5% interest compounded annually?

$R = 5\%$ and $N = 5$ years

| | |
|---|---|
| Table value = 0.78353 | The money is to be compounded for 5 periods, so we find periods row 5 in Table 13-3 and the 5% rate column to find the present value of $1.00. |
| $20,000(0.78353) = $15,670.60 | Multiply the present value factor times the desired future value to find the amount that must be invested at the present. |

The Absorbent Diaper Company should invest $15,670.60 today to have $20,000 in five years.

TIP

Which Table Do I Use?

Tables 13-1 and 13-3 have entries that are reciprocal. Except for minor rounding discrepancies, the product of corresponding entries is 1. And 1 divided by a table value equals its comparable table value in the other table.

Look at period row 1 at 1% on each table.

Table 13-1: 1.01000 1 ÷ 1.01000 = 0.99010 (rounded) Table 13-3: 0.99010

Look at period row 16 at 4% on each table.

Table 13-1: 1.87298 1 ÷ 1.87298 = 0.53391 (rounded) Table 13-3: 0.53391

One way to select the appropriate table is to anticipate whether you expect a larger or smaller amount. You expect a future value to be larger than what you start with. All entries in Table 13-1 are greater than 1 and produce a larger product.

You expect a present value to require a smaller investment to reach a desired amount. All entries in Table 13-3 are less than 1 and produce a smaller product.

FV table factors > 1
PV table factors < 1

TABLE 13-3
Present Value of $1.00

| | | | | | Rate per period | | | | | | |
| --- | --- | --- | --- | --- | --- | --- | --- | --- | --- | --- | --- |
| **Periods** | **1%** | **1.5%** | **2%** | **2.5%** | **3%** | **4%** | **5%** | **6%** | **8%** | **10%** | **12%** |
| 1 | 0.99010 | 0.98522 | 0.98039 | 0.97561 | 0.97087 | 0.96154 | 0.95238 | 0.94340 | 0.92593 | 0.90909 | 0.89286 |
| 2 | 0.98030 | 0.97066 | 0.96117 | 0.95181 | 0.94260 | 0.92456 | 0.90703 | 0.89000 | 0.85734 | 0.82645 | 0.79719 |
| 3 | 0.97059 | 0.95632 | 0.94232 | 0.92860 | 0.91514 | 0.88900 | 0.86384 | 0.83962 | 0.79383 | 0.75131 | 0.71178 |
| 4 | 0.96098 | 0.94218 | 0.92385 | 0.90595 | 0.88849 | 0.85480 | 0.82270 | 0.79209 | 0.73503 | 0.68301 | 0.63552 |
| 5 | 0.95147 | 0.92826 | 0.90573 | 0.88385 | 0.86261 | 0.82193 | 0.78353 | 0.74726 | 0.68058 | 0.62092 | 0.56743 |
| 6 | 0.94205 | 0.91454 | 0.88797 | 0.86230 | 0.83748 | 0.79031 | 0.74622 | 0.70496 | 0.63017 | 0.56447 | 0.50663 |
| 7 | 0.93272 | 0.90103 | 0.87056 | 0.84127 | 0.81309 | 0.75992 | 0.71068 | 0.66506 | 0.58349 | 0.51316 | 0.45235 |
| 8 | 0.92348 | 0.88771 | 0.85349 | 0.82075 | 0.78941 | 0.73069 | 0.67684 | 0.62741 | 0.54027 | 0.46651 | 0.40388 |
| 9 | 0.91434 | 0.87459 | 0.83676 | 0.80073 | 0.76642 | 0.70259 | 0.64461 | 0.59190 | 0.50025 | 0.42410 | 0.36061 |
| 10 | 0.90529 | 0.86167 | 0.82035 | 0.78120 | 0.74409 | 0.67556 | 0.61391 | 0.55839 | 0.46319 | 0.38554 | 0.32197 |
| 11 | 0.89632 | 0.84893 | 0.80426 | 0.76214 | 0.72242 | 0.64958 | 0.58468 | 0.52679 | 0.42888 | 0.35049 | 0.28748 |
| 12 | 0.88745 | 0.83639 | 0.78849 | 0.74356 | 0.70138 | 0.62460 | 0.55684 | 0.49697 | 0.39711 | 0.31863 | 0.25668 |
| 13 | 0.87866 | 0.82403 | 0.77303 | 0.72542 | 0.68095 | 0.60057 | 0.53032 | 0.46884 | 0.36770 | 0.28966 | 0.22917 |
| 14 | 0.86996 | 0.81185 | 0.75788 | 0.70773 | 0.66112 | 0.57748 | 0.50507 | 0.44230 | 0.34046 | 0.26333 | 0.20462 |
| 15 | 0.86135 | 0.79985 | 0.74301 | 0.69047 | 0.64186 | 0.55526 | 0.48102 | 0.41727 | 0.31524 | 0.23939 | 0.18270 |
| 16 | 0.85282 | 0.78803 | 0.72845 | 0.67362 | 0.62317 | 0.53391 | 0.45811 | 0.39365 | 0.29189 | 0.21763 | 0.16312 |
| 17 | 0.84438 | 0.77639 | 0.71416 | 0.65720 | 0.60502 | 0.51337 | 0.43630 | 0.37136 | 0.27027 | 0.19784 | 0.14564 |
| 18 | 0.83602 | 0.76491 | 0.70016 | 0.64117 | 0.58739 | 0.49363 | 0.41552 | 0.35034 | 0.25025 | 0.17986 | 0.13004 |
| 19 | 0.82774 | 0.75361 | 0.68643 | 0.62553 | 0.57029 | 0.47464 | 0.39573 | 0.33051 | 0.23171 | 0.16351 | 0.11611 |
| 20 | 0.81954 | 0.74247 | 0.67297 | 0.61027 | 0.55368 | 0.45639 | 0.37689 | 0.31180 | 0.21455 | 0.14864 | 0.10367 |
| 21 | 0.81143 | 0.73150 | 0.65978 | 0.59539 | 0.53755 | 0.43883 | 0.35894 | 0.29416 | 0.19866 | 0.13513 | 0.09256 |
| 22 | 0.80340 | 0.72069 | 0.64684 | 0.58086 | 0.52189 | 0.42196 | 0.34185 | 0.27751 | 0.18394 | 0.12285 | 0.08264 |
| 23 | 0.79544 | 0.71004 | 0.63416 | 0.56670 | 0.50669 | 0.40573 | 0.32557 | 0.26180 | 0.17032 | 0.11168 | 0.07379 |
| 24 | 0.78757 | 0.69954 | 0.62172 | 0.55288 | 0.49193 | 0.39012 | 0.31007 | 0.24698 | 0.15770 | 0.10153 | 0.06588 |
| 25 | 0.77977 | 0.68921 | 0.60953 | 0.53939 | 0.47761 | 0.37512 | 0.29530 | 0.23300 | 0.14602 | 0.09230 | 0.05882 |
| 26 | 0.77205 | 0.67902 | 0.59758 | 0.52623 | 0.46369 | 0.36069 | 0.28124 | 0.21981 | 0.13520 | 0.08391 | 0.05252 |
| 27 | 0.76440 | 0.66899 | 0.58586 | 0.51340 | 0.45019 | 0.34682 | 0.26785 | 0.20737 | 0.12519 | 0.07628 | 0.04689 |
| 28 | 0.75684 | 0.65910 | 0.57437 | 0.50088 | 0.43708 | 0.33348 | 0.25509 | 0.19563 | 0.11591 | 0.06934 | 0.04187 |
| 29 | 0.74934 | 0.64936 | 0.56311 | 0.48866 | 0.42435 | 0.32065 | 0.24295 | 0.18456 | 0.10733 | 0.06304 | 0.03738 |
| 30 | 0.74192 | 0.63976 | 0.55207 | 0.47674 | 0.41199 | 0.30832 | 0.23138 | 0.17411 | 0.09938 | 0.05731 | 0.03338 |

The table shows the lump sum amount of money, present value (PV), that should be invested now so that the accumulated amount will be $1.00 after a specified number of periods, N, at a specified rate per period, R. Table values can be generated using the formula $PV = \dfrac{\$1.00}{(1 + R)^N}$.

STOP AND CHECK

1. The 7th Inning needs $35,000 in four years to buy new framing equipment. How much should be invested at 4% interest compounded annually?

2. How much should be invested now to have $15,000 in two years if interest is 4% compounded quarterly?

3. How much should be invested now to have $15,000 in four years if interest is 4% compounded quarterly?

4. How much should be invested now to have $15,000 in six years if interest is 4% compounded quarterly? Compare your results for Exercises 2–4.

3 Find the present value using a formula (optional).

A formula for finding the present value can be found by solving the future value formula for the present value.

| | |
| --- | --- |
| $FV = P(1 + R)^N$ | Divide both sides of the equations by $(1 + R)^N$. |
| $\dfrac{FV}{(1 + R)^N} = \dfrac{P(1 + R)^N}{(1 + R)^N}$ | Reduce. |
| $\dfrac{FV}{(1 + R)^N} = P$ | Rewrite with P on the left side of the equation. |

$$P = \frac{FV}{(1 + R)^N}$$ Original principal is present value.

$$PV = \frac{FV}{(1 + R)^N}$$

HOW TO Find the present value using a formula.

The present value formula is

$$PV = \frac{FV}{(1 + R)^N}$$

where PV is the present value, FV is the future value, R is the interest rate per period, and N is the number of periods.

EXAMPLE 1 The Holiday Boutique would like to put away some of the holiday profits to save for a planned expansion. A total of $8,000 is needed in three years. How much money in a 5.2% three-year certificate of deposit that is compounded monthly must be invested now to have the $8,000 in three years?

Period interest rate $= \dfrac{5.2\%}{12} = \dfrac{0.052}{12} = 0.0043333333$

Number of periods $= 3(12) = 36$

$PV = \dfrac{FV}{(1 + R)^N}$ Substitute known values.

$PV = \dfrac{8,000}{(1 + 0.0043333333)^{36}}$ Mentally add inside parentheses.

$PV = \dfrac{8,000}{(1.0043333333)^{36}}$ Evaluate using a calculator.

$8000 \div (((1.0043333333) \wedge 36 = \Rightarrow 6846.78069$

$PV = \$6,846.78$ Rounded

The Holiday Boutique must invest $6,846.78 now at 5.2% interest for three years, compounded monthly to have $8,000 at the end of the three years.

 ## STOP AND CHECK

1. Mary Kaye Keller needs $30,000 in seven years. How much must she set aside today at 4.8% compounded monthly?

2. How much should a family invest now at 10% compounded annually to have a $7,000 house down payment in four years?

3. If you were offered $700 today or $800 in two years, which would you accept if money can be invested at 12% annual interest compounded monthly?

4. Bridgett Smith inherited some money and needs $45,000 in 15 years for her child's college fund. How much of the inheritance should she invest now at 5.6% compounded quarterly?

13-2 SECTION EXERCISES

SKILL BUILDERS

Find the amount that should be set aside today to yield the desired future amount; use Table 13-3 or the appropriate formula.

| | Future amount needed | Interest rate | Compounding period | Investment time |
|---|---|---|---|---|
| 1. | $4,000 | 3% | semiannually | 2 years |

| | Future amount needed | Interest rate | Compounding period | Investment time |
|---|---|---|---|---|
| **2.** | $7,000 | 2.5% | annually | 20 years |
| **3.** | $10,000 | 6% | quarterly | 4 years |
| **4.** | $5,000 | 8% | semiannually | 6 years |

APPLICATIONS

5. Compute the amount of money to be set aside today to ensure a future value of $2,500 in one year if the interest rate is 11% annually, compounded annually.

6. How much should Linda Bryan set aside now to buy equipment that costs $8,500 in one year? The current interest rate is 7.5% annually, compounded annually.

7. Ronnie Cox has just inherited $27,000. How much of this money should he set aside today to have $21,000 to pay cash for a Ventura Van, which he plans to purchase in one year? He can invest at 7.9% annually, compounded annually.

8. Shirley Riddle received a $10,000 gift from her mother and plans a minor renovation to her home. She also plans to make an investment for one year, at which time she plans to take a trip projected to cost $6,999. The current interest rate is 8.3% annually, compounded annually. How much should be set aside today for her trip?

9. Rosa Burnett needs $2,000 in three years to make the down payment on a new car. How much must she invest today if she receives 8% interest annually, compounded annually? Use Table 13-3.

10. Use Table 13-3 to calculate the amount of money that must be invested now at 6% annually, compounded quarterly, to obtain $1,500 in three years.

11. Dewey Sykes plans to open a business in four years when he retires. How much must he invest today to have $10,000 when he retires if the bank pays 10% annually, compounded quarterly?

12. Charlie Bryant has a child who will be college age in five years. How much must he set aside today to have $20,000 for college tuition in five years if he gets 8% annually, compounded annually?

Learning Outcomes

What to Remember with Examples

Section 13-1

1 Find the future value and compound interest by compounding manually. (p. 454)

Find the period interest rate. Divide the annual interest rate by the number of interest periods per year.

$$\text{Period interest rate} = \frac{\text{annual interest rate}}{\text{number of interest periods per year}}$$

Find the future value using the simple interest formula method.

1. Find the first end-of-period principal: Multiply the original principal by the sum of 1 and the period interest rate.

$$\text{First end-of-period principal} = \text{original principal} \times (1 + \text{period interest rate})$$

2. For each remaining period in turn, find the next end-of-period principal: Multiply the previous end-of-period principal by the sum of 1 and the period interest rate.

$$\text{End-of-period principal} = \text{previous end-of-period principal} \times (1 + \text{period interest rate})$$

3. Identify the last end-of-period principal as the future value.

$$\text{Future value} = \text{last end-of-period principal}$$

Find the compound interest. Subtract the original principal from the future value.

$$\text{Compound interest} = \text{future value} - \text{original principal}$$

Find the compound amount and compound interest on $5,000 at 7% compounded annually for two years.

($5,000)(1 + 0.07) = $5,350 end-of-first-period principal
($5,350)(1 + 0.07) = $5,724.50 end-of-last-period principal (future value)
Compound amount = $5,724.50
Compound interest = $5,724.50 − $5,000 = $724.50

Find the compound amount (future value) and compound interest on $1,500 at 8% compounded semiannually for two years.

Number of interest periods = 2(2) = 4 periods

$$\text{Period interest rate} = \frac{8\%}{2} = 4\% \text{ or } 0.04 \text{ per period}$$

$1,500(1 + 0.04) = $1,560 (first period)
$1,560(1 + 0.04) = $1,622.40 (second period)
$1,622.40(1 + 0.04) = $1,687.30 (third period)
$1,687.30(1 + 0.04) = $1,754.79 (fourth period)
Compound amount = $1,754.79
Compound interest = $1,754.79 − $1,500 = $254.79

2 Find the future value and compound interest using a $1.00 future value table. (p. 456)

1. Find the number of interest periods: Multiply the number of years by the number of interest periods per year.

$$\text{Interest periods} = \text{number of years} \times \text{number of interest periods per year}$$

2. Find the period interest rate: Divide the annual interest rate by the number of interest periods per year.

$$\text{Period interest rate} = \frac{\text{annual interest rate}}{\text{number of interest periods per year}}$$

3. Using Table 13-1, select the periods row corresponding to the number of interest periods.
4. Select the rate-per-period column corresponding to the period interest rate.
5. Locate the value in the cell where the periods row intersects the rate-per-period column.
6. Multiply the original principal by the value from step 5 to find future value or compound amount.

7. To find the compound interest:

$$\text{Compound interest} = \text{future value} - \text{original principal}$$

| | |
|---|---|
| Find the future value of \$2,000 at 12% compounded semiannually for four years. | Find the compound interest on \$800 at 8% compounded annually for four years. Annually indicates one period per year. Period interest rate is 8%. |
| $4(2) = 8$ periods | |
| $\dfrac{12\%}{2} = 6\%$ period interest rate. | Find periods row 4 in Table 13-1. |
| | Move across to the 8% rate column and find the compound amount per dollar of principal: 1.36049. |
| Find periods row 8 in Table 13-1 and move across to the 6% rate column: 1.59385. | |
| $\$2,000(1.59385) = \$3,187.70$ future value or compound amount | $800(1.36049) = \$1,088.39$ compound amount |
| | $\begin{aligned}\$1,088.39 &\quad \text{compound amount or future value} \\ -800.00 &\quad \text{principal} \\ \hline \$288.39 &\quad \text{compound interest}\end{aligned}$ |

3 Find the future value and compound interest using a formula (optional). (p. 459)

The future value formula is

$$FV = P(1 + R)^N$$

where FV is the future value, P is the principal, R is the period interest rate, and N is the number of periods.

| | |
|---|---|
| Find the future value of a three-year investment of \$3,500 that earns 5.4% compounded monthly. | |
| Find the period interest rate: | |
| $R = \dfrac{5.4\%}{12} = \dfrac{0.054}{12} = 0.0045$ | Change the annual rate to a decimal equivalent and divide by 12. |
| Find the number of periods: | |
| $N = (3)(12) = 36$ | Multiply the number of years by 12. |
| Evaluate the future value formula: | |
| $FV = P(1 + R)^N$ | Substitute known values. |
| $FV = 3,500(1 + 0.0045)^{36}$ | Mentally add inside of parentheses. |
| $FV = 3,500(1.0045)^{36}$ | Evaluate using a calculator or spreadsheet. |
| $3500\ (\ 1.0045\)\ \wedge\ 36\ = \Rightarrow 4114.015498$ | |
| $FV = \$4,114.02$ | Rounded |

The compound interest formula is

$$I = P(1 + R)^N - P$$

where I is the compound interest, P is the principal, R is the period rate, and N is the number of periods.

| | |
|---|---|
| Find the compound interest earned on a four-year investment of \$6,500 at 5.5% compounded monthly. | |
| Find the period interest rate: | |
| $R = \dfrac{5.5\%}{12} = \dfrac{0.055}{12} = 0.0045833333$ | Change the annual rate to a decimal equivalent and divide by 12. |
| Find the number of periods: | |
| $N = (4)(12) = 48$ | Multiply the number of years by 12. |
| Evaluate the compound interest formula: | |
| $I = P(1 + R)^N - P$ | Substitute known values. |
| $I = 6,500(1 + 0.0045833333)^{48} - 6,500$ | Mentally add inside of parentheses. |
| $I = 6,500(1.0045833333)^{48} - 6,500$ | Evaluate using a calculator or spreadsheet. |
| $6500\ (\ 1.0045833333\)\ \wedge\ 48\ =\ -\ 6500\ = \Rightarrow 1,595.428696$ | |
| $I = \$1,595.43$ | Rounded |

4 Find the effective interest rate. (p. 461)

Using the manual compound interest method: Divide the compound interest for the first year by the principal.

$$\text{Effective annual interest rate} = \frac{\text{compound interest for first year}}{\text{principal}} \times 100\%$$

Using the table method: Use Table 13-1 to find the future value of $1.00 of the investment. Subtract $1.00 from the future value of $1.00 after one year and divide by $1.00 to remove the dollar sign.

$$\text{Effective interest rate} = \frac{\text{future value of \$1.00 after 1 year} - \$1.00}{\$1.00} \times 100\%$$

Betty Padgett earned $247.29 interest on a one-year investment of $3,000 at 8% annually, compounded quarterly. Find the effective interest rate.

Using the simple interest formula method:

$$\text{Effective interest} = \frac{\$247.29}{\$3,000}(100\%) = 0.08243(100\%) = 8.24\%$$

Using Table 13-1: Periods per year = 4

$$\text{Rate per period} = \frac{8\%}{4} = 2\%$$
$$\text{Table value} = 1.08243 \text{ (from Table 13-1)}$$

Effective interest rate = 1.08243 − 1.00 = 0.08243 = 8.24%

5 Find the interest compounded daily using a table. (p. 462)

1. Determine the amount of money the table uses as the principal. (A typical table principal is $1, $100, or $1,000.)
2. Divide the loan principal by the table principal.
3. Using Table 13-2, select the days row corresponding to the time period (in days) of the loan.
4. Select the interest rate column corresponding to the interest rate of the loan.
5. Locate the value in the cell where the interest column intersects the days row.
6. Multiply the quotient from step 2 by the value from step 5.

Find the interest on a $300 loan borrowed at 9% compounded daily for 21 days.

Select the 21 days row of Table 13-2; then move across to the 9% rate column. The table value is 0.519087.

$$\frac{\$300}{100}(0.519087) = \$1.56$$

The interest on $300 is $1.56.

Section 13-2

1 Find the present value based on annual compounding for one year. (p. 467)

Divide the future value by the sum of 1 and the decimal equivalent of the annual interest rate.

$$\text{Present value (principal)} = \frac{\text{future value}}{1 + \text{annual interest rate}}$$

Find the amount of money that must be invested to produce $4,000 in one year if the interest rate is 7% annually, compounded annually.

$$\text{Present value} = \frac{\$4,000}{1 + 0.07} = \frac{\$4,000}{1.07} = \$3,738.32$$

How much must be invested to produce $30,000 in one year if the interest rate is 6% annually, compounded annually?

$$\text{Present value} = \frac{\$30,000}{1 + 0.06} = \frac{\$30,000}{1.06} = \$28,301.89$$

| **2** | Find the present value using a $1.00 present value table. (p. 469) | **1.** Find the number of interest periods: Multiply the time period, in years, by the number of interest periods per year. |

$$\text{Interest periods} = \text{number of years} \times \text{number of interest periods per year}$$

2. Find the period interest rate: Divide the annual interest rate by the number of interest periods per year.

$$\text{Period interest rate} = \frac{\text{annual interest rate}}{\text{number of interest periods per year}}$$

3. Using Table 13-3, select the periods row corresponding to the number of interest periods.
4. Select the rate-per-period column corresponding to the period interest rate.
5. Locate the value in the cell where the periods row intersects the rate-per-period column.
6. Multiply the future value by the value from step 5.

Find the amount of money that must be deposited to ensure $3,000 at the end of three years if the investment earns 6% compounded semiannually.

$(3)(2) = 6$ periods

$\dfrac{6\%}{2} = 3\%$ rate per period

Find periods row 6 in Table 13-3 and move across to the 3% rate column: 0.83748.

$3,000(0.83748) = 2,512.44$

The amount that must be invested now to have $3,000 in three years is $2,512.44.

| **3** | Find the present value using a formula (optional). (p. 470) | Present Value Formula |

$$PV = \frac{FV}{(1 + R)^N}$$ where *PV* is the present value, *FV* is the future value, *R* is the interest rate per period, and *N* is the number of periods.

Ezell Allen has saved some money that he wants to put away for a down payment on a home in five years. He can invest the money in a 5.4% five-year certificate of deposit that is compounded monthly. How much of his money should he set aside now for a down payment of $10,000 in 5 years?

$$\text{Period interest rate} = \frac{5.4\%}{12} = \frac{0.054}{12} = 0.0045$$

Number of periods $= 5(12) = 60$

$$PV = \frac{FV}{(1 + R)^N} \qquad \text{Substitute known values.}$$

$$PV = \frac{10,000}{(1 + 0.0045)^{60}} \qquad \text{Mentally add inside parentheses.}$$

$$PV = \frac{10,000}{(1.0045)^{60}} \qquad \text{Evaluate using a calculator.}$$

$10000 \boxed{\div} \boxed{(} \boxed{(} 1.0045 \boxed{)} \boxed{\wedge} 60 \boxed{=} \Rightarrow 7638.420009$

$PV = 7,638.42 \qquad$ Rounded

Ezell must invest $7,638.42 now at 5.4% interest for five years, compounded monthly to have $10,000 at the end of the five years.

EXERCISES SET A

CHAPTER 13

Use Table 13-1 or the appropriate formula for Exercises 1–4.

| Principal | Term (years) | Rate of compound interest | Compounded | Compound amount | Compound interest |
|---|---|---|---|---|---|
| **1.** $2,000 | 3 | 3% | semiannually | _____ | _____ |
| **2.** $5,000 | 4 | 6% | quarterly | _____ | _____ |
| **3.** $10,000 | 2 | 2.5% | annually | _____ | _____ |
| **4.** $8,000 | 4 | 8% | semiannually | _____ | _____ |

Find the amount that should be set aside today to yield the desired future amount. Use Table 13-3 or the present value formula.

| Future amount needed | Interest rate | Compounding | Investment time (years) | Future amount needed | Interest rate | Compounding | Investment time (years) |
|---|---|---|---|---|---|---|---|
| **XCEL 5.** $20,000 | 4% | semiannually | 5 | **EXCEL 6.** $8,000 | 6% | quarterly | 6 |
| **XCEL 7.** $9,800 | 2% | semiannually | 12 | **EXCEL 8.** $14,700 | 3% | annually | 20 |

9. Manually calculate the compound interest on a loan of $1,000 at 8%, compounded annually for two years.

10. Manually calculate the compound interest on a 13% loan of $1,600 for three years if the interest is compounded annually.

11. Use Table 13-1 or the appropriate formula to find the future value of an investment of $3,000 made by Ling Lee for five years at 12% annual interest compounded semiannually.

12. Use Table 13-1 or the appropriate formula to find the interest on a certificate of deposit (CD) of $10,000 for five years at 4% compounded semiannually.

13. Find the future value of an investment of $8,000 compounded quarterly for seven years at 8%.

14. Find the compound interest on $5,000 for two years if the interest is compounded quarterly at 12%.

15. Mario Piazza was offered $900 now for one of his salon photographs or $1,100 in one year for the same photograph. Which would give Mr. Piazza a greater yield if he could invest the $900 for one year at 16% compounded quarterly? Use Table 13-1.

16. Lauren McAnally invests $2,000 at 8% compounded semiannually for two years, and Inez Everett invests an equal amount at 8% compounded quarterly for 18 months. Use Table 13-1 to determine which investment yields the greater interest.

17. Use Table 13-2 to find the compound interest and the compound amount on an investment of $2,000 if it is invested for 21 days at 8% compounded daily.

18. Use Table 13-2 to find the amount of interest on $100 invested for 10 days at 8.5% compounded daily.

In the following exercises, find the amount of money that should be invested (present value) at the stated interest rate to yield the given amount (future value) after the indicated amount of time. Use Table 13-3 or the appropriate formula.

19. $1,500 in three years at 10% compounded annually

20. $1,000 in seven years at 8% compounded quarterly

21. $4,000 in two years at 12% annual interest compounded quarterly

22. $500 in 15 years at 8% annual interest compounded semiannually

23. Find the amount that should be invested today to have $1,800 in one year at 12% annual interest compounded monthly.

24. Myrna Lewis wishes to have $4,000 in four years to tour Europe. How much must she invest today at 8% annual interest compounded quarterly to have $4,000 in four years?

EXERCISES SET B

Use Table 13-1 for Exercises 1–4.

| Principal | Term (years) | Rate of compound interest | Compounded | Compound amount | Compound interest |
|---|---|---|---|---|---|
| **1.** $5,000 | 5 | 5% | semiannually | _____ | _____ |
| **2.** $12,000 | 7 | 4% | quarterly | _____ | _____ |
| **3.** $7,000 | 10 | 2% | semiannually | _____ | _____ |
| **4.** $2,985 | 8 | 3% | annually | _____ | _____ |

Find the amount that should be set aside today to yield the desired future amount. Use Table 13-3 or the Present Value table.

| | Future amount needed | Interest rate | Compounding | Investment time (years) | | Future amount needed | Interest rate | Compounding | Investment time (years) |
|---|---|---|---|---|---|---|---|---|---|
| CEL **5.** | $3,000 | 6% | quarterly | 5 | EXCEL **6.** | $46,000 | 2.5% | annually | 25 |
| CEL **7.** | $17,000 | 3% | semiannually | 8 | EXCEL **8.** | $11,200 | 4% | quarterly | 3 |

9. Manually calculate the compound interest on a loan of $200 at 6% compounded annually for four years.

10. Calculate the compound interest on a loan of $6,150 at $11\frac{1}{2}$% annual interest compounded annually for three years.

11. EZ Loan Company loaned $500 at 8% annual interest compounded quarterly for one year. Use Table 13-1 or the appropriate formula to calculate the amount the loan company will earn in interest.

12. Use Table 13-2 to find the daily interest on $2,500 invested for 21 days at 8.75% compounded daily.

13. Find the factor for compounding an amount for 25 periods at 8% per period.

14. Find the compound interest on $5,000 for two years if the interest is compounded semiannually at 12%.

15. An investment of $1,000 is made for two years and is compounded semiannually at 10%. Find the compound amount and compound interest at the end of the two years.

16. Carlee McNally invests $5,000 at 6% compounded semiannually for one year, and Jake McNally invests an equal amount at 6% compounded quarterly for one year. Use Table 13-1 to determine the interest for each investment. Find the effective rate to the nearest hundredth percent for each investment.

17. Use Table 13-2 to find the compound interest and the compound amount on an investment of $24,982 if it is invested for 28 days at 7% compounded daily.

18. Use Table 13-2 to find the accumulated daily interest on an investment of $5,000 invested for 30 days at 9%.

In the following exercises, find the amount of money that should be invested (present value) at the stated interest rate to yield the given amount (future value) after the indicated amount of time. Use Table 13-3 or the appropriate formula.

19. $2,000 in five years at 10% compounded semiannually

20. $3,500 in 12 years at 12% compounded annually

21. $10,000 in seven years at 16% annual interest compounded quarterly

22. $800 in four years at 10% annual interest compounded annually

23. Find the amount that should be invested today to have $700 in six years at 8% annual interest compounded quarterly

24. Louis Banks was offered $15,000 cash or $19,500 to be paid in two years for a resort cabin. If money can be invested in today's market for 12% annual interest compounded quarterly, which offer should Louis accept?

PRACTICE TEST

1. Manually calculate the compound interest on a loan of $2,000 at 7% compounded annually for three years.

2. Manually calculate the compound interest on a 6.25% annual interest loan of $3,000 for four years if interest is compounded annually.

3. Use Table 13-1 or the appropriate formula to find the interest on a loan of $5,000 for six years at 10% annual interest if interest is compounded semiannually.

4. Use Table 13-1 to find the future value on an investment of $12,000 for seven years at 6% annual interest compounded quarterly.

5. An investment of $1,500 is made for two years at 12% annual interest compounded semiannually. Find the compound amount and the compound interest at the end of two years.

6. Use Table 13-1 to find the compound interest on a loan of $3,000 for one year at 12% annual interest if the interest is compounded quarterly.

7. Find the effective interest rate for the loan described in Exercise 6.

8. Use Table 13-2 to find the interest compounded on an investment of $2,000 invested at 5.75% for 28 days compounded daily.

9. Use Tables 13-1 and 13-2 to compare the interest on an investment of $3,000 that is invested at 8% annual interest compounded quarterly and daily, respectively, for one year.

Find the amount that should be invested today (present value) at the stated interest rate to yield the given amount (future value) after the indicated amount of time.

10. $3,400 in four years at 8% annual interest compounded annually

11. $5,000 in eight years at 8% annual interest compounded semiannually

12. $8,000 in 12 years at 12% annual interest compounded annually

13. $6,000 in six years at 12% annual interest compounded quarterly

14. Jamie Juarez needs $12,000 in 10 years for her daughter's college education. How much must be invested today at 8% annual interest compounded semiannually to have the needed funds?

15. If you were offered $600 today or $680 in one year, which would you accept if money can be invested at 12% annual interest compounded monthly?

16. Derek Anderson plans to buy a house in four years. He will make an $8,000 down payment on the property. How much should he invest today at 6% annual interest compounded quarterly to have the required amount in four years?

17. Which of the two options yields the greatest return on your investment of $2,000?
Option 1: 8% annual interest compounded quarterly for four years
Option 2: $8\frac{1}{4}$% annual interest compounded annually for four years

18. If you invest $2,000 today at 8% annual interest compounded quarterly, how much will you have after three years? (Table 13-1)

19. If you invest $1,000 today at 5% annual interest compounded daily, how much will you have after 20 days? (Table 13-2)

20. How much money should Bryan Trailer Sales set aside today to have $15,000 in one year to purchase a forklift if the interest rate is 10.4% compounded annually?

1. The compound amount or future value can be found using two formulas: $I = PR$ (assuming $T = 1$) and $A = P + I$. Show how these two formulas relate to the single formula $A = P(1 + R)$.

2. Since the entries in the present value table (Table 13-3) are reciprocals of the corresponding entries in the future value table (Table 13-1), how can Table 13-3 be used to find the future value of an investment?

3. In finding a future value, how will your result compare in size to your original investment?

4. In finding a present value, how will your result compare in size to your desired goal?

5. How can the future value table (Table 13-1) be used to find the present value of a desired goal?

6. Banking regulations require that the effective interest rate (APR or APY) be stated on all loan or investment contracts. Why?

7. Illustrate the procedure described in Exercise 5 to find the present value of an investment if you want to have $500 at the end of two years. The investment earns 8% compounded quarterly. Check your result using the present value table.

8. How does the effective interest rate compare with the compounded rate on a loan or investment? Illustrate your answer with an example that shows the compounded rate and the effective rate.

Challenge Problem

One real estate sales technique is to encourage customers or clients to buy today because the value of the property will probably increase during the next few years. "Buy this lot today for $28,000. In two years, I project it will sell for $32,500." The buyer has a CD worth $30,000 now, which earns 4% compounded annually and will mature in 2 years. Cashing in the CD now requires the buyer to pay an early withdrawal penalty of $600.
a. Should the buyer purchase the land now or in two years?

b. What are some of the problems with waiting to buy land?

c. What are some of the advantages of waiting?

d. Lots in a new subdivision sell for $15,600. Assuming that the price of the lot does not increase, how much would you need to invest today at 8% compounded quarterly to buy the lot in one year?

e. 1. You have inherited $60,000 and plan to buy a home. If you invest the $60,000 today at 5%, compounded annually, how much could you spend on the house in one year?
 2. If you intend to spend $60,000 on a house in one year, how much of your inheritance should you invest today at 5%, compounded annually? How much do you have left to spend on a car?

CASE STUDIES

13.1 How Fast Does Your Money Grow?

Barry heard in his Personal Finance class that he should start investing as soon as possible. He had always thought that it would be smart to start investing after he finishes college and when his salary is high enough to pay the bills and to have money left over. He projects that will be 5–10 years from now. Barry wants to compare the difference between investing now and investing later. A financial planner who spoke to the class suggested that a Roth IRA (Individual Retirement Account) would be a more profitable investment over the long term than a regular IRA, so Barry wants to seriously consider the Roth IRA.

When table values do not include the information you need, use the formula $FV = \$1(1 + R)^N$ where R is the period rate and N is the number of periods.

1. If Barry purchases a $2,000 Roth IRA when he is 25 years old and expects to earn an average of 6% per year compounded annually over 35 years (until he is 60), how much will accumulate in the investment?

2. If Barry doesn't put the money in the IRA until he is 35 years old, how much money will accumulate in the account by the time he is 60 years old? How much less will he earn because he invested 10 years later?

3. Interest rate is critical to the speed at which your investment grows. If $1 is invested at 2%, it takes approximately 34.9 years to double. If $1 is invested at 5%, it takes approximately 14.2 years to double. Use Table 13-1 to determine how many years it takes $1 to double if invested at 10%; at 12%.

4. At what interest rate would you need to invest to have your money double in 10 years?

13.2 Planning: The Key to Wealth

Abdol Akhim has just come from a Personal Finance class where he learned that he can determine how much his savings will be worth in the future. Abdol is completing his two-year business administration degree this semester and has been repairing computers in his spare time to pay for his tuition and books. Abdol got out his savings records and decided to apply what he had learned. He has a balance of $1,000 in a money market account at First Savings Bank, and he considers this to be an emergency fund. His instructor says that he should have 3–6 months of his total bills in an emergency fund. His bills are currently $700 a month. He also has a checking account and a regular savings account at First Savings Bank, and he will shift some of his funds from those accounts into the emergency fund. One of Abdol's future goals is to buy a house. He wants to start another money market account to save the $8,000 he needs for a down payment.

1. How much interest will Abdol receive on $1,000 in a 365-day year if he keeps it in the money market account earning 5.5% compounded daily?

2. How much money must Abdol shift from his other accounts to his emergency fund to have four times his monthly bills in the account by the end of the year?

3. Find the amount Abdol needs to invest to have the $8,000 down payment for his house in 5 years. Assume annual compounding on an account that pays 5.5% interest annually.

13.3 Future Value/Present Value

At 45 years of age, Seth figured he wanted to work only 10 more years. Being a full-time landlord had a lot of advantages: cash flow, free time, and being his own boss; but it was time to start thinking towards retirement. The real estate investments that he had made over the last 15 years had paid off handsomely. After selling a duplex and a four-unit and paying the associated taxes, Seth had $350,000 in the bank and was debt-free. With only 10 years before retirement, Seth wanted to make solid financial decisions that would limit his risk exposure. Fortunately, he had located another property that seemed to meet his needs—an older, but well maintained four-unit apartment. The price tag was $250,000, well within his range, and the apartment would require no remodeling. Seth figured he could invest the other $100,000, and between the two hoped to have $1 million to retire on by age 55.

1. Seth read an article in the local newspaper stating the real estate in the area was appreciating by 6% per year. Assuming the article is correct, what would the future value of the $250,000 apartment be in 10 years?

2. Seth's current bank offers a 1-year certificate of deposit account paying 5% compounded quarterly. A competitor bank is also offering 5%, but compounded daily. If Seth invests the $100,000, how much more money will he have in the second bank after one year, due to the daily compounding?

3. A friend of Seth's who is a real estate developer needs to borrow $80,000 to finish a development project. He is desperate for cash and offers Seth 18%, compounded monthly, for $2\frac{1}{2}$ years. Find the future value of the loan using the future value table. Does this loan meet Seth's goals of low risk? How could he reduce the risk associated with this loan?

4. After purchasing the apartment, Seth receives a street, sewer, and gutter assessment for $12,500 due in 2 years. How much would he have to invest today in a CD paying 6%, compounded semiannually, to fully pay the assessment in 2 years?

Annuities and Sinking Funds

Is Social Security in Crisis?

Will Social Security be there when you need it? Social Security payroll taxes currently produce more revenue than is needed to pay benefits to current retirees. Social Security projections are that benefits will begin to exceed revenues in 2017. By 2032, the trust fund will be exhausted, and will be unable to pay the full benefits that have been promised to older Americans.

So started the formal Social Security debate, which has dominated most of the past decade, and has since become largely a political fight. But what was the original purpose of Social Security? And what are the implications for you today?

Social Security provided a critical foundation of income for retired and disabled workers. For one-third of Americans over 65, Social Security benefits represent 90% of their total income. It was originally structured to resemble private-sector pensions (retirement plans). The retirement benefit was based on a worker's wages and years of service. In most plans, the monthly lifetime benefit after 35 years of service would be at least half of the income earned in the final working year.

Congress expected that company pensions would eventually replace Social Security benefits. But pension coverage peaked at 40% in the 1960s. Today, only 16% of private-sector workers are covered by defined-benefit pensions.

So how can you avoid relying on Social Security when you retire? One of the best things you can do is start a supplemental retirement program right now with an annuity. Annuities may be single- or flexible-payment; fixed or variable; deferred or immediate. No matter the type, annuities are financial contracts with an insurance company that are designed to be a source of retirement income. The very best plans are systematic and enable the investor to make regular and consistent payments into the annuity fund, which compounds interest. And these plans are not expensive; many require as little as $25 a month, or $300 annually to get started. Let's say you're age 25. By investing $300 annually for 40 years at 7%, you would end up with $59,890.50 at age 65. Not a bad investment for $25 a month—about the same price as dinner and a movie.

Will Social Security still be there when you retire? It's impossible to say. Better to get started investing with an annuity now (or soon), rather than find out later when it's too late.

LEARNING OUTCOMES

14-1 Future Value of an Annuity

1. Find the future value of an ordinary annuity using the simple interest formula method.
2. Find the future value of an ordinary annuity with periodic payments using a $1.00 ordinary annuity future value table.
3. Find the future value of an annuity due with periodic payments using the simple interest formula method.
4. Find the future value of an annuity due with periodic payments using a $1.00 ordinary annuity future value table.
5. Find the future value of an ordinary annuity or an annuity due using a formula.

14-2 Sinking Funds and the Present Value of an Annuity

1. Find the sinking fund payment using a $1.00 sinking fund payment table.
2. Find the present value of an ordinary annuity using a $1.00 ordinary annuity present value table.
3. Find the sinking fund payment or the present value of an annuity using a formula.

Annuity: a contract between a person (the annuitant) and an insurance company (the insurer) for receiving and disbursing money for the annuitant or the beneficiary of the annuitant.

Accumulation phase of an annuity: the time when money is being paid into the fund and earnings are being added to the fund.

Liquidation or payout phase of an annuity: the time when the annuitant or beneficiary is receiving money from the fund.

So far we have discussed interest accumulated from one *lump-sum* amount of money. Another type of investment option is an annuity. An **annuity** is a contract between you (the **annuitant**) and an insurance company (the **insurer**) for receiving and disbursing money for the annuitant or the beneficiary of the annuitant. An annuity has two phases—the accumulation phase and the liquidation phase. The **accumulation phase of an annuity** is the time when you are paying money into the fund. The **liquidation or payout phase of an annuity** is the time when you are receiving money from the fund. During both phases of the annuity, the fund balance may earn compound interest. An annuity is purchased by making either a single lump-sum payment or a series of periodic payments. Under the terms of the contract the insurer agrees to make a lump-sum payment or periodic payments to you beginning at some future date. This investment option is a long-term investment option that is commonly used for retirement planning or as a college fund for small children. Penalties are normally applied if funds are withdrawn before a time specified in the agreement.

There are many options to consider when purchasing an annuity. You can choose how the money is invested (stocks, bonds, money market instruments, or a combination of these) and the level of risk of the investment. High-risk options have the potential to earn a high rate of return but the investment may be at risk. Low-risk options normally earn a lower rate of interest but the risk is also lower. A guaranteed rate of interest has no risk at all on the principal and guarantees a specific interest rate.

You can choose if the investment is made with pre-taxed money or with taxed money. If pre-taxed money is invested, the tax on the entire fund is deferred until you begin receiving payments. If taxed money is invested, only the tax on the earnings is deferred until you begin receiving payments. In our study of annuities, we will examine only some basic interest-based options. Other options can be investigated by contacting insurance agencies or brokers or the Office of Investor Education and Assistance with the U.S. Securities and Exchange Commission. (*http://www.sec.gov/investor/pubs/varannty.htm*).

14-1 FUTURE VALUE OF AN ANNUITY

LEARNING OUTCOMES

1 Find the future value of an ordinary annuity using the simple interest formula method.
2 Find the future value of an ordinary annuity with periodic payments using a $1.00 ordinary annuity future value table.
3 Find the future value of an annuity due with periodic payments using the simple interest formula method.
4 Find the future value of an annuity due with periodic payments using a $1.00 ordinary annuity future value table.
5 Find the future value of an ordinary annuity or an annuity due using a formula.

Annuity certain: an annuity paid over a guaranteed number of periods.

Contingent annuity: an annuity paid over an uncertain number of periods.

Ordinary annuity: an annuity for which payments are made at the end of each period.

Annuity due: an annuity for which payments are made at the beginning of each period.

An annuity paid out over a guaranteed number of periods is an **annuity certain**. An annuity paid out over an uncertain number of periods is a **contingent annuity**.

We can also categorize annuities according to when payment is made into the fund. For an **ordinary annuity**, payment is made at the *end* of the period. For an **annuity due**, payment is made at the *beginning* of the period.

1 Find the future value of an ordinary annuity using the simple interest formula method.

Finding the future value of an annuity into which periodic payments are made means finding the amount of the annuity at the end of the accumulation phase. This is similar to finding the future value of a lump sum. The significant difference is that for each interest period, more principal— the annuity payment—is added to the amount on which interest is earned. The simple interest formula $I = PRT$ is still the basis of calculating interest for each period of the annuity.

| HOW TO | Find the future value of an ordinary annuity in the accumulation phase with periodic payments using the simple interest formula method |
|---|---|

1. Find the first end-of-period principal.

$$\text{First end-of-period principal} = \text{annuity payment}$$

2. For each remaining period in turn, find the next end-of-period principal.
 (a) Multiply the previous end-of-period principal by the sum of 1 and the decimal equivalent of the period interest rate.

(b) Add the product from step 2a and the annuity payment.

End-of-period principal = previous end-of-period principal
$$\times \ (1 + \text{period interest rate}) + \text{annuity payment}$$

3. Identify the last end-of-period principal as the future value.

Future value = last end-of-period principal

For an ordinary annuity, no interest accumulates on the annuity payment during the period in which it is paid because the payment is made at the *end* of the period. For the first period, this means no interest accumulates at all.

EXAMPLE 1 What is the future value of an ordinary annuity with annual payments of $1,000 after three years at 4% annual interest?

The period interest rate is 0.04. The annuity is $1,000.
End-of-year value = (previous end-of-year value)(1 + 0.04) + 1,000

End-of-year 1 = $1,000.00 No interest earned the first year.
End-of-year 2 = $1,000.00(1.04) + $1,000.00
 = $1,040.00 + $1,000.00
 = $2,040.00

End-of-year 3 = $2,040.00(1.04) + $1,000.00
 = $2,121.60 + $1,000.00
 = $3,121.60

The future value is $3,121.60.

HOW TO **Find the total interest earned on an annuity**

1. Find the total amount invested:

Total invested = payment amount × number of payments

2. Find the total interest:

Total interest = future value of annuity − total invested

EXAMPLE 2 Find the total interest earned on the annuity in the preceding example.

Total invested = $1,000(3) Payment = $1,000
 Number of payments = 3
 = $3,000
Total interest = $3,121.60 − $3,000 Future value = $3,121.60
 = $121.60

The total interest earned is $121.60.

A lump-sum investment earns more interest than an annuity. Compare the earnings of a $3,000 lump-sum investment (Figure 14-1) and an annuity of the same accumulated investment (Figure 14-2).

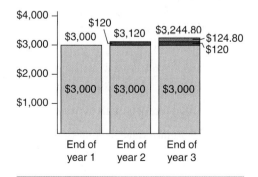

FIGURE 14-1
Lump-Sum Investment of $3,000

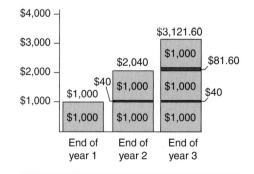

FIGURE 14-2
Three-Year Ordinary Annuity of $1,000 per Year

The advantages of the lump-sum annuity are obvious, but an annuity with periodic payments also offers some advantages. When a lump sum is not available, an annuity with periodic payments provides an alternative investment strategy.

 STOP AND CHECK

1. Find the future value and total interest of an ordinary annuity with annual payments of $5,000 at 2.9% annual interest after four years.

2. Find the future value and total interest of an annuity with annual payments of $3,500 at 3.42% annual interest after three years.

3. Find the value of an annuity after two years of $1,500 invested semiannually at 4% annual interest.

4. What is the value after 2 years of an annuity of $300 paid semiannually at 3% annual interest?

2 Find the future value of an ordinary annuity with periodic payments using a $1.00 ordinary annuity future value table.

Calculating the future value of an ordinary annuity with periodic payments can become quite tedious if the number of periods is large. For example, a monthly annuity such as a monthly savings plan running for five years has 60 periods and 60 calculation sequences. For this reason, most businesspeople rely on prepared tables, calculators, or computers.

HOW TO Find the future value of an ordinary annuity with periodic payments using a $1.00 ordinary annuity future value table

Using Table 14-1:

1. Select the periods row corresponding to the number of interest periods.
2. Select the rate-per-period column corresponding to the period interest rate.
3. Locate the value in the cell where the periods row intersects the rate-per-period column.
4. Multiply the annuity payment by the table value from step 3.

$$\text{Future value} = \text{annuity payment} \times \text{table value}$$

EXAMPLE 1 Use Table 14-1 to find the future value of a semiannual ordinary annuity of $6,000 for five years at 6% annual interest compounded semiannually.

$$5 \text{ years} \times 2 \text{ periods per year} = 10 \text{ periods}$$

$$\frac{6\% \text{ annual interest rate}}{2 \text{ periods per year}} = 3\% \text{ period interest rate}$$

The Table 14-1 value for 10 periods at 3% is 11.464.

$$\text{Future value of annuity} = \text{annuity payment} \times \text{table value}$$
$$= \$6,000(11.464)$$
$$= \$68,784$$

The future value of the ordinary annuity is $68,784.

TABLE 14-1
Future Value of $1.00 Ordinary Annuity

| Periods | 2% | 3% | 4% | 5% | 6% | 7% | 8% | 9% | 10% | 12% |
|---|---|---|---|---|---|---|---|---|---|---|
| 1 | 1.000 | 1.000 | 1.000 | 1.000 | 1.000 | 1.000 | 1.000 | 1.000 | 1.000 | 1.000 |
| 2 | 2.020 | 2.030 | 2.040 | 2.050 | 2.060 | 2.070 | 2.080 | 2.090 | 2.100 | 2.120 |
| 3 | 3.060 | 3.091 | 3.122 | 3.153 | 3.184 | 3.215 | 3.246 | 3.278 | 3.310 | 3.374 |
| 4 | 4.122 | 4.184 | 4.246 | 4.310 | 4.375 | 4.440 | 4.506 | 4.573 | 4.641 | 4.779 |
| 5 | 5.204 | 5.309 | 5.416 | 5.526 | 5.637 | 5.751 | 5.867 | 5.985 | 6.105 | 6.353 |
| 6 | 6.308 | 6.468 | 6.633 | 6.802 | 6.975 | 7.153 | 7.336 | 7.523 | 7.716 | 8.115 |
| 7 | 7.434 | 7.662 | 7.898 | 8.142 | 8.394 | 8.654 | 8.923 | 9.200 | 9.487 | 10.089 |
| 8 | 8.583 | 8.892 | 9.214 | 9.549 | 9.897 | 10.260 | 10.637 | 11.028 | 11.436 | 12.300 |
| 9 | 9.755 | 10.159 | 10.583 | 11.027 | 11.491 | 11.978 | 12.488 | 13.021 | 13.579 | 14.776 |
| 10 | 10.950 | 11.464 | 12.006 | 12.578 | 13.181 | 13.816 | 14.487 | 15.193 | 15.937 | 17.549 |
| 11 | 12.169 | 12.808 | 13.486 | 14.207 | 14.972 | 15.784 | 16.645 | 17.560 | 18.531 | 20.655 |
| 12 | 13.412 | 14.192 | 15.026 | 15.917 | 16.870 | 17.888 | 18.977 | 20.141 | 21.384 | 24.133 |
| 13 | 14.680 | 15.618 | 16.627 | 17.713 | 18.882 | 20.141 | 21.495 | 22.523 | 24.523 | 28.029 |
| 14 | 15.974 | 17.086 | 18.292 | 19.599 | 21.015 | 22.550 | 24.215 | 26.019 | 27.975 | 32.393 |
| 15 | 17.293 | 18.599 | 20.024 | 21.579 | 23.276 | 25.129 | 27.152 | 29.361 | 31.772 | 37.280 |
| 16 | 18.639 | 20.157 | 21.825 | 23.657 | 25.673 | 27.888 | 30.324 | 33.003 | 35.950 | 42.753 |
| 17 | 20.012 | 21.762 | 23.698 | 25.840 | 28.213 | 30.840 | 33.750 | 36.974 | 40.545 | 48.884 |
| 18 | 21.412 | 23.414 | 25.645 | 28.132 | 30.906 | 33.999 | 37.450 | 41.301 | 45.599 | 55.750 |
| 19 | 22.841 | 25.117 | 27.671 | 30.539 | 33.760 | 37.379 | 41.446 | 46.018 | 51.159 | 63.440 |
| 20 | 24.297 | 26.870 | 29.778 | 33.066 | 36.786 | 40.995 | 45.762 | 51.160 | 57.275 | 72.052 |
| 21 | 25.783 | 28.676 | 31.969 | 35.719 | 39.993 | 44.865 | 50.423 | 56.765 | 64.002 | 81.699 |
| 22 | 27.299 | 30.537 | 34.248 | 38.505 | 43.392 | 49.006 | 55.457 | 62.873 | 71.403 | 92.503 |
| 23 | 28.845 | 32.453 | 36.618 | 41.430 | 46.996 | 53.436 | 60.893 | 69.532 | 79.543 | 104.603 |
| 24 | 30.422 | 34.426 | 39.083 | 44.502 | 50.816 | 58.177 | 66.765 | 76.790 | 88.497 | 118.155 |
| 25 | 32.030 | 36.459 | 41.646 | 47.727 | 54.865 | 63.249 | 73.106 | 84.701 | 98.347 | 133.334 |
| 26 | 33.671 | 38.553 | 44.312 | 51.113 | 59.156 | 68.676 | 79.954 | 93.324 | 109.182 | 150.334 |
| 27 | 35.344 | 40.710 | 47.084 | 54.669 | 63.706 | 74.484 | 87.351 | 102.723 | 121.100 | 169.374 |
| 28 | 37.051 | 42.931 | 49.968 | 58.403 | 68.528 | 80.698 | 95.339 | 112.968 | 134.210 | 190.699 |
| 29 | 38.792 | 45.219 | 52.966 | 62.323 | 73.640 | 87.347 | 103.966 | 124.135 | 148.631 | 214.583 |
| 30 | 40.568 | 47.575 | 56.085 | 66.439 | 79.058 | 94.461 | 113.283 | 136.308 | 164.494 | 241.333 |
| 35 | 49.994 | 60.462 | 73.652 | 90.320 | 111.435 | 138.237 | 172.317 | 215.711 | 271.024 | 431.663 |
| 40 | 60.402 | 75.401 | 95.026 | 120.800 | 154.762 | 199.635 | 259.057 | 337.882 | 442.593 | 767.091 |
| 45 | 71.893 | 92.720 | 121.029 | 159.700 | 212.744 | 285.749 | 386.506 | 525.859 | 718.905 | 1358.230 |
| 50 | 84.579 | 112.797 | 152.667 | 209.348 | 290.336 | 406.529 | 573.770 | 815.084 | 1163.909 | 2400.018 |
| 55 | 98.587 | 136.072 | 191.159 | 272.713 | 394.172 | 575.929 | 848.923 | 1260.092 | 1880.591 | 4236.005 |
| 60 | 114.052 | 163.053 | 237.991 | 353.584 | 533.128 | 813.520 | 1253.213 | 1944.792 | 3034.816 | 7471.641 |
| 65 | 131.126 | 194.333 | 294.968 | 456.798 | 719.083 | 1146.755 | 1847.248 | 2998.288 | 4893.707 | 13173.937 |
| 70 | 149.978 | 230.594 | 364.290 | 588.529 | 967.932 | 1614.134 | 2720.080 | 4619.223 | 7887.470 | 23223.332 |
| 75 | 170.792 | 272.631 | 448.631 | 756.654 | 1300.949 | 2269.657 | 4002.557 | 7113.232 | 12708.954 | 40933.799 |
| 80 | 193.772 | 321.363 | 551.245 | 971.229 | 1746.600 | 3189.063 | 5886.935 | 10950.574 | 20474.002 | 72145.693 |
| 85 | 219.144 | 377.857 | 676.090 | 1245.087 | 2342.982 | 4478.576 | 8655.706 | 16854.800 | 32979.690 | 127151.714 |
| 90 | 247.157 | 443.349 | 827.983 | 1594.607 | 3141.075 | 6287.185 | 12723.939 | 25939.184 | 53120.226 | 224091.119 |
| 95 | 278.085 | 519.272 | 1012.785 | 2040.694 | 4209.104 | 8823.854 | 18701.507 | 39916.635 | 85556.760 | 394931.472 |
| 100 | 312.232 | 607.288 | 1237.624 | 2610.025 | 5638.368 | 12381.662 | 27484.516 | 61422.675 | 137796.123 | 696010.548 |

Rate per period

Table values show the future value, or accumulated amount of the investment and interest, of a $1.00 investment for a given number of periods at a given rate per period.

Table values can be generated using the formula FV of \$1.00 per period $= \left(\dfrac{(1 + R)^N - 1}{R} \right)$, where FV is the future value, R is the interest rate per period, and N is the number of periods.

EXAMPLE 2
Find the total interest earned on the annuity in Example 1.

Total invested = $6,000(10)

 = $60,000

Total interest = $68,784 − $60,000

 = $8,784

Payment = $6,000

Number of payments = 10

Future value = $68,784

The total interest earned is $8,784.

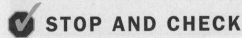
1. Use Table 14-1 to find the accumulation phase future value and total interest of an ordinary annuity of $4,000 for eight years at 2% annual interest.

2. Use Table 14-1 to find the accumulated amount and total interest of an ordinary annuity with semiannual payments of $6,000 for five years at 4% annual interest.

3. John Crampton put $1,200 in an ordinary annuity account every quarter of the accumulation phase for five years at an 8% annual rate compounded quarterly. What is the future value of the annuity?

4. Tiffany Evans created an ordinary annuity with $2,500 payments made semiannually at 6% annually. Find her annuity value at the end of six years.

3 Find the future value of an annuity due with periodic payments using the simple interest formula method.

Because an annuity due is paid at the *beginning* of each period rather than at the end, the annuity due payment earns interest throughout the period in which it is paid. The future value of an annuity due, then, is greater than the future value of the corresponding ordinary annuity, given the same number of periods, the same period interest rate, and the same annuity payment. The difference in the future value of an ordinary annuity and an annuity due is exactly one additional period's worth of interest.

HOW TO Find the future value of an annuity due with periodic payments using the simple interest formula method

1. Find the first end-of-period principal: Multiply the annuity payment by the sum of 1 and the decimal equivalent of the period interest rate.

 First end-of-period principal = annuity payment × (1 + period interest rate)

2. For each remaining period in turn, find the next end-of-period principal:
 (a) Add the previous end-of-period principal and the annuity payment.
 (b) Multiply the sum from step 2a by the sum of 1 and the period interest rate.

 End-of-period principal = (previous end-of-period principal + annuity payment)
 × (1 + period interest rate)

3. Identify the last end-of-period principal as the future value.

 Future value = last end-of-period principal

EXAMPLE 1
What is the future value of an annuity due with an annual payment of $1,000 for three years at 4% annual interest? Find the total investment and the total interest earned.

The annuity payment is $1,000; the period interest rate is 4%.
End-of-year value = (previous end-of-year + $1,000)(1 + 0.04)

End-of-year 1 = $1,000(1.04) The annuity due earns interest
 = $1,040 during the first period.
End-of-year 2 = ($1,040 + $1,000)(1.04) Second payment is made.
 = ($2,040)(1.04)
 = $2,121.60
End-of-year 3 = ($2,121.60 + $1,000)(1.04) Third payment is made.
 = ($3,121.60)(1.04)
 = $3,246.46 Future value of annuity due
Total investment = investment per period × total periods
 = $1,000(3)
 = $3,000
Total interest earned = future value − total investment
 = $3,246.46 − $3,000
 = $246.46

The future value of the annuity due is $3,246.46, the total investment is $3,000, and the total interest earned is $246.46.

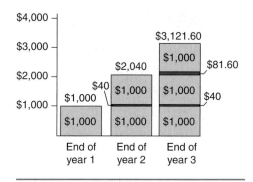

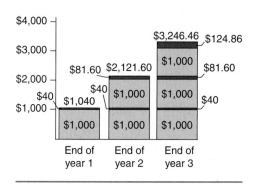

FIGURE 14-3
Three-year ordinary annuity of $1,000 per year

FIGURE 14-4
Three-year annuity due of $1,000 per year

In the three-year ordinary annuity (Figure 14-3, repeated from Figure 14-2 for comparison purposes) the final interest earned is $121.60. In the annuity due (Figure 14-4) the first $1,000 payment earns interest during the first period and then interest is earned on that interest throughout the duration of the annuity. The total interest earned is $246.46.

 STOP AND CHECK

1. Manually calculate the future value of an annuity due that sets aside $1,500 annually for four years at 3.75% annual interest compounded semianually. How much interest is earned?

2. Manually calculate the value of an annuity due after two years of $4,000 payments at 4.25% compounded annually.

3. DeMarco receives $5,000 semiannually from his grandmother's estate. He invests the money at 3.8%. How much will he have after two years investing as an annuity due?

4. If you make six monthly payments of $50 to an annuity due and receive 6% annual interest compounded monthly, how much will you accumulate?

4 Find the future value of an annuity due with periodic payments using a $1.00 ordinary annuity future value table.

Because the future value of an annuity due is so closely related to the future value of the corresponding ordinary annuity, we can also use Table 14-1 to find the future value of an annuity due. An annuity due accumulates interest one period more than does the ordinary annuity, but has the same number of payments. Thus, we adjust Table 14-1 values by multiplying by the sum of 1 and the period interest rate. This applies interest for the first payment, which is made at the beginning of the first period, for the entire time of the annuity.

> **HOW TO** Find the future value of an annuity due with a periodic payment using a $1.00 ordinary annuity future value table
>
> Use Table 14-1:
>
> 1. Select the periods row corresponding to the number of interest periods.
> 2. Select the rate-per-period column corresponding to the period interest rate.
> 3. Locate the value in the cell where the periods row intersects the rate-per-period column.
> 4. Multiply the annuity payment by the table value from step 3. This is equivalent to an *ordinary annuity.*
> 5. Multiply the amount that is equivalent to an ordinary annuity by the sum of 1 and the period interest rate to adjust for the extra interest that is earned on an annuity due.
>
> Future value = annuity payment × table value × (1 + period interest rate)

EXAMPLE 1 Use Table 14-1 to find the future value of a quarterly annuity due of $2,800 for four years at 8% annual interest compounded quarterly.

$$4 \text{ years} \times 4 \text{ periods per year} = 16 \text{ periods}$$

$$\frac{8\% \text{ annual interest rate}}{4 \text{ periods per year}} = 2\% \text{ period interest rate}$$

The Table 14-1 value for 16 periods at 2% is 18.639.

| | | |
|---|---|---|
| Future value | = annuity payment × table value × (1 + period interest rate) | |
| | = $2,800(18.639)(1.02) | Future value for ordinary annuity |
| | = $52,189.20(1.02) | Adjustment for annuity due |
| | = $53,232.98 | Future value for annuity due |

The future value is $53,232.98.

EXAMPLE 2 What is the total interest earned on the annuity due in the previous example?

| | |
|---|---|
| Total invested = $2,800(16) | Payment = $2,800 |
| = $44,800 | Number of payments = 16 |
| Total interest = $53,232.98 − $44,800 | |
| = $8,432.98 | |

The total interest earned is $8,432.98.

EXAMPLE 3 Sarah Smith wants to select the best annuity plan. She plans to invest a total of $40,000 over ten years' time at 8% annual interest. Annuity 1 is a quarterly ordinary annuity of $1,000; interest is compounded quarterly. Annuity 2 is a semiannual ordinary annuity of $2,000; interest is compounded semiannually. Annuity 3 is a quarterly annuity due of $1,000; interest is compounded quarterly. Annuity 4 is a semiannual annuity due of $2,000; interest is compounded semiannually. Which annuity yields the greatest future value?

| What You Know | What You Are Looking For | Solution Plan |
|---|---|---|
| Annuity 1: Ordinary annuity of $1,000 quarterly for ten years at 8% annual interest compounded quarterly | Which annuity yields the greatest future value?

 Future value of each annuity | Number of periods = years × periods per year

 $\text{Period interest rate} = \dfrac{\text{annual interest rate}}{\text{periods per year}}$ |
| Annuity 2: Ordinary annuity of $2,000 semiannually for ten years at 8% annual interest compounded semiannually | | Future value of ordinary annuity = annuity payment × Table 14-1 value |
| Annuity 3: Annuity due of $1,000 quarterly for ten years at 8% annual interest compounded quarterly | | Future value of annuity due = annuity payment × Table 14-1 value × (1 + period interest rate) |
| Annuity 4: Annuity due of $2,000 semiannually for ten years at 8% annual interest compounded semiannually. | | |

Solution

Annuity 1

$$\begin{aligned} \text{Number of periods} &= \text{years} \times \text{periods per year} \\ &= 10(4) \\ &= 40 \end{aligned}$$

$$\begin{aligned} \text{Period interest rate} &= \frac{\text{annual interest rate}}{\text{periods per year}} \\ &= \frac{8\%}{4} = 2\% \end{aligned}$$

Table value $= 60.402$
Future value $=$ annuity payment \times table value
Future value $=$ ($1,000)(60.402)
$\qquad = \$60,402$

Annuity 2
Number of periods $=$ years \times periods per year
$\qquad = 10(2)$
$\qquad = 20$

Period interest rate $= \dfrac{\text{annual interest rate}}{\text{periods per year}}$

$\qquad = \dfrac{8\%}{2} = 4\%$

Table value $= 29.778$
Future value $=$ annuity payment \times table value
$\qquad = \$2,000(29.778)$
$\qquad = \$59,556$

Annuity 3
The number of periods and period interest rate are the same as those for annuity 1.
Future value $=$ annuity payment \times table value \times (1 $+$ period interest rate)
$\qquad = \$1,000(60.402)(1.02)$
$\qquad = \$61,610.04$

Annuity 4
The number of periods and period interest rate are the same as those for annuity 2.
Future value $=$ annuity payment \times table value \times (1 $+$ period interest rate)
$\qquad = \$2,000(29.778)(1.04)$
$\qquad = \$61,938.24$

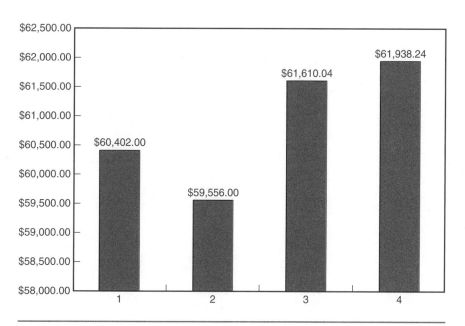

FIGURE 14-5
Four Two-Year Annuities at 8% Annual Interest

Conclusion

Annuity 4, with the larger annuity due payment, yields the greatest future value. Notice that the ordinary annuity with fewer periods per year yields the least future value of all four annuities. If the total investment is the same, the number of years is the same, and the annual rate of interest is the same, any annuity due yields a larger future value than any corresponding ordinary annuity. The annuity due with the largest payment is the most profitable, while the ordinary annuity paid most frequently is the most profitable ordinary annuity.

STOP AND CHECK

1. Use Table 14-1 to find the future value of an annual annuity due of $3,000 for ten years at 5%.

2. Use Table 14-1 to find the future value of a semiannual annuity due of $1,000 for five years at 6% annually compounded semiannually.

3. Use Table 14-1 to find the future value of a quarterly annuity of $500 invested at 8% annually compounded quarterly for five years.

4. Use Table 14-1 to find the future value of a semiannual annuity of $1,000 for five years invested at 8% annually compounded semiannually. Compare the interest earned on this annuity with the interest earned on the annuity in Exercise 3.

5 Find the future value of an ordinary annuity or an annuity due using a formula.

Using tables to find the future value of an annuity can be limiting. Annuity rates may not be stated as whole number percents. Evaluating an annuity formula requires a business, scientific, or graphing calculator or computer software like Excel. Many of the calculator or software features can be used to facilitate these calculations. Be sure to apply the *order of operations*. For more details, review Chapter 5, Section 1, Learning Outcome 5.

HOW TO Find the future value of an ordinary annuity or an annuity due using a formula:

1. Identify the period rate R as a decimal equivalent, the number of periods N, and the amount of the annuity payment PMT.
2. Substitute the values from Step 1 into the appropriate formula.

$$FV_{\text{ordinary annuity}} = PMT\left(\frac{(1 + R)^N - 1}{R}\right)$$

$$FV_{\text{annuity due}} = PMT\left(\frac{(1 + R)^N - 1}{R}\right)(1 + R)$$

3. Evaluate the formula.

EXAMPLE 1 Find the future value of an ordinary annuity of $100 paid monthly at 5.25% for 10 years.

$$R = \frac{5.25\%}{12} = \frac{0.0525}{12} = 0.004375 \qquad \text{Periodic interest rate}$$

$$N = 10(12) = 120 \qquad \text{Number of payments}$$

$$PMT = \$100$$

$$FV_{\text{ordinary annuity}} = \$100\left(\frac{(1 + 0.004375)^{120} - 1}{0.004375}\right) \qquad \text{Mentally add within the innermost parentheses.}$$

$$FV_{\text{ordinary annuity}} = \$100\left(\frac{(1.004375)^{120} - 1}{0.004375}\right)$$

Calculator sequence:

$$100\ (\ 1.004375\ ^\wedge\ 120\ -\ 1\)\ \div\ 0.004375\ = \Rightarrow 15737.69632$$

The future value of the ordinary annuity is $15,737.70.

EXAMPLE 2

Find the future value of an annuity due of $50 monthly at 5.75% for 5 years.

$$R = \frac{5.75\%}{12} = \frac{0.0575}{12} = 0.0047916667 \qquad \text{Periodic interest rate}$$

$$N = 5(12) = 60 \qquad\qquad\qquad\qquad \text{Number of payments}$$

$$PMT = \$50$$

$$FV_{\text{annuity due}} = \$50\left(\frac{(1 + 0.0047916667)^{60} - 1}{0.0047916667}\right)(1 + 0.0047916667) \qquad \begin{array}{l}\text{Mentally add within}\\ \text{the parentheses.}\end{array}$$

$$FV_{\text{annuity due}} = \$50\left(\frac{(1.0047916667)^{60} - 1}{0.0047916667}\right)(1.0047916667)$$

Calculator sequence:

$$50\;\boxed{(}\;1.0047916667\;\boxed{\wedge}\;60\;\boxed{-}\;1\;\boxed{)}\;\boxed{\div}\;0.0047916667\;\boxed{=}$$

$$\boxed{\text{ANS}}\;\boxed{(}\;1.0047916667\;\boxed{)}\;\boxed{=}\;\Rightarrow\;3482.788889$$

The future value of the annuity due is $3,482.79.

STOP AND CHECK

1. Use the formula to find the future value of an ordinary annuity of $250 paid monthly at 4.62% for 25 years.

2. Use the formula to find the future value of an ordinary annuity of $30 paid weekly at 5.2% for 15 years.

3. Use the formula to find the future value of an annuity due of $200 monthly at 7.35% for 14 years.

4. Marquita is creating an annuity due of $25 every two weeks at 6% for 35 years. Find the future value of her annuity due.

14-1 SECTION EXERCISES

SKILL BUILDERS

Use Table 14-1 to find the future value of the annuities.

| | Annuity type | Periodic payment | Annual interest rate | Payment paid | Years |
|---|---|---|---|---|---|
| 1. | Ordinary annuity | $1,000 | 5% | Annually | 8 |
| 2. | Ordinary annuity | $ 500 | 4% | Semiannually | 4 |
| 3. | Ordinary annuity | $2,000 | 8% | Quarterly | 3 |
| 4. | Annuity due | $3,000 | 6% | Semiannually | 3 |
| 5. | Annuity due | $5,000 | 3% | Annually | 4 |
| 6. | Annuity due | $ 800 | 7% | Annually | 5 |

7. Manually find the future value of an ordinary annuity of $300 paid annually at 5% for three years. Verify your result by using the table method.

8. Manually find the future value of an annuity due of $500 paid semiannually for two years at 6% annual interest compounded semiannually. Verify your result by using the table method.

APPLICATIONS

Use the simple interest formula method for Exercises 9–12.

9. Find the future value of an ordinary annuity of $3,000 annually after two years at 3.8% annual interest. Find the total interest earned.

10. Len and Sharron Smith are saving money for their daughter Heather to attend college. They set aside an ordinary annuity of $4,000 annually for ten years at 7% annual interest. How much will Heather have for college after two years? Find the total interest earned.

11. Harry Taylor plans to pay an ordinary annuity of $5,000 annually for ten years so he can take a year's sabbatical to study for a master's degree in business. The annual rate of interest is 3.8%. How much will Harry have at the end of three years? How much interest will he earn on the investment after three years?

12. Scott Martin is planning to establish a retirement annuity. He is committed to an ordinary annuity of $3,000 annually at 3.6% annual interest. How much will Scott have accumulated after three years? How much interest will he earn?

Use Table 14-1 or the appropriate formula for Exercises 13–17.

13. Find the future value of an ordinary annuity of $6,500 semiannually for seven years at 6% annual interest compounded semiannually. How much was invested? How much interest was earned?

14. Pat Lechleiter pays an ordinary annuity of $2,500 quarterly at 8% annual interest compounded quarterly to establish supplemental income for retirement. How much will Pat have available at the end of five years?

15. Latanya Brown established an ordinary annuity of $1,000 annually at 7% annual interest. What is the future value of the annuity after 15 years? How much of her own money will Latanya have invested during this time period? By how much will her investment have grown?

16. You invest in an ordinary annuity of $500 annually at 8% annual interest. Find the future value of the annuity at the end of ten years. How much have you invested? How much interest has your annuity earned?

17. You invest in an ordinary annuity of $2,000 annually at 8% annual interest. What is the future value of the annuity at the end of five years? How much have you invested? How much interest has your annuity earned?

18. Make a chart comparing your results for Exercises 16 and 17. Use these headings: Years, Total Investment, Total Interest. What general conclusion might you draw about effective investment strategy?

Use the simple interest formula method for Exercises 19–22:

19. Find the future value of an annuity due of $12,000 annually for three years at 3% annual interest. How much was invested? How much interest was earned?

20. Bernard McGhee has decided to establish an annuity due of $2,500 annually for 15 years at 7.2% annual interest. How much is the annuity due worth after two years? How much was invested? How much interest was earned?

21. Find the future value of an annuity due of $7,800 annually for two years at 8.1% annual interest. Find the total amount invested. Find the interest.

22. Find the future value of an annuity due of $400 annually for two years at 6.8% annual interest compounded annually.

Use Table 14-1 or the appropriate formula for Exercises 23–26.

23. Find the future value of a quarterly annuity due of $4,400 for three years at 8% annual interest compounded quarterly. How much was invested? How much interest was earned?

24. Find the future value of an annuity due of $750 semiannually for four years at 8% annual interest compounded semiannually. What is the total investment? What is the interest?

25. Which annuity earns more interest: an annuity due of $300 quarterly for one year at 8% annual interest compounded quarterly, or an annuity due of $600 semiannually for one year at 8% annual interest compounded semiannually?

26. You have carefully examined your budget and determined that you can manage to set aside $250 per year. So you set up an annuity due of $250 annually at 7% annual interest. How much will you have contributed after 20 years? What is the future value of your annuity after 20 years? How much interest will you earn?

14-2 SINKING FUNDS AND THE PRESENT VALUE OF AN ANNUITY

LEARNING OUTCOMES

1 Find the sinking fund payment using a $1.00 sinking fund payment table.
2 Find the present value of an ordinary annuity using a $1.00 ordinary annuity present value table.
3 Find the sinking fund payment or the present value of an annuity using a formula.

Businesses and individuals often use sinking funds to accumulate a desired amount of money by the end of a certain period of time to pay off a financial obligation, to use for a retirement or college fund, or to reach a specific goal such as retiring a bond issue or paying for equipment replacement and modernization. Essentially, a **sinking fund** is payment into an ordinary annuity to yield a desired future value. That is, the future value is known and the payment amount is unknown.

Sinking fund: payment into an ordinary annuity to yield a desired future value.

| | Payment | Future Value |
|---|---|---|
| **Sinking Fund** | Unknown | Known |
| **Accumulation Phase of an Annuity** | Known | Unknown |

1 Find the sinking fund payment using a $1.00 sinking fund payment table.

A sinking fund payment is made at the *end* of each period, so a sinking fund payment is an ordinary annuity payment. These payments, along with the interest, accumulate over a period of time in order to provide the desired future value.

To calculate the *payment* required to yield a desired future value, use Table 14-2. The procedure for locating a value in Table 14-2 is similar to the procedure used for Table 14-1.

HOW TO Find the sinking fund payment using a $1.00 sinking fund payment table

Use Table 14-2:

1. Select the periods row corresponding to the number of interest periods.
2. Select the rate-per-period column corresponding to the period interest rate.
3. Locate the value in the cell where the periods row intersects the rate-per-period column.
4. Multiply the table value from step 3 by the desired future value.

Sinking fund payment = future value × Table 14-2 value

TABLE 14-2
$1.00 Sinking Fund Payments

| Periods | 1% | 2% | 3% | Rate per period 4% | 6% | 8% | 12% |
|---|---|---|---|---|---|---|---|
| 1 | 1.0000000 | 1.0000000 | 1.0000000 | 1.0000000 | 1.0000000 | 1.0000000 | 1.0000000 |
| 2 | 0.4975124 | 0.4950495 | 0.4926108 | 0.4901961 | 0.4854369 | 0.4807692 | 0.4716981 |
| 3 | 0.3300221 | 0.3267547 | 0.3235304 | 0.3203485 | 0.3141098 | 0.3080335 | 0.2963490 |
| 4 | 0.2462811 | 0.2426238 | 0.2390270 | 0.2354900 | 0.2285915 | 0.2219208 | 0.2092344 |
| 5 | 0.1960398 | 0.1921584 | 0.1883546 | 0.1846271 | 0.1773964 | 0.1704565 | 0.1574097 |
| 6 | 0.1625484 | 0.1585258 | 0.1545975 | 0.1507619 | 0.1433626 | 0.1363154 | 0.1232257 |
| 7 | 0.1386283 | 0.1345120 | 0.1305064 | 0.1266096 | 0.1191350 | 0.1120724 | 0.0991177 |
| 8 | 0.1206903 | 0.1165098 | 0.1124564 | 0.1085278 | 0.1010359 | 0.0940148 | 0.0813028 |
| 9 | 0.1067404 | 0.1025154 | 0.0984339 | 0.0944930 | 0.0870222 | 0.0800797 | 0.0676789 |
| 10 | 0.0955821 | 0.0913265 | 0.0872305 | 0.0832909 | 0.0758680 | 0.0690295 | 0.0569842 |
| 11 | 0.0864541 | 0.0821779 | 0.0780774 | 0.0741490 | 0.0667929 | 0.0600763 | 0.0484154 |
| 12 | 0.0788488 | 0.0745596 | 0.0704621 | 0.0665522 | 0.0592770 | 0.0526950 | 0.0414368 |
| 13 | 0.0724148 | 0.0681184 | 0.0670295 | 0.0601437 | 0.0529601 | 0.0465218 | 0.0356772 |
| 14 | 0.0669012 | 0.0626020 | 0.0585263 | 0.0546690 | 0.0475849 | 0.0412969 | 0.0308712 |
| 15 | 0.0621238 | 0.0578255 | 0.0537666 | 0.0499411 | 0.0429628 | 0.0368295 | 0.0268242 |
| 16 | 0.0579446 | 0.0536501 | 0.0496108 | 0.0458200 | 0.0389521 | 0.0329769 | 0.0233900 |
| 17 | 0.0542581 | 0.0499698 | 0.0459525 | 0.0421985 | 0.0354448 | 0.0296294 | 0.0204567 |
| 18 | 0.0509820 | 0.0467021 | 0.0427087 | 0.0389933 | 0.0323565 | 0.0267021 | 0.0179373 |
| 19 | 0.0480518 | 0.0437818 | 0.0398139 | 0.0361386 | 0.0296209 | 0.0241276 | 0.0157630 |
| 20 | 0.0454153 | 0.0411567 | 0.0372157 | 0.0335818 | 0.0271846 | 0.0218522 | 0.0138788 |
| 25 | 0.0354068 | 0.0312204 | 0.0274279 | 0.0240120 | 0.0182267 | 0.0136788 | 0.0075000 |
| 30 | 0.0287481 | 0.0246499 | 0.0210193 | 0.0178301 | 0.0126489 | 0.0088274 | 0.0041437 |
| 40 | 0.0204556 | 0.0165558 | 0.0132624 | 0.0105235 | 0.0064615 | 0.0038602 | 0.0013036 |
| 50 | 0.0155127 | 0.0118232 | 0.0088655 | 0.0065502 | 0.0034443 | 0.0017429 | 0.0004167 |

Table values show the sinking fund payment earning a given rate for a given number of periods so that the accumulated amount at the end of the time will be $1.00. The formula for generating the table values is $TV = \dfrac{R}{(1 + R)^N - 1}$, where TV is the table value, R is the rate per period, and N is the number of periods or payments.

EXAMPLE 1 Use Table 14-2 to find the annual sinking fund payment required to accumulate $140,000 in 12 years at 6% annual interest.

$$12 \text{ years} \times 1 \text{ period per year} = 12 \text{ periods}$$

$$\frac{6\% \text{ annual interest rate}}{1 \text{ period per year}} = 6\% \text{ period interest rate}$$

The Table 14-2 value for 12 periods at 6% is 0.0592770

$$\text{Sinking fund payment} = \text{desired future value} \times \text{table factor}$$
$$= \$140,000(0.0592770)$$
$$= \$8,298.78$$

A sinking fund payment of \$8,298.78 is required at the end of each year for 12 years at 6% to yield the desired \$140,000.

EXAMPLE 2 Find the total interest earned on the sinking fund in the previous example.

$FV = \$140,000$ Number of payments = 12

Total investment = amount of payment \times 12
$$= \$8,298.78(12)$$
$$= \$99,585.36$$

Total interest earned = $\$140,000 - \$99,585.36$
$$= \mathbf{\$40,414.64}$$

 STOP AND CHECK

1. Use Table 14-2 to find the annual sinking fund payment needed to accumulate $12,000 in six years at 4% annual interest.

2. What is the total amount paid and the interest on the sinking fund in Exercise 1?

3. Use Table 14-2 to find the quarterly sinking fund payment needed to accumulate $25,000 in ten years at 4% annual interest compounded quarterly.

4. What is the amount paid and the interest on the sinking fund in Exercise 3?

2 Find the present value of an ordinary annuity using a $1.00 ordinary annuity present value table.

In the liquidation or payout phase of an annuity, a common option is for periodic payments to be made to the annuitant or beneficiary for a certain period of time. The future value of the *accumulation phase* of the annuity becomes the present value of the *liquidated or payout phase* of the annuity. Figure 14-6 shows the accumulation phase or future value growth of an annuity. The **present value of an annuity** is the amount needed in a fund to receive a specific periodic payment over a specified period of time during the liquidation or payout phase. The balance that is in the fund continues to earn interest while payouts are being made, but the balance is steadily declining. At the end of the specified time of the liquidation phase, the balance will be zero. See Figure 14-7.

Present value of an annuity: the amount needed in a fund so that the fund can pay out a specified regular payment for a specified amount of time.

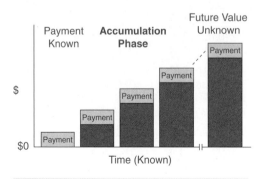

FIGURE 14-6
Future Value of an Annuity

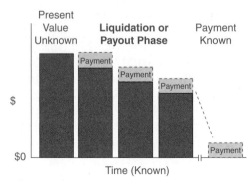

FIGURE 14-7
Present Value of an Annuity

Use Table 14-3:

1. Locate the table value for the given number of payout periods and the given rate per period.
2. Multiply the table value times the periodic annuity payment.

$$\text{Present value of annuity} = \text{periodic annuity payment} \times \text{table value}$$

EXAMPLE 1 Use Table 14-3 to find the present value of an ordinary annuity in the payout phase with semiannual payments of $3,000 for seven years at 6% annual interest compounded semiannually.

$$7 \text{ years} \times 2 \text{ periods per year} = 14 \text{ periods}$$

$$\frac{6\% \text{ annual interest}}{2 \text{ periods per year}} = 3\% \text{ period interest rate}$$

The Table 14-3 value for 14 periods at 3% is 11.296.

$$\begin{aligned} \text{Present value of annuity} &= \text{annuity payment} \times \text{table factor} \\ &= \$3,000(11.296) \\ &= \$33,888 \end{aligned}$$

A fund of $33,888 is needed now at 6% interest compounded semiannually to receive an annuity payment of $3,000 twice a year for seven years.

TABLE 14-3
Present Value of a $1.00 Ordinary Annuity

| Periods | 2% | 3% | 4% | 5% | 6% | 7% | 8% | 9% | 10% | 12% |
|---------|------|------|------|------|------|------|------|------|------|------|
| 1 | 0.980 | 0.971 | 0.962 | 0.952 | 0.943 | 0.935 | 0.926 | 0.917 | 0.909 | 0.893 |
| 2 | 1.942 | 1.913 | 1.886 | 1.859 | 1.833 | 1.808 | 1.783 | 1.759 | 1.736 | 1.690 |
| 3 | 2.884 | 2.829 | 2.775 | 2.723 | 2.673 | 2.624 | 2.577 | 2.531 | 2.487 | 2.402 |
| 4 | 3.808 | 3.717 | 3.630 | 3.546 | 3.465 | 3.387 | 3.312 | 3.240 | 3.170 | 3.037 |
| 5 | 4.713 | 4.580 | 4.452 | 4.329 | 4.212 | 4.100 | 3.993 | 3.890 | 3.791 | 3.605 |
| 6 | 5.601 | 5.417 | 5.242 | 5.076 | 4.917 | 4.767 | 4.623 | 4.486 | 4.355 | 4.111 |
| 7 | 6.472 | 6.230 | 6.002 | 5.786 | 5.582 | 5.389 | 5.206 | 5.033 | 4.868 | 4.564 |
| 8 | 7.325 | 7.020 | 6.733 | 6.463 | 6.210 | 5.971 | 5.747 | 5.535 | 5.335 | 4.968 |
| 9 | 8.162 | 7.786 | 7.435 | 7.108 | 6.802 | 6.515 | 6.247 | 5.995 | 5.759 | 5.328 |
| 10 | 8.983 | 8.530 | 8.111 | 7.722 | 7.360 | 7.024 | 6.710 | 6.418 | 6.145 | 5.650 |
| 11 | 9.787 | 9.253 | 8.760 | 8.306 | 7.887 | 7.499 | 7.139 | 6.805 | 6.495 | 5.938 |
| 12 | 10.575 | 9.954 | 9.385 | 8.863 | 8.384 | 7.943 | 7.536 | 7.161 | 6.814 | 6.194 |
| 13 | 11.348 | 10.635 | 9.986 | 9.394 | 8.853 | 8.358 | 7.904 | 7.487 | 7.103 | 6.424 |
| 14 | 12.106 | 11.296 | 10.563 | 9.899 | 9.295 | 8.745 | 8.244 | 7.786 | 7.367 | 6.628 |
| 15 | 12.849 | 11.938 | 11.118 | 10.380 | 9.712 | 9.108 | 8.559 | 8.061 | 7.606 | 6.811 |
| 16 | 13.578 | 12.561 | 11.652 | 10.838 | 10.106 | 9.447 | 8.851 | 8.313 | 7.824 | 6.974 |
| 17 | 14.292 | 13.166 | 12.166 | 11.274 | 10.477 | 9.763 | 9.122 | 8.544 | 8.022 | 7.120 |
| 18 | 14.992 | 13.754 | 12.659 | 11.690 | 10.828 | 10.059 | 9.372 | 8.756 | 8.201 | 7.250 |
| 19 | 15.678 | 14.324 | 13.134 | 12.085 | 11.158 | 10.336 | 9.604 | 8.950 | 8.365 | 7.366 |
| 20 | 16.351 | 14.877 | 13.590 | 12.462 | 11.470 | 10.594 | 9.818 | 9.129 | 8.514 | 7.469 |
| 25 | 19.523 | 17.413 | 15.622 | 14.094 | 12.783 | 11.654 | 10.675 | 9.823 | 9.077 | 7.843 |
| 30 | 22.396 | 19.600 | 17.292 | 15.372 | 13.765 | 12.409 | 11.258 | 10.274 | 9.427 | 8.055 |
| 40 | 27.355 | 23.115 | 19.793 | 17.159 | 15.046 | 13.332 | 11.925 | 10.757 | 9.779 | 8.244 |
| 50 | 31.424 | 25.730 | 21.482 | 18.256 | 15.762 | 13.801 | 12.233 | 10.962 | 9.915 | 8.304 |

Table values show the present value of a $1.00 ordinary annuity, or the lump sum amount that, invested now, yields the same compounded amount as an annuity of $1.00 at a given rate per period for a given number of periods. The formula for generating the table values is $TV = \dfrac{(1 + R)^N - 1}{R(1 + R)^N}$, where TV is the table value, R is the rate per period, and N is the number of periods.

1. Use Table 14-3 to find the present value of an ordinary annuity with an annual payout of $5,000 for five years at 4% interest compounded annually.

2. What is the present value of an ordinary annuity with an annual payout of $20,000 at 7% annual interest for 20 years?

3. What lump sum must be set aside today at 8% annual interest compounded quarterly to provide quarterly payments of $7,000 to Demetrius Ball for the next ten years?

4. Tim Warren is setting up an ordinary annuity and wants to receive $10,000 semiannually for the next 20 years. How much should he set aside at 6% annual interest compounded semiannually?

3 Find the sinking fund payment or the present value of an annuity using a formula.

As with future value, tables do not always have the values that you need to find a sinking fund payment or a present value of an annuity. A formula allows you the flexibility of using any interest rate or any number of periods.

HOW TO Find the sinking fund payment or present value of an ordinary annuity using a formula

1. Identify the period rate R as a decimal equivalent, the number of periods N, and the future value FV of the annuity.
2. Substitute the values from Step 1 in the appropriate formula.

$$PMT_{\text{ordinary annuity}} = FV\left(\frac{R}{(1 + R)^N - 1}\right)$$

$$PV_{\text{ordinary annuity}} = PMT\left(\frac{(1 + R)^N - 1}{R(1 + R)^N}\right)$$

3. Evaluate the formula.

EXAMPLE 1 Debbie Bennett wants to have $100,000 in a retirement fund to supplement her retirement. She plans to work for 20 more years and has found an annuity fund that earns 5.5% annual interest. How much does she need to contribute to the fund each month to reach her goal?

$$R = \frac{5.5\%}{12} = \frac{0.055}{12} = 0.0045833333 \qquad \text{Periodic interest rate}$$

$$N = 20(12) = 240 \qquad \text{Number of payments}$$

$$FV = \$100,000$$

$$PMT_{\text{ordinary annuity}} = \$100,000\left(\frac{0.0045833333}{(1 + 0.0045833333)^{240} - 1}\right)$$

$$100000 \times 0.0045833333 \div (\ (\ 1.0045833333 \ \wedge \ 240 \ - \ 1 \) \) \ = \ \Rightarrow$$

$$PMT = 229.5539756 \text{ (round to nearest cent)}$$

The payment that Debbie should make into the sinking fund each month is $229.55.

EXAMPLE 2 At retirement Debbie Bennett will begin drawing a payment each month from her retirement fund. How much does she need in a fund that pays 5.5% interest to receive a $700 per month payment for 20 years?

$$R = \frac{5.5\%}{12} = \frac{0.055}{12} = 0.0045833333 \qquad \text{Periodic interest rate}$$

$$N = 20(12) = 240 \qquad \text{Number of payments}$$

$$P = \$700$$

$$PV_{\text{ordinary annuity}} = \$700\left(\frac{(1 + 0.0045833333)^{240} - 1}{0.0045833333(1 + 0.0045833333)^{240}}\right)$$

700 $\boxed{(}$ 1.0045833333 $\boxed{^\wedge}$ 240 $\boxed{-}$ 1 $\boxed{)}$ $\boxed{\div}$

$\boxed{(}$ 0.0045833333 $\boxed{\times}$ 1.0045833333 $\boxed{^\wedge}$ 240 $\boxed{)}$ $\boxed{=}$ \Rightarrow

$PV = 101760.8545$ Round to nearest cent.

Debbie needs to have \$101,760.85 in the fund to receive an annuity payment of \$700 each month for 20 years.

 STOP AND CHECK

1. Shameka plans to have \$350,000 in a retirement fund at her retirement. She plans to work for 26 years and has found a sinking fund that earns 4.85% annual interest compounded monthly. How much does she need to contribute to the fund each month to reach her goal?

2. At retirement Mekisha will begin drawing a payment each month from her retirement fund. Use the formula to determine the amount she needs in a fund that pays 5.25% interest to receive a \$2,000 per month payment for 25 years.

14-2 SECTION EXERCISES

SKILL BUILDERS

1. What semiannual sinking fund payment would be required to yield \$48,000 nine years from now? The annual interest rate is 6% compounded semiannually.

2. The Bamboo Furniture Company manufactures rattan patio furniture. It has just purchased a machine for \$13,500 to cut and glue the pieces of wood. The machine is expected to last five years. If the company establishes a sinking fund to replace this machine, what annual payments must be made if the annual interest rate is 8%?

3. Tristin and Kim Denley are establishing a college fund for their 1-year-old daughter, Chloe. They want to save enough now to pay college tuition at the time she enters college (17 years from now). If her tuition is projected to be \$35,000 for a two-year degree, what annual sinking fund payment should they establish if the annual interest is 8%?

4. Kathy and Patrick Mowers have a 12-year-old daughter and are now in a financial position to begin saving for her college education. What annual sinking fund payment should they make to have her entire college expenses paid at the time she enters college six years from now? Her college expenses are projected to be \$30,000 and the annual interest rate is 6%.

5. Matthew Bennett recognizes the value of saving part of his income. He has set a goal to have $25,000 in cash available for emergencies. How much should he invest semiannually to have $25,000 in ten years if the sinking fund he has selected pays 8% annually, compounded semiannually?

6. Stein and Company has established a sinking fund to retire a bond issue of $500,000, which is due in ten years. How much is the quarterly sinking fund payment if the account pays 8% annual interest compounded quarterly?

7. What is the present value of an ordinary annuity with annual payments of $680 at 9% annual interest for 25 years?

8. Erin Calipari plans to have a stream of $2,500 payments each year for two years at 8% annual interest. How much should she set aside today?

9. Emily Bennett is setting up an annuity for a memorial scholarship. What lump sum does she need to set aside today at 7% annual interest to have the scholarship pay $3,000 annually for 10 years?

10. Kristin Bennett, a nationally recognized philanthropist, set up an ordinary annuity of $1,600 for ten years at 9% annual interest. How much does Bennett have to deposit today to pay the stream of annual payments?

11. Ken and Debbie Bennett have agreed to pay for their granddaughter's college education and need to know how much to set aside so annual payments of $15,000 can be made for five years at 3% annual interest.

12. Janice and Terry Van Dyke have decided to establish a quarterly ordinary annuity of $3,000 for the next ten years at 8% annual interest compounded quarterly. How much should they invest in a lump sum now to provide the stream of payments?

Learning Outcomes

Section 14-1

1 Find the future value of an ordinary annuity using the simple interest formula method. (p. 488)

What to Remember with Examples

1. Find the first end-of-period principal.

$$\text{First end-of-period principal} = \text{annuity payment}$$

2. For each remaining period in turn, find the next end-of-period principal:
 (a) Multiply the previous end-of-period principal by the sum of 1 and the decimal equivalent of the period interest rate.
 (b) Add the product from step 2a and the annuity payment.

$$\text{End-of-period principal} = \text{previous end-of-period principal} \times$$
$$(1 + \text{period interest rate}) + \text{annuity payment}$$

3. Identify the last end-of-period principal as the future value.

$$\text{Future value} = \text{last end-of-period principal}$$

Find the future value of an annual ordinary annuity of $2,000 for two years at 4% annual interest.

$$\text{End-of-year 1} = \$2,000$$
$$\text{End-of-year 2} = \$2,000(1.04) + \$2,000$$
$$= \$2,080 + \$2,000$$
$$= \$4,080$$

The future value is $4,080.

Find the future value of a semiannual ordinary annuity of $300 for one year at 5% annual interest, compounded semiannually.

$$\frac{5\% \text{ annual interest rate}}{2 \text{ periods per year}} = 2.5\% = 0.025 \text{ period interest rate}$$
$$\text{End-of-period 1} = \$300$$
$$\text{End-of-period 2} = \$300(1.025) + \$300$$
$$= \$307.50 + \$300$$
$$= \$607.50$$

The future value is $607.50.

Find the total interest earned on an annuity:

1. Find the total amount invested:

$$\text{Total invested} = \text{payment amount} \times \text{number of payments}$$

2. Find the total interest:

$$\text{Total interest} = \text{future value of annuity} - \text{total invested}$$

Find the total interest earned on the semiannual ordinary annuity in the previous example.

$$\text{Total invested} = \$300(2) \qquad \text{Payment} = \$300$$
$$= \$600 \qquad\qquad \text{Number of payments} = 2$$
$$\text{Total interest} = \$607.50 - \$600 \qquad \text{Future value} = \$607.50$$
$$= \$7.50$$

2 Find the future value of an ordinary annuity with periodic payments using a $1.00 ordinary annuity future value table. (p. 490)

Using Table 14-1:

1. Select the periods row corresponding to the number of interest periods.
2. Select the rate-per-period column corresponding to the period interest rate.
3. Locate the value in the cell where the periods row intersects the rate-per-period column.
4. Multiply the annuity payment by the table value from step 3.

$$\text{Future value} = \text{annuity payment} \times \text{table value}$$

Find the future value of an ordinary annuity of $5,000 semiannually for four years at 4% annual interest compounded semiannually.

$$4 \text{ years} \times 2 \text{ periods per year} = 8 \text{ periods}$$

$$\frac{4\% \text{ annual interest rate}}{2 \text{ periods per year}} = 2\% \text{ period interest rate}$$

The Table 14-1 value for eight periods at 2% is 8.583.

$$\text{Future value} = \$5,000(8.583)$$
$$= \$42,915$$

The future value is $42,915.

3 Find the future value of an annuity due with periodic payments using the simple interest formula method. (p. 492)

1. Find the first end-of-period principal: Multiply the annuity payment by the sum of 1 and the decimal equivalent of the period interest rate.

$$\text{First end-of-period principal} = \text{annuity payment} \times (1 + \text{period interest rate})$$

2. For each remaining period in turn, find the next end-of-period principal:
 (a) Add the previous end-of-period principal and the annuity payment.
 (b) Multiply the sum from step 2a by the sum of 1 and the period interest rate.

$$\text{End-of-period principal} = (\text{previous end-of-period principal} + \text{annuity payment}) \times (1 + \text{period interest rate})$$

3. Identify the last end-of-period principal as the future value.

$$\text{Future value} = \text{last end-of-period principal}$$

Find the future value of an annual annuity due of $3,000 for two years at 5% annual interest.

$$\text{End-of-year 1} = \$3,000(1.05)$$
$$= \$3,150$$
$$\text{End-of-year 2} = (\$3,150 + \$3,000)(1.05)$$
$$= \$6,150(1.05)$$
$$= \$6,457.50$$

Find the future value and the total interest earned of a semiannual annuity due of $400 for one year at 4% annual interest compounded semiannually.

$$\frac{4\% \text{ annual interest rate}}{2 \text{ periods per year}} = 2\% = 0.02 \text{ period interest rate}$$

$$\text{End-of-period 1} = \$400(1.02)$$
$$= \$408$$
$$\text{End-of-period 2} = (\$408 + \$400)(1.02)$$
$$= (\$808)(1.02)$$
$$= \$824.16$$

The future value is $824.16.

Find the total interest earned on the semiannual annuity:

| | |
|---|---|
| Total invested = $400(2) | Payment = $400 |
| = $800 | Number of payments = 2 |
| Total interest = $824.16 − $800 | Future value = $824.16 |
| = $24.16 | |

4 Find the future value of an annuity due with periodic payments using a $1.00 ordinary annuity future value table. (p. 493)

Use Table 14-1:

1. Select the periods row corresponding to the number of interest periods.
2. Select the rate-per-period column corresponding to the period interest rate.
3. Locate the value in the cell where the periods row intersects the rate-per-period column.

4. Multiply the annuity payment by the table value from step 3. This is equivalent to an ordinary annuity.

5. Multiply the product from step 4 by the sum of 1 and the period interest rate.

$$\text{Future value} = \text{annuity payment} \times \text{table value} \times (1 + \text{period interest rate})$$

Find the future value of a quarterly annuity due of $1,500 for three years at 8% annual interest compounded quarterly.

$$3 \text{ years} \times 4 \text{ periods per year} = 12 \text{ periods}$$

$$\frac{8\% \text{ annual interest rate}}{4 \text{ periods per year}} = 2\% \text{ period interest rate}$$

The Table 14-1 value for 12 periods at 2% is 13.412.

$$\text{Future value} = \$1,500(13.412)(1.02)$$
$$= \$20,520.36$$

The future value is $20,520.36.

5 Find the future value of an ordinary annuity or an annuity due using a formula. (p. 496)

Find the future value of an ordinary annuity or an annuity due using the formula.

1. Identify the period rate R as a decimal equivalent, the number of periods N, and the amount of the annuity payment PMT.

2. Substitute the values from Step 1 into the appropriate formula.

$$FV_{\text{ordinary annuity}} = PMT\left(\frac{(1 + R)^N - 1}{R}\right)$$

$$FV_{\text{annuity due}} = PMT\left(\frac{(1 + R)^N - 1}{R}\right)(1 + R)$$

3. Evaluate the formula.

Use the formula to find the future value of an ordinary annuity of $50 paid monthly at 5% for 20 years.

$$R = \frac{5\%}{12} = \frac{0.05}{12} = 0.0041666667 \qquad \text{Periodic interest rate}$$

$$N = 20(12) = 240 \qquad \text{Number of payments}$$

$$PMT = \$50$$

$$FV_{\text{ordinary annuity}} = \$50\left(\frac{(1 + 0.0041666667)^{240} - 1}{0.0041666667}\right) \qquad \begin{array}{l}\text{Mentally add within innermost}\\ \text{parentheses.}\end{array}$$

$$FV_{\text{ordinary annuity}} = \$50\left(\frac{(1.0041666667)^{240} - 1}{0.0041666667}\right)$$

Calculator sequence:

$$50 \boxed{(} 1.0041666667 \boxed{\wedge} 240 \boxed{-} 1 \boxed{)} \boxed{\div} 0.0041666667 \boxed{=} \Rightarrow 20551.68352$$

The future value of the ordinary annuity is $20,551.68.

Section 14-2

1 Find the sinking fund payment using a $1.00 sinking fund payment table. (p. 501)

Use Table 14-2:

1. Select the periods row corresponding to the number of interest periods.

2. Select the rate-per-period column corresponding to the period interest rate.

3. Locate the value in the cell where the periods row intersects the rate-per-period column.

4. Multiply the table value from step 3 by the desired future value.

$$\text{Sinking fund payment} = \text{future value} \times \text{table value}$$

Find the quarterly sinking fund payment required to yield $15,000 in five years if interest is 8% compounded quarterly.

$$5 \text{ years} \times 4 \text{ periods per year} = 20 \text{ periods}$$

$$\frac{8\% \text{ annual interest rate}}{4 \text{ periods per year}} = 2\% \text{ period interest rate}$$

The Table 14-2 value for 20 periods at 2% is 0.0411567.

$$\text{Sinking fund payment} = \$15,000(0.0411567)$$
$$= \$617.35$$

The required quarterly payment is $617.35.

2 Find the present value of an ordinary annuity using a $1.00 ordinary annuity present value table. (p. 502)

Use Table 14-3:

1. Locate the table value for the given number of periods and the given rate per period.
2. Multiply the table value by the periodic annuity payment.

$$\text{Present value of annuity} = \text{periodic annuity payment} \times \text{table value}$$

Find the lump sum required today earning 6% annual interest compounded semiannually to yield a semiannual ordinary annuity payment of $2,500 for 15 years.

$$15 \text{ years} \times 2 \text{ periods per year} = 30 \text{ periods}$$

$$\frac{6\% \text{ annual interest rate}}{2 \text{ periods per year}} = 3\% \text{ period interest rate}$$

The Table 14-3 value for 30 periods at 3% is 19.600.

$$\text{Present value} = \$2,500(19.600)$$
$$= \$49,000$$

The lump sum required for deposit today is $49,000.

3 Find the sinking fund payment or the present value of an annuity using a formula. (p. 504)

Find the sinking fund payment or present value of an ordinary annuity using a formula:

1. Identify the period rate R as a decimal equivalent, the number of periods N, and the future value FV of the annuity.
2. Substitute the values from Step 1 in the appropriate formula.

$$PMT_{\text{ordinary annuity}} = FV\left(\frac{R}{(1 + R)^N - 1}\right)$$

$$PV_{\text{ordinary annuity}} = P\left(\frac{(1 + R)^N - 1}{R(1 + R)^N}\right)$$

3. Evaluate the formula.

Camesa plans to have $500,000 in her retirement fund when she retires in 23 years. She is investigating a sinking fund that earns 4.75% annual interest. How much does she need to contribute to the fund each month to reach her goal?

$$R = \frac{4.75\%}{12} = \frac{0.0475}{12} = 0.0039583333 \qquad \text{Periodic interest rate}$$

$$N = 23(12) = 276 \qquad\qquad\qquad\qquad \text{Number of payments}$$

$$FV = \$500,000$$

$$PMT_{\text{ordinary annuity}} = \$500,000\left(\frac{0.0039583333}{(1 + 0.0039583333)^{276} - 1}\right)$$

$500000 \boxed{\times} 0.0039583333 \boxed{\div} \boxed{(} \boxed{(} 1.0039583333 \boxed{\wedge} 276 \boxed{-} 1 \boxed{)} \boxed{=}$

$PMT = 1,001.959664$ (round to next cent)

Camesa should make monthly payments of $1,001.96 into the sinking fund.

EXERCISES SET A

Use Table 14-1 to complete the following table.

| Annuity payment | Annual rate | Annual interest | Years | Type of annuity | Future value of annuity |
|---|---|---|---|---|---|
| **1.** $1,400 | 3% | Compounded annually | 5 | Ordinary | _____ |
| **2.** $2,900 | 8% | Compounded quarterly | 10 | Ordinary | _____ |
| **3.** $1,250 | 6% | Compounded semiannually | $1\frac{1}{2}$ | Annuity due | _____ |
| **4.** $800 | 5% | Compounded annually | 15 | Annuity due | _____ |

Use Table 14-2 to find the sinking fund payment.

| | Desired future value | Annual interest rate | Years | Frequency of payments |
|---|---|---|---|---|
| **CEL 5.** | $240,000 | 6% | 15 | Annually |
| **CEL 6.** | $3,000 | 4% | 10 | Semiannually |
| **CEL 7.** | $50,000 | 4% | 5 | Quarterly |
| **CEL 8.** | $45,000 | 3% | 8 | Annually |

Use Table 14-3 to find the amount that needs to be invested today to provide a stream of payments in the annuity liquidation phase.

| Payment amount | Annual interest rate | Years | Frequency of payments |
|---|---|---|---|
| **9.** $10,000 | 4% | 20 | Annually |
| **10.** $12,000 | 4% | 10 | Semiannually |
| **11.** $5,000 | 8% | 4 | Quarterly |
| **12.** $1,000 | 3% | 15 | Annually |

13. Roni Sue deposited $1,500 at the beginning of each year for three years at an annual interest rate of 9%. Find the future value manually.

Use Table 14-1.

14. Barry Michael plans to deposit $2,000 at the end of every six months for the next five years to save up for a boat. If the interest rate is 6% annually, compounded semiannually, how much money will Barry have in his boat fund after five years?

15. Bob Paris opens a retirement income account paying 5% annually. He deposits $3,000 at the beginning of each year.
 (a) How much will be in the account after ten years?
 (b) When Bob retires at age 65, in 19 years, how much will be in the account?

16. The Shari Joy Corporation decided to set aside $3,200 at the beginning of every six months to provide donation funds for a new Little League baseball field scheduled to be built in 18 months. If money earns 4% annual interest compounded semiannually, how much will be available as a donation for the field?

Use Table 14-2 for Exercises 17–18.

17. How much must be set aside at the end of each six months by the Fabulous Toy Company to replace a $155,000 piece of equipment at the end of eight years if the account pays 6% annual interest compounded semiannually?

18. Lausanne Private School System needs to set aside funds for a new computer system. What quarterly sinking fund payment would be required to amount to $45,000, the approximate cost of the system, in $1\frac{1}{2}$ years at 4% annual interest compounded quarterly?

EXERCISES SET B

CHAPTER 14

Use Table 14-1 to complete the table below.

| Annuity payment | Annual rate | Annual interest | Years | Type of annuity | Future value of annuity |
|---|---|---|---|---|---|
| 1. $1,900 | 8% | Compounded quarterly | 3 | Ordinary | _____ |
| 2. $5,000 | 5% | Compounded annually | 20 | Ordinary | _____ |
| 3. $2,150 | 7% | Compounded annually | 8 | Annuity due | _____ |
| 4. $600 | 6% | Compounded semiannually | 5 | Annuity due | _____ |

Use Table 14-2 to find the sinking fund payment.

| | Desired future value | Annual interest rate | Years | Frequency of payments | Sinking fund payment |
|---|---|---|---|---|---|
| EL 5. | $24,000 | 6% | 10 | Semiannually | _____ |
| EL 6. | $45,000 | 8% | 4 | Quarterly | _____ |
| EL 7. | $8,000 | 6% | 17 | Annually | _____ |
| EL 8. | $10,000 | 4% | 19 | Annually | _____ |

Use Table 14-3 to find the amount that needs to be invested today to receive payments for the specified length of time.

| Payment amount | Annual interest rate | Years | Frequency of payments |
|---|---|---|---|
| 9. $7,000 | 2% | 30 | Annually |
| 10. $20,000 | 6% | 15 | Semiannually |
| 11. $10,000 | 8% | 5 | Quarterly |
| 12. $6,000 | 5% | 10 | Annually |

13. Manually find the future value of an annuity due of $1,100 deposited annually for three years at 5% interest.

14. Sam and Jane Crawford had a baby in 1998. At the end of that year they began putting away $2,000 a year at 10% annual interest for a college fund. How much money will be in the account when the child is 18 years old?

15. A business deposits $4,500 at the end of each quarter in an account that earns 8% annual interest compounded quarterly. What is the value of the annuity in five years?

16. University Trailers is setting aside $800 at the beginning of every quarter to purchase a forklift in 30 months. The annual interest will be 8% compounded quarterly. How much will be available for the purchase?

Use Table 14-2 for Exercises 17–18.

17. Tasty Food Manufacturers, Inc., has a bond issue of $1,400,000 due in 30 years. If it wants to establish a sinking fund to meet this obligation, how much must be set aside at the end of each year if the annual interest rate is 6%?

18. Zachary Alexander owns a limousine that will need to be replaced in four years at a cost of $65,000. How much must he put aside each year in a sinking fund at 8% annual interest to purchase the new limousine?

PRACTICE TEST

1. Manually find the future value of an ordinary annuity of $9,000 per year for two years at 3.25% annual interest.

2. Manually find the future value of an annuity due of $2,700 per year for three years at 4.5% annual interest.

3. What is the future value of an annuity due of $5,645 paid every six months for three years at 6% annual interest compounded semiannually?

4. What is the future value of an ordinary annuity of $300 every three months for four years at 8% annual interest compounded quarterly?

5. What is the sinking fund payment required at the end of each year to accumulate $125,000 in 16 years at 4% annual interest?

6. What is the present value of an ordinary annuity of $985 paid out every six months for eight years at 8% annual interest compounded semiannually?

7. Mike's Sport Shop deposited $3,400 at the end of each year for 12 years at 7% annual interest. How much will Mike have in the account at the end of the time period?

8. How much would the annuity amount to in Exercise 7 if Mike had deposited the money at the beginning of each year instead of at the end of each year?

9. How much must be set aside at the end of each year by the Caroline Cab Company to replace four taxicabs at a cost of $90,000? The current interest rate is 6% annually. The existing cabs will wear out in three years.

10. How much must Johnny Williams invest today to have an amount equivalent to investing $2,800 at the end of every six months for the next 15 years if interest is earned at 8% annually compounded semiannually?

11. Maurice Eftink owns a lawn design business. His lawnmower cost $7,800 and should last for six years. How much must he set aside each year at 6% annual interest to have enough money to buy a new mower?

12. Reed and Sondra Davis want to know how much they must deposit in a retirement savings account today to have payments of $1,500 every six months for 15 years. The retirement account is paying 8% annual interest compounded semiannually.

13. Morris Stocks wants to save $2,200 at the end of each year for 11 years in an account paying 7% annual interest. What is the future value of the annuity at the end of this period of time?

14. Maura Helba is saving for her college expenses. She sets aside $175 at the beginning of each three months in an account paying 8% annual interest compounded quarterly. How much will Maura have accumulated in the account at the end of four years?

15. What is the present value of a semiannual ordinary annuity of $2,500 for seven years at 6% annual interest compounded semiannually?

16. How much will you need to invest today to have quarterly payments of $800 for ten years? The interest rate is 8% annually, compounded quarterly.

17. Goldie's Department Store has a fleet of delivery trucks that will last for three years of heavy use and then need to be replaced at a cost of $75,000. How much must they set aside every three months in a sinking fund at 8% annual interest, compounded quarterly, to have enough money to replace the trucks?

18. Linda Zuk wants to save $25,000 for a new boat in six years. How much must be put aside in equal payments each year in an account earning 6% annual interest for Linda to be able to purchase the boat?

19. What is the present value of an ordinary annuity of $3,400 at 5% annual interest for seven years?

20. An annual ordinary annuity of $2,500 for five years at 5% annual interest requires what lump-sum payment now?

21. Danny Lawrence Properties, Inc., has a bond issue that will mature in 25 years for $1 million. How much must the company set aside each year in a sinking fund at 8% annual interest to meet this future obligation?

22. How much money needs to be set aside today at 10% annual interest compounded semiannually to pay $500 for five years?

23. You are starting an ordinary annuity of $680 for 25 years at 5% annual interest. What lump-sum amount would have to be set aside today for this annuity?

24. Your parents are retiring and want to set aside a lump sum earning 8% annual interest compounded quarterly to pay out $5,000 quarterly for ten years. What lump sum should your parents set aside today?

25. Ted Davis has set the goal of accumulating $80,000 for his son's college fund, which will be needed 18 years in the future. How much should he deposit each year in a sinking fund that earns 8% annual interest? How much should he deposit each year if he waits until his son starts school (at age six) to begin saving? Compare the two payment amounts.

1. Select three table values from Table 14-1 and verify them using the formula

$$FV = \frac{(1 + R)^N - 1}{R}$$

2. To find the future value of an annuity due, you multiply the future value of an ordinary annuity by the sum of 1 + the period interest rate. Explain why this is the same as adding the simple interest earned on the first payment for the entire length of the annuity.

3. In Example 3 on page 494, we found that the annuity due with semiannual payments had the greater future value. Also, the ordinary annuity with the quarterly payments was more than the ordinary annuity with semiannual payments. Why?

4. How are future value of a lump sum and future value of an annuity similar?

5. How are future value of a lump sum and future value of an annuity different?

6. How are the present value of a lump sum and the periodic payment of a sinking fund similar? How are they different?

7. How are annuities and sinking funds similar? How are they different?

8. Select three table values from Table 14-2 and verify them using the formula

$$TV = \frac{R}{(1 + R)^N - 1}$$

9. Select three table values from Table 14-3 and verify them using the formula

$$TV = \frac{(1 + R)^N - 1}{R(1 + R)^N}$$

10. Explain the difference in an ordinary annuity and an annuity due.

Challenge Problem

Carolyn Ellis is setting up an annuity for her retirement. She can set aside $2,000 at the end of each year for the next 20 years and it will earn 6% annual interest. What lump sum will she need to set aside today at 6% annual interest to have the same retirement fund available 20 years from now? How much more will Carolyn need to invest in periodic payments than she will if she makes a lump sum payment if she intends to accumulate the same retirement balance?

14.1 Annuities for Retirement

Naomi Dexter is 20 years old and attends Southwest Tennessee Community College. Her Business English instructor asked her to write a report detailing her plans for retirement. Naomi decided she would investigate several ways to accumulate $1 million by the time she retires. She also thinks she would like to retire early when she is 50 years old so she can travel around the world. She has a money market account that pays 3% interest annually. She checked the rate on a 10-year certificate of deposit (CD) through her bank and found that it currently pays 6%. She also did a little research and learned that the average long-term return from stock market investments is between 10% and 12%. Now she needs to calculate how much money she will need to deposit each year to accumulate $1 million.

1. If Naomi wants to accumulate $1,000,000 by investing money every year into her savings account at 3% for 30 years until retirement, how much does she need to deposit each year?

2. If she decides to invest in certificates of deposit at 6% interest, how much will she need to deposit annually to accumulate the $1,000,000?

3. If Naomi invests in a stock portfolio, her returns for 10 or more years will average 10%–12%. Naomi realizes that the stock market has higher returns because it is a more risky investment than a savings account or a CD. She wants her calculations to be conservative so she decides to use 8% to calculate possible stock market earnings. How much will she need to invest annually to accumulate $1,000,000 in the stock market?

4. After looking at the results of her calculations, Naomi has decided to aim for $500,000 savings by the time she retires. She expects to have a starting salary after college of $25,000 to $35,000 and she has taken into account all of the living expenses that will come out of her salary. What will Naomi's annual deposits need to be to accumulate $500,000 in a CD at 6%?

5. If Naomi decides that she will invest $3,000 per year in a 6% annuity for the first ten years, $6,000 for the next ten years, and $9,000 for the next ten years, how much will she accumulate? Treat each ten-year period as a separate annuity. After the ten years of an annuity, then it will continue to grow at compound interest for the remaining years of the 30 years.

14.2 Accumulating Money

Joseph reads a lot about people who are success-oriented. He loves to learn about courage, risk-taking, and as he describes it, "the road less traveled." His local bookstore has a large business section where he has found biographies of entrepreneurs and maverick corporate leaders. He also finds fascinating some of the books he has seen on financial planning and ways to accumulate wealth. One interesting savings plan he read about challenges the reader to put aside one full paycheck at the end of the year as a "holiday present to yourself." Joseph had never thought about saving in that way, and wondered if it would really accumulate much savings.

1. He decided to test the numbers by seeing how much money he would accumulate by a retirement age of 65 if he put one paycheck away at the end of each year. Right now that would mean depositing $1,000 at year-end for the next 35 years. Assuming he makes one yearly deposit of $1,000 at 5% compounded annually, how much interest would he earn?

2. Joseph was surprised at how large the sum would be and then realized that he would be able to put more money away in future years because most likely, his salary would go up. He also thought that he could invest the money over the long term at a higher interest rate, so he redid the calculations with a $1,500 annual year-end deposit, at 8% for 35 years. What was his result?

3. Joseph was amazed at how much he could save in this manner and decided to design a detailed savings plan based on projected yearly increases. He realized that he could not start depositing $1,500 now, but that he would be able to deposit more than that in the future. If he were able to deposit $1,000 at the end of each year for the next 5 years at 8% compounded annually, $1,500 at the end of years 6–10 at 8% compounded annually, and $2,000 at the end of years 11–35 at 5% compounded annually, how much would he accumulate at the end of 35 years? Assume that any balances from earlier depositing periods would continue to earn the same rate of annual interest. Use the tables for future value of annuities.

4. By how much does the result differ from the amount calculated above for $1,500 deposited for 35 years? What accounts for the difference?

5. If Joseph decided that he wanted to have $300,000 accumulated in 30 years by making an annual payment at the end of each year that would earn 12% compounded annually, what would his sinking fund payment be? Use the appropriate table to determine the answer.

14.3 Certified Financial Planner

After completing his Certified Financial Planner designation (CFP), Andre was excited about the prospects of working with small business owners and their employees regarding retirement planning. Andre wanted to show the value of an annuity program as one of the viable investment options in a salary reduction retirement plan. In addition, he wanted to demonstrate the substantial tax benefits that annuities can provide. For instance, qualified annuities (by definition) not only reduce your current taxable salary, they also accumulate earnings on a tax deferred basis—meaning you don't pay taxes on the earnings until they are withdrawn. Andre was developing a spreadsheet to show the way that annuities could grow using various rates of return.

1. If an individual put the equivalent of $50 per month, or $600 annually into an ordinary annuity, how much money would accumulate in 20 years at 3% compounded annually? How much at 5%?

2. Using the same information from Exercise 1 and assuming a 25% tax bracket, what would be the net effect of investing in a certificate of deposit at 8% for 20 years if taxes on the earnings were paid from the investment fund each year? How would this compare if no taxes had to be paid, such as in a tax-deferred annuity at 8% for 20 years?

3. Jessica, a 25-year-old client of Andre's, wants to retire by age 65 with $1,000,000. How much would she have to invest annually assuming a 6% rate of return?

4. Jessica decides that 40 years is just too long to work, and she thinks that she can do much better than 6%. She decides that she wants to accumulate $1,000,000 by age 55 using a variable annuity earning 12%. How much will she have to invest annually to achieve this goal? Do you think that 12% is a reasonable interest rate to use? Why or why not?

Real Estate Tax Benefits

Everyone knows that owning a home is the American dream, but did you know that borrowing to pay for one is a taxpayer's dream? Home mortgage interest is deductible on your income taxes if you itemize deductions. You can deduct the interest on up to $1 million of home mortgage debt, whether it is used to purchase a first or a second home. You can also deduct the interest on up to $100,000 of home equity debt, even if you don't use the money for home improvements. What could the home mortgage deduction mean to you? What follows is an example of the potential tax savings for Devin, age 27.

Devin rents a home at a cost of $1,200 per month. He is single with no children and takes the standard deduction on his income taxes. His adjusted gross income is $50,000. He has $3,500 in state income tax withheld from his paychecks throughout the year, but doesn't qualify for any other itemized deductions. Devin's federal income tax liability for 2007 will look something like this:

| | |
|---|---|
| Adjusted gross income: | $50,000 |
| Less standard deduction (single): | $5,350 |
| Less personal exemption: | $3,400 |
| Taxable income | $41,250 |

Devin's 2007 federal income tax is $6,736.25

However, if Devin purchases a home with a monthly mortgage payment of $1,200, his tax liability is lowered. At the end of the year Devin will receive a Form 1098 from his mortgage company that shows how much of his mortgage payments for the year went to mortgage interest. In this case, Devin's 1098 for the year 2007 shows that he paid $11,400 in mortgage interest. Devin also paid $2,500 in real estate taxes on his home in 2007. His federal income tax liability for 2007 will look something like this:

| | |
|---|---|
| Adjusted gross income: | $50,000 |
| Less itemized deduction (state taxes): | $3,500 |
| Less itemized deduction (real estate taxes): | $2,500 |
| Less itemized deduction (mortgage interest): | $11,400 |
| Less personal exemption: | $3,400 |
| Taxable income | $29,200 |

Devin's 2007 federal income tax is $3,988.75

In this example, Devin saves $2,747.50 in federal income taxes. This amount is more than enough to pay for Devin's real estate taxes of $2,500. In addition, his monthly housing cost stays the same and he owns his home rather than renting. Good deal, Devin!

LEARNING OUTCOMES

15-1 Mortgage Payments

1. Find the monthly mortgage payment.
2. Find the total interest on a mortgage and the PITI.

15-2 Amortization Schedules and Qualifying Ratios

1. Prepare a partial amortization schedule of a mortgage.
2. Calculate qualifying ratios.

 A corresponding Business Math Case Video for this chapter, *The Real World: Video Case: Should I Buy a House?* can be found in Appendix A.

LEARNING OUTCOMES

1 Find the monthly mortgage payment.
2 Find the total interest on a mortgage and the PITI.

Real estate or real property: land plus any permanent improvements to the land.

Mortgage: a loan in which real property is used to secure the debt.

Collateral: the property that is held as security on a mortgage.

Equity: the difference between the expected selling price and the balance owed on property.

Market value: the expected selling price of a property.

First mortgage: the primary mortgage on a property.

Conventional mortgage: mortgage that is not insured by a government program.

Fixed-rate mortgage: the interest rate remains the same for the entire loan.

Biweekly mortgage: payment made every two weeks for 26 payments per year.

Graduated payments mortgage: payments at the beginning of the loan are smaller and they increase during the loan.

Adjustable-rate mortgage: the interest rate may change during the time of the loan.

Federal Housing Administration (FHA): a governmental agency within the U.S. Department of Housing and Urban Development (HUD) that insures residential mortgage loans. To receive an FHA loan, specific construction standards must be met and the lender must be approved.

Veterans Administration (VA): a governmental agency that guarantees the repayment of a loan made to an eligible veteran. The loans are also called GI loans.

Second mortgage: a mortgage in addition to the first mortgage that is secured by the real property.

Equity line of credit: a revolving, open-end account that is secured by real property.

Amortization: the process for repaying a loan through equal payments at a specified rate for a specific length of time.

Monthly mortgage payment: the amount of the equal monthly payment that includes interest and principal.

The purchase of a home is one of the most costly purchases individuals or families make in a lifetime. A home is a type of "real" property. **Real estate** or **real property** is land plus any permanent improvements to the land. The improvements can be water or sewage systems, homes, commercial buildings, or any type of structure. Most individuals must borrow money to pay for the real property. These loans are referred to as **mortgages** because the lending agency requires that the real property be held as **collateral**. If the payments are not made as scheduled, the lending agency can take possession of the property and sell it to pay against the loan.

As a home buyer makes payments on a mortgage, the home buyer builds equity in the home. The home buyer's **equity** is the difference between the expected selling price of a home or **market value** and the balance owed on the home. A home may increase in value as a result of rising prices and average prices of other homes in the neighborhood. This increase in value also increases the owner's equity in the home.

A home buyer may select from several types of first mortgages. A **first mortgage** is the primary mortgage on a home and is ordinarily made at the time of purchase of the home. The agency holding the first mortgage has the first right to the proceeds up to the amount of the mortgage and settlement fees from the sale of the home if the homeowner fails to make required payments.

One type of first mortgage is the **conventional mortgage**. Money for a conventional mortgage is usually obtained through a savings and loan institution or a bank. These loans are not insured by a government program. Two types of conventional mortgages are the *fixed-rate mortgage* (FRM) and the *adjustable-rate mortgage* (ARM). The rate of interest on the loan for a **fixed-rate mortgage** remains the same for the entire time of the loan. Fixed-rate mortgages have several payment options. The number of years of the loan may vary, but 15- and 30-year loans are the most common. The home buyer makes the same payment (principal plus interest) each month of the loan. Another option is the **biweekly mortgage**. The home buyer makes 26 equal payments each year rather than 12. This method builds equity more quickly than the monthly payment method.

Another option for fixed-rate loans is the **graduated payments mortgage**. The home buyer makes small payments at the beginning of the loan and larger payments at the end. Home buyers who expect their income to rise may choose this option.

The rate of interest on a loan for an **adjustable-rate mortgage** may escalate (increase) or de escalate (decrease) during the time of the loan. The rate of adjustable-rate mortgages depends on the prime lending rate of most banks.

Several government agencies insure the repayment of first mortgage loans. Loans with this insurance include those made under the **Federal Housing Administration (FHA)** and the **Veterans Administration (VA)**. These loans may be obtained through a savings and loan institution, a bank, or a mortgage lending company and are insured by a government program.

Interest paid on home loans is an allowable deduction on personal federal income tax under certain conditions. For this reason, many homeowners choose to borrow money for home improvements, college education, and the like by making an additional loan using the real property as collateral. This type of loan is a **second mortgage** or an **equity line of credit** and is made against the equity in the home. In the case of a loan default, the second mortgage lender has rights to the proceeds of the sale of the home *after* the first mortgage has been paid.

1 Find the monthly mortgage payment.

The repayment of a loan in equal installments that are applied to principal and interest over a specific period of time is called the **amortization** of the loan. To calculate the **monthly mortgage payment**, it is customary to use a table, a formula, a business or financial calculator that has the formula programmed into the calculator, or computer software. The monthly payment table gives the factor that is multiplied by the dollar amount of the loan in thousands to give the total monthly payment, including principal and interest. A portion of a monthly payment table is shown in Table 15-1.

The interest rate for first mortgages has fluctuated between 5% and 9% for the past few years. Second mortgage rates are generally higher than first mortgage rates.

TABLE 15-1
Monthly Payment of Principal and Interest per $1,000 of Amount Financed

| Years financed | Annual interest rate | | | | | | | | | | | | | | | |
|---|---|---|---|---|---|---|---|---|---|---|---|---|---|---|---|---|
| | 5.00% | 5.25% | 5.50% | 5.75% | 6.00% | 6.25% | 6.50% | 6.75% | 7.00% | 7.25% | 7.50% | 7.75% | 8.00% | 8.25% | 8.50% | 8.75% |
| 10 | 10.61 | 10.73 | 10.85 | 10.98 | 11.10 | 11.23 | 11.35 | 11.48 | 11.61 | 11.74 | 11.87 | 12.00 | 12.13 | 12.27 | 12.40 | 12.53 |
| 12 | 9.25 | 9.37 | 9.50 | 9.63 | 9.76 | 9.89 | 10.02 | 10.15 | 10.28 | 10.42 | 10.55 | 10.69 | 10.82 | 10.96 | 11.10 | 11.24 |
| 15 | 7.91 | 8.04 | 8.17 | 8.30 | 8.44 | 8.57 | 8.71 | 8.85 | 8.99 | 9.13 | 9.27 | 9.41 | 9.56 | 9.70 | 9.85 | 9.99 |
| 17 | 7.29 | 7.42 | 7.56 | 7.69 | 7.83 | 7.97 | 8.11 | 8.25 | 8.40 | 8.54 | 8.69 | 8.83 | 8.98 | 9.13 | 9.28 | 9.43 |
| 20 | 6.60 | 6.74 | 6.88 | 7.02 | 7.16 | 7.31 | 7.46 | 7.60 | 7.75 | 7.90 | 8.06 | 8.21 | 8.36 | 8.52 | 8.68 | 8.84 |
| 22 | 6.25 | 6.39 | 6.54 | 6.68 | 6.83 | 6.98 | 7.13 | 7.28 | 7.43 | 7.59 | 7.75 | 7.90 | 8.06 | 8.22 | 8.38 | 8.55 |
| 25 | 5.85 | 5.99 | 6.14 | 6.29 | 6.44 | 6.60 | 6.75 | 6.91 | 7.07 | 7.23 | 7.39 | 7.55 | 7.72 | 7.88 | 8.05 | 8.22 |
| 30 | 5.37 | 5.52 | 5.68 | 5.84 | 6.00 | 6.16 | 6.32 | 6.49 | 6.65 | 6.82 | 6.99 | 7.16 | 7.34 | 7.51 | 7.69 | 7.87 |
| 35 | 5.05 | 5.21 | 5.37 | 5.54 | 5.70 | 5.87 | 6.04 | 6.21 | 6.39 | 6.56 | 6.74 | 6.92 | 7.10 | 7.28 | 7.47 | 7.65 |

Table values show the monthly payment of a $1,000 mortgage for the given number of years at the given annual interest rate if the interest is compounded monthly. Table values can be generated by using the formula: $M = (\$1,000R)/(1 - (1 + R)^{\wedge}(-N))$, where M = Monthly payment, R = the monthly interest rate, and N = total number of payments of the loan.

HOW TO Find the monthly mortgage payment of principal and interest using a per-$1,000 monthly payment table

1. Find the amount financed: Subtract the down payment from the purchase price.
2. Find the $1,000 units of amount financed: Divide the amount financed (from step 1) by $1,000.
3. Locate the table value for the number of years financed and the annual interest rate.
4. Multiply the table value from step 3 by the $1,000 units from step 2.

$$\text{Monthly mortgage payment} = \frac{\text{amount financed}}{\$1,000} \times \text{table value}$$

EXAMPLE 1 Lunelle Miller is purchasing a home for $87,000. Home Federal Savings and Loan has approved her loan application for a 30-year fixed-rate loan at 7% annual interest. If Lunelle agrees to pay 20% of the purchase price as a down payment, calculate the monthly payment.

| | |
|---|---|
| $87,000(0.20) = \$17,400$ | Down payment |
| $\$87,000 - \$17,400 = \$69,600$ | Amount to be financed |
| $\$69,600 \div \$1,000 = 69.6$ | $1,000 units |

Use Table 15-1 to find the factor for financing a loan for 30 years with a 7% annual interest rate. This factor is 6.65.

Multiply the number of thousands times the factor.

$$69.6(6.65) = \$462.84$$

The monthly payment of $462.84 includes the principal and interest.

HOW TO Find the monthly mortgage payment of principal and interest using a formula

1. Identify the monthly rate (R) as a decimal equivalent, the number of months (N) and the loan principal (P).
2. Substitute the values from step 1 in the formula.

$$M = P\left(\frac{R}{1 - (1 + R)^{-N}}\right)$$

3. Evaluate the formula.

EXAMPLE 2
Use the monthly payment of principal and interest formula to find the monthly payment for Lunelle Miller's loan from Example 1.

$R = \dfrac{7\%}{12} = \dfrac{0.07}{12} = 0.0058333333$ Monthly interest rate

$N = 30(12) = 360$ Total number of payments

$P = \$69,600$ Amount financed

$M = P\left(\dfrac{R}{1 - (1 + R)^{-N}}\right)$ Substitute known values.

$M = 69,600\left(\dfrac{0.0058333333}{1 - (1 + 0.0058333333)^{-360}}\right)$

$M = 69,600\left(\dfrac{0.0058333333}{1 - (1.0058333333)^{-360}}\right)$

$M = 69,600\left(\dfrac{0.0058333333}{1 - (0.1232058536)}\right)$

$M = 69,600\left(\dfrac{0.0058333333}{0.8767941464}\right)$

$M = 69,600(0.0066530246)$

$M = \$463.0505122$

$M = \$463.05$

Calculator sequence:

69600 (.0058333333) ÷ (1 − (1 + .0058333333) ^ ((−) 360)))
ENTER ⟹ 463.0505348

On many calculators entering a negative number like −300 requires using a special key (−).

The monthly payment of \$463.05 includes the principal and interest.

Note that the monthly payment using the table value, using the formula in steps, compared to using the formula using a calculator sequence, varies slightly because of rounding discrepancies.

 STOP AND CHECK

1. Natalie Bradley is purchasing a home for \$148,500 and has been preapproved for a 30-year fixed-rate loan of 5.75% annual interest. If Natalie pays 20% of the purchase price as a down payment, what will her principal-plus-interest payment be?

2. Find the monthly payment for a home loan of \$160,000 using a 20-year fixed-rate mortgage at 5.5%.

3. Find the monthly payment for a home loan of \$160,000 using a 25-year fixed-rate mortgage at 5.5%.

4. Find the monthly payment for a home loan of \$160,000 using a 30-year fixed-rate mortgage at 5.5%.

2 Find the total interest on a mortgage and the PITI.

Often, a person wants to know the total amount of interest that will be paid during the entire loan.

HOW TO Find the total interest on a mortgage

1. Find the total of the payments: Multiply the number of payments by the amount of the payment (principal + interest).
2. Subtract the amount financed from the total of the payments.

 Total interest = number of payments × amount of payment − amount financed

EXAMPLE 1

Calculate the total interest paid on the fixed-rate loan of $69,600 for 30 years at 7% interest rate.

Total interest = number of payments \times amount of payment $-$ amount financed

$$= 30(12)(\$462.84) - \$69,600$$
$$= \$166,622.40 - \$69,600$$
$$= \$97,022.40$$

The total interest is $97,022.40.

The two preceding examples show how to calculate the monthly payment and the total interest for a mortgage loan. There are other costs associated with purchasing a home. Lending companies may require the borrower to pay **points** at the time the loan is made or closed. Payment of points is a one-time payment of a percentage of the loan that is an additional cost of making the mortgage. One point is 1%, two points is 2%, and so on.

Fees charged for services that must be performed to process and close a home mortgage loan are called **mortgage closing costs**. Examples of these costs include credit reports, surveys, inspections, appraisals, legal fees, title insurance, and taxes. Even though these fees are paid when the loan is closed, lenders are required by law to disclose to the buyer in writing the estimated mortgage closing costs prior to the closing date. This estimate is known as the **good faith estimate**. Some fees are paid by the buyer and some by the seller. Average closing costs for most home purchases are about 6% of the loan amount.

Since the lending agency must be assured that the property taxes and insurance are paid on the property, the annual costs of these items may be prorated each year and added to the monthly payment for that year. These funds are held in **escrow** until the taxes or insurance payment is due, at which time the lending agency makes the payment for the home owner. These additional costs make the monthly payment more than just the principal and interest payment we found in the preceding examples. The adjusted monthly payment that includes the principal, interest, taxes, and insurance is abbreviated as **PITI**.

Points: a one-time payment to the lender made at closing that is a percentage of the total loan.

Mortgage closing costs: fees charged for services that must be performed to process and close a home mortgage loan.

Good faith estimate: an estimate of the mortgage closing costs that lenders are required to provide to the buyer in writing prior to the loan closing date.

Escrow: an account for holding the part of a monthly payment that is to be used to pay taxes and insurance. The amount accumulates and the lender pays the taxes and insurance from this account as they are due.

PITI: the adjusted monthly payment that includes the principal, interest, taxes, and insurance.

HOW TO Find the total PITI payment

1. Find the principal and interest portion of the monthly payment.
2. Find the monthly taxes by dividing the annual taxes by 12.
3. Find the monthly insurance by dividing the annual insurance by 12.
4. Find the sum of the monthly principal, interest, taxes, and insurance.

EXAMPLE 2

Find the total PITI payment for Lunelle Miller's loan from Example 1 if her annual taxes are $985 and her annual homeowner's insurance is $560.

| | |
|---|---|
| $462.84 | Monthly principal and interest found in Example 1 |
| $985 ÷ 12 = $82.08333333 | Monthly taxes |
| $560 ÷ 12 = $46.66666667 | Monthly insurance |

PITI = $462.84 + $82.08 + $46.67
 = $591.59

The total PITI payment is $591.59.

EXAMPLE 3

Qua Wau is trying to determine whether to accept a 25-year 6.5% mortgage or a 20-year 6% mortgage on the house he is planning to buy. He needs to finance $125,700 and has planned to budget $1,000 monthly for his payment of principal and interest. Which mortgage should Qua choose?

| What You Know | What You Are Looking For |
|---|---|
| Amount financed: $125,700
Annual interest rate: 6.5% and 6%
Monthly budget
allowance for payment: $1,000 | Monthly payment and total cost for 25-year mortgage and monthly payment and total cost for 20-year mortgage.
Which mortgage should Qua choose? |

Solution Plan

Total cost = monthly payment × 12 × number of years financed

Number of $1,000 units of amount financed = amount financed ÷ $1,000

Monthly payment = number of $1,000 units of amount financed × table value

Solution

Number of $1,000 units financed = $125,700 ÷ $1,000
$$= 125.7$$

25-Year Mortgage
The Table 15-1 value for 25 years and 6.5% is $6.75.

Monthly payment = number of $1,000 units financed × table value
$$= 125.7 (\$6.75)$$
$$= \$848.48$$

Total cost = monthly payment × 12 × number of years financed
$$= \$848.48(12)(25)$$
$$= \$254,544.00$$

20-Year Mortgage
The Table 15-1 value for 20 years and 6% is $7.16.

Monthly payment = number of $1,000 units financed × table value
$$= 125.7 (\$7.16)$$
$$= \$900.01$$

Total cost = monthly payment × 12 × years financed
$$= \$900.01(12)(20)$$
$$= \$216,002.40$$

The monthly payment for the 25-year mortgage is $848.48 for a total cost of $254,544.00. The monthly payment for the 20-year mortgage is $900.01 for a total cost of $216,002.40.

Conclusion

Qua's budget of $1,000 monthly can cover either monthly payment. He would save $38,541.60 over the 20-year period if he chooses the 20-year plan. That is the plan he should choose. Other considerations that could impact his decision would be the return on an investment of the difference in the monthly payments ($51.53) if an annuity were started with the difference. Also, will the addition of the taxes and insurance to the monthly payment (PITI) be more than he can manage?

 STOP AND CHECK

1. Find the monthly payment on a home mortgage of $195,000 at 6.25% annual interest for 17 years.

2. How much interest is paid on the mortgage in Exercise 1?

3. The annual insurance premium on the home in Exercise 1 is $1,080 and the annual property tax is $1,252. Find the adjusted monthly payment including principal, interest, taxes, and insurance (PITI).

4. Marcella Cannon can budget $1,200 monthly for a house note (not including taxes and insurance). The home she has fallen in love with would have a $185,400 mortgage. She can finance the loan for 15 years at 5.75% or 30 years at 6.25%. Which terms should she choose to best fit her budget?

SKILL BUILDERS

Find the indicated amounts for the fixed-rate mortgages.

| Purchase price of home | Down payment | Annual mortgage amount | Interest rate | Years | Monthly payment per $1,000 | Mortgage payment | Total paid for mortgage | Interest paid |
|---|---|---|---|---|---|---|---|---|
| **1.** $100,000 | $0 | | 5.75% | 30 | | | | |
| **2.** $183,000 | $13,000 | | 5.50% | 30 | | | | |
| **3.** $95,000 | $8,000 | | 5.75% | 25 | | | | |
| **4.** $125,500 | 20% | | 6.25% | 20 | | | | |
| **5.** $495,750 | 18% | | 5.00% | 35 | | | | |
| **6.** $83,750 | 15% | | 6% | 22 | | | | |

APPLICATIONS

7. Stephen Black has just purchased a home for $155,000. Northridge Mortgage Company has approved his loan application for a 30-year fixed-rate loan at 6%. Stephen has agreed to pay 25% of the purchase price as a down payment. Find the down payment, amount of mortgage, and monthly payment.

8. Find the total interest Stephen will pay if he pays the loan on schedule.

9. If Stephen made the same loan for 20 years, how much interest would he save?

10. How much would Stephen's monthly payment increase for a 20-year mortgage over a 30-year mortgage?

15-2 AMORTIZATION SCHEDULES AND QUALIFYING RATIOS

LEARNING OUTCOMES

1 Prepare a partial amortization schedule of a mortgage.
2 Calculate qualifying ratios.

1 Prepare a partial amortization schedule of a mortgage.

Amortization schedule: a table that shows the balance of principal and interest for each payment of the mortgage.

Homeowners are sometimes given an **amortization schedule** that shows the amount of principal and interest for each payment of the loan. With some loan arrangements, extra amounts paid with the monthly payment are credited against the principal, allowing for the mortgage to be paid sooner.

HOW TO Prepare an amortization schedule of a mortgage

1. For the first month:
 (a) Find the interest portion of the first monthly payment (principal and interest portion only):

 Interest portion of the first monthly payment = original principal
 $\qquad\qquad\qquad\qquad$ × monthly interest rate

 (b) Find the principal portion of the monthly payment:

 Principal portion of the first monthly payment = monthly payment
 $\qquad\qquad\qquad\qquad$ − interest portion of the first monthly payment

 (c) Find the first end-of-month principal:

 First end-of-month principal = original principal
 $\qquad\qquad\qquad\qquad$ − principal portion of the first monthly payment

2. For the interest portion, principal portion, and end-of-month principal for each remaining month in turn:

(a) Find the interest portion of the monthly payment:

Interest portion of the monthly payment
$$= \text{previous end-of-month principal} \times \text{monthly interest rate}$$

(b) Find the principal portion of the monthly payment:

Principal portion of the monthly payment $=$ monthly payment
$$- \text{interest portion of the monthly payment}$$

(c) Find the end-of-month principal:

End-of-month principal $=$ previous end-of-month principal
$$- \text{principal portion of the monthly payment}$$

EXAMPLE 1 Complete the first two rows of the amortization schedule for Lunelle's mortgage of $69,600 at 7% annual interest for 30 years. The monthly payment for interest and principal was found to be $462.84.

First month

$$\text{Interest portion of monthly payment} = \text{original principal} \times \text{monthly rate}$$

$$= \$69{,}600\left(\frac{0.07}{12}\right) \qquad 7\% = 0.07$$

$$= \$406.00$$

Principal portion of monthly payment $=$ monthly payment (without insurance and taxes) $-$ interest portion of monthly payment

$$= \$462.84 - \$406.00$$
$$= \$56.84$$

End-of-month principal $=$ previous end-of-month principal $-$ principal portion of monthly payment

$$= \$69{,}600 - \$56.84$$
$$= \$69{,}543.16$$

Second month

$$\text{Interest portion of monthly payment} = \$69{,}543.16\left(\frac{0.07}{12}\right)$$

$$= \$405.67$$

$$\text{Principal portion of monthly payment} = \$462.84 - \$405.67$$
$$= \$57.17$$

$$\text{End-of-month principal} = \$69{,}543.16 - \$57.17$$
$$= \$69{,}485.99$$

The first two rows of an amortization schedule for this loan are shown in the following chart.

Portion of payment applied to:

| Month | Monthly payment | Interest [previous end-of-month principal × monthly rate] | Principal [monthly payment − interest portion] | End-of-month principal [previous end-of-month principal − principal portion] |
|---|---|---|---|---|
| 1 | $462.84 | $406.00 | $56.84 | $69,543.16 |
| 2 | $462.84 | $405.67 | $57.17 | $69,485.99 |

Software programs such as Excel are normally used to generate an amortization schedule that shows the interest and principal breakdown for each payment of the loan.

1. Complete two rows of an amortization schedule for Natalie's home mortgage in Exercise 1 on p. 526.

2. Complete two rows of an amortization schedule for the mortgage in Exercise 2 on p. 526.

3. Complete three rows of an amortization schedule for the mortgage in Exercise 3 on p. 526.

4. Complete rows 4–6 of an amortization schedule for the mortgage in Exercise 4 on p. 526.

2 Calculate qualifying ratios.

Loan-to-value ratio: the amount mortgaged divided by the appraised value of the property.

Housing or front-end ratio: monthly housing expenses (PITI) divided by the gross monthly income

Debt-to-income or back-end ratio: fixed monthly expenses divided by the gross monthly income

Mortgage ratios are the most important factors, after your credit report, that lending institutions examine to determine loan applicants' capacity to repay a loan. The **loan-to-value ratio (LTV)** is found by dividing the amount mortgaged by the appraised value of the property. If this ratio, when expressed as a percent, is more than 80%, the borrower may be required to purchase private mortgage insurance (PMI). The **housing ratio** or **front-end ratio** is found by dividing the monthly housing expenses (PITI) by your gross monthly income. In most cases the housing ratio should not exceed 28%.

The **debt-to-income ratio (DTI)** or **back-end ratio** is found by dividing your fixed monthly expenses by your gross monthly income. The debt-to-income ratio should be no more than 36%. Fixed monthly expenses are monthly housing expenses (PITI plus any other expenses directly associated with home ownership), monthly installment loan payments, monthly revolving credit line payments, alimony and child support, and other fixed monthly expenses. Monthly income includes income from employment, including overtime and commissions, self-employment income, alimony, child support, Social Security, retirement or VA benefits, interest and dividend income, income from trusts, partnerships, and so on.

HOW TO Find the qualifying ratio for a mortgage

1. Select the formula for the desired qualifying ratio.

$$\text{Loan-to-value ratio} = \frac{\text{amount mortgaged}}{\text{appraised value of property}}$$

$$\text{Housing ratio} = \frac{\text{total mortgage payment (PITI)}}{\text{gross monthly income}}$$

$$\text{Debt-to-income ratio} = \frac{\text{total fixed monthly expenses}}{\text{gross monthly income}}$$

2. Evaluate the formula.

EXAMPLE 1
Find the loan-to-value ratio for a home appraised at $250,000 that the buyer will purchase for $248,000. The buyer plans to make a down payment of $68,000.

Amount mortgaged = $248,000 − $68,000 = $180,000
Appraised value = $250,000

$$\text{Loan-to-value ratio} = \frac{\text{Amount mortgaged}}{\text{Appraised value of property}}$$ Substitute values in the formula.

$$\text{Loan-to-value ratio} = \frac{\$180,000}{\$250,000}$$ Divide.

Loan-to-value ratio = 0.72 or 72%

The loan-to-value ratio is 72%.

STOP AND CHECK

1. Reed Davis has $84,000 for a down payment on a home and has identified a property that can be purchased for $386,000. The appraised value of the property is $395,000. What is the loan-to-value ratio?

2. If Sheri Rieth has total gross monthly earnings of $5,893 and the total PITI for the loan she wants is $1,482, what is the housing ratio? How does this ratio compare with the desired acceptable ratio?

3. Emily Harrington has $1,675 total fixed monthly expenses and gross monthly income of $4,975. What is the debt-to-income ratio she would use in purchasing a home?

4. Pam Cox expects to pay monthly $1,845 in principal and interest, $74 in homeowner's insurance, and $104 in real estate tax for her home mortgage. Her gross monthly salary is $5,798 and she receives alimony of $200 per month. Find the housing ratio she would have when purchasing the home. Is her ratio favorable?

15-2 SECTION EXERCISES

SKILL BUILDERS

Make an amortization table to show the first two payments for the mortgages.

| | Amount of mortgage | Annual interest rate | Years in mortgage | Monthly payment |
|---|---|---|---|---|
| 1. | $100,000 | 5.75% | 30 | $584 |
| 2. | $180,000 | 5.5% | 30 | $1,022.40 |
| 3. | $87,000 | 5.75% | 25 | $547.23 |
| 4. | $100,400 | 6.25% | 20 | $733.92 |
| 5. | $406,515 | 5% | 35 | $2,052.90 |
| 6. | $71,187.50 | 6% | 22 | $486.21 |

| | Amount of mortgage | Annual interest rate | Years | Monthly payment | | Amount of mortgage | Annual interest rate | Years | Monthly payment |
|---|---|---|---|---|---|---|---|---|---|
| 1. | $100,000 | 5.75% | 30 | $584 | 2. | $180,000 | 5.5% | 30 | $1,022.40 |

| Amount of mortgage | Annual interest rate | Years | Monthly payment | Amount of mortgage | Annual interest rate | Years | Monthly payment |
|---|---|---|---|---|---|---|---|
| 3. $87,000 | 5.75% | 25 | $547.23 | 4. $100,400 | 6.25% | 20 | $733.92 |

| Amount of mortgage | Annual interest rate | Years | Monthly payment | Amount of mortgage | Annual interest rate | Years | Monthly payment |
|---|---|---|---|---|---|---|---|
| 5. $406,515 | 5% | 35 | $2,052.90 | 6. $71,187.50 | 6% | 22 | $486.21 |

APPLICATIONS

7. Justin Wimmer is financing $69,700 for a home at 7% interest with a 20-year fixed-rate loan. Find the interest paid and principal paid for each of the first two months of the loan and find the principal owed at the end of the second month.

8. Heike Drechsler is financing $84,700 for a home in the mountains. The 17-year fixed-rate loan has an interest rate of 6%. Create an amortization schedule for the first two months of the loan.

9. Conchita Martinez has made a $210,300 loan for a home near Albany, New York. Her 20-year fixed-rate loan has an interest rate of $8\frac{1}{2}\%$. Create an amortization schedule for the first two payments.

10. Jake Drewrey is financing $142,500 for a ten-year fixed-rate mortgage at 5.75%. Create an amortization schedule for the first two payments.

11. Conchita Martinez will have a monthly interest and principal payment of $1,825.40. Her monthly real estate taxes will be $58.93 and her monthly homeowner's payments will be $84.15. If her gross monthly income is $6,793, find the housing ratio.

12. Jake Drewrey has total fixed monthly expenses of $1,340 and his gross monthly income is $3,875. What is his debt-to-income ratio? How does his ratio compare to the desired ratio?

Learning Outcomes

What to Remember with Examples

Section 15-1

1 Find the monthly mortgage payment. (p. 524)

1. Find the amount financed: Subtract the down payment from the purchase price.
2. Find the $1,000 units of amount financed: Divide the amount financed (from step 1) by $1,000.
3. Locate the table value for the number of years financed and the annual interest rate.
4. Multiply the table value from step 3 by the $1,000 units from step 2.

$$\text{Monthly mortgage payment} = \frac{\text{amount financed}}{\$1,000} \times \text{table value}$$

Find the monthly payment for a home selling for $90,000 if a 10% down payment is made, payments are made for 30 years, and the annual interest rate is 7.5%.

$$\$90,000(0.1) = \$9,000 \text{ down payment}$$
$$\$90,000 - \$9,000 = \$81,000 \text{ mortgage amount}$$
$$\$81,000 \div \$1,000 = 81 \text{ units of } \$1,000$$

The table value for 30 years and 7.5% is $6.99.
Payment = 81($6.99) = $566.19

2 Find the total interest on a mortgage and the PITI. (p. 526)

1. Find the total of the payments: Multiply the number of payments by the payment (principal + interest).
2. Subtract the amount financed from the total of the payments.

$$\text{Total interest} = \text{number of payments} \times \text{amount of payment} - \text{amount financed}$$

Find the total interest on the mortgage in the preceding example.

$$\text{Total interest} = 30(12)(\$566.19) - \$81,000$$
$$= \$203,828.40 - \$81,000$$
$$= \$122,828.40$$

To find the total PITI payment

1. Find the principal and interest portion of the monthly payment.
2. Find the monthly taxes by dividing the annual taxes by 12.
3. Find the monthly insurance by dividing the annual insurance by 12.
4. Find the sum of the monthly principal, interest, taxes, and insurance.

Find the total PITI payment for a loan that has monthly principal and interest payments of $2,134, annual taxes of $1,085, and annual homeowners insurance of $1,062.

| | |
|---|---|
| $2,134 | Monthly principal and interest |
| $1,085 ÷ 12 = $90.41666667 | Monthly taxes |
| $1,062 ÷ 12 = $88.50 | Monthly insurance |

PITI = $2,134 + $90.42 + $88.50 = $2,312.92

The total PITI payment is $2,312.92.

Section 15-2

1 Prepare a partial amortization schedule of a mortgage. (p. 530)

1. For the first month:
 (a) Find the interest portion of the first monthly payment:

$$\text{Interest portion of the first monthly payment} = \text{original principal}$$
$$\times \text{monthly interest rate}$$

(b) Find the principal portion of the monthly payment:

Principal portion of the first monthly payment = monthly payment

− interest portion of first monthly payment

(c) Find the first end-of-month principal:

First end-of-month principal = original principal

− principal portion of the first monthly payment

2. For each remaining month in turn:

(a) Find the interest portion of the monthly payment:

Interest portion of the monthly payment = previous end-of-month principal

× monthly interest rate

(b) Find the principal portion of the monthly payment:

Principal portion of the monthly payment = monthly payment

− interest portion of the monthly payment

(c) Find the end-of-month principal:

End-of-month principal = previous end-of-month principal

− principal portion of the monthly payment

Complete an amortization schedule for three months of payments on a $90,000 mortgage at 8% for 30 years.

$$\text{Monthly payment} = \frac{\$90,000}{\$1,000} \times \text{table value}$$
$$= 90(7.34)$$
$$= \$660.60$$

Month 1

$$\text{Interest portion} = \$90,000\left(\frac{0.08}{12}\right)$$
$$= \$600$$
$$\text{Principal portion} = \$660.60 - \$600$$
$$= \$60.60$$
$$\text{End-of-month principal} = \$90,000 - \$60.60$$
$$= \$89,939.40$$

Month 2

$$\text{Interest portion} = \$89,939.40\left(\frac{0.08}{12}\right)$$
$$= \$599.60$$
$$\text{Principal portion} = \$660.60 - \$599.60$$
$$= \$61.00$$
$$\text{End-of-month principal} = \$89,939.40 - \$61.00$$
$$= \$89,878.40$$

Month 3

$$\text{Interest portion} = \$89,878.40\left(\frac{0.08}{12}\right)$$
$$= \$599.19$$
$$\text{Principal portion} = \$660.60 - \$599.19$$
$$= \$61.41$$
$$\text{End-of-month principal} = \$89,878.40 - \$61.41$$
$$= \$89,816.99$$

Portion of payment applied to:

| Month | Monthly payment | Interest | Principal | End-of-month principal |
|-------|-----------------|----------|-----------|------------------------|
| 1 | $660.60 | $600.00 | $60.60 | $89,939.40 |
| 2 | $660.60 | 599.60 | 61.00 | 89,878.40 |
| 3 | $660.60 | 599.19 | 61.41 | 89,816.99 |

2 Calculate qualifying ratios. (p. 532)

Find the qualifying ratio for a mortgage

1. Select the formula for the desired qualifying ratio.

$$\text{Loan-to-value ratio} = \frac{\text{amount mortgaged}}{\text{appraised value of property}}$$

$$\text{Housing ratio} = \frac{\text{total mortgage payment (PITI)}}{\text{gross monthly income}}$$

$$\text{Debt-to-income ratio} = \frac{\text{total fixed monthly expenses}}{\text{gross monthly income}}$$

2. Evaluate the formula.

Find the loan-to-value ratio for a home appraised at $398,400 that the buyer will purchase for $398,000. The buyer plans to make a down payment of $100,000.

Amount mortgaged = $398,000 − $100,000 = $298,000

Appraised value = $398,400

$$\text{Loan-to-value ratio} = \frac{\text{amount mortgaged}}{\text{appraised value of property}} \qquad \text{Substitute values in the formula.}$$

$$\text{Loan-to-value ratio} = \frac{\$298,000}{\$398,400} \qquad \text{Divide.}$$

Loan-to-value ratio = 0.7479919679 or 75%

EXERCISES SET A

Find the monthly payment.

| Mortgage amount | Annual percentage rate | Years |
|---|---|---|
| **1.** $287,500 | 5.75% | 20 |
| **2.** $146,800 | 5.25% | 30 |
| **3.** $152,300 | 6.25% | 25 |
| **4.** $113,400 | 5% | 15 |

EXCEL5. Find the total interest paid for the mortgage in Exercise 1.

EXCEL6. Find the total interest paid for the mortgage in Exercise 2.

EXCEL7. Find the total interest paid for the mortgage in Exercise 3.

EXCEL8. Find the total interest paid for the mortgage in Exercise 4.

9. Create an amortization schedule for the first two months' payments on a mortgage of $487,700 with an interest rate of 6% and monthly payment of $2,926.20.

10. Louise Grantham is buying a home for $198,500 with a 20% down payment. She has a 5.75% loan for 25 years. Create an amortization schedule for the first two months of her loan.

11. James Author's monthly principal plus interest payment is $1,565.74 and his annual homeowner's insurance premium is $1,100. His annual real estate taxes total $1,035. Find his PITI payment.

12. Find the loan-to-value ratio for a home appraised at $583,620 that the buyer will purchase for $585,000. The buyer plans to make a down payment of $175,000.

13. Find James Author's housing ratio if his PITI is $1,743.66 and his gross monthly income is $6,310.

14. Find Julia Rholes' debt-to-income ratio if her fixed monthly expenses are $1,836 and her gross monthly income is $4,934.

EXERCISES SET B

Find the monthly payment.

| | Mortgage amount | Annual percentage rate | Years |
|---|---|---|---|
| **1.** | $487,700 | 6% | 30 |
| **2.** | $212,983 | 6.75% | 15 |
| **3.** | $82,900 | 8.5% | 35 |
| **4.** | $179,500 | 8% | 17 |

5. Find the total interest paid for the mortgage in Exercise 1.

6. Find the total interest paid for the mortgage in Exercise 2.

7. Find the total interest paid for the mortgage in Exercise 3.

8. Find the total interest paid for the mortgage in Exercise 4.

9. Create a partial amortization schedule for the first two payments on a mortgage of $152,300 at 6.25% that has a monthly payment of $1,005.18 and is financed for 25 years.

10. Mary Starnes is paying $14,000 down on a house that costs $138,200 and she has a 6% loan for 30 years. Create a partial amortization table for the first two months of her mortgage.

11. Jerry Corless' monthly principal plus interest payment is $2,665.45 and his annual homeowner's insurance premium is $1,320. His annual real estate taxes total $1,325. Find his PITI payment.

12. Find the loan-to-value ratio for a home appraised at $135,230 that the buyer will purchase for $135,000. The buyer plans to make a down payment of $25,000.

13. Find Jerry Corless' housing ratio if his PITI is $2,885.87 and his gross monthly income is $8,310.

14. Find Elizabeth Herrington's debt-to-income ratio if her fixed monthly expenses are $1,236 and her gross monthly income is $4,194.

1. Find the table value for a 25-year mortgage at 6%.

2. Find the monthly payment on a mortgage of $230,000 for 30 years at 7.5%.

3. Find the total amount of interest that will be paid on the mortgage in Exercise 2.

4. What percent of the mortgage in Exercise 2 is the interest paid?

Hullett Houpt is purchasing a home for $197,000. He will finance the mortgage for 15 years and pay 7% interest on the loan. He makes a down payment that is 20% of the purchase price. Use Table 15-1 as needed.

5. Find the down payment.

6. Find the amount of the mortgage.

7. If Hullett is required to pay two points for making the loan, how much will the points cost?

8. Find the monthly payment that includes principal and interest.

9. Find the total interest Hullett will pay over the 15-year period.

10. Calculate the monthly payment and the total interest Hullett would have to pay if he decided to make the loan for 30 years instead of 15 years.

11. How much interest can be saved by paying for the home in 15 years rather than 30 years?

12. Find the interest portion and principal portion for the first payment of Hullett's 15-year loan.

13. Make an amortization schedule for the first three payments of the 15-year loan Hullett could make.

14. Make an amortization schedule for the first three payments of the 30-year loan Hullett could make.

15. Find Leshaundra's debt-to-income ratio if her fixed monthly expenses are $1,972 and her gross monthly income is $5,305.

1. How does a mortgage relate to a sinking fund?

2. For a mortgage of a given amount and rate, what happens to the total amount of interest paid if the number of years in the mortgage increases?

3. How can you reduce your monthly payment on a home mortgage?

4. Describe the process for finding the monthly payment for a mortgage of a given amount at a given rate for a given period.

Challenge Problem

Bob Owen is closing a real estate transaction on a farm in Yocona, Mississippi, for $385,900. His mortgage holder requires a 25% down payment and he also must pay $60.00 to record the deed, $100 in attorney's fees for document preparation, and $350 for an appraisal report. Bob will also have to pay a 1.5% loan origination fee. Bob chooses a 35-year mortgage at 7%. (a) How much cash will Bob need to close on the property? (b) How much will Bob's mortgage be? (c) What is Bob's monthly payment on the property?

15.1 Home Buying: A 30-Year Commitment?

Shantel and Kwamie are planning to buy their first home. Although they are excited about the prospect of being homeowners, they are also a little frightened. A mortgage payment for the next 30 years sounds like a huge commitment. They visited a few new developments and scanned the real estate listings of preowned homes, but they really have no idea how much a mortgage payment would be on a $150,000, $175,000, or $200,000 loan. They have come to you for advice.

1. After you explain to them that they can borrow money at different rates and for different amounts of time, Shantel and Kwamie ask you to complete a chart indicating what the monthly mortgage payment would be under some possible interest rates and borrowing periods. They also want to know what their total interest would be on each if they chose a 25-year loan. Complete the chart.

| Amount borrowed | 6.25% 15 year | 6.5% 20 year | 6.75% 25 year | 7% 30 year | Total interest paid |
|---|---|---|---|---|---|
| $150,000 | | | | | |
| $175,000 | | | | | |
| $200,000 | | | | | |

2. If Shantel and Kwamie made a down payment of $20,000 on a $175,000 home, what would be their monthly mortgage payment assuming they finance for 25 years at 6.75%? How much would they save on each monthly payment by making the down payment? How much interest would they save over the life of the loan?

15.2 Flippin' Houses

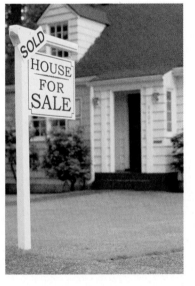

Jacob had finally found the house that he was looking for, and was anxious to make an offer. He knew that one of the keys to success with turning over real estate profitably and quickly was to make money on the front end by buying properties for at least 30% below market value. He had done his research, and with an asking price of only $124,500, this 2-bedroom ranch-style home was a bargain and well within his price range. The house, though, needed a number of repairs including paint, carpet, appliances, and a new wall to turn an open area into another bedroom. After contacting several contractors, he felt confident that the work could be completed for $12,000. With that figure in mind, Jacob decided that the total cost of the house would be $140,000 or less, including any settlement charges. He just needed to finalize some of the payment details to make sure the house was right for him.

1. By putting 20% down on the house, Jacob can get a 30-year fixed-rate mortgage for 6.25%. Based on a purchase price of $140,000, compute the down payment, and the principal and interest payment for the loan.

2. Although Jacob hopes to have the house sold within a few months, he knows there is a possibility that it will not sell quickly. In that case, he would likely end up keeping it as a rental property. Using the information from Exercise 1, find the total amount of interest that Jacob will pay on the mortgage if he keeps it for the full 30 years.

3. Jacob finds a lender that will offer him 100% financing using an adjustable-rate mortgage based on a 30-year amortization, with a 5-year interest lock at 5.0%. The loan, however, would include a prepayment penalty, which is applied as follows: prepayment penalty is 80% of the balance of the first mortgage, times the interest rate, divided by 2. Compute the new mortgage payment, along with the maximum prepayment penalty. Is it a good idea for Jacob to take this loan? Why or why not?

4. Jacob decides that the 30-year fixed-rate mortgage in Exercise 1 is the best for him. Construct an amortization table for the first three payments of the mortgage. The monthly payment will be $689.92.

1. Introduction to the 7th Inning Business and Personnel

Business Math Topics Covered

1. Whole Numbers
2. Fractions

Learning Outcomes

After viewing this video, you should be able to:

1. Identify the different departments of The 7th Inning business.
2. Identify the gross revenue of The 7th Inning business.
3. Identify the fraction of revenue each department contributes to the gross revenue.
4. Calculate the value of each department based upon the fraction of gross revenue.

Synopsis

The 7th Inning Sports Memorabilia Company is a small business located in Memphis, Tennessee, owned and operated by Charlie Cleaves. Charlie got his start in the memorabilia business collecting, trading, and selling sports cards. He also collected autographs and other historically interesting items. At some point during the 1990s Charlie realized that his hobby could become his career. He opened a small store, which he rapidly outgrew. Now, he owns his own building and his business has grown to include several departments: a sports and historical memorabilia department where he sells sports, music, political, and general interest historical memorabilia; a card and collectible supplies department where he sells a variety of sports, entertainment, and fantasy game cards, caps, buttons, pennants, and collecting supplies; a custom framing department; a trophy and engraving department; and a barbecue restaurant.

Charlie has recently hired an assistant manager, Joe, and a clerk, Sharese. Today is Joe and Sharese's first day on the job, so Charlie takes them on a tour of the business. As they move from department to department, Charlie introduces the other 7th Inning employees and gives them an overview of how much each business contributes to overall revenue.

Worksheet and Discussion Questions

1. Download the worksheet for this video and then watch the video. Work through the calculations to figure out the dollar revenue generated by each department.
2. Why would Charlie have five different departments under one roof? How are the departments related?

Extension Activity

1. At the very end of the video, Joe asked Charlie where they can make the most money. Even though you do not know all of the cost factors involved in each department, consider each of the following questions and try to figure out which department can generate the greatest profit.
 (a) Which department(s) involve the most money (capital) in inventory?
 (b) Which department(s) involve the highest costs for labor?
 (c) Which items or services are the most expensive and likely to generate the most money per sale?
 (d) Which department(s) pose the greatest risk of losing money?

2. Which Bank Account Is Best?

Business Math Topics Covered

1. Banking
 (a) Checking Accounts
 (b) Savings Accounts

Learning Outcomes

After viewing this video, you should be able to:

1. Understand the terminology of opening a checking account.
2. Compare different types of checking accounts.
3. Understand the terminology of opening a savings account.
4. Compare the different types of savings accounts.

Synopsis

Sharese has realized that she can't keep her entire paycheck in cash at her apartment or carry it around with her in her purse. She has also discovered that it is costly to get her check cashed at a check-cashing shop. She has decided that she needs to open a checking account. After work on payday, Sharese takes the bus to the local branch of InSouth. She talks to a bank officer about the various checking account options. While at the bank, the bank officer also brings up the idea of opening a savings account and explains why it is beneficial to start saving early in life.

Worksheet and Discussion Questions

1. Download the worksheet for this video and after viewing the video, utilize the worksheet to figure out which checking account and savings account might be best for Sharese.
2. Now look at your own situation. Which checking or savings account is best for your personal situation?
3. Why is it important for most people to have a relationship with a bank?
4. What are the benefits of starting to save early in your life?

Extension Activities

1. Visit a local bank and ask for a summary of checking and savings account options. Which one is best for your situation?
2. Investigate *www.ofac.gov* for questions and answers regarding banking issues.
3. Use *www.google.com* to investigate the Patriot Act of 2003. Why is this act important to consumers?

3. How Many Hamburgers?

Business Math Topics Covered

1. Decimals
2. Basic Equations
3. Percents

Learning Outcomes

After viewing this video, you should be able to:

1. Calculate and compare order quantities based upon historical information.
2. Identify a variety of business variables involved in making purchasing decisions.

Synopsis

While Charlie is out of the shop, a local meat vendor calls and asks to speak to the manager of Brubaker's Grill regarding an attractive deal he can offer on hamburger meat. Joe is excited to talk with the vendor. He is anxious to prove to Charlie that he can be a manager, so he arranges a meeting with the vendor to explore the offer. The deal, as proposed by the vendor, would require Brubaker's to buy a lot of hamburgers, but the price per patty sounds very attractive. Joe listens to the proposal and wonders if this offer is worth pursuing, given their historical rate of hamburger usage and the prices per patty that they are currently paying.

Worksheet and Discussion Questions

1. Download the worksheet for this video and after viewing the video, utilize the worksheet to compare the new deal and the existing deal. What is positive about the new deal? What is negative about the new deal?
2. What factors should Joe consider, beyond the price per patty, before making a recommendation to Charlie?

4. How Many Baseball Cards?

Business Math Topics Covered

1. Basic Equations
2. Percentages

Learning Outcomes

After viewing this video, you should be able to:

1. Calculate ordering quantities based on historical data.
2. Calculate gross revenue and net revenue.
3. Calculate net profit on gross revenue.

Synopsis

It is time for Joe to start learning about the trading card business. The 7th Inning maintains around ten million cards in-stock year round, though the number is highest early each year following the release of the new professional sports team cards. In addition to major professional sports cards, Charlie also carries cards that feature movies, military hardware, and fantasy game-related cards. The trading card industry has grown so much over the past several years that ordering cards is a complicated business that requires market savvy and hands-on experience. Charlie has decided to let Joe try to figure out what quantity they should order of two of his most popular selling sports trading cards, the *Topps* cards and the *Fleer EX* cards. He gives Joe a budget of $18,500 to spend and provides him with the basic cost, pricing, and other data he will need to arrive at a recommended purchase quantity.

Worksheet and Discussion Questions

1. Download the worksheet for this video and after viewing the video, utilize the worksheet to work through the process of figuring out how many of each card to order, how much the inventory will cost, and what the likely net revenue and net profit will be for each card order and for the total order of both cards.
2. Why is it important to know the historical sales pattern of each brand before ordering cards for the next year?
3. Make a list of the factors that influence the business of selling trading cards.

Extension Activity

1. Obtain a professional sports player card. Go to *www.beckett.com* to find the current estimated market value of the card. In the "Your Card" box, enter the name of the player you want to investigate and, when prompted, enter the name of the card manufacturer. Keep in mind that the values you see reflect prices that other cards in mint condition have recently sold for at auction. If there is any damage to your card whatsoever, the value of your card will likely be substantially less.

5. An All-Star Signing!

Business Math Topics Covered

1. Basic Equations
2. Markup

Learning Outcomes

After viewing this video, you should be able to:

1. Calculate selling price based on markup.
2. Calculate gross profit.
3. Calculate net profit.

Synopsis

One of Charlie's earliest business ventures in the trading card business involved organizing local signing events for popular pro athletes. In the past he has hosted signing events by many of the big names in sports including baseball players like Yogi Berra, Ted Williams, and Hank Aaron and he even hosted prizefighter Joe Frazier. Some of the signings made a good return, while others did not cover the costs involved in hosting the signing. Charlie and The 7th Inning try to host at least one autograph session with a major sports figure each year. This year, he wants to bring Derek Jeter of the New York Yankees to Memphis for an autograph session. The going rate to bring a player of Derek's stature to a signing is $40,000 plus travel costs. For this fee, the athlete will spend around 4–6 hours at The 7th Inning and sign 1,000 items including photographs, baseballs, and reproduction jerseys. There is a bit of a hitch—the athlete usually specifies the maximum number of each item he will

sign. In this case, Derek will agree to sign up to 650 photos, 400 baseballs, and 100 jerseys. Charlie wants Joe and Sharese to help him figure out how many of each item they should have Derek sign in order to make the greatest potential profit overall and how much net profit they can make on the signing over costs, if they sell all of the items.

Worksheet and Discussion Questions

1. Download the worksheet for this video and after viewing the video, utilize the worksheet to work through the process of figuring out which combination of signed items will generate the most revenue and net profit and how much net profit they will make if they sell all items the day of the signing.
2. Why would Derek Jeter be willing to sign more photographs than baseballs or jerseys?
3. Why do you think that there can be a larger markup on the jerseys than on the photographs?
4. If Charlie sells 427 photographs, 315 baseballs, and 68 jerseys the day of the signing, figure out what his total revenue from the signing is at that time and calculate the profit.

Extension Activity

1. To investigate the current retail price of any athlete's signature on various items, go to *www.prosportsmemorabilia.com* and type in the athlete's name in the "Search Our Products" box. If you type in Derek Jeter's name and look at posted prices for items such as signed baseballs, you will see higher prices than those discussed in the video. Why do you think that the prices offered through this online company are so much higher than Charlie's prices?

6. Should I Buy New Equipment Now?

Business Math Topics Covered

1. Simple Interest
2. Margins and Profitability

Learning Outcomes

After viewing this video, you should be able to:

1. Understand and calculate a net profit margin.
2. Calculate simple interest on a 1-year loan.
3. Calculate a simple break-even period for a capital purchase.

Synopsis

The engraving department uses an aging rotary engraver to engrave plaques and trophies. The machine has been reliable, but does require regular maintenance and periodic replacement of parts. Charlie has just found out that this engraver will no longer be supported by the manufacturer. This means that service and parts will be hard to get in the future and if it breaks it could take up to three weeks to get a new one up and running. They keep this machine running almost 8 hours a day, every day. Every day that the engraver is down will cost around $975 in lost income. If he has to buy a new engraver, it would cost around $25,000. He can get a 1 year loan at 12% to buy a new engraver, but he worries that this is a lot of money to spend, especially since the old engraver is still working fine. He has to make a decision. Should he purchase a new engraver now or wait until the old engraver breaks before ordering a new engraver?

Worksheet and Discussion Questions

1. Download the worksheet for this video and after viewing the video, utilize the worksheet to figure out what the total cost of the engraver will be and how much revenue will be lost if the engraver is down for 18 business days.
2. If Charlie makes a 25% net profit margin on the engraving revenue, calculate the number of days it will take to pay for the engraver if all of the net profit is applied to the purchase cost.
3. Why is it important to calculate the number of days it will take for a capital purchase to break even?
4. Besides the lost income, what other business costs would be associated with the failure of the rotary engraver?

7. Which Credit Card Deal Is Best?

Business Math Topics Covered

1. Consumer Credit
2. Interest Rates
3. Calculating Interest

Learning Outcomes

After viewing this video, you should be able to:

1. Evaluate credit card offers based upon features, interest rates, fees, and other important criteria.
2. Identify the appropriate credit card offer based upon need.
3. Understand credit terms.

Synopsis

Sharese thinks that it is about time for her to get a credit card. She would like to buy a car in the not-too-distant future and knows that she needs to establish a credit history. She has received several offers in the mail and has downloaded offers from several card companies from card websites. As she reviews the various offers, she finds that the process of evaluating cards is more complicated than she expected.

Worksheet and Discussion Questions

1. Download the worksheet for this video and after viewing the video, utilize the worksheet to evaluate the four credit card offers and choose a card that would be good for Sharese.
2. Which card is best for your personal situation?
3. What questions should a consumer ask before accepting a credit card?
4. What are the advantages of building a good credit history?
5. What are the disadvantages of having access to credit?

Extension Activities

1. Review the Federal Trade Commission website discussed in the video: *http://www.ftc.gov/bcp/conline/pubs/credit/gettingcredit.pdf*
2. Credit card offers change often. Use an Internet search engine, such as *www.google.com* to find current credit card offers for young adults. Type "Student Credit Card Offers" into the search box and press the Enter key.
3. Find other websites that discuss the advantages and disadvantages of credit cards.

8. Should I Buy or Lease a Car?

Business Math Topics Covered

1. Consumer Credit
2. Purchasing versus Leasing a Car

Learning Outcomes

After viewing this video, you should be able to:

1. Understand basic leasing and buying terminology.
2. Understand the difference between leasing and buying a car.
3. Evaluate different financial purchasing options.

Synopsis

Sharese is tired of riding the bus. She has been saving since she began working at The 7th Inning and she thinks that she has saved up enough to buy a car. After doing her homework and investigating the possibilities, she has settled on a cute, red Honda Civic. She does not have a lot of money to put down on the car and she wants her payments to be as low as possible. When she talks with the salesman about financing, she discovers that she has several financing options to consider.

Worksheet and Discussion Questions

1. Download the worksheet for this video and after viewing the video, utilize the worksheet to analyze different financial options.
2. List the advantages and disadvantages of leasing versus buying.
3. What are your driving habits and why should they matter in the decision to lease or purchase?
4. What is the reason that many dealerships will provide a leasing option to a recent college graduate, but not to a high school graduate?

Extension Activities

1. Pick a new car that you would like to own and that you might be able to afford. Call up a local dealership and ask them for the actual costs of buying or leasing a car in your area.
2. For the same car, go to the following two popular auto websites that collect and publish basic information about new car sticker prices, dealer costs, and average selling prices. How does dealer cost compare to the sticker price?
 (a) *http://www.edmnds.com*
 (b) *http://www.kbb.com*
3. In most cases, your car will be worth less than you paid for it the moment that you drive it off of the lot. Almost all cars' values depreciate over time, some more than others. Search on the web for information on depreciation rates for new cars. See if you can find the actual rate of depreciation for the car that you might want to buy. One good way to check this out is to figure out the used value—the trade-in and private resale values of a 2-year-old model of the car that you like—using the two websites listed above.

9. Should I Invest in Elvis?

Business Math Topics Covered

1. Compound Interest
2. Percents
3. Basic Equations
4. Future and Present Value

Learning Outcomes

After viewing this video, you should be able to:

1. Calculate the future value of an item based upon historical and projected rates of appreciation over time.
2. Consider risk issues related to buying and selling memorabilia.

Synopsis

One day, a man looking something like a famous entertainer from the 1970s enters The 7th Inning memorabilia department and begins examining the items in the showroom. Charlie, intrigued by the stranger's appearance, greets him and asks him if he is interested in anything in particular. The stranger is particularly interested in Elvis memorabilia. Now, Charlie is a lifelong fan of Elvis and he actually met and talked with Elvis on many occasions. He enjoys collecting, displaying, and talking about Elvis merchandise with other fans and collectors. It is amazing, but Elvis gear does appreciate at a pretty consistent rate and the supply of items is limited enough to withstand the ups and downs in the economy. There always seems to be enough money in the hands of collectors to continue to bid up items from year to year, especially any item that had a personal association with Elvis, like his clothes, jewelry, or other personal possessions. The stranger wants to know what he can expect in terms of a return on his investment, should he buy several of the items in the shop.

Worksheet and Discussion Questions

1. Download the worksheet for this video and after viewing the video, utilize the worksheet to calculate the possible future value of selected Elvis memorabilia.
2. Keep in mind that the increase in value is not guaranteed for a variety of reasons. Make a list of the factors that could cause the value of Elvis memorabilia to drop in the future.
3. What questions should an investor ask before investing in anything?
4. Charlie indicated that since Elvis is dead, no new memorabilia can be created with his autograph. How does the idea of scarcity increase the value of an item?
5. Why would the autograph by a contemporary artist like Justin Timberlake not appreciate in value as much as an Elvis autograph over the next 10 years?

10. Should I Buy a House?

Business Math Topics Covered

1. Consumer Credit
2. Home Mortgages
3. Basic Equations
4. Percents

Learning Outcomes

After viewing this video, you should be able to:

1. Understand the basic terminology of buying a home.
2. Understand and evaluate basic loan types for purchasing a home.
3. Understand ownership and closing costs.

Synopsis

Joe has decided that he is tired of paying rent and not building equity of his own. He thinks that he is ready to assume the responsibility of owning a home and has found what he believes is the perfect first home. Joe meets with the loan officer at his bank where the process of buying a home is started. The loan officer provides Joe with a great deal of information, leaving him excited and apprehensive at the same time.

Worksheet and Discussion Questions

1. Download the worksheet for this video and after viewing the video, utilize the worksheet to familiarize yourself with terminology used in buying a home, and then evaluate different financing alternatives.
2. What is a credit score?
3. How do you determine your personal credit score?
4. How do you determine how much you can afford for a down payment?
5. How do you determine how much you can afford for a monthly payment?
6. Why is it important to have an idea about how long you intend to live in the house?
7. Why is closing on a house so complicated?

Extension Activities

1. Interview a real estate agent, mortgage officer, and home owner's insurance agent to find out what is involved in buying a house or condominium in your local area.
2. Using an Internet search engine, type the words "Mortgage Rates" and the name of your city or area and state (e.g., "Mortgage Rates Atlanta Georgia"). Visit at least two of the many mortgage sites available and note the differences in the rates quoted and the terms that are given. Call one of the sites with a higher-than-average rate. Ask them why their rates are higher than the other mortgage brokers. Be sure to ask them about points and closing costs. Call the broker with the lowest rates and ask the same questions. Following the conversations, summarize what they tell you about how rates are set.
3. Why not just pick the broker with the lowest rate and finance with that broker? What do you need to know to make an informed choice?

Stop and Check Solutions

CHAPTER 1

Section 1-1

1

1. Seven million, three hundred fifty-two thousand, four hundred ninety-six

2. Four million, twenty-three thousand, five hundred eight

3. Sixty-two billion, eight hundred five million, nine hundred twenty-seven

4. Five hundred eighty-seven billion, nine hundred twelve

2

1. 18,078,397,203

2. 36,017

3. $932,806

4. 52,896

3

1. 3,785,000

2. 6,100

3. 53,000

4. 20,000

5. 600,000 tickets

6. $57,000

Section 1-2

1

1.
| 372 | 400 | 372 |
|---|---|---|
| 583 | 600 | 583 |
| 697 | 700 | 697 |
| | 1,700 | 1,652 |

2.
| 9,823 | 10,000 | 9,823 |
|---|---|---|
| 7,516 | 8,000 | 7,516 |
| 8,205 | 8,000 | 8,205 |
| | 26,000 | 25,544 |

3.
| $618 | 600 | $618 |
|---|---|---|
| 736 | 700 | 736 |
| 107 | 100 | 107 |
| | $1,400 | $1,461 |

4.
| $1,809 | 2,000 | $1,809 |
|---|---|---|
| 3,521 | 4,000 | 3,521 |
| | $6,000 | $5,330 |

5.

| What You Know | What You Are Looking For | Solution Plan |
|---|---|---|
| Projected total revenue = $1,200,000
Revenue from 10 largest = $789,000
Revenue from others = $342,000 | Total revenue

Did the company reach its projection? | Add and compare total revenue with projected revenue. |

Solution

| | |
|---|---|
| $ 789,000 | revenue from 10 largest clients |
| 342,000 | revenue from other clients |
| $1,131,000 | total revenue |

Conclusion

The total revenue of $1,131,000 is less than $1,200,000 so the company did not reach its projection.

6.

| What You Know | What You Are Looking For | Solution Plan |
|---|---|---|
| Projected total revenue = $2,500,000

Revenue from Quarter 1 = $492,568

Revenue from Quarter 2 = $648,942

Revenue from Quarter 3 = $703,840

Revenue from Quarter 4 = $683,491 | Total revenue

Did the shop reach its projected revenue? | Add and compare total revenue with projected revenue. |

Solution

492568 $+$ 648942 $+$ 703840 $+$ 683491 \Rightarrow 2528841 Calculator steps for the sum.

Conclusion

The shop exceeded its revenue goal of $2,500,000 since $2,528,841 is more than $2,500,000.

2

1.

| 138 | 100 | 138 |
|---|---|---|
| − 96 | −100 | − 96 |
| | 0 | 42 |

2.

| 1,352 | 1,000 | 1,352 |
|---|---|---|
| − 787 | − 800 | − 787 |
| | 200 | 565 |

3.

| $3,807 | $4,000 | $3,807 |
|---|---|---|
| − 2,689 | − 3,000 | − 2,689 |
| | $1,000 | $1,118 |

4.

| 10,523 | 10,000 | 10,523 |
|---|---|---|
| − 5,897 | − 6,000 | − 5,897 |
| | 4,000 | 4,626 |

5.

| What You Know | What You Are Looking For | Solution Plan |
|---|---|---|
| Jet Blue sold 2,196,512 tickets Southwest sold 1,993,813 tickets | Difference in number of tickets sold by two airlines | Difference = Jet Blue tickets minus Southwest tickets |

Solution

| 2,196,512 | Jet Blue tickets |
|---|---|
| − 1,993,813 | Southwest tickets |
| 202,699 | difference |

Conclusion

Jet Blue sold 202,699 more tickets than Southwest.

6.

| What You Know | What You Are Looking For | Solution Plan |
|---|---|---|
| Number of firms with 1 to 4 employees = 2,734,133. Number of firms with 5 to 9 employees = 1,025,497. | Difference in number of employees by size of firm. | Difference = number of firms with 1 to 4 employees minus number of firms with 5 to 9 employees. |

Solution

2734133 $-$ 1025497 \Rightarrow 1708636 Calculator steps for the difference.

Conclusion

There are 1,708,636 more firms with 1 to 4 employees than there are firms with 5 to 9 employees.

3

1.

| 317 | 300 | 317 |
|---|---|---|
| × 52 | × 50 | × 52 |
| | 15,000 | 634 |
| | | 15 85 |
| | | 16,484 |

2.

| 6,723 | 7,000 | 6,723 |
|---|---|---|
| × 87 | × 9 0 | × 87 |
| | 63 0,000 | 47 061 |
| | | 537 84 |
| | | 584,901 |

3.

| 4,600 | 5,000 | 4,600 |
|---|---|---|
| × 70 | × 70 | × 70 |
| | 350,000 | 322,000 |

4.

| 538,000 | 5 00,000 | 538 ,000 |
|---|---|---|
| × 420 | × 4 00 | × 42 0 |
| | 20 0,000,000 | 10 76 0 000 |
| | | 215 2 |
| | | 225,96 0,000 |

5.

| What You Know | What You Are Looking For | Solution Plan |
|---|---|---|
| One machine produces 75 rolls per hour. There are 15 machines. | Number of rolls produced in 24 hours by 1 machine; by 15 machines. | Multiply production per hour times number of hours times number of machines. |

Solution

75 rolls × 24 hours = 1,800 rolls per machine
1,800 rolls × 15 machines = 27,000 rolls

Conclusion

1,800 rolls can be produced by 1 machine in 24 hours. 27,000 rolls can be produced by 15 machines in 24 hours.

6.

| What You Know | What You Are Looking For | Solution Plan |
|---|---|---|
| Number of coffee cups produced in a day = 48. Number of bowls produced in a day = 72. Number of coffee cups and number of bowls sold in the 22-day month. | Number of coffee cups and number of bowls that can be produced in a 22-day month and number of each item left in inventory at the end of the month. | Multiply the number of items produced in one day by the number of days of production, which is 22 days. Subtract the number of each item sold from the number produced in the month. |

Solution

48 $\boxed{\times}$ 22 ⟹ 1056 Calculator steps for the product.
72 $\boxed{\times}$ 22 ⟹ 1584

1056 $\boxed{-}$ 809 ⟹ 247 Calculator steps for the difference.
1584 $\boxed{-}$ 1242 ⟹ 342

Conclusion

At the end of the month 247 coffee cups and 342 bowls remained in inventory.

4

1.
$$\begin{array}{r} 462 \\ 6\overline{)2{,}772} \\ \underline{2\,4} \\ 37 \\ \underline{36} \\ 12 \\ \underline{12} \end{array}$$

2.
$$\begin{array}{r} 281 \\ 24\overline{)6{,}744} \\ \underline{4\,8} \\ 1\,94 \\ \underline{1\,92} \\ 24 \\ \underline{24} \end{array}$$

3.
$$\begin{array}{r} 305 \\ 47\overline{)14{,}335} \\ \underline{14\,1} \\ 235 \\ \underline{235} \end{array}$$

4.
$$\begin{array}{r} 84\ \text{R}3 \\ 15\overline{)1{,}263} \\ \underline{1\,20} \\ 63 \\ \underline{60} \\ 3 \end{array}$$

5.

| What You Know | What You Are Looking For | Solution Plan |
|---|---|---|
| The Gap purchases 5,184 pairs of jeans and divides them among 324 stores. | How many pairs are sent to each store? | Divide the number of pairs of jeans by the number of stores. |

Solution

$$\begin{array}{r} 16 \\ 324\overline{)5{,}184} \\ \underline{3\,24} \\ 1\,944 \\ \underline{1\,944} \end{array}$$

Conclusion

Each store should be sent 16 pairs of jeans.

6.

| What You Know | What You Are Looking For | Solution Plan |
|---|---|---|
| Auto Zone purchases 26,560 cans of car wax in cases of 64 cans per case. | How many stores can get 1 case of the wax? | Divide the total number of cans purchased by the number of cans in each case. |

Solution

$$
\begin{array}{r}
415 \\
64\overline{)26{,}560} \\
\underline{25\ 6} \\
96 \\
\underline{64} \\
320 \\
\underline{320} \\
\end{array}
$$

Conclusion

One case of 64 cans of wax can be shipped to each of 415 stores.

CHAPTER 2

Section 2-1

1

1. $\frac{3}{7}$; the numerator is less than the denominator so the fraction is proper.

2. $\frac{4}{3}$; the numerator is greater than the denominator so the fraction is improper.

3. $\frac{3}{7}$ is a proper fraction since the numerator is smaller than the denominator.

4. $\frac{12}{5}$ is an improper fraction since the numerator is larger than the denominator.

5. $\frac{16}{16}$ is an improper fraction since the numerator is equal to the denominator.

6. $\frac{5}{9}$ is a proper fraction since the numerator is smaller than the denominator.

2

1.
$$
\begin{array}{r}
5\frac{5}{28} \\
28\overline{)145} \\
\underline{140} \\
5 \\
\end{array}
$$

2.
$$
\begin{array}{r}
11 \\
12\overline{)132} \\
\underline{12} \\
12 \\
\underline{12} \\
\end{array}
$$

3.
$$
\begin{array}{r}
4 \\
12\overline{)48} \\
\underline{48} \\
\end{array}
$$

4.
$$
\begin{array}{r}
2\frac{4}{7} \\
7\overline{)18} \\
\underline{14} \\
4 \\
\end{array}
$$

5.
$$
\begin{array}{r}
2 \\
17\overline{)34} \\
\underline{34} \\
\end{array}
$$

$$\frac{145}{28} = 5\frac{5}{28}$$

$$\frac{132}{12} = 11$$

$$\frac{48}{12} = 4$$

$$\frac{18}{7} = 2\frac{4}{7}$$

$$\frac{34}{17} = 2$$

3

1. $(4 \times 3) + 1 = 12 + 1 = 13; 3\frac{1}{4} = \frac{13}{4}$

2. $(3 \times 7) + 2 = 21 + 2 = 23; 7\frac{2}{3} = \frac{23}{3}$

3. $(8 \times 5) + 7 = 40 + 7 = 47; 5\frac{7}{8} = \frac{47}{8}$

4. $3 = \frac{3}{1}$

5. $2 = \frac{2}{1}$

4

1. $\dfrac{18 \div 6}{24 \div 6} = \dfrac{3}{4}$

2. $\dfrac{12 \div 12}{36 \div 12} = \dfrac{1}{3}$

3. $16\overline{)24}^{\,1}\quad 8\overline{)16}^{\,2}$
 $\underline{16}\qquad \underline{16}$
 $\ 8\qquad\ \ 0$

 8 is the GCD.

 $\dfrac{16 \div 8}{24 \div 8} = \dfrac{2}{3}$

4. $39\overline{)51}^{\,1}\quad 12\overline{)39}^{\,3}\quad 3\overline{)12}^{\,4}$
 $\underline{39}\qquad \underline{36}\qquad \underline{12}$
 $12\qquad\ \ 3\qquad\ \ 0$

 3 is the GCD.

 $\dfrac{39 \div 3}{51 \div 3} = \dfrac{13}{17}$

5. $12\overline{)28}^{\,2}\quad 4\overline{)12}^{\,3}$
 $\underline{24}\qquad \underline{12}$
 $\ 4\qquad\ \ 0$

 4 is the GCD.

 $\dfrac{12 \div 4}{28 \div 4} = \dfrac{3}{7}$

6. $18\overline{)24}^{\,1}\quad 6\overline{)18}^{\,3}$
 $\underline{18}\qquad \underline{18}$
 $\ 6\qquad\ \ 0$

 6 is the GCD.

 $\dfrac{18 \div 6}{24 \div 6} = \dfrac{3}{4}$

5

1. $36 \div 12 = 3;$

 $\dfrac{7}{12} = \dfrac{7 \times 3}{12 \times 3} = \dfrac{21}{36}$

2. $32 \div 4 = 8;$

 $\dfrac{3}{4} = \dfrac{3 \times 8}{4 \times 8} = \dfrac{24}{32}$

3. $18 \div 2 = 9;$

 $\dfrac{1}{2} = \dfrac{1 \times 9}{2 \times 9} = \dfrac{9}{18}$

4. $25 \div 5 = 5;$

 $\dfrac{3}{5} = \dfrac{3 \times 5}{5 \times 5} = \dfrac{15}{25}$

5. $36 \div 12 = 3;$

 $\dfrac{5 \times 3}{12 \times 3} = \dfrac{15}{36}$

6. $24 \div 8 = 3;$

 $\dfrac{7}{8} = \dfrac{7 \times 3}{8 \times 3} = \dfrac{21}{24}$

Section 2-2

1

1. $\begin{array}{r}\frac{3}{4}\\[2pt]\frac{1}{4}\\[2pt]\frac{1}{4}\\[2pt]\hline\frac{5}{4}=1\frac{1}{4}\end{array}$

2. $\begin{array}{r}\frac{3}{8}\\[2pt]\frac{7}{8}\\[2pt]\frac{1}{8}\\[2pt]\hline\frac{11}{8}=1\frac{3}{8}\end{array}$

3. $\begin{array}{r}\frac{1}{5}\\[2pt]\frac{2}{5}\\[2pt]\frac{2}{5}\\[2pt]\hline\frac{5}{5}=1\end{array}$

4. $\begin{array}{r}\frac{5}{8}\\[2pt]\frac{3}{8}\\[2pt]\frac{1}{8}\\[2pt]\hline\frac{9}{8}=1\frac{1}{8}\end{array}$

5. $\begin{array}{r}\frac{5}{12}\\[2pt]\frac{7}{12}\\[2pt]\frac{11}{12}\\[2pt]\hline\frac{23}{12}=1\frac{11}{12}\end{array}$

2

1. $2\overline{)6\ \ \ 12}$
 $2\overline{)3\ \ \ \ 6}$
 $3\overline{)3\ \ \ \ 3}$
 $1\ \ \ \ 1$
 LCD =
 $2 \times 2 \times 3 = 12$

2. $2\overline{)24\ \ \ 48}$
 $2\overline{)12\ \ \ 24}$
 $2\overline{)\ 6\ \ \ 12}$
 $2\overline{)\ 3\ \ \ \ 6}$
 $3\overline{)\ 3\ \ \ \ 3}$
 $\ 1\ \ \ \ 1$
 LCD =
 $2 \times 2 \times 2 \times 2 \times 3 =$
 48

3. $2\overline{)2\ \ \ 8}$
 $2\overline{)1\ \ \ 4}$
 $2\overline{)1\ \ \ 2}$
 $1\ \ \ 1$
 LCD =
 $2 \times 2 \times 2 = 8$

4. $7\overline{)11\ \ \ 7}$
 $11\overline{)11\ \ \ 1}$
 $1\ \ \ 1$
 LCD = $7 \times 11 = 77$

5. $2\overline{)42\ \ \ 30\ \ \ 35}$
 $3\overline{)21\ \ \ 15\ \ \ 35}$
 $5\overline{)\ 7\ \ \ \ 5\ \ \ 35}$
 $7\overline{)\ 7\ \ \ \ 1\ \ \ \ 7}$
 $\ 1\ \ \ \ 1\ \ \ \ 1$
 LCD –
 $2 \times 3 \times 5 \times 7 =$
 210

3

1.
$$4\frac{3}{8}$$
$$5\frac{5}{8}$$
$$3\frac{7}{8}$$
$$12\frac{15}{8} = 12 + \frac{8}{8} + \frac{7}{8} = 13\frac{7}{8}$$

2.
$$\frac{5}{12} = \frac{5}{12}$$
$$\frac{3}{4} = \frac{9}{12}$$
$$\frac{2}{3} = \frac{8}{12}$$
$$\frac{22}{12} = 1\frac{10}{12} = 1\frac{5}{6}$$

3.
$$4\frac{3}{5} = 4\frac{18}{30}$$
$$5\frac{7}{10} = 5\frac{21}{30}$$
$$3\frac{4}{15} = 3\frac{8}{30}$$
$$12\frac{47}{30} = 12 + \frac{30}{30} + \frac{17}{30} = 13\frac{17}{30}$$

4.
$$23\frac{5}{14} = 23\frac{25}{70}$$
$$37\frac{9}{10} = 37\frac{63}{70}$$
$$60\frac{88}{70} = 60 + \frac{70}{70} + \frac{18}{70}$$
$$= 61\frac{18}{70} = 61\frac{9}{35}$$

5.
$$25\frac{3}{8} = 25\frac{3}{8}$$
$$+ 6\frac{3}{4} = + 6\frac{6}{8}$$
$$= 31\frac{9}{8}$$
$$= 32\frac{1}{8}$$

$32\frac{1}{8}$ **yards of fabric are needed.**

6.
$$32\frac{5}{8} = 32\frac{5}{8}$$
$$+ 8\frac{3}{4} = + 8\frac{6}{8}$$
$$= 40\frac{11}{8}$$
$$= 41\frac{3}{8}$$

$41\frac{3}{8}$ **yards of fabric were used.**

4

1.
$$\frac{7}{8}$$
$$- \frac{3}{8}$$
$$\frac{4}{8} = \frac{1}{2}$$

2.
$$\frac{5}{8} = \frac{5 \times 3}{8 \times 3} = \frac{15}{24}$$
$$- \frac{1}{12} = -\frac{1 \times 2}{12 \times 2} = -\frac{2}{24}$$
$$\frac{13}{24}$$

3.
$$12\frac{5}{8} = 11 + \frac{8}{8} + \frac{5}{8} = 11\frac{13}{8}$$
$$- 3\frac{7}{8} \qquad\qquad\qquad = - \ 3\frac{7}{8}$$
$$8\frac{6}{8} = 8\frac{3}{4}$$

4.
$$15\frac{11}{12} = 15\frac{11 \times 3}{12 \times 3} = 15\frac{33}{36}$$
$$-7\frac{5}{18} = -7\frac{5 \times 2}{18 \times 2} = -7\frac{10}{36}$$
$$8\frac{23}{36}$$

```
2)12  18
2) 6  9
3) 3  9
3) 1  3
   1   1
```
LCD = 2 × 2 × 3 × 3 = 36

5.
$$32 = 31\frac{12}{12}$$
$$-14\frac{5}{12} = -14\frac{5}{12}$$
$$17\frac{7}{12}$$

6.
$$27\frac{4}{15} = 27\frac{4 \times 4}{15 \times 4} = 27\frac{16}{60} = 26\frac{60}{60} + \frac{16}{60} = 26\frac{76}{60}$$
$$-14\frac{7}{12} = -14\frac{7 \times 5}{12 \times 5} = -14\frac{35}{60} = -14\frac{35}{60} = -14\frac{35}{60}$$
$$12\frac{41}{60}$$

```
2)15  12
2)15   6
3)15   3
5) 5   1
   1   1
```
LCD = 2 × 2 × 3 × 5 = 60

7.

| What You Know | What You Are Looking For | Solution Plan |
|---|---|---|
| Amount of land originally owned = 100 acres

Acreage of 3 additional purchases = $12\frac{3}{4} + 23\frac{2}{3} + 5\frac{1}{8}$

Acreage that was sold during the year = $65\frac{2}{3}$ | Acres that Marcus still owns | Acreage originally owned plus acreage purchased minus acreage sold equals acreage still owned |

$$100 = 100$$

$$12\frac{3}{4} = 12\frac{18}{24}$$

$$23\frac{2}{3} = 23\frac{16}{24}$$

$$5\frac{1}{8} = 5\frac{3}{24}$$

$$140\frac{37}{24} =$$

$$141\frac{13}{24} \quad \text{Acres owned before sale.}$$

LCD = 24

$$141\frac{13}{24} = 141\frac{13}{24} = 140\frac{37}{24}$$

$$- 65\frac{2}{3} = - 65\frac{16}{24} = - 65\frac{16}{24}$$

$$= 75\frac{21}{24}$$

$$= 75\frac{7}{8} \quad \text{Acres owned after sale.}$$

Conclusion

There are $75\frac{7}{8}$ acres remaining after the purchases and sale.

8.

| What You Know | What You Are Looking For | Solution Plan |
|---|---|---|
| Amount of frame material = 60 inches.

 Frame material needed =
 $10\frac{3}{4} + 10\frac{3}{4} + 12\frac{5}{8} + 12\frac{5}{8}$ | Length of frame material remaining. | Total frame length minus amount used equals frame material remaining. |

Solution

$$10\frac{3}{4} + 10\frac{3}{4} + 12\frac{5}{8} + 12\frac{5}{8} =$$

$$10\frac{6}{8} + 10\frac{6}{8} + 12\frac{5}{8} + 12\frac{5}{8} =$$

$$44\frac{22}{8} = 46\frac{3}{4} \text{ inches used}$$

$$60 - 46\frac{3}{4} = 59\frac{4}{4} - 46\frac{3}{4} = 13\frac{1}{4}$$

Conclusion

There are $13\frac{1}{4}$ inches of frame material remaining.

Section 2-3

1

1. $\dfrac{3}{7} \times \dfrac{5}{8} = \dfrac{15}{56}$

2. $\dfrac{\overset{1}{\cancel{4}}}{\underset{3}{\cancel{9}}} \times \dfrac{\overset{1}{\cancel{3}}}{\underset{2}{\cancel{8}}} = \dfrac{1}{6}$

3. $3\dfrac{1}{4} \times \dfrac{5}{13} = \dfrac{\overset{1}{\cancel{13}}}{4} \times \dfrac{5}{\underset{1}{\cancel{13}}} = \dfrac{5}{4} = 1\dfrac{1}{4}$

4. $1\dfrac{1}{9} \times 3 = \dfrac{10}{\underset{3}{\cancel{9}}} \times \dfrac{\overset{1}{\cancel{3}}}{1} = \dfrac{10}{3} = 3\dfrac{1}{3}$

5. $2\dfrac{2}{5} \times \dfrac{15}{21} = \dfrac{\overset{4}{\cancel{12}}}{\underset{1}{\cancel{5}}} \times \dfrac{\overset{3}{\cancel{15}}}{\underset{7}{\cancel{21}}} = \dfrac{12}{7} = 1\dfrac{5}{7}$

6. $2\dfrac{3}{8} \times 16 = \dfrac{19}{\underset{1}{\cancel{8}}} \times \dfrac{\overset{2}{\cancel{16}}}{1} = 38 \text{ feet}$

7. $2\dfrac{1}{3} \times 14 = \dfrac{7}{3} \times \dfrac{14}{1} = \dfrac{98}{3} = 32\dfrac{2}{3} \text{ feet}$

2

1. $\dfrac{5}{12}$; reciprocal $\dfrac{12}{5}$

2. $32 = \dfrac{32}{1}$; reciprocal $\dfrac{1}{32}$

3. $7\dfrac{1}{8} = \dfrac{57}{8}$; reciprocal $\dfrac{8}{57}$

4. $\dfrac{7}{8} \div \dfrac{3}{4} = \dfrac{7}{\underset{2}{\cancel{8}}} \times \dfrac{\overset{1}{\cancel{4}}}{3} = \dfrac{7}{6} = 1\dfrac{1}{6}$

5. $2\dfrac{2}{5} \div 2\dfrac{1}{10} = \dfrac{12}{5} \div \dfrac{21}{10} = \dfrac{\overset{4}{\cancel{12}}}{\underset{1}{\cancel{5}}} \times \dfrac{\overset{2}{\cancel{10}}}{\underset{7}{\cancel{21}}} = \dfrac{8}{7} = 1\dfrac{1}{7}$

6. $3\dfrac{3}{8} \div 9 = \dfrac{27}{8} \div \dfrac{9}{1} = \dfrac{\overset{3}{\cancel{27}}}{8} \cdot \dfrac{1}{\underset{1}{\cancel{9}}} = \dfrac{3}{8}$

7. $72 \div \dfrac{3}{4} = \dfrac{\overset{24}{\cancel{72}}}{1} \times \dfrac{4}{\underset{1}{\cancel{3}}} = 96 \text{ pieces of plywood}$

CHAPTER 3

Section 3-1

1

1. Five and eight-tenths
2. Seven hundred twenty-one thousandths
3. Thirty-eight dollars and fifteen cents
4. 434.76
5. 0.3548
6. $4.87

2

1. 14.342 3 is in the tenths place and 4 is less than 5. Round down by leaving 3 as it is and dropping the 4 and 2.

 14.3

2. 48.7965 9 is in the hundredths place and 6 is 5 or more. Round up by adding 1 to 9.

 48.80

3. $768.57 Round to the ones place. 5 is in the tenths place and is 5 or more. Round up by adding 1 to 8.

 $769

4. $54.834 Round to the hundredths place. 4 is in the thousandths place and is less than 5. Round down.

 $54.83

Section 3-2

1

1.
$$
\begin{array}{r}
67. \\
4.38 \\
+\ 0.291 \\
\hline
71.671
\end{array}
$$

2.
$$
\begin{array}{r}
57.5 \\
13.4 \\
+\ 5.238 \\
\hline
76.138
\end{array}
$$

3.
$$
\begin{array}{r}
17.53 \\
-\ 12.17 \\
\hline
5.36
\end{array}
$$

4.
$$
\begin{array}{r}
542.830 \\
-\ 219.593 \\
\hline
323.237
\end{array}
$$

5.
$$
\begin{array}{r}
\$\ 20.00 \\
-\ 18.97 \\
\hline
\$\ 1.03
\end{array}
$$

6. $120.01 − $95.79 = $24.22

2

1.
$$
\begin{array}{r}
4.35 \\
\times\ 0.27 \\
\hline
30\,45 \\
87\,0 \\
\hline
1.17\,45
\end{array}
$$

2.
$$
\begin{array}{r}
7.03 \\
\times\ 0.0\,35 \\
\hline
3515 \\
2109 \\
\hline
0.24605
\end{array}
$$

3.
$$
\begin{array}{r}
5.32 \\
\times\ 15 \\
\hline
26\,60 \\
53\,2 \\
\hline
79.8\cancel{0}
\end{array}
$$

4.
$$
\begin{array}{r}
\$8.31 \\
\times\ 4 \\
\hline
\$33.24
\end{array}
$$

5.
$$
\begin{array}{r}
\$27.42 \\
\times\ 500 \\
\hline
\$13,710.00
\end{array}
$$

The dinner costs $13,710.

6. $94.05 × 1,000 = $94,050

3

1.
$$
\begin{array}{r}
6.72 \\
15\overline{)100.80} \\
90 \\
\overline{10\,8} \\
10\,5 \\
\overline{30} \\
30 \\
\hline
\end{array}
$$

2.
$$
\begin{array}{r}
17.06 \\
21\overline{)358.26} \\
21 \\
\overline{148} \\
147 \\
\overline{1\,2} \\
0 \\
\overline{1\,26} \\
1\,26
\end{array}
$$

3.
$$
\begin{array}{r}
3.41 \approx 3.4 \\
3.8\overline{)12.970} \\
114 \\
\overline{15\,7} \\
15\,2 \\
\overline{50} \\
38 \\
\overline{12}
\end{array}
$$

4.
$$
\begin{array}{r}
1\,7.469 \approx 17.47 \\
5.9\overline{)103.0\,700} \\
59 \\
\overline{44\,0} \\
41\,3 \\
\overline{2\,77} \\
2\,36 \\
\overline{4\,10} \\
3\,54 \\
\overline{560} \\
531 \\
\overline{29}
\end{array}
$$

5.
$$
\begin{array}{r}
37 \\
19.36\overline{)716.32} \\
580\,8 \\
\overline{135\,52} \\
135\,52
\end{array}
$$

Gwen worked 37 hours.

6. $648,000,000 ÷ 1,000,000 = $648

1

1. $\dfrac{7}{10}$

2. $\dfrac{32}{100} = \dfrac{8}{25}$

3. $2\dfrac{87}{1{,}000}$

4. $23\dfrac{41}{100}$

5. $\dfrac{7}{100}$

2

1. $\dfrac{3}{5} = 0.6$ $\begin{array}{r} 0.6 \\ 5\overline{)3.0} \end{array}$

2. $\dfrac{7}{8} = 0.88$

$\begin{array}{r} 0.875 \approx 0.88 \\ 8\overline{)7.000} \\ \underline{6\,4} \\ 60 \\ \underline{56} \\ 40 \\ \underline{40} \end{array}$

3. $\dfrac{5}{12} = 0.42$

$\begin{array}{r} 0.416 \approx 0.42 \\ 12\overline{)5.000} \\ \underline{4\,8} \\ 20 \\ \underline{12} \\ 80 \\ \underline{72} \\ 8 \end{array}$

4. $7\dfrac{4}{5} = 7.8$

$\begin{array}{r} 0.8 \\ 5\overline{)4.0} \end{array}$

5. $8\dfrac{4}{7} = 8.57$

$\begin{array}{r} 0.571 \approx 0.57 \\ 7\overline{)4.000} \\ \underline{3\,5} \\ 50 \\ \underline{49} \\ 10 \\ \underline{7} \\ 3 \end{array}$

CHAPTER 4

Section 4-1

1

1.

2.

DEPOSIT TICKET

Please be sure all items are properly endorsed. List checks separately.
FOR CLEAR COPY, PRESS FIRMLY WITH BALL POINT PEN

DATE April 11, 20xx

| | DOLLARS | CENTS |
|---|---|---|
| CURRENCY | 821 | 00 |
| COIN | | |
| CHECKS | | |
| 1 Olson | 18 | 15 |
| 2 Drewrey | 38 | 15 |
| 3 Tinkler | 82 | 15 |
| 4 Brannon | 17 | 19 |
| 5 McCready | 38 | 57 |
| 6 Mowers | 132 | 86 |
| 7 Lee | 15 | 21 |
| 8 Wang | 38 | 00 |
| 9 | | |
| 10 | | |
| 11 | | |
| 12 | | |
| 13 | | |
| 14 | | |
| 15 | | |
| 16 | | |
| **TOTAL** | 1,201 | 28 |

TOTAL ITEMS 8

Sellit.com
10325 Apple Rd.
Tulsa, OK 38121

⑆074302589⑆ 23 271b 4⑈

Community First Bank
2177 GERMANTOWN ROAD SOUTH
GERMANTOWN, TENNESSEE 38138

Checks and other items are received for deposit subject to the provisions of the Uniform Commercial Code or any applicable collection agreement.

© DELUXE SDM-3

DEPOSITS MAY NOT BE AVAILABLE FOR IMMEDIATE WITHDRAWAL

3.

| ABC Plumbing | 4359 |
|---|---|

408 Jefferson
Rexburg, ID 00000

October 18 20 XX 87-278/840

PAY TO THE ORDER OF Frances Johnson $ 583.17

Five hundred eighty-three and ¹⁷/₁₀₀ DOLLARS

First National Bank
400 Washington
Rexburg, ID 00000

MEMO tool chest Albert Adkins

⑆044503279⑆

4.

| Max's Motorcycle Shop | 5887 |
|---|---|

1280 State Street
Tulsa, OK 00000

August 18 20 XX 87-278/840

PAY TO THE ORDER OF Harley Davidson, Inc. $ 2,872.15

Two thousand eight hundred seventy-two and ¹⁵/₁₀₀ DOLLARS

Tulsa State Bank
295 Adams Street
Tulsa, OK 00000

MEMO motorcycle parts Max Murphy

⑆584325911⑆

5. Answers will vary. Bank statements are available online. Bills can be paid online. Accounts are accessible 24 hours a day. Bank statements can be reconciled online. Bank records can be stored electronically.

2

1. a. $152.87
 b. $2,896.15
 c. $3,543.28

2.

| 4359 | Date Oct 18 20 XX |
|---|---|

Amount 583.17
To Frances Johnson
For tool chest

| Balance Forward | 5,902 | 08 |
|---|---|---|
| Deposits | | |
| Total | 5,902 | 08 |
| Amount This Check | 583 | 17 |
| Balance | 5,318 | 91 |

3.

RECORD ALL TRANSACTIONS THAT AFFECT YOUR ACCOUNT

| NUMBER | DATE | DESCRIPTION OF TRANSACTION | DEBIT (–) | √T | FEE (IF ANY) (–) | CREDIT (+) | BALANCE | |
|---|---|---|---|---|---|---|---|---|
| | | | | | | | 6,007 | 82 |
| 5887 | 8/18 | Harley Davidson, Inc. | 2,872 15 | | | | −2,872 | 15 |
| | | motorcycle parts | | | | | 3,135 | 67 |
| Debit | 8/20 | Remmie Raynor | 498 31 | | | | −498 | 31 |
| | | pool services | | | | | 2,637 | 36 |

4.

RECORD ALL TRANSACTIONS THAT AFFECT YOUR ACCOUNT

| NUMBER | DATE | DESCRIPTION OF TRANSACTION | DEBIT (−) | √ T | FEE (IF ANY) (−) | CREDIT (+) | BALANCE |
|---|---|---|---|---|---|---|---|
| | | | | | | | 5,108 31 |
| 4358 | 10/6 | Quesha Blunt | 49 80 | | | | −49 80 |
| | | Cleaning Service | | | | | 5,058 51 |
| Dep | 10/6 | Deposit | | | | 843 57 | +843 57 |
| | | travel reimb. | | | | | 5,902 08 |
| 4359 | 10/8 | Frances Johnson | 583 17 | | | | −583 17 |
| | | **tool chest** | | | | | **5,318 91** |
| ATM | 10/8 | Cash | 250 00 | | | | −250 00 |
| | | | | | | | 5,068 91 |

Section 4-2

1

1. four
2. $5.00
3. $8,218.00
4. five
5. $700.81
6. $3,485.73
7. $490.00
8. 6/20
9. Answers will vary. Yes, provided the amount requested does not exceed the limit set by the Kroger company nor the limit set by Lindy's bank.

10.

RECORD ALL TRANSACTIONS THAT AFFECT YOUR ACCOUNT

| NUMBER | DATE | DESCRIPTION OF TRANSACTION | DEBIT (−) | √ T | FEE (IF ANY) (−) | CREDIT (+) | BALANCE |
|---|---|---|---|---|---|---|---|
| | | | | | | | 700 81 |
| 8213 | 5/28 | Lands End | 647 93 | √ | | | −647 93 |
| | | | | | | | 52 88 |
| Deposit | 6/1 | Receipts | | √ | | 1,830 00 | +1,830 00 |
| | | | | | | | 1,882 88 |
| 8214 | 6/1 | Collier Management Co. | 490 00 | √ | | | −490 00 |
| | | | | | | | 1,392 88 |
| 8215 | 6/3 | Jinkins Wholesale | 728 32 | √ | | | −728 32 |
| | | | | | | | 664 56 |
| Deposit | 6/5 | Receipts | | √ | | 2,583 00 | +2,583 00 |
| | | | | | | | 3,247 56 |
| 8216 | 6/5 | Minneapolis Utility Co. | 257 13 | | | | −257 13 |
| | | | | | | | 2,990 43 |
| 8217 | 6/10 | State of MN | 416 83 | √ | | | −416 83 |
| | | | | | | | 2,573 60 |
| Deposit | 6/15 | Receipts | | √ | | 3,800 00 | +3,800 00 |
| | | | | | | | 6,373 60 |
| 8218 | 6/15 | Tracie Burke salary | 2,000 00 | | | | −2,000 00 |
| | | | | | | | 4,373 60 |
| 8219 | 6/20 | Brown's Wholesale | 3,150 00 | √ | | | −3,150 00 |
| | | | | | | | 1,223 60 |
| Deposit | 7/2 | Receipts | | | | 1,720 00 | +1,720 00 |
| | | | | | | | 2,943 60 |
| | 6/30 | Interest Earned | | √ | | 5 00 | +5 00 |
| | | | | | | | 2,948 60 |
| | 6/30 | Statement Reconciled | | | | | |

| $ 3,485.73 | BALANCE AS SHOWN ON BANK STATEMENT | | BALANCE AS SHOWN IN YOUR REGISTER | $ 2,943.60 |
| +1,720.00 | TOTAL OF OUTSTANDING DEPOSITS | | SUBTRACT AMOUNT OF SERVICE CHARGE | 0 |
| 5,205.73 | NEW TOTAL | | NEW TOTAL | 2,943.60 |
| −2,257.13 | SUBTRACT TOTAL OF OUTSTANDING CHECKS | | ADJUSTMENTS IF ANY Interest | + 5.00 |
| $2,948.60 | YOUR ADJUSTED STATEMENT BALANCE | SHOULD EQUAL | YOUR ADJUSTED REGISTER BALANCE | $2,948.60 |

| Outstanding Deposits (Credits) | |
|---|---|
| Date | Amount |
| 7/2 | $ 1,720.00 |
| | |
| | |
| | |
| | |
| Total | $ 1,720.00 |

| Outstanding Checks (Debits) | | |
|---|---|---|
| Check Number | Date | Amount |
| 8216 | 6/5 | $ 257.13 |
| 8218 | 6/20 | 2,000.00 |
| | | |
| | | |
| | | |
| Total | | $ 2,257.13 |

CHAPTER 5

Section 5-1

1

1. $3A = 24$
$\dfrac{3A}{3} = \dfrac{24}{3}$
$A = 8$

2. $5N = 30$
$\dfrac{5N}{5} = \dfrac{30}{5}$
$N = 6$

3. $8 = \dfrac{B}{6}$
$(6)8 = \dfrac{B}{6}(6)$
$48 = B$
$B = 48$

4. $\dfrac{M}{5} = 7$
$5\left(\dfrac{M}{5}\right) = 7(5)$
$M = 35$

5. $\dfrac{K}{2} = 3$
$(2)\dfrac{K}{2} = 3(2)$
$K = 6$

6. $7 = \dfrac{A}{3}$
$(3)7 = \dfrac{A}{3}(3)$
$21 = A$
or
$A = 21$

2

1. $A + 12 = 20$
$\quad -12 \quad -12$
$A \quad = \quad 8$

2. $A + 5 = 28$
$\quad -5 \quad -5$
$A \quad = \quad 23$

3. $N - 7 = 10$
$\quad +7 \quad +7$
$N \quad = \quad 17$

4. $N - 5 = 11$
$\quad +5 \quad +5$
$N \quad = \quad 16$

5. $15 = A + 3$
$-3 \quad -3$
$12 = A$
or
$A = 12$

6. $28 = M - 5$
$+5 \quad +5$
$33 = M$
or
$M = 33$

3

1. $3N + 4 = 16$
$\quad -4 \quad -4$
$3N \quad = 12$
$\dfrac{3N}{3} = \dfrac{12}{3}$
$N = 4$

2. $5N - 7 = 13$
$\quad +7 \quad +7$
$5N \quad = 20$
$\dfrac{5N}{5} = \dfrac{20}{5}$
$N = 4$

3. $\dfrac{B}{8} - 2 = 2$
$\quad +2 \quad +2$
$\dfrac{B}{8} \quad = 4$
$(8)\dfrac{B}{8} = 4(8)$
$B = 32$

4. $\dfrac{M}{3} + 2 = 5$
$\quad -2 \quad -2$
$\dfrac{M}{3} \quad = 3$
$(3)\dfrac{M}{3} = 3(3)$
$M = 9$

5. $\dfrac{S}{6} - 3 = 4$
$\quad +3 \quad +3$
$\dfrac{S}{6} \quad = 7$
$(6)\dfrac{S}{6} = 7(6)$
$S = 42$

6. $12 = \dfrac{A}{5} - 8$
$+8 = \quad +8$
$20 = \dfrac{A}{5}$
$(5)20 = \dfrac{A}{5}(5)$
$100 = A$
or
$A = 100$

4

1. $B + 3B - 5 = 19$
$4B - 5 = 19$
$ + 5 \quad +5$
$4B = 24$
$\dfrac{4B}{4} = \dfrac{24}{4}$
$B = 6$

2. $4B - 7 = 13$
$ + 7 \quad + 7$
$4B = 20$
$\dfrac{4B}{4} = \dfrac{20}{4}$
$B = 5$

3. $7 + 3B + 2B = 17$
$7 + 5B = 17$
$-7 \qquad -7$
$5B = 10$
$\dfrac{5B}{5} = \dfrac{10}{5}$
$B = 2$

4. $5A - 3 + 2A = 18$
$7A - 3 = 18$
$ + 3 \quad + 3$
$7A = 21$
$\dfrac{7A}{7} = \dfrac{21}{7}$
$A = 3$

5. $3C - C = 16$
$2C = 16$
$\dfrac{2C}{2} = \dfrac{16}{2}$
$C = 8$

6. $12 = 8C - 5C$
$12 = 3C$
$\dfrac{12}{3} = \dfrac{3C}{3}$
$4 = C$
or
$C = 4$

5

1. $2(N + 4) = 26$
$2N + 2(4) = 26$
$2N + 8 = 26$
$ - 8 \quad - 8$
$2N = 18$
$\dfrac{2N}{2} = \dfrac{18}{2}$
$N = 9$

2. $3(N - 30) = 45$
$3N - 90 = 45$
$ + 90 \quad + 90$
$3N = 135$
$\dfrac{3N}{3} = \dfrac{135}{3}$
$N = 45$

3. $4(R - 3) = 8$
$4R - 12 = 8$
$ + 12 \quad +12$
$4R = 20$
$\dfrac{4R}{4} = \dfrac{20}{4}$
$R = 5$

4. $7(2R - 3) = 21$
$14R - 21 = 21$
$ + 21 \quad +21$
$14R = 42$
$\dfrac{14R}{14} = \dfrac{42}{14}$
$R = 3$

5. $5(3R + 2) = 40$
$15R + 10 = 40$
$ - 10 \quad -10$
$15R = 30$
$\dfrac{15R}{15} = \dfrac{30}{15}$
$R = 2$

6. $30 = 6(2A + 3)$
$30 = 12A + 18$
$-18 = - 18$
$12 = 12A$
$\dfrac{12}{12} = \dfrac{12A}{12}$
$1 = A$
or
$A = 1$

6

1. $\dfrac{5}{7} \stackrel{?}{=} \dfrac{20}{28}$
$5(28) = 7(20)$
$140 = 140$
$\dfrac{5}{7}$ is proportional to $\dfrac{20}{28}$.

 $\dfrac{3}{4} \stackrel{?}{=} \dfrac{20}{28}$
$3(28) \stackrel{?}{=} 4(20)$
$84 \stackrel{?}{=} 80$
$\dfrac{3}{4}$ is not proportional to $\dfrac{20}{28}$.

2. $\dfrac{1}{2} \stackrel{?}{=} \dfrac{12}{18}$
$1(18) \stackrel{?}{=} 2(12)$
$18 \stackrel{?}{=} 24$
$\dfrac{1}{2}$ is not proportional to $\dfrac{12}{18}$.

 $\dfrac{2}{3} \stackrel{?}{=} \dfrac{12}{18}$
$2(18) = 3(12)$
$36 = 36$
$\dfrac{2}{3}$ is proportional to $\dfrac{12}{18}$.

3. $\dfrac{3}{4} = \dfrac{N}{8}$
$4N = 3(8)$
$4N = 24$
$\left(\dfrac{1}{4}\right)4N = 24\left(\dfrac{1}{4}\right)$
$N = \dfrac{24}{4} = 6$

4. $\dfrac{5}{N} = \dfrac{4}{12}$
$4N = 5(12)$
$4N = 60$
$\dfrac{4N}{4} = \dfrac{60}{4}$
$N = 15$

5. $\dfrac{N}{4} = \dfrac{9}{6}$
$6N = 4(9)$
$6N = 36$
$\dfrac{6N}{6} = \dfrac{36}{6}$
$N = 6$

6. $\dfrac{5}{12} = \dfrac{15}{N}$
$5N = 12(15)$
$5N = 180$
$\dfrac{5N}{5} = \dfrac{180}{5}$
$N = 36$

1

1.

| What You Know | What You Are Looking For | Solution Plan |
|---|---|---|
| $\frac{1}{6}$ of earnings spent on groceries $117.50 spent on groceries each week | The amount of weekly earnings = N | One sixth times weekly earnings = amount spent on groceries |

Solution

$$\frac{1}{6}N = \$117.50$$

$$(6)\frac{N}{6} = 117.50(6)$$

$$N = \$705$$

Conclusion

Carrie earns $705 weekly.

2.

| What You Know | What You Are Looking For | Solution Plan |
|---|---|---|
| Total pounds of produce = 2,500 potatoes = 800 pounds broccoli = 150 pounds tomatoes = 390 pounds | Number of pounds of apples = N | Number of pounds of potatoes + pounds of broccoli + pounds of tomatoes + pounds of apples = 2,500 |

Solution

$$800 + 150 + 390 + N = 2,500$$
$$1,340 + N = 2,500$$
$$-1,340 \qquad -1,340$$
$$N = 1,160$$

Conclusion

Marcus purchased 1,160 pounds of apples.

3.

| What You Know | What You Are Looking For | Solution Plan |
|---|---|---|
| Total rooms = 873 8 times as many nonsmoking as there are smoking rooms. | Number of smoking rooms = N Number of nonsmoking rooms = 8N | The number of smoking rooms plus the number of nonsmoking rooms = 873. |

Solution

$$N + 8N = 873$$
$$9N = 873$$
$$\frac{9N}{9} = \frac{873}{9}$$
$$N = 97$$

Conclusion

The hotel has 97 rooms designated as smoking rooms.

4.

| What You Know | What You Are Looking For | Solution Plan |
|---|---|---|
| 480 notebooks cost $1,656. | The number of notebooks that can be purchased for $2,242.50 = N | Pair 1: 480 notebooks; $1,656

Pair 2: N notebooks; $2,242.50 |

Solution

$$\frac{480}{\$1,656} = \frac{N}{\$2,242.50}$$

Pair 1 Pair 2

$1,656N = 480(2,242.50)$

$1,656N = 1,076,400$

$$\frac{1,656N}{1,656} = \frac{1,076,400}{1,656}$$

$N = 650$

Conclusion

650 notebooks can be purchased for $2,242.50.

Section 5-3

1

1. $S = C + M$
 $S = 317 + 250$
 $S = \$567$

2. $\quad S = \quad C + M$
 $629 = \quad 463 + M$
 $\underline{-463 \quad\quad -463}$
 $\quad 166 = \quad M$
 $\quad\quad M = \quad \$166$

3. $P = RH$
 $P = 19.26(40)$
 $P = \$770.40$

4. $\quad P = RH$
 $612 = R(40)$
 $\dfrac{612}{40} = \dfrac{R(40)}{40}$
 $15.30 = R$
 $\quad R = \$15.30$

2

1. $\quad S = \quad C + M$
 $\underline{-C \quad\quad -C}$
 $S - C = \quad M$
 $\quad\quad M = \quad S - C$

2. $\quad M = S - N$
 $\underline{+N \quad\quad +N}$
 $M + N = S$
 $\quad\quad S = M + N$

3. $\quad U = \dfrac{P}{N}$
 $(N)U = \dfrac{P}{N}(N)$
 $NU = P$
 $\dfrac{NU}{U} = \dfrac{P}{U}$
 $N = \dfrac{P}{U}$

4. $\quad U = \dfrac{V}{P}$
 $U(P) = \dfrac{V}{P}(P)$
 $UP = V$
 $V = UP$

CHAPTER 6

Section 6-1

1

1. $0.82 = 0.82(100\%) = 0\underset{\frown}{8}2.\% = 82\%$

2. $3.45 = 3.45(100\%) = 3\underset{\frown}{4}5.\% = 345\%$

3. $0.0007 = 0.0007(100\%) = 0\underset{\frown}{0}0.07\% = 0.07\%$

4. $5 = 5(100\%) = 500\%$

5. $\dfrac{43}{100} = \dfrac{43}{\overset{}{\underset{1}{\cancel{100}}}}\left(\dfrac{\overset{1}{\cancel{100}\%}}{1}\right) = 43\%$

6. $\dfrac{3}{10} = \dfrac{3}{\overset{}{\underset{1}{\cancel{10}}}}\left(\dfrac{\overset{10}{\cancel{100}\%}}{1}\right) = 30\%$

7. $8\dfrac{1}{4} = 8\dfrac{1}{4}(100\%) = \dfrac{33}{\overset{}{\underset{1}{\cancel{4}}}}\left(\dfrac{\overset{25}{\cancel{100}\%}}{1}\right) = 825\%$

8. $\dfrac{1}{6} = \dfrac{1}{\overset{}{\underset{3}{\cancel{6}}}}\left(\dfrac{\overset{50}{\cancel{100}\%}}{1}\right) = \dfrac{50}{3}\% = 16\dfrac{2}{3}\%$

2

1. $52\% = 52\% \div 100\% = 0.\underset{\smile}{52} = 0.52$

2. $38.5\% = 38.5\% \div 100\% = 0.\underset{\smile}{385} = 0.385$

3. $143\% = 143\% \div 100\% = 1.\underset{\smile}{43} = 1.43$

4. $0.72\% = 0.72\% \div 100\% = 0.\underset{\smile}{0072} = 0.0072$

5. $72\% = 72\% \div 100\% = \dfrac{\overset{18}{\cancel{72}\%}}{1}\left(\dfrac{1}{\underset{25}{\cancel{100}\%}}\right) = \dfrac{18}{25}$

6. $\dfrac{1}{8}\% = \dfrac{1}{8}\% \div 100\% = \dfrac{1}{8}\%\left(\dfrac{1}{100\%}\right) = \dfrac{1}{800}$

7. $325\% = 325\% \div 100\% = \dfrac{325\%}{1}\left(\dfrac{1}{100\%}\right) = \dfrac{325}{100} = 3\dfrac{1}{4}$

8. $16\dfrac{2}{3}\% = 16\dfrac{2}{3}\% \div 100\% = \dfrac{\overset{1}{\cancel{50}\%}}{3}\left(\dfrac{1}{\underset{2}{\cancel{100}\%}}\right) = \dfrac{1}{6}$

Section 6-2

1

1. Base (of), 85; rate (%), 42%; portion (part), not known

2. Base (of), not know; rate (%), 15%; portion (part) 50

3. Base (of), 80; rate (%), not known; portion (part), 20

4. Base (of), not known; rate (%), 20%; portion (part), 17

5. Base (of), 72; rate (%), 125%; portion (part), not known

6. Base (of), 160; rate (%), not known; portion (part), 32

2

1. $P = RB$ $\qquad R = 15\% = 0.15$
 $P = 0.15(200)$ $\quad B = 200$
 $P = 30$

2. $B = \dfrac{P}{R}$ $\qquad P = 120$

 $B = \dfrac{120}{0.25}$ $\qquad R = 25\% = 0.25$

 $B = 480$

3. $R = \dfrac{P}{B}$ $\qquad P = 150$

 $R = \dfrac{150}{750}$ $\qquad B = 750$

 $R = 0.2$
 $R = 20\%$

4. $P = RB$ $\qquad R = 12\dfrac{1}{2}\% = 12.5\% = 0.125$

 $P = 0.125(64)$ $\quad B = 64$
 $P = 8$

5.

| What You Know | What You Are Looking For | Solution Plan |
|---|---|---|
| Total students or the base: 40
% of students who passed: 75% | Number of students who passed | $P = RB$, where $R = 0.75$ and $B = 40$ |

| Solution |
|---|
| $P = RB$
$P = 0.75(40)$
$P = 30$ |

| Conclusion |
|---|
| **30 students passed the test.** |

6. $R = \dfrac{P}{B}$

 $R = \dfrac{150}{500}$

 $R = 0.30$
 $R = 0.30(100\%)$
 $R = 30\%$

1

1.

| What You Know | What You Are Looking For | Solution Plan |
|---|---|---|
| New Lexus = $53,444
Previous model = $51,989 | Amount of increase | Amount of increase =
new price − previous price |

Solution

$53,444 − 51,989

```
  53,444
−51,989
$  1,455
```

Conclusion

The Lexus increased by $1,455.

2.

| What You Know | What You Are Looking For | Solution Plan |
|---|---|---|
| Ending price of $73.57
Beginning price $81.99 | Amount of decrease | Amount of decrease =
beginning price − ending price |

Solution

$81.99 − $73.57 = $8.42

Conclusion

The stock price fell $8.42

3.

| What You Know | What You Are Looking For | Solution Plan |
|---|---|---|
| Current earnings: $62,870
4.3% raise | Amount of her raise | Amount of raise = current
earnings × percent raise |

Solution

$62,870 × 4.3% = $62,870(0.043) = $2,703.41

Conclusion

Her raise was $2,703.41.

4.

| What You Know | What You Are Looking For | Solution Plan |
|---|---|---|
| Original cost of stock = $145 million | Amount of decrease of stock | $P = RB$ |
| Percent of decrease = 16% | | Decrease = percent of
decrease × original cost |

Solution

Decrease = 16%($145) = 0.16($145)
 = $23.2 million or $23,200,000

Conclusion

The stock decreased $23.2 million, or $23,200,000.

5.

| What You Know | What You Are Looking For | Solution Plan |
|---|---|---|
| Zack's original weight = 230 pounds | The number of pounds Zack lost | $P = RB$
Decrease = percent of
weight loss × original weight |
| Zack's percent of weight loss = 12% | | |

Decrease = 0.12(230)
Decrease = 27.6

Conclusion

Zack lost 27.6 pounds

6.

| What You Know | What You Are Looking For | Solution Plan |
|---|---|---|
| Number of active nurses = 2,249,000

Percent of nurses added by 2020 = 20.3% | Number of new nurses to be added by 2020 | $P = RB$
Increase = percent of nurses needed × original number of nurses |

Solution

Increase = 20.3%(2,249,000)
 = 0.203(2,249,000)
 = 456,547

Conclusion

The number of additional nurses needed in 2020 is 456,547.

2

1. 100% + 4.3% = 104.3%
 $62,870(1.043) = $65,573.41

2. 100% − 16% = 84%
 $145 million (0.84) = $121.8 million, or $121,800,000

3. 100% − 12% = 88%
 230(0.88) = 202.4 pounds

4. 100% + 250% = 350%
 $9,500(3.5) = $33,250

5. 100% + 51% = 151%
 $24.25(1.51) = $36.62

6. 100% + 20.3% = 120.3%
 2,249,000(1.203) = 2,705,547

3

1.

| What You Know | What You Are Looking For | Solution Plan |
|---|---|---|
| Third quarter sales (original amount) = $23,583,000

Fourth quarter sales (new amount) = $38,792,000 | Percent of increase | Amount of increase = new amount − original amount

Percent of increase = $\dfrac{\text{amount of increase}}{\text{original amount}}$ |

Solution

Amount of increase = $38,792,000 − $23,583,000
 = $15,209,000

Percent of increase = $\dfrac{\$15,209,000}{\$23,583,000}$
 = 0.644913709
 = 64.5% (rounded)

Conclusion

The percent of increase in sales is 64.5%.

2.

| What You Know | What You Are Looking For | Solution Plan |
|---|---|---|
| Fall semester spending = $9,524 (original amount)

Spring semester spending = $8,756 (original amount) | Percent of decrease in spending | Amount of decrease = original amount − new amount

Percent of decrease = $\dfrac{\text{amount of decrease}}{\text{original amount}}$ |

Solution

Amount of decrease = $9,524 − $8,756 = $768

Percent of decrease $= \dfrac{\$768}{\$9,524}$

$= 0.08063838723$

$= 8\%$ (rounded)

Conclusion

Stephen's spending decreased 8%.

3.

| What You Know | What You Are Looking For | Solution Plan |
|---|---|---|
| Sale (reduced) price = $148,500

Percent decrease = 10% | Original price | Percent representing sale price = 100% − percent decrease

$B = \dfrac{P}{R}$

Original price $= \dfrac{\text{sale price}}{\text{percent representing sale price}}$ |

Solution

Percent representing sale price = 100% − 10% = 90%

Original price $= \dfrac{\$148,500}{0.9}$

Original price = $165,000

Conclusion

The house was originally priced at $165,000.

4.

| What You Know | What You Are Looking For | Solution Plan |
|---|---|---|
| Amount DVD is reduced = $6.25

Percent DVD is reduced = 25% | Original price of DVD
Discounted price of DVD | $B = \dfrac{P}{R}$; Original price $= \dfrac{\text{amount of reduction}}{\text{percent of reduction}}$

Discounted price = original price − amount of reduction |

Solution

Original price $= \dfrac{\$6.25}{0.25}$

$= \$25$

Discounted price = $25 − $6.25

$= \$18.75$

Conclusion

The DVD originally cost $25 and was reduced to sell for $18.75.

5.

| What You Know | What You Are Looking For | Solution Plan |
|---|---|---|
| Used price (reduced price) = $14,799

Percent of reduction = 48% | "New" price (original price) | Percent representing the used or reduced price = 100% − percent of reduction

"New" price (original price) $= \dfrac{\text{used price}}{\text{percent representing used price}}$ |

Solution

Percent representing the used or reduced price = 100% − 48% = 52%

"New" price $= \dfrac{\$14,799}{0.52} = \$28,459.61538$

$= \$28,460$ rounded

Conclusion

The "new" price is $28,460.

6.

| What You Know | What You Are Looking For | Solution Plan |
|---|---|---|
| Average ticket price for 2006 = $62.38 | Percent of increase in ticket price | Increase in ticket price = 2006 ticket price − 2005 ticket price |
| Average ticket price for 2005 = $58.95 | | Percent increase in ticket price = $\dfrac{\text{Amount of increase}}{\text{Original amount}}$ |

Solution

Increase = $62.38 − $58.95

 = $3.43

Percent of increase = $\dfrac{\$3.43}{\$58.95}$ $3.43 \boxed{\div} 58.95 \boxed{=} \Rightarrow .0581849025$

Percent of increase = 0.058(100%) rounded

Percent of increase = 5.8%

Conclusion

The average NFL ticket price increased by 5.8%.

CHAPTER 7

Section 7-1

1

1. $\dfrac{\$37,500 + \$32,000 + \$28,800 + \$35,750 + \$29,500 + \$47,300}{6} = \dfrac{\$210,850}{6} = \$35,142$

2. $\dfrac{2,400 + 2,100 + 1,800 + 2,800 + 3,450}{5} = \dfrac{12,550}{5} = 2,510 \text{ hours}$

3. $\dfrac{2 + 15 + 7 + 3 + 1 + 3 + 5 + 2 + 4 + 1 + 2 + 6 + 4 + 2}{14} = \dfrac{57}{14} = 4.07 \text{ or } 4 \text{ days}$

4. $\dfrac{12 + 7 + 5 + 2 + 1 + 8 + 0 + 3 + 1 + 2 + 7 + 5 + 30 + 5 + 2}{15} = \dfrac{90}{15} = 6 \text{ CDs per months}$

5. ($9,633,736,000 + $10,237,247,000 + $10,411,450,000 + $11,433,495,000 + $13,500,126,000 + $13,326,051,000 + $15,350,591,000 + $17,595,484,000 + $21,314,933,000 + $23,627,320,000) ÷ 10 = $14,643,043,300

2

1. Arrange in order by size: $28,800; $29,500; $32,000; $35,750; $37,500; $47,300. Since the number of scores is even, average the two middle scores.

 Median = $\dfrac{\$32,000 + \$35,750}{2} = \dfrac{\$67,750}{2} = \$33,875$

2. Arrange in order by size: 1,800; 2,100; 2,400; 2,800; 3,450. Since the number of scores is odd, select the middle score.

 Median = 2,400 hours

3. Arrange in order by size: 1 day, 1 day, 2 days, 2 days, 2 days, 2 days, 3 days, 3 days, 4 days, 4 days, 5 days, 6 days, 7 days, 15 days. The number of scores is even so average the middle 2.

 Median = $\dfrac{3 \text{ days} + 3 \text{ days}}{2} = \dfrac{6 \text{ days}}{2} = 3 \text{ days}$

4. Arrange in order from smallest to largest: 0, 1, 1, 2, 2, 2, 3, 5, 5, 5, 7, 7, 8, 12, 30.

 Median = middle scores = 5 CDs per month

5. The data are shown in order from smallest to largest. Average the 5th and 6th scores.

 Median = $\dfrac{\$13,500,126,000 + \$13,326,051,000}{2} = \$13,413,088,500$

3

1. Arrange scores from smallest to largest: 0, 2, 6, 7, 9, 12, 17, 17, 18, 18, 19, 21, 23, 23, 32, 32, 32, 32, 32, 32, 32, 32, 38, 48, 48, 48, 48, 56, 62, 62, 66, 73, 74, 83, 86, 92. The mode is 32 since it is listed 8 times.

2. Arrange scores from smallest to largest: 0, 0, 0, 0, 0, 2.9, 4, 4, 4, 4, 4, 4, 4, 4.225, 4.5, 4.5, 4.5, 4.75, 5, 5, 5, 5, 5, 5, 5, 5, 5, 5, 5, 5.125, 5.3, 5.5, 5.6, 6, 6, 6, 6, 6, 6, 6, 6, 6.25, 6.25, 6.5, 6.5, 6.5, 7, 7, 7, 7.25. The mode is 5% since 11 states have a rate of 5%.

3. Arrange scores from smallest to largest: 42, 48, 76, 79, 83, 86, 92, 97, 98, 100. There is no mode since no score is reported more than once.

4. Arrange the scores from smallest to largest: 0, 2, 7, 8, 11, 11, 12, 22. The mode is 11.

5. Arrange the scores from smallest to largest: 148, 155, 158, 158, 160, 161, 162, 165, 170, 170, 172, 173. The modes are 158 and 170. Each mode is listed twice.

4

1.

| Class Intervals | Tally | Class Frequency |
|---|---|---|
| 0–19 | ⅲ ⅲ ⅰ | 11 |
| 20–39 | ⅲ ⅲ ⅱ | 12 |
| 40–59 | ⅲ | 5 |
| 60–79 | ⅲ | 5 |
| 80–99 | /// | 3 |
| | | 36 |

2. $5 + 5 + 3 = 13$ staff have more than 13 days vacation.

3. $12 + 11 = 23$ staff have fewer than 40 days vacation.

4. $\frac{3}{36}(100\%) = 8.3\%$

5. $\frac{(12 + 5)}{36}(100\%) = \frac{17}{36}(100\%) = 47.2\%$

6.

| Class interval | Class frequency | Calculations | Relative frequency |
|---|---|---|---|
| 0–19 | 11 | $\frac{11}{36}(100\%) = \frac{1100\%}{36} = 30.6\%$ | 30.6% |
| 20–39 | 12 | $\frac{12}{36}(100\%) = \frac{1200\%}{36} = 33.3\%$ | 33.3% |
| 40–59 | 5 | $\frac{5}{36}(100\%) = \frac{500\%}{36} = 13.9\%$ | 13.9% |
| 60–79 | 5 | $\frac{5}{36}(100\%) = \frac{500\%}{36} = 13.9\%$ | 13.9% |
| 80–99 | 3 | $\frac{3}{36}(100\%) = \frac{300\%}{36} = 8.3\%$ | 8.3% |
| Total | 36 | | 100% |

5

1. Find the midpoint of each class interval:

$$\frac{0 + 19}{2} = \frac{19}{2} = 9.5 \qquad \frac{20 + 39}{2} = \frac{59}{2} = 29.5 \qquad \frac{40 + 59}{2} = \frac{99}{2} = 49.5$$

$$\frac{60 + 79}{2} = \frac{139}{2} = 69.5 \qquad \frac{80 + 99}{2} = \frac{179}{2} = 89.5$$

| Class interval | Class frequency | Midpoint | Product of midpoint and frequency |
|---|---|---|---|
| 0–19 | 11 | 9.5 | 104.5 |
| 20–39 | 12 | 29.5 | 354 |
| 40–59 | 5 | 49.5 | 247.5 |
| 60–79 | 5 | 69.5 | 247.5 |
| 80–99 | 3 | 89.5 | 268.5 |
| Total | 36 | | 1,322 |

Mean of grouped data $= \dfrac{1,322}{36} = 36.7$

2. $\frac{60 + 64}{2} = \frac{124}{2} = 62$ $\frac{65 + 69}{2} = \frac{134}{2} = 67$ $\frac{70 + 74}{2} = \frac{144}{2} = 72$

 $\frac{75 + 79}{2} = \frac{154}{2} = 77$ $\frac{80 + 84}{2} = \frac{164}{2} = 82$ $\frac{85 + 89}{2} = \frac{174}{2} = 87$

| Class interval | Class frequency | Midpoint | Product of midpoint and frequency |
|---|---|---|---|
| 60–64 | 6 | 62 | 372 |
| 65–69 | 8 | 67 | 536 |
| 70–74 | 12 | 72 | 864 |
| 75–79 | 22 | 77 | 1,694 |
| 80–84 | 18 | 82 | 1,476 |
| 85–89 | 9 | 87 | 783 |
| Total | 75 | | 5,725 |

Mean of grouped data $= \frac{5,725}{75} = 76.33333333$ or 76.33 rounded

3. $\frac{0 + 19}{2} = \frac{19}{2} = 9.5$ $\frac{20 + 39}{2} = \frac{59}{2} = 29.5$ $\frac{40 + 59}{2} = \frac{99}{2} = 49.5$

 $\frac{60 + 79}{2} = \frac{139}{2} = 69.5$ $\frac{80 + 99}{2} = \frac{179}{2} = 89.5$

| Class interval | Class frequency | Midpoint | Product of midpoint and frequency |
|---|---|---|---|
| 0–4 | 3 | 2 | 6 |
| 5–9 | 7 | 7 | 49 |
| 10–14 | 4 | 12 | 48 |
| 15–19 | 2 | 17 | 34 |
| Total | 16 | | 137 |

Mean of grouped data $= \frac{137}{16} = 8.5625$ or 8.56

Section 7-2

1

1.

2. 20–39 interval

3. 5 students

4. $5 + 15 + 15 = 35$ students

5. $\frac{35}{50}(100\%) = 0.7(100\%) = 70\%$

2

1.

Personal Income for U.S. Workers

2. Increasing

3. September 2003

4. Fluctuating

5. $\dfrac{100 + 250 + 150 + 200 + 200 + 300}{6} = \dfrac{1,200}{6} = 200$ CDs

3

1. $0.35(360°) = 126°$
 $0.32(360°) = 115.2°$
 $0.05(360°) = 18°$
 $0.04(360°) = 14.4°$
 $0.04(360°) = 14.4°$
 $0.2(360°) = 72°$

 DC Comics 32%

 Marvel Comics 35%

 All others 20%

 Image Comics 5%

 Dark Horse Comics 4%

 Dreamweave Productions 4%

2. $35\% + 32\% + 5\% = 72\%$

3. $\$80,000,000(0.35) = \$28,000,000$

4. $\$80,000,000(0.05) = \$4,000,000$

Section 7-3

1

1. $\$47,300 - \$28,800 = \$18,500$

2. $3,450 - 1,800 = 1,650$ hours

3. $15 - 1 = 14$ days

4. $30 - 0 = 30$ CDs

5. $\$23,627,320,000 - \$9,633,736,000 =$
 $\$13,993,584,000$

2

1. Mean $= \dfrac{72 + 75 + 68 + 73 + 69}{5} = \dfrac{357}{5} = 71.4$

| Value | Mean | Deviation from the Mean |
|-------|------|-------------------------|
| 72 | 71.4 | 0.6 |
| 75 | 71.4 | 3.6 |
| 68 | 71.4 | −3.4 |
| 73 | 71.4 | 1.6 |
| 69 | 71.4 | −2.4 |

2. $0.6 + 3.6 + 1.6 = 5.8$
 $(-3.4) + (-2.4) = -5.8$
 $5.8 + (-5.8) = 0$

3.

| Deviation from the Mean | Square of Deviation |
|-------------------------|---------------------|
| 0.6 | 0.36 |
| 3.6 | 12.96 |
| −3.4 | 11.56 |
| 1.6 | 2.56 |
| −2.4 | 5.76 |

$0.36 + 12.96 + 11.56 + 2.56 + 5.76 = 33.2$

4. $\dfrac{33.2}{5 - 1} = \dfrac{33.2}{4} = 8.3$

5. $\sqrt{8.3} = 2.880972058$ or 2.88 (rounded)

6.

50 − 46 = 4 months

$$\frac{4 \text{ months}}{4 \text{ months per standard deviation}} = 1 \text{ standard deviation above the mean}$$

50% + 34.13% = 84.13%

0.8413(100) = 84.13 batteries or 84 batteries

CHAPTER 8

Section 8-1

1

1. a. Trade discount = 12%($89,765) = 0.12($89,765)
 = $10,771.80

 b. Net price = $89,765 − $10,771.80

 Net price = $78,993.20

3. Trade discount = 8%($425) = 0.08($425) = $34

 Net price = $425 − $34 = $391

5. Trade discount = 24%($21) = 0.24($21) = $5.04

 Net price = $21 − $5.04 = $15.96

2. Trade discount = 32%($124) = 0.32($124)
 = $39.68

 Net price = $124 − $39.68 = $84.32

4. Trade discount = 18%($395) = 0.18($395) = $71.10

 Net price = $395 − $71.10 = $323.90

6. Trade discount = 15%($20,588.24)
 = 0.15($20,588.24)
 = $3,088.24

 Net price = $20,588.24 − $3,088.24
 = $17,500.00

2

1. Net percent = 100% − 12% = 88%

 Net price = 88%($70)
 = 0.88($70)
 = $61.60

3. Net percent = 100% − 18% = 82%

 Net price = 82%($1,299)
 = 0.82($1,299)
 = $1,065.18

2. Net percent = 100% − 15% = 85%

 Net price = 85%($3,200)
 = 0.85($3,200)
 = $2,720

4. Total list price = 100($3.99) + 40($1.89) + 20($3.99)
 = $399 + $75.60 + $79.80
 = $554.40

 Net percent = 100% − 22% = 78%

 Net price = 78%($554.40)
 = 0.78($554.40)
 = $432.43

Section 8-2

1

1. Discount complements: 100% − 10% = 90% = 0.9
 100% − 5% = 95% = 0.95

 Net decimal equivalent = 0.9(0.95)
 = 0.855

 Net price = 0.855($4,800) = $4,104

3. Discount complements: 100% − 15% = 85% = 0.85
 100% − 10% = 90% = 0.9

 Net decimal equivalent = 0.85(0.9) = 0.765

 Net price = 0.765($600) = $459

2. Discount complements: 100% − 12% = 88% = 0.88
 100% − 6% = 94% = 0.94

 Net decimal equivalent = 0.88(0.94) = 0.8272

 Net price = 0.8272($535) = $442.55

4. Discount complements: 100% − 10% = 90% = 0.9
 100% − 6% = 94% = 0.94
 100% − 5% = 95% = 0.95

 Net decimal equivalent = 0.9(0.94)(0.95) = 0.8037

 Net price = 0.8037($219) = $176.01

5. *First manufacturer:*

Discount complements: $100\% - 10\% = 90\% = 0.9$
$\qquad\qquad\qquad\quad 100\% - 6\% = 94\% = 0.94$
$\qquad\qquad\qquad\quad 100\% - 4\% = 96\% = 0.96$

Net decimal equivalent $= 0.9(0.94)(0.96) = 0.81216$

Net price $= 0.81216(\$448) = \363.85

6. *First manufacturer:*

Discount complements: $100\% - 5\% = 95\% = 0.95$
$\qquad\qquad\qquad\quad 100\% - 10\% = 90\% = 0.9$
$\qquad\qquad\qquad\quad 100\% - 10\% = 90\% = 0.9$

Net decimal equivalent $= 0.95(0.9)(0.9) = 0.7695$

Net price $= 0.7695(\$695)$
$\qquad\quad\; = \$534.80$

The second manufacturer has the lower net price (better deal).

Second manufacturer:

Discount complements: $100\% - 15\% = 85\% = 0.85$
$\qquad\qquad\qquad\quad 100\% - 10\% = 90\% = 0.9$
$\qquad\qquad\qquad\quad 100\% - 10\% = 90\% = 0.9$

Net decimal equivalent $= 0.85(0.9)(0.9) = 0.6885$

Net price $= 0.6885(\$550) = \378.68

The first manufacturer has the lower price (better deal).

Second manufacturer:

Discount complements: $100\% - 6\% = 94\% = 0.94$
$\qquad\qquad\qquad\quad 100\% - 10\% = 90\% = 0.9$
$\qquad\qquad\qquad\quad 100\% - 12\% = 88\% = 0.88$

Net decimal equivalent $= 0.94(0.9)(0.88) = 0.74448$

Net price $= 0.74448(\$705)$
$\qquad\quad\; = \$524.86$

2

1. Complements of discounts: $100\% - 12\% = 88\% = 0.88$
$\qquad\qquad\qquad\qquad\quad 100\% - 10\% = 90\% = 0.9$
$\qquad\qquad\qquad\qquad\quad 100\% - 5\% = 95\% = 0.95$

Net decimal equivalent $= 0.88(0.9)(0.95) = 0.7524$

Single discount equivalent $= 1 - 0.7524 = 0.2476$

Trade discount $= 0.2476(\$504) = \124.79

2. Complements of discounts: $100\% - 10\% = 90\% = 0.9$
$\qquad\qquad\qquad\qquad\quad 100\% - 5\% = 95\% = 0.95$

Net decimal equivalent $= 0.9(0.95) = 0.855$

Single discount equivalent $= 1 - 0.855 = 0.145$

Trade discount $= 0.145(\$317) = \45.97

3. Complements of discounts: $100\% - 10\% = 90\% = 0.9$
$\qquad\qquad\qquad\qquad\quad 100\% - 5\% = 95\% = 0.95$
$\qquad\qquad\qquad\qquad\quad 100\% - 3\% = 97\% = 0.97$

Net decimal equivalent $= 0.9(0.95)(0.97) = 0.82935$

Single discount equivalent $= 1 - 0.82935 = 0.17065$

Trade discount $= 0.17065(\$24) = \4.10

4. Complements of discounts: $100\% - 12\% = 88\% = 0.88$
$\qquad\qquad\qquad\qquad\quad 100\% - 8\% = 92\% = 0.92$
$\qquad\qquad\qquad\qquad\quad 100\% - 6\% = 94\% = 0.94$

Net decimal equivalent $= 0.88(0.92)(0.94) = 0.761024$

Single discount equivalent $= 1 - 0.761024 = 0.238976$

Trade discount $= 0.238976(\$74) = \17.68

5. Complements of discounts: $100\% - 8\% = 92\% = 0.92$
$\qquad\qquad\qquad\qquad\quad 100\% - 6\% = 94\% = 0.94$
$\qquad\qquad\qquad\qquad\quad 100\% - 5\% = 95\% = 0.95$

Net decimal equivalent $= 0.92(0.94)(0.95) = 0.82156$

Single discount equivalent $= 1 - 0.82156 - 0.17844$

Trade discount $= 0.17844(\$289.95) = \51.74

6. Answers will vary. The single discount equivalent, when multiplied by the list price, gives the discount amount directly and would normally be the preferred method.

Section 8-3

1

1. Latest day to pay and get discount: March $15 + 15$ days $=$ March 30.

Cash discount $= 0.02(\$985) = \19.70

Net amount $= \$985 - \$19.70 = \$965.30$

2. Cash discount $= 0.01(\$3,848.96)$
$\qquad\qquad\qquad = \$38.49$

Net amount $= \$3,848.96 - \38.49
$\qquad\qquad\; = \$3,810.47$

3. August has 31 days.

\qquad August $+ 20$
$\qquad\qquad\;\; + 15$ days
\qquad _____
\qquad "August 35"
$\qquad\qquad\;\; - 31$
\qquad _____
\qquad September 4

The invoice must be paid by September 4 to get the discount.

4. a. 3% discount; $0.97(\$3,814) = \$3,699.58$

 b. No discount because payment date is after the discount period. Amount due is \$3,814

 c. Since May has 31 days, June 7 is 30 days from billing, so invoice amount of \$3,814 must be paid.

 d. A penalty of 1% is assessed.
 $\qquad 0.01(\$3,814) = \38.14
 \qquad Amount to be paid $= \$3,814 + \$38.14 = \$3,852.14$

2

1. The discount applies since the invoice was paid before December 15.
 Amount paid $= 0.97(\$2,697) = \$2,616.09$

2. The invoice must be paid by January 10 to get a discount of $11.97.
 $0.02(\$598.46) = \11.97

3. The invoice must be paid by June 10.
 $100\% - 2\% = 98\%$ of the invoice amount must be paid.

4. The discount applies:
 $$100\% - 1\% = 99\%$$
 $$99\% = 0.99$$
 $$0.99(\$1,096.82) = \$1,085.85$$

5. The entire amount of the invoice, $187.17, must be paid because the discount terms require the invoice to be paid within the first 10 days of the next month.

6. The discount applies:
 $$100\% - 3\% = 97\%$$
 $$97\% = 0.97$$
 $$0.97(\$84,896) = \$82,349.12$$

3

1. The invoice must be paid by September 27 for the discount.
 September 12 + 15 = September 27.
 $0.97(\$3,097.15) = \$3,004.24$ must be paid.

2. The invoice must be paid within 10 days of receipt of goods to get a 2% discount. The full invoice amount must be paid after 10 days and within 30 days of receipt of goods.

 March 20 is within 10 days of receipt of goods so the discount applies. Amount to be paid $= 0.98(\$8,917.48) = \$8,739.13$

3. Pay on May 28, $0.98(\$1,215) = \$1,190.70$; pay on June 14, $1,215

4. The full invoice of $797 must be paid since July 12 is more than 15 days from June 17, the date the dryers arrived.

4

1. Amount credited $= \dfrac{\$200,000}{0.97} = \$206,185.57$

2. Amount credited $= \dfrac{\$1,900,000}{0.98} = \$1,938,775.51$

3. Amount credited $= \dfrac{\$50,000}{0.98} = \$51,020.41$

4. Amount credited $= \dfrac{\$400,000}{0.97} = \$412,371.13$

 Amount of invoice (no discount) $= 6,000(\$79) = \$474,000$
 Amount still to be paid: $\$474,000 - \$412,371.13 = \$61,628.87$

5

1. Cash discount $= 0.02(\$2,896) = \57.92
 Net amount $= 0.98(\$2,896) = \$2,838.08$
 Total amount $= \$2,838.08 + \$72 = \$2,910.08$

2. Nortex Mills

3. Net amount $= 0.98(\$7,925) = \$7,766.50$
 Total amount $= \$7,766.50 + \$215 = \$7,981.50$

4. Cost of teak boards $= 10(\$26.50) = \265.00
 Cost of mahogany boards $= 25(\$7.95) = \198.75
 Total cost of merchandise $= \$265 + \$198.75 = \$463.75$
 Net amount $= 0.97(\$463.75) = \449.84
 Total $= \$449.84 + \$65 = \$514.84$

CHAPTER 9

Section 9-1

1

1. $32 + \$40 = \72

2. $12.95 - \$7 = \5.95

3. $34.95 - \$18 = \16.95

4. Markup $= \$5.25 - \$3 = \$2.25$

2

1. Markup = $599 − $220 = $379

 $M\% = \dfrac{\$379}{\$220}(100\%) = 172.3\%$

2. Markup = $197.20 − $145 = $52.20

 $M\% = \dfrac{\$52.20}{\$145}(100\%) = 36\%$

3. Markup = $395 − $245 = $150

 $M\% = \dfrac{\$150}{\$245}(100\%) = 61.2\%$

4. Markup = $1,420 − $690 = $730

 $M\% = \dfrac{\$730}{\$690}(100\%) = 105.8\%$

5. Markup = $249 − $89 = $160

 $M\% = \dfrac{\$160}{\$89}(100\%) = 179.8\%$

6. Markup = $1,048 − $738
 Markup = $310

 $M\% = \dfrac{\$310}{\$738}(100\%)$

 $M\% = 42.0\%$

 Calculator steps: $\boxed{(}\,1048\,\boxed{-}\,738\,\boxed{)}\,\boxed{\div}\,738\,\boxed{\times}\,100\,\boxed{=}$
 $\Rightarrow 0.4200542005$

 Multiply the decimal by 100% to get 42.0%.

3

1. $S\% = 100\% + 78\%$
 $S\% = 178\%$
 $S = 178\%(\$218)$
 $S = 1.78(\$218)$
 $S = \$388.04$

2. $S\% = 100\% + 95\%$
 $S\% = 195\%$
 $S = 195\%(\$87.50)$
 $S = 1.95(\$87.50)$
 $S = \$170.63$

3. $S\% = 100\% + 80\%$
 $S\% = 180\%$
 $S = 180\%(\$465)$
 $S = 1.8(\$465)$
 $S = \$837$

4. $S\% = 100\% + 365\%$
 $S\% = 465\%$
 $S = 465\%(\$0.86)$
 $S = 4.65(\$0.86)$
 $S = \$4.00$

5. $S\% = 100\% + 110\%$
 $S\% = 210\%$
 $S = 210\%(\$0.45)$
 $S = 2.1(\$0.45)$
 $S = \$0.95$

6. $S\% = 100\% + C\%$
 $S\% = 100\% + 70\%$
 $S\% = 170\%$
 $S = 170\%(\$58.82)$
 $S = 1.7(\$58.82)$
 $S = \$99.99$

4

1. $C = \dfrac{M}{M\%}$

 $C = \dfrac{\$38}{62\%}$

 $C = \dfrac{\$38}{0.62}$

 $C = \$61.29$

2. $C = \dfrac{M}{M\%}$

 $C = \dfrac{\$650}{92\%}$

 $C = \dfrac{\$650}{0.92}$

 $C = \$706.52$

3. $C = \dfrac{M}{M\%}$

 $C = \dfrac{\$358}{65\%}$

 $C = \dfrac{\$358}{0.65}$

 $C = \$550.77$

4. $C = \dfrac{M}{M\%}$

 $C = \dfrac{\$4.14}{125\%}$

 $C = \dfrac{\$4.14}{1.25}$

 $C = \$3.31$

5. $C = \dfrac{M}{M\%}$

 $C = \dfrac{\$7.82}{80\%}$

 $C = \dfrac{\$7.82}{0.8}$

 $C = \$9.78$

6. $C = \dfrac{M}{M\%}$

 $C = \dfrac{0.24}{32\%}$

 $C = \dfrac{0.24}{0.32}$

 $C = \$0.75$

5

1. $S\% = 100\% + M\%$
 $S\% = 100\% + 60\% = 160\%$

 $C = \dfrac{S}{S\%}$

 $C = \dfrac{\$39}{160\%}$

 $C = \dfrac{\$39}{1.6}$

 $C = \$24.38$
 $M = S − C$
 $M = \$39 − \24.38
 $M = \$14.62$

2. $S\% = 100\% + M\%$
 $S\% = 100\% + 110\%$
 $S\% = 210\%$

 $C = \dfrac{S}{S\%}$

 $C = \dfrac{\$149}{210\%}$

 $C = \dfrac{\$149}{2.1}$

 $C = \$70.95$
 $M = S − C$
 $M = \$149 − \70.95
 $M = \$78.05$

3. $S\% = 100\% + M\%$
 $S\% = 100\% + 85\%$
 $S\% = 185\%$

 $C = \dfrac{\$4.65}{185\%}$

 $C = \dfrac{\$4.65}{1.85}$

 $C = \$2.51$
 $M = S − C$
 $M = \$4.65 − \2.51
 $M = \$2.14$

4. $S\% = 100\% + 165\%$
 $S\% = 265\%$
 $C = \dfrac{\$595}{265\%}$
 $C = \dfrac{\$595}{2.65}$
 $C = \$224.53$
 $M = S - C$
 $M = \$595 - \224.53
 $M = \$370.47$

5. $S\% = 100\% + 45\%$
 $S\% = 145\%$
 $C = \dfrac{\$65}{145\%}$
 $C = \dfrac{\$65}{1.45}$
 $C = \$44.83$
 $M = S - C$
 $M = \$65 - \44.83
 $M = \$20.17$

6. $S\% = 100 + M\%$
 $S\% = 100\% + 62\%$
 $S\% = 162\%$
 $C = \dfrac{S}{S\%}$
 $C = \dfrac{\$9.99}{162\%}$
 $C = \dfrac{\$9.99}{1.62}$
 $C = \$6.17$
 $M = S - C$
 $M = \$9.99 - \6.17
 $M = \$3.82$

Section 9-2

1

1. $M = \$70 - \58
 $M = \$12$
 $M\% = \dfrac{\$12}{\$70}(100\%)$
 $M\% = 17.1\%$

2. $M = \$1,499 - \385
 $M = \$1,114$
 $M\% = \dfrac{\$1,114}{\$1,499}(100\%)$
 $M\% = 74.3\%$

3. $M = \$795 - \395
 $M = \$400$
 $M\% = \dfrac{\$400}{\$795}(100\%)$
 $M\% = 50.3\%$

4. $M = \$6.00 - \2.40
 $M = \$3.60$
 $M\% = \dfrac{\$3.60}{\$6.00}(100\%)$
 $M\% = 60\%$

5. $M = \$2.39 - \0.84
 $M = \$1.55$
 $M\% = \dfrac{\$1.55}{\$2.39}(100\%)$
 $M\% = 64.9\%$

6. $M = \$229 - \132
 $M = \$97$
 $M\% = \dfrac{\$97}{\$229}(100\%)$
 $M\% = 42.4\%$

2

1. $S = \dfrac{\$195}{60\%}$
 $S = \dfrac{\$195}{0.6}$
 $S = \$325$
 $C = \$325 - \195
 $C = \$130$

2. $S = \dfrac{\$21}{80\%}$
 $S = \dfrac{\$21}{0.8}$
 $S = \$26.25$
 $C = \$26.25 - \21
 $C = \$5.25$

3. $S = \dfrac{\$14}{75\%}$
 $S = \dfrac{\$14}{0.75}$
 $S = \$18.67$
 $C = \$18.67 - \14
 $C = \$4.67$

4. $S = \dfrac{\$145}{25\%}$
 $S = \dfrac{\$145}{0.25}$
 $S = \$580$
 $C = \$580 - \145
 $C = \$435$

5. $S = \dfrac{\$38}{70\%}$
 $S = \dfrac{\$38}{0.7}$
 $S = \$54.29$
 $C = \$54.29 - \38
 $C = \$16.29$

6. $S = \dfrac{\$70.08}{32\%}$
 $S = \dfrac{\$70.08}{0.32}$
 $S = \$219$
 $C = \$219 - \70.08
 $C = \$148.92$

3

1. $C\% = 100\% - 25\%$
 $C\% = 75\%$
 $S = \dfrac{\$2.99}{75\%}$
 $S = \$3.99$
 $M = \$3.99 - \2.99
 $M = \$1.00$

2. $C\% = 100\% - 38\%$
 $C\% = 62\%$
 $S = \dfrac{\$187}{62\%}$
 $S = \$301.61$
 $M = \$301.61 - \187
 $M = \$114.61$

3. $C\% = 100\% - 27\%$
 $C\% = 73\%$
 $S = \dfrac{\$3.84}{73\%}$
 $S = \$5.26$
 $M = \$5.26 - \3.84
 $M = \$1.42$

4. $C\% = 100\% - 23\%$
$C\% = 77\%$
$S = \dfrac{\$127.59}{77\%}$
$S = \$165.70$
$M = \$165.70 - \127.59
$M = \$38.11$

5. $C\% = 100\% - 65\%$
$C\% = 35\%$
$S = \dfrac{\$1.92}{35\%}$
$S = \$5.49$
$M = \$5.49 - \1.92
$M = \$3.57$

6. $C\% = 100\% - 35\%$
$C\% = 65\%$
$S = \dfrac{\$32.49}{65\%}$
$S = \$49.98$
$M = \$49.98 - \32.49
$M = \$17.49$

4

1. $C\% = 100\% - M\%$
$C\% = 100\% - 38\%$
$C\% = 62\%$
$C = 62\%(\$18.99)$
$C = 0.62(\$18.99)$
$C = \$11.77$
$M = \$18.99 - \11.77
$M = \$7.22$

2. $C\% = 100\%$
$M\% = 60\%$
$C = \dfrac{M}{M\%}$
$C = \dfrac{\$135}{0.6}$
$C = \$225$
$S = C + M$
$S = \$225 + \135
$S = \$360$

3. $C\% = 100\% - 58\%$
$C\% = 42\%$
$C = 42\%(\$349)$
$C = \$146.58$
$M = \$349 - \146.58
$M = \$202.42$

4. $C\% = 100\% - 80\%$
$C\% = 20\%$
$C = 20\%(\$49)$
$C = \$9.80$
$M = \$49 - \9.80
$M = \$39.20$

5. $C\% = 100\% - 46\%$
$C\% = 54\%$
$C = 54\%(\$675)$
$C = \$364.50$
$M = \$675 - \364.50
$M = \$310.50$

6. $C\% = 100\% - M\%$
$C\% = 100\% - 38\%$
$C\% = 62\%$
$S = \dfrac{\$3,034.90}{62\%}$
$S = \dfrac{\$3,034.90}{0.62}$
$S = \$4,895$
$M = \$4,895 - \$3,034.90$
$M = \$1,860.10$

5

1. $M = S - C$
$M = \$38 - 12.50$
$M = \$25.50$
$M\%_{\text{cost}} = \dfrac{M}{C} \times 100\%$
$M\%_{\text{cost}} = \dfrac{\$25.50}{\$12.50}(100\%)$
$M\%_{\text{cost}} = 204\%$
$M\%_{\text{selling price}} = \dfrac{M}{S} \times 100\%$
$M\%_{\text{selling price}} = \dfrac{\$25.50}{\$38}(100\%)$
$M\%_{\text{selling price}} = 67.1\%$

2. $M = S - C$
$M = \$18,900 - \12.500
$M = \$6,400$
$M\%_{\text{cost}} = \dfrac{M}{C} \times 100\%$
$M\%_{\text{cost}} = \dfrac{\$6,400}{\$12,500}(100\%)$
$M\%_{\text{cost}} = 51.2\%$
$M\%_{\text{selling price}} = \dfrac{M}{S} \times 100\%$
$M\%_{\text{selling price}} = \dfrac{\$6,400}{\$18,900}(100\%)$
$M\%_{\text{selling price}} = 33.9\%$

3. $M = S - C$
$M = \$535 - \375
$M = \$160$
$M\%_{\text{cost}} = \dfrac{M}{C} \times 100\%$
$M\%_{\text{cost}} = \dfrac{\$160}{\$375}(100\%)$
$M\%_{\text{cost}} = 42.7\%$
$M\%_{\text{selling price}} = \dfrac{M}{S} \times 100\%$
$M\%_{\text{selling price}} = \dfrac{\$160}{\$535}(100\%)$
$M\%_{\text{selling price}} = 29.9\%$

4. $M\%_{\text{cost}} = \dfrac{M\%_{\text{selling price}}}{100 - M\%_{\text{selling price}}} \times 100\%$
$M\%_{\text{cost}} = \dfrac{40\%}{100\% - 40\%}(100\%)$
$M\%_{\text{cost}} = 66.7\%$

5. $M\%_{\text{selling price}} = \dfrac{M\%_{\text{cost}}}{100\% + M\%_{\text{cost}}} \times 100\%$
$M\%_{\text{selling price}} = \dfrac{120\%}{100\% + 120\%}(100\%)$
$M\%_{\text{selling price}} = \dfrac{120\%}{220\%}(100\%)$
$M\%_{\text{selling price}} = 54.5\%$

6. $M\%_{\text{cost}} = \dfrac{M\%_{\text{selling price}}}{100\% - M\%_{\text{selling price}}} \times 100\%$
$M\%_{\text{cost}} = \dfrac{75\%}{100\% - 75\%}(100\%)$
$M\%_{\text{cost}} = \dfrac{75\%}{25\%}(100\%)$
$M\%_{\text{cost}} = 3(100\%)$
$M\%_{\text{cost}} = 300\%$

1

1. Markdown = $135 − $75
 Markdown = $60
 $$M\% = \frac{\$60}{\$135}(100\%)$$
 $M\% = 44.4\%$

2. Markdown = $15 − $8
 Markdown = $7
 $$M\% = \frac{\$7}{\$15}(100\%)$$
 $M\% = 46.7\%$

3. Markdown = $249 × 35%
 Markdown = $249(0.35)
 Markdown = $87.15
 New price = $249 − $87.15
 New price = $161.85

4. Markdown = $38.99(25%)
 Markdown = $38.99(0.25)
 Markdown = $9.75
 Reduced price = $38.99 − $9.75
 Reduced price = $29.24

5. Markdown = $85(40%)
 Markdown = $85(0.4)
 Markdown = $34
 Sale price = $85 − $34
 Sale price = $51

6. Markdown = 12.563%($398)
 Markdown = 0.12563($398)
 Markdown = $50.00
 Reduced price = $398.00 − $50.00
 Reduced price = $348.00

2

1. $S\% = C\% + M\%$
 $S\% = 100\% + 60\%$
 $S\% = 160\%$
 $S = 160\%(\$189)$
 $S = \$302.40$
 $N\% = 100\% − 30\%$
 $N\% = 70\%$
 $N = 70\%(\$302.40)$
 $N = \$211.68$
 $Final\% = 100\% − 40\%$
 $Final\% = 60\%$
 Final price = $60\%(\$211.68)$
 Final price = $127.01

2. Net decimal equivalent = 0.9(0.7) = 0.63
 Final reduced price = 0.63($128) = $80.64
 Final rate of reduction = 1 − 0.63 = 0.37
 Percent equivalent = 0.37(100%) = 37%

3. $S\% = 100\% + 85\%$
 $S\% = 185\%$
 $S = 185\%(\$262)$
 $S = \$484.70$
 $N\% = 100\% − 25\%$
 $N\% = 75\%$
 $N = 75\%(\$484.70)$
 $N = \$363.53$
 $Final\% = 100\% − 30\%$
 $Final\% = 70\%$
 Final price = $70\%(\$363.53)$
 Final price = $254.47

4. Net decimal equivalent = 0.85(0.6) = 0.51
 Final reduced price = 0.51($249) = $126.99

3

1. $C = \$0.30(300) = \90
 $M = 1.8(\$90) = \162
 $S = C + M = \$90 + \$162 = \$252$
 $100\% − 5\% = 95\%$ will sell
 $0.95(300) = 285$ pounds will sell
 $$\text{Selling price per pound} = \frac{\$252}{285} = \$0.88$$

2. $C = \$0.35(500) = \175
 $M = 1.75(\$175) = \306.25
 $S = C + M = \$175 + \306.25
 $S = \$481.25$
 Pounds that will sell = 0.92(500)
 = 460 pounds
 $$\text{Selling price per pound} = \frac{\$481.25}{460}$$
 Selling price per pound = $1.05

3. $C = \$0.27(2,000) = \540
 $M = 1.6(\$540) = \864
 $S = C + M = \$540 + \$864 = \$1,404$
 Pounds that will sell = 0.96(2,000)
 = 1,920 pounds
 $$\text{Selling price per pound} = \frac{\$1,404}{1,920}$$
 Selling price per pound = $0.73

4. $C = \$0.92(1,000) = \920
 $M = 1.8(\$920) = \$1,656$
 $S = C + M = \$920 + \$1,656 = \$2,576$
 Pounds that will sell = 0.9(1,000) = 900 pounds
 $$\text{Selling price per pound} = \frac{2,576}{900} = \$2.86$$

CHAPTER 10

Section 10-1

1

1. $42,822 ÷ 26 = $1,647

2. $32,928 ÷ 24 = $1,372

3. $1,872(52) = $97,344

4. $3,315(12) = $39,780

2

1. $48 - 40 = 8$ hours overtime
 $40(\$15.83) = \633.20
 $8(\$15.83)(1.5) = \189.96
 Gross pay = $\$633.20 + \$189.96 = \$823.16$
3. $55 - 40 = 15$ hours overtime
 $40(\$14.27) = \570.80
 $15(\$14.27)(1.5) = \321.08
 Gross pay = $\$570.80 + \$321.08 = \$891.88$

2. $52 - 40 = 12$ hours overtime
 $40(\$13.56) = \542.40
 $12(\$13.56)(1.5) = \244.08
 Gross pay = $\$542.40 + \$244.08 = \$786.48$
4. $62 - 40 = 22$ hours overtime
 $22 - 8 = 14$ hours overtime at time and a half
 $40(\$22.75) = \910
 $14(\$22.75)(1.5) = \477.75
 $8(\$22.75)(2) = \364
 Gross pay = $\$910 + \$477.75 + \$364 = \$1,751.75$

3

1. $12(\$70) = \840

2. $21 + 27 + 18 + 29 + 24 = 119$ tires
 $119(\$5.50) = \654.50

3. First 200 units: $200(\$1.18) = \236
 Next 200 units: $200(\$1.35) = \270
 Next 135 units: $135(\$1.55) = \209.25
 Gross pay = $\$236 + \$270 + \$209.25 = \715.25

4. Total units = $37 + 42 + 40 + 46 + 52 = 217$
 First 50 units = $50(\$2.95) = \147.50
 units 51–150 = $100(\$3.10) = \310.00
 Last 67 units = $67(\$3.35) = \224.45
 Gross pay = $\$147.50 + \$310.00 + \$224.45 = \681.95

4

1. Gross earnings = $0.06(\$17,945) =$
 $\$1,076.70$

2. Earnings for listings = $\$4.00(547) =$
 $\$2,188$
 Earnings for commission =
 $0.01(\$30,248) = \302.48
 Gross earnings = $\$2,188 + \$302.48 =$
 $\$2,490.48$

3. Amount on which commission is paid =
 $\$26,572 - \$3,000 = \$23,572$
 Commission = $0.02(\$23,572) = \471.44
 Gross earnings = $\$471.44 + \$200 =$
 $\$671.44$
 Annual gross earnings = $\$671.44(52) =$
 $\$34,914.88$

4. Commission = $0.04(\$32,017) = \$1,280.68$
 Gross earnings = $\$1,280.68 + \$275 = \$1,555.68$
 Annual gross earnings = $\$1,555.68(26) = \$40,447.68$

Section 10-2

1

1. Use Figure 10-2. Select row for interval "At least 1,680 but less than 1,700." Move across to the column for two withholding allowances. The withholding tax is $180.
3. Use Figure 10-2. Select row for interval "At least 2,020 but less than 2,040." Move across to the column for one withholding allowance. The withholding tax is $300.

2. Use Figure 10-3. Select row for interval "At least 700 but less than 710." Move across to the column for four withholding allowances. The withholding tax is $29.
4. Find taxable earnings: $\$640 - \$30 = \$610$.
 Use Figure 10-3. Select row for interval "At least 610 but less than 620." Move across to the column for seven withholding allowances. The withholding tax is $0.

2

1. $3(\$65.38) = \196.14

2. $\$850 - \$196.14 = \$653.86$

3. $\$653.86 - \$645 = \$8.86$
 $\$8.86(0.25) = \2.22
 Total withholding tax =
 $\$81.90 + \$2.22 = \$84.12$

4. Withholding allowance = 4($141.67) = $566.68

Adjusted gross income = $1,700 − $566.68 = $1,133.32

Use Table 3b.

$1,133.32 − $973 = $160.32

$160.32(0.15) = $24.05

Total withholding tax = $64 + $24.05 = $88.05

3

1. Maximum annual income = $1,730(26) = $44,980

All earnings will be taxed.

Social Security tax = $1,730(0.062) = $107.26

Medicare tax = $1,730(0.0145) = $25.09

3. Accumulated pay for 23 pay periods = $4,135(23) = $95,105

Maximum amount subject to Social Security = $97,500.

$97,500 − $95,105 = $2,395

Social Security tax = $2,395(0.062) = $148.49

Medicare tax = $4,135(0.0145) = $59.96

2. Maximum annual income = $6,230(12) = $74,760

All earnings will be taxed.

Social Security tax = $6,230(0.062) = $386.26

Medicare tax = $6,230(0.0145) = $90.34

4. Accumulated pay for 46 weeks = $1,892(46) = $87,032

$97,500 − $87,032 = $10,468 earnings subject to Social Security tax in 47th week.

Social security tax = $1,892(0.062) = $117.30

Medicare tax = $1,892(0.0145) = $27.43

4

1. Retirement = $732(0.06) = $43.92
Social Security tax = $732(0.062) = $45.38
Medicare tax = $732(0.0145) = $10.61

3. Total deductions = $110.15 + $43.92 + $45.38 + $10.61 + $43.00 = $253.06

2. Use the table in Figure 10-3. Use the "At least 730 but less than 740" row and move across to the column with three deductions. The amount is $43.

4. Net pay = $732 − $253.06 = $478.94

Section 10-3

1

1. $63 + $88.37 + $29 + $57 = $237.37
3. $10.73 + $12.57 + $9.14 + $10.08 = $42.52

2. $45.88 + $53.74 + $39.06 + $43.09 = $181.78
4. Employer's share of Social Security and Medicare taxes = $181.77 + $42.62 = $224.39

Employer's deposit = $237.37 + $181.78 + $42.52 + $224.30 = $685.97

2

1. SUTA = 5.4%($7,000)
= 0.054($7,000) = $378

2. FUTA = 0.8%($7,000)
= 0.008($7,000)
= $56

3.

| Pay period | Employee 1 salary | Accumulated salary subject to FUTA tax | FUTA tax | Employee 2 salary | Accumulated salary subject to FUTA tax | FUTA tax |
|---|---|---|---|---|---|---|
| Jan 15 | $1,320 | $1,320 | $10.56 | $1,275 | $1,275 | $10.20 |
| Jan 31 | $1,320 | $2,640 | $10.56 | $1,275 | $2,550 | $10.20 |
| Feb 15 | $1,320 | $3,960 | $10.56 | $1,275 | $3,825 | $10.20 |
| Feb 28 | $1,320 | $5,280 | $10.56 | $1,275 | $5,100 | $10.20 |
| Mar 15 | $1,320 | $6,600 | $10.56 | $1,275 | $6,375 | $10.20 |
| Mar 31 | $1,320 | $7,920 | $3.20 | $1,275 | $7,650 | $5.00 |

For Employee 1 on March 31: $7,000 − $6,600 = $400

FUTA = $400(0.008) = $3.20

For Employee 2 on March 31: $7,000 − $6,375 = $625

FUTA = $625(0.008) = $5.00

First quarter FUTA tax − ($10.56(5) + $3.20) + ($10.20(5) + $5.00) = $56 + $56 = $112

The deposit should be made at the end of the first quarter since the total is more than $100.

4. The first quarter payment of FUTA tax is $112.

CHAPTER 11

Section 11-1

1

1. $38,000(0.105)(1) = $3,990
2. $17,500(0.0775)(6) = $8,137.50
3. $6,700(0.095)(3) = $1,909.50
4. $38,500(0.123)(5) = $23,677.50

2

1. $MV = $8,000 + $660 = $8,660

2. $I = $7,250(0.12)(3) = $2,610$
 $MV = $7,250 + $2,610 = $9,860$

3. $MV = P(I + RT)$
 $MV = $1,800(1 + 0.0975(2))$
 $MV = $1,800(1 + 0.195)$
 $MV = $1,800(1.195)$
 $MV = $2,151$

4. $MV = P(I + RT)$
 $MV = $7,275(1 + 0.11(3))$
 $MV = $7,275(1 + 0.33)$
 $MV = $7,275(1.33)$
 $MV = $9,675.75$

3

1. $\dfrac{8}{12} = \dfrac{2}{3}; 8 \div 12 = 0.666667$

2. $\dfrac{15}{12} = 1\dfrac{3}{12} = 1\dfrac{1}{4}; 15 \div 12 = 1.25$

3. 18 months $= 18 \div 12 = 1.5$ years
 $I = $1,200(0.095)(1.5)$
 $I = 171

4. $28 \div 12 = 2.333\overline{3}$
 $MV = $1,750(1 + 0.098(2.3333))$
 $MV = $1,750(1.22867)$
 $MV = $2,150.17$

4

1. $\dfrac{$636.50}{$2,680(2.5)} = \dfrac{$636.50}{$6,700} = 0.095 = 9.5\%$

2. $\dfrac{$1,762.50}{$5,000(3)} = \dfrac{$1,762.50}{$15,000} = 0.1175 = 11.75\%$

3. $\dfrac{$904.88}{3.5(0.0925)} = \dfrac{$904.88}{0.32375} = $2,795$

4. $\dfrac{$4,167.90}{$16,840(0.09)} = \dfrac{$4,167.90}{$1,515.60} = 2.75$ years, or $2\dfrac{3}{4}$ years

Section 11-2

1

1. April 15: 105th day
 October 15: 288th day
 $288 - 105 = 183$ days

2. Days in March: $31 - 20 = 11$
 Days in April: $= 30$
 Days in May: $- 31$
 Days in June: $= 30$
 Days in July: $= 31$
 Days in August: $= 31$
 Days in September: $\underline{= 20}$
 184 days
 or $263 - 79 = 184$ days

3. December 21: 355th day
 October 14: 287th day
 $355 - 287 = 68$ days

4. December 31: 365th day
 November 1: 305th day
 $365 - 305 = 60$ days
 March 1: 60th day
 $60 + 60 = 120$ days
 In a leap year: $120 + 1 = 121$ days

2

1. June 12 is day number 163.

 $163 + 120 = 283$

 October 10 is day number 283.

2. July 17 is day number 198.

 $198 + 150 = 348$

 December 14 is day number 348.

3. January 29 is the 29th day of the year.

 $29 + 90 = 119$

 The 119th day of the year is April 29.

4. November 22 is day number 326.

 $326 + 120 = 446$

 $446 - 365 = 81$ days in the next year

 March 22 is the 81st day in the next year.

3

1. March 3: 62nd day

 September 3: 246th day

 $246 - 62 = 184$ days

 $I = \$1,350(0.065)\left(\dfrac{184}{360}\right) = \44.85

2. $I = \$1,350(0.065)\left(\dfrac{184}{365}\right) = \44.24

3. $\$44.85 - \$44.24 = \$0.61$

 Ordinary interest is \$0.61 more than exact interest. Bankers offer borrowers ordinary interest.

4. April 12: 102nd day

 October 12: 285th day

 $285 - 102 = 183$ days

 $I = \$4,250(0.072)\left(\dfrac{183}{360}\right) = \155.55

 $MV = \$4,250 + \$155.55 = \$4,405.55$

4

1. $\$10,000(0.09)\left(\dfrac{60}{360}\right) = \150.00

 $\$3,000 - \$150 = \$2,850$

 $\$10,000 - \$2,850 = \$7,150$

 $\$7,150(0.09)\left(\dfrac{210}{360}\right) = \375.38

 $\$7,150 + \$375.38 = \$7,525.38$

2. $\$5,800(0.075)\left(\dfrac{30}{360}\right) = \36.25

 $\$2,500 - \$36.25 = \$2,463.75$

 $\$5,800 - \$2,463.75 = \$3,336.25$

 $\$3,336.25(0.075)\left(\dfrac{90}{360}\right) = \62.55

 $\$3,336.25 + \$62.55 = \$3,398.80$

 Total interest $= \$36.25 + \$62.55 = \$98.80$

 $\$5,800(0.075)\left(\dfrac{120}{360}\right) = \145

 $\$145 - \$98.80 = \$46.20$

Section 11-3

1

1. Exact days $= 312 - 220 = 92$ days

 Bank discount $= \$7,200(0.0825)\left(\dfrac{92}{360}\right) = \151.80

 Proceeds $= \$7,200 - \$151.80 = \$7,048.20$

3. Exact days $= 327 - 54 = 273$ days

 Bank discount $= \$3,250(0.0875)\left(\dfrac{273}{360}\right) = \215.65

 Proceeds $= \$3,250 - \$215.65 = \$3,034.35$

2. Exact days $= 198 - 17 = 181$ days

 Bank discount $= \$9,250(0.0775)\left(\dfrac{181}{360}\right) = \360.43

 Proceeds $= \$9,250 - \$360.43 = \$8,889.57$

4. Exact days $= 191 - 130 = 61$ days

 Bank discount $= \$32,800(0.075)\left(\dfrac{61}{360}\right) = \416.83

 Proceeds $= \$32,800 - \$416.83 = \$32,383.17$

2

1. $I = PRT$

$$I = \$8{,}000(0.11)\left(\frac{120}{360}\right)$$

$$I = \$293.33$$

Proceeds = principal − bank discount

Proceeds = \$8,000 − \$293.33

Proceeds = \$7,706.67

Find the effective interest rate:

$$R = \frac{I}{PT}$$

$$R = \frac{\$293.33}{\$7{,}706.67\left(\dfrac{120}{360}\right)}$$

$$R = \frac{\$293.33}{\$2{,}568.89}$$

$$R = 0.1141855042$$

$$R = 11.4\%$$

The effective interest rate for a simple discount note of \$8,000 for 120 days is 11.4%.

2. $I = PRT$

$$I = \$22{,}000(0.0836)\left(\frac{90}{360}\right)$$

$$I = \$459.80$$

Proceeds = principal − bank discount

Proceeds = \$22,000 − \$459.80

Proceeds = \$21,540.20

Find the effective interest rate:

$$R = \frac{I}{PT} \qquad \text{Substitute proceeds for principal.}$$

$$R = \frac{\$459.80}{\$21{,}540.20\left(\dfrac{90}{360}\right)}$$

$$R = \frac{\$459.80}{\$5{,}385.05}$$

$$R = 0.0853845368$$

$$R = 8.5\% \qquad \text{Effective interest rate}$$

The effective interest rate for a simple discount note of \$22,000 for 120 days is 8.5%.

3

1.
```
  201    July 20
− 46     February 15
 155 days
```

2. Interest $= \$19{,}500(0.0825)\left(\dfrac{155}{365}\right)$

$\qquad = \$683.17$

Maturity value $= \$19{,}500 + \683.17

$\qquad\qquad = \$20{,}183.17$

3.
```
  201    July 20
−125     May 5
  76 days
```

Third-party discount $= \$20{,}183.17(0.1)\left(\dfrac{76}{360}\right)$

$\qquad\qquad = \$426.09$

4. Proceeds to Hugh's Trailers $= \$20{,}183.17 − \426.09

$\qquad\qquad\qquad\qquad = \$19{,}757.08$

CHAPTER 12

Section 12-1

1

1. Amount financed = \$1,095 − \$100 = \$995
Total of payments = 18(\$62.50) = \$1,125
Installment price = \$1,125 + \$100 = \$1,225
Finance charge = \$1,225 − \$1,095 = \$130

2. Amount financed = \$2,695 − \$200 = \$2,495
Total of payments = 24(\$118.50) = \$2,844
Installment price = \$2,844 + \$200 = \$3,044
Finance charge = \$3,044 − \$2,695 = \$349

3. Amount financed = \$2,295 − \$275 = \$2,020
Total of payments = 30(\$78.98) = \$2,369.40
Installment price = \$2,369.40 + \$275 = \$2,644.40
Finance charge = \$2,644.40 − \$2,295 = \$349.40

4. Finance charge = \$3,115.35 − \$2,859 = \$256.35

2

1. Total of installment payments $= \$2,087 - \150
 $$= \$1,937$$
 $$\text{Installment payment} = \frac{\$1,937}{24}$$
 $$= \$80.71$$

2. Total of installment payments $= \$8,997.40 - \$1,000$
 $$= \$7,997.40$$
 $$\text{Installment payment} = \frac{\$7,997.40}{36}$$
 $$= \$222.15$$

3. Total of installment payments $= \$2,795.28 - \600
 $$= \$2,195.28$$
 $$\text{Installment payment} = \frac{\$2,195.28}{36}$$
 $$= \$60.98$$

4. Total of installment payments $= \$3,296.96 - \800
 $$= \$2,496.96$$
 $$\text{Installment payment} = \frac{\$2,496.96}{30}$$
 $$= \$83.23$$

3

1. $\text{Installment price} = \$347.49(36) + \$1,500$
 $$= \$12,509.64 + \$1,500$$
 $$= \$14,009.64$$
 $\text{Amount financed} = \$11,935 - \$1,500$
 $$= \$10,435$$
 $\text{Finance charge (Interest)} = \$14,009.64 - \$11,935$
 $$= \$2,074.64$$
 $$\text{Interest per } \$100 = \frac{\$2,074.64}{\$10,435}(\$100) = \$19.88$$

In Table 12-1, move down the Monthly Payments column to 36. Move across to 20.00 (nearest to 19.88). Move to the top of the column to find 12.25%. APR = 12.25%.

2. $\text{Installment price} = \$279.65(24) + \$900$
 $$= \$6,711.60 + \$900$$
 $$= \$7,611.60$$
 $\text{Amount financed} = \$6,800 - \$900$
 $$= \$5,900$$
 $\text{Finance charge (interest)} = \$7,611.60 - \$6,800$
 $$= \$811.60$$
 $$\text{Interest per } \$100 = \frac{\$811.60}{\$5,900}(\$100) = \$13.76$$

In Table 12-1, move down the Monthly Payments column to 24. Move across to 13.82 (nearest to 13.76). Move to the top of the column to find 12.75%. APR = 12.75%.

3. $\text{Installment price} = \$295.34(36) + \$2,000$
 $$= \$10,632.24 + \$2,000$$
 $$= \$12,632.24$$
 $\text{Amount financed} = \$9,995 - \$2,000 = \$7,995$
 $\text{Finance charge} = \$12,632.24 - \$9,995$
 $$= \$2,637.24$$
 $$\text{Interest per } \$100 = \frac{\$2,637.24}{\$7,995}(\$100) = \$32.99$$

In Table 12-1, move down the Monthly Payments column to 36. Move across to 32.87 (nearest to 32.99). Move to the top of the column to find 19.5% APR.

4. $\text{Installment price} = \$296.37(48) + \$2,500$
 $$= \$14,225.76 + \$2,500$$
 $$= \$16,725.76$$
 $\text{Amount financed} = \$12,799 - \$2,500 = \$10,299$
 $\text{Finance charge} = \$16,725.76 - \$12,799$
 $$= \$3,926.76$$
 $$\text{Interest per } \$100 = \frac{\$3,926.76}{\$10,299}(\$100) = \$38.13$$

In Table 12-1, move down the Monthly Payments column to 48. Move across to 37.88 (nearest to 38.13). Move to the top of the column to find 16.75% APR.

Section 12-2

1

1. $$\text{numerator} = \frac{5(6)}{2} = 15$$
 $$\text{denominator} = \frac{12(13)}{2} = 78$$
 $$\text{refund fraction} = \frac{15}{78} = \frac{5}{26}$$

2. $$\text{numerator} = \frac{18(19)}{2} = 171$$
 $$\text{denominator} = \frac{48(49)}{2} = 1,176$$
 $$\text{refund fraction} = \frac{171}{1,176} = \frac{57}{392}$$

3. $$\text{refund fraction} = \frac{21}{666}$$
 $$\text{refund} = \frac{21}{666}(\$1,798) = \$56.69$$

4. number of months remaining $= 60 - 50$
 $$= 10 \text{ months}$$
 $$\text{refund fraction} = \frac{55}{1,830} = \frac{11}{366}$$
 $$\text{refund} = \frac{11}{366}(\$4,917) = \$147.78$$

1

1.

| Day | Balance | Day | Balance | Day | Balance |
|---|---|---|---|---|---|
| 25 | $1,406.54 | 5 | $1,418.47 | 15 | $706.02 |
| 26 | $1,418.47 | 6 | $1,433.71 | 16 | $706.02 |
| 27 | $1,418.47 | 7 | $1,433.71 | 17 | $706.02 |
| 28 | $1,418.47 | 8 | $1,520.69 | 18 | $706.02 |
| 29 | $1,418.47 | 9 | $1,520.69 | 19 | $706.02 |
| 30 | $1,418.47 | 10 | $592.83 | 20 | $776.26 |
| 1 | $1,418.47 | 11 | $592.83 | 21 | $776.26 |
| 2 | $1,418.47 | 12 | $592.83 | 22 | $776.26 |
| 3 | $1,418.47 | 13 | $592.83 | 23 | $776.26 |
| 4 | $1,418.47 | 14 | $706.02 | 24 | $776.26 |

2. [$1,406.54 + 10($1,418.47) + 2($1,433.71) + 2($1,520.69) + 4($592.83) + 6($706.02) + 5($776.26)] ÷ 30 = ($1,406.54 + $14,184.70 + $2,867.42 + $3,041.38 + $2,371.32 + $4,236.12 + $3,881.30) ÷ 30 = $31,988.78 ÷ 30 = $1,066.29

3. $1,066.29(0.01075) = $11.46

4. $1,406.54 + $297.58 − $927.86 + $11.46 = $787.72

2

1. Monthly rate $= \dfrac{18\%}{12} = \dfrac{0.18}{12} = 0.015$

Finance charge $= \$1,285.96(0.015) = \19.29

Total purchases and cash advances $= \$98.76 + \$50 + \$46.98 = \195.74

Total payments and credits $= \$135$

New balance $= \$1,285.96 + \$19.29 + \$195.74 - \$135 = \$1,365.99$

2. Monthly rate $= \dfrac{15\%}{12} = \dfrac{0.15}{12} = 0.0125$

Finance charge $= \$2,531.77(0.0125) = \31.65

Total purchases and cash advances $= \$58.63 + \$70 + \$562.78 = \691.41

Total payments and credits $= \$455 + \$85.46 = \$540.46$

New balance $= \$2,531.77 + \$31.65 + \$691.41 - \$540.46 = \$2,714.37$

3. Monthly rate $= \dfrac{24\%}{12} = 2\% = 0.02$

Finance charge $= \$2,094.54(0.02)$
$= \$41.89$

Total purchases $= \$65.82 + \$83.92 + \$12.73 + \$29.12 + \$28.87$
$= \$220.46$

Payments $= \$400$

New balance $= \$2,094.54 + \$41.89 + \$220.46 - \400
$= \$1,956.89$

4. Monthly rate $= \dfrac{9\%}{12} = 0.75\% = 0.0075$

Finance charge $= \$245.18(0.0075) = \1.84

Total purchases $= \$45.00 + \$22.38 + \$36.53 = \103.91

Total payments and credits $= \$100 + \$74.93 = \$174.93$

New balance $= \$245.18 + \$1.84 + \$103.91 - \$174.93 = \$176.00$

CHAPTER 13

Section 13-1

1

1. Monthly rate $= \dfrac{9.2}{12} = 0.767\%$

2. Period interest rate $= 8\% = 0.08$
First end-of-period principal $= \$2,950(1 + 0.08)$
$= \$3,186$
Second end-of-period principal $= \$3,186(1 + 0.08)$
$= \$3,440.88$

The future value is $3,440.88.

Compound interest $= \$3,440.88 - \$2,950$
$= \$490.88$

3. $$\text{Period interest rate} = \frac{3.5\%}{2 \text{ periods annually}} = 1.75\%$$

$$\begin{aligned}\text{Number of periods} &= 2 \text{ periods annually}(2 \text{ years}) \\ &= 4 \text{ periods}\end{aligned}$$

$$\begin{aligned}\text{First end-of-period principal} &= \$20{,}000(1 + 0.0175) \\ &= \$20{,}350\end{aligned}$$

$$\begin{aligned}\text{Second end-of-period principal} &= \$20{,}350(1 + 0.0175) \\ &= \$20{,}706.13\end{aligned}$$

$$\begin{aligned}\text{Third end-of-period principal} &= \$20{,}706.13(1 + 0.0175) \\ &= \$21{,}068.49\end{aligned}$$

$$\begin{aligned}\text{Fourth end-of-period principal} &= \$21{,}068.49(1 + 0.0175) \\ &= \$21{,}437.19\end{aligned}$$

The future value is $21,437.19.

4. $$\text{Period interest rate} = \frac{2.8\%}{2 \text{ periods annually}} = 1.4\%$$

$$\text{Number of periods} = 2 \text{ periods annually}(3 \text{ years}) = 6 \text{ periods}$$

$$\begin{aligned}\text{First end-of-period principal} &= \$15{,}000(1 + 0.014) \\ &= \$15{,}210\end{aligned}$$

$$\begin{aligned}\text{Second end-of-period principal} &= \$15{,}210(1 + 0.014) \\ &= \$15{,}422.94\end{aligned}$$

$$\begin{aligned}\text{Third end-of-period principal} &= \$15{,}422.94(1 + 0.014) \\ &= \$15{,}638.86\end{aligned}$$

$$\begin{aligned}\text{Fourth end-of-period principal} &= \$15{,}638.86(1 + 0.014) \\ &= \$15{,}857.80\end{aligned}$$

$$\begin{aligned}\text{Fifth end-of-period principal} &= \$15{,}857.80(1 + 0.014) \\ &= \$16{,}079.81\end{aligned}$$

$$\begin{aligned}\text{Sixth end-of-period principal} &= \$16{,}079.81(1 + 0.014) \\ &= \$16{,}304.93\end{aligned}$$

The future value is $16,304.93.

2

1. $$\text{Number of interest periods} = 5(1) = 5 \text{ periods}$$
$$\text{Period interest rate} = \frac{4\%}{1} = 4\%$$

Move down the Periods column to row 5. Move across to the column with 4% at the top. Read 1.21665.
$2,890(1.21665) = $3,516.12
The compound amount is $3,516.12.
The compound interest = $3,516.12 − $2,890
$$= \$626.12$$

2. $$\text{Number of interest periods} = 3(4) = 12 \text{ periods}$$
$$\text{Period interest rate} = \frac{10\%}{4} = 2.5\%$$

From Table 13-1, find the intersection of 12 periods and 2.5%. The future value of $1.00 is 1.34489.
Compound amount = $2,982(1.34489)
$$= \$4{,}010.46$$
Compound interest = $4,010.46 − $2,982
$$= \$1{,}028.46$$

3. $$\text{Number of periods} = 5(1) = 5 \text{ periods}$$
$$\text{Period interest rate} = \frac{2.5\%}{1} = 2.5\%$$

From Table 13-1, find the intersection of the 5-periods row and the 2.5% column. The future value of $1.00 is 1.13141.
Compound amount = $7,598.42(1.13141)
$$= \$8{,}596.93$$
Compound interest = $8,596.93 − $7,598.42
$$= \$998.51$$

4. $$\text{Number of interest periods} = 3(2) = 6$$
$$\text{Period interest rate} = \frac{5\%}{2} = 2.5\%$$

From Table 13-1, find the intersection of the 6-periods row and the 2.5% column. The future value of $1.00 is 1.15969.
Compound amount = $25,000(1.15969) = $28,992.25

3

1. $$\text{Number of interest periods} = 4(12) = 48$$
$$\text{Period interest rate} = \frac{4.68\%}{12} = 0.39\% = 0.0039$$

$$FV = P(1 + R)^N$$
$$FV = \$20{,}000(1 + 0.0039)^{48}$$
$$FV = \$24{,}108.59$$

2. $$\text{Number of interest periods} = 10(2) = 20$$
$$\text{Period interest rate} = \frac{5.2\%}{2} = 2.6\% = 0.026$$

$$FV = P(1 + R)^N$$
$$FV = \$17{,}500(1 + 0.026)^{20}$$
$$FV = \$29{,}240.53$$

3. Number of interest periods $= 5(4) = 20$

$$\text{Period interest rate} = \frac{4.8\%}{4} = 1.2\% = 0.012$$

$FV = P(1 + R)^N$
$FV = \$18{,}200(1 + 0.012)^{20}$
$FV = \$23{,}103.71$
Compound interest $= \$23{,}103.71 - \$18{,}200 = \$4{,}903.71$

4. For twice a year compounding:
Number of periods $= 5 \times 2 = 10$ periods

$$\text{Period interest rate} = \frac{4\%}{2} = 2\%$$

Compound amount $= \$12{,}000(1.02)^{10} = \$14{,}627.93$
Compound interest $= \$14{,}627.93 - \$12{,}000 = \$2{,}627.93$

For quarterly compounding:

Number of periods $= 5 \times 4 = 20$ periods

$$\text{Period interest rate} = \frac{4\%}{4} = 1\%$$

Compound amount $= \$12{,}000(1.01)^{20} = \$14{,}642.28$
Compound interest $= \$14{,}642.28 - \$12{,}000$
$\phantom{\text{Compound interest }}= \$2{,}642.28$

Compounding quarterly yields more interest than compounding semiannually.

$\$2{,}642.28 - \$2{,}627.93 = \$14.35$

The quarterly compounding yields $14.35 more interest than semiannual compounding.

4

1. $\text{Period interest rate} = \dfrac{8\%}{2} = 4\%$

$$\begin{aligned}
\text{First end-of-period principal} &= \$2{,}800(1 + 0.04) \\
&= \$2{,}912 \\
\text{Second end-of-period principal} &= \$2{,}912(1 + 0.04) \\
&= \$3{,}028.48 \\
\text{Compound interest after first year} &= \$3{,}028.48 - \$2{,}800 \\
&= \$228.48 \\
\text{Effective annual interest rate} &= \frac{\$228.48}{\$2{,}800}(100\%) \\
&= 8.16\%
\end{aligned}$$

2. Number of periods per year $= 2$ (semiannually)

$$\text{Period interest rate} = \frac{8\%}{2} = 4\%$$

From Table 13-1, find the intersection of the 2-period row and the 4% column. The table value is 1.08160.

$$\begin{aligned}
\text{Effective annual interest rate} &= (1.08160 - 1.00)(100\%) \\
&= 0.08160(100\%) \\
&= 8.16\%
\end{aligned}$$

The manual rate is the same as the table rate.

3. Number of periods per year $= 4$

$$\text{Period interest rate} = \frac{4\%}{4} = 1\%$$

From Table 13-1, find the intersection of the 4-period row and the 1% column. The table value is 1.04060.

$$\begin{aligned}
\text{Effective annual interest rate} &= (1.04060 - 1.00)(100\%) \\
&= 0.0406(100\%) \\
&= 4.06\%
\end{aligned}$$

4. Number of periods per year $= 2$

$$\text{Period interest rate} = \frac{3\%}{2} = 1.5\%$$

From Table 13-1, find the intersection of the 2-period row and the 1.5% column. The table value is 1.03023.

$$\begin{aligned}
\text{Effective annual interest rate} &= (1.03023 - 1.00)(100\%) \\
&= 0.03023(100\%) \\
&= 3.023\%
\end{aligned}$$

5

1. $\$1{,}850 \div \$100 = 18.5$

Find the table value at the intersection of the 60-day row and the 7.25% column.

Table value $= 1.198791$

$$\begin{aligned}
\text{Compound interest} &= 18.5(\$1.198791) \\
&= \$22.18
\end{aligned}$$

2. $\$3{,}050 \div \$100 = 30.5$

Find the table value at the intersection of the 365-day row and the 6% column.

Table value $= 6.183131$

$$\begin{aligned}
\text{Compound interest} &= 30.5(\$6.183131) \\
&= \$188.59
\end{aligned}$$

3. $\$10{,}000 \div \$100 = 100$

Find the table value at the intersection of the 730-day row and the 6.75% column. Table value $= 14.452250$.

$$\begin{aligned}
\text{Compound interest} &= 100(\$14.452250) \\
&= \$1{,}445.23
\end{aligned}$$

4. $\$20{,}000 \div \$100 = 200$

3 years $= 365(3) = 1{,}095$ days

Find the table value at the intersection of the 1,095-day row and the 5.25% column. Table value $= 17.056750$.

$$\begin{aligned}
\text{Compound interest} &= 200(\$17.056750) \\
&= \$3{,}411.35
\end{aligned}$$

1

1. Present value $= \dfrac{\$15,000}{1 + 0.02} = \$14,705.88$

2. Present value $= \dfrac{\$15,000}{1 + 0.04} = \$14,423.08$

3. Present value $= \dfrac{\$30,000}{1 + 0.028} = \$29,182.88$

4. Present value $= \dfrac{\$148,000}{1 + 0.0346} = \$143,050.45$

2

1. Number of periods $= 4(1) = 4$ periods

 Period interest rate $= \dfrac{4\%}{1} = 4\%$

 Table value $= 0.85480$
 Present value $= \$35,000(0.8548)$
 $= \$29,918$

2. Number of periods $= 2(4) = 8$ periods

 Period interest rate $= \dfrac{4\%}{4} = 1\%$ per period

 Table value $= 0.92348$
 Present value $= \$15,000(0.92348)$
 $= \$13,852.20$

3. Number of periods $= 4(4) = 16$ periods

 Period interest rate $= \dfrac{4\%}{4} = 1\%$

 Table value $= 0.85282$
 Present value $= \$15,000(0.85282)$
 $= \$12,792.30$

4. Number of periods $= 6(4) = 24$ periods

 Period interest rate $= \dfrac{4\%}{4} = 1\%$

 Table value $= 0.78757$
 Present value $= \$15,000(0.78757)$
 $= \$11,813.55$

3

1. Number of interest periods $= 7(12) = 84$

 Period interest rate $= \dfrac{4.8\%}{12} = 0.4\% = 0.004$

 $PV = \dfrac{FV}{(1 + R)^N}$

 $PV = \dfrac{\$30,000}{(1 + 0.004)^{84}}$

 $PV = \dfrac{\$30,000}{(1.004)^{84}}$

 $PV = \$21,453.07$

 Calculator steps:
 30000 \div $($ 1.004 $)$ $^\wedge$ 84 \Rightarrow 21453.06649

2. Number of interest periods $= 4(1) = 4$

 Period interest rate $= \dfrac{10\%}{1} = 10\% = 0.1$

 $PV = \dfrac{FV}{(1 + R)^N}$

 $PV = \dfrac{\$7,000}{(1 + 0.1)^4}$

 $PV = \dfrac{\$7,000}{(1.1)^4}$

 $PV = \$4,781.09$

 Calculator steps:
 7000 \div $($ 1.1 $)$ $^\wedge$ 4 \Rightarrow 4781.094188

3. Number of interest periods $= 2(12) = 24$

 Period interest rate $= \dfrac{12\%}{12} = 1\% = 0.01$

 $PV = \dfrac{FV}{(1 + R)^N}$

 $PV = \dfrac{\$800}{(1 + 0.01)^{24}}$

 $PV = \dfrac{\$800}{(1.01)^{24}}$

 $PV = \$630.05$

 $800 in two years is worth $630.05 now. $700 today is better.

4. Number of interest periods $= 15(4) = 60$

 Period interest rate $= \dfrac{5.6\%}{4} = 1.4\% = 0.014$

 $PV = \dfrac{FV}{(1 + R)^N}$

 $PV = \dfrac{\$45,000}{(1 + 0.014)^{60}}$

 $PV = \dfrac{\$45,000}{(1.014)^{60}}$

 $PV = \$19,540.48$

1

1. Periodic interest rate $= 2.9\%$. Number of periods $= 4$
 Annuity payment $= \$5,000$
 End-of-year 1 $= \$5,000$
 End-of-year 2 $= \$5,000(1.029) + \$5,000$
 $\qquad = \$5,145 + \$5,000$
 $\qquad = \$10,145$
 End-of-year 3 $= \$10,145(1.029) + \$5,000$
 $\qquad = \$10,439.21 + \$5,000$
 $\qquad = \$15,439.21$
 End-of-year 4 $= \$15,439.21(1.029) + \$5,000$
 $\qquad = \$15,886.95 + \$5,000$
 $\qquad = \$20,886.95$ future value
 Total investment $= \$5,000(4) = \$20,000$
 Total interest $= \$20,886.95 - \$20,000 = \$886.95$

2. Periodic interest rate $= 3.42\%$. Number of periods $= 3$
 Annuity payment $= \$3,500$
 End-of-year 1 $= \$3,500$
 End-of-year 2 $= \$3,500(1.0342) + \$3,500$
 $\qquad = \$3,619.70 + \$3,500$
 $\qquad = \$7,119.70$
 End-of-year 3 $= \$7,119.70(1.0342) + \$3,500$
 $\qquad = \$7,363.19 + \$3,500$
 $\qquad = \$10,863.19$ future value
 Total investment $= \$3,500(3) = \$10,500$
 Total interest $= \$10,863.19 - \$10,500 = \$363.19$

3. Periodic interest rate $= \dfrac{4\%}{2} = 2\%$
 Number of payments $= 2(2) = 4$ periods
 Annuity payment $= \$1,500$
 End-of-period 1 $= \$1,500$
 End-of-period 2 $= \$1,500(1.02) + \$1,500$
 $\qquad = \$1,530 + \$1,500$
 $\qquad = \$3,030$
 End-of-period 3 $= \$3,030(1.02) + \$1,500$
 $\qquad = \$3,090.60 + \$1,500$
 $\qquad = \$4,590.60$
 End-of-period 4 $= \$4,590.60(1.02) + \$1,500$
 $\qquad = \$4,682.41 + \$1,500$
 $\qquad = \$6,182.41$

4. Periodic interest rate $= \dfrac{3\%}{2} = 1.5\%$
 Number of payments $= 2(2) = 4$ periods
 Annuity payment $= \$300$
 End-of-period 1 $= \$300$
 End-of-period 2 $= \$300(1.015) + \300
 $\qquad = \$304.50 + \300
 $\qquad = \$604.50$
 End-of-period 3 $= \$604.50(1.015) + \300
 $\qquad = \$613.57 + \300
 $\qquad = \$913.57$
 End-of-period 4 $= \$913.57(1.015) + \300
 $\qquad = \$927.27 + \300
 $\qquad = \$1,127.27$

2

1. Number of periods $= 8$
 Period rate $= 2\%$
 Table value at intersection of 8-periods row and 2% column $= 8.583$
 Future value $= \$4,000(8.583) = \$34,332$
 Total interest $= \$34,332 - (\$4,000)(8)$
 $\qquad = \$34,332 - \$32,000$
 $\qquad = \$2,332$

2. Number of periods $= 5(2) = 10$
 Period rate $= \dfrac{4\%}{2} = 2\%$
 Table value at intersection of 10-periods row and 2% column
 $= 10.950$
 Future value $= \$6,000(10.950) = \$65,700$
 Total interest $= \$65,700 - (\$6,000)(10)$
 $\qquad = \$65,700 - \$60,000$
 $\qquad = \$5,700$

3. Number of periods $= 5(4) = 20$
 Period rate $= \dfrac{8\%}{4} = 2\%$
 Table value at intersection of 20-periods row and 2% column
 $= 24.297$
 Future value $= \$1,200(24.297) = \$29,156.40$

4. Number of periods $= 6(2) = 12$
 Period rate $= \dfrac{6\%}{2} = 3\%$
 Table value at intersection of 12-periods row and 3% column
 $= 14.192$
 Future value $= \$2,500(14.192) = \$35,480$

3

1. Number of periods $= 4$
 Period rate $= 3.75\%$
 End-of-year 1 $= \$1,500(1 + 0.0375)$
 $= \$1,500(1.0375)$
 $= \$1,556.25$
 End-of-year 2 $= (\$1,556.25 + \$1,500)(1.0375)$
 $= (\$3,056.25)(1.0375)$
 $= \$3,170.86$
 End-of-year 3 $= (\$3,170.86 + \$1,500)(1.0375)$
 $= (\$4,670.86)(1.0375)$
 $= \$4,846.02$
 End-of-year 4 $= (\$4,846.02 + \$1,500)(1.0375)$
 $= (\$6,346.02)(1.0375)$
 $= \$6,584.00$
 Total paid in $= \$1,500(4) = \$6,000$
 Interest $= \$6,584 - \$6,000 = \$584$

3. Number of periods $= 2(2) = 4$
 Period rate $= \dfrac{3.8\%}{2} = 1.9\%$
 End-of-period 1 $= \$5,000(1.019)$
 $= \$5,095$
 End-of-period 2 $= (\$5,095 + \$5,000)(1.019)$
 $= \$10,095(1.019)$
 $= \$10,286.81$
 End-of-period 3 $= (\$10,286.81 + \$5,000)(1.019)$
 $= \$15,286.81(1.019)$
 $= \$15,577.26$
 End-of-period 4 $= (\$15,577.26 + \$5,000)(1.019)$
 $= \$20,577.26(1.019)$
 $= \$20,968.23$

2. Number of periods $= 2$
 Period rate $= 4.25\%$
 End-of-year 1 $= \$4,000(1.0425)$
 $= \$4,170$
 End-of-year 2 $= (\$4,170 + \$4,000)(1.0425)$
 $= \$8,170(1.0425)$
 $= \$8,517.23$

4. Number of periods $= 6$
 Period rate $= \dfrac{6\%}{12} = 0.5\%$
 End-of-period 1 value $= (\$50)(1.005)$
 $= \$50.25$
 End-of-period 2 value $= (\$50.25 + \$50)(1.005)$
 $= (\$100.25)(1.005)$
 $= \$100.75$
 End-of-period 3 value $= (\$100.75 + \$50)(1.005)$
 $= \$150.75(1.005)$
 $= \$151.50$
 End-of-period 4 value $= (\$151.50 + \$50)(1.005)$
 $= \$201.50(1.005)$
 $= \$202.51$
 End-of-period 5 value $= (\$202.51 + \$50)(1.005)$
 $= \$252.51(1.005)$
 $= \$253.77$
 End-of-period 6 value $= (\$253.77 + \$50)(1.005)$
 $= \$303.77(1.005)$
 $= \$305.29$

4

1. Number of periods $= 10$
 Period rate $= 5\%$
 Table value for 10-periods row and 5% column $= 12.578$
 Future value $= \$3,000(12.578)(1.05)$
 $= \$39,620.70$

3. Number of periods $= 5(4) = 20$
 Period rate $= \dfrac{8\%}{4} = 2\%$
 Table value for 20-periods row and 2% column $= 24.297$
 Future value $= \$500(24.297)(1.02)$
 $= \$12,391.47$

2. Number of periods $= 5(2) = 10$
 Period rate $= \dfrac{6\%}{2} = 3\%$
 Table value for 10-periods row and 3% column $= 11.464$
 Future value $= \$1,000(11.464)1.03$
 $= \$11,807.92$

4. Number of periods $= 5(2) = 10$
 Period rate $= \dfrac{8\%}{2} = 4\%$
 Table value for 10-periods row and 4% column $= 12.006$
 Future value $= \$1,000(12.006)(1.04)$
 $= \$12,486.24$

 For both exercises, the amount paid is \$10,000 over the term of the investment.

 Interest in #3 $= \$2,391.47$
 Interest in #4 $= \$2,486.24$

 The interest is slightly higher for payments of \$1,000 because a larger amount earns interest from the very beginning.

5

1. $R = \dfrac{4.62\%}{12} = \dfrac{0.0462}{12} = 0.00385$ Periodic interest rate

 $N = 25(12) = 300$ Number of payments

 $PMT = \$250$

 $FV_{\text{ordinary annuity}} = \$250\left(\dfrac{(1 + 0.00385)^{300} - 1}{0.00385}\right)$

 Mentally add within innermost parentheses.

 $FV_{\text{ordinary annuity}} = \$250\left(\dfrac{(1.00385)^{300} - 1}{0.00385}\right)$

 Calculator sequence:

 250 $[(]$ 1.00385 $[\wedge]$ 300 $[-]$ 1 $[)]$ $[\div]$ 0.00385 $[=]$ \Rightarrow 140713.7814

 The future value of the ordinary annuity is \$140,713.78.

2. $R = \dfrac{5.2\%}{52} = \dfrac{0.052}{52} = 0.001$ Periodic interest rate

 $N = 15(52) = 780$ Number of payments

 $PMT = \$30$

 $FV_{\text{ordinary annuity}} = \$30\left(\dfrac{(1 + 0.001)^{780} - 1}{0.001}\right)$

 Mentally add within innermost parentheses.

 $FV_{\text{ordinary annuity}} = \$30\left(\dfrac{(1.001)^{780} - 1}{0.001}\right)$

 Calculator sequence:

 30 $[(]$ 1.001 $[\wedge]$ 780 $[-]$ 1 $[)]$ $[\div]$ 0.001 $[=]$ \Rightarrow 35418.66671

 The future value of the ordinary annuity is \$35,418.67.

3. $R = \dfrac{7.35\%}{12} = \dfrac{0.0735}{12} = 0.006125$ Periodic interest rate

 $N = 14(12) = 168$ Number of payments

 $PMT = \$200$

 $FV_{\text{annuity due}} = \$200\left(\dfrac{(1 + 0.006125)^{168} - 1}{0.006125}\right)(1 + 0.006125)$

 Mentally add within parentheses.

 $FV_{\text{annuity due}} = \$200\left(\dfrac{(1.006125)^{168} - 1}{0.006125}\right)(1.006125)$

 Calculator sequence:

 200 $[(]$ 1.006125 $[\wedge]$ 168 $[-]$ 1 $[)]$ $[\div]$ 0.006125 $[=]$

 $[\text{ANS}]$ $[(]$ 1.006125 $[)]$ $[=]$ \Rightarrow 58790.47317

 The future value of the annuity due is \$58,790.47.

4. $R = \dfrac{6\%}{26} = \dfrac{0.06}{26} = 0.0023076923$ Periodic interest rate

 $N = 35(26) = 910$ Number of payments

 $PMT = \$25$

 $FV_{\text{annuity due}} = \$25\left(\dfrac{(1 + 0.0023076923)^{910} - 1}{0.0023076923}\right)$

 $\times (1 + 0.0023076923)$ Mentally add within parentheses.

 $FV_{\text{annuity due}} = \$25\left(\dfrac{(1.0023076923)^{910} - 1}{0.0023076923}\right)(1.0023076923)$

 Calculator sequence:

 25 $[(]$ 1.0023076923 $[\wedge]$ 910 $[-]$ 1 $[)]$ $[\div]$ 0.0023076923 $[=]$

 $[\text{ANS}]$ $[(]$ 1.0023076923 $[)]$ $[=]$ \Rightarrow 77598.39391

 The future value of the annuity due is \$77,598.39.

Section 14-2

1

1. Number of periods = 6

 Period rate = 4%

 Table value = 0.1507619

 Sinking fund payment = \$12,000(0.1507619)

 = \$1,809.14

2. Total paid = \$1,809.14(6)

 = \$10,854.84

 Interest = \$12,000 − \$10,854.84

 = \$1,145.16

3. Number of periods = 10(4) = 40

 Period rate = $\dfrac{4\%}{4}$ = 1%

 Table value = 0.0204556

 Sinking fund payment = \$25,000(0.0204556)

 = \$511.39

4. Total paid = \$511.39(40)

 = \$20,455.60

 Interest = \$25,000 − \$20,455.60

 = \$4,544.40

2

1. Number of periods = 5

 Period rate = 4%

 Table 14-3 value = 4.452

 Present value = \$5,000(4.452)

 = \$22,260

2. Number of periods = 20

 Period rate = 7%

 Table value = 10.594

 Present value = \$20,000(10.594)

 = \$211,880

3. Number of periods = 10(4) = 40

 Period rate = $\dfrac{8\%}{4}$ = 2%

 Table value = 27.355

 Present value = \$7,000(27.355)

 = \$191,485

4. Number of periods = 20(2) = 40

 Period rate = $\dfrac{6\%}{2}$ = 3%

 Table value = 23.115

 Present value = \$10,000(23.115)

 = \$231,150

3

1. $R = \dfrac{4.85\%}{12} = \dfrac{0.0485}{12} = 0.0040416667$ Periodic interest rate

$N = 26(12) = 312$ Number of payments

$FV = \$350,000$

$\text{PMT}_{\text{ordinary annuity}} = \$350,000\left(\dfrac{0.0040416667}{(1 + 0.0040416667)^{312} - 1}\right)$

$350000 \boxed{\times} 0.0040416667 \boxed{\div} \boxed{(} \boxed{(} 1.0040416667 \boxed{\wedge}$

$312 \boxed{-} 1 \boxed{)} \boxed{=} \Rightarrow \text{PMT} = 561.3444827$ (round to nearest cent)

Shameka should pay $561.34 into the sinking fund each month.

2. $R = \dfrac{5.25\%}{12} = \dfrac{0.0525}{12} = 0.004375$ Periodic interest rate

$N = 25(12) = 300$ Number of payments

$P = \$2,000$

$PV_{\text{ordinary annuity}} = \$2,000\left(\dfrac{(1 + 0.004375)^{300} - 1}{0.004375(1 + 0.004375)^{300}}\right)$

$2,000 \boxed{(} \boxed{(} 1.004375 \boxed{\wedge} 300 \boxed{-} 1 \boxed{)} \boxed{\div}$

$\boxed{(} 0.004375 \boxed{\times} 1.004375 \boxed{\wedge} 300 \boxed{)} \boxed{)} \boxed{=} \Rightarrow$

$PV = 333751.794$ Round to nearest cent.

Mekisha needs to have $333,751.79 in the fund to receive an annuity payment of $2,000 each month for 25 years.

CHAPTER 15

Section 15-1

1

1. $\$148,500(0.20) = \$29,700$

 Amount financed $= \$148,500 - \$29,700$
 $= \$118,800$

 Number of $1,000 units $= \$118,800 \div 1,000$
 $= 118.8$

 Table 15-1 factor for 30 years and 5.75% interest rate $= \$5.84$
 Monthly payment $= 118.8(\$5.84)$
 $= \$693.79$

2. Number of $1,000 units $= \$160,000 \div \$1,000 = 160$

 Table 15-1 factor for 20 years and 5.5% interest rate $= \$6.88$

 Monthly payment $= 160(\$6.88) = \$1,100.80$

3. Number of $1,000 units $= \$160,000 \div \$1,000 = 160$

 Table 15-1 factor for 25 years and 5.5% interest rate $= \$6.14$

 Monthly payment $= 160(\$6.14) = \982.40

4. Number of units $= \$160,000 \div \$1,000 = 160$

 Table 15-1 factor for 30 years and 5.5% interest rate $= \$5.68$

 Monthly payment $= 160(\$5.68) = \908.80

2

1. Number of $1,000 units $= \$195,000 \div \$1,000$
 $= 195$

 Table 15-1 value for 17 years and 6.25% interest rate $= \$7.97$

 Monthly payment $= 195(\$7.97)$
 $= \$1,554.15$

3. Monthly insurance payment $= \$1,080 \div 12$
 $= \$90$

 Monthly taxes payment $= \$1,252 \div 12$
 $= \$104.33$

 Adjusted monthly payment $= \$1,554.15 + \$90 + \$104.33$
 $= \$1,748.48$

2. Total paid $= \$1,554.15(17)(12)$
 $= \$317,046.60$

 Interest $= \$317,046.60 - \$195,000$
 $= \$122,046.60$

4. Monthly payment for loan of 15 years at 5.75%

 Interest $= 185.4(\$8.30)$
 $= \$1,538.82$

 Monthly payment for loan of 30 years at 6.25%

 Interest $= 185.4(\$6.16)$
 $= \$1,142.06$

 Marcella should finance for 30 years at 6.25%.

1

1. Month 1 interest $= \$118{,}800\left(\dfrac{0.0575}{12}\right)$

 $= \$569.25$

 Principal portion of 1st payment $= \$693.79 - \569.25
 $= \$124.54$

 End-of-month principal $= \$118{,}800 - \124.54
 $= \$118{,}675.46$

 Month 2 interest $= \$118{,}675.46\left(\dfrac{0.0575}{12}\right)$

 $= \$568.65$

 Principal portion of 2nd payment $= \$693.79 - \568.65
 $= \$125.14$

 End-of-month principal $= \$118{,}675.46 - \125.14
 $= \$118{,}550.32$

 | Month | Monthly payment | Interest | Principal | End-of-month principal |
 |---|---|---|---|---|
 | 1 | $693.79 | $569.25 | $124.54 | $118,675.46 |
 | 2 | $693.79 | $568.65 | $125.14 | $118,550.32 |

2. Month 1 interest $= \$160{,}000\left(\dfrac{0.055}{12}\right)$

 $= \$733.33$

 Principal portion of 1st payment $= \$1{,}100.80 - \733.33
 $= \$367.47$

 End-of-month principal $= \$160{,}000 - \367.47
 $= \$159{,}632.53$

 Month 2 interest $= \$159{,}632.53\left(\dfrac{0.055}{12}\right)$

 $= \$731.65$

 Principal portion of 2nd payment $= \$1{,}100.80 - \731.65
 $= \$369.15$

 End-of-month principal $= \$159{,}632.53 - \369.15
 $= \$159{,}263.38$

 | Month | Monthly payment | Interest | Principal | End-of-month principal |
 |---|---|---|---|---|
 | 1 | $1,100.80 | $733.33 | $367.47 | $159,632.53 |
 | 2 | $1,100.80 | $731.65 | $369.15 | $159,263.38 |

3. Month 1 interest $= \$160{,}000\left(\dfrac{0.055}{12}\right)$

 $= \$733.33$

 Principal portion of 1st payment $= \$982.40 - \733.33
 $= \$249.07$

 End-of-month principal $= \$160{,}000 - \249.07
 $= \$159{,}750.93$

 Month 2 interest $= \$159{,}750.93\left(\dfrac{0.055}{12}\right)$

 $= \$732.19$

 Principal portion of 2nd payment $= \$982.40 - \732.19
 $= \$250.21$

 End-of-month principal $= \$159{,}750.93 - \250.21
 $= \$159{,}500.72$

 Month 3 interest $= \$159{,}500.72\left(\dfrac{0.055}{12}\right)$

 $= \$731.04$

 Principal portion of 3rd payment $= \$982.40 - \731.04
 $= \$251.36$

 End-of-month principal $= \$159{,}500.72 - \251.36
 $= \$159{,}249.36$

 | Month | Monthly payment | Interest | Principal | End-of-month principal |
 |---|---|---|---|---|
 | 1 | $982.40 | $733.33 | $249.07 | $159,750.93 |
 | 2 | $982.40 | $732.19 | $250.21 | $159,500.72 |
 | 3 | $982.40 | $731.04 | $251.36 | $159,249.36 |

4. Month 4 interest $= \$159{,}471.18\left(\dfrac{0.055}{12}\right)$

 $= \$730.91$

 Principal portion of 4th payment $= \$908.80 - \730.91
 $= \$177.89$

 End-of-month principal $= \$159{,}471.18 - \177.89
 $= \$159{,}293.29$

 Month 5 interest $= \$159{,}293.29\left(\dfrac{0.055}{12}\right)$

 $= \$730.09$

 Principal portion $= \$908.80 - \730.09
 $= \$178.71$

 End-of-month principal $= \$159{,}293.29 - \178.71
 $= \$159{,}114.58$

 Month 6 interest $= \$159{,}144.58\left(\dfrac{0.055}{12}\right)$

 $= \$729.28$

 Principal portion $= \$908.80 - \729.28
 $= \$179.52$

 End-of-month principal $= \$159{,}114.58 - \179.52
 $= \$158{,}935.06$

 | Month | Monthly payment | Interest | Principal | End-of-month principal |
 |---|---|---|---|---|
 | 4 | $908.80 | $730.91 | $177.89 | $159,293.29 |
 | 5 | $908.80 | $730.09 | $178.71 | $159,114.58 |
 | 6 | $908.80 | $729.28 | $179.52 | $158,935.06 |

2

1. Amount mortgaged $= \$386{,}000 - \$84{,}000 = \$302{,}000$

 $\text{Loan-to-value ratio} = \dfrac{\text{Amount mortgaged}}{\text{Appraised value of property}}$

 $\text{Loan-to-value ratio} = \dfrac{\$302{,}000}{\$395{,}000}$

 Loan-to-value ratio $= 0.764556962$ or 76%

2. $\text{Housing ratio} = \dfrac{\text{total mortgage payment (PITI)}}{\text{gross monthly income}}$

 $\text{Housing ratio} = \dfrac{\$1{,}482}{\$5{,}893}$

 Housing ratio $= 0.2514848125$ or 25%, which is below the maximum percentage.

3. Debt to income ratio $= \dfrac{\text{total fixed monthly expenses}}{\text{gross monthly income}}$

 Debt to income ratio $= \dfrac{\$1,675}{\$4,975}$

 Debt to income ratio $= 0.3366834171$ or 34%

4. Housing ratio $= \dfrac{\text{total mortgage payment (PITI)}}{\text{gross monthly income}}$

 PITI $= \$1,845 + \$74 + \$104 = \$2,023$

 Housing ratio $= \dfrac{\$2,023}{\$5,798}$

 Housing ratio $= 0.3489134184$ or 35%, which is above the maximum desired percentage, so her ratio is not favorable.

Answers to Odd-Numbered Exercises

CHAPTER 1

Section Exercises

1-1

1. Twenty-two million, three hundred fifty-six thousand, twenty-seven

3. Seven hundred thirty million, five hundred thirty-one thousand, nine hundred sixty-eight

5. Five hundred twenty-three billion, eight hundred million, seven thousand, one hundred ninety

7. 14,985

9. 17,000,803,075

11. 306,541

13. 480

15. 300,000

17. Three billion, five hundred eighty-five million dollars

19. 86,000,000

1-2

1. 1,600

3. 1,843

5. 33

7. 43,800

9. 89,445

11. 407

13.

| Region | W | Th | F | S | Su | Region Totals |
|---|---|---|---|---|---|---|
| Eastern | $ 72,492 | $ 81,948 | $ 32,307 | $ 24,301 | $32,589 | $243,637 |
| Southern | 81,897 | 59,421 | 48,598 | 61,025 | 21,897 | 272,838 |
| Central | 71,708 | 22,096 | 23,222 | 21,507 | 42,801 | 181,334 |
| Western | 61,723 | 71,687 | 52,196 | 41,737 | 22,186 | 249,529 |
| Daily Sales Total | $287,820 | $235,152 | $156,323 | $148,570 | $119,473 | $947,338 |

Difference = $436,662 Goal was not reached.

15. $923

17. Wages = $441
Gross profit = $399

19. 29 boxes

21. $199,500,000

23. $1,680,000

EXERCISES SET A, P. 25

1. Four thousand, two hundred nine

3. $7,000,000,000

5. 400

7. 830

9. 300,000; 6,300,000

11. 5,000

13. 63,601

15. 22,000; 21,335

17. 240; 230 items

19. 4,000; 4,072

21. 50,000; 55,632

23. 244 fan belts

25. 782,878

27. 47,220,000

29. 1,550,000; 1,495,184

31. 336 radios per thousand

33. 7,777; (or 8,000 rounded); 8,805 R6

35. $12 per hour

EXERCISES SET B, P. 27

1. ninety-seven thousand, one hundred sixty-eight

3. 26

5. 8,200

7. 30,000

9. 2,000 radios

11. 20,000,000,000

13. 59,882

15. 8,400; 8,759

17. 723 cards

19. 200,000; 182,902

21. 60,000; 74,385

23. 13 pounds

25. 6,840,462

27. 162,000

29. 200,000; 206,388

31. 88 R1 TVs per thousand people

33. 666; 505 R161

35. 77 coins

PRACTICE TEST, P. 29

1. five hundred three

2. twelve million, fifty-six thousand, thirty-nine

3. 84,300

4. 59,000

5. 80,000

6. 600,000

7. 5,017,135,632

8. 17,500,608

9. 2,200; 2,117

10. 700; 641

11. 45,000; 41,032 **12.** 80; 75 R46 **13.** 1,153 items were counted **14.** Only 15 boxes can be stacked **15.** 249 packages

16. 20 pairs of shoes **17.** $17 per hour **18.** 280 pieces of fruit **19.** 48 pages **20.** 37 novels

CHAPTER 2

Section Exercises

2-1

1. proper **3.** improper **5.** proper **7.** $1\frac{5}{7}$ **9.** 1

11. 2 **13.** $\frac{25}{4}$ **15.** $\frac{7}{3}$ **17.** $\frac{13}{8}$ **19.** $\frac{4}{5}$

21. $\frac{3}{4}$ **23.** $\frac{2}{3}$ **25.** $\frac{6}{16}$ **27.** $\frac{12}{32}$ **29.** $\frac{5}{15}$

2-2

1. $\frac{8}{9}$ **3.** $1\frac{3}{10}$ **5.** $12\frac{1}{3}$

7. $137\frac{47}{72}$ **9.** $9\frac{1}{6}$ **11.** $\frac{1}{2}$

13. $\frac{1}{28}$ **15.** $2\frac{2}{9}$ **17.** $8\frac{7}{60}$

19. $3\frac{1}{3}$ **21.** $42\frac{1}{8}$ yards **23.** 89 feet

25. She can use the fabric. **27.** $1\frac{5}{16}$ feet; $1\frac{1}{2}$ feet; $1\frac{3}{8}$ feet; $1\frac{3}{16}$ feet

2-3

1. $\frac{3}{10}$ **3.** $22\frac{13}{36}$ **5.** $\frac{12}{7}$ **7.** $\frac{1}{9}$

9. $\frac{7}{39}$ **11.** $\frac{5}{6}$ **13.** $2\frac{1}{10}$ **15.** $\frac{3}{20}$

17. $20\frac{20}{39}$ rooms **19.** 6 **21.** $16\frac{1}{2}$ feet

EXERCISES SET A, P. 63

1. $\frac{3}{5}, \frac{7}{9}, \frac{5}{8}, \frac{100}{301}, \frac{41}{53}$; proper fractions **3.** $20\frac{2}{3}$ **5.** $8\frac{1}{2}$ **7.** $\frac{13}{3}$

9. $\frac{5}{6}$ **11.** $\frac{5}{8}$ **13.** $\frac{20}{32}$ **15.** $\frac{1}{7}$ of the employees

17. 168 **19.** $1\frac{2}{5}$ **21.** $11\frac{7}{8}$ **23.** 29 yards

25. $3\frac{3}{10}$ **27.** $1\frac{1}{2}$ **29.** $\frac{5}{18}$ **31.** 28

33. 4 **35.** 3 **37.** $\frac{4}{7}$ **39.** $1\frac{1}{4}$ inches

41. $192

1. $3\dfrac{7}{15}$ **3.** 7 **5.** $\dfrac{59}{8}$ **7.** $\dfrac{9}{10}$ **9.** $\dfrac{2}{7}$

11. $\dfrac{63}{81}$ **13.** $\dfrac{4}{15}$ of the class **15.** 72 **17.** 1 **19.** $9\dfrac{5}{12}$

21. $\dfrac{1}{2}$ **23.** $7\dfrac{7}{8}$ **25.** Maxine Ford worked $2\dfrac{1}{2}$ hours more than George. **27.** $3\dfrac{3}{7}$ **29.** 18

31. $\dfrac{3}{2}$ **33.** $\dfrac{8}{19}$ **35.** $6\dfrac{2}{3}$ **37.** $4\dfrac{1}{2}$ **39.** $5\dfrac{9}{20}$ feet

41. 13 feet

PRACTICE TEST, P. 67

1. $\dfrac{1}{5}$ **2.** $\dfrac{5}{3}$ **3.** $\dfrac{5}{8}$ **4.** $\dfrac{4}{5}$ **5.** $\dfrac{3}{7}$

6. $\dfrac{7}{17}$ **7.** $\dfrac{21}{8}$ **8.** $\dfrac{37}{12}$ **9.** $2\dfrac{1}{3}$ **10.** $4\dfrac{4}{13}$

11. $\dfrac{1}{6}$ **12.** $1\dfrac{21}{40}$ **13.** $\dfrac{7}{16}$ **14.** $1\dfrac{1}{9}$ **15.** $1\dfrac{19}{23}$

16. 1,840 **17.** $5\dfrac{5}{6}$ **18.** $47\dfrac{1}{5}$ **19.** $\dfrac{1}{2}$ of the truckload remains to be unloaded **20.** $\dfrac{3}{20}$

21. 100 sheets **22.** $7\dfrac{3}{4}\%$

CHAPTER 3

Section Exercises

3-1

1. Five hundred eighty-two thousandths **3.** One and nine ten-thousandths **5.** Seven hundred eighty-two and seven hundredths

7. 0.312 **9.** 5.03 **11.** $785

13. $0.52 **15.** $32,048.87 **17.** 17.0

19. Nineteen dollars and eighty-nine cents

3-2

1. 933.935 **3.** $80.30 **5.** 109.57 **7.** $244.85 **9.** $7,270.48

11. 78.8 **13.** 1.474 **15.** 0.36719 **17.** 10.31 **19.** ≈ 0.02

21. $85.81 **23.** $7.52 in change **25.** $236.04 **27.** $1,470.00 **29.** Yes, each person will pay $6.18.

3-3

1. $\dfrac{3}{5}$ **3.** $\dfrac{5}{8}$ **5.** $7\dfrac{5}{16}$ **7.** 0.7 **9.** ≈ 0.58 **11.** ≈ 2.13

EXERCISES SET A, P. 127

1. five-tenths **3.** two hundred seventy-five hundred-thousandths **5.** one hundred twenty-eight and twenty-three hundredths **7.** 0.135 **9.** 1,700

11. 1.246 **13.** $28.82 **15.** 376.74 **17.** 135.6 **19.** 193.41

21. 21.2352 **23.** ≈ 8.57 **25.** ≈ 1,559.79 **27.** $\dfrac{11}{20}$ **29.** 0.85

31. $20.93 **33.** $88.96 **35.** $19.20

EXERCISES SET B, P. 131

1. twenty-seven hundredths
3. one hundred twenty thousand seven hundred four millionths
5. three thousand and three thousandths
7. 384.7
9. 33

11. 41.233 **13.** $34.93 **15.** 479.41 **17.** 277.59 **19.** 1,347.84

21. 1,101.15 **23.** 13.52 **25.** ≈ 1,706.45 **27.** $\dfrac{3}{4}$ **29.** 0.05

31. 183.4 square meters **33.** $555.00 **35.** 212.14 inches

PRACTICE TEST, P. 135

1. 42.9 **2.** 30 **3.** twenty-four and one thousand seven ten-thousandths **4.** 3.028 **5.** 24.092

6. 2,741.8 **7.** 224.857 **8.** 0.566 ≈ 0.57 **9.** 447.12 **10.** 0.0138
11. 89.82 **12.** 5.76875 **13.** 34.366 **14.** 7.3 **15.** 179.24
16. 37,417 **17.** 1.7 degrees **18.** $7,980.00 **19.** $11,043.50 **20.** $31.55

CHAPTER 4

Section Exercises

4-1

1.

3. **5.**

7. $8,762.60;

| NUMBER | DATE | DESCRIPTION OF TRANSACTION | DEBIT (−) | √ | FEE (IF ANY) | CREDIT (+) | BALANCE |
|---|---|---|---|---|---|---|---|
| | | | | | | | 7,869 40 |
| Dep | 4/29 | Deposit Payroll | $ | | | $ 1,048 50 | +1,048 50 |
| | | | | | | | 8,917 90 |
| 456 | 4/29 | Green Harvest | 155 30 | | | | −155 30 |
| | | | | | | | 8,762 60 |

RECORD ALL TRANSACTIONS THAT AFFECT YOUR ACCOUNT

9. For Deposit to acct 26-8224021; Ronald H. Cox Realty; restricted endorsement

11. Answers will vary. Deposits can be made to checking or savings accounts. Withdrawals can be made from checking or savings accounts. Loan payments can be made on bank loans. Checking and savings account information can be accessed. Funds can be transferred from savings accounts to checking accounts and from checking accounts to savings accounts. All these transaction options must be arranged between the account holder and the bank and mutually agreed upon by both. Banks may charge from some or all of these transactions.

4-2

1. Leader Federal: $942.18; LG&W: $217.17

3. lowest: $2,403.55; highest: $4,804.87

5.

RECORD ALL TRANSACTIONS THAT AFFECT YOUR ACCOUNT

| NUMBER | DATE | DESCRIPTION OF TRANSACTION | DEBIT (−) | √ T | FEE (IF ANY) (−) | CREDIT (+) | BALANCE |
|---|---|---|---|---|---|---|---|
| | | | | | | | 2472 86 |
| 1094 | 8/28 | K-mart | 42 37 | √ | | | −42 37 |
| | | | | | | | 2430 49 |
| 1095 | 8/28 | Walgreen's | 12 96 | √ | | | −12 96 |
| | | | | | | | 2417 53 |
| Deposit | 9/1 | Payroll Schering-Plough | | √ | | 2401 32 | +2401 32 |
| | | | | | | | 4,818 85 |
| AW | 9/1 | Leader Federal | 942 18 | √ | | | −942 18 |
| | | | | | | | 3876 67 |
| AW | 9/1 | LG & W | 217 17 | √ | | | −217 17 |
| | | | | | | | 3,659 50 |
| 1096 | 9/11 | Kroger | 36 01 | √ | | | −36 01 |
| | | | | | | | 3,623 49 |
| 1097 | 9/11 | Texaco | 178 13 | √ | | | −178 13 |
| | | | | | | | 3445 36 |
| 1098 | 9/1 | Univ. of Memphis | 458 60 | √ | | | −458 60 |
| | | | | | | | 2986 76 |
| 1099 | 9/15 | GMAC Credit Corp | 583 21 | √ | | | −583 21 |
| | | | | | | | 2403 55 |
| 1100 | 9/18 | Visa | 283 21 | √ | | | −283 21 |
| | | | | | | | 2120 34 |
| 1101 | 9/10 | Radio Shack | 189 37 | | | | −189 37 |
| | | | | | | | 1930 97 |
| 1102 | 9/10 | Auto Zone | 48 23 | √ | | | −48 23 |
| | | | | | | | 1,882 74 |
| Deposit | 9/15 | Payroll-Schering Plough | | √ | | 2401 32 | +2,401 32 |
| | | | | | | | 4284 06 |

REMEMBER TO RECORD AUTOMATIC PAYMENTS/DEPOSITS ON DATE AUTHORIZED.

RECORD ALL TRANSACTIONS THAT AFFECT YOUR ACCOUNT

| NUMBER | DATE | DESCRIPTION OF TRANSACTION | DEBIT (−) | √ T | FEE (IF ANY) (−) | CREDIT (+) | BALANCE |
|---|---|---|---|---|---|---|---|
| | | | | | | | 4,284 06 |
| 1103 | 9/15 | Geoffrey Beane | 71 16 | √ | | | −71 16 |
| | | | | | | | 4212 90 |
| 1104 | 9/14 | Heaven Scent Flowers | 12 75 | √ | | | −12 75 |
| | | | | | | | 4200 15 |
| 1105 | 9/20 | Kroger | 87 75 | | | | −87 75 |
| | | | | | | | 4,112 40 |
| ATM | 9/20 | Kirby Woods | 60 00 | √ | | | −60 00 |
| | | | | | | | 4052 40 |
| 1106 | 9/21 | Travelers Insurance | 1,238 42 | √ | | | −1,238 42 |
| | | | | | | | 2,813 98 |
| 1107 | 9/23 | Nation's Bank - Savings | 500 00 | √ | | | −500 00 |
| | | | | | | | 2,313 98 |
| | 9/27 | Interest earned | | √ | | 9 48 | +9 48 |
| | | | | | | | 2,323 46 |
| | 9/29 | Statement reconciled | | | | | |

| $ 6,982 68 | BALANCE AS SHOWN ON BANK STATEMENT |
|---|---|
| 0 | TOTAL OF OUTSTANDING DEPOSITS |
| 6,982 68 | NEW TOTAL |
| −717 21 | SUBTRACT TOTAL OF OUTSTANDING CHECKS |
| $6,265 47 | YOUR ADJUSTED STATEMENT BALANCE |

SHOULD EQUAL

| BALANCE AS SHOWN IN YOUR REGISTER | $ 6,284 42 |
|---|---|
| SUBTRACT AMOUNT OF SERVICE CHARGE | 0 |
| NEW TOTAL | 6,265 42 |
| ADJUSTMENTS IF ANY | −18 95 |
| YOUR ADJUSTED REGISTER BALANCE | $6,265 47 |

| Outstanding Deposits (Credits) | |
|---|---|
| Date | Amount |
| | $ 0 |
| | |
| Total | $ 0 |

| Outstanding Checks (Debits) | | |
|---|---|---|
| Check Number | Date | Amount |
| 3785 | 3/5 | $ 346 18 |
| 3789 | 3/15 | 72 83 |
| 3790 | 3/17 | 146 17 |
| 3791 | 3/17 | 152 03 |
| Total | | $ 717 21 |

| $ 2,600 58 | BALANCE AS SHOWN ON BANK STATEMENT |
|---|---|
| 0 | TOTAL OF OUTSTANDING DEPOSITS |
| 2,600 58 | NEW TOTAL |
| −277 12 | SUBTRACT TOTAL OF OUTSTANDING CHECKS |
| $2,323 46 | YOUR ADJUSTED STATEMENT BALANCE |

=

| BALANCE AS SHOWN IN YOUR REGISTER | $ 2,313 98 |
|---|---|
| SUBTRACT AMOUNT OF SERVICE CHARGE | 0 |
| NEW TOTAL | 2,313 98 |
| ADJUSTMENTS IF ANY Interest | +9 48 |
| YOUR ADJUSTED REGISTER BALANCE | $2,323 46 |

| Outstanding Deposits (Credits) | |
|---|---|
| Date | Amount |
| | $ |
| Total | $ 0 |

| Outstanding Checks (Debits) | | |
|---|---|---|
| Check Number | Date | Amount |
| 1101 | 9/10 | $ 189 37 |
| 1105 | 9/20 | 87 75 |
| Total | | $ 277 12 |

1.

| | | | |
|---|---|---|---|
| Balance Forward | $4,307 | 21 | |
| Deposits | | | |
| Total | 4,307 | 21 | |
| Amount This Check | 296 | 83 | |
| Balance | $4,010 | 38 | |

3.

DEPOSIT TICKET

S & R Consulting Co.
PO Box 921
Flint, MI 00000

DATE May 8 20 XX
DEPOSITS MAY NOT BE AVAILABLE FOR IMMEDIATE WITHDRAWAL

SIGN HERE FOR CASH RECEIVED (IF REQUIRED)

Community First Bank
2177 Germantown Road • 7808 Farmington
Germantown, TN 38138 • (901) 754-2400 • Member FDIC

⑆084000026⑆9998

CHECKS AND OTHER ITEMS ARE RECEIVED FOR DEPOSIT SUBJECT TO THE PROVISIONS OF THE UNIFORM COMMERCIAL CODE OR ANY APPLICABLE COLLECTION AGREEMENT.

| CASH | CURRENCY | 480 | 00 |
|---|---|---|---|
| | COIN | | |
| LIST CHECKS SINGLY | | 136 | 00 |
| | | 278 | 96 |
| TOTAL FROM OTHER SIDE | | | |
| TOTAL | | | |
| LESS CASH RECEIVED | | | |
| NET DEPOSIT | | 894 | 96 |

26-2/840

USE OTHER SIDE FOR ADDITIONAL LISTING

BE SURE EACH ITEM IS PROPERLY ENDORSED

5. three **7.** $238.00 **9.** $4,782.96 **11.** $29.36

13.

RECORD ALL TRANSACTIONS THAT AFFECT YOUR ACCOUNT

| NUMBER | DATE | DESCRIPTION OF TRANSACTION | DEBIT (−) | | √ T | FEE (IF ANY) (−) | CREDIT (+) | | BALANCE | |
|---|---|---|---|---|---|---|---|---|---|---|
| | | | | | | | | | 4,782 | 96 |
| 716 | 7/1 | Dabney Nursery | 90 | 23 | ✓ | | | | 4,692 | 73 |
| 717 | 7/1 | Office Max | 42 | 78 | ✓ | | | | 4,649 | 95 |
| Deposit | 7/3 | Louis Lechlelter | | | ✓ | | 200 | 00 | 4,849 | 95 |
| Deposit | 7/5 | Tony Trim | | | ✓ | | 175 | 00 | 5,024 | 95 |
| Deposit | 7/9 | Dale Crosby | | | ✓ | | 50 | 00 | 5,074 | 95 |
| 718 | 7/10 | Texaco Gas | 29 | 36 | ✓ | | | | 5,045 | 59 |
| 719 | 7/10 | Nation's Bank | 238 | 00 | ✓ | | | | 4,807 | 59 |
| Deposit | 7/15 | Bobby Cornelius | | | | | 300 | 00 | 5,107 | 59 |
| ATM | 7/20 | Withdrawal Branch | 80 | 00 | ✓ | | | | 5,027 | 59 |
| Debit card | 7/20 | AT&T | 30 | 92 | ✓ | | | | 4,996 | 67 |
| 720 | 7/20 | Visa | 172 | 83 | | | | | 4,823 | 84 |
| | 7/25 | Check Order | 21 | 17 | ✓ | | | | 4,802 | 67 |
| | 8/2 | Statement Reconciled | | | | | | | — | |

REMEMBER TO RECORD AUTOMATIC PAYMENTS/DEPOSITS ON DATE AUTHORIZED.

| $ 4,675 50 | BALANCE AS SHOWN ON BANK STATEMENT | | | BALANCE AS SHOWN IN YOUR REGISTER | $ 4,823 84 |
|---|---|---|---|---|---|
| +300 00 | TOTAL OF OUTSTANDING DEPOSITS | | | SUBTRACT AMOUNT OF SERVICE CHARGE | 0 |
| 4,975 50 | NEW TOTAL | | | NEW TOTAL | 4,823 84 |
| −172 83 | SUBTRACT TOTAL OF OUTSTANDING CHECKS | | | ADJUSTMENTS IF ANY Check Order | −21 17 |
| $4,802 67 | YOUR ADJUSTED STATEMENT BALANCE | SHOULD EQUAL | | YOUR ADJUSTED REGISTER BALANCE | $4,802 67 |

Outstanding Deposits (Credits)

| Date | Amount | |
|---|---|---|
| 7/15 | $ 300 | 00 |
| | | |
| | | |
| | | |
| Total | $ 300 | 00 |

Outstanding Checks (Debits)

| Check Number | Date | Amount | |
|---|---|---|---|
| 721 | | $ 172 | 83 |
| | | | |
| | | | |
| | | | |
| Total | | $ 172 | 83 |

15.

| $ 275.25 | BALANCE AS SHOWN ON BANK STATEMENT | | | BALANCE AS SHOWN IN YOUR REGISTER | $ 587.63 |
|---|---|---|---|---|---|
| +745.99 | TOTAL OF OUTSTANDING DEPOSITS | | | SUBTRACT AMOUNT OF SERVICE CHARGE | −7.50 |
| 1,021.24 | NEW TOTAL | | | NEW TOTAL | 580.13 |
| −441.11 | SUBTRACT TOTAL OF OUTSTANDING CHECKS | | | ADJUSTMENTS IF ANY | 0 |
| $580.13 | YOUR ADJUSTED STATEMENT BALANCE | SHOULD EQUAL | | YOUR ADJUSTED REGISTER BALANCE | $580.13 |

| Outstanding Deposits (Credits) | |
|---|---|
| Date | Amount |
| | $ 120.43 |
| | 625.56 |
| | |
| | |
| | |
| | |
| Total | $ 745.99 |

| Outstanding Checks (Debits) | | |
|---|---|---|
| Check Number | Date | Amount |
| | | $ 144.24 |
| | | 154.48 |
| | | 24.17 |
| | | 18.22 |
| ATM | | 100.00 |
| | Total | $ 441.11 |

EXERCISES SET B, P. 131

1.

| 789 | Date Aug. 18 20 XX |
|---|---|
| Amount $189.32 | |
| To Valley Electric Co-op | |
| For Utilities | |

| Balance Forward | $1,037 | 15 |
|---|---|---|
| Deposits | — | |
| Total | 1,037 | 15 |
| Amount This Check | 189 | 32 |
| Balance | 847 | 83 |

Fileclip, Co.
10003 Lapolma Av.
Radcliff, NH 00000 789

Aug. 18 20 XX 87-278/840

PAY TO THE ORDER OF Valley Electric Co-op $ 189.32

One hundred eighty-nine and 32/100 _____ DOLLARS

Neshoba Bank
1518 S. Bramlett
Radcliff, NH 00000

MEMO Utilities Your Name

⑆084000789⑆

3.

DEPOSIT TICKET

T. J. Jackson
3232 Faxon Ave.
Cordora, ME 00000

DATE Nov. 11 20 XX
DEPOSITS MAY NOT BE AVAILABLE FOR IMMEDIATE WITHDRAWAL

SIGN HERE FOR CASH RECEIVED (IF REQUIRED)

| CASH | CURRENCY | 100 | 00 | |
|---|---|---|---|---|
| | COIN | | | |
| LIST CHECKS SINGLY | | 87 | 83 | |
| | | 42 | 97 | |
| | | 106 | 32 | 26-2/840 |
| TOTAL FROM OTHER SIDE | | 472 | 13 | |
| TOTAL | | 809 | 25 | USE OTHER SIDE FOR ADDITIONAL LISTING |
| LESS CASH RECEIVED | | | | |
| NET DEPOSIT | | 809 | 25 | BE SURE EACH ITEM IS PROPERLY ENDORSED |

DELUXE HD-17

Community First Bank
2177 Germantown Road • 7808 Farmington
Germantown, TN 38138 • (901) 754-2400 • Member FDIC

⑆084000080⑆ 21346

CHECKS AND OTHER ITEMS ARE RECEIVED FOR DEPOSIT SUBJECT TO THE PROVISIONS OF THE UNIFORM COMMERCIAL CODE OR ANY APPLICABLE COLLECTION AGREEMENT.

5. three **7.** $82.75 **9.** $1,034.10 **11.** $82.75

13.

RECORD ALL TRANSACTIONS THAT AFFECT YOUR ACCOUNT

| NUMBER | DATE | DESCRIPTION OF TRANSACTION | DEBIT (–) | √ T | FEE (IF ANY) (–) | CREDIT (+) | BALANCE |
|--------|------|----------------------------|-----------|-----|------------------|------------|---------|
| | | | | | | | 1,034 10 |
| Deposit | 4/1 | Payroll | | √ | | 850 00 | +850 00 |
| | | | | | | | 1,884 10 |
| Deposit | 4/3 | Payroll - Bonus | | √ | | 800 00 | +800 00 |
| | | | | | | | 2,684 10 |
| 5374 | 4/3 | First Union Mortgage Co. | 647 53 | √ | | | –647 53 |
| | | | | | | | 2,036 57 |
| 5375 | 4/3 | South Florida Utility | 82 75 | √ | | | –82 75 |
| | | | | | | | 1,953 82 |
| 5376 | 4/5 | First Federal Credit Union | 219 95 | √ | | | –219 95 |
| | | | | | | | 1,733 87 |
| 5377 | 4/15 | Banc Boston | 510 48 | | | | –510 48 |
| | | | | | | | 1,223 39 |
| Deposit | 4/15 | Payroll | | √ | | 850 00 | +850 00 |
| | | | | | | | 2,073 39 |
| 5378 | 4/20 | Northwest Airlines | 403 21 | | | | –403 21 |
| | | | | | | | 1,670 18 |
| 5379 | 4/26 | Auto Zone | 18 97 | | | | –18 97 |
| | | | | | | | 1,651 21 |
| ATM | 5/4 | Cordova Branch | 100 00 | | | | –100 00 |
| | | | | | | | 1,551 21 |
| | 4/30 | Service Fee | 12 50 | √ | | | –12 50 |
| | | | | | | | 1,538 71 |
| | 4/30 | Statement Reconciled | | | | | |

REMEMBER TO RECORD AUTOMATIC PAYMENTS/DEPOSITS ON DATE AUTHORIZED.

| $ 2,571 37 | BALANCE AS SHOWN ON BANK STATEMENT | | BALANCE AS SHOWN IN YOUR REGISTER | $ 1,551 2 |
|---|---|---|---|---|
| 0 | TOTAL OF OUTSTANDING DEPOSITS | | SUBTRACT AMOUNT OF SERVICE CHARGE | –12 50 |
| 2,571 37 | NEW TOTAL | | NEW TOTAL | 1,538 7 |
| –1,032 66 | SUBTRACT TOTAL OF OUTSTANDING CHECKS | SHOULD EQUAL | ADJUSTMENTS IF ANY | 0 |
| $1,538 71 | YOUR ADJUSTED STATEMENT BALANCE | ← SHOULD EQUAL → | YOUR ADJUSTED REGISTER BALANCE | $1,538 7 |

Outstanding Deposits (Credits)

| Date | Amount |
|------|--------|
| | $ |
| | |
| | |
| | |
| Total | $ 0 |

Outstanding Checks (Debits)

| Check Number | Date | Amount |
|--------------|------|--------|
| 5377 | | $ 510 4 |
| 5378 | | 403 2 |
| 5379 | | 18 9 |
| ATM | | 100 0 |
| | Total | $ 1,032 6 |

15.

| $ 1,102 35 | BALANCE AS SHOWN ON BANK STATEMENT | | BALANCE AS SHOWN IN YOUR REGISTER | $ 336 51 |
|---|---|---|---|---|
| +265 49 | TOTAL OF OUTSTANDING DEPOSITS | | SUBTRACT AMOUNT OF SERVICE CHARGE | –6 50 |
| 1,367 84 | NEW TOTAL | | NEW TOTAL | 330 01 |
| –1,073 83 | SUBTRACT TOTAL OF OUTSTANDING CHECKS | | ADJUSTMENTS IF ANY | –36 00 |
| $294 01 | YOUR ADJUSTED STATEMENT BALANCE | ← SHOULD EQUAL → | YOUR ADJUSTED REGISTER BALANCE | $294 01 |

Outstanding Deposits (Credits)

| Date | Amount |
|------|--------|
| | $ 265 49 |
| | |
| | |
| | |
| | |
| | |
| Total | $ 265 49 |

Outstanding Checks (Debits)

| Check Number | Date | Amount |
|--------------|------|--------|
| | | $ 617 23 |
| | | 456 60 |
| | | |
| | | |
| | | |
| | | |
| | Total | $ 1,073 83 |

PRACTICE TEST, P. 135

1.

| 195 | | Date 5/25 20 XX |
|-----|---|-----------------|
| Amount $152.50 | | |
| To Lon Associates | | |
| For Supplies | | |

| Balance Forward | 2,301 | 42 |
|-----------------|-------|----|
| Deposits | 283 | 17 |
| Total | 2,584 | 59 |
| Amount This Check | 152 | 50 |
| Balance | 2,432 | 09 |

Khayat Cleaners
2438 Broad St.
Oklahoma City, OK 00000

195

May 25 20 XX 87-278/840

PAY TO THE ORDER OF Lon Associates $ 152.50

One hundred fifty-two and 50/100 —————— DOLLARS

First State Bank
1543 S. Main
Oklahoma City, OK 00000

MEMO supplies Lonnie Branch

⑆074200195⑈

2. $5,283.17 **3.** five **4.** $0 **5.** $142.38 **6.** 3/15

7. $3,600 **8.** $6,982.68 **9.** $1,881.49

10.

RECORD ALL TRANSACTIONS THAT AFFECT YOUR ACCOUNT

| NUMBER | DATE | DESCRIPTION OF TRANSACTION | DEBIT (-) | √T | FEE (IF ANY) (-) | CREDIT (+) | BALANCE |
|---|---|---|---|---|---|---|---|
| | | | | | | | 5,283 17 |
| 3784 | 2/27 | | 96 03 | ✓ | | | −96 03 |
| | | | | | | | 5,187 14 |
| 3785 | 3/5 | | 346 18 | | | | −346 18 |
| | | | | | | | 4840 96 |
| 3786 | 3/5 | | 142 38 | ✓ | | | −142 38 |
| | | | | | | | 4698 58 |
| 3787 | 3/11 | | 487 93 | ✓ | | | −487 93 |
| | | | | | | | 4,210 65 |
| 3788 | 3/11 | | 973 12 | ✓ | | | −973 12 |
| | | | | | | | 3,237 53 |
| 3789 | 3/15 | | 72 83 | | | | −72 83 |
| | | | | | | | 3,164 70 |
| Dep. | 3/15 | | | ✓ | | 1,600 00 | +1,600 00 |
| | | | | | | | 4,764 70 |
| 3790 | 3/17 | | 146 17 | | | | −146 17 |
| | | | | | | | 4,618 53 |
| 3791 | 3/20 | | 152 03 | | | | −152 03 |
| | | | | | | | 4,466 50 |
| 3792 | 3/31 | ★ | 182 08 | ✓ | | | −182 08 |
| | | | | | | | 4,284 42 |
| Deposit | 3/31 | | | ✓ | | 2000 00 | +2,000 00 |
| | | | | | | | 6,284 42 |
| | 3/31 | adjust for check # 3792 add 0.05 back | | ✓ | | | +.05 |
| | | | | | | .05 | 6,284 47 |
| | 3/17 | Return check charge | 19 00 | ✓ | | | −19 00 |
| | 3/31 | statement Reconciled | | | | | 6,265 47 |

REMEMBER TO RECORD AUTOMATIC PAYMENTS/DEPOSITS ON DATE AUTHORIZED.

| $ 6,982 68 | BALANCE AS SHOWN ON BANK STATEMENT | | BALANCE AS SHOWN IN YOUR REGISTER | $ 6,284 42 |
|---|---|---|---|---|
| 0 | TOTAL OF OUTSTANDING DEPOSITS | | SUBTRACT AMOUNT OF SERVICE CHARGE | 0 00 |
| 6,982 68 | NEW TOTAL | | NEW TOTAL | 6,284 42 |
| −717 21 | SUBTRACT TOTAL OF OUTSTANDING CHECKS | SHOULD EQUAL | ADJUSTMENTS IF ANY | −18 95 |
| $6,265 47 | YOUR ADJUSTED STATEMENT BALANCE | | YOUR ADJUSTED REGISTER BALANCE | $6,265 47 |

| Outstanding Deposits (Credits) | |
|---|---|
| Date | Amount |
| | $ 0 |
| | |
| | |
| | |
| | |
| Total | $ 0 |

| Outstanding Checks (Debits) | | |
|---|---|---|
| Check Number | Date | Amount |
| 3785 | 3/5 | $ 346 18 |
| 3789 | 3/15 | 72 83 |
| 3790 | 3/17 | 146 17 |
| 3791 | 3/17 | 152 03 |
| | | |
| | Total | $ 717 21 |

11.

| $ 860 21 | BALANCE AS SHOWN ON BANK STATEMENT | | BALANCE AS SHOWN IN YOUR REGISTER | $ 1,817 93 |
|---|---|---|---|---|
| +1,212 13 | TOTAL OF OUTSTANDING DEPOSITS | | SUBTRACT AMOUNT OF SERVICE CHARGE | −15 00 |
| 2,072 34 | NEW TOTAL | | NEW TOTAL | 1,802 93 |
| −483 24 | SUBTRACT TOTAL OF OUTSTANDING CHECKS | SHOULD EQUAL | ADJUSTMENTS IF ANY | −213 83 |
| $1,589 10 | YOUR ADJUSTED STATEMENT BALANCE | | YOUR ADJUSTED REGISTER BALANCE | $1,589 10 |

| Outstanding Deposits (Credits) | |
|---|---|
| Date | Amount |
| | $ 800 00 |
| | 412 13 |
| | |
| | |
| | |
| Total | $ 1,212 13 |

| Outstanding Checks (Debits) | | |
|---|---|---|
| Check Number | Date | Amount |
| | | $ 243 17 |
| | | 167 18 |
| | | 13 97 |
| | | 42 12 |
| | | 16 80 |
| | Total | $ 483 24 |

5-1

1. $A = 4$ **3.** $C = 8$ **5.** $R = 36$ **7.** $B = 5$ **9.** $R = 21$ **11.** $X = 84$
13. $A = 6$ **15.** $B = 4$ **17.** $K = 4$ **19.** $C = 20$ **21.** $A = 5$ **23.** $K = 20$
25. $J = 7$ **27.** $B = 3$ **29.** $X = 6$ **31.** $B = 8$ **33.** $N = 3$ **35.** $N = 8$

5-2

1. The number of full-time hours is 9.

3. 132 tie-dyed shirts sold

5. 4 boxes of felt-tip pens and 8 boxes of ballpoint pens

7. 131,304,347.8 shares of stock

9. $\frac{5}{6}$ of a cup of milk

11. The seller pays $1,740.75 and the buyer pays $580.25.

13. Charris' salary is $17,155.20 and Chloe's is $11,436.80.

15. $N = 1,527.06$ Yuan

5-3

1. $S = \$39.99$ **3.** $C = \$33.87$ **5.** $C = T - S - I$ **7.** $V = LY$

EXERCISES SET A, P. 171

1. $N = 7$ **3.** $N = 17$ **5.** $A = 24$

7. $x = 11$ **9.** $X = 7$ **11.** The number of cars sold is 9.

13. $96 **15.** $8.75 each hour **17.** 280 headlights were purchased at a total cost of $3,906.
720 taillights were purchased at a total cost of $5,436.

19. $T = \$4,258.72$ **21.** $T = Np$

EXERCISES SET B, P. 173

1. $N = 9$ **3.** $N = 12$ **5.** $A = 12$

7. $B = 5$ **9.** $X = 3$ **11.** 18 cookbooks

13. 27 hours **15.** The purse sells for $43.49. **17.** 1,897 imprints in 1 hour.

19. $C = \$137,509$ **21.** $A = LC$

PRACTICE TEST, P. 175

1. $N = 11$ **2.** $A = 18$ **3.** $A = 5$ **4.** $N = 6$

5. $A = 12$ **6.** $R = 1$ **7.** $N = 9$ **8.** $B = 15$

9. $A = 5$ **10.** $A = 5$ **11.** The new salary is $285. **12.** 130 containers are needed.

13. 116 ceramic cups and 284 plastic cups were sold. The value of the ceramic cups was $464. The value of the plastic cups was $994.

14. The cost of 200 suits is $27,200.

15. The cost of 2,000 pounds of chemicals is $1,940.

16. $N = 1,904.04$ EUR

17. $N = 28,982.147$ JPY **18.** $I = \$27,346.38$ **19.** $D = \$3,173.50$ **20.** $D = I - T$

Section Exercises

6-1

1. 39% **3.** 75% **5.** 292% **7.** 39% **9.** 340% **11.** 225%

13. $\frac{2}{3}$% **15.** 80% **17.** 0.00125 **19.** 1.5 **21.** 0.004 (rounded) **23.** $\frac{3}{5}$

25. $1\frac{4}{5}$ **27.** $\frac{1}{3}$

6-2

1. rate (%) = 48% **3.** rate (%) = unknown number **5.** rate (%) = 15% **7.** $P = 75$
base (of) = 12 base (of) = 158 base (of) = unknown number
portion (is) = unknown portion (is) = 47.4 portion (is) = 80
number

9. $P = 50$ **11.** $B = 54$ **13.** $P = 12$ **15.** $B = 70$

17. $R = 25\%$ **19.** $P = 86$ **21.** $R = 83.55\%$ (rounded) **23.** $B = 4,285.71$ (rounded)

25. $51.66 saved **27.** 74 gallons (rounded) **29.** $6,373.91 original cost **31.** 92%

33. 6% (rounded)

6-3

1. 2,309 **3.** $P = 108$ **5.** 33.75 **7.** 50% **9.** 875

11. 7% **13.** $1,752.75 **15.** $14.72 **17.** 12.5%

EXERCISES SET A, P. 201
1. 23% **3.** 3% **5.** 60.1% **7.** 300% **9.** 20% **11.** 17%

13. 52% **15.** 125% **17.** 0.0025 **19.** 2.56 **21.** 0.005 **23.** $\frac{1}{10}$

25. $\frac{89}{100}$ **27.** $2\frac{1}{4}$ **29.** 12.5%; $\frac{1}{8}$ **31.** $P = 81$ **33.** $B = \$12,000$ **35.** $R = 250\%$

37. $B = 30$ **39.** $169.26 **41.** 2,270 people **43.** 26% (rounded) is *not* within the budgeted 25% **45.** $145

EXERCISES SET B, P. 203
1. 67.5% **3.** 0.7% **5.** 0.04% **7.** 24.2% **9.** 99% **11.** 65% **13.** 40%

15. 3.284 **17.** 0.52 **19.** 0.0002 **21.** $\frac{1}{5}$ **23.** $3\frac{61}{100}$ **25.** $\frac{1}{8}$ **27.** $\frac{1}{2}$; 0.5

29. 45%; $\frac{9}{20}$ **31.** $R = 200\%$ **33.** $R = 80\%$ **35.** $B = 305.88$ **37.** 115 **39.** $54 **41.** 540 fuses

43. $2,754.70 **45.** $56

PRACTICE TEST, P. 205
1. 24% **2.** 92.5% **3.** 60% **4.** 21% **5.** 37.5%

6. $\frac{1}{400}$ **7.** $72 **8.** 250% **9.** 87.5%, or $87\frac{1}{2}$% **10.** $2.52

11. 22 rooms **12.** 3% **13.** 90 employees **14.** $2.92 tip; Total bill = $22.39 **15.** 56,600 automobiles

16. 55% **17.** $92,287.80 **18.** $140,790 **19.** $486 **20.** $271.19

7-1

1. 5,470

3. $15,679

5. 79.5

7. No score is reported more than once so there is no mode.

9. $14,978

11. a. $34,746

b. $34,991

c. There is no mode.

13. $29,840

15.

| Class Intervals | Tally | Class Frequency |
|---|---|---|
| 60–69 | // | 2 |
| 70–79 | /// | 3 |
| 89–89 | ₩₦ /// | 8 |
| 90–99 | ₩₦ // | 7 |

17.

| Class Intervals | Tally | Class Frequency |
|---|---|---|
| $0-$9.99 | ₩₦ ₩₦ | 10 |
| $10-$19.99 | ₩₦ //// | 9 |
| $20-$29.99 | ₩₦ | 5 |
| $30-$39.99 | /// | 3 |
| $40-$49.99 | /// | 3 |

19. 10%

7-2

1. Highest: Saturday ($611.77); lowest: Monday ($233.94)

3.

Salespersons at Happy's Gift Shoppe

5. April–June

7. 50%

9. 40 mph

11. 20 mph; compact car

13. Take-home pay = $1,600
Transportation percent = 10%

15. Percent of take home pay allocated for food = 25%.

17. 20%

19. $1000; 2.5%

21. Yes, the salary percent of increase was 13.9%, and it exceeded the rate of inflation.

7-3

1. 13

3. 1, 7, −6, −1, −1

5. 22

7. a. 15.87 scores (approximately 16 scores)
b. 97.72 scores (approximately 98 scores)

9. 12

11. 90

13. 4.242640687 or 4.24 (rounded)

EXERCISES SET A, P. 245

1. Range = 14;
Mean = 22;
Median = 22, there is no mode

3. Range = $9.27;
Mean = $8.42;
Median = $5.53 (rounded);
Mode = $13.95

5.
1 = 291
2 = 624
3 = 799
4 = 790
5 = 801
6 = 640
7 = 639
8 = 584
9 = 293
10 = 123

7. Period 10

9. Early and late classes have lower enrollment than mid-morning classes.

11. 2006: $125,115; 2007: $137,340

13. Sales for The Family Store, 2006–2007

| | 2006 | 2007 |
|-------------------|-----------|-----------|
| Girls' clothing | $ 74,675 | $ 81,534 |
| Boys' clothing | 65,153 | 68,324 |
| Women's clothing | 125,115 | 137,340 |
| Men's clothing | 83,895 | 96,315 |

15. September

17. 20%

19. $153

21. Mean = 87.1;
Median = 88;
Mode—no mode

23. 6.402256547 or 6.4

EXERCISES SET B, P. 249

1. Range = 32; Mean = 74.33; Median = 71; No mode

3. Range = 0.17; Mean = 1.145 kg;
Median = 1.125 kg; Mode = 1.1 kg

5. misc. expenses and general government

7. education costs

9. 90°

11.

13. 15.1%

15. $69,000 cost of house with furnishings; 80.2%

17. 276°

19.

21. range = 13;
There are two modes: 89, 90

23. 79

Automobile Dealership's New and Repeat Business

PRACTICE TEST, P. 253

1. a. 77; b. 41.8;
c. 29.5; d. 15

2. $120

3. 37.5%

4. 33.3%

5. 29.2%

6. labor: 135°;
materials: 120°;
overhead: 105°

7.

8. fresh flowers: $23,712; silk flowers: $17,892

9. fresh flowers: $10,380; silk flowers: $5,829

10. c. $5,000; other interval sizes would provide too many or too few intervals.

11.

Sales for Katz Florist, January–June

12. smallest; 250; greatest; 1,117

13.

Sales of Laser Printers by Smart Brothers Computer Store

14. 11 bulbs (rounded)

CHAPTER 8

Section Exercises

8-1

1. $120

3. $58.68 trade discount

5. $234.72 net price

7. $234.72 net price

9. Answers will vary.

11. Notebooks: $22.50;
Loose leaf paper: $8.90;
Ballpoint pens: $23.70;
Total list price = $55.10;
40% trade discount = $22.04;
Net price = $33.06

13. Net price rate = 72%
Net price = $106,766.64

8-2

1. $17,095.73 total net price of TVs

3. $595.58

5. $72.90 trade discount; $196.10 net price

7. The better deal is $189.97 with discounts of 5/5/10.

9. The better deal is $1,899 with discounts of 5/10/10.

11. The better deal is $410 with a discount series of 10/10/5.

8-3

1. $10.80 cash discount

3. $432 net amount

5. No cash discount allowed. $450 is due.

7. $641.52 net amount

9. $667.44 total bill

11. $1,257.56 net amount

13. $1,225 net amount

15. $478.21 net amount

17. No cash discount allowed. $900 is due.

19. No cash discount allowed. $392.34 is due.

21. $2,061.86 amount credited to account; $1,920.62 outstanding balance

23. Better Bilt Bicycles paid the freight to the freight company.

25. The vendor pays the shipping company and adds the charge to Phyllis's invoice.

EXERCISES SET A, P. 283

1. $45.00

3. $6.00

5. $307.23

7. Trade discount = $4.00;
Net price = $195.95

9. Net price rate = 96%;
Net price = $315.84

11. Net price rate = 89%;
Net price = $1,419.55

13. Decimal equivalents of complements = 0.9, 0.85, and 0.9;
Net decimal equivalent = 0.6885
Net price = $963.89

15. % form = 76.5%;
Single discount equivalent = 23.5%

17. % form = 74.34%;
Single discount equivalent = 25.66%

19. 16.21% single discount equivalent

21. $102.50

23. $94.50

25. $3.42 net price

27. $60 − $9.45 = $50.55; better deal

29. $5.40

31. $5,139.06

EXERCISES SET B, P. 285

1. $4.80

3. $63.75

5. $0.77

7. Trade discount = $0.83;
Net price = $26.67

9. Complement = 95%;
Net price = $399.95

11. Complement = 92%;
Net price = $3,664.36

13. Decimal equivalents of complements:
0.8(0.85)(0.95);
Net decimal equivalent: 0.646
Net price: $22.61

15. Net decimal equivalent in percent form: 82%;
Single discount equivalent in percent form: 18%

17. Net decimal equivalent in percent form: 75.8%;
Single discount equivalent in percent form: 24.2%

19. 23.05%

21. $0.375 or $0.38

23. $1,179

25. $513 net price

27. $190 less 10% or $171 = better deal

29. $0.50 cash discount

31. $515.46 amount credited;
$310.54 outstanding balance

PRACTICE TEST, P. 287

1. $110 trade discount

2. $532.50 net price

3. $29.24 net price

4. $250 less 20% better deal

5. $47.88 net price

6. 42.4%

7. 0.684 net decimal equivalent

8. 85%

9. $42 trade discount

10. $1,080 net price

11. $2 cash discount

12. 3% discount if she pays on or before September 11.

13. $392 net amount

14. $294.00 net amount

15. $400; no discount if not paid on or after December 21.

16. $31 less 10%, 10%, 5% is the better deal.

17. $201.60 net price for dartboards;
$288 net price for bowling balls
$489.60 total net price

18. Manufacturer

CHAPTER 9

Section Exercises

9-1

1. $50

3. $24

5. a. $84.34
b. $154.34

7. a. $90
b. 150%

9. $4

11. $214

13. $8

15. $1.75

17. a. 80%
b. $318.40

19. 125%

21. 101.5%

23. $268.57

25. $15

9-2

1. 20%

3. 59.8%

5. $1,666.67

7. a. $18.46
b. $6.46

9. 42.8%

11. a. $333.33
b. $233.33

13. 150%

15. 49.6%

17. a. $935.94
b. $336.94

19. a. $7.80
b. $7.20

21. 170.3%

9-3

1. $M = $18; M\% = 37.5\%$

3. $M = $350; M\% = 41.2\%$

5. 49%

7. $0.38 (rounded)

9. $191.95 sale price

11. $101.25 first sale price;
$86.06 second sale price;
Final selling price = $33.75

13. $0.72

15. $4,632

EXERCISES SET A, P. 331

1. $S = \$75$; $C\% = 100\%$; $S\% = 150\%$

5. $C = \$57$; $M\%_{\text{cost}} = 56.14\%$; $M\%_{\text{selling price}} = 35.96\%$

9. $C = \$16.11$; $M = \$2.84$; $M\%_{\text{cost}} = 17.63\%$

13. a. $24
 b. $36

17. 25%

21. a. $50
 b. $199.99

3. $S\% = 100\%$; $M\% = 58\%$; $S = \$90.48$; $M = \$52.48$

7. $C = \$68.45$; $S = \$95.83$; $M\%_{\text{selling price}} = 28.57\%$

11. a. $36
 b. 25%

15. a. $18.50
 b. 31.62%

19. a. $38
 b. 10%

23. First markdown = $9.90;
Sale price = $39.60;
Second markdown = $11.88;
Second sale price = $27.72

EXERCISES SET B, P. 333

1. $C\% = 100\%$; $S = \$5$; $S\% = 125\%$

5. $C = \$486$; $M\%_{\text{cost}} = 42.86\%$; $M\%_{\text{selling price}} = 30\%$

9. $C = \$16.28$; $M = \$15.92$; $M\%_{\text{cost}} = 97.79\%$

13. a. $14.35
 b. $14.35

17. 525%

21. $M = \$12.00$; $N = \$27.99$

3. $S\% = 100\%$; $M\% = 50\%$; $S = \$172$; $M = \$86$

7. $S = \$48.08$; $M\%_{\text{cost}} = 92.32\%$; $M\%_{\text{selling price}} = 48.00\%$

11. a. $19.20
 b. 60%

15. 33.3%

19. $M = \$4.58$; $M\% = 15.3\%$

23. $M = \$200$; $M\% = 16.7\%$

PRACTICE TEST, P. 335

1. $7.16 **2.** $73.80 **3.** $15.50 **4.** $173.25 **5.** $22.68 **6.** $91.65

7. $26.07 **8.** $60.83 **9.** $798.15 **10.** $489.99 **11.** 28.5% **12.** 60%

13. $160 **14.** 40% **15.** $331.31 **16.** $0.35 **17.** $1.67 **18.** 40%

19. $C = \$15.75$;
$M = \$29.25$

20. $C = \$127$;
$M\% = 25.2\%$

CHAPTER 10

Section Exercises

10-1

1. $677.00 **3.** $4,415.00 **5.** $383.80 **7.** $802.95 **9.** $581.12 **11.** $538.32 **13.** $566.05

10-2

1. $14 **3.** $140 **5.** $62.34 **7.** Social Security
tax = $160.15;
Medicare tax = $37.45

9. Social Security tax for
December = $441.01;

Medicare tax for
December = $119.15

11. $997.71

10-3

1. Employer's share of Social
Security and Medicare =
$595;

Employer's tax deposit =
$2,823

3. Total withholding = $409;

Total Social Security =
$305.91;

Total Medicare = $71.54

Employer's tax deposit =
$1,163.90

5. $378.00

7. Payment of $122.64 must be
deposited by April 30.

Payment of $45.36 must be
deposited by January 31 of
the next year since it does not
exceed $100.

EXERCISES SET A, P. 369

1. $483.14

3. $452.80

5. $7,938

7. Her gross weekly earnings are still $425 since a salaried job does not normally pay overtime for hours worked over 40.

9. $722.10

11. $700

13. $1,191.20

15. $11

17. $15

19. $27.41

21. Social Security = $52.20; Medicare = $12.21

23. Social Security = $115.07; Medicare = $26.91

25. Social Security tax = $41.85; Medicare tax = $9.79; Net earnings = $523.16

27.

| Employee | Filing status/allowances | Gross earnings | Withholding | Social Security | Medicare |
|---|---|---|---|---|---|
| Guess, Marthe | Married/2 | $595 | $32 | $36.89 | $8.63 |
| Juarez, Abdul | Married/3 | $983 | $80.18 | $60.95 | $14.25 |
| Pounds, Clay | Single/1 | $2,840 | $653.08 | $176.08 | $41.18 |
| Totals | | | $765.26 | $273.92 | $64.06 |

EXERCISES SET B, P. 371

1. $432.85

3. $318.40

5. $2,648

7. She earns $1,896 because salaried employees do not normally receive overtime pay.

9. $1,076.40

11. $763

13. $579.32

15. $51

17. $41

19. no withholding tax

21. Social Security = $217; Medicare = $50.75

23. Social Security = $76.01; Medicare = $17.78

25. Net pay = $1,426.38

27.

| Employee | Filing status/allowances | Gross earnings | Withholding | Social Security | Medicare |
|---|---|---|---|---|---|
| Chirinos, Chad | Married/4 | $845 | $49.67 | $52.39 | $12.25 |
| Claassen, Lars | Married/1 | $1,295 | $146.59 | $80.29 | $18.78 |
| Naramore, Lera | Single/3 | $4,240 | $1,054.11 | $262.88 | $61.48 |
| Totals | | | $1,250.37 | $395.56 | $92.51 |

PRACTICE TEST, P. 373

1. $1,827

2. $371.91

3. $1,050

4. $1,374.75

5. $1,092

6. $875

7. $706.68

8. Social Security = $31.86; Medicare = $7.45

9. Social Security = $53.40; Medicare = $12.49

10. $20

11. $16

12. $1,138.90

13. Social Security = $45.57; Medicare = $10.66; Withholding = $72.00; Other deductions = $25.12; Net earnings = $581.65

14. Social Security = $41.78; Medicare = $9.77; Withholding tax = $54.00; Other deductions = $12.87; Net earnings = $555.38

15. Social Security = $30.51; Medicare = $7.14; Withholding = $21.00; Net earnings = $433.52

16. Social Security = $35.78; Medicare = $8.37; Withholding tax = $23.00; Other deductions = $4.88; Net earnings = $505.12

17. Social Security = $37.83; Medicare = $8.85; Withholding = $20.00; Net earnings = $543.45

18. $285.66

19. $378

20. 0.8%, or $56

21. $248.70

Section Exercises

11-1

1. I = $264 **3.** I = $989.52 **5.** MV = $3,430 **7.** 0.75 year

9. 1.5 years **11.** MV = $43,743 **13.** R = 0.185, or 18.5% per year **15.** $T = \frac{1}{2}$ year, or 6 months

11-2

1. $213.04 **3.** $67.81 **5.** Non-leap year: 549 days Leap year: 550 days **7.** Exact time: 279 days

9. Exact time: September 16 **11.** $75.21 **13.** $10,463.97

11-3

1. $75 **3.** Discount = $149.50; Proceeds = $3,100.50 **5.** 8.9%

7. $5,138.59 **9.** Answers will vary. The payee may need quick cash and can sell the note to get the cash needed.

EXERCISES SET A, P. 409

1. $120 **3.** (a) $1,539; (b) $5,814 **5.** 9%

7. 3.75 years **9.** $2,812.50 **11.** $\frac{7}{12}$ year

13. $5 **15.** $16 **17.** 117 days

19. Exact time: August 8 **21.** a. = $51.29 b. = $52 **23.** $10,040.56

25. 11.4%

EXERCISES SET B, P. 411

1. $285 **3.** $19,252.80 (interest); $34,532.80 (MV) **5.** 8%

7. 3 years **9.** $800 **11.** $1\frac{1}{2}$ years

13. 10% **15.** $160.33 **17.** 217 days

19. 130 days **21.** September 11 **23.** $79.64 (discount); $1,900.36 (proceeds)

25. He will save $20.20 **27.** 9.2%

PRACTICE TEST, P. 413

1. $60 **2.** $1,500 **3.** 12.5% annually **4.** 2 years

5. 287 days **6.** 168 days **7.** 159 days **8.** $4,100; $4,168.33

9. $210 **10.** $206.80 **11.** $3,450 **12.** $15.11

13. 13.0% **14.** 0.75 or $\frac{3}{4}$ year or 9 months **15.** 8.5% annually **16.** $350

17. $52 **18.** Yes, he saves $27. **19.** $122.26 **20.** $8.66

CHAPTER 12

Section Exercises

12-1

1. $749.20 **3.** $1,375.84 **5.** $760.48 **7.** $213.24 **9.** $69.08 **11.** $87.79 **13.** 11.25% **15.** 11.00%

12-2

1. $\frac{171}{1,830}$ or 0.093 **3.** $190.34 **5.** $\frac{5}{28}$ **7.** $318.54

12-3

1. 1.15% **3.** $37.33 **5.** Average daily balance = $2,138.51; Interest = $17.82

7. $2.19 **9.** $3.61 **11.** Finance charge = $18.21 New balance = $464.65

EXERCISES SET A, P. 443
1. $1,585.96 **3.** $729 **5.** $30.51 **7.** $52.40 **9.** $390.25 **11.** $39.52
13. $3.98 **15.** $462.60 **17.** 13.75% **19.** 21.5% **21.** 14.25%

EXERCISES SET B, P. 445
1. $711 **3.** $577 **5.** $132.14 **7.** $375.65 **9.** $126.35 **11.** $8.85
13. $5.19 **15.** $8.75 finance charge; $611.61 unpaid balance **17.** 13% **19.** 15.75% **21.** 21.5%

PRACTICE TEST, P. 447
1. $34 **2.** $690 installment price; Finance charge = $112 **3.** $336 installment price; Finance charge = $36 **4.** 21.5%

5. 16.25% **6.** $2.89 **7.** 24% **8.** $12.60
9. 11.5% **10.** 10.75% **11.** 21.5% **12.** $875
13. $158.33 **14.** $654 **15.** $240.08 **16.** $393.93 average daily balance $6.89 finance charge $427.84 unpaid balance

17. Finance charge = $11.91 New balance = $746.39

CHAPTER 13

Section Exercises

13-1

1. Compound amount = $5,627.55; Compound interest = $627.55 **3.** Compound amount = $7,887.81; Compound interest = $887.81 **5.** Compound amount = $1,269.73; Compound interest = $269.73

7. $1,873.08 (third year) future value; Compound interest = $673.08; Simple interest = $576 **9.** Compound amount = $8,046.92; Compound interest = $1,746.92 **11.** $720.98

13. $15,373.05 compound amount; Interest = $4,873.05 **15.** $8\frac{1}{4}$% annually is the slightly better deal **17.** Effective rate = 4.06%

19. Effective rate = 6.14% **21.** Compound interest = $9.26 **23.** $27.99

13-2

1. $3,768.72 **3.** $7,880.30 **5.** $2,252.25 **7.** $19,462.47 **9.** $1,587.66 **11.** $6,736.20

EXERCISES SET A, P. 477
1. Compound amount = $2,186.88
Compound interest = $186.88
3. Compound amount = $10,506.30
Compound interest = $506.30
5. $16,407

7. $7,718.19
9. $166.40 interest
11. $5,372.55 future value

13. Future value = $13,928.16
15. $1,052.87 compound amount;
$1,100 in one year would have a greater
yield than $900 invested today
17. $9.23 compound interest;
$2,009.23 compound amount

19. $1,126.97
21. $3,157.64
23. $1,597.41

EXERCISES SET B, P. 479
1. Compound amount = $6,400.40;
Compound interest = $1,400.40
3. Compound amount = $8,541.33;
Compound interest = $1,541.33
5. $2,227.41

7. $13,396.51
9. $52.50
11. $41.22

13. 6.84848
15. $1,215.51 compound amount;
$215.51 compound interest
17. $134.50 compound interest;
$25,116.50 compound amount

19. $1,227.82
21. $3,334.80
23. $435.20

PRACTICE TEST, P. 481
1. $450.09
2. $823.29
3. $3,979.30
4. $18,206.64

5. $1,893.72 compound amount;
$393.72 compound interest
6. $376.53 compound interest
7. 12.55%
8. $8.84

9. Compounding daily yields
slightly higher interest.
10. $2,499.10
11. $2,669.55
12. $2,053.44

13. $2,951.58
14. $5,476.68
15. $680 in one year is better.
16. $6,304.24

17. Option 2 yields the greater
return by $0.68
18. $2,536.48
19. $1,002.74
20. $13,586.96

CHAPTER 14

Section Exercises

14-1

1. $9,549
3. $26,824
5. $21,547.60

7. $945.90
9. $114
11. Harry will have $15,577.22 at the end of
three years.
Interest = $577.22

13. Amount invested = $91,000;
Interest = $20,059
15. The future value is $25,129. Latanya will
have invested 15($1,000) or $15,000
of her own money and will have received
$10,129 in interest.
17. The future value of the annuity is $11,734;
Your investment = $10,000;
Your interest = $1,734

19. The future value is $38,203.52;
Investment = $36,000;
Interest = $2,203.52
21. The future value is $17,546.58;
Investment = $15,600;
Interest = $1,946.58
23. Future value = $60,193.06;
Investment = $52,800;
Interest = $7,393.06

25. The semiannual annuity yields more
interest.

14-2

1. $2,050.02 **3.** $1,037.03 **5.** $839.55 **7.** $6,679.64 **9.** $21,072 **11.** $68,700

EXERCISES SET A, P. 511

| | | | | | |
|---|---|---|---|---|---|
| **1.** $7,432.60 | **3.** $3,979.66 | **5.** $10,311.07 | **7.** $2,270.77 | **9.** $135,900 | **11.** $67,890 |
| **13.** $5,359.69 | **15.** (a) $39,620.70 (b) $96,197.85 | **17.** $7,689.67 | |

EXERCISES SET B, P. 513

| | | | |
|---|---|---|---|
| **1.** $25,482.80 | **3.** $23,603.13 | **5.** $893.18 | **7.** $283.56 |
| **9.** $156,772 | **11.** $163,510 | **13.** $3,641.14 | **15.** $109,336.50 |
| **17.** $17,708.46 | | | |

PRACTICE TEST, P. 515

| | | | | | |
|---|---|---|---|---|---|
| **1.** $18,292.50 | **2.** $8,851.12 | **3.** $37,607.22 | **4.** $5,591.70 | **5.** $5,727.50 | **6.** $11,477.22 |
| **7.** $60,819.20 | **8.** $65,076.54 | **9.** $28,269.88 | **10.** $48,417.60 | **11.** $1,118.23 | **12.** $25,938 |
| **13.** $34,724.80 | **14.** $3,327.06 | **15.** $28,240 | **16.** $21,884 | **17.** $5,591.97 | **18.** $3,584.07 |
| **19.** $19,672.40 | **20.** $10,822.50 | **21.** $13,678.80 | **22.** $3,861 | **23.** $9,583.92 | **24.** $136,775 |

25. $2,136.17 for payment starting at birth; $4,215.60 for payment starting at six years of age

CHAPTER 15

Section Exercises

15-1

| | Purchase price of home | Down payment | Mortgage amount | Annual interest rate | Years | Payment per $1,000 | Monthly mortgage payment | Total paid for mortgage | Interest paid |
|---|---|---|---|---|---|---|---|---|---|
| **1.** | $100,000 | $0 | $100,000 | 5.75% | 30 | $5.84 | $ 584 | $210,240 | $110,240 |
| **3.** | $ 95,000 | $8,000 | $ 87,000 | 5.75% | 25 | $6.29 | $ 547.23 | $164,169 | $ 77,169 |
| **5.** | $495,750 | 18% | $406,515 | 5.00% | 35 | $5.05 | $2,052.90 | $862,218 | $455,703 |

7. Down payment = $38,750;
Mortgage amount = $116,250;
Monthly payment = $697.50

9. $51,336

15-2

1.

| Month | Monthly payment | Interest | Principal | End-of-month principal |
|---|---|---|---|---|
| 1 | $584 | $479.17 | $104.83 | $99,895.17 |
| 2 | $584 | $478.66 | $105.34 | $99,789.83 |

3.

| Month | Monthly payment | Interest | Principal | End-of-month principal |
|---|---|---|---|---|
| 1 | $547.23 | $416.88 | $130.35 | $86,869.65 |
| 2 | $547.23 | $416.25 | $130.98 | $86,738.67 |

5.

| Month | Monthly payment | Interest | Principal | End-of-month principal |
|---|---|---|---|---|
| 1 | $2,052.90 | $1,693.81 | $359.09 | $406,155.91 |
| 2 | $2,052.90 | $1,692.32 | $360.58 | $405,795.33 |

7. Month 1 interest = $406.58;
Principal portion of 1st payment = $133.60;
End-of-month principal = $69,566.40;
Month 2 interest = $405.80;
Principal portion of 2nd payment = $134.38;
End-of-month principal = $69,432.02

9.

| Month | Monthly payment | Interest | Principal | End-of-month principal |
|---|---|---|---|---|
| 1 | $1,825.40 | $1,489.63 | $335.77 | $209,964.23 |
| 2 | $1,825.40 | $1,487.25 | $338.15 | $209,626.08 |

11. 29%

EXERCISES SET A, P. 539

1. $2,018.25 **3.** $1,005.18 **5.** $196,880 **7.** $149,254

9.

| Month | Monthly payment | Interest | Principal | End-of-month principal |
|---|---|---|---|---|
| 1 | $2,926.20 | $2,438.50 | $487.70 | $487,212.30 |
| 2 | $2,926.20 | $2,436.06 | $490.14 | $486,722.16 |

11. $1,743.66 **13.** 28%

EXERCISES SET B, P. 541

1. $2.926.20 **3.** $619.26 **5.** $565,732 **7.** $177,189.20

9.

| Month | Monthly payment | Interest | Principal | End-of-month principal |
|---|---|---|---|---|
| 1 | $1,005.18 | $793.23 | $211.95 | $152,088.05 |
| 2 | $1,005.18 | $792.13 | $213.05 | $151,875.00 |

11. $2,885.87 **13.** 35%

PRACTICE TEST, P. 543

1. 6.44 **2.** $1,607.70 **3.** $348,772 **4.** 151.64% **5.** $39,400

6. $157,600 **7.** $3,152 **8.** $1,416.82 **9.** $97,427.60

10. Monthly payment = $1,048.04; Interest = $219,694.40

11. $122,266.80 **12.** Interest = $919.33; Principal portion = $497.49

13.

Portion of payment applied to:

| Month | Monthly payment | Interest | Principal | End-of-month principal |
|---|---|---|---|---|
| 1 | $1,416.82 | $919.33 | $497.49 | $157,102.51 |
| 2 | $1,416.82 | $916.43 | $500.39 | $156,602.12 |
| 3 | $1,416.82 | $913.51 | $503.31 | $156,098.81 |

14.

Portion of payment applied to:

| Month | Monthly payment | Interest | Principal | End-of-month principal |
|---|---|---|---|---|
| 1 | $1,048.04 | $919.33 | $128.71 | $157,471.29 |
| 2 | $1,048.04 | $918.58 | $129.46 | $157,341.83 |
| 3 | $1,048.04 | $917.83 | $130.21 | $157,211.62 |

15. 37%

Account register: a separate form for recording all checking account transactions. It also shows the account balance, 107

Accumulation phase of an annuity: the time when money is being paid into the fund and earnings are being added to the fund, 488

Addends: numbers being added, 9

Adjustable-rate mortgage: the interest rate may change during the time of the loan, 524

Adjusted balance due at maturity: the remaining balance due at maturity after one or more partial payments have been made, 394

Adjusted gross income: the income that remains after allowable adjustments have been made, 349

Adjusted principal: the remaining principal after a partial payment has been properly credited, 394

Adjustment: amount that can be subtracted from the gross income, such as qualifying IRAs, tax-sheltered annuities, 401k's, or employer-sponsored child care or medical plans, 349

Adjusted statement balance: consists of the balance on the bank statement plus any outstanding deposits minus any outstanding checks, 115

Amortization: the process for repaying a loan through equal payments at a specified rate for a specific length of time, 524

Amortization schedule: a table that shows the balance of principal and interest for each payment of the mortgage, 530

Amount credited: the sum of the partial payment and the partial discount, 274

Amount financed: the cash price minus the down payment, 422; the total amount that is to be paid in regular payments, 488

Annual percentage rate (APR): the true rate of an installment loan that is equivalent to an annual simple interest rate; effective rate of interest for a loan, 424, 461
tables, 425–427

Annual percentage yield (APY): effective rate of interest for an investment, 461

Annuity: a contract between a person (the annuitant) and an insurance company (the insurer) for receiving and disbursing money for the annuitant or the beneficiary of the annuitant, 488

Annuity certain: an annuity paid over a guaranteed number of periods, 488

Annuity due: an annuity for which payments are made at the beginning of each period, 488

Annuity payment: a series of equal periodic payments put into an interest-bearing account for a specific number of periods, 488
annuity due, 488
ordinary annuity future value tables, 488
simple interest basis of annuity future value, 488

Approximate number: a rounded amount, 7

Associative property of addition: when more than two numbers are added, the addends can be grouped two at a time in any way, 9

Automatic drafts: periodic withdrawals that the owner of an account authorizes to be made electronically, 105

Automatic teller machine (ATM): an electronic banking station that accepts deposits and disburses cash when you use an authorized ATM card, a debit card, or some credit cards, 104, 114

Average daily balance: the average of the daily balances for each day of the billing cycle, 433

Average daily balance method: the daily balances of the account are determined, then the sum of these balances is divided by the number of days in the billing cycle. This is then multiplied by the monthly interest rate to find the finance charge for the month, 433

Bank discount: the interest or fee on a discounted note that is subtracted from the amount borrowed at the time the loan is made, 396

Bank draft: *See* Check, 104

Bank memo: a notification of a transaction error, 104

Bank reconciliation: the process of making the account register agree with the bank statement, 114
bank statements, 114
checking account forms, 102

Bank statement: an account record periodically provided by the bank for matching your records with the bank's records, 114

Banker's rule: calculating interest on a loan based on ordinary interest—which yields a slightly higher amount of interest, 393

Bar graph: a graph that uses horizontal or vertical bars to show how values compare to each other, 224

Base: the original number or one entire quantity, 186

Bill of lading: shipping document that includes a description of the merchandise, number of pieces, weight, name of consignee (sender), destination, and method of payment of freight charges, 275

Billing cycle: the days that are included on a statement or bill, 433

Biweekly: every two weeks or 26 times a year, 342

Biweekly mortgage: payment made every two weeks for 26 payments per year, 524

Borrow: regroup digits in the minuend by borrowing 1 from the digit to the left of a specified place and adding 10 to the digit in the specified place, 12

By inspection: using your number sense to mentally perform a mathematical process, 39

Cash discount: a discount on the amount due on an invoice that is given for prompt payment, 269
calculating using ordinary dating terms, 270
partial, 274

Cash price: the price if all charges are paid at once at the time of the purchase, 422

Catalog price: suggested price at which merchandise is sold to consumers, 260

Check: a banking form for recording the details of a withdrawal, 104

Checking account: a bank account for managing the flow of money into and out of the account, 102

Check stub: a form attached to a check for recording checking account transactions that shows the account balance, 107

Circle graph: a circle that is divided into parts to show how a whole quantity is being divided, 247

Class frequency: the number of tallies or values in a class interval, 236

Class intervals: special categories for grouping the values in a data set, 236

Closed-end credit: a type of installment loan in which the amount borrowed and the interest are repaid in a specified number of equal payments, 422

Collateral: the property that is held as security on a mortgage, 524

Commission: earnings based on sales, 345

Commission rate: the percent used to calculate the commission based on sales, 345

Commutative property of addition: two numbers can be added in either order without changing the sum, 9

Comparative bar graph: bar graph with two or more variables, 226

Compass: a tool for drawing circles, 229

Complement of a percent: the difference between 100% and the given percent, 261

Component bar graph: bar graph with each bar having more than one component, 226

Compound amount: *See* Future value, 454

Compound interest: the total interest that accumulates after more than one interest period, 454
finding the effective interest rate, 461
finding the future value, 454
finding the interest compounded daily, 462
finding the present value, 467–468
using the simple interest formula to find the future value, 454

Consumer credit: a type of credit or loan that is available to individuals or businesses. The loan is repaid in regular payments, 422
annual percentage rates, 424
installment loans, 422
open-end credit, 433
rule of 78, 430

Contingent annuity: an annuity paid over an uncertain number of periods, 456

Conventional mortgage: mortgage that is not insured by a government program, 524

Cost: price at which a business purchases merchandise, 296

Credit: a transaction that increases an account balance, 102

Credit memo: a notification of an error that increases the account balance, 104

Cross product: the product of the numerator of one fraction times the denominator of the other fraction of a proportion, 152

Data set: a collection of values or measurements that have a common characteristic, 214

Debit: a transaction that decreases an account balance, 104

Debit card: a card that can be used like a credit card but the amount of debit (purchase or withdrawal) is deducted immediately from the checking account, 105

Debit memo: a notification of an error that decreases the account balance, 104

Debt-to-income or back-end ratio: fixed monthly expenses divided by the gross monthly income, 532

Decimal part: the digits to the right of the decimal point, 74

Decimal point: the notation that separates the whole-number part of a number from the decimal part, 74

Decimal system: a place-value number system based on 10, 74

Decimals:
 adding and subtracting, 77
 multiplying and dividing, 78, 80–81
 reading, writing, and rounding, 74–75
 writing a decimal as a fraction and a fraction as a decimal, 84–86

Denominator: the number of a fraction that shows how many parts one whole quantity is divided into. It is also the divisor of the indicated division, 36

Deposit: a transaction that increases an account balance; this transaction is also called a credit, 102

Deposit ticket: a banking form for recording the details of a deposit, 102

Deviation from the mean: the difference between a value of a data set and the mean, 234

Difference: the answer or the result of subtraction, 12

Differential piece rate (escalating piece rate): piecework rate that increases as more items are produced, 344

Digit: one of the ten symbols used in the decimal-number system (0, 1, 2, 3, 4, 5, 6, 7, 8, 9), 4

Discount: an amount of money that is deducted from an original price, 260

Discount period: the amount of time that the third party owns the third-party discounted note, 398

Discount rate: a percent of the list price, 260

Discounted note: a promissory note for which the interest or fee is discounted or subtracted at the time the loan is made, 397

Dividend: the number being divided or the total quantity, 15

Divisor: the number divided by, 15

Down payment: a partial payment that is paid at the time of the purchase, 422

Effective interest rate for a simple discount note: the actual interest rate based on the proceeds of the loan, 397

Effective rate: the simple interest rate that is equivalent to a compound rate, 461

Electronic deposit: a deposit that is made by an electronic transfer of funds, 104

Electronic funds transfer (EFT): a transaction that transfers funds electronically, 104

Employers payroll taxes, 358

End-of-month (EOM) terms: a discount is applied if the bill is paid within the specified days after the end of the month. An exception occurs when an invoice is dated on or after the 26th of a month, 272

Endorsement: a signature, stamp, or electronic imprint on the back of a check that authorizes payment in cash or directs payment to a third party or account, 109

Equation: a mathematical statement in which two quantities are equal, 146
 solving using addition or subtraction, 147
 solving using more than one operation, 148–149
 solving using multiplication or division, 146
 solving with multiple unknowns, 150
 solving with parentheses, 151–152
 solving with proportions, 152–153
 using to solve problems, 155

Equity: the difference between the expected selling price and the balance owed on property, 524

Equity line of credit: a revolving, open-end account that is secured by real property, 524

Equivalent fractions: fractions that indicate the same portion of the whole amount, 39

Escalating piece rate: *See* Differential piece rate, 344

Escrow: an account for holding the part of a monthly payment that is to be used to pay taxes and insurance. The amount accumulates and the lender pays the taxes and insurance from this account as they are due, 527

Estimate: to find a reasonable approximate answer for a calculation, 9

Exact interest rate: a rate per day that assumes 365 days per year, 392

Exact time: time that is based on counting the exact number of days in a time period, 389

Face value: the amount borrowed; the maximum amount of insurance provided by a policy, 396

Factor: each number involved in multiplication, 13

Federal Housing Administration (FHA): a governmental agency within the U.S. Department of Housing and Urban Development (HUD) that insures residential mortgage loans. To receive an FHA loan, specific construction standards must be met and the lender must be approved, 524

Federal unemployment (FUTA) tax: a federal tax required of most employers.

The tax provides for payment of unemployment compensation to workers who have lost their jobs, 360

Federal tax withholding: the amount required to be withheld from a person's pay to be paid to the federal government, 347
 rates and the percentage method, 352

Finance charges (carrying charges): the interest and any fee associated with an installment loan, 422

First mortgage: the primary mortgage on a property, 524

Fixed-rate mortgage: the interest rate remains the same for the entire loan, 524

FOB destination: free on board at the destination point. The seller pays the shipping when the merchandise is shipped, 276

FOB shipping point: free on board at the shipping point. The buyer pays the shipping when the shipment is received, 275

Formula: a relationship among quantities expressed in words or numbers and letters, 186
 writing to find an unknown value, 187–188

Fraction line: the line that separates the numerator and denominator. It is also the division symbol, 36

Fractions:
 adding and subtracting, 52–57
 decimal, 74
 equivalent, 39
 identifying types of, 36
 multiplying and dividing, 50–54
 proper and improper, 36–39
 reducing, 39
 refund, 430

Freight collect: the buyer pays the shipping when the shipment is received, 275

Freight paid: the seller pays the shipping when the merchandise is shipped, 276

Freight payment terms, 275

Future value, maturity value, compound amount: the accumulated principal and interest after one or more interest periods, 454

Good faith estimate: an estimate of the mortgage closing costs that lenders are required to provide to the buyer in writing prior to the loan closing date, 527

Graduated payments mortgage: payments at the beginning of the loan are smaller and they increase during the loan, 524

Graph: a symbolic or pictorial display of numerical information, 224

Greatest common divisor (GCD): the greatest number by which both parts of a fraction can be evenly divided, 39

Gross earnings (gross pay): the amount earned before deductions, 342
 based on commission, 345
 based on hourly wage, 343
 based on piecework wage, 344
 based on salary, 342

Gross pay, 342

Grouped frequency distribution: a compilation of class intervals, tallies, and class frequencies of a data set, 218

Higher terms: a fraction written in an equivalent value, determined by multiplying the numerator and denominator by the same number; the process is used in the addition and subtraction of fractions, 40

Histogram: a special type of bar graph that represents the data from a frequency distribution, 225

Hourly rate (hourly wage): the amount of pay per hour worked based on a standard 40-hour work week, 343

Hourly wage: *See* Hourly rate, 343

Housing or front-end ratio: monthly housing expenses (PITI) divided by the gross monthly income, 532

Improper fraction: a fraction with a value that is equal to or greater than 1. The numerator is the same as or greater than the denominator, 36

Income tax: local, state, or federal tax paid on one's income, 347

Index numbers: numbers that represent percent of change for several successive operating time periods (usually years) while keeping one selected year (base year) to represent the base or 100%

Installment loan: a loan that is repaid in regular payments, 422

Installment payment: the amount that is paid (including interest) in regular payments, 422

Installment price: the total amount paid for a purchase, including all payments, the finance charges, and the down payment, 422

Interest: an amount paid or earned for the use of money, 382

Interest period: the amount of time after which interest is calculated and added to the principal, 454

Isolate: perform systematic operations to both sides of the equation so that the unknown or variable is alone on one side of the equation. Its value is identified on the other side of the equation, 146

Known amount (given amount): the known amounts or numbers in an equation, 146

Knuckle method, 269

Leading earnings: a company's projected earnings-per-share for the upcoming 12-month period.

Least common denominator (LCD): the smallest number that can be divided evenly by each original denominator, 43

Line graph: line segments that connect points on a graph to show the rising and falling trends of a data set, 227

Line-of-credit accounts: a type of open-end loan, 433

Liquidation or payout phase of an annuity: the time when the annuitant or beneficiary is receiving money from the fund, 488

List price: suggested price at which merchandise is sold to consumers, 260

Loan-to-value ratio : the amount mortgaged divided by the appraised value of the property, 532

Lowest terms: the form of a fraction when its numerator and denominator cannot be evenly divided by any whole number except 1, 39

Maker: the one who is authorizing the payment of the check; the person or business that borrows the money, 104, 396

Margin: markup or gross profit, 296

Markdown: amount the original selling price is reduced, 296, 316

Markup (gross profit or gross margin): the difference between the selling price and the cost, 296

comparing markup based on cost with markup based on selling price, 311

finding final selling price for a series of markups, 318

finding the selling price to achieve a desired profit, 320

using cost as a base in markup applications, 296

using selling price as a base in markup applications, 305

Mathematical operations: calculations with numbers. The four operations that are often called basic operations are addition, subtraction, multiplication, and division, 4

Maturity date: the date on which the loan is due to be repaid. 396

Maturity value: the total amount of money due at the end of a loan period—the amount of the loan and the interest, 383

Mean: the arithmetic average of a set of data or the sum of the values divided by the number of values, 214

Measures of central tendency: statistical measurements such as the mean, median, or mode that indicate how data group toward the center, 233

Measures of variation or dispersion: statistical measurements such as the range and standard deviation that indicate how data are dispersed or spread, 233

Median: the middle value of a data set when the values are arranged in order of size, 215

Medicare tax: a federal tax used to provide health-care benefits to retired and disabled workers, 354

Minuend: the beginning amount or the number that a second number is subtracted from, 12

Mixed number: an amount that is a combination of a whole number and a fraction, 37–39

adding, 44

multiplying and dividing, 50, 52–53

subtracting, 46

Mixed percents: percents with mixed numbers, 182

Mode: the value or values that occur most frequently in a data set, 216

Monthly: once a month or 12 times a year, 342

Monthly mortgage payment: the amount of the equal monthly payment that includes interest and principal, 524

Mortgage: a loan in which real property is used to secure the debt, 524

amortization schedule, 530–531

monthly mortgage payment and total interest, 524

See also individual types

Mortgage closing costs: fees charged for services that must be performed to process and close a home mortgage loan, 527

Multiplicand: the number being multiplied, 13

Multiplier: the number multiplied by, 13

Net amount: the amount you owe if a cash discount is applied, 271

Net decimal equivalent: the decimal equivalent of the net price rate for a series of trade discounts, 264

Net earnings (net pay or take-home pay): the amount of your paycheck, 342

Net pay: *See* Net earnings, 342

Net price: the price the wholesaler or retailer pays, or the list price minus the trade discount, 260

calculating using ordinary dating terms, 269

calculating using receipt-of-goods terms, 273

freight terms and, 275–276

net decimal equivalent and, 264

single discount equivalent and, 266

trade discount series and, 264

Net price rate: the complement of the trade discount rate, 262

Net profit: difference between markup (gross profit or gross margin) and operating expenses and overhead, 296

New amount: the ending amount after an amount has changed (increased or decreased), 192

Nonsufficient funds (NSF) fee: a fee charged to the account holder when a check is written for which there are not sufficient funds, 114

Nonterminating or repeating decimal: a quotient that never comes out evenly. The digits will eventually start to repeat, 86

Normal distribution: a characteristic of many data sets that shows that data graphs into a bell-shaped curve around the mean, 236

Numerator: the number of a fraction that shows how many parts are considered. It is also the dividend of the indicated division, 36

Online banking services: a variety of services and transaction options that can be made through Internet banking, 105

Open-end credit: a type of installment loan in which there is no fixed amount borrowed or fixed number of payments. Payments are made until the loan is paid off, 422

average daily balance method, 433

Opposites: a positive and negative number that represent the same distance from 0 but in opposite directions, 235

Order of Operations: the specific order in which calculations must be performed to evaluate a series of calculations, 149

Ordinary annuity: an annuity for which payments are made at the end of each period, 488

Ordinary annuity future value table, 490

Ordinary interest rate: a rate per day that assumes 360 days per year, 392

Outstanding balance: the invoice amount minus the amount credited, 274

Outstanding checks: checks that have been written and given to the payee but have not been processed at the bank, 114

Outstanding deposits: deposits that have been made but have not yet been posted to the maker's account, 114

Overtime pay: earnings based on overtime rate of pay, 343

Sinking fund: payment into an ordinary annuity to yield a desired future value, 500
payments, 501
present value of an ordinary annuity, 502

Social Security tax: a federal tax that goes into a fund that pays monthly benefits to retired and disabled workers, 354
calculating employee's contribution to, 342
employer's contribution to, 358–359

Solve: find the value of the unknown or variable that makes the equation true, 146

Spread: the variation or dispersion of a set of data, 233

Standard bar graph: bar graph with just one variable, 225

Standard deviation: a statistical measurement that shows how data are spread above and below the mean. The square root of the variance is the standard deviation, 235

State unemployment (SUTA) tax: a state tax required of most employers. The tax also provides payment of unemployment compensation to workers who have lost their jobs, 360

Statistic: a standardized, meaningful measure of a set of data that reveals a certain feature or characteristic of the data, 214
mean, 214
median, 215
mode, 216
range, 233
standard deviation, 235
variance, 235

Straight commission: entire pay based on sales, 345

Straight piecework rate: piecework rate where the pay is the same per item no matter how many items are produced, 344

Subtrahend: the number being subtracted, 12

Suggested retail price, catalog price, list price: three common terms for the price at which the manufacturer suggests an item should be sold to the consumer, 260

Sum or total: the answer or result of addition, 9

Symmetrical: a figure that if folded at a middle point, the two halves will match, 236

Take-home pay: *See* Net earnings (net pay), 342

Tally: a mark that is used to count data in class intervals, 218

Tax-filing status: status based on whether the employee is married, single, or a head of household that determines the tax rate, 347

Term: the length of time for which the money is borrowed, 396

Terminating decimal: a quotient that has no remainder, 86

Third party: an investment group or individual that assumes a note that was made between two other parties, 398

Third-party discount note: a note that is sold to a third party (usually a bank) so that the original payee gets the proceeds immediately and the maker pays the third party the original amount at maturity, 398

Time: the number of days, months, or years that money is borrowed or invested, 382

Time and a half: standard overtime rate that is $1\frac{1}{2}$ (or 1.5) times the hourly rate, 343

Total: *See* Sum, 9

Total (or installment) price: the total amount that must be paid when the purchase is paid for over a given period of time, 422

Trade discount: the amount of discount that the wholesaler or retailer receives off the list price, or the difference between the list price and the net price, 260

Trade discount series (chain discount): more than one discount deducted one after another from the list price, 264

Transaction: a banking activity that changes the amount of money in a bank account, 102

Undiscounted note: another term for a simple interest note, 397

Unemployment taxes, 360

Unknown (variable): the missing amount or amounts that are represented as letters in an equation, 146

Updated check register balance: consists of the checkbook balance minus any fees and minus any returned items, 107

U.S. rule: any partial loan payment first covers any interest that has accumulated. The remainder of the partial payment reduces the loan principal, 394

Variance: a statistical measurement that is the average of the squared deviations of data from the mean, 235

Veterans Administration (VA): a governmental agency that guarantees the repayment of a loan made to an eligible veteran. The loans are also called GI loans, 524

W-4 form: form required to be held by the employer for determining the amount of federal tax to be withheld, 348

Wages: earnings based on an hourly rate of pay and the number of hours worked, 342

Weekly: once a week or 52 times a year, 342

Whole number: a number from the set of numbers including zero and the counting or natural numbers (0, 1, 2, 3, 4, . . .), 4

Whole-number part: the digits to the left of the decimal point, 74

Whole numbers:
adding, 9
dividing, 15
multiplying, 13–14
reading and writing, 4, 6
rounding, 7
subtracting, 12

Withdrawal: a transaction that decreases an account balance; this transaction is also called a debit, 104

Withholding allowance (exemption): a portion of gross earnings that is not subject to tax, 347